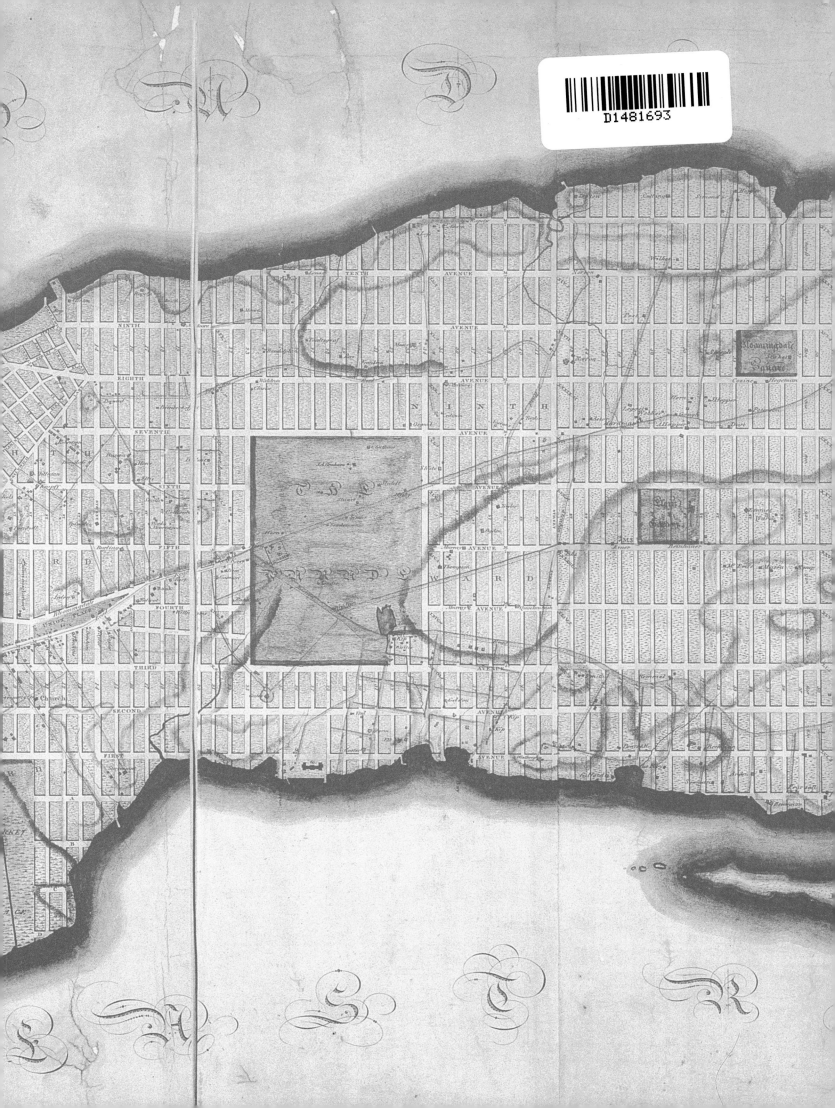

Art and the Empire City
New York, 1825–1861

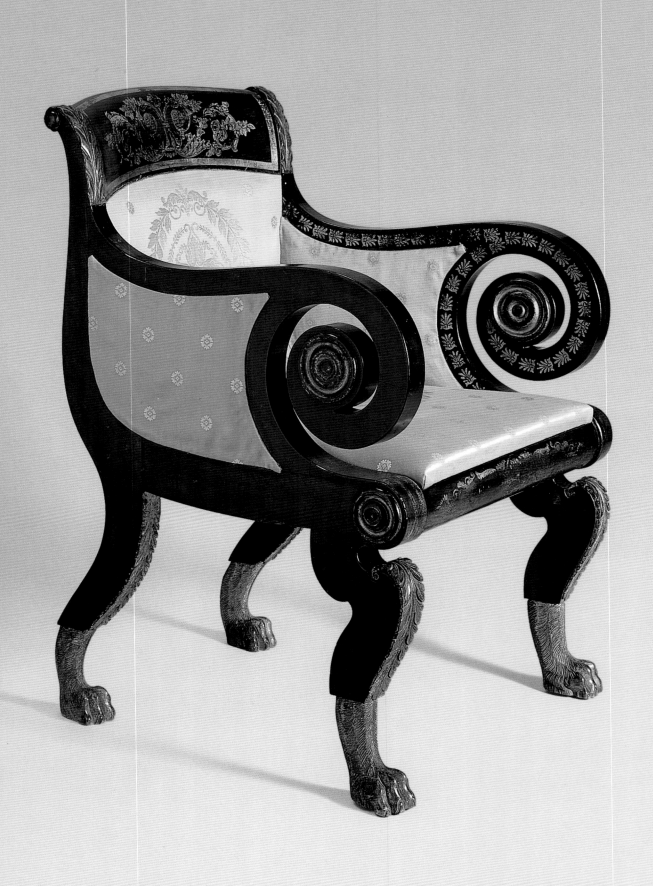

Art and the Empire City
New York, 1825–1861

Edited by Catherine Hoover Voorsanger and John K. Howat

The Metropolitan Museum of Art, New York

Yale University Press, New Haven and London

This volume has been published in conjunction with the exhibition "Art and the Empire City: New York, 1825–1861," organized by The Metropolitan Museum of Art, New York, and held there from September 19, 2000, to January 7, 2001.

The exhibition is made possible by ⟳ *Fleet*

The exhibition catalogue is made possible through the support of the William Cullen Bryant Fellows.

Published by The Metropolitan Museum of Art, New York

John P. O'Neill, Editor in Chief
Carol Fuerstein, Editor, with the assistance of Margaret Donovan
Bruce Campbell, Designer
Peter Antony and Merantine Hens, Production
Robert Weisberg, Computer Specialist
Jean Wagner, Bibliographer

New photography of Metropolitan Museum objects by Joseph Coscia Jr., Anna-Marie Kellen, Paul Lachenauer, Oi-Cheong Lee, Bruce Schwarz, Eileen Travell, Juan Trujillo, Karin L. Willis, and Peter Zeray, the Photograph Studio, The Metropolitan Museum of Art

Galliard typeface designed by Matthew Carter
Printed on Phoenix Imperial 135 gsm
Separations by Professional Graphics, Rockford, Illinois
Printed and bound by Arnoldo Mondadori, S.p.A., Verona, Italy

Jacket/cover illustration: Detail, cat. no. 143, William Wellstood, after Benjamin F. Smith Jr., *New York, 1855, from the Latting Observatory,* 1855
Frontispiece: Cat. no. 221, Unknown cabinetmaker, Armchair, ca. 1825
Endpapers: fig. 5, John Randel Jr., adapted and published by William Bridges, *This Map of the City of New York and Island of Manhattan as Laid Out by the Commissioners,* 1811

Library of Congress Cataloging-in-Publication Data

Art and the empire city : New York, 1825-1861 / edited by Catherine Hoover Voorsanger and John K. Howat.
 p. cm.
 Exhibition held Sept. 19, 2000 through Jan. 7, 2001 at the Metropolitan Museum of Art, New York.
 Includees bibliographical references and index.
 ISBN 0-87099-957-5 (hc. : alk. paper)—ISBN 0-87099-958-3 (pbk. : alk. paper)—0-300-08518-4 (Yale University Press)
 1. Art, American—New York (State)—New York—Exhibitions. 2. Art, Modern—19th century—New York (State)—New York—Exhibitions. I. Voorsanger, Catherine Hoover. II. Howat, John K. III. Metropolitan Museum of Art (New York, N.Y.)

N6535.N5 A28 2000
709'.747'10747471—dc21 00-041855

Contents

Sponsor's Statement

Fleet is proud to sponsor the exhibition "Art and the Empire City: New York, 1825–1861" at The Metropolitan Museum of Art. This beautiful exhibition, which celebrates New York's evolution into the country's cultural and commercial heart, is especially close to ours. Featuring works by Thomas Cole, Frederic E. Church, Gustave Herter, and Tiffany and Company, among many others, this exhibition of more than 310 objects is a visual celebration of the innovative spirit of New York and its unparalleled ability to lead the way for our country and the world.

This sponsorship, our first at The Metropolitan Museum of Art, marks a true coming of age for our company. FleetBoston Financial has evolved into a world-class provider of dynamic financial services, bringing innovative thinking and expertise to more than 20 million customers throughout the United States, Latin America, Asia, and Europe. Our customers and communities depend upon us for innovation in consumer and commercial banking, investment banking, institutional and individual investment services, and for creative investments in our communities. In that regard, we are pleased to fund the largest school-pass program in the Museum's history, issuing free admission passes to 1.5 million schoolchildren and their families throughout New York City. With this program and this exhibition, we hope to convey our unwavering commitment to the arts and our stakeholders and to playing a vital role in the glorious future of the Empire City.

We hope you enjoy the exhibition and, for many years to come, the treasures and history depicted in this catalogue.

Terrence Murray
Chairman and Chief Executive Officer
FleetBoston Financial

Director's Foreword

The years 1825 to 1861 are those between the completion of the Erie Canal and the outbreak of the Civil War. This was a time of remarkable growth, when the small and lively city of New York became a great and vibrant metropolis. One of the most extraordinary developments that marked the period was an astonishing flowering of all the arts, a flowering that assured the city its place as the cultural capital of the nation. The Metropolitan Museum is proud to present "Art and the Empire City: New York, 1825–1861," an exhibition that offers an exceptionally broad selection of the finest examples of the visual arts produced or acquired during the memorable years it covers. Together the exhibition and its accompanying catalogue illuminate the nature, range, and refinement of those objects as well as the cultural life of the era.

The Museum is deeply grateful for the generosity of the eighty-four institutions and private individuals whose loans of objects of significant quality allow us to display the history of art in New York City rather than the history of New York City as seen in its art. A particular debt is owed to The New-York Historical Society and the Museum of the City of New York, which, not surprisingly, after the Metropolitan Museum made by far the largest number of loans. Other sister institutions also granted multiple loans that were essential to the realization of our exhibition; especially important were those from The New York Public Library; the Brooklyn Museum of Art; the Museum of Fine Arts, Boston; the Rare Book and Manuscript Library of Columbia University; and Columbia's Avery Architectural and Fine Arts Library.

Many acknowledgments follow, but here I wish to single out for particular notice John K. Howat, Lawrence A. Fleischman Chairman of the Departments of American Art at the Metropolitan Museum, for originating the concept of the exhibition and for his leadership throughout its realization, and Catherine Hoover Voorsanger, Associate Curator, Department of American Decorative Arts, and Project Director, for her exceptional skills as organizer and diplomat, which guaranteed success in the enterprise.

Undertakings of this importance and scale require significant financial expenditure, and various organizations have made major contributions in this respect. The Metropolitan Museum is extremely grateful to Fleet and its Chairman, Terrence Murray, for their generous support of the exhibition. The support provided by the Homeland Foundation is also noteworthy, as it has helped to make possible the conservation of several objects in the exhibition. In addition, the Museum is thankful for the assistance provided by the Private Art Dealers Association, Inc. Conner-Rosenkranz has also kindly provided support for this project. The publication accompanying the exhibition was made possible by the William Cullen Bryant Fellows of the Metropolitan Museum.

Philippe de Montebello
Director

Lenders to the Exhibition

Preface and Acknowledgments

With the exhibition "Art and the Empire City: New York, 1825–1861" and the publication of this volume, the Metropolitan Museum presents the engaging story of how New York became a world city and assumed its vital role as the visual arts capital of the nation—a position it retains as we enter the twenty-first century.

The organizers of the exhibition and the authors of the catalogue have considered the full range of the visual arts and the related themes that assumed major importance in the city, and the nation as well, in the four decades prior to the Civil War. The physical and cultural growth of New York City; the city's development as a marketplace for art and a center for public exhibitions and private collecting; new departures in architecture, painting, and sculpture; printmaking, a fine art and a democratic one; the new medium of photography; New York as a fashion center; the embellishment of the domestic interior; changing styles in furniture, and the evolution of the ceramics, glass, and silver industries are the primary subjects represented by the works chosen for the exhibition and discussed in the essays contained herein.

A coherency of historical, cultural, and artistic forces in the years 1825 through 1861 provides ample license for the choice of these dates as the framework for the exhibition. The year 1825 was critical: it was then that the Erie Canal was completed, after sections of the waterway opened in 1820 and 1823, making a crucial contribution to the robust financial condition of both the city and state of New York. By 1825 the city had surpassed all other American seaports to become the financial and commercial center of the nation. During the antebellum years New York City grew physically, commercially, and culturally with such vigor that it earned not only the enthusiastic epithets the Empire City and the Great Emporium but also attracted the sometimes envious, and frequently bemused, attentions of the world.

The cultural component of New York's dramatic burgeoning was as significant as its aggressive commercial expansion. The year 1825 saw the establishment of the National Academy of Design, which became the focus of fine arts activities in the city throughout the pre–Civil War era. The concurrent development of other institutions, associations, and professions devoted to the arts and an increase in the numbers of people involved in the production of the arts were among the most notable signs that New York was becoming a metropolis of primary importance and considerable cultural sophistication. With Broadway at the heart of the Great Emporium, New York was transformed into the nation's major manufacturing and retailing center, the depot for luxury goods both made in and around the city and imported from abroad. Despite occasional catastrophic fires (in 1835 and 1845, notably) and financial depressions (in 1837 and 1857, for example) visited on the city, the New York art world flourished in the decades prior to 1861. But this felicitous situation came to a painful end that year.

Southern forces fired on Fort Sumter on April 12, 1861, to begin the Civil War. In both the North and South energies that had been applied to trade, building prosperity, and creating a rich and sophisticated culture in America were turned toward the conflict. The impact of the war on the New York art world was immediate. As Charles Cromwell Ingham, acting president of the National Academy of Design, reported in May 1861, "the great Rebellion has startled society from its propriety, and war and politics now occupy every mind. No one thinks of the arts, even among the artists, patriotism has superceded painting, and many have laid by the palette and pencil, to shoulder the musket. . . ." The post–Civil War years witnessed significant growth in and support for the visual arts of all kinds: thus, the Metropolitan Museum, founded in 1870, and many other great institutions were established. However, in cosmopolitan New York City there emerged a renewed appreciation of both early and contemporary European art and decoration, and there was a concomitant waning of interest in American culture. It was a decidedly new cultural climate.

Planning and executing an exhibition and a book of the magnitude of the present project is an extended process that involves many individuals who must be acknowledged. "Art and the Empire City" is the largest exhibition undertaken by the Museum's Departments

of American Art since 1970, when "19th-Century America" celebrated the institution's one-hundredth birthday, and it has been over five years in the making. It is also unique in its focus, for, while aspects of the arts in America during this period have been examined previously, until now the subject of New York as the primary crucible for the nation's visual arts has not been addressed.

Our first thanks are to Philippe de Montebello, Director of the Metropolitan Museum, who endorsed the exhibition and stood behind it from its inception. We are also deeply grateful to the lenders, whose names appear elsewhere in this catalogue, for generously allowing us to show their works, many of which normally do not travel, and to hundreds of colleagues throughout this country and abroad, whose willing collaboration guaranteed the project's successful realization. Special gratitude is due to The New-York Historical Society and the Museum of the City of New York, which have lent more works than any other institution save the Metropolitan Museum. Their curatorial and administrative staffs, under the leadership of Betsy Gotbaum and Robert Macdonald, respectively, have supported our endeavors wholeheartedly. Our indebtedness to the sponsors whose financial assistance has been crucial is detailed in the Director's Foreword.

"Art and the Empire City" was conceived in the early 1990s, with the understanding that the visual arts of the second quarter of the nineteenth century in America had not been studied adequately. H. Barbara Weinberg, Alice Pratt Brown Curator of American Paintings and Sculpture at the Metropolitan Museum, and Paul Staiti and Elizabeth Johns, J. Clawson Mills Fellows in the American Wing in 1991–92 and 1992–93, respectively, helped frame the questions we needed to address. At first the scope of our inquiry was national, but over time it became clear that New York City should be our focus. Kenneth T. Jackson, Jacques Barzun Professor of History and Social Sciences, Columbia University, and editor of the *Encyclopedia of New York,* took an interest in our undertaking early on and served as an informal advisor throughout. Historians Kenneth Myers, Postdoctoral Fellow in 1995–96, and Valentijn Byvanck, Predoctoral Fellow in 1996–98, contributed valuable perspectives

during the planning of the exhibition, which began in earnest in 1995.

In 1996 and 1997 many colleagues participated in a series of seminars on exhibition themes and the selection of objects, and to them we express our appreciation. Ulysses G. Dietz, Donald L. Fennimore, Katherine S. Howe, Frances G. Safford, D. Albert Soeffing, Kevin L. Stayton, and Deborah Dependahl Waters discussed silver and other metalwork with us; Alan M. Stahl guided our choice of medals. Mary-Beth Betts, Elizabeth Blackmar, Andrew Dolkart, Sarah Bradford Landau, Peter Marcuse, the late Adolph K. Placzek, Dell Upton, and Mary Woods contributed views on architecture, city planning, and related subjects. Michele Bogart, Valentijn Byvanck, H. Nichols B. Clark, David B. Dearinger, Linda Ferber, Elizabeth Johns, David Meschutt, Jan Seidler Ramirez, Paul Staiti, and John Wilmerding conferred on American paintings and sculpture, and Stephen R. Edidin made recommendations about foreign works. Mary Ann Apicella, Frances Bretter, Wendy A. Cooper, Barry R. Harwood, Peter M. Kenny, John Scherer, Thomas Gordon Smith, Page Talbott, and Deborah Dependahl Waters shared their knowledge of furniture. Florence I. Balasny-Barnes, Barbara and David Goldberg, Esther and Arthur Goldberg, and Emma and Jay Lewis participated in a discussion of ceramics. Georgia B. Barnhill, Thomas P. Bruhn, Nancy Finlay, Harry S. Katz, Shelley Langdale, Leslie Nolan, Wendy A. Shadwell, and John Wilmerding consulted on the history of printmaking and print collecting. Laurie Baty, Dale Neighbors, Mary Panzer, Sally Pierce, Alan Trachtenberg, Julie Van Haaften, and, later, Herbert Mitchell advised us about early American photography.

Valentijn Byvanck recommended the portraits shown, and Janet Zapata selected the jewelry. Phyllis D. Magidson of the Museum of the City of New York worked closely with Caroline Rennolds Milbank on choosing the costumes and related accoutrements. Chantal Hodges researched bookbindings. Laurence Libin, Research Curator, Department of Musical Instruments at the Metropolitan Museum, served in an adjunct curatorial capacity.

In every aspect of the preparation of both the exhibition and the catalogue, we have been supported by

our superb research assistants, who have contributed significantly in matters both scholarly and professional. Medill Higgins Harvey, who coordinated the research campaign, was a supremely accomplished leader. Julie Mirabito Douglass directed research pertaining to collectors and with Medill Harvey compiled a bibliography of nineteenth- and twentieth-century sources, which provided the curators with a platform from which to embark on studies of their own. For assistance during this phase of the project, we are grateful to have had access to the Seymour B. Durst Old York Library Collection and especially thank Eva Carrozza, former Librarian, for her help. While the icons of American painting and sculpture of our period were well known from the outset, masterpieces in the other arts were not well documented. In search of objects from New York that might have been dispersed nationwide, hundreds of art museums, historic-house museums, historical societies, and regional centers were contacted. To all who answered our queries, and to those who hosted our visits, we extend appreciation. Jeni L. Sandberg took charge of periodical research. Her insightful survey of periodicals and travelers' accounts published between 1825 and 1861 yielded the raw material on which many of the catalogue essays and the themes of the exhibition are predicated.

Austen Barron Bailly researched foreign works of art and oversaw countless administrative and art-historical details. Brandy S. Culp skillfully researched art patrons, surveyed manuscript collections, and managed the database of exhibition objects. In the last task she relied on the indispensable assistance of Frances Redding Wallace, as well as the support of Jennie W. Choi of Systems and Computer Services. Jodi A. Pollack coordinated the photography for the catalogue with consummate efficiency. Cynthia Van Allen Schaffner contributed expert research assistance and unflagging support of myriad kinds.

During the course of the project, the staffs of the libraries of many institutions graciously assisted our researchers. We thank the following institutions and individuals: the library of The New-York Historical Society, especially Richard Fraser, Megan Hahn, Wendy S. Raver, and May Stone; the New York Society Library, especially Heidi Haas, Janet Howard, and Mark Piel; the New York Biographical and Genealogical Library, especially Joy Rich; The New York Public Library, especially Virginia Bartow, Robert Rainwater, and Roberta Waddell; Janet Parks and the staff of the Avery Architectural and Fine Arts Library, Columbia University; Claudia Funke and Jennifer Lee of the Rare Books and Manuscript Library, Columbia University; Special Collections, Baker Library, Harvard Business School, Cambridge, Massachusetts, especially A. F. Bartovics; Stephen Van Dyk, Cooper-Hewitt, National Design Museum, New York; W. Gregory Gallagher, The Century Association, New York; Judith Gelernter, The Union Club, New York; Burt Denker, Decorative Arts Photographic Collection, and E. Richard McKinstrey, Gail Stanislow, and Eleanor McD. Thompson, Winterthur Museum Library, Delaware; Linda Ayres and C. Ford Peatross, Library of Congress, Washington, D.C.; and Brian Cuthrell and Henry Fulmer, South Caroliniana Library, University of South Carolina, Columbia. Our work was enriched by the holdings of the Archives of American Art, Washington, D.C.; the Boston Public Library; and the Inventories of American Paintings and Sculpture, Smithsonian Institution, Washington, D.C. William H. Gerdts, Professor Emeritus of Art History, City University of New York, shared nineteenth-century exhibition reviews in his files. Last, but certainly not least, we acknowledge our colleagues in the Thomas J. Watson Library, Metropolitan Museum, especially Kenneth Soehner, Arthur K. Watson Chief Librarian, Linda Seckelson, Robert Kaufmann, and Katria Czerwoniak.

Graduate, undergraduate, and high-school interns, as well as volunteers, contributed invaluable assistance, without which we could not have realized this project. They combed primary documents for information on works of art, artists and manufacturers, collectors and dealers, and other subjects germane to our efforts. In this category we thank: Mary Ann Apicella, Lisa Bedell, Gilbert H. Boas, Rachel D. Bonk, Alexis L. Boylan, Millicent L. Burns, Vivian Chill, Elizabeth Clark, Amy M. Coes, Claire Conway, Gina D'Angelo, Tara Dennard, Jennifer M. Downs, Cynthia Drayton, Margarita Emerson, Dinah Fried, Michal Fromer, Kevin R. Fuchs, Palma Genovese, Angela George, Alice O. Gordon, Joelle Gotlib, Rachel Ihara, Carol A. Irish, Jamie Johnson, Melina Kervandjian, Lynne Konstantin, Amy Kurtz, Barbara Laux, Katharine P. Lawrence, Ruth Lederman, Karen Lemmey, Josephine Loy, Constance C. McPhee, Andrea Miller, Mark D. Mitchell, Jennifer Mock, Francesca Pietropaolo, Anne Posner, Katherine Reis, Katherine Rubin, Emily U. Satloff, Suzannah Schatt, Elizabeth Schwartz, Lonna Schwartz, Nanette Scofield, Sheila Smith, Susan Solny, David Sprouls, Lois Stainman, Susan Stainman, Jennifer Steenshorne, Margaret Stenz, Rush Sturges, Michele L. Symons, Jeffrey Trask, Barbara W. Veith, Daphne M. Ward, Julia H. Widdowson, Jennifer

Wingate, and Katharine Voss. Amy M. Coes, Barbara Laux, Heather Jane McCormick, Jodi A. Pollack, and Cynthia Van Allen Schaffner wrote masters' theses that contributed to our knowledge of furniture making in the Empire City.

The subject of the exhibition spawned several graduate courses, which resulted in useful new research. Princeton students Peter Barberie, Peter Betjemann, Lorna Britton, Thomas Forget, Andrew E. Herschberger, Gordon Hughes, Sarah Anne Lappin, and Mark D. Mitchell enlarged our understanding of nineteenth-century printmaking through their work for a seminar conducted in 1997 by John Wilmerding, Christopher B. Sarofim '86 Professor of American Art, and Elliot Bostwick Davis. In 1999 the Ph.D. program in Art History at the City University of New York offered a broadly focused seminar in conjunction with "Art and the Empire City" taught by Professor Sally Webster and several of the exhibition's curators. The same year Paul Bentel and Dorothy M. Miner initiated a year-long study of the Empire City itself with students in the Historic Preservation Program at Columbia University.

Many other colleagues, collectors, friends, and family members extended themselves in countless ways. In particular, we are grateful for the help of Clifford S. Ackley, Sue Allen, Lee B. Anderson, Elizabeth Bidwell Bates, Thomas Bender, John Bidwell, Mosette Broderick, Sally B. Brown, Frank Brozyna, Nicholas Bruen, Douglas G. Bucher, Stanley and Sara Burns, Richard T. Button, Teresa Carbone, Sasha Chermayeff, Janis Conner and Joel Rosenkranz, Holly Connor, Tom Crawford, Anna T. D'Ambrosio, Leslie Degeorges, Ellen Denker, Ed Polk Douglas, Stacy Pomeroy Draper, Richard and Eileen Dubrow, Inger McCabe Elliott, Richard Fazzini, Stuart P. Feld, David Fraser, Margaret Halsey Gardiner, Max Harvey, Donna J. Hassler, Ike Hay, Paul M. Haygood, Sam Herrup, Peter Hill, Erica Hirshler, R. Bruce Hoadley, Anne Hadley Howat, Margize Howell, Joseph Jacobs, Mr. and Mrs. Charles F. Johnson, Richard Kelly, Julia Kirby, Joelle Kunath, Leslie LeFevre-Stratton, Margaretta M. Lovell, Bruce Lundberg, Maureen McCormick, Brooks McNamara, Mimi and Ron Miller, Patrick McCaughey, Richard J. Moylan, Marsha Mullin, Arlene Katz Nichols, Arleen Pancza-Graham, John Paolella, David Scott Parker, Martin H. Pearl, Joanna Pessa, the late Churchill B. Phyfe, Dr. and Mrs. Henry Pinckney Phyfe, Mrs. James D. Phyfe, Catha Rambusch, Hugo A. Ramirez, Sue Welsh Reed, Ethan Robey, Mary P. Ryan, Annamarie V. Sandecki, Cynthia H. Sanford, Arlene Palmer

Schwind, Lisa Segal, Mimi Sherman, Kenneth Snodgrass, Jane Shadel Spillman, S. Frederick Spira, Theodore E. Stebbins Jr., Diana and Gary Stradling, Laura Turansick, Bart Voorsanger, Malcolm Warner, Fawn White, Shane White, Robert Wolterstorff, Sylvia Yount, and Philip D. Zimmerman.

Colleagues throughout the Museum supported our efforts with good grace, good advice, and assistance. We offer warm thanks to Mahrukh Tarapor, Associate Director for Exhibitions, and her assistants Martha Deese and Sian Wetherill; Doralynn Pines, Associate Director for Administration; Linda M. Sylling, Associate Manager for Operations and Special Exhibitions; Emily Kernan Rafferty, Senior Vice President for External Affairs; Nina McN. Diefenbach, Chief Development Officer; Kersten Larsen, Deputy Chief Development Officer, her predecessor Lynne Morel Winter, and Sarah Lark Higby, Assistant Development Officer; Missy McHugh, Senior Advisor to the President; Kay Bearman, Administrator for Collections Management; and Jeanie M. James and Barbara W. File, Archives. Aileen K. Chuk, Registrar, deserves special notice for her seemingly effortless coordination of the comings and goings of the many objects in the exhibition.

For important loans from within the Museum, we thank Everett Fahy, John Pope-Hennessy Chairman, European Paintings; George R. Goldner, Drue Heinz Chairman, Drawings and Prints; Maria Morris Hambourg, Curator in Charge, Photographs; J. Kenneth Moore, Frederick P. Rose Curator in Charge, Musical Instruments; Olga Raggio, Iris and B. Gerald Cantor Chairman, European Sculpture and Decorative Arts; and Myra Walker, Acting Associate Curator in Charge, Costume Institute. We are also grateful to Maxwell K. Hearn, Asian Art; Deirdre Donohue, Minda Drazin, Emily Martin, and Chris Paulocik, Costume Institute; Heather Lemonedes, Valerie von Volz, David del Gaizo, John Crooks, and Stephen Benkowski, Drawings and Prints; Katharine Baetjer, Keith Christiansen, Walter Liedtke, and Gary Tinterow, European Paintings; and Thomas Campbell, James David Draper, Johanna Hecht, Danielle O. Kisluk-Grosheide, and William Rieder, European Sculpture and Decorative Arts; as well as Giovanni Fiorino-Iannace, Antonio Ratti Textile Center. Particular recognition is owed to Helen C. Evans, Medieval Art, and Malcolm Daniel, Photographs, for exceptional collegial support.

The extraordinary expertise of the Museum's conservators has been of central importance. Gratitude is due to Marjorie Shelley, Conservator in Charge, Ann Baldwin, Nora Kennedy, Margaret Lawson, Rachel

Mustalish, Nancy Reinhold, and Akiko Yamazaki-Kleps, Paper Conservation; Dorothy Mahon, Paintings Conservation; Elena Phipps, Textile Conservation; Mindell Dubansky, Watson Library; James H. Frantz, Conservator in Charge, Hermes Knauer, Yale Kneeland, Jack Soultanian Jr., and especially Marinus Manuels, who was assisted by Tad Fallon, and Pascale Patris, Objects Conservation. Nancy C. Britton, Objects Conservation, merits special mention for her extensive investigation and interpretation of nearly all the upholstered furniture in the exhibition. She was assisted by Susan J. Brown, Hannah Carlson, L. Ann Frisina, Charlotte Stahlbusch, and Agnes Wnuk. We also thank Mary Schoeser, who researched furnishing fabrics in England, Guy E. O. Evans, John Buscemi, and Edward Goodman for help with upholstery research.

Jeffrey L. Daly, Chief Designer, with the assistance of Dennis Kois, expertly shepherded the exhibition through its preliminary laying out. Daniel Bradley Kershaw inventively designed the exhibition, and Sophia Geronimus created the compelling graphics, while Zack Zanolli worked his usual magic with the lighting. We also thank installers Jeffrey W. Perhacs, Fred A. Caruso, Nancy S. Reynolds, Frederick J. Sager, and Alexandra Wolcott.

Kent Lydecker, Associate Director for Education, and Nicholas Ruocco, Stella Paul, Pia Quintaro, Alice I. Schwarz, Jean Sorabella, and Vivian Wick are among the colleagues in the Education Department who created lively special programs to enhance the exhibition. Other members of the Education Department to whom we are grateful are Rika Burnham, Esther M. Morales, and Michael Norris. Hilde Limondjian, General Manager of Concerts and Lectures, also produced special events. Harold Holzer, Vice President for Communications, and his staff members Elyse Topalian and Egle Zygas skillfully publicized "Art and the Empire City." Valerie Troyansky and her merchandizing team brought out handsome products to accompany the exhibition.

On behalf of all the authors of the catalogue, we express our sincere thanks to John P. O'Neill, Editor in Chief, and his outstanding staff for making this magnificent book a reality. Carol Fuerstein, our lead editor, masterminded the massive editing project with crucial assistance from Margaret Donovan and additional expert help from Ellyn Allison, Ruth Lurie Kozodoy, and M. E. D. Laing. Jean Wagner, with assistance from Mary Gladue, verified the accuracy of the notes and created the bibliography. Peter Antony and Merantine Hens, with assistance from Sally VanDevanter, superbly executed the production, and Robert Weisberg adroitly managed the desktop publishing. Bruce Campbell is responsible for the book's elegant design. For producing the lion's share of the photographs used in the book, we thank Barbara Bridgers, Manager, the Photograph Studio, and her staff, especially Joseph Coscia Jr., Anna-Marie Kellen, Paul Lachenauer, Oi-Cheong Lee, Bruce Schwarz, Eileen Travell, Juan Trujillo, Karin L. Willis, and Peter Zeray. Eugenia Burnett Tinsley printed the black-and-white images, and Chad Beer, Josephine Freeman, and Nancy Rutledge contributed administrative and archival assistance. Jerry Thompson photographed sculpture in the American Wing as well as other objects. We are extremely grateful to colleagues who supplied photographs of exhibition objects and images for the essays in record time. We are appreciative also of the help received from Deanna D. Cross, Diana H. Kaplan, Carol E. Lekarew, Lucinda K. Ross, and Sandra Wiskari-Lukowski in the Museum's Photograph and Slide Library.

For enduring the inconveniences occasioned by this project for more than five years, we thank all our colleagues in the American Wing, especially Peter M. Kenny, Curator and Administrator, his assistant Kim Orcutt, and her predecessor the late Emely Bramson. As always, we are grateful to our administrative assistants Noe Kidder and her predecessor Kate Wood, Dana Pilson and her predecessor Julie Eldridge, Ellin Rosenzweig, and Catherine Scandalis and her predecessor Yasmin Rosner. Our technicians Don E. Templeton, Gary Burnett, Sean Farrell, and Rob Davis are the best in the business and we are grateful for their participation. Finally, we salute our fellow curators, the authors of this mighty tome. "Art and the Empire City: New York, 1825–1861" and its accompanying volume are the product of your collective expertise and collaboration.

John K. Howat
Lawrence A. Fleischman Chairman,
Departments of American Art

Catherine Hoover Voorsanger
Associate Curator, Department of
American Decorative Arts

Contributors to the Catalogue

KEVIN J. AVERY, Associate Curator, Department of American Paintings and Sculpture, The Metropolitan Museum of Art

CARRIE REBORA BARRATT, Associate Curator, Department of American Paintings and Sculpture, and Manager, The Henry R. Luce Center for the Study of American Art, The Metropolitan Museum of Art

ELLIOT BOSTWICK DAVIS, Assistant Curator, Department of American Paintings and Sculpture, The Metropolitan Museum of Art

ALICE COONEY FRELINGHUYSEN, Curator, Department of American Decorative Arts, The Metropolitan Museum of Art

MORRISON H. HECKSCHER, Anthony W. and Lulu C. Wang Curator, Department of American Decorative Arts, The Metropolitan Museum of Art

JOHN K. HOWAT, Lawrence A. Fleischman Chairman, Departments of American Art, The Metropolitan Museum of Art

CAROLINE RENNOLDS MILBANK, fashion historian

AMELIA PECK, Associate Curator, Department of American Decorative Arts, The Metropolitan Museum of Art

JEFF L. ROSENHEIM, Assistant Curator, Department of Photographs, The Metropolitan Museum of Art

THAYER TOLLES, Associate Curator, Department of American Paintings and Sculpture, The Metropolitan Museum of Art

DELL UPTON, Professor of Architectural History, University of California, Berkeley

CATHERINE HOOVER VOORSANGER, Associate Curator, Department of American Decorative Arts, The Metropolitan Museum of Art, and Project Director, "Art and the Empire City: New York, 1825–1861"

DEBORAH DEPENDAHL WATERS, Curator of Decorative Arts and Manuscripts, Museum of the City of New York

Medill Higgins Harvey, Austen Barron Bailly, Brandy S. Culp, Julie Mirabito Douglass, Jodi A. Pollack, Jeni L. Sandberg, and Cynthia Van Allen Schaffner, research assistants

Note to the Reader

Spelling and punctuation of original titles are standardized according to modern usage. Modern titles are listed first, preceding period titles in parentheses.

The photographer Victor Prevost's work survives primarily as waxed paper negatives. The three original works by him in this exhibition are reproduced as negatives. The Prevost photographs illustrated in the essays are reproduced from new gelatin silver prints made for this book from original negatives.

All works in the exhibition are illustrated in a section of the catalogue that immediately follows the essays. Works are grouped by medium as follows: paintings (portraits, portrait miniatures, American paintings, foreign paintings); sculpture (foreign, American); architectural drawings and related works; watercolors; prints, bindings, and illustrated books (American works, foreign prints); photography; costumes; jewelry; decorations for the home; furniture; ceramics;

glass; silver and other metalwork. Within each category works are arranged chronologically, unless the point of a comparison supersedes the significance of chronology. Abbreviated captions are provided.

Fuller information on the exhibited works appears in the checklist, which is arranged in the same order as the illustrated works. For measurements in the checklist, height precedes width, precedes depth or length, precedes diameter. Measurements of sculpted busts include the socle. Measurements of daguerreotypes are based on the standard plate size and do not include the case. Unless otherwise specified, artists were active in New York City, works were made in New York City, and original owners were residents of New York City. For most works, the title, subject, sitter, or inscription communicates the object's relevance to the exhibition. For others, an explanatory sentence or noteworthy information is given.

Art and the Empire City
New York, 1825–1861

Inventing the Metropolis: Civilization and Urbanity in Antebellum New York

DELL UPTON

On October 26, 1825, the canal boat *Seneca Chief* left Buffalo at the head of a parade of gaily decorated craft to celebrate the opening of the Erie Canal. On November 4 the procession reached New York City, where a small flotilla carrying members of the City Council and other New York dignitaries greeted it (cat. no. 118). Twenty-nine steamboats and a host of sailing vessels and smaller craft formed a circle three miles in diameter around the *Seneca Chief*. Governor De Witt Clinton (cat. nos. 4, 122B), the canal's most ardent promoter, lifted a keg of Lake Erie water high above his head, then poured it into the ocean. Other participants added waters from the Mississippi, Columbia, Orinoco, La Plata, and Amazon rivers, as well as from the Nile, Gambia, Thames, Seine, Rhine, and Danube. The party landed at the Battery and led a great parade up Broadway to City Hall, and ultimately to a dinner for three thousand at the Lafayette Theatre.[1]

As the celebrants understood, the Erie Canal—imagined for a century, projected for thirty years, and under construction for eight—cemented New York's position as the "capital of the country," in the words of the painter and inventor Samuel F. B. Morse.[2] New York had emerged from the Revolution as the new nation's largest city, surpassing Philadelphia, the colonial metropolis. By 1825 New York's economic dominance was secured, as a result of its favorable location and year-round harbor, the establishment of regular transatlantic packet lines on the Black Ball Line in 1818, and its good fortune in being the site where Britain chose to dump its surplus textiles after the War of 1812, which gave it primacy in the national dry-goods market (cat. no. 35; fig. 1).[3] If New York had no equal by the time the Erie Canal was completed, the "artificial river" nevertheless assured the city's future preeminence at the geographical and financial center of a web of national and international commerce. Not only did the canal's path set the pattern for

I am grateful to Michele H. Bogart, Margaretta M. Lovell, Mary P. Ryan, Catherine Hoover Voorsanger, and Shane White for comments on an earlier draft of this essay.

1. E. Idell Zeisloft, ed., *The New Metropolis: Memorable Events of Three Centuries, 1600–1900, from the Island of Mana-hat-ta to Greater New York at the Close of the Nineteenth Century* (New York: D. Appleton, 1899), pp. 83–84; Mary P. Ryan, *Civic Wars: Democracy and Public Life in the American City during the Nineteenth Century* (Berkeley: University of California Press, 1997), pp. 61–68.
2. Samuel F. B. Morse (1831), quoted in Paul J. Staiti, *Samuel F. B. Morse* (Cambridge: Cambridge University Press, 1989), p. 150. See also Evan Cornog, *The Birth of Empire: De Witt Clinton and the American Experience, 1769–1828* (New York: Oxford University Press, 1998), pp. 104–6, 171.
3. See Robert Greenhalgh Albion, *The Rise of New York Port (1815–1860)* (New York: C. Scribner's Sons, 1939; reprint, Boston: Northeastern University Press, 1984), pp. 16–38; and Eugene P. Moehring, "Space, Economic Growth, and the Public Works Revolution in New York," in *Infrastructure and Urban Growth in the Nineteenth Century* (Chicago: Public Works Historical Society, 1985), p. 31.

Fig. 1. William Guy Wall, *New York from the Heights near Brooklyn*, 1823. Watercolor and graphite. The Metropolitan Museum of Art, New York, The Edward W. C. Arnold Collection of New York Prints, Maps, and Pictures, Bequest of Edward W. C. Arnold, 1954 54.90.301

Opposite: detail, cat. no 135

4. See Cornog, *Birth of Empire*, pp. 161–72; and Carol Sheriff, *The Artificial River: The Erie Canal and the Paradox of Progress, 1817–1862* (New York: Hill and Wang, 1996), pp. 5, 18–21.

5. *A Philadelphia Perspective: The Diary of Sidney George Fisher Covering the Years 1834–1871*, edited by Nicholas B. Wainwright (Philadelphia: Historical Society of Pennsylvania, 1967), p. 197.

6. Lady Emmeline Stuart-Wortley, *Travels in the United States, etc. during 1849 and 1850* (New York: Harper and Brothers, 1851), p. 13; "Monumental Structures," *New-York Mirror, and Ladies' Literary Gazette*, December 12, 1829, p. 183.

7. Northern Star, "The Observer: The City of New-York," *New-York Mirror, and Ladies' Literary Gazette*, November 15, 1828, p. 147.

8. Mrs. Felton, *American Life: A Narrative of Two Years' City and Country Residence in the United States* (Bolton Percy: The Author, 1843), p. 35.

9. Timothy Dwight, *Travels in New-England and New-York*, 4 vols. (New Haven: Timothy Dwight, 1821–22; facsimile edited by Barbara Miller Solomon, Cambridge, Massachusetts: Harvard University Press, 1969), vol. 3, p. 330.

10. Stuart-Wortley, *Travels*, p. 13; "The City of Modern Ruins," *New-York Mirror*, June 13, 1840, p. 407.

11. "Widening of Streets," *New-York Mirror*, November 2, 1833, p. 143.

12. E. E., "Letters Descriptive of New-York, Written to a Literary Gentleman in Dublin, No. 11," *New-York Mirror, and Ladies' Literary Gazette*, January 6, 1827, p. 187.

13. John F. Watson, *Annals of Philadelphia . . . to Which Is Added an Appendix, Containing Olden Time Researches and Reminiscences of New York City* (Philadelphia: E. L. Carey and A. Hart, 1830), appendix p. 74.

14. "Editor's Easy Chair," *Harper's New Monthly Magazine* 21 (June 1860), p. 127.

15. "Great Cities," *Putnam's Monthly* 5 (March 1855), pp. 257, 256.

urban, railroad, road, and communication networks focused on the Empire City (cat. nos. 145, 152), but its construction also attracted foreign investment to the city and assured the dominance of New York–based capital in the nation's economy.[4]

The story of antebellum New York is the story of New Yorkers' struggle to come to grips with a city exponentially larger than any ever before known on the American continent. By 1825 its population had passed 125,000. That figure was in turn dwarfed by the nearly 815,000 people who lived in New York thirty-five years later. After a visit in 1847 the Philadelphia diarist Sidney George Fisher noted ruefully, "Philad: seems villagelike."[5]

To visitors New York was the "Empress City of the West," the "queen of American cities," the "London of the Western world."[6] As impressed as these visitors were, they could not match New Yorkers' own self-absorption. There was no aspect of their town that did not seem vaster or more numerous, grander or meaner, more sophisticated or cruder, more refined or more debased, more virtuous or more vicious than elsewhere. No element was too subtle to escape attention or too trivial to convey some vitally significant insight into the life of the city. Confronted with the "little world" they lived in, New Yorkers marveled.[7]

However great it had become, antebellum New York was still a work in progress over which hung a pervasive "air of newness."[8] "The bustle in the streets, the perpetual activity of the carts, the noise and hurry at the docks which on three sides encircle the city; the sound of saws, axes, and hammer at the shipyards; the continually repeated views of the numerous buildings rising in almost every part of it, and the multitude of workmen employed upon them form as lively a specimen of 'the busy hum of populous cities' as can be imagined," observed Yale University president Timothy Dwight.[9] But a work in progress was, from another perspective, a "half-finished city," a "city of perpetual ruin and repair. No sooner is a fine building erected than it is torn down to put up a better."[10] New York would be a "fine place—if they ever got it done."[11]

New Yorkers' public bravado was tempered by an equally public uncertainty about the city's standing and its future. What did it mean to be the Empire City, "the greatest commercial emporium of the world"?[12] As early as 1830 a New York–born historian of Philadelphia discerned in his birthplace "the very ambition to be the metropolitan city," a quality which "gave them cares which I am willing to see remote enough from Philadelphia."[13] All agreed that quantity—mere size and wealth—was not enough. Some elusive qualities

of character and accomplishment were also necessary. "It is curious and melancholy to observe how little manly and dignified pride New York has in its own character and position," lamented *Harper's New Monthly Magazine*. "A man may be large; but if his size be bloat, there is nothing imposing in it."[14]

"Great cities," claimed another essayist, are "the greatest and noblest of God's physical creations on earth." The nineteenth century was an age of great cities, and the greatest were characterized by "Civilization" and "Urbanity" (as well as by Protestant Christianity and the English language). The first meant "'making a person a *citizen*;' that is—the inhabitant of a city," developing the ability to live responsibly and effectively with one's neighbors; the second, "the quality, condition, or manners of the inhabitant of a city," cultivating the ability to live with style. This was not to suggest, the writer added hastily, "that the bustling, staring, heedless, rude, offensive manners of most self-important inhabitants of *some* modern commercial cities are the perfected result of the highest possible civilization, or are the acme of genuine urbanity."[15]

Antebellum New Yorkers pursued many paths to bringing civilization, or citizenship, and urbanity to their city and its residents. Art was one path, for it offered both diagnostic and ideal images that helped educated New Yorkers define themselves and influence the development of their city, and it embodied the refinement that urbanity implied. At the same time, the arts were deeply embedded, intellectually and practically, in antebellum New York's urban demographic upheaval and economic efflorescence. They were commodities and spectacles—"public entertainments"—offered for sale alongside laxatives and fine carriages and freak shows and houses and operas and food and women's bodies and fashionable clothing and grain futures. Art was shown and sold cheek by jowl with these other commodities and spectacles on the streets, in stores and offices, and (except for the brothels) in the classified columns of New York's newspapers. Thus consideration of the arts entails understanding them in the context of the entire universe of material culture that defined antebellum New York, including the planning and construction of the city, its verbal and pictorial representations, and its consumption of a vastly expanded world of goods and images.

Regulating New York

New York's phenomenal economic and demographic growth was dramatically visible in its urban landscape. At the time of the Revolution the city was

confined to the southern end of the otherwise-rural Manhattan Island. Antebellum New Yorkers often described the colonial section of their city (those streets south of City Hall Park—then called simply "The Park") as "essentially defective," "a labyrinth—a puzzle—a riddle—incomprehensible to philosophers of the present day."[16] It was nothing of the sort. Laid out by the Dutch as a rough grid (adapted to the shoreline) with major streets paralleling the East River waterfront and perpendicular streets leading back into the core of the island, the city was continually extended in the process of land reclamation along the shore (cat. no. 124; fig. 2).

The colonial district was embellished and rationalized (or "regulated," as it was called) as money and occasion permitted. When New York emerged from the Revolution heavily damaged by British military occupation and by a disastrous fire of 1776 that burned much of the city west of Broad Street, city officials took advantage of the destruction to modify Broadway's grade as it descended from Wall Street to Bowling Green and to straighten and widen some streets.[17] The improvement of the old town continued through the antebellum era, particularly during the 1830s, when Ann, Cedar, and Liberty streets were straightened and widened, William and Nassau streets enlarged, and Beekman, Fulton, and Platt streets newly cut.[18] During the same years the waterfront was continually redeveloped as landfill extended the shoreline into the river (cat. no. 119).

In the years following the Revolution urbanization began to creep along the East River beyond the Common, which comprised the present City Hall Park and the land adjacent to it, and the Collect Pond to the north. By the end of the eighteenth century a patchwork of gridded plats lay between the Park and Houston Street. Some had been created by the city from its common lands in the decades after the Revolution. Others were laid out by private landowners as urban development moved northward. In the east Henry Rutgers issued ground leases for his farm along the East River, laying the foundations of the present Lower East Side. In the west Trinity Church, a major landowner in Manhattan from colonial times to the present, subdivided some of its properties, notably to create Hudson, or Saint John's, Square as an elite residential enclave focused on Saint John's Church, Trinity's chapel of ease. The section of Broadway that passed through these private grids was the scene of the most active retail commercial development during the three decades after 1825 (cat. no. 123).[19]

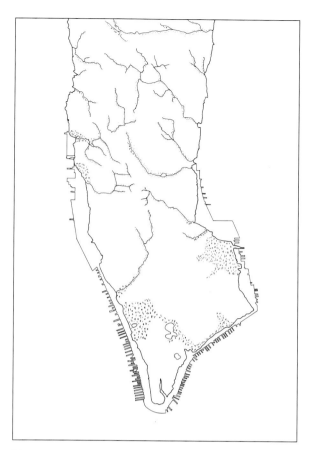

Fig. 2. *Water Courses of Manhattan*, 1999. Line drawing by Sibel Zandi-Sayek, after Egbert L. Viele, *Sanitary and Topographical Map of the City and Island of New York*, 1865, reprinted in Paul E. Cohen and Robert T. Augustyn, *Manhattan in Maps, 1527–1995* (New York: Rizzoli International Publications, 1997)

Then the city exploded (fig. 3). By 1828 the streets had been paved and gaslit as far north as Thirteenth Street across most of the island.[20] At midcentury urban development had reached Madison Square, and by the opening of the Civil War outlying residential neighborhoods were being built in the Thirties and Forties (cat. no. 136; fig. 4).

In the second quarter of the nineteenth century New York was an irregular collection of mostly regular grids, a patchwork but not a labyrinth. As a correspondent to *Putnam's Monthly* noted, in terms more measured than those of most of his contemporaries, lower Manhattan was "quite irregular. This irregularity, however, is in the position of the streets, rather than in their direction," as he demonstrated by comparing lower Manhattan to a baby's bootee with a few misplaced threads.[21]

Although the old city was no medieval maze, it was dramatically different from those parts north of Houston Street (and especially north of Fourteenth Street) that were shaped by the single most dramatic

16. Thomas N. Stanford, *A Concise Description of the City of New York . . .* (New York: The Author, 1814), quoted in Hendrik Hartog, *Public Property and Private Power: The Corporation of the City of New York in American Law, 1730–1870* (Chapel Hill: University of North Carolina Press, 1983), p. 159; "The Walton Mansion-House.—Pearl Street," *New-York Mirror*, March 17, 1832, p. 289.

17. Paul E. Cohen and Robert T. Augustyn, *Manhattan in Maps, 1527–1995* (New York: Rizzoli International Publications, 1997), p. 94.

18. "Late City Improvements," *New-York Mirror, and Ladies' Literary Gazette*, March 27, 1830, p. 303; "Widening of Streets," *New-York Mirror*, November 2, 1833, p. 143; "City Improvements," *New-York Mirror*, November 3, 1833, p. 175; John F. Watson, *Annals and Occurrences of New York City and State, in the Olden Time . . .* (Philadelphia: H. F. Anners, 1846), pp. 144–45.

19. Elizabeth Blackmar, *Manhattan for Rent, 1785–1850* (Ithaca: Cornell University Press, 1989), pp. 30–31, 41; Peter Marcuse, "The Grid as City Plan: New York City and Laissez-Faire Planning in the Nineteenth Century," *Planning Perspectives* 2 (September 1987), p. 297; Edward K. Spann, "The Greatest Grid: The New York Plan of 1811," in *Two Centuries of American Planning*, edited by Daniel Schaffer (Baltimore: Johns Hopkins University Press, 1988), pp. 14–16. Marcuse's and Spann's essays, along with Hartog, *Public Property*, chap. 11, are the best treatments to date of the evolution of New York's plan between the Revolution and the mid-nineteenth century, and they are the sources of the following paragraphs, unless otherwise noted.

20. Watson, *Annals and Occurrences of New York City*, pp. 144–45.

21. "New-York Daguerreotyped. Group First: Business-Streets, Mercantile Blocks, Stores, and Banks," *Putnam's Monthly* 1 (February 1853), p. 124.

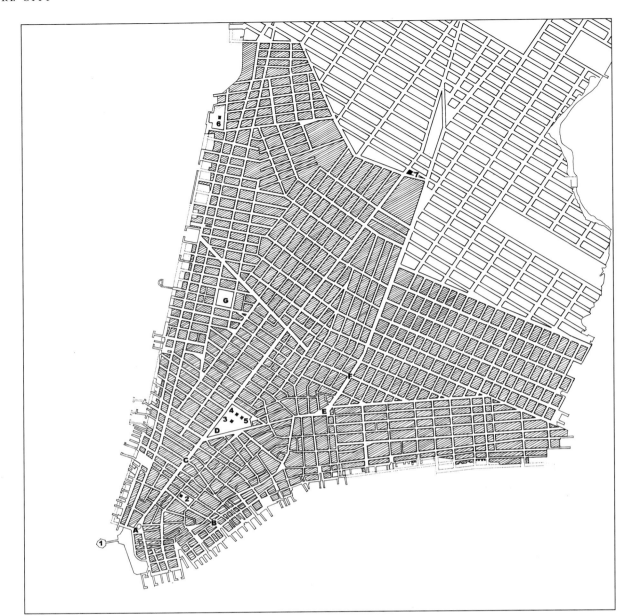

A. Bowling Green
B. Wall Street
C. Broadway
D. The Park
E. Chatham Square
F. The Bowery
G. Hudson (Saint John's) Square

1. Castle Clinton
2. Branch Bank of the United States
3. City Hall
4. Old Almshouse
5. The Rotunda
6. New York State Prison
7. Vauxhall Gardens

Fig. 3. *New York Settlement in 1820*, 1999. Line drawing by Sibel Zandi-Sayek, after Egbert L. Viele, *Sanitary and Topographical Map of the City and Island of New York*, 1865, reprinted in Paul E. Cohen and Robert T. Augustyn, *Manhattan in Maps, 1527–1995* (New York: Rizzoli International Publications, 1997)

22. Cohen and Augustyn, *Manhattan in Maps,* p. 102; Hartog, *Public Property,* pp. 167–75.

physical project to achieve civilization and urbanity, the Commissioners' Plan of 1811 (fig. 5). This was the work of a blue-ribbon panel appointed by the state legislature in 1807 to make a long-range plan for the city's growth after the Common Council and property owners had been unable to agree on a satisfactory course of action. The three commissioners in turn hired John Randel Jr. to survey the island. Together Randel and his employers established the all-encompassing framework for nearly every subsequent urban development in Manhattan.

Randel made three large maps on which he later drew the plan chosen by the commissioners, a grid that

was divided into 200-by-800-foot blocks extending up the island as far as 155th Street. For a decade after the plan's publication, the young surveyor and his assistants tramped Manhattan placing marble posts at the sites of all future intersections, although the regulation and construction of streets and avenues proceeded on a block-by-block basis as urbanization moved northward over the course of the nineteenth century.[22]

In creating the plan the commissioners and their surveyor carefully considered the nature of cities and the future of their own, as they made clear in the "Remarks" issued to accompany William Bridges's

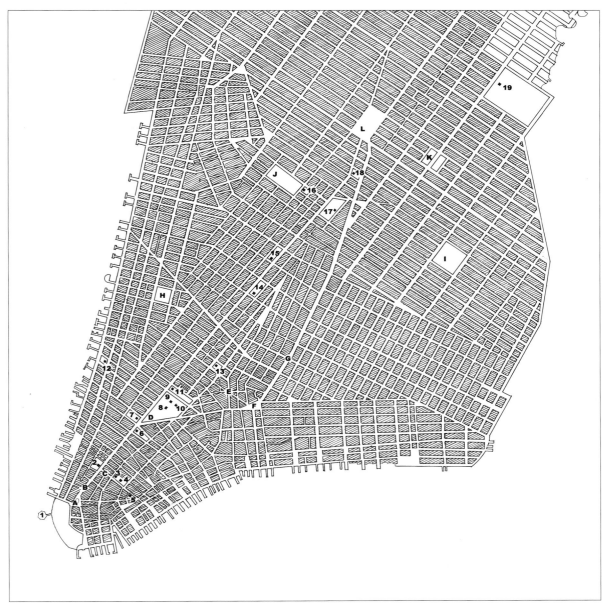

A. Bowling Green
B. Broadway
C. Wall Street
D. The Park
E. Five Points
F. Chatham Square
G. The Bowery
H. Hudson (Saint John's)
 Square
I. Tompkins Square
J. Washington Square
K. Stuyvesant Square
L. Union Square

1. Castle Garden
2. Trinity Church
3. Custom House
4. Branch Bank of the
 United States
5. Second Merchants'
 Exchange
6. American (Barnum's)
 Museum
7. Astor House
8. City Hall
9. Old Almshouse
10. The Rotunda
11. A. T. Stewart store
 (The Marble Palace)
12. Edgar H. Laing stores
13. New York Halls of Justice
 and House of Detention
 (The Tombs)
14. E. V. Haughwout store
15. Niblo's Garden
16. New York University
17. La Grange Terrace/
 Colonnade Row
18. Grace Church
19. Bellevue institutions

Fig. 4. *New York Settlement in 1860*, 1999. Line drawing by Sibel Zandi-Sayek, after Egbert L. Viele, *Sanitary and Topographical Map of the City and Island of New York*, 1865, reprinted in Paul E. Cohen and Robert T. Augustyn, *Manhattan in Maps, 1527–1995* (New York: Rizzoli International Publications, 1997)

published version. In a famous passage they reported that "one of the first objects" they had considered was

whether they should confine themselves to rectilinear and rectangular streets, or whether they should adopt some of those supposed improvements by circles, ovals, and stars, which certainly embellish a plan, whatever may be their effect as to convenience and utility. In considering that subject, they could not but bear in mind that a city is to be composed principally of the habitations of men, and that strait-sided, and right-angled houses are the most cheap to build and the most convenient to live in. The effect of these plain and simple reflections was decisive.

In addition, they wanted to devise a plan that would mesh with "plans already adopted by individuals" in a way that would not require major adjustments.[23]

The product was New York's famous grid. Looking back half a century after the creation of the Commissioners' Plan, Randel boasted that many of its opponents (who objected to the costs of the improvements and to their conflict with already established land uses and building dispositions) had been forced to admit "the facilities afforded by it for the buying,

23. "Remarks of the Commissioners for Laying out Streets and Roads in the City of New York, under the Act of April 3, 1807," in *Manual of the Corporation of the City of New York*, edited by David T. Valentine (New York: The Council, 1866), p. 756.

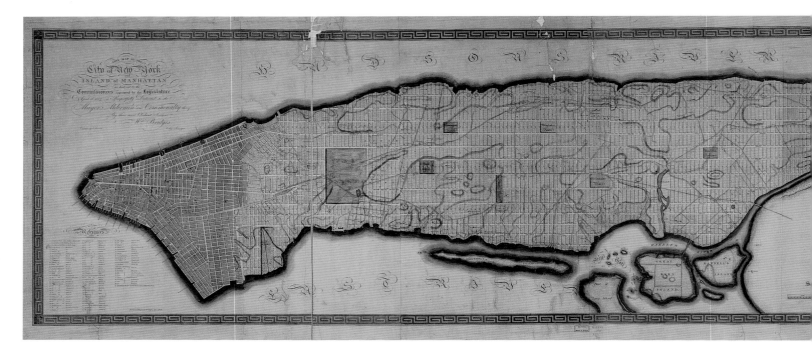

Fig. 5. John Randel Jr., cartographer; adapted and published by William Bridges, *This Map of the City of New York and Island of Manhattan as Laid Out by the Commissioners,* 1811. Hand-colored line engraving on copper. Library of Congress, Washington, D.C., Geography and Map Division

24. John Randel Jr. (1866), quoted in Spann, "Greatest Grid," p. 26.

25. On the new economic theories, see Joyce O. Appleby, *Economic Thought and Ideology in Seventeenth Century England* (Princeton: Princeton University Press, 1978); for their influence in the early republic, see Joyce O. Appleby, *Capitalism and a New Social Order: The Republican Vision of the 1790s* (New York: New York University Press, 1984).

26. "Remarks of the Commissioners."

27. [Samuel L. Mitchill], *The Picture of New-York; or, The Traveller's Guide, through the Commercial Metropolis of the United States, by a Gentleman Residing in This City* (New York: I. Riley and Co., 1807), pp. 128–43.

28. Edward K. Spann, *The New Metropolis: New York City, 1840–1857* (New York: Columbia University Press, 1981), pp. 144–45.

29. "Washington Market," *Gleason's Pictorial Drawing-Room Companion,* March 5, 1853, p. 160.

and improving real estate, on streets, avenues, and public squares, already laid out and established on the ground by monumental stones and bolts."[24]

Still, the 1811 plan was not *simply* a partition for resale. Although it has been criticized for its lack of public squares and broad processional avenues conducive to civic grandeur and ritual, these already existed in the old city. As the plan was being drawn, a monumental new city hall was rising on the Park at the head of Broadway (cat. nos. 186, 254), then and throughout the antebellum era New York's principal processional street.

The Commissioners' Plan can most accurately be described as the embodiment of an economically informed vision of urban society. It was created at a time when large-scale merchants and public officials were converting to economic theories that envisioned commerce as an all-encompassing, impersonal, systematic exchange of commodities rather than, as it had traditionally been regarded (and still was by many small traders), a series of discrete, highly personal, morally tinged relationships.[25]

This sense of trade as a commodity system was incorporated most explicitly in the commissioners' provision of a large marketplace (for foodstuffs and other "provisions") between First Avenue and the East River, and Seventh and Tenth streets. Eventually, they argued, householders would recognize that their time and money could be more efficiently spent shopping in a centralized venue than among the city's many dispersed marketplaces. At the same time, vendors would enjoy a more stable clientele and a more predictable demand, which "has a tendency to fix and equalize prices over the whole city."[26]

The commissioners' vision, unexceptionable to modern eyes, marked a radical change in the time-honored conception of the relationship between urban government and the markets. One of the functions of European and American city governments was to protect the food supply. City officials determined the sites of marketplaces, rented stalls, set market hours, controlled the quality, weight, and sanitary condition of goods sold, and most of all regulated prices. In the early nineteenth century New York had one main market, the Fly Market, replaced by Fulton Market in 1816 (cat. no. 120), and seven local ones.[27] At midcentury there were thirteen.[28] The Commissioners' Plan envisioned a single large market whose prices would be governed by competition rather than law. This was the de facto system by the middle of the nineteenth century when, as one journalist noted of Washington Market, the traditional rules for pricing, quantity, and quality, although stringent, were "dead letters, for they are seldom or never carried into execution."[29]

Increasingly New York's city government stepped away from economic regulation and devoted itself instead to creating the infrastructure that would enable an ostensibly benign system to operate freely.

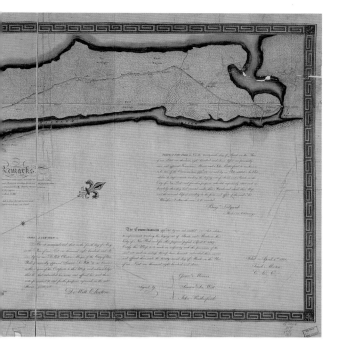

Even had they wished to continue regulation, New York's superior harbor (cat. no. 121) and good fortune in controlling access to the easiest inland route, which were the foundations of its power, also integrated it into a world economy no longer susceptible to local control.[30] The opening of the Erie Canal in 1825 and the completion of the transatlantic cable in 1858 reinforced the city's position as a key node in the geography of trade (cat. nos. 307–309).

The Commissioners' Plan, revised in minor ways and published in definitive form in 1821, laid out both the intellectual assumptions and the physical framework within which New York grew throughout the antebellum period. The theoretically grounded belief in a systematic economic order inspired a conception of the city as a spatial system that would articulate all uses and all users, permitting maximum freedom of individual action while ensuring transparent overall order. Again this differed from traditional concepts, which regarded urban spaces as static, unrelated aggregations of adjacent properties gathered around public spaces. Early-nineteenth-century writers sometimes used the analogy of a table, with a grid of "cells," each of which varies independently in its values but stands in clear relationship to every other one. It was an appropriate metaphor for the image of the articulated grid, which the New York commissioners shared with their merchant counterparts in other cities throughout the new nation.[31]

In New York, as in other American cities, public officials threw themselves into the business of regulation with a vengeance, cutting and filling and smoothing to make Manhattan Island resemble as closely as possible the flat surface and regular lines of the Commissioners' Plan. The Collect Pond and the Swamp, the Beekman property east of City Hall Park, were drained, watercourses were filled, the shoreline was extended, and, one by one, hills were leveled and valleys and ravines filled (cat. no. 124). The *Evening Post* complained in 1833 of the many plans "for opening new streets, widening others, ploughing through church yards, demolishing block after block of buildings, for miles in length, filling up streets so that you can step out of your second story bed room window upon the side walk, and turning your first story parlors and dining rooms into cellars and kitchens, with various other magnificent projects for changing the appearance of the city, and for preventing any part of it from ever getting a look of antiquity."[32] "The great principle which governs these plans is, to reduce the surface of the earth as nearly as possible to dead level," complained the poet and academic Clement Clark Moore.[33] Moore was right, but his objections and those of his fellow landowners had less to do with the intention than with the assessments levied against them for work adjacent to their properties.

The campaign to supply the city with water, the most conspicuous and, in some New Yorkers' minds, the most heroic effort to regulate the city, strikingly illustrates the power of the systematic urban vision. New Yorkers obtained their water from wells far into the nineteenth century. As neighborhoods were populated, the city typically ordered the provision of wells and pumps along with the paving of streets. The earliest efforts to create a systematic water supply also depended on wells.[34] One after another those few of these schemes that progressed beyond the planning stage failed. Even as other cities, such as Philadelphia and New Orleans, managed to get their water systems under way, New York's efforts stalled.[35]

The major difficulty lay in the conception of the government's role. City corporations like New York's had traditionally accomplished major public works by offering construction incentives to private landowners.[36] At the beginning of the nineteenth century the city decided to undertake in its own name an ambitious plan to obtain water from the Bronx River. It was opposed by those who did not believe that the city should take on a project with uncertain financial returns and by others who regarded such works as

30. Amy Bridges, *A City in the Republic: Antebellum New York and the Origins of Machine Politics* (Cambridge: Cambridge University Press, 1984), p. 1.

31. Dell Upton, "Another City: The Urban Cultural Landscape in the Early Republic," in *Everyday Life in the Early Republic*, edited by Catherine E. Hutchins (Winterthur, Delaware: Henry Francis Du Pont Winterthur Museum, 1994), pp. 67–70; Dell Upton, "The City as Material Culture," in *The Art and Mystery of Historical Archaeology: Essays in Honor of James Deetz*, edited by Anne E. Yentsch and Mary C. Beaudry (Boca Raton, Florida: CRC Press, 1992), pp. 53–56.

32. Untitled item, *Evening Post* (New York), February 26, 1833.

33. Quoted in Cohen and Augustyn, *Manhattan in Maps*, p. 108.

34. E. Porter Belden, *New-York: Past, Present, and Future; Comprising a History of the City of New-York, a Description of Its Present Condition and an Estimate of Its Future Increase*, 2d ed. (New York: G. P. Putnam, 1849), p. 37; Edward Wegmann, *The Water-Supply of the City of New York, 1658–1895* (New York: J. Wiley and Sons, 1896), pp. 3–10; "Corporation Notice" (advertisement), *New-York Evening Post*, September 30, 1826, p. 3.

35. Jane Mork Gibson, "The Fairmount Waterworks," *Philadelphia Museum of Art, Bulletin* 84 (summer 1988), pp. 2–11; Gary A. Donaldson, "Bringing Water to the Crescent City: Benjamin Latrobe and the New Orleans Waterworks System," *Louisiana History* 28 (fall 1987), pp. 381–96.

36. Hartog, *Public Property*, pp. 8, 21–24, 62–68.

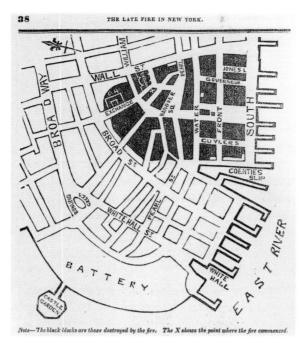

38 THE LATE FIRE IN NEW YORK.

Note—The black blocks are those destroyed by the fire. The X shows the point where the fire commenced.

Fig. 6. *Map of the Great Fire of December 16, 1835.* Wood engraving, from *Atkinson's Casket* 11 (January 1836), p. 38. Courtesy of the American Antiquarian Society, Worcester, Massachusetts

37. Wegmann, *Water-Supply*, pp. 11–12.
38. Belden, *New-York*, p. 38; Wegmann, *Water-Supply*, pp. 12–14; "Pure and Wholesome Water," *New-York Mirror, and Ladies' Literary Gazette,* December 22, 1827, p. 190. The Manhattan Company merged with Chase National Bank in 1955 to become the Chase Manhattan Bank.
39. "Pure and Wholesome Water," p. 190.
40. Wegmann, *Water-Supply*, pp. 16–37; Larry D. Lankton, *The "Practicable" Engineer: John B. Jervis and the Old Croton Aqueduct* (Chicago: Public Works Historical Society, 1977), pp. 4–16.
41. Wegmann, *Water-Supply*, pp. 49–51, 57–59; Lankton, *"Practicable" Engineer*, p. 24.
42. "The Croton Aqueduct," *Niles' National Register,* July 16, 1842, pp. 308–9; Wegmann, *Water-Supply*, pp. 39–40, 55.
43. "Croton Aqueduct," pp. 308–9. The editors added that the Egyptian-style architecture of the distributing reservoir was "well fitted by its heavy and imposing character for a work of such magnitude."
44. Belden, *New-York*, p. 41.

business opportunities rather than public obligations and wished to reap the profits themselves. Some of the latter, including Aaron Burr, obtained a charter as the Manhattan Company in 1799 and set up operations on Chambers Street. They dug a well, built a small reservoir, and began to lay wooden pipes through the streets of the city.[37]

In the early nineteenth century state legislatures commonly allowed private undertakers of public projects such as waterworks and canals to establish banks in order to finance themselves. The Manhattan Company's charter permitted them to raise capital as they saw fit and to make whatever use they wished of it over and above the costs of building and operating the works. The company concentrated its efforts on its banking enterprise and pumped only as much water as was necessary to protect its franchise, a practice that it maintained until the end of the nineteenth century, fighting off all attempts to charter bona fide water companies to serve New York.[38]

By the 1830s the water supply desperately needed reconstruction: public wells had become polluted, and firemen were hampered by lack of water in extinguishing major fires, such as the conflagration of December 16 and 17, 1835, which destroyed much of lower Manhattan's business district (cat. nos. 110, 111; fig. 6).[39] With the publicly financed construction of

the Erie Canal to offer as precedent, the city negotiated with the state the right to explore potential sources of water from newly drilled wells on Manhattan Island, from the Bronx River, and from the more distant Croton River. Engineer David B. Douglass was hired to draft a report, which favored the Croton River as the only source capable of supplying the anticipated population of the city over the next several decades. When the Common Council and the voters approved the project, Douglass was named project engineer and began work in May 1835. His lack of progress led to his replacement in the fall of 1836 by John B. Jervis, an engineer who had learned his profession during eight years' employment in the construction of the Erie Canal.[40]

Within a year construction of the water system was in full swing along the forty-one-mile aqueduct that connected a dam, created six miles upstream from the mouth of the Croton River, to a double receiving reservoir between Sixth and Seventh avenues and Seventy-ninth and Eighty-sixth streets, in an area that would later become Central Park. From there water was conducted to a distributing reservoir on Murray Hill (cat. no. 90), on the present site of the New York Public Library.[41]

The builders' most vexing problem was to devise a means of carrying the water across the Harlem River. After considering an inverted siphon under the river and a pipe laid across a suspension bridge (the suggestion of renowned suspension-bridge builder Charles Ellet), the Water Commission and its engineers chose to build a 1,450-foot aqueduct, now known as High Bridge, across the river (cat. no. 91).[42]

The Egyptian-style architecture of the distributing reservoir and the High Bridge's resemblance to a Roman aqueduct were meant to remind New Yorkers that their new waterworks rivaled the greatest monuments of antiquity. The Baltimore-based *Niles' National Register* wondered whether New Yorkers were aware of the magnitude of their achievement. In constructing "this stupendous structure" they were "surpassing ancient Rome in one of her proudest boasts. None of the hydraulic structures of that city, in spite of the legions of slaves at her command, equal, in magnitude of design, perfection of detail, and prospective benefits, this aqueduct."[43] Guidebook writer E. Porter Belden agreed that the aqueduct dwarfed all modern engineering works and rivaled ancient Rome's Aqua Marcia and Anio Novus.[44]

The waterworks projects called into question some basic assumptions that underlay the sense of the city as a system, specifically the beliefs that the pursuit of

individual advantages would mesh smoothly into an overarching general good and that government should be a neutral arbiter rather than an active agent of development. The interests of the Manhattan Company directly conflicted with those of the city at large. Nor was the Croton Waterworks as neutral as it seemed. Its construction was embraced by the Democratic city administration, which saw it as a way to employ four thousand party faithful, mostly Irish, and was driven forward by its contractors in the face of repeated strikes and disturbances on the part of their underpaid, overworked laborers. After its completion water was supplied to the populace only through public hydrants and even then over the objections of the water commissioners, who believed that ordinary people "abused" the privilege. Only paying customers—well-to-do householders and businesses—had water delivered directly to them.[45]

Republican New York

A day of civic ritual and public merriment marked the official opening of the Croton Waterworks on October 14, 1842. A parade moved from the Battery up Broadway to Union Square, down the Bowery, across East Broadway, and back to City Hall Park. The procession threaded its way through some of the most emblematic New York spaces, connecting the elite and plebeian shopping streets along Broadway and the Bowery and the rich and poor neighborhoods at Union Square and East Broadway. The last marchers passed City Hall Park just as the head of the procession was returning to it down Chatham Street, forming a human chain that tied the city's diverse neighborhoods to the center of its political universe at City Hall and the Park, where speeches and choral odes solemnized the day.

These festivities produced a sense of oneness in democratic fellowship among New Yorkers of all classes (or at least among those who wrote about it). It was the "proud consciousness which every citizen of New-York felt that his or her own cherished and honored city had, in this mighty undertaking, accomplished a work with no superior," a "gratification such as it is not often the pleasant lot of a municipal people to enjoy," wrote the *New World*.[46]

After the parades, speeches, and illuminations the *New World*'s correspondent concluded:

There was much, . . . very much—indeed we may say everything—in this celebration—to excite strongly the most grateful feelings and reflections. . . . [T]here was the sense of grandeur always called into being by the sight . . . of a great multitude, animated by one impulse, and moving or acting in the attainment of a common object. Nor was the proud reflection absent, that under the benign influence of political institutions which give and secure to every man his equal share in the general rights, powers, and duties of citizenship; amid this great convulsion, as it may be called—this mighty upheaving and commingling of society—where half-a-million of people were brought together into one mass as it were, there was not a guard, a patrol, a sentry, not even a solitary policeman, stationed any where to hold in check the ebullition of social or political excitement; that there was need of none.[47]

The *New World*'s observer articulated a characteristically republican vision of New York society, but one that was rapidly fading by the time the Croton Waterworks opened. At its heart was the seductive image of a diverse population acting freely but as though animated by a single will.

A republic was a polity of independent but related citizens who shared essential values and qualities but were differentiated in the degree to which they possessed them. Sometimes republicans made the point by comparing citizens to currency, whose denominations represented various quantities of the same essential value. The simile led one ambitious scholar of "National Arithmetic" to attempt to set a monetary value on the population of the United States and to use that to calculate the inevitable increase in national wealth.[48]

The central theoretical problem of republicanism was to reconcile economic and political liberty with order and the notion of a single overarching public good. How could one allow citizens the maximum self-determination and still hope to have an orderly society? As it was worked out by the earliest American political theorists, a republic depended heavily on the concept of virtue, a quality of character that prompted its members to discipline themselves and to subordinate personal interests to the larger good. Virtue depended on the inculcation of common values into citizens who, whatever their differences, all possessed an inherent, trainable moral sense.[49] Because republicans could not imagine the state's surviving without roughly equivalent degrees of knowledge, values, and goals among all its citizens, they asserted the necessity of "republican equality," of a society not rent by

45. Bridges, *City in the Republic*, p. 130; Edwin G. Burrows and Mike Wallace, *Gotham: A History of New York City to 1898* (New York: Oxford University Press, 1999), pp. 625–28; Wegmann, *Water-Supply*, pp. 64–65.

46. "The Croton Celebration," *New World*, October 22, 1842, p. 269.

47. Ibid.

48. [Samuel Blodget], *Thoughts on the Increasing Wealth and National Economy of the United States of America* (Washington: Printed by Way and Groff, 1801), pp. 7–10.

49. Dell Upton, "Lancasterian Schools, Republican Citizenship, and the Spatial Imagination in Early Nineteenth-Century America," *Journal of the Society of Architectural Historians* 55 (September 1996), pp. 243–46.

50. Gwendolyn Wright, *Building the Dream: A Social History of Housing in America* (New York: Pantheon Books, 1981), pp. 24–25.

51. Ronald Schultz, *The Republic of Labor: Philadelphia Artisans and the Politics of Class, 1720–1830* (New York: Oxford University Press, 1993), pp. 6–7; Margaretta M. Lovell, "'Such Furniture as Will Be Most Profitable': The Business of Cabinetmaking in Eighteenth-Century Newport," *Winterthur Portfolio* 26 (spring 1991), pp. 27–28; Sean Wilentz, *Chants Democratic: New York City and the Rise of the American Working Class, 1788–1850* (New York: Oxford University Press, 1984), pp. 61–103; Howard B. Rock, *Artisans of the New Republic: The Tradesmen of New York City in the Age of Jefferson* (New York: New York University Press, 1979), pp. 142–43; Bridges, *City in the Republic*, pp. 102–7.

52. Blackmar, *Manhattan for Rent*, pp. 51–61; Rock, *Artisans*, pp. 295–301; Wilentz, *Chants Democratic*, pp. 27–35; Elva Tooker, *Nathan Trotter, Philadelphia Merchant, 1787–1853* (Cambridge, Massachusetts: Harvard University Press, 1955), pp. 60, 137–38.

53. Watson, *Annals and Occurrences of New York City*, p. 205.

54. Appleby, *Capitalism and a New Social Order*, pp. 14–15; Rowland Berthoff, "Independence and Attachment, Virtue and Interest: From Republican Citizen to Free Enterprise, 1787–1837," in *Uprooted Americans: Essays to Honor Oscar Handlin*, edited by Richard Bushman et al. (Boston: Little, Brown, 1979), pp. 97–124.

55. Brooke Hindle, *The Pursuit of Science in Revolutionary America, 1735–1789* (Chapel Hill: University of North Carolina Press, 1956), pp. 260–62; John C. Greene, *American Science in the Age of Jefferson* (Ames: Iowa State University Press, 1984), pp. 52–57; Robert E. Schofield, "The Science Education of an Enlightened Entrepreneur: Charles Willson Peale and His Philadelphia Museum, 1784–1827," *American Studies* 30 (fall 1989), p. 21; Charles Coleman Sellers, *Mr. Peale's Museum: Charles Willson Peale and the First Popular Museum of Natural Science and Art* (New York: W. W. Norton, 1980), pp. 193, 214.

excessive disparities, or excessively visible disparities, of wealth and condition.[50]

Republican equality was most strongly emphasized in the "artisan republicanism" favored by craftsmen and small tradesmen. Artisan republicanism endorsed the workers' long-held belief that every economic actor, high or low, earned a niche in society by providing a service to the community and that each person consequently had a right to a "competency," the resources necessary to live an independent life with access to the necessities and comforts appropriate to his or her station. Self-respect demanded economic independence as a sign of public recognition. For artisans, then, republicanism incorporated an ideal of independent existence based on the ownership of one's own residence and place of business. Its echoes can be heard in the commissioners' "Remarks," in their assumption that the city they laid out would primarily be a city of individual residences.[51] Artisan republicanism viewed society as a network of interdependent relationships and obligations. Artisans were responsible for their apprentices' and employees' welfare, and their patrons were in turn responsible for theirs. Artisans and merchants counted on a loyal clientele, making unseemly competition among themselves unnecessary.[52] The historian John Fanning Watson, who decried the "painted glare and display" of capitalist competition (even though he was one of its prime movers in Philadelphia), emphasized this difference as he looked back nostalgically on business practices in prerevolutionary New York. "None of the stores or tradesmen's shops then aimed at rivalry as now," he wrote in 1843; "they were content to sell things at honest profits, and to trust an earned reputation for their share of business."[53]

For some patrician conservatives, on the other hand, republicanism was a hierarchical concept that emphasized the variations among individuals in the desirable qualities of citizenship. Those who traditionally ruled should continue to rule, but on the basis of superior virtue and wisdom rather than inherited privilege. Like artisans, although for different reasons, they worried about the consequences of extreme differences between the top and the bottom of republican society. They sought to marshal their personal social and cultural authority over their inferiors in defense of stability.

Eventually a third variety, liberal republicanism, emerged as the dominant strain. This emphasized the degree of personal liberty that was permitted if society and the economy were assumed to be governed by higher ordering forces that would act no matter what individuals might do. Liberal republicanism replaced the call for self-denying virtue with a definition of virtue that stressed enterprise and self-reliance in promoting one's own and one's dependents' welfare. Self-interest would be restrained by the self-regulation of a market-based political economy, integrating disparate individual goods into a common one.[54]

Republicans of all stripes hoped that universal public education would inculcate republican equality and civic virtue. In early-nineteenth-century America knowledge was still popularly imagined in Enlightenment terms: to list and classify was to know. At his celebrated museum in Philadelphia, for example, the artist, scientist, and educator Charles Willson Peale amassed an ever-expanding collection of natural history specimens and a portrait gallery of American patriots that grew to nearly one hundred paintings as he added politicians, American and European scientists and artists, and (as he grew older) Americans famous for their longevity. Peale wished to create an articulated, totalizing system of knowledge that would educate his fellow Americans for republican citizenship.[55]

Given these assumptions, it is easy to understand how the grid might have been viewed as the spatial order most likely to encourage republican equality by coordinating citizens' activities and interests. The grid was particularly congenial to the republican concept of knowledge, for it was thought to facilitate the *separation* and *classification* (two ubiquitous watchwords of antebellum cultural life) that Americans then valued in every aspect of human activity. New York's gridded spaces satisfied the republican love of a kind of order that could be laid out in a simple, quickly and easily grasped scheme.

Yet the prospects for republican community seemed threatened by significant changes in the social and economic structure. Liberal republicanism's embrace of capitalist political economy eventually eradicated the mutual dependency that artisan republicans advocated. Until the late eighteenth century employers had provided the necessities of life—food, shelter, clothing—in addition to or in place of wages, and had exercised broad control over their employees' lives. Male heads of households assumed the same rights of social and moral direction over those who worked for them as over their relatives.[56]

Traditional labor relations disintegrated under the impact of the new commodity-driven, capitalist economy. Employers rapidly abandoned responsibility for their workers' social and spiritual, as well as their economic, welfare, substituting a simple wage-labor system. Workers may have gained independence from paternalistic supervision, but they were rarely paid

enough to enjoy their freedom or to compensate for some of the material benefits they had derived from living under their employer's roofs. Artisan employers, too, suffered the loss of a dependable living, as advertising, display windows, and longer hours marked the growing desire for customers' immediate patronage rather than their long-term loyalty.[57]

The new, rough-and-tumble, laissez-faire capitalism transformed the lives of New Yorkers of all classes. The old colonial mercantile and agrarian elite were affected as surely as small shopkeepers, artisans, and laborers. Those who clung to their former habits entered upon a long decline, while others discovered ways to profit from urban land speculation and invested in banks, insurance companies, manufacturing, the infrastructure, and retail sales. By the time of the Civil War 115 millionaires resided in New York. They and their predecessors of a generation or two earlier—men such as banker John Pintard, auctioneer and diarist Philip Hone (cat. no. 58), fur trader and land speculator John Jacob Astor, merchant and art collector Luman Reed (cat. no. 9), and banker and art collector Samuel Ward—formed a self-designated elite who increasingly retreated into luxurious seclusion.[58]

The new elite dismayed many of their fellow citizens, for republican equality survived in popular sentiment even though it was theoretically outmoded by liberal republicanism. At midcentury the journalist Caroline M. Kirkland criticized the new rich of Fifth Avenue for building houses "in luxury and extravagance emulating the repudiated aristocracy of the old world" (cat. no. 185).[59] Another journalist took the opposite tack: those mansions were "the spontaneous outgrowth of good old Knickerbocker industry, enterprise and thrift, engrafted on a freedom-loving and liberal spirit, and are scarcely possible under any other than republican institutions." Consequently everything along Fifth Avenue was "suggestive of equality, although wealth has made that equality princely."[60]

The social and economic elite withdrew from their traditional political activism in the quarter-century before the Civil War, as they had from urban social life, leaving politics in the hands of new, up-from-the-ranks career politicians who catered to middling and lower-class constituencies. As economic interests diverged and ethnic and class divisions hardened, the extension of the franchise to all white men and the active participation of working-class men in politics made the process of governing the city more democratic, but also more fragmented and more difficult, and the eighteenth-century assumption of a single public good collapsed.[61]

Republican values appeared to be threatened from below as well as from above. By 1860 just under half of the city's population was foreign born, with most immigrants having arrived after 1845. Of these the Irish-born comprised about 30 percent of the population and the German-born another 15 percent. Only 1.5 percent were African Americans, down from just under 10 percent in 1820. Their numbers had remained roughly stable since then as the white population expanded, after having kept pace with the city's growth in the decades just before the opening of the Erie Canal. In 1825 a few remained enslaved or held as indentured servants under the provision of New York State's Gradual Manumission Act of 1799. They were finally freed in 1827, but African Americans remained at the bottom of New York's social and economic hierarchies.[62]

In the opinion of many middling and elite New Yorkers, these groups—immigrants and blacks—formed the cadres of a vast army of paupers, criminals, and lunatics. Beginning with the construction of the New York State Penitentiary on the Hudson River side of Washington Street between Christopher and Perry streets in Greenwich Village in 1796–97, the city was encircled by a growing corps of institutions intended to rescue and reform New Yorkers—almost exclusively poor New Yorkers—from their failures as republican citizens, substituting institutional oversight for the personal relationships and direct supervision of dependents that well-off urbanites had abandoned with the advent of wage labor.[63] These new institutions included the complex of a hospital, jail, workhouse, and almshouse built at Bellevue in 1816 to replace their predecessors around City Hall Park; a third generation of the same institutions built on Blackwell's (now Roosevelt) Island between 1828 and 1859; the Bloomingdale Insane Asylum, successor to the wing for lunatics in the old New York Hospital on lower Broadway; the House of Refuge, or reform school, on the parade grounds (Madison Square); and a dizzying assortment of asylums—for deaf mutes, the blind, orphans, Jewish widows and orphans, Protestant half-orphans, Roman Catholic orphans, friendless "respectable, aged, indigent females," friendless boys, aged and ill sailors (the Sailors' Snug Harbor), magdalens (reformed prostitutes), and female ex-convicts. *Peterson's Monthly* counted twenty-two asylums plus eight hospitals in New York City in 1853.[64]

In addition to meticulously separating and classifying their charges among these institutions, their founders all assumed the need for separation and classification within each institution, and they assumed as well that gridded spaces, like those that organized

56. Appleby, *Capitalism and a New Social Order*, pp. 59–78, 95–96; Blackmar, *Manhattan for Rent*, pp. 60–68.

57. Bridges, *City in the Republic*, pp. 11, 50–54, 70–71; Blackmar, *Manhattan for Rent*, pp. 61–68.

58. Cornog, *Birth of Empire*, p. 162; Blackmar, *Manhattan for Rent*, pp. 36–43; Alan Wallach, "Thomas Cole and the Aristocracy," *Arts Magazine* 56 (November 1981), pp. 98, 103–4; Spann, *New Metropolis*, pp. 205–11.

59. C[aroline] M. Kirkland, "New York," *Sartain's Union Magazine of Literature and Art* 9 (August 1851), p. 149.

60. "Fifth Avenue," *Home Journal*, April 1, 1854, p. 2.

61. Bridges, *City in the Republic*, pp. 62, 71–75, 127–31; Ryan, *Civic Wars*, pp. 8–11, 108–13. The wealthy continued to be active behind the scenes as financial contributors and party functionaries, but their authority was diminished.

62. Nathan Kantrowicz, "Population," in *The Encyclopedia of New York City*, edited by Kenneth Jackson (New Haven: Yale University Press, 1995), pp. 921–23; Rock, *Artisans*, p. 14; Spann, *New Metropolis*, p. 430; Bridges, *City in the Republic*, pp. 39–41; Eric Homberger, *The Historical Atlas of New York City: A Visual Celebration of Nearly 400 Years of New York City's History* (New York: H. Holt and Co., 1994), p. 45; Shane White, *Somewhat More Independent: The End of Slavery in New York City, 1770–1810* (Athens: University of Georgia Press, 1991), pp. 38, 47, 53–55, 153–54.

63. [Thomas Eddy], *An Account of the State Prison or Penitentiary House, in the City of New-York; by One of the Inspectors of the Prison* (New York: Isaac Collins and Son, 1801), pp. 17–18.

64. "The Benevolent Institutions of New-York," *Peterson's Monthly* 1 (June 1853), pp. 673–86.

SUBURBAN GOTHIC VILLA.

Fig. 7. Alexander Jackson Davis, architect and artist, *House of William C. H. Waddell, Fifth Avenue and Thirty-eighth Street, Perspective and Plan*, 1844. Watercolor and ink. The New York Public Library, Astor, Lenox and Tilden Foundations, Miriam and Ira D. Wallach Division of Art, Prints and Photographs, The Phelps Stokes Collection

65. Quoted in Samuel L. Knapp, *The Life of Thomas Eddy; Comprising an Extensive Correspondence with Many of the Most Distinguished Philosophers and Philanthropists of This and Other Countries* (New York: Conner and Cooke, 1834), p. 76.

66. Belden, *New-York*, p. 49; "A Visit to the Tombs Prison, New York City," *Frank Leslie's Illustrated Newspaper*, November 29, 1856, pp. 388–89; John Haviland, "Description of the House of Detention, New York, 1835–38, and List of Other Works," manuscript, 1846, p. 6, Simon Gratz Collection, case 8, box 11, Historical Society of Pennsylvania, Philadelphia.

good citizens, could correct—civilize—errant ones. By the second quarter of the nineteenth century, all large institutional buildings were planned on a grid of identical cells or rooms opening off one or both sides of a corridor. Ideally each prisoner, inmate, or patient was assigned to a separate unit. This isolated the subject and prevented infection of the body or of the character, for as the Quaker merchant and reformer Thomas Eddy noted of prison inmates, where criminals were housed in groups, "each one told to his companions his career of vice, and all joined by sympathetic villainy to keep each other in countenance."[65]

The New York State Prison at Auburn, converted to separate cells in 1819–21 partly at Eddy's urging, and the renowned Eastern State Penitentiary at Philadelphia (1821–36) established separate cells for individual

offenders as the standard of up-to-date prison design. New York City's antebellum penal institutions followed this model, most notably in the jail portion of the New York Halls of Justice and House of Detention (1835–38), popularly known as the Tombs and built on Centre Street near City Hall to replace the old Bridewell (cat. no. 83). Its architect, John Haviland, had made his reputation as the architect of the Eastern State Penitentiary. In the House of Detention portion of the Tombs, a freestanding 142-by-45-foot block on three levels, the 148 separate cells, "constructed after the model of the State Penitentiary at Philadelphia," were additionally "divided into four distinct classes for *prisoners,* and rooms for male and female, white and black vagrants" (cat. no. 82).[66] In this way, jailers could mete out food, reading matter, labor, and human contact individually. Most important, in his

Fig. 8. *Modest Artisan-Type Houses, Gay Street, Greenwich Village, New York,* buildings, second quarter 19th century; photograph by Dell Upton, July 1998

cell, "where he is unseen and unheard, nothing can reach [the convict] but the voice which must come to him, as it were, from another world."[67]

The failure of the cell system was evident by the 1840s, and institutional discipline relaxed. When the Swedish novelist and travel writer Fredrika Bremer visited the Tombs in the 1850s, she found the prisoners sharing cells and even worse, "walking about, talking, smoking cigars."[68] Although New Yorkers continued to voice hopes for republican community

after the 1830s, they turned their main attention to the excitements of commercial society.

Selling New York

Liberal republicanism and capitalist enterprise had transformed the landscape of antebellum New York. Until the late eighteenth century merchants and artisans commonly lived in or beside their places of business or work, in households that included their servants,

67. Knapp, *Life of Thomas Eddy,* p. 94.
68. Fredrika Bremer, *The Homes of the New World; Impressions of America,* translated by Mary Howitt, 2 vols. (New York: Harper and Brothers, 1853), vol. 2, p. 605.

Fig. 9. Seth Geer, designer and builder, *La Grange Terrace, Astor Place,* buildings, 1833; photograph by Dell Upton, July 1998

Fig. 10. *Grove Court, Greenwich Village, New York: Rear Tenements behind a Street of Modest Working-Class and Artisans' Houses,* buildings, ca. 1850; photograph by Dell Upton, July 1998

69. Diana diZerega Wall, "The Separation of Home and Workplace in Early Nineteenth-Century New York City," *American Archeology* 5, no. 3 (1985), pp. 185–86; Blackmar, *Manhattan for Rent,* pp. 78, 100–105.

70. Spann, *New Metropolis,* p. 220.

71. James Gallier, *Autobiography of James Gallier, Architect* (Paris: E. Briere, 1864; reprint, New York: Da Capo, 1973), p. 18.

72. "Marble Houses at Auction" (advertisement), *Evening Post* (New York), March 28, 1833, p. 4. As a result of ambiguity in the record, the authorship of La Grange Terrace has long been a matter of disagreement. See, for instance, "Building the Empire City" by Morrison H. Heckscher in this publication, p. 179.

apprentices, and employees. As they disengaged from these, merchants began to move away from their waterfront stores and residences, slowly at first, then in earnest around 1820, with artisans following suit a decade later.[69] The city's builders and its growing coterie of professional architects erected comfortable, sometimes luxurious, houses for the mercantile migrants near the western side of the island and up its center at the advancing urban edge, near Washington Square, Bond Street, and Astor Place, on Union Square, and then (after the mid-1840s) up Fifth Avenue, the hotbed of the "Codfish Aristocracy," as the new rich were called (cat. nos. 185, 188; fig. 7).[70]

Before Fifth Avenue was developed, all but the wealthiest New Yorkers were satisfied to live in dwellings erected by speculative builders, most often created as ready-made commodities fitted to the demands of the grid rather than to those of individual clients. They ran the gamut from endless rows of small, two-to-four-room houses for artisans up to substan-

tial semidetached houses (cat. nos. 84, 85; fig. 8). Builders for middling and well-to-do tenants sometimes retained architects to design relatively standardized facades to enliven highly standardized plans, paying a few dollars for a drawing that might be dashed off in a morning (cat. nos. 87, 88).[71] At the upper end were luxurious, architecturally ambitious rows such as La Grange Terrace (Colonnade Row) on Lafayette Place (now Astor Place), carved out of Vauxhall, the old pleasure garden on John Jacob Astor's land (cat. no. 86; fig. 9). Designed and built by the developer Seth Geer, this "splendid Terrace Row" of marble-fronted houses was offered at auction by Geer in April 1833.[72] Even those wealthy enough to construct freestanding residences, such as Luman Reed, who was said to have "the most expensive house in New York" in 1835, and Samuel Ward, often relied on a master builder to construct a more or less standard Georgian-plan house, sometimes distinguished by an architect-designed facade.[73]

Even the brisk rate of construction that characterized New York building through most of the antebellum era was inadequate to accommodate the growing urban population. By 1840 the city was engulfed in a housing crisis from which it never emerged.[74] While well-off people enjoyed improved accommodation, more and more wage earners were paying higher and higher rents for smaller and worse quarters. Houses meant for one family were subdivided, often with a

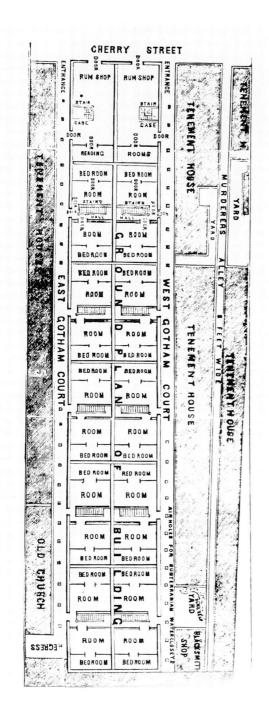

Fig. 11. *Gotham Court, Five Points,* 1850. Wood engraving, from *Frank Leslie's Sunday Magazine* 5 (June 1879), p. 643

different family or tenant group in every room. Buildings of the flimsiest and most insubstantial sort were converted to dwellings for those who were too poor to afford anything better or who were excluded from it by racial discrimination. On a lot on Ludlow Street, between Grand and Hester streets, were "7 or 8 huts in close connection, . . . mere sheds," subdivided into more than fifty rooms occupied by 60 to 100 African Americans in 1830.[75] Four years later an alderman complained to the council about that portion of Laurens Street (now West Broadway) between Canal and Spring streets: at number 33 he found 21 whites and 96 blacks in residence, with 10 more of the latter living in a small building at the rear; this address and its nine nearest neighbors had a total population of 280 whites and 173 blacks, an average of 45 people per house.[76]

To take advantage of the need for low-end housing that these documents reveal, new buildings were erected as tenant dwellings in backyards and in districts heavily occupied by working people, where, after the 1830s, speculators constructed three-story tenements for multifamily occupancy in place of the older, subdivided two-story single-family houses (fig. 10).[77] A few developers built rental housing that looked forward to post–Civil War practices, such as the seven-story tenement reputedly constructed at 65 Mott Street in the 1820s, or Silas Wood's Gotham Court of 1850, near Murderer's Row in the Five Points district (fig. 11). This six-story structure provided ten-by-fourteen-foot, two-room apartments for 140 families. By 1855 reformers found the situation so dire that they erected the first model tenement, the Workingmen's Home, designed by architect John W. Ritch. Familiarly known as the Big Flat, this philanthropic building stood just north of Canal Street on a lot spanning Mott and Elizabeth streets. Within a few years it had become a problem in its own right.[78]

Even middle-income people, especially if they were single, turned to multiple-occupancy housing, such as the "well regulated lodging-house . . . fitted up with all the modern improvements, the furniture entirely new and of the best quality" that was advertised in the *Home Journal* in 1850, and to boardinghouses, hotels, and rooms in private houses.[79] Like their impoverished fellow citizens, middle-class families were often forced to "a species of uncomfortable communism," the sharing of houses, "so that the direct order of the family is lost."[80]

Although workplaces and living quarters were beginning to be separated and residential districts to be differentiated by class and race, and although, crudely speaking, the west side of Manhattan was more

73. Thomas U. Walter, Diary, 1834–36, p. 33, Thomas U. Walter Papers, Athenaeum of Philadelphia. Both Reed's and Ward's houses were designed and built by Isaac G. Pearson, although Alexander Jackson Davis apparently made a facade drawing for Reed's; see Ella M. Foshay, *Mr. Luman Reed's Picture Gallery: A Pioneer Collection of American Art* (New York: New-York Historical Society, 1990), pp. 32, 50. Philadelphia architect Thomas U. Walter, who visited both houses in 1835, attributed them to the "pseudo Architect" Pearson, "a merchant from Boston who thought he had peculiar talents for architecture, and left his mercantile persuits [*sic*], plunging headlong into the practice of the art, without a single qualification." See Walter, Diary, 1834–36, pp. 22–24 (quotes), 33–34.

74. Blackmar, *Manhattan for Rent,* pp. 204–12.

75. Deposition of Doctor Knapp, in *The People v. Barclay Fanning,* District Attorney Indictment Papers, New York, May 14, 1830.

76. "Laurens Street, New York," *Niles' Weekly Register,* June 28, 1834, p. 303.

77. Blackmar, *Manhattan for Rent,* pp. 70, 199–201.

78. Richard Plunz, *A History of Housing in New York City: Dwelling Type and Social Change in the American Metropolis* (New York: Columbia University Press, 1990), pp. 5–7; Robert H. Bremner, "The Big Flat: History of a New York Tenement House," *American Historical Review* 64 (October 1958), pp. 54–62.

79. "Rooms with Breakfast Only" (advertisement), *Home Journal,* January 1, 1850, p. 3; Blackmar, *Manhattan for Rent,* pp. 134–35, 197–98. The *Home Journal* lodging house was at the corner of Broadway and Bleecker Street.

80. "New York Society," *United States Magazine, and Democratic Review* 31 (September 1852), p. 253.

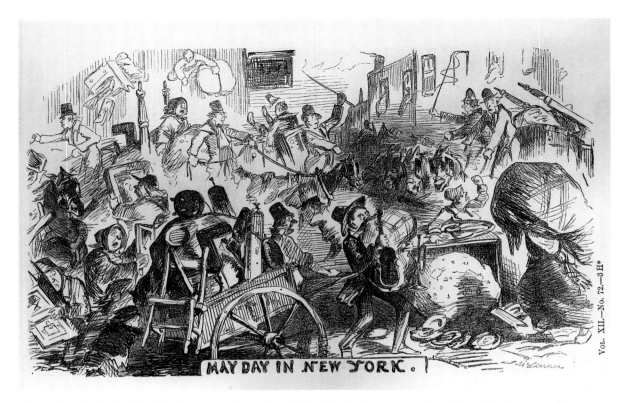

Fig. 12. *May Day in New York*. Wood engraving, from *Harper's New Monthly Magazine* 12 (May 1856), p. 862. Courtesy of the American Antiquarian Society, Worcester, Massachusetts

81. Alice B. Haven, "A Nice Neighborhood," *Godey's Lady's Book and Magazine* 62 (January 1861), p. 33.

82. "May-Day," *New-York Mirror*, February 29, 1840, p. 287; "First of May in New York," *Gleason's Pictorial Drawing-Room Companion*, May 10, 1851, p. 21; "Effects of Moving," *Niles' Weekly Register*, May 9, 1835, p. 172; "House-Hunting," *New-York Mirror*, February 29, 1840, p. 287; Felton, *American Life*, p. 52.

83. *Longworth's American Almanac, New-York Register, and City Directory for the Sixty-Second Year of American Independence* (New York: Thomas Longworth, 1837), pp. 17–22.

84. Alexander Mackay, *The Western World; or, Travels in the United States in 1846–47: Exhibiting Them in Their Latest Development Social, Political, and Industrial; Including a Chapter on California*, 2d ed., 3 vols. (London: R. Bentley, 1849), vol. 1, pp. 83, 87 (quote); E. E., "Letters Descriptive of New-York, Written to a Literary Gentleman in Dublin, No. III," *New-York Mirror, and Ladies' Literary Gazette*, January 13, 1827, p. 195.

prosperous than the east, New York was organized on a microscale rather than a macroscale, like most other cities of the first half of the nineteenth century in Europe and America. However exclusive the block or row in which one lived, one was never far from a factory or from people of a different class or ethnicity. This was painfully obvious to Mrs. Ballard, the protagonist of a *Godey's Lady's Book and Magazine* story. She and her husband, Fred, lived in a block of four houses on Nineteenth Street, west of Eighth Avenue, that were "unexceptionable," but "one had to pass certain tenement houses to reach them, and the entire square [block] presented an incongruous mixture of comfort and squalor which one often sees in respectable localities in New York city." The Ballards each suffered their own particular torments in the mixed neighborhood. For him it was "the noisy children swearing on the sidewalk near their pleasant home," while for her it was "the rag man's cart with its noisy bell." The rag man "must have" lived in a rear tenement behind their house, for he tied his dogs to the curbstone in front.[81]

If they were used to mixed neighborhoods, New Yorkers were also used to frequent changes of scene occasioned by the tight housing market and the rapid development of the city. Even wealthy homeowners such as Philip Hone or George Templeton Strong periodically sold their houses and moved farther uptown. Renters of all classes were accustomed to the annual spectacle of Moving Day, May 1, when all leases expired and tenants scrambled to find cartmen who would move them (fig. 12). The streets were full of vehicles rushing from one location to the other, and the failure of a single tenant to move before a new one arrived could induce a chain paralysis that might end up in police court. A side effect of the moving-day custom was that New Yorkers enjoyed an extensive view of the ways their social peers lived. One journalist described two (probably fictitious) sisters who made a hobby of house hunting as a pretext for sniffing out scandalous gossip about their neighbors.[82]

New York's burgeoning antebellum residential neighborhoods complemented its booming commercial and industrial districts. On Wall Street, the center of finance and channel of European capital into the Empire City, banks proliferated (cat. nos. 38, 71). Fifteen of the twenty-nine banks in Manhattan in 1837 were located on or just off Wall Street, along with the Custom House and a succession of merchants' exchanges that culminated in Isaiah Rogers's monumental marble building of 1836–42. Its predecessor, Josiah R. Brady and Martin Euclid Thompson's

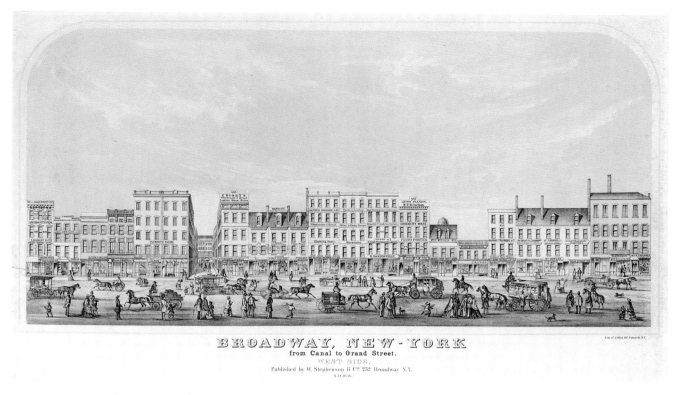

Fig. 13. *Broadway, New York, from Canal to Grand Street, West Side,* 1856. Tinted lithograph by Julius Bien, published by W. Stephenson and Company. The Metropolitan Museum of Art, New York, The Edward W. C. Arnold Collection of New York Prints, Maps, and Pictures, Bequest of Edward W. C. Arnold, 1954 54.90.1171

exchange of 1825–26 (cat. nos. 74, 75), had been destroyed in the Great Fire of December 16 and 17, 1835, together with much of the rest of Wall Street and its environs.[83] Along the waterfronts, on Pearl and Front and South streets, wholesale merchants were so busy that they commandeered the sidewalks to stack goods, leaving pedestrians "to jump over boxes, or squeeze yourself, as best you can, between bales of merchandize."[84]

Although New York is no longer commonly thought of as an industrial city, its position at the center of a trade network and its new waterworks made it an industrial power in the mid-nineteenth century. Croton water, used as a raw material in the chemical industry and to supply steam power to a host of other manufacturers, underpinned a 550-percent increase in industrial investment in Manhattan in the two decades after 1840. In 1860 there were over four thousand factories of various sizes scattered throughout the city.[85] There were few New Yorkers of any social class who did not live in close, often vexatious, proximity to several of them.[86]

Retail shops snaked up Broadway and pushed out along its side streets. At the time of the opening of the Erie Canal the premier shopping district centered around City Hall Park, with the portion of Broadway south of Wall Street given over to elite residences and small hotels (cat. nos. 109, 123). Over the decades the retail district moved gradually north, passing Washington Square by the beginning of the Civil War (cat. no. 180; figs. 13–15).

85. Moehring, "Space, Economic Growth, and the Public Works Revolution," pp. 34–35.
86. See Christine Meisner Rosen, "Noisome, Noxious, and Offensive Vapors: Fumes and Stenches in American Towns

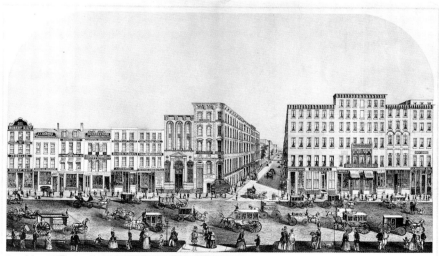

Fig. 14. *Broadway, from Warren to Reade Streets,* ca. 1855. Tinted lithograph with hand coloring by Dumke and Keil, published by W. Stephenson and Company. The Metropolitan Museum of Art, New York, The Edward W. C. Arnold Collection of New York Prints, Maps, and Pictures, Bequest of Edward W. C. Arnold, 1954 54.90.1044

Fig. 15. *The Ruins of Phelps and Peck's Store, Fulton and Cliff Streets, May 4, 1832*, 1832. Lithograph by Edward W. Clay. Collection of The New-York Historical Society

and Cities, 1840–1865," *Historical Geography* 25 (1997), pp. 67–82.

87. "The Peculiar Advantages of Shopping at Columbian Hall" (advertisement), *Christian Parlor Magazine* 9 (1852), p. 2; "Shopping in New-York," *Home Journal*, November 17, 1849, p. 4.

88. [William M. Bobo], *Glimpses of New-York City, by a South Carolinian (Who Had Nothing Else to Do)* (Charleston: J. J. McCarter, 1852), p. 162.

89. Dickens, *American Notes* (1842), in *American Notes and Pictures from Italy* (London and New York: Oxford University Press, 1957), p. 83; Kirkland, "New York," p. 150.

90. [Bobo], *Glimpses of New-York City*, pp. 117–19; "Economy" (advertisement), *Evening Post* (New York), October 22, 1832, p. 4; "A Card" (advertisement), *Morning Courier and New-York Enquirer*, November 1, 1832, p. 1; Madisonian, "Sketches of the Metropolis. The Streets of New-York. Broadway–Chatham-Street," *New-York Mirror*, April 13, 1839, pp. 329–30.

91. "Modern Buildings," *New-York Mirror*, March 15, 1834, p. 295.

92. John F. Watson, *Annals of Philadelphia and Pennsylvania in the Olden Time*, 2d ed.

Broadway was not the only commercial strand. Grand Street was the discount shopping district, while Canal and Catherine streets were also popular retail thoroughfares.[87] On the Bowery, according to South Carolina visitor William Bobo, one could find goods equal to those offered on Broadway at prices 15 to 20 percent lower.[88] Most of the Bowery's businesses, however, dealt in more ordinary commodities such as ready-made clothing, cooked meats, and lively entertainment. One of the city's principal showplaces, the often-burned Bowery Theatre, was located there, along with a zoo and a riding school.[89] Chatham Street and Chatham Square, which connected the southern end of the Bowery to the Park, were the home not only of sidewalk booksellers, pawnbrokers, old-clothes merchants, and "mock auction" houses (where the bidding was rigged against the unsuspecting) but also of silversmiths, jewelers, furniture dealers, and shoe stores (cat. no. 178). Chatham Square was a Jewish residential center (the city's oldest Jewish cemetery is there), and so many Chatham Street merchants were Jewish that it was sometimes referred to as "Jerusalem." It was also the site of the Italian Opera House, which failed and was converted to the National Theatre, a favorite working-class venue.[90]

A stroll along any of these streets in the antebellum decades would have made clear how comfortably the grid accommodated commerce (figs. 13, 14).

Each owner filled his property as he or she saw fit, but the lot lines and the street network articulated the individually defined units into a legible overall order. Each wholesale and retail store was often arranged as a grid within a grid for the same purpose (figs. 15, 16).

Over time commercial prosperity and soaring real-estate values encouraged more and more intensive lot coverage, causing individual structures to balloon upward. This "babel style of building" was already noteworthy in the 1830s.[91] By 1860 it was possible to read a street's real-estate history in its cornice lines, superimposed like archaeological strata (figs. 13, 14). The lowest were the two- and three-story buildings constructed during the 1820s and 1830s. By the 1840s the stories grew taller, and sometimes a fourth or fifth floor was added. After about 1850 six- or seven-story buildings broke what a frantic John Fanning Watson called, in reaction to the same changes in Philadelphia, "the former *line* of equality, and beauty." "*A city building on top of the former!*" he exclaimed. "*All go now on stilts!*"[92] The upward trajectory continued throughout the century. These antebellum buildings, designed to make more intensive use of a lot, were products of real-estate theories that, combined with newer building technologies, produced the skyscrapers of the late nineteenth century.

In commercial streets the thinnest of architectural membranes separated public space from private, and merchants discovered that it was to their advantage to make this membrane as permeable as possible. In wholesale districts granite-piered shopfronts, an idea introduced from Boston about 1830, superseded the round-arched fronts of the 1820s (fig. 17).[93] The granite piers permitted wider openings and less separation between store and street. For the same reasons cast-iron piers replaced granite at midcentury. Except for these thin supports, the fronts of the buildings were completely opened up to extend the circulatory space of the sidewalk into the stores and to spill their contents onto the sidewalk. There they were sheltered by block-long rows of awnings, supported on curbside posts, that commandeered public space as a commercial showroom.[94] In retail districts the process of opening up led from the bow or "bulk" windows of the late eighteenth century to the large plate-glass shopfronts of midcentury (fig. 14). In unpretentious shopping districts such as the Bowery, even retail stores might have open fronts. One visitor discovered that in the Bowery's most commercial stretches, no residences or offices interrupted the unbroken line of open-fronted shops, so that "the sides of the streets

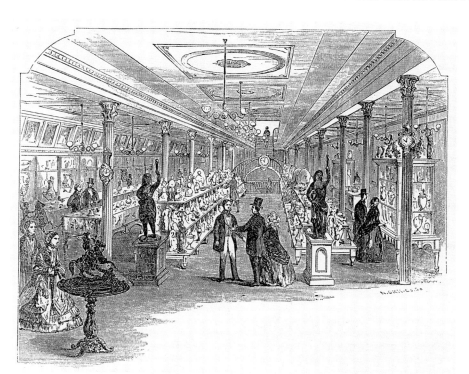

Fig. 16. *Salesroom, Main Floor, Haughwout Building, New York.* Wood engraving by Nathaniel Orr and Company, from *Cosmopolitan Art Journal* 3 (June 1859), p. 142. The Metropolitan Museum of Art, New York, The Thomas J. Watson Library

(Philadelphia: J. B. Lippincott, 1868), p. 591. These lines were written for Watson's "Final Appendix of the Year 1856."

93. One journalist identified Ithiel Town's Pearl Street store for Arthur Tappan as the first granite-piered warehouse in New York; see "The Architects and Architecture of New York," *Brother Jonathan,* May 27, 1843, pp. 91–92.

94. Mackay, *Western World,* vol. 1, p. 87; Asa Greene, *A Glance at New York: Embracing the City Government, Theatres, Hotels, Churches, Mobs, Monopolies, Learned Professions, Newspapers, Rogues, Dandies, Fires and Firemen, Water and Other Liquids, &c., &c.* (New York: A. Greene, Craighead and Allen, Printers, 1837), pp. 7, 10.

95. [Bobo], *Glimpses of New-York City,* p. 163; Kirkland, "New York," p. 150.

appear to be all door, and the walls only separate the different concerns."[95]

Whatever their size or date these buildings were constructed as layers of open, flexible, but carefully arranged space, unbroken except for stairs. This is evident in an unusually detailed interior description of the renowned Haughwout Building, built in 1856 at the corner of Broadway and Broome Street as the second home of E. V. Haughwout and Company (cat. no. 98). Like many antebellum retailers Haughwout's manufactured much of what it sold, and it decorated or embellished merchandise procured from other suppliers as well. The new building was a "monster manufacturing and sales establishment" that "embraces

Fig. 17. *Wholesale Store, 200 Block, Water Street, New York,* building, 1827; photograph by Dell Upton, July 1998

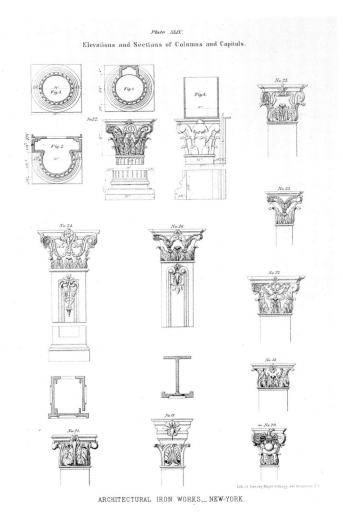

Fig. 18. *Cast-Iron Components*. Lithograph, from *Badger's Architectural Iron Work Catalogue* (New York: Baker and Godwin, 1865), pl. 49. Cooper-Hewitt, National Design Museum, Smithsonian Institution, Washington, D.C.

organizational patterns of contemporary textile mills, where ancillary services were confined to projecting towers to keep the manufacturing floor free of obstructions, Haughwout's shipping and receiving clerks worked in the vaults under Broadway and Broome Street, leaving the cellar floor unencumbered. Other offices were located at the rear of the first floor, a legacy of eighteenth- and early-nineteenth-century merchants' counting houses.

The fabrication of antebellum commercial structures was as rationalized as their operation. Building construction was organized by modules based on the customary sizes of building materials. American and British bricks were made to a standard size that determined wall thicknesses, wall heights, and the size and position of openings. Timbers, window lights, and other components were also made to standard proportions. This meant that many building parts could be prefabricated off site. With the introduction of steam machinery in the second quarter of the nineteenth century, sash-and-blind factories turned out vast numbers of standardized doors, windows, shutters, mantels, and decorative elements.[97]

Beginning with James Bogardus's remodeling of John Milhau's drugstore at 183 Broadway in 1848, ironmasters made cast-iron decorative elements and entire facades that could be fastened to commercial structures such as the Haughwout Building, whose facades were fabricated by the pioneer cast-iron manufacturers Daniel D. Badger and Company (cat. no. 98; fig. 18).[98] Cast iron offered economies of scale in production over even the wooden components produced by sash-and-blind factories. Rather than carving the same decorative element in an endless series of wooden or marble blocks, the artisan could make

96. "Department of Useful Art. First Article. The Haughwout Establishment," *Cosmopolitan Art Journal* 3 (June 1859), pp. 141–47, quote on p. 141. The Haughwout firm was founded in 1832. The Haughwout Building's steam-powered elevator was Elisha Otis's first commercial installation, although other kinds of mechanical elevators had been used in New York at least since Holt's Hotel opened on Fulton Street in 1832. See Sarah Bradford Landau and Carl W. Condit, *Rise of the New York Skyscraper, 1865–1913* (New Haven: Yale University Press, 1996), pp. 35–36; and "Holt's Marble Building," *Morning Courier and New-York Enquirer,* January 1, 1833, p. 2.

97. Carl R. Lounsbury, "The Wild Melody of Steam: The Mechanization of the Manufacture

more in value and interest than any single building in the world (if we except the Crystal Palace at Sydenham, England)," according to a journalist who visited it soon after it opened. The seven stories, five above ground and two below, were arranged like a grain mill, meaning that goods entered at the lowest level, the cellar, and were taken by steam-powered elevator to the top. There they were processed on the fourth and fifth floors, before filtering down, level by level, as far as the basement, where "plain and heavy goods (crockery)" for ships, hotels, and the wholesale trade were sold, along with seconds. The first floor offered silver and silver plate, as well as antiques and luxury items such as bronze and Parian statuettes (fig. 16); china and glass occupied the second floor; and Haughwout's original stock-in-trade, chandeliers and lamps, was displayed on the third.[96]

As in many commercial buildings, vaults extended under the sidewalks. Borrowing a page from the

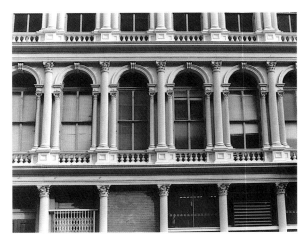

Fig. 19. *Haughwout Building,* constructed 1856; photograph by Dell Upton, November 1999

a single wooden mold from which an infinite number of cast-iron elements could be formed.[99] This promoted building design that was as modular as the street grid, with monumental facades built up of many small, repeated elements (fig. 19).

Consuming New York

Haughwout's rationalized spatial organization, building process, and business practices served the consumption of luxury goods, a distinctly irrational social process. Consumption is the construction of self through seeking, acquiring, and appreciating material objects; we might describe it as a search for personal urbanity. It hinges on the promise that in purchasing an object, the consumer acquires access to some desirable but intangible experience that cannot be directly bought. Consumption aims less to satisfy a desire for a social identity than one for the sense of secure being that the sociologist Colin Campbell calls, simply, *pleasure*. Pleasure encompasses both sensory stimulation—"an 'excited state in us'"—say, in the feel of a silk garment, the sound of a song well sung, or the glint of the polished surfaces of a mahogany table, and the satisfaction that these sensations create.[100] Since such pleasures produce only a momentary sense of fulfillment, the process of consumption never comes to an end but exists as a constant state of desire, acquisition, and renewed desire.

The material language of consumption in antebellum New York was borrowed from the preindustrial aristocracy. To nineteenth-century eyes cast-iron classical ornament (and the marble ornament to which it referred) gave the city's retail stores the air of "mercantile palaces."[101] Haughwout's was a "palace of industry" (cat. no. 98).[102] According to the editor of *Harper's,* an immigrant, on first beholding A. T. Stewart's dry-goods store or Broadway's luxury hotels such as the Irving, the Astor House, and the Saint Nicholas, would be likely to ask: "What are these splendid palaces?"[103] On the one hand, such buildings served to democratize American luxury as a form of republican equality: "*Here* palaces are for the people."[104] On the other, they offered New Yorkers the luxuries of the "repudiated aristocracy" that Caroline Kirkland challenged.

The association of mass-produced consumer goods with the tastes and prestige of aristocracy was a sales technique invented by English ceramic manufacturer Josiah Wedgwood in the eighteenth century, but luxury-goods vendors in antebellum New York found that it was still effective a century later.[105]

The journalist who visited Haughwout's store was careful to list the prestigious commissions that the firm had received—from the governor-general of Cuba, Czar Nicholas II of Russia, the "Imaum of Muscat," and the United States government as a gift to the emperor of Japan, among others.[106] To buy the same chandelier as Nicholas II would not make the purchaser a czar, or cause him to be mistaken for one, but it offered the possibility that by inhabiting the same material world he might enjoy some of the sybaritic pleasures that the czar commanded—that he might, in short, feel czarlike.

The association with specific elite customers at establishments such as Haughwout's was corollary to an evocation of luxury that began with the architectural imagery of the long procession of "palaces" that lined Broadway and continued inside each one, where customers found counters "heaped in wild profusion with every imaginable dainty that loom and fingers and rich dyes and the exhausted skill of human invention have succeeded in producing—drawn together by the magic power of taste and capital."[107] Profusion was the key. Shoppers confronted items too numerous to count or to experience individually. The generalized experience of luxury en masse promised nonspecific, and thus potentially more intense, pleasure.

Alexander T. Stewart, who emigrated from Ireland and opened a store at 283 Broadway in 1823, quickly mastered and refined these techniques. For that reason he enjoyed a reputation throughout the antebellum period as New York's premier dry-goods merchant, a man with a "character for urbanity, fairness of dealing and the immense stock of goods," at a time when dry goods accounted for over half the city's business.[108] His success eventually made him the second wealthiest property owner in New York, after William B. Astor, and allowed him to become one of the city's premier art collectors.[109]

In 1844 Stewart began to construct a five-story *"drygoods palace"* on Broadway at Chambers Street (soon extended to Reade Street), across from "the low-browed and dingy long-room" he had occupied for two decades: "'Shopping' is to be invested with architectural glories—as if its Circean cup was not already sufficiently seductive."[110] The project attracted great interest, spurred by the tantalizing refusal of the architect Joseph Trench to let his design be published before the building was finished (cat. no. 96).[111] The interior of A. T. Stewart's was organized around a light court, treated as a hall 100 feet by 40, 80 feet high, topped by a dome. As befit a royal setting, the

of Building Materials, 1850–1890," in *Architects and Builders in North Carolina: A History of the Practice of Building,* by Catherine W. Bishir et al. (Chapel Hill: University of North Carolina Press, 1990), pp. 212–19, 221–26.

98. "New Uses of Iron," *Home Journal,* October 21, 1854, p. 2; Margot Gayle and Carol Gayle, *Cast-Iron Architecture in America: The Significance of James Bogardus* (New York: W. W. Norton, 1998), pp. 77–81, 224–25.

99. See James Bogardus [with John W. Thompson], "Cast Iron Buildings" (1856), in *America Builds: Source Documents in American Architecture and Planning,* edited by Leland M. Roth (New York: Harper and Row, 1983), p. 72; and Gayle and Gayle, *Cast-Iron in America,* pp. 220–21.

100. Colin Campbell, *The Romantic Ethic and the Spirit of Modern Consumerism* (Oxford: Basil Blackwell, 1987), p. 63; Peter Lunt, "Psychological Approaches to Consumption: Varieties of Research—Past, Present and Future," in *Acknowledging Consumption: A Review of New Studies,* edited by Daniel Miller (London: Routledge, 1994), p. 249.

101. "Mercantile Palaces of New York," *Frank Leslie's Illustrated Newspaper,* June 20, 1857, p. 38.

102. "Palace of Industry," *The Independent,* May 7, 1857, p. 1.

103. "Editor's Easy Chair," *Harper's New Monthly Magazine* 7 (November 1853), p. 845.

104. "Fashionable Promenades," *United States Review,* n.s., 2 (September 1853), p. 233.

105. Neil McKendrick, "Josiah Wedgwood and the Commercialization of the Potteries," in *The Birth of a Consumer Society: The Commercialization of Eighteenth-Century England,* by Neil McKendrick, John Brewer, and J. H. Plumb (Bloomington: Indiana University Press, 1982), pp. 108–12.

106. "Department of Useful Art," pp. 143–44.

107. "Shopping in Broadway," *Holden's Dollar Magazine* 3 (May 1849), p. 320.

108. "New-York Daguerreotyped. Business-Streets, Mercantile Blocks, Stores, and Banks," *Putnam's Monthly* 1 (April 1853), p. 356; "The Dry Goods Stores of Broadway," *Home Journal,* October 27, 1849, p. 3 (quote). New York imported 75

percent of the nation's textiles; see Moehring, "Space, Economic Growth, and the Public Works Revolution," p. 31.

109. Spann, *New Metropolis*, p. 208.

110. "Diary of Town Trifles," *New Mirror*, May 18, 1844, p. 104; "Topics of the Month," *Holden's Dollar Magazine* 1 (March 1848), p. 187.

111. "Architecture," *Broadway Journal*, March 22, 1845, p. 188.

112. "New-York Daguerreotyped," p. 358; "Dry Goods Stores of Broadway," p. 3.

113. Alice B. Neal, "The Flitting," *Godey's Lady's Book and Magazine* 54 (April 1857), p. 331.

114. "Shop Windows," *New-York Mirror, and Ladies' Literary Gazette*, September 27, 1828, p. 93.

115. "Directions to Ladies for Shopping," *Anglo American*, October 26, 1844, p. 14.

116. Alexander Walker, *Woman Physiologically Considered, as to Mind, Morals, Marriage, Matrimonial Slavery, Infidelity and Divorce* (New York: N.p., 1843), pp. 7–10; "Literary Notices. Domestic Duties," *American Ladies' Magazine* 2 (January 1829), p. 45; Mary R. Mitford, "Shopping," *New-York Mirror, and Ladies' Literary Gazette* January 31, 1829, pp. 233–34; "Going a Shopping," *Arthur's Home Magazine* 2 (November 1853), pp. 329–31.

117. "Shopping in Broadway," p. 320.

118. "Why People Board," *Godey's Lady's Book* 46 (May 1853), p. 476.

119. "The Wife's Error," *Godey's Lady's Book* 46 (June 1853), p. 495.

120. Bridges, *City in the Republic*, p. 81.

121. "Directions to Ladies for Shopping," p. 14; "Literary Notices. Domestic Duties," p. 45; "Shopping in Broadway," p. 320.

122. "Shopping in Broadway," p. 320.

123. "Shop Windows," *New-York Mirror, and Ladies' Literary Gazette*, September 27, 1828, p. 93.

walls of his "Marble Palace" were hung with paintings, while merchandise—"every variety and every available style of fabrics in the market"—was piled on every surface and suspended from the ceilings and even the dome (cat. nos. 201, 219).[112] This spectacle finally overcame Mrs. Cooper, the protagonist of an Alice B. Neal short story, on a visit to Stewart's: "She cared very little for dress, and could look at the gorgeous brocades, suspended in the rotunda, as quietly as she did at the painted window-shades of her opposite neighbor. It cost no effort to pass by the lace and embroideries of the intervening room, or to turn her back upon the enticing cloaks and mantles beyond; but those fleecy blankets, those serviceable tablecovers, the rolls of towelling, and, above all, the snowy damask piled endwise, as children do their cob-houses, were a sore temptation."[113]

Nineteenth-century commentators recognized the ways in which sales techniques stimulated desire, even if they could not always put their fingers on them. The *New-York Mirror, and Ladies' Literary Gazette* described shop windows as the staging ground of a dance of desire that involved both consumer and merchant. The passerby who "looks attentively and delightedly at a shop-window, pleases two people. He pleases himself by indulging his curiosity, or by gratifying his taste; and he pleases the shopkeeper by the unartificial homage which he thus pays to the taste which arranged the articles, and by the promise which he thus holds out of the probability of his becoming a purchaser."[114] The *Anglo American*, too, sensed the nonspecific nature of consumer desire, offering a vignette of the shopper who sets out in search of a specific item, only to end up with a whole wardrobe as the result of the clerk's inquiry as to "'whether there is any other article today?' Whether there is or not, let the shopman show you what wares he pleases; you will very likely desire one or more of them."[115]

Women were already stereotyped as the primary shoppers and the most avid and helpless of consumers. As weak-minded creatures with tenuous senses of selfhood, they were peculiarly susceptible to the blandishments of goods for sale, for their sensibilities were powerful but their reason was not.[116] Shopping seemed to produce in them "unnatural excitements," and in some unfortunates "a morbid excitement of the organ of acquisitiveness," leading them to shoplift.[117] Worse, consumption seemed to violate the ideology that identified women as the keepers of higher values in the home, and therefore as creatures who existed outside the realm of commerce. Domestic moralists

decried middle-class women's willingness to sacrifice "the very root and foundation of domestic privacy, and love, and faith" by taking in boarders, an act that they attributed to a craving for "ornamental statuettes, vases, clocks, and literally 'what-nots.'"[118]

Shopping was the complement of business: while men toiled to earn money at the Merchants' Exchange, women spent it at the "Ladies' Exchange"—Stewart's.[119] Yet antebellum political economy recognized only production and accumulation as healthy economic activities.[120] In consuming, women entered the economy at the wrong end, for consumption was a kind of fraud. If a woman bought, she squandered her husband's laboriously acquired wealth; if she simply browsed, she cheated male clerks out of their livelihoods; if she shoplifted, she committed the equivalent of stock speculation and fraudulent bankruptcy.[121]

As the antithesis of production, consumption threatened republican values, particularly the rights of men to the fruits of their labor. Women were "the empresses and sultanas of our republican metropolis," seated before counters heaped with luxurious goods, while their husbands were "slaves of the dirty mines and dingy laboratories of Wall street and 'down town' . . . delving their lives out to wring from the accidents, the mistakes and the necessities of society the yellow dust that invests their ambitious household divinities with these magnificent adornments."[122]

The World in Little

The political economy of consumption dramatically challenged a primordial assumption of republican citizenship, which emphasized the pursuit of knowledge as a path to virtue and the obligation of the learned and the talented to instruct their fellow citizens. The impulses to investigate and to educate were alive in New York intellectual life and popular culture throughout the antebellum era, but more and more they flowed through commercial channels. "We have heard of a young man who learned geography by means of mapsellers' windows," wrote the *New-York Mirror, and Ladies' Literary Gazette* in 1828. "That was certainly stealing knowledge; but he could not afford to pay for it, and therefore, the theft was easily forgiven."[123]

The expansive Enlightenment confidence in the human ability to encompass all knowledge was subsumed by New Yorkers' sense of their power to acquire anything the world offered. "Every article which can please the fancy is here daily exposed to the gaze of the curious," wrote the pseudonymous

Fig. 20. *The Five Senses—No. 1, Seeing.* Wood engraving, from *Harper's New Monthly Magazine* 9 (October 1854), p. 714. Courtesy of the American Antiquarian Society, Worcester, Massachusetts

Madisonian.[124] In the words of another observer of the city, "Whatever art has manufactured for the comfort and convenience of man, is exposed for sale in her markets. If Europe affords a luxury, it is there; and if Asia has aught rich or splendid, *money* will procure it in New-York."[125]

Not only merchandise but also lectures, theatrical performances, minstrel shows, symphonic, vocal, and band concerts, operas, freak shows, public gardens, fireworks displays, botanical exhibits, commercial museums and galleries, and other diversions were available for a price along New York's great commercial streets, side by side with the more carnal delights available in the many saloons and brothels scattered throughout the city, but particularly thick in the mid-nineteenth century in the entertainment district of Broadway.

As it was commercialized, though, the universal popular education of republican ideals was transformed into privatized spectacle, its content from public knowledge to salable commodity, its purpose from civic training to personal pleasure (fig. 20). Spectacle emphasized the striking and exaggerated fragment over the systematic totality, astonishment over understanding, passive consumption over active investigation, gratification over edification.

The process was most evident in the transformation of such characteristically republican institutions as Charles Willson Peale's Philadelphia Museum, which was briefly reincarnated at the corner of Broadway and Vesey Street in New York by his son Rubens. The younger Peale presented his Museum and Gallery of the Fine Arts, which opened on October 26, 1825, the day of the Erie Canal celebration, as an enterprise with the same intent and format as his father's, but his instructive human prodigies soon became a collection of freaks to compete with the American Museum across Broadway.[126] After P. T. Barnum bought the American Museum in 1840, General Tom Thumb was usually in residence there (cat. no. 168), and from time to time customers could inspect such sights as a "real *Albiness* and his mighty *highness,* the Irish Giant," or "*fifteen Indians and Squaws . . . in their* NATIVE *costume,*" who were "well authenticated as the first people of their important tribes." A journalist who covered the Native Americans' appearances wondered whether, "in becoming a shilling show at the Museum, they have entered civilized society upon a stratum parallel to their own."[127]

Freak shows and the like were offered under the guise of "rational amusement" and republican education, not only at the American Museum but at more

124. Madisonian, "Sketches of the Metropolis," pp. 329–30.

125. Northern Star, "The Observer," p. 147.

126. Sellers, *Mr. Peale's Museum,* pp. 249, 256–57; "Fourth of July. Peale's Museum" (advertisement), *New-York Evening Post,* July 1, 1826, p. 3; "Peale's Museum" (advertisement), *New-York Evening Post,* July 14, 1826, p. 2; "American Museum" (advertisement), *New-York Evening Post,* October 1, 1832, p. 1.

127. "American Museum," *The New-Yorker,* May 12, 1838, p. 125; "Sketches of New-York," *New Mirror,* May 13, 1843, p. 86. Many of the Indians died in New York before they could return to their homes.

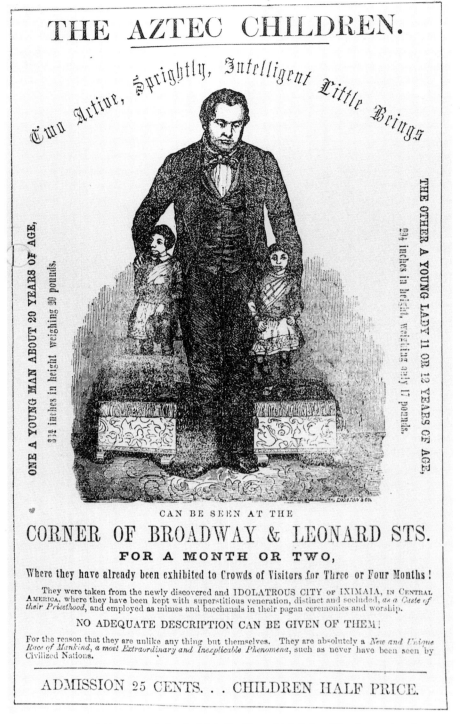

THE AZTEC CHILDREN.

Two Active, Sprightly, Intelligent Little Beings

ONE A YOUNG MAN ABOUT 20 YEARS OF AGE, 33¾ inches in height weighing 20 pounds.

THE OTHER A YOUNG LADY 11 OR 12 YEARS OF AGE, 29½ inches in height, weighing only 17 pounds.

CAN BE SEEN AT THE

CORNER OF BROADWAY & LEONARD STS.

FOR A MONTH OR TWO,

Where they have already been exhibited to Crowds of Visiters for Three or Four Months!

They were taken from the newly discovered and IDOLATROUS CITY of IXIMAIA, in CENTRAL AMERICA, where they have been kept with superstitious veneration, distinct and secluded, *as a Caste of their Priesthood*, and employed as mimes and bacchanals in their pagan ceremonies and worship.

NO ADEQUATE DESCRIPTION CAN BE GIVEN OF THEM!

For the reason that they are unlike any thing but themselves. They are absolutely a *New and Unique Race of Mankind*, a most *Extraordinary and Inexplicable Phenomena*, such as never have been seen by Civilized Nations.

ADMISSION 25 CENTS. . . CHILDREN HALF PRICE.

Fig. 21. *The Aztec Children: Two Active, Sprightly, Intelligent Little Beings.* Wood engraving, from *The Republic* 3 (February 1852), unpaginated advertisement at end of issue

128. "The Hybrid or Semi-Human Indian" (advertisement), *New-York Daily Times,* December 8, 1854, p. 5.
129. "Two Living Specimens of the Aztec Race" (advertisement), *The Independent,* January 1, 1852, p. 4; "The Aztec Children," *The Independent,* January 15, 1852, p. 10.

genteel institutions as well. Masonic Hall offered "the hybrid or semi-human Indian from Mexico," purportedly a cross between a woman and an orangutan, whose appearances were said to be "daily thronged by medical or scientific men."[128] At the New York Society Library one could see the famed Aztec Children, "a PIGMEAN VARIETY OF THE HUMAN RACE!" (fig. 21). Again the exhibition was claimed to be of scientific interest and sparked a debate over whether the children were "specimens of a historic race now extinct" or merely "idiotic dwarfs."[129]

New Yorkers made little effort to distinguish "high" from "low" culture among these offerings. Instead the entertainment offered for sale in antebellum New York was classified as moral, uplifting, and respectable or immoral, debasing, and disreputable. While Barnum assured visitors to his American Museum that the exhibitions were "conducted with the utmost propriety," and the hybrid or semihuman Indian from Mexico was commended for her "refined taste and remarkable disposition," a journalist attacked the drama *Camille,* then playing in New York, as a work in which "the morals of a courtesan [are] presented for the admiration of youth." It was an "attempt to make consumption and the interior of a sick room, a subject fit only for the wards of a hospital, attractive and artistic," which he thought "melancholy proof of a depraved public taste."[130]

Consequently a hybrid experience awaited most patrons of the city's commercial pleasures. The public gardens that antebellum New Yorkers enthusiastically patronized offer a good example of the routine mixture of what would now be thought of as radically different kinds of entertainment. Public gardens did not necessarily include gardens in the commonly understood sense of the term, although that was their origin. Instead they were primarily staging areas for any sort of entertainment for which New Yorkers would willingly pay.

Niblo's Garden, opened by William Niblo at 576 Broadway in 1828, was the best known and probably the favorite of these establishments (fig. 22).[131] At first music and fireworks were Niblo's staples, but he continually added attractions. On July 15, 1839, he offered the Ravel family's "astonishing performance on the CORD ELASTIQUE," along with "THREE ROMAN GLADIATORS" by three of the Ravels; then, after intermission, "L'UOMO ROSSO: Or, the Unforeseen Illusion," a "pantomime" that featured "a full Gallopade, by the Corps-de-Ballet of 30 persons." In addition Niblo's own orchestra played two overtures.[132] Early on Niblo added Italian opera and "Vaudevilles" to his bill, and at other times he presented military bands, operatic ballets, and Signor Gambati, a celebrated valve trumpeter.[133] On one occasion visitors could examine a panorama of Jerusalem, based on a David Roberts painting.[134] Niblo's "was more like a bazaar of all amusements, than a mere theatre, a garden, or a *salon de plaisir.*"[135] At the same time its owner assured the public that "efficient officers" were present

Fig. 22. *Niblo's Garden, Broadway, New York.* Wood engraving, from *Gleason's Pictorial Drawing-Room Companion* 2 (March 6, 1852), p. 145. Courtesy of the American Antiquarian Society, Worcester, Massachusetts

to prevent the admission of "improper persons," by which he meant unaccompanied women.[136]

Public gardens were traditionally relandscaped and embellished anew each year to keep patrons from becoming bored. Niblo not only regularly reconfigured his garden but also filled it with "saloons," theaters, and concert halls, all cast in the palatial imagery of consumerism, to house his long-running acts.[137] On September 18, 1846, Niblo's Garden burned, destroying his greenhouses, theaters, and workshops.[138] The fate of the site was uncertain until the *Home Journal* reported in 1849 that William Niblo had "regained possession of the field of his former triumphs" and intended to rebuild a theater, garden, restaurant, dancing saloon, and arbor.[139] In that year the rebuilt theater became the home of the New York Philharmonic.

The Urban Spectacle

The consumption of goods and images transformed the concept of republican citizenship. Theoretically New Yorkers knew there was a difference between outward appearance and the true self. In his diary Philip Hone wrote a brief essay, "Dress," in which he commented on the responsibility of older men and women to dress well: "An old House requires painting more than a new one." But they also ought to dress appropriately, soberly and not gaudily. He was scandalized by the refusal of his friend Daniel Webster to appear "in the only dress in which he should appear—the

respectable and dignified suit of black." Instead Webster was fond of "tawdry," multicolored clothes: "I was much amused a day or two since by meeting him in Wall Street, at high noon, in a bright, blue Satin Vest, sprigged with gold flowers, a costume incongruous for Daniel Webster, as Ostrich feathers for a Sister of Charity, or a small Sword for a Judge of Probates. There is a strange discrepancy in this instance between 'the outward and visible form, and the inward and spiritual grace,' the integuments and the intellect."[140]

In practice, though, New Yorkers were beginning to judge one another by their public presentation. The respectable and those who aspired to respectability adopted new codes of refinement that identified them to one another visually, set them apart from their neighbors, and rendered them more like people of similar social standing in other parts of the world.[141] As Caroline Kirkland observed, New York was "fast assuming a cosmopolitan tone," making it "difficult to speak of any particular style of manners as prevailing."[142] This code of gentility emphasized bodily comportment and speech, tasteful consumption, and highly selective sociability. The satirist Francis J. Grund was amused to see how assiduously the New York gentry avoided their fellow citizens: "our fashionable Americans do not wish to be seen with the people; they dread that more than the tempest."[143]

Gentility was learned behavior. Readers of the *Home Journal* could seek out the services of Madame Barbier, at 4 Great Jones Street, to teach them "a cultivated

130. "American Museum," *Ladies' Companion* 19 (July 1843), p. 154; "Hybrid or Semi-Human Indian," p. 5; "The Church. All-Soul's Church.– (Unitarian)," *United States Magazine* 4 (April 1857), p. 417.

131. "Niblo's," *Gleason's Pictorial Drawing-Room Companion*, May 14, 1853, p. 308.

132. "Niblo's Garden" (advertisement), *Morning Courier and New-York Enquirer*, July 15, 1839.

133. "Niblo's Garden," *New-York Mirror*, June 7, 1834, p. 391; "Niblo's Garden," *The New-Yorker*, May 26, 1838, p. 158; "Niblo's Garden Is Now Open for the Season" (advertisement), *Evening Post* (New York), June 30, 1836, n.p.; "Niblo's Garden," *Ladies' Companion* 11 (May 1839), p. 50; "Niblo's Garden," *Evening Post* (New York), June 30, 1836.

134. "Fine Arts—Niblo's," *Ladies' Companion* 2 (February 1835), p. 192; "The Diorama," *New-York Mirror*, January 3, 1835, p. 214.

135. "The New Niblo," *Home Journal*, April 21, 1849, p. 2.

136. "Niblo's Garden Is Now Open for the Season"; George G. Foster, *New York by Gas-Light and Other Urban Sketches*, edited by Stuart M. Blumin (Berkeley: University of California Press, 1990), p. 157.

137. "Niblo's Garden," *The Corsair*, June 15, 1839, p. 219; "Niblo's

Garden," *Ladies' Companion* II (May 1839), p. 50; "Niblo's" (*Gleason's*), pp. 308–9.

138. Philip Hone, Diary, entry for September 18, 1846, The New-York Historical Society; microfilm available at the Thomas J. Watson Library, Metropolitan Museum; "Niblo's" (*Gleason's*), p. 308.

139. "New Niblo," p. 2.

140. Hone, Diary, entry for March 29, 1845, The New-York Historical Society.

141. Richard L. Bushman, *The Refinement of America: Persons, Houses, Cities* (New York: Knopf, 1992); John F. Kasson, *Rudeness and Civility: Manners in Nineteenth-Century Urban America* (New York: Hill and Wang, 1990); Cary Carson, "The Consumer Revolution in Colonial British America: Why Demand?" in *Of Consuming Interests: The Style of Life in the Eighteenth Century*, edited by Cary Carson, Ronald Hoffman, and Peter J. Albert (Charlottesville: University Press of Virginia for the United States Capitol Historical Society, 1994), p. 521.

142. Kirkland, "New York."

143. Francis J. Grund, *Aristocracy in America from the Sketch-Book of a German Nobleman*, 2 vols. (London: Richard Bentley, 1839), vol. I, p. 19.

manner of speaking" French and of Clark's Broadway Tailoring, nearby at the corner of Broadway and Bleecker Street, to obtain men's clothes that "impart ease and elegance to the figure," even "TO THOSE WHO HAVE NO TASTE," with the assistance of Clark's "gentlemanly assistants."[144] Although it was learned, gentility was also thought to signal some essential difference between the genteel and the hoi polloi. Some groups, notably African Americans and the Irish, were constitutionally unable to learn gentility, while ordinary white artisans and working-class men and women never quite got it. Try as they might, they fell far short of the mark or overshot it laughably (fig. 23). Conservative satirists such as the cartoonist Edward W. Clay made a living lampooning their efforts (fig. 31).[145]

In short, while early republicans emphasized the essential similarities among all citizens, antebellum New Yorkers began to stress the differences. Immigration and the growing segregation of social classes within the city meant that, as midcentury passed, middle-class and well-to-do New Yorkers had less contact with their inferiors and knew less about them. Increasingly the city seemed to them to be populated with men and women whose departure from the neutral standard of refined behavior was at best picturesque, at worst threatening. In art, literature, journalism, theater, and other forms of popular culture,

Inconveniency of tight lacing.

ah! ah! ah! I shall communicate this to the morning Courier & N.Y. Enquirer

Lithograph, &c by ——

Fig. 23. *Life in New York, No. 4, Inconveniency of Tight Lacing, Saint John's Park, September 28, 1829.* Lithograph by Anthony Imbert. The Library Company of Philadelphia

better-off New Yorkers viewed their poorer neighbors as spectacles only slightly less exotic than the Aztec Children (figs. 24, 25).

As they confronted this human spectacle, New York's cultural arbiters turned toward what the art historian Elizabeth Johns has called *typing*, a process that tamed the complexity of the antebellum city by grouping its occupants into a limited number of generic characters.[146] Visual and verbal reporters also imagined urban spatial types as habitats for their human types, mapping a series of distinctive social regions onto the evenly articulated grid of republican New York.

Writers and artists heightened the effect of typing by juxtaposition, a technique that we have already seen employed in merchandising and one that was an artistic cliché by midcentury. To set the most disparate human and spatial types into the closest possible proximity transformed the classificatory list of eighteenth-century science into a dramatic, high-relief portrait of nineteenth-century New York. In this mode one writer described the ships in New York harbor as national types: there were the "Yorker," the "substantial representative of Old England," the "Dutchman," the "clumsy Dane," the Norwegian polacca, and the "'long-limbed' brigs and schooners that come from 'down east.'"[147]

Despite the rapid growth of their city and the mixture of people and activities that characterized every block of it, New Yorkers seized on a handful of sites as emblematic of fundamental truths about its makeup. Wall Street, Five Points, the Bowery, and, most of all, Broadway were particular favorites.

Wall Street, with the elite Trinity Church at its head and the docks at its foot, punctuated by the great banking houses, by Brady and Thompson's Merchants' Exchange (cat. no. 74), succeeded by that of Isaiah Rogers, and by the grand Greek Revival Custom House (cat. no. 81), stood for contemporary New York as a financial center in all its positive and negative aspects. Because so much of the street was burned in the fire of 1835 (cat. nos. 110, 111; fig. 6), there was little to remind one of the past; it spoke of New York's present and its future. In Wall Street, "the far-famed mart for bankers, brokers, underwriters, and stock-jobbers," "Every thing is on a grand scale [and] the talk is of millions."[148] But in an age when a large portion of the political public was suspicious of "speculation" as a nonproductive drain on the economy and an assault on those who worked for an honest living, Wall Street was also seen as the home of "*Shylocks* and *over-reachers*, yclept Money

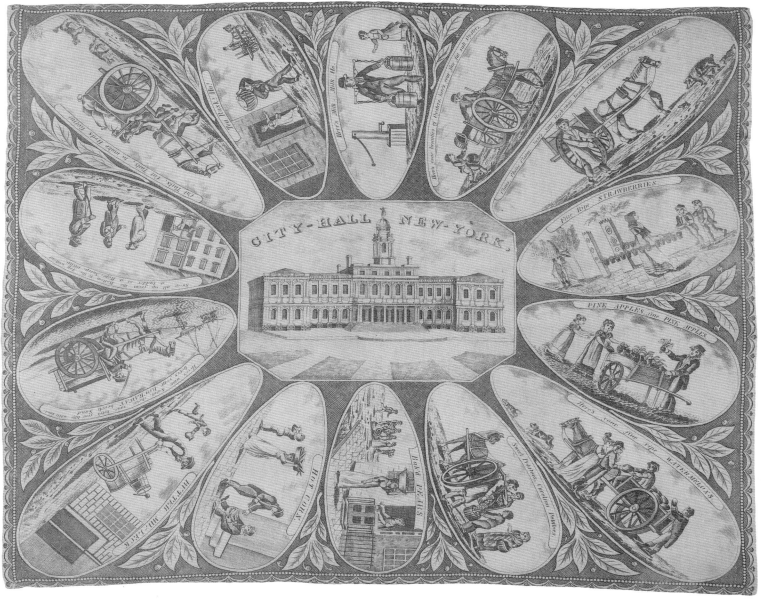

Fig. 24. Manufacturer unknown, probably English for the New York City market, The Cries of New York commemorative handkerchief, 1815–20. Copperplate-printed cotton. The Metropolitan Museum of Art, New York, Rogers Fund, 1968 68.60

Brokers," who "carry on their occult operations against the fortunes and opulence of the unwary and credulous portion of the community."[149] The disruption of traffic occasioned by reconstruction after the fire brought out New Yorkers' feelings. Forced to pick their way through the confusion, passersby muttered "what d—d nonsense!," which registered "generally expressed feelings of bitterness against the banks—for bearing so hard on the mercantile community," in the opinion of George Templeton Strong.[150] Antebellum Americans were acutely aware of the volatility of individual fortunes, and Wall Street seemed to exemplify that: "We never pass Wall-street without a shudder. Who knows but what at the

moment we pass it, some infernally ingenious speculator is planning a financial juggle by which he is to make a fortune, and at least fifty of us to be ruined somehow or other right off!"[151]

A wood engraving of the street in 1855 shows a busy thoroughfare lined with substantial buildings, including the Merchants' Exchange at the left (fig. 26). According to the accompanying text, the sidewalk swarms with types personifying Wall Street's suspect character. The artist

has shown us the "bulls and bears," the curb stone brokers, the speculators in "fancies," the heavy capitalists, the needy "shinners," all who blow bubbles

144. "Madame Barbier" (advertisement), Home Journal, October 6, 1855, p. 3; "Clark's Broadway Tailoring" (advertisement), Home Journal, May 3, 1851, p. 3.

145. Nancy Reynolds Davison, "E. W. Clay: American Political Caricaturist of the Jacksonian Era" (Ph.D. dissertation, University of Michigan, Ann Arbor, 1980).

146. Elizabeth Johns, American Genre Painting: The Politics of Everyday Life (New Haven: Yale University Press, 1991), pp. xii–xiii, 12–22.

147. Northern Star, "The Observer"; "Editor's Drawer," Harper's

New Monthly Magazine 9
(August 1854), p. 421.

148. "Street Views in New-York.
Wall-Street," *New-York Mirror*,
January 21, 1832, pp. 225–26;
"Wall-street," *New-York Mirror*,
December 6, 1834, p. 183.

149. E. E., "Letters Descriptive of
New-York . . . No. III," p. 195.

150. George Templeton Strong,
Diary, entry for October 5, 1839,
The New-York Historical
Society.

151. "Fashionable Promenades,"
p. 235.

152. "New York in 1855 and 1660,"
*Ballou's Pictorial Drawing-
Room Companion*, April 21,
1855, p. 248. The writer of the
article, published in a Boston
periodical, confuses the Mer-
chants' Exchange, illustrated in
fig. 26, with the Custom
House, not represented.

153. [Nathaniel P. Willis], "Diary
of Town Trifles," *New Mirror*,
May 18, 1844, p. 104; Moehr-
ing, "Space, Economic Growth
and the Public Works
Revolution," p. 34.

Fig. 25. Nicolino Calyo, *The Hot-Corn Seller*, 1840–44.
Watercolor. Museum of the City of New York, Gift of Mrs.
Francis P. Garvin in Memory of Francis P. Garvin Rowse

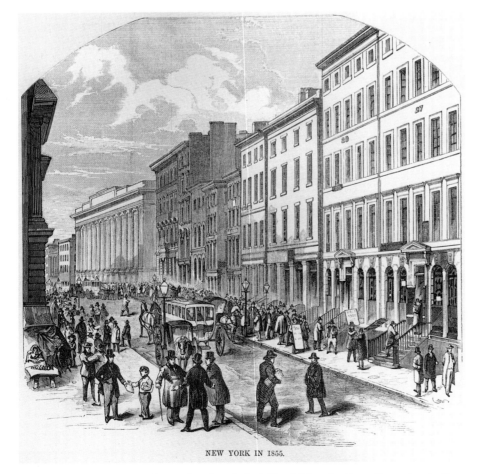

Fig. 26. *New York in 1855*. Wood engraving, from *Ballou's Pictorial Drawing-Room Companion*, April 21,
1855, p. 248. Courtesy of the American Antiquarian Society, Worcester, Massachusetts

*and buy bubbles, who disperse wealth and pursue
wealth, congregated about the choicest abodes of
Plutus, the haunts of mammon, in the great imper-
ial city. You see men there who live in palaces, and
dispense a regal hospitality away up town—you
behold flashy adventurers whose whole wealth is on
their backs—many a wealthy old Israelite who could
draw a check for two hundred thousand dollars at
a moment's notice, and yet who dresses as shab-
bily as an "o'clo" man, while young Judea exhibits
his degeneracy in varnished boots, oiled mustachios,
finger-rings, chains and a diamond breastpin.*[152]

The juxtaposed types and the casually employed eth-
nic stereotype leapt from the writer's mind far more
readily than they did from the illustration.

At the opposite end of the economic ladder, Five
Points stood for the worst that could be feared of an
enormous democratic city (figs. 11, 27). The name was
derived from the since-vanished irregular intersection
of five streets: Mulberry, Anthony (now Worth),
Cross (Park), Orange (Baxter), and Little Water (no
longer extant); but it applied more generally to the
Sixth Ward just northeast of City Hall, north of
Chatham Street, on and around the filled-in Collect
Pond (fig. 4). This "Valley of Poverty" was repre-
sented as a collection of run-down housing and ques-
tionable businesses, occupied by some of New York's
poorest citizens, although it was also an important
industrial district, the scene of various sorts of metal
fabrication and sugar and confectionery manufac-
ture.[153] Bogardus's and Badger's ironworks stood just
two blocks from the notorious intersection. As early
as 1810 Five Points' population was one-quarter black
or foreign born. Later in the century most of the for-
mer had left, but three-quarters of the district's resi-
dents were immigrants.[154]

To outsiders Five Points was the place where society
seemed to sink below the horizon of viability. When
Charles Dickens inspected the neighborhood—after
carefully procuring the protection of two policemen—
he visited a house in which "mounds of rags are seen
to be astir, and rise slowly up, and the floor is cov-
ered with heaps of negro women, waking from their
sleep." The language implies that the women were
barely human, as Dickens suggested more openly in
observing that many of New York's free-roaming pigs
seemed to headquarter themselves in Five Points. "Do
they ever wonder why their masters walk upright in
lieu of going on all-fours? and why they talk instead
of grunting?" Like nearly every other visitor, Dickens

thought he knew the reason for what he saw: for the people as for the buildings, "debauchery" had made them "prematurely old."[155]

Five Points threatened the respectable because it offered abundant and unabashed lower-class entertainment. It appeared to outsiders that every building contained a bar. The neighborhood also boasted the highest concentration of brothels in the city, including seventeen on a single block.[156] Moreover, the streets seemed to be filled with idle people with nothing on their minds—least of all honest work.[157]

As a type of depravity, Five Points slipped easily from the pages of reformers' and travelers' tracts into the lurid "lights and shadows" literature of mid-century that purported to show respectable urbanites hidden aspects of their cities. It figured, for instance, in George G. Foster's sensationalist *New York by Gas-Light* (1850), a work claiming "to discover the real facts of the actual condition of the wicked and wretched classes."[158]

From another vantage point Five Points took on a very different cast. Careful observers recognized that it was less a resort for criminals than a neighborhood for the working poor in which most people's plight owed more to destitution than to vice. It was a district, as George Templeton Strong memorably put it, of "warens [sic] of seamstresses to whom their utmost toil in monotonous daily drudgery gives only bare subsistence in a life barren of hope & of enjoyment."[159] When the perceptive Swedish visitor Fredrika Bremer toured the neighborhood about 1850, most of the people she met seemed to her "wretched rather through poverty than moral degradation."[160]

The evidence of modern archaeology and historical research, which depict Five Points as a hub of working-class life and culture rather than as a haven for criminal behavior, supports Bremer's conclusion.[161] The bars were small businesses and centers of a lively neighborhood conviviality that won over even Dickens, who described his visit to the black-owned Almack's sympathetically.[162] Given the cramped quarters most Five Pointers occupied, bars and the streets were natural sites of social life and, as the historian Christine Stansell has pointed out, important for fostering networks of mutual assistance among women and as places where children scavenged to help support their families.[163] The life of Five Points was flavored with a keen patriotism and an active involvement in the politics of city and nation. As Dickens noted, "on the bar-room walls are coloured prints of Washington and Queen Victoria of England, and the American Eagle."[164]

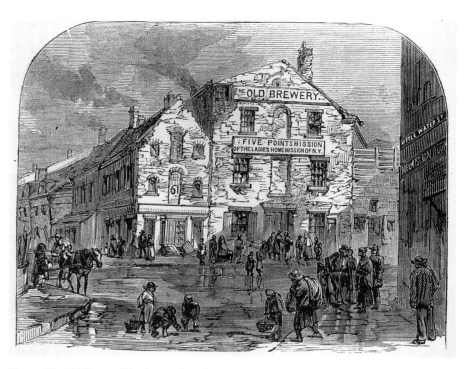

Fig. 27. *The Old Brewery.* Wood engraving, from B. K. Peirce, *A Half Century with Juvenile Delinquents; or, The New York House of Refuge and Its Times* (New York: D. Appleton and Company, 1869), p. 208. The New York Public Library, Astor, Lenox and Tilden Foundations

If Five Points was not the birthplace of all vice in the city, neither was it the only poor or mixed-race neighborhood. West Broadway and its extension, Laurens Street, and parts of Corlears Hook and of the waterfront were comparable places.[165] It was the closeness of Five Points to the city's center of government that made it so striking and so easy to visit, and thus one of the emblematic neighborhoods of New York. The careful siting of the Tombs between City Hall and Five Points in the 1830s dramatized the contrast. Few observers missed the connection. Dickens, Bremer, and Nathaniel Parker Willis all combined visits to the slum and to the prison.

The most titillating aspect of Five Points was its proximity to New York's two emblematic thoroughfares, Broadway and its plebeian double, the Bowery. Broadway, the "grand feature" of New York and "the pride of the Yorkers," was "like nothing in existence but itself": "In this most cosmopolitan of our cities, this great artery of life is the most cosmopolitan of streets" (cat. nos. 109, 123; figs. 13, 14).[166]

The frenetic activity that masked Broadway's motley, ever-changing sequence of houses and commercial buildings—architecturally a "confused assemblage of high, low, broad, narrow, white, gray, red, brown, yellow, simple and florid," "its glories . . . rather traditional

154. J. A. Lobbia, "Slum Lore," *Village Voice*, January 2, 1996, pp. 34, 36.

155. Dickens, *American Notes*, pp. 88–90.

156. Ibid., p. 89; Timothy J. Gilfoyle, *City of Eros: New York City, Prostitution, and the Commercialization of Sex, 1790–1920* (New York: W. W. Norton, 1992), pp. 34, 38–41.

157. [Willis], "Diary of Town Trifles," p. 105.

158. Foster, *New York by Gas-Light*, p. 69.

159. Strong, Diary, entry for July 7, 1851, The New-York Historical Society.

160. Bremer, *Homes of the New World*, vol. 2, p. 602.

161. Lobbia, "Slum Lore," pp. 34, 37.

162. Dickens, *American Notes*, pp. 90–91.

163. Christine Stansell, *City of Women: Sex and Class in New York, 1789–1860* (Urbana: University of Illinois Press, 1987), pp. 41–42, 50.

164. Dickens, *American Notes*, p. 89.

165. Stansell, *City of Women*, p. 42; Blackmar, *Manhattan for Rent*, p. 176.

166. "Transformations of Our City," *New-York Mirror*, January 30, 1836, p. 247; "Broadway," *New-York Mirror, and Ladies' Literary Gazette*, September 9, 1826,

p. 55; "Broadway, New York, by Gaslight," *Ballou's Pictorial Drawing-Room Companion*, December 13, 1856, p. 381.

167. "City Improvements. The New Custom-House," *New-York Mirror*, August 23, 1834, p. 57.

168. "Broadway as Proposed to Be," *Home Journal*, October 22, 1847; "Genin's Bridge," *Gleason's Pictorial Drawing-Room Companion*, December 25, 1852, p. 416.

169. Strong, Diary, entry for August 24, 1845, The New-York Historical Society.

170. Madisonian, "Sketches of the Metropolis," p. 329.

171. "Sketchings. Broadway," *The Crayon* 5 (August 1858), p. 234.

172. Edward S. Abdy, *Journal of a Residence and Tour in the United States of North America, from April, 1833, to October, 1834*, 3 vols. (London: J. Murray, 1835), vol. 1, p. 69.

173. Strong, Diary, entry for July 7, 1851, The New-York Historical Society; "Things in New York," *Brother Jonathan*, March 4, 1843, p. 250.

174. "Sketchings. Broadway," p. 234; Felton, *American Life*, p. 33.

175. "Astor's Park Hotel," *Atkinson's Casket* 10 (April 1835), p. 217; "Town Gossip. Glass Walk over Broadway," *Home Journal*, November 17, 1849, p. 2.

176. "Stewart's Temple," *Morris's National Press*, April 18, 1846, p. 2.

177. "Facts and Opinions of Literature, Society, and Movements

than actual"—excited New Yorkers and visitors alike.[167] The human mass, with pedestrians crowded so densely on the sidewalks that someone proposed to build a glass-paved mezzanine above, and packed into so many vehicles that the hatter John N. Genin built a pedestrian bridge across the street from his shop at 214 Broadway to Saint Paul's Chapel, stood for all of New York (fig. 28).[168]

This "river deep & wide of live, perspiring humanity" encompassed the entire democratic public of America, represented, as always, by types.[169] There were "the gay and serious—the wealthy and the houseless, the clothed in purpose and the half-clad in linsey-woolsey."[170] There were newsboys and immigrants, merchants and clerks. "French and German dry goods jobbers, Bremen merchants, Jew financiers, southern, eastern, and western speculators and peculators, auctioneers, men of straw and men of substance; New York, New Orleans, Hamburg, Liverpool, San Francisco, Boston, and Cincinnati are huddled together in a six cent omnibus pélé-mélé with St. Louis, Lyons, Charleston, Manchester, and Savannah; all rushing to—Wall street, Broad street, Pearl street, Front street, South street," wrote a correspondent in *The Crayon*. Unlike other parts of the New York business district, Broadway was heavily populated by "the lady-element," whom the writer described as "rather of a mixed character": a "small sprinkling of lady-like women" along with "a great number of undomesticated ladies, not necessarily of doubtful character, but ladies unattached." The journal went on to include in

the lady-element "many female day-dreamers, lounging women, or she-loafers, whose hopeless vacancy of mind calls for the stimulant of the noise, the shops, the dust, the variety of faces, of the hissing, seething street."[171] The English visitor Edward S. Abdy was "not a little surprised" to encounter unaccompanied women on Broadway in the 1830s.[172]

The Broadway crowd mixed occupations, origins, and genders, as well as social classes and races. Although they were seldom mentioned in the celebratory catalogues of the street's denizens, beggars were common on Broadway, including "hideous troops of ragged girls, from 12 years down," described by Strong in his diary, and the beggars who took shelter in the portico of the Astor House hotel.[173] Small-time vendors and a wide variety of roving tradespeople sought business along the street, filling the air with their distinctive identifying cries (figs. 24, 25). *The Crayon* recorded the "mixture of races," including blacks and Asians, on Broadway, while the English visitor Mrs. Felton experienced the great street as "the fashionable lounge for all the black and white belles and beaux of the city."[174]

If Broadway was the epitome of democratic New York, it also stood for the fissures in urban society. The street had its fashionable and unfashionable sides. The west side, on which the Astor House and the other luxury hotels stood, nearer to the wealthy residences along Greenwich Street, was the fashionable side, where one was "sure to find the elite of the commercial metropolis."[175] The east side, toward the commercial waterfront and Five Points, and also toward Wall Street, was the unfashionable side. One journalist hoped that the completion of A. T. Stewart's elegant new store at the northeast corner of Broadway and Chambers Street in 1846 would draw carriage trade east, and create "a fair division" of foot traffic between the two sides.[176]

What Broadway was to the fashionable shopping streets of Europe, what the east side of Broadway was to the west side, the Bowery was to Broadway as a whole: its "democratic rival."[177] The Bowery, too, had its fashionable and unfashionable sides, but they mirrored Broadway's: its west side was the unfashionable, "dollar" side, while the other was the "shilling" side "from the fact . . . that all the fancy stores are upon that side."[178]

Tellingly, the Bowery, unlike Broadway, was not punctuated by a single church. It had no time for the formalities or pieties of respectable life. Compared to Broadway, the Bowery was "wrapt in no cloak of convention or pseudo-refinement. The fundamental

GENIN'S NEW AND NOVEL BRIDGE, EXTENDING ACROSS BROADWAY, NEW YORK.

Fig. 28. *Genin's New and Novel Bridge, Extending across Broadway, New York.* Wood engraving by John William Orr, from *Gleason's Pictorial Drawing-Room Companion*, December 25, 1852, p. 416. Courtesy of the American Antiquarian Society, Worcester, Massachusetts

business of life is carried on as being confessedly the main business; not, as in Broadway, as if it were a thing to be huddled into a corner, to make way for the carved work and gilding, the drapery and colour of the great panorama."[179]

If Broadway was the haunt of many urban types, but most notably of the "fashionables," the Bowery was home to one type, the Bowery "b'hoy" and his brash but amiable "g'hal." Mose and Lize (names derived from characters in Benjamin A. Baker's 1848 play *A Glance at New York*) were ambiguous figures. In one sense they were quintessential Americans, genuine and unsophisticated people indistinguishable from "the rowdy of Philadelphia, the Hoosier of the Mississippi, the trapper of the Rocky Mountains, and the gold-hunter of California," according to George Foster. All these types embodied the "*free development of Anglo-Saxon nature*" (cat. no. 127).[180] In this light the Bowery b'hoy seemed a frontiersman in his own city. Like the figure of the Western trapper in the antebellum genre paintings discussed by Elizabeth Johns, he evidently lived a free life that his more respectable chroniclers envied even as they condescended to it.[181] William Bobo compared the "pale and sickly beings who pace languidly" along Broadway with the heartier Bowery b'hoys and g'hals who inhabited the Bowery. In this respect, the b'hoy and g'hal were unurbane and nearly uncivilized.

When Lize and Mose were described in detail, though, they seemed quintessentially urban, and at least parodically urbane. Lize was "independent in her tastes and habits," moved with "the swing of mischief and defiance," spoke in a loud and hearty voice, and dressed "'high' . . . in utter defiance of those conventional laws of harmony and taste imposed by Madame Lawson and the French mantua-makers of Broadway."[182]

Mose strode along,

black silk hat, smoothly brushed, sitting precisely upon the top of the head, hair well oiled, and lying closely to the skin, long in front, short behind, cravat a-la-sailor, with the shirt collar turned over it, vest of fancy silk, large flowers, black frock coat, no jewelry, except in a few instances, where the insignia of the [fire] engine company to which the wearer belongs, as a breastpin, black pants, one or two years behind the fashion, heavy boots, and a cigar about half smoked, in the left corner of the mouth, as near perpendicular as it is possible to be got [fig. 29].[183]

The b'hoy and his g'hal were avid consumers of popular entertainments, with opinions on theater, litera-

ture, and politics as strong as any journalist's. Indeed, one journalist, Walt Whitman, sang their praises and occasionally adopted the persona of the b'hoy in his writings.[184] Although the Broadway stroller knew few people except those in his immediate circle, the Bowery b'hoy "speaks to every acquaintance he meets, and is hail-fellow-well-met with every body, from the mayor to the beggar."[185]

The Bowery b'hoy's volunteer-fire-company insignia declared his membership in a significant institution in antebellum New York. In addition to providing a necessary public service, fire companies were quasi-gangs offering male camaraderie and an active role in the city's transition from the world of the patrician public servant to that of the career politician up from the ranks (cat. no. 176).[186] The real Bowery boys who joined them were men employed in lower-middle-class occupations in shops and industries. In fire companies or as members of gangs (including one called, confusingly, the Bowery Boys), they were not so much the criminals they were often reputed to be as engaged political activists happy to glad-hand during election campaigns but ready to back up their loyalties with their fists when necessary. During one of the periodic nativist episodes in New York political life, the Bowery Boys and an Irish gang, the Dead Rabbits (fig. 30), conducted a protracted and bloody skirmish in the streets of Five Points. This "battle between Irish blackguardism & Native Bowery Blackguardism," on the Fourth of July 1857, ended with the two sides joining forces to fight the police.[187]

"A good big cigar placed in his mouth at the proper angle to express perfect content with himself and perfect indifference to all the rest of the world put the last and finishing touch" on the Bowery b'hoy's appearance.[188] Cigars, ubiquitous on antebellum American streets, where they were smoked by men and boys of all classes and even by some lower-class women, were objects of wide discussion and multiple significance. Edward W. Clay's *The Smokers*, a lively image of a New York street, vividly depicts the way the cigar's pervasive, offensive odor claimed public space as a male domain (fig. 31). Plebeian cigar smoke emphasized the overbearing, even claustrophobic presence of the lower classes. In the eyes of the respectable (like the Whig propagandist Clay), cigars stood for unwanted democratic equality. Their smoke clung to the clothes of the genteel and pursued them into their homes.[189] Indeed, Strong noted in his diary that on a hot day the entire city smelled like "the stale cigar smoke of a country bar room."[190]

In urban literature, the cigar-smoking b'hoy was the type of "the Democracy," the worldly lower-class

of the Day," *Literary World*, January 11, 1851, p. 32.

178. [Bobo], *Glimpses of New-York City*, p. 13.

179. Kirkland, "New York," p. 150.

180. Foster, *New York by Gas-Light*, p. 170.

181. Johns, *American Genre Painting*, pp. 60–100.

182. Foster, *New York by Gas-Light*, pp. 175–76.

183. [Bobo], *Glimpses of New-York City*, pp. 164–65.

184. David S. Reynolds, *Beneath the American Renaissance: The Subversive Imagination in the Age of Emerson and Melville* (New York: Knopf, 1988), pp. 508–12.

185. [Bobo], *Glimpses of New-York City*, pp. 164–65.

186. Bridges, *City in the Republic*, pp. 74–75.

187. Ibid., pp. 29–31, 76–77; "The Riot in the Sixth Ward," *Frank Leslie's Illustrated Newspaper*, July 18, 1857, pp. 108–9; Strong, Diary, entry for July 5, 1857 (quote), The New-York Historical Society; Luc Santé, *Low Life: Lures and Snares of Old New York* (New York: Farrar Straus Giroux, 1991), pp. 200–204.

188. Henry Collins Brown, ed., *Valentine's Manual of the City of New York for 1916–7*, new series (New York: Valentine Company, 1916), p. 111.

189. "Customs of New-York," *New-York Mirror, and Ladies' Literary Gazette*, July 5, 1828, p. 23.

190. Strong, Diary, entry for September 5, 1839, The New-York Historical Society.

A "BOWERY BOY" SKETCHED FROM LIFE

Fig. 29. *A Bowery Boy.* Wood engraving, from *Frank Leslie's Illustrated Newspaper,* July 18, 1857, p. 109. Courtesy of the American Antiquarian Society, Worcester, Massachusetts

A "DEAD RABBIT." SKETCHED FROM LIFE.

Fig. 30. *A Dead Rabbit.* Wood engraving, from *Frank Leslie's Illustrated Newspaper,* July 18, 1857, p. 109. Courtesy of the American Antiquarian Society, Worcester, Massachusetts

191. [Bobo], *Glimpses of New-York City,* p. 165.
192. "Frazee's Bust of John Jay," *New-York Evening Post,* March 21, 1832, p. 2; "The Late Awful Conflagration in New York," *Atkinson's Casket* 11 (January 1836), p. 29; Frederick S. Voss, with Dennis Montagna and Jean Henry, *John Frazee, 1790–1852, Sculptor* (exh. cat., Washington, D.C.: National Portrait Gallery, Smithsonian Institution; Boston: Boston Athenaeum, 1986), pp. 32–33, 77.
193. Voss, Montagna, and Henry, *John Frazee,* p. 31; Bridges, *City in the Republic,* pp. 19, 104–7. In the parlance of artisan republicanism, a workingman was anyone, including a shopkeeper or small businessman, who made a living by his own efforts rather than through financial speculation. Although the Workingman's Party was short-lived and unsuccessful at the polls, it bequeathed several of its active figures and its central ideas to both the Whigs and the Democrats in Jacksonian New York;

urbanite determined to have his say in the degentrified politics and civic life of post-Jacksonian America. He was "a fair politician, a good judge of horse flesh . . . and renders himself essentially useful, as well as ornamental, at all the fires in his ward." Compared to this engaging specimen the Broadway man "is not only a fop but a ninny, knows about as much of what is going on out of the very limited circle of his lady friends, as a child ten years old." His cigar smoking is limited to a single cigar after dinner, after which this emasculated dandy visits a lady friend, "if he should be lucky enough to have one."[191] Once again the b'hoy seemed at least as enviable as he was contemptible.

The Arts in the Empire City

Many New Yorkers believed that the visual and decorative arts were essential to the effort to bring both civilization and urbanity to the Empire City. Early in the antebellum era republicans conceived art as a form of manual and intellectual accomplishment that should be directed to the edification of fellow citizens,

who in turn were expected to support art for patriotic reasons. Artists inspired by republican civic values acted in this spirit to create portraits for public places (cat. nos. 1, 2, 55). John Frazee's bust of John Jay (fig. 111), commissioned by Congress for the Supreme Court's chamber in the United States Capitol, was displayed to the public in New York's Merchants' Exchange before being sent to Washington; four thousand people reportedly came to see it. The same building housed Robert Ball Hughes's statue of Alexander Hamilton (fig. 110), which was destroyed with the exchange itself in the fire of 1835.[192]

Works such as these were hailed as examples of the native genius of American artisans and marvelous products of American industry on a par with complex machine tools or suspension bridges. There is evidence that some artists also saw themselves as artisans, socially and economically, with all that implied for their understanding of their place in society, their manner of working, and their right to a competency. Frazee, for example, was an active member of the Workingmen's Party, the last and most eloquent bastion of artisan republicanism in New York politics.[193]

The Workingmen promoted the idea that society was a family in which people of various stations in life should assist one another for the common good. This viewpoint animated self-made architects of the first forty years of the nineteenth century, men such as New York's Minard Lafever, who bootstrapped themselves up from the status of builders and who then often published builders' guides and handbooks with the express intention of offering their brethren the means to advance themselves as well.[194]

Belief in the civic role of art and in the artist as honest artisan survived throughout the antebellum decades. In the last years before the Civil War New Yorkers could visit a gallery of historical art in City Hall or they could pay a quarter to see that "sublime tableau of beauty and patriotism," James Burns's painting *Washington Crowned by Equality, Fraternity, and Liberty* at the Apollo Rooms.[195] They could also enjoy the marbles of Erastus Dow Palmer (cat. no. 69), hailed by the cognoscenti as a self-taught specimen of native genius who had transformed himself from carpenter to sculptor solely through "his own innate ideas of excellence."[196]

As time passed, those who clung to the notion of art's civic value were increasingly pessimistic about the fate of republicanism. Samuel F. B. Morse's conservative

Calvinist beliefs led him to fear for the future of the nation. As he understood it, his mission, like that of his Puritan forebears, was to call the people to reform. As an artist, Morse sought to use the "refining influences of the fine arts" to stem "the tendency in the democracy of our country to low and vulgar pleasures and pursuits."[197] He and such of his contemporaries as Thomas Cole (cat. nos. 10, 62, 161) evoked the traditional aesthetic hierarchy that gave history painting—exemplary images from the historical or mythic past—the highest value and hoped, usually in vain, to sway their fellow citizens through uplifting portrayals of legitimate leadership and an uncorrupted past. Patrons such as Philip Hone or Luman Reed, who purchased and sometimes publicly exhibited works by Morse and Cole among others, also saw art in this light. To the same ends they commemorated worthy ancestors through the fledgling New-York Historical Society (cat. no. 104), served on church vestries, and helped to organize and govern the prisons, asylums, and other so-called therapeutic institutions of the antebellum era (cat. no. 73). All served the common goal of recapturing civic and moral authority in a city rapidly slipping from their grasp.[198]

Just as the republican ideal of the citizenry as members of a common family disintegrated, so the notion

see Bridges, *City in the Republic*, pp. 19, 22–23.

194. Dell Upton, "Pattern Books and Professionalism: Aspects of the Transformation of American Domestic Architecture, 1800–1860," *Winterthur Portfolio* 19 (summer/autumn 1984), pp. 116–17.

195. "Public Buildings of New-York," *Putnam's Monthly* 3 (January 1854), p. 12; "Apollo Rooms, 410 Broadway" (advertisement), *Evening Post* (New York), October 2, 1849, p. 3; "Apollo, 410 Broadway" (advertisement), *New-York Daily Tribune*, October 2, 1849, p. 3.

196. "Palmer's Marbles," *Frank Leslie's Illustrated Newspaper*, December 20, 1856, p. 42.

197. Staiti, *Samuel F. B. Morse*, pp. 2–5, 67–68; Edward Lind Morse, ed., *Samuel F. B. Morse, His Letters and Journals*, 2 vols. (Boston: Houghton Mifflin, 1914), vol. 2, p. 26 (quote).

198. Staiti, *Samuel F. B. Morse*, pp. 71, 75; Wallach, "Thomas Cole," p. 101; Joy S. Kasson, *Marble Queens and Captives: Women in Nineteenth-Century Sculpture* (New Haven: Yale University Press, 1990), p. 17; Thomas Bender, *New York Intellect: A History of Intellectual Life in New York City from 1750 to the Beginnings of Our Own Time* (New York: Knopf, 1987), pp. 126, 128.

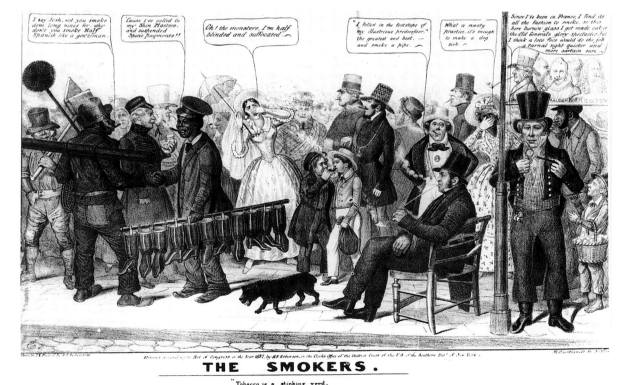

Fig. 31. *The Smokers,* 1837. Lithograph by Edward W. Clay, printed and published by H. R. Robinson. The Library Company of Philadelphia

199. Angela L. Miller, *The Empire of the Eye: Landscape Representation and American Cultural Politics, 1825–1875* (Ithaca: Cornell University Press, 1993), pp. 2, 7–10; Spann, *New Metropolis*, pp. 235–39; "Editor's Easy Chair," *Harper's New Monthly Magazine* 15 (June 1857), p. 128.

200. "American Art," *New York Quarterly* 1 (June 1852), pp. 229–51, 230 (quote).

201. "Cheap Art," *The Crayon*, October 17, 1855, p. 248; T. W. Whitley, "The Progress and Influence of the Fine Arts," *Sartain's Union Magazine of Literature and Art* 10 (March 1852), p. 213; "Knowledge and Patronage," *Atkinson's Casket* 7 (January 1832), p. 27; "Fine Arts in New York," *United States Magazine* 4 (April 1857), pp. 413–14; Upton, "Pattern Books," pp. 123, 128.

202. Clarence Cook, "Shall We Have a Permanent Free Picture Gallery?" *The Independent*, July 5, 1855.

203. "Free Galleries of Art," *Home Journal*, May 7, 1854, p. 2.

204. "Fine Arts in New York," pp. 413–14.

205. "The Bryan Gallery," *United States Magazine* 4 (May 1857), p. 526.

206. Johns, *American Genre Painting*, pp. 42, 59.

207. [A. J. Downing], "Critique on the February Horticulturist," *The Horticulturist* 7 (April 1852), p. 174.

208. "The Growth of Taste," *The Crayon*, January 17, 1855, pp. 33–34.

209. "Taste in New-York," *New York Quarterly* 4 (1855), pp. 56, 59.

210. A. J. Downing, *The Architecture of Country Houses, Including Designs for Cottages, Farmhouses, and Villas . . .* (New York: D. Appleton and Co., 1850), p. 20; Upton, "Pattern Books," pp. 125–26. The other two books by Downing were *A Treatise on the Theory and Practice of Landscape Gardening, Adapted to North America . . .* (New York: Wiley and Putnam, 1841) and *Cottage Residences; or, A Series of Designs for Rural Cottages and Cottage Villas, and Their Gardens and Grounds Adapted to North America* (New York: Wiley and Putnam, 1842).

211. W. L. Tiffany, "Art, and Its Future Prospects in the United States," *Godey's Lady's Book* 46 (March 1853), p. 220; "Knowledge and Patronage," p. 27.

of art fragmented, and the concept of art as a civic expression weakened. The arts continued to stir national pride and to be understood as expressions of national identity, but gradually they came to seem more a matter of urbanity than citizenship. One common answer to the question, What makes a city a metropolis? was "A proper respect for Art."[199]

Writers about art and architecture spoke of the artist's duty to address "all classes, because he appeals to sympathies common to the race, and is thus truly national."[200] To do so, however, required some education of the public taste through exhibitions, reproductions, and exhortation, if only to create a market for good works.[201] More important, the progress of urbanity required the enduring influence of art in civic life, and in the 1850s some New Yorkers began to call for the establishment of a "permanent free picture gallery" to supplement ephemeral commercial exhibitions and the annual shows of the National Academy of Design (for which admission was charged), then the only places where ordinary New Yorkers could enjoy the fine arts.[202] The *Home Journal* urged the state to establish free galleries of art as moral supplements to the mundane vocational training offered in public schools and colleges.[203] The *United States Magazine* agreed, but observed that one of the problems with such an institution was "the difficulty of preserving the rooms from the intrusion of disreputable persons"; security guards like those found in Stewart's would do the trick, the editors thought.[204] Like Thomas Jefferson Bryan, who opened the Bryan Gallery of Christian Art on Broadway at Thirteenth Street, most gallery operators found that a 25-cent admission charge was essential to preserve "that quiet and elegant taste" such a setting required.[205] Although the commercial galleries professed to welcome the serious-minded artisan and the respectable poor, they were anxious to exclude the "sovereigns," the patrician term for those lower-class Americans who asserted their right to participate in politics and social life on an equal footing with everyone else.[206] The sovereigns' appreciation of art was allegedly epitomized by the one overheard to say of Horatio Greenough's statue of Washington: "I say Bob—if I had a hammer, I'd crack this nut on that old chap's toes!"[207]

In some minds, then, art was transformed from a medium for reinforcing ties of republican citizenship to a medium for cultivating and demonstrating personal urbanity. A subtle shift in the concept of taste, defined simply by *The Crayon* as "the capacity of receiving pleasure, from Beauty in some form," transferred art from the realm of the universally accessible

and instructive to one that required an arcane and highly developed sensibility.[208] As with gentility, of which taste was one major index, not everyone could be educated. A critic advised the opera conductor at the Academy of Music not to bother trying to please the patrons in the galleries, since those in the parquet and dress circles were much more capable of appreciating his work. He compared "An admiration for fine bearing on the street, for high-born features or noble-gifted" ones to "superior judgment, a vigorous intellect, and ambition with deep-moved feeling" and concluded that "the *elite* of society . . . are ever the patrons of genuine art."[209]

The landscape gardener and architectural popularizer Andrew Jackson Downing made the same point less stridently as he worked out his aesthetic theory in three books published between 1841 and 1850. Downing borrowed his premise from the British writer and horticulturist J. C. Loudon, who argued that everyone could appreciate those aspects of art and architecture that were accidents of history and culture, such as historical styles, while the deeper forms of beauty were based on geometrical principles and required close study. Downing inverted the relationship, assigning the "absolute" beauty of geometry to the realm of the widely accessible while arguing that the cultural elements of architecture were "the expression of elevated and refined ideas of man's life" and "the manifestation of his social and moral feelings." These higher forms of expression were beyond the grasp of uneducated men and women, who would only make themselves ridiculous by striving to attain them.[210]

While conceptions of the arts' social value varied widely, everyone understood that they had to come to terms with the democratic, commercial milieu of the new nation. Reception of the arts was shaped by the reality that, whatever else they might be, they were commodities, thrown in among and often indistinguishable from, the many other goods to which New Yorkers' money gave them access. The jeweler W. L. Tiffany thought wealthy Americans bought art as they "bought cotton and corn" or "as they buy a watch or a buhl cabinet" (fig. 32).[211] They guarded their artistic property closely rather than sharing the uplifting power of their collections with the public.[212]

If artworks were commodities to be snapped up by the wealthy and even the not-so-wealthy, they were also the stuff of popular spectacle, along with every other form of entertainment. The *Literary World* conveyed a vivid sense of this in its review of

Fig. 32. Mr. Brown Visits a Picture Factory. Wood engraving, from *Harper's Weekly*, January 16, 1858, p. 48. The Metropolitan Museum of Art, New York, The Irene Lewisohn Costume Reference Library

an exhibition of Edward Augustus Brackett's *Shipwrecked Mother and Child,* 1850 (fig. 123):

Although the deficiency of vital power and true growth in the public entertainments of New York, is by no means slight nor accidental, there is never a lack in variety and numbers, of popular exhibitions. We can always range the scale pretty freely, from the tiny Aztecs up to Mons. Gregoire, the stone-breaking Hercules; from the negro burlesque two minutes and a half long, to the complex opera of three hours; from the amateur farce of the "spout-shop," to the elaborate tragedy of the legitimate "temple of the drama." In the pictorial we are quite as opulent, and find no end to sketches, scratches, and colorings—from the chalk outline on the fence, to the mature finish of the Napoleon at Fontainebleau. Sculpturewise, we claim the entire circle of achievement, beginning, if you please, with the faces and heads casually knocked out of free-stone and granite by the house-mason's hammer,

up to a work like this "Shipwrecked Mother and Child," wrought by the finest chisel, from the pure marble, by the patient and well tempered genius of Brackett.[213]

Brackett's work fared poorly in this market and went unsold, despite having been shown in New York, Philadelphia, and Boston.[214]

The fine arts' status as commodity and spectacle inflected every attempt to assign them a significant role in the creation of civilization and urbanity. For collectors such as Luman Reed, acquired wealth bought art, which in turn bought entrée to the social circles to which he believed his wealth entitled him.[215] Like others of his kind Reed focused his buying on contemporary American works when it became clear that many of the "old masters" favored by earlier American collectors were fraudulent or were otherwise bad investments.[216]

During the antebellum decades some artists and architects groped toward a view of art as a separate realm—"a higher and better realm," in historian Thomas Bender's words—of human experience from the everyday world of ordinary people. But the realization of such an ideal was conditioned by the artists' and architects' own circumstances. In these transitional years many of them combined the then new but now familiar romantic notion of artist as a kind of prophet of the spiritual with a more traditional aspiration to gentility, cultivation, and acceptance as the social peers of their patrons.[217]

To succeed, artistic and social claims required reciprocal acknowledgment by patrons and the public, and it was slow in coming. The artist's traditional relations with both survived long into the antebellum years. Artists, like other sorts of manual workers, were accustomed at first to producing commissioned works, usually portraits, for known clients—what artisans called "bespoke" works. While continuing to depend on the goodwill of wealthy patrons, artists increasingly sought a larger audience, working on speculation for sale through exhibitions and even, through such organizations as the American Art-Union and the Cosmopolitan Art Association, for mass distribution by means of reproductions.[218] This required that they compete in the commercial marketplace on its own terms. William Sidney Mount admonished himself in his diary to "Paint pictures that will take with the public. . . . In other words, never paint for the few, but for the many."[219] T. W. Whitley, the author of an article on the state of the fine arts published in *Sartain's* magazine, offered in a newspaper advertisement "to paint

212. "Fine Arts," *Putnam's Monthly* 1 (March 1853), pp. 351–52.

213. "The Fine Arts. A 'Brackett' in Public Amusements," *Literary World,* April 10, 1852, p. 268.

214. Kasson, *Marble Queens and Captives,* pp. 101–2.

215. Wallach, "Thomas Cole," pp. 103–4; Johns, *American Genre Painting,* p. 32.

216. Neil Harris, *The Artist in American Society: The Formative Years, 1790–1860* (New York: Clarion Books, 1970), p. 103; Foshay, *Luman Reed's Picture Gallery,* pp. 16, 52.

217. Bender, *New York Intellect,* pp. 121–24, 128–30 (quote); Harris, *Artist in American Society,* pp. 94, 98; Upton, "Pattern Books," pp. 112–13.

218. Foshay, *Luman Reed's Picture Gallery,* pp. 14–16, 60; Johns, *American Genre Painting,* pp. 75–76; "The Greek Slave!" (advertisement), *Spirit of the Times,* January 27, 1855, p. 598; Kasson, *Marble Queens and Captives,* p. 9; Harris, *Artist in American Society,* p. 106.

219. Quoted in Staiti, *Samuel F. B. Morse,* p. 236.

220. Whitley, "Progress and Influence of Fine Arts," pp. 213–15; "Landscape Painting" (advertisement), *Evening Post* (New York), May 23, 1849, p. 3.

221. Fisher, *Philadelphia Perspective*, p. 198.

222. "Christ Healing the Sick," *Broadway Journal*, September 13, 1845, p. 155; Dell Upton, ed., *Madaline: Love and Survival in Antebellum New Orleans* (Athens: University of Georgia Press, 1996), p. 255.

223. Kevin J. Avery and Peter L. Fodera, *John Vanderlyn's Panoramic View of the Palace and Gardens of Versailles* (New York: The Metropolitan Museum of Art, 1988), pp. 18–21, 33.

224. "Public Buildings," *New-York Mirror, and Ladies' Literary Gazette*, September 25, 1829, pp. 89–90; "Panorama of Jerusalem" (advertisement), *The Expositor*, December 8, 1838; "New Panorama," *The Knickerbocker* 11 (June 1838), p. 572; "The Last Week at the Minerva Rooms" (advertisement), *New York Herald*, December 3, 1849, p. 3; "Evers's Grand Panorama of New York and Its Environs," *Evening Post* (New York), November 20, 1849, p. 2; "City Saloon" (advertisement), *Morning Courier and New-York Enquirer*, July 15, 1839.

225. "Public Buildings," p. 89.

226. "City Saloon."

227. Harris, *Artist in American Society*, p. 100.

228. "The Fine Arts. A 'Brackett' in Public Amusements," p. 268.

229. Morse, *Samuel F. B. Morse*, vol. 1, pp. 276–77; Staiti, *Samuel F. B. Morse*, pp. 64–65, 149–69; Bender, *New York Intellect*, pp. 122, 127–30; Upton, "Pattern Books," pp. 109–50; Mary N. Woods, *From Craft to Profession: The Practice of Architecture in Nineteenth-Century America* (Berkeley: University of California Press, 1999), pp. 28–38. The American Institution of Architects folded quickly. Its successor, the American Institute of Architects, was organized in 1857 under the aegis of New York architect Richard Upjohn.

230. For the development of this sense of cultural hierarchy in the late nineteenth century, see Lawrence W. Levine, *Highbrow/Lowbrow: The Emergence of Cultural Hierarchy in America* (Cambridge, Massachusetts: Harvard University Press, 1988).

Landscapes at every price," in a style that would "compare favorably with the works of our city artists," as well as to copy old master landscapes and to restore damaged paintings.[220]

Other artists and entrepreneurs exhibited works commercially. The sculptor Hiram Powers, established in Italy since 1837, sent a version of his celebrated *Greek Slave* to America in 1847, expecting to make about $25,000 from its tour of major cities (cat. no. 60).[221] A Mr. Morris, "a well-known amateur," sent one version of Benjamin West's *Christ Healing the Sick* on a similar tour of American cities, while entrepreneur George Cooke compiled a "National Gallery of Paintings," featuring John Gadsby Chapman's portrait of Davy Crockett, that he exhibited in New York for some time before taking it for an extended stay in New Orleans.[222]

Whatever their professional aspirations, then, both artists and architects were embedded in the marketplace of commodities and spectacles, as the history of panoramas illustrates. John Vanderlyn attempted to make a living by exhibiting his panorama of Versailles (figs. 33, 34) in the purpose-built New-York Rotunda on the Park (cat. no. 70), but his effort was doomed to failure by his inattention to business.[223] Vanderlyn also rented and exhibited other painters' panoramas of Paris, Mexico City, Athens, and Geneva, while at different venues antebellum New Yorkers were offered panoramic views of Jerusalem (by the artist Frederick Catherwood), Niagara Falls, the Great Lakes, and their own city, as well as one of "the Infernal Regions."[224]

Panorama painters differed in their aspirations to fine-art status, but all pitched their works to the public as illusionistic spectacles. The light in Vanderlyn's Rotunda "seems to give life and animation to every figure on the canvass. . . . so complete is the illusion . . . that the spectator might be justified in forgetting his locality, and imagining himself transported to a scene of tangible realities!"[225] "The Infernal Regions" were enlivened with the skeletons of executed Ohio criminals and preceded by "NIGHT ILLUSIONS! Produced by the New Philosophical Apparatus (lately from London) called the NOCTURNAL POLYMORPHOUS FANTASCOPE."[226]

Ideology as well as commerce bound antebellum art to the world of spectacle. When a painter such as Morse argued for the fine arts' refining and elevating qualities, he accepted the traditional notion of them as a moral and civic force. Successful artists accommodated the widely held belief that art must be criticized within the scope of popular understanding, not arcane theories.[227] Like other forms of cultural expression, fine art was to be read narratively and evaluated morally. "We need not speak of such a work in any technicalities," wrote the *Literary World*'s critic in praise of Brackett's *Shipwrecked Mother and Child*. "The mother and child belong to human nature at large," and thus to the public rather than to the connoisseur.[228]

Artists and architects responded to the market context by organizing themselves professionally. The National Academy (cat. no. 105), founded by Morse and his colleagues in 1825 in opposition to the patron-dominated American Academy of the Fine Arts, and the American Institution of Architects, convened by a group of New York, Boston, and Philadelphia architects in 1836, were among the first fruits of these professional aspirations.[229] These organizations were aimed less at establishing the high-art claims of either group than at situating them within the marketplaces of ideas and services as men with something distinctive to sell. They sought to create a group identity through publicity (publications and exhibitions), training, ostracism of amateurs, and the definition of a common body of professional knowledge.

At the end of the antebellum era claims that the arts and their makers inhabited a realm of expression inherently superior to that of popular culture began to be more widely voiced.[230] Some writers started to treat the artist as a man of feeling and talent—"we should call the former Love and the latter Power"—which set him apart from ordinary mortals, as taste distinguished the connoisseur from the unenlightened viewer on the other side of the easel.[231] In architecture professional skill, defined early in the century as a body of empirical knowledge—"architectural science"—accessible to anyone willing to study, was redefined as a mysterious quality available only to those few with talent and formal professional training.[232] Occasionally people referred to this quality—and by extension to the person possessing it—as *genius*, by which they meant surpassing brilliance, not the characteristic quality of a place or a source of inspiration, as the word had been traditionally understood.[233] Even these claims must be seen in the context of the market. Part of their purpose was to distinguish the professional product from that of others—amateurs, craftsmen—by distinguishing the professional himself.

This new aesthetic elitism met vigorous opposition among New Yorkers. Few were willing to accept either a single standard of taste in the arts or its confinement to a small segment of the population. Nor would many New Yorkers agree to a hierarchy of pleasures or commodities that set the fine arts at its

Fig. 33. John Vanderlyn, *The Palace and Gardens of Versailles,* circular panoramic painting created for display in the Rotunda, 1818–19. Oil on canvas. The Metropolitan Museum of Art, New York, Gift of Senate House Association, Kingston, N.Y., 1952 52.184

Fig. 34. Detail of *The Palace and Gardens of Versailles* (fig. 33)

231. "Feeling and Talent," *The Crayon*, January 10, 1855, front page.

232. Upton, "Pattern Books," pp. 120–28.

233. Strong wrote that John Cisco "Thinks [the English immigrant architect Jacob Wrey] Mould a genius; So does Dix;" Strong, Diary, entry for April 26, 1860, The New-York Historical Society.

234. "Daniel in the Lion's Den," *New York Herald*, October 31, 1849, p. 3.

235. "Powers's Statuary" (advertisement), *Evening Post* (New York), October 2, 1849, p. 2.

236. "The Greek Slave!", p. 598.

237. "Panorama Saloon" (advertisement), *New York Herald*, November 1, 1849, p. 3.

238. "Wallhalla" (advertisement), *New York Herald*, May 21, 1849, p. 3.

239. Foster, *New York by Gas-Light*, pp. 77–78.

240. "Franklin Theatre" (advertisement), *New York Herald*, October 31, 1849, p. 3.

241. "Wallhalla, 36 Canal Street" (advertisement), *New York Herald*, October 31, 1849.

242. Foster, *New York by Gas-Light*, p. 157.

243. "Model Artists," *New York Herald*, December 13, 1849, p. 2.

244. Bender, *New York Intellect*, p. 121; Fisher, *Philadelphia Perspective*, pp. 198–99; "Palmer's 'White Captive,'" *Atlantic Monthly* 5 (January 1860), pp. 108–9; "The Art of the Present," *The Crayon*, May 9, 1855, pp. 289–90; Kasson, *Marble Queens and Captives*, pp. 46–72. On verisimilitude and prurience in Western high and popular art, see David Freedberg, *The Power of Images: Studies in the History and Theory of Response* (Chicago: University of Chicago Press, 1989), chaps. 9, 12.

pinnacle. They embraced spectacle in all its commercial variety. On Broadway in 1849 those with 25 cents to spend could see a watercolor painting of Daniel in the Lion's Den—twenty feet by twelve, so one received value for money—along with a collection of what purported to be old-master oil paintings ("Corregio, Poussin, &c."), and, as if those were not enough, there was "the genuine Egg Hatching Machine, in which chicks are seen bursting the shell, in the presence of visiters." [234]

The contest for cultural authority often took the form of a struggle for control of the contexts that would determine the meaning of iconic visual images. Powers's *Greek Slave* was one of the most popular, and was certainly the most hotly contested, of icons in antebellum New York. When it was exhibited for the sculptor's benefit at the Gallery of Old Masters, along with his *Fisher Boy* (fig. 73), *Proserpine* (fig. 119), and *Andrew Jackson* (cat. no. 55), it was shown in the context of paintings by "the best old masters," making them part of "the choisest [sic] and most instructive collection of works of Art ever brought to this country." [235]

The statue was a hit in New York, and as a result it was absorbed into the world of luxury consumption and commercial spectacle all the more quickly. The Cosmopolitan Art Association included an original version in its first annual distribution of prizes to its members. [236] Suddenly the *Greek Slave* materialized all over the city. In 1849 the Panorama Saloon at the corner of Lispenard Street and Broadway announced the exhibition of a panorama of paintings of classical subjects, the finest of their sort "in spite of 'Art Union' criticism or 'Scorpion' slander." They included "a more faithful representation of the Greek Slave." [237]

The same year New Yorkers enjoyed a flurry of exhibitions of "model artists" staging tableaux vivants after famous works of art. At the Wallhalla, a hall on Canal Street, Professor Hugo Grotin offered his "celebrated Marble Statues and Tableaux Vivants, represented by 25 ladies of unparalleled beauty, graces, and accomplishments." [238] In *New York by Gas-Light* Foster described the Wallhalla as a hall over a stable, with a prominent bar dispensing crude firewater, an atmosphere redolent of horse and cigar, and a floor covered with mud and tobacco juice. To the accompaniment of a badly played violin and piano, a model portrayed Venus, Psyche, and the Greek Slave, her body covered only by a flimsy, hand-held veil of gauze. [239] At the Franklin Theatre on Chatham Square, Madame Pauline's model artists offered an equally

eclectic gallery of well-known images, including "the Three Graces," "Venus Rising from the Sea," "The Rape of the Sabines," and "The Greek Slave." [240]

New Yorkers were unsure whether these were blatant striptease shows or legitimate entertainment. An advertisement for the Wallhalla's "Classical Museum of Art" assured readers that the performance was conducted in "the most decent manner." [241] Foster, characteristically, labeled them "disgusting exhibitions." [242] A correspondent of the *New York Herald* saw in tableaux vivants "an illegitimate offshoot from those that are perfectly correct and proper—such, for instance, as that of the beautiful piece of sculpture by Power [sic]—the Greek slave." [243]

The panoramas and tableaux challenged genteel and professional definitions of the content and purposes of art. At the Panorama Saloon the old demand of truth to life and the desire for a verisimilitude bordering on illusionism, a common point of discussion in mid-nineteenth-century professional and popular art criticism, were reasserted as the proper goal of the artist. Tableaux vivants openly addressed the strong erotic content that respectable critics and viewers saw but euphemized in such statues as the *Greek Slave* or Palmer's *White Captive* (cat. no. 69), and defied genteel views of art as the uplifting attempt to transform "this hard, angular, and grovelling age" into "something beautiful, graceful, and harmonious" that shows us "always the image of God." [244] Popular reinterpretations of the *Greek Slave* insisted on anchoring the experience of art firmly in the realm of sensory pleasure, in the process tying the urbane to urban spectacle rather than to refined moral or intellectual experience.

The Palace and the Park

In their confrontations with the changing city and with each other, the ideals of civilization and urbanity, of republican citizenship and metropolitan refinement were themselves transformed. Yet both concepts informed New York's self-definition throughout the antebellum decades and animated the two great urban projects of the 1850s, the New York Crystal Palace, for the New-York Exhibition of the Industry of All Nations, and Central Park.

The Crystal Palace exhibition was conceived in the wake of the phenomenal success of the first modern world's fair, the London Great Exhibition of 1851, and of its iron-and-glass building, the original Crystal Palace. The Association for the Exhibition of the Industry of All Nations was chartered by the New York State legislature in April 1852 to undertake a fair in New

Fig. 35. Charles Gildemeister and George J. B. Carstensen, architects, *New York Crystal Palace, Ground and Gallery Plans,* 1852. Lithograph, from *Appleton's Mechanics' Magazine* 3 (February 1853), pp. 35–36. Courtesy of the American Antiquarian Society, Worcester, Massachusetts

York City.[245] A competition for the design of the exhibit hall, which the organizers assumed from the beginning would resemble the London Crystal Palace, attracted several noteworthy competitors, including Andrew Jackson Downing, cast-iron entrepreneur James Bogardus, and Joseph Paxton, architect of the London building. The winners, New York architect Charles Gildemeister and the Danish immigrant architect George J. B. Carstensen, designed an iron-and-glass structure with two tall, perpendicular galleries, 365 feet long and 68 feet high, forming a Greek cross crowned by a dome 100 feet across (cat. nos. 141, 218). The angles between the arms were filled in at ground level to create an octagonal footprint.[246]

In many respects the New York Crystal Palace was the valedictory festival of artisan republicanism. Its organizers aimed to stir patriotic feelings of admiration for American "triumphs of genius and industry," to promote the diffusion of mechanical skill and the growth of manufacturing, and to educate the public.[247] An equestrian statue of George Washington stood under the dome, and the *Literary World* recommended that busts and portraits of American "sons of light" (inventors) be placed in the building.[248] Works of art, including the *Greek Slave,* were scattered throughout, but their status was ambiguous (cat. no. 179). The picture gallery was predictably described as "a school of taste," but most journalists concentrated on art's role as a civic lesson (as in the statue of Washington, "the grandest of Nature's models") or as a species of artisanry.[249] By housing a

"Republican lesson on the capacities of man, the dignities of labor, and on the obligations of society to genius and toil" in a "People's Palace," "the institutions of civilized life are put upon a firmer basis and each one is brought to feel how nearly his neighbor's interest is allied to his own."[250]

Located on the western half of the blocks delineated by Fortieth and Forty-second streets, between Fifth and Sixth avenues, the Crystal Palace, like the streets of the commercial city, combined rational organization with picturesque presentation. The colorful massing and impressive size of the building (somewhat diminished, everyone thought, by its unfortunate proximity to the even more imposing Croton Reservoir) disguised its layout as an extensive structural grid (fig. 35).[251] In line with the principles of the London exhibition,[252] the exhibits were organized systematically, falling into thirty-one subcategories and distributed throughout the space on a grid with a twenty-seven-foot module; the products of the United States were separated from those of other nations.[253] To the knowing visitor, a first glimpse of the building offered "a dazzle; a thousand sparkles and rainbows; light and movement undistinguishable for a while; then, as the eye settled, order emerging here and there; . . . vast climaxes of Art, Industry, and Invention, extending away and away in long perspective on every side; . . . in which various national emblems and devices suggest the world-wide interest of an Industrial unity" (cat. no. 142). The combination of order and profusion implied totality: the

245. "Association for the Exhibition of the Industry of All Nations" (advertisement), *New-York Daily Tribune,* April 5, 1852, p. 3.

246. "Notices and Correspondence. The American Association for the Exhibition of the Industry of All Nations," *Appleton's Mechanics' Magazine* 2 (September 1882), p. 216; "The New-York Crystal Palace," *National Magazine* 2 (January 1853), pp. 80–81. Carstensen had designed the Tivoli Gardens and the Casino in Copenhagen.

247. "Association for the Exhibition of the Industry of All Nations," p. 3.

248. "The Crystal Palace—Opening of the Exhibition," *New-York Daily Times,* June 18, 1853, p. 4; "The Industrial Exhibition," *Literary World,* September 25, 1852, p. 202.

249. "The American Crystal Palace," *Illustrated Magazine of Art* 2 (1853), p. 263; "The Great Exhibition and Its Visitors," *Putnam's Monthly* 2 (December 1853) p. 579.

250. "The Crystal Palace," *New-York Daily Times,* June 20, 1853, p. 4; "The Crystal Palace," *New-York Daily Times,* May 20, 1853, p. 4.

251. "World's Exhibition—1853," *New-York Daily Tribune,* April 23, 1853, p. 5; "The New York Crystal Palace," *The Albion,* July 23, 1853, p. 357.

252. "Movements at the Crystal Palace—General Arrangements and Regulations," *New-York Daily Tribune,* June 24, 1853, p. 7.

253. "The Crystal Palace—Opening of the Exhibition," p. 4; "The American Crystal Palace," *Illustrated Magazine of Art* 2 (1853), pp. 254–55.

254. "Great Exhibition and Its Visitors," pp. 578–79.

255. Ibid., p. 578.

256. "Movements at the Crystal Palace—General Arrangements and Regulations," p. 7.

257. "Editor's Easy Chair," *Harper's New Monthly Magazine* 7 (June 1853), pp. 129–30.

258. *Morning Courier and New-York Enquirer*, May 25, 1853, p. 3; "Our Crystal Palace," *Putnam's Monthly* 2 (August 1853), p. 122.

259. "The New York Crystal Palace," *Gleason's Pictorial Drawing-Room Companion*, April 23, 1853, p. 269.

260. Strong, Diary, entry for October 5, 1858, The New-York Historical Society.

261. "Godey's Arm-Chair. Barnum," *Godey's Lady's Book* 48 (May 1854), p. 469.

262. "Our Window," *Putnam's Monthly* 10 (July 1857), pp. 135–38.

263. "The Latting Observatory," *Christian Parlor Magazine* 10 (1853), pp. 378–79; "Destruction of the Latting Observatory," *Frank Leslie's Illustrated Newspaper*, September 13, 1856, pp. 213–14.

264. "World's Exhibition—1853," p. 5; "The Surroundings of the Crystal Palace," *Evening Post* (New York), April 26, 1853, p. 2; "The Crystal Palace," *New-York Daily Times*, June 16, 1853, p. 4.

265. "Progress of the Crystal Palace," *New-York Daily Times*, June 28, 1853, p. 1; "The Crystal Palace," *New-York Daily Times*, June 16, 1853, p. 4.

Crystal Palace seemed to contain everything worth seeing in the world of human ingenuity, so that visitors "resented any blanks in the picture" created by the incomplete state of the exhibition on opening day.[254]

If the aims and organizing principles of the Crystal Palace exhibition sound like those of Peale's museum, they were transformed by the rituals of consumption. World's fairs perfected the spectacle of juxtaposition, while their claims of totality also implied the ability to consume without limit. Fashionable visitors, who were "not famed for their rational curiosity," were nevertheless willing to visit because the exhibition seemed to promise a glimpse of "the Art and Elegance of All Nations."[255]

The resemblance of world's fairs to department stores, a familiar theme among historians today, already resonated with visitors to the first fairs in London and New York. The New York organizers borrowed a page from Stewart's and other dry-goods emporiums in surrounding their visitors with goods, suspending "light and showy articles" from the gallery railings and carpets from the gallery girders. The walls were covered with mirrors, paper hangings, and decorative furniture.[256] Inevitably the editor of *Harper's New Monthly Magazine* described Broadway, "when it is completed," as "the three-miles-long nave of a Crystal Palace, for admittance to which no charge is made."[257]

The Crystal Palace exhibition was a private undertaking, but, argued the *Morning Courier and New-York Enquirer*, "it enjoys something of the prestige that attaches to a public enterprise." It was chartered by the state, its site was leased to it by the city, and it was endorsed by the federal government. More important, it bore the burden of defending the national honor in presenting American products in a favorable light.[258] Yet critics chose to see it as merely another commercial spectacle, the "simple speculation of a few private individuals."[259] When the building burned on October 5, 1858, Strong wrote it off as the final bursting of a "bubble rather noteworthy in the annals of N.Y."[260]

If members of the elite thought the Crystal Palace too involved in spectacle to succeed as an educational endeavor, other New Yorkers thought it too genteel to succeed financially, and fail it did. During the uncertainty about the future of the building and its contents that followed the closing of the original exhibition, Barnum briefly stepped in to take it over. *Godey's Lady's Book* thought him the best person to make it succeed and certainly a better choice than the "old fogy concern" that had initiated the enterprise, whose members "had about as good an idea of managing an establishment like the Crystal Palace as they had of earning the money which their fathers left them."[261] Yet even Barnum could not make a go of it, and rather than inaugurating the improvement of the Crystal Palace's fortunes, his advent was said to have initiated the decline of his own.[262]

The Crystal Palace was the central attraction in a zone of commercial spectacles that quickly grew up around it, housed in temporary and poorly built structures of all sorts (cat. no. 141). Although it was unofficial and unwanted, this was the liveliest segment of the fair and the most popular among the "sovereigns." Its centerpiece was Waring Latting's Observatory, a 315-foot wooden tower adjacent to the fairgrounds on Forty-second Street that offered patrons a panoramic view of New York and its environs (cat. no. 143). Latting incorporated an art gallery, a refreshment saloon, and an ice-cream parlor to support his business, but few visitors were willing to expend the labor to walk to the top of the "Heaven-kissing peak" and the tower failed. It was sold to a firm of stonecutters, who used it for storage until it burned on August 30, 1856.[263]

In the streets surrounding the Crystal Palace, saloons, gaily decorated with flags and featuring crowd-pleasing attractions such as a group of mechanized wax figures that struck bells, were more eagerly patronized.[264] Balladmongers wandered the streets selling lyrics to the latest minstrel tunes. Animal sideshows, a merry-go-round, and a moving panorama of Mount Vesuvius also beckoned fun seekers. In short, there were all the makings of a modern midway, the kinds of things attractive to "mechanics and laboring men, with their wives and children, apprentice boys, and the miscellaneous group which such a show usually collects," along with seamstresses and their boyfriends, and stage drivers. The whole presented a scene of "drunkenness and rowdyism" reminiscent of the Fourth of July.[265] Central Park was meant to supplant entertainment such as this.

In the early nineteenth century, public open spaces were valued as urban "lungs" that ventilated the city, dispelling miasmas, dangerous natural gases to which epidemic diseases were attributed. The commissioners provided relatively few such spaces in the 1811 plan because they were thought less necessary in New York than in other cities. Manhattan was a relatively narrow island, and the commissioners believed that the breezes from the two rivers would dispel hazardous gases. Open spaces were also valued as promenades for fashionable men and women. Promenading was

a ritual of seeing and being seen by one's peers, preferably out of the sight of the "sovereigns." A promenading ground was a constricted space, laid out in a circle or oval so that people could walk and talk without worrying about changing direction and, more important, so that they could observe one another without violating a cardinal rule of gentility, not to stare directly at another person.[266] The preexisting squares of New York made perfectly adequate promenading grounds, although Francis J. Grund observed that "the people follow their inclinations and occupy what they like; while our exclusives are obliged to content themselves with what is abandoned by the crowd."[267]

By the 1840s New York's booming population had outgrown the existing parks and squares, and no new ones were created as the terrain between Twenty-third and Fiftieth streets was developed at midcentury.[268] Pressure on the city's open spaces increased as they became "recreation grounds," places of more active sociability than promenading entailed.

It was at this time that certain New Yorkers began to conceive of a new kind of park, one that would "be the resort of the student, of the professional man, of the artist, of the mechanic; of the invalid, of the young and the old. All classes and ages would resort to it to enjoy the simple pleasures of exercise, of walking and talking in the open air."[269] Advocates of such new-style parks accused the commissioners of forgetting or deliberately omitting land for something that had not been imagined in 1811, and they disparaged New York's existing parks and squares: "we have nothing worthy to be called a park," declared the Reverend Henry M. Field.[270] In 1849, in a famous essay originally published in his magazine *The Horticulturist,* Downing called attention to the widespread use of churchyards and the new rural cemeteries, such as Brooklyn's Green-Wood, for recreation, as evidence of an opportunity available to the city.[271]

The city seized the opportunity soon afterward, with an initial effort in 1851 to acquire Jones Wood, a tract that lay along the East River between Sixty-sixth and Seventy-fifth streets. In 1853 the legislature granted expropriation rights over the present site of the park, and in 1856 Frederick Law Olmsted and Calvert Vaux won a competition for the design of the new public grounds with their Greensward Plan (cat. nos. 192, 193; fig. 36).[272]

Vaux once described Central Park as the "big art work of the Republic," meaning that he saw it as a specimen of republican simplicity and civic engagement, but it was republican in more ways than that.[273]

Its naturalistic imagery often distracts us from its urban character, as a product of the systematic, diverse city of the 1850s (cat. no. 151). Olmsted and Vaux thought of the park as a retreat, but they also recognized that its size and location required it to be integrated into the working and residential city outside; accordingly they devised a multilevel pattern of circulation that separated internal from through traffic and vehicles from pedestrians. Thus the park was linked to the circulatory system of the city grid.

Central Park was, furthermore, a product of the urban economy. It was promoted by merchants and property owners who recognized its potential as a magnet that would bring them riches. Once it was clear that the park would be realized, elite development on the Upper East Side was facilitated by city-sponsored construction of streets, sewers, gas lines, and water mains.[274]

The process of converting the open, irregular site into the dramatic, highly artificial "rural" landscape of Central Park was a major engineering project that created "the most imposing industrial spectacle to be seen upon the continent" while it was under way.[275] The work was undertaken with such alacrity because New York's Democratic mayor, Fernando Wood, saw it as an opportunity to employ a thousand of his supporters each day—the "small army of Hibernians" that Strong observed toiling there—during slack economic times.[276] Ironically, like the Croton Waterworks (whose receiving reservoirs were located within the park), this public work was a product of the kind of immigrant-directed political patronage that scandalized most of the park's genteel proponents.

The nuts-and-bolts origins and infrastructure of Central Park served a vigorous crusade for urban uplift, in which all kinds of wholesome recreation would combine to improve the quality of civic and personal life. In Olmsted's eyes much of Central Park's good work would be done by the landscape itself. Where an early republican educator might have sought to improve his neighbors through systematic instruction, Olmsted looked for an inward transformation inspired by New Yorkers' direct experience of spiritual resources previously available only through landscape painting.[277] The Greensward Plan offered a heterogeneous mixture of cultural and recreational facilities, including a concert hall, a sculpture walk, a formal garden, and playgrounds—anything that would edify the public (cat. no. 153). Art, music, and nature were all expected to produce the same result: an elevation of public sensibilities nearer to those of genteel men and women.

266. "Landscape Gardening. Public Squares," *Godey's Lady's Book* 47 (September 1853), p. 215.

267. Grund, *Aristocracy in America,* vol. 1, p. 19.

268. Moehring, "Space, Economic Growth, and the Public Works Revolution," pp. 38–39.

269. Henry M. Field, "The Parks of London and New York," *Christian Parlor Magazine* 6 (1850), p. 64.

270. Field, "Parks of London and New York," p. 64; "City Improvements," *Morris's National Press,* March 7, 1846, p. 2.

271. A. J. Downing, "Public Cemeteries and Public Gardens" (1849), in his *Rural Essays,* edited by George W. Curtis (New York: G. P. Putnam, 1853), pp. 154–59.

272. The well-known history of Central Park's creation is told best and most completely in Roy Rosenzweig and Elizabeth Blackmar, *The Park and the People: A History of Central Park* (Ithaca, New York: Cornell University Press, 1992).

273. Quoted in Rosenzweig and Blackmar, *Park and the People,* p. 136.

274. Elizabeth Blackmar, "Uptown Real Estate and the Creation of Times Square," in *Inventing Times Square: Commerce and Culture at the Crossroads of the World,* edited by William R. Taylor (New York: Russell Sage Foundation, 1991), p. 56; Moehring, "Space, Economic Growth, and the Public Works Revolution," p. 42.

275. "The Lounger. The Central Park," *Harper's Weekly,* October 1, 1859, p. 626.

276. Strong, Diary, entry for June 11, 1859, The New-York Historical Society; Bridges, *City in the Republic,* p. 123; Rosenzweig and Blackmar, *Park and the People,* pp. 151–58.

277. Rosenzweig and Blackmar, *Park and the People,* pp. 131, 239–41; Miller, *Empire of the Eye,* pp. 12–15.

Fig. 36. Frederick Law Olmsted and Calvert Vaux, landscape architects, *"Greensward" Plan for Central Park,* 1858. Pen and ink. New York City Department of Parks, The Arsenal

278. Clarence Cook, "More About the Permanent Free Picture Gallery," *The Independent,* August 23, 1855, p. 265.

Central Park is often interpreted as an antiurban gesture, but it was one of several related tools in the quest for urbanity, as the art critic Clarence Cook, who campaigned vigorously for the park, a public library, and a public art gallery, acknowledged: "How much drunkenness and opium eating does any reasonable man suppose there would be in New-York, Boston, or Philadelphia, or in any large city or town, if there were in each of these places proper provision for the amusement of the people?" [278]

Two founding documents, coincidentally nearly identical in size—the Commissioners' Plan of 1811 and the Greensward Plan of 1858—bracket this essay. The first took the entire city as its subject and the second encompassed a major redesign of one section of it. They are often set up as opposing visions, the former artificial and utilitarian, an unimaginative, money-minded approach, the latter natural and romantic, an attempt to ameliorate the worst effects of its ill-considered predecessor. It seems more accurate to see them as complementary blueprints for citizenship and urbanity during the decades between the opening of the Erie Canal and the opening shots of the Civil War. If it succeeded, Central Park's planners thought it would create a harmonious, virtuous urban community without class antagonisms—very much like the one that early republicans envisioned—while creating a real-

estate bonanza for themselves.[279] The park, however, would be based not on republican equality (although Vaux did evoke that idea) or on the transparency of universally disseminated knowledge, but on a commonality of feeling inculcated by public institutions.[280]

This was the final answer to the question of what was required to make New York a metropolis. "Our city has hotels that surpass in splendor and extent most of the public hotels of Europe; an Academy of Music that will compare favorably with the best Opera-houses in the Old World; and with our new Park, which the public will insist on having, we shall lack but one of the most attractive features of the great European capitals (and this we shall soon have)—their galleries of art."[281] In the 1850s New York's elite remained convinced that cultural authority, not republican equality, was the key to social and political harmony, and they began to call for the establishment of free public institutions—parks, art galleries, and libraries foremost among them—that would transmit these values to the masses.[282] Central Park, brought to completion by a political machine catering to the people that the elite were trying to reach, was the first fruit of this campaign. The Civil War interrupted it, and when it resumed after the war, New York's elite took direct control of the process, organizing such Gilded Age monuments to cultural authority as The Metropolitan Museum of Art.

279. Field, "Parks," p. 64; "The Lounger. The Central Park," p. 626; Blackmar, "Uptown Real Estate," p. 56.

280. Rosenzweig and Blackmar, *Park and the People,* pp. 136–37.

281. *Frank Leslie's Illustrated Newspaper,* January 26, 1856, p. 102.

282. Cook, "Shall We Have a Permanent Free Picture Gallery?"; Cook, "More About the Permanent Free Picture Gallery," p. 265; Carol Duncan, *Civilizing Rituals: Inside Public Art Museums* (London: Routledge, 1995), pp. 54–55.

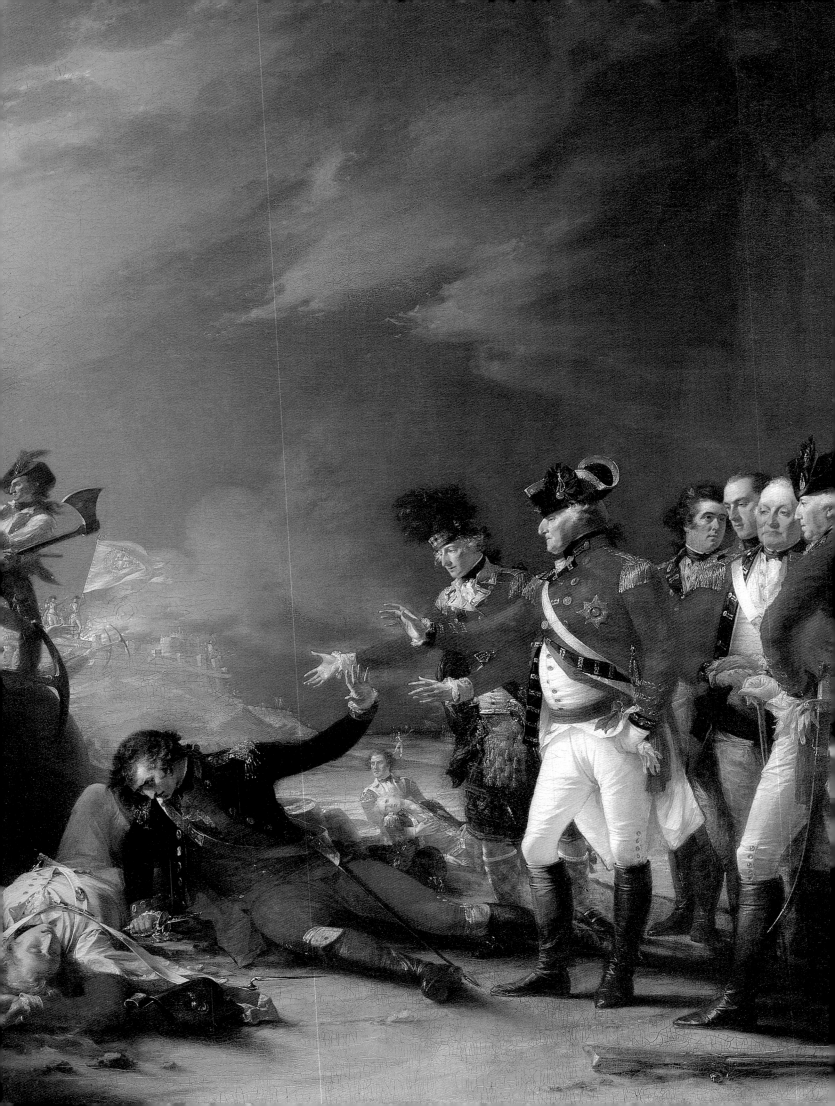

Mapping the Venues: New York City Art Exhibitions

CARRIE REBORA BARRATT

In June of 1818, only shortly before the beginning of our period, a notice in the New York *National Advocate* of peculiarly Knickerbockerian parodic tone described the city's cultural enterprise as owing its welfare to seven men, "the same auspicious number as the wise men of Greece."[1] These men not only gave impetus to the visual arts, literature, and science but also provided "the sole support of the character of this state." They moved through their cultural affairs with the sort of efficiency possible only in a very small world, as they took their seats first as the executive cabinet of the New-York Historical Society and then, after they "brushed one another's coats of the cobwebs from the shelves and books, and marched off, Indian file, into the *next* room," proceeded to convene as the Philosophical Society, the Medical Society, the Bible Society, and finally the Academy of Arts. "We are," they sang in unison around the last board table, "the guardians of the pierean spring, and we will deal it out like soda water."

Tongue-in-cheek but bitingly accurate, the article portrayed New York's cultural establishment, in which the few dominated the few in an art world that was highly circumscribed. It would be another four decades before authority was effectively transferred from a tiny committee of elite comrades to an enormous cast of art dealers, auctioneers, curators, and impresarios, in which trained professionals were outnumbered by mere claimants to expertise that no one else presumed to assert.

Before midcentury an impromptu exhibition at the City Dispensary could rival a fully orchestrated show at the New-York Athenaeum. And the owner of an artists' supply shop could hold an auction in competition with one run by a saloonkeeper who might make better sales because in the evening he illuminated his lots by gaslight and served refreshments. The two major art institutions in town, the American Academy of the Fine Arts and the National Academy of Design, moved their operations from hall to hall and, when finally settled in spaces of their own, evidently let their rooms to one and all for diverse exhibitions apart from their own shows. Supplementing these veritable *Kunsthallen* were displays in store windows, hospitals, artists' studios, patrons' parlors, and other disparate spots. "Auction house" was a contradiction in terms, as most auctioneers had no permanent homes but rented space from various and sundry establishments for the day or week. Some venues were surely more prestigious than others, and some surely more appropriate for art, but relevant criteria had not yet been established. It is telling that the Marble Buildings at Broadway near Ann Street, across from Saint Paul's, were described in 1836 as having "the most complete and beautiful public exhibition room in America,"[2] praise that makes us now wonder why this place languishes in obscurity save for a few mentions in passing. No institution had a monopoly on either talent or the ability to attract viewers. There were paintings to be purchased on virtually every corner from many salesmen who dealt not only in art but in other commodities as well. For artists there was a teeming market characterized by myriad choices and strategies.

The map of New York's antebellum art scene can be plotted, and the list of venues and exhibitions can be charted, as the appendixes to this essay demonstrate.[3] The richer picture, however, can be neatly, if not completely, conveyed in series of vignettes, beginning with the so-called discovery story of the landscape painter Thomas Cole, a tale that encapsulates the configuration of the New York art scene on the brink of the second quarter of the nineteenth century.[4]

Thomas Cole and His Many Dealers

Cole arrived in the city in the spring of 1825 and placed a number of works with George Dixey, a carver and gilder who plied his trade and sold art supplies on Chatham Street. A local merchant, George W. Bruen, purchased at least one of the pictures for $10 and, after subsequently meeting with the artist, sent the young man to the Catskills to seek fresh inspiration. By early fall Cole was back in New

This essay could not have been written without the expert research assistance of Gina d'Angelo, Austen Barron Bailly, Amy Kurtz, and Lois Stainman. The author is most grateful for their help.

1. Kaleidoscope, "First View in the Chamber of Vision," *National Advocate* (New York), June 23, 1818.
2. "Opening of Dioramas," *New York Herald*, December 22, 1836.
3. The story of art venues throughout the United States in this period has been told in Neil Harris, *The Artist in American Society: The Formative Years, 1790–1860* (New York: Braziller, 1966), esp. pp. 139–72; Lillian B. Miller, *Patrons and Patriotism: The Encouragement of the Fine Arts in the United States, 1790–1860* (Chicago: University of Chicago Press, 1982), esp. pp. 254–83; and Alan Wallach, "Long-Term Visions, Short-Term Failures: Art Institutions in the United States, 1800–1860," in *Art in Bourgeois Society, 1790–1850*, edited by Andrew Hemingway and William Vaughan (Cambridge: Cambridge University Press, 1998), pp. 297–313.
4. The phrase "discovery story" was coined, and the tale most recently retold, by Alan Wallach, "Thomas Cole: Landscape and the Course of American Empire," in *Thomas Cole: Landscape into History*, edited by William H. Truettner and Alan Wallach (exh. cat., Washington, D.C.: National Museum of American Art, Smithsonian Institution; New Haven: Yale University Press, 1994), pp. 23–24. See also Ellwood C. Parry III, *The Art of Thomas Cole: Ambition and Imagination* (Newark: University of Delaware Press, 1988), pp. 21–27; and Carrie Rebora, "The American Academy of the Fine Arts, New York, 1802–1842" (Ph.D. dissertation, City University of New York, Graduate Center, 1990), pp. 79–80.

Opposite: detail, fig. 38

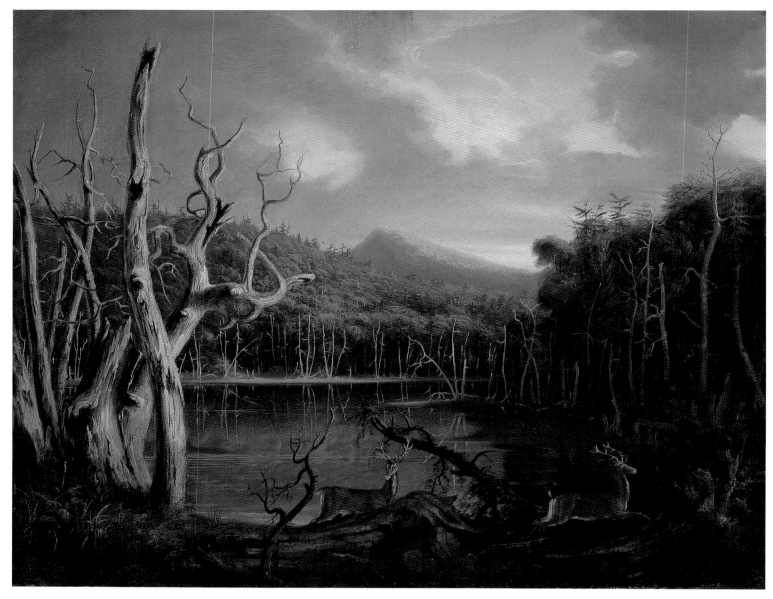

Fig. 37. Thomas Cole, *Lake with Dead Trees (Catskill)*, 1825. Oil on canvas. Allen Memorial Art Museum, Oberlin College, Oberlin, Ohio, Gift of Charles F. Olney, 1904 1904.1183

The primary sources for the story are: An Artist [William Dunlap], "To the Editors of the *American*," *New-York American*, November 15, 1825, reprinted in the *New-York Evening Post*, November 22, 1825; An Artist [William Dunlap], "To the Editors of the *American*," *New-York American*, November 22, 1825; "A Review of the Gallery of the American Academy of Fine Arts," *New-York Review, and Atheneum Magazine* 1 (December 1825), pp. 77, 1 (January 1826), p. 153; and William Dunlap, *History of the Rise and Progress of the Arts of Design in the United States*, 2 vols. (New York: George P. Scott, 1834), vol. 2, pp. 359–60.

York with several new paintings, three of which Bruen helped him place at the artists' supply shop of the antiquarian William A. Colman. Cole, reportedly counseled by Bruen, asked $20 for each canvas. Colman offered them for sale at $25.

In short order, the pictures sold to three of Cole's colleagues: John Trumbull bought a view of Kaaterskill Falls (unlocated), William Dunlap got *Lake with Dead Trees (Catskill)* (fig. 37), and Asher B. Durand procured a scene of the ruins of Fort Putnam (unlocated). Dunlap and Durand quickly placed their purchases in the exhibition on view at the American Academy of the Fine Arts, which had opened in October, a month before the paintings changed hands. Almost as swiftly, Dunlap sold his Cole for $50

to Mayor Philip Hone, who was accustomed to free-market transactions of this kind, as he had once run an auction and commission business in textiles, tea, liquor, and fine arts with his brother. Trumbull also added his Cole to the exhibition at the Academy, of which he was president, but waited another month, however, until sometime in December. He wished first to show his purchase privately to the Baltimore collector Robert Gilmor Jr., to his nephew by marriage Daniel Wadsworth, and to the businessman and Academy board member William Gracie before putting it on public view. Each of these men would commission a work from Cole within the next few months.

This story of Cole's brilliant entry into New York, which expedited the successes of his subsequent

career, is a key chapter in the artist's biography. Moreover, the episode reveals the complicated and flexible workings of New York's contemporary art scene, which was populated by characters who slipped in and out of their roles to suit the situation at hand. First there was Dixey, who played a minor part in the narrative as the owner of a shop to which an artist might have gone for assistance. Many artists' supply shops sold works of art as an extension of their primary business and as a favor to their clients, a practice that engendered additional business: the paintings were made of the very materials purchased by their creators, who responded by buying more supplies. Furthermore, these artists had nowhere else to turn, since there were few formal galleries in the city, and those few, such as Michael Paff's establishment, preferred European pictures. The modest price Dixey charged for Cole's works suggests that the relationship between shop owner and artist was based on the granting of favors rather than on hopes for great profits, although Dixey surely took a bit off the top.

Then there was Bruen. There is no reason to doubt that he cherished Cole's work, nor to suspect that his assistance to the artist was motivated purely by monetary interests. But Bruen did take Cole for his protégé for a single summer, introduced him to a new dealer, and doubled his prices. While Bruen was initially a patron in the most traditional sense, he later became a middleman; in the latter role he did not buy all the works that resulted from the Catskills trip he financed but shepherded to market certain examples, the display and sale of which may have inflated the value of his own Coles. Bruen helped Cole place his pictures with Colman, who not only sold art supplies like Dixey but was in addition a seasoned book dealer. Although the precise details of how Colman marketed Cole's paintings—their placement in the shop, his business methods, and the like—are lost to history, it is clear that the works sold rapidly and at asking price.

An element of happenstance in the story of Cole's discovery in New York pervades traditional retellings of it: Trumbull went to Colman's, where he bought a Cole, and when he praised it to his friend Dunlap, Durand overheard him by chance. Yet the purchases made by Dunlap, Durand, and especially Trumbull were not entirely fortuitous. Colman owed Trumbull money for pictures—either painted or owned by Trumbull—he had sold at his shop. The financial relationship between the two men is pertinent since Trumbull did not, in fact, pay $25 for his Kaaterskill Falls picture but was out of pocket only the difference between that price and what Colman owed him.

Colman, in turn, forfeited the cash he might have received from another client for Cole's painting but may have profited by bartering with Trumbull rather than paying him.

Trumbull was no stranger to art dealing, which had, in fact, been a critical component of his career since the 1790s, when he took partners in Paris and amassed a collection of old master paintings for sale at Christie's, London.[5] The pictures not sold at auction Trumbull brought to New York in 1804, when he displayed them in a riding stable and offered them again. As president of the American Academy from 1816, he exerted considerable influence on the market, orchestrating myriad purchases of pictures for the Academy, for himself, and for individual artists and patrons.[6]

Trumbull undertook most of his enterprises to enhance his career and the Academy's stature rather than as strictly lucrative ventures. He promoted himself as the city's keenest connoisseur, one of the few, as the *Commercial Advertiser* reported, who would have recognized, as he did, a Domenichino if he saw it.[7] A talented, clever, and resourceful man with an abiding interest in every aspect of New York's art scene, Trumbull participated in what would now be considered multiple professions. His involvement with Cole brought most of them into play. As a painter, he greatly admired Cole's artistic skills and vision. As the head of the American Academy, he wished to cultivate Cole and other contemporary artists whose work suited his exhibition program and collecting initiatives. As an enterprising participant in New York's art scene at large, Trumbull took part in transactions between artists such as Cole and collectors that in some cases were remunerative and in others extended his controlling influence. In fact, Cole scarcely made a sale in the decade after the purchase of the Kaaterskill picture that cannot in some fashion be linked to Trumbull's machinations.[8]

Perhaps the most important part of the Cole discovery story emerges after the purchase of the Kaaterskill painting, when the impact of Trumbull's interest in the young artist became significant. At this point the roles of Dixey, Bruen, and Colman began to diminish. Dunlap and Durand merely followed through, as pawns for Trumbull, making it possible for him to have all three of Cole's pictures for the fall exhibition at the Academy, which, after all, was a sales gallery. Taking the paintings from Colman's to the Academy did not remove them from the market but transferred them to a more advantageous venue. In a matter of months the value of Cole's work

5. For more detailed information on Trumbull's collecting efforts in the 1790s, see Irma B. Jaffe, *John Trumbull: Patriot Artist of the American Revolution* (Boston: New York Graphic Society, 1975), pp. 172–75.

6. On Trumbull and the American Academy, see Rebora, "American Academy of the Fine Arts," pp. 57–101.

7. "An Old Picture," *Commercial Advertiser* (New York), October 20, 1827.

8. See Wallach, "Thomas Cole," p. 35; and Alan Wallach, "Thomas Cole and the Aristocracy," *Arts Magazine* 56 (November 1981), pp. 94–106.

9. The price is recorded in Cole's letter to Wadsworth of December 4, 1827, a year after the picture was bought and paid for. See J. Bard McNulty, ed., *The Correspondence of Thomas Cole and Daniel Wadsworth* (Hartford: Connecticut Historical Society, 1983), p. 25.

10. For a detailed account of the founding of the National Academy of Design, see Rebora, "American Academy of the Fine Arts," pp. 244–336.

11. This characterization was most recently put forward in Rachel Klein, "Art and Authority in Antebellum New York City: The Rise and Fall of the American Art-Union," *Journal of American History* 81 (March 1995), p. 1536.

12. Denon, "The Two Academies," *New-York Evening Post,* May 17, 1828. For a complete account on the war of words in New York papers during the summer of 1828, see Rebora, "American Academy of the Fine Arts," pp. 287–305.

quintupled, as it escalated along parallel trajectories of price and place of sale, from $10 at Dixey's, to $25 at Colman's, to $50 at the Academy, where Dunlap brought *Lake with Dead Trees* to Hone's attention.

The nature of free and flexible trade allowed Dunlap to keep the profit he realized in the sale to Hone rather than share it with Cole; Dunlap justified himself by pleading his straitened circumstances, but in any event there existed no market regulation or precedent that would have compelled him to be generous to Cole. Trumbull also would certainly have held on to any extra profits if he had sold the artist's Kaaterskill view to Gilmor, Wadsworth, or Gracie. The prices for Cole's landscapes remained high, in some measure thanks to Trumbull, whose nephew Wadsworth paid $50 for his Cole (Wadsworth Atheneum, Hartford), a picture reportedly identical to Trumbull's and commissioned at Trumbull's behest.[9]

The House of Trumbull, Barclay Street

The single most important figure on the New York art scene before his death in 1843, Trumbull wielded tremendous influence in many spheres. Notoriously irascible, especially in his later years, he is typically regarded as an anachronistic figure, a thorn in the side of those with more modern views. He was, as is commonly recounted, the old man who moved his *retardataire* institution in a direction other than that desired by the community of artists, which, under the leadership of Samuel F. B. Morse in 1825, founded the National Academy of Design. Morse began to organize his colleagues by hosting socials in his spacious Canal Street studio. These soirees quickly evolved into the New York Association of Artists and, within months, into the National Academy, which offered classes, lectures, and an exhibition of contemporary paintings and sculpture by local American artists each spring. The National Academy's success can be gauged by the favorable reviews of its shows, the great legacies of the artists trained there, and the impressive number of important paintings it exhibited over the years. Morse's idea that his academy would coexist with Trumbull's proved untenable, and the two institutions operated competitively until the American Academy ultimately closed in 1842.[10] In writing about their rivalry, historians have always favored the artists, who are cast as industrious, modern, and democratic foils to Trumbull's idle, old-fashioned, and elite board of directors.[11] Such stereotypes fuel the story of a clash between progressive forces and tradition-bound cultural authority, at least in the version of

history that considers the American Academy useless. The American Academy's demise as a meaningful institution is allegedly proved by its increasing lack of connection with contemporary American art in the 1830s and 1840s. Yet the American Academy was never involved in this field; its vital concern, both before and after the founding of the National Academy, was the market for old masters and contemporary European painting. This was a market that owed its existence in New York in significant measure to Trumbull, who had been its driving force since his return from abroad in 1804.

The sometimes antagonistic coexistence of the two rival academies reflected the flourishing and complicated nature of New York's art market. Editorials published in the papers during the summer of 1828, when the National was still new and the American still smarting from the sting of competition where there had been little before, agreed on just one point: the city required only one institution for the fine arts. One of the first and most vehement editorialists, a supporter of the National, writing in the *New-York Evening Post* described the American's dearth of lectures, classes, and "any evidence of prosperity and of energetic and discreet government."[12] The exhibitions at the American, he explained, consisted of works "by all manner of artists, *known* and *unknown, ancient* and *modern* . . . and there are *huge* copies, and *little* copies, and *whole* copies, and *half* copies, and *good* copies, and *bad* copies; indeed it is a sort of Noah's ark, in which were things of every kind, *clean* and *unclean, noble animals,* and *creeping things.*"

The National, by promising contrast, offered all of the things deemed missing from the American's program—lectures, classes, and exhibitions of contemporary work by local artists—and this, according to the author, was all the city needed. Yet the city could not have done without the bad copies and creeping things, for these were an intrinsic part of its art world and have continued to be so to this day. The modern National would have to coexist with the antiquated American, which thrived precisely by continuing to present the sort of art described so disparagingly in the *Evening Post.*

The American Academy was New York's host to all that was inappropriate for the National; its inclusiveness should not be interpreted in a negative light, for on its walls was a world of art that would move to multiple venues during the late 1840s and 1850s. It is true that Trumbull's institution featured much that is now known to have been of spurious attribution and provenance. But it would have been impossible

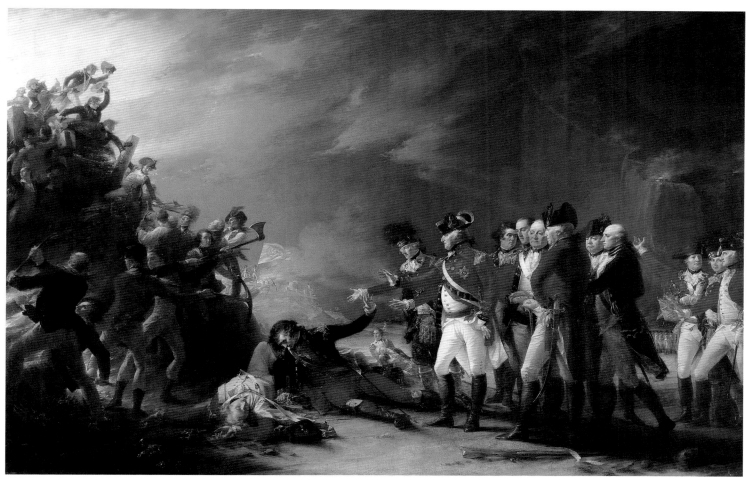

Fig. 38. John Trumbull, *Sortie Made by the Garrison at Gibraltar*, London, 1789. Oil on canvas. The Metropolitan Museum of Art, New York, Purchase, Pauline V. Fullerton Bequest; Mr. and Mrs. James Walter Carter and Mr. and Mrs. Raymond J. Horowitz Gifts; Erving Wolf Foundation and Vain and Harry Fish Foundation Inc. Gifts; Gift of Hanson K. Corning, by exchange; and Maria DeWitt Jesup and Morris K. Jesup Funds, 1976 1976.332

for any American establishment of the early nineteenth century to consistently put forward impeccable works, for no one of the period, neither Trumbull nor any other collector in this country, had the connoisseurship skills necessary to judge art of various dates and cultures. In the 1820s and 1830s the American Academy opened the market, took risks, and, ultimately, presented in microcosm all the elements of the vital, multifaceted, complicated art scene that burgeoned in the following decades.

Trumbull shaped his institution for would-be patrons and collectors seeking the broadest experience of art, and he did this at a time when and in a place where there were plenty of mistakes to be made. A man of contradictory tendencies, he espoused the grandest traditions of art but had a business sense that led him to show unknown works of many kinds.[13] Between 1828 and 1839 the American Academy hosted nine exhibitions of old masters, each one brought to New York by a different entrepreneur, ranging in character from irreproachable to criminal. The collection of Antonio

Sarti of Florence came to the American Academy in December 1828 on the advice of the collector, sometime dealer, and American Academy board member Pierre Flandin, who did not so much vouch for the collection as simply introduce Signor Sarti as his friend.[14] The prospect of having over two hundred Italian paintings in the Academy's gallery was enough for Trumbull, who did not see the collection before extending Sarti a contract, and the show was apparently more than satisfactory for the nearly two thousand visitors who saw it during its first two weeks. The crowds came in steady numbers for six weeks and then increased in mid-April 1829, after Sarti authorized the Academy to offer the entire collection at public auction in the gallery.

The Sarti sale was not Trumbull's first venture into the auction business. During the summer of 1828 he had orchestrated a silent auction for his own *Sortie Made by the Garrison at Gibraltar*, 1789 (fig. 38), a work painted in London that depicted a British military victory over the Spanish. Trumbull had failed to

13. On Trumbull's contradictory nature, see Jules David Prown, "John Trumbull as History Painter," in *John Trumbull: The Hand and Spirit of a Painter*, by Helen A. Cooper et al. (exh. cat., New Haven: Yale University Art Gallery, 1983), p. 22.

14. See American Academy of the Fine Arts, Minutes (BV), November 3, 7, 1828, The New-York Historical Society; and American Academy of the Fine Arts, *Exhibition of Rare Paintings at the Academy of Fine Arts, New York* (exh. cat., New York, 1828).

Fig. 39. Benjamin West, *King Lear*, London, 1788; retouched 1806. Oil on canvas. Courtesy of the Museum of Fine Arts, Boston, Henry H. and Zoë Oliver Sherman Fund 1979.476

15. [John Trumbull], "Trumbull's Picture of Elliott's Sortie from Gibraltar," *Commercial Advertiser* (New York), October 20, 1827; [John Trumbull], "American Academy of the Fine Arts," *Commercial Advertiser* (New York), June 2, 5, 6, 14, 28, 1828.

16. See Carrie Rebora Barratt, "John Trumbull and the Art of War," manuscript available for inspection.

17. [Trumbull], "American Academy of the Fine Arts," June 6, 1828.

18. See Carrie Rebora, "Robert Fulton's Art Collection," *American Art Journal* 22 (1990), pp. 40–63.

sell the picture abroad and kept it under wraps in his New York studio for nearly twenty-five years before mounting it at the Academy in 1828—to great fanfare that he generated by advertising the painting as "splendid and faultless" and by penning anonymous laudatory reviews.[15] The presentation was a single-picture exhibition meant to draw attention to Trumbull and the American Academy during a summer of heated public debate between the two academies.[16] The precise details of the military event depicted would have been lost on most New Yorkers, but Trumbull may have hoped that those caught up in the battle between the academies would read the painting's key figures—the victorious aging General George Elliott and the defeated young Don Juan de Barboza—as allegorical representations of the two institutions. He wrote in the New York *Commercial Advertiser* of his picture, "The victor stands in the full blaze and splendor of light and glory—the vanquished [hero], dies in the deep gloom of adversity and despair."[17] This, he perhaps thought, was how Samuel F. B. Morse ought graciously to lie down and die in the face of a more powerful force.

In the end, Trumbull was disappointed to find not only that his grand canvas had little if any impact on the relationship between the academies but also that there was little interest in the *Sortie* among New York collectors. He was pleased, however, to sell the picture to the Boston Athenaeum. The sale encouraged him in his desire to bring the art marketplace into his academy, and in October 1828 he used the site for an auction of the paintings in Robert Fulton's collection—principally Shakespearean subjects by Benjamin West, including *King Lear*, 1788 (fig. 39), and *Ophelia before the King and Queen*, 1792 (Cincinnati Art Museum)—which had been on loan at the Academy since 1816 and were being sold by Fulton's heirs.[18]

For two of these events Trumbull called in others to make the sales: John Boyd for the Fulton pictures and Michael Henry for Sarti's collection. Neither had a space of his own and neither was ever heard of again: they were auctioneers for a day. If Trumbull's Academy received a percentage of the profits for use of its rooms, it is not recorded, but the institution was certainly enriched by the entrance fees paid by everyone, whether mere spectator or ready buyer. In the view of

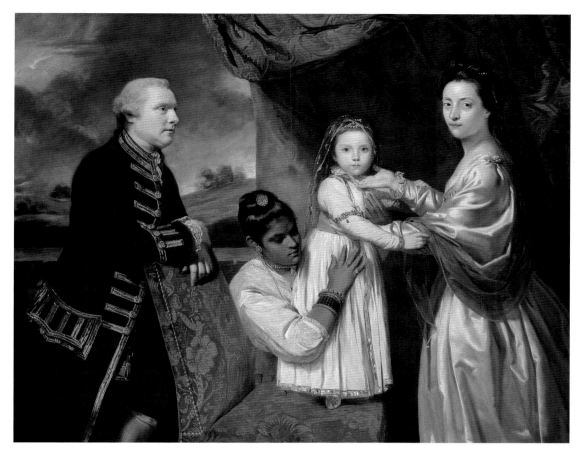

Fig. 40. Joshua Reynolds, *George Clive (1720–1779) and His Family*, London, 1765–66. Oil on canvas. Staatliche Museen zu Berlin, Preussischer Kulturbesitz, Gemäldegalerie 78.1

those who believed—or still believe—that an institution bearing the name Academy must be untainted by commercialism, Trumbull defiled his galleries by welcoming public sales in them. However, those who have observed that he was among the first Americans to recognize that art can be a business may consider him not impure but prescient.

In 1830 the very existence of the American Academy was threatened when it was forced to leave its quarters in the New York Institution in City Hall Park. In response to this crisis, Trumbull mounted the extraordinarily controversial exhibition of Richard Abraham's collection of European paintings. This collection, according to the catalogue published by Abraham, an English picture dealer and conservator, included Leonardo's *Virgin of the Rocks,* Titian's *Magdalen in the Wilderness,* Raphael's *Adoration,* and works by Velázquez, Andrea del Sarto, Watteau, Van de Velde, Ruisdael (cat. no. 47), Lodovico Carracci, Murillo (cat. no. 44), and Tiepolo. Although it is now known that the vast majority of the pictures were copies, at the time of the show the authenticity of the works was not at issue. Dunlap summed up

generally held opinion when he described them as "the best pictures from old masters which America had seen." [19] They were, in any event, notorious because of "the peculiar circumstances attending their importation." Abraham, it was charged, had "collected a number of good pictures, under various pretences," having duped their English owners. [20] He was arrested on his arrival in New York, and the collection went on view and was auctioned under the aegis of Goodhue and Company, the agency responsible for the pictures after his imprisonment. His victims in England pressed charges but were nonetheless keen to sell their family treasures in America.

The exhibition was a huge success, reflecting the strength of the New York market. Thousands of people saw the show—paying steep admission prices of 50 cents for a single entry or $3 for the season—and the critics applauded loudly. The reviewer in the *Morning Courier and New-York Enquirer* was dumbfounded: "Language would convey but a faint idea of the effect which is produced upon the mind in examining [the paintings]." [21] As the closing act at the Academy's old building, the show epitomized Trumbull's mission: to

19. Dunlap, *Rise and Progress,* vol. 1, p. 305.
20. American Academy of the Fine Arts, Minutes (BV), February 4, 1830, The New-York Historical Society.
21. "Paintings.—Academy of Arts," *Morning Courier and New-York Enquirer,* March 24, 1830. See also C., "The Pictures," *New-York American,* April 2, 1830; C., "The Pictures at the Academy," *New-York Mirror,* April 3, 1830, p. 307; "Academy of Fine Arts," *Commercial Advertiser* (New York), April 5, 1830.

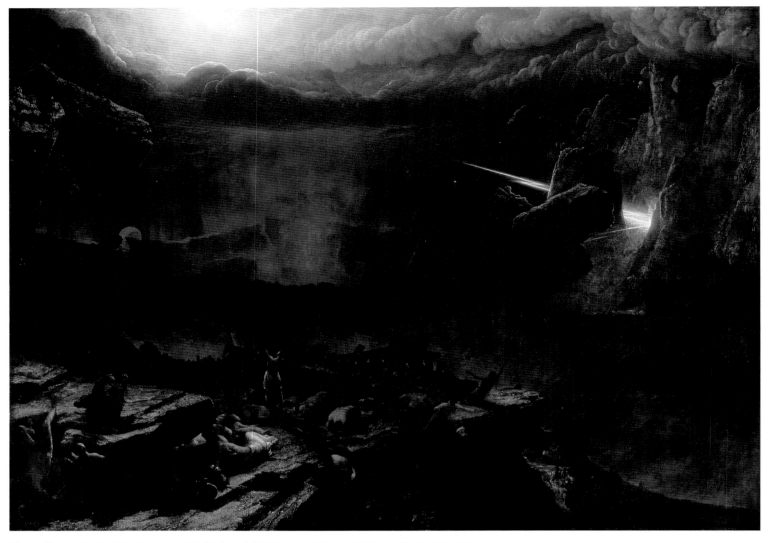

Fig. 41. Francis Danby, *The Opening of the Sixth Seal*, Dublin, 1828. National Gallery of Ireland, Dublin

22. "Paintings by the Great Masters, Barclay Street," *Evening Post* (New York), December 26, 1832. See American Academy of the Fine Arts, *A Descriptive Catalogue of the Paintings, by the Ancient Masters, Including Specimens of the First Class, by the Italian, Venetian, Spanish, Flemish, Dutch, French, and English Schools* (New York: W. Mitchell, 1832).

keep the visitors coming by maintaining an edge on the market—that is, to show and sell what could be seen nowhere else in the city.

The American Academy moved to Barclay Street, next door to the Astor Hotel; David Hosack, a founding director, donated the land behind his home for the new building, which was designed by Trumbull, who also acted as contractor. The reopening was fraught with anxiety and the Academy's position remained tenuous, but during the 1830s Trumbull pursued his two basic goals: to continue to show European art and, of course, to keep the doors open. His struggles of the early 1830s resulted in a lively series of exhibitions. In 1831, for example, the Academy's season opened with a display of Trumbull's own paintings of scenes from the American Revolution, which ran almost concurrently with a showing of Horatio Greenough's sculpture *Chanting Cherubs* (unlocated; see fig. 108), and closed with the single-picture

exhibition of George Cooke's copy of Gericault's *Raft of the Medusa* (New-York Historical Society). John Watkins Brett, "a gentleman of great wealth and taste in England" and a friend of Trumbull, presented his collection at the Academy in 1832, causing the *Evening Post* critic to proclaim that "no collection surpassing it has been exhibited in this city."[22] Brett's pictures included Sir Joshua Reynolds's *Self-Portrait in Doctoral Robes*, 1773 (private collection), and his *George Clive (1720–1779) and His Family*, 1765–66 (fig. 40); Benjamin West and Robert Livesay's *Introduction of the Duchess of York to the Royal Family of England*, about 1791 (National Trust, Upton House, Oxfordshire); and forty-five other European paintings, most of which were of undisputed pedigree.

The schedule for 1833 was a product of Trumbull's relationship with Brett, who brought to New York Claude-Marie Dubufe's *Temptation of Adam and Eve* and *Expulsion from Paradise*, 1828 (unlocated; see

figs. 42, 43), and Francis Danby's *Opening of the Sixth Seal*, 1828 (fig. 41). Trumbull supplemented this roster with a showing of James Thom's comedic sculptural group *Tam O'Shanter, Souter Johnny, the Landlord and Landlady* (unlocated). The next year saw presentations of Cole's enormous *Angel Appearing to the Shepherds,* 1834 (Chrysler Museum, Norfolk, Virginia), Robert Ball Hughes's *Uncle Toby and Widow Wadman* (unlocated), four views of Rome by Giovanni Paolo Panini (see cat. no. 48), the collection of the Marquis de Gouvello, and immense dioramic paintings. In 1835 Brett's collection returned and was followed by Daniel Blake's collection of old masters, more sculpture by Thom, and more history paintings by Trumbull. With no precise method of selection or exacting criteria, Trumbull took what came and was pleased by the crowds that kept his Academy open.

According to this rather haphazard approach, he allowed his institution to become the city's principal venue for large shows and odd shows. By about the mid-1830s the American Academy faced competition from the Marble Buildings, the City Dispensary, Clinton Hall, Masonic Hall, Reichard's Art Rooms, and John Vanderlyn's New-York Rotunda (see cat. no. 70), and myriad storefronts as well as from the increasingly professional National Academy of Design. The business of exhibitions, which had proved reasonably profitable for Trumbull, was expanding to accommodate growing demand from New Yorkers, and new venues were springing up to take over. Trumbull's Academy closed not because it was overwhelmed by the power of the National Academy, as most have suggested, but because it was superseded by these new establishments.

At this point even the officers of the National Academy found the competition too threatening and the potential profits too attractive to pass up and rented its galleries out for displays of private collections and for auctions. In 1842, nearly two decades after the academies debated on matters of principle and purpose, the American Academy shut its doors. Ironically, it closed just as the National Academy was mounting an exhibition and auction of old masters. The two academies had become one.

Dubufe's Adam and Eve Paintings and the Art Unions

The Opening of the Sixth Seal by Francis Danby was a spectacular component of the American Academy's 1833 program of exhibitions. This Irish artist's splendid interpretation of Revelation 6:12–16 was a type of picture never before seen in this country and influenced several key American painters, including Cole and Durand. But the Danby exhibition, in fact, had nothing on the other two shows presented that year. Crowds flocked to see Thom's statues based on Robert Burns's verse: there were hundreds of visitors every day and even more came on the occasions when Mr. Graham, "the blind Scotch poet," recited from Burns in the galleries.[23] Thom's Ayrshire stone alehouse tableau, large as life, reported *The Knickerbocker,* was "so much written about . . . that every phrase of critical eulogy has been exhausted."[24]

But not even this novel group could hold a candle to Claude-Marie Dubufe's two fourteen-by-twelve-foot paintings of Adam and Eve. Dubufe was a French student of David chiefly known for his portraits. He executed the Adam and Eve pictures, advertised as "Grand Moral Paintings," in 1828 for Charles X of France, who was forced to sell them when he abdicated in 1830. Brett showed the giant canvases at the Royal Academy and the British Institution in London before introducing them to America in a two-month exhibition at the Boston Athenaeum in late 1832, after which he brought them to New York.[25] The paintings elicited a storm of favorable reviews, a poet wrote ten stanzas on them, and Dunlap, who judged the pictures "very beautiful," recorded in his diary that the exhibition was "unusually successful many days yealding 100 dollars ye day."[26] The *New-York Mirror* reported that "throngs of visitors have crowded to examine them, with lavish exclamations of surprise and delight."[27] One commentator was inspired to remark "But this is not a picture—'tis the life."[28] This was extravagant praise indeed for a painter considered in European circles to be merely competent. The only detractors in New York were sermonizers on the inherent vice and licentiousness of art.[29] An apparently timid bunch, they waited to speak out until the Dubufes left the Academy. But they were not gone for long.

Dubufe's paintings—not only those of Adam and Eve but other canvases as well—were the rage of the New York art critics and viewing public alike for nearly three decades. In 1833, when there was something for everyone in the city, Dubufe's biblical pictures successfully vied with the annual exhibitions of the American Institute of the City of New York and the National Academy of Design, which respectively featured amateur painting and contemporary American art and, as always, were well attended. Dubufe's work returned to the American Academy in 1836 and 1838 and appeared in New York in the intervening year at the Stuyvesant Institute. In the few years they were absent from the city, between 1833 and 1836, Dubufe's

23. "Tam O'Shanter," *Morning Courier and New-York Enquirer,* June 19, 1833.

24. "The Group from Tam O'Shanter," *The Knickerbocker* 2 (July 1833), p. 69.

25. For the complete history of the pictures and the American tour, see Kendall B. Taft, "*Adam and Eve* in America," *Art Quarterly* 22 (summer 1960), pp. 171–79.

26. J. M. M., "Adam and Eve," *New-York American,* March 8, 1833; *Diary of William Dunlap (1766–1839),* edited by Dorothy C. Barck, 3 vols. (New York: New-York Historical Society, 1931), vol. 3, pp. 643 (entry for January 3, 1833), 663 (entry for March 5, 1833). See also advertisement, *New-York American,* January 4, 1833; *Morning Courier and New-York Enquirer,* January 4, 1833; "Fine Pictures," *New-York American,* January 12, 1833; "Adam and Eve," *New-York Commercial Advertiser,* February 25, 1833; and "American Academy of Fine Arts," *American Monthly Magazine* 1 (March 1833), pp. 61–62.

27. "The Paintings of Adam and Eve, at the American Academy," *New-York Mirror,* March 30, 1833, pp. 306–7.

28. J. M. M., "Adam and Eve."

29. See True Modesty, "The Two Grand Moral Paintings," *New-York Mirror,* June 1, 1833, p. 379; and W. W., "Acknowledgment o the Piece Signed 'True Modesty,'" *New-York Mirror,* June 15, 1833, p. 399. The editor prefaced W. W.'s comments with a note reporting that the journal had received "several communications . . . pro and con" on True Modesty's article; although he had not intended to use any of them, he explained, he printed excerpts from W. W.'s piece because it discussed the question of displaying prints of nude figures in shop windows. See also "Fine Arts," *New-York Literary Gazette, and Journal of Belles Lettres, Arts, Sciences, &c.,* September 15, 1834, p. 28.

30. "Adam and Eve," *New-York American*, December 3, 1836.
31. "The Fine Arts," *New-York Mirror*, September 30, 1837, p. 112.
32. Advertisement, *New-York American*, December 20, 1838.
33. "News of the Week," *Literary World*, January 13, 1849, p. 36.

paintings reportedly enlightened more than three hundred thousand viewers across the country. The *New-York American* attributed to each of these anonymous viewers "soundness of judgment and purity of taste" and reported that "there is scarcely one such visitor, who dissents from the high encomiums which have been awarded by the best connoisseurs to these pictures, as works of art, and by the present moralists for their salutary effect upon the mind and feelings."[30]

The high encomiums awarded to the pictures as works of art were no doubt undeserved, and it may well be that Dubufe was so successful in America primarily because he produced admirable paintings expressing admirable values as opposed to extraordinary paintings expressing indifferent values. By the late 1830s for most Americans the didactic component was the most important element of art.

When an exhibition of Dubufe's *Don Juan and Haidee* and *Saint John in the Wilderness* (both unlocated) inaugurated the gallery at the new Stuyvesant Institute in 1857, a reviewer for the *New-York Mirror* hailed the enormous pictures as "striking and well-conceived" and altogether appropriate for the new edifice, which honored the memory of the last director general of the New Netherlands.[31] And if the grouping of Peter Stuyvesant, Dubufe, Lord Byron, and biblical subject matter represented here seems eccentric by today's standards, it well reflected the eclectic tastes of the New York art audience of 1837. By 1838, when the two paintings from the Stuyvesant show were joined by Dubufe's *Circassian Slave* and *Princess of Capua* (both unlocated) at the American Academy, the artist needed no introduction to this appreciative audience, which was treated to the musical accompaniment of two aeolian harps that added "to the enchantment of the scene."[32]

It is tempting to propose that Dubufe may have been popular in New York not because his work was didactic but because it was spectacle rather than fine art, akin to illuminated paintings, dioramas, and other pictures suited more for entertainment than for serious contemplation. New York was full of this sort of material in 1837, when the Dubufe show was at the Stuyvesant and works of similar stripe were on view elsewhere: D. W. Boudet's *La Belle Nature* and *Daphne de l'Olympe* (both unlocated) at 17 Park Row, Dunlap's *Christ Healing the Sick* after West (unlocated) at the American Museum, and a mosaic picture of the ruins of Paestum at the American Academy. Throughout the 1830s Vanderlyn's New-York Rotunda presented panoramas of exotic sites like so many theatrical offerings, one booked after the other, providing audiences with vicarious experiences of trips to far-away lands. Nineteenth-century observers rarely distinguished between the content of these shows, now considered low art, and the American paintings displayed at the National Academy and the American Art-Union or the old masters at the Lyceum Buildings, today's high art. Advertisements for exhibitions of all kinds were pitched to the same audiences and ran in the same newspapers, and the proprietors of galleries made their selections unbound by precise criteria. If such criteria had been in place, the mosaic picture would have been shown at the American Museum, a curiosity cabinet dedicated primarily to natural science and objects of random type, and Dunlap's paintings would have found their place at the more elite American Academy.

Matchups between venues and offerings remained unpredictable throughout the antebellum era. Perhaps one of the most unpredictable occurred in 1849, when Dubufe's Adam and Eve paintings returned to the city yet again, this time to the National Academy of Design. The show opened in January at the National's space in the New York Society Library. The Dubufe installation, like an exhibition of old masters booked for the Academy's large room later in the year, was undoubtedly meant to raise revenues needed to erect a building at Broadway and Bond Street. The National Academy did not entirely compromise its stated mission with these exhibitions—its galleries were used exclusively for the annual show of contemporary American painting by local artists between April and July. Nonetheless the Dubufe event in particular speaks of the competitive nature of the New York art market and the strategies many establishments were forced to adopt to remain financially viable. For the National Academy, founded with exacting programmatic standards, it must have been strange indeed to reprise a show that had originated sixteen years earlier at its archrival, the American Academy. The *Literary World* noted that it was hard to believe but true that "the celebrated Paintings . . . are the same."[33]

Yet, in fact, the National Academy Dubufes may not have been the American Academy Dubufes. The original pictures were destroyed by fire, but there is no indication where or when. It is known that John Beale Bordley painted copies during the winter of 1833–34, when the paintings were in Philadelphia. Bass Otis is said also to have copied them, and it is probable that other sets were made as well; thus by the 1840s numerous versions were traveling. Even if the National Academy had the originals, they would

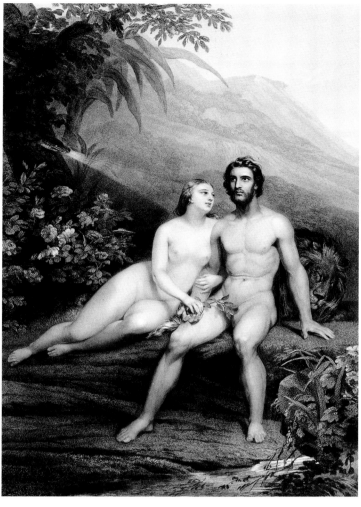

Fig. 42. Henry Thomas Ryall, after Claude-Marie Dubufe, *The Temptation of Adam and Eve*, London, 1860. Engraving. The British Museum, London

Fig. 43. Henry Thomas Ryall, after Claude-Marie Dubufe, *The Expulsion from Paradise*, London, 1860. Engraving. The British Museum, London

have been in a poor state of preservation: owing to their tremendous size, they must have been rolled and unrolled many times and, it seems certain, retouched by local artists at every stop. In any event, the announcement of the National's show explained that the paintings had been touring England, Ireland, and Scotland for eleven years to the delight of "one million seven hundred thousand persons," a statement that simultaneously accounted for their absence from America and added to their cachet as significant works of art.[34]

In 1849 the National presented the best of American painting, undisputed masterpieces by Frederic E. Church, Daniel Huntington, Emanuel Leutze, and Asher B. Durand, the Academy's president, who was represented by eleven pictures including his homage to Cole, *Kindred Spirits*, 1849 (cat. no. 30). The stark contrast between the American works and Dubufe's paintings of Adam and Eve underscores the complicated

nature of the exhibition scene. The *American Metropolitan Magazine* voiced the hope that the public would show some discrimination when considering the Dubufes: "These pictures, which some fifteen years ago were visited by thousands, the most successful Art exhibition that ever took place in this country, are again brought before the public; but we hope, for the sake of pure and correct taste, with not quite that extraordinary success that attended them before. Through such works as these Art is degraded."[35]

The competition for viewers and buyers of art in 1849 was fierce. Frequent auctions held by new professional houses, including Cooley; Dumont and Hosack; Leavitt (figs. 44, 45); Leeds; and Royal Gurley, brought more and more art objects to the attention of New Yorkers. Artists accustomed to selling their works through the National Academy or from their studios began to turn to auction houses, as did private collectors. The Lyceum Gallery, home of Gideon

34. "Return from Europe," *Home Journal*, January 6, 1849, p. 3.

35. "Fine Arts," *American Metropolitan Magazine* 1 (February 1849), p. 110.

Fig. 44. Trade card for Leavitt, Delisser and Company, 377–379 Broadway, ca. 1856. Wood engraving by William(?) Howland. Collection of The New-York Historical Society

Fig. 45. *Interior of Messrs. Leavitt and Delisser's Salesroom, Broadway, New York,* 1856. Wood engraving, from *Frank Leslie's Illustrated Newspaper,* April 5, 1856, p. 264. Courtesy of the American Antiquarian Society, Worcester, Massachusetts

36. "Lyceum Gallery—Old Masters," *Literary World,* March 10, 1849, p. 227.

37. "Fine-Arts Depository," *The Knickerbocker* 33 (February 1849), p. 170; "The Dusseldorf Gallery," *Home Journal,* May 5, 1849, p. 2.

Nye's collection of old masters, was in its second year of operation and actively promoted itself as a public venue.[36] The Paris print publisher and dealer Goupil, Vibert and Company, which had opened for business in the Lafarge Building at Broadway and Reade Street in 1848, was celebrating its arrival in New York by showing "worthy specimens" of modern European painting, including two—Ary Scheffer's *Holy Women at the Sepulchre,* 1845 (fig. 46), and Ferdinand Georg Waldmüller's *Letting Out of School,* 1841 (fig. 47)—that were described as "nails driven into the floor of the year, which shine and brighten with time and frequentation."[37] The Düsseldorf Gallery was inaugurated in April 1849 to great fanfare. Its proprietor, John

Fig. 46. Ary Scheffer, *The Holy Women at the Sepulchre,* 1845. Oil on panel. Manchester City Art Galleries, Manchester, England 1924.17

Fig. 47. Ferdinand Georg Waldmüller, *Letting Out of School,* Düsseldorf, 1841. Oil on wood. Staatliche Museen zu Berlin, Preussischer Kulturbesitz, Nationalgalerie

Godfrey Boker (formerly Johann Gottfried Bocker), had arrived in the city early in the year with the Kraus collection of paintings by artists trained at the Düsseldorf Academy, which he had bought with money he had earned as a wine merchant and statesman.[38] He hung the pictures at the Church of the Divine Unity on Broadway (fig. 48) and received unqualified praise, and the subsequent opening of the gallery was hailed as "an event of unusual magnitude in the way of Art."[39]

The New-York Gallery of the Fine Arts drew crowds, although its popularity would wane over the years; its 1848 installation, composed principally of American paintings collected by the late Luman Reed, complemented the National's typical American shows and attracted many visitors, but probably fewer than came to see the Dubufes the next year.[40] The much-maligned American Art-Union was flourishing early in 1849. For about a decade the Art-Union had been distributing engravings to $5 subscribers, who were entered in a Christmas lottery for one of the paintings it purchased each year.[41] There was no love lost between the Academy and the Art-Union, which bought works from local artists just before the Academy annuals; in fact, it may have been pressure from the Art-Union that drove the Academy to take up Dubufe.[42]

The Art-Union was successful despite adverse publicity and direct competition from the International Art Union, a similar organization developed by Goupil's. (The International differed in that it distributed European as well as American engravings and paintings and every year sent an American artist to Europe for two years of study.)[43] One writer likened the excitement surrounding the American Art-Union's December lottery to the thrills of the Gold Rush: "Not even the golden visions of California have been able wholly to banish from the minds of the fifteen thousand subscribers the pleasant thought that they were possibly to become each one a possessor of a fine picture as a small goldmine return for their ventured five dollars."[44] The big winner in December 1848 took home Cole's four-picture series The Voyage of Life (see figs. 49, 60), a prize so exceptional that word went out that the Art-Union intended to buy it back from the journeyman printer from Binghamton whose number came up that eventful night. Others grumbled that for every fine painting by Cole there were countless inferior works awarded to lottery winners throughout the country who knew no better.[45] Some of this carping may have originated with advocates of the International Art Union or the National Academy, and some

members of the Academy proposed establishing their own Painters' and Sculptors' Art Union.[46]

Partisans of each union fought it out in the papers, and by November 1849 the American was losing ground under full attack for falsifying its charter and misspending its members' dues, among other offenses.[47] One clever writer described the American Art-Union's unethical business practices obliquely, substituting shawls for paintings and pocket handkerchiefs for engravings.[48] The American Art-Union survived only until 1852, but the International, with the solid financial support of Goupil's, was unshakable, especially after it rented the grand and ornate Alhambra Building for its exhibitions in 1854. However, already in 1849, the year after the International was established, its managers had ensured against failure by offering subscribers a print of The Prayer by New York's favorite artist, Dubufe, at last giving Americans a chance to have what they clamored for: a Dubufe in every home.

Fig. 48. Artist unknown, after David H. Arnot, *Exterior of the Düsseldorf Gallery (Church of the Divine Unity)*, 1845. Lithograph by pen work. Collection of The New-York Historical Society

38. See R. H. Stehle, "The Düsseldorf Gallery of New York," *New-York Historical Society Quarterly* 58 (October 1974), pp. 305–14; and William H. Gerdts, "Die Düsseldorf Gallery," in *Vice Versa: Deutsche Maler in Amerika, amerikanische Maler in Deutschland, 1813–1913*, edited by Katharina Bott and Gerhard Bott (exh. cat., Berlin: Deutsches Historisches Museum; Munich: Hirmer, 1996), pp. 44–61.

39. "Dusseldorf Gallery," p. 2.

40. See Abigail Booth Gerdts, "Newly Discovered Records of the New-York Gallery of the Fine Arts," *Archives of American Art Journal* 21, no. 4 (1981), pp. 2–9; and Ella M. Foshay, *Mr. Luman Reed's Picture Gallery: A Pioneer Collection of American Art* (New York: Harry N. Abrams, 1990), pp. 19–20.

41. See Patricia Hills, "The American Art-Union as Patron for Expansionist Ideology in the 1840s," in *Art in Bourgeois Society, 1790–1850*, edited by Andrew Hemingway and William Vaughan (Cambridge: Cambridge University Press, 1998), pp. 314–39; Miller, *Patrons and Patriotism*, pp. 160–72; and Klein, "Art and Authority in Antebellum New York City," pp. 1534–61.

42. Justice, "The American Art-Union and the Academy of Design," *Home Journal*, November 19, 1849, p. 3.

43. See "International Art Union," *Literary World*, December 23, 1848, p. 959.

44. "The Fine Arts," *American Metropolitan Magazine* 1 (January 1849).

45. K., "A Suggestion for the Art-Union," *Literary World*, March 3, 1849, p. 201.

46. Thomas S. Cummings, *Historic Annals of the National Academy of Design, New-York Drawing Association, . . . from 1825 to the Present Time* (Philadelphia: George W. Childs, 1865), p. 218.

47. On the disputes, see "American Art-Union," *Literary World*, April 7, 1849, p. 318; "The Art-Union Distributions," *The Independent*, April 19, 1849, p. 80; Cousin Kate, "The International Art Union," *Home Journal*, April 28, 1849, p. 2; G. G. Foster, "International Art Union," *The Knickerbocker* 33 (May 1849), p. 452; "The American Art-Union," *The Independent*, July 5, 1849, p. 121; "The Fine Arts," *Literary World*, October 6, 1849, p. 298; "The Art-Union

Fig. 49. Thomas Cole, *The Voyage of Life: Youth*, 1840. Oil on canvas. Munson-Williams-Proctor Arts Institute, Utica, New York, Museum Purchase 55.106

Controversy," *Home Journal*, October 10, 1849, p. 2; "The Two Art-Unions," *Home Journal*, October 13, 1849, p. 2; and "The American Art-Union and Messrs. Goupil, Vibert, and Co.," *Literary World*, October 13, 1849, p. 317. Various articles were reprinted in *Bulletin of the American Art-Union* 2 (October 1849), pp. 2–12, (November 1849), pp. 10–15.

48. See "How the American Art-Union Belies Its Charter; or, Is What Would Be Disreputable Dealing, in a Lottery of Shawls, Honest in a Lottery of Pictures," *Home Journal*, November 3, 1849, p. 2. See also Lois Fink, "The Role of France in American Art" (Ph.D. dissertation, University of Chicago, 1970), pp. 188–91.

49. Henry James, *A Small Boy and Others* (London: Macmillan, 1913), p. 278.

50. "The Fine Arts," *Emerson's Magazine and Putnam's Monthly* 5 (December 1857), p. 754.

The Great Emporium of New York in 1857

The big business of art, or at least the business of art that was bigger than it had ever been before, changed the nature of art institutions in New York and determined their success or failure through the 1850s. The days of Colman's and Dixey's storefront dealerships were over; Colman modified his business by separating the sale of art supplies and books from that of paintings, which he took out of the shop and reserved for large auctions consigned to professional auctioneers. The other artists' supply shop dealers gave way to larger, more professional establishments, such as Goupil's; Williams, Stevens and Williams; the National Academy of Design; the Düsseldorf Gallery, and a growing number of auction houses. In later years Henry James described the dazzling array of art available along Broadway in those days, when he was still a teenager:

Ineffable, unsurpassable those hours of initiation which the Broadway of the 'fifties had been, when

all was said, so adequate to supply. If one wanted pictures there were pictures, as large, I seem to remember, as the side of a house, and of a bravery of colour and lustre of surface that I was never afterwards to see surpassed. We were shown without doubt, . . . everything there was, and as I cast up the items I wonder, I confess, what ampler fare we could have dealt with.[49]

It is hard to imagine a richer cultural milieu than that in place in New York by about 1857, when the art market survived the Panic, one of the worst financial calamities of the century. Nearly five thousand businesses went under that year. Yet by December 1857, when most businesses were still surveying the damage done by the Panic, it could be reported that "New York is the center of much that is rare and attractive in [the fine arts]."[50]

The season had started off strong and continued apace. Before the failure of the New York branch of the Ohio Life Insurance and Trust Company in August, which signaled the crisis, "the finest oil picture ever

painted on this side of the Atlantic,"[51] Church's *Niagara* (fig. 50), went on view at Williams, Stevens and Williams on Broadway. The dealers had been in business since the mid-1840s, at first principally as purveyors of looking glasses, picture frames, and art supplies, but had expanded and professionalized their involvement in the market by the early 1850s. Immediately upon Church's completion of *Niagara* they purchased the picture, as well as its copyright, from the artist. The painting was displayed in New York and London, where sales of chromolithographs of it yielded even greater profits than those accruing from the exhibitions. The New York showing, which opened in May 1857, was a staggering success for the artist, the owners, and the viewers. The numerous visitors, awestruck by Church's accomplishment, must have shared the sentiments of the critic for *The Albion*: "The more one looks at it, the less there is to say about it; the deeper and more absorbing the enjoyment."[52]

Williams, Stevens and Williams may have begun negotiations with Church early on. The proprietors did not commission *Niagara*, but surely knew that others would see the picture in progress, as studio visits were common by this time. A reporter for *Putnam's Kaleidoscope* recommended giving New York the epithet "the Artist City, or the City of Studios," in recognition of the more than three hundred spaces for artists open for independent business each day.[53] Many artists shared room in buildings dedicated to such studios, among them the old Art-Union Building,

the Tenth Street Studio Building, and the Dodworth Studio Building, while others rented single rooms and shop fronts. Some advertised opening hours. Knowledgeable collectors and critics previewed, reserved, and purchased works destined for the annual exhibitions at the National Academy. Clever collectors in the great emporium of New York shopped early and often, rather than wait for the public opening of the show. Works acquired from the studio might still be shown at the Academy, with the buyer listed as the lender.

In 1857 the National Academy was still the city's principal gallery of contemporary art, both for exhibitions and sales. The institution had never been stronger. Housed in an appropriate building of its own at the corner of Tenth Street and Fourth Avenue, and with a more clearly defined mission than in previous decades, the venerable Academy had a high profile among New York's community of artists, collectors, and viewing public. It was a reassuring presence in a burgeoning and increasingly international art marketplace. As the *New-York Daily Times* put it on the occasion of the annual of 1857, "very glad then we are to see the doors of the National Academy once more opened—the good old doors of the good old place," and the critic of *The Albion* wrote that "it would be difficult to find a pleasanter lounge than the Academy Rooms."[54] Reviewers declared that the 1857 exhibition was the finest ever presented by the Academy and singled out for particular praise Church's

51. "Church's Niagara," *The Albion*, May 2, 1857, p. 213. For a similar opinion, see "The Fine Arts," *United States Democratic Review*, n.s., 4 (June 1857), pp. 628–29.
52. "Church's Niagara," p. 213.
53. "A Morning in the Studios," *Putnam's Kaleidoscope* 9 (May 1857), p. 555.
54. "The National Academy Exhibition," *New-York Daily Times*, May 27, 1857, p. 2; "The Academy Exhibition," *The Albion*, June 6, 1857, p. 273.

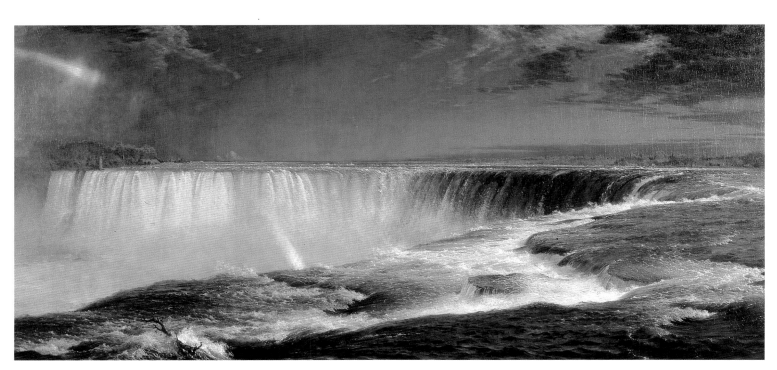

Fig. 50. Frederic E. Church, *Niagara*, 1857. Oil on canvas. Corcoran Gallery of Art, Washington, D.C., Museum Purchase, Gallery Fund 76.15

Fig. 51. Francis William Edmonds, *Time to Go*, 1857. Oil on canvas. The Montgomery Museum of Fine Arts, Montgomery, Alabama, The Blount Collection

55. See above noted reviews and "Exhibition of the National Academy: Third Notice," *New-York Daily Times*, June 20, 1857, p. 4; "The Fine Arts," *Emerson's United States Magazine* 5 (July 1857), pp. 91–93.

56. "An Hour's Visit to the National Academy of Design," *Frank Leslie's Illustrated Newspaper*, July 11, 1857, pp. 88–90.

57. "Sketchings. The Venerable Rembrandt Peale," *The Crayon* 4 (July 1857), p. 224. See also "An Hour with Rembrandt Peale," *Harper's Weekly*, June 13, 1857, p. 373; "Rembrandt Peale, the Artist," *Ballou's Pictorial Drawing-Room Companion*, October 17, 1857, p. 241.

Andes of Ecuador (fig. 70), an untitled landscape by John F. Kensett, Francis William Edmonds's *Time to Go*, 1857 (fig. 51), and John W. Ehninger's *Foray* (unlocated).[55] *Frank Leslie's Illustrated Newspaper* published line engravings of several paintings in the show and portraits of nine of the principal exhibitors, announcing "a new era" for pictures in which "money to purchase them is abundant . . . the prices willingly paid our artists for their works, and the large commissions given out show that a movement has at last been made in the right direction, and our wealthy men are learning the fact that there is intellectual and money value in the happy creations of genius."[56]

Leslie's and others celebrated American art, wishfully pronouncing that the dubious old masters had had their day in New York. In September many papers rejoiced in the presence of Rembrandt Peale, who came to town to lecture on his portraits of Washington and to exhibit his huge *Court of Death*, 1820 (Detroit Institute of Arts), which he had first shown in New York a quarter century earlier. Peale himself garnered more attention than did his painting. Hailed as a genius, he was characterized as a man who had known the country's Founding Fathers yet, remarkably, still remained vital in the modern age. "The halo of Washington's personality seemed also to reflect upon the artist, investing him with peculiar attractiveness," noted one commentator.[57]

The "new era" of American art notwithstanding, in 1857 traveling shows of paintings from Europe were more, rather than less, numerous; the pictures were, however, new rather than old. At the Düsseldorf Gallery (fig. 52), Boker maintained a core display of prized works by Leutze, Karl Friedrich Lessing, Christian Köhler, and other notables, while constantly adding to and refining the collection so that his presentation was always fresh. Henry James described how he had returned again and again to see the "new accessions . . . vividly new ones, in which the freshness and brightness of the paint, particularly lustrous in our copious light, enhanced from time to

time the show," noting also that the "gothic excrescences" and "ecclesiastical roof" of the old church in which the Düsseldorf pictures hung enhanced the experience of the collection.[58] But Boker apparently suffered reverses during 1857 and sold the collection as well as its building, the Church of the Divine Unity, to Chauncey L. Derby.

Derby represented the Cosmopolitan Art Association, an art union based in Sandusky, Ohio, that would use the church as the site of its New York branch. Among those who mourned the loss of the Düsseldorf Gallery and considered art unions illegal and destructive to art, the Cosmopolitan Art Association was, in the words of an observer in *The Crayon,* "one of those fungus inspirations that are entirely supported by the corruptions of commercial life . . . in short, a gross humbug."[59] Others, however, lauded "this meritorious and triumphantly successful institution," which, in fact, prevailed; the Cosmopolitan's New York gallery remained open for three years at the church and in 1860 was transformed by Derby and his brother Henry W. into the Institute of Fine Arts, a combination salesroom and exhibition hall (fig. 53).[60]

Uniting sales and exhibitions, the Derbys competed with other major dealers in the city, all of whom experimented with variations on the same marketing strategy, building inventories of modern European pictures and mounting shows of them. The American Academy had initiated this scheme in the 1830s, albeit haphazardly, applying it to both American and European paintings, and Goupil's professionalized it in the 1850s. Goupil's had nimbly engineered its entrance to New York in 1846 by sending an agent, Michael Knoedler, to test the market for French and British prints and European paintings. Knoedler opened Goupil's first New York gallery in 1848 and significantly influenced the burgeoning collectors' market by establishing the International Art Union the next year to spread a taste for European painting. Knoedler's program was brilliant in that it embraced American as well as European art. Not only did the Union devote some of its profits to the education of American artists but in 1850 Goupil's also offered a partnership to the popular local art supplier and occasional dealer in American painting William Schaus. That year, thanks to Schaus's participation, the International Art Union distributed the print after William Sidney Mount's *The Power of Music* (figs. 69, 164). Goupil's subsequently commissioned other works from Mount and published series of portraits of distinguished Americans and views of American scenery, all executed by American artists.

Once the American component of the business was in place, by about 1852, Knoedler focused on modern European art: that year Goupil's showed Paul Delaroche's *Napoleon at Fontainebleau,* 1845 (fig. 54); by 1855 the gallery was full of pictures by Delaroche, Scheffer, and Horace Vernet; and in 1857, shortly after Knoedler bought out the business and made it his own (fig. 55), the firm mounted a grand exhibition of

58. James, *Small Boy,* p. 278.
59. "The Cosmopolitan Art-Association," *The Crayon* 4 (August 1857), p. 252.
60. "Cosmopolitan Art Association," *Ballou's Pictorial Drawing-Room Companion,* December 19, 1857, p. 389.

Fig. 52. *Interior View of the Düsseldorf Gallery.* Wood engraving by Nathaniel Orr, from *Cosmopolitan Art Journal* 2 (December 1857), p. 57. The Metropolitan Museum of Art, New York, The Thomas J. Watson Library

Fig. 53. *Interior View of the Cosmopolitan Art Association, Norman Hall.* Wood engraving by Nathaniel Orr, from *Cosmopolitan Art Journal* 1 (November 1856), p. 94. The Metropolitan Museum of Art, New York, The Thomas J. Watson Library

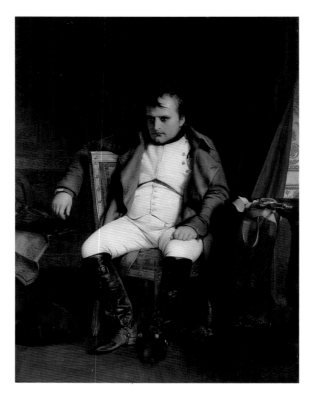

Fig. 54. Paul Delaroche, *Napoleon at Fontainebleau*, Paris, 1845. Oil on canvas. Museum der Bildenden Künste, Leipzig

greater impact, caused even more of an uproar. Typical of the ecstatic reviews that appeared in every paper is the notice published in *Frank Leslie's Illustrated Newspaper*, which proclaimed that it is "one of the most remarkable paintings ever exhibited on this continent."[62] Not one writer missed the opportunity to remark that the picture was all the more extraordinary for having been painted by a woman—"all executed by the delicate hand of a lady!," as one commentator put it.[63]

Gambart's third venture in 1857 was an exhibition of modern British paintings mounted in the galleries of the National Academy. Like the two French shows, it opened in October, and, like them, it had great success, despite the reigning economic crisis; indeed, of the three presentations it probably caused the most impressive stir. The selection favored Pre-Raphaelites, including William Holman Hunt, Ford Madox Brown, and Arthur Hughes, and was novel for Americans in that over half of the more than 350 pictures were watercolors, which were not yet considered appropriate for serious work or exhibition in this country. Critics uniformly praised the meticulousness and

61. On Gambart, see Jeremy Maas, *Gambart: Prince of the Victorian Art World* (London: Barrie and Jenkins, 1975); and Lois M. Fink, "French Art in the United States, 1850–1870: Three Dealers and Collectors," *Gazette des Beaux-Arts*, ser. 6, 92 (September 1978), pp. 87–100.

62. "The Fine Arts—Rosa Bonheur," *Frank Leslie's Illustrated Newspaper*, October 17, 1857, p. 310; see also "Rosa Bonheur's 'The Horse Fair,'" *The Albion*, October 3, 1857, p. 477; and "Rosa Bonheur," *Emerson's Magazine and Putnam's Monthly* 5 (November 1857), p. 640.

63. "Female Artists," *Ballou's Pictorial Drawing-Room Companion*, November 14, 1857, p. 317.

modern French painting at the old American Art-Union building with the assistance of Ernest Gambart. Gambart, a Belgian-born London dealer who took his inventory on the road, as Brett had done two decades earlier, brought to Goupil's a collection of well over two hundred paintings by Jules Breton, Thomas Couture, Jean-Léon Gérôme, Tony Robert-Fleury, Constant Troyon, Vernet, and Charles-Edouard Frère. Goupil's had entered the market by wooing collectors of American art and within less than a decade created New York's first gallery of French painting.[61]

Gambart helped Goupil's put together this exhibition, but he was very much an independent entrepreneur and simultaneously worked with the competition. It is to him, indeed, that the city owed a considerable part of its late fall exhibition schedule in 1857. Goupil's display of French paintings included two works by the celebrated Rosa Bonheur, in addition to a portrait of her by Dubufe. But Gambart saved her spectacular *Horse Fair*, 1853–55 (cat. no. 51), for a separate showing, a single-picture exhibition at Williams, Stevens and Williams. If *Niagara* had created a sensation when Williams and company presented it, *The Horse Fair*, over twice the size of Church's picture and with far

Fig. 55. *Exterior of Goupil & Co., Fine Art Gallery, 772 Broadway*, ca. 1860. Wood engraving by Augustus Fay. Courtesy of the American Antiquarian Society, Worcester, Massachusetts

Fig. 56. Franz Xaver Winterhalter, *The Empress Eugénie Surrounded by Her Ladies-in-Waiting,* Paris, 1855. Château de Compiègne

intensity of the British pictures, which were invariably compared to the more broadly painted French works on display up the street.[64]

All over the city, galleries offered an array of choices. By November viewers of the French pictures at the Art-Union building would undoubtedly have been advised to stop by Goupil's gallery to see the German Franz Xaver Winterhalter's *Empress Eugénie Surrounded by Her Ladies-in-Waiting,* 1855 (fig. 56). Visitors to the British exhibition could also have looked at the collection of August Belmont in adjacent galleries at the Academy. A New York banker whose career took him to Europe as United States Minister to The Hague, Belmont had acquired over one hundred paintings, mainly French, Belgian, and Dutch, which were "liberally thrown open to the public" for the fall season.[65] Down the block at Leeds's, an art lover could have seen J. M. Burt's collection of European paintings prior to its auction. "We rolled up to see the new pictures," wrote the editor of *Harper's New Monthly Magazine* in December. "There was the great Rosa Bonheur, the *Horse Market* [*sic*], and the new French Gallery, and the New English Gallery, and the old German or Düsseldorf Gallery, and the old Bryan or Christian Gallery."[66] It was "a new era . . . what more could be expected or wished?"[67]

64. See Brownlee Brown, "The French Gallery and the Horse Market," *The Independent,* October 29, 1857, p. 1; and "Pictures in New York," *Frank Leslie's Illustrated Newspaper,* October 31, 1857, p. 342.

65. "The Belmont Collection," *The Albion,* December 26, 1857, p. 621.

66. "The Easy Chair," *Harper's New Monthly Magazine* 16 (December 1857), pp. 129–30.

67. "The Old World Coming to the New," *The Albion,* October 24, 1857, p. 513.

Appendix A

The following are venues culled from periodical advertisements, exhibition reviews, exhibition catalogues, and city directories. Artists' studios and private collections are included only if they advertised exhibitions or were open to the public. Complete dates of operation are listed when available, but addresses are given only for the period under discussion.

American Academy of the Fine Arts

1802–42

1816–30 *New York Institution, City Hall Park, Chambers Street*

1831–42 *8½ Barclay Street*

Founded as New York Academy of Arts with subscriptions from businessmen, physicians, and politicians. Purchased plaster casts after Greek and Roman statues in Musée Napoléon, Paris, and acquired paintings. Incorporated as American Academy of the Arts in 1808; in 1816 renamed itself American Academy of the Fine Arts and began annual exhibitions of contemporary painting and sculpture and renting the gallery to artists for single-picture exhibitions and to dealers for display of old masters. From 1816 to 1826 sponsored series of annual discourses on the arts delivered by patrons. Upon dissolution sold sculpture collection to National Academy of Design and paintings to Wadsworth Atheneum, Hartford.

American and Foreign Snuff Store (Mrs. Newcombe's Store)

ca. 1830s *297½ Broadway*

Dry-goods and sundries shop run by wife of miniature painter and carpenter George Newcombe. Held 1836 exhibition of a wood sculpture of a Highlander by Anthony W. Jones.

American Art-Union

1839–53

1839–40 *410 Broadway*

1842–47 *322 Broadway*

1847–53 *497 Broadway*

Founded by artist and entrepreneur James Herring as Apollo Association for the Promotion of the Fine Arts in the United States to maintain a free public gallery and exhibit, purchase, and sell works by Americans. Changed name to American Art-Union in 1842. Mounted annual exhibitions, selected a painting to be engraved for distribution to subscribers, purchased paintings, and also sculpture, for award by lottery, and held auctions. In 1853 presented exhibition of paintings treating life of George Washington as a benefit for New-York Gallery of the Fine Arts. Published *Transactions of the Apollo Association* (1839–43); *Transactions of the American Art-Union* (1844–50); *Bulletin of the American Art-Union*

(1848–53). Dissolved after it was accused of illegal business practices.

American Female Guardian Society

1834–1946

1834–at least 1857 *29 East Twenty-ninth Street*

Founded as New York Female Moral Reform Society to protect women and children from the dangers of city life. Incorporated in 1849 as American Female Guardian Society. Issued various publications pertinent to its mission and in 1857 hosted exhibition of Rembrandt Peale's *Court of Death*.

American Institute of the City of New York

1827–77 *various addresses*

Held annual fairs primarily featuring manufactured goods, among them items related to agriculture, but also including paintings, sculpture, and decorative arts. Moved offices frequently but held most fairs at Masonic Hall, Niblo's Garden, or, by 1844, National Academy of Design; site of 1855 fair was Crystal Palace. Hosted annual addresses, delivered at close of each exhibition, and published annual reports (1841–77).

American Museum

1790–1874

1817–25 *New York Institution, City Hall Park, Chambers Street*

1826–27 *130 Chatham Street*

1830–65 *Marble Buildings, 218–222 Broadway*

Natural history museum and cabinet of curiosities founded by John Scudder as Tammany Museum; name changed to American Museum in 1810 and taken over by P. T. Barnum in 1841. Occasionally mounted exhibitions of paintings and sculpture, especially panoramas and large spectacle pictures.

Apollo Association (see American Art-Union)

Appleton's Building

1854–60 *346–348 Broadway*

Opened as space for artists' studios by owner, publisher Daniel Appleton and Company; remodeled in 1857, adding seventy-five square feet of exhibition space and reconfiguring upper floors.

Arcade Baths

1827–30 *39 Chambers Street*

Exhibition hall, principal rooms of National Academy of Design

Artists' Fund Society of New York

1859–75 *Broadway and Tenth Street*

Founded to provide financial support to widows and

children of artists. Each member contributed a work to
an exhibition and auction, a benefit for the survivors of
an artist chosen by AFS. First exhibition, held in 1860,
mounted at National Academy of Design for benefit of
the AFS itself. Miniaturist Thomas Seir Cummings was
founding president.

William Henry Aspinwall's Gallery
1859–75 99 Tenth Street
Private gallery attached to home of Aspinwall; built to
house his collection of European paintings and opened
to the public "upon stated occasions" during 1859 and
perhaps thereafter.

William Aufermann
1859–61 694 Broadway
Picture dealer

David Austen Jr.
1852 497 Broadway
Auctioneer

Bangs (see also Cooley)
1837–1903
Cooley and Bangs (1837–38); Bangs, Richards and Platt
(1839–48); Bangs, Platt and Company (1849–50); Bangs,
Brother and Company (1851–58); Bangs, Merwin and
Company (1858–76); Bangs and Company (1876–1903)
1837–44 196 Broadway
1845–50 204 Broadway
1851–60 13 Park Row
Auctioneer of European paintings, especially old mas-
ters, and coins, manuscripts, and books

Barnum's Museum (see American Museum)

F. J. Bearns
1842 139 Fulton Street
Auctioneer

William Beebe
1848–49 91 Liberty Street
Picture importer

Thomas Bell and Company
1825 80 Broadway
1843 32 Ann Street
Auctioneer

August Belmont's Collection
1857–90 109 Fifth Avenue
Gallery at home of Belmont housing his collection of
European paintings formed while he traveled; opened
to "the visitor who comes properly commended." In
1857 exhibition of collection held at National Academy
of Design, as benefit for the city's poor.

**James Bleecker and Company (Bleecker and
Van Dyke)**
1840 Broadway and Chambers Street
Auctioneer, principally of European paintings

Bourne's Depository
1827–29 359 Broadway
Shop of George Melksham Bourne, who exhibited
engravings and also sold them as well as decorative
stationery, sheet music, and drawing materials

John Brady
1854–60
1854–55 36 Catherine Street
1855–56 22½ Catherine Street
1857–60 36 Catherine Street
Picture dealer

Charles Brandis
1850–61
1850–52 566 Fourth Avenue
1860–61 200 East Houston Street
Picture dealer

Browere's Gallery of Busts and Statues
1821–34
1821–26 315 Broadway
1827 92 Nassau Street
1828 154 Nassau Street
1828–29 34 Arcade Street
1830–31 512 Pearl Street
1832–34 78 Christopher Street
Studio, gallery, and shop of sculptor John Henri Isaac
Browere, who specialized in taking life masks of
famous Americans

Bryan Gallery of Christian Art
1852–59
1852–53 348 Broadway
1853–54 843 Broadway
1855–57 839 Broadway
1859 Cooper Union, 41 Cooper Square
Gallery, open by appointment, of Thomas Jefferson
Bryan's private collection of more than two hundred
paintings, nearly half of them Dutch or Flemish. Bryan
presented the collection to New-York Historical Society
in 1867.

Thomas Campbell
1851–52 25 Pine Street
Picture dealer

Century Association
1847–present
1847–49 495 Broadway
1849–50 435 Broome Street
1850–52 575 Broadway
1852–56 24 Clinton Place
1857–91 42 East Fifteenth Street
Social club primarily for artists and writers; exhibits
permanent collection of paintings by many artist-
members and a distinguished group of portraits. Holds
temporary exhibitions, especially in conjunction with
club's annual Twelfth Night Festival.

John Childs

1852–53 84 Nassau Street
Picture dealer, formerly a print colorer

Chinese Assembly Rooms

ca. 1850–55 539–541 Broadway
Venue rented primarily for displays of large panorama paintings

City Dispensary

1835 113 White Street
Hosted October benefit exhibition of collection of Joseph Capece Latro, archbishop of Taranto, Naples.

City Hall (see Governor's Room)

City Saloon

1834 Broadway opposite Saint Paul's Chapel
Exhibition hall and café

Clinton Hall

1830–69 9 Beekman Street
Exhibition hall used by National Academy of Design, Apollo Association, New-York Gallery of the Fine Arts, and for display of various private collections. Taken over by Leavitt auction house in 1869.

William A. Colman (Colman's Store)

1821–50
1821–24 45–46 William Street
1824–28 86 Broadway
1829–36 237–239 Broadway
1836–45 205 Broadway
1846–50 203 Broadway
Artists' supply shop and antiquarian bookstore, which also assembled extensive inventory of oil paintings and engravings for sale. Made many major sales through auction houses such as Park Place House, Royal Gurley, Leeds, and James E. Cooley.

Edmund I. Cook

1857–62
1857–58 614 Broadway
1860–62 618 Broadway
Picture dealer

George Cooke

1832–33 86 Broadway
Picture gallery of painter

Cooley (see also Bangs; Horatio Hill)

1833–66
James E. Cooley (1833–36, 1850–66); Cooley and Bangs (1837–38); Cooley, Keese and Hill (1846–48); Cooley and Keese (1849–50)
1833 134 Cedar Street
1834 151 Broadway
1837–38 196 Broadway
1846–50 191 Broadway
1850 304 Broadway
1850–63 377–379 Broadway

Auction house, which originated in Boston as Cooley and Drake, for books and fine arts. Held sales for William A. Colman in 1850. Shared rooms at 377–379 Broadway with Leavitt and with Lyman.

Cooper Union for the Advancement of Science and Art

1859–present 41 Cooper Square
Private college founded by inventor and philanthropist Peter Cooper. Offers instruction in art, architecture, and engineering, and free public lectures and exhibitions pertinent to its teaching mission. Absorbed New-York School of Design for Women in 1858.

Cosmopolitan Art Association

1854–62
1857–59 Church of the Divine Unity, 548 Broadway
1860–62 Institute of Fine Arts, 625 Broadway
Founded in Sandusky, Ohio, by Chauncey L. Derby as art union and to promote fine arts through exhibitions, distribution of works to subscribers, and publication of monthly *Cosmopolitan Art Journal* (1856–60). Main operation remained in Ohio, but New York branch installed in Church of the Divine Unity, building owned by Düsseldorf Gallery when that establishment was purchased by CAA. Became Institute of Fine Arts, combination salesroom and gallery, upon transfer to building owned by Derby's brother, art dealer Henry W.

Crayon Gallery (G. W. Nichols Gallery)

1860 768 Broadway
Site of exhibition space and studios rented out to artists by George Ward Nichols

John Crumby

1851–60
1851–52 25 Pine Street
1852–58 87 Cedar Street
1858–60 347 Broadway
Picture dealer

Crystal Palace

1853–58 Sixth Avenue and Tenth Street
Cast-iron and glass building opened for New-York Exhibition of the Industry of All Nations, 1853–54, America's first world's fair. Included picture gallery that was rented out after the fair closed in 1854.

Mrs. Dassel's Home

1859 30 East Twelfth Street
Residence of now obscure artist Herminia Borchard Dassel; upon Dassel's death was site of exhibition and sale by lottery, organized by committee headed by Henry T. Tuckerman, to benefit her children.

David Davidson

1855–56 109 Nassau Street
Picture dealer

Dexter's Store (Elias Dexter)

1860 562 Broadway

Exhibited and sold by subscription the Saint-Mémin collection of portraits, as engraved by Jeremiah Gurney from artist's original proofs. Dexter also rented studio space on the premises to artists.

Dioramic Institute (see Marble Buildings)

S. N. Dodge

1858 189 Chatham Square

Presumed dealer to whom paintings and drawings in William Ranney's studio were consigned by the artist's widow in 1858.

Dodworth Studio Building

early 1850s–85

early 1850s 806 Broadway

1858 896 Broadway

early 1860s 204 Fifth Avenue

Opened by Allen Dodworth as spaces for artists' studios. Site of group shows and opening-night receptions organized by Artists' Reception Association, formed in 1858, the year series of Art Conversazioni was advertised. Exhibitions, which included nonresident foreign artists as well as artists in residence, may have taken place in room otherwise devoted to Dodworth's Dance Academy. By 1860 ARA had sixty members and gave three receptions annually.

John Doyle

1827 237 Broadway

Auctioneer

Simeon Draper

1858 497 Broadway

Auctioneer

Dumont and Hosack

1848–54 11 Wall Street

Auctioneer

Düsseldorf Gallery (see also Cosmopolitan Art Association)

1849–62

*1849–56, 1858–59 Church of the Divine Unity,
 548 Broadway*

1857 497 Broadway

1860–62 Institute of Fine Arts, 625 Broadway

Exhibition and sales space for collection of Düsseldorf School paintings owned by wine merchant John Godfrey Boker. Collection, which Boker continually sold from and added to, bought by Cosmopolitan Art Association in 1857. Although Düsseldorf Gallery retained its name, its pictures were sold or distributed by CAA. Last remaining pictures in collection sold in 1862.

T. Fitch and Company

1831 151 Broadway

Auctioneer

Pierre Flandin

1850–53 293 Broadway

Venue of picture dealer who had been active for decades without permanent gallery

William H. Franklin and Son

1832, 1846 68 Wall Street

Auction house, probably evolved from Franklin and Mindurn, established in 1816

Frazer's Gallery

1840 322 Broadway

Held exhibition and sale of American portraits, many by John Trumbull, and landscape paintings.

Peter Funk Picture Making Establishment

1856 Broadway

Produced copies of American paintings.

Ernest Gambart

1857–67 various addresses

Belgian-born London print and painting dealer located in rented spaces; brought touring exhibitions to United States. First American ventures: simultaneous exhibitions of French painting at Goupil and Company, British painting at National Academy of Design, and Rosa Bonheur's *Horse Fair* at Williams, Stevens and Williams

Michael Genings

1852–53 283 Third Avenue

Picture dealer

John B. Glover

1841–45 Granite Buildings

Auctioneer

Goupil and Company

1846–57

1846–53 289 Broadway

1854–57 366 Broadway

New York branch of Paris print and picture dealers; Michael Knoedler was American agent. Changed name from Goupil, Vibert and Company in 1850, after death of Vibert. Sold artists' supplies as well as fine art. In 1848 established International Art Union to exhibit and distribute European paintings. In 1857 hosted first exhibition of French paintings in America, which evolved into annual event at successor firm Knoedler and Company.

Governor's Room, City Hall

1815–present

Long gallery housing approximately sixty portraits; used for government receptions and open to public occasionally.

William Gowans

1839–43

1839–42 New-York Long Room, 169 Broadway

1843 Waverly Sales Room, 204 Broadway

Auctioneer

James Griffen
1858–59 7 Chambers Street
Picture dealer

Royal Gurley (see also Horatio Hill)
1831–49
Pearson and Gurley (1831–32); Royal, Gurley and Company (1833–41, 1846–49); Gurley and Hill (1842–46); George H. Gurley (1848)
1831–41, 1842–46 New-York Long Room, 169 Broadway
1841 20 John Street
1846–49 304 Broadway
Auctioneer of books and paintings

Oliver Halsted
1825 3 Law Buildings
Auctioneer

George M. Harding
1854–56 6 Division Street
Picture dealer

Amos Hawley
1827 22 Wall Street
Auctioneer

Mr. Henry's New-York Gallery of Fine Arts
1827–30 100 Broadway
Gallery of European paintings

Horatio Hill (see also Cooley; Royal Gurley)
1846 169 Broadway
Auctioneer

Martin Hoffman and Sons
1826 63 Wall Street
Auctioneer

Hubard Gallery
1824–25 208 Broadway
Gallery of William James Hubard, silhouettist

Institute of Fine Arts (see Cosmopolitan Art Association)

International Art Union (see also Goupil and Company)
1848–50
Founded by Goupil and Company to exhibit paintings and prints and sell and distribute them to subscribers. Dealt principally in European art, unlike similar American Art-Union, which focused on American works. Profits used to send Americans abroad to study art. Published *International Art Union Journal* (1849–50).

William Irving and Company
1853 8 Pine Street
Auctioneer

Jordan and Norton
1854–55 356 Broadway
Auctioneer

Philip Keefe
1830–31 72 Oliver Street
Picture dealer

John Keese (see also Cooley)
1855 337 Broadway
Auctioneer

Joseph Kelbley
1852–53 346 Seventh Avenue
Picture dealer

Elijah C. Kellogg
1858–59 6 West Fourteenth Street
Picture dealer

Michael Knoedler and Company (see also Goupil and Company)
1857–present
1857 289 Broadway
1858–59 366 Broadway
1859–69 A. T. Stewart mansion, 772 Broadway
Successor to Goupil and Company, which Knoedler, Goupil's American agent, bought out. Continued to pursue Goupil's sales and exhibition policies but gradually shifted focus to American art.

Joseph Koeble
1850–60
1850–52 161 Third Avenue
1852–54 161 and 163 Third Avenue
1855–57 163 Third Avenue
1857–58 167 Third Avenue
1858–60 142 Third Avenue
Picture dealer

George Lambert
1855–58
1855–58 343 Broadway
1857–58 12 Fourth Avenue
Picture dealer

Landscape Gallery
1835 311½ Broadway
Held exhibition "Richardson's Gallery of Landscape Paintings," twenty scenes of America, England, Scotland, and Asia to be distributed by lottery. Artist was presumably Scottish landscape painter Andrew Richardson.

Leavitt
1856–92
Leavitt, Delisser and Company (1856); George A. Leavitt and Company (1857–64, 1871–92); Leavitt, Strebeigh and Company (1866–71)
1856–60 377–379 Broadway
1860 24 Walker Street, 21 Mercer Street

One of city's busiest auction houses, shared Broadway rooms with Cooley and with Lyman. Founded by George A. Leavitt and partners Richard L. Delisser and John K. Allen. Specialized in book and fine art auctions.

Leeds
1848–70
Henry H. Leeds and Company (1848–59); Henry H. Leeds and Miner (1864–70)
1848 290 Broadway
1849–53 8 Wall Street
1854–56 19 Nassau Street
1857–59 23 Nassau Street
City's leading auction house at midcentury; held several important auctions each year.

Joseph Lemonge
1857–61 159 Second Avenue
Picture dealer

Philip Levy
1856–58 3 North William Street
Picture dealer

Levy's Auction Room (Aaron Levy)
1830–44
R. N. Hamson and A. Levy (1830); Levy's Auction Room (1834–43); Levy and Spooner (1844)
1834–37 128 Broadway
1837–38 18 Cortlandt Street
1839–43 151 Broadway
1844 72 Greenwich Street
Auctioneer specializing in old masters pictures and European, statuary. In 1838 held six-day sale of Michael Paff's collection of more than one thousand paintings in store rented from Mr. Platt, 6 Spruce Street. Sold business to Jonathan Leavitt.

Lithographic Office
1836 Corner of Nassau and Spruce Streets
Sold engravings.

S. L. Loewenherz
1855–57 128 Nassau Street
Picture dealer

George W. Lord and Company
1853–54 356 Broadway
Auctioneer, branch of Lord and Carlile of Philadelphia

E. H. Ludlow and Company
1840–75
1840 11 and 13 Broad Street
1852–55 11 Wall Street and 2–3 New Street
1856 12 Pine Street
1857 11 Pine Street
1858–60 14 Pine Street
1860–75 3 Pine Street
Major auction house; sold collection of Philip Hone in 1852 and of Charles M. Leupp in 1860.

Valentine Lutz
1850–62
1850–51 184 Bowery
1852–53 185 Bowery
1854–62 142 Third Avenue
Picture dealer

Lyceum Gallery (Lyceum of Natural History)
1833–49
1833–37 Centre and White Streets
1848–49 563 Broadway
Displayed and researched mineralogical and zoological specimens from New York State; let its space for various exhibitions, including shows of Audubon's drawings and old masters from collection of Gideon Nye.

Lyman
1839–58
Lewis Lyman and Company (1839, 1853–58); Lyman and Rawdon (1851–52)
1839 27 Wall Street
1851–58 377–379 Broadway
Auctioneer, shared Broadway rooms with Cooley and with Leavitt

Lyrique Hall
1859 765 Broadway
Housed various shows, including single-picture exhibition of Frederic E. Church's *Heart of the Andes.*

Marble Buildings (Dioramic Institute)
1835–37 Broadway near Ann Street
Presented changing displays of dioramas; operated by W. J. and H. Harrington, who advertised themselves as "transparent painters."

Masonic Hall
1826–43 314–316 Broadway
Space rented out for fairs, dances, circus performers, magicians, and, less often, as exhibition hall for private collections.

W. McGavin
1841–42 47 Liberty Street
Picture dealer

Bernard McQuillin
1844–58
1844–52 44 Catherine Street
1852–53 40 and 44 Catherine Street
1854–58 40 Catherine Street
Picture dealer

William Mead and Company
1844–60 112 Bowery
Picture dealer

Mechanics' Institute of the City of New York
1833–61 Castle Garden
Held annual fairs at Castle Garden and Niblo's Garden and hosted annual addresses. Fairs included paintings and sculpture and some fine decorative arts, but bulk of the numerous entries were manufactured goods. Published circular (1835–37).

Menger's
1860 Dey Street
Housed July exhibition of Jasper F. Cropsey's *Four Seasons*.

Merchants' Exchange
1827–35; 1842–present
1827–35 44 Wall Street
1842–present 55 Wall Street
Occasional site of exhibitions and sales held by local dealers and auctioneers, including Henry H. Leeds's auction of Hiram Powers's *Greek Slave* in 1857 and Cosmopolitan Art Association's sale of William Randolph Barbee's *Fisher Girl* in 1860

Thomas J. Miller and William L. Morris Jr.
1856 25 Wall Street
Auctioneer

Mills
1816–31
P. L. Mills and Company (1816–17, 1820–22); Mills, Minton and Company (1818–19); Mills and Minton (1823–30); Mills Brothers and Company (1831)
1816 211 Pearl Street
1818–20 148 Pearl Street
1821 58 Wall Street
1823–30 178 Pearl Street
1831 151 Pearl Street
Auctioneer

T. M. Moore and Company
1828 43 Maiden Lane
Auctioneer

Homer Morgan
1849 1 Pine Street
Auctioneer

National Academy of Design
1825–present
1825–26 exhibitions, 287 Broadway; classes, Chambers Street
1827–30 Arcade Baths, 39 Chambers Street
1830–40 Clinton Hall, 9 Beekman Street
1840–49 348 Broadway
1850–54 663 Broadway
1855–56 548 Broadway
1857 663 Broadway
1858–64 Broadway and Tenth Street
Founded by New York Association of Artists (also known as Drawing Association) after that group unsuccessfully attempted to merge with American Academy of the Fine Arts. Modeled after Royal Academy, London; mounts annual exhibitions of works of living artists, offers classes and lectures, and grants honors to members. Special exhibitions have included shows of Richard Worsam Meade Collection, 1831, and British and French pictures, 1857. Upon establishment began building permanent collection, requiring each member to donate a portrait of himself or herself and another work.

New-York Athenaeum
1824–60
1824–32 New York Institution, City Hall Park, Chambers Street
1835–60 Athenaeum Building, Broadway and Leonard Street
Private library that borrowed paintings and drawings from private collections for display in its rooms. Such exhibitions included "Francesco Annelli's Private Gallery of Paintings," 1836, and "W. Hayward's Collection of Pictures," 1837. In 1860 announced plans for annual appropriation to an American painter or sculptor for study abroad, but no such allocations were made. Merged with New York Society Library in 1860.

New-York Gallery of the Fine Arts
1844–58
1844, 1850–52 National Academy of Design, 348 Broadway and 663 Broadway
1844–48 New-York Rotunda, City Hall Park, Chambers Street
1848–58 New-York Historical Society, various addresses
Evolved from private gallery of Luman Reed; constituted of his collection of European and American paintings; purchased by son-in-law, Theodore Allen, and business partner, Jonathan Sturges. Collection, augmented after Reed's death, conceived as basis of a national gallery. Donated to New-York Historical Society in 1858.

New-York Historical Society
1804–present
1804–57 various addresses
1857–1908 Second Avenue and Eleventh Street
Founded by business and government leaders to collect, display, and preserve material pertaining to history of United States, in particular New York State. Began building portrait collection early on; in 1858 received donation of New-York Gallery of the Fine Arts collection.

New-York Long Room
1822–39 143 Front Street, 169 Broadway, and various nearby addresses
Space rented by auctioneers, including C. W. Oakley, William Gowans, Royal Gurley, Horatio Hill, and J. Pearson.

New-York Rotunda
1818–70 City Hall Park, Chambers Street
Erected by John Vanderlyn for display of his *Palace and Gardens of Versailles*, 1818–19. This panorama and others shown there until 1829, when building was taken over by New York City and space was used for various offices. In 1844 city gave space rent-free to New-York Gallery

of the Fine Arts, which remained there until 1848, after which time building served governmental functions.

New-York School of Design for Women
1846–58 487 Broadway
Provided artistic training for women, primarily in practical disciplines of wood engraving, china painting, and decorative pattern design. Held public lectures and exhibitions and sales of students' work. Merged with Cooper Union for the Advancement of Science and Art.

New York Society Library
1754–present
1825–27 16 Nassau Street
1827–36 33 Nassau Street
1836–40 12 Chambers Street
1840–56 346 Broadway
1856–1937 109 University Place
New York's first institutional library, held occasional exhibitions, including Thomas Cole's series The Voyage of Life, 1840, and paintings by Claude-Marie Dubufe, 1849.

Niblo's Garden
1828–46; 1849–95
1828–46 576 Broadway
1849–95 576 Broadway
Fashionable coffeehouse and saloon run by William Niblo. Hosted theatrical performances, concerts, and exhibitions of panoramas and paintings.

G. W. Nichols Gallery (see Crayon Gallery)

Albert H. Nicolay
1853 National Academy of Design, 663 Broadway
Auctioneer

Paff's Gallery of Fine Arts
1811–38
1820–33 221 Broadway
1836–38 10 Barclay Street
1838 204 Fulton Street
Michael Paff, New York's earliest dealer in European art, opened his business on Broadway.

Painting Rooms
1836 359½ Broadway
Sales shop and studio of James De Jongh and Franklin B. Ladd, portrait and miniature painters

Panorama Building
1834 Mercer and Prince Streets
Venue for panoramas by Frederick Catherwood and Robert Barker

Park Place House
1832–36 239 Broadway
Venue for auction sales, including that of William Colman's inventory of oil paintings

Peale's New York Museum and Gallery of the Fine Arts
1825–43 The Parthenon, 252 Broadway
New York branch of Peale family's natural history and fine arts museum in Philadelphia; operated by Rubens and Rembrandt Peale

J. Pearson (see also Royal Gurley)
1830–31 169 Broadway
Auctioneer

Marshall Pepoon
1860 52 Wall Street
Mounted exhibition of Heinrich Anton Heger's *Cathedral at Halberstadt* in July 1860.

John Pfeiffer
1857–58 335 Broadway
Picture dealer

L. Power and Company
1826 46 Maiden Lane
Auctioneer

Luman Reed's Gallery
1832–36 13 Greenwich Street
Third floor of Reed's home, converted by collector into private art gallery for exhibition of his Flemish, Dutch, German, Italian, and American paintings; open to public once a week. Collection, sold after death of Reed to his son-in-law, Theodore Allen, and business partner, Jonathan Sturges, became New-York Gallery of the Fine Arts.

Reichard's Art Rooms
1840 226 Fifth Avenue
Space for auction of statues by Chauncey Bradley Ives

Henry E. Riell and Jacob Arcularious
1842 304 Broadway
Auctioneer

T. P. Rossiter's Studio House
1856–60 17 West Thirty-eighth Street
House designed by Richard Morris Hunt; opened by narrative painter Thomas P. Rossiter as art school and exhibition space for works by many artists. Admission on Wednesdays was free and on Thursdays and Fridays by tickets sold at color shops and bookstores.

J. Sabin and Company
1860 Broadway at Fourth Street and Lafayette Place
Auctioneer

Schaus Gallery
1820–91
1820s 204 Fifth Avenue
1854–55 303 Broadway
1855–56 311 Broadway
1857–61 629 Broadway

Artists' supply shop run by importer and art collector William Schaus, who kept inventory of paintings for sale. Between 1850 and 1852 Schaus was a partner in Goupil and Company.

Schenck

1860–76
Edward and F. H. Schenck (1860); Edward Schenck (1860–76)
1860–76 141 Broadway
Auctioneer, principally of European art

C. S. Smith

1843 27 Jay Street
Auctioneer

Snedecor's

1855–61 544 Broadway and 38 White Street
Auctioneer
Shop for artists' supplies, frames, mirrors, where proprietor John Snedecor also sold paintings, primarily by American artists.

Stollenwerck and Brothers (Washington Divan)

1817–36 157 Broadway
From 1817 exhibited Stollenwerck's *Mechanical Panorama* and later also displayed old master and modern paintings. New York venue for Colonel McKinney's collection of portraits of American Indians in 1836

Stuyvesant Institute

1837–56 659 Broadway
Building with picture hall that was site of numerous exhibitions of painting and sculpture by American and foreign artists as well as of antiquities and other material

Alexander H. Taylor

1841–45
1841–42 138 Fulton Street
1842–43 212 Norfolk Street
1843–45 87 Cedar Street
Picture dealer and picture cleaner

Tenth Street Studio Building

1857–1920 15 Tenth Street
Building designed by Richard Morris Hunt; included twenty-five studios and a double-height exhibition gallery. Studios were generally open to public on Saturdays, and group exhibitions were held in gallery. Some artists lent their studios to friends for exhibitions.

Tuttle and Ducluzeau

1846–48 88 William Street
Auctioneer

University Building

1837–94 Washington Square East
Building with studio spaces rented to artists by New York University starting in 1837. Most artists held informal exhibitions of their work in their studios.

John L. Vandewater and Company

1852 12 Wall Street
Auctioneer

Washington Divan (see Stollenwerck and Brothers)

Waverly House

ca. 1851–67 697 Broadway
Studio building designed by Thomas P. Rossiter, often opened for exhibitions of works by artists in residence, including Louis Lang, John F. Kensett, and John Casilear.

James H. Weeks

1822–37 Successively at 406, 404, 93, and 423 Pearl Street
Dry-goods shop and bookstore that sold and exhibited prints

Wiggins and Pearson

1826–28
1826 68 William Street
1828 Mr. Henry's New-York Gallery of Fine Arts,
* 100 Broadway*
Auctioneer

Wilkins, Rollins and Company

1840 322 Broadway
Auctioneer

Williams, Stevens and Williams

1810–59
1851–59 353 Broadway
Art gallery, shop for looking glasses, and importer and manufacturer of prints, books, and artists' supplies. Firm, founded by John H. Williams, his son George H. Williams, and Colonel Stevens, held many exhibitions.

Wills and Ellsworth

1860 66 Liberty Street
Auctioneer

Appendix B

Exhibitions and Auctions

The following exhibitions and sales are culled from periodical advertisements, exhibition reviews, and exhibition catalogues. Dates of openings are indicated by the citation of a single month or month and day, when available; closing dates are given when known. Unless sale or auction is noted, the event is an exhibition. The following abbreviations are used: AAFA, American Academy of the Fine Arts; AAU, American Art-Union; AICNY, American Institute of the City of New York; NAD, National Academy of Design. * signifies accompanied by a published catalogue.

1825
May 12, Eleventh Exhibition, part 1, AAFA *
October 25, 1825–January 6, 1826, William Dunlap, *Death on the Pale Horse,* AAFA
October 26, Eleventh Exhibition, part 2, AAFA *
December, Panorama of Athens, New-York Rotunda

1826
January 10–April 15, Jacques-Louis David, *Coronation of Napoleon,* AAFA
May 10, auction, Old Masters, L. Power and Company *
May 10, Twelfth Exhibition, AAFA *
May 14–July 16, First Exhibition, NAD *
May 17, Jacques-Louis David, *Coronation of Napoleon,* Washington Hall

1827
February 15, auction, New York Collection of European Art, Mills and Minton *
May 6–July 16, Second Exhibition, NAD *
May 17, Thirteenth Exhibition, AAFA *
October, François-Marius Granet, *Capuchin Chapel,* Washington Hall
October, Mr. Henry's New-York Gallery of Fine Arts

1828
March 10, William Bullock and John and Robert Burford, Panorama of Mexico, New-York Rotunda
May 6–July 10, Third Exhibition, NAD *
May 15, Exhibition and sale, Ancient Paintings, Mr. Henry's New-York Gallery of Fine Arts
May 23, auction, Paintings by Francis Guy and Dutch and Flemish Masters, Wiggins and Pearson *
May–September, William Dunlap, *Christ on Calvary,* Arcade Baths
May, Fourteenth Exhibition, AAFA *
October 29, auction, Benjamin West, Paintings from Fulton Collection, John Boyd at AAFA
October, First Fair, AICNY
December 2, Antonio Sarti Collection of Old Masters, AAFA *

1829
April 18, Panorama of Geneva, New-York Rotunda
April 23, auction, Antonio Sarti Collection of Old Masters, Michael Henry at AAFA
May 11–July 13, Fourth Exhibition, NAD *
May 16, Fifteenth Exhibition, AAFA *
May 19, auction, Ancient Paintings, Mr. Henry's New-York Gallery
September 18, Hugh Reinagle, *Belshazzar's Feast,* AAFA
October 9, auction, Paintings, Engravings, and Ephemera, T. M. Moore and Company *
October, Second Fair, AICNY

1830
March 24–December 10, Richard Abraham Collection of Old Masters, AAFA *
April 22, auction, Paintings, R. N. Hamson and A. Levy *
May 1–July 5, Fifth Exhibition, NAD *
August 30, National Gallery of Old and Modern European Masters, Arcade Baths
August 30, Hugh Reinagle, *Belshazzar's Feast,* Peale's New York Museum and Gallery of the Fine Arts
October, Third Fair, AICNY

1831
April 15–October 8, John Trumbull, Paintings, AAFA *
April 28–July 9, Sixth Exhibition, NAD *
April 30–December 1, Horatio Greenough, *Chanting Cherubs,* AAFA
May 5, auction, Mr. Rodgers Collection, 128 Broadway
August, James Ward, Paintings of Cattle, NAD *
September–November, Richard W. Meade Collection of European Paintings, NAD *
October 15, 1831–February 1, 1832, George Cooke, *Raft of the Medusa,* AAFA
October, Fourth Fair, AICNY
November 11, George Cooke, Paintings, William A. Colman *

1832
February, William Dunlap, Historical Paintings, NAD
March–June, De Saireville Collection of European Paintings, 271 Broadway
May 12, Fourteenth Exhibition, AAFA *
May 21–July 8, Seventh Exhibition, NAD *
June 8, auction, William A. Colman Collection of Paintings, Park Place House
September 19–December 31, John Watkins Brett Collection of Old Masters, AAFA *
October, Fifth Fair, AICNY
November 10, D'Angier, Sculptures, Park Place House

1833

January 1–April 15, Claude-Marie Dubufe, *Temptation of Adam and Eve* and *Expulsion from Paradise,* AAFA

January, John Watkins Brett Collection of Old Masters, AAFA *

February 20, Thomas Cole, Italian Paintings, Broadway and Wall Street

May 8–July 6, Eighth Exhibition, NAD *

May 10–June 11, James Thom, *Tam O'Shanter, Souter Johnny, the Landlord and Landlady,* AAFA *

June 10, Fifteenth Exhibition, AAFA *

September 9, Francis Danby, *Opening of the Sixth Seal,* AAFA *

September, Samuel F. B. Morse, *Gallery of the Louvre,* Broadway and Pine Street

October, Sixth Fair, AICNY

November 7, 1833–January 1834, James Thom, *Tam O'Shanter, Souter Johnny, the Landlord and Landlady,* AAFA *

November, Baron Christian Burckhardt Collection of Old Masters, Broadway and Chambers Street

1834

March–June, Thomas Cole, *Angel Appearing to the Shepherds,* AAFA

April 17–June 14, Robert Ball Hughes, *Uncle Toby and Widow Wadman,* AAFA *

April 25–July 5, Ninth Exhibition, NAD *

June 16–July 26, Giovanni Paolo Panini, Paintings, AAFA *

June 30–July 1, M. Le Marquis de Gouvello Collection, AAFA *

September 11, Dioramic Paintings, AAFA

October, Seventh Fair, AICNY

November 1, Tapestries of Raphael's Cartoons and Rubens's *Crucifixion,* City Saloon

1835

April 24–June 30, John Watkins Brett Collection of Old Masters, AAFA *

May 5–July 4, Tenth Exhibition, NAD *

June 30, Daniel Blake Collection of Old Masters, AAFA *

Summer, Mr. Saunders Collection of European and American Paintings, Stollenwerck and Brothers

September, H. Harrington, Moving Panorama of Lunar Discoveries and Diorama of the Deluge, Marble Buildings

September, First Fair, Mechanics' Institute of the City of New York, Castle Garden

October 13, James Thom, *Tam O'Shanter, Souter Johnny, the Landlord and Landlady* and Other Works, AAFA

October 28, John Trumbull, Paintings, AAFA *

October, Eighth Fair, AICNY

October, Joseph Capece Latro Collection, City Dispensary *

November, exhibition and sale, Richardson's Gallery of Landscape Paintings, Landscape Gallery

December 12, Sixteenth Annual Exhibition, AAFA *

December, H. Harrington, Dioramas, Marble Buildings

December, H. Harrington, Grand Moving Diorama, American Museum

1836

April 9–July 9, Benjamin West, *Death on the Pale Horse,* AAFA

April 27–July 9, Eleventh Exhibition, NAD *

June, H. Harrington, Dioramas, Marble Buildings

June, Henry Inman after C. B. King, Gallery of Portraits of American Indians, Stollenwerck and Brothers

July 4, Anthony W. Jones, Statue of a Highlander, American and Foreign Snuff Store

July, Stanfield's Great Moving Panorama, Niblo's Garden

September, Second Fair, Mechanics' Institute of the City of New York, Castle Garden

September, auction, Ancient and Modern Paintings, Thomas Bell at Stollenwerck and Brothers

October, Francesco Annelli's Private Gallery of Paintings, New-York Athenaeum

October, Thomas Cole, Course of Empire series, NAD

October, Ninth Fair, AICNY

December 3, Claude-Marie Dubufe, *Temptation of Adam and Eve* and *Expulsion from Paradise,* AAFA

December, H. Harrington, Dioramas, Marble Buildings

1837

January, W. Hayward, Collection of Pictures, New-York Athenaeum

March, D.W. Boudet, *La Belle Nature* and *Daphne de l'Olympe,* 17 Park Row

April 21–July 4, Twelfth Exhibition, NAD *

May, William Dunlap after Benjamin West, *Christ Healing the Sick,* American Museum

September, Claude-Marie Dubufe, Paintings, Stuyvesant Institute

September, Third Fair, Mechanics' Institute of the City of New York, Niblo's Garden

October–November, Mosaic Picture of the Ruins of Paestum, AAFA

October, George Catlin, Indian Gallery

October, Tenth Fair, AICNY

1838

March 25–31, auction, part 1, Michael Paff Collection, Levy at Mr. Platt's Store *

April 1, auction, part 2, Michael Paff Collection, Levy at Mr. Platt's Store *

April 23–July 7, Thirteenth Exhibition, NAD *

June 16–October 12, Mr. Sanguinetti's Collection of Ancient Italian Paintings, AAFA *

July, Thomas Sully, *Queen Victoria,* AAFA

October, Eleventh Fair, AICNY *

October, Exhibition of Works of Modern Artists, Apollo Association *

November 19, Claude-Marie Dubufe, Dioramic Pictures and Four Paintings, AAFA *

November 19, Exhibition of American Paintings (The Dunlap Exhibition), Stuyvesant Institute *

1839

January, Exhibition of Paintings (American Artists and Choice Old Masters), Apollo Association *

January, W. Hayward's Gallery of Old Masters, AAFA *

April 17, auction, Frederick Catherwood, Watercolors, Drawings, and Paintings, Levy's Auction Room

April 24–July 6, Fourteenth Exhibition, NAD *

May 8–December 30, John Clark Collection of Old Italian Paintings, AAFA *

May 9–22, Alfred J. Miller, Paintings and Drawings of the Rocky Mountains, 410 Broadway *

May, Francesco Annelli's Private Gallery of Paintings, AAFA

May, Exhibition of Paintings (American Artists and Choice Old Masters), Apollo Association *

June, Thomas Sully, *Queen Victoria,* 155 Broadway

August, John Clark Collection of Old Italian Paintings, 281 Broadway *

October, John James Audubon, Drawings, Lyceum Gallery

October, Exhibition of Paintings (American Artists and Choice Old Masters), Apollo Association *

October, Twelfth Fair, AICNY

October, Benjamin West, *Christ Rejected,* Stuyvesant Institute

November 4, auction, John Clark Collection of Old Italian Paintings, Lyman at AAFA *

November, Panorama of Lima, New-York Rotunda

November, Alexander Vattemare Collection, NAD

1840

January 22, auction, Chauncey Bradley Ives, Statues, Reichard's Art Rooms

February, Exhibition of Paintings, Apollo Association *

March 25, auction, Old Masters, Levy *

April 23, auction, Old Masters, James Bleecker at Granite Buildings *

April 27–July 8, Fifteenth Exhibition, NAD *

May 4–June 8, Old Masters, AAFA *

May 26, auction, Old Masters, Wilkins, Rollins and Company *

July, Frederick Catherwood, Panorama of the Eternal City, New-York Rotunda

September 18, auction, Old Masters, Bleecker and Van Dyke *

September, Exhibition of Paintings, Apollo Association *

October, Thirteenth Fair, AICNY

November, John Clark Collection of Old Italian Paintings, 333 Broadway *

December, Thomas Cole, The Voyage of Life, New York Society Library

1841

March, Exhibition of Paintings, Apollo Association *

May 3–July 5, Sixteenth Exhibition, NAD *

June 18, auction, Modern European Paintings, John B. Glover *

October, Exhibition of Paintings, Apollo Association *

October, Fourteenth Fair, AICNY

November 8, auction, Old Masters, Levy's Auction Room *

November 8, auction, Old Masters, Henry E. Riell and Jacob Arcularious *

1842

April 27–July 9, Seventeenth Exhibition, NAD *

April–December, Annual Free Exhibition, AAU

October 12, auction, Old Masters, Henry E. Riell at NAD *

October, John Clark Collection of Old Italian Paintings, 281 Broadway

October, Fifteenth Fair, AICNY

1843

March, Daniel Huntington, *Pilgrims' Progress,* Granite Buildings

April 12, auction, William Franquinet Collection, Levy's Auction Room *

April 27–July 4, Eighteenth Exhibition, NAD *

April–December, Annual Free Exhibition, AAU

October 3, auction, J. C. Wadleigh Collection, C. S. Smith *

October, Sixteenth Fair, AICNY

October, Robert Walter Weir, *Embarkation of the Pilgrims* *

December 7, auction, Old Master and Modern Paintings, Thomas Bell and Company *

December, George Harvey, Watercolors and Oils, 232 Broadway *

1844

April 24–July 6, Nineteenth Exhibition, NAD *

April–December, Annual Free Exhibition, AAU

June 12, auction, Professor Kleynenberg Collection, Levy and Spooner *

October, Francesco Annelli, *The End of the World,* Apollo Association *

October, Leclerc, Paintings, NAD

October 1844–September 1845, New-York Gallery of the Fine Arts, Clinton Hall *

October, Seventeenth Fair, AICNY *

November 13, auction, A. Cor Collection, Levy and Spooner *

1845

January 14, auction, Modern European Paintings, John B. Glover *

April 17–July 5, Twentieth Exhibition, NAD *

April–December, Annual Free Exhibition, AAU

May, Titian, *Venus,* 449 Broadway

September 1845–1848, New-York Gallery of the Fine Arts, New-York Rotunda

October, Eighteenth Fair, AICNY

1846

February 14–March 15, The Inman Gallery (Henry Inman Memorial Exhibition), AAU *

April 16–July 4, Twenty-first Exhibition, NAD *

April–December, Annual Free Exhibition, AAU

October 15, auction, Modern Paintings, Tuttle and Ducluzeau *

October, Nineteenth Fair, AICNY, Niblo's Garden
November 7, John Vanderlyn, *Landing of Columbus,*
 NAD
November, H. K. Brown, Statues, Bas-reliefs, and Busts,
 NAD *
December 4, auction, William A. Colman Collection,
 William H. Franklin and Son *

1847
March, Emanuel Leutze, *The Court of Henry VIII,*
 AAU
April 2–July 3, Twenty-second Exhibition, NAD *
April–December, Annual Free Exhibition, AAU
June 25, auction, Joseph Bonaparte Collection, James
 Bleecker and Company *
August 1847–January 1848, Hiram Powers, *Greek Slave,*
 NAD
October, Twentieth Fair, AICNY

1848
March 22, auction, James Thomson Collection, Dumont
 and Hosack *
April 3–July 8, Twenty-third Exhibition, NAD *
April 19, auction, John G. Chapman, Paintings, Dumont
 and Hosack *
April, Thomas Cole Memorial Exhibition, AAU *
April, Gallery of Old Masters (Gideon Nye Collection),
 Lyceum Gallery *
May–December, Annual Free Exhibition, AAU
May, Opening Exhibition, Goupil, Vibert and Company
June 8, auction, Royal Gurley inventory, Cooley, Keese
 and Hill *
June 29, auction, Daniel Stanton Collection, Henry H.
 Leeds and Company *
October 30, auction, Paintings, Cooley, Keese and Hill
October, John Frazee, Design for Washington
 Monument, AAU *
October, Paul Delaroche, *Napoleon Crossing the Alps,*
 Goupil, Vibert and Company
October, Twenty-first Fair, AICNY
November, Old Masters, Lyceum Gallery
December, Exhibition of Paintings, International Art
 Union *

1849
January, Claude-Marie Dubufe, *Temptation of Adam
 and Eve* and *Expulsion from Paradise,* New York
 Society Library
March, Gallery of Old Masters (Gideon Nye
 Collection), Lyceum Gallery *
April 3–July 7, Twenty-fourth Exhibition, NAD *
April 18, 1849–August 1857, Paintings and Drawings by
 Artists of the Düsseldorf Academy, Düsseldorf
 Gallery *
April 25, auction, Charles de la Forest Collection,
 Henry H. Leeds and Company *
April–December, Annual Free Exhibition, AAU
May, Paintings, International Art Union, LaFarge
 Building *
October, Twenty-second Fair, AICNY

October–December, Hiram Powers, Sculptures, Lyceum
 Buildings
November 8, auction, Aaron Arnold Collection, Homer
 Morgan
Autumn, Old Masters (Gideon Nye Collection), NAD *
December 17, auction, William A. Colman Collection,
 through Henry H. Leeds and Company *

1850
January–March, Daniel Huntington, Paintings, AAU
April 3, auction, J. P. Beaumont Collection, Henry H.
 Leeds and Company *
April 10, auction, William A. Colman Collection,
 James E. Cooley *
April 15–July 6, Twenty-fifth Exhibition, NAD *
April–December, Annual Free Exhibition, AAU
May, Gallery of Old Masters, Niblo's Garden
June 18, auction, Gideon Nye Collection, James E.
 Cooley
September 23, New-York Gallery of the Fine Arts,
 Clinton Hall, NAD *
October, William Dunlap, *Death on the Pale Horse,*
 Stoppani's Building
October, Twenty-third Fair, AICNY
Ten Thousand Things on China and the Chinese,
 Chinese Assembly Rooms *
Roman Gallery of Ancient Pictures, Stuyvesant Institute *
Velázquez, *Charles I,* Stuyvesant Institute *

1851
April 8–July 5, Twenty-sixth Exhibition, NAD *
April–December, Annual Free Exhibition, AAU
October 28–30, auction, Williams, Stevens and Williams
 Inventory, Henry H. Leeds and Company *
October 1851–February 1852, Emanuel Leutze, *Washington
 Crossing the Delaware,* Stuyvesant Institute
October, Twenty-fourth Fair, AICNY
November 11, auction, Reverend Samuel Farmar
 Collection, Lyman and Rawdon

1852
March 31–June 12, Edward Augustus Brackett, *Ship-
 wrecked Mother and Child,* Stuyvesant Institute *
April 1, auction, Private Collection, Lyman and Rawdon *
April 13–July 7, Twenty-seventh Exhibition, NAD *
April 28, auction, Philip Hone Collection, E. H. Ludlow
 and Company *
May 5, auction, John A. Boker Collection, Henry H.
 Leeds and Company *
May–June, Peter Stephenson, *Wounded Indian,*
 Stuyvesant Institute
June 9, auction, Paintings, Bangs, Brother and
 Company *
October 27, auction, Williams, Stevens and Williams
 Inventory, Leeds *
October, De Brakekleer Collection of Paintings by the
 Belgian Masters, 518 Broadway *
October, Twenty-fifth Fair, AICNY
November 23, auction, Paintings and Decorative Arts,
 Leeds at NAD *

December 15–17, 30, auction, AAU Inventory, David Austen Jr. at AAU *

December 1852–1857, Bryan Gallery of Christian Art, 843 Broadway *

1853

February 24, auction, Private Collection of Paintings, Henry H. Leeds and Company *

March 5, The Washington Gallery of Art, AAU

April 19–July 9, Twenty-eighth Exhibition, NAD *

April 28, auction, J. P. Beaumont Collection, Henry H. Leeds and Company *

June, De Brakekleer Collection of Paintings by the Belgian Masters, 547 Broadway *

July 14, 1853–October 5, 1858, Crystal Palace Exhibition *

July 26, auction, Paintings and Decorative Arts, Henry H. Leeds and Company *

July, Edward Augustus Brackett, *Shipwrecked Mother and Child,* Stuyvesant Institute

October 8–10, auction, Rhenish-Belgian Gallery of Paintings, Leeds at NAD *

October, Twenty-sixth Fair, AICNY

November 23, auction, Brooklyn Art Association Inventory, Henry H. Leeds and Company *

December 6, auction, Paintings and Decorative Arts, William Irving and Company *

December 16, auction, Paintings, Albert H. Nicolay *

Theodore Kaufmann, Paintings of Religious Liberty, the artist's studio, 442 Broadway *

1854

March 22–April 25, Twenty-ninth Exhibition, NAD *

May, Washington Exhibition in Aid of the New-York Gallery of the Fine Arts, AAU

October 31, auction, Private Collection, Henry H. Leeds and Company *

Henry Abbott Collection of Egyptian Antiquities, Stuyvesant Institute *

1855

February, A. T. Derby, Watercolor Portraits, Williams, Stevens and Williams

February, Horace Vernet, *Joseph and His Brethren,* Goupil and Company

March 14–May 10, Thirtieth Exhibition, NAD *

March, William Sidney Mount, *The Power of Music,* Williams, Stevens and Williams

April, Thomas Duncan, *The Triumphant Entry of Prince Charles Edward into Edinburgh,* Williams, Stevens and Williams

April, Daniel Maclise, *Sacrifice of Noah,* Goupil and Company

May, Richard Ansolell, *Dogs and Their Game* (7 Paintings), Williams, Stevens and Williams

May, John Rowson Smith, Panorama of the Tour of Europe, Chinese Assembly Rooms *

June, Lilly Martin Spencer, Paintings, Schaus Gallery

September, Ary Scheffer, *Dante and Beatrice,* Goupil and Company

October, Richard Greenough, *Young Shepherd Boy*

Attacked by an Eagle, and Charles Baxter, *The Spanish Maid,* Williams, Stevens and Williams

October, Twenty-seventh Fair, AICNY *

October, various artists, Summer Studies, Dodworth Studio Building

November, Thomas Faed, *Shakespeare in His Study* and *Milton in His Study,* Williams, Stevens and Williams

December 18, auction, Private Collection, Henry H. Leeds and Company *

December, Thomas Faed, *Sir Walter Scott and His Literary Friends at Abbotsford,* and N. Gasse, *Galileo at Florence,* Williams, Stevens and Williams

1856

March 14–May 10, Thirty-first Exhibition, NAD *

April 1, auction, Oil Paintings, Henry H. Leeds and Company *

April 17, auction, Oil Paintings and Engravings, Henry H. Leeds and Company *

April, James Smillie, Engravings after Thomas Cole, The Voyage of Life, Spingler Institute

June, Paul Delaroche, *Marie Antoinette on Her Way from the Tribunal,* Goupil and Company

October 28, auction, J. P. Beaumont Collection, Henry H. Leeds and Company *

October, Twenty-eighth Fair, AICNY *

November 10, auction, Edward Brush Corwin Collection, Bangs, Brother and Company *

November, John Martin, Judgment series, Williams, Stevens and Williams

December 1856–April 1857, Erastus Dow Palmer, Marbles, Church of the Divine Unity

1857

February 20, auction, paintings from Ferdinand Joachim Richardt's Niagara Gallery, Henry H. Leeds and Company *

March 26, auction, A. E. Douglass Collection, Henry H. Leeds and Company *

May 5, auction, Goupil and Company Inventory and a Private Collection, Henry H. Leeds and Company *

May 28, auction, William Schaus Collection, Henry H. Leeds and Company *

May 28, Thirty-second Exhibition, NAD *

May, Frederic E. Church, *Niagara,* Tenth-Street Studio Building

May, Frederic E. Church, *Niagara,* Williams, Stevens and Williams

June, auction, Hiram Powers, *Greek Slave,* Leeds at Merchants' Exchange

June, Robert Walter Weir, *Embarkation of the Pilgrims,* Williams, Stevens and Williams

September 28, Frederic E. Church, *Niagara,* Williams, Stevens and Williams

September, Rembrandt Peale, *Court of Death,* American Female Guardian Society

October 20, 1857–February 1858, Exhibition of British Art, Williams, Stevens and Williams at NAD *

October–November, Twenty-ninth Fair, AICNY *

October 1857–March 1858, Exhibition of French Paintings, Goupil and Company at AAU *

October, Rosa Bonheur, *The Horse Fair,* Williams, Stevens and Williams

November 5, auction, J. M. Burt Collection, Henry H. Leeds and Company *

November 18, auction, Paintings, Henry H. Leeds and Company *

November 1857–January 1860, Erastus Dow Palmer, *The White Captive,* Schaus Gallery

November, Franz Xaver Winterhalter, *Empress Eugénie Surrounded by Her Ladies-in-Waiting,* Goupil and Company

December, August Belmont Collection, NAD

December 1857–January 1858, Hiram Powers, *Greek Slave,* Düsseldorf Gallery

1858

January, reception and exhibition, Dodworth Studio Building

February 4, auction, D. D. Byerly Collection, Henry H. Leeds and Company *

February 9, auction, Dr. S. Spooner Collection, Henry H. Leeds and Company *

March, George Hering, *The Village Blacksmith,* and T. Buchanan Read, *Spirit of the Waterfall*

April 2, Edward Troye, Oriental Paintings, Apollo Association

April 13–June 30, Thirty-third Exhibition, NAD *

April 22, auction, Joseph Fagnani Collection, E. H. Ludlow and Company

May, Gideon Nye Collection of Old Masters, AAU *

May, William T. Ranney, Memorial Exhibition and Sale, S. N. Dodge

June 9, auction, Paintings, Bangs, Brother and Company *

July, F. Wenzler, *A Scene in Berkshire County, Mass.,* Dodworth Studio Building

September 28, Frederic E. Church, *Niagara,* Williams, Stevens and Williams

October 21, auction, J. Swinbourne, Mr. Jenkins, and G. W. Alson Collections, Henry H. Leeds and Company *

December 20, auction, Paintings to Benefit William T. Ranney Fund, Henry H. Leeds and Company *

December, Louis Sonntag, *Dream of Italy,* Williams, Stevens and Williams

1859

January, Mrs. Dassel's Works, Mrs. Dassel's Home

January, Exhibition, International Art Union

February, benefit exhibition, Régis-François Gignoux, *Niagara by Moonlight,* Goupil and Company

March 16, 17, auction, Goupil and Company Inventory, Henry H. Leeds and Company *

March, opening of William Henry Aspinwall's Gallery

March, opening of August Belmont's Collection

March, Paintings and Drawings by Artists of the Düsseldorf Academy, Düsseldorf Gallery *

April 7, auction, Modern Paintings, Henry H. Leeds and Company *

April 13–June 25, Thirty-fourth Exhibition, NAD *

April 19, 20, auction, Paintings, Henry H. Leeds and Company *

April 27, 28, Frederic E. Church, *The Heart of the Andes,* Lyrique Hall

April 29–May 23, Frederic E. Church, *The Heart of the Andes,* Tenth Street Studio Building

September–November, Exhibition of British and French Paintings, NAD *

September–December 5, Frederic E. Church, *The Heart of the Andes,* Tenth Street Studio Building

October–November, Hiram Powers, *Washington at the Masonic Altar,* Goupil and Company

November 5, Louis Sonntag, *Dream of Italy,* Düsseldorf Gallery

November 10, auction, Rollin Sandford and James Journeay Collections, Henry H. Leeds and Company *

November, Chevalier Pettich, Statues, Cooper Union for the Advancement of Science and Art

November, Thomas P. Rossiter and Louis Remy Mignot, *The Home of Washington after the War,* NAD

December, auction, J. P. Beaumont Collection, Henry H. Leeds and Company *

December, Paul Akers, *Dead Pearl Diver,* Düsseldorf Gallery

1860

January 31–February 1, auction, Snedecor's Inventory, Henry H. Leeds and Company at NAD

January, Exhibition of Paintings, International Art Union *

January, reception and exhibition, Dodworth Studio Building

January, Charles Barry, Crayon Drawings, Crayon Gallery

February 29, auction, George H. Hall, Paintings and Studies, Henry H. Leeds and Company *

February, Thomas Crawford, *Dancing Jennie,* Düsseldorf Gallery

February, First Exhibition, Artists' Fund Society *

February, reception and exhibition, Dodworth Studio Building

March, reception and exhibition, Dodworth Studio Building

March, reception and exhibition, T. P. Rossiter's Studio House

March, Thomas P. Rossiter, Scriptural Paintings, T. P. Rossiter's Studio House *

April 14–June 16, Thirty-fifth Exhibition, NAD *

April 24, auction, Paintings and Decorative Arts, Henry H. Leeds and Company *

April, Leonard Volk, Statuette of Senator Douglas, Crayon Gallery

May 22, 23, auction, William E. Burton Collection, Henry H. Leeds and Company *

May, Paintings and Drawings by Artists of the Düsseldorf Academy with the Jarves Collection of Old Masters, Düsseldorf Gallery, Institute of Fine Arts *

July, Jasper Cropsey, Four Seasons, Menger's

July, Heinrich Anton Heger, *Cathedral at Halberstadt,* Marshall Pepoon

August, Charles-Balthazar-Julien Févret de Saint-Mémin, Engravings, Dexter's Store

October 13, auction, Paintings, Manuscripts, and Engravings, Bangs, Merwin and Company *

October 19, auction, Paintings, Henry H. Leeds and Company *

October 24, auction, Paintings, Henry H. Leeds and Company *

November 13, auction, Charles M. Leupp Collection, Ludlow *

November, Exhibition of French and Flemish Paintings, Goupil and Company *

December 5, auction, French and Belgian Paintings, Henry H. Leeds and Company *

December 12, auction, Modern Paintings, Henry H. Leeds and Company *

December 14, auction, Modern Paintings, Henry H. Leeds and Company *

December 18, auction, Snedecor's Inventory, Henry H. Leeds and Company *

December 19, auction, A. d'Heyvetter Collection, Edward and F. H. Schenck *

December 24, auction, Paintings and Decorative Arts, Henry H. Leeds and Company *

December, George Loring Brown, *The City and Harbor of New York* and Paintings by American Artists, Crayon Gallery

December, Exhibition of Paintings and Sculpture, Artists' Fund Society

1861

January 24, auction, Fine Modern Oil Paintings, Henry H. Leeds and Company *

February 6, auction, French and Flemish Paintings from Goupil and Company, Henry H. Leeds and Company *

February 20, auction, French, Flemish, and American Paintings, Schenck *

March 28, auction, Italian Paintings, Bangs *

April 20–June 17, Thirty-sixth Exhibition, NAD *

May 4, auction, Modern Paintings and Watercolors, Bangs *

May, Frederic E. Church, *The Icebergs,* Goupil and Company

December 15, auction, Paintings by George L. Brown, Henry H. Leeds and Company *

Private Collectors and Public Spirit: A Selective View

JOHN K. HOWAT

The dramatic growth in the number of private art collectors in New York City during the years 1825 through 1861 reflected the concurrent rapid development of an increasingly great metropolis. In 1825 New York City, which is to say the small urban cluster gathered at the bottom of Manhattan Island, had a population of about 166,000. Society was presided over by a prosperous but not very large group of leaders—landholders, merchants, bankers, lawyers, manufacturers (including sophisticated craftsmen), physicians, educators, politicians, a few artists and writers, and people of leisure—only a few of whom had traveled extensively abroad. These leaders had only a circumscribed knowledge and experience of fine-art objects, especially items from other cultures, and only a limited access to art publications. New York, like the nation, was in its cultural youth.

By 1861 the city, still legally constituted only of Manhattan Island, boasted more than 820,000 citizens (1,000,000 in Greater New York, which unofficially included Brooklyn), who composed a population remarkable for its diversity and entrepreneurial verve.[1] In a brief thirty-six years revolutionary changes in technologies, modes of travel and communication, industry and commerce—and in their capitalization—provided the backdrop for a much expanded, considerably wealthier group of people who devoted themselves to acquiring fine art in many of its varieties. New York City's world of visual arts was transformed from a small, close-knit, mostly private, and somewhat naive community into a large, complicated, and sophisticated one with a much broader view of the role of the arts in public life. By 1861 this art world was primed and poised to help inaugurate a great age—one that continues to this day throughout the nation—in which art acquisition became better informed and public art museums and galleries were established through the generosity of philanthropists.

Before 1825 the city had a limited number of institutions, whether public, private, or commercial, that concerned themselves with the visual arts. The thoughtful but quite small band of civic leaders who established and supported these organizations—men such as De Witt Clinton, Asher B. Durand, Dr. John W. Francis, Robert Fulton, Philip Hone, Dr. David Hosack, the brothers Edward and Robert Livingston, Samuel F. B. Morse, John Trumbull, John Vanderlyn, and Gulian Crommelin Verplanck—either had no personal collections, or relatively small ones, or, as in the case of the artists Durand, Trumbull, and Vanderlyn, had larger aggregations of their own works, with some by other artists.

One noteworthy, although hardly typical, collector during these early years was Eliza Jumel (1775–1865), who, before her marriage to the wealthy Stephen Jumel, had been a prostitute in Rhode Island. In 1817 Mme Jumel put her large collection of European paintings on view at the American Academy of the Fine Arts, apparently in the hope of gaining entrée to New York society. The attempt failed, and on April 24, 1821, the collection was auctioned. The sale catalogue of 242 items, prepared by one Claude G. Fontaine, was solemnly titled *Catalogue of Original Paintings. From Italian, Dutch, Flemish and French Masters of the Ancient and Modern Times, Selected by the Best Judges from Eminent Galleries in Europe and Intended for a Private Gallery in America.*[2] Famous artists' names abounded therein, with glaring misspellings—as in "Cannoletty," "Goltius," and "Pictro di Cortone"—that provided an insight into the naïveté with which the collection had been formed and catalogued.

The items that were not sold at the 1821 auction were later used to decorate Mme Jumel's house in Harlem Heights, now known as the Morris-Jumel Mansion. An 1862 visit to the mansion was recorded by an awestruck Miss Ann Parker in her diary:

> *Everything looked as if it was many years since they dusted, and the atmosphere was very disagreeable— as though fresh air was unknown. These two halls had inlaid tables, choicely and beautifully set-in gilt frames, hanging baskets and etageriers covered with articles of virtue. The walls were hung with*

1. For population figures in 1825 and 1860, see Ira Rosenwaike, *Population History of New York City* (Syracuse: Syracuse University Press, 1972), p. 33.
2. See Michel Benisovich, "Sales of French Collections of Paintings in the United States during the First Half of the Nineteenth Century," *Art Quarterly* 19 (autumn 1956), p. 288.

3. Miss Ann Parker, Diary, typed transcript, Jumel Papers, box 1, folder 14, Manuscript Collection, New-York Historical Society.

4. William Dunlap, *History of the Rise and Progress of the Arts of Design in the United States*, 2 vols. (New York: George P. Scott, 1834; new ed., 3 vols., edited by Frank W. Bayley and Charles E. Goodspeed, Boston: C. E. Goodspeed and Co., 1918), vol. 3, p. 270.

rare paintings—one especially, a full length of General Washington, which was my admiration. . . . She was very magnificent and amiable in her manners and conversation and called our attention to the superb paintings on the walls, where they were bought, etc.[3]

Mme Jumel died in 1865, having lived for decades as an aged curiosity, surrounded by her pictures and furniture in a setting of famous disarray (fig. 57).

The more typical art collector in New York during the late 1820s and early 1830s was part of a small, progressive, and public-minded group, engaged in a scope of admirable although restricted activities. The growing importance of this group was made clear in 1825, when the conflict surrounding the establishment of the National Academy of Design took center stage in the public press. The unpleasant public and private running battle between supporters of the elitist American Academy of the Fine Arts (most prominently the elderly portraitist Trumbull) and of the younger artists who banded together to form the National Academy (most prominently Morse and William Dunlap) was waged for almost two decades. Yet, despite the prevailing thunderous art weather, Trumbull, Dunlap, and Durand (the latter one of the new guard) found it possible to unite in their enthusiasm for the work of the fledgling Thomas Cole, himself a founding member of the National Academy. All three purchased

landscapes by Cole when they were shown in a shop window in 1825, as did patrons such as Hone, Verplanck, and Hosack, who relied on their position as cultural benefactors in order to straddle the gulf between the two camps (see "Mapping the Venues" by Carrie Rebora Barratt in this publication, pp. 47–50). These patrons had started out as supporters of the American Academy, which was the regular showplace in the city for traveling European "collectors," many of whom were in fact dealers who came to New York to work a rich market. When the Academy dissolved in 1842, the same collectors became loyal backers of the new organization, founded and dominated by artists.

At the center of the city's cultural world was Dunlap (1766–1839), a painter of only moderate distinction but a prolific playwright, biographer, historian, diarist, and theater manager. Dunlap's position was doubly assured by the publication in 1832 of his *History of the American Theatre*, followed two years later by his two-volume *History of the Rise and Progress of the Arts of Design in the United States*. The latter, the first published history of the visual arts in the nation, is still consulted regularly as a rich compilation of facts and anecdotes. The work ends with a nine-page discussion entitled "Collections of Pictures," for which Dunlap apologized unnecessarily: "In our extensive country these are so far asunder, and my knowledge of them so imperfect, that I fear my readers may exclaim, as it regards my account of them, 'O lame and impotent conclusion.'"[4] The collections listed ranged along the Atlantic coast, from Boston to Baltimore, but, understandably enough, given Dunlap's residence in New York City, most were concentrated there.

Also understandable was Dunlap's focus on the collection of Philip Hone (1780–1851; cat. no. 58, fig. 58), who had made a comfortable fortune before retiring in May 1821 to turn his attention to other interests. An active social leader, admirable diarist, and enthusiastic art collector, Hone would serve a one-year term as mayor in 1825. Shortly after his retirement, Hone traveled to England, where he ordered a canvas from each of the two best-known American painters resident in London: from Charles Robert Leslie, *Slender, Shallow, and Anne Page*, 1825 (unlocated; first version, also 1825, Yale Center for British Art, New Haven), and from Gilbert Stuart Newton, *Old Age Reading and Youth Sleeping*, ca. 1821–25 (unlocated). Both artists were intimates of the famous New York author Washington Irving, who doubtless recommended their work to his close friend Hone, still in the early stages of forming a collection.

Fig. 57. Abraham Hosier, *Hall of the Roger Morris or Jumel Mansion, Harlem Heights, Manhattan*, ca. 1830s. Watercolor. Museum of the City of New York, Gift of Mrs. Eliot Tuckerman

Because New York was relatively small and its art enterprise limited, the arrival of the two pictures in the city in late 1825 caused something of a furor in the local press. Among the several notices that appeared, this one in the *New-York Review* helped to establish Hone as an important art patron:

The present seems to be an auspicious era for the Fine Arts in our city. Our corporation [has] always liberally encouraged every attempt at improvement; and now we have, in our chief magistrate, Philip Hone, Esq. a man whose taste and knowledge make him competent to judge of merit, and whose liberality has displayed itself by the patronage of living artists. Mr. Hone is no collector of old pictures. The picture dealers . . . have not in him a dupe or a customer. He encourages painters, by employing the meritorious; and his walls honour, and are honoured by, the works of Leslie, Newton, Wall, Cole, Peale, and other artists, who are thus stimulated to persevere in the road to perfection.[5]

In 1834 Hone supplied Dunlap with a list of pictures in his collection, to be published in the *Rise and Progress*. It contained entries on works (including copies after several old masters) by fourteen American artists, among whom were Cole, Morse, Dunlap himself, Vanderlyn, Rembrandt Peale, Robert Walter Weir, and William Guy Wall. Only three of the painters listed—one each from England, Scotland, and France—were not American. With pardonable parochial pride Hone wrote Dunlap, "The above are all the works of artists now living, and I do not know of a finer collection of modern pictures. I have several old pictures, some of which are dignified by the names of celebrated painters; but I do not esteem them sufficiently to induce me to furnish you with a catalogue."[6] Like the reporter for the *New-York Review*, Hone was obviously aware that picture dealers in the city were known to sell—or, at the best, were routinely suspected of handling—pictures of doubtful authenticity and condition. In fact, throughout the period in question (as indeed before and after), the world of New York collectors was loosely divided between those who, like Hone, preferred the safer road of acquiring works by living artists and those who sought the more recherché but riskier works by "old masters," or at least by European artists who were securely deceased.

On April 28, 1852, Hone's collection was sold at a posthumous auction. The catalogue recorded almost three hundred items, including small statuary, paintings, prints (many portraits and historical scenes),

Fig. 58. Shobal Vail Clevenger, *Philip Hone*, 1839. Plaster. Collection of The New-York Historical Society, Gift of James Herring 1862.7

and French and English medals. Among the European artists listed—presumably including some that Hone did "not esteem . . . sufficiently" and again with some misspellings—were "Von Ostade," "Cannaletto," "Gerard Dow," Ruisdael, Turner, Hobbema, and Murillo.[7]

For those collectors who preferred to seek out "old masters" primarily, the chief art dealer in the city was Michael Paff (d. 1838). A German immigrant, probably from Baden-Württemberg, Paff arrived in New York in 1784 on the same ship as John Jacob Astor, both having been attracted by the golden prospects presented by the new United States of America. The two competed in the business of selling musical instruments and sheet music until 1802, when Paff and his brother bought out Astor's interests in that field (Astor had by then gone on to establish himself as a leader in the North American fur trade). Before long Paff also had moved beyond selling musical effects, and by 1811 he was in the business of operating his own art gallery.

5. *New-York Review* notice reprinted in "Fine Arts," *New-York Evening Post*, May 6, 1826.
6. Dunlap, *Rise and Progress*, vol. 3, p. 277.
7. E. H. Ludlow, *Inventory of Paintings, Statuary, Medals, &c. &c., the Property of the Late Philip Hone . . . Wednesday, April 28, 1852* (sale cat., New York: P. Miller and Son, 1852).

Within a few years Paff rose to prominence in New York, both by meeting the city's newly perceived needs for the "old masters" and by presenting himself as a private collector of substance.[8] More than fifty years after Paff's death, Asher Durand's son John recalled that during his father's youth native works of art were sold in obscure frame makers' shops, while Paff more grandly offered works such as "The Last Supper by Michael Angelo"—having arrived at that attribution because the number of pavement stones (ten) depicted in the room was the same as the number of letters in the artist's name (Buonarotti). In retrospect, John Durand commented sardonically, "It is needless to say that Paff proved the authenticity of other originals by similar evidence."[9] Yet, despite such perceptions of charlatanism, Paff was liked and respected in the city for his engaging and enthusiastic artistic boosterism.

After Paff's death his private collection of more than one thousand paintings and sketches and eighty-four engraved reproductions was auctioned in sales lasting six days. The preface to the sales catalogue eulogized Paff briefly, stating that "more than 35 years of his life were devoted with undiminished zeal to the collection of *Rare and Valuable Paintings*—they were his great source of delight, he seemed but to live in the enjoyment of them, and it was always with reluctance he parted with a fine Picture, at however large a price."[10] It is tantalizing to think that perhaps a few of Paff's pictures may have been given proper attributions, for names such as Van Dyck, Rubens, Rembrandt, Tintoretto, Titian, Raphael, and Dürer are among the many hundreds enthusiastically scattered throughout his catalogue. Unfortunately there is no feasible way to trace the provenances of these paintings.

A collection of old masters clearly more distinguished than Paff's was that formed by the merchant Richard Worsam Meade (1778–1828). A native of Philadelphia, Meade had spent many years in Cádiz, where he was able to acquire what at the time was thought to be one of the most important groups of Italian, Spanish, and Flemish pictures yet imported to America. In September 1831 the *New-York Mirror,* the weekly paper most concerned with the arts in the city, discussed the posthumous preauction exhibition of Meade's collection and named Titian, Veronese, Domenichino, Murillo, and Rubens as among the artists represented. Also of considerable interest was a bust of George Washington (cat. no. 52) carved in 1795 by the Italian sculptor Giuseppe Ceracchi, which Meade had bought from the widow of the Spanish

ambassador to the United States. The Metropolitan Museum now owns this work, which is thought to be the only sculptural bust for which the notoriously impatient Washington ever sat.

Although Meade's business affairs had ended in controversy with both the Spanish and American governments, the *New-York Mirror* praised him warmly as a collector: "He secured and transmitted to his native country a treasure of art, such as had never been before possessed by an American citizen. A collection of genuine, authentic specimens, from which we may form a judgment, and by which we may model a taste, founded on a comparison of the works of some of the most celebrated masters."[11] Mrs. Meade, who had placed the collection on sale, retained ownership of the Ceracchi until her death in 1852, when Gouverneur Kemble of New York purchased it from her estate.

By 1835 New York City, already the brawling commercial and financial center of the nation, could claim leadership of the nation's art community as well. Primary among the developments that had led to such prominence were the advent of the American Academy of the Fine Arts in 1802, Paff's establishment as a dealer in 1811, the founding of the National Academy in 1825, and the 1834 publication of Dunlap's *Rise and Progress,* which described the flourishing relationship among artists and collectors. Despite occasional financial recessions, the city presented itself during the antebellum period as a pot of gold wherein amateurs could form collections and friendships that marked them as men of taste supporting, in their private way, the growing interest in the arts. Some collectors, remarkable for their local pride and pugnacious self-assertion in every area of public life, felt called upon to make regular pronouncements on the excellence of the city's artists and to support them with purchases. Others attempted, with less personal involvement, to recapture the cultural glories of the European past by forming collections that included old master paintings, drawings, and prints in addition to antiquities and decorative arts.

Luman Reed (1787–1836), who began collecting about 1830, is the ideal model for the first type of patron. As Mrs. Jonathan Sturges, widow of Reed's business partner, later recalled,

Mr. Reed had conceived the idea of a picture gallery in his new house. . . . Mr. Reed's first essay was with Michael Paff, the principal "old picture" dealer of the period in New York. A few pictures were purchased, but Mr. Reed had too much

8. Malcolm Goldstein, "Paff, Michael," in *American National Biography,* edited by John A. Garraty and Mark C. Carnes (New York: Oxford University Press, 1999), vol. 16, pp. 895–96.

9. John Durand, *The Life and Times of A. B. Durand* (New York: C. Scribner's Sons, 1894; facsimile ed., New York: Kennedy Graphics, 1970), p. 66.

10. *Catalogue of the Extensive and Valuable Collection of Pictures, Engravings, and Works of Art . . . Collected by Michael Paff . . .* (sale cat., New York: A. Levy, Auctioneer, 1838), p. 1.

11. "Exhibition of Paintings, Collected in Spain by the Late Richard W. Meade, Esq.," *New-York Mirror,* September 17, 1831, pp. 86–87.

Fig. 59. William Sidney Mount, *Bargaining for a Horse (Farmers Bargaining)*, 1835. Oil on canvas. Collection of The New-York Historical Society, Gift of the New York Gallery of Fine Arts 1858.59

intuitive good sense to be taken in by such "old pictures" as were on sale at that period of our country's history, and he soon began to look around among our own artists, sought their personal acquaintance and examined their works and purchased with great good taste and judgement.[12]

Cole, Durand, William Sidney Mount, and George Flagg were the primary beneficiaries of Reed's interest.[13] Despite Mrs. Sturges's recollections, however, Reed's house on Greenwich Street, designed by Isaac G. Pearson, also contained a large collection of paintings by Flemish, German, Dutch, Italian, English, and Scottish artists.[14] The heart of the collection, still kept intact at the New-York Historical Society, is Cole's five-picture series, The Course of

Empire, 1833–36 (figs. 91–95), arguably the artist's most successful effort in an ideal mode. In a far more realistic manner, Mount's *Bargaining for a Horse*, 1835 (fig. 59), remarkable for its tight composition and careful finish, is probably the finest genre scene in the Reed collection. Reed, a very generous man, allowed interested members of the public to visit his art gallery, located on the third floor of his house, as well as to consult his collection of art books and printed reproductions.

Jonathan Sturges (1802–1874) followed in Reed's footsteps as a collector, beginning in the late 1830s. As described by Henry T. Tuckerman in 1867, his collection was not large—just under three dozen examples—and was composed primarily of works commissioned from his friends, eleven of New York's best

12. Mrs. Jonathan Sturges [Mary Pemberton Cady], *Reminiscences of a Long Life* (New York: F. E. Parrish and Company, 1894), p. 158.

13. See Ella M. Foshay, *Mr. Luman Reed's Picture Gallery: A Pioneer Collection of American Art* (New York: Harry N. Abrams in association with the New-York Historical Society, 1990), for an admirable and complete discussion of Reed's collecting accomplishments.

14. Ibid., pp. 123–92.

Fig. 60. Thomas Cole, *The Voyage of Life: Manhood*, 1840. Oil on canvas. Munson-Williams-Proctor Arts Institute, Utica, New York, Museum Purchase 55.107

15. Henry T. Tuckerman, *Book of the Artists, American Artist Life, Comprising Biographical and Critical Sketches of American Artists: Preceded by an Historical Account of the Rise and Progress of Art in America* (New York: G. P. Putnam and Son; London: Sampson Low and Co., 1867), p. 627.

16. "Our Private Collections, No. II [Jonathan Sturges]," *The Crayon* 3 (February 1856), pp. 57–58.

17. William S. Mount, Memorandum, April 6, 1851, New-York Historical Society, quoted in Franklin Kelly, "Mount's Patrons," in *William Sidney Mount, Painter of American Life*, by Deborah J. Johnson et al. (exh. cat., Museums at Stony Brook; New York: American Federation of Arts, 1998), p. 118.

18. See Kelly, "Mount's Patrons," pp. 109–28.

artists.[15] Durand painted more than a dozen canvases for Sturges, including copies after European masters and four of his own landscape compositions, among the latter *In the Woods*, 1855 (cat. no. 31), a superb example of the high quality of Sturges's acquisitions. Cole's *View on the Catskill, Early Autumn*, 1837 (Metropolitan Museum), Charles Cromwell Ingham's *Flower Girl*, 1846 (cat. no. 32), and three canvases by Mount, especially *Farmers Nooning*, 1836 (The Museums at Stony Brook), maintain the Sturges standard. Like so many of his contemporaries, Sturges had an extensive collection of prints, many of which were reproductions of famous European masterworks. *The Crayon*, which published a description of the Sturges collection in 1856, singled out the holdings of prints after Turner for praise; *Crossing the Brook*, numbered and signed by Turner, although actually made by an artist he had hired, was thought to be the only print after that painting in America.[16]

Despite the acuity of his eye and his eagerness to support contemporary artists, Sturges achieved his greatest renown from the leadership and support he provided to the New-York Gallery of the Fine Arts, established in 1844. This gallery had as its nucleus the Reed Collection, which had been purchased from the Reed family by Sturges and T. H. Faile (another business associate of Reed), among others. Although ultimately unsuccessful, it was meant to be the first public museum in New York devoted solely to the visual arts. In 1851 Mount acknowledged Sturges's gifts as both art administrator and collector: "Since the death of Luman Reed, no man in this city, holds a more prominent place in the affections of artists & the public, than . . . Jonathan Sturges. He has apartments richly decorated with paintings, and busts, by native artists, and I believe, has but *one mirror*, which reflects well his taste."[17]

During the 1830s and 1840s most New York collectors acquired modestly, usually for the purpose of fitting out their parlors and sitting rooms. They would attend the annual exhibition of the National Academy, which presented artworks available for purchase and, in the accompanying catalogue, lists of what had already been sold to collectors.[18] It was rare

that a collector would acquire large groups of pictures, as Reed had, with the benevolent interest of exhibiting them to the public. Or that one would aim to establish a permanent public art gallery in New York City, as Sturges had in his attempts to build the New-York Gallery.

Occasionally, large-scale commissions by private collectors would reflect the hope, regularly reiterated in the press, of a more lasting, public art venue. Probably the most significant single commission received by any New York painter after the death of Luman Reed and before the Civil War was the one agreed on in 1839 by Cole and Samuel Ward (1786–1839), a prominent New York banker. The contract for the series The Voyage of Life stipulated that "the four paintings are to be 6 or 7/4 or 5 feet wide and high and to be executed in the style of those by the same artist known as 'The Course of Empire.'" (The latter series had been ordered by Reed from Cole and was completed in 1836, shortly after the collector's death.)[19]

The theme of The Voyage of Life, 1839–40 (see figs. 49, 60), a man's struggle through life, guided by religion, had particular appeal for Ward, a deeply devout man whose faith had been tested some years before by the death of his much-beloved wife. His daughter Julia Ward Howe noted that her mother's death caused Ward such pain that he immediately sold his elegant, beautifully furnished house on Bowling Green. The new home that he subsequently built, at the corner of Broadway and Bond Street, was then somewhat removed from the city center;[20] there, the Ward family studied, read widely, and played and listened to music. Describing her father as "a man of fine tastes, inclined to generous and even lavish expenditure," Howe remarks that "he filled his art gallery with the finest pictures that money could command in the New York of that day."[21] Yet she also relates that, one day not long before he died, he was visited by the famous English writer and authority on European art Anna Jameson. Jameson "asked to see my father's pictures. Two of these, portraits of Charles First and his queen, were supposed to be by Van Dyck. Mrs. Jameson doubted this."[22] Perhaps Ward, too, was a victim of yet another dubious attribution and sale by Paff.

When Ward died, in 1839, the country was still reeling from the Panic of 1837, and complications relating to his affairs, mostly involving real estate properties, had left his legatees short of cash. It was not until early 1841, following rather difficult negotiations with Samuel Ward Jr., that Cole received payment for The Voyage of Life; after a very successful

public exhibition, the suite of pictures was sent to the Ward house.[23]

Sturges's dream of a permanent public art gallery and Ward's ambitious, large-scale collecting, perhaps with the same dream in mind, were also reflected in a proposal promulgated in 1835 by the Connecticut-born architect Ithiel Town (1784–1844), well known in New York as the senior partner of Alexander Jackson Davis. An inventive and immensely productive architect, Town patented in 1820 a highly successful new design for a bridge truss. From this he enjoyed income sufficient to allow him to travel twice to Europe, where he fed his insatiable appetite for books (mostly on art and architecture), engravings, paintings, sculpture, coins, armor, and antiquities.[24] Town's proposal bore the imposing title *The Outlines of a Plan for Establishing in New-York an Academy and Institution of the Fine Arts, on Such a Scale as Is Required by the Importance of the Subject, and the Wants of a Great and Growing City, the Constant Resort of an Immense Number of Strangers from All Parts of the World. The Result of Some Thoughts on a Favourite Subject.* In it, Town suggested that shares be sold in a stock company that would operate a bipartite organization composed of an academy run by artists and an art gallery governed by the stockholders.[25]

Town's concept was a generous expansion of the ideas embodied in the National Academy, of which he had been a cofounder a decade earlier. His specific and lengthy recommendations covered every aspect of financing, organization, and governance. As to the collections, they were to consist of

> sculptures, bass-reliefs [sic], and paintings, ancient and modern; an extensive library of books relating to the fine arts, books of engravings, and engravings of history and mythology, portraits, etc.; coins and medals, ancient and modern; models of architecture, ancient and modern; drawings of all kinds; specimens and relics of antiquity of all kinds, such as vases, candelabra, ancient armour, etc.; specimens and objects of natural history; also, curious specimens of the mechanic's and manufacturer's arts; models of curious and useful inventions and improvements, especially such articles of improvements as relate to the fine arts, either directly or more remotely;—all of which to be obtained from time to time by the president and board of control, and arranged by them in the several buildings constructed and fitted up for the purpose.[26]

While this passage has not been documented as a blueprint for the organization in 1852 of London's

19. Ellwood C. Parry III, *The Art of Thomas Cole: Ambition and Imagination* (Newark: University of Delaware, 1988), p. 226.
20. Julia Ward Howe, *Reminiscences, 1819–1899* (Boston and New York: Houghton Mifflin and Company, 1899) p. 12.
21. Ibid., p. 46.
22. Ibid., p. 41.
23. Parry, *Art of Cole*, p. 259.
24. Jack Quinan, "Town, Ithiel," in *The Dictionary of Art*, edited by Jane Turner (New York: Grove, 1996), vol. 31, pp. 231–32.
25. Ithiel Town, *The Outlines of a Plan for Establishing in New-York an Academy and Institution of the Fine Arts . . .* (New York: George F. Hopkins and Son, 1835), passim.
26. Ibid., p. 11.

Victoria and Albert Museum or in 1870 of the Metropolitan Museum, its congruence with both museums' founding plans is remarkable. A good idea was clearly in the air.

In 1836 Town removed to New Haven, where he had maintained a part-time residence for years. Three years later, the Hartford writer Lydia H. Sigourney, an extraordinarily prolific author of unremarkable prose and poetry, published a description of Town's New Haven library, housed in a classic double-cube room in his residence on Hillhouse Avenue:

In the second story, is a spacious apartment, forty-five feet in length, twenty-three in breadth, and twenty-two in heighth, with two sky-lights, six feet square. . . . There, and in the lobbies, and study, are arranged, in Egyptian, Grecian and Gothic cases, of fine symmetry, between nine and ten thousand volumes. Many of these are rare, expensive, and valuable. More than three fourths are folios and quartos. A great proportion are adorned with engravings. It is not easy to compute the number of these embellishments—though the proprietor supposes them to exceed two hundred thousand. There are also some twenty or twenty-five thousand separate engravings—some of them splendid executions of the best masters, both ancient and modern. In these particulars, this library surpasses all others in our country. There are also one hundred and seventy oil paintings, besides mosaics, and other works of art, and objects of curiosity.[27]

In 1842 Town returned to New York City, where, after his death two years later, his collection was dispersed in a series of large auction sales.

Town's partner, Davis (1803–1892), was a noted collector of prints, which, because they were relatively inexpensive and easy to store and transport, offered an attractive basis for the formation of a large collection. As early as 1831 Davis bought four etchings of Roman scenes by Piranesi, and in 1844 he began to acquire aggressively at New York print auctions, including the posthumous sales of Town's collection. Davis ultimately brought together a very large holding of prints, numbering in the several hundreds, many of which are now in the Department of Drawings and Prints of the Metropolitan Museum. Most of the prints depicted architectural subjects, but there were also many reproductions of paintings (by artists such as Poussin, Rubens, Coypel, West, and Trumbull), as well as landscapes, religious, literary, and historical scenes, and portraits of famous people. These print materials, buttressed by numerous books and

the architect's own drawings and sketches, formed a distinguished library, typical of the best of such American collections in the pre–Civil War years.

Another avid collector of engravings was John Allan (1777–1863), a native of Scotland who had immigrated to New York as a teenager. While pursuing a modest career as a bookkeeper, commission agent, and rent collector, Allan also assembled an extensive library and a substantial art collection. In 1864 the well-known bibliographer and bookseller Joseph Sabin prefaced the 330-page catalogue of Allan's posthumous sale with this notice: "The Collection . . . was at once the pride, the pleasure, and the occupation of its late venerable owner for upwards of half a century, and is of so varied and interesting a character as to warrant some few remarks upon its leading specialties."[28] Among the "specialties" provided in Sabin's table of contents are books, autograph letters, engravings, watercolors and drawings, oil paintings, coins and medals, snuffboxes, seals, watches, silver plate, antique china, bronzes, arms and armor, and antiquities.

Books occupied the largest section of Sabin's catalogue, but the next largest (some twenty-six pages) was given over to 638 lots of engravings, containing more than eleven thousand individual images. Most of these were merely reproductions, "well suited to the taste of some 'Illustrator,'"[29] as Sabin commented. Since almost every lot heaped together batches of prints under a general description, it is almost impossible to identify the individual works or to determine their quality. Occasionally individual prints are listed, as, for example, Durand's engraving *Musidora*, which depicts a scene from James Thomson's poem *The Seasons* (fig. 61).

Reproductive prints, which had great value to those interested in the visual arts at a time long before art books became common, were also featured in the collection of Edward Brush Corwin (d. 1856). On November 10, 1856, Sabin published his hefty catalogue of Corwin's library and collection, with a title page listing the contents of the collector's bulging shelves: "[A] rare, curious, and valuable collection of books, tracts, autographs, Mss., engravings, paintings, &c. . . . Comprehending an immense assemblage of books in almost every department of literature . . . illustrated books, bibles, and biblical literature, old theology and sermons, history and biography, and books relating to America, Mss., autographs, &c., also, line and mezzotint engravings, oil paintings, &c., &c."[30] After reviewing the thousands of books, Sabin commented on the engravings, which were given a large, separate section of their own. He noted that Corwin "had

27. Lydia H. Sigourney, "Residence of Ithiel Town, Esq.," *Ladies' Companion* 10 (January 1839), pp. 123–26; see also Parry, *Art of Cole*, p. 245.

28. Joseph Sabin, *A Catalogue of the Books, Autographs, Engravings, and Miscellaneous Articles Belonging to the Estate of the Late John Allan* (sale cat., New York, 1864), p. iii. I am grateful to Elliot Bostwick Davis, Assistant Curator, Department of American Paintings and Sculpture, Metropolitan Museum, and Georgia Barnhill, Andrew W. Mellon Curator of Graphic Arts, American Antiquarian Society, Worcester, Massachusetts, for information on print collectors, especially that found in Barnhill's lecture "Print Collecting in New York to the Civil War," delivered in April 1986 at the National Academy of Design.

29. Sabin, *Catalogue of Estate of John Allan*, p. v.

30. Joseph Sabin, *Catalogue of the . . . Collection of . . . the Late Mr. E. B. Corwin* (sale cat., New York: Bangs, Brother and Co., November 10, 1856), title page.

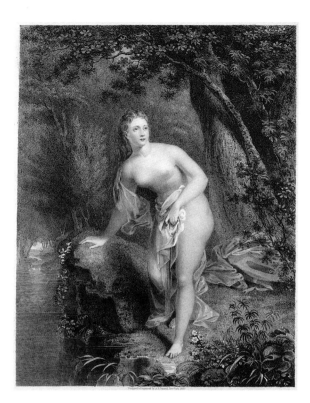

Fig. 61. Asher B. Durand, *Musidora*, 1825. Engraving. The Metropolitan Museum of Art, New York, Gift of Mrs. Frederic F. Durand, 1930 30.15.1

some practical acquaintance with the art [of engraving], and particularly a keen perception of all those niceties which distinguish a good from a poor impression of a print; and noticeable among the numerous examples of art, will be very fine specimens of

Bartolozzi, Sharp, Woollett, Wille, Finden, among European artists; while of American subjects there are many of the choicest productions of the burin."[31] Over twelve hundred engravings are cited, 145 of which, by Francesco Bartolozzi, recorded the compositions of other artists.

Another collection rich in engravings, but assembled for working purposes, was that of Durand (1796–1886), the grand old man of New York's art world. Durand had pursued a varied career, first as a young engraver, then as a portrait and genre painter, and finally as an august landscape painter. It is fair to assume that his collection was formed mostly before the Civil War, when he produced many landscapes under the influence of Turner. His estate sale, held consecutively on April 13 and 14, 1887, contained his own numerous oil studies, "a choice collection of Fine Illustrated Art Books,"[32] and an immense collection of engravings, some his own originals, many others after Turner, and some reproducing works by artists such as Bartolozzi, Raffaello Morghen, William Sharp, and Robert Strange.

Like many other artists, John M. Falconer (1820–1903) formed a sizable collection of paintings, watercolors, and engravings that he used as models for his work. Falconer was a native of Edinburgh who came to New York in 1848 and built a career as an etcher and a painter of portraits, genre subjects, and landscapes. During the 1850s he corresponded regularly with Mount, who shared with him an interest in prints after the genre pictures of David Wilkie. The

31. Ibid., p. vii.
32. *Executor's Sale: Studies in Oil by Asher B. Durand, N.A., Deceased, Engravings by Durand . . . and Others* (sale cat., New York: Ortgies' and Co., April 13, 14, 1887).

Fig. 62. James A. Suydam, *Paradise Rocks*, Newport, 1865. Oil on canvas. National Academy of Design, New York, Bequest of James A. Suydam

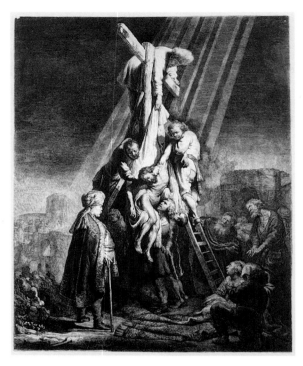

Fig. 63. Rembrandt van Rijn, *The Descent from the Cross:
The Second Plate.* The Netherlands, 1633. Etching and burin.
The Metropolitan Museum of Art, New York, Gift of
Henry Walters, 1917 17.37.69

33. Anderson Auction Company,
*Catalogue of the Interesting and
Valuable Collection of Oil Paint-
ings, Water-Colors and Engrav-
ings Formed by the Late John M.
Falconer* (sale cat., New York,
April 28, 29, 1904), passim.

34. *The Diary of George Templeton
Strong,* edited by Allan Nevins
and Milton Halsey Thomas
(New York: Macmillan Com-
pany, 1952), vol. 4, p. 34, entry
for September 16, 1865.

35. Bangs, Merwin and Co., *Cata-
logue of a Choice Private Library.
Being the Collection of the
Late Mr. James A. Suydam*
(sale cat., New York, Novem-
ber 22, 23, 1865).

36. David Dearinger, "James Augus-
tus Suydam," in *Catalogue of the
Permanent Collection of Paint-
ings and Sculpture of the
National Academy of Design,*
edited by Abigail Booth Gerdts
(New York: Hudson Hills
Press, forthcoming).

37. Eliot C. Clark, *History of the
National Academy of Design,
1825–1953* (New York: Columbia
University Press, 1954), p. 86.

38. *Boston Transcript,* May 2, 1896.

39. J. R. W. Hitchcock, *Etching
in America* (New York: White,
Stokes, and Allen, 1886), p. 49.

auction catalogue of Falconer's collection, issued in
1904, listed almost 350 prints, including dozens by
Durand, five by Rembrandt, and twelve each by
Turner and Wilkie.[33]

James A. Suydam (1819–1865), member of an old
New York Dutch family, enjoyed an inheritance, aug-
mented by his own business successes, that allowed
him to retire early to study painting as an amateur and
to travel abroad. A member of the Century Associa-
tion since 1849, Suydam was a popular figure in New
York's art world, although his landscape paintings
were not by any means unconventional (fig. 62). After
his death, on September 16, 1865, George Temple-
ton Strong recorded this acerbic opinion of the man
and his art: "Poor Jem Suydam dead of dysentery at
North Conway. . . . He devoted himself to landscape
art some years ago, first as amateur and then profes-
sionally, and was represented at every academy by pic-
tures that embodied no sentiment of any kind, but
that shewed he had made himself a very good painter.
An excellent fellow, with a streak of the Dutchiness
that belongs to his race."[34]

The catalogue of the posthumous sale of Suydam's
library, drawings, and engravings lists more than one
hundred original and reproductive prints; featured
are works by old masters such as Rembrandt, Dürer,
Ostade, and Raphael and contemporaries including
Rosa Bonheur, Ary Scheffer, and George Caleb Bing-
ham.[35] The Department of Drawings and Prints of
the Metropolitan Museum houses several dozen
Rembrandt etchings from the collection, including
multiple copies of *The Adoration of the Shepherds,
The Raising of Lazarus,* and *The Descent from the
Cross* (fig. 63). Most important to Suydam's lasting
good name was his generous bequest of $50,000 to
the National Academy, along with his collection of
ninety-two paintings by contemporary American and
European artists.[36] The pictures, including splendid
examples by Frederic E. Church, John F. Kensett,
Charles-Édouard Frère, and Andreas Achenbach, were
appraised by the Academy at $12,821.[37]

From the perspective of long-range importance to
American public collections, probably the greatest
group of prints assembled in New York City before
the Civil War was that belonging to Henry Foster
Sewall (1816–1896). Sewall, born in New York City,
was a descendant of Samuel Sewall, chief justice of
Massachusetts in the early eighteenth century, and was
associated with the New York shipping firm of Grin-
nell, Minturn and Company, owners of the great clip-
per *Flying Cloud.* He began to collect in 1847, bought
a few prints (by Durand, Dürer, and Rembrandt) at
the Corwin sale in 1856, and, according to his obitu-
ary in the *Boston Transcript,* "left one of the finest
collections of early prints in the world, outside of
the public art museums of England, France and Ger-
many."[38] Because of his business, Sewall was well
placed to involve himself directly and beneficially in
the European print market. As J. R. W. Hitchcock
pointed out in 1886, "he was, with the exception of a
Scotchman temporarily resident here, the only Amer-
ican correspondent of Edward Evans, then the chief
print-seller of London. The latter sent out by sailing-
vessels portfolios of prints from which Mr. Sewall
made his selections, thus beginning a collection chosen
with singular discrimination, and now famous among
print lovers."[39]

When Sewall's collection of approximately twenty-
three thousand prints was put on the market after his
death, the Museum of Fine Arts in Boston bought it
at the urging of Sylvester R. Koehler, the first curator
of the museum's Print Department. The funds for the
purchase came from the bequest of Harvey D. Parker,
proprietor of Boston's famous Parker House Hotel,
and thus the collection is named for him rather
than Sewall. The annual report of the trustees of the
museum, issued at the close of 1897, quoted Koehler's
perspicacious evaluation of the collection, the single

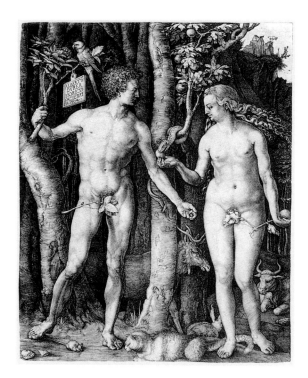

Fig. 64. Albrecht Dürer, *The Fall of Man (Adam and Eve)*, Germany, 1504. Engraving. Courtesy of the Museum of Fine Arts, Boston, Harvey D. Parker Collection P246

most remarkable acquisition of prints by an American art museum:

> *If Mr. Sewall had a penchant, it was for old prints, and the engravers, etc. of the 15th, 16th, 17th, and 18th centuries are therefore more fully represented in the collection he made than those of the 19th century, more especially those of the first half of it. This, however, is quite fortunate for the Museum, as in the prints heretofore acquired by it, mostly by gift, the prints last alluded to very decidedly preponderate. The richness of the collection in Dürer [see fig. 64] and Rembrandt is sufficiently evidenced by the exhibition which opened to-day, and its wealth in other departments,—old Germans, old Netherlanders, old Italians, followers of Rembrandt, Ostade, French etchers of the 17th century (Claude, Callot, etc.), French portraits, and so on,—will be demonstrated by future exhibitions.*[40]

In the past half century, historians of American art during the antebellum period have emphasized both the development of the domestic school and the avidity with which American paintings and sculptures were acquired by collectors at home. This is understandable, since the rise of an indigenous school was indeed an exciting act of social will, a cultural tale that had not been retold properly since the 1880s.

However, as William G. Constable noted in 1963, it is also significant that, while men such as Reed and Sturges were forming their collections of American works, others were searching abroad—in Europe and farther afield—and bringing together intriguing groups of paintings, sculptures, antiquities, and decorative arts.[41] These would later have a considerable impact on fashions in American collecting, especially during the post–Civil War years, when domestic landscape, genre, and history painting fell from favor.

James C. Colles (1788–1883), a native of New Jersey, made his fortune in mercantile pursuits in New Orleans before retiring in 1840. By 1845 Colles and his family had spent three productive years collecting in Europe. For their new home at Tenth Street and University Place in New York, Colles had bought a group of "old master" paintings bearing dubious attributions (Raphael, del Sarto, Leonardo) as well as sculptures by Thomas Crawford, an American residing in Rome, and the Italian Lorenzo Bartolini. While in Amsterdam, in 1843, he had acquired various works of antiquarian interest, including many Buhl-work furnishings, for the New York residence. Most significant were his lavish purchases in Paris: clocks, lamps, mantel garnitures, Sevres porcelains, a large, specially ordered Aubusson carpet, and a drawing-room suite (see cat. no. 236A, B). In 1843 Colles commissioned a sofa, dressing table, and sideboard, among other pieces, from Auguste-Émile Ringuet-Leprince, then one of the most fashionable furniture makers and upholsterers in Paris; subsequently, as part of his voluminous correspondence with Leprince, he continued to order additional furnishings (see "'Gorgeous Articles of Furniture': Cabinetmaking in the Empire City," by Catherine Hoover Voorsanger in this publication, pp. 309–12).[42] As a showcase for European art treasures, and especially for contemporary French decorative arts, the Colles house set the standard for elegance and sophistication in New York.

Colles's son-in-law, John Taylor Johnston (1820–1893), was also a patron of Ringuet-Leprince and a distinguished collector of the work of contemporary artists. Trained as a lawyer at Yale, he made investments in New Jersey and Pennsylvania railroads that soon earned him a substantial fortune. Equally early in his career, in the 1840s, Johnston began to travel abroad, collecting modern paintings as he went, while also buying pictures from artists in New York. By 1870, when he was elected the first president of the newly established Metropolitan Museum of Art, Johnston had amassed the largest collection of contemporary paintings in New York City. At its largest,

40. Trustees of the [Boston] Museum of Fine Arts, *Twenty-second Annual Report, for the Year Ending December 31, 1897* (Boston, 1898), pp. 12–13.

41. William G. Constable, *Art Collecting in the United States of America* (Edinburgh: Thomas Nelson and Sons; Paris: Société Française d'Éditions Nelson, 1963), p. 27.

42. Emily Johnston de Forest, *James Colles, 1788–1883, Life and Letters* (New York: Privately printed, 1926), passim.

Fig. 65. J. M. W. Turner, *Slave Ship*, England, 1840. Oil on canvas. Courtesy of the Museum of Fine Arts, Boston, Henry Lillie Pierce Fund 99.22

43. See Caroline Williams, "The Place of the New-York Historical Society in the Growth of American Interest in Egyptology," *New-York Historical Society Quarterly Bulletin* 4 (April 1920), pp. 3–20; and John D. Cooney, "Acquisition of the Abbott Collection," *Brooklyn Museum Bulletin* 10 (spring 1949), pp. 16–23.

just before its dispersal at auction in 1876 to raise capital for Johnston's railroad interests, the collection contained more than 100 American works (mostly oils but also several dozen drawings and watercolors) and about 210 from Europe (more than half of which were oils). American masterworks abounded, among them Church's *Twilight in the Wilderness*, 1860 (Cleveland Museum of Art), and *Niagara*, 1857 (fig. 50); Cole's series The Voyage of Life, 1839–40 (formerly in the Ward collection; see figs. 49, 60), and *The Mountain Ford*, 1846 (Metropolitan Museum); Winslow Homer's *Prisoners from the Front*, 1866 (Metropolitan Museum); and Turner's *Slave Ship*, 1840 (fig. 65). The familiar European names are too numerous to mention in full: Meissonier, Isabey, Corot, Bouguereau, Gérôme, and Delacroix are but a few.

Dr. Henry Abbott (1812–1859), British by birth and a New Yorker by occasional residence, was the first in the United States to form an important collection of Egyptian antiquities.[43] Abbott spent the years 1832 to 1852 in Cairo, eventually acquiring more than two thousand ancient Egyptian artifacts. He brought about half of these to New York in 1852, with the aim of selling the entire group to any institution for $60,000 ($40,000 less than the value he placed on it). At the same time, Abbott hoped to turn a profit by exhibiting the collection at the Stuyvesant Institute for an entrance fee of 50 cents a person. The collection remained on view, and available for purchase, after Abbott returned to Cairo in 1854.

Nothing happened until rumors cropped up that the group was being offered for sale in Europe. With that as a goad, shortly before Abbott's death in March 1859, a group of trustees of the New-York Historical Society, led by William C. Prime, raised $55,000 for the purchase, an amount that was apparently

acceptable to Abbott. Late in June 1860, while details of the purchase agreement were still being worked out with his estate, *Frank Leslie's Illustrated Newspaper* wrote the following:

> We rejoice that the Historical Society have received this noble collection, the only one in the country really deserving the name of a museum in the higher sense of the word. Let us trust that in time other museums, illustrating other races, may be added to it, until finally New York shall boast an institution which will make her the first city in the world at which the scholar and the artist may acquire practical knowledge of the past, and be thereby qualified to criticise correctly and erect a soundly based standard of judgment on men, works of literature and art. The first step has been taken; let us trust that the intelligence and liberality of our citizens will accomplish the rest.[44]

The collection was finally acquired officially by the Society on December 31, 1860, but not until *Harper's Weekly* had robustly browbeaten New York for its laggard behavior in not purchasing the collection sooner:

> That little city [Boston] does not call herself a metropolis, but somehow these things have a metropolitan air. Shall we not march with her, side by side, in these good works? The largest ships—the most spacious warehouses—the most "palatial residences"—the most expensive balls—the most unblushing and enormous taxes—the utmost civic corruption—are not, alone, enough to make a great metropolis. What renown the little Tuscan city of Florence has in history! It was not because the Medici were merchant princes. It was because the traders were not content that their city should be a shop, and so made it a museum, a library, a gallery—and collected in it, so far as they could, the choicest results of human genius in every department.[45]

The greatest assemblage of Egyptian antiquities in the United States until early in the twentieth century, the Abbott collection was transferred on long-term loan to the Brooklyn Museum in 1937.[46] It was purchased for Brooklyn's permanent collection in 1948, using the Wilbour Fund, and remains the most important group acquisition of Egyptian objects in the history of the museum (see fig. 66).[47]

Prime (1825–1905; fig. 67), who was instrumental in the initial purchase of the Abbott collection, was a distinguished collector, scholar, and author who also counted Egyptian art among his many interests. The son of a Presbyterian minister and country-school headmaster, he was born in relatively modest circumstances in a small upstate New York village. He graduated from Princeton in 1843, studied law, and began to practice in New York City in 1846. In 1851 he married Mary Trumbull (d. 1872) of Stonington, Connecticut, and thereafter the couple collected as a pioneering team, acquiring in a wide range of media: pottery, porcelain, and European woodcuts in particular but also coins, medals, and seals. In 1855 they made their first trip to Egypt and began to collect ancient Egyptian artifacts. In 1857 Prime published two books that reflect the couple's religious and scholarly interests: *Tent Life in the Holy Land* and

44. "The Abbott Egyptian Museum," *Frank Leslie's Illustrated Newspaper,* June 30, 1860, p. 83.
45. "The Lounger. A Metropolitan Meditation," *Harper's Weekly,* April 23, 1859, p. 259.
46. Cooney, "Acquisition of Abbott Collection," p. 17.
47. Ibid., p. 22.

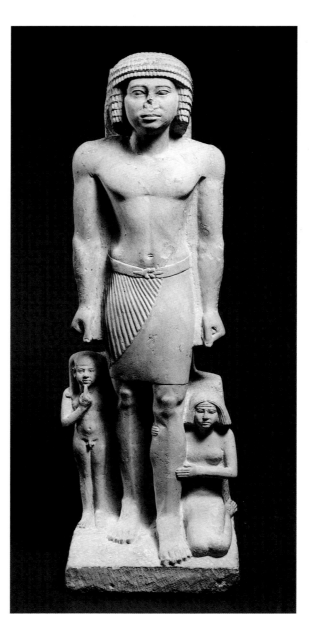

Fig. 66. *Family Group, Possibly Iru-Ka-Ptah and His Family,* Egypt (reportedly from Saqqara), Old Kingdom, Fifth Dynasty, ca. 2240–2200 B.C. Painted limestone. Brooklyn Museum of Art, Charles Edwin Wilbour Fund 37.17E

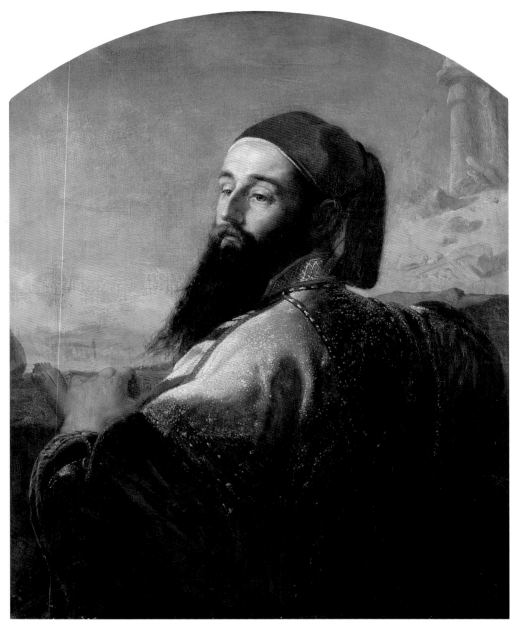

Fig. 67. Fridolin Schlegel, *William Cowper Prime*, 1857. Oil on canvas. Collection of The New-York Historical Society, Gift of Benjamin L. Prime, his great-grandson 1953.188

48. William C. Prime, *Coins, Medals, and Seals, Ancient and Modern* . . . (New York: Harper and Brothers, 1861).

49. William C. Prime, *The Little Passion of Albert Durer* (New York: J. W. Bouton, 1868).

Boat Life in Egypt and Nubia. Four years later he left the practice of law to become a full-time journalist and writer, publishing *Coins, Medals, and Seals, Ancient and Modern*, which confirmed the scholarly seriousness of his and his wife's collecting.[48] Prime had an abiding interest in early European prints, particularly those with religious themes, and in 1868 he published one of the earliest books of facsimilies after Dürer's work issued in this country.[49]

Prime was also a powerful early figure behind the growth of art museums and art education in the United States. Deeply involved in the establishment of the Metropolitan Museum, he served as an original trustee and later as a vice president before he resigned

in 1891 to protest the opening of the museum on Sundays. In 1884 he was named the first professor of art history at Princeton, to which he and his wife bequeathed their collection. The couple's view of art collecting is stated in Prime's *Pottery and Porcelain of All Times and Nations* (1878), an important early discussion of the subject in America:

> *Every man and woman should have a hobby. . . .*
> *No pleasure is more profitable than that found in*
> *surrounding one's daily life with works of the Great*
> *Artist or of man, arranged and classified in such*
> *way as to please the eye, afford instruction, or form*
> *material for intelligent study and examination.*

The refining influences which attend the formation of such collections are ample reward for time, labor, and money expended on them, if there were no other compensation.[50]

Among the wealthiest and most insightful of the collectors with wide-ranging interests was James Lenox (1800–1880), the founder of the Lenox Library, today an essential constituent of the New York Public Library's Astor, Lenox, and Tilden Foundations. To some, Lenox is best known as the starchy Presbyterian philanthropist who formed the largest private collection of Bibles in the nation, including the first Gutenberg Bible brought to America. Yet his scope and impact as an art collector were far broader, dating from his early years, when, as a young man of fortune, he traveled widely in Europe and began to collect with a catholic taste. Despite his predictable beginnings in partnership with his financially astute father, Robert, a merchant and real estate investor, James's "mind was rather on music, gems, engravings, paintings, fine arts and literature, than on merchandize."[51] Soon after his father's death in 1839, the very wealthy James retired from business to study, to collect, and to pursue philanthropic activities—all in an exceedingly private way.[52] He bought secretly, shared his treasures with a limited circle of friends, and quietly gave large sums of money to numerous charities.

Incorporated in 1870, the Lenox Library was located on Fifth Avenue between Seventieth and Seventy-first Streets and was housed in a building that Lenox commissioned from Richard Morris Hunt (today, the Frick Collection occupies the site). Over the next decade Lenox showered his library with treasures, many of which were paintings from his residence at 53 Fifth Avenue. These were largely by contemporary English and American artists, with a considerable sprinkling of French, German, and Netherlandish examples. Among the English artists included were Constable, Gainsborough, Raeburn, Reynolds, and Turner; some of the Americans were Church, Cole, Morse, Copley, Leslie (who, resident in England, was a regular adviser to Lenox), Daniel Huntington, and Henry Inman.

In his biography of Lenox, Henry Stevens recorded how, in 1845, Leslie acted on behalf of Lenox in negotiations with a surly Turner for the purchase of one of the master's great works, *Staffa, Fingal's Cave*, 1832 (cat. no. 49). Lenox did not care for the picture when he first received it and complained by letter to Leslie. Shortly thereafter he wrote again, repenting: "Burn my last letter, I have now looked *into* my 'Turner' and it is all that I could desire. Accept best thanks."[53]

Fingal's Cave, a memorable study of water, mist, clouds, smoke, and light, shared Lenox's walls with Church's *Cotopaxi*, 1862 (Detroit Institute of Arts), which is among the finest studies of similar effects by an American painter.

Lenox's philanthropic and wide-reaching vision is exemplified by his purchase, for $3,000, of the so-called Nineveh Marbles (fig. 68). This massive group of alabaster bas-reliefs, dating to about 870 B.C., was described by Stevens as "13 slabs [twelve, in fact], about a foot thick . . . generally about 7½ feet high, and averaging 6 feet in width, the whole, ranged side by side, measuring 72 feet 2 inches."[54] Despite their then popular name, the slabs actually came from the northwest palace of Ashurnasirpal II at Nimrud, located some twenty miles south of Nineveh. The quest for Assyrian antiquities such as these had begun in the 1840s, as French and English excavators (most notably, Austen Henry Layard) worked digs at Nineveh and Nimrud. By the late 1840s both the Louvre and the British Museum had impressive displays of

50. William C. Prime, *Pottery and Porcelain of All Times and Nations with Tables of Factory and Artists' Marks for the Use of Collectors* (New York: Harper and Brothers, 1878), p. 17.

51. Henry Stevens, *Recollections of James Lenox and the Formation of His Library*, edited by Victor H. Paltsits (New York: New York Public Library, 1951), p. 4.

52. It is characteristic of Lenox that he is said to have directed on his deathbed that "no particulars of his early life and career should be given for publication." *New-York Times*, February 19, 1880.

53. Stevens, *Recollections of James Lenox*, pp. 40–43.

54. Ibid., pp. 95–96.

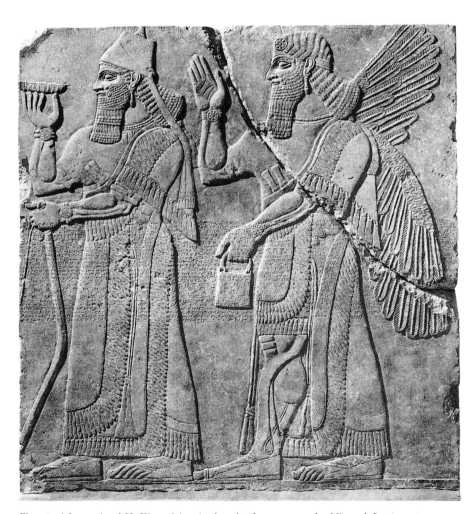

Fig. 68. *Ashurnasirpal II, King of Assyria*, Assyria (from present-day Nimrud, Iraq), ca. 870 B.C. Alabastrous limestone. Brooklyn Museum of Art, Gift of Hagop Kevorkian 55.155

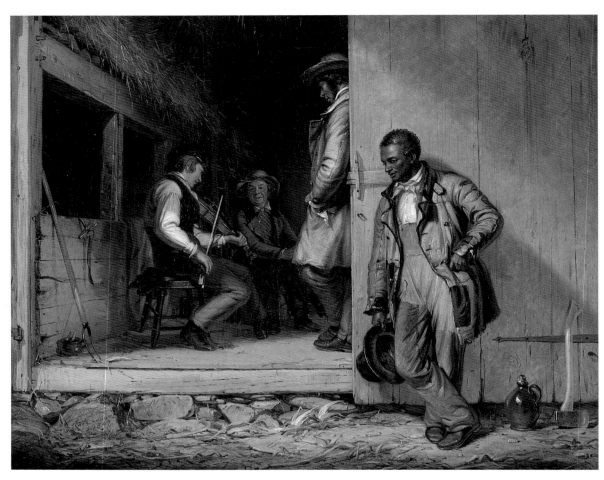

Fig. 69. William Sidney Mount, *The Power of Music*, 1847. Oil on canvas. The Cleveland Museum of Art, Leonard C. Hanna, Jr. Fund 1991.110

55. For a full history of the Lenox marbles, see Robert H. Dyson Jr., "A Gift of Nimrud Sculptures," *Brooklyn Museum Bulletin* 18 (spring 1957), pp. 1–13. I am grateful to Richard Fazzini, Curator of Egyptian, Classical, and Middle Eastern Art, Brooklyn Museum of Art, for this reference.

56. R. W. G. Vail, *Knickerbocker Birthday: A Sesqui-Centennial History of the New-York Historical Society, 1804–1954* (New York: New-York Historical Society, 1954), p. 109.

57. *The Crayon* 3 (January 1856), pp. 27–28 (Wolfe); (February 1856), pp. 57–58 (Sturges); (April 1856), p. 123 (Cozzens); (June 1856), p. 186 (Leupp); (August 1856), p. 249 (Roberts); (December 1856), p. 374 (Magoon).

Assyrian materials on exhibit. When the Nineveh Marbles were shopped around the international art market by several English entrepreneurs in 1853, they were deemed by both museums to be unnecessary additions to their collections. After they were also rejected by potential buyers in Boston in 1858, Lenox acquired them for immediate gift to the New-York Historical Society. So heavy that they had to be kept in the basements of the two buildings afterward occupied by the Society, the marbles (known as the Lenox Collection of Nineveh Sculptures) were placed on long-term loan at the Brooklyn Museum in 1937, when the Society changed its collection policy; in 1955 the museum purchased the pieces with help from the Hagop Kevorkian Foundation.[55]

Despite the subsequent history of the marbles, Lenox's gift to the Society was of remarkable museological importance, as the Society's director, R. W. G. Vail, recalled in 1954: "These splendid works of ancient art, the only others from the same site being in the British Museum and the Louvre, added greatly to the prestige and interest of the Society's art gallery during the period when we took the entire field of art history for our province."[56] On view today at the Brooklyn Museum, they are still regarded as one of the finest sets of Assyrian reliefs in the United States. And, although the Lenox Library no longer exists as a separate organization and Lenox's art collection has been dispersed, he still remains one of the greatest and most influential of New York's early collectors.

From January through December 1856 *The Crayon* published a series of articles, entitled "Our Private Collections," that briefly described six New York City art collections.[57] In addition to Sturges, the collectors discussed were John Wolfe, the Reverend Elias L. Magoon, Charles M. Leupp, Abraham M. Cozzens, and Marshall O. Roberts. This selection was presumably meant to highlight the city's most important private assemblages of art, which, *The Crayon* noted, were largely unknown to the public. What is most obvious in reviewing the characterizations of these collections is how examples of contemporary European art were becoming nearly as numerous in them as works by living Americans (the latter were almost

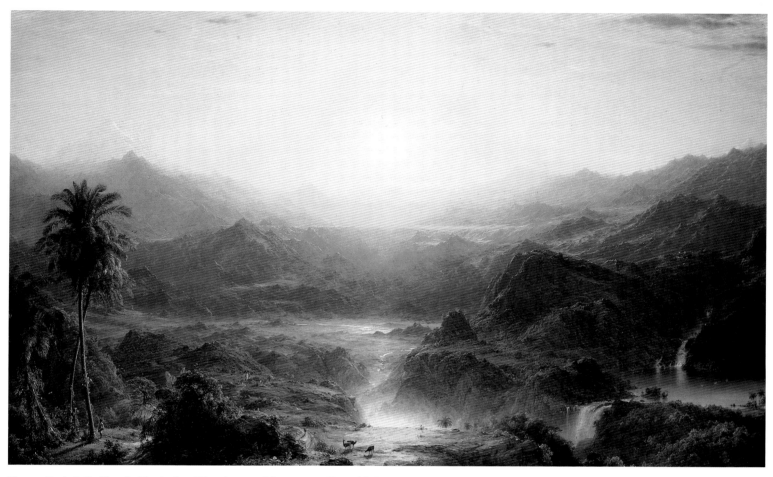

Fig. 70. Frederic E. Church, *The Andes of Ecuador,* 1855. Oil on canvas. Reynolda House, Museum of American Art, Winston-Salem, North Carolina 1966.12.21.01

all by artists active in New York). Wolfe (ca. 1821–1894), for instance, who later advised his cousin Catharine Lorillard Wolfe (1828–1887) on the formation of her European collection, concentrated almost wholly on nineteenth-century English, French, Flemish, and German (especially Düsseldorf School) paintings. The names of Leslie, Clarkson Stanfield, Delacroix, Alexandre Calame, Barend Cornelius Koekkoek, Andreas Schelfhout, Johann Peter Hasenclever, and Ferdinand Georg Waldmüller stand out prominently in Wolfe's listing, dwarfing his holdings of a few pictures by the Americans Durand, John Thomas Peele, and Thomas Hewes Hinckley.

The large collection acquired by Magoon (1810–1886), parts of which were later foundation blocks for the collections of Vassar College and the Metropolitan Museum, focused on contemporary sketches, watercolors, and oils from both Europe and America. Magoon, who must have been an annoying presence on the art scene, regularly coaxed pictures at low prices from almost every important painter in midcentury New York, including Church, Jasper F.

Cropsey, Thomas Doughty, Durand, Eastman Johnson, Kensett, Louis Lang, Mount, Robert Walter Weir, and William Trost Richards. From among Magoon's large holdings of English and European works *The Crayon* singled out those depicting "monumental antiquities" and noted that "through extraordinary success in that specialty [he] has acquired, probably, the best collection in America."[58] His group of five drawings by Turner was apparently also remarkable. The fact that Magoon made his treasures available for study was recognized by *The Crayon* as an important contribution to New York's art milieu: "Artists and Amateurs are much indebted to his enthusiasm for these foreign contributions to the Art-treasures of our city, and certainly to his courtesy for the facilities afforded for their inspection."[59]

Leupp (1807–1859), a remarkably successful New York merchant who, like many of his contemporaries, had achieved wealth through hard work and sage investments, put together a superb group of American and European paintings and sculptures during the 1840s and 1850s. After Leupp's death

58. "Our Private Collections, No. VI [E. L. Magoon]," *The Crayon* 3 (December 1856), p. 374.
59. Ibid.

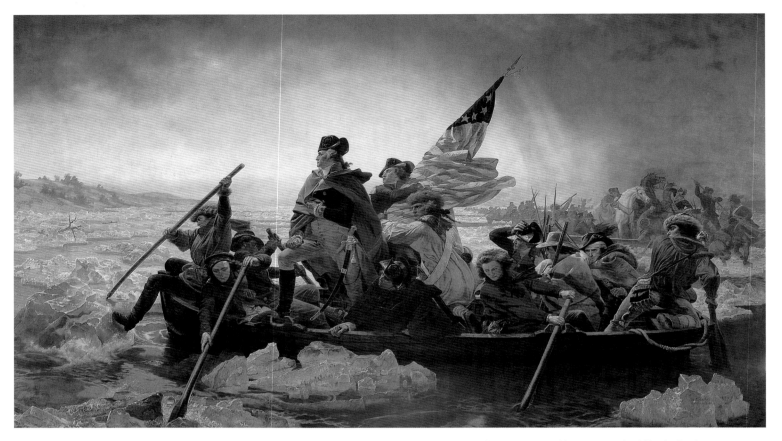

Fig. 71. Emanuel Leutze, *Washington Crossing the Delaware*, Germany, 1851. Oil on canvas. The Metropolitan Museum of Art, New York, Gift of John S. Kennedy, 1897 97.34

60. James T. Callow, "American Art in the Collection of Charles M. Leupp," *Antiques* 118 (November 1980), pp. 998–1009.

61. "Our Private Collections, No. III [A. M. Cozzens]," *The Crayon* 3 (April 1856), p. 123.

62. "Our Private Collections, No. IV [Marshall O. Roberts]," *The Crayon* 3 (August 1856), p. 249.

63. *Mr. Robert M. Olyphant's Collection of Paintings by American Artists . . .* (sale cat., New York: R. Somerville, December 18, 19, 1877).

by suicide, his collection—much admired then, as it would be today—was dispersed at auction on November 13, 1860. Among its American works were Cole's *Mountain Ford*, 1846, later owned by John Taylor Johnston (Metropolitan Museum), Emanuel Leutze's *Mrs. Schuyler Burning Her Wheat Fields on the Approach of the British*, 1852 (cat. no. 34), Mount's *Power of Music*, 1847 (fig. 69), and Henry Kirke Brown's forceful marble bust of William Cullen Bryant, 1846–47 (cat. no. 61).[60] Leupp's small group of European pictures contained paintings of cattle, genre scenes, landscapes, and a portrait each of Napoleon and Marat.

Of those named in *The Crayon* series, Sturges, Cozzens, and Roberts—along with Robert M. Olyphant and Robert L. Stuart—would probably have been deemed the most important by New York artists in the late 1850s, for these collectors were their major patrons.

Cozzens (1811–1868), a founding member of the Century Association, was active in managing the American Art-Union during the 1840s, serving as its president in 1850 and 1851; he was also a regular supporter of the National Academy. Always a steady friend of the city's artists, he had formed a collection

Fig. 72. John F. Kensett, *White Mountain Scenery*, 1859. Oil on canvas. Collection of The New-York Historical Society, on permanent loan from the New York Public Library, The Robert L. Stuart Collection, 1944

characterized by *The Crayon* as "conspicuous for the large proportion of American pictures it contains."[61] Especially noteworthy among the almost sixty contemporary American canvases were *The Andes of Ecuador,* 1855 (fig. 70), by Church; *The Beeches,* 1845 (Metropolitan Museum), by Durand; *Columbus before the Queen,* 1843 (Collection of Mrs. James H. Frier), by Leutze; and *The Microscope,* 1849 (Yale University Art Gallery, New Haven), by Robert Walter Weir.

Roberts (1814–1880) began his career humbly enough, as a ship's chandler, but he soon made an immense fortune in the shipping business (in association with William Henry Aspinwall) and in railroads. Thus possessing the means to support a youthfully acquired taste for pictures, he went on to assemble probably the largest holding of American paintings in the nation: in 1867 Tuckerman listed more than 110 such pictures belonging to Roberts. Although *The Crayon* had not recorded many of these in its 1856 article, it did comment on the collection's American focus and singled out Leutze's *Washington Crossing the Delaware,* 1851 (fig. 71), for special mention.[62] Roberts's sharp eye for quality continued to set an example for New York collectors for many years.

Olyphant (1824–1918) worked for his father in the China trade before achieving great success with the Delaware and Hudson Canal Company. He was an intimate friend of Kensett, who may have advised him in forming his collection of more than one hundred American paintings, recorded by Tuckerman in 1867. As early as 1854 Olyphant began buying pictures from Kensett and other New York artists, expressing a preference for genre scenes and landscapes. His collection grew to include works by Church, Cole, Cropsey, Sanford Robinson Gifford, William Stanley Haseltine, Eastman Johnson, Leutze, Arthur Fitzwilliam Tait, Elihu Vedder, and Worthington Whittredge. When Olyphant's collection was sold in 1877, the catalogue noted that many of the pictures had become well known through regular public exhibition, especially at the National Academy,[63] where the preauction display was mounted.

A highly successful sugar refiner, Stuart (1806–1882) formed an enormous collection of contemporary pictures, sculptures, and books. He began collecting in the 1850s, buying major works by American artists, notably Durand's *Franconia Notch,* 1857 (New York Public Library, on long-term loan to the New-York Historical Society), and Kensett's *White Mountain Scenery,* 1859 (fig. 72). Later he added perhaps his greatest acquisition, Johnson's *Negro Life at the South,* 1859

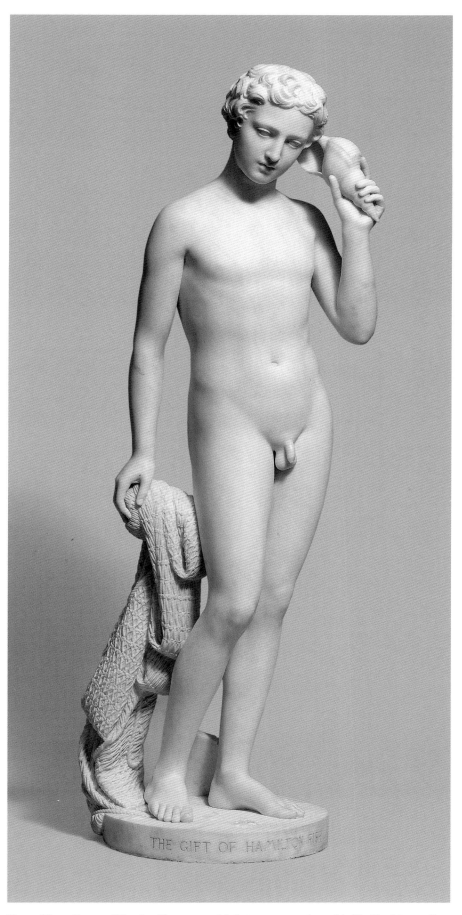

Fig. 73. Hiram Powers, *Fisher Boy,* Florence, modeled 1841–44; carved 1857. Marble. The Metropolitan Museum of Art, New York, Bequest of Hamilton Fish, 1894 94.91

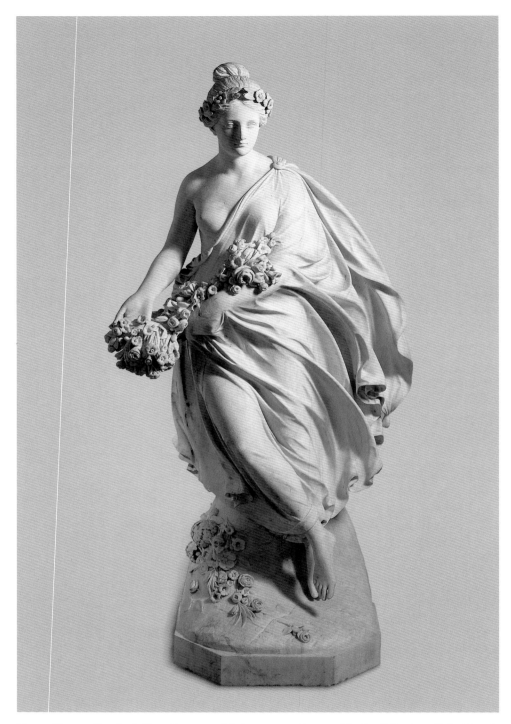

Fig. 74. Thomas Crawford, *Flora*, Rome, modeled 1847; carved by 1853. Marble. Collection of The Newark Museum, Newark, New Jersey, Gift of Franklin Murphy, Jr., 1926 26.2786

64. *Catalogue of Mrs. R. L. Stuart's Collection of Paintings* (New York: Privately printed, 1885).

(cat. no. 40). In the 1860s Stuart began acquiring European pictures by such artists as Bouguereau, Hugues Merle, Jules Breton, and Eugène Verboeckhoven. A catalogue of the collection prepared in 1885, after Stuart's death, listed 49 American artists and 112 Europeans;[64] some years later his wife gave the collection to the New York Public Library.

Several prewar collectors in New York had larger than usual holdings of American sculpture. First among these was Hamilton Fish (1808–1893), one of New York State's most prominent political figures, who had served successively as a member of Congress, the lieutenant governor and governor of New York, a United States senator and secretary of state. During the 1850s Fish was a very active patron of American sculptors, traveling with his family to Europe from 1857 to 1859 in order to cultivate his artistic taste. In all, Fish bought ten marbles by Erastus Dow Palmer,

seven by Hiram Powers, and one by Crawford.[65] He later bequeathed to the Metropolitan Museum Powers's *Fisher Boy,* 1841–44 (fig. 73); Palmer's *Indian Girl,* 1853–56 (fig. 125), and *White Captive,* 1857–58 (cat. no. 69); and Crawford's *Babes in the Wood,* ca. 1850 (fig. 114)—all extraordinary additions to the Museum's young collection of American sculpture.[66] Fish's interest in marble carving extended to mantelpieces, one of which (cat. no. 220) was produced for his New York house by the firm of Fisher and Bird.

Another New Yorker of the late antebellum period who had a considerable impact on the public display of privately owned sculpture was Richard K. Haight (1797–1862), who had commissioned Crawford's *Flora* (fig. 74) in 1849 and received it in 1853.[67] The same year, *Flora* was displayed at the Crystal Palace exhibition along with Powers's *Greek Slave,* a version of 1847 (cat. no. 60); both marbles have long been together in the collection of the Newark Museum. In August 1860 *The Crayon* reported a rumor that Haight intended to present *Flora* to "the Central Park" for display;[68] sometime afterward, the work was shown in the park, in the Arsenal on Fifth Avenue, along with eighty-seven plaster casts of other works by Crawford, donated by the artist's widow. In 1867 Tuckerman referred to these sculptures as being on view in the "Central Park Museum, N.Y." (the Arsenal), which may be credited as the first art museum within Central Park.[69] Later the collection was transferred to "the Mt. St. Vincent buildings at McGown's Pass [in Central Park, near the East Drive and 105th Street] . . . for use as a statuary gallery and museum."[70] These structures were destroyed by fire in 1881, along with some of the artworks, so it is not clear how *Flora* survived to join the collection of the Newark Museum.

As the sculpture collections of Fish and Haight were being made available to a wider audience, three other collectors—Thomas Jefferson Bryan, Aspinwall, and August Belmont—were themselves forming impressive quasi-public galleries of paintings. Bryan (1802–1870; fig. 75) was born in Philadelphia and, as the son of a wealthy partner of Astor, was able to indulge his taste for fine art early in life. In 1829, six years after graduating from Harvard College, Bryan began a sojourn in Paris that lasted until 1850, when he took up residence in New York City. During those two decades Bryan assembled a collection of 230 European paintings, including works by old masters from the Italian, Spanish, German, Dutch, Flemish, French, and English schools; he also acquired a number of American paintings. The quality and

Fig. 75. Thomas Sully, *Thomas Jefferson Bryan,* 1831. Oil on canvas. Collection of The New-York Historical Society, The John Jay Watson Fund 1960.26

importance of the works varied widely, and many of the rosy attributions made during Bryan's lifetime have been downgraded in subsequent years. Certain paintings are still highly regarded, however, for the collection did contain authentic works by masters such as Rembrandt, Rubens, Dürer, Giotto, Raphael, Scheggia (see cat. no. 42), Poussin, and Watteau.

After Bryan's offer to donate the collection to a public institution in Philadelphia was refused, he put it on long-term public view in New York, beginning in 1852 at 348 Broadway. Richard Grant White, the father of the architect Stanford White, was commissioned to prepare the accompanying *Catalogue of the Bryan Gallery of Christian Art, from the Earliest Masters to the Present Time.*[71] White described the gallery as having "in its historical character, an importance not possessed by any other ever opened to the public in this country. The rise and progress of each of the great schools . . . can be traced by characteristic productions of those schools, in all the stages of their development, which hang upon these walls."[72] He also pointed out an admirable characteristic of Bryan's undertaking: "It has been the aim of the proprietor to collect a gallery which should not only give pleasure to casual visitants, but afford efficient aid to the student of the history of Art."[73] White pussyfooted

65. David B. Dearinger, "American Neoclassic Sculptors and Their Private Patrons in Boston" (Ph.D. dissertation, City University of New York, 1993), vol. 2, p. 687.

66. Thayer Tolles, ed., *American Sculpture in The Metropolitan Museum of Art, Volume 1, A Catalogue of Works by Artists Born before 1865* (New York: The Metropolitan Museum of Art, 1999), pp. 64–66, 68–71.

67. For a detailed discussion of the commission, see Lauretta Dimmick, "A Catalogue of the Portrait Busts and Ideal Works of Thomas Crawford (1813?–1857), American Sculptor in Rome" (Ph.D. dissertation, University of Pittsburgh, 1986), pp. 448–62.

68. "Domestic Art Gossip," *The Crayon* 7 (August 1860), p. 231, cited in Dimmick, "Portrait Busts of Crawford."

69. Tuckerman, *Book of Artists,* p. 622.

70. Winifred E. Howe, *A History of The Metropolitan Museum of Art* (New York: The Metropolitan Museum of Art, 1913), p. 42.

71. See [Richard Grant White], *Catalogue of the Bryan Gallery of Christian Art, from the Earliest Masters to the Present Time* (New York: George F. Nesbitt and Co., 1852); and Richard Grant White, *Companion to the Bryan Gallery of Christian Art . . .* (New York: Baker, Godwin and Co., Printers, 1853).

72. White, *Companion to Bryan Gallery,* p. iv.

73. Ibid., p. ix.

Fig. 76. Bartolomé Esteban Murillo, *The Immaculate Conception*, Spain, ca. 1660–70. Oil on canvas. The Detroit Institute of Arts, Gift of James E. Scripps, 1989 89.70

triptychs, of angular saints and seraphs, of black Madonnas and obscure Bambinos, of such market and approved "primitives" as had never yet been shipped to our shores. . . . I doubt whether I proclaimed that it bored me—any more than I have ever noted till now that it made me begin badly with Christian art. I like to think that the collection consisted without abatement of frauds and "fakes" and that if those had been honest things my perception wouldn't so have slumbered; yet the principle of interest had been somehow compromised, and I think I have never since stood before a real Primitive, a primitive of the primitives, without having to shake off the grey mantle of that night.[75]

More recently, and more knowledgeably, Constable wrote of the collection (now at the New-York Historical Society) that though "there are no great masterpieces . . . there are many that are of much interest and considerable merit."[76]

Bryan's attempt to provide the people of New York with an art-historical survey of European and American painting—and, in fact, to establish something like a national gallery of art—was a generous, even revolutionary, one; the need for such a resource continued for many years, until the Metropolitan Museum began to build its paintings collections in later decades. Bryan offered his collection, augmented by more European and American paintings, to the Society in 1864; six years later, as he lay dying onboard a ship bound from France to New York, he stipulated in writing that his more recent acquisitions should be added to the gift (the size of the collection has subsequently been reduced through deaccessioning and sales). Although Bryan was not actually "the first art collector and connoisseur in New York City,"[77] he should be remembered for the resonating value of his ideals and public spirit.

In the mid-1850s Aspinwall (1807–1875), a New York merchant who had amassed a vast fortune as an importer, shipping magnate, and railroad investor, retired from daily involvement in business to devote himself to charitable affairs, travel, and art collecting. Taking up the latter interest with the same energy that had marked his previous entrepreneurial activities, Aspinwall traveled widely in Europe, where he made lavish purchases of art. By 1857 his acquisitions had begun to attract attention in New York. Of particular note was a large Murillo canvas titled *The Immaculate Conception*, ca. 1660–70 (fig. 76), which was remarked on in *The Crayon* before it went on exhibition at

74. Ibid., pp. iv–v.
75. Frederick W. Dupee, ed., *Henry James: Autobiography—A Small Boy and Others, Notes of a Son and Brother, The Middle Years* (Princeton: Princeton University Press, 1983), pp. 152–53.
76. Constable, *Art Collecting*, p. 29.
77. John E. Stillwell, "Thomas J. Bryan—The First Art Collector and Connoisseur in New York City," *New-York Historical Society Quarterly Bulletin* 1 (January 1918), pp. 103–5.

around the most problematic aspect of the collection by noting that "the author declines to express any opinion upon the authenticity of the many pictures here which bear some of the greatest names in art; but he wishes it to be understood that he does this solely on account of his entire want of confidence in his ability to speak with the least authority upon that subject."[74]

The gallery was not a great success and was subject to the sneers of many, including Henry James, who recalled his visit there as a boy:

Deep the disappointment, on my own part, I remember, at Bryan's Gallery of Christian Art. . . . It cast a chill, this collection of worm-eaten diptychs and

Williams, Stevens and Williams, a commercial gallery, in January 1858.[78] That exhibition was apparently just a convenient way station for the famous canvas, since by January 1859 construction had been completed on an art gallery added to Aspinwall's house on Tenth Street.

The house was originally designed about 1845 by the architect Frederick Diaper, an English immigrant who was also responsible for several banks on Wall Street and the New York Society Library building, erected in 1840. The new gallery, designed by James Renwick Jr., had a separate entry from the street, which facilitated the visits by the public that Aspinwall allowed several days a week. Its entrance corridor contained several dozen works of art, both paintings and sculptures, many of which bore attributions (to Leonardo, Pontormo, and Titian, for example) that today would probably seem overenthusiastic. Mixed in with these were more modern works attributed to Gainsborough, Lawrence, Romney, Scheffer, and Bertel Thorvaldsen, as well as pictures by the Americans Gilbert Stuart (a portrait of George Washington) and Richard Caton Woodville. Beyond, in a large room that combined gaslight with natural light (introduced through concealed openings in the ceiling), were hung eighty-five pictures arranged densely in multiple rows, as was characteristic of the time. The famous Murillo held pride of place on the east wall (fig. 77). Works attributed to European masters of the fifteenth through the nineteenth century—"school of Raphael" through Jacques-Raymond Brascassat—predominated, but there were also a few paintings by the New York artists Régis-François Gignoux, Hinckley, Huntington, Kensett, and Frederick R. Spencer, as well as by the expatriate American John Rollin Tilton. Adjacent was a small gallery, illuminated and installed in the same manner as the larger one, containing two dozen pictures, most of which were landscapes, seascapes, animal subjects, and genre scenes by northern painters of the seventeenth through the nineteenth century; among the American works found there was Church's *Beacon, off Mount Desert Island*, 1851 (fig. 78). The collection was explained in a printed catalogue provided by Aspinwall.[79]

The public greeted Aspinwall's gallery enthusiastically and soon had another reason to rejoice. At about the same time, Belmont's picture gallery was also opened to them for several days a week, free of charge for artists and art students. The banker Belmont (1816–1890) had first begun to build his fortune in the 1830s as the New York representative of the

Rothschild interests; he had formed his collection from 1853 to 1857, while serving as the American minister to The Hague. The collection was reviewed in *The Crayon* for January 1858, after its exhibition at the National Academy,[80] and was then installed in a gallery in Belmont's house.

Unlike Aspinwall, Belmont had bought only pictures by living European artists. Those he chose—painters such as Bonheur, Calame, Meissonier, Theodore Rousseau, Constant Troyon, Horace Vernet, Koekkoek, and Meyer von Bremen—were all eminently acceptable to current taste, which was then evolving in favor of European art as opposed to American. Commenting on the cosmopolitan nature of Belmont's collection, *The Crayon* noted that it

embraces master-pieces by many of the first artists of continental Europe, and it contains masterly Art. The pictures come to us from a land where Art is beyond price; where money fails to tempt Art from the hands of comparative poverty, where statues in honor of artists stand in the thorough-fares, where fêtes are held to rejoice over artistic success, and from a land where artists have represented the people. No wonder that the Art of continental Europe is, and always has been, the Art of the world, for Art there stands at the head of

78. "Domestic Art Gossip," *The Crayon* 4 (October 1857), p. 316.
79. *Descriptive Catalogue of the Pictures of the Gallery of W. H. Aspinwall, No. 99 Tenth Street, New-York* (n.p., 1860).
80. *The Crayon* 5 (January 1858), p. 23.

MR. ASPINWALL'S GALLERY—EAST END.

Fig. 77. *The East End of Aspinwall's Principal Gallery*. Wood engraving from *Harper's Weekly*, February 26, 1859, pp. 132–34. The Metropolitan Museum of Art, New York, The Irene Lewisohn Costume Reference Library

Fig. 78. Frederic E. Church, *Beacon, off Mount Desert Island*, 1851. Oil on canvas. Private collection

81. Ibid.
82. "Shall New York Have a Public Gallery of Paintings?" *Harper's Weekly*, February 19, 1859, p. 114.
83. Ibid.

popular thought and feeling in recognized fellow-ship with the greatest subjects of human interest—Law and Religion.[81]

The advent of Aspinwall's and Belmont's galleries elicited from *Harper's Weekly* the presumptuous proposal "that the owners of these galleries should, by their wills, bequeath them to the city. The reasons urged in favor of this suggestion are, first, the strong probability that, in a country of vicissitudes like this, no gallery of works of art can be expected to remain over two generations in the same family; secondly, the public advantage of having a great gallery of paintings in this city; and lastly, the uselessness, as a general rule, of galleries kept exclusively for private inspection."[82] Forging on in the same vein, *Harper's* discussed possible sources of funds needed to build such a gallery: "There are half a dozen men in New York who could afford to build, in the Central Park, an edifice for a city gallery. Mr. William B. Astor, for

instance, would no doubt be delighted to have such an opportunity of using his wealth to noble advantages, and transmitting his name to posterity side by side with his father's."[83]

The beginning of the Civil War, in April 1861, closed many chapters in American life. By the war's end, the nature of the artist's life—fully chronicled in 1867 by Tuckerman's *Book of the Artists, American Artist Life*—had completely changed. Most noticeable was a radical shift in the taste of collectors, away from Hudson River landscapes and ideal marble figures toward the more painterly, realistic, and worldly works being created across the Atlantic, especially in the ateliers of France, Germany, and Holland. As collectors in New York City embraced the new tastes, many of the older artists, such as Durand, Church, and Albert Bierstadt, were stranded without active patronage. That the seeds of this change were sown in the years 1825 to 1861 is demonstrated in John Durand's *Life and Times*

of A. B. Durand (1894), which, except for its defensive tone, is one of the best artistic records of the period. The real theme of Durand's book is—to paraphrase Dunlap—the Rise and Decline of the American school of painting, as represented by the career of his father. For this decline Durand blamed the importation of European art to this country, beginning with the opening of the Düsseldorf Gallery in New York in 1849. To him the collection of Wolfe (composed mostly of Düsseldorf School pictures), the display of Bonheur's *Horse Fair*, 1853–55 (cat. no. 51), and other contemporary French works, and the far-reaching impact of John Ruskin's writings completed the damage, as collectors with new fortunes (unlike those whose wealth had been acquired earlier) deserted the artists of America.

At the close of his book, a downcast Durand came to this conclusion:

The American school of art is an invisible factor among literary and other intellectual products of the country. As far as native productions are concerned, they are scattered over the country, hidden away in private houses and displayed in gloomy drawing-rooms, where sunlight scarcely ever penetrates. . . . Even when American works find their way out of private collections before the public, or,

again, are purchased by local institutions, they are hung in proximity to works of older schools, inspired by different sentiments and executed according to different methods: American art thus suffers by comparison.[84]

Despite his sadness over the eclipse of American art, Durand did take the broader view: "In thus attributing the decline of the American school of art to the diversion of the native patronage which once insured its development, I do not deprecate or depreciate the result. On the contrary, one cannot too highly esteem the introduction into the country of foreign treasures of art of incalculable value in every sense."[85]

There was one indication, however, that the collectors who earlier had been the main support of American artists and designers continued to think well of their work: these patrons generously donated American paintings, sculptures, and other objects in later years, when the great public museums, like the Metropolitan, began the formation of their collections. The ethos of civic spirit that had characterized the prewar art world carried over into a new era, as the establishment of great institutions—museums, zoos, colleges, and hospitals—became the order of the day. And New York City, thanks in no small part to its art collectors, was in the forefront of the movement.

84. Durand, *Life and Times of A. B. Durand*, p. 191.
85. Ibid., p. 195.

Selling the Sublime and the Beautiful: New York Landscape Painting and Tourism

KEVIN J. AVERY

Cole and the Age of American Landscape Painting

America's age of landscape is often said to have begun in New York City in October 1825. It was then, according to the well-known story, that Colonel John Trumbull, the painter of the American Revolution and, as president of the American Academy of the Fine Arts, dictator of art matters in the city, discovered Thomas Cole, the father of the Hudson River School. As the account goes, Trumbull spotted three paintings of Hudson River and Catskill Mountain subjects in a local bookstore and art supply shop; he instantly purchased one, prevailed on two artist friends to buy the others, sought out and extravagantly praised Cole, the young painter of the pictures, and encouraged connoisseurs from New York and elsewhere to patronize him.[1] Cole's discovery took place within days of the celebration marking the opening of the Erie Canal, which more than any other single factor contributed to the rise of New York as the Empire City, America's first and most important metropolis.[2] Cole and the Empire City began their ascent at the same moment.

However, no group of artists sprang up instantly around Cole. For years he operated as a landscape painter in New York virtually without company or rivals. The fraternity of Cole's followers did not blossom and coalesce much earlier than about 1845. Even Asher B. Durand, Cole's contemporary and successor as the leader of New York landscapists, did not begin to focus on painting landscapes until about 1840. To be sure, when a community of landscapists did develop, it dominated American painting for at least a quarter century; some of its finest products were executed long after the beginning of the Civil War, which defines the final limit of this exhibition's purview. But during Cole's lifetime, American landscape painting was only in its formative stages as a movement.

Moreover, American landscape painting was not cultivated by Cole alone, or, in the years immediately preceding his death in 1848, by Cole and Durand together. Rather, the emergence and gradual growth of the school, as well as the meteoric rise of Cole's

own career, were part of the development of a broad landscape culture that took shape in New York and was lent impetus by the city. Paradoxically, it was precisely New York's preeminence among the nation's cities and its rapidly accelerating urbanization that gave rise to an American landscape culture. New York's commercial energy—empowered by a great natural harbor and river, which made the canal project possible, and primed by the expanded trade with the interior of the United States that the canal allowed—stimulated appreciation of the natural landscape. At the same time, restless Gotham was the foil against which America's natural places played, attracting city dwellers as refuges. Not least, for both foreigners and natives, excepting New Englanders, New York became the principal departure point in America for the most popular natural resorts of the time.

New York's landscape culture manifested itself principally in literature, tourism, suburban living, and urban parks, as well as in painting. To deal with all of those categories fairly would require a book-length exploration. This essay will, therefore, be confined chiefly to two areas, literature and, especially, tourism, concentrating on the resorts typically portrayed by the artists of the Hudson River School. With a few exceptions, artists chose the most popular destinations, and their pictures reinforced as well as reflected that popularity. These destinations—both at home and abroad—included the Catskill Mountains, Lake George, the White Mountains of New Hampshire, Newport, and Italy, most of which were painted by Cole, beginning in the early years of his career.

The Literary Context for Cole

Since Cole's appearance in New York in 1825 was such an important moment in the history of New York's landscape culture, we should explore the immediate context of this event. He had spent the whole of 1824 trying to be a landscape painter in Philadelphia, where he is reported to have compared his youthful

The author gratefully acknowledges the generous assistance of the following individuals in the preparation of this essay: Joelle Gottlieb, Vivian Chill, Claire Conway.

1. Cole's discovery is discussed and documented in detail in Ellwood C. Parry III, *The Art of Thomas Cole: Ambition and Imagination* (Newark: University of Delaware Press, 1988), pp. 24–27. See also "Mapping the Venues," by Carrie Rebora Barratt in this publication.
2. See Parry, *Art of Cole*, p. 21, for a discussion of the timeliness of the beginning of Cole's career in reference to the opening of the Erie Canal.

3. For Cole's life before he moved to New York, see Ellwood C. Parry III, "Thomas Cole's Early Career: 1818–1829," in *Views and Visions: American Landscape before 1830,* by Edward C. Nygren et al. (exh. cat., Washington, D.C.: Corcoran Gallery of Art, 1986), pp. 163–66. His envy of Doughty and Birch was reported by his earliest biographer, William Dunlap, *A History of the Rise and Progress of the Arts of Design in the United States,* new ed., edited by Frank W. Bayley and Charles E. Goodspeed (Boston: C. E. Goodspeed and Co., 1918), vol. 3, p. 148.

4. Parry, "Cole's Early Career," pp. 163–66.

5. Parry, *Art of Cole,* p. 23; Parry, "Cole's Early Career," pp. 167–69.

6. Bryant's early life and career are described in Charles H. Brown, *William Cullen Bryant* (New York: Charles Scribner's Sons, 1971), pp. 77–172. See also the detailed chronology of Bryant's life in Henry C. Sturges and Richard Henry Stoddard, eds., *The Poetical Works of William Cullen Bryant* (New York: D. Appleton and Company, 1910), pp. xxxiii–lxv, esp. pp. xliv–xlix. The standard portrait of Knickerbocker culture in New York, including discussion of Bryant, James Fenimore Cooper, Washington Irving, and other writers and their relationship to such artists as Cole and Durand, is James T. Callow, *Kindred Spirits: Knickerbocker Writers and American Artists, 1807–1855* (Chapel Hill: University of North Carolina Press, 1967), esp. chap. 1, "The New York Background," pp. 3–37.

7. A detailed chronology of Cooper's life and work is given in James Fenimore Cooper, *The Leatherstocking Tales,* vol. 1 (New York: Library of America, 1985), pp. 869–81, with his activities in New York City before his sojourn in Europe of 1826 to 1834 on pp. 871–73.

8. Charles Ingham quoted in Callow, *Kindred Spirits,* p. 13: the first recorded minutes of the Sketch Club were kept at the house of John L. Morton, in 1829, but the minutes indicate that the club had met earlier. See also Thos. S. Cummings, *Historic Annals of the National Academy of Design, New-York Drawing Association, . . . from 1825 to the Present Time* (Philadelphia:

efforts unfavorably with the mild, picturesque, park-like scenes fashioned by local painters Thomas Birch and Thomas Doughty.[3] When he went to New York the following year, it was chiefly to rejoin his parents and sisters, whom he had left in Steubenville, Ohio, when he began his artistic odyssey in 1822. Cole's family too had felt the need to move to improve its fortunes, and no American city held out more opportunities than New York in 1825, particularly in view of the coming opening of the canal.[4]

Soon after arriving in New York, Cole traveled north on the Hudson River to make sketches upstate for the pictures that launched his reputation.[5] Yet in New York City itself he could also find inspiration, for by 1825 a literature of landscape, if not yet a landscape painting tradition, was blossoming here. The Wordsworthian poet William Cullen Bryant, with whom Cole is portrayed in Durand's *Kindred Spirits* (cat. no. 30), was born and raised in New England but had settled for good in New York just a few months before the painter arrived. Publication of his nature poems in Boston journals as early as 1817 and of his first collection of verse, in 1821, had earned Bryant a name in New England but not a livelihood while he labored with increasing reluctance as a lawyer in Massachusetts. Then he accepted an invitation to coedit a new publication in New York, the *New-York Review, and Atheneum Magazine,* and this position eventually led to his appointment as editor of the city's principal daily, the *New-York Evening Post.*[6] That reliable job remained the perch from which Bryant presided over New York's landscape culture until his death in 1878, when the Hudson River School was falling from its preeminent place in American art.

The novelist James Fenimore Cooper was second only to Bryant as an influential literary figure in the rising landscape culture of New York in the early nineteenth century. Like Bryant and Cole, Cooper was not a native of the city: he was born in Burlington, New Jersey, and was raised in Cooperstown, an upstate New York settlement that his father had founded.[7] But by 1820, with the publication of his first novel, he had begun to socialize with the poet Fitz-Greene Halleck and the artist William Dunlap, among others in New York. In 1822 he formed the first salon in the city, the Bread and Cheese Club, which welcomed both writers and artists. The Bread and Cheese Club was short lived, dissolving with Cooper's departure for Europe in 1826; but it was succeeded by the Sketch Club, composed of several members of the Bread and Cheese along with such newcomers as Cole, who reportedly hosted the first

"regular meeting."[8] Cooper's early Leatherstocking Tales *The Pioneers* (1823) and *The Last of the Mohicans* (1826) bear the impress, respectively, of the author's youth in upstate New York and the "fashionable tour"[9] he took of the Lake George–Lake Champlain area; enormously well received by the public, they played an important part in popularizing the upstate regions in which they are set. And by the time Cooper left New York, he had already created a mythology of the state as both a frontier and a theater of American history. Cole rapidly exploited this mythology:[10] among his earliest narrative landscapes, painted in 1826 and 1827, are four pictures with scenes from *The Last of the Mohicans* (see cat. no. 24), two of which are set in the wilderness of upstate New York.

Also important among the city's principal literary exponents of landscape culture in our period was Washington Irving, the eldest and the only native New Yorker among the trio. Although he had left New York for Europe in 1815 and did not return until 1832, his contribution to the culture was significant. By the time of his departure he had published *A History of New-York* (1809; cat. no. 137), under the pseudonym Diedrich Knickerbocker, and *The Sketch Book of Geoffrey Crayon, Gent.* (1819–20), as Geoffrey Crayon. The first made the author famous in America, the second brought him renown both at home and in England, where he was living when it was published.[11] While Irving's voice in these early works is essentially that of a fabulist, the volumes do include delightful scenic sketches. The *History* is a satirical account of the formation of New York City, but one chapter consists of a broad declamation of the glories of the Hudson River's shores up to the highlands, as surveyed by Peter Stuyvesant during a cruise upriver in a galley.[12] And the well-known tale "Rip Van Winkle" in *The Sketch Book* is set in the Catskills and is replete with evocative descriptions of the view into the Hudson River valley from the mountain ledges (see cat. no. 23); of Kaaterskill Clove (see fig. 98), in sight of which Rip takes his legendary nap; and of Kaaterskill Falls.[13] All became subjects for Cole and his successors, the Hudson River School of landscape painters.

The Pictorial Context for Cole

The immediate pictorial context for Cole's landscapes appeared almost contemporaneously with Bryant's *Poems,* Cooper's *The Pioneers,* and Irving's *Sketch Book.* That context was *The Hudson River Portfolio* (see cat. no. 114; figs. 79, 152), the work of the

VIEW NEAR HUDSON.

Fig. 79. John Hill, after William Guy Wall, *View near Hudson*, 1822, from *The Hudson River Portfolio* (New York: Henry J. Megarey, 1821–25), pl. 15 (later pl. 12). Aquatint with hand coloring. The Metropolitan Museum of Art, The Edward W. C. Arnold Collection of New York Prints, Maps, and Pictures, Bequest of Edward W. C. Arnold, 1954 54.90.158

aquatint engraver John Hill and the watercolorist William Guy Wall. Both artists were born abroad, Hill in England, Wall in Ireland. In 1816 Hill emigrated from London to Philadelphia, where he produced the landmark *Picturesque Views of American Scenery* between 1819 and 1821. Based on the drawings of the English-born Philadelphia landscape painter Joshua Shaw, *Picturesque Views* included a single narrow image of the Hudson. The river did, however, become a major subject for Hill's burin when he was engaged to engrave the plates for the aquatints of Wall's watercolors that became *The Hudson River Portfolio*.[14] The series had been proposed by Wall, who had departed Ireland for New York in summer 1818 and had executed his watercolors of the Hudson River "During a Tour in Summer of 1820."[15] The New York artist John Rubens Smith was originally hired to engrave Wall's images, but by August 1820 Hill was approached by the publishers to replace him. Less than two years later, swayed by his publisher and completely preoccupied with the *Portfolio* project, Hill moved with his

family to New York and the rich opportunities Hudson River images would bring him.[16]

The Tourist Context for Cole; the Catskills

Like Wall, most visitors to upstate New York before 1820 maintained their distance from the Catskills. Horatio Spafford's entry on the Catskills in his 1813 *Gazetteer of the State of New-York* discloses only that they are "the largest and most extensive [mountains] in the state"—an inaccurate claim (the Adirondacks were later discovered to be higher)—that a turnpike made the vicinity of the range's eastern summits accessible, and that from their heights "the view is inexpressively grand."[17] But some travelers were taking Spafford's hint; before 1817, for example, former Yale president Timothy Dwight had ascended to the lofty ledge called Pine Orchard, site of the future Catskill Mountain House hotel, admired "the distinct and perfect view" of the hundred miles of Hudson River valley below him, as well as the Kaaterskill Clove and its spectacular waterfalls.[18] By the time Cole arrived in

George W. Childs, 1865), pp. 110–11.

9. The term is derived from the title of the guidebook by Gideon M. Davison, *The Fashionable Tour in 1825: An Excursion to the Springs, Niagara, Quebec, and Boston* (Saratoga Springs: G. M. Davison, 1825).

10. For an excellent discussion of the role of Cooper's early novels in the popularization of the Catskill Mountains, see Kenneth Myers, *The Catskills: Painters, Writers, and Tourists in the Mountains, 1820–1895* (exh. cat., Yonkers: Hudson River Museum of Westchester, 1987), pp. 34–36, with a discussion of Cole's paintings of the Catskills on pp. 40–46.

11. A chronology of Irving's life and work appears in Washington Irving, *History, Tales, and Sketches: Letters of Jonathan Oldstyle, Gent., Salmagundi; . . . A History of New York; . . . The Sketch Book of Geoffrey Crayon, Gent.*, edited by James W. Tuttleton (New York: Library of America, 1983), pp. 1093–1102.

12. Ibid., pp. 622–25.

13. Ibid., pp. 773–77. For a discussion of Irving's descriptions of the Hudson River and the Catskills in relation to tourism, see Myers, *Catskills*, pp. 33–34.

14. For *Picturesque Views of American Scenery*, see Richard J. Koke, *A Checklist of the American Engravings of John Hill (1770–1850) . . .* (New York: New-York Historical Society, 1961), pp. 16–26; Nygren et al., *Views and Visions*, pp. 46–54, 268–69, 289–90; Gloria Gilda Deák, *Picturing America, 1497–1899: Prints, Maps, and Drawings Bearing on the New World Discoveries and on the Development of the Territory That Is Now the United States* (Princeton: Princeton University Press, 1988), pp. 213–14. For a detailed account of Hill's engagement as the engraver of *The Hudson River Portfolio*, see Richard J. Koke, "John Hill, Master of Aquatint, 1770–1850," *New-York Historical Society Quarterly* 43 (January 1859), p. 87. For *The Hudson River Portfolio* in general, see Donald A. Shelley, "William Guy Wall and His Watercolors for the Historic *Hudson River Portfolio*," *New-York Historical Society Quarterly* 31 (January 1947), pp. 25–45; Koke, *Checklist of American Engravings of Hill*, pp. 29–41; Nygren et al.,

Views and Visions, pp. 54–58, 298–301; and Deák, *Picturing America,* pp. 217–18.

15. Prospectus for *The Hudson River Portfolio,* quoted in Deák, *Picturing America,* p. 217.

16. See Koke, "John Hill, Master of Aquatint," pp. 84–86, 92–94.

17. Horatio Gates Spafford, *A Gazetteer of the State of New-York . . .* (Albany: H. C. Southwick, 1813), p. 9.

18. Timothy Dwight, *Travels; in New-England and New-York,* 4 vols. (New Haven: Timothy Dwight, 1821–22), vol. 4, pp. 122–25.

19. Horatio Gates Spafford, *A Gazetteer of the State of New-York* (Albany: B. D. Packard, 1824; reprint, Interlaken, New York: Heart of the Lakes Publishing, 1981), pp. 414–15; see also "Ten Days in the Country," *Commercial Advertiser* (New York), August 26, 1824, p. [2]; September 25, 1824, p. [2]; Davison, *Fashionable Tour in 1825,* pp. 41–43; and Theodore Dwight, *The Northern Traveller* (New York: Wilder and Campbell, 1825), pp. 15–18. These and other guides directing tourists to Pine Orchard and vicinity are discussed in Myers, *Catskills,* pp. 50–63.

20. "Descriptive Journal of a Jaunt up the Grand Canal; Being a Letter from a Gentleman in New-York, to a Lady in Washington, in August, 1825," *Atheneum Magazine* 1 (October 1825), pp. 381–82.

21. Ibid., p. 383.

22. Dwight, *Northern Traveller,* p. iii.

23. An Amateur [James Kirke Paulding], *The New Mirror for Travellers; and Guide to the Springs* (New York: G. and C. Carvill, 1828), p. 219.

24. [Thomas Hamilton], *Men and Manners in America* (Edinburgh: William Blackwood, 1833), vol. 2, p. 381.

25. Parry, *Art of Cole,* pp. 38–49.

26. These paintings are *Landscape, with Figures, a Scene from Last of the Mohicans,* 1826 (Terra Museum of American Art, Chicago) and *Gelyna (View near Ticonderoga),* 1826 and 1829 (Military History Museum, Fort Ticonderoga, New York). Another may be *Landscape, Scene from "The Last of the Mohicans,"* 1827 (Van Pelt Library, University of Pennsylvania, Philadelphia). For these paintings, see Parry, *Art of Cole,* pp. 47–51.

New York, in 1825, Spafford's *Gazetteer,* two guidebooks, and the local newspapers were touting the new hotel at Pine Orchard, where only a scattering of intrepid white travelers had stood before.[19]

The Catskill Mountain House was no doubt established in response to the increase in Hudson River traffic brought about after 1810 by the advent of the steamboat; and its builders surely anticipated the surge in tourism that would follow the completion of the Erie Canal. Thus travel to Pine Orchard and the surrounding Catskill areas that were the early subjects of Cole and his successors proliferated as a direct consequence of New York's rising enterprise and new economic preeminence. Dynamic Gotham, it might be said, in this way fostered Cole's predilection for the sublime, the aesthetic of the dramatic and fearsome in landscape.

If the relationship between the perception of natural wonders and the heroic projects of civilization was not represented by the members of the Hudson River School, it was sometimes addressed by urban tourists inspired by the painters' haunts. One such was a "gentleman in New-York" who in October 1825 wrote an account of "a jaunt up the Grand Canal" to Utica between a stop at Pine Orchard and a visit to the famed Trenton Falls on the Mohawk River near Utica. In the eyes of this observer, and presumably in the view of others of his time, nature was an artist. From the ledge at Pine Orchard he conjured up the heavenly loom on which nature "weaves her clouds," and he was "awestruck" by "the towering vault of solid rock, as if built by art"[20] that is the cave behind Kaaterskill Falls. The "Grand Canal" the gentleman traveler saw as a comparable prodigy. He regarded as "fairy-work" the engineering miracle that made possible the novel sensation of "floating . . . in a large and lofty barge, through fields, and directly in front of houses" (see cat. no. 106) or upon an aqueduct spanning the eleven-hundred-foot width of the rushing Mohawk River.[21] Theodore Dwight, nephew of Timothy, in his *Northern Traveller,* a guidebook published in New York in 1825, was similarly moved, observing that the "magnificence of the [canal] itself," not merely the novelty of riding upon its gentle course, had already "attracted vast numbers of travellers."[22] Yet few artists other than topographical specialists such as Hill portrayed either the canal or much of the scenery visible from it. America lacked its John Constable to glorify the man-made waterway's utilitarian function. And the landscape it made accessible to New Yorkers tended to lose its picturesque qualities, changing irresistibly, apace with the

city itself, as ever more towns and industry rose up along its banks.

Saratoga and Lake George

Other sites rarely painted were Saratoga Springs and nearby Ballston. Although both lacked picturesque appeal, they were highly popular stops in the fashionable tour that America's first affluent classes undertook through New York State, New England, and lower Canada: their attraction was originally based on the therapeutic value of the mineral waters of their springs. When New Yorker James Kirke Paulding wrote of "the singular influence of beauty" at Saratoga and Ballston in his 1828 *New Mirror for Travellers,* he was referring not to the scenery, which he found ordinary at best, but to the young women who congregated there, attracting men of all ages.[23] A few years later, however, an Englishman visiting both resorts summarily dismissed even their social life when he observed: "If Saratoga was dull, Ballston was stupid."[24]

It could scarcely be said that nearby Lake George was not beautiful or a favored subject for artists. Cole visited Lake George as early as spring or early summer 1826 and painted it several times within the next year,[25] and his followers among the second generation of the Hudson River School—John F. Kensett, David Johnson, and Sanford Robinson Gifford—portrayed the area frequently through the Civil War period and after. To be sure, the purely picturesque character of Lake George appealed to the painters, but at least part of its attraction for Cole and contemporary tourists derived from its military past.

Two old forts (or their ruins), William Henry and George, occupied points on the south and middle of the thirty-mile-long lake, and Fort Ticonderoga was located near the northern tip of Lake George on Lake Champlain. Adding notably to its cachet as a military theater, Cooper had made Lake George (which he called by its Native American name, Horican) the focal setting of his most popular novel, *The Last of the Mohicans,* which addressed the collision of Native American and European cultures inflamed by the French and Indian Wars. In fact, writings about the conflict directly inspired Cole: one of his paintings of the Lake George–Lake Champlain region illustrates in the foreground a scene from *The Last of the Mohicans,* another a legendary episode of the war from a different source.[26]

Relative to Saratoga Springs, which already boasted several large hotels by the second decade of the

Fig. 80. Peter Maverick, *Lake George*, New York. Engraving, from Theodore Dwight, *The Northern Traveller* (New York: Wilder and Campbell, 1825), opp. p. 120. The New York Public Library, Astor, Lenox and Tilden Foundations

nineteenth century, Lake George was a belated discovery of the new tourist class. The earliest accommodation on the lake may have been what Yale naturalist Benjamin Silliman Jr. reported was the Fort George barrack until shortly before his visit to the area in 1819, about the time a public house opened at nearby Caldwell.[27] However, the numbers of visitors to upstate New York who wished to see beautiful water, not merely drink it as at Saratoga, gradually increased, and Lake George more than rewarded them. Writers were paying more attention too. Indeed, by the time Cole stopped there Lake George had been extolled at length in at least four books, two published in the year of the Canal opening.[28] Moreover, by then a steamboat had been launched to ferry tourists from Fort George north to the isthmus on which Fort Ticonderoga on Lake Champlain is located.[29] The authors of all of the guides agreed on Lake George's principal virtues: historical resonance, its vast extent (best viewed from south to north); its innumerable islands (several are conspicuous in a number of Kensett's canvases [see fig. 81]), one—Tea Island—equipped with a summerhouse offering refreshments;[30] its sublime foil of mountains, chiefly on the eastern shore (a British visitor in 1833 compared the eastern aspect to Windermere, in the English Lake District, but found the features of Lake George's setting "bolder and more decided"[31]), and its pastoral cultivated land on the western shore; the mirrorlike waters that became a window allowing the angler to select his quarry as much as thirty feet beneath the surface from the abundant shoals of trout. If the men fished, the ladies could collect "the beautiful crystals of quartz," six-sided prisms that studded so-called Diamond Island and other locations.[32]

Among contemporary observers it was Theodore Dwight, in his *Northern Traveller,* who best described Lake George's scenic appeal—later reflected so conspicuously in the paintings of Kensett and his colleagues:

This beautiful basin with its pure crystal water is bounded by two ranges of mountains, which in some places rising with a bold and hasty ascent from the water, and in others descending with a graceful sweep from a great height to a broad and level margin, furnish it with a charming variety of scenery, which every change of weather, as well as every change of position presents in new and countless beauties. The intermixture of cultivation with the wild scenes of nature is extremely agreeable; and the undulating surface of the well tilled farm is often contrasted with the deep shade of the native forest, and the naked, weather beaten cliffs, where no vegetation can dwell. . . . To a stranger who visits Lake George under a clear sky, and sails upon its surface . . . the place seems one of the most mild and beautiful on earth.[33]

It was the mildness of Lake George, not the mutability of its weather and the wild aspects of its environment described by Dwight, that became a leitmotiv of visitors' accounts and the characteristic subject of Hudson River School interpretations of the place, in particular Kensett's and Johnson's paintings. Even when tourists abounded, the lake in this mood offered the greatest contrast to urban hubbub and the calmest refuge. English author Harriet Martineau evoked the placid atmosphere and dolce-far-niente attitude induced by the lake on a fine day when she and her friends from New York sailed out to Tea Island one morning in the mid-1830s:

[Tea Island] is a delicious spot, just big enough for a very lazy hermit to live in. There is a teahouse to look out from, and, far better, a few little reposing places on the margin; recesses of rock and dry roots of trees, made to hide one's self in for thought and dreaming. We dispersed; and one of us might have been seen, by anyone who rode round the island, perched in every nook. The breezy side was cool and musical with the waves. The other side was warm as July, and the waters so still that the cypress twigs we threw in seemed as if they did not mean to float away.[34]

In his *Northern Traveller* Dwight disparaged the image of Lake George (fig. 80) that accompanied his text on the area, insisting that "no exertion of art can produce anything fit to be called a resemblance of such a noble exhibition of the grand and beautiful

27. Benjamin Silliman, *A Tour to Quebec in the Autumn of 1819* (London: Sir Richard Phillips and Co., 1822), p. viii.

28. Ibid., pp. 48–65; Davison, *Fashionable Tour in 1825,* pp. 92–97; Dwight, *Northern Traveller,* pp. 92–97; Spafford, *Gazetteer of State of New-York* (1981), pp. 55, 73, 272.

29. Davison, *Fashionable Tour in 1825,* p. 95.

30. Ibid., p. 93.

31. [Hamilton], *Men and Manners in America,* vol. 2, p. 368.

32. Silliman, *Tour to Quebec,* pp. 51–52.

33. Dwight, *Northern Traveller,* pp. 119–20.

34. Harriet Martineau, *Retrospect of Western Travel* (London: Saunders and Otley; New York: Harper and Brothers, 1838), vol. 2, pp. 226–27.

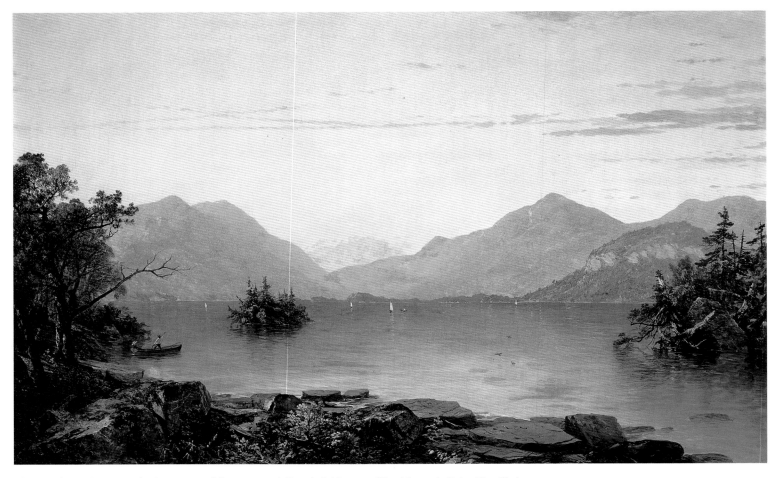

Fig. 81. John F. Kensett, *Lake George*, 1856. Oil on canvas. Adirondack Museum, Blue Mountain Lake, New York 65.079.01

35. Dwight, *Northern Traveller,* p. 120.

36. Parry, "Cole's Early Career," p. 178; see also Parry, *Art of Cole*, pp. 54–55. For modern perspectives on nineteenth-century artists in the White Mountains, see Donald D. Keyes, "Perceptions of the White Mountains: A General Survey," in *The White Mountains: Place and Perceptions* (exh. cat., Durham: University Art Galleries, University of New Hampshire, 1980), pp. 41–49.

37. Parry, *Art of Cole*, pp. 81–82, 218–19; Parry, "Cole's Early Career," pp. 178–83.

features of creation."[35] The remark is surely appropriate in reference to Cole's few paintings of Lake George and vicinity, the first pictorial accounts of the area, which were, in fact, rather limited scenically. Not until the 1850s would Cole's followers take up the subject again. Only then, with pictures by Kensett, Johnson, and Gifford, would painters' visions of the leisure charms of the lake equal their celebrations by writers.

The White Mountains

In July 1827, on the heels of his visits to the Catskills and Lake George, Cole made a brief but signal excursion to the White Mountains of New Hampshire. As Ellwood Parry has observed, the White Mountains "became Cole's new passion, overwhelming his earlier fondness for the Catskills and Lake George."[36] After a sojourn in the state of barely a week, Cole painted several pictures with New Hampshire scenery, some of which included views of Mount Chocorua as a prominent feature. Among these are some of his earliest historical landscapes (see cat. no. 24). He visited

the region again, with the Boston landscape painter Henry Cheever Pratt, in the following year, and once more, with Durand, in the summer of 1839, when he produced another White Mountain picture.[37]

Cole's first visit might not have occurred when it did had it not been urged on him by his patron Daniel Wadsworth of Hartford, who had been to the White Mountains the year before. Yet even without Wadsworth's intervention, Cole doubtless would have gone there before long. The establishment of accommodations in the White Mountains in the early nineteenth century, a great natural calamity that took place there, and the attention the region drew in publications that appeared in New York and elsewhere after the Erie Canal opened lured ever increasing numbers of tourists through the second quarter of the nineteenth century. Like Lake George, however, the area did not become a subject for Cole's followers until the 1850s, when New Hampshire attracted second-generation Hudson River School painters led by Durand. Small wonder, for by midcentury the White Mountains had evolved into one of the required tourist destinations in the eastern states.

Once discovered by travelers, the White Mountains were dubbed "the Switzerland of the United States,"[38] including as they do the Northeast's tallest mountain, Mount Washington (at 6,288 feet), and several neighboring high peaks christened with the names of other early presidents. But America's first Alps (tourists would not discover the grandeur of the Rocky Mountains for many years) were an inhospitable, indeed potentially lethal, wilderness during the early days of the Republic, and visitors needed at least one place of shelter. That refuge was supplied by the settlements established about the time of the Revolution by the Rosebrook and Crawford families in the region of the Notch, located between the Presidential and Franconia Ranges of the White Mountains. Later, Abel Crawford and his son, Ethan Allen Crawford, became the sole—and eventually the principal— hoteliers in that breathtaking chain of summits. The father established an inn in 1803, and by 1819 he and his son had already cleared a path to the top of Mount Washington; seven miles from the inn they built a camp where travelers hiking to the peak could rest for the night before continuing the ascent.[39]

In his *Northern Traveller* Theodore Dwight wrote at length of the journey from Boston to Concord, thence to Center Harbor, Red Mountain, Squam Lake, Lake Winnipesaukee, and up along the Saco River through the Notch to the Crawford farm, from which he ascended Mount Washington with Ethan Crawford, calling the view "sublime and almost boundless."[40] Although he described in some detail the wonders of the region for "the man of taste," he was rather apologetic about what he considered to be the summary nature of the descriptions of the landscape he provided and promised to improve on them in future editions.[41] He quickly did, but less to keep his word than to report on an event in the Notch that would decisively affect tourism in the White Mountains for years to come. In summer 1826 the Switzerland of the United States suffered, in Dwight's words, "*avalanches de terre*,"[42] terrific landslides induced by the swelling and raging course of the Saco through the Notch during a storm. The slides buried the Willeys, an isolated family living in the Notch, but spared their house, which they had fled. Alert to the commercial potential of the news, in 1827 Dwight and his publisher produced an insert describing the catastrophe and tipped it into the second "improved and extended" edition of his guide, published in 1826. Thanks to the natural disaster, noted the author in this insert, "the route [through the Notch] will offer many new objects interesting to an intelligent traveller. . . .

Scarcely any natural occurrence can be imagined more sublime."[43] Dwight guaranteed that the traces of the event "will always furnish the traveller with a melancholy subject of reflection."[44]

Through human tragedy, then, a region that by dint of its high, steep mountains had called forth the sublime became an even more powerful vehicle for expressing exalted and terrifying emotions. What Timothy Dwight had perceived as a titanic natural boulevard and amphitheater dwarfing the monuments of antiquity[45] became for his nephew Theodore brooding ruins created by nature's assault on its own splendors. In his *Sketches of Scenery and Manners in the United States* of 1829, Theodore Dwight wrote repeatedly of the contrast between his recollections of the pastoral Saco River valley before the avalanches and the present reality of the wasteland of much of the site, between the devastated parts of the Notch, which made nature seem "the enemy of civilization and humanity," and the mild sections of the valley that were left unscathed: "From the spot whence the traveller looked back, to admire the green meadow below, and the crowds of forest trees which invested the mountains, unbroken except here and there by a few gray rocks, the avalanches I have mentioned are all visible, each of them a course which no human power could have resisted, and before which the pyramids of Egypt might have been shaken if not swept away."[46]

Signs of the disaster persisted for years, with only spots of what Harriet Martineau called "rank new vegetation" gradually spreading and covering the natural wreckage.[47] The Willey house continued to stand amid the blasted landscape, a vestige of pioneer life in America, in much the same way that the

Fig. 82. Daniel Wadsworth, *Avalanches in the White Mountains.* Engraving, from [Theodore Dwight], *Sketches of Scenery and Manners in the United States* (New York: A. T. Goodrich, 1829), opp. p. 59. The New York Public Library, Astor, Lenox and Tilden Foundations

38. Dwight, *Northern Traveller,* p. 173.

39. The history of the Rosebrook and Crawford settlements in the White Mountains is summarized in Arthur W. Vose, *The White Mountains* (Barre, Massachusetts: Barre Publishers, 1968), pp. 76–80. See also R. Stuart Wallace, "A Social History of the White Mountains," in *White Mountains: Place and Perceptions,* p. 26.

40. Dwight, *Northern Traveller,* p. 183.

41. Ibid., p. 173.

42. Theodore Dwight, *The Northern Traveller,* 2d ed. (New York: A. T. Goodrich, 1826), p. 312.

43. Ibid., pp. 311–12.

44. Ibid., pp. 311, 313.

45. Dwight, *Travels; in New England and New York,* vol. 2, p. 152.

46. [Theodore Dwight], *Sketches of Scenery and Manners in the United States* (New York: A. T. Goodrich, 1829), pp. 69, 77.

47. Martineau, *Retrospect of Western Travel,* vol. 2, p. 112.

Fig. 83. Thomas Cole, *View of the White Mountains,* 1827. Oil on canvas. Wadsworth Atheneum, Hartford, Connecticut, Bequest of Daniel Wadsworth 1848.17

48. Quoted in J. Bard McNulty, ed., *The Correspondence of Thomas Cole and Daniel Wadsworth: Letters in the Watkinson Library, Trinity College, Hartford, and in the New York State Library, Albany, New York* (Hartford: Connecticut Historical Society, 1983), p. 26.

49. Cole quoted in Louis Legrand Noble, *The Course of Empire, Voyage of Life, and Other Pictures of Thomas Cole, N.A. . . .* (New York: Lamport, Blakeman and Law, 1853; reprint, edited by Elliot S. Vesell, Hensonville, New York: Black Dome Press, 1997), p. 67.

50. Benjamin G. Willey, *Incidents in White Mountain History . . .* [3d] ed. (Boston: Nathaniel Noyes, 1856).

rediscovered dwellings of Pompeii and Herculaneum preserve traces of ancient Roman domestic life.

The landslides and their aftermath not only attracted tourists but also inspired artists. Wadsworth's 1826 visit to the White Mountains could well have been motivated by the catastrophe, for he made a drawing of the avalanche paths in the Notch for Dwight's *Sketches of Scenery and Manners in the United States* (fig. 82). Although Cole never painted the scene of the Willey deaths, he drew the fatal slides for reproduction as a print (fig. 150) and represented avalanche paths on the shoulders of Mount Washington in a painting of the peak he made for Wadsworth in late 1827 (fig. 83), and he referred to the large numbers of scorings he observed "about nine miles from Crawford's [inn]" in a letter of December 8 of that year to Wadsworth.[48] His painting *A View of the Mountain Pass Called the Notch of the White Mountains,* 1839 (fig. 84), seems more directly to evoke the catastrophe and acknowledges the tourist traffic in the Notch. In the foreground a lone horseman approaches the

Crawford house, while in the background a stage-coach departs from the dwelling, moving in the direction of the Notch's narrow defile. The house is portrayed as a refuge amid looming mountains cloaked by storm clouds and rain at left and lashed raw in places by landslides. These details and the boulder perched precariously on a rocky knob over-looking the house are of a piece with both Dwight's vision and Cole's own characterization of the Notch as a place that nature had chosen as a "battleground" of the elements.[49]

Fascination with the Willey site was waning by 1856 despite efforts to perpetuate it. That year Benjamin Willey, brother of the elder Willey killed in the slide, published a history of the White Mountains in which the tragedy figures prominently.[50] By then also a 12½-cent admission was being charged for a guided tour of the Willey house, but Samuel Eastman, author of the 1858 travel book that cited this attraction, maintained that "there was nothing within the ruinous edifice of sufficient interest to warrant even this trifling

Fig. 84. Thomas Cole, *A View of the Mountain Pass Called the Notch of the White Mountains (Crawford Notch)*, 1839. Oil on canvas. National Gallery of Art, Washington, D.C., Andrew W. Mellon Fund 1967.8.1

expense."[51] Clearly, the visitors who were flocking to the White Mountains were coming for other kinds of attractions. Their change of focus was at least partly a consequence of the passage of time: interest in the calamity understandably faded over the years, and tourists, no longer keenly interested in old news, were able to perceive the natural beauties of the Notch and take pleasure in the benign aspects of the region.

In great measure, the change in taste was due to proliferating accommodations and improved transportation. By 1855 guide writer John H. Spaulding identified four "mammoth hotels" in the White Mountain area as well as many smaller inns. One of these was built on the summit of Mount Washington, on whose flank, he reported, a "macadamized" path was being constructed to allow a convenient ascent.[52] A key improvement was made in the early 1850s, when the Atlantic and St. Lawrence Railroad was cut through to Gorham, bringing visitors to the very base of the White Mountains.[53] For that matter, railroads now connected any number of points in New England. Eastman's book contains fourteen pages of advertisements for railroads as well as accommodations, and provides thirteen different routes, using many combinations of boats, trains, and stagecoaches, to the White Mountains.[54] Seven of those routes, moreover, originated at New York City, "the point of immediate departure," Eastman indicated, "for Southern, Western, and we may add, a large portion of European travel into New England."[55] Whereas the area had earlier been considered the preserve of landed gentlemen such as Daniel Wadsworth, who hoped to be awed by overwhelming sights, now it was presumed that the typical traveler was a resident of a large city who wished simply to escape, in Spaulding's words, "[to] free circulation of fresh mountain air, and pure water . . . a pleasant and healthful contrast to the sickly, pent-up city street, where floats a hot atmosphere of pestilence and death."[56]

Thus, the White Mountains came to be embraced by city dwellers, who sought them as a refuge; and they were being tamed—so much so that by the eve of

51. Samuel Coffin Eastman, *The White Mountain Guide Book* (Concord, New Hampshire: Edson C. Eastman, 1858), pp. 50–52.

52. John H. Spaulding, *Historical Relics of the White Mountains. Also, a Concise White Mountain Guide* (Mt. Washington: J. R. Hitchcock, 1855), pp. 71, 74, 76.

53. Willey, *Incidents in White Mountain History*, p. 262.

54. Eastman, *White Mountain Guide Book*, pp. 153–67; for the routes to the White Mountains, see ibid., pp. 89–108, 132.

55. Ibid., p. 1.

56. Spaulding, *Historical Relics*, p. 71.

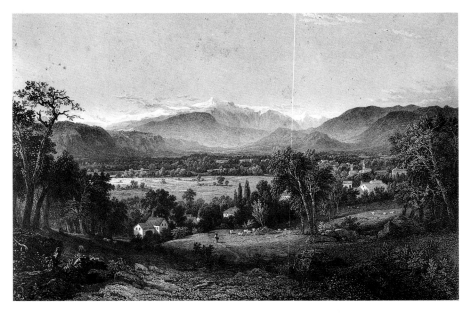

Fig. 85. James Smillie, after John F. Kensett, *Mount Washington from the Valley of Conway*, 1851. Steel engraving. Courtesy of the American Antiquarian Society, Worcester, Massachusetts

57. Thomas Starr King, *The White Hills; Their Legends, Landscape and Poetry* (Boston: Isaac N. Andrews, 1859).

58. For Ruskin's influence on American artists, see Roger Stein, *John Ruskin and Aesthetic Thought in America, 1840–1900* (Cambridge, Massachusetts: Harvard University Press, 1967); and Linda S. Ferber and

the Civil War Boston cleric and guide writer Thomas Starr King could call them the "White Hills."[57] It was in this light that the next generation of landscape artists arriving from New York and Boston with the rest of the tourists tended to picture them. The new pastoral vision was shaped not only by vacationers' growing preference for the beautiful over the sublime but also by the new aesthetics the artists brought with

Fig. 86. David Johnson, *Study, North Conway, New Hampshire*, North Conway, 1851. Oil on canvas. The Cleveland Museum of Art, Mr. and Mrs. William H. Marlatt Fund 1967.125

them. These aesthetics were profoundly influenced by the ideas of the English critic John Ruskin, who in his *Modern Painters* (1843–60) championed an art based on the exacting representation of the details of nature rather than the artist's emotional interpretation of scenery.[58] The new values were articulated by Durand in *The Crayon*, the short-lived New York periodical that became the voice of Ruskinian aesthetics in America. In *The Crayon* Durand published his now-famous "Letters on Landscape Painting" promoting plein-air painting and accurate rendering of detail, particularly in foreground elements, as the basis of a naturalistic landscape art.[59] Durand and his colleagues turned to this new naturalism exactly at the moment in the 1850s when they began frequenting the White Mountains, so that the region virtually became the laboratory of New York landscape painting aesthetics in the period.

In describing the White Mountain environment in a letter to *The Crayon*, Durand elucidated his aesthetic bias by explicitly rejecting the aspects of the landscape that called forth associations with the sublime, aspects preferred by his predecessor Cole (and many of Cole's patrons): "For those who have the physical strength and mental energy to confront the [sublime] among the deep chasms and frowning precipices, I doubt not it would be difficult to exaggerate . . . the full idea of 'boundless power and inaccessible majesty' represented by such scenes. But to one like myself, unqualified to penetrate the 'untrodden ways' of the latter, the *beautiful* aspect of White Mountain scenery is by far the predominant feature."[60] In the same letter he touted the many opportunities to enjoy beautiful scenery on excursions from his headquarters in North Conway but happily admitted that he had not yet made many such trips and felt no need to:

There is enough immediately before me for present attention. Mount Washington, the leading feature of the scene when the weather is fine . . . rises in all his majesty, and with his contemporary patriots, Adams, Jefferson, Munroe [sic], &c., bounds the view at the North. On either hand, subordinate mountains and ledges slope, or abruptly descend to the fertile plain that borders the Saco, stretching many miles southward, rich in varying tints of green fields and meadows, and beautifully interspersed with groves and scattered trees of graceful form and deepest verdure: rocks glitter in the sunshine among the dark forests that clothe the greater portion of the surrounding elevations; farmhouses peep out amidst the rich foliage below, and winding roads,

with their warm-colored lines, aided by patches of richly tinted earth break up the monotony, if monotony it can be called, where every possible shade of green is harmoniously mingled.[61]

The passage can stand as a fair description of Kensett's renowned painting *The White Mountains—Mount Washington*, 1851 (Davis Museum and Cultural Center, Wellesley College, Massachusetts), which was engraved (fig. 85) for the American Art-Union's thirteen thousand subscribers the year it was painted.[62] As in Durand's text, the sublime element of the scene—snow-draped Mount Washington—abides in the background, a mere foil for the beautifully detailed farm valley spread before it. The artists' penchant for sacred particulars is revealed more conspicuously in oil sketches and studies by Durand, Kensett, Johnson (see fig. 86), Samuel Colman, Aaron Shattuck, and other New York artists featuring the "delicious '*bits*'"[63] Durand spied along the streams near North Conway:

now the luxurious fern and wild flowery plants choke up the passage of the waters, and now masses of mossy rock and tangled roots diversify the banks, and miniature falls and sparkling rapids refresh the Art-student, and nourish the dainty trout. Along these streams at all reasonable times, you are sure to see the white umbrella staring amidst the foliage. I meet these signals of the toiling artist every day.[64]

The vision of the painters who frequented the White Mountains was quite literally expressed by Thomas Starr King in 1859 in *The White Hills; Their Legends, Landscape and Poetry*, one of the most popular tour guides of the time. In his preface King explained that he had planned to organize the book "artistically," under such headings as rivers, passes, ridges, and peaks but had been persuaded to make it a more conventional guide to White Mountain localities that would be "a stimulant to the enjoyment of them."[65] It was with the last aim in mind that King not only quoted liberally from poetry by Bryant, Emerson, Longfellow, and Whittier, as well as British and Continental Romantics but also invoked New York, Boston, and old master painters to enhance his verbal portraits of the scenery. In his most memorable use of this conceit he transformed the White Mountains, as seen from North Conway in changing light and weather conditions, into a salon of landscape paintings:

But what if you could go into a gallery . . . where a Claude or a Turner was present and changed the sunsets on his canvas, shifted the draperies of mist and shadow, combined clouds and meadows and ridges in ever-varying beauty, and wiped them all out at night? Or where Kensett, Coleman [sic], Champney, Gay, Church, Durand, Wheelock, were continually busy in copying from new conceptions the freshness of the morning and the pomp of evening light upon the hills, the countless passages and combinations of the clouds, the laughs and glooms of the brooks, the innumerable expressions that flit over the meadows, the various vestures of shadow, light, and hue, in which they have seen the stalwart hills enrobed? Would one visit then enable a man to say that he had seen the gallery?[66]

Newport

The bias toward pastoral experience that characterized pictorial and literary responses to the White Mountains beginning in the 1850s had its counterpart in contemporary interpretations of Newport, Rhode Island, the preeminent shore resort in America during most of the nineteenth century. Kensett became especially well known for his depictions of the coastline at Newport. His first visits to the town, presumably in 1852 or a little earlier, correspond almost exactly with its emergence as a fashionable resort, frequented in particular by wealthy New Yorkers. These initial forays may have been inspired by encounters with the coastal paintings of Cole or Church.[67] However, the character of his Newport pictures contrasts with the tempestuous, ominous marines of such models: serene and pellucid, they create the standard for his own views of other shore locations, in Massachusetts and Long Island, and for coastal scenes by several other painters, including Sanford Robinson Gifford, Worthington Whittredge, William Stanley Haseltine, and William Trost Richards.

Whatever encouraged his early visits, Kensett was undoubtedly the first artist to exploit Newport's quite sudden popularity—or rather its revival as a resort in the mid-nineteenth century. Since the early 1700s the town had attracted southern planters seeking escape from the subtropical heat of summer in the lower American colonies. Simultaneously, thanks to its excellent harbor Newport became a serious commercial rival of Boston, Philadelphia, and (then) lowly New York, and one that could boast its own culture: beginning with Bishop George Berkeley, who lived in Newport for three years, starting in 1728, the city

William H. Gerdts, *The New Path: Ruskin and the American Pre-Raphaelites* (exh. cat., Brooklyn: Brooklyn Museum, 1985).

59. A. B. Durand, "Letters on Landscape Painting," *The Crayon* 1 (January–June 1855), pp. 1–2, 34–35, 66–67, 97–98, 145–46, 209–11, 273–75, 354–55.

60. A. B. Durand, North Conway, August 20, 1855, "Correspondence," letter to the Editors, *The Crayon* 2 (August 1855), p. 133.

61. Ibid.

62. Carol Troyen, "The White Mountains—Mt. Washington, 1851," in *American Paradise: The World of the Hudson River School*, edited by John K. Howat (exh. cat., New York: The Metropolitan Museum of Art, 1987), pp. 149–51.

63. Durand, Letter to Editors, p. 133.

64. Ibid.

65. King, *White Hills*, p. vii.

66. Ibid., pp. 176–77.

67. For discussion of the coastal pictures of Cole and Church, see Parry, *Art of Cole*, pp. 300–301, 307–8; see also Franklin Kelly et al., *Frederic Edwin Church* (exh. cat., Washington, D.C.: National Gallery of Art, 1989), pp. 43–46, 159–62; and John Wilmerding, *The Artist's Mount Desert: American Painters on the Maine Coast* (Princeton: Princeton University Press, 1994), pp. 27–43, 69–103.

68. The summary of Newport's history is drawn from the following sources: John Collins, *The City and Scenery of Newport, Rhode Island* (Burlington, New Jersey: Privately printed, 1857), p. 3; James G. Edward, *The Newport Story* (Newport: Remington Ward, 1952), pp. 7–11; and C. P. B. Jefferys, *Newport: A Short History* (Newport: Newport Historical Society, 1992), pp. 9–42.

69. Tyrone Power, *Impressions of America; during the Years 1833, 1834, and 1835*, 2d ed., 2 vols. (Philadelphia: Carey, Lea and Blanchard, 1836), vol. 2, pp. 16–17.

70. Jefferys, *Newport*, pp. 47–49.

71. Ibid., p. 43; [John Ross Dix], *A Hand-book of Newport, and Rhode Island* (Newport: C. E. Hammett Jr., 1852), p. 159.

72. [Dix], *Hand-book of Newport*, pp. v, vii.

73. Ibid., p. 69.

74. George William Curtis, *Lotus-Eating: A Summer Book* (New York: Harper and Brothers, 1852), p. 165.

75. George C. Mason, *Newport Illustrated in a Series of Pen and Pencil Sketches* (Newport: C. E. Hammett Jr., 1854), p. 50.

76. Quoted in ibid., pp. 50–51.

became the center of a varied community of scientists, artists, architects, editors, theologians, and furniture makers. The American Revolution, however, turned the budding metropolis into a virtual ghost town. The British occupied Newport for three years, destroying its wharves and many of its buildings, even bearing off its church bells and municipal records to New York, which would surpass her sisters as an Atlantic port early in the succeeding century.[68]

Newport would never recover as a commercial power, but it struggled through the early 1800s to reassert its identity as a resort. As late as 1833 an English visitor described Newport as "relatively deserted"; however, he could not help admiring its seaside ambience, mild climate, and handsome streets —all of which put him in mind of the Isle of Wight on England's west coast—and he recommended that Newport follow the English model of the "cottage resort" to enhance its attractiveness to summer vacationers.[69] A few scattered private summerhouses were built in the 1830s, and the middle of the next decade saw serious real estate speculation led by Alfred Smith, a Newport native who had made his first fortune as a tailor in New York and then doubled it by buying and selling property for cottage development in his hometown.[70] By this time there were already one or two steamers a day traveling between New York and New England ports that stopped at Newport; but, with the introduction of overnight service to Newport in 1847, by 1852 the number of daily trips there from Gotham had increased to five.[71] Thus, the pieces were in place for Newport's renaissance, which, to be sure, reached its zenith during the Gilded Age but was well under way by midcentury, if art and literature are any measure.

The commercial and cultural past of Newport determined the town's evolution into a resort with a character different from that of others, except perhaps Saratoga Springs, which it surpassed as a summer mecca for wealthy urban society. Unlike most of those who frequented the Catskills, Lake George, or the White Mountains, many visitors to Newport, as to Saratoga, had no particular interest in picturesque landscape or affection for the outdoors; rather, it is safe to say, they came primarily to socialize with the fashionable crowd with which they mixed in the city. On the other hand, unlike Saratoga, Newport had beautiful scenery. Therein lay a conflict for the writers who promoted Newport and, in some measure perhaps, for its landscape portraitists: which of its various attractions should they commend or describe?

That Newport was promoted as a retreat from the infernal city is plain from the tourist literature that began sprouting up along with the rows of splendid "cottages" in the 1850s. John Ross Dix, in the dedication of his *Hand-book of Newport, and Rhode Island* of 1852, waxed poetic on how "unto Newport's sands repair/the town-tired gentlemen and ladies," adding in his preface that he himself, "glad to escape for a season from the Babel of a great city, chose Newport as a sometime residence."[72] In connection with Newport's four beaches, he emphasized that "to people who, month after month, are pent in populous cities, there is a positive coolness in the sound of [the word "Newport"]. On bright, summer days, when the stifling heat causes one to pant and perspire, how welcome the mere idea of a watering place, such as Newport!"[73] In his *Lotus-Eating: A Summer Book* of 1852, George William Curtis referred to Newport as "a synonyme of repose."[74] And in *Newport Illustrated* of 1854 George C. Mason invoked the reminiscences of the Unitarian divine William Ellery Channing and the verse of the aesthete Henry T. Tuckerman in touting the spiritual and psychic benefits of wandering Newport's beaches.[75] Intoned Tuckerman in his poem "Newport Beach":

> *Then here, enfranchised by the voice of God,*
> *O, ponder not, with microscopic eye,*
> *What is adjacent, limited and fixed;*
> *But with high faith gaze forth, and let thy thought*
> *With the illimitable scene expand,*
> *Until the bond of circumstance is rent,*
> *And personal griefs are lost in visions wide*
> *Of an eternal future!* . . .[76]

Such elevated rhetoric was perhaps a bit misplaced, since the beaches in question were the scenes of

THE BATHE AT NEWPORT.

Fig. 87. *The Bathe at Newport*. Wood engraving, from *Harper's Weekly*, September 4, 1858, p. 568. The Metropolitan Museum of Art, New York, The Irene Lewisohn Costume Reference Library

Fig. 88. John William Orr(?), after John F. Kensett, *The Cliff Walk, Newport*. Wood engraving, from George William Curtis, *Lotus-Eating: A Summer Book* (New York: Harper and Brothers, 1852), p. 192. The New York Public Library, Astor, Lenox and Tilden Foundations

young women had finished "splashing and paddling in the water with all their might, as unlike mermaids as possible," they compensated for their "moist deshabille by their rosy, refreshed and beaming looks, when they once more came forth, like rosy Christians, from their sea-side toilets."[77]

But the phenomenon of social bathing that seemed to threaten the aesthetic and moral chastity of Newport was merely a single, visible symbol of a more pervasive pollution affecting many resorts—Newport the most egregious among them—according to Curtis. In *Lotus-Eating*, which Kensett illustrated, he devoted two chapters to Newport, but the first was almost wholly a peroration decrying "Fashion upon the sea-shore."[78] It was not so bad, said the author, that city people had discovered havens such as Newport; it was what of the city they brought along with them that was to be despised:

> *we Americans are workers by the nature of the case, or sons of laborers, who spend foolishly what they wisely won. And, therefore, New York, as the social representative of the country, has more than the task of Sisyphus. It aims, and hopes, and struggles, and despairs, to make wealth stand for wit, wisdom and beauty. In vain it seeks to create society by*

77. [Dix], *Hand-book of Newport*, pp. 72, 74. For similar commentary on the bathing scene at Easton's Beach, see Mason, *Newport Illustrated*, p. 51.

78. Curtis, *Lotus-Eating*, p. 165.

frivolities and improprieties·that most writers observed with some degree of scorn. Dix, for example, perceived ideal female beauty to be profaned during the morning bathing hours at Easton's Beach (see fig. 87), where he winced at more than one baggily attired "marine monster" who emerged from the bathing house that a "charming, lovable sort of creature" had entered. He was relieved that, once the

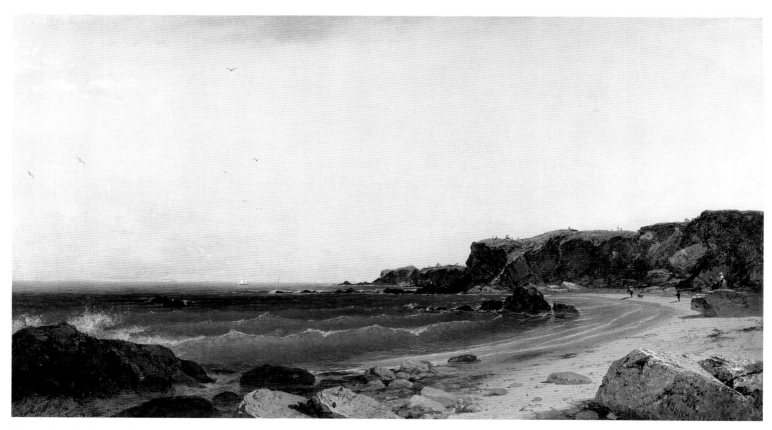

Fig. 89. John F. Kensett, *Forty Steps, Newport, Rhode Island*, 1860. Oil on canvas. Collection of Jo Ann and Julian Ganz, Jr.

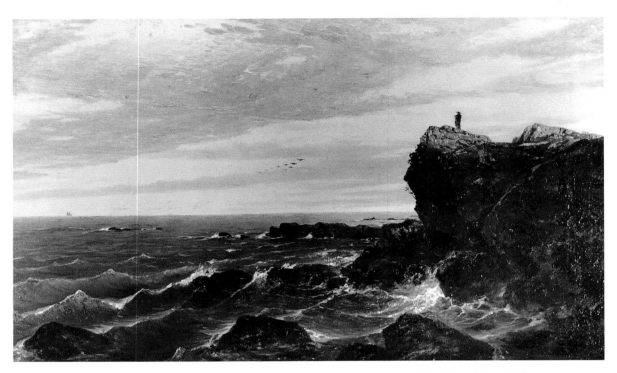

Fig. 90. John F. Kensett, *Berkeley Rock, Newport,* 1856. Oil on canvas. Frances Lehman Loeb Art Center, Vassar College, Poughkeepsie, New York, Gift of Matthew Vassar 1864.0001.0049.000

79. Ibid., pp. 173–74, 176.
80. Ibid., p. 184.
81. [Dix], *Hand-book of Newport,* p. 57.
82. Curtis, *Lotus-Eating,* p. 183.
83. Mason, *Newport Illustrated,* pp. 70–71; [Dix], *Hand-book of Newport,* p. 140.

dancing, dressing, and dining, by building fine houses and avoiding the Bowery. . . . Wealth will socially befriend a man at Newport or Saratoga, better than at any similar spot in the world, and that is the severest censure that could be passed upon those places.[79]

When Curtis called Newport "a synonyme of repose," he was remembering it in earlier times or referring not to the clamorous high season but to "the serene beauty of September." Then, he noted (perhaps alluding to those mermaids on Easton's Beach), "Fashion, the Diana of the Summer Solstice, is dethroned; that golden statue is shivered, and its fragments cast back into the furnace of the city, to be again fused and moulded."[80]

Most notably among the major Hudson River School painters, Kensett acknowledged the urban leisure class in his landscapes. Nowhere are these wealthy travelers more in evidence than in his paintings of Newport, and in few of them more than in the *Forty Steps, Newport, Rhode Island,* 1860 (fig. 89), a portrait of a popular spot along the scenic cliffs on the town's ocean side. Yet staffage is never a prominent feature of Kensett's landscapes, and even here the human presence is inconspicuous. The forty steps themselves, a wooden stairway down to the beach constructed by a "wealthy and considerate gentleman,"[81] are not visible; and only close inspection

reveals a generous sprinkling of fashionably attired figures, mostly women, atop the cliff in the distance, verifying Curtis's declaration that "it is thus the finest ocean-walk, for it is elevated sufficiently for the eye to command the water, and [with its grass extending to the precipice] is soft and grateful to the feet, like inland pastures" (see fig. 88).[82]

Such works notwithstanding, Kensett's Newport pictures are as often deserted as not, except for the occasional fisherman and the immaculate sail accenting the horizon. The gentle forms of his many Beacon Rock paintings (see cat. no. 37) offer no hint that Fort Adams, represented by the terraced mounds on the left of each image, was the site of a weekly military band concert as well as drills and artillery exercises. These events attracted flotillas of civilians from Newport harbor,[83] but Kensett could not have seen the bustling crowds from the distant viewpoint he deliberately chose.

It is no wonder that Kensett sanitized his Newport, emphasizing the beauties of its sea, land, and sky and minimizing the presence of the urban society Curtis disparaged. Given his collaboration with Curtis on *Lotus-Eating* and his association with enlightened, nature-loving patrons such as Jonathan Sturges of New York—who bought one of the artist's earliest pictures of Beacon Rock (cat. no. 37)—his choice was inevitable; it was assured as well, of course, by the tradition of reverence for nature that formed him.

Inevitable also was his interest in the theological and philosophical tradition that the natural environment of Newport seems to have encouraged. This was a tradition he addressed quite literally in one of his earliest Newport paintings, *Berkeley Rock, Newport* (fig. 90); here he posed the lone figure of Bishop Berkeley, looking out to sea, on the rock named for him, the site at which he was said to have composed his *Alciphron; or the Minute Philosopher* of 1732.

Kensett also addressed the resemblance of Newport's atmosphere to that of Venice, a theme pursued by Curtis and other writers. Most effectively among his American contemporaries, he approximated the warmth and transparency of Canaletto's Venetian views, evoking, for example, Curtis's description: "[Newport's climate] is an Italian air. These are Mediterranean days. They have the luxurious languor of the South."[84] Luxurious they may have been, but they were not immodest, for Kensett's vision is appropriate to the moralizing strain in Curtis's summary characterization of Newport's climate as "bland and beautiful. It is called bracing, but it is only pure."[85] Kensett's Newport pictures and the paintings of Massachusetts and New Jersey beaches that he, Gifford, Haseltine, and Alfred Bricher produced supply evidence, which Curtis could not find in New York's winter society itself, "that the city has summered upon the seaside."[86]

Italy

When Dix stood on Easton's Beach enjoying the balm of Newport's scenery and climate, he spied offshore "one of the great Atlantic ferry-boats—a floating bridge between the old world and the new," noting that "frequently are the ships of the Collins's line seen from here, as they speed their way to or from New York."[87] To be sure, by the 1850s fashionable travelers found Europe to be nearly as accessible as any of the American resorts discussed here. The adaptation of steam power to ocean vessels accomplished by mid-century had reduced the time it took to cross the Atlantic from as many as three to four weeks under sail to as few as ten days with steam power. Moreover, once Europe's shores were reached, travel was relatively cheap. To tour economically in the Old World one need not have been as hearty as the young Bayard Taylor, who boasted in his *Views A-Foot* of 1846 that his trek, mostly on foot, across England and the Continent cost him a mere $492.[88] As early as 1838, in *The Tourist in Europe*, the New York publisher George P. Putnam had been telling Americans expressly how to

save money and, that equally precious metropolitan commodity, time when traveling abroad.[89]

Nowhere in Europe could the traveler better economize than in Italy, where our necessarily brief remarks on Old World travel and American landscape art are focused. The Grand Tour, that extended sojourn on the Continent that was part of the education of northern Europeans, especially the Germans and the British, had attracted Americans from the colonial period until the Civil War and beyond. Among the notable Americans who took the Grand Tour were the expatriate artists Benjamin West and John Singleton Copley in the early era and Cole during the time of our study.

For Americans—and especially for citizens of New York, the fastest-growing city in the United States—Europe above all served as a point of comparison with their own country. As descendants of the immigrants who had founded American civilization, they felt obliged to explore their cultural roots. These included their roots in antiquity, which, in the Age of Enlightenment, became a powerful focus of interest for northern Europeans. Yet Americans brought with them to Europe the seasoning of a young civilization struggling with great but brutalizing success to extend its empire over a vast, obdurate natural domain with the modern equivalent of aqueducts, engineering marvels such as the Erie Canal. Italy in particular wore conspicuously the imposing monuments of the Western world's greatest early empire, perceived as a model of republican government for at least part of its history. But the monuments were only vestiges, ruins returning to nature and betokening the impermanence of lofty ideals and enterprise. The parent Europe, then, was both model and cautionary example to the child America, depending on the point of view.

For early-nineteenth-century American tourists, as for their British counterparts, travel to the Continent became safe only after the end of the Napoleonic Wars, in 1815. Among the Americans to visit Italy following the wars was Theodore Dwight, who wrote of the Grand Tour in his earliest published book, *Journal of a Tour in Italy, in the Year 1821*, which appeared in 1824. His commentaries in this volume offer some of the first notes of skepticism sounded in regard to the experience of Italy: staring in the face of divided and, to his mind, "degraded" modern Italy, still attired in the tattered finery of her ancient past, he was deeply pessimistic.[90] He seems to have most enjoyed his visit to Herculaneum and Pompeii, where "we mix with the subjects of Rome" in exploring their dwellings preserved beneath the ash.[91] But the uncanny perfection

84. Curtis, *Lotus-Eating*, p. 179.
85. Ibid., p. 180.
86. Ibid., p. 187.
87. [Dix], *Hand-book of Newport*, p. 43.
88. J. Bayard Taylor, *Views A-Foot; or, Europe Seen with Knapsack and Staff* (New York: Wiley and Putnam, 1846), p. 393. Two recent indispensable sources for bibliography on nineteenth-century Americans in Italy are William J. Vance, *America's Rome*, vol. 1, *Classical Rome* (New Haven: Yale University Press, 1989); and Theodore E. Stebbins Jr. et al., *Lure of Italy: American Artists and the Italian Experience, 1760–1914* (exh. cat., Boston: Museum of Fine Arts, 1992).
89. [George P. Putnam], *The Tourist in Europe: or, A Concise Summary of the Various Routes, Objects of Interest, &c. in Great Britain, France, Switzerland, Italy, Germany, Belgium, and Holland; with Hints on Time, Expenses, Hotels, Conveyances, Passports, Coins, &c.; Memoranda during a Tour of Eight Months in Great Britain and on the Continent* (New York: Wiley and Putnam, 1838), p. 5.
90. An American [Theodore Dwight], *A Journal of a Tour in Italy, in the Year 1821* (New York: Printed by Abraham Paul, 1824), p. 118.
91. Ibid., p. 110.

Fig. 91. Thomas Cole, *The Course of Empire: The Savage State*, 1834. Oil on canvas. Collection of The New-York Historical Society 1858.1

Fig. 92. Thomas Cole, *The Course of Empire: The Pastoral or Arcadian State*, 1834. Oil on canvas. Collection of The New-York Historical Society 1858.2

Fig. 93. Thomas Cole, *The Course of Empire: The Consummation of Empire*, 1835–36. Oil on canvas. Collection of The New-York Historical Society 1858.3

92. Ibid., pp. 112–13.
93. Ibid., p. 211.
94. Ibid., p. 210.

of these remains merely accentuated the contrast with the present: "And seen from this place, how does the present world appear? A mass of bones and ashes of men; a melancholy shore, which the waves of time have strewed with the wrecks of nations, and heaps of broken sceptres." [92] His ruminations only darkened as he entered Rome from the "dreary desert" [93] of the Campagna:

> *How unlike is such a scene as this, to the first view of one of our American cities; . . . Instead of the cheerful and exhilarating sight of a savage wilderness retreating before the progress of a free and* *enlightened society, and a new continent assuming the aspect of fertility and beauty, under the influence of an enterprising population, and a generous form of government; . . . here we have the poor remains of that mighty city—the cradle and the grave of an empire so long triumphant on earth—now dwindling away before the wide-spread desolation which surrounds it, and shrinking back upon itself, as if for dread of an invisible destroyer.[94]*

Still, Dwight conceded the beauty of such natural sites as the Bay of Naples and Vesuvius and the view from Tivoli over the Campagna toward Rome, "one

Fig. 94. Thomas Cole, *The Course of Empire: Destruction*, 1836. Oil on canvas. Collection of The New-York Historical Society 1858.4

Fig. 95. Thomas Cole, *The Course of Empire: Desolation*, 1836. Oil on canvas. Collection of The New-York Historical Society 1858.5

of the most precious morsels of composition in the world,"[95] which Cole, Gifford, and many other American artists interpreted on canvas. Moreover, the splendors of painting and sculpture at the Vatican galleries and the magnificence of Roman architecture, which Dwight found unsettling, challenged his American, inherently democratic distrust of imperial show and prompted at least a hint of envy: "I wished that America might possess such specimens of the arts. . . . The cultivation of painting and sculpture in our country should be promoted by every one who has the power; though architecture must have its limit among a people where there are no kings nor nobles, and where there

ought to be no aristocracy. Beyond that limit, it would not be patriotic not to wish architecture extended."[96]

Although James Fenimore Cooper, like Dwight, suffered few illusions about modern Italy, his Yankee origins did not dampen his enthusiasm for it or for the remnants of ancient Rome. Unlike Dwight, Cooper went to Europe with an entrée, for his novels were already known and popular in England and France, making him welcome in foreign society upon his arrival[97]—which may account for his more positive attitude. Moreover, he had had enough experience of both the physical environment and the culture of New York (a culture he had, after all, stimulated) to

95. Ibid., p. 279.

96. Ibid., p. 414.

97. Cooper, *Leatherstocking Tales*, p. 873 (chronology): Of his reception in Paris, Cooper remarked in a letter to a friend, "The people seem to think it marvelous that an American can write."

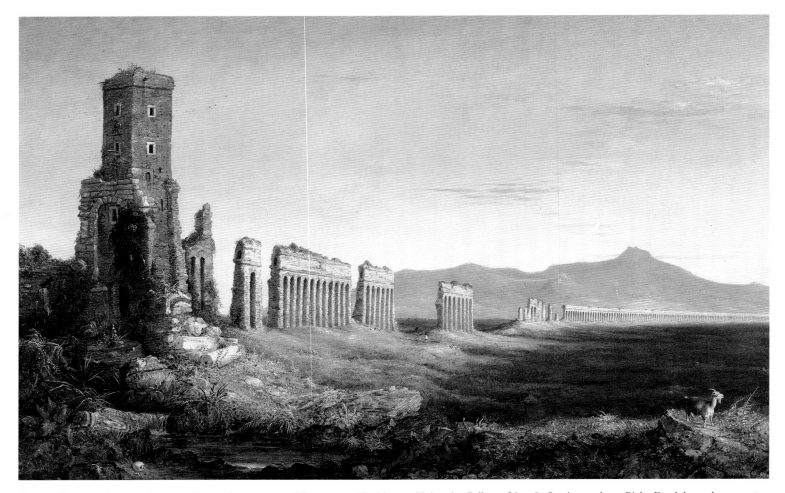

Fig. 96. Thomas Cole, *Aqueduct near Rome,* Florence, 1832. Oil on canvas. Washington University Gallery of Art, St. Louis, purchase, Bixby Fund, by exchange, 1987

98. James Fenimore Cooper, *Excursions in Italy,* 2 vols. (London: Richard Bentley, 1838), vol. 1, pp. 202–3.

99. Ibid., p. 203.

100. Ibid., p. 294.

101. Ibid., vol. 2, pp. 201, 202–3.

102. For Cole's travels in Europe, see Parry, *Art of Cole,* pp. 95–130, 263–72.

103. Ibid., pp. 116–18. Cole dubbed the series "The Cycle of Mutation" or "The Epitome of Man" when he first conceived it.

compare Gotham with Italian cities and find it pathetically wanting. In his *Excursions in Italy* of 1838, he sniffed at the turbid green waters of New York's harbor and the backdrop of her puny Palisades in contrast to the azure Bay of Naples lying in the shadow of Vesuvius and the Apennines.[98] Both in Naples and at Rome, his worshipful admiration of ancient and modern architecture, weighed against his recollections of the occasional "Grecian monstrosities and Gothic absurdities" scattered about New York,[99] caused him to predict that centuries hence Gotham would leave no trace "beyond imperishable fragments of stone. . . . Something [of the durability of Roman architecture] may be ascribed to climate, certainly; but more is owing to the grand and just ideas of these ancients, who built for posterity as well as for themselves."[100] Cooper concluded: "Rome is a city of palaces, monuments, and churches, that have already resisted centuries; New York, one of architectural expedients, that die off in their generations like men. . . . I would a thousand times rather that my own lot had been cast in Rome, than in New York, or in any other mere trading town that ever existed. As for the city of New York, I would 'rather be a dog and bay the moon, than such a Roman.'"[101]

Sharply contrasting responses to Italy such as those of Dwight and Cooper were encompassed by Cole in pictures he conceived and sometimes painted during his own Grand Tours. These journeys Cole undertook after his northern tours of the Catskills, Lake George, and the White Mountains and after he started to produce heroic landscapes based on biblical history. The first trip, begun in 1829, included a sojourn in Italy from June 1831 to October 1832; the second, in 1841–42, was spent mostly in mainland Italy and also in Sicily.[102] In The Course of Empire series, 1834–36 (figs. 91–95), conceived during his first visits to Florence, Cole in effect illustrated Dwight's moral view of Italy.[103] Here he conjured up an unnamed classical city in five pictures representing the civilization's rise *(The Savage State* and *The Pastoral or Arcadian State),* apogee *(The Consummation of Empire),*

and decline (*Destruction* and *Desolation*). Cole clearly meant the series as "the grand moral epic" a contemporary critic declared it to be.[104] *Destruction* and *Desolation* dramatize to striking effect, respectively, the sacking of the empire by invaders and its skeletal remains; and even *Consummation*, with the alabaster splendor of its colonnades and temple piles, hints at the hubris and corruption that will bring the society down. Yet at the same time, Cole's aim was surely to communicate, even exaggerate, the splendor of that empire and of the ancient Italy suggested and idealized in the middle picture. He said so himself in his program for the series published in a contemporary magazine: "In this scene is depicted the summit of human glory. The architecture, the ornamental embellishments, &c., show that wealth, power, knowledge, and taste have worked together, and accomplished the highest meed of human achievement and empire."[105] Indeed, he endowed his empire with a verticality that Rome never owned (and that New York would assume only in the twentieth century).

Cole seems also to have expressed American ambivalence toward Italy in his view of the Campagna, *Aqueduct near Rome* of 1832 (fig. 96). The skull at the base of the composition reminds the viewer of the many Roman tombs scattered across the Campagna. But more importantly, it functions as a conventional memento mori, alluding to the vanity of the human enterprise that built the aqueduct. Yet Cole showed this monument—the "*spine* to the skeleton of Rome," in Taylor's words[106]—bathed in the mild yellow light of evening, eloquently and poetically ameliorating the moral embodied in the skull. Conveyed above all is awe in confronting a grandeur that has persisted through the ages and has even been enhanced by the passage of time. Taylor wrote of the Coliseum, "A majesty like that of nature clothes this wonderful edifice,"[107] but his observation is eminently applicable to the aqueduct as Cole has presented it here.

Although Cole conjured up an ancient classical city, portrayed Roman ruins, and even painted a view of modern Florence, *View of Florence from San Miniato,* 1837 (The Cleveland Museum of Art), he never essayed a picture of New York, the city in which he attained success. In fact, views of New York City by his successors are exceedingly rare as well.[108] The painters by and large left portrayal of the city to the topographical watercolorists and printmakers, no doubt because of New York's deficiencies as a potential landscape subject: it lacked heroic or even picturesque, that is, irregular, terrain; it had, as Cooper

suggested, few impressive public buildings (most were wood structures); and nothing about it suggested permanence, let alone monumentality. Gotham was an ideal place in which to produce landscape paintings but not a good subject for them. Thus it may be said that Cole and his followers expressed Cooper's attitudes not only in what they painted but also in what they did not paint.

In our period American apprehensions of Italy evolved, until tourists were more often charmed by the contrast between grandeur and ruination than struck by its moral implications. It would seem that the softening of attitude was impelled by literature and, less often, by the example of painting. Most important in this respect was Byron's *Childe Harold's Pilgrimage.* With increasing frequency through the second quarter of the century, travel accounts and tour guides that appeared in New York invoke the poem with reference to European scenery, particularly its descriptions of the Rhine and the Alps in canto 3 and Italy in canto 4.[109] Indeed, in the third edition of his *Italian Sketchbook* of 1848 Tuckerman referred to Byron as "an intellectual and ideal *cicerone*."[110] Byron's pessimistic message in *Childe Harold*, a ruminative tour of the Continent, is little different from those offered in the prose of historians Edward Gibbon and the Comte de Volney—but it was poetry. It sang of human vanity, clothing it in rhyming verse that proved irresistible to tourists—who undoubtedly recited appropriate passages in the course of their travels—and imposed its romance and lyricism on sites that Americans might otherwise have regarded dismissively, fearfully, neutrally, or perhaps not at all.

Cole's pictures of Roman scenery are imbued with the spirit of the British Romantics, above all Byron. Not only *Childe Harold* but also other works by Byron inspired Cole: he painted a scene from *Manfred*, set in the Swiss Alps, which he, in fact, never visited. It therefore is fitting that the young Knickerbocker writer Nathaniel Parker Willis, in *Pencillings by the Way*, his published journal of his European tour of 1836, often enlisted Byron or Cole, and occasionally both, to help him describe particular locales. Like other authors Willis was inspired to invoke Byron by his encounter with the tomb of Cecilia Metella on the Campagna, on which occasion he recalled that "Nothing could exceed the delicacy and fancy with which Childe Harold muses on this spot." And, then, as he peered out from one of the tomb's "lofty turrets" over the dusty plain "to the long aqueducts stretching past at a short distance, and forming a chain of noble

104. *American Monthly Magazine,* n.s., 2 (November 1836), p. 513, quoted in Parry, *Art of Cole,* p. 186.

105. Cole, in *American Monthly Magazine,* p. 514, quoted in Parry, *Art of Cole,* p. 168.

106. Taylor, *Views A-Foot,* p. 337.

107. Ibid., p. 328.

108. At the very end of our period the Boston landscape painter George Loring Brown produced *The Bay and City of New York,* 1860 (Sandringham House, Norfolk, England), a view of the city from Weehawken, New Jersey. Measuring ten feet wide, it was surely the most ambitious portrait in oils of New York painted to that time. Among the very few New York landscapists to represent the city in oils by 1861 were Robert Havell Jr., an English immigrant, in a work of 1840; Jasper F. Cropsey, in pictures of 1856 and later; and Charles Herbert Moore, in a canvas of 1861. All adopted the point of view from Weehawken, originated by Wall in a watercolor of 1824 (Metropolitan Museum). I am grateful to Gerald L. Carr for information on Brown's paintings. For Havell's and Cropsey's paintings, see William S. Talbot, *Jasper F. Cropsey, 1823–1900* (Ph.D. dissertation, New York University, 1972; reprint, New York: Garland Publishing, 1977), pp. 389–90; for Moore's painting, see Ella M. Foshay and Sally Mills, *All Seasons and Every Light: Nineteenth Century American Landscapes from the Collection of Elias Lyman Magoon* (exh. cat., Poughkeepsie, New York: Vassar College Art Gallery, 1983), pp. 77–78.

109. For Byron's impact on Victorian travelers, see Maxine Feifer, *Going Places: The Ways of the Tourist from Imperial Rome to the Present Day* (London: Macmillan, 1985), p. 161.

110. Henry T. Tuckerman, *The Italian Sketchbook,* 3d ed. (New York: J. C. Riker, 1848), p. 210. Tuckerman gave the title "Byronia" to a chapter of his book, pp. 209–13.

Fig. 97. Sanford Robinson Gifford, *On the Roman Campagna, a Study*, 1859. Oil on canvas. Frances Lehman Loeb Art Center, Vassar College, Poughkeepsie, New York, Gift of Matthew Vassar 1864.0001.0034.000

111. N. P. Willis, *Pencillings by the Way* (1836; "First Complete Edition," New York: Morris and Willis, 1844), p. 82.

112. See also *The Roman Campagna* (private collection), illustrated in Ila Weiss, *Poetic Landscape: The Art and Experience of Sanford R. Gifford* (Newark: University of Delaware Press, 1987), p. 204.

113. Ibid., p. 70.

114. James Jackson Jarves, *Italian Sights and Papal Principles, Seen through American Spectacles* (New York: Harper and Brothers, 1856), p. 350.

115. Ibid.

116. [Dwight], *Journal of a Tour in Italy*, p. 210.

117. Willis, *Pencillings by the Way*, p. 76.

118. Sanford R. Gifford, "European Letters," vol. 2, March 1856–August 1857, p. 122, Archives of American Art, Smithsonian Institution, quoted in Weiss, *Poetic Landscape*, p. 195.

arches from Rome to the mountains of Albano," he turned to "Cole's picture of the Roman Campagna [fig. 96] . . . one of the finest landscapes ever painted" to perfect the impression he recorded.[111]

Several second-generation Hudson River School artists made pilgrimages to the aqueduct on the Campagna and painted it from the point of view adopted by Cole. The subtle differences between Cole's picture and the interpretations of his disciples testify to the shifting perceptions of American visitors to Italy. It is hardly surprising that Gifford eliminated from his two small views (see fig. 97)[112] the moralizing detail of the skull seen in Cole's picture, and it is even more significant that he ignored the imposing signs of the passage of time, such as the medieval tower rising from the aqueduct's foundations. The aqueduct in Gifford's *On the Roman Campagna, a Study*, 1859 (fig. 97), no taller than the mountains of Albano in the background, whose slopes echo the monument's contours, seems a natural eminence, in contrast to the majestic presence in Cole's canvas. With its prosaic afternoon light and shepherd and flock in the foreground, Gifford's picture is like a *veduta*, comparable to Kensett's views of Newport, while Cole's poetically lit composition, by comparison, has the flavor of a *capriccio*, a picturesque or classical fantasy.

Certainly the turn toward relatively realistic interpretations on the part of Gifford and other young New York landscape painters was influenced by the Ruskinian aesthetic of truth to nature (while he was in England in 1855, Gifford had visited Ruskin at Oxford).[113] But they were moved as well by the difficult emergence of a united modern Italy through a struggle that began in 1848 and ended in 1870, when Rome was absorbed into the new nation. The effects of the revolution in Italy were impossible to overlook for any American traveling in that country. American views of the political changes occurring there ranged from benignly hopeful to rabidly condemnatory, depending upon the events of the moment. In 1848, for example, Tuckerman published Pope Pius IX's portrait as the frontispiece to his *Italian Sketchbook*, in the expectation, shared by many, that the new and progressive pontiff would support the revolutionary movement. But eight years later, after Pius had fled riots in Rome and returned, as a reactionary, under the protection of France's Napoléon III, James Jackson Jarves savaged the city of the Caesars in his jeremiad of 1856, *Italian Sights and Papal Principles, Seen through American Spectacles*. For him it was "an isolated wreck amid the sea of the Campagna, clinging convulsively to the rock on which she foundered,"[114] with the Roman Catholic leadership grasping in vain at the extinct authority of empire. He, like Cooper, contrasted Rome with New York, but through the other end of the telescope: he saw "New York [as] . . . a focus of enterprise and riches, giving birth yearly to rival cities."[115]

As a modern American landscape painter, Gifford, who was patriotic but did not express strong political opinions, adopted the sympathetic view of Italy. For him and many of his contemporaries, the perception of a modern nation rising from the ashes of a long-dead empire cast the light of the present—of ordinary day—over the land and the vestiges of its antique civilization. It was a perception that lifted the elegiac twilight from the landscape, transforming it from what Theodore Dwight considered "the grave of an empire"[116] into a new frontier, the semblance of an American prairie. When Gifford produced his first major painting of an Italian scene, his *Lake Nemi*, 1856–57 (cat. no. 36), he preferred the natural landscape, distilled through its atmosphere, to ruins. Surely he was attracted by the beauty of the volcanic lake itself, which Willis had called "one of the sweetest gems of natural scenery in the world."[117] Although Gifford's emphasis on the reflective disklike surface of the water may well allude to the Latin designation of the lake as Speculum Dianae, or the mirror of Diana, the Roman goddess, the painter's main purpose was not to evoke such associations but to glorify natural phenomena. As his letters from Europe reveal, he was inspired by the pure visual effect of the lake contemplated under the light of the moon,[118] which he translated into the sun and radiant daylight in his picture. In fact, *Lake Nemi* reminded Hudson River School

Fig. 98. Sanford Robinson Gifford, *Kaaterskill Clove*, 1862. Oil on canvas. The Metropolitan Museum of Art, New York, Bequest of Maria DeWitt Jesup, from the collection of her husband, Morris K. Jesup, 1914 15.30.62

Fig. 99. Julius Schrader, *Baron Alexander von Humboldt*, Berlin, 1859. Oil on canvas. The Metropolitan Museum of Art, New York, Gift of H. O. Havemeyer, 1889 89.20

119. At Gifford's memorial service in 1880, Whittredge recalled of *Lake Nemi*, "It was treated in such a way that an American familiar with some of the small lakes among our hills could easily as he stood before it imagine himself at home." *Gifford Memorial Meeting of The Century . . . November 19th, 1880* (New York: Century Rooms, 1880), p. 37.

120. The exhibition of *The Heart of the Andes* is described at length in Kevin J. Avery, *Church's Great Picture: The Heart of the Andes* (exh. cat., New York: The Metropolitan Museum of Art, 1993), pp. 9, 33–44.

painter Worthington Whittredge of an American lake scene,[119] while Gifford's later Kaaterskill Clove pictures (see fig. 98), bathed in the same light, have an Italian quality. The dreamy, picturesque glow in all of them is unspecific, burning away details of place and time, and expressing a nostalgic longing for an indefinable not-here and not-now.

Vicarious Tourism and "The Heart of the Andes"

Neither the American taste for the Grand Tour nor merely vacationing in the northeastern United States accounts for the phenomenal popularity of Frederic E. Church's *Heart of the Andes* of 1859 (cat. no. 41; fig. 101) and the artistic progeny it inspired in succeeding decades. At the end of our period, the

painting assured the status of Church, whose technical dexterity and commercial success made him Cole's most important follower. Like the tale of Cole's discovery, the story of the most acclaimed American landscape painting of the nineteenth century has been told often.[120] Just after the painting was put on view in April 1859, Church contracted for its sale to a New York collector for $10,000, an enormous sum in its time; during its three-week debut on Tenth Street, twelve thousand people paid 25 cents each to see the picture; it went to London for exhibition in the summer; returned for a showing of three months in New York; and then toured seven more American cities until March 1861. To be sure, *The Heart of the Andes* offered myriad attractions, and the artist exercised entrepreneurial genius in promoting it in a

spectacularly theatrical display. However, unlike the views of Cole and of Church's colleagues, *The Heart of the Andes* did not represent a tourist destination known and loved by Americans, for only the rarest of the painting's original viewers had been to the Andes.

Still, it is fair to say that the culture and industry of travel helped make *The Heart of the Andes* a prized commodity. For if few members of Church's audience had seen South America, let alone wished to visit that largely undeveloped continent, many of them had read the eloquent, rapturous descriptions of it written by Alexander von Humboldt (fig. 99). Perhaps the nineteenth-century's most adventurous traveler and its first great natural scientist, Humboldt was a native of Prussia. He made a five-year expedition at the turn of the eighteenth century that ranged through the northern part of South America, Mexico, and Cuba and concluded with a visit to the United States, and he later explored southwestern Asia.[121] In an age before the first intrepid tourists attempted the ascent of Mont Blanc in the Alps or the relatively low Mount Washington in New Hampshire, Humboldt had climbed almost to the top of Chimborazo in Ecuador, at the time of his feat believed to be the tallest mountain in the world and the snowy peak that Church later portrayed in *The Heart of the Andes*.

More important in our context, over the five decades after his first expedition Humboldt published a succession of books describing his journey. In these he proposed the equatorial New World, with its unsurpassed geological, climatic, botanical, and zoological range, as a microcosm of global nature.

Most of Humboldt's writings were published in cheap English editions that had a vast audience.[122] In *Personal Narrative of Travels to the Equinoctial Regions of America*, which appeared in English translation in 1852–53, Humboldt sought to recapture for the reader his initial impressions of South America's tropical rain forests in a passage that the foreground of *The Heart of the Andes* closely evokes:

[The traveler] feels at every step, that he is not on the confines but in the centre of the torrid zone; . . . on a vast continent where everything is gigantic,— mountains, rivers, and the mass of vegetation. If he feel strongly the beauty of picturesque scenery he can scarcely define the various emotions which crowd upon his mind; he can scarcely distinguish what most excites his admiration, the deep silence of those solitudes, the individual beauty and contrast of forms, or that vigour and freshness of vegetable life which characterize the climate of the tropics.

121. Humboldt's career is summarized and documented in ibid., pp. 12–13.

122. The most important of these are Alexander von Humboldt and Aimé Bonpland, *Personal Narrative of Travels to the Equinoctial Regions of America, during the Years 1799–1804*, 3 vols., translated and edited by Thomasina Ross (London: H. G. Bohn, 1852–53) and especially Humboldt's last, culminating work, *Cosmos: A Sketch of a Physical Description of the Universe*, 5 vols., translated by E. C. Otté (London: H. G. Bohn, 1849–58). See Avery, *Church's Great Picture*, p. 57 n. 8. Church's personal library included both of the English editions cited.

123. Humboldt and Bonpland, *Personal Narrative*, vol. 1, p. 216.

124. Louis L. Noble, *Church's Painting: The Heart of the Andes* (New York: D. Appleton, 1859); Theodore Winthrop, *A Companion to The Heart of the Andes* (New York: D. Appleton, 1859).

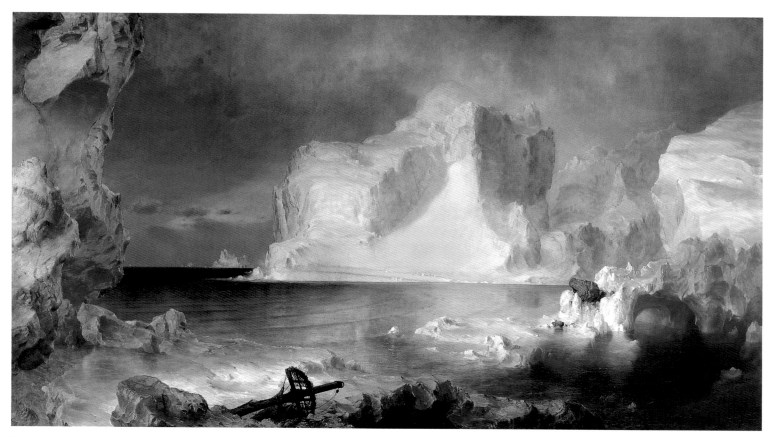

Fig. 100. Frederic E. Church, *The Icebergs*, 1861. Oil on canvas. Dallas Museum of Art, Anonymous Gift 1979.28

Fig. 101. Photographer unknown, possibly J. Gurney and Son, *"The Heart of the Andes" in Its Original Frame, on Exhibition at the Metropolitan Fair in Aid of the Sanitary Commission, New York, April 1864.* Stereograph (one panel shown). Collection of The New-York Historical Society

Fig. 102. *Oak Sideboard by Rochefort and Skarren.* Wood engraving by John William Orr, from B. Silliman Jr. and C. R. Goodrich, eds., *The World of Science, Art, and Industry Illustrated from Examples in the New-York Exhibition, 1853–54* (New York: G. P. Putnam and Company, 1854), p. 111. The Metropolitan Museum of Art, New York, The Thomas J. Watson Library

125. Church's exhibition strategies are detailed in Avery, *Church's Great Picture,* pp. 33–36; and especially in Kevin J. Avery, *"The Heart of the Andes* Exhibited: Frederic E. Church's Window on the Equatorial World," *American Art Journal* 18 (winter 1986), pp. 52–60.

126. Parry used the term "landscape theater" to describe panoramic exhibitions and the panoramic pictorial strategies adopted by Thomas Cole in his landscapes; see Ellwood C. Parry III, "Landscape Theater in America," *Art in America* 59 (December 1971), pp. 52–56.

127. Humboldt, *Cosmos,* vol. 2, pp. 456–57. Humboldt's recommendations for subject matter are discussed in Avery, *"Heart of the Andes* Exhibited," p. 61.

128. The history of panoramas is summarized in Kevin J. Avery, "Movies for Manifest Destiny: The Moving Panorama Phenomenon in America," in *The Grand Moving Panorama of Pilgrim's Progress* (exh. cat., Montclair, New Jersey: Montclair Art Museum, 1999), pp. 1–12. A thorough study of the panorama phenomenon is Stephan Oettermann, *The Panorama: History*

It might be said that the earth, overloaded with plants, does not allow them space enough to unfold themselves. The trunks of the trees are everywhere concealed under a thick carpet of verdure; . . . By this singular assemblage, the forests, as well as the flanks of the rocks and mountains, enlarge the domains of organic nature. The same lianas which creep on the ground, reach the tops of the trees, and pass from one to another at the height of more than a hundred feet. Thus, by the continual interlacing of parasite plants, the botanist is often led to confound one with another, the flowers, the fruits, and leaves which belong to different species.

We walked for some hours under the shade of these arcades, which scarcely admit a glimpse of the sky.[123]

Humboldt's descriptions of this kind unquestionably had enormous appeal for New Yorkers and certainly contributed to their appreciation of *The Heart of the Andes.* That this was recognized is indicated by the fact that texts reflecting Humboldt's views and even his discursive style were included in two programs sold at the New York exhibitions of the picture.[124]

As advertisements for the exhibition advised, viewers could enhance the sense of vicarious expedition encouraged by the texts with opera glasses, which allowed them to isolate and magnify sections of the picture and eliminate their awareness of the artifice of the frame. Church tailored that frame to foster the illusion that a real landscape was displayed. By designing it with a paneled embrasure and adorning it with curtains and a sill, he made the frame look like a window on the scene, yet he suppressed its imposing presence by staining it dark and keeping the gallery dark, concentrating all the available light on the image of the landscape.[125] Thanks to these spectacular strategies and the grand, panoramic scale of the picture, the exhibition became "landscape theater."[126]

Church's use of panoramic pictorial strategies, or landscape theater, can be attributed in part to the direct influence of Humboldt, who in *Cosmos,* his culminating work, promoted circular panoramas as "improvements in landscape painting on a large scale" and recommended the tropics, specifically the equatorial New World, as subjects for them.[127] However, the artist was also exploiting a broader, more popular current in the urban culture that was connected to travel: the taste for moving panoramas, which blossomed in the 1840s and 1850s.[128]

The huge moving panoramas were for the most part a kind of folk art, the primary purpose of which

was not to offer an aesthetic experience but to provide a vicarious travel experience for the eastern, urban middle-class viewers who paid a quarter or 50 cents each to see them. Although these panoramas came to depict all manner of subjects, they most typically showed landscapes, both native and foreign, as was appropriate to their scale and format. The destinations they offered imaginary tourists were neither urban nor fashionable: their usual subject was the frontier, regions visited by explorers or the occasional merely curious traveler, or regions settled by immigrants.[129] Among the moving panoramas of the mid-1840s, the most renowned was John Banvard's "three mile painting" of the banks of the Mississippi, viewed as if floating down the river. Hugely popular, Banvard's panorama was seen by 175,000 people in New York in 1848 and subsequently by millions in Great Britain.[130] The Mississippi panorama was followed by panoramas of the Far West—among them several Gold Rush subjects—and of the Arctic, Mexico, and areas as far south as Costa Rica.

The source for these themes was frequently the expeditionary literature that had become popular about midcentury. Humboldt's writings, of course, were central examples of the genre, but there were many others as well. One of the most famous (and still one of the most readable) was Captain Elisha Kent Kane's *Arctic Explorations* of 1856.[131] Kane's thrilling account of his nearly disastrous journey to the Arctic and his miraculous escape not only provided the subject matter for two moving panoramas but also fueled Church's determination to sail to Newfoundland in 1859 and, on his return to New York, to paint *The Icebergs,* 1861 (fig. 100).[132]

The popularity of *The Heart of the Andes* was not based entirely on the appeal of panoramas and tourist culture; it rested as well on the strong taste that emerged in the 1850s for the display of large, ambitious easel paintings, most of which were European. Examples were Rosa Bonheur's *The Horse Fair,* 1853–55 (cat. no. 51), and John Martin's Judgment Pictures, 1853 (Tate Gallery, London; see cat. no. 159), the latter the closest precedent for Church's painting in terms of size, landscape subject matter, and date.[133] Yet Church's picture went beyond the other grand-scale easel paintings in an important respect: it commodified the tourist impulse and in so doing responded to the consumerism that increasingly characterized affluent urban culture in the nineteenth century. Perhaps even more significantly it symbolized in the terms of landscape painting the growing global access and exchange seized by New Yorkers. Following Humboldt's literary lead, Church figuratively put the entire earth on canvas, describing tirelessly in its foreground the New World's botanical wealth and conveying the continental extent of that wealth in the infinite distances he suggested. This bounty of botany Church served up in a frame (fig. 101) that was likened to both a window and a theatrical proscenium.[134] However, the frame is also readily comparable to the highly embellished sideboards (see fig. 102) included in the New York Crystal Palace exhibition of 1853, which offered wares of all kinds to the public. Thus it is not merely a frame but what a contemporary critic called "a piece of furniture . . . in very good taste,"[135] and as such it presented the innumerable blossoms, fruits, leaves, grasses, birds, and butterflies of the picture as items to be consumed conceptually. Victorian New Yorkers apprehended the landscape portrayed in *The Heart of the Andes* in the same acquisitive spirit in which they approached the world it idealized.

of a Mass Medium (New York: Zone Books, 1997).

129. Several frontier moving panoramas are briefly described in Avery, "Movies for Manifest Destiny," pp. 6–8; and more thoroughly in Oettermann, *Panorama,* pp. 323–42; and Kevin J. Avery, "The Panorama and Its Manifestation in American Landscape Painting, 1795–1870" (Ph.D. dissertation, Columbia University, New York, 1995), vol. 1, pp. 108–203.

130. Joseph Earl Arrington, "John Banvard's Moving Panorama of the Mississippi, Missouri, and Ohio Rivers," *Filson Club History Quarterly* 32 (July 1958), pp. 224–27.

131. Elisha Kent Kane, *Arctic Explorations: The Second Grinnell Expedition in Search of Sir John Franklin, 1853, '54, '55,* 2 vols. (1856; reprint, London: T. Nelson and Sons, 1861).

132. For the Kane panoramas of the Arctic regions, see Avery, "Panorama and Its Manifestation," vol. 1, pp. 143–51. For others that anticipate Church's *Icebergs,* see Gerald L. Carr, *Frederic Edwin Church—The Icebergs* (Dallas: Dallas Museum of Fine Arts, 1980), pp. 34–41.

133. Ibid., pp. 27–28.

134. A description of the original frame and a consideration of its stylistic sources are given in Avery, "*Heart of the Andes* Exhibited," pp. 55–60.

135. "An Innovation," *The Albion,* April 30, 1859, p. 213, quoted in Avery, "The Heart of the Andes Exhibited," p. 60.

Modeling a Reputation: The American Sculptor and New York City

THAYER TOLLES

Between 1825 and 1861 American sculptors had an equivocal relationship with New York City. Henry Kirke Brown held high aspirations for the Empire City, writing from abroad in 1844: "For to tell the truth, for me, as a sculptor, I would prefer being in New York to Florence, on all accounts." Yet just over two years later the disillusioned artist wrote from his Broadway studio: "You don't know how changed a man I am since I came to this bedlam of a city. I have lost my quick way of doing things, and have become . . . drawn into the vortex and confusion of business. . . . The sound of B'way is like a distant thunder, it is the most unartistlike city on the face of the globe in my opinion."[1] Brown was hardly alone in his view, for many other antebellum sculptors arrived at similar conclusions and settled in locales (oftentimes foreign) more conducive to the making of art. Still, these men were entrepreneurs as well as artists, tied by necessity to New York. There was no better place to exhibit, publicize, and market sculpture—and indeed goods of nearly every type—in the United States during this period, when American sculptors were achieving professional status, their work was becoming a salable commodity, and the city was maturing as the national hub of commercial enterprise and material consumption. A subtext throughout these turbulent years is New York's quest to commission and install a public sculpture of national significance, one that would symbolically and physically proclaim the city as the leading cosmopolitan tastemaker in matters aesthetic and civic.

Before the 1820s sculpture in New York, and throughout America, was in an embryonic state of development; an article of 1827 on the condition of the arts rightly summarized the situation: "in sculpture there has been little more than an attempt."[2] The city's first public monuments were ordered by the assembly of the State of New York from London sculptor Joseph Wilton in 1768 and dedicated in 1770: a marble full-length portrait of William Pitt, earl of Chatham, located at Wall and William Streets, and a lifesize gilded lead equestrian of King George III that

stood on a fifteen-foot marble pedestal in Bowling Green. These statues did not survive for long, however. *King George* was destroyed by ardent patriots after the reading of the Declaration of Independence on July 9, 1776, and melted down for bullets for the Continental Army; in retaliation British troops mutilated *Pitt* in November 1777 (fragments of both *King George* and *Pitt* are at the New-York Historical Society). Even after independence, Americans continued to award sculpture commissions to Europeans. More highly skilled than native artists and craftsmen, these Europeans brought from abroad the Neoclassical aesthetic and high standards for portrait statuary that young American sculptors would emulate as wood yielded to marble as the medium of choice.

In the early decades of the nineteenth century foreign sculptors began to settle in New York, integrating themselves with moderate impact into its artistic fabric. Irish-born John Dixey emigrated in 1801 and for more than two decades carved architectural decoration. His best-known effort, the figure of Justice of about 1818 erected atop the new City Hall designed

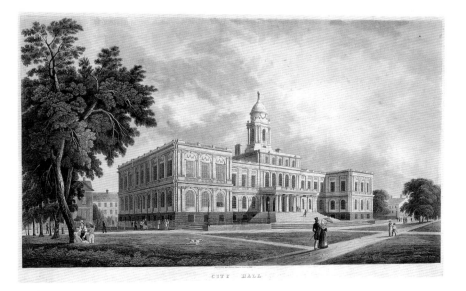

Fig. 103. John Hill, after William Guy Wall, *City Hall*, 1826. Aquatint with hand coloring. The New York Public Library, Astor, Lenox and Tilden Foundations, Miriam and Ira D. Wallach Division of Art, Prints and Photographs, The Phelps Stokes Collection, Print Collection

For research assistance for this essay, the author is grateful to Alexis L. Boylan, Julie Mirabito Douglass, and Karen Lemmey.

Dates given for sculpture in this text indicate when the piece was modeled.

1. Henry Kirke Brown to Ezra P. Prentice, March 8, 1844, and Brown to his wife Lydia L. Brown, November 4, 1846, Henry Kirke Bush-Brown Papers, vol. 2, pp. 422, 548/28, Manuscript Division, Library of Congress, Washington, D.C.
2. "Literature, Fine Arts, Amusements," *New-York Mirror, and Ladies' Literary Gazette*, July 28, 1827, p. 20.

Opposite: detail, fig. 125

Fig. 104. Alexander Jackson Davis, *City Hall Park*, 1826. Watercolor, pen, and black ink heightened with white. The Metropolitan Museum of Art, New York, The Edward W. C. Arnold Collection of New York Prints, Maps, and Pictures, Bequest of Edward W. C. Arnold, 1954 54.90.172

3. William Coffee to Thomas Jefferson, September 8, 1820, Thomas Jefferson Papers, Manuscript Division, Library of Congress, Washington, D.C., quoted in Anna Wells Rutledge, "William John Coffee as a Portrait Sculptor," *Gazette des Beaux-Arts*, ser. 6, 28 (November 1945), p. 300.

4. Quoted in H. W. French, *Art and Artists in Connecticut* (Boston: Lee and Shepard, 1879; reprint, New York: Kennedy Graphics, Da Capo Press, 1970), p. 49. The busts entered the sculpture collection of the American Academy of the Fine Arts.

5. "Statue of Washington," *New-York American*, December 10, 1822, p. 2.

by John McComb Jr. and Joseph-François Mangin (fig. 103), was destroyed by fire in 1858 (a lightweight copper copy replaced it in 1887). By 1816 William Coffee arrived from England, having worked as a terracotta modeler in London and Derby. In New York he completed and exhibited animal paintings as well as small terracottas and plasters of various subjects. Although New York served as his base, Coffee roved the East Coast for portrait commissions, and he had no affection for the town. Thus, when yellow fever scourged New York in 1820, he wrote his patron Thomas Jefferson of his dislike for "this stinking Pestilential City."[3] In 1827 the peripatetic Coffee finally settled in Albany. Thomas Coffee, also British, was resident in New York between 1830 and 1869. He churned out portraits and ideal groups, exhibiting them at venues ranging from the National Academy of Design to the Mechanics' Institute of the City of New York. And then there was the Florentine-born Giorgio (Pietro) Cardelli, whose example reveals how a sculptor's success in New York was subject to the approbation of its cultural establishment. In 1817 Cardelli received a commission from Colonel John Trumbull, history painter, portraitist, and newly elected president of the American Academy of the

Fine Arts, for busts of himself and his wife. Trumbull found the casts unacceptable and admonished Cardelli: "You cannot be a popular sculptor in New York if I refuse to indorse you."[4] The chastised artist soon gave up on sculpting—and New York—in favor of itinerant portrait painting.

It was to an immigrant sculptor that the city's cultural leaders turned in their ongoing concern, if not embarrassment, that New York, unlike several urban rivals, had no public statue of George Washington. Regarding monumental sculpture as a barometer of taste and refinement, self-made businessman Philip Hone, physician and Columbia professor David Hosack, and Trumbull banded together in 1822 and formed a short-lived committee to commission a bronze "Statue . . . worthy of the dignity and fame of the Hero, and of the munificence and public spirit of this city."[5] By the following year Enrico Causici, a native of Verona, Italy, was laboring on an equestrian statue of Washington in his Warren Street studio. In 1824 his thirteen-foot model, on a twenty-foot pedestal, was displayed first at the Arsenal at the corner of Elm and Leonard streets for a 25-cent admission fee and subsequently at the American Academy's exhibition gallery. Although Causici had not officially earned

the commission, the committee fanned out into the city's wards soliciting funds from private citizens to have his work cast in bronze. One newspaper cut to the heart of the matter, observing that "it concerns our honor that it should be [erected]."[6] Despite high praise for the sculpture's quality, the effort fell short, suggesting that reluctance to devote funds—public or private—to the arts rather than the character of the design thwarted the undertaking. (This scenario would be replayed several times over the next decades.) When the model was erected in City Hall Park (fig. 104) for the Fourth of July festivities of 1826, calls were renewed for "the first city in America . . . to dedicate a statue to America's first man."[7] Again, attempts to finance the casting failed, and the plaster model, which had remained on view for several months, fell into disrepair.[8]

If New Yorkers were hesitant to underwrite a statue of a national hero, even if produced by an Italian, they eagerly embraced European-made sculpture by established masters. The American Academy of the Fine Arts could boast of a collection of plaster casts that were for the most part copies after the most esteemed ancient examples. Assembled beginning in 1802 through the efforts of Robert Livingston when he was in Paris as United States minister to France, the collection had grown to impressive proportions within a short period, although by the early 1820s the omnipotent Trumbull allowed aspiring young artists only extremely restricted access to it for study.[9] Represented in these holdings were works by a few contemporary Europeans, such as Jean-Antoine Houdon (see cat. no. 53) and the venerated Neoclassicist Antonio Canova, whose *Creugas*, 1795–1801, *Damoxenes*, 1795–1806, *The Graces*, 1812–16, and *Aerial Hebe*, 1796, went on view in the cast gallery in May 1824 for admiration and, ultimately, emulation. In his seminal opening address for the Academy's 1824 annual exhibition, Gulian Crommelin Verplanck remarked on the institution's moral obligation to enlighten New Yorkers in aesthetic and intellectual matters by means of such casts: "The possession of these fine casts we consider of great importance to our improvement in the arts. Who knows but that the inspection of these admirable models may arouse the dormant genius of some American Canova."[10] Also in 1824 the Academy elected as honorary members the Italian Raimondo Trentanove, a favored pupil of Canova (who had been so elevated in 1817), and Danish Neoclassicist Bertel Thorvaldsen, an act calculated to emphasize the institution's connections to Europe and to counter criticisms of American cultural provincialism.

While foreign artists earned coveted commissions for the adornment of American public spaces, native carvers filled an unending need for more utilitarian goods, such as grave markers and mantelpieces. Stonecutters flourished in New York, among them Morris and Kain, a firm that served a clientele that extended as far as South Carolina, and similar establishments operated by the Frazee brothers and Fisher and Bird (see "The Products of Empire" by Amelia Peck in this publication, pp. 263–64). The wood-carving trade also thrived in the city through midcentury, in tandem with the construction of wood-hulled sailing vessels and steamships—an enterprise vital to the economy of the city, whose East River was, in turn, at the epicenter of the American shipbuilding industry. Wood-carvers, epitomized by father and son Jeremiah and Charles Dodge, supplied enormous numbers of lifesize figures and other decorative elements for not only the prows of ships but also the shop fronts of merchants, notably tobacconists. New Yorkers embraced these vernacular traditions tied to practical use and the city's commercial livelihood while only minimally patronizing sculptors who produced marble portraits and ideal figures in the Neoclassical style.

The leading local sculptor of promise during the 1820s was John Frazee, who initially made a name as a stonecutter and designer of mantels and tombstones. From 1818 until 1829 he and his brother William operated a successful marble-cutting shop; so successful was it, in fact, that the brothers purchased their own marble quarry in Eastchester, New York, in 1826 to supply material for the steady stream of commissions that came to them. In the early 1820s Frazee began to make the coveted transition from artisan to artist: in 1824, under the auspices of the American Academy of the Fine Arts, he modeled a bust of the Marquis de Lafayette (unlocated), the "Nation's Guest," who was then on a triumphant American tour. From a life mask he took of the living icon Lafayette, Frazee hoped to replicate plaster busts for the public. He was not able to carry out his plan, but the competency of the portrait led the New York Bar to commission him to produce the *John Wells Memorial* for the interior of Grace Church. (Executed in 1824–25, it was transferred in the mid-1840s to Saint Paul's Chapel.) This posthumous bust, the first documented likeness cut in marble by an American, surmounts an ornamental tablet with a dedicatory epitaph, thus uniting Frazee's artisanal and sculptural talents.

6. "Statue of Washington," *New-York American*, November 23, 1824, p. 2. For further discussion of these fund-raising efforts, see Dorothy C. Barck, "Proposed Memorials to Washington in New York City," *New-York Historical Society Quarterly Bulletin* 15 (October 1931), pp. 80–81.

7. "Statue of Washington," *New-York American*, June 24, 1826, p. 2.

8. Not only did the city fail to pay for the casting but in 1831 its Common Council also refused to compensate Causici for $6,000 in claimed expenses. Furthermore, Baltimore joined the growing number of American cities that had erected public monuments to Washington when in November 1829 it dedicated a sixteen-foot marble statue of the president by Causici himself.

9. Evidence of Trumbull's ill will toward young artists is captured in his caustic comment: "these young men should remember that *the gentlemen* have gone to a great expense in importing casts, and that they (the students) have no property in them. . . . They must remember that beggars are not to be choosers." Quoted in William Dunlap, *History of the Rise and Progress of the Arts of Design in the United States*, 2 vols. (New York: George P. Scott, 1834), vol. 2, p. 280.

10. Reprinted in "The Fine Arts," *Atlantic Magazine* 1 (June 1824), p. 155. A transcript of the address is in the Gulian Crommelin Verplanck Papers, Manuscript Department, New-York Historical Society. For the 1824 annual exhibition, see Carrie Rebora, "The American Academy of the Fine Arts, New York, 1802–1842" (Ph.D. dissertation, City University of New York Graduate Center, 1990), pp. 368–71. For a listing of casts in the Academy's collection, see ibid., pp. 537–45.

11. John Frazee to Academy secretary Archibald Robertson, June 10, 1824, American Academy of the Fine Arts Papers (BV), vol. 1, item 71, Manuscript Department, The New-York Historical Society.

12. "The Autobiography of Frazee, the Sculptor," part 2, *North American Quarterly Magazine* 6 (July 1835), pp. 17–18.

13. Frederick S. Voss, with Dennis Montagna and Jean Henry, *John Frazee, 1790–1852, Sculptor* (exh. cat., Washington, D.C.: National Portrait Gallery, Smithsonian Institution; Boston: Boston Athenaeum, 1986), pp. 74–75.

14. "The Exhibition of the National Academy of Design, 1827. The Second," *United States Review and Literary Gazette* 2 (July 1827), p. 261.

15. "Browere the Sculptor," *New-York American*, November 19, 1825, p. 2.

16. For Jefferson's versions of the incident, see Thomas Jefferson to James Madison, October 18, 1825, James Madison Papers, Manuscript Division, Library of Congress, Washington, D.C.; and Thomas Jefferson to John H. I. Browere, June 6, 1826, Jefferson Papers, Library of Congress, quoted in David Meschutt, *A Bold Experiment: John Henri Isaac Browere's Life Masks of Prominent Americans* (Cooperstown: New York State Historical Association, 1988), p. 20. See also David Meschutt, "'A Perfect Likeness': John H. I. Browere's Life Mask of Thomas Jefferson," *American Art Journal* 21, no. 4 (1989), pp. 11–13.

17. I. N. Phelps Stokes, *The Iconography of Manhattan Island, 1498–1909, Compiled from Original Sources and Illustrated by Photo-intaglio Reproductions of Important Maps, Plans, Views, and Documents in Public and Private Collections*, 6 vols. (New York: Robert H. Dodd, 1915–28), vol. 5 (1926), p. 1658 (May 22).

As New York's most proficient marble sculptor, Frazee was soon welcomed into the city's inner circle of artists. The American Academy named him a full academician in June 1824, in tacit recognition of his new standing as a professional artist. In his acceptance letter Frazee wrote of his ambition to be an "American Canova" and of his elevated artistic calling, declaring: "I have done nothing, save to grasp the chissel [*sic*] and approach the block; and thus I stand waiting the will of Heaven and the voice of my Country to direct the stroke. If it be true that I am the first American that has lifted the tool, then it is not less true that I have before me an arduous task—Nevertheless, I am not disheartened—nor shall I shrink from the undertaking."[11] The formidable challenge he faced was made all the more difficult by Trumbull's unwillingness to advocate younger artists, an unwillingness underscored by the irascible colonel's "sincere" opinion that "there would be little or nothing wanted in [sculpture], and no encouragement given to it in this country, for yet a hundred years!"[12] It is not surprising, then, that Frazee changed his institutional allegiance to become the only sculptor among the founding members of the National Academy of Design, organized in 1825 by and for artists in opposition to the patron-dominated American Academy.

Frazee's vivid self-portrait of 1827 (fig. 105) conveys in three dimensions his vision of himself as a pioneering American sculptor. The inscription on the front of the herm base translates as "he himself made it in the fifty-second year of American Liberty," announcing his status as a self-assured independent artist and suggesting that he is no less than a founding father of American sculpture by linking his work to the birth of American liberty.[13] When Frazee displayed *Self-Portrait* (as "Bust of Himself") in the second annual exhibition of the new academy in 1827, it was deemed "well finished . . . showing the judicious selection of parts and precise marking, which are indicative of the real sculptor. The likeness is, in some degree, sacrificed to general effect." The equivocal nature of these remarks mirrors contemporary attitudes toward the dualities and conflicts of Frazee's career during the 1820s and 1830s. At once an artisan with a thriving practice in decorative sculpture as well as an ambitious fine artist, Frazee was not entirely satisfied: although he produced commanding and sought-after portraits in the Neoclassical mode in his role as sculptor, he longed to create imaginative figural compositions "in the higher departments of sculpture."[14] Moreover, paradoxically, his very success as an artisan was a disadvantage, for the rigorous labors of carving stigmatized in an era that held that the creative process resided in the act of modeling in clay rather than working in stone.

John Henri Isaac Browere was also an accomplished portrait sculptor in New York during this period, but one whose acceptance as a fine artist remained marginal at most. A New York native of Dutch descent, he began to experiment with taking life masks in the city before setting off in 1817 for a two-year tour of Europe. When he returned to New York, he refined the process and materials of mold making, creating a lighter-than-usual plaster that hardened rapidly, the exact composition of which he closely guarded. In 1825 he twice made masks of the Marquis de Lafayette, at first unsuccessfully in New York and later with better results in Philadelphia. This effort gained Browere renown, and he subsequently traveled the East Coast taking life masks of prominent Americans, including New Yorkers Hosack, Hone, De Witt Clinton, and the popular actor Edwin Forrest. From each life mask the artist made a plaster positive, which he secured to an armature supporting a chest and shoulders swathed in a classicizing drape; the result was a highly objective portrait bust marked by a stylistic hybrid of naturalism and Neoclassicism that particularly appealed to Americans over the next several decades.

Browere was never able to infiltrate the artistic establishment, mainly because that establishment believed his replicative technique of taking life masks produced mere physiognomic facsimiles of his subjects rather than true sculpture. He was dogged by a judgment that labeled him an "eccentric genius . . . *eccentric* in his manners, and *coarse* in his taste of composition."[15] And despite undeniable proficiency and the testimonials of satisfied sitters, he was often the victim of negative press. Most persistent among the stories published in East Coast papers was one asserting that he had badly injured and nearly suffocated the elderly Thomas Jefferson during the process of taking facial molds, although the alleged victim denied the charge.[16]

Whatever his disappointments, Browere managed to show his busts with some frequency. On Independence Day 1826, the very date of Jefferson's death, Browere exhibited a full-length polychromed plaster portrait of the former president in City Hall, a display he had proposed to the city's Common Council in May 1825.[17] The statue was flanked with Browere's busts of John Adams, 1825 (fig. 106), and Charles Carroll of Carrollton, 1826 (both New York State Historical Association, Cooperstown), fellow signers of the Declaration of Independence (the three forming an appropriate ensemble with Causici's equestrian

Fig. 105. John Frazee, *Self-Portrait*, 1827. Plaster. National Academy of Design, New York

Fig. 106. John Henri Isaac Browere, *John Adams*, Quincy, Massachusetts, 1825. Plaster. New York State Historical Association, Cooperstown

18. [A. T. Goodrich], *The Picture of New-York, and Stranger's Guide to the Commercial Metropolis of the United States* (New York: A. T. Goodrich, 1828), p. 375.

19. John H. I. Browere to John Trumbull, July 12, 1826, John Henri Isaac Browere letters, microfilm reel 2787, frame 600, Archives of American Art, Smithsonian Institution, Washington, D.C.

20. *The Diary of Philip Hone, 1828–1851*, 2 vols., edited by Allan Nevins (New York: Dodd, Mead and Company, 1927), vol. 1, p. 33, entry for December 24, 1830.

21. "Statue of Hamilton," *New-York Evening Post*, November 24, 1829, p. 2; ibid., December 12, 1829, p. 2; "Arts and Sciences: Statue of Clinton," *New-York Mirror*, February 13, 1830, p. 251; and "Works of Art," *New-York Evening Post*, November 4, 1831, p. 2.

Washington installed in City Hall Park). In addition, Browere displayed his busts for an admission fee in order to "hand down to posterity, the features and forms of distinguished American personages, as they actually were at the period of the execution of their likenesses."[18] These he showed in the Gallery of Busts and Statues he operated in his studio, the location of which frequently changed and which perhaps was inspired by the popular example of John Scudder's American Museum on Broadway.

Under the pseudonym Middle-Tint the Second, Browere also wrote art criticism, often vituperative in tone, that may have alienated both William Dunlap of the National Academy and Trumbull of the American Academy. Testifying to this possibility is an acrimonious letter of 1826 to Trumbull in which Browere wrote: "the very illiberal and ungentlemanlike manner in which Col. Trumbull treated the execution . . . of my portrait Busts [of Jefferson, Adams, and Carroll when shown in New York] . . . has evidenced a personal ill-will and hostility to me."[19] Browere hoped the federal government would commission bronze casts of his plasters of eminent personages for exhibition in Washington, but funding was not forthcoming; nor

were any of the honors a gifted sculptor in New York would have expected. He remained an outsider, never elected to membership in the National Academy of Design or the American Academy of the Fine Arts. In September 1834 he succumbed to cholera, and his reputation soon faded into obscurity.

The reception of Robert Ball Hughes was very different. This talented artist arrived in New York from England in 1829 and earned instant cachet with the city's cultural elite, for he had studied at the Royal Academy of Arts and worked in the studio of Neoclassical sculptor Edward Hodges Baily, a follower of John Flaxman, the leading Neoclassical sculptor and draftsman of his time in England. The credentials and technical proficiency of this ambitious foreigner immediately raised the standards for sculptors in New York. Hughes served as a lecturer in sculpture at the National Academy of Design in 1829 and 1830, and in 1831 he was named an honorary member of both the National Academy and the American Academy, evidence that each institution was eager to lay claim to him. He was soon awarded three coveted monumental commissions, ones that Frazee no doubt had hoped to earn. In late 1829 Hughes produced a model for the first, a marble statue of Alexander Hamilton for the Merchants' Exchange, the heart of commercial New York, to be funded through the subscriptions of city businessmen. When the preliminary model was accepted in December 1830, committee member Hone offered it high praise: "I have no doubt that if the artist finishes the statue agreeably to the promise given by the model, it will be the best piece of statuary in the United States."[20] He designed but never executed the second, a full-length portrait of De Witt Clinton requested in early 1830 by the Clinton Hall Association for the area in front of Clinton Hall. Finally, in 1831 Hughes completed his plaster alto-relief model for the third, the *Bishop John Henry Hobart Memorial*, a reclining portrait of the dying bishop attended by an allegorical figure of Religion in the tradition of Flaxman's funerary monuments. Translated into marble, it was dedicated in Trinity Church in 1835.[21]

Hughes's accomplishments must have made a considerable impression on Trumbull, for he ardently supported the sculptor. Trumbull, who himself had studied in London, with Benjamin West, clearly felt a kinship with the London-trained Hughes. As the most important figure in the New York art world, Trumbull welcomed the Englishman into the inner circle of the American Academy, in 1830 allowing him use of its sculpture gallery to produce his full-size working

model for the statue of Hamilton. By making Hughes a sort of artist in residence, Trumbull all but guaranteed the sculptor's loyalty and linked the American Academy with the Hamilton project, the most prestigious monumental sculpture commission begun in New York to date.[22] He further aided Hughes by encouraging prominent New Yorkers to come to him with orders for portraits in lifesize plasters and marbles as well as in smaller waxes, and by procuring restoration projects for him.[23] About 1833 Hughes commenced a bust of Trumbull; the result (cat. no. 57) is arguably his finest sculpture. The dramatic portrait, which reflects the sitter's forceful and acerbic personality, represents Trumbull less as an artist than as an American colonel and patriot, with the badge of the Order of the Cincinnati prominently visible. Any friendship that developed between Trumbull and Hughes seems to have cooled over the years after the bust was made, as the sculptor repeatedly badgered the painter for payment so that his model could be translated into marble (the marble was not completed until at least 1840).[24]

The 1830s, like the 1820s, saw sculptors establishing themselves in New York; in the new decade, however, the emerging artists made use of a new phenomenon, the single-sculpture exhibition, a vehicle for publicity and a means of attracting patronage and generating profit. The first such event of the decade, the presentation of Boston-born Horatio Greenough's ideal group *Chanting Cherubs,* 1829–30 (unlocated; see fig. 108), was a harbinger of a new generation of rising native talent, which looked to New York more as a center for marketing art than as a place in which to make sculpture. Educated in the classics at Harvard College, Greenough brought a nonartisanal, intellectual background to the practice of sculpture, a background with which moneyed patrons clearly felt a kinship. In 1825 he traveled to Rome, where he met Thorvaldsen and encountered the riches of antiquity. Greenough returned to Boston for a year in 1827 and modeled portraits of prominent sitters. At this time he gained entrée with New York's leading cultural figures, meeting Samuel F. B. Morse and Dunlap, as well as William Cullen Bryant and Thomas Cole. In May 1828, just before Greenough returned to Italy to settle in Florence for two decades, he was elected an honorary member of the National Academy of Design. A year later the Academy named him a lecturer in sculpture, although his residence abroad made this title, and that of professor, granted later, purely honorific. However,

the bestowing of these positions indicated acceptance not only of the medium of sculpture but also of the highly educated and socially elevated Greenough as its most favored native practitioner. Indeed, in the eyes of the Academy's leaders, he quickly superseded Frazee in the role of American genius sculptor.[25]

In Florence, in winter 1828–29, Greenough modeled a bust of American novelist James Fenimore Cooper (fig. 107), who would become a lifelong friend as well as an instrumental patron and advocate. Cooper, pleased with the result, commissioned *Chanting Cherubs,* which was based on Raphael's painting *Madonna of the Baldachino* in the Palazzo Pitti, Florence. Greenough's marble was first exhibited in spring 1831 in Boston, where the response was decidedly mixed, engendering debates about propriety and prudery. In fact, the two nude angels were "napkinned" with dimity aprons tied around their waists. When the group went on view in November 1831 at the American Academy in New York, where the Boston events had been followed eagerly by the press,[26] reactions varied as well: the general public was lukewarm, while more enlightened connoisseurs saluted Cooper for his liberal and patriotic patronage of a kindred artist. Despite positive press coverage and an alluring advertisement touting the piece as "an object of considerable curiosity" and "the *first* [multifigure group] ever executed by an *American Sculptor,*"[27] the exhibition drew fewer visitors in New York than in Boston. According to Greenough's friend New York attorney Peter Augustus Jay, some literal-minded residents of the city failed to appreciate the group's sentiment and felt duped because the figures did not actually sing; embarrassed by their ignorance, he lamented: "I wish the scene of this story lay anywhere but in New York, but it cannot be helped, and I must continue to consider my townsmen as a race of cheating, lying money getting blockheads."[28] Still others criticized the derivative nature of *Chanting Cherubs,* complaining that it lacked the spark of artistic genius since it was copied after another work. Such discontent notwithstanding, Cooper left the marble in New York for public display at the National Academy in 1832 and at the American Academy in 1833. *Chanting Cherubs* remained at the American Academy until 1837, when it was removed to safety to a private home during a ruinous fire.

Like Greenough, Hezekiah Augur was a native New Englander who lived outside New York when he showed his work in the Empire City. An autodidact wood-carver resident in New Haven, in 1823 he attempted to develop a machine for carving stone

22. Minutes of the American Academy of the Fine Arts, December 11, 1829, and January 2, 1830, American Academy of the Fine Arts Papers, Manuscript Department, New-York Historical Society; and Rebora, "American Academy," p. 78.

23. Trumbull asked Hughes to conserve Wilton's damaged statue *William Pitt, Earl of Chatham* (fragments at the New-York Historical Society), then languishing on City Hall grounds but in the Academy's care since 1811. In 1831–32 he secured for him a second restoration project, that of Canova's badly burned statue of Washington, 1820, for the State House in Raleigh, North Carolina (fragments at North Carolina Museum of History, Raleigh). Although Hughes reportedly accepted payment, he never carried out the work. See Philipp Fehl, "John Trumbull and Robert Ball Hughes's Restoration of the Statue of Pitt the Elder," *New-York Historical Society Quarterly* 56 (January 1972), pp. 7–28.

24. The correspondence is held in the John Trumbull Papers, Manuscripts and Archives, Yale University Library, New Haven, Connecticut. Reprinted in Thomas B. Brumbaugh, "A Ball Hughes Correspondence," *Art Quarterly* 21 (winter 1958), pp. 423–27.

25. Evidence of Greenough's social and artistic ascendancy in New York is revealed in Dunlap's *Rise and Progress,* which devotes some fifteen pages to him and gives Frazee just three. Although Dunlap (ibid., vol. 2, p. 268) deemed Frazee "without a rival at present in the country," later Thomas Seir Cummings tellingly wrote, "he was entirely self-educated, and therefore, perhaps, wanting in that exterior refinement which would have rendered him popular." See Thomas S. Cummings, *Historic Annals of the National Academy of Design, New-York Drawing Association . . . from 1825 to the Present Time* (Philadelphia: George W. Childs, 1865), p. 230. See also Frazee's unsigned diatribe, "American Statuaries," *North American Quarterly Magazine* 5 (January 1835), pp. 204–7; also discussed in Voss, Montagna, and Henry, *John Frazee,* p. 41. The article pointedly concludes: "If we are Americans, let us cherish and caress our own [Frazee] in our

Fig. 107. Horatio Greenough, *James Fenimore Cooper*, Florence, 1828–29. Marble. Courtesy of the Trustees of the Boston Public Library

Fig. 108. *Horatio Greenough's "Chanting Cherubs."* Wood engraving, from *Illustrated News*, January 8, 1853, p. 24. Avery Architectural and Fine Arts Library, Columbia University, New York

Fig. 109. Hezekiah Augur, *Jephthah and His Daughter,* New Haven, ca. 1828–32. Marble. Yale University Art Gallery, New Haven, Connecticut, Gift of the Citizens of New Haven 1835.11

in collaboration with Samuel F. B. Morse, then also settled in New Haven.[29] When Augur exhibited a bust based on a copy of the head of *Apollo Belvedere* at Morse's Broadway studio from December 1824 to January 1825, he was heralded as a "Yankee Phidias."[30] The sculptor continued to build his reputation in the city while living in New Haven, displaying marble portrait busts in the 1827 and 1828 annuals of the National Academy of Design, of which Morse was president. In 1828 Augur was elected an honorary member of the National Academy.

Thus, Augur was no stranger to New York when he showed his half-size statues *Jephthah and His Daughter,* ca. 1828–32 (fig. 109), between November 1832 and January 1833 at Park Place House on Broadway—his most successful use of the Empire City as a marketing base. The pair, based on Judges XI: 34–35, presents an appealing moral melodrama: the figures are shown at a moment of supreme remorse and anguish, when Jephthah returns from battle and meets his only daughter, whom he now must sacrifice to fulfill

a vow to God. The group was well received by critics, becoming Augur's most celebrated accomplishment. One writer, for example, commended the execution, remarking, "if such an evidence of enthusiastic love for the fine arts and of talent overcoming difficulties without aid, does not arouse the feelings of our public, let genius despair, and all men turn to buying and selling and changing of money, in or out of the Temple."[31] Despite such critical approbation, the statues failed to sell in New York; the citizens of New Haven, however, purchased them for Yale University in 1835. Indeed, Augur had extremely limited financial success: when Dunlap published his 1834 history of the arts in America, he wrote extensively of Augur but noted the sculptor's complaint that "he has received [an] abundance of compliments and little money."[32] Although Dunlap and other writers who were eager to celebrate the emergence of American talent seized on Augur as an exemplar of the new breed, they seem to have been attracted largely by his qualities of Yankee perseverance and mechanical ingenuity (revealed in

own land, and leave all foreigners [Hughes] and residents in foreign countries [Greenough] to the enjoyment of their transatlantic fame!" ([Frazee], "American Statuaries," p. 207).

26. See, for instance, "Greenough's *Chanting Cherubs," New-York Evening Post,* May 17, 1831, p. 2; and "*Chanting Cherubs," New-York Commercial Advertiser,* May 20, 1831, p. 2. On *Chanting Cherubs,* see Nathalia Wright, "The Chanting Cherubs: Horatio Greenough's Marble Group for James Fenimore Cooper," *New York History* 38 (April 1957), pp. 177–97.

27. Advertisement, *New-York Evening Post,* November 23, 1831, p. 3.

28. Peter Augustus Jay to James Fenimore Cooper, April 1, 1832, in *Correspondence of James Fenimore-Cooper,* 2 vols., edited by his grandson James Fenimore Cooper (New Haven: Yale University Press, 1922), vol. 1, p. 264.

29. The two men abandoned this effort after they discovered that Thomas Blanchard had received a patent for a carving machine in 1820. See Paul J. Staiti, *Samuel F. B. Morse* (Cambridge: Cambridge University Press, 1989), p. 102.

30. Untitled item, *New-York American,* January 6, 1825, p. 2.

31. "For the Evening Post," *Evening Post* (New York), November 12, 1832, p. 2.

32. Dunlap, *Rise and Progress,* vol. 2, p. 440.

33. For examples, see Z., "Sculpture and Sculptors in the United States," *American Monthly Magazine* 1 (May 1829), pp. 130–31; "Mr. Augur's Statues," *New-York Daily Advertiser,* October 8, 1831, p. 2; and "Hezekiah Augur," *American Historical Magazine* 1 (February 1836), pp. 44–53.

34. On Thom, see his obituary in "Chronicle of Facts and Opinions. Thom, the Sculptor," *Bulletin of the American Art-Union,* May 1850, p. 28. According to this obituary, which was reprinted from the *Evening Post,* Thom died in New York, having come to the United States "some fourteen years ago in pursuit of a runaway debtor." He was employed for a time as a stonecutter on Trinity Church.

35. *Exhibition. Tam O'Shanter, Souter Johnny, and the Landlord and Landlady, Executed in Hard Ayrshire Stone, by the Self-taught Artist, Mr. J. Thom* [New York, 1833?]. Souvenirs such as a lithograph showing the group and a publication titled *The Life of Thom* were available for purchase at the exhibition thanks to the ministrations of an enterprising manager named J. H. Field.

36. Rebora, "American Academy," p. 407.

37. See, for instance, "Miscellaneous Notices. Sculpture," *American Monthly Magazine* 3 (May 1834), p. 213, which proclaims "the present group to be the finest piece of sculpture that has ever been produced in the United States." The exhibition was accompanied by a pamphlet, *Description of the Colossal Group of Uncle Toby and Widow Wadman, by Ball Hughes. Now Exhibiting at the American Academy of Fine Arts, Barclay-Street* [New York, 1834].

38. "Statue of Washington," *New-York Evening Post,*

the tools and inventions he produced).[33] In fact, Augur's impact remained marginal.

Under Trumbull's stewardship, the American Academy in its waning years judiciously continued in its limited way to promote sculptors. Among these was the self-taught Scottish sculptor James Thom, whose overwhelming popularity was one of the more curious phenomena of the 1830s.[34] Thom's four lifesize Ayrshire stone statues, titled *Tam O'Shanter, Souter Johnny, the Landlord and Landlady,* were first displayed at the Academy between May and June 1833 and from November 1833 until January 1834. Based on a poem by Robert Burns, they depicted a scene in an alehouse where the characters are "enjoying with most comic satisfaction the undisturbed possession of their ale and the chimney corner."[35] In the Empire City, art—whether high or low—like theater or opera and other music, could be situated within the spectrum of popular entertainment, as the vulgar theme and crude execution of Thom's group asserted. It was a curious choice for installation at the Academy, which had long promoted itself as an arbiter of moral and aesthetic standards for the public, but then the exhibitions of the figures had had considerable success in England and Scotland. The experiential nature of the first Thom show at the Academy was underscored by recitations held there by Mr. Graham, "the blind Scotch poet," who soon was presenting Burns's poem nightly, with the group illuminated by gaslight.[36] An audience said to number in the thousands was entertained and enchanted by a sculptural tableau that seemed to capture a theatrical moment frozen in time, but Academy officers were criticized for lowering the institution's aesthetic standards and pandering for profit.

Thom's group appeared at the Academy for a third time in October 1835, this time in expanded form with *Old Mortality and His Pony, Willie and Allan,* a self-portrait, and statues of Burns and Sir Walter Scott. The novelty of Thom's work apparently had worn off, for this installation failed to turn a profit (the sculptures did, however, tour East Coast cities). Nevertheless, Thom's approach had a certain influence. In an apparent attempt to capitalize on the dramatic popular success of the *Tam O'Shanter* ensemble, Hughes exhibited his lifesize plaster *Uncle Toby and Widow Wadman* (unlocated) at the Academy between April and June 1834, shortly after Thom's second New York installation ended. Like Thom's *Tam O'Shanter,* Hughes's group was comic theater played out in sculpture: drawn from Laurence Sterne's novel *Tristram Shandy,* it represented the moment when Toby looks

for a speck of dust in Mrs. Wadman's eye. Unlike the Scotsman's first two New York displays, the presentation of *Uncle Toby and Widow Wadman* was not profitable and closed after two months, despite glowing reviews.[37]

During the 1830s, while single-sculpture exhibitions were proliferating, the movement to erect a statue of George Washington in New York continued, albeit haltingly. When Greenough's *Chanting Cherubs* was on view at the American Academy in 1831, the sculptor was asked to prepare a model for a proposed monument, which he completed that year. Visitors to the exhibition were encouraged to contribute to this endeavor, and at the same time the National Academy council resolved to support Greenough's project, a rare instance of concord between the rival institutions.[38] The subscription effort failed, but Greenough's labors were not in vain: in 1832 he became the first American sculptor to receive a major commission from the United States government, for a colossal seated statue of Washington for the rotunda of the United States Capitol, which was installed in 1841.[39] Another attempt to collect money was made in April 1833, when the New York State legislature incorporated the New York Monument Association to raise $100,000 for a memorial to Washington. By early 1834, however, the campaign was defunct (less than $1,000 had been gathered), and for nearly another decade there would be no further action in this regard.

While attempts to erect a monument to a national icon foundered, a memorial for a tragic local hero was realized when Hughes's statue of Alexander Hamilton was unveiled in the rotunda of the Merchants' Exchange on Wall Street in April 1835. The event represented a symbolic intersection of art and commerce, for the brilliant Federalist Hamilton had powerfully advanced New York's financial and mercantile interests during his service as the nation's first secretary of the treasury from 1789 to 1795. The work itself, the first marble portrait statue carved in the United States, brought honor to the city; but it was an honor achieved at the cost of tension, for Hughes had refused to use Frazee's marble or to employ his workshop, choosing instead to import Carraran marble and British carvers to execute the piece. After a flaw appeared in the back of the marble block, Hughes altered the composition, embellishing the contemporary dress of the figure with a flowing mantle. For Hamilton's facial features, the sculptor presumably relied on John Dixey's copy of Giuseppe Ceracchi's bust, which had been presented to the New-York Historical Society in 1809

and was considered the authoritative likeness of the martyred statesman.

The *Alexander Hamilton,* which with its gray granite pedestal stood fifteen feet high, drew admiring crowds and earned universal praise. A notice in the *New-York Commercial Advertiser* speaks for the body of critical reviews: "It is a magnificent production, worthy of the man in whose honor it was formed, of the liberality in which the city of New York is indebted for its possession, and of the talents and high reputation of the sculptor, Mr. Hughes." Trumbull offered his own ringing endorsement: "There are very few pieces of statuary superior to this and not twenty-five sculptors in the universe who can surpass this work."[40] Eight months after its completion, the sculpture—and the optimism attending its presence—were destroyed in the Great Fire of December 16–17, 1835, which ravaged twenty square blocks of the city's pier and commercial districts.

Calls to raise funds through subscriptions for a new statue of Hamilton arose in early 1836; some, like the following plea in the *New-York Mirror,* assumed a tone of urgency:

There are few cities of the civilized world, at all, comparable with New-York in other respects, which has not greatly surpassed her in matters of taste. . . . Do our wealthy fellow-townsmen know that there is a certain censure directed against New-York by the inhabitants of other cities and countries. We have no statues. *There is no reason why we should not have them. Their influences in no way militate against the spirit of a republick any more than music and dancing. On the contrary, they perpetuate in the minds of the people ideas of nobleness, patriotism and virtue. . . . there is no good reason why the citizens of New-York, who expend thousands in wine and tawdry furniture, should not apply some of their vast incomes to painting and sculpture.*[41]

However, the effort to raise another public sculpture was ill timed: the city faced an enormous rebuilding project after the fire, and the Panic of 1837 ushered in a decade of commercial uncertainty, reduced fortunes, and flagging confidence.

Hughes cast some of his sculptures in plaster for a popular market that was developing slowly in spite of the economic downturn. One of the first artists in America to replicate his work in this manner, he resourcefully cast twenty eight-inch plaster statuettes from his reduced model of the *Alexander Hamilton* (fig. 110) in about 1835. Among a number of other such plasters he produced were casts of his bust of

Fig. 110. Robert Ball Hughes, *Alexander Hamilton,* 1835. Plaster. Museum of the City of New York, Gift of Mrs. Alexander Hamilton and General Pierpont Morgan Hamilton 71.31.12

Washington Irving, ca. 1836 (National Portrait Gallery, Smithsonian Institution, Washington, D.C.). Of the Irving replicas, which were available for $15 each in 1836, one writer remarked, "at this price the Knickerbockers alone should send Mr. Hughes more commissions . . . in a single day, than he would be able to execute in a lifetime."[42] Yet Hughes, like his statue of Hamilton, was ultimately unlucky in New York, for the enterprising artist who had captured the most important monumental portrait commissions of the

December 2, 1831, p. 2. See also a notice describing the monument project that ran for several consecutive days in the *New-York Evening Post* and that noted (December 10, 1831, p. 3): "the total proceeds of the Group of Cherubs, now open in Barclay street, will be added to the subscription list." (The exhibition, however, did not yield a profit.)

39. The progress of the commission was closely followed in the New York press. See, for instance, "Statue of Washington," *Niles' Weekly Register,* October 27, 1832, pp. 141–42. The marble was later moved outdoors to the Capitol grounds and is now in the National Museum of American History, Smithsonian Institution, Washington, D.C. The statue, which depicted Washington as a modern-day deity in classical dress, was widely criticized.

40. "Statue of Hamilton," *New-York Commercial Advertiser,* April 20, 1835, p. 2; John Trumbull quoted in Georgia Stamm Chamberlain, "The Ball Hughes Statue of Alexander Hamilton," in *Studies on American Painters and Sculptors of the Nineteenth Century* (Annandale, Virginia: Turnpike Press, 1965), p. 6. For John Frazee's sharply dissenting view, never published, titled "Statue in Breeches," see Linda Hyman, "From Artisan to Artist: John Frazee and the Politics of Culture in Antebellum America" (Ph.D. dissertation, City University of New York, 1978), pp. 127–30.

41. "New Statue of Hamilton," *New-York Mirror,* April 9, 1836, p. 327.

42. "Bust of Washington Irving," *New-York Mirror,* September 10, 1836, p. 83.

Fig. III. John Frazee, *John Jay*, modeled 1831; carved, 1834–35. Marble. Collection of the City of New York, courtesy of the Art Commission of the City of New York

day was almost always impoverished. About 1838 he left the Empire City for Philadelphia and by the early 1840s settled in the Boston area, where, in 1847, he cast his seated statue of Nathaniel Bowditch for Mount Auburn Cemetery, Cambridge. The first bronze monument produced in this country, it was cast defectively—another piece of bad luck for Hughes. Thus, the sculptor's career, so promising on his arrival in

New York, was perhaps marked more by misfortune than honor. He ended his life in obscurity, specializing in pyrography, the art of burning sketches into wood using a hot poker.

When Hughes came to New York, he had irrevocably changed the landscape of taste and patronage and replaced John Frazee as the clear local favorite of the cultural establishment. To the bitter Frazee's mind,

his rival's popularity was evidence of America's continuing dependence on imported talent to assert artistic refinement: "if some of our people were told of an *American sculptor,* and attempted to compare his merits with those of other artists abroad, a sneer and a smile of contempt would be his reward," he complained.[43] Still, during the 1830s Frazee earned prestigious commissions, including one awarded by the United States Congress in March 1831 for a bust of John Jay, first chief justice of the United States and scion of a powerful New York family, to be placed in the Supreme Court chamber in the United States Capitol. Frazee's posthumous portrait of the highly respected Jay was based on a likeness taken in 1792, during the subject's lifetime, by Ceracchi (United States Supreme Court, Washington, D.C.). In 1832 Frazee enjoyed what was arguably his finest moment in New York, when he arranged for his *John Jay* (fig. 111) to be exhibited in the Merchants' Exchange, where it is said to have drawn upward of four thousand visitors a day.[44]

The popularity of this portrait bust gives pause, for the sculptures that attracted great crowds were usually works that entertained as spectacle—such as Greenough's *Chanting Cherubs* and Thom's *Tam O'Shanter.* It may be that some who flocked to see Frazee's piece were lured by notices, probably placed by the artist, in newspapers. One such invited New Yorkers to "call and examine [the bust]—*gratis*" before it was shipped to Washington, adding, "gentlemen are respectfully solicited to bring their ladies with them. . . ."[45] Moreover, the *John Jay* elicited uniform and unstinting praise of the sort recorded by a columnist of the *New-York Mirror:* "That so delicate and beautiful a piece of workmanship should have been executed by one of our countrymen in New-York, created universal astonishment."[46]

The renown of Frazee's worthy portrait of Jay carried the sculptor's reputation for the next several years, as he filled a growing demand for likenesses of venerable leaders in politics and business. Among these was his heroicizing 1832–34 portrait of one of Manhattan's five wealthiest residents, self-made financier Nathaniel Prime (cat. no. 56), a piece that in all likelihood was ordered in 1832 as a retirement gift from Prime's business associates, Samuel Ward and James Gore King.[47] The Prime bust, in which a naturalistic likeness coexists with classicizing conventions of draped shoulders and unincised pupils, represented a watershed in Frazee's career. Ward's cousin, Thomas Wren Ward, saw it in Frazee's studio in mid-1833 and was much impressed. He subsequently convinced the Boston Athenaeum,

of which he was treasurer, to order portraits from the artist, first of Nathaniel Bowditch, then of Daniel Webster, and eventually five others, in effect elevating Frazee from a sculptor of local note to one of national reputation. Moreover, the artist's importance in the Empire City was underscored in 1837, when a marble replica of his portrait of John Jay was presented by the subject's daughter to New York's City Hall and the city acquired his bust of John Marshall of about 1835.

Still, Frazee considered his glass half empty and believed himself consistently undone by the accomplishments of others and the thwarting of his efforts to obtain public patronage. Obsessed about his legacy as the self-proclaimed first American sculptor, Frazee published a two-part autobiography in 1835, detailing an arduous climb from humble roots and the creation of his stonecutting business, through which his "labours have contributed to raise this beautiful, although accessary [*sic*] art, to an elevated standard of taste." He outlined his career as a portrait sculptor and confidently announced: "If my countrymen continue to appreciate my labours, I may hope soon to exhibit something of greater interest and merit in the art, than mere *heads and shoulders of men.* . . . I intend, erelong, to sculpture the WHOLE FIGURE."[48] However, his wish to move beyond portrait busts was incompatible with the desires of his patrons; Frazee would never produce full-length figures or the more prestigious ideal subjects he longed to create. In 1835 he began gradually to abandon sculpture as his primary profession, ostensibly because he was appointed architect and superintendent of New York's new Custom House (now the Federal Hall National Memorial). But lack of consistent private patronage also motivated him, as did "the *cool treatment* . . . of Government. . . ." This last indignity, Frazee wrote, "has . . . almost made me resolve never to lift the chisel again in America."[49] He did continue to sculpt, but on a very limited basis.

Frazee's disavowal of foreign talent was based largely on his competitive relationship with Hughes, but he did not entirely reject European artists. Indeed, he developed a harmonious and fruitful partnership with Robert E. Launitz, a well-educated Latvian-born sculptor, who arrived in New York in 1828 after studying for several years in Rome with Thorvaldsen. For whatever reason, this pedigree did not threaten Frazee, who employed Launitz as a journeyman carver in the marble business he ran with his brother. In 1831 Launitz and Frazee initiated a partnership in an ornamental stonecutting firm, "by the union of genius and talent, [to] render their works in every respect worthy

43. John Frazee to his brother Noah Frazee, February 2, 1835, John Frazee Papers, microfilm reel 1103, frame 350, Archives of American Art, Smithsonian Institution, Washington, D.C.

44. "Occurrences of the Day. Frazee's Bust of Jay," *New-York Evening Post,* March 23, 1832, p. 2.

45. "Bust of John Jay, by Frazee," *New-York Evening Post,* March 21, 1832, p. 2.

46. "The Fine Arts. Sculpture. Frazee's Bust of John Jay," *New-York Mirror,* March 31, 1832, p. 310.

47. See Hyman, "From Artisan to Artist," pp. 118–20; and Voss, Montagna, and Henry, *John Frazee,* p. 82.

48. "Autobiography of Frazee, the Sculptor," part 2, pp. 16, 21. The first installment of the autobiography was published in *North American Quarterly Magazine* 5 (April 1835), pp. 395–403. Frazee must have felt a particular need to publish this lengthy treatise because Dunlap had drastically edited the manuscript the sculptor provided for Dunlap's *Rise and Progress,* published in 1834 (see note 25 above).

49. John Frazee to Robert Launitz, April 18, 1837, Robert Launitz Papers, Mellen Chamberlain Collection, Department of Rare Books and Manuscripts, by courtesy of the Trustees of the Boston Public Library. On Frazee as an architect, see Louis Torres, "John Frazee and the New York Custom House," *Journal of the Society of Architectural Historians* 23 (October 1964), pp. 143–50. Frazee remained in the post of architect and superintendent at the Custom House until 1842 and served there as inspector of customs from 1843 to 1847.

50. See announcement of the partnership in "Marble Works," *Working Man's Advocate*, July 14, 1832, p. 3. For Frazee's intimate involvement with the prolabor Workingmen's Party, see "Inventing the Metropolis" by Dell Upton in this publication, pp. 34–35; and Voss, Montagna, and Henry, *John Frazee*, p. 31.

51. Launitz's work for Green-Wood includes a grave marker for the Sac Indian woman Do-Hum-Me, ca. 1844, one of the earliest carved statues for an American cemetery; his first major public commission, a recumbent figure of Charlotte Canda, ca. 1845; and the New York Firemen's Monument, 1845, a shaft adorned at its top with a firefighter saving a child from a roaring blaze. Launitz published an influential book on tombstone designs: see *Collection of Monuments and Head Stones, Designed by R. E. Launitz* (New York: L. Prang and Co., 1866).

52. Truman H. Bartlett, "Early Settler Memorials.—XII," *American Architect and Building News*, September 3, 1887, p. 109; Thomas Crawford to Robert Launitz, June 27, 1837, reprinted in "Reminiscences of Crawford," *The Crayon* 6 (January 1859), p. 28.

53. "Reminiscences of Crawford," p. 28.

54. [Hannah Farnham Lee], *Familiar Sketches of Sculpture and Sculptors*, vol. 2 (Boston: Crosby, Nichols, and Company, 1854), p. 197. For positive assessments of Brackett's work that mention portraits executed in New York, see "Mr. Brackett, the Sculptor," *New-York Mirror*, December 14, 1839, p. 199; and "Mr. Brackett, the Sculptor," *New-Yorker*, October 3, 1840, p. 45.

[of] the highest patronage of the country."[50] Over the next few years, while the firm of Frazee and Launitz prospered, Launitz pursued a career as an independent sculptor. In 1833 he earned full membership in the National Academy of Design, thereafter regularly contributed ideal works and portraits in marble to the institution's annual exhibitions, and during the 1840s served on its council.

From 1837, when Frazee notified Launitz that he was dissolving their partnership because of his Custom House appointment, Launitz continued the business alone. He was particularly esteemed for his funerary monuments, including several made for Green-Wood Cemetery in Brooklyn, established in 1838 as a nonsectarian burial ground and nature retreat.[51] Recurrent financial reverses aside, Launitz had a career that represents one of the archetypal success stories of foreign sculptors who established themselves in New York. Even so, his own accomplishments as a sculptor, including many monuments executed for southern clients, are overshadowed by his role as mentor and employer. As his student Truman Howe Bartlett reported, "up to 1860, very few of the foreign skilled workmen who came to New York did not work for Launitz." And in 1837 Thomas Crawford, one of many grateful colleagues, referred to him as "my best friend and instructor, at a time when I so much needed one."[52]

Crawford, who is thought to have been born in New York of Irish immigrant parents, enjoyed the best training that America had to offer a sculptor in the 1820s and 1830s. He was first apprenticed to a woodcarver and drew from plaster casts at the American Academy of the Fine Arts and the National Academy of Design (which had assembled a small cast collection through the efforts of Morse). Beginning in 1832 Crawford spent two and a half years with Frazee and Launitz carving mantelpieces and architectural ornament; during this time he occasionally assisted Frazee in portrait work, notably on his commissions for the Boston Athenaeum. Crawford also modeled his own portraits, exhibiting a bust of the artist William Page (unlocated) at the National Academy of Design in 1835 (to his dismay, it was placed on the floor).

When the young sculptor set off for Rome in May 1835, he carried a letter of introduction from Launitz to Thorvaldsen that facilitated a period of study of about a year with the revered Neoclassicist. Crawford soon discovered what a subsequent generation of his compatriots would come to understand: for an aspiring sculptor the Empire City paled in comparison to the Eternal City. In Italy carvers who could translate models into stone were skilled and inexpensive, the cost of living was low, the climate moderate, live models and marble, not to mention the surrounding artistic riches, were plentiful, and an international fraternity of artists flourished. Writing to his mentor Launitz, Crawford observed:

Rome is the only place in the world fit for a young sculptor to commence his career in. Here he will find everything he can possibly require for his studies; he lives among artists, and every step he takes in this garden of the Arts presents something which assists him in the formation of his taste. You can imagine my surprise upon seeing the wonderful halls of the Vatican—after leaving Barclay street [home of the American Academy of the Fine Arts] and the National (Academy). Only think of it—a green one like me, who had seen but half-a-dozon [sic] statues during the whole course of his life—to step thus suddenly into the midst of the greatest collection in the world![53]

The removal of Crawford and of Greenough before him to Italy inspired a growing band of American-born sculptors in the late 1830s, redefining New York's role for them. As artistic interchange between the Old World and the New increased, New York became a temporary destination: a stopping point on an East Coast portrait-sculpting tour, a potential exhibition venue, a place to live for a short time, or a departure point for transatlantic travel. Greenough was in New York briefly in September 1836 before embarking for London the following month. Hiram Powers, a resident of Cincinnati, visited in July 1837 between trips to model portraits in Boston and Washington. In October of the same year he sailed from New York to Europe, where he settled in Florence, never to return to American shores. He attained international stature, and of all the American sculptors living abroad he maintained the most visible and profitable long-distance relationship with New York.

Far less successful was Edward Augustus Brackett, another sculptor from Cincinnati, who arrived in New York in autumn 1839 and remained for two years, "gaining a scanty and precarious subsistence by modelling busts."[54] Although Brackett befriended prominent New Yorkers, among them Bryant, journalist and playwright Mordecai Manuel Noah, and sculptor Mary Ann Delafield DuBois, he found almost no market for his own portraiture. Cincinnati patron Nicholas Longworth wrote to Powers of Brackett's ill

fortune: ". . . the *stupid Gothamites* let him starve whilst they give Clevenger 500$ for Busts. I understand he has got but 2 busts, at 40$."[55] In 1841 the disappointed Brackett moved to Boston, maintaining occasional professional ties to New York but never working in Europe.

By way of contrast, Chauncey Bradley Ives, a Connecticut native who may have studied with Augur, found a way to profitably use New York, where he established a studio for modeling portraits in the early 1840s. He settled in Florence in 1844 and lived in Rome after 1851, but his relationship with and reliance on New York lasted a lifetime. His example, as forthrightly as that of any sculptor of this period, demonstrates a pattern of creating and carving in Italy and exhibiting and marketing in New York. His works were modeled in Italy, shown in plaster and ordered in stone in New York, then translated into marble in Italy, and finally displayed in Manhattan homes in their stone versions. Ives was a particular favorite with New Yorkers, and he cultivated buyers for replicas of his sculptures, both in Italy and during several return visits to the city in the 1840s and 1850s. He also developed a loyal clientele for his ideal works (see cat. no. 64) and portraits, which included some of the city's most prominent collectors, such as Philip Kearny, Isaac Newton Phelps, and Marshall O. Roberts. These men were critical to Ives's success, since his reputation, unlike that of Powers, remained principally American.

That a sculptor could spend relatively little time in New York and achieve significant success in the city is also demonstrated by the career of Shobal Vail Clevenger, who earned respect as the preeminent portraitist active in America after Powers moved to Italy. Another resident of Cincinnati, Clevenger worked in Washington, Philadelphia, and Boston in addition to the Empire City. He was in New York in the spring of 1839 and again in mid-1840, modeling portraits, among them busts of Philip Hone, James Kent (both New-York Historical Society), and Julia Ward Howe (Boston Public Library) as well as several other members of the Ward family. Clearly the sculptor's New York following was devoted: in December 1840 various prominent citizens showed their eagerness to share Clevenger's legacy by donating five of his plaster portraits to the New-York Historical Society.[56] When he traveled to Florence earlier in 1840, Clevenger took with him thirty-three plaster busts to be translated into marble versions—and many of these were completed before his premature death in 1843. The passing of the young sculptor inspired an outpouring of

support from New Yorkers for his impoverished widow, an indication of his popularity in the city. The standing he achieved is witnessed also by complimentary assessments published in 1844 in two New York–based periodicals, the *Columbian Lady's and Gentleman's Magazine,* and the *United States Magazine, and Democratic Review.*[57] Each article called for New Yorkers to raise $3,000 for the translation of Clevenger's *Indian Warrior* from plaster into marble by Powers's studio. The exhibition of a plaster sketch of the piece was organized by Joseph Mozier, a businessman who would turn sculptor, but subscription efforts failed, with only $600 gathered.[58]

A group of twenty-three distinguished New York merchants did, however, eventually succeed in acquiring an example of Clevenger's work in marble, a version of his 1839 portrait of Hone (cat. no. 58), for the Mercantile Library Association, a circulating library for merchant clerks located in a building operated by the Clinton Hall Association. Hone's bust, which apparently had been ordered in marble by the merchants prior to Clevenger's death, was translated posthumously from plaster into stone in Powers's Florentine workshop. Powers likely altered or "improved" the drapery, for that of the commanding marble version differs significantly from Clevenger's original plaster (fig. 58). The portrait pleased Hone, who, in December 1846, described its placement in the Mercantile Library's main room as "an excellent position, on a beautiful pedestal of marble slightly veined, and enclosed with a circular iron railing tastefully bronzed and gilded," and praised the bust as "worthy of the liberal and generous motives which prompted the contributors to this most delicate and touching compliment."[59]

During the 1840s and 1850s all of the well-known sculptors discussed, and many others who labored in obscurity, submitted their works to a variety of exhibition venues in New York, whose numbers grew in this period. These institutions, which ranged in type from the American Institute of the City of New York to the National Academy of Design, assured sculptors the opportunity to show their new works to critics and potential patrons alike and to target viewing audiences. However, New York did not have a professional establishment set aside specifically for showing sculpture until the National Sculpture Society was founded in 1893. (In Boston, by contrast, the Athenaeum held sculpture annuals for nearly three decades beginning in 1839.) The National Academy of

55. Nicholas Longworth to Hiram Powers, April 30, 1840, Hiram Powers and Powers Family Papers, microfilm reel 817, no frame number, Archives of American Art, Smithsonian Institution, Washington, D.C.

56. See *Catalogue of American Portraits in the New-York Historical Society* (New Haven: Yale University Press for the New-York Historical Society, 1974), vol. 1, pp. 141–42, 259, 335–36, 419–20, vol. 2, pp. 902–3. The portraits were of Henry Clay, 1838 (gift of Samuel Verplanck); Edward Everett, 1839 (gift of George Folsom); William Henry Harrison, 1837 (gift of Benjamin R. Winthrop); James Kent, 1840 (gift of John Jay); and Oliver Wolcott Jr., 1840 (gift of George Gibbs).

57. See H[enry] T. Tuckerman, "Clevenger," *Columbian Lady's and Gentleman's Magazine* 1 (January 1844), pp. 10–11; and "Clevenger," *United States Magazine, and Democratic Review* 14 (February 1844), pp. 202–6, which includes a line drawing of the *Indian Warrior.*

58. See *The Twenty-third Annual Report of the Board of Directors of the Mercantile Library Association, Clinton Hall, New York, January, 1844* (New York: Printed by George W. Wood, 1844), pp. 3–4; Thomas B. Brumbaugh, "Shobal Clevenger: An Ohio Stonecutter in Search of Fame," *Art Quarterly* 29 (1966), pp. 42–43; and Richard P. Wunder, *Hiram Powers: Vermont Sculptor, 1805–1873,* 2 vols. (Newark: University of Delaware Press, 1991), vol. 1, p. 134.

59. *Diary of Philip Hone,* vol. 2, p. 775, entry for October 19, 1846, p. 782, entry for December 25, 1846.

Fig. 112. Edward Augustus Brackett, *Washington Allston*, Boston, modeled 1843; carved 1843–44. Marble. The Metropolitan Museum of Art, New York, Gift in memory of Jonathan Sturges, by his children, 1895 95.8.2

Design was New York's premier exhibition venue, yet its commitment to presenting sculpture in its annuals was random at best for many years, in large part due to the paucity of local artists and to logistical problems attendant on the display, lighting, and shipping of works. Thus, while no sculpture was exhibited in 1839 or 1840, the annual of 1841 featured no fewer than eighteen pieces by ten sculptors, among them Greenough, Hughes, Ives, and Launitz. Again in 1846 no sculpture appeared, moving one critic to lament: "Tell us, oh ye POWERS, and CRAWFORD's, and KNEELANDS, and PERICOS [*sic*], and *persecutors*— ye of the [Academy's] council, we mean—what is the *upshot* of all this negligence, or indifference, or whatever else ye please to term it."[60] The Academy's inconsistency, in fact, did have a positive result in one respect: it encouraged sculptors to install their works in studios and rented spaces, where they could show at any time of the year, control viewing conditions and publicity, and charge admission.

One of the forums for American sculpture was the American Art-Union. During its short but intense life span of 1842 to 1853, the Art-Union displayed works by Americans and gave out paintings and sculptures as premiums in annual lotteries offered to a national body of subscribers, who each year paid $5 to participate. (The phenomenally popular organization met its end when this method of distribution was declared in violation of state antilottery laws.) The proportion of sculpture in relation to the total number of works exhibited by the Art-Union was extremely small, and very few examples in marble were included among the lottery prizes. In fact, the organization's support of sculpture was symbolic: the mere presence of sculpture in the displays and lotteries increased public awareness of the medium and situated it within the mass market for American art.

Logistics may have played a part in the Art-Union's decision to show and distribute so few works in marble: sculpture was difficult and expensive to ship (the prizewinner assumed the cost), and artists generally hesitated to pay for the translation of a plaster into stone before earning a commission. Whatever the reasons for this dearth, the sculptors whose works were commissioned as lottery prizes, such as Brown, Mozier, and Brackett, had direct ties to the managers of the organization. Thus it was through the auspices of the institution's president, William Cullen Bryant, that Brackett's portrait bust of Washington Allston, 1843 (fig. 112), based on a death mask of the recently deceased painter, became a prize. The first sculpture distributed by the Art-Union, this naturalistic marble

Fig. 113. Francis Michelin, after Thomas Crawford and Frederick Catherwood, *Proposed Colossal Statue of Washington for the City of New York*, 1845. Lithograph with tint stone. The Metropolitan Museum of Art, New York, The Edward W. C. Arnold Collection of New York Prints, Maps and Pictures, Bequest of Edward W. C. Arnold, 1954 54.90.721

was awarded to P. G. Buchan of Rochester, New York.[61] Whether Buchan ever took ownership is unknown, but it is likely that he did not or that he resold it, for several years after the drawing a marble replica, probably the version awarded in the lottery, was in the collection of Jonathan Sturges, a member of the Art-Union's committee of management. It was not uncommon for the prizes distributed by lottery to follow such circuitous paths of ownership, but it was more usual for works of art to make their way quite directly from the Empire City into homes throughout the country. This typical route is illustrated by the example of *Diana*, ca. 1850 (cat. no. 65), by Mozier, who had retired from New York's world of commerce and moved to Florence in 1845 to pursue his career as

60. "The Fine Arts. National Academy of Design. Smaller Saloon," *Morris's National Press*, June 20, 1846, p. 4.

61. "Transactions at the Annual Meeting of the American Art-Union for 1844," in *Transactions of the American Art-Union, for the Promotion of the Fine Arts in the United States, for the Year 1844* (New York, 1844), p. 4. See also Thayer Tolles, ed., *American Sculpture in The Metropolitan Museum of Art, Volume I: A Catalogue of Works by Artists Born before 1865* (New York: The Metropolitan Museum of Art, 1999), p. 74.

62. *The Diary of George Templeton Strong* [vol. 1], *Young Man in New York, 1835–1849*, edited by Allan Nevins and Milton Halsey Thomas (New York: Macmillan, 1952), p. 297; "Fountains," *Broadway Journal*, June 7, 1845, p. 354.

63. "Monuments to Mr. Clay," *Broadway Journal*, January 11, 1845, p. 22, quoted in Jacob Landy, "The Washington Monument Project in New York," *Journal of the Society of Architectural Historians* 28 (December 1969), p. 293.

64. See *Description of J. Frazee's Design for the Washington Monument (in Four Large Drawings) Now Exhibiting at the Art-Union* (New York: Printed by Jared W. Bell, 1848); and "Editor's Table," *The Knickerbocker* 32 (November 1848), p. 473.

65. Editor's note, in [Charles Sumner], "Crawford's *Orpheus*," *United States Magazine, and Democratic Review* 12 (May 1843), p. 455; William Mitchell Gillespie, *Rome: As Seen by a New Yorker in 1843–4* (New York: Wiley and Putnam, 1845), p. 187. On *Orpheus*, see Lauretta Dimmick, "Thomas Crawford's *Orpheus*: The American *Apollo Belvedere*," *American Art Journal* 19, no. 4 (1987), pp. 47–84.

66. On this subject, see David Bernard Dearinger, "American Neoclassic Sculptors and Their Private Patrons in Boston," 2 vols. (Ph.D. dissertation, City University of New York, 1993).

a sculptor. Mozier's chaste, classicizing portrait of the Roman goddess was awarded in 1850 to Levi Hasbrouck of New Paltz, New York, a farming community about seventy miles north of New York City. The bust was transported to New Paltz by wagon soon thereafter and installed in Hasbrouck's home, Locust Lawn (now administered by the Huguenot Historical Society), where it remains today.

Throughout this period the movement to erect a monument to Washington in the city endured. It gathered steam in July 1843, when the Washington Monument Association of the City of New York was established and started to raise funds. In June 1844 the Association made a preliminary selection of Calvin Pollard's design for a 425-foot Gothic-style tower, a choice it continued to favor over subsequent submissions, such as Thomas Crawford and Frederick Catherwood's design of 1845, a proposal for a 75-foot cast-iron figure on a 55-foot granite pedestal (fig. 113). The search faltered as New Yorkers considered the various merits and failings of the designs, and many despaired. George Templeton Strong, for example, noted that the choices were "all on a scale of impracticable splendor and magnitude, and with two exceptions, all execrable," and the *Broadway Journal* commented, "we have long since given up all expectation of ever seeing a Washington Monument in New York."[62]

Yet the movement revived in October 1847, when a cornerstone for the monument was laid with great ceremony at Hamilton Square, a large tract on the city's outskirts between Sixty-sixth and Sixty-eighth streets and Third and Fifth avenues. Again Pollard's design was tentatively selected, although many New Yorkers protested that its style was aesthetically and symbolically unfit for an American hero, one observer remarking: "a Gothic monument, in honour of Washington, is the very sublime of nonsense."[63] Still, the Association solicited yet more designs. In autumn 1848, at the American Art-Union, Frazee displayed an ambitious drawing for a memorial to Washington in the form of a domed building topped by an allegorical statue of History, which he estimated would cost more than $1,000,000 and take ten years to complete. Although it earned plaudits from the public, this flamboyant conception, as well as many other designs, was rejected in a popular contest (with votes purchased at $1 each) in favor of Minard Lafever's Egyptian obelisk. The Association's subscription drive was discontinued in 1849, and Lafever's monument was never erected.[64]

New Yorkers were inconsistent in their support of homegrown talent Thomas Crawford. Crawford spent his first years in Rome producing stern classicizing portrait busts as well as copies after the antique. Among the former were a small number commissioned by New Yorkers, including a likeness of Matthias Bruen of 1837 (New Jersey Historical Society, Newark) and one of Mrs. John James (Mary Hone) Schermerhorn of 1837 (New-York Historical Society). However, when Crawford progressed from bread-and-butter portraits to the more prestigious realm of ideal compositions, Bostonians, not New Yorkers, encouraged him. It was Boston attorney and future United States senator Charles Sumner who raised the funds to translate into marble for the Boston Athenaeum Crawford's first achievement in this idiom, the masterly *Orpheus*, 1839–43 (Museum of Fine Arts, Boston). And it was the Boston Athenaeum that showed the *Orpheus* in spring 1844 with five other examples of Crawford's work, in the first one-person exhibition held for a sculptor in America.

That Boston had outdone New York did not go unnoticed: "It is a sin and a shame that Boston should have been suffered by New York to possess itself of the Orpheus. . . . The only atonement that can be made . . . will consist in an order for some other work of kindred inspiration from the same chisel," observed one critic. William Gillespie, in his *Rome: As Seen by a New Yorker*, was more succinct: "Should not the native city of the sculptor secure from him at least one great work?"[65] Boston consistently outstripped New York as a source of steady patronage for expatriate American Neoclassicists in general, thanks to the efforts of several extraordinary individuals, a strong appreciation of classical civilization on the part of its educated citizens, and the presence of the taste-making Athenaeum.[66]

Even though Crawford married into New York's prestigious Samuel Ward family in 1844, he continued to have difficulty earning support in the Empire City. During three trips back to the United States to solicit orders, the sculptor attracted only a limited number of private patrons for ideal compositions in New York. To be sure, some of these individuals were important: among them were Henry Hicks, for whom Crawford executed the lighthearted *Genius of Mirth*, 1842 (cat. no. 59), an ideal subject of the sculptor's own choosing, and also *Mexican Girl Dying*, by 1846 (Metropolitan Museum); Richard K. Haight, who ordered *Flora*, modeled in 1847 (fig. 74); and Hamilton Fish, who commissioned *The Babes in the Wood*,

Fig. 114. Thomas Crawford, *The Babes in the Wood*, Rome, modeled ca. 1850; carved 1851. Marble. The Metropolitan Museum of Art, New York, Bequest of Hamilton Fish, 1894 94.9.4

ca. 1850 (fig. 114), a poignant rendering of a brother and sister in eternal slumber.[67] Crawford above all the sculptors of the first generation of American Neoclassicists succeeded as a master of public statuary, earning major commissions for the United States Capitol and a monument to Washington for the grounds of the Virginia State House in Richmond. Yet even in this area his achievement in New York fell short. A scheme Hone initiated in 1844–45 to employ Crawford to produce a statue of Henry Clay for the new Merchants' Exchange "or some other suitable place"[68] failed, and no other public projects were forthcoming from the city.

The sculptor faced an additional problem: certain New York collectors were unwilling to allow public display of their works by Crawford, limiting his exposure and thus his opportunities to attract new clients. Hicks, for instance, through his early purchases helped Crawford establish a New York presence but ultimately frustrated the artist by limiting public exhibition of

his two sculptures. He probably refused a request from Crawford to include *Mexican Girl Dying* in the National Academy's annual of 1848; and he declined to show his pieces subsequently at other public venues, despite "a personal application to him for that purpose during my last visit to the United States," according to a letter from Crawford to New York lawyer Theodore Sedgwick.[69] Crawford encouraged Sedgwick to approach Hicks for permission to show *Genius of Mirth* and *Mexican Girl Dying* at the Crystal Palace in New York in 1853, but if any attempts were made by the lawyer, who was president of the fair, they proved futile. Although his efforts to present an ideal subject to the public were thwarted, Crawford did have some success in showing the elegant portrait of his wife, Louisa, which he modeled in 1845 (cat. no. 63). Crawford must have hoped this bust would become a showpiece, an ambition that probably accounts for the high degree of finish and detail lavished on it, from the innovative floral termination

67. For a list of works produced by Crawford that records his patrons, see "Mr. Crawford's Works," *Literary World*, March 2, 1850, pp. 206–7.

68. *Diary of Philip Hone*, vol. 2, p. 724, entry for December 28, 1844. Hone recorded that $10,000 would be needed to fund the project.

69. Thomas Crawford to Theodore Sedgwick, January 20, 1853, Mss. Crawford, Manuscript Department, The New-York Historical Society. See also Lauretta Dimmick, "A Catalogue of the Portrait Busts and Ideal Works of Thomas Crawford (1813?–1857), American Sculptor in Rome" (Ph.D. dissertation, University of Pittsburgh, 1986), pp. 526–27.

70. N. Cleaveland, "Henry Kirke Brown," *Sartain's Union Magazine of Literature and Art* 8 (February 1851), p. 137. For another contemporary account of Brown's early years in New York, see "Brown's Studio," *Bulletin of the American Art-Union* 2 (April 1849), pp. 17–20. See also Wayne Craven, "Henry Kirke Brown: His Search for an American Art in the 1840's," *American Art Journal* 4 (November 1972), pp. 44–58.

71. Henry Kirke Brown to Lydia L. Brown, October 12, 1846, Bush-Brown Papers, vol. 2, p. 548/11, Library of Congress.

72. Henry Kirke Brown to Ezra P. Prentice, November 21, 1846, Bush-Brown Papers, vol. 2, p. 548/30, Library of Congress.

73. Henry Kirke Brown to Lydia L. Brown, July 4, 11, 1847, Bush-Brown Papers, vol. 2, pp. 548/51, 548/57, Library of Congress.

to the elaborate hairstyle and the intricate arrangement of drapery. The portrait was exhibited at the American Art-Union galleries in 1849 and four years later at the great Crystal Palace fair, where it was accorded an honorable mention, a high point in Crawford's relationship with New York.

Although New York had no public monument by Crawford and saw little of his work in exhibitions during the artist's life, his sculpture was shown in abundance in the city after his early death. Some eighty-seven plasters donated by Crawford's widow were presented to the Board of Commissioners of Central Park in 1860 and eventually were joined by Haight's gift of the marble *Flora*. Further, five marbles, including the *Dying Indian Chief*, 1856 (New-York Historical Society), from Crawford's design for a pediment of the United States Capitol, were on display at the New-York Historical Society throughout the 1860s, and *Dancing Girl (Dancing Jenny)* was exhibited at New York's Düsseldorf Gallery during the same period.

Henry Kirke Brown was the first American-born sculptor to achieve a solid reputation as a member of the New York artistic establishment. Of this determined advocate for American independence from European sculptural models and materials, one contemporary critic accurately observed: "It was his ambition to become, not a European, but an American sculptor. To him it seemed that, if a school of art, with characteristics in any degree national, is ever to grow up among us, its work must be done mainly upon American ground, and amidst American influences."[70] His deep-seated nationalism notwithstanding, he followed a rigorous course of study in Italy from 1842 to 1846, first in Florence and then, after 1844, in Rome. Abroad he developed a network of American patrons, artists, and writers, among whom were Bryant, Charles M. Leupp, and Henry G. Marquand. It was largely on the advice of this circle that Brown decided to settle in New York when he came back to America.

Brown quickly made a place for himself in the burgeoning cultural community of New York, developing close friendships with artists Asher B. Durand, Henry Peters Gray, and Daniel Huntington. In colorful letters the sculptor described his enthusiastic reception and active social schedule, including a festive evening with managers of the American Art-Union, where, he wrote, "they quite 'Lionized' me."[71] While in Rome he had been urged to display his

works in New York on his return, and he did so with dispatch, thereby announcing that a sculptor of talent was now resident on American shores. In rented gallery space at the National Academy of Design in November 1846, Brown exhibited fifteen works in what was the first one-person show mounted for a sculptor in New York. Only one portrait was included; the rest were classicizing ideal compositions modeled in Italy that the artist hoped to translate from plaster into marble on commissions from New Yorkers. However, he failed to attract many new patrons, for the exhibition was poorly attended and almost entirely ignored by the press.

Although he was well liked and well connected and maintained that he was "gratified by the interest manifested in [the National Academy show] by the first Artists here and people generally,"[72] Brown was disappointed in New York. He complained of the city's comparatively high cost of living and of being able to find only one competent assistant; and to his wife he lamented: "I have worked in this infernal city now some eight months and am worse off in almost every respect than when I came here. . . ." and "My improvement in the art is comparatively at an end if we stay here."[73] To make ends meet, he was obliged to design ceremonial sword hilts as well as utilitarian objects such as vases and candelabras for Ball, Tompkins and Black, a New York firm specializing in silver wares that for a time was owned by his patron Marquand.

But gradually Brown began to find acceptance for his work, especially with newly moneyed patrons for whom collecting brought social entrée and who hoped an embrace of American art implied patriotic values. In December 1846 Leupp commissioned him to execute a portrait of their mutual friend Bryant; the resulting likeness of 1846–47 (cat. no. 61) typifies Brown's marble busts from the late 1840s in its presentation of a highly realistic likeness elaborated with a conventional classicizing drape. Another important commission of this time may have come from Sturges, who was already well acquainted with Brown's work—he had shown interest in acquiring a replica of *Ruth*, 1845 (fig. 115), during the artist's Rome days, and he owned Brown's *Good Angel Conducting the Soul to Heaven*, by 1850 (unlocated). Sturges likely ordered a bust of Thomas Cole that was completed by 1850 (cat. no. 62); probably commissioned after the painter's death in 1848, it may have been based on a daguerreotype by Mathew Brady, ca. 1846 (cat. no. 161), that was on display in the photographer's Broadway studio by the late 1840s.

Brown also began to have good fortune in terms of showing his work on a regular basis. Two of his Italian pieces, *Ruth* and *Boy and Dog,* 1844 (New-York Historical Society), were given to the New-York Gallery of the Fine Arts in 1846 by, respectively, Eliza Hicks and Leupp. These went on view with the entire New-York Gallery of the Fine Arts collection at the New-York Rotunda in City Hall Park, where Brown briefly had his studio. Additionally, thirteen of his sculptures were featured in the 1850 annual exhibition of the National Academy of Design, including the *Cole* and the *Good Angel Conducting the Soul to Heaven,* lent by Sturges.

By mid-1848 Brown, like many other New Yorkers past and present, moved across the East River to Brooklyn. There he was able to enjoy more spacious living and working quarters (large enough for keeping a tame bear and deer) and still maintain social and business ties to nearby Manhattan. Until 1857, when Brown removed permanently to Newburgh, New York, Brooklyn remained for him a refuge from the urban chaos and constant interruptions in Manhattan of which he complained. In Brooklyn Brown's career truly began to thrive, as a passage in a letter he wrote to Huntington reveals: "My little tree of hope is planted here and its roots are spreading by nourishing waters, and tho' a very little plant at first is now beginning to spread its branches towards the light."[74] With the assistance of two French workmen and a little ingenuity, Brown established a foundry in his Pacific Street studio to cast his earliest bronzes as well as jewelry and other metalwork for Ball, Tompkins and Black.

Brown, more than any other individual, inspired the American Art-Union to expand its mission, originally focused on the distribution of paintings and prints, and promote sculpture, specifically the small bronze, as a democratic national art with potential appeal for a wide American audience. In 1849 the Art-Union's managers named a special committee to investigate the possibility of distributing bronze sculptures to its subscribers. The group's report makes clear, but does not explicitly state, that its favorable response was determined primarily by the success of Brown's foundry: "There has always been a difficulty in this country in obtaining proper workmen, which is the principal reason why reduced copies in bronze have not already been made of several exquisite statues, modelled by our own artists. . . . This obstacle has been removed, and there are here at present several persons, lately arrived from Europe, who are fully competent to undertake this kind of work." Shortly before

Fig. 115. Henry Kirke Brown, *Ruth,* Rome, 1845. Marble. Collection of The New-York Historical Society

it issued its report, the committee passed a resolution calling for Brown to model a statuette "illustrative of Indian form and character" for replication in an edition of twenty.[75]

Brown promptly complied, and casts of *The Choosing of the Arrow* (fig. 116), a nude man drawing an arrow from his quiver, based on sketches from the sculptor's 1848 trip to Mackinac Island, were distributed in 1849—but not without some objection to the figure's nudity. Unable to comprehend the symbolic import of a naturalistic American subject rendered in an "American" medium (bronze rather than imported marble) or, for that matter, to appreciate the piece in purely visual terms, one journalist wrote: "the bronze is so near to the natural copper of the skin, that there is nothing to modify the complete disgust with which its undisguised nakedness must be looked upon. . . . what any modest person can do with such a 'prize,' except to refuse to receive it, is difficult to imagine."[76]

74. Henry Kirke Brown to Daniel Huntington, December 24, 1852, Bush-Brown Papers, vol. 3, p. 639, Library of Congress.

75. "Bronze Statuettes," *Bulletin of the American Art-Union* 2 (April 1849), p. 10.

76. "Nudity in Art," *Home Journal,* January 5, 1850, p. 2. The article further notes that Art-Union officials hastily affixed removable tinfoil fig leaves so badly constructed that "the concealment, at the best, was just so partial as to be worse than complete exposure."

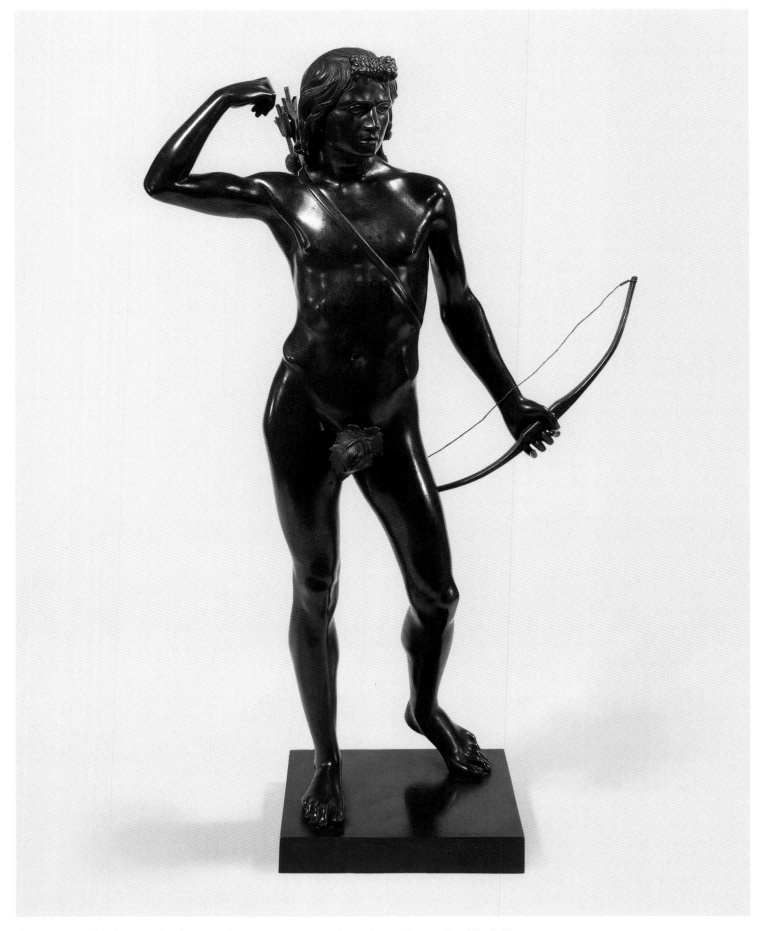

Fig. 116. Henry Kirke Brown, *The Choosing of the Arrow*, 1849. Bronze. Amon Carter Museum, Fort Worth, Texas

Fig. 117. Victor Prevost, *Daniel Appleton's Bookstore, Lower Broadway, with Henry Kirke Brown's "Plato and His Pupils,"* 1854. Modern gelatin silver print from original waxed paper negative. Collection of The New-York Historical Society

in 1852 on the façade of Daniel Appleton's bookstore on lower Broadway (fig. 117), Ames and Brown focused their attention on a statue of De Witt Clinton for Green-Wood Cemetery (fig. 118), which was funded by public subscription through the Clinton Monument Association. As a promotional publication for the memorial noted, the bronze medium was deliberately selected to place the *Clinton* within a distinguished artistic lineage: "A bronze statue is not only one of the most significant and durable tributes which can be offered to the memory of a deceased statesman, but it has been rendered by historical associations one of the most appropriate also."[77]

The monument did indeed serve the memory of Clinton, recalling his public career in two bas-reliefs on its base, "The Digging of the Erie Canal" and "Commerce on the Erie Canal." Like contemporaneous portraits with realistic likenesses and draped terminations, the ambitious $10\frac{1}{2}$-foot figure is a stylistic hybrid: the naturalistically rendered subject appears in modern dress but with an incongruous Roman mantle and sandals. Yet the contemporary clothes make Clinton more an American statesman than an idealized hero—and in this respect the memorial established a

77. *Monument to De Witt Clinton* (New York, ca. 1849), quoted in Michael Edward Shapiro, *Bronze Casting and American Sculpture, 1850–1900* (Newark: University of Delaware Press, 1985), p. 49.

Reactions of this kind notwithstanding, the Art-Union pursued its program, for the production and distribution of works of art in quantity was perfectly suited to the rapidly growing appetite for the arts, however prudish or untutored the viewing audience. The Art-Union's inaugural attempt in the area of sculpture replicas was followed in 1850 by its distribution of six bronze casts of a bust of George Washington of about 1850 by longtime New York sculptor Horace Kneeland and twenty of Brown's *Filatrice*, 1850 (cat. no. 66). The latter, an unobjectionable figure of a peplos-clad spinner, eschews the American subject matter of *The Choosing of the Arrow* and reflects the sculptor's lingering penchant for the classicizing themes of his Italian sojourn.

Because he lacked the facilities to cast large projects, Brown, beginning in 1851, turned to the Ames Manufacturing Company in Chicopee, Massachusetts, which specialized in casting cannons and swords. He and James Tyler Ames collaborated to develop a firm able to cast oversized sculptures, initiating a tremendously productive working relationship and establishing a resource for other American artists, who formerly had to rely exclusively on European foundries. After casting Brown's bas-relief *Plato and His Pupils,* installed

Fig. 118. Henry Kirke Brown, *De Witt Clinton*, 1850–52. Bronze. The Green-Wood Cemetery, Brooklyn

78. "City Intelligence: Statue of De Witt Clinton," *New York Herald*, May 25, 1853, p. 4, cited in Stokes, *Iconography of Manhattan Island*, vol. 5, p. 1849; "The Clinton Statue," *New-York Daily Times*, September 21, 1853, p. 4.

79. *Morning Courier and New-York Enquirer*, August 31, 1847, quoted in Samuel A. Roberson and William H. Gerdts, "The Greek Slave," *The Museum* (Newark), n.s., 17 (winter-spring 1965), pp. 16–17. On the *Greek Slave*, see also Wunder, *Hiram Powers*, vol. 1, pp. 207–74, vol. 2, pp. 157–68; Linda Hyman, "The Greek Slave by Hiram Powers: High Art as Popular Culture," *Art Journal* 35 (spring 1976), pp. 216–23; and Joy S. Kasson, *Marble Queens and Captives: Women in Nineteenth-Century American Sculpture* (New Haven: Yale University Press, 1990), pp. 46–72. The *Greek Slave* shown in New York in 1847 is now in the collection of the Corcoran Gallery of Art, Washington, D.C. Subsequent showings in New York featured the Newark Museum's marble (cat. no. 60).

80. *Diary of Philip Hone*, vol. 2, p. 819, entry for September 13, 1846.

81. *Sarmiento's Travels in the United States in 1847*, translated by Michael Aaron Rockland (Princeton: Princeton University Press, 1970), pp. 277–78.

82. [Horace Greeley], "City Items. Powers's Great Statue," *New-York Daily Tribune*, 1847, p. 2.

83. "The Crystal Palace. Progress of the Exhibition," *New-York Daily Times*, August 19, 1853, p. 4.

new standard for American portrait statuary. Cast in April 1852, the bronze was placed in front of City Hall from May to September 1853 prior to its unveiling in Green-Wood Cemetery later that year.[78]

However impressive, Brown's achievements—and in fact those of any New York artist, entrepreneur, or showman of the 1840s and 1850s—must be considered within the context of Hiram Powers's extraordinary impact and international fame. In August 1847 Powers's marble *Greek Slave*, 1841–43 (cat. no. 60), made the first stop on its national tour, which lasted until 1849. This ideal figure, a full-length nude representing a young female prisoner, alluded to the atrocities the Turks committed during the Greek War of Independence and by implication to the ongoing American debate over slavery. Shown until early January 1848 at the exhibition gallery of the National Academy of Design, the statue attracted thousands of viewers. Among the throngs who paid admission, it was noted, "the grey-headed man, the youth, the matron, and the maid alike [were awed]. . . . Loud talking men are hushed into a silence . . . groups of women hover together as if to seek protection from the power of their own sex's beauty."[79] Hone wrote in his diary of the crowds and concluded, "I have no personal acquaintance with Powers, nor had I with Praxiteles; but . . . I certainly never saw anything more lovely."[80]

The figure's nudity gave some pause, although it provoked less criticism in New York than in other American cities. As one visitor to the National Academy reported: "The first few days there was a great scandal, but finally the prigs lifted their eyes and accustomed themselves to contemplating the artistic beauty in that looking glass of marble."[81] Apologists argued that the statue's classicizing style as well as the subject's evident Christian devotion in the face of adversity excused her undress. Thus, Horace Greeley offered moral approbation in the *New-York Daily Tribune*: "But in that nakedness she is unapproachable to any mean thought. The very atmosphere she breathes is to her drapery and protection. In her pure, unconscious naturalness, her inward chastity of soul and sweet, womanly dignity, she is more truly clad than a figure of lower character could be though ten times robed."[82] The need to supply moralizing justifications of this sort and to satisfy the popular thirst for information led Miner Kellogg, manager of the statue's tour, to assemble a descriptive pamphlet; this included an excerpt from an article in defense of the figure's nudity

by the Reverend Orville Dewey that appeared in the *Union Magazine* of October 1847 and a history of the *Greek Slave* and Powers's career, along with promotional puffs.

After traveling to cities from Boston to New Orleans, the *Greek Slave* returned to New York between October and December 1849, this time for exhibition at the Lyceum Gallery on Broadway. Here it was joined by Powers's commanding portrait of Andrew Jackson, 1834–35 (cat. no. 55), his oft-replicated ideal bust *Proserpine*, 1844–49 (fig. 119), and the nude *Fisher Boy*, 1841–44 (fig. 73), the last enhanced with a fig leaf to maintain standards of propriety. All four were installed in the Gallery of Old Masters, which housed sixty paintings from the well-known collection of Gideon Nye, an honor that accorded them additional status. Although this display was not as profitable as the first New York exhibition of the piece, the cumulative impact of the two showings on residents of the Empire City was nothing short of phenomenal. As an artistic icon the *Greek Slave* exemplified "good" or "correct" taste and thus instructed New Yorkers in the formation of that taste. Moreover, it inspired an unprecedented response in forms of popular culture (see "Inventing the Metropolis" by Dell Upton in this publication, pp. 38, 40), including poems and engravings, as well Parian ware, plaster, and alabaster reductions sold in emporiums and peddled on the streets by Italian image-vendors. If the *Greek Slave* represented the highest form of artistic achievement, it was also a spectacle on a par with P. T. Barnum's Fejee Mermaid, Ethiopian Serenaders, and other curiosities.

Powers's showing at the New York Crystal Palace exhibition, while impressive, was not equally overwhelming. This fair, the New-York Exhibition of the Industry of All Nations, opened in July 1853 and offered a broad viewing public the largest assemblage of sculpture presented to date on American shores (see cat. no. 179). A veritable maze of mechanical and useful objects, as well as fine and decorative arts, the display asserted a continuing American predilection for foreign works, rather than demonstrating the ascendance of native talent, as its organizers had intended. Of the American submissions, Powers's works attracted the most attention, drawing "a constant circle of humanity. . . . Artists, amateurs, countrymen and citizens alike."[83] The *Greek Slave* (cat. no. 60; fig. 186), *Proserpine, Fisher Boy*, and *Eve Tempted*, 1839–42 (National Museum of American Art, Smithsonian Institution, Washington, D.C.; see fig. 120), collectively earned an honorable mention,

Fig. 119. Hiram Powers, *Proserpine*, Florence, 1844–49. Marble. Chrysler Museum of Art, Norfolk, Virginia, Gift of James H. Ricau and Museum Purchase 86.505

Fig. 120. Victor Prevost, *Hiram Powers's "Eve Tempted" at the Crystal Palace*, 1853–54. Modern gelatin silver print from waxed paper negative. Collection of The New-York Historical Society

as did Crawford's marble bust of his wife and Thomas Ball's plaster statuette of Daniel Webster. There was wonder "that the far-famed statuary of Mr. Hiram Powers is not quite so highly rated as it has been hitherto by the public at large;"[84] but this was not surprising, for the jury was composed of artists such as Morse, Asher B. Durand, and Brown, who, although champions of American painters and sculptors, held uncharitable opinions of the expatriate Powers. Furthermore, Powers's offerings had to compete with a rich array of foreign sculptures in plaster, marble, and bronze, including Baron Carlo Marochetti's colossal equestrian statue of George Washington and August Kiss's *Amazon*. Thorvaldsen, at the height of his American popularity, was represented by several sculptures, key among them a marble replica of *Ganymede and the Eagle*, 1817–29 (cat. no. 54), and massive plaster models for the highly ambitious multifigure group *Christ and the Apostles*, begun in 1821, from the Church of Our Lady in Copenhagen,[85] and these too vied for attention.

The Crystal Palace exhibition, with its competing and dizzying range of goods, and the continuing phenomenal success of the *Greek Slave* popularized the private patronage of sculpture in New York: the wealthy buyers who unevenly supported native-born sculptors were eclipsed by clients from a broader socioeconomic base who eagerly collected inexpensive foreign and American works in plaster, Parian ware, and bronze as symbols of refinement and taste. One purveyor of such works was the Cosmopolitan Art Association, founded in 1854 by Chauncey L. Derby to encourage and popularize the fine arts through the publication of a monthly journal and a lottery-based distribution of both paintings and sculpture. The Cosmopolitan Art Association solicited sculpture far more extensively than had its unlucky predecessor the American Art-Union, evading antilottery laws by holding its drawings in Sandusky, Ohio, while mounting its displays in New York. In the Cosmopolitan's inaugural year Derby purchased a replica of the *Greek Slave* for the organization; exploiting its universal familiarity to maximum promotional effect, he used it to attract subscribers by making it a prize. The statue was awarded to a Pennsylvania resident in 1855 and repurchased by the Cosmopolitan for $6,000 in 1857 at an auction held in the rotunda of the Merchants' Exchange.[86] In 1858, after a showing at the Düsseldorf Gallery (fig. 121), managed by Derby, the *Greek Slave* was again awarded by lottery, this time to a Cincinnati woman, who immediately sold it to New York department-store magnate A. T. Stewart.

The Cosmopolitan Art Association shrewdly purchased many other works that reflected the popular, if not always sophisticated taste of its patrons. Inexpensive Parian-ware sculptures had become favorite domestic adornments by this period and had proliferated on the market; one advertisement run repeatedly by a Maiden Lane proprietor boasted of more than 400 selections.[87] Accordingly, the Association's stock included many ideal statuettes in Parian ware as well as in bronze, along with portrait busts of notable statesmen and authors and such items as a reduced copy of Kiss's *Amazon*, distributed in 1856, and 112 sets of mounted photographs of Thorvaldsen's familiar bas-reliefs *Night* and *Day*, given out in 1860. In 1860 John Rogers, newly arrived in New York from Chicago, executed a fifteen-inch plaster after William Randolph Barbee's marble *Fisher Girl*, ca. 1858 (fig. 122), which had been purchased by the Association in 1859. Capitalizing on the fashion for Parian ware, the Association had copies in the medium cast by W. T. Copeland in England and distributed eleven of them in 1861. Rogers himself would go on to achieve fame catering to a broad audience with inexpensive tinted plaster groups—anecdotal vignettes of everyday American life—publicized through modern marketing tactics, including the use of mail-order catalogues and a studio showroom.

During the 1850s American sculptors attempted to match Powers's astounding success in New York; with the twin goals of turning a profit and attracting new patrons, they produced ideal works with timely implications and dramatic resonance and displayed them in rented spaces or any of the growing number of the city's commercial galleries. If James Thom and Robert Ball Hughes in the 1830s had aspired to amuse and entertain their audiences, their commercially astute successors of the 1850s manipulated and excited the emotions of viewers. Edward Augustus Brackett's lifesize Vermont marble group *Shipwrecked Mother and Child*, 1850 (fig. 123), typifies the genre. The artist's finest achievement and only ideal composition, it was shown between March and June 1852 at the Stuyvesant Institute, a Broadway hall that was a favorite exhibition venue. Although it went unsold, the piece appealed powerfully to viewers' morbid curiosity about victimization and death. It also responded to a widespread contemporary fascination with shipwrecks, which inspired numerous prints and songs. In Boston, where *Shipwrecked Mother and Child* was shown before it

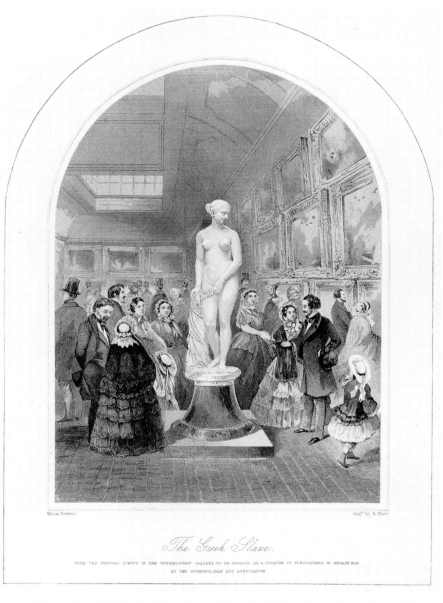

Fig. 121. *Hiram Powers's "The Greek Slave" at the Düsseldorf Gallery.* Engraving by Robert Thaw, from *Cosmopolitan Art Journal* 2 (December 1857), between pp. 40 and 41. The Metropolitan Museum of Art, New York, The Thomas J. Watson Library

appeared in New York, the group inspired encomiums by the likes of statesman and orator Edward Everett and sculptor Greenough. Greenough considered the image when viewed at a proper distance "no longer marble, but poetry," and an anonymous critic wrote that "we felt, after a little while spent in its presence, with what dramatic truth the conception had been wrought out. We were on the sea-shore with the artist, the storm was raging far out, the ship was laboring, the blow was struck, the mother and the child engulphed [*sic*], the rugged shore received them."[88] Viewers in the general audience agreed, reading the composition as a narrative that transported them to the realm of watery death.

84. "Fine Arts. The Prizes at the New York Crystal Palace," *The Albion*, January 28, 1854, p. 45. On Powers's response to the judging, which occurred before the fair opened, see Wunder, *Hiram Powers*, vol. 1, pp. 252–53.

85. See *How to See the New York Crystal Palace: Being a Concise Guide to the Principal Objects in the Exhibition as Remodelled, 1854. Part First. General View,—Sculpture,—Paintings* (New York: G. P. Putnam and Co., 1854), pp. 25–29. See also "The Chronicle. American Art and Artists. Exhibition of Models of Works by Thorvaldsen,"

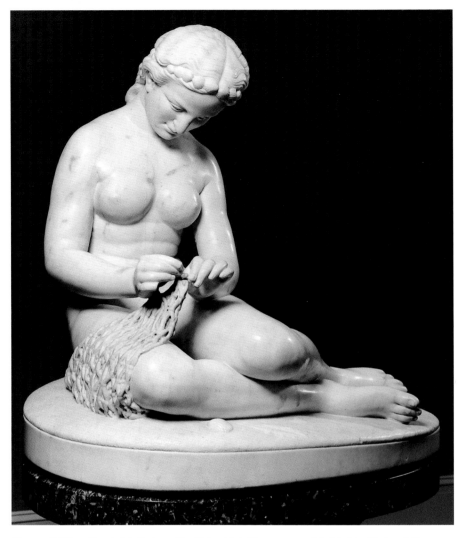

Fig. 122. William Randolph Barbee, *The Fisher Girl*, Florence, ca. 1858. Marble. National Museum of American Art, Smithsonian Institution, Washington, D.C., Museum Purchase 1968.140

Not only shipwrecks but also the romantic notion, then current, of Native Americans as an exotic and vanishing race fed the popular imagination and was an important source of subject matter for sculptors. It inspired Peter Stephenson's *Wounded Indian,* ca. 1848–49 (fig. 124), for example, which was shown in 1851 at London's Crystal Palace and from May to June 1852 at the Stuyvesant Institute, overlapping for a time with Brackett's *Shipwrecked Mother and Child.* The public appetite for the dramatic themes of these works was matched by an appreciation of their visual realism, conveyed by virtuoso displays of carving. That this appreciation compensated for deficiencies in emotional expression is suggested by reviewers who found no perceptible storytelling qualities in *The Wounded Indian* but praised the realistically rendered ethnic characteristics and bloody gash and the complex pose of the figure, noting that "the interest in the work seems to us to centre rather in the accurate anatomical imitation, than in any ideality or sentiment" and "the subject is not a pleasing one; but it is executed with fidelity and force."[89]

While Powers's American reputation was made by a nationwide tour of the *Greek Slave,* it is fair to say that the self-taught Erastus Dow Palmer was catapulted to fame primarily in New York and by New Yorkers. In September 1846, as a cameo cutter and aspiring sculptor, Palmer visited New York to get modeling tools and materials; two years later he cut and displayed cameos in the city in a temporary studio he set up for the purpose on Franklin Street. At this time Palmer

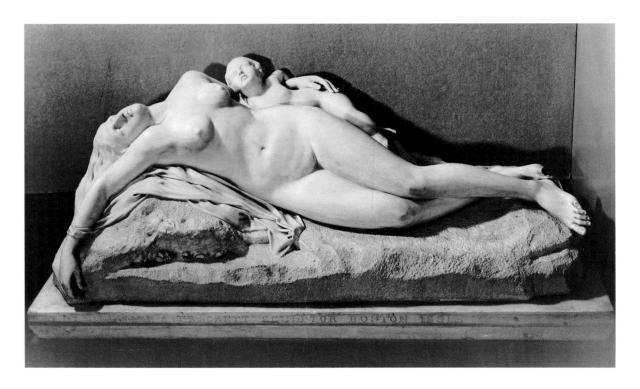

Fig. 123. Edward Augustus Brackett, *Shipwrecked Mother and Child,* Boston, 1850. Marble. Worcester Art Museum, Worcester, Massachusetts, Gift of Edward Augustus Brackett 1909.64

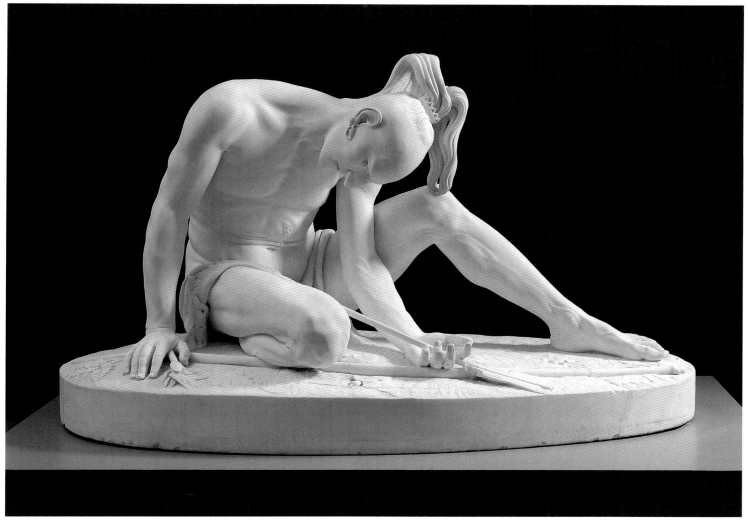

Fig. 124. Peter Stephenson, *The Wounded Indian*, Boston, modeled ca. 1848–49; carved 1850. Marble. Chrysler Museum of Art, Norfolk, Virginia, Gift of James H. Ricau and Museum Purchase 86.522

began seriously to pursue a career as a sculptor in Albany, where he established a studio and later served as mentor for numerous assistants, several of whom became accomplished sculptors in their own right. Palmer had devoted local patrons, but he shrewdly determined to showcase and market his work in New York, capitalizing on his proximity to the city, an easy trip down the Hudson River. That he considered contact with New York vital is captured in a passage from a letter of 1850 he wrote to John P. Ridner of the American Art-Union: "I wish you to lay it [the bas-relief *Morning*] before the committee of the Art-Union asking them to order it in the marble . . . [I] shall be very glad if they do as I am very desirous to have *one* thing at least of mine go there. . . . I need not say that I can dispose of it here at any moment. . . . I wish for my own sake to have it go to N.Y."[90] *Morning* did indeed go to New York, and beyond, for the Art-Union bought the bas-relief and awarded it as a

prize to John Sparrow of Portland, Maine, in the institution's lottery of 1850.

The sale and subsequent disposition of *Morning* constituted the first instance of Palmer's successful introduction of his work to an urban and, in turn, national audience. From Albany in the early 1850s Palmer continued to cultivate his relationship with New York, forging connections with many of the most powerful cultural figures of the metropolis, including patrons Hamilton Fish and Edwin D. Morgan, and artists Frederic E. Church and Daniel Huntington. In April 1856 Palmer's growing reputation as a self-taught genius was substantially enhanced with the publication of a laudatory article Henry T. Tuckerman had written after a visit to the sculptor's Albany studio.[91]

The following October a committee of twenty distinguished citizens invited Palmer to exhibit in New York. As a result, twelve of his works, "The Palmer Marbles," were displayed at the hall of the Church of

Bulletin of the American Art-Union, August 1851, p. 78; and "The Exhibition of Sculpture in the Crystal Palace," *New-York Daily Times,* July 1, 1853, p. 1.

86. An engaging account of the auction is given in "Appendix. The Greek Slave," in Cosmopolitan Art Association, *Catalogue of Paintings by Artists of the Academy at Dusseldorf . . .* (New York, 1857), pp. 33–34.

87. See, for instance, "Parian Marble Statuettes," *The Crayon,* January 10, 1855, p. 32.

88. Horatio Greenough to Richard Dana, February 23, 1852, reprinted in *New-York Daily Tribune,* March 29, 1852, p. 5; "The Fine Arts. A 'Brackett' in Public Amusements," *Literary World,* April 10, 1852, p. 268.

89. "Statue of the Wounded Indian," *New-York Daily Tribune,* May 25, 1852, p. 6; "Fine Arts.

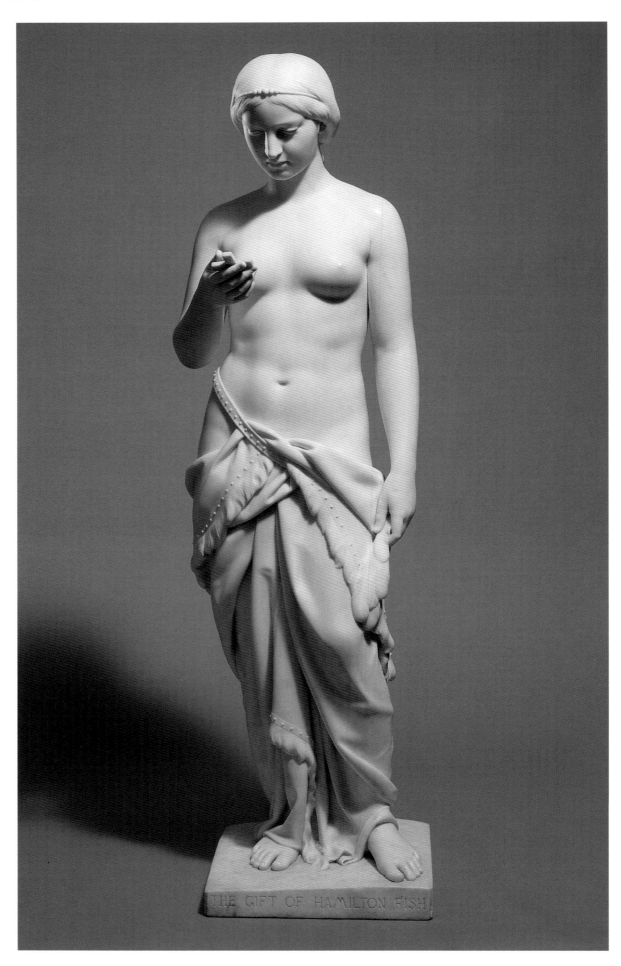

Fig. 125. Erastus Dow Palmer, *Indian Girl* or *The Dawn of Christianity*, Albany, modeled 1853–56; carved 1855–56. Marble. The Metropolitan Museum of Art, New York, Bequest of Hamilton Fish, 1894 94.9.2

Fig. 126. Erastus Dow Palmer, *Morning*, Albany, modeled 1850; carved 1854. Marble. Collection of the Albany Institute of History and Art, Gift of Thomas Woods 1993.46.2

Fig. 127. Erastus Dow Palmer, *Evening*, Albany, modeled 1851; carved probably 1854. Marble. Collection of the Albany Institute of History and Art, Gift of Thomas Woods 1993.46.1

the Divine Unity on Broadway between December 1856 and April 1857.[92] Among these were the semi-nude statue *Indian Girl,* or *The Dawn of Christianity,* 1853–56 (fig. 125), commissioned by Fish; four allegorical busts, including *Spring,* 1855 (Pennsylvania Academy of the Fine Arts, Philadelphia), lent by the Cosmopolitan Art Association; and five relief medallions, including *Morning,* 1850, and *Evening,* 1851 (figs. 126, 127). The exhibition marked a pivotal moment in Palmer's career, attracting extensive critical notice, nearly all positive. Many observers celebrated the sculptor as a native-born talent and lauded the patriotism of his themes and his patrons. One reviewer commended the marbles to any "person in our city, who claims to have taste," while another remarked, "It must be a very dull soul that could step from the Vanity Fair of Broadway into this Exhibition, and not be possessed with something of the charm that pervades it."[93] Attention focused on the exhibition's centerpiece, the *Indian Girl,* which the Reverend A. D. Mayo praised at length in the accompanying catalogue, arguing that the subject's imminent conversion to Christianity pardoned her seminudity. To those eager to assert an American cultural identity, Palmer's marbles, like Brown's bronzes, offered proof that the nation was able to produce meaningful art as well as worthy manufactured goods.

Within months of the show's closing, Fish commissioned Palmer to make a full-length figure to accompany his *Indian Girl.* Palmer's response was

The White Captive, 1857–58 (cat. no. 69), a portrayal of a young pioneer girl who has been kidnapped by Native Americans and stripped of her nightdress, a piece that balances the meaning of its pendant: as the artist explained, the *Indian Girl* was meant "to show the influence of Christianity upon the Savage," while *The White Captive* reveals "the influence of the Savage upon Christianity."[94] Fish permitted *The White Captive* to be displayed in a solo exhibition at the Broadway gallery of William Schaus, a move calculated to make money for Palmer in the short term and to encourage new commissions. Between November 1859 and January 1860 viewers paid 25 cents to see the sculpture, installed alone in Schaus's carpeted main room. Standing beneath a canopy, the statue was illuminated by gaslight filtered through a tinted shield that lent its marble surface a realistic fleshlike tone. The figure surmounted a rotating pedestal with "an attendant . . . always present to put in motion the simple mechanism at the first request." More than three thousand people reportedly visited Schaus's gallery in the first two weeks of the exhibition, with attendance at times climbing to upward of four hundred a day.[95]

Palmer must have deliberately chosen the subject of *The White Captive* to elicit comparisons with Powers's *Greek Slave,* which was a recurrent presence in New York and as recently as June 1858 had made an appearance in the city when a replica was distributed by the Cosmopolitan Art Association. To be sure, Powers's figure purports to represent a victim of the

Statue of the Wounded Indian," *The Albion,* June 12, 1852, p. 285.

90. Erastus D. Palmer to John P. Ridner, June 14, 1850 (BV), American Art-Union, Letters from Artists, The New-York Historical Society.

91. See [Henry T. Tuckerman], "The Sculptor of Albany," *Putnam's Monthly* 7 (April 1856), pp. 394–400.

92. See Committee to Erastus D. Palmer, October 1, 1856, and Palmer's reply of October 6, reprinted in "Palmer's Exhibition of Sculpture," *Evening Post* (New York), November 11, 1856; and *Catalogue of the Palmer Marbles, at the Hall Belonging to the Church of the Divine Unity, 548 Broadway, New York* (Albany: J. Munsell, 1856).

93. "Palmer's Marbles," *Frank Leslie's Illustrated Newspaper,* December 20, 1856, p. 42; "Fine Arts. The Palmer Marbles," *The Albion,* December 18 [i.e. 13], 1856, p. 597.

94. Erastus D. Palmer to John Durand, January 11, 1858, Dreer Collection, Historical Society of Pennsylvania, Philadelphia, on microfilm (reel P21, frame 27) at the Archives of American Art, Smithsonian Institution, Washington, D.C. For further discussion of the polarized worlds of such subjects, see Kasson, *Marble Queens and Captives,* pp. 73–100.

95. Quoted in J. Carson Webster, *Erastus D. Palmer* (Newark: University of Delaware Press, 1983), p. 29; see also "Metropolitan Art Exhibitions," *New York Herald,* December 2, 1859, p. 4.

96. "Art. Palmer's 'White Captive,'" *Atlantic Monthly* 5 (January 1860), p. 109; [Henry T. Tuckerman], "Palmer's Statue, the White Captive," *Evening Post* (New York), November 10, 1859, p. 1. The latter text was printed as an accompanying broadside for the exhibition. It was republished numerous times, including in Henry T. Tuckerman, *Book of the Artists, American Artist Life, Comprising Biographical and Critical Sketches of American Artists: Preceded by an Historical Account of the Rise and Progress of Art in America* (New York: G. P. Putnam and Son, 1867; reprint, New York: James F. Carr, 1967), pp. 359–60.

Fig. 128. *Union Square and Vicinity, with Henry Kirke Brown's "George Washington,"* ca. 1860. From I. N. Phelps Stokes, *The Iconography of Manhattan Island* (New York: Robert H. Dodd, 1918), vol. 3, addenda pl. 27 B-a. The Metropolitan Museum of Art, New York, The Thomas J. Watson Library

97. "Wonderful Development of American Art—Uprising of Enthusiasm," *New York Herald,* December 5, 1859, p. 6; "The Vagabond. Painting and Statuary," *Sunday Times and Noah's Weekly Messenger,* November 20, 1859, p. 1. See also "Art Matters," *New York Dispatch,* November 19, 1859, p. 7, which surveys American and European art on view in New York galleries during the 1859 season.

Greek War of Independence against the Turks, and Palmer's a character in a frontier conflict, but each portrays a full-length female figure caught in a moment of adversity whereby her nudity is pardonable, her purity preserved, and her Christianity triumphant. However, there are significant stylistic and conceptual distinctions. Powers's *Slave* shows classicizing Greek proportions and emotional impassivity, while Palmer's *Captive* reveals a preference for naturalism, with its fleshy body and expressive face. Furthermore, with *The White Captive* Palmer answered a persistent call for subjects drawn from the American experience. And he was shrewdly responding as well to a contemporary fascination with stories of kidnapped white women, such as the real Jane McCrea and Olive Oatman and the fictional heroine Ruth from Cooper's 1829 novel *The Wept of Wish-ton-Wish.* His apt choice drew applause; one writer, for example, wrote of the subject: "It is original, it is faithful, it is American; our

women may look upon it, and say, 'She is one of us.'" Moreover, Tuckerman proclaimed the figure "thoroughly American," and an exemplar of the moral superiority of the civilized nation.[96]

The exhibition of *The White Captive* emerged not only as a financial and popular success but also as a highlight of the rich—and richly—American art season of autumn 1859 for discriminating viewers. Church's epic *Heart of the Andes,* 1859 (cat. no. 41) was also on view in New York, as were Paul Akers's dramatic sculpture *Dead Pearl Diver,* 1858 (Portland Museum of Art, Maine), and large canvases by William Page, William L. Sonntag, and Louis Mignot and Thomas P. Rossiter. Nationalist critics praised this collective American creativity; one writer heralded it as "the inauguration of [a] new art epoch." Another proclaimed Palmer and Church, neither of whom had yet been to Europe, as "the product[s] of American civilization and

culture . . . developments of American genius; manifestations of American character."[97]

Palmer's role in the creation of a new, independent American art must be considered alongside Henry Kirke Brown's triumphant realization of his monument to George Washington (fig. 128) in 1856. A successful subscription effort for the financing of the statue, concluded just before its dedication, had been led by an indefatigable shipping merchant, James Lee, who collected more than $29,000 from ninety-seven individuals. Lee's democratizing plan had limited individual contributions to $500, and the subscription list featured not only the city's new patrons and civic leaders but also lesser lights among the citizenry. With financial backing, Brown was able to proceed. He modeled the likeness of his dignified but unapologetically naturalistic *Washington* on a copy of Houdon's authoritative portrait bust, which he borrowed from Hamilton Fish, and based the uniform on one of Washington's garments that was preserved at the United States Capitol; the prancing steed was drawn from the best examples of Roman equestrian monuments. By May 1855 the Ames Manufacturing Company had completed casting and the pieces were sent to Brooklyn for finishing and assembly by a talented band of assistants, notably John Quincy Adams Ward, who had served in Brown's studio since 1849. Finally, New York saw the culmination of its long battle to erect a public monument to the first president, a memorial that a contemporary termed a necessary element "in a great city's existence":[98] Brown's *George Washington* was dedicated at the southern tip of Union Square on the Fourth of July 1856.

The unveiling of the statue, witnessed by some twenty thousand spectators, can be seen as a metaphor for the difficult but ultimately successful struggle of American sculptors to define themselves in New York between 1825 and 1861. The tarpaulin over the bronze became tangled around the horse's legs and the rider's arms, but after a brigade of firemen with a ladder freed the covering, "the noble statue was revealed to the eager gaze of the delighted multitude; a universal shout rent the air; hundreds of pistols that had been expressly loaded for the occasion . . . went off in a simultaneous explosion."[99] This crowning achievement of sculpture in New York was a tangible symbol of the cosmopolitanism achieved by American sculptors in the years between 1825 and 1861 and a validation of their art's progress during that period, a period that initiated a remarkable era of public sculpture and artistic professionalism in the post–Civil War Empire City. New York's evolution as an art capital was at least matched by the evolution of its sculptors and their understanding of the city's benefits and limitations; as Henry Kirke Brown discerned in 1858: "Brooklyn and New York seem different to me from what they used to. I see that it is myself that has changed more than they."[100]

98. "Brown's Equestrian Statue of Washington," *Frank Leslie's Illustrated Newspaper*, July 19, 1856, p. 86. For the history of the commissioning of the statue and its modeling, too extensive to retell here, see James Lee, *The Equestrian Statue of Washington* (New York: John F. Trow, printer, 1864); Agnes Miller, "Centenary of a New York Statue," *New York History* 38 (April 1957), pp. 167–76; and Shapiro, *Bronze Casting and American Sculpture*, pp. 56–59. For the brief collaboration between Brown and Greenough on the equestrian statue of Washington, see Nathalia Wright, *Horatio Greenough: The First American Sculptor* (Philadelphia: University of Pennsylvania Press, 1963), pp. 274–76.

99. "Inauguration of the Washington Statue—Imposing Spectacle—Rev. Dr. Bethune's Address," *New-York Daily Times*, July 5, 1856, p. 1.

100. Henry Kirke Brown to Lydia L. Brown, October 26, 1858, Bush-Brown Papers, vol. 4, p. 1038, Library of Congress.

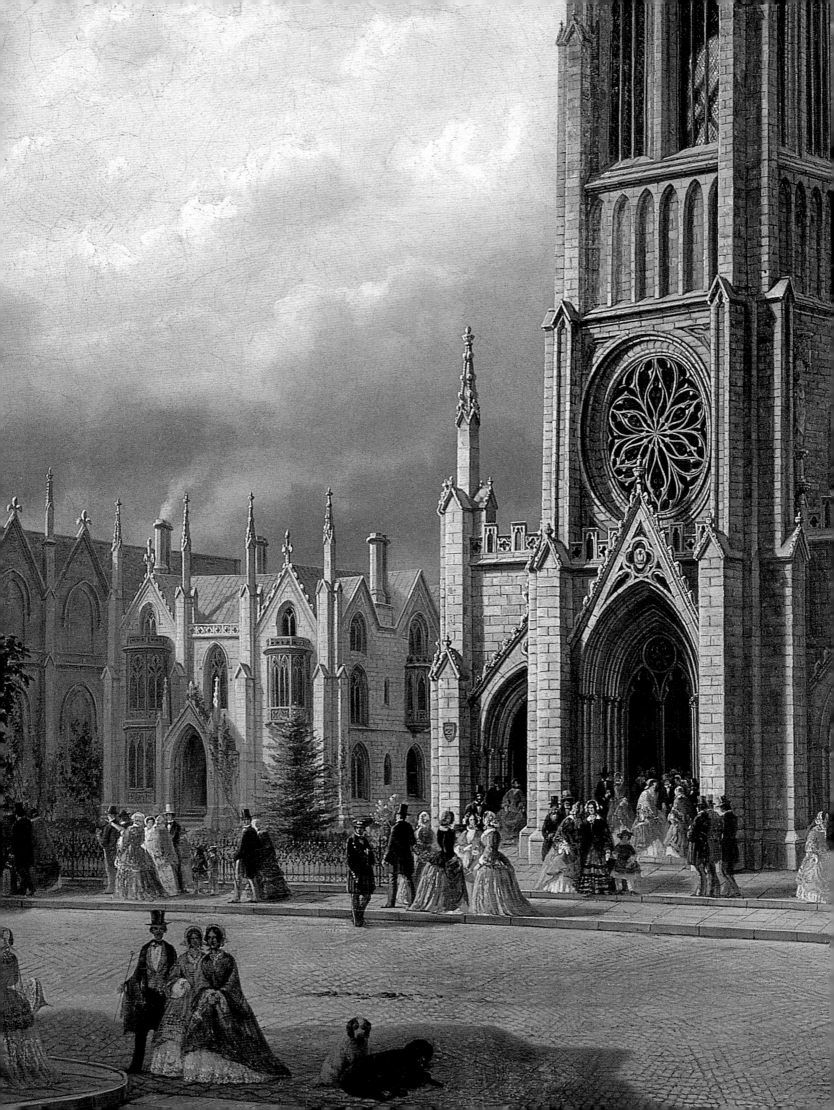

Building the Empire City: Architects and Architecture

MORRISON H. HECKSCHER

Compared with Boston, Philadelphia, and Washington, D.C., New York City in 1825 was an architectural backwater. The city had had no brilliant professionals like the native-born Charles Bulfinch or the immigrant Benjamin Henry Latrobe, no inspired amateur like Thomas Jefferson. It was not a capital city that could readily command monumental governmental structures; nor did the steady northward grasp of its street grid allow them many appropriately dramatic sites. Nevertheless, such was the city's rapid growth and accumulation of wealth over the next thirty-five years, such was its primacy as the commercial center of the nation, such was the sheer amount of building, that architects naturally gravitated there. By 1860, it is fair to say, New York had become the center of architectural activity in America; it was even the seat of the recently founded American Institute of Architects.[1]

The years 1825 through 1840, the heyday of the Greek Revival in New York, are best seen through the eyes and writings of Alexander Jackson Davis, illustrator and artist as well as architect.[2] Davis was born in New York City, but he was raised upstate and later trained as a printer in Alexandria, Virginia. By 1823 he was back in the city, where he studied at the American Academy of the Fine Arts and later at the Antique School of the National Academy of Design. His first job, beginning in 1825, was as an illustrator for A. T. Goodrich's pocket-sized visitors' guides; the next year, he worked as a draftsman for the architect Josiah R. Brady. In 1827 Davis went into business as an "Architectural Composer" (his listing in Longworth's city directory), supplying drawings on demand for builders and architects. At the same time, he began a more or less systematic effort to record the buildings of the city. As part of this project, he provided illustrations, principally of prominent new buildings, for *Views of the Public Buildings in the City of New-York,* an elegant folio of lithographs published by Anthony Imbert in 1827–28. Twelve of Davis's subjects were printed in the *Views,* eight in 1827 and four in 1828 (see cat. nos. 70–72). In addition, between 1827 and

1832, Davis drew public buildings for the *New-York Mirror,* including historic structures threatened with demolition. These images proved to be invaluable since nearly all the buildings he recorded were subsequently demolished. Finally, of course, there are Davis's own designs, as well as his voluminous daybooks and journals, all of which are rich sources of information concerning the world of New York architecture. In light of this valuable legacy, Davis probably looms somewhat larger in history than he did in life.

Davis's composite illustration for the September 1829 *New-York Mirror* (fig. 129), mostly taken from the Imbert lithographs, gives a fair summary of the city's public architecture at the time.[3] The stylistic extremes are represented by the overtly Roman Rotunda (top left), built in 1818 to exhibit John Vanderlyn's paintings, and possibly designed by the artist himself, and the decoratively Gothic Masonic Hall, 1825 (bottom right), by the landscape painter Hugh Reinagle. The other four images depict important buildings by the two most prominent architects in New York, Brady and Martin Euclid Thompson.

By the mid-1820s Brady was the elder statesman of the local architectural scene. Davis described him as "at that time . . . the only architect in New York who had been a practical builder and ingenious draughtsman, writer of contracts and specifications."[4] Most of Brady's designs, such as the Greco-Georgian-Gothic church that later became the B'nai Jeshurun Synagogue (fig. 129, lower left), tend toward the awkward or naive. Yet the classical facade of his Second Unitarian Church, Mercer Street, 1826 (cat. no. 72; fig. 129, upper right), "covered with a beautiful white cement, in imitation of marble,"[5] exhibits an unexpected monumentality and clarity, and must reflect the influence of Thompson, his sometime collaborator.[6] Although Thompson was more than a quarter of a century younger than Brady, the two worked well together. Davis captured the easy informality of their relationship when describing how, one day in 1826, Thompson entered Brady's office unannounced and whisked Davis

In thanks for many years of friendship and wise counsel, this essay is dedicated to the memory of Adolf K. Placzek, who, first as Avery Librarian at Columbia University and later as a member of the New York City Landmarks Commission, was a tireless advocate for the study and preservation of New York City's architectural patrimony. Let me also acknowledge the advice of Herbert Mitchell and Amelia Peck and, on all things Davisean, the late Jane B. Davies. For research assistance, my thanks to Kevin R. Fuchs, Jeni Lynn Sandberg, and Thomas Rush Sturges III.

1. For some of the most creative and thought-provoking writing about nineteenth-century American architecture, see William H. Pierson Jr., *American Buildings and Their Architects,* vol. 1, *The Colonial and Neo-Classical Styles* (Garden City: Doubleday, 1970), and vol. 2, *Technology and the Picturesque: The Corporate and the Early Gothic Styles* (Garden City: Doubleday, 1978). For New York City architecture from 1825 to 1850, Talbot Hamlin, *Greek Revival Architecture in America: Being an Account of Important Trends in American Architecture and American Life Prior to the War between the States* (London: Oxford, 1944; reprint, New York: Dover Publications, 1964), remains essential reading.

2. See Carrie Rebora, "Alexander Jackson Davis and the Arts of Design," in *Alexander Jackson Davis, American Architect, 1803–1892,* edited by Amelia Peck (exh. cat., New York: The Metropolitan Museum of Art and Rizzoli, 1992), pp. 23–39.

3. Alexander Jackson Davis, Daybook, [vol. 1], February 1828–September 1853, p. 69 (April 4, 1829), New York Public Library: "Six building[s] on a sheet of Bristol board, of a quarto size, for *Mirror* $12-." All but one of the images, the B'nai Jeshurun Synagogue, were originally issued in 1827 as lithographs by Imbert.

Opposite: detail, cat. no. 95

Fig. 129. Alexander Jackson Davis, *Public Buildings in the City of New York: Rotunda, Chambers Street; Merchants' Exchange, Wall Street; Second Unitarian Church, Mercer Street; B'nai Jeshurun Synagogue, Elm Street; United States Branch Bank, Wall Street; Masonic Hall, Broadway*, 1829. Wood engraving by William D. Smith, from *New-York Mirror and Ladies' Literary Gazette*, September 26, 1829, opp. p. 89. Collection of The New-York Historical Society

4. Quoted in Roger Hale Newton, *Town & Davis, Architects: Pioneers in American Revivalist Architecture, 1812–1870, Including a Glimpse of Their Times and Their Contemporaries* (New York: Columbia University Press, 1942), pp. 83, 92.

5. "Public Buildings," *New-York Mirror, and Ladies' Literary Gazette*, September 26, 1829, p. 90.

6. By contrast, Brady's contemporary John McComb Jr.—the architect, with Joseph-François Mangin, of the City Hall, about 1803–12, and the city's leading builder-architect for the first two decades of the century—never

away for another job: "As I was amusing myself in shading some prints of the city-hall in Mr Brady's office . . . Mr. Thompson, architect, called, and in his blunt way told me 'to pack up for a trip to the North.'"[7]

Thompson first appears in the city directories in 1816, as a carpenter; in 1823 he is listed as an architect-builder. By then his first major commission, the Branch Bank of the United States, 1822–24 (cat. no. 71; fig. 129, bottom center), was under construction on the north side of Wall Street, directly east of the old Custom House. His next, the Merchants' Exchange, on the south side of Wall Street, designed in conjunction with Brady, was begun in 1825.[8] The focus of its plan is the great trading room with apsidal ends

and flanking columns (cat. no. 75; fig. 130; see also cat. no. 251). These handsome marble-clad buildings, which transformed the face of Wall Street and, in the case of the Exchange, served as the preeminent symbol of the city's commercial importance, catapulted Thompson to prominence in his profession.

Thompson's two buildings exemplified the best of the eclectic classicism that then characterized the city's architecture. The Branch Bank was partly Palladian (the treatment of its three projecting center bays suggesting a pedimented portico) and partly Grecian (the orders and the molding profiles). The Exchange (cat. no. 74; fig. 129, top center) was, in broad outline, a larger version of the Bank, but all its details were

Grecian. The handling of the Exchange's three center bays, with colonnade and cupola, was closely modeled on contemporary English practice. All across England, in the years of peace, prosperity, and rapid urban growth after Waterloo, towns and cities felt the need for new public buildings—town halls, custom houses, post offices. An act of 1818 even authorized the expenditure of one million pounds on new church buildings, known as the "Commissioners' Churches."[9] To provide the requisite gravitas, these buildings were enlivened with Greek colonnades and antae (pilasters formed by thickening the end of a wall), full entablatures, and parapets. The same circumstances held true in burgeoning New York City, and with very much the same result. Thompson's Merchants' Exchange, for example, shares features with Francis Goodwin's Old Town Hall, Manchester, 1822–24: a broad, two-story block with giant-order Ionic columns screening a central entrance porch, the whole surmounted by a continuous entablature, an attic story, and a raised central dome.[10]

To keep abreast of the latest designs from London, New Yorkers consulted English books. For information on technology and construction, they depended on the builders' manuals published by Peter Nicholson; for facade treatments, they found models in books by Nicholson and William Pocock.[11] The illustrations in T. H. Shepherd's *Metropolitan Improvements* (London, 1827), a book promoting Regency London, were demonstrably influential. From one plate in Shepherd, for example, the ambitious young New Yorker Minard Lafever borrowed the facade of John Soane's Holy Trinity, Marylebone, 1826–27, and the circular tower of Robert Smirke's Saint Mary's, Wyndam Place, 1821–23, combining them as his own design for a church in the "Grecian Ionic Order," which appeared in his *Young Builder's General Instructor* (1829).[12] That the portico and tower of Lafever's church design have much in common with Thompson's Exchange reflects the similar British antecedents of both.

Meanwhile, in October 1825, Ithiel Town, an engineer, inventor, and architect from New Haven, arrived on the scene.[13] The establishment of Town's office would signal the beginning of a new era in New York architecture, for his influence would bring about two fundamental changes. The Regency eclecticism of most buildings would be replaced by an archaeologically correct Greek Revival style, introduced by Town. And the carpenter-builders who had been responsible for such buildings would give way to trained designers, as Town's office became the incubator for the fledgling architectural profession.

Just slightly older than Thompson, Town started out as a carpenter in Connecticut, worked a number of years with the Boston architect and builder Asher Benjamin, and then set up his own practice in New Haven. In 1816 he turned to bridge building and four years later took out a patent on a bridge truss, which soon made him wealthy. This circumstance enabled him to return to the practice of architecture in New Haven, but as a designer rather than as a builder, as well as to indulge his passion for books, scholarship, travel, and cultivated society. In 1824 Town designed a bank building in the form of a Greek Ionic temple, using as his inspiration engravings in the early volumes of James Stuart and Nicholas Revett's *Antiquities of Athens* (London, 1762–1830), the most influential source for the Greek Revival.

Once in New York, Town associated with prominent residents such as the artist and inventor Samuel F. B. Morse. When Morse organized the National Academy of Design in 1825, he invited Town, Thompson, and the sculptor John Frazee to be the founding members representing architecture. The next year Town built the New York Theatre (later renamed the Bowery Theatre), with facades on the Bowery and Elizabeth Street, his first structure in the city and the first there in the true Greek Revival style. His original design was for a hexastyle (six-column) Doric porticoed front, in the manner of a Greek temple; what was actually built (fig. 131) was a Doric distyle in antis (two columns between antae).[14]

The New York Theatre immediately spawned a number of eye-catching progeny, all porticoed like Doric temples but serving a variety of purposes: in 1827, Thompson's tetrastyle (four-column) Phenix Bank,

Fig. 130. Charles Burton, artist; Martin Euclid Thompson and Josiah R. Brady, architects, *Exchange Room, First Merchants' Exchange, 35–37 Wall Street*, ca. 1831. Sepia watercolor. Collection of The New-York Historical Society

gave up his attachment to the British tradition of Wren and Gibbs, of Adam and Chambers, shied away from the younger generation, and, by the mid-1820s, was out of the picture.

7. Alexander Jackson Davis, Pocket Diary, May 29, 1826, Metropolitan Museum, 24.66.1420.

8. For the Merchants' Exchange, see Lois Severini, *The Architecture of Finance: Early Wall Street* (Ann Arbor: UMI Research Press, 1983), pp. 31–36 (the first Exchange), 41–47 (the second). Some authors have considered the Exchange's original location, in the Tontine Coffee House, from 1782 to 1827, as the first Exchange, but that building was not purpose-built and probably should not be so regarded.

9. See John Summerson, *Architecture in Britain, 1530–1830*, 4th ed. (Harmondsworth: Penguin, 1963), pp. 305, 314–15.

10. For an illustration of the Old Town Hall, see ibid., pl. 212A.

11. For example, Peter Nicholson, *The New Practical Builder and Workman's Companion*, 2 vols. (London: Thomas Kelly, 1823–25), vol. 2, pl. 23: "Principal Elevation of a Chapel," 1823; and William Pocock, *Designs for Churches and Chapels . . .* (London: J. Taylor, 1819; [2d ed.], 1824), pls. 25–27. I am indebted to Herbert Mitchell for these references.

12. Minard Lafever, *The Young Builder's General Instructor . . .* (Newark, New Jersey: W. Tuttle, 1829), pl. 65. For Lafever's debt to Shepherd, see Jacob Landy, *The Architecture of Minard Lafever* (New York: Columbia University Press, 1970), p. 28.

13. For Town, see Newton, *Town & Davis*.

14. "The entire front is the boldest execution of the doric order in the United States, and is also more exactly according to the true spirit and style of the best Grecian examples in the detail, than any other specimen yet executed. Had there been six columns in front, as was originally intended by the architect, but prevented by a wish on the part of the proprietors for greater economy of room, this would unquestionably have been the most perfect as well as boldest specimen of Grecian Doric in the country." A. T. Goodrich, *The Picture of New-York, and Stranger's Guide to the Commercial Metropolis of the United States* (New York: A. T. Goodrich, 1828), p. 381.

Fig. 131. Alexander Jackson Davis, artist; Ithiel Town, architect, *New York (Bowery) Theatre, Elizabeth Street Facade,* 1828. Watercolor. The Metropolitan Museum of Art, New York, The Edward W. C. Arnold Collection of New York Prints, Maps, and Pictures, Bequest of Edward W. C. Arnold, 1954 54.90.25

Davis credited Town with having introduced, during his first years in the city, a number of features that became important to the design vocabulary of New York buildings, including several that would come to typify the local style. He mentions not only temple-inspired porticoes (both hexastyle and distyle in antis) but also blocks of terrace housing, vertical stone piers for storefronts, and Doric or Ionic front doors for houses.[16] Thompson was clearly closely involved with Town in the introduction of the Greek Revival style. Indeed, during 1827–28 the two men were briefly in partnership together, with offices at 32 Merchants' Exchange, in Thompson's splendid new building. In 1828, at the National Academy, they jointly exhibited drawings for the Church of the Ascension. The same year, Davis moved his drawing practice nearby, to 42 Merchants' Exchange, and Goodrich's guide mentioned the "Architectural Room" of Town, Thompson, and Davis at the Exchange.

In his unswerving commitment to Town, Davis attempted to downplay Thompson's considerable talents:

> *Mr Town was the first to introduce a pure taste in classical architecture. . . . Mr Town was assisted by Thomas Rust, a draftsman, and associated with Martin E. Thompson, Builder, for a time. After Mr. Town withdrew from these, nothing creditable for an architect was designed or executed by them, which goes to prove that Mr. Town was possessed with invention, and a proper feeling for the beauties of moral classical art . . . the best Gothic also was introduced by Mr. Town.*[17]

15. When the New York Theatre burned in 1828, its replacement, the New Bowery Theatre, was built according to Town's original design.

16. As compiled by Davis and transcribed in Newton, *Town & Davis,* pp. 61–64.

17. Transcribed from Davis's Journal, p. 11, Metropolitan Museum, 24.66.1401; the Avery Architectural and Fine Arts Library, Columbia University, New York, version of the journal is quoted in Newton, *Town & Davis,* p. 60.

Wall Street; in 1828, Thompson and Town's hexastyle Church of the Ascension, Canal Street (fig. 132); and, also in 1828, Town's New Bowery Theatre.[15] Thereafter, the temple portico—popular icon of the Greek Revival—was widely accepted for buildings of all sorts. In June 1828 Davis made his own debut as an architectural designer with an ambitious and accomplished proposal for remodeling the old almshouse, which had been constructed in 1778 on the north side of City Hall Park, facing Chambers Street, and was then home to the National Academy of Design. He envisioned a hexastyle portico, placed in the middle of the long Chambers Street facade and leading into a central domed area; tetrastyle porticoes marked either end (cat. no. 73).

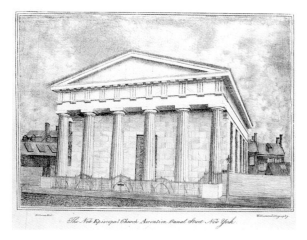

Fig. 132. Michael Williams, artist; Martin Euclid Thompson and Ithiel Town, architects, *Church of the Ascension, Canal Street,* ca. 1828. Lithograph. The Metropolitan Museum of Art, New York, Gift of Mary Knight Arnold, 1974 1974.673.45

By contrast, when Lafever illustrated the Church of the Ascension in his *Young Builder's General Instructor,* calling it "as good a model of the Grecian Doric order, if not superior, to any yet erected in this city," he gave exclusive credit for the design to Thompson.[18]

For whatever reason, probably the natural competition between two men of similar ages and talents, the Town-Thompson partnership did not outlast 1828, and the promising Thompson faded from center stage. Town turned instead to Davis. The two had known each other since 1827, and it was in Town's library, on March 15, 1828, that Davis had first studied Stuart and Revett's *Antiquities,* which led him to choose architecture as his calling.[19] At twenty-five, nineteen years Town's junior, Davis was artistic and romantic in temperament, a brilliant draftsman, and a compulsive archivist—everything Town, an engineer and inventor, was not. The partnership began on February 1, 1829, with a move into offices at 34 Merchants' Exchange and flourished for more than six years, with Town often traveling and Davis managing the office.[20] On a drawing of the Exchange's floor plan (cat. no. 75), Davis precisely delineated the office layout and even included his own bed. In the fall of 1829 Town left Davis in charge and set off on the Grand Tour (England, France, and Italy), which would give him firsthand experience of European architecture as well as the opportunity to purchase a great many books for his library (see "Private Collectors and Public Spirit" by John K. Howat in this publication, pp. 89–90). The urbanity Town gained during his travels was clearly reflected in the firm's schemes of the early 1830s.

Among the most remarkable things to come out of the Town and Davis office in those first, heady years from 1829 to 1831 were a number of splendid renderings by Davis of truly visionary designs. These proposals for various projects are characterized by screens of giant-order pilasters and continuous vertical strip windows, all in a distinctive, pared-down classical idiom. Included are designs for the Astor House (cat. nos. 77, 78), for a block of terrace houses (cat. no. 85), and for Thompson's Merchants' Exchange, shown as Davis would have designed it (cat. no. 76). On the last, the colonnade screens a veritable wall of glass— the vertical strip window (what Davis called his "Davisean" window) taken to its logical conclusion. None of these superbly creative abstract studies was built, and nothing else like them was dreamed of elsewhere in America; they were a century ahead of their time.

All told, in the early 1830s the Town and Davis architectural firm had no equal in New York. Town had his incomparable library and personal experience of the Grand Tour; Davis, the outstanding draftsman and artist, ran the office and welcomed students and other architects. The center for architectural activity in the city, the firm was as close to an atelier as then existed. As James Gallier, an Irish architect who first arrived in New York in April 1832, later recollected, "There was at that time, properly speaking, only one architect's office in New York, kept by Town and Davis."[21] In 1843, when Town briefly rejoined Davis, eight years after their partnership had been dissolved, a local periodical editorialized: "A large proportion of this improvement, so observable throughout our city and State, has been brought about by the unceasing exertions of ITHIEL TOWN and ALEXANDER J. DAVIS, to whose designs in villas, cottages, bridges and public buildings, we shall devote these articles. They occupy a commodious suite of rooms (No. 93) in the Merchants' Exchange, Wall Street, and possess the most valuable library in this country."[22]

During the years Town and Davis were together, they competed aggressively for almost every public building project in the city, winning a number, but by no means all, of the commissions for which they made submissions.[23] Their most important success was the Custom House on Wall Street, 1833–42, the principal United States government building erected in New York City in the years before the Civil War. The original design (cat. no. 81), a magnificent octastyle (eight-column) Greek Doric temple in white marble, is closely modeled on the Parthenon, except that antae replace the side columns and a ribbed dome rises up from the roof. The plan (cat. no. 80) is dominated by a great hall in the shape of a Greek cross. The section (cat. no. 79), one of Davis's most bravura renderings, is emblematic of his passion for the project. Town and Davis had no say in the actual construction of the Custom House, and Davis was deeply dismayed when, in the interests of economy and efficiency, the exterior dome and the inner row of portico columns were sacrificed. Construction was finally completed in 1842, and even in its reduced state, the building loomed magnificently at the head of Broad Street, overshadowing its old-fashioned neighbor, Thompson's Branch Bank (cat. no. 71). Today, the Custom House survives as Federal Hall.

The partners, Town in particular, also sought new business far and wide, winning commissions for the state capitols at Indianapolis, Indiana, 1831–35, and

18. Lafever, *Young Builder's General Instructor,* p. 83, pls. 10, 52.
19. Davis, Daybook, p. 13, New York Public Library.
20. Ibid., pp. 495–511.
21. James Gallier, *Autobiography of James Gallier, Architect* (Paris: E. Briere, 1864; reprint, New York: DaCapo Press, 1973), p. 18.
22. "The Architects and Architecture of New York," *Brother Jonathan,* May 20, 1843, p. 62.
23. Among Town and Davis's other executed New York City commissions were three churches and a Lyceum of Natural History (all Grecian), two public asylums (one Tuscan, one Gothic), and, with Dakin, the main building (Gothic) of the University of the City of New York (now New York University).

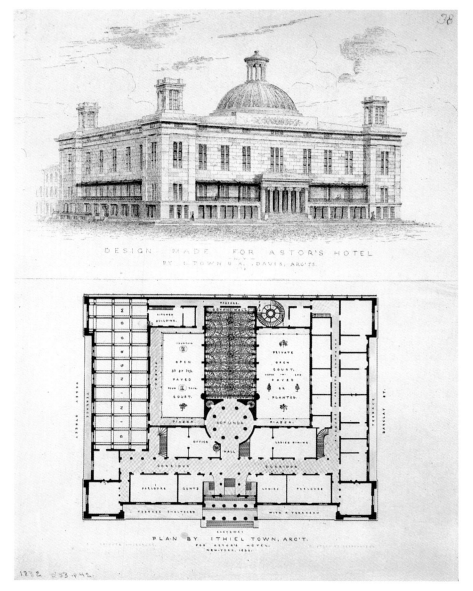

Fig. 133. Alexander Jackson Davis, artist; Ithiel Town and Alexander Jackson Davis, architects, *Design Made for Astor's Hotel*, 1834. Lithograph with watercolor highlights. The Metropolitan Museum of Art, New York, Harris Brisbane Dick Fund, 1924 24.66.1146

24. For the Tombs, see Richard G. Carrott, *The Egyptian Revival: Its Sources, Monuments, and Meaning, 1808–1858* (Berkeley: University of California Press, 1978), pp. 146–78.

25. William H. Eliot, *A Description of the Tremont House, with Architectural Illustrations* (Boston: Gray and Bowen, 1830).

Raleigh, North Carolina, 1833–40. They were unsuccessful in competing for the Patent Office in Washington, D.C., 1832–34, and (when no longer partners) for the state capitol at Springfield, Illinois, 1837. Worse yet, back home, they lost out on three of the greatest architectural competitions of the time—the Halls of Justice, the Astor House hotel, and a new Merchants' Exchange. These commissions went to two architects without prior connections to New York City, John Haviland of Philadelphia and Isaiah Rogers of Boston, each of whom was selected because he was an acknowledged expert in a specialized type of building.

In 1835 the city decided to build a new house of detention and held an open competition to select

its designer. While the second premium was shared by two New Yorkers (one of them Davis), the first was won by Haviland, the internationally acclaimed architect of Philadelphia's Eastern State Penitentiary, 1821–36. Haviland's design for New York's Halls of Justice and House of Detention, popularly called The Tombs, 1835–38 (cat. nos. 82, 83), was the masterpiece of the Egyptian Revival in America.[24] He and his colleague, Thomas Ustick Walter (later one of the architects of the United States Capitol), had both recently employed the same style—thought to embody enlightened justice and eternal wisdom—in Philadelphia, the center of prison reform in the nation.

The process of selecting an architect for the Astor House hotel was more circuitous. John Jacob Astor, the richest man in America and a major owner of New York real estate, lived on the west side of Broadway, between Vesey and Barclay streets, facing the tip of City Hall Park—one of the city's busiest and most fashionable intersections. In 1831 he began to acquire adjacent lots for the purpose of building a hotel on the site. Town and Davis had already, during the previous year, made studies for a project called the Park Hotel at this location. These designs, some of their best and most creative, provide circumstantial evidence that they were working for Astor. In one (cat. no. 77), an austere colonnade of giant-order square columns recalls Karl Friedrich Schinkel's Altes Museum, Berlin, 1822–30, although no direct connection can be demonstrated. In another (cat. no. 78), Davis experimented with a Corinthian colonnade and a central dome; the multistoried, recessed "Davisean" fenestration, barely visible behind the columns, is characteristic of Davis's emerging style. In what must be their final scheme, judging from the fact that Davis had it engraved, Town did away with the colonnade in favor of projecting corner pavilions topped by square towers (fig. 133).

In the end, however, Astor chose to engage Rogers, the architect responsible for Boston's Tremont House, 1828–29, a hotel with a dignified exterior and innovative plan that had been made famous by William H. Eliot's laudatory monograph of 1830.[25] Astor charged Rogers to build a hotel that would best the Tremont in size, cost, and splendor—which Rogers proceeded to do. He devised an austere and monumental exterior of Quincy granite (fig. 134), with antae at the corners and a Doric porticoed entrance, and then lavished his attention on the hotel's plumbing and interior appointments. Erected between 1834 and 1836, the Astor House was surpassed in size and luxury (but not in architectural grandeur) by uptown hotels in the

early 1850s; it was demolished in part in 1913 and totally in 1926.

Rogers was still in New York at work on the Astor House in December 1835 when Thompson's seven-year-old Merchants' Exchange became the most high-profile victim of the great fire that laid waste a large area south of Wall Street and east of Broadway. Perfectly positioned to enter the competition for the replacement, Rogers ultimately won out over Town and Davis. However, his design—the Wall Street elevation with a magnificent raised Ionic colonnade, the whole surmounted by a central dome (fig. 135)—is very much in the Town and Davis idiom: for the colonnade and central dome, see one of their designs for the Astor House (cat. no. 78); for the raised colonnade, see John Stirewalt's 1833–34 drawing of the facade of their terrace-house project, La Grange Terrace (cat. no. 86). Only the Quincy granite, hard, gray, and resistant to weathering, was foreign to New York practice. Rogers remained in New York until 1841, supervising the construction of the Exchange, which was finally completed in 1842. It survives today, although surmounted by an additional story.

Few of the names of the students and apprentices who passed through the Town and Davis firm are recognizable today, but that does not lessen the influence of these acolytes in spreading wide the firm's classical style and professional practices, particularly in the South.[26] Best known of these is James H. Dakin, a carpenter from Dutchess County, New York.[27] In October 1829 Dakin began drawing under Davis's supervision, quickly becoming a skilled draftsman and watercolorist, very much in his master's manner. Between May 1832 and November 1833, when the firm was busy with major projects and exploring the possibility of establishing an office in Washington, D.C., to handle government commissions, Dakin was actually a partner in the firm. In addition to being involved in such major projects as the Custom House, the Astor House hotel, and La Grange Terrace, he was the principal designer of a number of public buildings, including the Greek Revival Washington Street Methodist Episcopal Church, Brooklyn, 1832, and the Gothic Revival main building of the University of the City of New York (now New York University), 1833 (fig. 136). During the same period he also prepared illustrations for Lafever's *Beauties of Modern Architecture*. Thereafter, Dakin opened his own office, where Gallier (who subsequently described him as a man of genius) briefly worked for him. Both architects soon left New York for New Orleans, and it is not surprising that the public buildings of the 1830s

and 1840s in that city and in New York are almost indistinguishable.

While neither a pupil of Town and Davis nor a Greek Revival architect of any note, Lafever was the author of the finest and most influential American pattern books of the Greek Revival style.[28] Born near Morristown, New Jersey, he settled as a carpenter-draftsman in Newark in 1824 and moved to New York City three or four years later. He and Gallier later opened an architect's office together, Gallier recalling

26. Davis took seventeen students between 1829 and 1861, according to Mary N. Woods, *From Craft to Profession: The Practice of Architecture in Nineteenth-Century America* (Berkeley: University of California Press, 1999), p. 62.

27. For Dakin, see Arthur Scully Jr., *James Dakin, Architect: His Career in New York and the South* (Baton Rouge: Louisiana State University Press, 1973).

28. For Lafever, see Landy, *Architecture of Minard Lafever*.

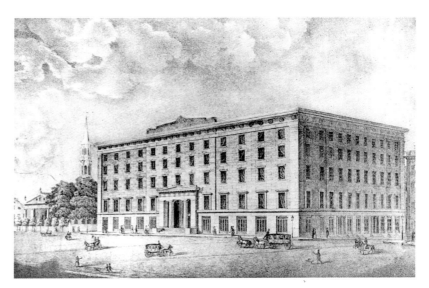

Fig. 134. Frederick Schmidt, artist; Isaiah Rogers, architect, *Park Hotel (Later Called the Astor House), Broadway between Vesey and Barclay Streets,* 1834. Lithograph by George Endicott, from I. N. Phelps Stokes, *The Iconography of Manhattan Island* (New York: Robert H. Dodd, 1918), vol. 3, pl. 22a. The Metropolitan Museum of Art, New York, The Thomas J. Watson Library

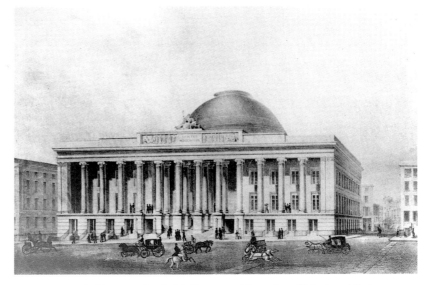

Fig. 135. Cyrus L. Warner, artist; Isaiah Rogers, architect, *Second Merchants' Exchange, 31–37 Wall Street,* 1837. Lithograph by John H. Bufford, from I. N. Phelps Stokes, *The Iconography of Manhattan Island* (New York: Robert H. Dodd, 1918), vol. 3, pl. 118. The Metropolitan Museum of Art, New York, The Thomas J. Watson Library

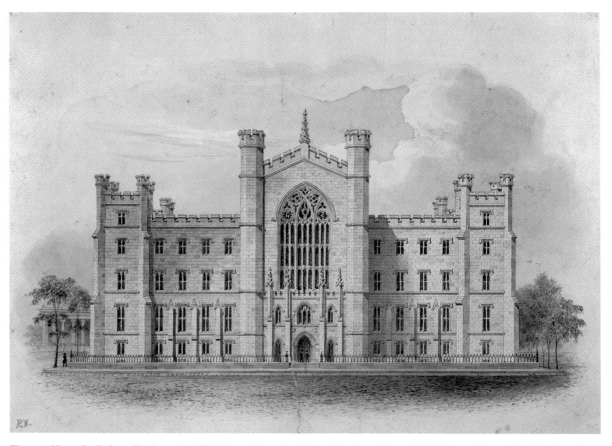

Fig. 136. Alexander Jackson Davis, artist; Ithiel Town, Alexander Jackson Davis, and James H. Dakin, architects; David B. Douglass, engineer, *University of the City of New York (now New York University), Washington Square, Facade of Main Building,* ca. 1833. Watercolor. The Metropolitan Museum of Art, New York, The Edward W. C. Arnold Collection of New York Prints, Maps, and Pictures, Bequest of Edward W. C. Arnold, 1954 54.90.24

29. Gallier, *Autobiography*, p. 20.
30. Lafever, *Young Builder's General Instructor*, p. 83.
31. In the caption to plate 32 of *The Beauties of Modern Architecture, Illustrated by Forty-eight Original Plates Designed Expressly for This Work* (New York: D. Appleton, 1835), Lafever acknowledged the work of "Mr. James H. Daken [sic], whose talents, taste and ideas, are of the first order, and by the writer held in very high esteem."
32. Minard Lafever, *Modern Builders' Guide* (New York: Henry C. Sleight, Collins and Hannay, 1833), preface, p. 4.

that "we obtained from the builders orders for as many drawings as we could well make; but I found it very disagreeable work, and so badly rewarded."[29] Gallier ultimately resolved his frustrations by moving to New Orleans, Lafever by preparing architectural books.

Lafever's first book, *The Young Builder's General Instructor*, promoted a version of the eclectic Greco-Roman classicism then being practiced in England by architects such as Soane and Smirke. In New York in 1829, however, the pure Greek Revival mode introduced by Town had begun to supersede this style. In fact, Lafever's praise in the *General Instructor* for Thompson's Greek Doric Church of the Ascension[30] and Phenix Bank has the feel of an afterthought and suggests he realized that the book was out of date even before its publication. Lafever actually withdrew the *General Instructor* from print and produced instead two handsome volumes targeted to promote the authentic Greek Revival to builders of New York row houses.

Lafever's *Modern Builders' Guide* came out in 1833 and went through seven editions by 1855; *The Beauties of Modern Architecture* was issued in 1835. Both books contained compilations of previously published material: technical texts from Nicholson, descriptions of major monuments from Stuart and Revett, and plates depicting Greek temples and details of the Greek orders. What was new and important about them, however, were the Grecian designs for use in town houses (a number drawn by Dakin),[31] both for front doors and for parlor fittings, including walls, windows, and columnar screens, all ornamented with great imagination and beauty. Lafever's elegant palmettes and anthemia quickly became the canon for Greek Revival ornament throughout America. Although Lafever acknowledged having consulted with Brady and Thompson,[32] he made no mention of Town or Davis, the rival faction. Ironically, Lafever built only one significant classical building, the First Reformed Dutch Church, Brooklyn, 1834–35; his fame as an architect rests on Gothic Revival churches.

During the period 1825 through 1861 housing was the bread and butter of New York's building business. As the city's population swelled, so did the demand for new houses—row after row on street after street. The city's grid plan, adopted in 1811 and calling for

cross streets just two hundred feet apart, led to standardized building lots of twenty-five by one hundred feet, as well as to relatively standardized facades. City guidebooks delighted in reporting the number of new houses built in a given year. In 1828 Goodrich estimated a total of thirty thousand houses in the city, up from seventeen thousand in 1817—an average of nearly twelve hundred new houses per year, enough to fill twenty city blocks. The great majority of these houses were modest, two-story affairs, but some were fine, first-rate dwellings, three or four stories in height.[33]

Construction of houses was, for the most part, the realm of the builder rather than the architect. Longworth's directory for 1831–32 listed eighty-two builders in New York; drawings exist that depict the row houses built by two of these, Samuel Dunbar and Calvin Pollard,[34] and there is documentation concerning the involvement in housing projects of three others—Gideon Tucker, John Morss, and Seth Geer.

As New York grew and its commercial and industrial areas expanded downtown, so its fashionable residential areas moved inexorably uptown. Traditionally, the

best houses had been found on State Street, facing the Battery, and around Bowling Green. That focus changed about 1820, and over the next fifteen years, the entire area west of Broadway and north to Canal Street was built up with fine houses.

Columbia College's development of lands adjacent to its campus, a two-block area west of Broadway and City Hall Park, is a case in point. What distinguishes this project is not the architecture, which is typical, but the survival of a number of drawings (attributed to Thompson) that shed a great deal of light on the domestic architecture of the period.[35] On the plot plan (fig. 137), a row of houses is laid out on the west side of Chapel Street, between Murray and Robinson streets; at first six houses were contemplated, each twenty-nine feet wide, but this was changed to seven, each twenty-five feet wide. A rendering of the seven facades (cat. no. 87) was endorsed, on April 1, 1830, by William Johnston, Columbia's treasurer, and by the builders, Tucker and Morss. The facades are little different from those found on turn-of-the-century New York houses in the Federal style, except that one, at the far left, has a front door flanked by Greek Doric columns, a motif that is repeated in the more detailed drawing for a single house on Columbia's land (cat. no. 88). This Doric entrance clearly derives from the distinctive New York domestic doorway that Town had introduced about 1828. Although the neighborhood developed by Columbia was popular for a short while, the building of Astor's hotel on nearby Broadway was the death knell for the area as a residential enclave.

The spread of first-rate housing north of Houston Street was to continue with little change until midcentury. Exemplifying this process was the development, between 1831 and 1833, of a group of handsome four-story brick houses on the north side of Washington Square, known as The Row (made famous by Henry James, and still intact). By 1835 fine houses were being built south and east of the Square, on Bleecker, Bond, and Great Jones streets, and on Lafayette and Saint Mark's places. West of the Square, in Greenwich Village, more modest dwellings were the norm, and these survive in considerable numbers today.

Typical of the later houses in the area north of Houston is one built in 1844–45 for Samuel Tredwell Skidmore at 369 Fourth Street (now 37 East Fourth Street), just three lots east of the house of his cousin Seabury Tredwell (now the Merchant's House Museum, 29 East Fourth Street), which had been erected in 1831–32. To prepare drawings and specifications for the house (figs. 138, 139), Skidmore employed Thomas

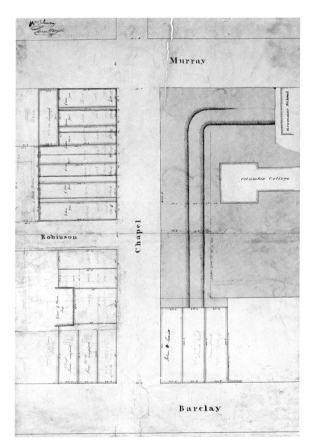

Fig. 137. Attributed to Martin E. Thompson, *Columbia College, Plot Plan for Chapel Street Houses*, 1830. Ink. Avery Architectural and Fine Arts Library, Columbia University, New York

33. For New York City houses, see Charles Lockwood, *Bricks and Brownstone: The New York Row House, 1783–1929, an Architectural and Social History* (New York: McGraw-Hill, 1972).

34. The Dunbar drawings are at the Museum of the City of New York and Pollard's are at the New-York Historical Society.

35. Hamlin, *Greek Revival*, p. 136.

. Principal . Elevation .

. First Story .

Fig. 138. Thomas Thomas and Son, *Samuel T. Skidmore House, 369 Fourth Street, Principal Elevation*, 1844. Ink and watercolor. Courtesy of The Winterthur Library, Winterthur, Delaware, Joseph Downs Collection of Manuscripts and Printed Ephemera 70X30.1

Fig. 139. Thomas Thomas and Son, *Samuel T. Skidmore House, 369 Fourth Street, Floor Plan*, 1844. Ink and watercolor. Courtesy of The Winterthur Library, Winterthur, Delaware, Joseph Downs Collection of Manuscripts and Printed Ephemera 70X30.2

Thomas and Son, one of a number of new firms of English immigrant architects.[36] The plans for the house, which was brick with brownstone trim, are much more complete than those drawn up for Columbia College fourteen years earlier. Both show similar facades, however, except that the Skidmore house does not have the pitched roof of the Columbia design.

Town and Davis did not usually involve themselves in the building of everyday residences, but they were fascinated with the problem of designing a group of houses as a unified whole, the so-called block or terrace, in order to achieve monumentality. Davis credited Town with the first such block development in New York, citing Town's 1828 project on Greenwich Street for Henry Byard.[37] Although no image of that project survives, the partners' keen interest in such designs is suggested by entries in Davis's accounts for 1830 and 1831 (referring, for example, to a "study for a block of dwelling Houses/Ionic/chaste")[38] as well as by a number of Davis's own drawings. Their favored facade treatment for residential blocks may be seen in the proposal for Syllabus Row (cat. no. 84), a seventeen-bay, seven-house design, and in the dramatic perspective of a cross-block terrace development (cat. no. 85), sixteen bays and eight houses per side. In both, a rusticated ground floor is surmounted by giant-order

pilasters between the second- and third-story windows and by an all-encompassing full entablature.

The same facade treatment, except for the "chaste" Ionic pilasters having been replaced by richly carved freestanding Corinthian columns, is found on the most famous of all the New York terrace-house projects, La Grange Terrace, begun in 1832 on Lafayette Place, due east of Washington Square, and surviving in part today. Described in 1833 as "the terrace, *par excellence*,"[39] it was developed and constructed by Geer, the city's leading builder. Davis's accounts indicate that Geer paid him handsomely for the designs.[40] The only extant drawing (cat. no. 86), by John Stirewalt, who was in Davis's employ from November 1833 to April 1834, shows the facade as executed, except that the roof terrace was not built and the final design had a width of twenty-eight rather than eighteen bays. Similar freestanding Greek Revival structures, with comparable colonnades or temple porticoes, were being designed at the same time for country houses, among them the Matthew Clarkson Jr. mansion, built in Flatbush, Brooklyn, about 1835 (cat. no. 89A, B).

The layout of the New York row house followed a standard convention that had been adopted to accommodate the exigencies of the long, narrow lots resulting from the 1811 grid. The basement, with the kitchen,

36. The drawings and specifications are in the Joseph Downs Collection of Manuscripts and Printed Ephemera, Winterthur Library, Henry Francis Du Pont Winterthur Museum, Winterthur, Delaware. The specifications include estimates from the mason (David Lauderback, $5,900) and the carpenter (W. Ellis Blackstone, $5,200). See also Carol Emily Gordon, "The Skidmore House: An Aspect of the Greek Revival in New York" (Master's thesis, University of Delaware, Newark, 1978).

37. Newton, *Town & Davis*, p. 63.

38. Davis, Daybook, March 1, 1830, p. 89, New York Public Library.

39. *Atkinson's Casket* 8 (November 1833), p. 505.

40. In April 1832, $30 for "drawing La Grange Terrace, Lafayette Place, so named by me, for Seth Geer . . . Perspective view" (Davis, Daybook, p. 131, New York Public Library); between May and October, $200, of which he paid Dakin $100, for "designs and drawings for the interiors of La Grange Terrace" (Davis, Journal, p. 26, Metropolitan Museum, 24.66.1400).

Fig. 140. Alexander Jackson Davis, *Columnar Screen Wall between Parlors, Plans and Elevation*, ca. 1830. Ink and watercolor. The Metropolitan Museum of Art, New York, Harris Brisbane Dick Fund, 1924 24.66.612

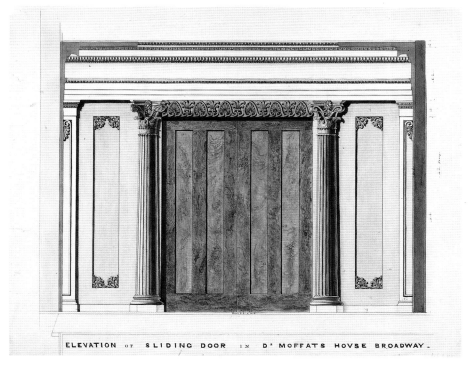

ELEVATION OF SLIDING DOOR IN Dʳ MOFFATS HOVSE BROADWAY.

Fig. 141. Calvin Pollard, *Parlor Sliding Door, Dr. Moffat's House, Broadway, Elevation*, 1844. Ink and watercolor. Collection of The New-York Historical Society, Pollard Collection 44

was half below grade. The raised first floor was reached by outside steps along one side (the traditional New York stoop), leading to the front door and a long, narrow stair hall from which doors opened into a pair of large, matching parlors (see fig. 139). In houses of the 1820s, the parlors were nearly square and separated by pairs of closets with folding doors between them. By 1830, in the larger Greek Revival houses, the matching parlors were much longer and were separated only by a narrow wall that encased a pair of sliding double doors, flanked by pairs of Ionic or Corinthian columns. Davis, in a drawing from about 1830 (fig. 140), proposed a number of different ways to link matching parlors. Beneath an elevation showing sliding mahogany doors and flanking pilasters are two alternate plans: at the left, a wall cut away to accommodate a column and, at the right, a freestanding column.

The canonical solution to linking two parlors—pairs of columns flanking sliding doors—is seen in the plan of the Skidmore house (fig. 139) and also in an elaborate rendering of the same date for the house of a Dr. Moffat on Broadway (fig. 141). Designed by Pollard, now risen from builder to architect, the Moffat house has Corinthian columns and a band of carved anthemia in the architrave above the door opening, both of which come directly from Lafever's *Beauties of Modern Architecture*. A columnar screen treatment following Davis's suggestion to carve away part of a wall appears in Francis H. Heinrich's group portrait of about 1850 of the Fiedler family in their parlor at 38 Bond Street (fig. 211), probably the most faithful contemporary illustration of the parlors of a New York Greek Revival town house. And the same architect's famous idealized portrayal of a pair of Greek Revival parlors (cat. no. 112) depicts two pairs of Ionic columns, without doors, an unusual treatment found only in the grandest of houses, such as those of La Grange Terrace (cat. no. 86).

The year 1835 was the last in which Town and Davis dominated the city's architectural community: on May 1, just after Town received his second engineering patent and went back to bridge building, they terminated their partnership, and on December 16 Davis was burned out of his office in the Great Fire. On May 1 of the next year Davis settled permanently into new quarters in the building recently completed for the University of the City of New York, to the designs of Town and Dakin, on Washington Square (fig. 136).

On his own, Davis would maintain an active practice, designing statehouses, asylums, libraries, and other public buildings, but he would not adapt in the following decades to the wrenching changes taking place in New York City, particularly in the commercial and residential spheres. Increasingly, Davis's attention would turn to domestic architecture, which offered him the best opportunity to pursue his love of the picturesque. As early as 1834 he had begun designing Gothic villas for sites overlooking the Hudson River, and in 1837 he published *Rural Residences* "with a View to the Improvement of American Country Architecture."[41]

In some ways, *Rural Residences* was similar to Davis's *Views of the Public Buildings in the City of New-York* from a decade before; both were lavishly produced, issued in parts, and never completed. But in others it was a new kind of publication—a house pattern book, offering prospective clients choices of styles and floor plans—distinct from, for example, Lafever's manuals for builders and carpenters. Realizing the potential of such an idea, the landscape architect Andrew Jackson Downing of Newburgh, New York, promptly engaged Davis to provide illustrations for his forthcoming *Treatise on the Theory and Practice of Landscape Gardening, Adapted to North America . . . with Remarks on Rural Architecture* (1841). As a result, woodcut illustrations of Davis's designs were widely disseminated, both in the *Treatise* and in Downing's two succeeding volumes, *Cottage Residences* (1842) and *The Architecture of Country Houses* (1850). Davis's 1855 design for Ericstan (cat. no. 102), John J. Herrick's castleated villa at Tarrytown, exemplifies this side of his work.

It is perhaps symptomatic of Davis's resistance to change that the two grandest houses built in New York in the mid-1840s, both of which were designed by him, were dinosaurs from day one. John Cox Stevens's magnificent classical palace, built in 1845, was downtown on College Place, an area already going commercial. William C. H. Waddell's Gothic villa on Fifth Avenue and Thirty-eighth Street, from the previous year, was squarely in the line of much denser residential development. Built in the wrong place at the wrong time, both mansions would be demolished within a decade.

No picture of New York's architecture in the 1830s and 1840s would be complete without mention of the massive distributing reservoir built on Murray Hill. Located on the west side of Fifth Avenue, between Fortieth and Forty-second streets, the highest ground in the vicinity, the reservoir was completed in 1842. With its forty-foot-high brick walls, battered in the Egyptian Revival manner, it was the only visual manifestation within the city of the Croton Aqueduct,

41. From the dedication in Alexander Jackson Davis, *Rural Residences* (New York: The Author, 1837).

an altogether unprecedented public-works project. The cholera epidemic of 1832 had finally forced the city to confront its chronic failure to provide a reliable, safe water supply. In 1834 the legislature passed an act to supply the city with "pure and wholesome water"; in 1835 the Croton River, forty miles away in Westchester County, was selected to be the source; and in 1836 John B. Jervis was made chief engineer of the Croton Aqueduct. When completed, the remarkably extensive system spanned forty miles and encompassed the Croton Dam, a bridge at Sing Sing, another over the Harlem River (High Bridge), sixteen tunnels, 114 culverts, thirty-three ventilators, six waste weirs, and the reservoir. The drawings from Jervis's shop—including artistic renderings of the distributing reservoir (cat. no. 90) and engineering presentations of High Bridge (cat. no. 91) and a pipe chamber (cat. no. 92)—are works of art in themselves. Combining architecture and engineering, they indicate the high degree of professionalism required to effect the urban improvements vital to the welfare of the nineteenth-century city.[42]

Several developments from the 1830s through the 1850s continued to advance the movement toward architectural professionalism. In the early 1830s the great majority of American architects were native-born artisans, coming from the ranks of carpenter-builders. The best of them relied on self-education and perseverance to meet the challenge of designing and executing public buildings of an unprecedented size and complexity. Thompson and his Merchants' Exchange and Town and Davis and their Custom House are but two instances. Such men ultimately developed interests in common with office-trained professionals such as the Philadelphia architects Haviland, originally a pupil of James Elmes in London, and William Strickland, a pupil of Latrobe. In December 1836 twenty-three American architects—including eight from New York (among them Town, Davis, Lafever, and Rogers), five from Boston, and four from Philadelphia—met at the Astor House with the goal of forming an association, to be known as the American Institution of Architects, that would aim to promote professionalization in the practice of architecture. Strickland was to be president, Davis vice president, and Thomas Ustick Walter secretary. In the end, however, nothing came of the effort, in part because of the financial panic of 1837, in part because of rivalries between Philadelphia and New York. It would be another twenty years before the time would be ripe for such a society.[43]

Concurrent with these efforts at organization was an influx of trained architects from abroad, which would irrevocably alter New York's architectural complexion. Those newcomers who stayed and thrived would be active participants in the commercial and residential growth of the city. The first wave was from England: in 1833 Thomas Thomas; in 1838 his son Griffith; about 1835 Frederick Diaper; and in 1839 Richard Upjohn. The second was from the Continent: in 1843 Leopold Eidlitz, trained in Vienna; and in 1848 Detlef Lienau, trained in Berlin and Paris. The third was, again, from England: in 1852 Jacob Wrey Mould and Frederick Withers; and in 1856 Calvert Vaux (the last two came to New York after first working for Downing in Newburgh).

And, of course, there was Gallier, who succinctly recalled the New York architectural scene on his arrival from Ireland in 1832:

> The majority of people could with difficulty be made to understand what was meant by a professional architect; the builders, that is, the carpenters and bricklayers, all called themselves architects, and were at that time the persons to whom owners of property applied when they required plans for building; the builder hired some poor draftsman, of whom there were some half dozen in New York at that time, to make the plans, paying him a mere trifle for his services.

But, Gallier added, "All this was soon changed . . . and architects began to be employed by proprietors before going to the builders; and in this way, in a short time, the style of buildings public and private showed signs of rapid improvement."[44]

It was Upjohn who would prove to be the single most influential of New York's immigrant architects.[45] Like Town a generation before, he would act as a catalyst by transforming architectural styles and by elevating the practice of architecture to a new level of professionalism. In particular, he introduced the true Gothic Revival to American church architecture.[46] Symbolic, perhaps, of the pending changes in architectural style, building materials, and geographic location was the fate of Town and Thompson's trendsetting Church of the Ascension on Canal Street (fig. 132). Destroyed by fire in 1839, the year of Upjohn's arrival in New York, this marble structure with a Greek-temple facade was rebuilt by Upjohn in 1840–41 in brownstone in the Gothic Revival style, on Fifth Avenue and Tenth Street.

Upjohn had left England for America in 1829 and had lived in Boston from 1834 to 1839. In 1835, while working for the architect Alexander Parris, he had met Dr. Jonathan Mayhew Wainwright, rector of Trinity

42. For the Croton Aqueduct, see *The Old Croton Aqueduct: Rural Resources Meet Urban Needs* (Yonkers: Hudson River Museum of Westchester, 1992).

43. Woods, *From Craft to Profession*, pp. 28–32.

44. Gallier, *Autobiography*, p. 18.

45. For Upjohn, see Everard M. Upjohn, *Richard Upjohn and American Architecture* (New York: Columbia University Press, 1939).

46. For the Gothic Revival, see Phoebe B. Stanton, *The Gothic Revival and American Church Architecture: An Episode in Taste, 1840–1856* (Baltimore: Johns Hopkins University Press, 1968; reprint, 1997).

Fig. 142. John Forsyth and E. W. Mimee, *Bird's-Eye View, Trinity Church, Broadway, opposite Wall Street,* 1847. Lithograph. The Metropolitan Museum of Art, New York, Gift of Mrs. Edmund R. Burry, 1948 48.132.31

Fig. 143. Fanny and Seymour Palmer, artists; Minard Lafever, architect, *Church of the Holy Trinity, Brooklyn* (now St. Ann and the Holy Trinity Church), ca. 1844. Lithograph. Collection of St. Ann and the Holy Trinity Church, Brooklyn

47. A. W. N. Pugin, *The True Principles of Pointed or Christian Architecture Set Forth in Two Lectures Delivered at St. Marie's, Oscott* (London: J. Weale, 1841), ill. p. 50.

48. Quoted in *Catalogue of Ferdinand Richardt's Gallery of Paintings of American Scenery, and Collection of Danish Painting Exhibited at the Rooms of the National Academy of Design, Tenth Street, between Broadway and Fourth Avenue* (New York, 1859). I am indebted to Lynn Hoke, Assistant Archivist, Grace Church, for this reference.

Church in Boston. When Wainwright accepted the post of rector of Trinity Church in New York, three years later, and discovered that the church building was dangerously unstable, he naturally called on Upjohn for help. And when the decision was made to build anew, Upjohn was engaged for the task.

There had been a few modest attempts at serious Gothic Revivalism in the city—witness Saint Peter's, Chelsea, 1836–38, by the poet and amateur architect Clement Clarke Moore—but nothing to compare with the size, richness, and erudition of Upjohn's new Trinity Church, located on Broadway, facing Wall Street. Upjohn submitted his first studies in September 1839, but it would be two years before the design was finalized (cat. no. 93) and the cornerstone laid, and nearly seven before the church was consecrated, on May 21, 1846. A bird's-eye view of the completed building (fig. 142) shows it towering over the city.

A devout Anglican, Upjohn viewed churches both as sacred vessels and as buildings having a pragmatic purpose. He thus sought out those specific features of Gothic churches—principally the long, high nave with clerestory windows, side aisles, and a chancel—that would serve the contemporary liturgical needs of the Episcopal Church. Ironically, this kind of functional Gothic Revival style was chiefly promulgated through the writings of the English Catholic convert A. W. N. Pugin. In fact, the executed design for Trinity bears a striking resemblance to the illustration of an "ideal church" in Pugin's *True Principles of Pointed or Christian Architecture,* published in London early in 1841.[47] Upjohn was obviously au courant with the latest developments in English church architecture.

Trinity was the oldest and richest Anglican parish in New York, and its new building had a profound impact on the numerous churches being constructed in the city. First to feel its effect was Grace Church, Trinity's immediate neighbor on Broadway. In the early 1840s, following its fashionable congregation uptown, Grace secured a dramatic site at the bend of

Broadway at Tenth Street; in 1843 the church hired James Renwick Jr. to design its new building. Renwick, later famous as the architect of Saint Patrick's Cathedral, was at this time only twenty-five years old. The son and namesake of a distinguished professor of natural philosophy at Columbia, he created for Grace a masterly essay in the Gothic Revival style. Grace followed Trinity in its general conception (central entrance tower, high nave, chancel), but the two buildings differed dramatically in appearance. Renwick's use of white marble and allover decoration produced an effect that was light, airy, and elegant, while Upjohn's use of brownstone was massive, enclosed, and severe: the connoisseur as opposed to the doctrinaire. Ferdinand Joachim Richardt's painting of Grace (cat. no. 95), described as "taken from 10th street and represent[ing] the congregation leaving the church at the end of Sunday afternoon service,"[48] was exhibited in 1859 at the National Academy, virtually next door on Tenth Street.

Trinity and Grace were but the largest and most elaborate of dozens of important Gothic Revival churches built in New York during the 1840s and 1850s. Lafever, although best remembered for his Greek Revival pattern books, made a specialty of them, particularly in Brooklyn. His masterpiece was the large and luxurious Holy Trinity, Brooklyn Heights, 1844–47 (fig. 143), noted for its exceptional stained-glass windows by William Jay Bolton (see cat. no. 280).

In 1846, having just made his name with Grace Church, Renwick was commissioned by a newly formed congregation to build the Church of the Puritans at the southwest corner of Broadway and Fifteenth Street, on Union Square. His design for the handsome twin-towered facade (cat. no. 94), a characteristic French Gothic formula, was inspired by the famous Abbey Church of Saint-Denis, near Paris, but with one major change. Renwick transformed the pointed Gothic windows of the French church into round-arched ones, thus giving Manhattan its first Romanesque church. In this he was following Upjohn's lead at another Congregational church, Brooklyn's Church of the Pilgrims, 1844, in which the architect had selected the Romanesque style as most appropriate for the nonliturgical Congregationalists.[49] Closer to the heart of the Empire City, Eidlitz, who had come from Vienna just three years before, was beginning a vast Romanesque hall for Saint George's in Stuyvesant Square.

Trinity and Grace stood like magnificent Gothic bookends south and north on Broadway, but in between, all was business. What had been in the 1820s

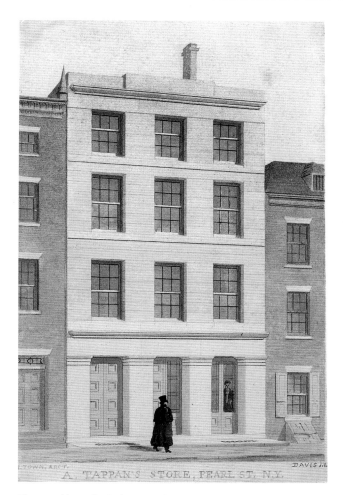

Fig. 144. Alexander Jackson Davis, artist; Ithiel Town, architect, *Arthur Tappan Store, 122 Pearl Street,* ca. 1829. Watercolor. The Metropolitan Museum of Art, New York, The Edward W. C. Arnold Collection of New York Prints, Maps, and Pictures, Bequest of Edward W. C. Arnold, 1954 54.90.123

the most fashionable residential street in town became during the 1840s the center of retail commerce. Along its sidewalks stretched a great chain of department stores and hotels, a mix of new building types and old architectural styles, a whole new architecture of commerce.[50]

It all began with A. T. Stewart, the retail genius who had come to New York from Ireland in 1818.[51] In 1846, after having operated dry-goods stores out of existing buildings on three different Broadway sites, Stewart constructed his famous Marble Palace on the southeast corner of Broadway and Reade Street. Prior to this, most New York storefronts, whether purpose-built or inserted in existing row houses, were of a distinctive post-and-lintel construction in which one-piece granite posts supported granite lintels. The prototype had been introduced in 1829 with Town's building at 122 Pearl Street for the store of Lewis and Arthur Tappan (fig. 144). Stewart's structure was

49. The connection between the two churches is noted in Gwen W. Steege, "The *Book of Plans* and the Early Romanesque Revival in the United States: A Study in Architectural Patronage," *Journal of the Society of Architectural Historians* 46 (September 1987), p. 217. It was also the subject of a lecture by William H. Pierson Jr., entitled "James Renwick's Church of the Puritans," and given at Grace Church, New York, October 5, 1996.

50. Broadway is the focus of Ellen W. Kramer's brilliant overview of New York City at midcentury, "Contemporary Descriptions of New York City and Its Public Architecture ca. 1850," *Journal of the Society of Architectural Historians* 27 (December 1968), pp. 264–80.

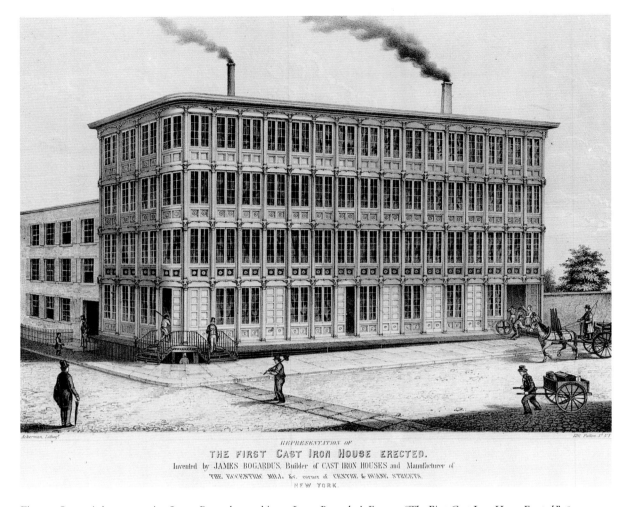

REPRESENTATION OF
THE FIRST CAST IRON HOUSE ERECTED.
Invented by JAMES BOGARDUS, Builder of CAST IRON HOUSES and Manufacturer of
THE ECCENTRIC MILL, &c. corner of CENTRE & DUANE STREETS.
NEW YORK.

Fig. 145. James Ackerman, artist; James Bogardus, architect, *James Bogardus's Factory: "The First Cast-Iron House Erected,"* 1849 or 1850. Lithograph. Museum of the City of New York, Gift of Mrs. Elon Hamilton Hooker 39.339

51. For the New York department store, see Winston Weisman, "Commercial Palaces of New York: 1845–1875," *Art Bulletin* 36 (December 1954), pp. 285–302.

52. *Broadway Journal,* March 22, 1845, p. 188. For Trench and Snook, see Mary Ann Smith, "John Snook and the Design for A. T. Stewart's Store," *New-York Historical Society Quarterly* 58 (January 1974), pp. 18–33.

53. *Broadway Journal,* March 22, 1845, p. 188.

revolutionary in several ways. It introduced both a new building type to New York, the purpose-built department store, and a new architectural style, the Anglo-Italianate, or palazzo, based on the architecture of London clubs. It was also the first dry-goods store to have exterior walls clad in marble and huge plate-glass windows protected by rolling cast-iron shutters (such windows had become practical when the duty on glass was repealed in London in 1845).

The architects of Stewart's store were the little-known Joseph Trench, in 1845 said to have "erected some of the finest street fronts in the country," and his young partner, John Butler Snook, at the beginning of a long and productive New York career.[52] The Corinthian columns and pilasters on the ground floor were made by Ottaviano Gori, the city's leading marble cutter (see "The Products of Empire" by Amelia Peck in this publication, p. 265), and the shutters were supplied by the recently arrived iron

manufacturer Daniel D. Badger. The upper three floors, in the palazzo style—their astylar walls (that is, without columns or pilasters) easily subdivided by the use of quoins and pedimented window frames—were well suited to accommodate expansion. A surviving design for the first of several extensions, down Broadway and along Chambers Street (cat. no. 96), shows the original unit essentially being repeated.

To some extent, the ease of expansion must have informed Stewart's choice of style; he would also have been aware, however, that in England the palazzo style was seen as a symbol of the rising political power of the middle classes—in effect, as a symbol of urbanity and wealth. Even before the store was built, a New York paper reported of it that "the style of architecture . . . makes a nearer approach to some of the facades of the London Club houses than that of any building in the city."[53] The reference is clearly to Charles Barry's two clubs on Pall Mall, the Travellers',

1829–31, and the Reform, 1837–40; the designs for the former had been published in 1839, those for the latter in 1843.[54]

Although the Astor House long reigned as the city's premier hotel, it was Stewart's store, with its endlessly repeatable Anglo-Italianate modules, that served as the model for most of the hotels built on Broadway in the late 1840s and the 1850s. Two of the finest—the Metropolitan, between Houston and Prince streets, 1850–52, and the Saint Nicholas, a block below, at Spring Street, 1853, both by Trench and Snook—were built in anticipation of the Crystal Palace exhibition of 1853. The grandest was Griffith Thomas and William Washburn's Fifth Avenue Hotel at Twenty-third Street, 1857–59.

By 1850 Stewart's success had precipitated a rush of new shops along Broadway. Outstanding among them, for its building as well as for the variety and quality of its goods, was E. V. Haughwout and Company, manufacturers and retailers of glass, china, tablewares, and lighting fixtures. The massive five-story, twenty-three-bay structure, with fronts on both Broadway and Broome Street, had cast-iron facades notable for their beautifully proportioned Venetian Renaissance ornament. The design was by John P. Gaynor, an architect not otherwise of consequence in New York, but the cast iron was from Badger, one of the leaders in the business. Badger's firm, Architectural Iron Works of the City of New York, was incorporated in 1856, the year the Haughwout Building was constructed. When, in 1865, he published a catalogue of the firm's work,[55] pride of place—the first illustration after the title page and view of the factory—was given to the Haughwout Building (cat. no. 98). Today it is the best-known iron-front structure in Manhattan and one of the two earliest surviving examples of such buildings (the other is the Cary Building, 1856, also by Badger).

Although the Haughwout Building was a true cast-iron structure—that is, one with a multistory, self-supporting, totally iron front—it was not the first to be built. That honor goes to a factory (fig. 145) that the inventor James Bogardus designed for himself in 1847 at the corner of Duane and Centre streets.[56] In 1848 Bogardus erected a new four-bay, five-story facade for Dr. John Milhau's pharmacy at 183 Broadway, and in 1849 he built a group of stores for Edgar H. Laing at the corner of Washington and Murray streets, from which only fragments survive (see cat. no. 97). The Laing storefronts were virtually identical to the facade of Bogardus's own factory. Four stories high, with simple Doric colonnettes flanking rectangular windows,

these structures were the modest precursors of the Haughwout and the myriad other cast-iron commercial buildings that today make up one of the city's unique treasures, the Cast-Iron District, located south of Houston Street.

By the 1850s Fifth Avenue had clearly become the new residential address of choice.[57] Originating at Washington Square, the avenue had been opened to Thirteenth Street in 1824, to Twenty-fourth Street in 1830, and to Forty-second Street in 1837. Since the completion of that last, large extension exactly coincided with the great financial panic, nothing much happened anywhere along the thoroughfare for several years. The first tangible evidence of the future residential growth was the relocation to the avenue of two fashionable churches: the Church of the Ascension at Tenth Street in 1840, and the First Presbyterian Church at Eleventh Street in 1842. After 1846 development was rapid.

One particularly influential house, on Sixteenth Street, just off Fifth Avenue, was that designed in 1846 for Colonel Herman Thorne by Trench and Snook. As the architects' design for Stewart's store transformed the facades of commercial New York, so did their Thorne house, with its introduction of the Italianate style, have a profound effect on the city's domestic architecture. The large, square, freestanding house was of brownstone, not marble, but otherwise its upper floors—with slightly projecting center bay, pedimented window surrounds, and bold cornice—were not unlike those of Stewart's emporium.[58] (The ground floor, which had a covered porch and round-arched windows, could not so readily be compared to a storefront.) Praised for its restrained elegance, the house was immediately emulated, first on Fifth Avenue and later as the prototypical brownstone row house in the Italianate style. Even Davis tried out the new mode, with a double house on Twelfth Street, just off Fifth, in 1847.

In 1850 Hart M. Shiff, a French-born merchant recently arrived in New York from New Orleans, commissioned Lienau to build a mansion at 32 Fifth Avenue, at Tenth Street (cat. nos. 99, 100). Lienau, whose thorough technical training in Germany had been followed by several years in Henri Labrouste's atelier in Paris, used the opportunity to introduce the French Renaissance style to New York.[59] The walls of the Shiff house were red brick, the trim brownstone. The roof—a visible emblem of the Second Empire style, marked "*à la mansard*" in the specifications—was the first of its kind in the city and was widely remarked upon. At the end of the decade, in 1859,

54. Charles Barry, *The Travellers' Club House* (London: J. Weale, 1839); *Surveyor, Engineer and Architect*, 1843.

55. Daniel D. Badger, *Illustrations of Iron Architecture Made by the Architectural Iron Works of the City of New York* (New York: Baker and Godwin, 1865); reprinted as *Badger's Illustrated Catalogue of Cast-Iron Architecture* (New York: Dover Publications, 1981).

56. For Bogardus, see Margot Gayle and Carol Gayle, *Cast-Iron Architecture in America: The Significance of James Bogardus* (New York: W. W. Norton, 1998).

57. See Mosette Broderick, "Fifth Avenue, New York, New York," in *The Grand American Avenue, 1850–1920*, edited by Jan Cigliano and Sarah Bradford Landau (exh. cat., New Orleans: Historic New Orleans Collection; Washington, D.C.: Octagon Museum, 1994), pp. 3–34.

58. For the Thorne house, see Lockwood, *Bricks and Brownstone*, pp. 132–33, ill.

59. See Ellen W. Kramer, "The Architecture of Detlef Lienau, A Conservative Victorian" (Ph.D. dissertation, New York University, 1958).

John Jacob Astor II would simply build a larger version of the same structure uptown, on Fifth at Thirty-third Street.

In September 1855 the architect Richard Morris Hunt settled in New York after nine years in Paris, having been the first American to study architecture at the École des Beaux-Arts. Hunt's initial commission was a modest house on Thirty-eighth Street, just off Fifth, for Thomas P. Rossiter, a painter and friend from Paris. The architect's elegantly rendered study of the three-story, four-bay limestone-and-brick facade (cat. no. 101) featured French Renaissance elements, including much-simplified echoes of the Pavillon de la Bibliothèque at the Louvre, on which he himself had labored. The only features characteristic of a traditional New York house were the partly raised basement, the stoop, and the flat roof. In fact, in order to make it blend better with its neighbors, the house was actually constructed with an extra story and faced with two varieties of brownstone. The Rossiter house is important as the first American work by a man who was to be the nation's leading architect during the last third of the century. But it is perhaps best remembered today as the subject of a legal dispute that helped establish the principle that architects are professionals entitled to commissions based on a percentage of the cost of construction.[60]

Although known mainly for his Gothic Revival churches, Upjohn was also an accomplished practitioner in two additional styles—the Italianate (for country houses) and the Romanesque (for urban secular structures). For the Trinity Building, 1851–52, an office structure adjacent to Trinity churchyard, Upjohn employed the heavy cornice and plain, flat walls of the palazzo style but punctuated the walls with Romanesque round-arched windows. Together with his son Richard Michell, he chose a similar treatment in 1856 for the great mansion (cat. no. 103) that Henry Evelyn Pierrepont engaged him to erect in Brooklyn Heights.[61] A massive block, four stories above a raised basement, its flat, bare walls of warm red New Jersey freestone interrupted by arched openings of darker Connecticut brownstone, the Pierrepont mansion was the finest Romanesque town house ever built in New York.

Buoyed by expansive and prosperous times during the 1850s, many of the city's urban institutions chose to build themselves permanent homes. In 1855 the Union Club erected a splendid structure, in the London-club style, on Fifth Avenue at Twenty-first Street. Shortly thereafter, the New-York Historical Society followed suit. Having purchased a lot at Eleventh Street and

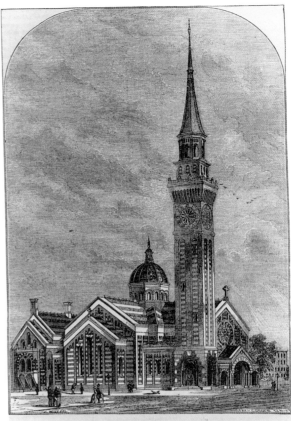

ALL-SOULS' CHURCH, CORNER OF FOURTH AVENUE AND TWENTIETH ST., NEW YORK.

Fig. 146. Jacob Wells; artist, Jacob Wrey Mould, architect, *All Souls' Church, Fourth Avenue at Twentieth Street,* 1859. Wood engraving by Augustus Fay and Edward P. Cogger, from *Ballou's Pictorial Drawing-Room Companion,* August 20, 1859. Courtesy of the American Antiquarian Society, Worcester, Massachusetts

Second Avenue (after Fifth, the most fashionable new residential street), the society hired Charles Mettam and Edmund A. Burke to design its headquarters in the palazzo style, termed by the society "Italian-Roman-Doric."[62] Although neither Mettam and Burke nor their design was particularly distinguished in the architectural milieu of the time, the partners' presentation rendering (cat. no. 104)—all that survives of the building—is exceptionally attractive.

The National Academy was more adventurous. It began its search for a location in 1859, purchased a lot at the corner of Fourth Avenue and Twenty-third Street in 1860, and then began the lengthy process of selecting an architect. Those originally proposed for consideration were Eidlitz (from Vienna), Mould (from London), and Hunt (from the École in Paris). In the end, however, the academy chose Peter Bonnett Wight, a native New Yorker who had trained with Thomas R. Jackson, once Upjohn's chief draftsman.[63] It was not until 1862 that a final design was agreed to, and construction dragged on into 1865. Wight's design

60. See Paul R. Baker, *Richard Morris Hunt* (Cambridge, Massachusetts: MIT Press, 1980); for the Rossiter house, see ibid., pp. 80–87.

61. For Upjohn's involvement with Pierrepont, see Judith Salisbury Hull, "Richard Upjohn: Professional Practice and Domestic Architecture" (Ph.D. dissertation, Columbia University, New York, 1987), pp. 319–37, 562–65.

62. Quoted in R. W. G. Vail, *Knickerbocker Birthday: A Sesqui-Centennial History of the New-York Historical Society, 1804–1954* (New York: New-York Historical Society, 1954), p. 98.

63. For Wight, see Sarah Bradford Landau, *P. B. Wight—Architect, Contractor, and Critic, 1838–1925* (exh. cat., Chicago: Art Institute of Chicago, 1981).

was inspired by Mould's dramatic All Souls' Unitarian Church (fig. 146), 1853–55, just three blocks to the south. That building, Mould's first major commission in New York (the tower was never executed), was the first in America to employ polychromatic construction materials. Wight's exotic, polychrome design (cat. no. 105), with the cornice and the diamond pattern of the brick-and-stone walls strongly suggesting the Doge's Palace, Venice, represents an early instance of the influence in New York of the English writer and critic John Ruskin.

By the mid-1850s New York's architects had come to recognize the need for a professional association, and it was Upjohn who was to provide the impetus. He had labored, he claimed, "under the most adverse circumstances when the profession was in its infancy . . . [and] in an isolated position."[64] In February 1857 twelve New York architects assembled in his office and agreed to establish a society to "promote the scientific and practical perfection of its members and elevate the standing of the profession."[65] They chose to keep the membership select, drawing it from their immediate circle of acquaintances, and to limit it principally to New York City, no doubt remembering that the failure of the American Institution of Architects in 1836–37 was in good part because of regional rivalries. Their new organization was to be called the American Institute of Architects, the first viable professional association of architects in the United States. On April 15, with elaborate ceremonies in Davis's great Gothic Revival chapel at the University of the City of New York, the AIA celebrated the adoption of its constitution. The first board of trustees included Upjohn (president), Walter (first vice president), Hunt (librarian), and Davis. Years later, from 1888 to 1891, Hunt would serve as president, having become the leading American proponent of the architectural profession.

All told, then, in the years 1825 through 1861, New York City had transformed itself in the realm of architecture from a calm backwater to the turbulent mainstream. Its architects, at first native-born carpenter-builders, at the end of the period were largely immigrants who had been professionally trained. Its buildings evolved from local variations on English classical designs into structures reflecting the full panoply of Revival styles—the English ecclesiological Gothic, the Venetian Gothic, the Anglo-Italianate, the French Renaissance. Its building materials changed from red brick to white marble, brownstone, and cast iron. Wall Street, with its banks and exchanges, became the symbol of the architecture of finance; Broadway, with its hotels and department stores, the symbol of the architecture of commerce; and Fifth Avenue, with its palatial residences, the symbol of the architecture of private pleasure. New York, by way of becoming a world-class city, had become the epicenter of American architecture.

64. Quoted in Woods, *From Craft to Profession*, p. 33.
65. Ibid.

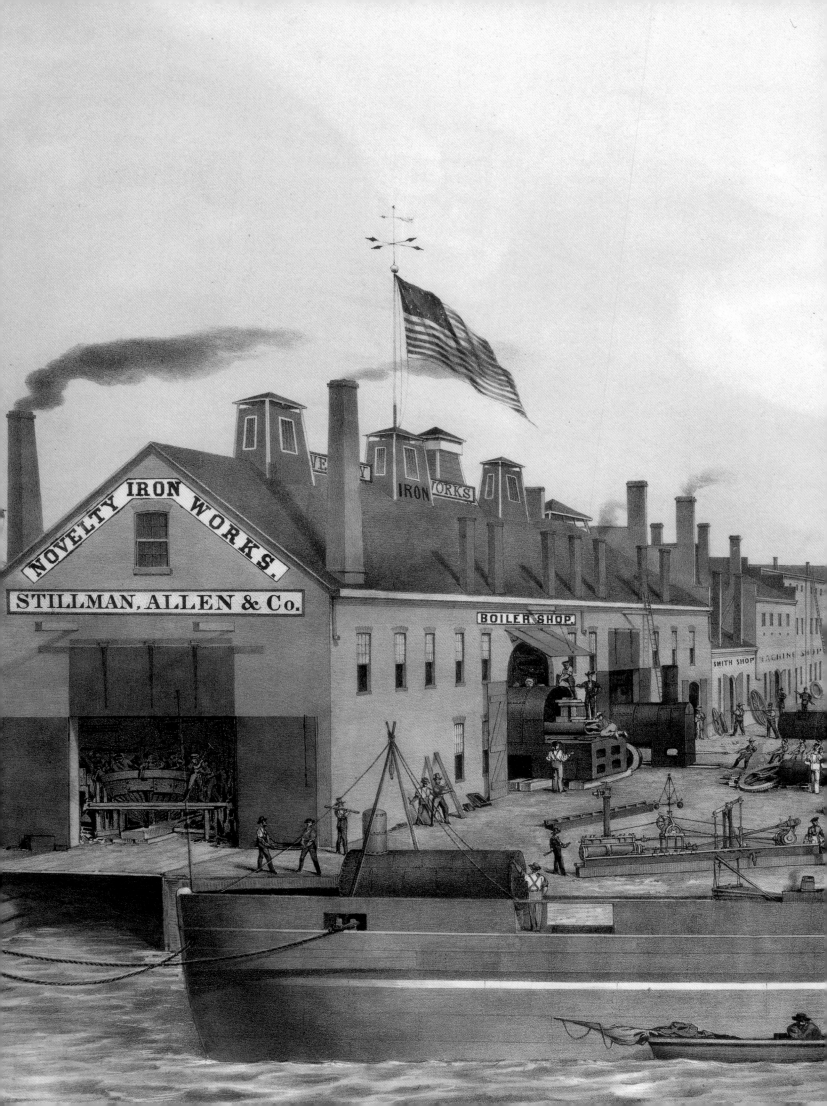

The Currency of Culture: Prints in New York City

ELLIOT BOSTWICK DAVIS

Between the opening of the Erie Canal in 1825 and the beginning of the Civil War in 1861, printmaking in New York City flourished on an unprecedented scale. The popularity of city views of this era among early-twentieth-century collectors—which is reflected in Isaac Newton Phelps Stokes's six-volume *Iconography of Manhattan Island*—has obscured the fact that reams of prints of many other types were also produced by New York presses during those years. Those of exceptionally high quality, which supported New York's aspiration to be the cultural capital of the United States, attracted an elite circle of connoisseurs, while the popular marketplace demanded a spectrum of prints in the form of currency, maps, illustrations for books and periodicals, and political cartoons, as well as vast quantities of trade cards, billheads, and advertising materials beyond the scope of the present exhibition. Indeed, as a response to the combined momentum of rising artistic standards and increasing mass production, a consciousness of the city's manifest destiny emerged. Nowhere is this more clearly evident than in the printed views of Manhattan, which grew ever more expansive and proclaimed the metropolis "The Empire City" as early as 1855.

Between 1825 and 1861 the burgeoning of New York as a bustling marketplace for domestic and foreign goods worked to the great advantage of the city's numerous commercial industries, including the printing trade. As the primary port of entry into the United States following the opening of the Erie Canal, Manhattan welcomed to its shores a steady supply of highly skilled artists and printers from Europe. Regular packet-boat service and cost-efficient wharves and warehouses (see fig. 170) expedited the flow of all the supplies and equipment necessary to produce prints, especially the prized limestone ideally suited to lithography that was imported from Bavaria. Iron foundries throve in their proximity to the North River (now known as the Hudson), and printers were able to update their presses and equipment, incorporating the latest technological developments from abroad.

The official opening of the Erie Canal ensured that all roads of the Empire State led to the Port of New York (see cat. no. 118). To commemorate that occasion, several of the most prominent American engravers practicing in the city joined forces with the newly arrived French lithographer Anthony Imbert to create an ambitious presentation volume with extensive printed illustrations documenting the elaborate celebration (cat. no. 117). Entitled *Memoir, Prepared at the Request of a Committee of the Common Council of the City of New York, and Presented to the Mayor of the City, at the Celebration of the Completion of the New York Canals*, the book included a splendid illustration by Archibald Robertson of the fleet preparing to form in line when the boat *Seneca Chief*, conveying De Witt Clinton and his entourage, approached the lower tip of Manhattan near Battery Park at the culmination of the aquatic festivities (cat. no. 118). Imbert required two lithographic stones to capture the grandiose scene in its entirety—a complex and expensive undertaking. Earlier panoramic views of New York Harbor generally represented the city from the vantage point of a small vessel at sea level. Charles-Balthazar-Julien Févret de Saint-Mémin's engraving of New York from Brooklyn Heights, drawn with a pantograph in 1798 (fig. 147), exemplifies this earlier topographical style, which derived from detailed drawings required for planning military campaigns.[1] In contrast, Robertson designed an atmospheric view from the elevated promenade of the Battery. An instructor in one of the first drawing academies in New York City, Robertson was a highly proficient draftsman capable of fully collaborating with Imbert in the lithographic process, which was relatively new in the United States. Because of his artistic abilities and his role as a major figure in the New York art world, the Committee of Arrangements for the canal celebrations had made Robertson head of its Department of Fine Arts, which would prepare the illustrations for the *Memoir*. Exploiting the ability of the lithographic crayon to render subtle gradations of tone, Imbert drew Robertson's image on stone with the assistance of Félix Duponchel.[2] A former

The author wishes to thank Georgia B. Barnhill, Andrew Mellon Curator of Graphic Arts, The American Antiquarian Society; John Wilmerding, Christopher B. Sarofim '86 Professor of American Art, Princeton University; and Catherine Hoover Voorsanger for reading an earlier draft of this essay and for their insightful comments. She also thanks Ellyn Childs Allison, John S. Paolella, and Carol Fuerstein for their attentive editing of the manuscript; and Heather Lemonedes, John Crooks, Constance C. McPhee, Marguerita Emerson, Mark D. Mitchell, and Katherine P. Lawrence for their research assistance on the American prints in the Metropolitan Museum.

1. See Gloria Gilda Deák, *Picturing America, 1497–1899: Prints, Maps, and Drawings Bearing on the New World Discoveries and on the Development of the Territory That Is Now the United States* (Princeton: Princeton University Press, 1988), p. 144.
2. John Carbonell, "Anthony Imbert: New York's Pioneer Lithographer," in *Prints and Printmakers of New York State, 1825–1940*, edited by David Tatham (Syracuse: Syracuse University Press, 1986), p. 18.

Opposite: detail, fig. 170

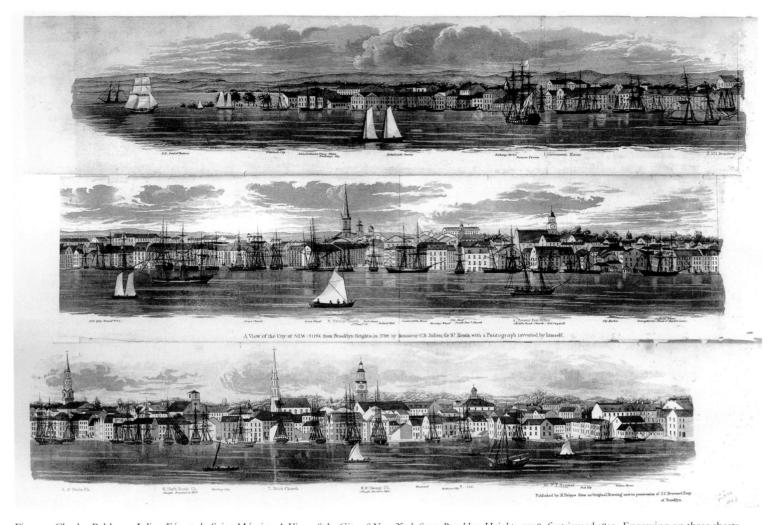

Fig. 147. Charles-Balthazar-Julien Févret de Saint-Mémin, *A View of the City of New York from Brooklyn Heights*, 1798, first issued 1850. Engraving on three sheets, first state. The New York Public Library, Astor, Lenox and Tilden Foundations, Miriam and Ira D. Wallach Division of Art, Prints and Photographs, The Phelps Stokes Collection, Print Collection P. 1796–E–44

3. Ibid., pp. 17, 39 n. 8. As Carbonell notes, "not only do different copies have different combinations of plates, but several of the lithographs exist in variant states." See also Harry T. Peters, *America on Stone: The Other Printmakers to the American People. A Chronicle of American Lithography Other Than That of Currier & Ives, from Its Beginning, Shortly before 1820, to the Years When the Commercial Single-Stone Hand-Colored Lithograph Disappeared from the American Scene* (Garden City: Doubleday, Doran, and Co., 1931; reprint, New York: Arno Press, 1976), pp. 228–35.

4. Carbonell, "Anthony Imbert," p. 39 n. 8.

member of the French navy, Imbert was responsible for the depiction of the vessels, but it was Robertson who likely enlivened the composition by contrasting thick clouds of black smoke made by steamships with the white clouds of exploding gunpowder emanating from the canons in the lower foreground and near the hull of the tall ship just offshore.

The *Memoir* also included lithographs printed by Imbert of the numerous associations that participated in the celebrations. Fire companies are represented in several illustrations, and the symbols of such important guilds as the chair-makers' society also appear (fig. 234). The novelty of the lithographic medium and its association with scientific reportage may have discouraged Robertson from choosing it for the portraits in the *Memoir*. Instead, he and Imbert enlisted the foremost engravers of the day, including

Peter Maverick, Asher B. Durand, and James Barton Longacre, to portray the prime movers of the canal project, De Witt Clinton and Cadwallader Colden, a former mayor of New York who was the author of the *Memoir*. Nevertheless, thirty-seven of the fifty-four illustrations in the book were lithographs, all but two printed by Imbert.[3] Robertson and Imbert even included a plate reproducing a facsimile of a letter dated July 6, 1826, in order to demonstrate the practical applications of transfer lithography.[4] Just as the opening of the Erie Canal was a watershed in the history of New York City, so Robertson and Imbert's ambitious project served to set a high standard for New York lithographers, who would soon follow their lead.

In 1825 lithography was still considered a novelty in the United States. Robertson lauded the medium

Fig. 148. John Rubens Smith, *Portrait of a Lady [Mrs. John Rubens Smith?]*, 1821–22. Lithograph. Courtesy of the American Antiquarian Society, Worcester, Massachusetts

as a "curious discovery" of "useful importance" not unworthy of comparison with "Fulton's application of steam to the purposes of navigation."[5] The technique operates on the principle that oil and water do not easily mix.[6] To execute a lithograph, the artist first draws an image on a stone—during the antebellum period most often limestone—with greasy crayons, pens, or pencils. The drawing is then affixed to the stone by means of a solution of gum arabic and nitric acid to prevent the ink from spreading. The stone is washed with water, which dampens the exposed areas. Printer's ink is then rolled over the entire surface, and the grease in the ink adheres to the sticky surface of the prepared drawing but not to the wet surface of the stone. The stone is inked and covered with paper. After passing through a printing press, the paper reveals a mirror image of the original drawing.

Introduced in Germany by Aloys Senefelder in 1796, lithography was first attempted in the United States by the portrait painter and engraver Bass Otis, who in 1819 produced what is frequently considered the first American lithograph, a crudely executed landscape with a mill.[7] Shortly thereafter, William Armand Barnet and Isaac Doolittle brought to New York their firsthand knowledge of lithography as it was

practiced in Paris. Their early efforts drew praise from the *American Journal of Science and Arts* in 1821: "Messrs. Barnet & Doolittle have in their possession, a great variety of lithographic prints, which sufficiently evince the adaptedness of the art to an elegant as well as a common style of execution. The finest things done in this way are really very beautiful; and they possess a softness which is peculiarly their own."[8] Barnet and Doolittle produced lithographs of some quality, exemplified by the execution of a delicate portrait by British-born artist and printmaker John Rubens Smith (fig. 148). But lithographs cost twice as much as copperplate engravings, and the partners became discouraged. By June 1822 Barnet returned to France, after selling the firm they had established to geologist William Leseur, who himself lamented the lack of patronage for lithography in New York. Writing to the former proprietors, Leseur observed: "In order for lithography to succeed here it is necessary for there to be more connoisseurs of fine arts than there are now. You only find a few individuals who have portfolios full of engravings, and those who have them send them to auction to get rid of them."[9]

With the entrepreneurial spirit that would bolster New York City's bid to become the business capital of the country, various local printers continued to try their hands at lithography, despite the failure of Barnet and Doolittle. The engraver Peter Maverick had

Fig. 149. Peter Maverick, after Thomas Lawrence, *The Daughters of Charles B. Calmady*, 1829. Lithograph. Courtesy of the American Antiquarian Society, Worcester, Massachusetts

5. Cadwallader D. Colden, *Memoir, Prepared at the Request of a Committee of the Common Council of the City of New York, and Presented to the Mayor of the City, at the Celebration of the Completion of the New York Canals* (New York: Printed by Order of the Corporation of New York by W. A. Davis, 1825), conclusion. p. 398, Department of Drawings and Prints, Metropolitan Museum.

6. As described in Peter C. Marzio, *The Democratic Art, Chromolithography, 1840–1900: Pictures for a 19th-Century America* (Boston: David Godine, 1979), pp. 8–9, with descriptive definitions of single-color, hand-colored, tinted lithographs, and chromolithographs on p. 9.

7. See Sally Pierce, with Catharina Slautterback and Georgia Brady Barnhill, *Early American Lithography: Images to 1830* (exh. cat., Boston: Boston Athenaeum, 1997), pp. 10–11, 80–81. See also Peter C. Marzio, "American Lithographic Technology before the Civil War," in *Prints in and of America to 1850*, edited by John D. Morse, Winterthur Conference on Museum Operation and Connoisseurship, 16th, 1970 (Charlottesville: University Press of Virginia, 1970), pp. 215–56; and Joseph Jackson, "Bass Otis, America's First Lithographer," *Pennsylvania Magazine of History and Biography* 37 (1913), pp. 385–94.

8. "Notice of the Lithographic Art," *American Journal of Science and Arts* 4 (October 1821 [1822]), p. 170, as quoted in Pierce, Slautterback, and Barnhill, *Early American Lithography*, p. 11.

9. Quoted in Pierce, Slautterback, and Barnhill, *Early American Lithography*, p. 12.

10. For a detailed account of Maverick's career, see Stephen DeWitt Stephens, *The Mavericks, American Engravers* (New Brunswick, New Jersey: Rutgers University Press, 1950); and Peters, *America on Stone*, pp. 273–75.

11. See Mary Bartlett Cowdrey and Theodore Sizer, *American Academy of Fine Arts and American Art-Union, 1816–1852* (New York: New-York Historical Society, 1953), vol. 2, *Exhibition Record*, pp. 351–52.

12. Several figures in the foreground of Thompson's print are usually identified as his wife, daughters, and sister. See Olive S. De Luce, "Percival DeLuce and His Heritage," *Northwest Missouri State Teachers College Studies*, June 1, 1948, pp. 73–74. The two prints that recall Thompson's *New York Harbor from the Battery* are an engraving, *Arrival of the Great Western Steam Ship, Off New York Bay of New York* (1838), published by W. & H. Cave of Manchester, England, and a tinted lithograph, *Bay of New York from the Battery* (1838) by an artist identified by the initials H. D.

13. Carbonell, "Anthony Imbert," pp. 12–13; Peters, *America on Stone*, p. 228.

14. See I. N. Phelps Stokes, *The Iconography of Manhattan Island, 1498–1909, Compiled from Original Sources and Illustrated by Photo-intaglio Reproductions of Important Maps, Plans, Views, and Documents in Public and Private Collections*, 6 vols. (New York: Robert H. Dodd, 1915–28), vol. 3 (1925), p. 603. Stokes writes: "The [New-York Historical] Society owns also one of the original brown wrappers, bearing the following inscription: 'Views of the Public Buildings, Edifices and Monuments, In the Principal Cities of the United States, Correctly drawn on Stone by A. J. Davis. Printed and Published by A. Imbert, Lithographer, 79 Murray-Street, New-York. . . . The Work will be issued in Numbers, each containing 4 Plates; The first number to each City, will be ornamented with a title page and a vignette;—The Price of Subscription is per number, . . . \$2:00. Each Plate Separately, . . . 0:50. Subscriptions are received at the Office of the Publisher, 79 Murray-Street,

Fig. 150. Anthony Imbert, after Thomas Cole, *Distant View of the Slides That Destroyed the Willey Family, White Mountains*, ca. 1828. Lithograph. Courtesy of the American Antiquarian Society, Worcester, Massachusetts

experimented with the new technique on a small scale to augment his thriving trade in portraits, banknotes, and maps. Maverick was an accomplished draftsman, and the skill he achieved in lithography is evident in *The Daughters of Charles B. Calmady* (fig. 149), a print of 1829 after an oil painting by Thomas Lawrence.[10] Maverick would also produce numerous popular lithographs for book illustrations and sheet-music covers.

One lithographer who would rapidly match Imbert's success was British immigrant Thomas Thompson. A painter who exhibited regularly at the American Academy of the Fine Arts, the Apollo Association (later the American Art-Union), and the National Academy of Design, where he became an associate member in 1834,[11] Thompson undertook what would become a milestone of early American lithography because of its unprecedented scale. In 1829, utilizing Saint-Mémin's and Imbert's technique of joining several sheets together to form one panorama, Thompson joined three large lithographs to form a continuous, well-populated scene of New York Harbor from the

southern tip of the Battery promenade (cat. no. 121). Although Thompson did not continue to produce lithographs, his print, which is now rare, inspired several other similar scenes of an elegant assembly of New Yorkers strolling along the Battery.[12]

Meanwhile, Imbert continued in business at a number of downtown addresses until at least 1835,[13] and he succeeded in attracting some of the foremost American artists to experiment with lithography. The distinguished architect Alexander Jackson Davis collaborated with him to produce a portfolio of depictions of public buildings in New York (see cat. nos. 70–72). The inscription on one of the extant portfolio wrappings indicates that Imbert intended to publish subsequent portfolios of public buildings located in the principal cities of the United States; however, as with many printmaking projects planned during the first half of the nineteenth century, the subsequent installments were abandoned.[14]

Thomas Cole, who would later change the course of American landscape painting, found his way to Imbert's

press while he was struggling to establish himself professionally. In hopes of raising funds for a trip to Europe through the sale of prints, Cole produced two lithographs printed by Imbert that reflect his interest in the American wilderness.[15] Perhaps inspired by Robertson's reportage for the *Memoir,* Cole based one of them on a dramatic location he himself had visited. Intended to appeal to human curiosity in the wake of a natural disaster, *Distant View of the Slides That Destroyed the Willey Family, White Mountains* of about 1828 represents the raging forces of nature that inspire awe, an essential component of Cole's notion of the sublime (fig. 150). Describing the scene in a journal entry for October 1828, Cole recalled his sense of utter desolation as he gazed at the Willey house, miraculously left standing by a landslide that killed all the members of the household, who had rushed outside.[16] The distinctive bald patches on the slope evoke Cole's contemporaneous paintings of Kaaterskill Clove in the Catskills, and they may have inspired his rendering of a similarly scarred mountainside in the central background of *The Oxbow* (Metropolitan Museum), a monumental canvas he painted for New York art patron Luman Reed in 1836. Although modest in scale, the two early prints designed by Cole and executed by Imbert represent some of the earliest efforts by an American painter to create high-quality landscapes in the medium of lithography.

Imbert kept a keen eye on the popular-print market. Views of street life in New York were in demand and they often took the form of humorous satires. Seeking to engage an ever broader audience, Imbert issued a series of lithographic caricatures entitled Life in New York that are reminiscent of the popular etchings Life in Philadelphia produced by Edward W. Clay.[17] In one of these an urban dandy is shown comically striving to climb New York's social ladder while encumbered by fashionably tight lacing (fig. 23). One of Imbert's more unusual popular lithographs, which combines portraiture and social commentary, depicts the formidable Mr. John Roulstone of the New York Riding School (fig. 151). Rendered by an anonymous artist and printed by Imbert, the image depicts the imposing figure of the elegantly dressed Roulstone. The inscription below the scene, which testifies to the print's preparation "in compliance with the unanimous vote of the class," expresses the high regard of Roulstone's students for their teacher.[18] The large scale of the lithograph suggests the enormous resources of fashionable New Yorkers put through their paces by Roulstone. The work was probably commissioned by students of the riding school, and

Fig. 151. *Mr. John Roulstone of the New York Riding School,* ca. 1829. Lithograph published by Anthony Imbert. Collection of The New-York Historical Society, Print Room

the cost of designing and printing the image was passed on to subscribers, who presumably received a portrait of their beloved instructor.

Despite the fine work done by Imbert and other lithographers, high-quality printmaking was dominated by aquatint engraving. An intaglio process, aquatint achieves effects that are tonal rather than linear, much like those of a watercolor wash. To effectively imitate watercolors, the early aquatints created in New York City were generally prepared with black or sepia ink and later hand colored, although aquatints could also be printed in colors. Paul Sandby, father of the eighteenth-century British watercolor school, was the first artist to use the aquatint process in England, having learned the technique from a friend who had purchased the secret from the inventor, Jean-Baptiste Le Prince.[19] Aquatint was promoted vigorously in London by print publisher Rudolph Ackermann, whose instruction manuals and art periodical, the *Repository of Arts, Literature, Fashions, Manufactures, &c.,* were imported into the United States during the early nineteenth century and served as models for aspiring American printmakers and publishers.

By 1816 British-born printmaker John Hill had arrived in America, where he fostered the popularity and success of the medium. Hill, who began his career in Philadelphia that year, recognized the merits

Behr & Kahl's Book Store, 359 Broadway; Judah Dobson, 108 Chestnut-street, Philadelphia; Fielding Lucas, Baltimore." See also Deák, *Picturing America,* p. 234.

15. See Janet Flint, "The American Painter-Lithographer," in *Art and Commerce: American Prints of the Nineteenth Century. Proceedings of a Conference Held in Boston May 8–10, 1975, Museum of Fine Arts, Boston, Massachusetts* (Charlottesville: University Press of Virginia, 1978), p. 129, for the dating of the two Cole lithographs, *Distant View of the Slides That Destroyed the Willey Family, White Mountains* and *The Falls at Catskill,* and the likelihood that both were printed at Imbert's press.

16. Cole wrote in his journal: "The sight of that deserted dwelling (the Willee House) standing with a little patch of green in the midst of that dread wilderness of desolation called to mind the horrors of that night (the 28th of August, 1826) when these mountains were deluged and rocks and trees were hurled from their high places down the steep channelled sides of the mountains— the whole family perished and

Fig. 152. John Hill, after William Guy Wall, *Palisades,* 1820, issued 1823–24, *The Hudson River Portfolio* (New York: Henry J. Megarey, 1821–25), pl. 19. Aquatint with hand coloring, proof before letters. The Metropolitan Museum of Art, New York, The Edward W. C. Arnold Collection of New York Prints, Maps, and Pictures, Bequest of Edward W. C. Arnold, 1954 54.90.601

yet had they remained in the house they would have been saved—though the slides rushed on either side they avoided it as though it had been a sacred place. A strange mystery hangs over the events of that night. . . . We looked up at the pinnacles above us and measured ourselves and found ourselves as nothing . . . it is impossible for description to give an adequate idea of this scene of desolation." Flint, "The American Painter-Lithographer," p. 129.

17. See Carbonell, "Anthony Imbert," pp. 27–28; and Nancy Davison, "E. W. Clay and the American Political Carica-ture Business," in *Prints and Printmakers of New York State,* pp. 91–110.

18. The original print is housed in the Print Room of the New-York Historical Society. I am grateful to Wendy Shad-well, Curator of Prints, The New-York Historical

of aquatint as a means of producing a series of printed scenes that could be used as models for aspiring ama-teur painters and decorative artists. He used aquatint in his portfolio *Picturesque Views of American Scen-ery,* 1821. Inspired by the success of Baltimore pub-lisher Fielding Lucas, who had issued an extensively illustrated drawing book in 1815, Hill also produced thirteen aquatint plates for a similar manual that was published by Henry J. Megarey in New York City in 1821. A popular success, Hill's *Drawing Book of Land-scape Scenery: Studies from Nature* established his reputation, and he was soon approached by Irish-born watercolorist William Guy Wall to engrave the illustrations for a project in aquatint, *The Hudson River Portfolio.*[20]

The success of early-nineteenth-century aquatint endeavors in the United States depended upon the close collaboration of artist, printmaker, and publisher. It required the keen eye of an accomplished print-maker like Hill to translate the watercolor washes of the artist's original composition as black and white

tones; moreover, the printmaker supervised the hand coloring of the aquatints to ensure their close resem-blance to the original watercolors. Regardless of the quality of the final prints, the publisher's ability to attract subscribers for future installments and to sell the works in the marketplace determined the ulti-mate success or failure of a project. Wall, the premier watercolorist of the day, whose work was greatly admired by Thomas Jefferson, interested Megarey in the project and he agreed to publish Wall's watercolor views along the historic Hudson.[21] That Wall and Hill worked hand in glove on *The Hudson River Portfolio* is strikingly clear. Wall had initially com-missioned John Rubens Smith to render the plates for the portfolio. Although he was an accomplished mez-zotint engraver, Smith found that aquatint eluded his talents, and he abandoned the venture. Hill reworked several of Smith's plates and devoted himself to the project for the next five years.

The resulting suite of picturesque vistas selected from vantage points along the 315-mile river served

Fig. 153. Thomas Hornor, *Broadway, New York,* ca. 1834. Pen and ink with wash. The New York Stock Exchange Lunch Club, New York City

to focus public attention on the indigenous American landscape, setting the stage for the development of the Hudson River School of landscape painting. John F. Kensett, a second-generation member of the school, found inspiration for his series of paintings of the Shrewsbury River in Wall and Hill's *Palisades* (fig. 152), with its distinctive horizontality and glistening reflections of sailboats on the surface of the water.[22] The imagery of *The Hudson River Portfolio* also served decorative artists. Given the crisp appearance of the etched lines delineating the areas of aquatint tone, the scenes could be readily transferred to porcelains. Plate 20 in the *Portfolio,* a view of New York City from Governors Island, appears on one of a pair of Paris porcelain vases dating from the 1830s,[23] complementing a scene showing the Elysian Fields, Hoboken, on the other vase (fig. 266).

In 1822, at the urging of Megarey, Hill moved to New York City and established his residence and workroom on Hammond Street, which he depicted in a watercolor dated 1825 (Metropolitan Museum).[24]

Hill's business immediately flourished in Manhattan. Although he alone received the credit and commissions for the work, he relied upon his wife to print the plates he etched and on his daughters, Caroline and Catherine, to hand color the prints under his watchful eye.[25] Domestic printshops like Hill's would be replaced about the middle of the century by large workshops, such as those owned by George Endicott and Nathaniel Currier, both of whom employed numerous artists, printers, and colorists. Hill supervised the reissue of *The Hudson River Portfolio* plates throughout the late 1820s and early 1830s, when he worked with Megarey's successor, the firm of G. and C. and H. Carvill.[26] He also trained his son, John William Hill, who became a successful printmaker and artist in his own right in New York City.

Securing patronage for large printmaking projects like *The Hudson River Portfolio* proved challenging. Several extant watercolors associated with prints made during the 1820s and 1830s indicate that artists produced finished drawings that would

Society, for her assistance throughout the course of this project.

19. See Dale Roylance, "Aquatint Engraving in England and America," in *William James Bennett: Master of the Aquatint View,* by Gloria Gilda Deák (exh. cat., New York: New York Public Library, 1988), p. 4.

20. For a thorough discussion of Hill's career and his involvement in *The Hudson River Portfolio,* see Richard J. Koke, "John Hill, Master of Aquatint, 1770–1850," *New-York Historical Society Quarterly* 43 (January 1959), pp. 51–117. Koke notes (p. 88) that on September 4, 1821, Hill brought with him to Philadelphia a copy of one of Wall's original drawings to engrave.

21. Ibid., p. 86.

22. Elliot Bostwick Davis, "Training the Eye and the Hand: Drawing Books in Nineteenth-Century America" (Ph.D. dissertation, Columbia

Fig. 154. William James Bennett, *Broadway from the Bowling Green,* ca. 1826. Aquatint, from *Megarey's Street Views in the City of New-York* (New York: Henry J. Megarey, 1834). The New York Public Library, Astor, Lenox and Tilden Foundations, Miriam and Ira D. Wallach Division of Art, Prints and Photographs, The Phelps Stokes Collection, Print Collection C. 1826–E–114

University, New York, 1992), p. 256.

23. See Alice Cooney Frelinghuysen, "Paris Porcelain in America," *Antiques* 153 (April 1998), p. 563 n. 44.

24. See Koke, "John Hill," pp. 92–94, for the various residences of the Hill family before they acquired the two-story brick building on Tenth Street that the artist owned until his death, in 1850.

25. Ibid., p. 97.

26. Ibid., p. 103.

27. For the original documents, consult the New-York Historical Society, Manuscript Division, Francis. The first, a form of promissory note, is dated February 1834. Also quoted in Stokes, *Iconography,* vol. 3, pp. 625–27. I am grateful to Mark Mitchell of Princeton University for obtaining transcriptions of the documents.

serve not only as models for the engraver but also as samples to attract subscribers. Occasionally, proofs were used for the same purpose. Wall and Hill's *Palisades* is likely an example of such a prepublication proof, pulled before the final lettering was added to the plate and then hand colored. A highly finished drawing (fig. 153) by another of Hill's collaborators, British-born Thomas Hornor, represents a similar effort to stimulate interest in an ambitious plan (never realized) to publish several large-scale aquatint views of the city. Hornor strengthened his drawing with fine outlines in pen and ink to suggest the look of the engraving that would follow (cat. no. 123). His efforts to attract subscribers are recorded in an exchange of letters with Dr. John W. Francis, an eminent New York physician and patron of the arts. In one of the rare documents describing the terms of patronage for a print produced at the time, Hornor acknowledges receipt of a loan of $500 from Dr. Francis and "several

gentlemen" for his view of New York Harbor from the East River. In return, Francis and the other contributors stood to receive a set of prints "colored in imitation of highly finished Drawings." [27]

Hill's preeminence as master of the printed aquatint in New York during the early nineteenth century was threatened only by William James Bennett, who immigrated to New York from Britain in 1826, just as the era that would be called the Golden Age of aquatint was reaching its peak. [28] Trained in London at the Royal Academy of Arts, Bennett observed the principles of the British watercolor school as practiced at its highest level by Thomas Girtin, J. M. W. Turner, and his own teacher, Richard Westall. Through his association with Hill in England, where they both produced aquatint illustrations for Ackermann, Bennett was swiftly embraced upon arrival by Hill's circle of English artist-friends at work in New York.

Bennett's first major project was a suite of New York City views for Megarey. Like many other print portfolios of the early nineteenth century, including *The Hudson River Portfolio* and *Views of the Public Buildings in the City of New-York*, Bennett's proposal was envisioned on a scale grander than could be supported by the existing market for prints. Although *Megarey's Street Views in the City of New-York* was initially conceived as a group of twelve prints issued in four sets of three, only the first installment ever appeared.[29] Recalling British precedents, particularly the view of Leicester Square published in Ackermann's *Repository of Arts* (1812), Bennett's *Broadway from the Bowling Green* from the Megarey project (fig. 154) invests New York City with all the trappings of eighteenth-century Georgian towns in Britain.[30] For this view of about 1826, Bennett selected a row of building facades along a cobbled street that suggests the graceful curve of the Royal Crescent at Bath. Moreover, like Thomas Thompson's monumental *New York Harbor from the Battery* (cat. no. 121), Bennett's scene is populated by fashionably dressed New Yorkers who have an air of cosmopolitan elegance. The two other scenes in the suite (cat. nos. 119, 120) show New York City's thriving waterfront and mercantile districts and represent Bennett's tribute to the brash and bustling commercial life of his new home.

Bennett's aquatints are among the finest of the period, owing to his adeptness at imitating the appearance of colored washes, a skill that was much appreciated by artists who wished to expand the market for their own watercolors by issuing prints of them. John William Hill collaborated with Bennett on one of the most spectacular folio views of New York from Brooklyn Heights (cat. no. 128). It was conceived as the pièce de résistance in a series of nineteen views of American cities published by Lewis P. Clover and Megarey. Several other artists collaborated with Bennett to create scenes of major American ports for the series, including Mobile, Alabama, and Charleston, South Carolina—two southern cities that shipped their goods for northern markets through New York. Bennett and his publishers undoubtedly sought the patronage of wealthy merchants in all three cities whose fortunes swelled owing to their involvement in the cotton trade. Although the elevated topography of Brooklyn Heights had long attracted early printmakers, Hill bested them by climbing upon a rooftop for an even higher vantage point. Hill's sense of humor can be detected in the central foreground. As though to underscore the lofty elevation of the

bird's-eye view, he included several pigeons roosting just below.

Inspired by the Hudson River School painters, particularly Cole, Bennett devoted himself to rendering in aquatint the atmospheric effects of the American landscape as captured in watercolor by British-born artist George Harvey. Working in the fifteenth-century Northern Renaissance tradition of depicting landscape at different times of the day and year, Bennett and Harvey planned a portfolio of forty atmospheric studies of ancient forests in Ohio and Canada at different hours and seasons.[31] Entitled *Harvey's American Scenery*, the first installment of four aquatints and a title page (fig. 155) was published with an accompanying text by Washington Irving in 1841. The prints were rendered with great refinement and treated with carefully stippled applications of hand coloring in a labor-intensive process that resulted in a close approximation of Harvey's watercolors. To rally support for the publication, the American Art-Union offered ten sets in its annual lottery, but the project foundered, suggesting that interest in aquatinted views—a field dominated by British-born artists and engravers—had begun to decline in the New York City print world.[32]

The reputation of one British-born printmaker, Robert Havell Jr., preceded his arrival in New York City in 1839 and remained elevated owing to the popularity of the double-elephant-folio engravings with aquatint and hand coloring he had made after John James Audubon's watercolors for *The Birds of America* (1827–38). Havell produced two colorful panoramas of New York Harbor from the North and East rivers before midcentury (cat. no. 129; fig. 156).[33] That this artist's American prints were known in England is suggested by his collaboration with Rudolph Ackermann, the name and address of whose firm appear on the fifth state of Havell's *Panoramic View of New York (Taken from the North River)*. The popularity of Havell's scenes of New York Harbor inspired Italian-born Nicolino Calyo, who settled in New York City about 1835, to produce copies of the prints as gouache drawings.[34] Calyo is best known today for his gouaches of the Great Fire (cat. nos. 110, 111) and his charming studies of peddlers crying their wares on the streets of New York (see fig. 25).

Several British-born dealers ran successful printshops in New York City beginning in the 1820s. One of the most important of these emporiums was established by George Melksham Bourne, who in 1828 was responsible for republishing the popular Wall views *New York from the Heights near Brooklyn* (fig. 1)

28. See Deák, *William James Bennett*, p. 28; and Koke, "John Hill," pp. 69, 109.

29. Deák, *Picturing America*, pp. 238, 244–45.

30. Deák, *William James Bennett*, p. 30.

31. Deák, *Picturing America*, pp. 315–18. See also Barbara N. Parker, "George Harvey and His Atmospheric Landscapes," *Bulletin of the Museum of Fine Arts* (Boston) 41 (February 1943), p. 8; and Donald A. Shelley, "George Harvey and His Atmospheric Landscapes of North America," *New-York Historical Society Quarterly* 32 (April 1948), p. 106.

32. Those who received sets are listed in Cowdrey and Sizer, *American Academy of Fine Arts and American Art-Union*, vol. 1, *Introduction*, p. 173.

33. See Deák, *Picturing America*, p. 336.

34. I am grateful to Leonard L. Milberg for bringing these works to my attention.

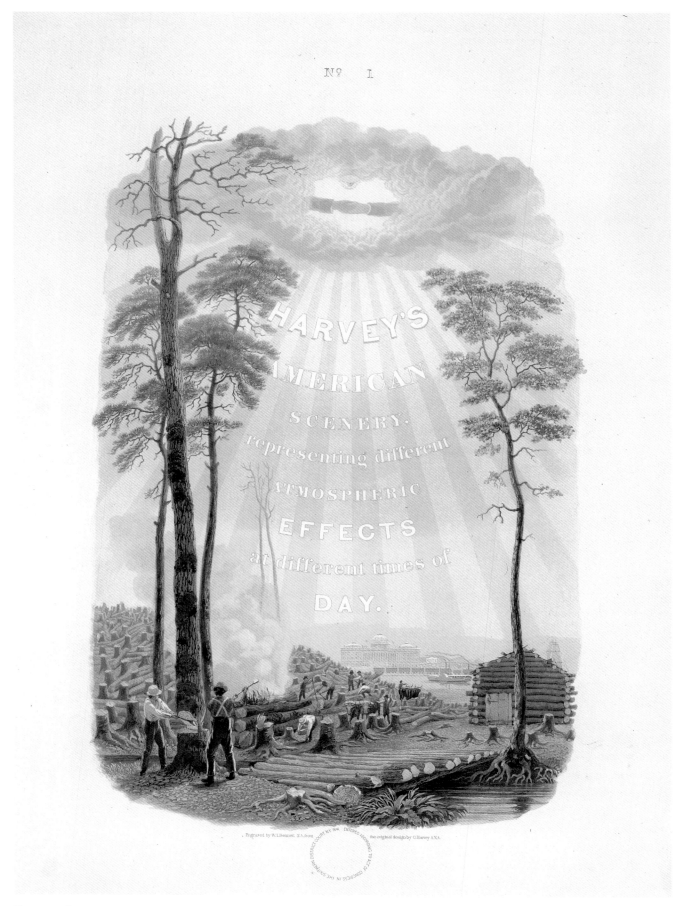

Fig. 155. William James Bennett, after George Harvey, Title page to *Harvey's American Scenery, Representing Different Atmospheric Effects at Different Times of Day* (New York: Printed by Charles Vinten, 1841), 1841. Aquatint with hand coloring. The New York Public Library, Astor, Lenox and Tilden Foundations, Miriam and Ira D. Wallach Division of Art, Prints and Photographs, The Phelps Stokes Collection, Print Collection

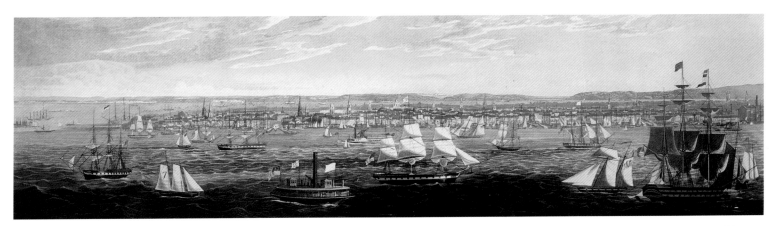

Fig. 156. Robert Havell Jr., *Panoramic View of New York, from the East River*, 1844. Engraving and aquatint with hand coloring. The Metropolitan Museum of Art, New York, The Edward W. C. Arnold Collection of New York Prints, Maps, and Pictures, Bequest of Edward W. C. Arnold, 1954 54.90.643

and *New York from Weehawk* (Weehawken), first printed by Hill in 1823.[35] Bourne, who also sold stationers' and artists' supplies from his store at 359 Broadway, was probably the shop owner targeted for criticism by the *New-York Mirror*, which devoted an entire column to the "obscenity of printshop-windows" in 1833, only two years before Durand created his controversial large-scale engraving of John Vanderlyn's nude *Ariadne Asleep on the Island of Naxos* (cat. no. 125). Americans were not yet ready to accept nudes—either in paintings, prints, or, for that matter, sculptures—as suitable subjects for contemplation by the public. According to the anonymous journalist who wrote the *Mirror* article: "Immoralities, so obvious and so gross, demand the prompt attention of every conductor of a public press."[36] So great was his outrage that he actually envisioned a situation in which Mrs. Trollope might constructively criticize American society (the English writer's *Domestic Manners of the Americans* had been published in England the previous year):

> *If Mrs. Trollope, instead of caricaturing the poor or the uneducated people, scattered over half settled tracts of country, had held up a few of the New-York printshop-windows to the astonishment and disgust of the British public, she would have wandered less from the truth, and the notoriety of the facts would have kept us dumb, or been testified to by all her countrymen as well as our own. We trust, hereafter, to see this loathsome and insolent trash withdrawn. Shall decency be thus outrageously violated, in the most frequented promenades of the city, merely that the attention may be attracted of now and then half a dozen customers, who are willing to*

> *encourage impropriety? Such an impudent insult to men, as well as to women and children, has been endured long enough.*[37]

For the most part, British engravers in New York concentrated their efforts on high-quality aquatints for connoisseurs; American engravers, meanwhile, were honing their skills by producing prints for the popular and commercial markets. Based in Newark, New Jersey, Peter Maverick rose to prominence as the most important American printmaker to New York City during the early decades of the nineteenth century. To support himself and his large family, which included sixteen children by 1822, Maverick diversified his output, making engravings for illustrated books, maps, banknotes, and trade cards. He also trained many apprentices who eventually set up shop in the metropolitan region. In 1816, as a tribute to Maverick's personal achievements and his dedication to training students, Archibald Robertson invited the master printer to join the American Academy of Arts (later known as the American Academy of the Fine Arts). Like Robertson, who taught drawing at his own New York Academy, Maverick engraved plates for a book of elementary exercises for apprentices.

Among Maverick's most important pupils was Asher B. Durand, an artist who would later dominate the field of engraving and landscape painting in New York City. After finding his way to Maverick's Newark shop as a young man, Durand set to work lettering Maverick's plates and copying from prints.[38] At the end of his apprenticeship, in 1817, Durand entered into partnership with Maverick and by October of that year had established himself in

35. Koke, "John Hill," pp. 100, 103.
36. *New-York Mirror*, August 10, 1833, p. 47.
37. Ibid.
38. See Stephens, *The Mavericks*, p. 48.

Fig. 157. Asher B. Durand, after John Trumbull, *The Declaration of Independence*, 1821. Engraving, second state. The Metropolitan Museum of Art, New York, Bequest of Charles Allen Munn, 1924 24.90.1514

39. Ibid., p. 53.
40. For a more extensive description of the relationship between banknote engraving and painting of the period, see Maybelle Mann, "The Arts in Banknote Engraving, 1836–1864," *Imprint* 4 (April 1979), pp. 29–36.
41. See William H. Dillistin, "National Bank Notes in the Early Years," *The Numismatist*, December 1948, pp. 796–97.
42. I am particularly grateful to Mark D. Tomasko for sharing with me his expertise on American banknotes and the New York banknote industry. See Mark D. Tomasko, *Security for the World: Two Hundred Years of American Bank Note Company* (exh. cat., New York: Museum of American Financial History, 1995).

New York City in the business, renamed Maverick and Durand. It was there in 1820 that the history painter and portraitist John Trumbull inquired about commissioning an engraving to promote his painting *The Declaration of Independence* (fig. 157), a proposition Durand accepted; in so doing he engendered the wrath of Maverick, who severed their partnership.[39]

Since commissions to reproduce paintings were few and far between, Durand concentrated on the bread-and-butter business of banknote engraving in order to survive, as did other leading American artists of the period, including Durand's own pupil John Casilear, as well as James Smillie and Kensett. Between 1836 and 1863, when there were no federal regulations or standards for printed paper money, New York City emerged as a mecca for banknote engravers.[40] Even after Congress authorized a national currency in 1863, paper money continued to be printed by private companies in New York until

1875, when the work was divided between the Continental Bank Note Company in New York, which printed the green backs of the bills, and the Columbian Bank Note Company in Washington, D.C., which printed the black fronts and seal of the Bureau of Engraving and Printing.[41]

Banknote engravers were expected to supply fanciful vignettes of allegorical figures, detailed portraits, and an elaborate array of calligraphic strokes. These were executed with a tool called the graver, which the artist had to wield with virtuoso skill in order to foil counterfeiters. With the advent of black-and-white photography in 1840, counterfeiters could create photographic reproductions of bills, but printers kept one step ahead of them by printing the bills in colored inks. Green was eventually selected as the color for federal currency because it was the most difficult to simulate when color photography was in its infancy.[42]

Between 1824 and 1833 Asher Durand and his brother Cyrus dedicated themselves to designing paper currency. Benefiting from the technical expertise of Cyrus and of Asa Spencer, who are credited with inventing the geometric lathe for engraving the intricate linear designs on banknotes,[43] Asher formed a partnership in 1828 with Jacob Perkins, a technological innovator of the steel die and cylinder diesinker.[44] One of Durand's sample sheets dating from the years when he was associated with Perkins illustrates his inventiveness and facility as an engraver and attests to his command of the current technology (cat. no. 116). The sample sheet is a display of vignettes, many in the form of allegorical figures and their attributes. It was mailed around the country to bankers responsible for selecting the motifs and designs for bills issued by the institutions they represented (see cat. no. 115). The creases on the sample reflect the folding and unfolding that occurred as the sheet made its way through the mail service, a means of marketing prints that would be exploited later in the century to maximum effect by the popular New York lithographer Currier and Ives.

In 1830 Durand tested the market for high-quality reproductive engravings after paintings by American artists. He engraved two of Bennett's oils, *Weehawken from Turtle Grove* (fig. 158) and *The Falls of Sawkill, near Milford, Pike County, Pennsylvania,* for a project entitled *The American Landscape.* Poet William Cullen Bryant was to provide the text, and Durand planned to execute sixty engravings after works by the leading landscape painters of the day to fill ten volumes of six prints each. A writer for the *New-York Mirror,* which was instrumental in cultivating an audience for print production in New York City, endorsed Durand's project in the following terms:

To those who are fond of the charms of nature in all her grandeur, loneliness, and magnificence, as well as in her softer features; to those who feel their hearts warm and expand at the contemplation of American scenery, pictured by American artists, and embellished by American writers, we warmly recommend this production. It would reflect disgrace on the taste as well as the patriotism of our countrymen were it to fall to the ground for want of patronage.[45]

Although *The American Landscape* was abandoned after publication of the first installment of six prints, the *New-York Mirror* reproduced Bennett's two designs

for engravings by Durand in 1833 along with accompanying descriptions by Bryant.

In the early 1830s Durand began work on an engraving after John Vanderlyn's oil of 1812, *Ariadne Asleep on the Island of Naxos,* an important American painting with a classical theme, which he had purchased with the intention of copying it as a print. When Durand's large engraving appeared in 1835, it received high praise from a small circle of New York artists and connoisseurs, notably the avid print collector Henry Foster Sewall, who purchased several of the progressive proofs (see cat. no. 125).[46] But despite its virtuosity, Durand's *Ariadne* was a financial failure, most likely because of its controversial subject matter, a female nude. Thereafter Durand turned his attention to painting, executing only an occasional engraving, such as a few small plates for James Barton Longacre and James Herring's monumental *National Portrait Gallery of Distinguished Americans.* Although Durand failed to interest sufficient individual collectors in purchasing prints of *Ariadne,* he set a high standard for the American engravers who followed him in the 1840s and 1850s, when the market for reproductive prints of American paintings blossomed with the support of the Apollo Association and its successor organization, the American Art-Union.

43. See Alice Newlin, "Asher B. Durand, American Engraver," *Metropolitan Museum of Art Bulletin,* n.s., 1 (January 1943), pp. 165–70. See also John Durand, *The Life and Times of A. B. Durand* (New York: C. Scribner's Sons, 1894), pp. 70–72.

44. See Newlin, "Asher B. Durand," pp. 165–70. Newlin writes (p. 167): "Perkins substituted steel for copper, which had previously been the standard material for engraved plates. The small bank-note designs were engraved on separate plates of soft steel, which were then hardened by a process he invented. These intaglio designs were transferred, under heavy pressure, in a transfer press to a soft steel cylinder, from one half to three inches wide, on which the designs then appeared in relief. The cylinders, or transfer rolls, were in turn hardened and served as dies from which a complete intaglio plate for a bank note could be rolled out in the press by combining a number of vignettes, portraits, or decorative and denominational designs in any variety desired." See also Henry Meier, "The Origin of the Printing and Roller Press," *Print Collector's*

Fig. 158. Asher B. Durand, after William James Bennett, *American Landscape, Weehawken from Turtle Grove.* Engraving, from the *New-York Mirror,* April 20, 1833. The Metropolitan Museum of Art, New York, Gift of Mrs. Frederic F. Durand, 1930 30.15.59

Quarterly 28 (1941), pp. 9–55; and Barbara Gallati, "Asher B. Durand as an Engraver," in *Asher B. Durand, an Engraver's and a Farmer's Art* (exh. cat., Yonkers: Hudson River Museum, 1983), p. 16.

45. *New-York Mirror*, January 8, 1831, p. 214, as quoted in Deák, *William James Bennett*, pp. 34–35.

46. The *American Monthly Magazine* (5 [April 1835], pp. 159–60) exalted Durand's achievement in the medium of engraving, which had already begun to fall out of favor in Manhattan.

47. Edward K. Spann, *The New Metropolis: New York City, 1840–1857* (New York: Columbia University Press, 1981), pp. 37–38. Harper's inexperience, however, contributed to his becoming "the first in a long line of reform-minded mayors who vanished from government almost as quickly as they came."

48. For an excellent discussion of the *National Portrait Gallery* and its context, see Gordon M. Marshall, "The Golden Age of Illustrated Biographies," in *American Portrait Prints: Proceedings of the Tenth Annual American Print Conference*, edited by Wendy Wick Reaves (Charlottesville: University Press of Virginia, for the National Portrait Gallery, Smithsonian Institution, 1984), pp. 29–82; and Robert G. Stewart, *A Nineteenth-Century Gallery of Distinguished Americans* (exh. cat., Washington, D.C.: National Portrait Gallery, Smithsonian Institution, 1969).

49. Edwin G. Burrows and Mike Wallace, *Gotham: A History of New York City to 1898* (New York: Oxford University Press, 1999), p. 433.

50. For an excellent overview of the role of the popular press in portraying the nineteenth-century American city, see Sally Lorensen Gross, *Toward an Urban View: The Nineteenth-Century American City in Prints* (exh. cat., New Haven: Yale University Art Gallery, 1989).

51. In a lengthy article entitled "A History of Wood Engraving," by An Amateur Artist, *Graham's* noted: "It may not probably be known to ordinary readers that while a copperplate-engraving begins to fail after two or three thousand copies have been taken from it, and is worthless after six or

The financial panic of 1837 notwithstanding, New York City's mercantile class prospered, and with prosperity came leisure and a desire to cultivate literary and cultural pursuits. New Yorkers began to stock their private libraries with books, many of which were temptingly illustrated with engravings. That a background in book publishing was considered not unworthy of a political leader was reflected in the overwhelming victory in the mayoral election in April 1844 of James Harper, founder of Harper and Brothers publishing house.[47] New York offered fertile ground for major printing houses, which required large-scale presses, a steady supply of paper, and a substantial workforce. With the rise of the printing trade, the city began to rival Philadelphia and Boston as a major center for publishing of all kinds. One of the first important illustrated books produced during the Empire City's development into a major printing and publishing center was the *National Portrait Gallery of Distinguished Americans*, a collaborative effort between Philadelphia artist Longacre and New York artist Herring (see cat. no. 122A, B). Before securing the full financing he required, Longacre began work in late 1830 or early 1831 on a project he had long dreamed of realizing, a book of illustrated biographies of distinguished Americans.[48] When Herring issued his own prospectus for a similar project in October 1831, it came as a complete shock to Longacre that there existed a rival in a field he believed was his alone. The two artists joined forces, however, and together they planned a publication that resembled Herring's proposal for a literary portrait gallery of figures from America's past and present that would commemorate their contributions to the rising nation. Attempting to reach as broad an audience as possible, the partners issued the series in several formats, utilizing papers of different qualities and several bindings, including both cloth and special embossed plaque bindings of long-grained green or red morocco, as well as unbound sheets. Despite various financial setbacks, the *National Portrait Gallery*, produced in four volumes between 1833 and 1839, stands among the highest achievements of American engravers during the first half of the nineteenth century.

Along with magazines and books, newspapers flourished in New York, and they were increasingly accompanied by illustrations. Since 1818 packet boats had been departing on a regular schedule from New York Harbor to Liverpool and Le Havre, bringing international news and publications back to the city.[49] As the distance between New York and the rest of the world narrowed, readers of the popular press began to expect the latest reportage. Illustrated newspapers thrived as editors realized that stories were more titillating when accompanied by spectacular pictures of people and current events.[50]

Most popular newspapers and periodicals were illustrated with wood engravings, which were considered technologically unsophisticated by metal-plate engravers, who were assured a place above the salt in the hierarchy of printmakers. There were several practical reasons why wood engravings supplanted engravings on steel in the popular press. Paramount was the fact that wood engravings could be printed at the same time as movable type and on both sides of a sheet of paper; they were thus cheaper and more efficient to use than metal engravings, which had to be printed on a different kind of press and on separate pages from the type. Moreover, the end-grain blocks on which wood engravings were cut were tougher than copperplates and nearly as durable as steel plates.[51] Further tipping the scales in favor of wood engravings was the fact that large illustrations could be prepared quickly by dividing the composition among several blocks and farming them out to a fleet of cutters, who worked simultaneously on small portions of the image. When all the blocks had been completed and were bolted together, the master cutter was responsible for joining the lines between them to form one continuous composition. The aesthetics of the humble and ubiquitous wood engraving also had its admirers; *Gleason's Pictorial Drawing-Room Companion* published the following assessment of the technique in 1852:

> *The taste for wood engraving has, . . . constantly grown, and now gives employment to a host of admirable artists, both as designers and as engravers. . . . The number of periodicals, especially weekly ones, that are now illustrated by wood engravings is great. The great beauty, taste and finish of the illustrations, and the spirit with which all the important passing events are seized upon, and by which whole galleries of scenes of the hour are given, making the chief personages of the day, and the places in which they perform their public duties, or pursue their pleasures, as familiar to the eye, as the press does to the mind, deserve particular notice.[52]*

Innumerable wood-engraved illustrations of a vast range of subjects were produced in New York City between the opening of the Erie Canal and the beginning of the Civil War. This is in part attributable to

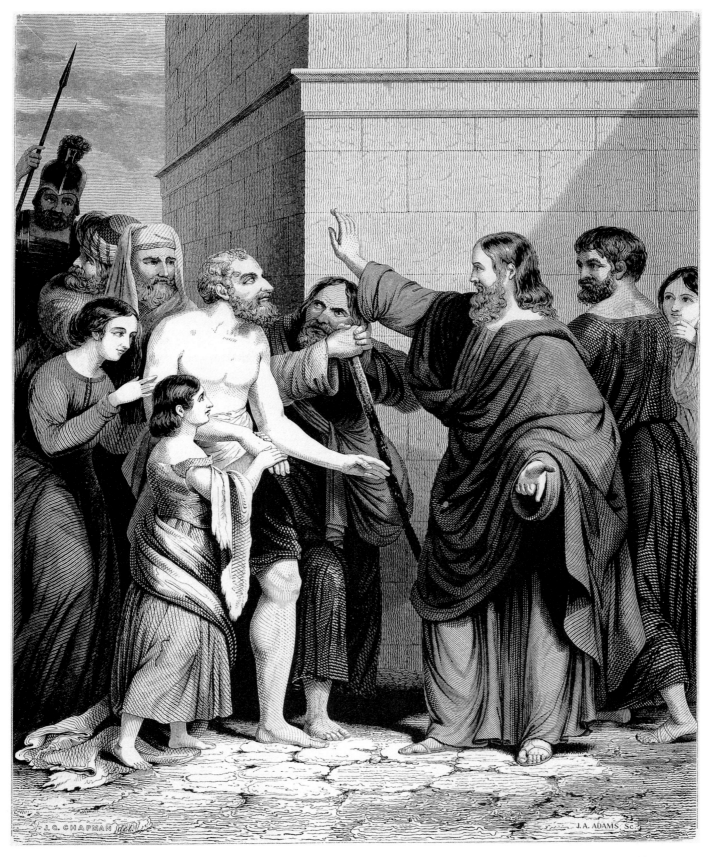

Fig. 159. John Gadsby Chapman, *Christ Healing Bartimeus*, frontispiece to the New Testament. Wood engraving, from *The Illuminated Bible, Containing the Old and New Testaments, Translated Out of the Original Tongues, and with the Former Translations Diligently Compared and Revised* (New York: Harper and Brothers, Publishers, 1846). The Metropolitan Museum of Art, New York, Harris Brisbane Dick Fund, 1939 39.93

144 PERSPECTIVE.

horizontal line through the point on which his leading figure stands, he takes the height of that figure (say six parts, or six feet), which, reduced to a scale on that line, gives all that he requires as a basis for after-operations. He must now decide upon the point of sight, which necessarily gives with it the line of the horizon, then the distance of the picture, etc. If he desires to tesselate the floor, for instance, lines drawn from the point of sight through the divisions on this horizontal line will repeat the scale as justly on the ground line and throughout the whole perspective plan of the picture as if he had begun as first suggested; the horizontal line first assumed, serving the practical purposes of a base line and with equal efficiency.

62. Again, as in the case of a view that it would be almost impracticable, if it were even necessary, to reduce to a measured perspective plan, we may select any one object which may be considered as a definite standard, and on such premises reduce all other objects and details into perfect perspective harmony, by means most simple and easy. In the case before us, it would be as difficult as unnecessary to draw a geometrical plan. It is easier to tesselate a

pavement and define every inch of it than to tesselate the traceless ocean, and yet do objects floating on its calm or disturbed surface come as equally within the government of the laws of perspective. Here we have all our lines of operation and verification to assume, except our line of the horizon and point of sight. Whichever object we select as our standard, if it be the sloop (B) nearest to us, for instance, we take its full height by a perpendicular from its vane to a central point between the water lines which mark its floating position on the perspective plane of the picture (64), and connect the extreme points of this perpendicular with the point of sight. We next decide upon the position of the ship (A) by the line F F. Supposing the ship (A) to be *three* times the height of the sloop (B), a perpendicular elevated anywhere on the line F F three times the height that the sloop would be if she were perspectively on that line (F F), will give the true height of the ship as exemplified; for it is evident that if the sloop were at the same distance as the ship (A), that is, on the line F F, her height would appear as indicated—a b—etc. Again, still more remote from us, let us suppose another ship (D) *four* times the height of the sloop, the horizontal line o o expressing that distance. By a like process do we attain the height of the ship D under such circumstances; while another ship (E), still more remote, supposed to be of the same height as A, may be thus equally, and by a similar method, brought into true

Fig. 160. John Gadsby Chapman, *Perspective in a Marine Scene*, from *The American Drawing-Book: A Manual for the Amateur and Basis of Study for the Professional Artist* (1847; New York: W. J. Widdleton, 1864), p. 144. The Metropolitan Museum of Art, New York, Harris Brisbane Dick Fund, 1954 54.425.2

improvements in technology that made it possible to reproduce both wood engravings and text by means of stereotyped plates. *Ballou's Pictorial Drawing-Room Companion* noted in 1857 that the American public's hunger for pictures was becoming insatiable: "The demand for pictures and engravings is gradually increasing among the people of our country as the means for procuring them becomes more abundant."[53] The more pictures and illustrations there were available, the more of them people wanted.

One of the most successful graphic artists in New York City, John Gadsby Chapman, produced two books with wood-engraved illustrations that appealed to a wide audience and sold so well that the artist

was able to retire to Italy. *The Illuminated Bible* (see fig. 159), which Chapman undertook in 1836, was issued in 1846 and carried the imprint of Harper and Brothers, the largest publishing house in New York City. The artist rendered the images so skillfully and in such fine detail that the illustrations resemble prints pulled from copper or steel plates. The publication was thus produced by the most economically efficient means and offered exceptionally good value because metal-plate engravings were thought at the time to bestow distinction on illustrated books.[54]

In 1847, at the height of a crusade to mandate drawing instruction in public schools, Chapman's *American Drawing-Book* was published in New York City, where it received high praise. Soon after the first installment appeared, the *Literary World* issued a lengthy notice encouraging readers to accept as an "axiom of education" Chapman's motto "Any one who can learn to write can learn to draw."[55] For the expanded edition of this comprehensive drawing book, published initially in 1858, Chapman enlisted Durand to render one of the landscape illustrations (cat. no. 132). *The American Drawing-Book* was widely favored by school boards for use in public schools and also served aspiring amateur and professional artists who did not have access to formal training. Self-taught artists such as Fitz Hugh Lane used the wood-engraved illustrations in *The American Drawing-Book* as the basis for their own drawings and oils.[56] Many of Lane's panoramic seascapes of Boston, as well as his view of New York Harbor (cat. no. 35), recall Chapman's diagrams for rendering perspective in a marine scene, for instance. The popularity of *The American Drawing-Book* ultimately cultivated among American artists and their patrons a taste for marine pictures that could be analyzed according to Chapman's specific drawing instructions (see fig. 160).

Daguerreotyped portraits became popular during the 1840s, replacing more expensive oil portraits in bourgeois households, although not among the wealthy or socially prominent. Recognizing a new source of illustrative material to please their readers, the editors of newspapers and books began to commission wood and steel engravings after daguerreotypes and print them along with stories printed with steel type. One noteworthy example of an engraving appeared as the frontispiece of the first edition of Walt Whitman's *Leaves of Grass*, published in 1855 (cat. no. 146).[57] By virtue of its association with the increasingly ubiquitous medium of daguerreotypy (see cat. no. 163), the portrait would have suggested to the readers of Whitman's book of poems that the

Fig. 161. After Winslow Homer, *The Ladies' Skating Pond in the Central Park, New York.* Wood engraving, from *Harper's Weekly,* January 28, 1860. The Metropolitan Museum of Art, New York, Harris Brisbane Dick Fund, 1928 28.111.1 (3)

author was a man of the people. Whitman's unconventionality and informality are conveyed by his open collar, broad-brimmed hat, and air of approachability, in contrast to the stiff poses and costumes of the subjects of the traditional portraits engraved on steel in the *National Portrait Gallery.*

Manhattan gradually eclipsed Boston and Philadelphia as a destination for aspiring artists seeking gainful employment in printmaking. Winslow Homer's early career as a printmaker illustrates this shift in opportunities during the final decade before the Civil War. From the 1830s until the 1850s, Boston was home to several active print workshops that employed apprentices. Between 1855 and 1857 the firm of John H. Bufford, who was an acquaintance of Homer's father, trained the young artist in lithography. Homer described his life at Bufford's, churning out lithographs to illustrate sheet music and books, as "bondage" and "slavery."[58] After completing his apprenticeship, Homer set up on his own in Boston as a freelance illustrator for a number of popular periodicals. Designing wood engravings based on sketches from life became his strong suit, and in 1857 he began working for *Harper's Weekly.* After producing several illustrations for the rising New

York periodical, Homer moved to Manhattan in 1859. The following year he took a studio at the main building of the University of the City of New York in Washington Square. The first drawing based on New York City life he submitted to *Harper's Weekly* shows the elegant crowd that gravitated on crisp winter days to the newly opened Central Park Skating Pond (fig. 161). Charles Parsons made a brilliant lithograph of the same subject about 1861 for Currier and Ives (cat. no. 153). As if to announce his arrival in New York City's art world, Homer boldly inscribed his signature below the figure of a graceful and dynamic male skater; the artist's calligraphic flourishes rendered on the wood block move with the same ease as the young man's blade on the ice.

While engraved illustrations proliferated in the popular press, the market for reproductions of major American and European paintings also strengthened. In 1835 Durand's engraving of Vanderlyn's *Ariadne Asleep on the Island of Naxos* had been a financial failure, chiefly because of its subject matter, but also because a class of newly sophisticated urban plutocrats had not yet come into existence in the United States. By 1860 there were 115 millionaires in New York City, and they and other wealthy business leaders

eight thousand, fifty or sixty thousand can be taken from wood-blocks, and yet more from steel, without detriment." *Graham's American Monthly Magazine of Literature, Art, and Fashion* 41 (December 1852), p. 568.

52. "Thomas Bewick," *Gleason's Pictorial Drawing-Room Companion,* March 6, 1852, p. 156.

53. "Something about Pictures," *Ballou's Pictorial Drawing-Room Companion,* November 21, 1857, p. 333. There was a simultaneous increase in the number of wood engravings that accompanied advertisements published in periodicals. Rita S. Gottesman has observed that from the publication of the first newspaper in New York City in 1725 until the end of the eighteenth century, only eighty-four newspaper advertisements were accompanied by wood engravings. See Rita S. Gottesman, "Early Commercial Art," *Art in America* 43 (December 1955), p. 34.

54. Sinclair Hamilton, *Early American Book Illustrators and Wood Engravers, 1670–1870* (Princeton: Princeton University Press, 1968), pp. 90–91.

Fig. 162. John Casilear, after Daniel Huntington, *A Sibyl*, 1847. Engraving published by the American Art-Union. Courtesy of the Pennsylvania Academy of Fine Arts, Philadelphia, John S. Phillips Collection 1876.9.32b

55. "How to Learn to Draw," *Literary World*, February 12, 1848, p. 29.

56. For a more detailed discussion of Chapman's drawing book and its impact on Lane, see Elliot Bostwick Davis, *Training the Eye and the Hand: Fitz Hugh Lane and Nineteenth Century American Drawing Books* (exh. cat., Gloucester, Massachusetts: Cape Ann Historical Association, 1993).

57. The caption states that the engraving is based on a daguerreotype; however, the original has never come to light.

58. As quoted in Nicolai Cikovsky Jr., "The School of War," in *Winslow Homer*, by Nicolai Cikovsky Jr. and Franklin Kelley (exh. cat., Washington, D.C.: National Gallery of Art, 1995), p. 17.

59. See Spann, *New Metropolis*, esp. chap. 9, "Wealth," pp. 205–41.

60. The prints were: *General Marion Inviting a British Officer to Dinner*, engraved by John Sartain after John Blake White (1840), and *The Artist's Dream*, engraved by John Sartain after George H. Comegys (1841); for illustrations, see Maybelle Mann,

and to extend among the people, the knowledge and admiration of the productions of 'HIGH ART.'"[62] It seemed, however, to the editor of the *Bulletin*, William J. Hoppin, that the committee's selection that same year of a mezzotint after George Caleb Bingham's *Jolly Flatboatmen* (cat. no. 127) failed to reflect the principles expressed in the resolution. The very name of the print, he claimed, "gives a death blow to all one's preconceived notions of 'HIGH ART.'"[63] Hoppin singled out for praise the other print offered to subscribers that year, Casilear's 1847 engraving after Daniel Huntington's painting *A Sibyl* (fig. 162), describing it as a work that "will amply atone for all that the other may lack."[64] In fact, Bingham's pyramidal composition is based on one of Raphael's great altarpieces, but his subject of boatmen dancing and singing on the Mississippi was so authentically American and so candidly presented that it seemed naive to many critics. In contrast, Huntington's portrait of a sibyl is a pastiche and its sources are obvious: Michelangelo's sibyls painted for the Sistine Chapel and Federico Barocci's proto-Baroque madonnas with eyes cast heavenward. A debate about what constituted "high art" ensued, and since the New York art world tended to favor European reproductive engravings, which were considered to be in that exalted category, the latter began to flood the marketplace as more and more European dealers established a foothold in Manhattan.

The ability of the American Art-Union to attract subscribers derived not so much from its annual gift of prints as from the lotteries of important oil paintings by American artists held annually on the association's Broadway premises. A lithograph by French-born Francis D'Avignon showing the distribution of prizes at an 1846 Art-Union lottery documents the social importance of these occasions (fig. 163). In 1848 the association's membership doubled because the offering that year consisted of four well-known paintings, Cole's Voyage of Life series (see figs. 49, 60). The *Literary World* described the excitement that gripped New York during the weeks before the drawing:

were ready to spend lavishly, on works of art as well as on clothing, jewelry, furniture, and entertainment.[59] The middle class, too, had become more sophisticated and was eager to acquire the trappings of culture. Reproductive engravings on steel found a new market, and new avenues opened up for their distribution and sale.

Each year, beginning in 1840, the Apollo Association, a New York institution engaged in promoting American art, offered its members a print of a painting by an American artist. In 1840 and 1841 the association's gifts to its membership were standard fare: engravings depicting a scene of the Revolutionary War and an allegory titled *The Artist's Dream*.[60] In 1842 the selection committee favored what was then considered "high art": an engraving by Stephen Alonzo Schoff after Vanderlyn's painting *Caius Marius on the Ruins of Carthage*. Their choice was lauded in the popular press as "one of the finest specimens of art in its kind ever produced in this country."[61]

Five years later the association, which had been renamed the American Art-Union in 1842, published a resolution in its *Bulletin* that described the criteria used to select prints for distribution among its members: "Resolved, That it is the duty of this Association to use its influence to elevate and purify public taste,

Everybody is the friend of the Art-Union . . . In the shifting panorama of dress, action, expression, and character, [one] would find a complete epitome of the city life . . . gentlemen . . . who drop in between nine and ten in the morning . . . are merchants in South and Front Street . . . Lawyers, brokers, stockjobbers, and financiers there are too, who on their "down town" way, give five minutes to the arts . . . [in] the middle of the day, [the] scene

grows brighter with bevies of ladies . . . it is in the evening . . . that the Art Union is in all its glory . . . Here they all . . . are, from the millionaire of 5th Avenue, to the B'hoy [tough] of the 3rd, from the disdainful beauty of Fourteenth Street . . . to the belle of the Bowery . . . all . . . are unanimous in their amazement at the stupendous realization *to somebody's five dollars, which will be afforded in Cole's four famous pictures.*[65]

As Art-Union members became more savvy about American painting, they demanded greater variety in the subscription prints. As the *Boston Daily Advertiser* expressed it in 1848:

The public have, long ago, seen quite too much of "The Jolly Flat-boat Men." . . . On every other center table will be Darley's illustrations [cat. nos. 133, 134], in every other parlor will hang the picture of Queen Mary [The Signing of the Death Warrant of Lady Jane Grey]. *. . . . There is, therefore, really no inducement for a subscriber to induce his friends to subscribe with him, for they will all together become weary of the pictures which meet them every day as they pass from house to house in friendly intercourse.*[66]

Since the process of producing a large engraving such as James Smillie's *Voyage of Life: Youth* after Cole (cat. no. 130) was labor-intensive, it was in fact advantageous for the Art-Union to diversify its offerings. In 1850 the association distributed a suite of smaller engravings to its members. The subjects reflect a range of interests among subscribers, including genre scenes (*The Card Players*, engraved by Charles Burt after Richard Caton Woodville, and *The New Scholar*, engraved by Alfred Jones after Francis William Edmonds), historical subjects (*The Image Breaker*, engraved by Alfred Jones after Emanuel Leutze), and, for the first time, landscapes (*The Dream of Arcadia*, engraved by Smillie after Cole, and *Dover Plains*, engraved by Smillie after Durand). The selection was highly acclaimed in the *Literary World*, which called the prints "pictorial treasures, now transmitting to thousands of homes through the country, making our painters among the authors and their books of the country, by the extent and character of diffusion."[67]

The American Art-Union was eventually brought down by its lottery system, which was declared illegal. When the institution closed in 1853, it had inculcated in the American public an appreciation for native art.[68] At the same time, Americans were becoming

Fig. 163. Francis D'Avignon, after T. H. Matteson, *Distribution of the American Art-Union Prizes at the Tabernacle, Broadway, New York, December 24, 1846*. Lithograph printed by Sarony and Major and published by John P. Ridner, 1847. The Metropolitan Museum of Art, New York, The Edward W. C. Arnold Collection of New York Prints, Maps, and Pictures, Bequest of Edward W. C. Arnold, 1954 54.90.1056

more sophisticated about European art, as reproductive engravings arrived from foreign ports on New York City's wharves each day and were rapidly purchased by dealers and auction houses. The demand for European prints was so great that New Yorkers were willing to compromise on quality. As New York art connoisseur and print publisher Shearjashub Spooner recounted, "I have seen thousands of mockproofs sold at auction in New York, from which, if they were mezzotints, the bloom was entirely worn off. . . . The London Art Journal frequently comes to us so much worn as to be useless except for the designs. They send us *pastiches,* or imitations of the old masters, and we buy them and hang them up in our rooms, and invite the connoisseur to see them, to excite his pity or contempt."[69]

British print purveyors continued to thrive in New York City throughout the 1840s and 1850s, although during those years Manhattan came of age as a center for print publication and began to compete successfully for prime projects initiated abroad. In several widely publicized incidents that document New York's rivalry with London's printing establishments, original English copperplates of famous works were shipped to New York City and used to produce American editions. In 1852 Spooner, who was an avid

The American Art-Union, rev. ed. (exh. cat., Jupiter, Florida: Distributed by ALM Associates, 1987), pp. 36–37.

61. Quoted in ibid., p. 5. See also Jay Cantor, "Prints and the American Art-Union," in *Prints in and of America to 1850,* pp. 300–301.

62. Quoted in Mann, *American Art-Union,* p. 15.

63. Quoted in ibid.

64. Quoted in ibid., citing *Literary World,* April 3, 1847, p. 209, as the source of Hoppin's article.

65. *Literary World,* November 25, 1848, p. 853, as quoted in Mann, *American Art-Union,* p. 19.

66. Quoted in Cantor, "Prints and the American Art-Union," p. 314.

67. "The Gallery of the American Art-Union," *Literary World,* May 10, 1851, p. 380. See also *Literary World,* November 30, 1850, p. 432; and Mann, *American Art-Union,* pp. 23–24.

68. According to Charles E. Baker, the following precepts for an American school of art were issued in the various publications of the American Art-Union: "Break the shackles of the past / Renounce subservience to Europe / Develop individuality / Paint native subject matter."

Fig. 164. Alphonse-Léon Noël, after William Sidney Mount, *The Power of Music,* 1847. Lithograph with hand coloring published by Goupil, Vibert and Company. The Museums at Stony Brook, Stony Brook, New York, Museum Purchase, 1967 67.12.1

See Charles E. Baker, "The American Art-Union," in Cowdrey and Sizer, *American Academy of Fine Arts and American Art-Union,* pp. 65–68. This passage is quoted in Mann, *American Art-Union,* p. 22.

69. Shearjashub Spooner, *An Appeal to the People of the United States in Behalf of Art, Artists, and the Public Weal* (New York: J. J. Reed, Printer, 1854), p. 12.

70. *The American Edition of Boydell's Illustrations of the Dramatic Works of Shakespeare, by the Most Eminent Artists of Great Britain. Restored and Published with Original Descriptions of the Plates* (New York: Shearjashub Spooner, 1852). The print of West's *King Lear* reproduced a painting that Robert Fulton had acquired together with West's *Ophelia* for his art collection housed in New York City. See Carrie Rebora, "Robert Fulton's Art Collection," *American Art Journal* 22, no. 3 (1990), pp. 41–63.

print collector, issued the first American edition of John and Josiah Boydell's *Shakespeare Gallery* using the original plates that the English engravers had prepared in London from 162 oil paintings of scenes from Shakespeare's plays, including an engraving after Benjamin West's *King Lear* (cat. no. 156; fig. 39).[70] Praising John Boydell as "the father of engraving in England," Spooner decried British attempts to sabotage his own efforts. After British journalists sought to libel his work in popular illustrated English newspapers that circulated widely in the United States, Spooner obtained his own certificate of approbation, signed in 1848 by numerous members of New York City's inner circle of art connoisseurs, who heartily endorsed his efforts to attract American subscribers.[71] The copperplates engraved by British artist Havell for American naturalist John James Audubon's double-elephant portfolio of *The Birds of America,* which had been published in London, traveled with Audubon to New York City in 1839.[72] Two decades later, working with the original copperplates, which had suffered damage in a fire, as well as with the hand-colored

Havell engravings, German immigrant Julius Bien combined forces with Audubon's son John Woodhouse Audubon to produce a double-elephant-folio edition of color lithographs offered at half the price of the original edition (see cat. no. 149).

During the 1840s French print dealers found the New York marketplace increasingly responsive to their wares. In 1846 Michael Knoedler traveled to "the American Athens" to establish a branch for his employer, Adolphe Goupil, and the following year he was joined there by Léon Goupil and William Schaus.[73] In October 1848 the New York press announced the opening of the firm—Goupil, Vibert and Company (later Goupil and Company)—which began to compete directly with the American Art-Union for the privilege of publishing engravings after foremost works by American artists. In 1848 William Schaus established the International Art-Union for Goupil, Vibert, ostensibly to cultivate a taste for European masterpieces in America but also to disperse its stock of contemporary French paintings, which were not popular abroad but appealed to a New York audience

eager for European sophistication.[74] In 1851 Goupil and Company symbolically undercut the American Art-Union, an avid promoter of Leutze's work, when it purchased the second version of Leutze's monumental painting *Washington Crossing the Delaware* (fig. 71) directly from the artist for $6,000.[75] Goupil also wooed American artist William Sidney Mount, who produced several lithographs after his own paintings with the French publisher, most notably *The Power of Music* (fig. 164), which was advertised in Goupil's French catalogue in 1850.[76] Mount, who did not have the opportunity to travel abroad, favored Goupil's International Art-Union, and observed in 1850: "I have long had a desire to see France, her great painters are dear to me. The works of Le Sueur, Le Brun, Poussin, Claude, Guérin, Regnault, Perrin, Jouvenet, Lairesse, David, and latterly, the Vernets, Delaroche, Scheffer, Debuffe [*sic*], etc., all have given me instruction and pleasure (principally through engravings of their works)."[77]

Periodicals of the era devoted to art are replete with the latest offerings to be found at Goupil. Indeed, the French dealer played a leading role in developing a taste in America for nineteenth-century French painting, and it is likely thanks to Goupil that an engraving after Paul Delaroche's *Hemicycle* received a silver medal at the New York Crystal Palace exhibition in 1853. In 1854 Spooner noted, probably in reference to Goupil's Broadway establishment (see fig. 55), "There are not only frequent day sales, where a catalogue of 150 or 200 pictures are offered, but there are two establishments in Broadway where French pictures and prints, books, &c., are sold every evening."[78] Spooner estimated that "New York alone cannot pay less than half a million annually"[79] on French prints and pictures, a sum that reflects the universality of the fashion since the consumers who bought prints were frequently on a more limited budget than those who bought paintings. In 1855 Goupil offered two engraved reproductions of paintings by nineteenth-century French artists that were received by the New York press with great acclaim: *Joseph Sold by His Brothers* after Horace Vernet, and *Dante and Beatrice* after Ary Scheffer (fig. 165). Goupil encouraged New York collectors to find virtue in these literary pictures, and they did in droves. In October 1855 *Putnam's Monthly*, which exhorted readers to see the Scheffer engraving, reported that the work on view at Goupil was "finer" than the painting, which had been much admired by New York audiences when it was exhibited there in 1848.[80]

Since the seventeenth century, reproductive prints depicting major monuments of Western art had

Fig. 165. Narcisse Lecomte, after Ary Scheffer, *Dante and Beatrice,* 1855. Engraving, proof before letters. The Metropolitan Museum of Art, New York, Gift of Mrs. Alice G. Taft, Miss Hope Smith, Mrs. Marianna F. Taft, Mrs. Helen Bradley Head, and Brockholst M. Smith 45.78.10

71. Spooner, *Appeal*, p. 23. The certificate published the following assessment of the proofs pulled by Spooner: "We, the undersigned, having examined some of the original copper-plates of *'Boydell's Illustrations of Shakspeare,'* and compared the proofs taken from them by Boydell himself, with those taken by *Dr. S. Spooner,* within the last few weeks, from a number of the plates restored by him, give it as our deliberate opinion and judgment, that his efforts to restore this magnificent work, have, so far, proved entirely successful; and we heartily recommend it to the American public as being in every respect worthy of their liberal patronage, and as eminently calculated not only to gratify those who may become its possessors, but also, to encourage and promote the advancement of the Fine Arts in our country."

72. The bibliography on Audubon is extensive. See especially Waldemar H. Fries, *The Double Elephant Folio: The Story of Audubon's Birds of America* (Chicago: American Library Association, 1973); Peter C. Marzio, "Mr. Audubon and Mr. Bien: An Early Phase in the History of American Chromolithography," *Prospects*, 1975, pp. 138–54; Ann Lee Morgan, "The American Audubons: Julius Bien's Lithographed Edition," *Print Quarterly* 4 (December 1987), pp. 362–78; and Annette Blaugrund, "John James Audubon: Producer, Promoter, and Publisher," *Imprint* 21 (March 1996), pp. 11–19.

73. Hélène Lafont-Couturier, "'Le bon livre' ou la portée éducative des images éditées et publiées par la maison Goupil," in *État des lieux* (Bordeaux: Musée Goupil, 1994), pp. 30–31. I am grateful to Richard MacIntosh of the Carnegie Museum, Pittsburgh, and Pierre-Lin Renié of the Musée Goupil for their generous assistance in locating Goupil prints and for bringing this catalogue to my attention.

74. Ibid., p. 31. See International Art Union, *Prospectus* (New York: Printed by Oliver and Brother, 1849).

75. Cantor, "Prints and the American Art-Union," p. 20. See also John K. Howat, "Washington Crossing the Delaware," *Metropolitan Museum of Art*

Fig. 166. Raphael Morghen, after Leonardo da Vinci, *The Last Supper,* 1800. Engraving, fifth state. The Metropolitan Museum of Art, New York, Gift of Lucy Chauncey, in memory of her father, Henry Chauncey, 1935 35.85.94

provided American artists with a basis for their training. Three art institutions in New York—the American Academy of the Fine Arts (founded in 1802); the National Academy of Design (founded in 1825); and the Cooper Union for the Advancement of Science and Art (founded in 1859)—maintained collections of reproductive prints for the use of artists and amateurs who were unable to travel abroad to view the European masters firsthand. The stipulation in the 1817 bylaws of the American Academy of the Fine Arts that the "tracing or chalking" of prints was strictly forbidden provides evidence for the common practice among artists of copying prints.[81] The National Academy of Design established a library as one of its initial projects, and in 1838 its council appropriated $400 to be used by the academy's president, Samuel F. B. Morse, for the purchase of books and engravings during his forthcoming sojourn in Europe.[82] The Cooper Union, which initiated regular drawing classes and opened a free reading room in November 1859, allowed both men and women access to books and current periodicals illustrated with prints between the hours of eight in the morning and ten at night, in order to fulfill the dream of founder Peter Cooper, who hoped to draw workers from "less desirable places of resort."[83] The importance of the role of reproductive engravings in New York art academies is expressed by a gesture of Morse, who was often considered an American Leonardo because of his artistic talent and scientific inventions. When he left his post as president of the National Academy, Morse presented his successor, Durand, with Raphael Morghen's engraving after Leonardo's *Last Supper* (fig. 166).[84]

Connoisseurs, perhaps anxious to temper their conspicuous consumption with social acceptability, emphasized the role of prints in cultural edification. Spooner, for example, observed that collecting prints was a useful activity, elevating personal taste generally and combining entertainment and instruction. In his introduction to *A Biographical and Critical Dictionary of Painters, Engravers, Sculptors, and Architects* (1852), this keen collector wrote that his passion afforded "an interesting amusement for every stage in life. . . . As with a masterful painting, so with the engraving, more beauties will constantly be discovered; so that a portfolio of fine prints is a source of endless instruction, amusement, and gratification—not only to the possessor, but to his friends and acquaintance[s]."[85] In his *Appeal to the People of the United States* of 1854, in which he requested government support for his proposal to execute engravings after the major masterpieces of Western art housed in the Musée du Louvre, Spooner attested that "these works were intended as a great treasury of art; from which not only artists, but the whole world might derive instruction and profit."[86]

Like Spooner, the wealthy art amateur Luman Reed, who assembled the foremost private New York collection of American art during the period, found prints a source of endless instruction, amusement, and gratification. Reed, who never traveled abroad,

gathered a large quantity of reproductive engravings after the great painters of the Italian Renaissance, which he used to hone his powers of discrimination (see cat. no. 155; fig. 167). Eager to share his collection with American artists and the public, who could visit his residence at 13 Greenwich Street once a week, Reed commissioned print connoisseur and architect Alexander Jackson Davis to design his picture gallery. Davis created a setting in which visitors could enjoy prints along with the paintings. In addition to two ottomans and twelve mahogany chairs, the gallery was furnished with "long, low mahogany tables . . . where the large books of engravings could be conveniently laid and examined."[87] In this room, Cole may have consulted Reed's impression of an engraving after Rubens's *Amazons on the Moravian Bridge,* 1623 (New-York Historical Society), an inspiration for the battling figures displayed in the foreground of *Destruction,* one of the five paintings in The Course of Empire series Reed commissioned from the artist (see figs. 91–95).

Although many of the private print collections formed between 1825 and 1861 in New York are now dispersed, extant auction catalogues and inventories of print collections that entered public institutions reveal certain preferences among the city's print connoisseurs of those years.[88] Attributions made in these lists to the great Italian Renaissance masters Leonardo, Raphael, and Michelangelo would be considered more than generous today. Art patrons who had taken the Grand Tour of Europe—John Allan and Spooner, for example—acquired reproductive engravings after major monuments no doubt as souvenirs of their firsthand experience of European art. In addition to Italian Renaissance art (see cat. no. 155; fig. 167), the national schools that are most strongly represented are the Flemish and Dutch (see cat. no. 154), French (see cat. no. 158), British (see cat. nos. 156, 157), and German. Within those schools there was a marked preference for eighteenth- and nineteenth-century British mezzotints and reproductive engravings and fine Northern Renaissance woodcuts and engravings, especially by the masters Albrecht Dürer (see fig. 64) and Lucas van Leyden. When prints are listed separately in the catalogues and inventories, a preference for intaglio prints, whether original works or

Bulletin 26 (March 1968), pp. 292–93. As Howat notes: "The *Bulletin of the American Art-Union* for April 1851 could not hide its displeasure with Leutze over his willingness to deal with Goupil, reminding its readers that the American Art-Union had 'done a great deal to advance Mr. Leutze to the position he now occupies.' The *Bulletin* went on to comment dryly: 'Mr. Goupil, it is said, is one of the best judges of art in Europe. He visited Düsseldorf on purpose to see this picture, and bought it immediately upon Leutze's own terms, viz., 10,000 thalers—about $6,000 of our money.'"

76. Lafont-Couturier, "'Le bon livre,'" p. 33.

77. William Sidney Mount to Goupil, Vibert and Co., Feb[ruary] 14, 1850, New-York Historical Society, quoted in Georgia Brady Barnhill, "Print Collecting in New York to the Civil War," delivered at the Eighteenth North American Print Conference, New York, April 1986, p. 14; and reproduced in Alfred Frankenstein, *William Sidney Mount* (New York: Harry N. Abrams, 1975), p. 160. Goupil was successful in promoting Mount's genre paintings abroad through his prints, especially those rendered on stone by French lithographers. One of several lithographs of minstrels executed by Mount with French printmakers, *Just in Tune* was published as a two-color lithograph, included as the third plate of a drawing book entitled *Études de portraits et groupes* (1850). See Lafont-Couturier, "'Le bon livre,'" p. 35.

78. Spooner, *Appeal,* p. 11.

79. Ibid.

80. "Plastic Art," *Putnam's Monthly* 6 (October 1855), p. 448; *Literary World* 3 (December 1848), p. 983.

81. *The Charter and By-laws of the American Academy of Fine Arts, Instituted February 12, 1802 under the Title of the American Academy of the Arts. With an Account of the Statues, Busts, Paintings, Prints, Books, and Other Property Belonging to the Academy* (New York: David Longworth, 1817), p. 20. See Davis, "Training the Eye and the Hand," chap. 3, "Drawing Books and Art Academies in the United States," esp. pp. 40–41: "The initial provisions allowed no book or print to be removed from the library,

Fig. 167. Conrad Metz, after Michelangelo Buonarroti, *Detail from the "Last Judgment,"* 1808–16. Soft-ground etching. Collection of The New-York Historical Society 1858.92.069

although every Academician and Associate was allowed free access to the materials, and 'upon application to the Keeper of the Academy or Librarian' was 'permitted to make sketches from the books or prints.'"

82. Eliot C. Clark, *History of the National Academy of Design, 1825–1953* (New York: Columbia University Press, 1954), pp. 18–19. See also Archives of the National Academy of Design, *Constitution and Bylaws of the National Academy of Design with a Catalogue of the Library and Property of the Academy* (New York: I. Sackett, 1843), pp. 27–30.

83. Thomas Micchelli, "Ex Libris Anno 1859: Books from the Original Cooper Union Reading Room," exhibition mounted December 10, 1998, through February 19, 1999. I am grateful to Dana Pilson, Administrative Assistant, Department of American Paintings and Sculpture, Metropolitan Museum, for calling this reference to my attention.

84. *Studies in Oil by Asher B. Durand, N.A., Deceased. Engravings by Durand, Raphael Morghen, Turner, W. Sharp, Bartolozzi, Wille, Strange, and Others, . . .* (Executor's sale, Ortgies' Art Gallery, 845 and 847 Broadway, New York, April 13–14, 1887), lot 54.

85. *A Biographical and Critical Dictionary of Painters, Engravers, Sculptors, and Architects from Ancient to Modern Times; with Monograms, Ciphers, and Marks Used by Distinguished Artists to Certify Their Works* (New York: George P. Putnam, 1852), p. xi. I am grateful to Georgia Brady Barnhill for this quotation, which she cites in "Print Collecting in New York to the Civil War," as an insert between pages 10 and 11.

86. Spooner, *Appeal*, p. 5.

87. Mrs. Jonathan Sturges [Mary Pemberton Cady], *Reminiscences of a Long Life* (New York: F. E. Parrish and Company, 1894), quoted in Ella M. Foshay, "Luman Reed, a New York Patron of American Art," *Antiques* 138 (November 1990), p. 1076.

88. I am indebted to Georgia Brady Barnhill for generously lending me a typescript of her lecture on New York print collections.

89. Quoted in Foshay, "Luman Reed," p. 1078.

90. I am indebted to Sue Reed,

reproductions, is evident. Only the occasional lithograph appears, usually a portfolio reproducing European scenery.

The general interest in both the Italian Renaissance masters and the Dutch and Flemish schools was encouraged by British art pundits, including John Burnet, whose popular instruction manual intended for professional and amateur artists, *A Practical Treatise on Painting, in Three Parts* (London, 1828), was read by collector Reed and artist Mount, among others. Burnet advised that "painters should go to the Dutch school to learn the art of painting, as they would go to a grammar school to learn languages. They must go to Italy to learn the higher branches of knowledge."[89]

The largest private print collection assembled in New York between 1825 and 1861 that survives relatively intact is Henry Foster Sewall's; his twenty-five thousand impressions became the core of the print holdings at the Museum of Fine Arts, Boston.[90] Sewall, whose goal in building his collection was comprehensiveness, sought prints by the Northern Renaissance school and acquired a fine selection of works by Rembrandt (see cat. no. 154), Dürer, and Lucas, among others. He also purchased a substantial group of contemporary American prints, among them Alexander Jackson Davis's lithographic portfolio *Views of the Public Buildings in the City of New-York* (see cat. nos. 70–72) and proofs representing several states of Durand's engraving *Ariadne* (cat. no. 125).

The popularity of American genre scenes at mid-century is reflected in the number of subjects in this category published by the American Art-Union. At the same time an interest in European genre scenes prevailed among print connoisseurs. One important New York collector living in Europe between 1829 and 1850, Thomas Jefferson Bryan (fig. 75), became infatuated with Jean-Antoine Watteau's distinctive presentation of the fête galante. Pursuing an interest unusual among his contemporaries, he acquired several fine examples of etchings after that French master to round out his collection of paintings, which were exhibited at the Cooper Union beginning in 1858, when they were highly acclaimed in the *Cosmopolitan Art Journal*.[91] Mount found inspiration in prints after paintings by the Scottish genre artist David Wilkie, whose influence was bolstered by the British popular press. One of the most widely read European art publications in New York, the *London Art Journal*, provided an engraving after Wilkie's *Blind Fiddler* (cat. no. 157) as a premium for subscribers, one of whom may have presented a copy to Mount.[92]

Catching the wave of interest in European reproductive engravings as it trickled down to those of more modest means, Andrew Jackson Downing recommended them as interior decoration in his influential book of 1850, *The Architecture of Country Houses:* "Nothing gives an air of greater refinement to a cottage than good prints or engravings hung upon its parlor walls. In selecting these, avoid the trashy, coloured show-prints of the ordinary kind, and choose engravings or lithographs, after pictures of celebrity by ancient or modern masters. The former please but for a day, but the latter will demand our admiration forever."[93] During the decade that followed, many New Yorkers took Downing's suggestion, whether they were living in a country or an urban residence.[94] In 1860 a Washington Square dealer named H. Smith, who stocked large and small reproductive lithographs of "single heads, groups, small and large full-length figures, flowers, fruit, and sacred subjects, by Portals, Chazal, Brochart, Rosa Bonheur, and others, colored by Carrie A. Rowand (Frost)," reminded the public that "scarcely any drawing-room is considered furnished without one or more paintings of this description."[95]

Already by 1857, when *Ballou's Pictorial Drawing-Room Companion* published an article titled "Something about Pictures," engravings of the highest quality were within the means of middle-class New Yorkers despite the financial panic of that year:

Colored and plain engravings are also another great means of pictorial pleasure and profit to our people; and here too we are struck with the great increase which there has been of late years in the demand for these works. Formerly, a few engravings piled up in one corner of booksellers' stores, supplied the whole demand, and were regarded as a drug by the trade, in consequence of their slow sale. Now there are large, commodious stores in all our cities and large towns, devoted exclusively to the sale of engravings, and the business affords ample present returns, and favorable prospects of steady increase. And with this great increase in the demand there has been a corresponding improvement in the character of the pictures, so that fine engravings which in former days were scarce, and of such high cost as to be found only in the portfolios of the rich, are now by improvements in the art, and a more extended market for them, made so cheap and plenty, as to put it within the reach of our citizens of moderate means to adorn their dwellings with them.[96]

As *Ballou's* further observed: "Side by side with the growth of the business in engravings, we witness also the increased demand for paintings. Almost every one now decorates his walls with oil paintings, and at a very moderate expense, and there is a constant change for the better going on in the quality of these pictures."[97]

For those who desired oil paintings but could afford only prints, engravings were colored by hand in the New York printshops. The process was expedited by using stencils to apply broad swaths of color; nonetheless, applying pigment to create the fine details required precision and time. To meet the demand for inexpensive colored prints, a huge lithography industry developed in the city.[98] Although lithographic stones were more expensive initially than metal plates, the rapidity and ease with which designs could be drawn on the stones ultimately made lithographs cheaper than intaglio prints, which were prepared by the more laborious process of

engraving a metal plate. Recognizing that by virtue of its speed and cheapness lithography served the masses, the young Nathaniel Currier described his fledgling New York lithographic firm—which he founded in 1835 and ran in partnership after 1857 with James Ives—as purveyors of "Colored Engravings for the People."[99] From 1857 until 1907—the lifetime of the firm—approximately seven thousand subjects were issued, and hundreds of each were sold to Americans in all walks of life.

Following the lead of the American Art-Union, Currier and Ives built a national distribution system that enabled the firm to dominate the marketplace for prints suitable for framing. The working parts of this well-oiled print-selling machine included the "traveling agent-peddler, the inscrutable fancy-goods middleman, the direct mail-order systems, the risky branch showrooms, and the fiercely competitive premium systems of national magazines."[100] The numerous subject categories for lithographs produced

Shelley Langdale, Clifford Ackley, and Patrick Murphy of the Museum of Fine Arts, Boston, for their generous assistance with researching Sewall, whose prints, which were purchased for the museum with funds from the Parker Bequest, are listed in four volumes housed in the Department of Prints, Drawings, and Photographs.

91. "Some Notices of Metropolitan Art-Wealth," *Cosmopolitan Art Journal: A Record of Art Criticism, Art Intelligence, and Biography, and Repository of Belle-Lettres Literature* 3 (1858–59), p. 85, published the following assessment of Bryan's collection: "Next in value and interest is the Bryan collection of Old Masters, now in the Cooper Institute building, on free exhibition. This gallery is also the fruits of the efforts of one man, Mr. Bryan, who has devoted a large fortune to the purchase of undoubted originals by the old painters, of the Italian, Spanish, Dutch, Flemish and French Schools, with a very few by the early English artists. . . . Some public institution ought to be possessed of this superb collection. It is barely possible that the worthy proprietor and the noble Peter Cooper may place it upon the basis of a perpetual charity, for the benefit of the School of Design for Women, now in successful operation in the Institute."

92. An example of the Wilkie engraving published by the *London Art Journal* is housed in the Department of Drawings and Prints, Metropolitan Museum.

93. A. J. Downing, "Treatment of Interiors," in *The Architecture of Country Houses* (New York: D. Appleton and Co., 1850; facsimile ed., with a new introduction by J. Stewart Johnson, New York: Dover Publications, 1969), p. 372.

94. See also E. McSherry Fowble, "Currier & Ives and the American Parlor," *Imprint* 15 (autumn 1990), pp. 14–19.

Fig. 168. Nathaniel Currier, *Awful Conflagration of the Steamboat "Lexington" in Long Island Sound on Monday Evening, January 13, 1840, by which Melancholy Occurrence over 100 Persons Perished*, 1840. Lithograph with hand coloring, published by Napoleon Sarony. Courtesy of the American Antiquarian Society, Worcester, Massachusetts

Fig. 169. Louis Maurer, *Preparing for Market*, 1856. Lithograph printed in colors with hand coloring by Currier. The Metropolitan Museum of Art, New York, Bequest of Adele S. Colgate, 1962 63.550.548

95. "Large and Small Crayon Lithographs," *Godey's Lady's Book and Magazine* 60 (June 1860), p. 565.

96. "Something about Pictures," *Ballou's Pictorial Drawing-Room Companion*, November 21, 1857, p. 333.

97. Ibid.

98. For a thorough discussion of the early years of chromolithography in the United States, see Marzio, *Democratic Art*, esp. chaps. 1–4.

99. The Currier and Ives bibliography is extensive. See Harry T. Peters, *Currier & Ives: Print-makers to the American People. A Chronicle of the Firm, and of the Artists and Their Work, with Notes on Collecting; Reproductions of 142 of the Prints and Originals, Forming a Pictorial Record of American Life and Manners in the Last Century; and a Checklist of All Known Prints Published by N. Currier and Currier & Ives*, 2 vols. (Garden City: Doubleday, Doran and Company, 1929–31); and *Currier and Ives: A Catalogue Raisonné. A Comprehensive Catalogue of*

by Currier and Ives—Views, Political Cartoons and Banners, Portraits, Historical Prints, Certificates, Moral and Religious Prints, Sentimental Prints, Prints for Children, Country and Pioneer Home Scenes, Humor, Sheet Music Covers, Mississippi River Prints, Railroad Scenes, Emancipation, Speculation, Horse Prints, and Sporting Events—attest to the firm's resourcefulness and thoroughness in leaving no stone unturned by their lithographers.[101] As the saying goes, fires always sell newspapers, and they certainly sold prints in a city frequently ravaged by flames. After establishing himself as a lithographer in New York, Currier rapidly made his early reputation with a lithograph of the burning of the Merchants' Exchange and reinforced it with the *Awful Conflagration of the Steamboat "Lexington,"* illustrating a disaster that occurred on Long Island Sound in January 1840 (fig. 168).[102]

Although several account books that record the firm's transactions survive, the edition sizes of particular prints are unknown. The only example that has been documented is a print in a series designed by Thomas Worth titled Darktown Comics, which was published in an edition of 73,000.[103] Given the

number of prints that survive today, it is reasonable to assume that the editions were large; the range of subjects was broad enough to ensure mass appeal. Astute at marketing, Currier and Ives essentially produced prints on speculation and maintained a large inventory. One 1851 sales catalogue indicates that the company had on hand 22,364 impressions.[104]

Currier and Ives implemented two types of print production. Whereas early lithographers such as Imbert worked closely with a single artist or patron to produce a print in an edition of perhaps fifty to one hundred copies, Currier and Ives was obliged to hire a group of artists and colorists to work together in a factory-like setting.[105] For maximum efficiency, the shop was organized so that designers were responsible for developing compositions and drawing them on the stones; after the lithographs were printed in black ink, they were colored in assembly-line fashion, as described by Currier and Ives scholar Harry Peters, based on his discussions with former members of the firm:

The "stock prints" were colored, in the [work] shop on the fifth floor at 33 Spruce Street, by a staff of

Fig. 170. George Endicott, after J. Penniman, *Novelty Iron Works*, 1841–44. Lithograph printed in colors with hand coloring. The Metropolitan Museum of Art, New York, The Edward W. C. Arnold Collection of New York Prints, Maps, and Pictures, Bequest of Edward W. C. Arnold, 1954 54.90.588

about twelve young women and girls, all trained colorists and mostly of German descent. They worked at long tables, from a model. Many of these models were colored by Mr. Maurer and Mrs. Palmer, and all were first approved by one of the partners. The model was put in the middle of the table, in a position that made it visible to all. Each colorist would apply one color, and then pass the print on to the next colorist, and so on until the print had been fully colored. It would then go to the woman in charge, who was known as the "finisher," and who would touch it up where necessary.[106]

Outside the workshop Currier and Ives supported a cottage industry of print designers and artists who submitted sketches for compositions and performed hand coloring, much of which was done by women working at home.

Before any print went into production, it was subject to final approval by one of the partners, and thus, despite their varied subjects and formats, lithographs by Currier and Ives displayed a characteristic appearance. Whether one considered their coloring brilliant or gaudy, that they appealed to a popular audience

was undisputed. None other than Charles Dickens alluded to their ubiquitous presence in New York when he recalled in his *American Notes* of 1842:

So far, nearly every house is a low tavern; and on the barroom walls, are colored prints of Washington, and Queen Victoria of England, and the American Eagle. . . . [And] as seamen frequent these haunts, there are maritime pictures by the dozen: of partings between sailors and their lady-loves, portraits of William, of the ballad, and his Black-eyed Susan; of Will Watch, the Bold Smuggler; of Paul Jones the Pirate, and the like: on which the painted eyes of Queen Victoria, and of Washington to boot, rest in as strange companionship, as on most of the scenes that are enacted in their wondering presence.[107]

Dickens's observations are consistent with Currier and Ives's own advertisements, which touted its pictures as "most interesting and attractive features for Libraries, Smoking Rooms, Hotels, Bar and Billard Rooms, Stable offices or Private Stable Parlors. Also, for display by dealers in Harness, Carriages, and House

the Lithographs of Nathaniel Currier, James Merritt Ives, and Charles Currier, Including Ephemera Associated with the Firm, 1834–1907 (Detroit: Gale Research, 1984).

100. Peter C. Marzio, "Chromolithography as a Popular Art and an Advertising Medium: A Look at Strobridge and Company of Cincinnati," in *Prints of the American West: Papers Presented at the Ninth Annual North American Print Conference*, edited by Ron Tyler (Fort Worth: Amon Carter Museum, 1983), p. 109.
101. Peters, *Currier & Ives*, pp. 209–10.
102. See James Brust and Wendy Shadwell, "The Many Versions and States of *The Awful Conflagration of the Steam Boat Lexington*," *Imprint* 15 (autumn 1990), pp. 2–13.
103. Peters, *Currier & Ives*, p. 42.
104. Ibid., p. 49.
105. Ibid., pp. 33–34.
106. Ibid.
107. Charles Dickens, *American Notes for General Circulation* (London: Chapman and Hall, 1842), chap. 6, pp. 137–38, as

Fig. 171. George and William Endicott, after "Spoodlyks" (possibly George T. Sanford), *Santa Claus's Quadrilles*, 1846. Lithograph. Courtesy of the American Antiquarian Society, Worcester, Massachusetts

Furniture of all descriptions."[108] In short, they were considered suitable decoration for a variety of public and commercial settings and were displayed in much the same way as other popular lithographs of the period, such as those by the firms of Endicott and Fay (see figs. 170, 173).

Among the designers who worked for Currier and Ives, those who demonstrated superior draftsmanship —Fanny Palmer, Parsons, Worth, and Louis Maurer— were frequently permitted to sign their names on the stone or include them in the margin of a print. That selective distinction likely served not only to enhance the value of particular prints but also to reward and retain such artists, who otherwise might have severed ties with the firm. Maurer's *Preparing for Market* (fig. 169) represents the cream of popular lithographic production in New York and shows Currier at its best.[109] Urban dwellers besieged by grit, noise, and bustling activity pined for the idyllic agrarian existence portrayed in many of the firm's characteristic prints, such as this one of 1856. Maurer, who was often the draftsman chosen to design the trotting scenes

THE NEW-YORK ELEPHANT, Pl. 3.

NATIONAL MONUMENT
to be erected at the top of New City-Hall.

Fig. 172. Adam Weingartner, *The New York Elephant,* from *The American Museum* (New York, 1851), pl. 3. Lithograph. The Metropolitan Museum of Art, New York, The Edward W. C. Arnold Collection of New York Prints, Maps, and Pictures, Bequest of Edward W. C. Arnold, 1954 54.90.1310 (3)

quoted in Peters, *Currier & Ives,* pp. 41–42.

108. "Portraits of the Great Trotters, Pacers, and Runners: Currier & Ives' Celebrated Cheap Popular Edition," as quoted in Marzio, *Democratic Art,* p. 61.

109. Harry S. Newman, *Best Fifty Currier & Ives Lithographs, Large Folio Size* (New York: Old Print Shop, 1938); and *Currier & Ives: The New Best Fifty* (Fairfield, Connecticut: American Historical Print Collectors Society, 1991).

Fig. 173. Augustus Fay, *Temperance, but No Maine-Law,* 1854. Lithograph. The Metropolitan Museum of Art, New York, The Edward W. C. Arnold Collection of New York Prints, Maps, and Pictures, Bequest of Edward W. C. Arnold, 1954 54.90.1054

Fig. 174. James A. Walker, *The Storming of Chapultepec, September 13, 1847*, 1848. Chromolithograph with hand coloring, published by Sarony, Major and Knapp. Amon Carter Museum, Fort Worth, Texas 1974.48

110. For an excellent and thorough discussion of the firm of George Endicott and its successors, see Georgia Brady Bumgardner, "George and William Endicott: Commercial Lithography in New York, 1831–51," in *Prints and Printmakers of New York State,* pp. 43–66. On Endicott's contribution to lithographic portraiture and his image of Fanny Elssler, in particular (cat. no. 126), see Wendy Wick Reaves, "Portraits for Every Parlor: Albert Newsam and American Portrait Lithography," in *American Portrait Prints,* pp. 83–134.

111. See Peters, *America on Stone,* pp. 171–79.

112. Spann, *New Metropolis,* p. 405.

113. Burrows and Wallace, *Gotham,* p. 435 n. 1; the authors observe that cheap docks "kept wharf-age rates down, enhancing the port's competitiveness."

that became increasingly popular after midcentury, displays his mastery of equine anatomy front and center in this composition; moreover, the unmatched pair of farm horses, one dapple gray and one black, exhibit to full effect his ability to coax the widest range of tones from the lithographic crayon. The bountiful display of produce from the farm, proudly exhibited in the foreground, would have undoubtedly caught the eye of savvy New York consumers, who were accustomed to choosing the best from a large selection of goods spread out to tempt them along the emporium of Broadway.

Although Currier and Ives dominates the story of lithography in New York City, the firm was not without its share of competition. Beginning in 1839 George Endicott ran a highly respected printing establishment, often employing the same artists as Currier and Ives. In addition to a steady business in printing sheet-music covers, George Endicott, the firm later named G. and W. Endicott and Endicott and Company, produced fine promotional lithographs printed in colors.[110] While located at 22 John Street in New York, Endicott issued *Novelty Iron*

Works (fig. 170), a lithograph that likely served to aggrandize the manufacturer.[111] The quality of the draftsmanship and the details of the activities at the wharf suggest that the image may have appealed to both suppliers and clients of the factory, which was the largest manufacturer of steam engines in New York.[112] The lithographer vividly conveys New York City's ability to facilitate light manufacturing owing to its superior port and warehouses.[113] The extent to which dock-front activity supported a whole host of industries is charmingly represented in the foreground, where several workers are dwarfed by the scale of a cast-iron wheel.

Endicott and other New York lithographers also supplied popular lithographs for sheet-music covers that would appeal to prospective purchasers and look attractive when displayed on the piano in a domestic setting. One such example of thousands produced by the firm shows an early picture of Santa Claus, who, after the fashion of Saint Nicholas, prepares to climb down a chimney. Produced by Endicott in 1846 and drawn by an artist identified only as "Spoodlyks," the print (fig. 171) recalls an engraving published in the

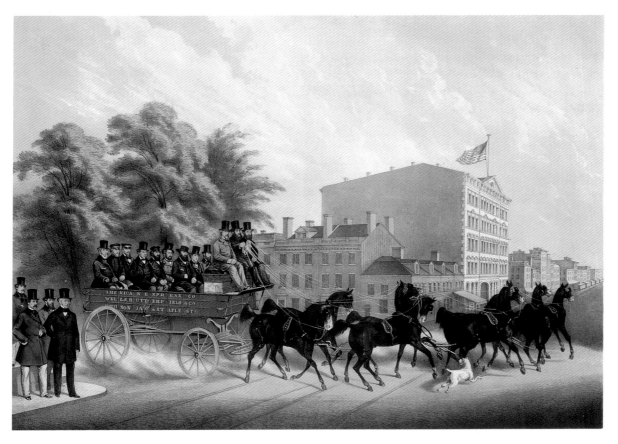

Fig. 175. Otto Bottischer, *Turnout of the Employees of the American Express Company,* 1858. Lithograph with hand coloring printed by Sarony and Major. The Metropolitan Museum of Art, New York, The Edward W. C. Arnold Collection of New York Prints, Maps, and Pictures, Bequest of Edward W. C. Arnold, 1954 54.90.763

New-York Mirror in 1841, purportedly the earliest depiction of Santa Claus in the United States.[114]

Another acknowledged master of lithography in the Empire City was Francis D'Avignon, who, in collaboration with Mathew B. Brady, produced one of the finest illustrated biographies of the time, *The Gallery of Illustrious Americans* (1850), which celebrated national unity by highlighting the virtues of twelve eminent Americans from every region of the Union. Considered without equal in the field, even in Europe, D'Avignon's portraits (see cat. no. 165A), based on daguerreotypes by Brady, were praised by New York lithographer Charles Hart as "highly finished, and classical in style, possessing all the beauty of the very best schools of lithographic art."[115] The book included biographical descriptions by Charles Edwards Lester that cast the twelve subjects as present-day republicans true in spirit to the ideals of ancient Rome and America's Founding Fathers.[116] Regally bound in royal blue cloth stamped in gold (cat. no. 165B), the volume took the "first prize away from all the world" at the 1851 Crystal Palace exhibition in London.[117]

The firm of Nagel and Weingartner produced not only important commemoratives of the Crystal Palace exhibition in New York but also sarcastic caricatures in the spirit of the British periodical *Punch* and the French *Charivari*. A previously unpublished lithographic pamphlet bearing the monogram of one of the firm's partners, Adam Weingartner, reflects that artist's special talent for caricature and inventiveness. Issued on April Fool's Day, 1851, the pamphlet vividly pokes fun at life in New York City. In one scene Weingartner alludes to P. T. Barnum's curiosities on view at the American Museum at Broadway and Ann Street: forming the body of an elephant representing Gotham are stonemasons and street people of every type found on Broadway (fig. 172).

Popular lithographers frequently produced prints with a political message. Currier and Ives contributed numerous examples, many of which were drawn by Worth. On occasion, political caricature achieved a scale and a level of finish more typical of fine prints. An example is Augustus Fay's lithograph of the Gem Saloon at the corner of Broadway and Worth (formerly Anthony) Street. Bearing the inscription

114. For discussion of the *New-York Mirror* frontispiece by Roberts after Ingham, see Jock Elliott, *"A Ha! Christmas": An Exhibition of Jock Elliott's Christmas Books* (exh. cat., New York: Grolier Club, 1999), pp. 44–45. Elliott suggests that the image in the *New-York Mirror* actually appeared before the same image was published in the *Dollar Magazine: A Monthly Gazette of Current American and Foreign Literature, Fashion, Music, and Novelty* 1 (January 1841).

115. See Charles Hart, "Lithography, Its Theory and Practice, Including a Series of Short Sketches of the Earliest Lithographic Artists, Engravers, and Printers of New York," 1902 manuscript, p. 175, Manuscript Division, New York Public Library. For a thorough discussion of D'Avignon, see William F. Stapp, "Daguerreotypes onto Stone: The Life and Work of Francis D'Avignon," in Reaves, *American Portrait Prints*, pp. 194–231.

116. In his description of Daniel Webster, for example, Lester associates the great orator with none other than General George Washington in the following passage: "July 4, 1826, our greatest festival, just half a century after the Declaration of Independence, two patriarchs of Freedom [Jefferson and Adams] left their blessing on the Nation, and died almost at the same hour. The day was hallowed by a holier consecration; and Webster commemorated the services of the ascended patriots. Finally, on the 22nd of February, 1832, which completed the century of Washington, he portrayed the character of the great deliverer. With these August names and occasions, the genius of Webster is linked forever." Charles Edwards Lester, *The Gallery of Illustrious Americans . . .* (New York: M. B. Brady, F. D'Avignon, C. E. Lester, 1850), Webster biography. I am grateful to Peter Barberie of the Princeton University graduate seminar on American prints for his research on *The Gallery of Illustrious Americans*.

117. Reflecting upon his achievements in an article published in *The World* in 1891, Brady recalled his work on *The Gallery of Illustrious Americans:* "In 1850 I had engraved on stone twelve great pictures of mine, all Presidential personages like

Scott, Calhoun, Clay, Webster, and Taylor; they cost me $100 a piece for the stones, and the book sold for $30. John Howard Payne, the author of 'Home, Sweet Home,' was to have written the letter-press, but Lester did it. In 1851 I exhibited at the great Exhibition of London, the first exhibition of its kind, and took the first prize away from all the world." George Alfred Townsend, "A Man Who Has Photographed More Prominent Men Than Any Other Artist in the Country—Interesting Experiences with Well Known Men of Other Days Look Pleasant," *The World*, April 12, 1891, p. 26.

118. Spann, *New Metropolis*, pp. 348–49.

119. Peters, *America on Stone*, p. 351; and Marzio, *Democratic Art*, pp. 49–51.

120. Quoted in Peters, *America on Stone*, p. 356.

121. Hart, "Lithography, Its Theory and Practice," as quoted in Marzio, "Chromolithography as Popular Art," p. 106.

122. Marzio, *Democratic Art*, p. 92.

"Temperance, but No Maine-Law," Fay's print of 1854 (fig. 173) displays a New York City barroom in all its glory. Businessmen at their leisure gulp down oysters, seal a deal with a handshake, gaze at the taxidermy display under glass, or dine in semiprivacy within a curtained banquette. The tavern, famous for housing the largest mirror in Manhattan, reflects one New York saloonkeeper's aspiration to sophistication expressed in the heavily encrusted ornamentation on the frame and the front panel of the bar. The men imbibing spirits support the inscription, which expresses opposition to a proposal—vigorously debated—to shut down all saloons or at least to enforce the laws requiring drinking establishments to close on Sundays.[118]

Along with political caricatures, New York lithographers offered a range of popular illustrations of contemporary events at home and abroad. Napoleon Sarony, who became one of the most successful lithographic publishers in New York, established his reputation with Currier's print of the burning of the steamboat *Lexington* in 1840 (fig. 168).[119] Sarony excelled at creating large compositions populated by numerous figures, such as the folio-sized prints of the Mexican War produced in partnership with Henry B. Major, who had also worked with Currier (see fig. 174). The partners rose to prominence printing the four folio prints of Commodore Perry's expedition to Japan in 1853. Sarony also worked with military lithographer Lieutenant Colonel Otto Bottischer, who drew on stone an animated scene of the top-hatted employees of the American Express Company sitting on the rapid stagecoaches for which the company was known (fig. 175). By 1859 Sarony and Major were dueling with Currier and Ives for preeminence as the leading lithographic firm in New York, proclaiming in one four-page advertisement that the company occupied four floors at 49 Broadway, had forty presses, and produced work "better than any done in this country, equalling that done abroad."[120]

Following the European upheavals of the 1848 Revolution, a number of German lithographers, notably John Bachmann, Charles Magnus, and Julius Bien, traveled to New York City, where they could take advantage of higher wages, "securing two dollars a day against forty and fifty cents a day in Germany."[121] The desperate need for skilled lithographers was reflected in United States immigration laws, which favored artisans trained in the field and encouraged them to join American firms. Although immigrant lithographers were allowed to bring in their own tools and other equipment duty free, they were not

Fig. 176. Nagel and Weingartner, Inscription page for John James Audubon's *Birds of America*, 1840–44. Lithograph with hand coloring. Museum of the City of New York, Gift of Arthur S. Vernay

allowed exemptions on "machinery or other articles imported for use in any manufacturing establishment," since these would enable them to compete with established American lithographic firms.[122]

Bachmann, who frequently published with the lithographic mapmaker Magnus, was an innovator of the bird's-eye view of Manhattan and a staunch promoter of the image of New York as the Empire City. Typical of the earlier city views that presented the panorama of bustling New York Harbor from sea level or slightly above it are examples by Bennett (cat. no. 128) and Havell (cat. no. 129). Henry Papprill, who with John William Hill made a spectacular aquatint of New York City from the steeple of Saint Paul's Chapel (cat. no. 135), took New Yorkers fascinated with city views to new heights from a traditional vantage point, the church steeple. In 1851 Williams, Stevens and Williams, the Broadway print dealer, advertised a "splendid Bird's-Eye View of the Empire City" in a commercial register published in New York. According to the advertisement, "To the mind of a

Fig. 177. Napoleon Sarony, *The Horse Fair, after the Celebrated Painting by Rosa Bonheur*, 1859. Lithograph printed in colors, published by Sarony, Major and Knapp. Courtesy of the American Antiquarian Society, Worcester, Massachusetts

stranger, this picture at once conveys a perfect idea of the exact location of New-York, with reference to surrounding parts, making it a most desirable acquisition to the Counting House of the Merchant, and a very satisfactory description to a friend abroad."[123] In 1855 William Wellstood and Benjamin F. Smith Jr. went higher still to view southern Manhattan from the "Heaven-kissing peak" of Latting Observatory (cat. no. 143).[124] The same year, perhaps inspired by Honoré Daumier's lithograph of French photographer Nadar sailing above Paris in a balloon, Bachmann produced a sky-high view of the Empire City, in which a flying machine hovers at the center of the uppermost margin (cat. no. 145). Bachmann later produced the most impressive antebellum view of Manhattan in his circular image *New York City and Environs* (cat. no. 150). He artfully distorted the landmass of the island to resemble the shape of North and South America, configuring New Jersey, to the west, as Asia and, to the east, Brooklyn and Queens as Europe and Africa. In Bachmann's image New York City looms at the center of the world.[125]

Until the late 1840s lithographs were printed in black and white and carefully colored by hand. Production of popular lithographs increased dramatically when skilled printers could effectively print in color using tint stones.[126] By inking a stone with a single color, such as blue for the sky or brown for the buildings, broad areas of color could be printed in a single pass through the press. In the case of DeWitt Clinton Hitchcock's *Central Park, Looking South from the Observatory*, 1859 (cat. no. 151), for example, the swaths of grass made possible by the Greensward Plan for the park and the urban sprawl surrounding it were printed on tint stones of green and brown.

With the advent of chromolithography came elaborately illustrated gift books. During the midcentury decades, about one thousand of these presentation volumes were produced.[127] New York City competed fiercely—although not always successfully—with Boston and Philadelphia for prime commissions, which previously were colored by hand. Between 1845 and 1854, Philadelphia printer John T. Bowen, for example, managed to edge out New York lithographers in the competition for the job of printing the hand-colored elephant-folio and octavo editions of John James Audubon's *Viviparous Quadrupeds of North America*, produced in collaboration with the artist's sons, Victor and John Woodhouse Audubon, who resided in Manhattan.[128] New York, however, did achieve one

123. *United States Commercial Register Containing Sketches of the Lives of Distinguished Merchants, Manufacturers, and Artisans with an Advertising Directory at Its Close* (New York: George Prior, 1851), New York Advertisements, p. 2, describes the print as follows: "Just completed. The only accurate and comprehensive View of New-York City & Environs. This VIEW is taken from opposite the easterly side, over Williamsburgh, and presents the entire length and breadth of the great CITY of NEW-YORK, delineating the outline of the *Jersey Shore*—showing *Jersey City* and *Hoboken*, the *North River, Governor's* and *Staten Islands*, the extensive *Bay* and the *Narrows*: on the left, a large portion of *Brooklyn*—the *Navy Yard* and *Williamsburgh* in the foreground. Against *New-York* reposes the forest of Shipping—its great Commercial stamp; while the *River* is studded with Steamers and Sailing Vessels.

DRAWN with the most careful regard to accuracy of position and perspective, in the relative location and height

of every prominent object, it combines an admirable view and an interesting picture." I am grateful to Austen Barron Bailly, Research Assistant, Department of American Paintings and Sculpture, Metropolitan Museum, and Brandy Culp, Research Assistant, Department of American Decorative Arts, Metropolitan Museum, for providing me with this reference.

124. *Frank Leslie's Illustrated Newspaper,* September 13, 1856, p. 214.

125. For European nineteenth-century bird's-eye views and panoramas, see Ralph Hyde, *Panoramania! The Art and Entertainment of the 'All-Embracing' View* (London: Barbican Art Gallery and Trefoil Publications, 1988); and Stephan Oettermann, *The Panorama: History of a Mass Medium,* translated by Deborah L. Schneider (New York: Zone Books, 1997).

126. For the rise of chromolithography in New York City, see Marzio, *Democratic Art,* esp. chap. 3, "New York and Düsseldorf: Mecca and Inspiration," and chap. 4, "The Giants of New York Lithography," pp. 41–63.

127. See Daniel Francis McGrath, "American Colorplate Books, 1800–1900" (Ph.D. dissertation, University of Michigan, Ann Arbor, 1966), p. 104; and Ralph Thompson, *American Literary Annuals and Gift Books* (New York: H. W. Wilson Company), 1936, p. i.

128. William S. Reese, *Stamped with a National Character: Nineteenth Century American Color Plate Books* (exh. cat., New York: Grolier Club, 1999), pp. 56–61.

129. McGrath, "American Colorplate Books," p. 104, as quoted in Thompson, *American Literary Annuals and Gift Books,* p. i.

130. McGrath, "American Colorplate Books," p. 105.

131. Ibid., p. 112.

132. Much has been published on Audubon's *Birds of America.* See especially Fries, *Double Elephant Folio;* and Blaugrund, "Audubon: Producer, Promoter, and Publisher," pp. 11–19.

133. Marzio, "Chromolithography as Popular Art," p. 116. Marzio notes that the practice of tinting chromolithographic photographs was common among firms such as Louis Prang of Boston, P. S. Duval of Phila-

Fig. 178. Felix Octavius Carr Darley, *The Bee Hunter.* Steel engraving, from *The Cooper Vignettes* (New York: James G. Gregory, 1862). The Metropolitan Museum of Art, New York, The Elisha Whittelsey Collection, The Elisha Whittelsey Fund, 1964 64.667

notable first in the field of chromolithographic book illustration. The first American book with tinted lithographs was produced there in 1848: *Squier's Ancient Monuments of the Mississippi Valley,* with pictures by lithographer Sarony working with two tint stones.[129] Some of the finest gift books of the 1840s and 1850s were published in New York. They include Thomas W. G. Mapleson's *Lays of the Western World* (1848) and *Songs and Ballads of Shakespeare* (1849).[130] From 1852 to 1856 Charles Mason Hovey's *Fruits of America,* published simultaneously in Boston and New York, established a standard for quality chromolithography in an American book.[131] The volume offered an unprecedented number of plates—ninety-six in all—and demonstrated the strength of the medium in its ability to render color brilliantly.

In 1858 Bien attempted one of the most ambitious chromolithographic projects ever—the replication of Havell's hand-colored aquatints and engravings for Audubon's *Birds of America.*[132] Bowen's smaller, octavo version of *The Birds* with hand-colored lithographs (1826–39) had proved so popular that New Yorkers chose a set of the volumes to present to Jenny

Lind following the Swedish singer's Manhattan debut at a concert in 1850 to benefit the widows and orphans of the city's firemen (see cat. no. 239; fig. 176). In collaboration with John Woodhouse Audubon, Bien created 105 chromolithographs based on 150 of the elder Audubon's original compositions, doubling up on a single sheet smaller birds drawn to scale. Through a variety of painstaking applications of color that mixed during the printing process, Bien managed to re-create on large lithographic stones the texture of the metal plates Havell had meticulously prepared. This monumental undertaking brought Bien little financial reward, since subscribers reneged on their commitment at the outbreak of the Civil War, despite the high quality of the first plate, *Wild Turkey* (cat. no. 149). Bien nonetheless persevered as a printer, later focusing his efforts on custom-made "chromos" executed for publishers and art dealers, chromolithographic illustrations to accompany federal geological surveys, and tinted chromolithographic photographs.[133]

Chromolithographs on a scale befitting the Empire City and promoting its image as the cultural capital of the United States were displayed in Manhattan. For example, in 1858 the major art and print dealer Williams, Stevens and Williams advertised its exhibition of eminent landscape painter Frederic E. Church's oil painting *Niagara* (fig. 50) along with "a *fac-simile* of this celebrated Picture, beautifully printed in colors, after the original."[134] No project seemed to be too large for New York lithographers to consider. While Bien was at work reproducing Audubon's watercolors for *The Birds of America* as color lithographs, Sarony and Major, who by then had invited Joseph Knapp on board as a third partner, took on the reproduction of Rembrandt Peale's celebrated twenty-four-foot-long painting, the *Court of Death,* as a large color lithograph. Printed in 1859, the work was praised by Peale himself shortly before his death: "The Drawing is correct, and the Colouring (considering the difficulty of the process and its cheapness) gives a good idea of the Painting."[135] Popular as well were chromolithographic reproductions of European oil paintings, among them the monumental *Horse Fair* by the French artist Rosa Bonheur (cat. no. 51; fig. 177), which was also printed just before the Civil War by Sarony, Major and Knapp.

While lithographers were enticing readers with color illustrations, engravers were busy perfecting their illustrations to accompany writings by American and European authors. Many aspiring artists produced engraved book illustrations to supplement their incomes until they could establish themselves as

painters. Others, such as New York engraver Felix Octavius Carr Darley, devoted themselves to the medium, creating banknotes, reproductive engravings, and some of the finest book illustrations produced prior to the Civil War.[136] Darley played a major role in creating the cult of George Washington through his immensely popular steel and wood engravings for Washington Irving's five-volume *Life of George Washington*, published between 1857 and 1859 by George P. Putnam, a leading New York publisher. Correctly anticipating good sales, Putnam supported Darley's proposal to produce large prints for the biography, including a monumental engraving titled *The Triumph of Patriotism* (1858), in which Washington is shown leading his troops into New York City in 1783 with all the confidence of a Roman emperor. Following the publication of Darley's successful lithographic outline illustrations for Sylvester Judd's novel *Margaret* and for two of Washington Irving's best-loved tales of Knickerbocker New York, "The Legend of Sleepy Hollow" and "Rip van Winkle" (see cat. nos. 133, 134), W. A. Townsend and Company of New York City commissioned the artist to produce illustrations for James Fenimore Cooper's complete works, which were published between 1859 and 1861. *The Cooper Vignettes* (see fig. 178) swiftly became de rigueur volumes for a proper New York library. Advertised by Townsend as a "monument of

American Art," Darley's work consisted of 64 steel engravings and 120 wood engravings dispersed among 32 volumes.[137]

As private libraries multiplied in New York City, many fine binderies sprang up to meet the demand for beautiful books. Enhancing the visual appeal of gift books were richly colored bindings stamped in gold.[138] Each year *The Garland*, a popular gift book published between 1847 and 1855, offered the purchaser a choice of three different gilt bindings stamped on either scarlet or purple morocco, for a total of six different volumes, each of which included different chromolithographed decorations, such as a page for a personal inscription.[139] Gift books were snatched up by a largely female audience, who bestowed them on family members and friends to mark holidays and special occasions. Especial favorites for the Christmas season were Dickens's *A Christmas Carol in Prose* (1844) and later imitations of it, such as W. H. Swepstone's *Christmas Shadows, a Tale of the Poor Needle Woman* (cat. no. 138), its accompanying blue binding stamped in gold with a picture of a poor needleworker appearing as an apparition before her miserly employer. Washington Irving's *History of New-York* of 1809, written under the pseudonym of its fictitious protagonist, Diedrich Knickerbocker, was issued in many subsequent editions, including one produced by Putnam in 1850 (cat. no. 137). Centered on the

delphia, and Strobridge of Cincinnati.

134. "At Williams, Stevens, Williams & Co.'s," *The Independent*, September 30, 1858, p. 5. On May 2, 1857, *The Albion* reported on *Niagara* (p. 213): "With spirit and judgment, Messrs. Williams & Co. have stepped in and become purchasers of this rare work, their intention being to carry it to London, (where it will undoubtedly create a sensation,) and have it there drawn and printed in colours by the chromo-lithographic process. They have paid Mr. Church, we understand, $4,500, for the picture and the copyright; and he is further to receive one half the price at which it may be finally sold."

135. Rembrandt Peale to Tristram Coffin, July 3, 1860, Joseph Downs Collection of Manuscripts and Printed Ephemera, The Winterthur Library, Henry Francis Du Pont Winterthur Museum, Winterthur, Delaware, as quoted in Marzio, *Democratic Art*, p. 51.

136. See Nancy Finlay, *Inventing the American Past: The Art of F.O.C. Darley*, with a foreword by Roberta Waddell (exh. cat., New York: New York Public Library, 1999). I am grateful to Nancy Finlay,

Fig. 179. George Loring Brown, *Bay of New York*, 1861. Etching. Museum of the City of New York

Roberta Waddell, Elizabeth Wycoff, and the entire staff of the Prints Division of the library for their assistance with this project.

137. Ibid., p. 20.

138. For an excellent discussion of innovations in nineteenth-century American book-binding, see Sue Allen, "Machine-Stamped Bookbindings, 1834–1860," *Antiques* 115 (March 1979), p. 567. For American bookbindings, see especially Edwin Wolf, *From Gothic Windows to Peacocks: American Embossed Leather Bindings, 1825–1855* (Philadelphia: Library Company of Philadelphia, 1990).

139. McGrath, "American Color-plate Books," p. 108.

140. Burrows and Wallace, *Gotham*, p. 417.

141. Marzio, *Democratic Art*, p. 83.

142. For the technological transformation of the chromolithographic industry during the 1860s, see ibid., esp. chap. 5, "Tools, Techniques, and Tariffs," pp. 64–93.

143. Spann, *New Metropolis*, p. 406.

144. Marzio, *Democratic Art*, pp. 17–18. Marzio notes that Sarony and Bien in New York and British-born printmaker William Sharp, who immigrated to Boston about 1830, practiced photography as well and became involved in reproducing photographs lithographically.

145. See Clifford S. Ackley, "Sylvester Rosa Koehler and the American Etching Revival," in *Art and Commerce: American Prints of the Nineteenth Century: Proceedings of a Conference Held in Boston, May 8–10, 1975* (Charlottesville: University Press of Virginia, 1978), pp. 143–51; Maureen C. O'Brien and Patricia C. F. Mandel, *The American Painter-Etcher Movement* (exh. cat., Southampton, New York: Parrish Art Museum, 1984); and Thomas P. Bruhn, *The American Print: Originality and Experimentation, 1790–1890* (exh. cat., Storrs: William Benton Museum of Art, University of Connecticut, 1993).

binding of the front cover is a silhouette of Diedrich, whose surname, derived from the Dutch words *knicker* (to nod) and *boeken* (books), came to identify Irving's circle.[140] The larger format of the 1855 edition of *The Knickerbocker Gallery* (cat. no. 140) was probably intended to appeal to men as well as the usual audience of women. This publication was offered in a wide selection of leathers stamped with motifs ranging from floral borders to an image of Washington Irving's home Sunnyside, near Tarrytown, a popular gathering place for Knickerbocker writers.

Even before the Civil War, the steam-operated press was beginning to challenge the handpress, particularly in the realm of printing popular lithographs. In 1859 New York lithographer Charles Hart recalled an incident that reflected the intense competition between man and machine that would dominate the post–Civil War print world:

> *[The printers] then came up to the table, by the windows, where the steam press and hand press work were lying side by side, and while the excited printers were pointing out the superiority of the hand press work [the operator of the steam press] . . . placed his hands, one under each pile of work, and lifting them suddenly mixed both lots of work in one indistinguishable mass upon the table. "Now gentlemen" [he said], . . . "Separate, if you can, the hand press from the steam press work." That was an impossibility. Great indeed was the indignation of the printers. . . . But they still declared the hand press work was the better.*[141]

In the late 1850s chromolithography was on the brink of evolving from the skilled craft of creating hand-tooled prints, such as those made by Bien, to the mechanized industry it would become as the steam-driven presses took over at the end of the 1860s.[142]

As New York City developed into the commercial capital of the United States, printing firms became increasingly specialized. By 1861 the city was responsible for 30 percent of the nation's printing and publishing; the industry employed more than five thousand printers, bookbinders, engravers, typefounders, and others needed to meet the demand for printed materials and pictures.[143] As the steam-driven presses and stamping machines enabled New York printers to produce ever larger editions of prints and books, printing giants such as Currier and Ives and Harper and Brothers were able to outstrip the competition. Smaller printmaking firms were forced to specialize in

popular advertisements and custom-printing jobs. At the outset of the period covered in this catalogue, printmakers worked in a variety of mediums, including engravings on wood and metal as well as lithographs. After the Civil War two major New York printers, Sarony and Bien, developed their businesses by reproducing photographs lithographically.[144]

By 1861 the outlook of New Yorkers had become cosmopolitan, thanks to their easy access to books, periodicals, and printed works of art and to a growing interest in foreign travel. With the support of newly wealthy art connoisseurs, many New York artists were able to go abroad, and there they developed a growing appreciation of prints as original works of art rather than as reproductions. During their Grand Tours of Europe, bourgeois Americans had an opportunity to see great works of art firsthand and they, too, became increasingly disenchanted with reproductive engravings after, for instance, the Italian Renaissance masters, which had been so eagerly sought by New York art patrons at midcentury. The travelers began to favor original etchings of familiar European sights that they could bring back to New York City as souvenirs of their tours.

Two Americans who created such etchings for the New York market are the expatriate John Gadsby Chapman (see cat. no. 147), who retired to Italy and became a leader of the circle of Americans living in Rome, and the Boston landscapist George Loring Brown (see cat. no. 131). By 1861 the American Etching Revival, which would dominate printmaking in New York City during the 1870s and 1880s, was under way.[145] When H.R.H. the Prince of Wales visited New York in October 1860, he was presented with a monumental painting of Manhattan by Brown, and the painting was widely reproduced as an etching (fig. 179).

The New York Etching Club was established in the city in 1877 to celebrate the new preference among connoisseurs for original etchings over engravings and lithographs. The next generation of New York print lovers would form the Society of Iconophiles and seek to assemble large collections of views of Manhattan, expressing their fascination with American printmaking and with the rise of the United States on the international stage following World War I. As their predecessors had, early-twentieth-century business magnates often chose Curriers and views of old New York to decorate their Manhattan offices and clubs, and many of those collections of fine nineteenth-century prints may still be seen in

their original settings. Among them, Edward W. C. Arnold's collection of approximately 2,500 prints, maps, and pictures of New York City at the Metropolitan Museum remains one of the most outstanding examples in Manhattan, along with those formed by Isaac Newton Phelps Stokes and Amos F. Eno, both of which are now at the New York Public Library.[146] The enthusiastic efforts of the Iconophiles to recover many of the splendid prints of New York during its flowering as the Empire City were forgotten during World War II, when the Works Progress Administration's Federal Art Project supported an innovative printmaking division in New York City that forged an interest in lithography and silkscreen. The scope of the present exhibition permits only a fleeting glimpse of the wealth of prints produced in New York City between 1825 and 1861; it would be difficult to imagine or comprehend the ascent of the Empire City without the rich store of images that rolled off its presses during those years.

146. See Stokes, *Iconography of Manhattan Island*, vol. 1 (1915), pp. xiii, xxi, where many of the other print collectors in Stokes's circle are listed.

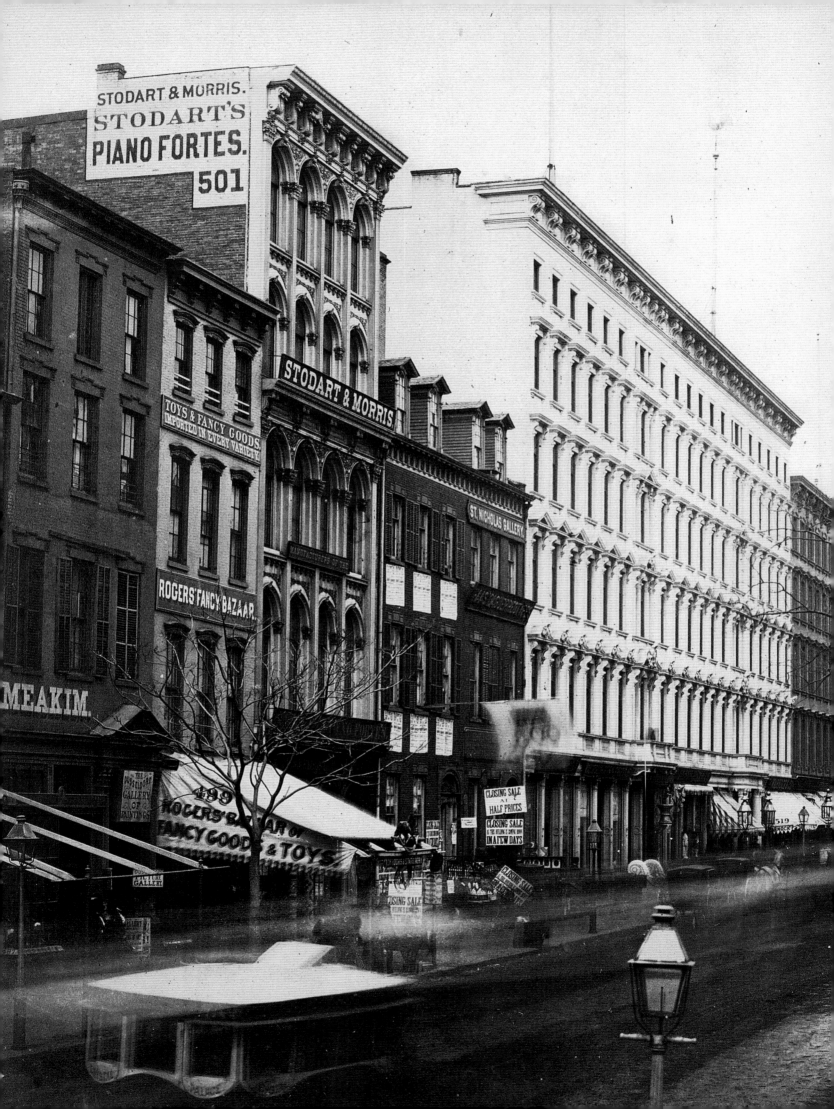

"A Palace for the Sun": Early Photography in New York City

JEFF L. ROSENHEIM

Wonderful wonder of wonders!! Vanish equa-tints and mezzotints—as chimneys that consume their own smoke, devour yourselves. Steel engravers, copper engravers, and etchers, drink up your aquafortis, and die! There is an end of your black art . . . The real black art of true magic arises and cries avaunt. All nature shall paint herself—fields, rivers, trees, houses, plains, mountains, cities, shall all paint themselves at a bidding, and at a few moment's notice.

—*The Corsair*, April 13, 1839

In 1825—when that marvel of engineering the Erie Canal opened, and when goods of all varieties began to flow into New York and to transform it from a small city into the financial capital of America—photography did not exist. Even the word "photography" would not be coined for another decade and a half. The first successful photographic experiments with cameras and light-sensitive silver materials were still years away, and the idea itself had only begun to germinate in the minds of a few isolated scientists in Europe. It is remarkable that by the start of the Civil War, just over twenty years after the medium's birth in 1839, photography had emerged as the most common form of visual language in America, present in even the most humble of homes and used to record the features not only of statesmen, poets, and industrial tycoons but also of soldiers, urban laborers, mothers, infants, and the recently deceased. In New York City hundreds of photographers vied with one another for clients, offering lavish studios (often referred to as "temples") on the upper floors of buildings on and just off Broadway.

The story of this remarkable revolution begins in October 1832, when Samuel F. B. Morse, New York's most celebrated portrait painter of the age, had an epiphany, not of the artistic but of the technological sort. Bound for New York from France aboard the packet ship *Sully,* he conceived of a new form of long-distance communication based on magnetism and electricity. By 1835, when he was appointed Professor

of the Literature of the Arts of Design at the University of the City of New York, Morse the painter had traded his brush for a metal lathe and had become an inventor. He had developed and constructed the first telegraph machine, an apparatus that used electrical impulses to transmit a coded message from one place to another. Rather than actively continuing his painting career, Morse directed most of his creative energy during the subsequent years to refining the electric telegraph, "which produced a revolution in his life, and on the commerce and intercourse of mankind." [1]

Despite the rearrangement of his priorities, Morse still relied on art to support himself. Using fees paid by his art students for instruction in painting and aesthetics, Morse continued to improve on his invention until August 1837, when he publicly exhibited the telegraph in the large hall of his university. This was immediately followed by an application to the patent office and by a formal presentation to Congress in the winter of 1837–38. Although he remained dedicated to the arts as both professor and president of the National Academy of Design, Morse believed that the telegraph would bring him wealth and fame. Surprisingly, he was unsuccessful in his attempt to convince the United States government to subsidize his experiments; the small amount of money he received fell far short of the funding required to produce the large coils of wire across which his telegraph would communicate. Nor could his meager income as a professor meet the expenses required to promote the telegraph and create the necessary infrastructure.

Seeking capital, Morse traveled in late 1838 and 1839 to England and France, hoping to sell the patent rights to his invention. He had no success in England, as competitors there were developing their own ideas about how to use electromagnetism. When he arrived in France in the spring of 1839 he made his presentation to the Académie des Sciences, where just a few months earlier another painter and inventor, Louis-Jacques-Mandé Daguerre, the proprietor of the Paris Diorama theater, had shown an equally astonishing invention—a seemingly magical process that held an

This essay is dedicated to Malcolm Daniel, my colleague in the Department of Photographs. Without his wisdom, generous spirit, and superb organizational skills, "'A Palace for the Sun'" would still be latent—like the earliest photographic experiments, a half-formed image without any real substance. For the kind invitation to participate in this grand endeavor to celebrate the "Great Emporium," I thank John K. Howat and Catherine Hoover Voorsanger. Their dedication and patience provided encouragement when it was most needed. Like many research projects, this one was greatly enriched by a team of assistants who photocopied volumes of original documents and read through hours of microfilm. I especially thank Suzannah Schatt, who performed this grueling work as an indefatigable volunteer research assistant. The quotation that introduces this chapter is taken from "The Pencil of Nature: A New Discovery," *The Corsair*, April 13, 1839, pp. 70–71.

1. Samuel Irenaeus Prime, *The Life of Samuel F. B. Morse, LL.D., Inventor of the Electro-magnetic Recording Telegraph* (New York: D. Appleton and Company, 1875), p. 249.

image permanently on a silver-plated sheet of copper. It was suggested that Morse meet France's own inventor of the moment, and he soon received an invitation to Daguerre's studio on March 5. Morse was highly impressed by the images he saw and wrote in a letter to his brother: "You have perhaps heard of the Daguerreotype, so called from the discoverer, M. Daguerre. It is one of the most beautiful discoveries of the age. . . . they resemble aquatint engravings, for they are in simple *chiaro-oscuro* and not in colors. But the exquisite minuteness of the delineation cannot be conceived. No painting or engraving ever approached it. . . . The impressions of interior views are Rembrandt perfected." [2] Morse in turn invited Daguerre to a demonstration of the electric telegraph, and on the very day that they met this second time, Daguerre's Diorama—and with it his notes and early daguerreotypes—burned to the ground. This tragic coincidence forever linked the fate of these two figures and ingratiated Daguerre to Morse.

Morse returned to America in spring 1839 dazzled by Daguerre's invention but—like everyone else—ignorant of the complex steps required to produce a daguerreotype, for Daguerre had shrewdly withheld the details until he could conclude an arrangement with the French government under which he would receive an annuity in exchange for placing his invention in the public domain. Arriving back in New York, Morse immediately nominated his French colleague for honorary membership in the National Academy of Design, indicating his belief that Daguerre's invention would benefit the arts as well as the sciences. Then he eagerly awaited news from Paris. Not until late September 1839 did a boat arrive with a published text with step-by-step instructions for creating the plates and making the exposures. Morse and others in New York, Boston, and Philadelphia immediately set about to build their cameras, find usable lenses, and experiment with the new invention. Interestingly, Morse was not the first artist in America to succeed in making a daguerreotype. By his account, that honor goes to an obscure artist named D. W. Seagar. [3] Morse claimed that his own earliest success, a view of the Unitarian Church made from a window on the staircase at the University of the City of New York, dated to late September 1839. [4]

On February 22, 1840, *The Corsair* described "a picture [by Morse] quite as remarkable for strength and distinctness as the most perfect specimens yet exhibited. . . . His drawing represents the front of the City Hall." [5] Neither of these early daguerreotypes of New York, nor any other views of the city by

Morse, survive. While experimenting with architectural subjects, Morse also set himself the task of overcoming what he considered the great shortcoming of Daguerre's invention—portraits, it seemed, were beyond the reach of the medium, for it was nearly impossible for a sitter to remain motionless during the long exposure time. Daguerre himself doubted that his invention could ever be used successfully to record the human face, but Morse set out to achieve just that goal. No sooner had he read the details of the process than he built two portrait studios—glassed-in boxes with glass roofs—one atop his residence at the university, on Washington Square, and one on the roof of his brothers' new building on the northeast corner of Nassau and Beekman streets. Morse dubbed the latter "a palace for the sun." [6] Working in this light-filled studio with John Draper, a fellow professor at the university, Morse soon succeeded in shortening the exposure times by polishing the silvered plates to a higher degree than previously attained and adding bromine, an accelerator, to the chemistry. By late 1839 or early 1840 they had succeeded in making portraits. Despite all the potential scientific uses for the daguerreotype—Morse had suggested that the discovery would "open a new field of research in the depths of microscopic Nature" [7]—the most enduring legacy of the new medium was its role as a preserver of likenesses of men and women, not details of nature.

The earliest—indeed, the only—surviving daguerreotype by Morse (cat. no. 160) is a portrait. The strength of this image is in the anonymous young man's rapt expression, which seems to reflect a subtle awareness of his participation in a grand endeavor. The subject stares directly into the camera, straining to keep his eyes open during the ten-to-twenty-minute exposure in direct sunlight. The mindful sitter is one of the first in photography to return the gaze of the viewer, something Daguerre thought not possible. Morse's very first portraits likely showed figures with their eyes closed, and a small drawing by Morse (fig. 180), dated May 1840, is likely drawn from one such daguerreotype, rather than from life.

Although New York City was the locus of much of the activity (and public commentary) surrounding the introduction of the daguerreotype in America, the invention quickly found its way into every large city in the country. *Godey's Lady's Book* commented on the earliest experimental daguerreotype portraits by Robert Cornelius, a young Philadelphia lamp maker and metalworker. They found his work "unsurpassable. . . . Catching a shadow is a thing no more to be

2. Ibid., pp. 400–401.

3. For further details on the date of the first daguerreotype produced in New York, see *Image, Journal of Photography of the George Eastman House* 1 (January 1952). Seagar also gave the first public lecture and demonstration on the daguerreotype process in the United States. This took place at the Stuyvesant Institute on October 5, 1839. See the advertisement in the *Morning Herald* (New York), October 3, 1839.

4. Prime, *Life of Morse*, p. 403.

5. *The Corsair*, February 22, 1840, p. 794.

6. Prime, *Life of Morse*, p. 403.

7. Ibid., p. 401.

Fig. 180. Samuel F. B. Morse, *Head of a Young Man*, May 1840. Brown ink on paper. The Metropolitan Museum of Art, New York, Gift of James C. McGuire, 1926 26.216.49

of the thing itself; the hair of the human head, the gravel on the roadside, the texture of a silk curtain, or the shadow of the smaller leaf reflected upon the wall, are all imprinted as carefully as nature or art has created them in the objects transferred; and those things which are invisible to the naked eye are rendered apparent by the help of a magnifying glass. It appears to me not less wonderful that light should be made an active operating power in this manner, and that some such effect should be produced by sound; . . . we may not be called upon to marvel at the exhibition of a tree, a horse, or a ship produced by the human voice muttering over a metal plate, prepared in the same or some other manner, the words "tree," "horse," and "ship." How greatly ashamed of their ignorance the by-gone generations of mankind ought to be![11]

laughed at."[8] The journals with a scientific bent also began to muse on various uses for the daguerreotype. In a column entitled "Anticipated results from the Daguerreotype" the editors of the *American Repertory of Arts, Sciences, and Manufactures* suggested that several members of the Egyptian Institute in Paris take Daguerre's apparatus to Egypt and copy "the millions and millions of hieroglyphics, which entirely cover the exteriors of the great monuments at Thebes, Memphis, Carnac, &c. . . . [or] make photographic charts of our satellite [the moon]."[9]

Popular interest in the new medium was spurred by the arrival of daguerreotypes—and an instructor—direct from the French capital. The earliest exhibition in the United States of original daguerreotypes produced by the hands of Daguerre took place on December 4, 1839, in New York City. The public exhibition in a building on Broadway consisted of still-life studies and views of Paris presented by Daguerre's American agent, M. Gouraud.[10] Former mayor Philip Hone, who recorded the event in his diary, marveled at the images and commented with remarkable prophecy on the invention:

The manner of producing them constitutes one of the wonders of modern times, and, like other miracles, one may almost be excused for disbelieving it without seeing the very process by which it is created. . . . Every object, however minute, is a perfect transcript

Niles' National Register also reported on

a large number of pictures from a collection of the exquisitely beautiful results of this wonderful discovery [the daguerreotype], just arrived from Paris, several of them by Daguerre himself. The collection is in the hands of M. Gourraud, a gentlemen [sic] of taste, who arrived in the steam packet British Queen, and who made himself acquainted with the mode of obtaining these results, under the immediate instruction of M. Daguerre. . . . We can find no language to express the charm of these pictures painted by no mortal hand. . . . We hope Mr. Gourraud will stay so long among us as to give us a few practical lectures; and also to furnish an opportunity for our citizens of taste to see this collection of nature's own paintings.[12]

Indeed he did. *The Knickerbocker* reported just a few weeks later that the "*true* Daguerreotype views, exhibiting at the corner of Chambers-street and Broadway, by Mr. GOURAUD, the only accredited agent of Mr. DAGUERRE, in America, have attracted crowds of enthusiastic admirers. The lectures upon the art, promised by Mr. GOURAUD, have been commenced; and we cannot doubt, will be numerously attended; the poor attempts of a pseudo Daguerreotypist to prevent such a result, to the contrary notwithstanding."[13] The lectures took place in the exhibition gallery at 57 Broadway and secured the city's most important street as the new home of the daguerreotype in America.

Daguerreotypy had already begun to develop as a profession in New York by March 1840, when the *American Repertory of Arts* published D. W. Seagar's

8. *Godey's Lady's Book and Ladies' American Magazine* 20 (April 1840), p. 190. Cornelius's experiments in portraiture are presumed to date from October or November 1839.

9. *American Repertory of Arts, Sciences, and Manufactures* 1 (May 1840), p. 304. John Draper would do just that, producing in March 1840 the earliest photograph of the moon.

10. On August 19 the daguerreotype process was announced to the public by the Académie des Sciences in Paris. In that announcement the name of Daguerre's agent is spelled "Gouraud," but in other references in newspapers and journals, it is spelled "Gourraud."

11. *The Diary of Philip Hone, 1828–1851*, edited by Bayard Tuckerman (New York: Dodd, Mead and Company, 1889), vol. 1, pp. 391–92, entry for December 4, 1839.

12. "The Daguerreotype," *Niles' National Register*, January 11, 1840, p. 312. The story was based on an article in the *New York Observer*.

13. "The Daguerreotype," *The Knickerbocker* 15 (February 1840), p. 176.

elaborate "Table of General Rules for Exposure of the Plate in the Camera, in Taking Exterior Views." The recommended exposure times range from five minutes between eleven and one o'clock on a "very brilliant and clear" day to fifty to seventy minutes after three in the afternoon on a "quite cloudy" day. The editors noted that the exposure depended on the selection of the view ("a white marble edifice, for instance, requires less time than darker buildings") and that these exposure times, correct for October through February, would necessarily decrease during the more intensely sunlit months of summer.[14] The earliest of New York's commercial portrait studios opened shortly thereafter. A. S. Wolcott, who built one of Morse's early cameras, had set up shop with John Johnson by May 1840 and their firm produced consistently successful portrait daguerreotypes—none of which survive today. *Burton's Gentleman's Magazine* described Wolcott as having "nearly revolutionized the whole process of Daguerre and brought the photogenic art to high perfection. The inventor [Daguerre], it is well known, could not succeed in taking likenesses from the life, and, in fact, but few objects were perfectly represented by him, unless positively white, and in broad sunlight. By means of a concave mirror, in place of the ordinary lens, Mr. W. has succeeded in taking miniatures from the living subject, with absolute exactness, and in a very short space of time."[15]

In the years that followed, popular interest swelled and commercial studios proliferated. One commentary in the press described "*beggars* and the *takers of likeness by daguerreotype*" as the only two groups of people who made money in New York "in these Jeremiad times." Begging, according to this cynical observer in 1843, was the more lucrative pursuit, but "*Daguerreotyping,* which is now done for a dollar and a half, is the next most profitable vocation. It will soon be as difficult to find a man who has not his likeness done by the sun . . . as it was, before the *rain* of portrait painters, to find one without a profile cut in black. . . . the immortality of this generation is as sure, at least, as the duration of a metallic plate."[16] By the mid-1840s New York could boast more daguerreotype studios than any other American city, and by the early 1850s a visitor commented that "there is hardly a block in New-York that has not one or more of these concerns upon it, and some of them a dozen or more, and all seem to be doing a good and fair amount of business."[17]

Among those who seized upon and helped define the new profession was a jewel-case and miniature-case

Fig. 181. Mathew B. Brady, *Henry Clay,* ca. 1849. Daguerreotype. The Museum of Modern Art, New York, Gift of A. Conger Goodyear

maker who, beginning in 1843, catered to the new demand for daguerreotypes by offering "a new style case with embossed top and extra fine diaframe."[18] This young entrepreneur, Mathew B. Brady, established his own "Daguerreian Miniature Gallery" in 1844 at 207 Broadway, at Fulton Street, just steps from P. T. Barnum's American Museum.[19] In October of that year Brady exhibited daguerreotypes at the American Institute, the premier location for workers in any technological medium to present their products to the public for consideration—something like a small and periodic world's fair in downtown New York; Brady was awarded a premium medal for his submissions. The following year, in a savvy move that set him apart from his competitors, Brady began to make or collect the portraits of America's most noted citizens, including politicians, artists, writers, and others (see cat. no. 161). This effort led, in 1850, to the publication of a lithographic series entitled *The Gallery of Illustrious Americans,* in which Brady's daguerreotype portraits were copied by the skilled French-born lithographer Francis D'Avignon and complemented by an extensive biographical text (cat. no. 165B). Brady's subjects included John C. Calhoun, Daniel Webster, Henry Clay (fig. 181), and John James Audubon (cat. no. 165A).

14. "The Daguerreotype," *American Repertory of Arts, Sciences, and Manufactures* 1 (March 1840), pp. 116–32; Seagar's table is reproduced on pp. 131–32.

15. "Improvements in the Daguerreotype," *Burton's Gentleman's Magazine and American Monthly Review* 6 (May 1840), p. 246.

16. "Things in New York," *Brother Jonathan,* March 4, 1843, p. 250.

17. William M. Bobo, *Glimpses of New-York City by a South Carolinian (Who Had Nothing Else to Do.)* (Charleston: J. J. McCarter, 1852), p. 120.

18. The original letter from Mathew B. Brady to Albert Sands Southworth, the preeminent daguerreotypist in Boston, dates from June 17, 1843, and is in the Boyer Collection, George Eastman House, Rochester, New York.

19. See listing in *New-York City Directory for 1844 & 1845* (New York: John Doggett Jr., 1844), copy in the New-York Historical Society; also see the advertisement in the *New World,* April 19, 1845, p. 256.

Brady's original daguerreotype of Audubon, author and illustrator of *The Birds of America,* survives, the subject's raptorlike features minutely detailed by the camera with more exactitude than even he could bring to the description of his subjects. (This daguerreotype, like most early examples, is laterally reversed; copied in the same orientation by D'Avignon on stone, the image was reversed a second time in printing, so that it appeared correct on the printed sheet.) Reasonably priced, *The Gallery of Illustrious Americans* was meant to overcome the nagging deficiencies of the daguerreotype—that each was a one-of-a-kind image and that they were small in size (in part a technical consideration, since smaller plates required shorter exposures, and in part a legacy of the miniature tradition, into whose shoes the daguerreotype slipped quickly and effortlessly).

Brady and D'Avignon's project is one of the great early links between the nascent medium of photography and printmaking, although from a financial standpoint it was a failure. However, the underlying idea proved wildly successful, for, displayed in Brady's luxurious studio, his images of the powerful and famous drew a broad audience that wanted to associate itself with the greatest figures of the age. "This collection," Brady could claim, "embraces portraits of the most distinguished men of this country. The President and Cabinet, also the late President Polk and his Cabinet, members of the United States' Senate and House of Representatives, Judges of the Supreme Court at Washington, and many other eminent persons."[20] In another advertisement Brady "respectfully invites the attention of the citizens, also strangers visiting the city, to the very fine specimens of Daguerrotype Likenesses on exhibition at his establishment, believing they will meet the approbation of the intelligent public."[21]

In many ways Brady and Barnum, on opposite sides of Broadway, represented two sides of the same coin. Brady believed—in truth, not just as a marketing strategy—that the likenesses of America's elite could serve as an ennobling example for a broader populace; ordinary citizens came to Brady's New York Miniature Gallery, gazed upon the visages of great men, and emulated their demeanor as they themselves sat before the camera. They took part in the same endeavors as the nation's famous and powerful men. By setting up a studio gallery unlike that of a painter—opulently appointed with brocaded furniture, heavy curtains, and huge picture mirrors in which to compose oneself—Brady created a public space and addressed the theater of having one's picture made.

Barnum, from whom Brady learned to master the art of publicity, made his visitors feel superior, not by association but by contrast. Along with the objects that filled his oversized *cabinet des curiosités,* Barnum displayed oddities and exotica of the human race, in comparison with whom even the most common of common men and women could feel themselves superior.

Another of the pioneer photographers, perhaps Brady's most accomplished competitor, was Jeremiah Gurney, who, like Brady, was born in New York State and moved to New York City to work in the jewelry trade. Gurney arrived in the metropolis earlier than Brady, in 1840, and in the same year learned the daguerreotype process and opened a gallery at 189 Broadway. As one of the first daguerrean artists, he was active in writing the constitution and in serving as vice president of the American Daguerre Association, which was an influential trade organization of photographers established in 1851. Gurney effortlessly established himself, not by soliciting daguerreotype portraits of illustrious Americans but simply by producing the finest daguerreotypes in the city. He was blessed with remarkable technical skills and created tonally delicate, startlingly three-dimensional portraits that were consistently described in the press as extraordinary:

Mr. Gurney has long taken rank among the best Daguerreans in the country, and yet his style of pictures is entirely peculiar to his own process. Nobody produces pictures of the same tone and character, yet others may produce pictures quite as good as his—the style *is a mere matter of taste, and what some would prefer, others would object to. In fidelity of* line *however, and consequent resemblance, Mr. Gurney is unsurpassed. The peculiar effect produced by his process, and in which he prides himself, is the fullness of light obtained without solarization—a full development of all the natural lights as they fall upon the object, without regard to color or material of dress, and a consequent softness of tone which pervades the whole picture.*[22]

In 1846 Gurney was advertising his Premium Daguerrian Gallery in *Morris's National Press,* among listings for pianofortes, an auction of horse carriages, cured hams, beef tongues, and pork lard. "As in every art and science, years of study and practice are necessary to success," boasted Gurney. "[S]o especially is it indispensable in an art that has progressed so rapidly as Daguerreotype. Mr. G. being one of its pioneers in this country, his claims upon the confidence of the community, cannot be questioned."[23] Gurney

20. "Brady's National Gallery of Daguerreotypes," *The Independent,* November 7, 1850, p. 184.
21. *New World,* April 19, 1845, p. 256.
22. "The Daguerreotype," *The Republic* 1 (January 1851), p. 41.
23. "Gurney's Premium Daguerrian Gallery," *Morris's National Press,* November 7, 1846, p. 3.

Fig. 182. Jeremiah Gurney, *Two Girls in Identical Dresses,* ca. 1857. Daguerreotype. Gilman Paper Company Collection, New York

24. His Paris branch was located at 46 rue Basse du Rempart. *The Crayon,* July 25, 1855, front page.

25. By 1850, however, the taste for miniature portraits had revived, primarily among New York's wealthiest citizens. "The miniature business had been greatly cut up by the Daguerreotype: but latterly fine miniatures are again coming into vogue. The Daguerreotype business, though *spreading* among the factory hands and farming classes, is declining among the opulent." Thomas Mooney, *Nine Years in America, . . .* 2d ed. (Dublin: James McGlashan, 1850), p. 131.

26. "Gurney's Premium Daguerrian Gallery," p. 3.

brought a different clientele into his studio than did Brady; he attracted not only the cultural elite of the city but also ordinary families with children (see cat. no. 167; fig. 182). The New-York Historical Society's extensive collection of daguerreotypes of identified sitters, for instance, reveals that the Kellogg-Comstock family made annual visits to Gurney's studio and that each of the children was photographed year after year. In a particularly grand picture the Kelloggs and Comstocks gathered before Gurney's lens (cat. no. 172). The image—a horizontal, whole-plate daguerreotype—suggests that Gurney attracted a faithful following by the refined craftsmanship and aesthetics of his products, rather than by the showmanship that characterized Brady's enterprise. In 1851 Edward Anthony, the major supplier of daguerrean apparatus and plates, announced a competition to select the finest group of daguerreotypes. The judges—Morse, Draper, and the architect James Renwick Jr.—awarded Gurney the first prize in 1853, a silver pitcher

that he proudly displayed in his gallery as proof of his superiority (fig. 183). So confident and ambitious was Gurney that alone among New York daguerreotypists he established a branch office, in partnership with Charles DeForest Fredricks, in the center of the daguerrean world—Paris—boldly advertising New York–style daguerreotypes.[24]

One of the criticisms of the daguerreotype was that it translated the world into black and white—that it lacked color. Within five years of the new medium's introduction, the portrait-miniature painters, so recently and rapidly put out of business by the daguerreotype, were soon employed by all the major studios to add color to the monochromatic mirrored surfaces of their plates.[25] Gurney, for instance, invited the public to pay "particular attention . . . to the *lifelike* appearance of his coloured likenesses."[26] The image of a seated young girl with peach ruffles on the sleeves of her white dress and with a delicate blush to her cheeks (cat. no. 174) is a particularly fine

example of the subtle coloring that characterized the finest daguerreotypes of the period.

In 1846 Walt Whitman, then editor of the *Brooklyn Daily Eagle*, paid a visit to the gallery of John Plumbe, a successful competitor of Brady and Gurney who had begun his trade in Boston in 1840.

In whatever direction you turn your peering gaze, you see naught but human faces! There they stretch, from floor to ceiling—hundreds of them. . . . Even as you go by in the door you see the withered features of a man who has occupied the proudest place on earth: you see the bald head of John Quincy Adams, and those eyes of undimmed but still quenchless fire. There too, is the youngest of the Presidents, Mr. Polk. From the same case looks out the massive face of Senator Benton. . . . Indeed, it is little else on all sides of you, than a great legion of human faces— human eyes gazing silently but fixedly upon you, and creating the impression of an immense Phantom concourse—speechless and motionless, but yet realities. You are indeed in a new world— a peopled world, although mute as the grave.[27]

In addition to the press of faces, Whitman is also commenting on the discrepancy between the vitality and dynamism he sees on the streets and the stillness—near death—that he found in the collection of daguerrean images. Perhaps he would have taken comfort if the display had included more working-class Americans, such as the fireman with his cap and horn (cat. no. 176), who dropped by Gurney's studio probably only once to take home a quick likeness for a loved one. Collectively these images of the fireman, the grocery boy with his delivery package (cat. no. 173), the blind man and his reader (cat. no. 175), and even young Henry James with his father (fig. 184) constituted the bread and butter of such studios and suggest the changing world of art, commerce, and society that defined New York in the 1840s and 1850s.

In part, the lifeless quality that Whitman commented on was also a characteristic result of the medium; although exposure times were short enough to make portraiture practical, the process did not encourage ease. Henry James, in later life, recalled a childhood visit with his father to Brady's studio to have a portrait made as a surprise gift for his mother. He recalled that his head was held in place by "Mr. Brady's vise" and that the exposure was "interminably long" with a result of "facial anguish."[28] But it was not just the poets of the day who commented on the often dour expressions characteristic of many daguerrean portraits. The celebrated painter Thomas Cole wrote in

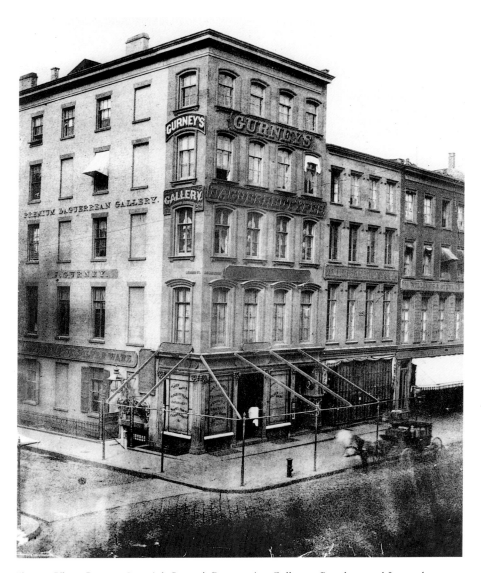

Fig. 183. Victor Prevost, *Jeremiah Gurney's Daguerreian Gallery at Broadway and Leonard Streets*, 1854. Modern gelatin silver print from waxed paper negative. Collection of The New-York Historical Society

February 1840 that he was completing The Voyage of Life series and that he had read a great deal about the daguerreotype: "If you believe everything the newspapers say . . . you would be led to suppose that the poor craft of painting was knocked in the head by this new machinery for making Nature take her own likeness, and we [have] nothing to do but to give up the ghost. [But] the art of painting is a creative, as well as an imitative art, and is in no danger of being superseded by any mechanical contrivance. 'What fine chisel did ever yet cut breath?'"[29]

Another of the photographers established on Broadway was Martin Lawrence, an artist less well known than Brady and Gurney, and probably functioning a tier below them. Like all the major owners of studios, Lawrence employed studio operators—the men who actually handled the camera and carried out the

27. Quoted in Justin Kaplan, *Walt Whitman: A Life* (New York: Simon and Schuster, 1980), p. 112.

28. Frederick W. Dupee, ed., *Henry James: Autobiography—A Small Boy and Others, Notes of a Son and Brother, The Middle Years* (Princeton: Princeton University Press, 1983), p. 52.

29. Letter to Mr. Adams, February 26, 1840, quoted in Louis L. Noble, *The Course of Empire, Voyage of Life, and Other Pictures of Thomas Cole, N.A. with Selections from His Letters and Miscellaneous Writings: Illustrative of His Life, Character, and Genius* (New York: Cornish, Lamport and Company, 1853), p. 282.

Fig. 184. Mathew B. Brady, *Henry James Sr. and Henry James Jr.,* 1854. Daguerreotype. James Family Photographs, Courtesy of the Houghton Library, Harvard University, Cambridge, Massachusetts

30. "Gossip," *Photographic Art-Journal,* September 1853. Henry Snelling published the *Photographic Art-Journal* (later the *Photographic and Fine Art Journal*) from January 1851 to 1860. *The Journal* provides contemporary scholars with an invaluable resource of period commentary, advertisements, and art gossip just as it did the daguerrean artists of the day.

photographic manipulations. Among Lawrence's operators was a playwright, poet, and actor, Gabriel Harrison, who produced a series of allegorical tableaux. One, *California News,* 1850–51 (cat. no. 169), more narrative than allegorical, was included with other plates by Harrison in a suite of pictures submitted by Lawrence under his own name to the Great Exhibition of the Works of Industry of All Nations, the world's fair at the Crystal Palace in London in 1851. Lawrence was awarded a gold medal for his submission, prompting in due time a debate over who should appropriately receive the honors. When Lawrence exhibited the daguerreotypes two years later in New York, again under his own name, Harrison, by that time an operator of his own gallery, wrote to the editor of the *Photographic Art-Journal,* challenging him to state "that these pictures *were all taken by Gabriel Harrison,* and that every process, from the polishing of the plates to the finishing of each separate picture, *was performed by him alone.* A fair expression of opinion is all that is required by myself, and if these pictures of Mr. Lawrence . . . *are* really worth noticing, why not give the name of the operator *by whom they were taken?*"[30]

California News is indeed remarkable among early American daguerreotypes, for rather than being a portrait or view, it is a tableau constructed with great panache by Harrison. It relates directly to the painting of the same subject, title, and date by William Sidney Mount, the Long Island genre painter, and is an artistic response to the enormous interest in New York that was generated by newspaper accounts a few years earlier of the discovery of gold in California. The actors in the scene seem to be Harrison, his son, and his employer, Martin Lawrence. Theatrical in its poses and narrative in its content, this picture shares qualities with Harrison's portraits of Whitman, one of which was engraved as the frontispiece of Whitman's *Leaves of Grass* (1855; cat. no. 146) and another of which is known historically as the "Christ likeness" because of the strong sense of spirit, compassion, and life emanating from the subject (cat. no. 163).

It is not surprising that the vast majority of surviving daguerreotypes—and certainly the vast majority of those made—are portraits of people indoors, for the complex steps in producing daguerreotypes were best carried out in the studio, with its controlled conditions and ready darkroom. Furthermore, the reason the daguerreotype was so enthusiastically embraced by the general public was that it fulfilled the profound human need to record the features of oneself and one's family for posterity. Nonetheless, a few photographers ventured out into the streets to record a portrait of the city with their clumsy daguerrean apparatus designed primarily for studio applications (fig. 185). In many ways, the medium was well suited to the task: static and sunlit, monuments of architecture required no gentle coaxing or rigid head clamps to sit for a long exposure. Daguerre's earliest demonstration pieces included city views, and Morse and Draper's first subjects were the buildings immediately opposite the university, where they had their studios.

The earliest surviving photographic view of New York City shows the laying of granite cobblestones known as Russ pavement along Broadway south of Canal Street (cat. no. 180). In fact, it is one of only two extant stereoscopic daguerreotypes of New York City—the other shows City Hall. Each view is composed of two similar photographs that, seen through a special apparatus, provide the illusion of a three-dimensional scene. Introduced at the world's fair in London, stereo daguerreotypes were more popular in America than anywhere else in the world and were advertised and discussed extensively in the journals and scientific magazines of the era. The rare view of Broadway was published as a woodcut in a magazine

Fig. 185. Artist unknown, *The First Meserole House, Home of Almon Roff, Wallabout, Brooklyn*, 1840s. Daguerreotype. Museum of the City of New York, Gift of Sally Meserole Hollins 42.121

article of 1853 that provided a survey of activity on New York's "business-streets, mercantile blocks, stores, and banks."[31] The plunging perspective and idiosyncratic description of the chaos of street construction distinguish this picture and its wood engraving from many of the others in the article, which seem cleansed of detail and filled with typical incident—stock figures, carriages, and the like. All of this recalls what the editor of the *New-York Mirror* commented on in July 1840, that New York was a "city of modern ruins. No sooner is a fine building erected than it is torn down to be put up a better. . . . Oh, for the day when some portion of New-York may be considered finished for a few years."[32] Above the street, and providing its context, is an endless backdrop of new buildings, the sky-lighted top floors of which often housed the city's proliferating daguerrean galleries.

Astonishingly, the only other surviving daguerreotype street scene in New York City is an 1853–55 view of the corner of Chatham (now Park Row) and Pearl streets, looking toward Chatham Square (cat. no. 178). Like Broadway, Chatham Street was home to numerous daguerrean galleries, and we presume that this view over the sweeping canvas awnings that

shaded the corrupt street auctions and sidewalk commerce in dry goods was made from the window of one such studio. Unlike those on Broadway, however, these establishments catered to a rough clientele, of day laborers and immigrants. A visitor to the city from South Carolina commented about this section of the city, also known as "Jerusalem," that "there is more to be seen within that quarter of a mile, than in twice the distance on any street of the city of New-York. . . . Chatham-street is a sort of museum or old curiosity shop, and I think Barnum would do well to buy the whole concern, men, women, and goods and all out, and have it in his world of curiosities on the corner of Ann and Broadway. I think it would pay finely."[33]

Unlike the period's printed views (see cat. no. 123, for example), which were generally designed for clarity and filled with drafting-table anecdote, this photograph of Chatham Square shows the city as an inelegant confusion of traffic, commercial signs, and pedestrians. The small daguerreotype may not be prepossessing but it is important; it captures the spirit of the street, of "downtown," where the busy, unmannerly commerce in furniture and feathers, window

31. "New-York Daguerreotyped," *Putnam's Monthly* 1 (April 1853), pp. 353, 368 (Russ pavement).

32. *New-York Mirror*, July 13, 1840, p. 407, quoted in I. N. Phelps Stokes, *The Iconography of Manhattan Island, 1498–1909, Compiled from Original Sources and Illustrated by Photo-intaglio Reproductions of Important Maps, Plans, Views, and Documents in Public and Private Collections*, 6 vols. (New York: Robert H. Dodd, 1915–28), vol. 4 (1926), p. 1764.

33. Bobo, *Glimpses of New-York*, pp. 115, 117.

Fig. 186. Victor Prevost, *Hiram Powers's "Greek Slave" at the Crystal Palace*, 1853–54. Modern gelatin silver print from waxed paper negative. Collection of The New-York Historical Society

shades, tea, and even daguerreotypes gave rise to New York's prominence as the "Great Emporium." Visible far down the street are horse-drawn carriages pulled along tracks laid in the street, the city's first streetcars, which carried passengers from Chatham Square as far north as Forty-second Street, the site of New York's own Crystal Palace exhibition.

The success of London's Crystal Palace inspired New York to host its own world's fair in 1853–54, in a specially designed glass and cast-iron exhibition hall on the site of present-day Bryant Park. The exhibits were classified according to the same divisions as had been used in London, and photography was included among "Philosophical Instruments and Products." Alongside scales for weighing gold, solar compasses, and Morse's patent electric-telegraph apparatus in operation (connecting to Philadelphia and other cities) were daguerreotypes by many of the early New York practitioners, including Brady, Gurney, Harrison, and Lawrence. The fair drew immense crowds and heralded the city's arrival as a competitor of London and Paris. In the center of the sole surviving daguerreotype of the exhibit hall's interior (cat. no. 179) is an arrangement of European sculpture surrounding the central rotunda.

Among those who visited the Crystal Palace was a thirty-three-year-old French-born artist, Victor Prevost, who had arrived in America in 1848. There survive in

Fig. 187. Victor Prevost, *Display of Machinery at the Crystal Palace*, 1854. Modern gelatin silver print from waxed paper negative. Collection of The New-York Historical Society

the New-York Historical Society, the Museum of the City of New York, and other New York public collections negatives by Prevost, several of which present exhibits at the Crystal Palace, ranging from Hiram Powers's *Greek Slave* to industrial machinery (figs. 186, 187). What sets Prevost's work apart from that of other New York City photographers of the early 1850s is that his images are on paper rather than on metal. Although negative-positive paper-print photography, invented by the Englishman William Henry Fox Talbot, had been announced to the world just days after Daguerre's process, the technique had found little favor in America. While the daguerreotype process was free of restrictions, Talbot's patented process required a license. More important, however, was the fact that compared to the daguerreotype's extraordinary clarity of detail, the slightly fibrous texture of Talbot's prints —a quality admired as "artistic" in Europe—seemed like a defect to an American public that prized fact.

Prevost, however, arrived in America having been tutored by the leading French photographer of the day, Gustave Le Gray, whose waxed-paper-negative process yielded paper prints of admirable clarity. The chief appeal of all paper photography was that, unlike the one-of-a-kind daguerreotypes, multiple prints could be made from a single camera negative, and the resulting pictures could be treated in a fashion similar to other prints—tipped into books or albums, folded

up in a letter, or framed and hung on the wall. The first book published in America that incorporated an original photograph was *Homes of American Statesmen* (New York, 1854). Other books soon followed, including the New York Crystal Palace catalogue, *The World of Science, Art, and Industry Illustrated from Examples in the New-York Exhibition, 1853–54*, edited by B. Silliman Jr. and C. R. Goodrich (New York, 1854), which in addition to hundreds of illustrations engraved primarily from daguerreotypes also included twelve photographic prints.

Whether Prevost's documentation of the Crystal Palace was commissioned or made on speculation remains unknown, but he must have met with enough success to encourage him to undertake a larger project, focusing on exterior views of New York's most important commercial and residential buildings, many of them along Broadway (figs. 188, 189, 217). By 1853 the taste for photographic views in America was well established; as early as 1851 the New York press had celebrated Robert H. Vance's panoramic views of California—"*three hundred full plate views . . .* of the principal cities and most conspicuous places in the land of gold."[34] In February 1853 Meade Brothers advertised that in its gallery, along with portraits of illustrious Americans and Europeans, were "fine panoramic views of the city of San Francisco, California, the Falls of Niagara, Shakespeare's house at

34. "Daguerreotype Panoramic Views in California," *Daguerreian Journal*, November 1, 1851, p. 371.

Fig. 188. Victor Prevost, *Alfred Munroe and Company, Clothing, 441 Broadway*, 1853–54. Modern gelatin silver print from waxed paper negative. Collection of The New-York Historical Society

Fig. 189. Victor Prevost, *Dr. Valentine Mott House, Ninety-fourth Street and Bloomingdale Road*, 1853–54. Modern gelatin silver print from waxed paper negative. Collection of The New-York Historical Society

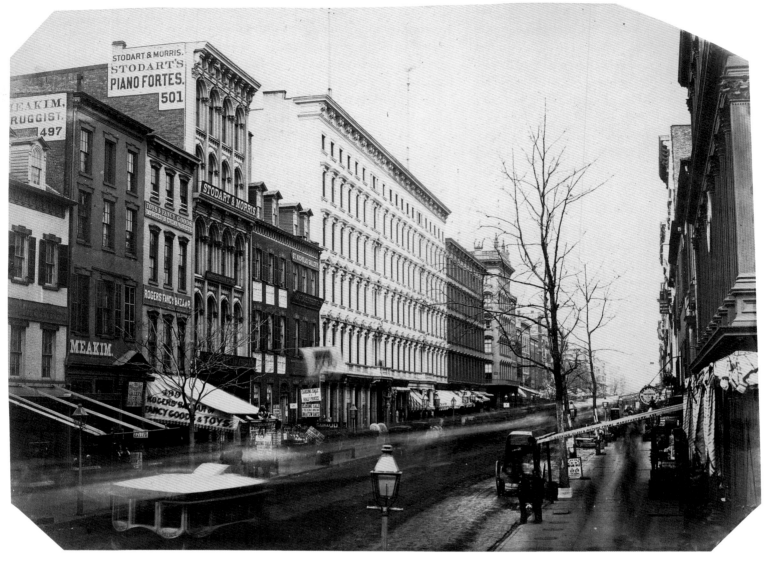

Fig. 190. Attributed to Silas A. Holmes or Charles DeForest Fredricks, *Broadway between Spring and Prince Streets,* ca. 1855. Salted paper print from glass negative. The J. Paul Getty Museum, Los Angeles 84.XM.351.8

35. "Daguerreotype Galleries of Meade Brothers," *Gleason's Pictorial Drawing-Room Companion,* February 5, 1853, p. 96.

Stratford on Avon, the Boulevards, Place de la Concorde. . . ."[35] Since Prevost was familiar with the work of the principal French photographers, he would have known of the ongoing effort to document his nation's great architectural monuments, from Roman aqueducts and Gothic cathedrals to the construction of the *grands boulevards* of Paris. In America, where there was no such historic architecture, Prevost found his subject in the changing shape of New York City—a monument constantly in the making.

One of Prevost's earliest views of New York is a study of Battery Place looking across an open lot, soon to be built upon, toward newly constructed warehouses and both Trinity Church and Saint Paul's Chapel (cat. no. 182). Prevost was deeply interested in documenting the ever changing facades of businesses on Broadway, producing more than forty pictures of

the city's most active commercial artery. However, his unusual aesthetic sensitivity is perhaps best seen in two intimate views made from the rear window of his home on Twenty-eighth Street, where no such explicit subject justified the effort. One view (cat. no. 183) shows a patchwork of fencing, shingled roofs, brick walls, and louvered shutters, each with its distinctive pattern and texture picked out by strong summer light; the other (cat. no. 184) is more a study of planes, softened by a dusting of snow. Together, these two views compose a rare glimpse of a photographic artist working only to please himself. To the degree that we understand his ambitions, the absence of contemporary publication or comment on this work and the almost total lack of surviving positive prints suggest that there was not yet an audience or market for Prevost's city views. No subsequent work by Prevost

is known, and although he may have intended to publish these views, his career in photography seems to have ended abruptly. By 1857 he was teaching physics, drawing, and painting near West Point.

Other artists, such as Fredricks and Silas A. Holmes, picked up where Prevost left off, using the next generation of photographic technique.[36] Rather than making negatives on paper, photographers of the mid- to late 1850s employed glass negatives, which combined the exquisite clarity of the daguerreotype and the endless reproducibility of paper-print photography (fig. 190). The fast exposure of the glass negatives allowed the artists to capture more of the life of the city—its inhabitants as well as its monuments—than had previously been possible. Like the heroic Washington gesturing proudly from atop his steed, the pedestrians, neighborhood boys, and local residents pose grandly before the newly erected statue in Union Square (cat. no. 188). Holmes or Fredricks composed an elegant view, balancing the human incident against the architectural backdrop of the city. Similarly, in Washington Square the artist created a complex layering of subject using a reflective plane of water, a crowd of onlookers, a screen of leafless trees, and distant buildings (cat. no. 187). Other subjects ranged from City Hall in winter (cat. no. 186) to the Yonkers Docks along the Hudson, where river commerce and railroad tracks joined against a background of the Palisades (cat. no. 189). Holmes or Fredricks also traveled to Long Island to photograph Fort Hamilton and constructed an impressive marine scene, a two-part panorama including the battlements, docks, and sailing vessels (cat. nos. 190, 191). Among the most memorable views of the city is one of Fredricks's own studio at 585 Broadway (cat. no. 194); the circular vignetting in the untrimmed print echoes the enormous arched sign that grandly advertises "Fredricks' Photographic Temple of Art."

The earliest reference to Fredricks is as a partner to Gurney in both the latter's New York and Paris galleries. In 1855 the *Home Journal*, in a long article entitled "The Poetry of Art, as Exhibited in the Daguerreotype and Photograph," commented that not all photographers are worthy of the appellation artist, the rest being mere practitioners. The author recommended a visit to the gallery of Gurney and Fredricks:

Gurney is a painter, an artist who uses the light as a pencil, to paint in truthful characters the object before him. Mr. Fredericks [sic], to whom the credit is due of introducing Photographs into this country, as well as Paris, and who has advanced his branch

of art to its most perfect state, has now associated himself with Mr. Gurney, and with the aid of several foreign artists, all perfect in their line, such as pastel, oil and water colors, it must be evident that the establishment of Gurney will admit of no equal rivalship, and consequently remains alone as the personification of the Poetry of Art.[37]

Clearly the ambition was to rival painting. The *New-York Times* noted Gurney had "added to the long array of pictures in his own line of art which grace his walls, a row of oil-paintings by various native masters. He does this ostensibly by way of adding to the other attractions of his gallery, but our opinion is that the artful fellow has hung the oil-paintings up to show, by contrast, the superiority of the Photographic article."[38]

By 1858 the *New-York Times* estimated that there were two hundred photographic galleries in New York, producing on average fifty pictures per day and bringing in an annual total of $2 million—an amazing sum for an upstart profession. But the popularity of the daguerreotype had begun to wane, and most artists had introduced into their business new styles of portraiture to entice the public to visit their galleries. One such new type of photograph was the ambrotype

Fig. 191. Mathew B. Brady, *Greenville Kane*, 1856–60. Ambrotype. The Metropolitan Museum of Art, New York, The Rubel Collection, Purchase, Lila Acheson Wallace Gift, 1997 1997.382.48

36. In period accounts and advertisements, Fredricks's name also appears as "Fredericks." A small number of unsigned views of New York believed to be by either Fredricks or Holmes are in the collection of the J. Paul Getty Museum, Los Angeles. The prints came from a disbound album that also included signed works by Fredricks and by Holmes, which led to the attribution of the unsigned examples to one or the other of these two artists.

37. *Home Journal*, February 24, 1855, p. 3.

38. "Pictures on Broadway," *New-York Times*, December 9, 1858. The editor noted particularly two marine scenes by the Boston painter Fitz Hugh Lane.

Fig. 192. Alexander Gardner, *Antietam Battlefield*, 1862. Albumen silver print from glass negative. Gilman Paper Company Collection, New York

(fig. 191), which first appeared in New York in 1856. Cheaper to produce than a daguerreotype—but technically inferior to it—an ambrotype is a unique image produced on a silver-coated sheet of glass. Set into a miniature case, it was exceptionally popular for a few years, before paper photography completely replaced it and the daguerreotype by the beginning of the Civil War.

The coup de grâce to both the daguerreotype and the ambrotype was the successful introduction into America in the summer of 1859 of the carte de visite, a small photograph, most often a portrait, mounted on a card measuring approximately 4 by 2½ inches. There are conflicting opinions as to who introduced this novelty in the United States, but Fredricks is generally given the honor.[39] Using a special camera apparatus that produced eight simultaneous images on a single glass plate, photographers were quickly able to produce inexpensive portraits, which then could be freely distributed by the sitter as a visiting or calling card. Almost immediately the fashion for collecting cartes de visite swept the world—a phenomenon that captivated even Queen Victoria, who by report kept albums of them and "could be bought and sold for a Photograph!"[40]

As the decade ended, in an effort to differentiate themselves from the mass of "mere practitioners," the major photographic artists continued to introduce new styles of portraiture. The most ambitious began to sell large-format portraits on paper or canvas, which were often heavily overpainted with ink, crayon, and oils in order to flatter the sitters, something not possible with daguerreotypes. In *The Crayon*, for instance, Gurney and Fredricks advertised that they had "just patented their new process for taking Photographic Impressions on Canvas." They boasted that their "IMPORTANT DISCOVERY!" possessed "correctness of delineation and beauty . . . with two short sittings, and a trifling expense." The same listing noted that the gallery also offered "other various styles of colored Parisian Photographs, taken as usual, and at no other establishment in America."[41]

In 1856 Mathew Brady welcomed the services of Alexander Gardner, an operator skilled in the use of both glass-plate negatives and the paper-print process. Brady eventually became less engaged in the manipulation of plates and chemicals, preferring to use the assistance of Gardner in the mechanical aspects of the process. Instead of occupying himself with technique, the studio founder—who had begun to lose his eyesight—focused his attention on the arrangement of the sitters, their physical and psychological comfort, and, perhaps most important, the promotion of his business. By January 1858 Brady was managing two separate portrait studios in New York and one in the nation's capital.

Brady specifically advertised all the new photographic processes in the city's important newspapers and magazines. With this technology, negatives could be enlarged to yield lifesize prints that still retained excellent detail, color, and tone. Brady's impressive "imperial" portraits, measuring 17 by 21 inches and selling for the substantial sum of $50 to $500 apiece, were a huge success. Cornelia Van Ness Roosevelt, wife of Congressman James J. Roosevelt, sat for such a portrait dressed in a tiered skirt of silk taffeta, a pagoda-sleeved bodice, and a black lace shawl (cat. no. 196). Pinned to her collar is a portrait miniature, likely a daguerreotype of her husband. Mrs. Roosevelt presents herself in the highest fashion of the day as a central figure in the social and intellectual world of New York.

Among Brady's other notable subjects was the eighth president of the United States, Martin Van Buren, a seasoned statesman whose own clout was synonymous with that of the Democratic Party (cat. no. 195). He held office as attorney general and governor of New York, United States senator, secretary of state, and vice president under Andrew Jackson. Short in stature, Van Buren was a shrewd political stalwart whom the press dubbed "The Little Magician." By the mid-1850s, however, Van Buren had fallen out of

39. See Marcus A. Root, *The Camera and the Pencil; or, The Heliographic Art* (Philadelphia: M. A. Root, 1864; reprint, Pawlet, Vermont: Helios, 1971), p. 381.

40. Eleanor Julian Stanley Long, *Twenty Years at Court, from the Correspondence of the Hon. Eleanor Stanley, Maid of Honour to Her Late Majesty Queen Victoria 1842–1862* (London: Nisbeet and Co., 1916), p. 377; quoted in William C. Darrah, *Cartes de visite in Nineteenth Century Photography* (Gettysburg, Pennsylvania: W. C. Darrah, 1981), p. 6.

41. "Photographic Oil Paintings on Canvas," *The Crayon*, July 25, 1855, front page.

political favor. Nonetheless, he was just the right type of American Brady could use to promote his burgeoning New York portrait practice. Brady's portrait disguises Van Buren's small size and recalls his former prominence as an American president, one of only four living in 1855.

Alongside Brady's, Gurney's, and Harrison's portraits of a wide range of New Yorkers—from aristocratic Knickerbockers, to prominent politicians, to Brooklyn delivery boys—are likenesses of an altogether different sort. Photography was first put to service for the identification and apprehension of criminals in the late 1850s. In New York, 450 photographs of known miscreants could be viewed by the public in a rogues' gallery at police headquarters, the portraits arranged by category, such as "Leading pickpockets, who work one, two, or three together, and are mostly English." Yet, the reading of individual portraits is not always self-evident. Would the seemingly affable young man in the overcoat and silk tie appear villainous without the caption "Amos Leeds—Confidence Operator" below his portrait (cat. no. 177)?

In 1856 a preliminary plan for the improvement of a large tract of land that came to be known as Central Park was drawn up by the city's chief engineer. Within a year the commissioners had selected the proposal submitted by Frederick Law Olmsted and Calvert Vaux, one of thirty-three submitted to a competition. The schematic design for their firm's elaborate program of bridges, walkways, and fountains survives in the municipal archives. Olmsted and Vaux employed Brady to produce photographs of the existing outlines of the terrain, which they used to construct their Greensward Plan, a series of "before" and "after" scenes on large presentation boards showing the proposed transformation of the landscape (cat. nos. 192, 193). On virtually every board, the designers presented an engraved map of their plan marking a particular feature and vantage point, a photograph entitled "Present Outlines," and a small oil painting, "Effect Proposed." In perhaps the most ambitious landscape project ever undertaken in America, photography played an integral role in communicating Olmsted and Vaux's task and vision. For the modern New Yorker, Brady's photographs remain the singular evidence of the terrain's original topography before

Fig. 193. Mathew B. Brady, *Abraham Lincoln*, 1860. Carte de visite; salted paper print from glass negative. National Portrait Gallery, Smithsonian Institution, Washington, D.C. NPG.96.179

its transformation. If these landscapes seem reticent and rather undramatic compared to the luxury of Brady's studio portraits, they do, nevertheless, serve as a precedent for what would soon occupy the artist: a five-year effort to document the Civil War, which would divide the century as it did the country (fig. 192). One could argue that Brady's first war portrait was of a tall young lawyer from Illinois named Abraham Lincoln, who spoke to a large Republican Party audience at the Cooper Union on February 27, 1860 (fig. 193). When elected president in the fall, Lincoln simultaneously acknowledged the astonishing power of both New York politics and the new medium of photography: "Brady and the Cooper Institute made me President."[42]

42. Quoted in Mary Panzer, *Mathew Brady and the Image of History* (exh. cat., Washington, D.C.: Smithsonian Institution Press for the National Portrait Gallery, 1997), p. 169.

"Ahead of the World": New York City Fashion

CAROLINE RENNOLDS MILBANK

It was a rare visitor to the Empire City during the nineteenth century who was not struck by the spectacle of stylish persons promenading up and down the avenues, by the diversity and quality of the shops, and by those wondrous must-see bazaars, the large department stores. Evidently the onetime colony had gone a long way toward shaking off its reputation for social backwardness. As for the early American style of unpretentious simplicity that honored the ideals of a new republic, it had proven no match for the alluring range of wares offered in what was becoming the greatest shopping city in the world.

Arriving in New York City, one docked at the southern end of Manhattan and proceeded up its widest, most accessible thoroughfare, Broadway. When travelers published their impressions of the new country they almost always commented on the hustle and bustle of this main artery (see fig. 194). What in 1819 seemed to a delighted British observer "one moving crowd of painted butterflies"[1] became, as the city ballooned in size, more intimidating to others: in 1853 a Swedish visitor worried, "I merely think of getting across the street alive,"[2] and a Russian writer grumbled in 1857, "Starting in the morning until late in the evening, Broadway and the adjoining streets are crowded with magnificently dressed women and with Americans rushing about on business. Despite the wide sidewalks, the crush is so great that one cannot make a step without poking someone with elbows or body. If you want to excuse yourself or if you wait for apologies, the American has flown by like an arrow."[3]

1. Frances Wright, *Views of Society and Manners in America in a Series of Letters from That Country to a Friend in England during the Years 1818, 1819, 1820* (London: Longman, Hurst, Rees, Orme and Brown, 1822), p. 28.
2. Fredrika Bremer, *The Homes of the New World: Impressions of America*, 2 vols., translated by Mary Howitt (London: Arthur Hall, Virtue and Co., 1853), vol. 2, p. 12.
3. Alexandr Borisovich Lakier, *A Russian Looks at America*, translated from the 1857 Russian ed. and edited by Arnold Schrier and Joyce Story (Chicago: University of Chicago Press, 1979), p. 65.

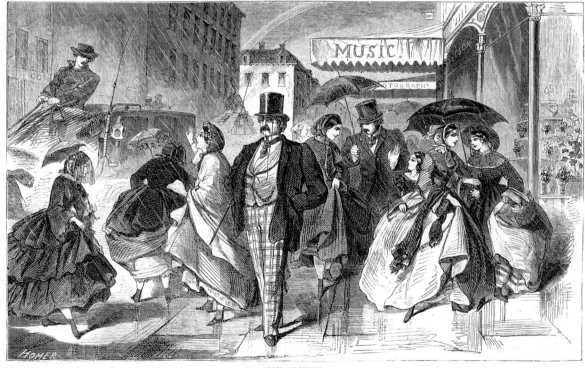

APRIL SHOWERS.

Fig. 194. After Winslow Homer, *April Showers*, 1859. Wood engraving, from *Harper's Weekly*, April 2, 1859, p. 216. The Metropolitan Museum of Art, New York, The Irene Lewisohn Costume Reference Library

Opposite: detail, cat. no. 205

Fig. 195. *Fall and Winter Fashions for 1835 and 1836 by James G. Wilson, New York*, shown in front of houses at 714–716 Broadway built in 1833 for hat manufacturer Elisha Bloomer, 1835. Lithograph with hand coloring by Curtis Burr Graham. Collection of The New-York Historical Society

4. Charles Dickens, *American Notes for General Circulation* (London: Chapman and Hall, 1850), p. 55.

5. William Thomson, *A Tradesman's Travels in the United States and Canada in the Years 1840, 41, and 42* (Edinburgh: Oliver and Boyd, 1842), p. 15.

6. Lady Emmeline Stuart-Wortley, *Travels in the United States, etc., during 1849 and 1850*, 3 vols. (London: R. Bentley, 1851), p. 268.

7. James Fenimore Cooper, *America and the Americans: Notions Picked up by a Travelling Bachelor*, 2 vols., 2d ed. (London: Published for Henry Colburn by R. Bentley; Edinburgh: Bell and Bradfute; Dublin: John Cuming; 1836), p. 194.

8. *Frank Leslie's Ladies Gazette of Fashion* 3 (January 1855), p. 2.

That the crowds were "magnificently dressed" remained undisputed (see figs. 195, 196). In an 1850 description of his visit to New York, Charles Dickens wrote, "Heaven save the ladies, how they dress! We have seen more colours in these ten minutes, than we should have seen elsewhere, in as many days. What various parasols! What rainbow silks and satins! What pinking of thin stockings, and pinching of thin shoes, and fluttering of ribbons and silk tassels, and display of rich cloaks with gaudy hoods and linings!"[4] Showy or prosperous-looking attire was not restricted to women: a visiting tradesman described a fellow boarder "who came out about five years ago, with only one coat; now he has plenty, sports a gold watch, and a silver-headed cane."[5] Another writer noted, "A mob in the United States is a mob in broad-cloth. If we may talk of a rabble in a republic, it is a rabble in black silk."[6]

Selling Fashion

Although Philadelphia, Boston, and New Orleans, like New York, were port cities known for their sophistication, only the Empire City became a shopping mecca regularly mentioned in the same breath as Paris and London. Broadway could "safely challenge competition with most if not all of the promenades of the old world," wrote James Fenimore Cooper.[7] Exclusive to New York was the great range of its emporiums, from showman A. T. Stewart's department store (perhaps the world's first) to the small but extravagantly luxurious establishments run by modistes or couturiers, milliners, fancy-goods dealers, and jewelers. As one journalist declared in 1855, "The windows in Broadway alone are enough to make the money leap from one's pocket, if in these times any one is fortunate enough to have any."[8]

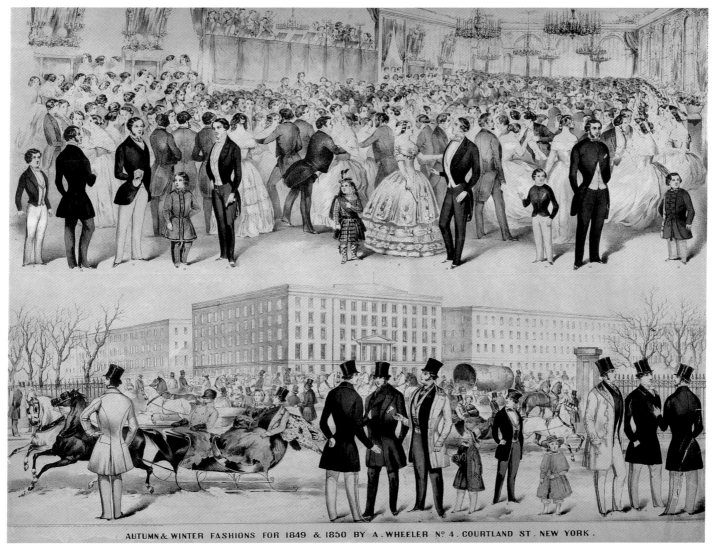

AUTUMN & WINTER FASHIONS FOR 1849 & 1850 BY A. WHEELER Nº 4. COURTLAND ST. NEW YORK.

Fig. 196. *Autumn and Winter Fashions for 1849 and 1850 by Saxony and Major,* shown in the Astor House ballroom and outside the hotel on Broadway, 1850. Lithograph with hand coloring by Asa H. Wheeler. Museum of the City of New York, The J. Clarence Davies Collection

Most likely the windows that were the cynosure of all eyes belonged to Stewart, a successful and influential merchant and a visionary who became one of New York's first millionaires. The Irish-born Stewart got his start in 1823 selling a shipment of Irish laces at 283 Broadway, then slightly north of the most fashionable area. The great appeal of a dry-goods store (from which the department store would develop) was that for the price of a packet of pins one could gaze in wonder at a thousand-dollar shawl. Sensing the possibilities of something bigger, Stewart expanded and moved his business several times until, in 1846, he built his "Marble Palace" (see fig. 197). While most shops occupied the ground floor of a residentially scaled building about twenty-five feet wide,[9] this new marble-faced structure (cat. no. 96), perhaps the first ever built specifically to be a store, was far larger. Both

architecturally and in terms of its offerings, it would be enormously influential. Its plate-glass windows, which had to be imported, struck the public as extravagant and novel. A rotunda provided interior light. Inside were impressive columns, wall and ceiling frescoes, ornate chandeliers, and gaslights. Features that awed visitors most were the size of the space, the height of the mirrors, the number of mirrors and windows, and, of course, the profusion of goods. These included carpets, sold on the basement levels; upholstery and drapery fabrics; dress goods; silk goods; embroidery; fancy articles; shawls, displayed in a shawl room; and hosiery and gloves, in their own room.[10] As in the early days of Stewart's shop, fine lace and lace articles (see cat. no. 201) were always available. On the top floor was a wholesale department from which dry-goods merchants from around

9. Harry E. Resseguie, "Stewart's Marble Palace—the Cradle of the Department Store," *New-York Historical Society Quarterly* 48 (April 1964), p. 131.

10. The variety of goods available at A. T. Stewart made it easy to buy a trousseau there. The list of purchases made in preparation for an 1850 marriage by Elizabeth Ann Valentine of Richmond, Virginia, and her parents, survives as part of the Valentine Museum collection, along with some of the items on it (including her wedding veil of Irish Carrickmacross lace [cat. no. 201]). The list gives an idea of what were considered necessities for setting up a young lady in a new household: dresses of silk, muslin, and calico; handkerchiefs; bonnets for outdoor wear, headdresses for evening parties, caps

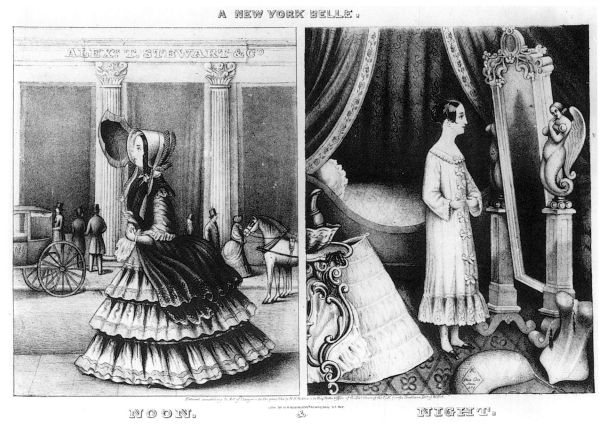

Fig. 197. *A New York Belle, Noon and Night: The Secrets of the Crinoline Silhouette, as Demonstrated by a Patron of A. T. Stewart,* 1846. Lithograph published by H. H. Robinson. Museum of the City of New York, The Harry T. Peters Collection 57.300.548

to wear at home; a cashmere scarf, a crepe shawl, a silk mantilla; pretty nightgowns and caps; gaiter boots and slippers; as well as many other items.

11. *New-York Times,* November 19, 1858, p. 8.
12. Ibid.
13. *Godey's Lady's Book* 48 (May 1854), p. 479.
14. Ibid.

the country could acquire stock. Dazzling though it was, the Marble Palace was expanded a number of times until by 1858 it boasted a frontage of 151 feet on Broadway and 175 feet on Reade and Chambers streets.[11] At that time the *New-York Times* called A. T Stewart "the largest dry-goods establishment in the world," with a stock valued at from "three to five millions of dollars."[12]

Stewart's influence extended beyond the world of dry goods. During the 1850s all kinds of fashion businesses in New York began to emulate his innovative approach. George Brodie, one of New York's most enterprising clothing merchants (see cat. no. 199; fig. 198), specialized in luxurious wraps of all sorts, which were sold ready-made. As was typical for a New York business, Brodie manufactured the garments and then sold them directly to customers on a retail basis, as well as wholesale to other merchants. If an effusive (and probably paid-for) editorial published in 1854 in *Godey's Lady's Book* can be believed, Brodie's was unusually impressive for a limited, specialized establishment. While most store windows of the period displayed a small, somewhat static array of merchandise, Brodie's beckoned the customer with

such novelties as lifesize mechanical mannequins. *Godey's* described the large windows: "in reality, small Crystal palaces for the accommodation of two slowly revolving dames in court costume of brocade or *soie d'antique,* bearing upon their regal shoulders the chef d'oeuvres of the establishment, whether velvet, guipure, or taffeta. . . . At their feet are thrown, in apparent careless, but really artistic confusion, other designs not less elegant and attractive. These figures are of wax, modeled and colored from life. . . ."[13] Once inside, the visitor ascended a staircase covered by velvet runners to a richly carpeted main salon lined with white and gold French wallpaper and suggestive of "a drawing-room rather than a business establishment. . . . Here there are piles of the most elegant and costly styles of mantillas and scarfs . . . the busy crowd of purchasers flutter back and forth, exclaiming, 'rapturizing,' choosing, and trying on the profusion of styles before them."[14] On the floor above were showrooms catering to the wholesale trade, whence Brodie's wraps were shipped all over the United States, to Canada, and to the West Indies; farther up still were the embroidery workrooms. The handwork executed in these rooms, the hallmark of Brodie garments,

was thought to rival European examples. The best laces and ornately woven silks were always imported, but embroidered goods were luxuries that could be manufactured by American entrepreneurs, since embroidery was easily taught and mastered, and a business dealing in the craft might start small and grow as needed.

Initially, the fashions pictured in American magazines—the first such appearance was in 1830, in *Godey's Lady's Book*—were styles purchased or copied from French or English sources. By the 1840s *Godey's* was publishing, in addition to French fashions, designs described as "Americanized."[15] In the 1850s the magazines that covered fashion[16] began to rely less and less on French looks and to show drawings of American designs, for the first time describing actual clothing available in actual stores. Many more fashion goods were being produced in New York now, an expansion that accommodated the growing population of the city itself, which had tripled in size in a quarter of a century. Magazine articles noted enlargements and improvements to stores as well as fashion innovations. Much of what was newsworthy in 1855 was extravagantly luxurious, like the "magnificent set of white guipure point lace, a scarf, two flounces, a handkerchief, a berthe" available for $500 at A. T. Stewart, or the diamond-and-ruby earrings in the shape of pendant blossoms for $800 at Ball, Black and Company. Also of interest were technological novelties, such as the devices that gave a pinked or crimped edge to silks, displayed at Madame Demorest's. Perhaps the city's favorite fabric in 1855 was a white moiré antique available at Arnold Constable and Company, which was singled out because it had been manufactured for the Paris Exposition of 1855.[17]

Newspaper and magazine write-ups about "opening days" make clear which were the city's most fashionable shops at the end of the decade. A. T. Stewart, Lord and Taylor, and Arnold Constable and Company were *the* stores for dry goods. Brodie's main competition for elegant cloaks, mantillas, and wraps was the Mantilla Emporium of George P. Bulpin, who displayed at the New York Crystal Palace exhibition of 1853 a sumptuously embroidered velvet cloak that had been made, he proclaimed, entirely in America. Top dressmakers included Madame Deiden, Madame Plazanet (who advertised that she had been the fitter at Deiden), Madame Ferrero (see fig. 201), and Madame Ralling, also a milliner. (Rare was the practitioner of either trade who did not adopt the title "Madame.") The leading milliners, Madame Tillman and Madame Harris, were both associated with

Parisian establishments—Madame Harris with Duteis, silk flower purveyor to Empress Eugénie of France. (Mary Todd Lincoln ordered bonnets and headdresses from Madame Harris throughout her White House stay.) John N. Genin was a renowned hatter, providing beaver and silk top hats for men, caps and other hats for men and boys, and tailored hats for ladies; he also expanded his business to include children's and women's clothing, lingerie, and furs, all sold at his shop on Broadway (see figs. 28, 203). William Jennings Demorest and his wife, (Madame) Ellen Curtis Demorest, ran an establishment of unusual range: their New York store featured a full-service dressmaking department (see fig. 204), their paper dressmaking patterns and fashion magazines were distributed around the world, and they later marketed such items as perfumes and cosmetics, sheet music, skirt elevators (which raised a skirt so the wearer could step onto a curb), even bicycles.[18]

Not only were the stores places to find every sort of marvelous creation, but shopping also became an ever more acceptable pastime; it was something ladies

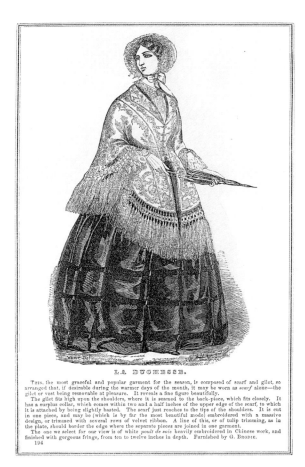

LA DUCHESSE.

THIS, the most graceful and popular garment for the season, is composed of scarf and gilet, so arranged that, if desirable during the warmer days of the month, it may be worn as scarf alone—the gilet or vest being removable at pleasure. It reveals a fine figure beautifully.
The gilet fits high upon the shoulders, where it is seamed to the back-piece, which fits closely. It has a surplus collar, which comes within two and a half inches of the upper edge of the scarf, to which it is attached by being slightly basted. The scarf just reaches to the tips of the shoulders. It is cut in one piece, and may be (which is by far the most beautiful mode) embroidered with a massive design, or trimmed with several rows of velvet ribbon. A line of this, or of tulip trimming, as in the plate, should border the edge where the separate pieces are joined in one garment.
The one we select for our view is of white poult de soie heavily embroidered in Chinese work, and finished with gorgeous fringe, from ten to twelve inches in depth. Furnished by G. BRODIE.
194

Fig. 198. *"La Duchesse" Mantilla Furnished by Brodie.* Wood engraving by William Roberts, after Lewis Towson Voight, from *Godey's Lady's Book*, August 1853, p. 194. The Metropolitan Museum of Art, New York, The Irene Lewisohn Costume Reference Library

15. Other aspects of European culture were "Americanized" as well. According to Dinitia Smith, "Christmas trees became popular only after 1848, when the *Illustrated London News* published a drawing of Queen Victoria, Prince Albert and their children gathered around a tree hung with ornaments. That image was transformed for New World consumption when it appeared in *Godey's Lady's Book* in 1850, democraticized with the removal of the Queen's coronet, and Albert's mustache, sash and royal insignia." Dinitia Smith, "Spirit of Christmas Past and Present, All Stuffed into One Man's Collection," part 2, *New York Times*, December 15, 1999, p. B17.

16. Besides *Godey's Lady's Book* these included *Peterson's Magazine*, *Graham's American Monthly Magazine of Literature and Art*, and *Frank Leslie's Ladies Gazette of Fashion*.

17. *Frank Leslie's Ladies Gazette of Fashion* 3 (January 1855), pp. 2 (quote), 12 (earrings); ibid. 3 (March 1855), p. 42 (moiré).

18. For information about the career of the Demorests, see Ishbel Ross, *Crusades and Crinolines: The Life and Times of Ellen Curtis Demorest and William Jennings Demorest* (New York: Harper and Row, 1963).

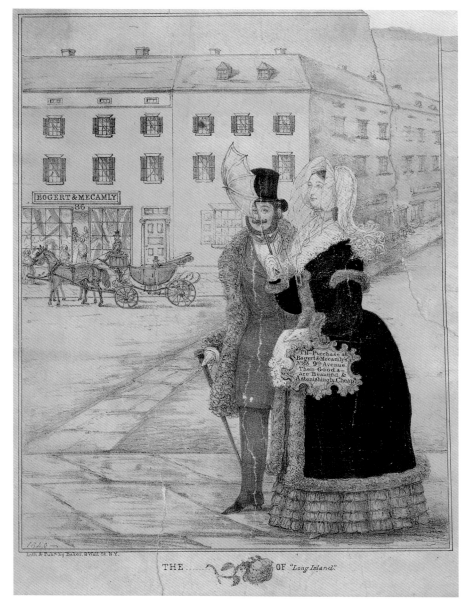

Fig. 199. *"The Rose of Long Island," Miss Julia Gardiner and Gentleman in Front of Bogert and Mecamly's, 86 Ninth Avenue,* 1839 or 1840. Lithograph with hand coloring by Alfred E. Baker. Museum of the City of New York, Gift of Miss Sarah Gardiner 39.5

19. Marie Fontenay de Grandfort, *The New World*, translated by Edward C. Wharton (New Orleans: Sherman, Wharton and Co., 1855), p. 18.
20. Amelia M. Murray, *Letters from the United States, Cuba, and Canada* (New York: G. P. Putnam and Company, 1856), p. 146.
21. A hat owned by Queen Victoria and made by one of her suppliers is labeled "W. C. Brown Riding & Fancy Hatter, To Queen Victoria, The Empress of the French, and the Elite of Europe, 13 & 14, New Bond Street," illustrated in Kay Staniland, *In Royal Fashion: The Clothes of Princess Charlotte of Wales*

could do without chaperones, and thanks to such instore enhancements as art exhibitions, lectures, and architectural novelties, it even acquired the gloss of a cultural excursion. That American women occupied their time thus was occasion for comment. Wrote a Frenchwoman, "Broadway is to New York what the *Boulevard des Italiens* is to Paris. It is the general *rendezvous* of the fashionable ladies, who go from store to store, looking at the newest stuffs or examining the latest styles of jewelry. They call this 'shopping.' A New York lady, without a hundred dollars a month to spend in these rounds, would look upon herself as the most unfortunate woman in the world."[19] Another observer from Europe, Queen Victoria's

maid of honor, drew an unfavorable comparison: "American ladies bestow those hours of leisure, which English women of the same class give to drawing, to the study of nature, and to mental cultivation, almost wholly on personal adornment."[20]

In Europe it was customary for a purveyor of quality goods to obtain permission to display a royal warrant;[21] in republican America merchants turned early to the idea of publicity featuring celebrities. In 1824 a hatter sent General Lafayette one of his creations and presented additional hats to Lafayette's son, ostensibly in recognition of our country's debt to the general but probably also hoping to promote his wares as Lafayette-worthy.[22] In 1839 Julia Gardiner, a society belle known as "The Rose of Long Island" and the future wife of President John Tyler, allowed her picture to appear in an advertisement for a store called Bogert and Mecamly's, an event that sparked considerable controversy (fig. 199).[23] By midcentury the savviest merchants were sending articles of clothing to prominent persons in order to advertise their patronage. Genin, possibly New York's best-known hatter, generated a great deal of publicity by delivering a riding hat to singer Jenny Lind—newly arrived from Sweden in 1850 to begin what would be a wildly successful tour—and then selling duplicates known as "the Jenny Lind hat" at his store.[24] President Millard Fillmore wrote several letters, beginning in 1851, to the New York tailor Charles Patrick Fox, thanking Fox for fabric, for an offer to make him a pair of pantalons (pants), and for fitting him for a suit of clothes.[25] In 1852 a newspaper called *The Lily* published a testimonial about the Genin hat that had been sent as a present to its editor, Amelia Bloomer, and helpfully furnished Genin's address for anyone wanting to order a hat of her own.[26]

New York merchants set many precedents for the presentation and selling of clothing throughout the country. Their innovations included the new and widely copied architectural settings (Marshall Field advertised his Chicago store as the Stewart's of the West),[27] an emphasis on all things French, and the unabashed use of celebrity cachet, as well as set prices, advertising, use of catalogues and promotional booklets, and organized displays of the latest wares. These last ranged from coordinated "opening days," when stores displayed their latest imports and creations to both customers and the press, begun in the 1850s, to exhibitions such as the annual fairs of the American Institute of the City of New York, which were precursors of international expositions such as those at the Crystal Palace in London in 1851 and in New York in 1853.

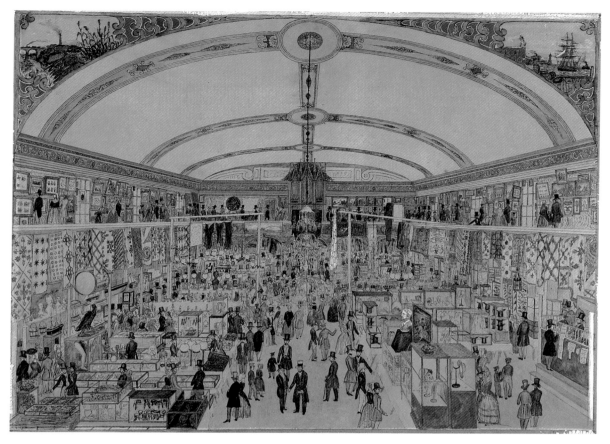

Fig. 200. Benjamin J. Harrison, *Annual Fair of the American Institute at Niblo's Garden,* 1845. Watercolor. Museum of the City of New York 51.119

Manufacturing Clothes

It was natural for the manufacture of ready-to-wear clothing to expand dramatically in an American setting. The biggest advantage of early ready-made clothing was not that it might cost less but that its production saved considerable time and effort. Well into the nineteenth century, the process of acquiring a dress was complicated. Although bills of sale from the period record the price of a "robe," the consumer who purchased that robe was really buying the stuff, trimmings, and other necessities for making a dress. The fabric was then taken to a dressmaker or modiste, or just brought home, to be made into a full article of clothing; if it was done professionally, this added to the cost.[28] The typical consumer of fashion in the late eighteenth or the nineteenth century had to be quite knowledgeable about fabrics and construction. Fashion plates—black-and-white engravings that sometimes had been hand colored—were the only visual information about styles available and necessarily were more like recipes that could be interpreted than directions that had to be followed exactly. Before the invention of the paper pattern, first demonstrated by the Demorests in 1854, the process of having a dress made

involved participating in its design, and not everyone had the talent, patience, or interest for this. Jane Austen, for example, who was attentive to fashion in a general way, wrote in a letter of 1798, "I cannot determine what to do about my new Gown; I wish such things were to be purchased ready made."[29]

American ready-made men's clothes were for sale in New York by the mid-eighteenth century, and by the beginning of the nineteenth century the city was already producing ready-made clothing for women and children as well as uniforms for servants and sailors, along with a variety of items such as fancy dress, hats, wigs, shoes, and every kind of printed fabric. In the course of the nineteenth century New York became not just a giant of retail but the center of a rapidly growing garment industry, fed by the city's ideal location for incoming and outgoing goods, a constantly renewed immigrant workforce, and an explosion of new technologies. Some of the innovations, such as the sewing machine and the paper pattern graded for size, had applications at home as well as in business. Manufacturing benefited from the invention of power-driven looms that wove specialty fabrics and machines that made lace, covered buttons,

and Queen Victoria, 1796–1901 (London: Museum of London, 1997). p. 152.

22. Cooper, *America and the Americans,* p. 238.

23. Posing for an advertisement lithograph was simply not done: not by established matrons, not by actresses, and certainly not by young ladies of the social stature of Julia Gardiner, whose prominent New York family had settled and owned Gardiner's Island. No other such occurrence in that period is known. To rub salt in the Gardiner family wound there were the facts that the store, forgotten today except for this one episode, was less than fashionable (the family patronized A. T. Stewart); that Julia was shown ostentatiously dressed; and worst of all that she was shown practically arm-in-arm with "an unidentified older man, clad like a dandy in top hat and light topcoat . . . carrying an expensively wrought cane." Had a young lady ventured out for an unchaperoned promenade with such a scamp in real life, her reputation would have been ruined. As it was, the Gardiners "were embarrassed and humiliated" and sent her to Europe. That Julia's reputation survived is perhaps most clearly proven by her marriage five years later, in 1844, to then-President John Tyler. See Robert Seager II, *And Tyler Too, A Biography of John and Julia Gardiner Tyler* (New York: McGraw-Hill Book Company, 1963), p. 35.

24. For more information about Genin's career, see Wendy Shadwell, "Genin, the Celebrated Hatter," *Seaport, New York's History Magazine,* spring 1999, pp. 22–27.

25. Fox eventually included all the letters in his book, Charles Patrick Fox, *Fashion: The Power That Influences the World,* 3d ed. (New York: Sheldon and Co., 1872), pp. 204–5.

26. *The Lily* (Seneca Falls) 4 (March 1852), front page.

27. Lloyd Wendt and Herman Kogan, *Give the Lady What She Wants! The Story of Marshall Field & Company* (Chicago: Rand McNally, 1952), pp. 58–59.

28. Examples of dressmakers' fees are given in *Godey's Lady's Book* 48 (June 1854), p. 572. "No city dressmakers, with any pretense to good style, will undertake to make a dress for less than three dollars. In the really fashionable shops, $4.75 is the charge of

making a basque waist, apart from the skirt—silk, buttons, all trimmings charged separately in the bill; so that you have from seven to nine, and even fifteen dollars to add to your two yards and a half of silk, the quantity usually purchased for a basque."

29. Jane Austen to an unknown correspondent, in Claire Tomalin, *Jane Austen: A Life* (New York: Alfred A. Knopf, 1997), p. 110.

Fig. 201. *Emerald Green Velvet Bonnet from the Establishment of Madame V. Ferrero, 5 Great Jones Street,* 1854. Wood engraving, from *Frank Leslie's Gazette of Paris, London and New-York Fashions,* January 1854, p. 7. The Metropolitan Museum of Art, New York, The Irene Lewisohn Costume Reference Library

printed in many colors on fabrics, tucked or embroidered, or cut through several layers of fabric at once. The development of aniline (man-made) dyes made rich, strong colors more obtainable and affordable than ever before.

The manufacture of clothing in America was less expensive than importation, since it did away with shipping and especially import taxes; and it was patriotic, which suited the independent American spirit. From 1828 on, the American Institute of the City of New York held an annual fair at which awards were given for excellence in the areas of agriculture, horticulture, manufactures, commerce, and the arts (see fig. 200) . Items of clothing of all sorts were to be seen there, as they were later at expositions such as the Crystal Palace exhibitions in the early 1850s. New York–made articles included—in addition to boots and shoes (rubber, patent leather, cork soled) and hats (of fur plush, for fur, along with rare plumage, was still one of America's most abundant natural resources)—corsets, umbrellas, clothing of homegrown merino wool, even homespun silk from the cocoons of silkworms fed on peanut plants. Evidently New York's fashion ingenuity was applied to producing what people wanted at least as much as to supplying what they needed.

Technology's greatest contribution to fashion was to make good-quality clothes widely available. Although Americans did not invent ready-to-wear, they perfected its mass manufacture, marketing, and distribution; by the end of the nineteenth century, what was produced in New York and sold throughout

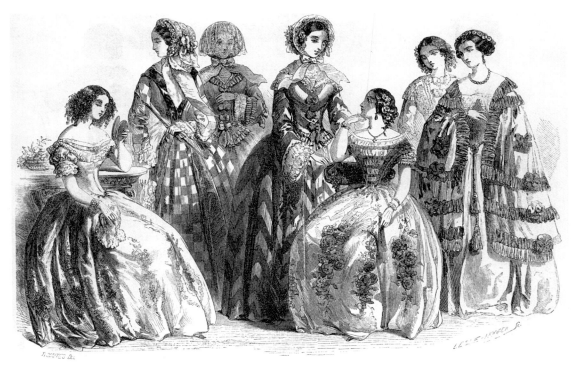

Fig. 202. *A Selection of Day and Evening Dresses Available in New York,* including a ball gown (far left) imported by A. T. Stewart and others made from materials available at A. T. Stewart and Arnold Constable and Company, 1854. Wood engraving by Leslie and Hooper, after Edward Waites, from *Frank Leslie's Gazette of Paris, London and New-York Fashions,* January 1854, p. 9. The Metropolitan Museum of Art, New York, The Irene Lewisohn Costume Reference Library

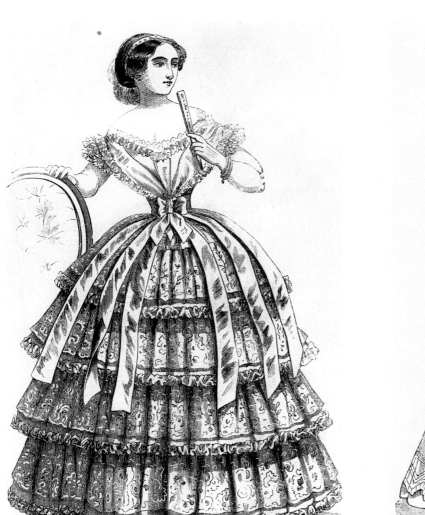

Fig. 203. *Ball Gown Made by Genin with Silk from A. T. Stewart and Lace from Genin*, 1854. Wood engraving, from *Frank Leslie's Gazette of Paris, London and New-York Fashions*, May 1854, p. 85. The Metropolitan Museum of Art, New York, The Irene Lewisohn Costume Reference Library

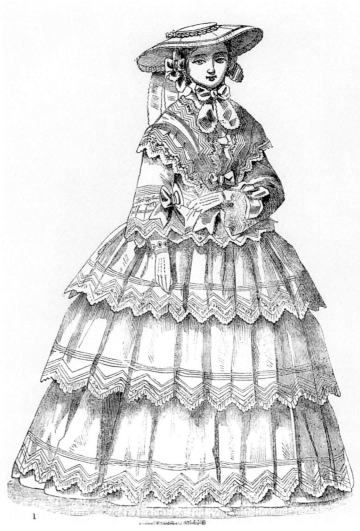

Fig. 204. *Country Excursion Dress Made by Madame Demorest*, 1854. Wood engraving, from *Frank Leslie's Gazette of Paris, London and New-York Fashions*, August 1854, p. 144. The Metropolitan Museum of Art, New York, The Irene Lewisohn Costume Reference Library

the country was a profusion of well-made, well-fitting clothes for men, women, and children, obtainable in every price range. When, well into the twentieth century, European couture houses decided to dip into the lucrative market of better ready-to-wear, they turned to New York manufacturers for machinery, skilled workers, and expertise.

Fashion and Manners

Technology affected not just how clothes were produced and distributed but also how they looked. Men's clothing, the first to be standardized and mass-produced, as the nineteenth century unfolded grew soberer and simpler than ever before. First the frock coat and long trousers and then the lounge suit (pre-

cursor of the business suit) became a uniform that had an equalizing effect. In the previous century both sexes had worn powdered wigs, colorful brocaded and embroidered silks, shoes with heels and elaborate buckles. As a definite masculine style emerged that was tailored and somber, women's clothes became far more feminine by comparison, particularly in silhouette and degree of decoration (see figs. 201–204). Novel types of ornament could now be produced in copious amounts by machine, and changing attitudes toward display and ostentation encouraged the proliferation of elaborate effects. Moreover, as the population became increasingly upwardly mobile, new codes of behavior abetted consumerism.

The republic had certainly come a long way since George Washington's schoolboy days, when he kept a

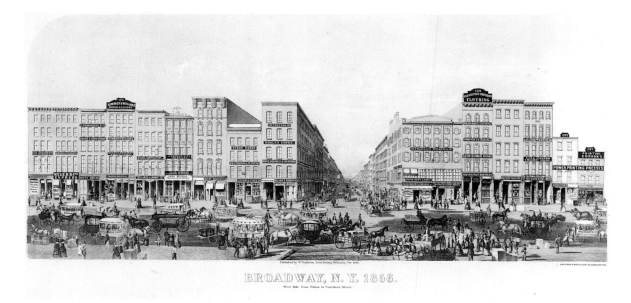

Fig. 205. *Broadway, West Side from Fulton Street to Cortlandt Street*, 1856. Tinted lithograph, published by W. Stephenson. The Metropolitan Museum of Art, New York, The Edward W. C. Arnold Collection of New York Prints, Maps, and Pictures, Bequest of Edward W. C. Arnold, 1954 54.90.1161

workbook of rules about decent and polite comportment. Its numbered maxims included these: "7th: Put not off your Cloths in the presence of Others, nor go out your Chamber half Drest. . . . 13th: kill no Vermin as Fleas, lice ticks &c in the Sight of Others, if you see any filth or thick Spittle put your foot Dexterously upon it if it be upon the Cloths of your Companions, Put it off privately, and if it be upon your own Cloths return thanks to him who puts it off. . . . 51st: Wear not your Cloths, foul, unript or Dusty but see they be Brush'd once every day at least and take heed tha[t] you approach not to any uncleanness."[30] By the late eighteenth century advice about clothing etiquette was somewhat more developed, but it still had a simple message: "Dress should only second beauty, and not shroud it; the choice, and heap of ornaments, are the foil."[31]

Yet in a few decades the dictates of etiquette had multiplied, reinforcing a newly strong relationship between consumerism and propriety. Rules of civilized conduct prescribed what ladies and gentlemen should wear at all hours of the day and for all types of occasions. Magazine coverage of etiquette was closely intertwined with that of fashion, and the advice given was so specific that an insecure customer paying close attention could purchase secure fashion footing:

For morning excursions, or what is called shopping, it is the very best taste to be dressed with the most unpretending simplicity—in the darkest colors,

without either flowers, feathers, or jewelry. The elegance of the cut of the garments; the neatness of the black gaiter boot; the fineness of the texture of the handkerchief, and the plain cambric or India muslin undersleeves and collar, are alone sufficient marks of distinction. No lace, except Valenciennes, is admissible in early morning costume; no bracelets, excepting plain gold circles round the wrist. . . . As the day advances towards its meridian, all its useful avocations having been performed, the time for displaying the elegancies and richness of the fashions arrives. Visits are supposed to be paid, and the object of being in the street is that of promenading and meeting friends and acquaintances [see fig. 205]. Even now, however, there are certain colors, materials and forms, which should never be worn in the street. No precious stones are made for sunlight—they are made to glisten beneath the brilliant chandelier of a ball-room, and appear tawdry at all other times. Now, rich embroideries may be worn—richer laces, and lighter colors, though sky blue, pink and yellow, should be studiously avoided. . . . In the early morning toilette, dark gloves— gray, brown and olive green, should be worn. In the afternoon toilette, all the more delicate tints, straw color being the best, are allowed. White kid gloves should on no occasion be worn in the street.[32]

It is no coincidence that just when fashion was turning into a more exacting dictator and the role of the fair sex was becoming increasingly connected with

30. *George Washington's Rules of Civility and Decent Behavior in Company and Conversation*, edited by Charles Moore (Boston: Houghton Mifflin Company, 1926).

31. *The Ladies' Friend* (Philadelphia: Matthew Carey, 1793), p. 38.

32. *Graham's American Monthly Magazine of Literature and Art* 46 (February 1855), p. 195.

display, a small group of women were beginning the first push for suffrage. This too had fashion repercussions. In the 1830s Frances Wright, the author of a popular book about American society who had left Scotland for the United States and become an abolitionist, utopian, and defender of equal rights for women, was spotted in Turkish trousers. The 1840s saw anticorset societies. In 1851 a small band led by Amelia Bloomer adopted an antifashion uniform consisting of a knee-length dress worn over voluminous Turkish trousers. The public response to this costume was intense, so much so that its original wearers abandoned it in hope of being able to concentrate on other areas of women's rights. The outfit continued to be worn, however, as a political statement and for active sports. In 1858 *Godey's Lady's Book and Magazine* published an engraving of a feminine gymnastic costume by Madame Demorest featuring what had come to be called "bloomers."[33]

During the nineteenth century fashion became newsworthy in a way it had never been before. Journalism had generally treated the latest styles as one of women's domestic interests and grouped them with sentimental stories, songs, crafts projects, articles on health, and recipes; but now a consideration of highly entertaining Dame Fashion began to seep into the general culture. Absurd novelties such as immense sleeves, anything related to hoop skirts, and, of course, the bloomer costume were fodder for political cartoonists and commentators. Excessive display, ever on the increase, was becoming news. In 1840 a private costume ball given by Henry Brevoort was described on the front page of the *Morning Herald,* occasioning a great hue and cry about the invasion of privacy. Nevertheless readers lapped up all the details about who was there and what was worn—the paper even published floor plans of the house.[34] Thus was born an insatiable appetite for information about society and fashion. In a pattern that would continue, the ball was both fawningly described and (in another article) satirized.[35] By 1860, when the renowned Prince of Wales ball took place, a number of newspapers devoted front-page articles to speculation about what people might wear and descriptions of what they did wear.[36]

Dresses for Two New York Balls

Of garments from our period definitively known to have been purchased or worn in New York—or anywhere else, for that matter—relatively few survive. Articles of dress disappear over time because they are remade, discarded, or too fragile to last. The origins of most clothes that survive from the nineteenth century and earlier are unknown. Labels had yet to come into common use; much of the information supplied by donors of clothes to museums has been lost; and what remains is not always reliable, since a donor may easily be a generation off when trying to recollect the owner of a garment. Thus it is remarkable to be able to compare dresses known to have been worn to two historic New York balls almost four decades apart, one given for General Lafayette in 1824 (fig. 206) and the other feting the Prince of Wales in 1860 (cat. nos. 204, 205). Each dress well exemplifies, for its own era, the height of fashion in Manhattan. An examination of the way one style developed into the other provides a brief history of the period's modes and mores.

In the early years of the nineteenth century the dominant style continued to be the one known as Empire, a look that alluded to the ideals of the French Revolution and had been fashionable internationally since that time. It might also aptly be called republican dress, since its hallmarks were simplicity, a comparatively natural silhouette, and plain, unassuming fabrics. The Empire style was meant to recall the dress of ancient Greece and Rome and followed the lines of antique sculpture almost literally: dresses were white and columnar, with high waists. This narrow silhouette, interpreted in sheer, revealing fabrics, was demanding to wear, since it left little room for artificial aids such as corsets. On the other hand, the unconstricting design freed the body, and the use of relatively inexpensive fabrics such as muslin made high fashion affordable to many more women. (Strict adherence to the year-round mode for lightweight fabrics could have dire consequences, however—pneumonia came to be known as "the muslin disease.")

Empire characteristics—simple lines, a high waistline, a preference for white, unpretentious fabrics such as muslin and gauze, embroidery in noncolor thread (white or metallic) to suggest a classical precedent—all appear in the Lafayette ball dress. The cut-steel necklace also worn that evening (see fig. 206) typifies another aspect of Revolutionary dress that well suited a republic: nothing could be less royal than jewelry made of a common metal rather than a precious one.

The Lafayette dress was made of imported fabric, perhaps obtained from an establishment similar to the one that advertised in 1803, "Received by the latest importation from Calcutta, a trunk of the most fashionable Gold and Silver worked Muslin."[37]

33. *Godey's Lady's Book and Magazine* 56 (January 1858), p. 68, caption: "'The Metropolitan Gymnastic Costume' from Demorest's Emporium of the Fashions, 375 Broadway, New York."

34. *Morning Herald* (New York), March 2, 1840, front page.

35. Ibid., February 19, 1840.

36. Newspapers and illustrated weeklies covering the fete included the *New-York Times,* the *New York Herald,* and *Harper's Weekly.*

37. From an advertisement placed by "Ephm. Hart, No. 50 Broad-street," in *The Arts and Crafts in New York 1800–1804,* a collection of advertisements assembled by Rita S. Gottesman (New York: New-York Historical Society, 1965), p. 347.

38. Three evening dresses in the collection of the Valentine Museum, Richmond (L.55.2, V.60.14.3, V.60.14.4A,B), are associated with balls given in Virginia in Lafayette's honor. Compared with the two dresses in New York collections known to have been worn for similar occasions the same year (Museum of the City of New York, 33.112.1; Metropolitan Museum, 1979.346.8), the Virginia examples are considerably more fashionable. They are all made of rich silks brocaded with small figures; one is in a burnished brown that looks ahead to the dark yet intense colors of the 1830s. The trimmings, including rows of cording, puffs of sheer silk, dog-tooth edging, three-dimensional appliqués, and sheer ruffles edged with satin bands, are just the kind of dressmaker details seen in fashion plates.

One dress (V.60.14A,B) has a sash printed with a small portrait of General Lafayette. Other items printed with his likeness and worn in his presence include men's kid gloves and a lady's fan, kerchief, and gloves. The engraved image of Lafayette copied on a pair of man's kid gloves (New-York Historical Society, 1949.118ab) is by Asher B. Durand.

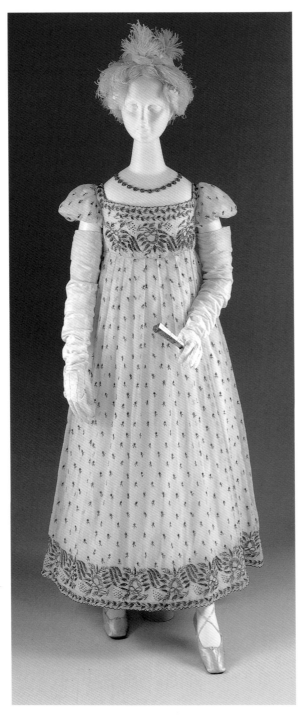

Fig. 206. Ball gown worn by Elizabeth Champlin to the Lafayette Ball at Castle Garden, September 14, 1824. Silver-embroidered muslin imported from India, 1824. Museum of the City of New York, Gift of Mrs. Frederick S. Wombell 33.112.1

Necklace, part of a parure worn to the Lafayette Ball, English, ca. 1820. Cut steel. Collection of The New-York Historical Society 1920.11–17

Long gloves, 1810s–20s. Linen, bias-cut. Museum of the City of New York, Gift of Miss Elisabeth B. Brundige 30.44.4

Fan, European, early 19th century. Spangled net and ivory. The Metropolitan Museum of Art, New York, Gift of Miss Agnes Miles Carpenter, 1955 55.43.12

That a type of fabric considered stylish in 1803 was thought worthy of wearing to a grand ball in 1824 is not unlikely. Fabrics were precious, and dresses were often remade to suit the next generation of wearers. Moreover, early in the century, styles changed slowly. Fads, such as the turbans so loved by First Lady Dolley Madison, could last for years and years. The simple cut of the Lafayette dress resembles not the styles of contemporaneous fashion plates but those of about five years earlier. Comparison of this dress with several others worn the same year in Virginia for celebrations of Lafayette's visit there reveals that in the 1820s New Yorkers, although well dressed, were less up-to-date than Virginians. While the New York dress could have been worn some years earlier, the examples from Virginia, with their darker colors, silk fabrics, and intricate dressmaking details, relate closely to fashion plates of the day and to the color palette of the coming decade.[38]

As the 1830s opened, a new silhouette appeared that seems a harbinger of things to come. The waistline dropped closer to its natural position and the skirt began to assume the shape of a bell. The fuller skirt was balanced by various widening devices at the shoulder such as pelerines or cape collars or, for more formal dress, wide, open necklines. Silk, usually woven with a subtle texture, was much worn. Gauzy whites gave way to browns, mustards, indigo, and rose, rich but somber colors that mirrored the relative absence of color in the uniform men had adopted. It would be the last time in the century that the two sexes complemented each other in dress by similarity rather than by contrast (see cat. nos. 197, 198).

From the 1830s on, novelty most often took the form of exaggeration. Sleeves ballooned, making observers worry lest their wearers take off; such sleeves were followed in the 1840s by tight-fitting ones, which were so impractical, critics complained, that they could be worn only by women who did not need to lift a finger. The one constant was growth in the size of the skirt, the part of the dress best suited to amplification for the sheer sake of display. As long as skirts got their fullness from layers of petticoats there remained a limit to their possible girth, but by the 1850s and 1860s, crinolines—lightweight contraptions made of steel, whalebone, and fabric tape—allowed skirts to reach frequently lampooned proportions (see fig. 197). Although utterly of their period, 1860 dresses, with their fitted bodices and full skirts, convey an air of the previous century. While the manufacture, materials, and distribution of attire had been modernized, women's clothes had over the course of the nineteenth century become more and more constraining because

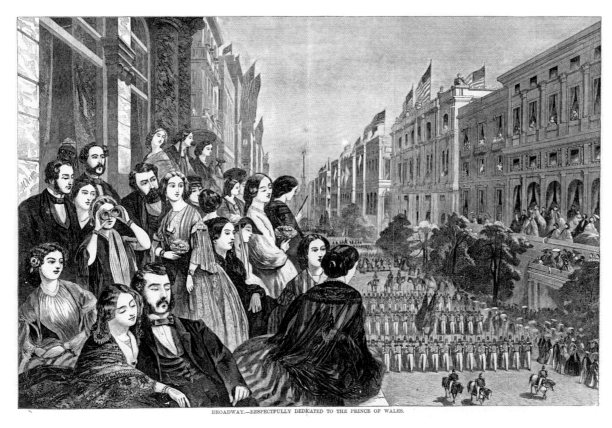

Fig. 207. *Broadway—Respectfully Dedicated to the Prince of Wales,* 1860. Wood engraving by John McNevin, from *Harper's Weekly,* October 6, 1860, pp. 632–33. The Metropolitan Museum of Art, New York, The Irene Lewisohn Costume Reference Library

of increased physical mass, the restrictiveness of corsets, bustles, and hoops, and the oppressive degree of compliance now required by society's conventions.

That fashionable New York had forsaken republican simplicity could not have been made clearer than it was on the night of October 12, 1860, when a lavish ball celebrated the much heralded visit of Albert Edward, Prince of Wales, the future King Edward VII (see fig. 207). Whereas several decades earlier America's proud anti-British stance had been remarked on by many (including the sharp-tongued Frances Trollope), and General Lafayette had been feted as a political—almost a moral—hero, the Prince of Wales was purely and extravagantly Royalty, not to mention an eligible bachelor. Costliness and luxury were the order of the day. Already sumptuous ball gowns were made more elaborate with accessories: no lady felt completely dressed without a headdress; a bouquet holder (see cat. no. 204) with a nosegay by New York's top florist, Chevalier and Brower; gloves of white kid; a fan; a lace-edged handkerchief; slippers or gaiter boots of silk satin; a wrap, or *sortie de bal,* preferably white; and, especially, a parure, or matched set, of jewels (see fig. 208). Diamonds—previously scarce because they had to be imported and in any case regarded as too

flashy in an immediately post-Revolutionary America—were here so prevalent that the fete acquired another name, the Diamond Ball. The *New-York Times* reported, "One splendid *rivière* which recently astounded the city in the cases of Tiffany was most charmingly displayed upon the graceful beauty of Mrs. Belmont. . . . We have already spoken of Mrs. Morgan and her diamonds, and of Mrs. Belmont and her diamonds. We might go on the same way, with perfect truth, to speak of half the ladies of New York and their diamonds."[39]

After diamonds, the element of attire most mentioned was lace, the costliest material of the time, comparable in price to precious stones. Numerous dresses were described as being entirely composed of this painstakingly handmade stuff, which would have seemed too ostentatious even five years before.[40] None of these survive; lace was too valuable not to be reused in another garment. Fortunately, a number of dresses worn to the grand ball for the Prince of Wales still exist,[41] along with accessories and outer garments—far more than for any other event of the nineteenth century—and of these, several showcase silks woven in Lyon that were among the finest fabrics available anywhere in the world. In an attempt to revive the

39. *New-York Times,* October 13, 1860.

40. *Graham's American Monthly Magazine of Literature and Art* 46 (January 1855), p. 97, noted, "There is very little real guipure [a lace made without a net ground] in America. For, though the May-Flower brought over so many things and came over at the very time guipure was the height of fashion, its sage and stately matrons were not likely to bring anything which, like this lace, recalled the painted dames and the follies of the court from which they fled."

41. Most of them were donated to the Museum of the City of New York.

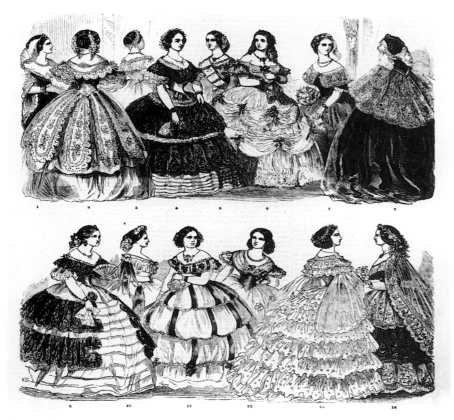

Fig. 208. *Superb Toilettes of the Ladies of New York, at the Grand Ball Given in Honor of the Prince of Wales at the Academy of Music, October 18, 1860,* 1860. Wood engraving, from *Frank Leslie's Illustrated Newspaper,* October 27, 1860, p. 1. Museum of the City of New York 92.51.80

42. The two-piece dress (Museum of the City of New York, 47.146.1–2) worn by a Quaker woman is made of silk taffeta in shades of periwinkle and beige woven with a design of patterned stripes alternating with narrow floral bands, and is trimmed with beige handmade lace and trios of periwinkle silk satin bands. The cape (47.146.3) is of bright pink serge lined with white quilted taffeta and is trimmed on the flat collar and down the front with bands of pink and lavender loop-edged braid. A mention in *Frank Leslie's Monthly* 7 (November 1860), p. 467, of George A. Hearn's shop at 425 Broadway could have been describing this dress material: "if we could fancy the style of goods that Quakeresses dressing themselves like 'the world's people' would select for their *début*—the dainty tiny patterns, the quiet colours, the judicious and very slight intermingling of bright hues with sober slate or delicate fawn—the general air of excellence rather than of showiness, we shall have some idea of the sorts of silks which are to be had here in great abundance."

French silk industry, dormant since Napoleon's time, Louis-Philippe had encouraged couturiers to make liberal use of the looms' products, and a ball gown worn that evening is attributed to Worth et Bobergh, the couture house most closely associated with implementing this plan. While the silhouette is rather simple, with an off-the-shoulder neckline, a narrow, corseted waist, and a tiered skirt held out by a crinoline, all of which had been in style for almost a decade, the material is nothing short of spectacular: coral velvet cut to a ground of silver gauze. According to information handed down with the dress, the material had been woven in Lyon for the empress of Russia and another piece obtained for the use of the Gardiner family. (The dress was worn to the Prince of Wales ball by the wife of David Lyon Gardiner, Julia Gardiner Tyler's brother.)

A second Prince of Wales ball dress of superb cut velvet from Lyon (cat. no. 205) was likely made in New York. In shades of brown and other colors, it is trimmed at the neckline and sleeves with a particularly fine point-de-gaze lace that would have stood out that evening even among stiff competition. The fabric itself is a fine example of a trompe l'oeil textile: in this case,

velvet designed to look like swags of floral lace on a ground of point d'esprit. It was created on the loom *en disposition,* that is, with a pattern intended to be used in a specific way. Accordingly, the dress is fashioned to best display the fabric: the part of the cloth with the largest pattern is used for the overskirt, that with a narrower band of corresponding design for the tiered underskirt, and that with a still narrower strip of pattern to ornament the cap sleeves and the cuffs of the day bodice (not shown here) and the cap sleeves of the evening waist. An uncut piece of the same textile in another color exists. The dress appears to have been made by an able modiste who used care and caution in handling this top-quality fabric.

Even a dress and wrap worn to the ball by a Quaker woman are of very fine fabric, a bright, brocaded silk.[42] The textile design is much more reserved, however, and the style of the dress more covered up than those of the other ball gowns. Beyond the special restraint of religious conviction demonstrated here, the factors that regulated style of dress were age and marital status: older ladies, or "matrons," could display elaborate cut velvets and laces; younger women, particularly unmarried ones, were expected to choose less showy tulle, tarlatan, and other light, gauzy stuffs. A bell-skirted frock of white tulle remained popular garb for debutantes and prom-goers well into the following century.

The coral and silver dress attributed to Worth et Bobergh is one of three Prince of Wales ball gowns that appear to be Parisian in origin. Open for business less than three years when the ball was held, Worth et Bobergh had been founded by the English-turned-French master Charles Frederick Worth, who was destined to become one of the most celebrated and influential couturiers of all time. Another dress bears the label of Worth's closest rival, Émile Pingat, then also new in the business. The third dress, although not certainly from Paris, is likely to have been made there as well, since it was worn to a ball given at the Tuileries by Napoleon III and Empress Eugénie before it appeared at the Prince of Wales event.[43] While in New York the world of clothing was becoming a vast mix of department stores, specialty shops, custom or couture houses, and manufacturers and retailers of ready-to-wear, in mid-nineteenth-century Paris the fashion structure was beginning to revolve around elite couture houses. Instead of buying fabric at a top draper's and taking it to a modiste, one might have a dress made by a couturier (conducting himself like an *artiste*), a procedure that was brand new. Well-traveled, well-heeled New Yorkers were, typically, among the first clients of French couture.

Despite obvious differences, the dresses New Yorkers wore to the Prince of Wales ball share some important characteristics with the gown worn to the Lafayette ball decades earlier. With the exception of two of the Paris-made dresses, the Pingat creation and the ball gown worn to the Tuileries, which are elaborately cut in accordance with the latest fashion plates, the dresses of both eras have what can be described as simple silhouettes.[44] The most elaborate aspect of the designs is the fabrics, which are the best the world had to offer. Because New Yorkers had access to all the very latest fashions, it is safe to assume that they preferred simpler designs that did not detract from connoisseur-level silks and laces. The Paris-made clothes are more sophisticated in cut, but the workmanship of dresses made in the two centers seems equal. In treasuring fine materials New Yorkers were perhaps holding on to their colonial past, when "clothing was much more difficult to obtain than food or shelter" because importing textiles was extremely expensive and making them at home was enormously time-consuming.[45]

Scarcely three months after the Prince of Wales ball, Mary Todd Lincoln celebrated her husband's election with a shopping expedition in New York City. Newspaper and magazine accounts of the marvelous New York–made clothes worn that notable evening must have been on her mind as she sought to outfit herself appropriately for her future role as First Lady (see fig. 209). Offered credit, easily persuaded by able salesclerks to overspend, and flattered by the attentions of reporters following her around, Mrs. Lincoln spent freely: at A. T. Stewart she bought more than one black lace shawl for $650 each as well as a camel-hair shawl for $1,000. There seems to have been no celebrity discount for the wife of a new president likely to be involved in a civil war. Once in the White House, she wrote to her favorite New York stores placing order after order.[46] It was often said that Mrs. Lincoln lived in fear that her husband would fail to be reelected, as this would result in the calling in of all her debts—and some idea of those debts is given by her Washington dressmaker, Elizabeth Keckley, who quoted her remark, "I owe altogether about twenty-seven thousand; the principal portion at Stewart's, in New York."[47] The First Lady subsequently tried to liquidate what she clearly felt were real commodities, but the attempt backfired, and for the rest of her life she regarded her unmade silks, lace flounces, and other New York purchases as her most valuable possessions.

Mrs. Lincoln was hardly the only one to succumb to the allure of New York's wares. After the Civil War extravagance proliferated, so much so that in reaction there arose expressions of moral indignation. In a book published in 1869, *The Women of New York,* George Ellington included a disapproving yet fawningly detailed chapter entitled "Extravagance in Dress." "In the matter of female dress New York City is ahead of the world," he wrote. "The women of Boston may be well and richly dressed, but the prevailing fashions are always toned down to a more sensible and classical elegance, which is well-befitting the Athens of America. Brains rule at the Hub; gold is the god in Gotham. The quiet dames of Philadelphia are much more plainly clad than their Manhattan sisters; while even the women of Cincinnati, Chicago and St. Louis do not go to such extreme lengths as those of the metropolis."[48] That New York women had become walking displays of dry goods was only the beginning. From the Gilded Age on, every generation would have to come to terms with conspicuous consumption in its most visible form: dress.

Fig. 209. Mathew B. Brady, *Preinauguration Portrait of Mary Todd Lincoln,* wearing the Tiffany pearl parure (cat. no. 211) as well as a fashionable ball gown likely made with silk brocade purchased during her New York trip, taken in Washington, D.C., 1861. Albumen silver print from glass negative. Collection of The New York-Historical Society

43. The Pingat ball gown and the dress worn to the Tuileries are in the collection of the Museum of the City of New York. The former (61.193) is pale mauve pink silk satin with bands of embroidered flowers and ivory silk fringe, and the latter (46.315) is ivory silk taffeta trimmed with lavender. Like many Prince of Wales dresses, they have never been photographed.

44. While the construction of the 1860 dresses may seem elaborate, it is not actually complicated; gathering even a wide tubular skirt into a waistband and making tiers or ruffles would be among the first sewing skills acquired by any novice.

45. Claudia Kidwell and Margaret C. Christman, *Suiting Everyone: The Democratization of Clothing in America* (Washington, D.C.: National Museum of History and Technology, Smithsonian Institution, 1974), p. 21.

46. For Mary Todd Lincoln's letters to such favorite Manhattan merchants as J. Dartois, who sold trimmings; E. Uhlfelder, a dealer in fancy goods; Edwin A. Brooks, famous for shoes and boots; George A. Hearn, dry goods; May and Company, which billed her $628.01 for, among other items, eighty-four pairs of gloves; and Madame Harris, known for exclusive hats, see Justin G. Turner and Linda Levitt Turner, *Mary Todd Lincoln: Her Life and Letters,* reprint (New York: Fromm International, 1987).

47. Elizabeth Keckley, *Behind the Scenes: Formerly a Slave, but More Recently Modiste, and Friend to Mrs. Lincoln; or, Thirty Years a Slave and Four Years in the White House* (New York: G. W. Carleton & Co., 1868), p. 149.

48. George Ellington, pseud., *The Women of New York; or, The Under-world of the Great City . . .* (New York: New York Book Co., 1869), p. 28.

The Products of Empire: Shopping for Home Decorations in New York City

AMELIA PECK

New York City, also known as the "Great Emporium," became a shopping capital that rivaled London and Paris during the middle of the nineteenth century. Goods from all over the world could be found in the stores lining Broadway. This essay will survey what was available to New Yorkers in the way of mantels, carpets, wallpapers, and upholstery goods and services between 1825 and 1861 and discuss some of the principal merchandisers and manufacturers of these home decorations.

During this period consumers in New York became less dependent on European products. In a fervor of nationalism following the War of 1812, Americans demanded that domestic manufacturers produce goods that equaled those made in Britain and France. Some industries, such as marble working and carpet weaving, quickly rose to the challenge; others, such as wallpaper manufacture and silk weaving, took a few additional decades to perfect their products.

As New York City grew northward, the main shopping district shifted accordingly. In the 1820s and 1830s many of the businesses investigated in this study were located in small shops on or near Pearl Street. By the 1850s most had moved into palatial stores on Broadway. This grand avenue—the city's widest north-south artery—changed during these decades from a residential street to one lined with stores, theaters, and hotels.[1] Among other things, Broadway became the amusement destination for city dwellers. As the economy grew, allowing more and more people to purchase myriad goods, shopping took on a recreational quality. Large stores with huge glass display windows, such as A. T. Stewart's magnificent dry-goods emporium (commonly called the "Marble Palace") on Broadway, attracted people to the area. Even such specialty shops as wallpaper and carpet warehouses assumed grand proportions to match the grand scale of Broadway.

It is interesting and somewhat surprising to discover that the female consumer did not take on a much more active role during this period. In fact, things remained much as they had been in earlier times. Women continued to be the primary shoppers for clothing textiles, household linens, and basic kitchen furnishing items. The large dry-goods palaces on Broadway, such as A. T. Stewart (which opened its doors in 1846) and Lord and Taylor (which followed suit in 1860), catered to women shoppers. These embryonic department stores, which had begun their existence downtown in the 1820s (A. T. Stewart in 1823 and Lord and Taylor in 1826), sold fabrics, trimmings, and accessories for clothing, adding household linens to their inventories by 1840 but not expanding into carpets and upholstery fabrics until the 1850s.[2] Men held the purse strings more tightly for home furnishings. Although the women of the household energetically researched and spoke their minds about these major purchases for the home, the male wage earners in the family had a proportionately larger vote. This pattern changed during the Civil War, when women were obliged to act more independently in the realms of family and work. Home life itself was redefined after 1865; men became preoccupied with the dramatic expansion of business and industry during the postwar years and left the domestic sphere completely to women, who at that time emerged as the primary shoppers for the home.[3]

Perhaps the most interesting change in the way people shopped during the middle of the nineteenth century lies in the realm of the psychological. Consuming became a pleasure often fraught with discomfort. Contemporary journalism celebrates the grand shops opening on Broadway, the high quality of the goods, and the opportunities for both social and personal transformation that items such as new wallpaper or a beautiful carpet could bring to a purchaser. By contrast, much of the fiction of the period focuses on the purchase of goods inappropriate to the buyer's class and lifestyle, things that are too expensive and ultimately bring misfortune to the owner. High anxiety about shopping had entered the arena. Before the industrial revolution, when wealth and class were determined by land ownership, only a small segment of society had the means to purchase luxury

The author would like to thank Carol Irish, Lonna Schwartz, Rachel Bonk, and Anna Maria Canatella, as well as the exhibition staff, for their help in researching this essay.

1. For more on the history of Broadway, see Charles Lockwood, *Manhattan Moves Uptown: An Illustrated History* (Boston: Houghton Mifflin Company, 1976); and David W. Dunlap, *On Broadway: A Journey Uptown over Time* (New York: Rizzoli, 1990).

2. Lord and Taylor's first known advertisement, published in the *New-York Enquirer*, October 30, 1826, was for plaid silk dress fabric and other items of apparel, such as cashmere shawls. An 1838 sales receipt lists Lord and Taylor as "Dealers in Dry Goods, Irish Linens, Sheetings, Diapers, Shawls, Laces, Gloves, Silk & Cotton Hosiery, &c." For both, see *The History of Lord & Taylor* (New York: Lord and Taylor, 1926), pp. 7, 14. In 1857–58 they advertised both "carpetings and upholstery goods" (*The Albion*, May 16, 1857, p. 240) and "Fashionable Dry Goods . . . for Fall and Winter Wear" (*The Albion*, November 20, 1858, p. 563).

3. For perspectives on women and consumerism, see *Making the American Home: Middle-Class Women and Domestic Material Culture, 1840–1940*, edited by Marilyn Ferris Motz and Pat Browne (Bowling Green, Ohio: Bowling Green State University Popular Press, 1988), especially the essay "American Women and Domestic Consumption, 1800–1920: Four Interpretive Themes," by Jean Gordon and Jan McArthur, pp. 27–47.

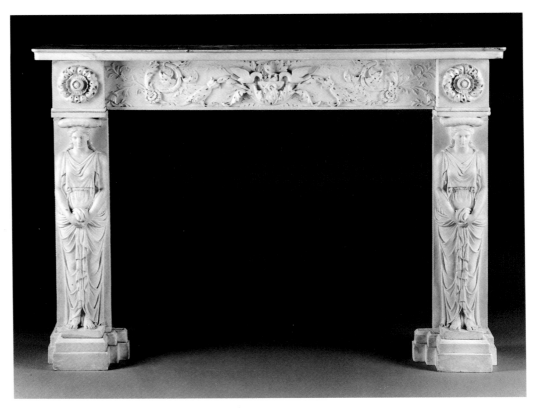

Fig. 210. Manufacturer unknown, probably Italian, Mantel with caryatid supports, ca. 1830. Marble. The Metropolitan Museum of Art, New York, Purchase, 1977 1999.125

goods for the home; now almost anyone could afford inexpensive but decorative American-made wallpaper or brightly colored American-woven ingrain carpet. It became increasingly hard to use the furnishing of home interiors as an index of social class. Newly purchased brownstones owned by upper-level clerks could be decorated quite well for relatively little money. Home decorating had always been a way to declare one's status in society; now, as more and more people had attractive and well-furnished homes, the established gentry began to feel concern about society's more permeable boundaries.

As a reflection of this class discomfort, a new type of economic moralism began to appear in novels and magazine stories, many of which were written and edited by members of the traditional elite. The subtext of these narratives may be interpreted as a warning to the nouveaux riches. This new city-based middle class, made up of people from rural New England as well as the more threatening immigrants from Ireland and the British Isles, was being told to know its place; making and spending too much money and attempting to rise in society were portrayed as potentially disastrous. A good example of this type of parable is found in the novel *Fashion and Famine* (1855) by Ann S. Stephens, a well-respected

editor and writer who was educated in Connecticut, where her father managed several woolen mills. Second in popularity in its day only to *Uncle Tom's Cabin*, it tells the story of Ada Wilcox Leicester, a very unhappy woman who lives in a grand house, surrounded by all the luxuries New York City could offer. Ada was once an innocent country girl, but she let herself be corrupted by the evil Mr. Leicester, a liar and a womanizer, who filled her head with the promise of material wealth in order to "have his way with her." Ada is finally redeemed after her father convinces her to give up her material possessions, since they are not the key to true happiness. She transforms her house into a charity home for destitute old gentlewomen (gone are the heavy carpets and the silken draperies, replaced with India straw matting and white muslin curtains) and reenters the moral world.

Another recurring plot is illustrated by "Sparing to Spend; or, The Loftons and the Pinkertons" (1853) by T. S. Arthur, a top editor and writer of the day, who traced his lineage back to a Revolutionary War officer. The tale charts the parallel lives of two couples. The husbands are both clerks with similar positions, but one wife is modest and careful in her spending while the other is grandiose and a spendthrift.[4] The grandiose wife, Flora Pinkerton, convinces her husband to

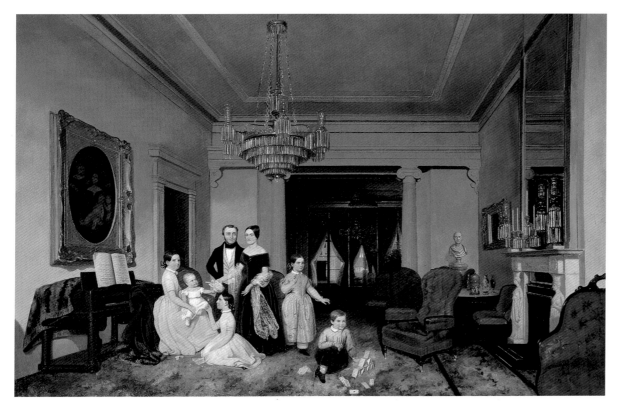

Fig. 211. Francis H. Heinrich, *The Ernest Fiedler Family, 38 Bond Street, New York,* ca. 1850. Oil on canvas. Courtesy of Nicholas L. Bruen

buy expensive furniture and a big house that is far beyond their means. She snubs the modest wife, Ellen Lofton, who is not sufficiently fashionable to be her friend. All this spending eventually drives Pinkerton to wreck his career by stealing money from his employer in order to maintain the image his wife is trying to project. The modest Loftons rise slowly and steadily in the world and eventually are in a position to be kind and helpful to the ruined couple. The message of the story is that it is immoral to be showy and to live beyond one's means. When the novel was reviewed in *Godey's Lady's Book,* its message was spelled out clearly: "The high moral aim of the present volume is 'to exhibit the evils that flow from the too common lack of prudence, self-denial, and economy in young people at the beginning of life; and also to show, by contrast, the beneficial results of a wise restriction of the wants to the means.' No one will rise from the perusal of this naturally written story without feeling himself strengthened in all good and honorable resolutions."[5] Yet this must have been a hard message to live by when Broadway beckoned.

Mantels

Marble yards were important, lucrative businesses in New York City from about 1830 on. They provided builders and homeowners with exterior products— such as marble facing, which was most often used for large public buildings and hotels—and interior products, such as marble floor tiles and carved mantelpieces. When the fashionable, picturesque cemeteries were created in the areas surrounding Manhattan (the first, established in 1838, was Green-Wood Cemetery in Brooklyn), fancy and often figural monuments became a large segment of a typical marble yard's business.

Before 1825 in Federal-period New York, mantels in even the best houses were usually made of wood ornamented with composition material, a plasterlike substance. If a very grand house had a real marble mantel, it was imported from Europe. After 1825 and through the 1830s, most row houses built in lower Manhattan had imported mantels in their parlors, often carved in Italy of white statuary marble. One Italian model with two classically draped maidens who hold the mantel entablature and shelf on their heads was especially popular. The Metropolitan Museum owns an example that came down through the Hewitt family, and it may have been installed originally in one of the houses of Colonnade Row (1833) on Lafayette Street (fig. 210). A portrait of the Fiedler family painted about 1850 in the parlor of their house, which dates to about 1830, still proudly displays a mantel of the same type (fig. 211).

4. T. S. Arthur, "Sparing to Spend; or, The Loftons and the Pinkertons," parts 1–4, Arthur's *Home Magazine* 1 (February 1853), pp. 365–74, (March 1853), pp. 413–31, (April 1853), pp. 494–512, (May 1853), pp. 572–86.
5. *Godey's Lady's Book* 48 (January 1854), p. 81.

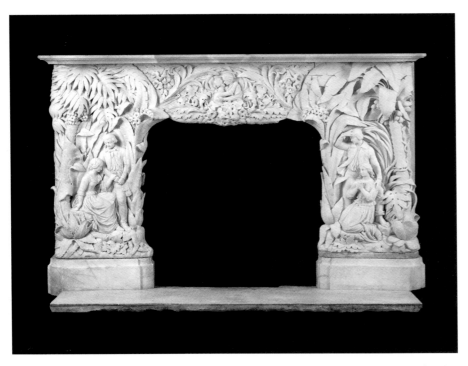

Fig. 212. Fisher and Bird, Mantel depicting scenes from Jacques-Henri Bernardin de Saint-Pierre's *Paul et Virginie* (1788), 1851. Marble. Museum of the City of New York, Gift of Mrs. Edward W. Freeman, 1932 32.269a–h,j

6. See *The New York Business Directory, for 1840 & 1841* and for *1850 & 1851* . . . (New York: Publication Office, 1840 and 1850); and *Manufactures of the United States in 1860; Compiled from the Original Returns of the Eighth Census* (Washington, D.C.: Government Printing Office, 1865).

7. The 1871 edition of *The Marble-Workers' Manual*, first published in New York in 1856, contained an appendix listing the appearance and properties of marbles found in many American states. Vermont is especially rich in various marbles, which were quarried from the Green Mountains. White marble from West Rutland was said to surpass Italian white statuary marble in quality. See *The Marble-Workers' Manual*, . . . translated from French by M. L. Booth (Philadelphia: Henry Carey Baird, 1871). Some of the earliest advertisements for marble sculpture, such as those placed by John Frazee in the *Workingman's Advocate*, March 5, 1831, p. 6, state that monuments, fountains, and so forth could be provided in either American or foreign marble.

8. Advertisements for Alexander Roux and Julius Dessoir (*The Albion*, November 20, 1858, p. 564) listed wood

At the end of the 1830s the marble-working industry boomed when steam-powered tools became available for cutting marble. In 1833 there were only four marble manufacturers listed in the New York City directories; by 1840 nine yards appeared under "Marble Manufacturers and Dealers." The number rose to thirty-seven in 1850–51, and according to the special schedule of the 1860 federal census devoted to the products of industry, there were in that year forty marble-cutting establishments in New York City, with 832 employees and an annual product of $1,260,949.[6] Fancy mantels became more common as time went on because the new steam-powered drills and saws lowered the cost of cutting the stone at the quarry and also reduced the time spent performing the gross carving. Also during this period, quarries were discovered in the United States that provided marble adequate for mantels intended to adorn the less important rooms of a house.[7] Better methods of transportation in and out of the city also had a positive effect on the marble industry.

Throughout the period of this study, Italian white statuary marble was always the first choice for parlor mantels. By 1840 New York craftsmen were proficient at carving high-style mantels from imported Italian stone. It is likely that some of the carvers employed by the marble yards were highly trained Italian immigrants; the late 1840s saw great unrest in Italy, and at that time the first small wave of skilled Italian

workers made their way to New York. While some immigrants opened their own businesses, the majority of the names of owners of marble enterprises in the 1850–51 New York business directories seem to be Anglo-Saxon.

As is true today, there was always a demand for good secondhand mantels. A truly special figural mantel, such as the *Paul et Virginie* example made by Fisher and Bird for Hamilton Fish (cat. no. 220; fig. 212), was often salvaged and reinstalled in another place after the house for which it had been made was sold or torn down. After Fish's death, in 1893, publisher William H. Appleton bought the *Paul et Virginie* mantel; it is unclear whether it was acquired at auction, bought through a dealer, or purchased directly from the family. By then more than forty years old and certainly out of style, it was installed in the parlor of Appleton's Riverdale house.

Other materials for mantels, such as cast iron and, once again, wood, gained popularity during the 1850s. Highly decorative carved wood examples were available through fine cabinetmakers, such as Alexander Roux and Julius Dessoir.[8] Cast-iron mantels, marbleized to deceive the eye, were often used for secondary rooms or throughout lesser houses (see fig. 213). One of the leading cast-iron mantel companies in New York placed the following advertisement in 1853:

THE SALAMANDER MARBLE COMPANY invite attention to their unique and splendid assortment of MARBLEIZED IRON MANTELS, COLUMNS, TABLE TOPS, &c., &c., exhibiting at their Warerooms, 813 Broadway.

This new and beautiful combination obtained the GOLD MEDAL at the last Fair of the American Institute, and is pronounced by scientific men to be one of the most practically useful improvements of the

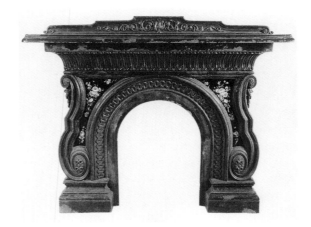

Fig. 213. Manufacturer unknown, Mantel, United States, ca. 1850. Painted cast iron. Location unknown

present age. It possesses many advantages over real marble, being cheaper, more durable, and capable of resisting a greater amount of heat, whilst it so closely resembles it, that the most practised eye can scarcely discover the difference.[9]

Another company, the New York Marbleized Iron Works, which had its manufactory at 401–405 Cherry Street, claimed that its mantels were "about one-third the cost, in comparison with all other kinds of Mantels; also [they have] the advantage of being packed and sent with safety to any part of the country."[10] As this advertisement indicates, both cast-iron and marble mantels made in New York were shipped to many other areas of the United States, places that did not have skilled labor, an active harbor, or easy access to sources of natural stone—advantages that brought New York City's marble industry to prominence during the middle of the nineteenth century.

Retailers and Manufacturers

FISHER AND BIRD was for many years the premier marble-working firm in New York.[11] One of the founders, John Thomas Fisher, arrived in New York from Dublin in 1829. He married Eliza Bird of Orange County, New York, and in 1832 started the business with two of his brothers-in-law, Clinton G. Bird and Michael Bird. It is not known who among them had marble-working expertise. They used both imported and American marble stocks and offered a variety of products to their customers. Although they advertised among their wares finished mantels from Europe, it seems likely that they cut and carved most of their marble products on their New York City premises

Firm names: **Fisher and Bird** (1832–85),
Robert C. Fisher (1885–1915)
Owners: John T. Fisher (d. 1860), Michael Bird (not listed after 1853), Clinton G. Bird (d. 1861), Robert C. Fisher (1837–1893; son of John T. Fisher, joined business in 1854, succeeded father as senior partner in 1859), Clinton G. Bird II (son of Michael Bird, joined business in 1861)
Locations

1832–35	354 Broome Street
1836–52	287 Bowery
1853	287 Bowery and 899 Broadway
1854	287 Bowery and 904 Broadway
1855	287 Bowery, 904 Broadway, and 460–465 Houston Street
1856–60	287 Bowery and 460–465 Houston Street
1861–1915	97–103 East Houston Street

(fig. 214). The long-lived firm was large and apparently profitable. In the 1860 federal census, Fisher and Bird was described as having $50,000 worth of invested capital, sixty-five employees, and an average monthly payroll of $2,000. The firm reported annual sales as follows:

mantels	$30,000
marble tiling	17,000
funerary monuments	11,000
monument stock	11,000
marble blocks	10,000
marble slabs	10,000
other articles	5,000
Total	$94,000[12]

Fisher and Bird sold both relatively modest mantels from stock and extremely luxurious custom examples. In 1846 a customer ordered ten stock mantels for his house at a total cost of $480, plus $14.40 for shipping insurance. The price tag for the most expensive piece was $100; the cheapest cost him $27.50.[13] At the

mantels among the products they could supply.

9. *Illustrated News* (New York), February 5, 1853, p. 94.

10. Ibid., April 2, 1853, p. 222.

11. Biographical information on John Thomas Fisher and the Birds may be found in the entry on Robert Cockburn Fisher (son of John Thomas), in *America's Successful Men of Affairs: An Encyclopedia of Contemporaneous Biography,* edited by Henry Hall (New York: New York Tribune, 1895), vol. 1, p. 239. Information about their business comes from New York City directories and advertisements they placed in newspapers and journals, such as one in the *Cottage Keepsake; or, Amusement and Instruction Combined . . .* (Philadelphia: J. E. Potter, 1857), p. 63, in which they advertise stocking "American and Foreign Marble Mantels."

12. See *Manufactures of the United States in 1860.*

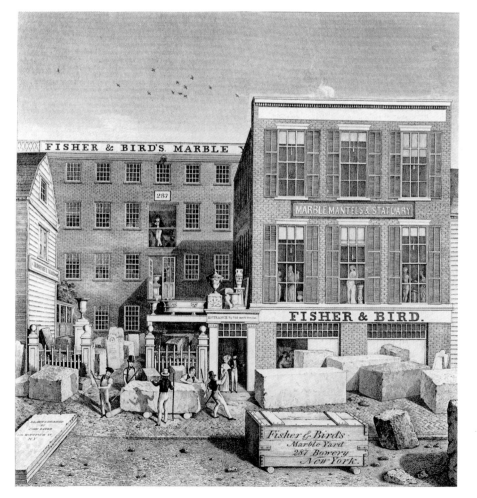

Fig. 214. *Fisher and Bird's Marble Yard, 287 Bowery, New York,* ca. 1836. Engraving and etching by John Baker. The Metropolitan Museum of Art, New York, The Edward W. C. Arnold Collection of New York Prints, Maps, and Pictures, Bequest of Edward W. C. Arnold, 1954 54.90.673

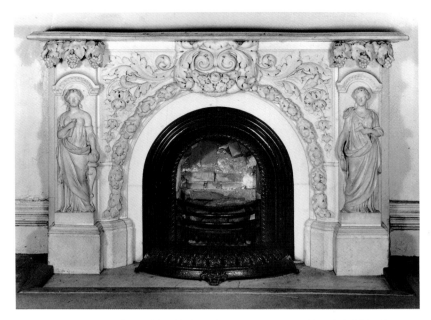

Fig. 215. Fisher and Bird, Mantel with figural supports, 1857. Marble. Litchfield Villa, New York City Parks Department Headquarters, Prospect Park, Brooklyn

13. We know that they were stock designs because the invoice lists them by design numbers. The most expensive was number one and the least expensive was number fourteen. Fisher and Bird to Mr. David [], invoice, December 31, 1846, Joseph Downs Collection of Manuscripts and Printed Ephemera, no. 97 x 28.8,

other end of the spectrum was the figural mantel that wealthy Hamilton Fish ordered for his New York parlor in 1851. Custom designed and custom carved, Fish's mantel depicted scenes from the French novelette *Paul et Virginie* and probably cost many hundreds of dollars (cat. no. 220; fig. 212). Another figural mantel attributed to Fisher and Bird was specified by architect Alexander Jackson Davis for the parlor of Litchfield

Fig. 216. Alexander Jackson Davis, *Study for Dining-Room Mantel at Knoll, Tarrytown, New York,* 1839. Ink, wash, and graphite. The Metropolitan Museum of Art, New York, Harris Brisbane Dick Fund, 1924 24.66.56

Villa in 1857.[14] Although Edwin Litchfield, the owner of this grand Brooklyn house, grumbled at paying $550 for the white Carrara marble mantel, which features two completely carved allegorical female figures, pay he did; the piece survives in the house today (fig. 215). In 1866, for $325, Davis commissioned Fisher and Bird to make the mantel carved of exotic deep-red and tawny marbles that still stands in the dining room at Lyndhurst in Tarrytown, New York.[15] Clearly, Fisher and Bird was the manufacturer of choice for the best-quality mantels of the day.

UNDERHILL AND FERRIS was also a stable and well-established marble yard. One of the first large manufacturers of marble mantels in New York, the firm won a silver medal for "a beautiful Cararra marble fire place" in 1834 at the seventh annual fair of the American Institute of the City of New York.[16] In 1840 Alexander Jackson Davis ordered all the Gothic Revival mantels he had designed for Knoll (later Lyndhurst) in Tarrytown, New York, from Underhill and Ferris. A number of drawings for these mantels survive; the one for the mantel in the original dining room (today the room is the library) includes information about prices, the marble, and possible choices of makers (fig. 216). The mantel selected by Davis's clients, William and Philip R. Paulding, was of white statuary marble, and it was made by Underhill and Ferris for $200. Philip Paulding was very well pleased with Underhill and Ferris's work; in a letter to Davis, he pronounced the mantels for the house "extremely elegant" and gloated, "How the ladies will *dote* on them."[17] In the 1848–49 volume of the *New-York Mercantile Register,* the firm ran a large illustrated advertisement, naming itself a "Marble Factory and Marble Works" and calling attention to its holdings of "the largest and most elegant assortment of superior Marble Mantels ever exhibited in this country." The

Firm names: **Underhill and Ferris** (1821–50), **John H. Ferris** (1851–52), **Ferris and Taber** (1852–57), **Augustus Taber** (1858–87)
Owners: Edmund Underhill (left business in 1850), John H. Ferris (left business in 1858), Augustus Taber (d. 1898; son-in-law of John H. Ferris, joined business in 1852)
Locations
1821–24 Greenwich Avenue at Beach Street
1825–37 64 Beach Street
1838–51 372 Greenwich Avenue
1852–57 386 Greenwich Avenue
1858–72 713 Water Street
1873–87 714 Water Street

advertisement continued, "Monuments and ornamental Marble work in general for sale, and the Trade supplied on the most liberal terms at the old establishment Steam Marble Works of UNDERHILL & FERRIS."[18] In 1853 the firm, now called Ferris and Taber, contributed a "sculptured" mantelpiece and a marble vase and pedestal to the New York Crystal Palace exhibition. Although the company won an honorable mention for the mantel, its artistic standards were probably not as high as Fisher and Bird's. In 1857, the same year Davis ordered the $550 parlor mantel for Litchfield Villa from Fisher and Bird, he purchased the next most expensive mantel for the house from Ferris and Taber. Described as having spiral columns, and destined for either the dining room or the first-floor bedchamber, it cost only $150.[19] This mantel was probably competently made but more ordinary than those at the high end of Fisher and Bird's list. After John H. Ferris retired from the business in 1858, his son-in-law, Augustus Taber, turned the company into a wholesale marble business.[20]

Unlike the principals of Fisher and Bird and Underhill and Ferris, OTTAVIANO GORI was first and foremost a marble sculptor. However, during the 1850s he ran a major retail marble showroom specializing in both monuments and mantels. A photograph taken by Victor Prevost about 1853 shows Gori's establishment in all its splendor (fig. 217). Standing on the west side of Broadway between Nineteenth and Twentieth streets, Gori's warerooms display monuments outside at street level, while smaller, more delicate statuary can be glimpsed through the second-story windows. Although nowhere to be seen in the photograph, mantels were an important part of Gori's business, judging from the sign on the building, where marble mantels are the first item listed. Gori probably emigrated from Italy after completing his training there; he first appears in New York City directories listed as a sculptor. By 1840 he called himself a sculptor and scagliola (imitation marble) manufacturer; in his most complete directory entry (for 1848–49), he lists himself as "sculptor and modeller, marble mantels, statuary, monuments &c., scagliola and plaster ornaments." Some of Gori's most prominent works were the ornamental capitals, each depicting "a cornucopia intertwined with the caduceus of Mercury, the god of commerce," made for the interior of A. T. Stewart's 1846 Marble Palace dry-goods emporium.[21] At the 1853 Crystal Palace exhibition, Gori received an honorable mention for a "mantelpiece of variegated marble."[22] In 1855 the New York State census reported that Gori had invested $40,000 in his "Marble

Manufactory," that the annual value of his product, listed only as "Statuary," was $80,000, and that he had fifty men and six boys working for him, earning an average monthly wage of $60.[23]

Surprisingly, in spite of the appearance of Gori's grand establishment, the mantels that Davis ordered from him for Litchfield Villa were probably relatively modest, judging by their prices; in the list of invoices at the end of Davis's personal specifications for the Litchfield job, this notation appears: "June 1857 Chimney pieces of O. Gori, one 90./one 40./one 60./one 18./one 20. . . . $228.00."[24] Soon after, the business ran into trouble. According to the reports of R. G. Dun and Company, a financial rating service, in 1857 Gori was doing a "large & flourishing trade" and owned twenty-four lots of real estate in Harlem as well as six other houses and lots in other parts of the city. He also had the contract to furnish the marble front for Eno's Hotel on Broadway. But the financial panic of 1857 combined with real-estate speculation must have adversely affected his business. In March 1858 he was trying to raise money by selling his real estate and his marble business. By 1860 the business had failed, and Gori had left for Italy, although Gori's wife, Catherine, and his partner, Alfred Bourlier, continued running the firm in New York in a small way until 1864. In the late 1850s Gori also opened a marble business in San Francisco that probably existed only until 1861.[25]

Floor Coverings

Between 1825 and 1861 the carpet business in New York City was, for the most part, a wholesaling and retailing industry. During the 1820s and 1830s almost all the carpets sold in the city were made in England, Scotland, or France. Oilcloths also came from the British Isles, and straw matting was imported from

Firm names: **Ottaviano Gori** (1837–58, 1861–64), **Gori and Bourlier** (1859–61)
Owners: Ottaviano Gori, Alfred J. B. Bourlier
Locations

1837–38	73 Bleecker Street
1838–39	566 Broadway
1839–40	35 Dey Street
1840–41	16 and 18 Downing Street
1841–42	428 Broadway
1842–43	99 Merchants' Exchange
1843–45	315 Broadway
1845–51	893 Broadway
1851–58	895 and 897 Broadway
1858–60	895 Broadway
1861–64	West Fifty-second Street

courtesy The Winterthur Library, Henry Francis Du Pont Winterthur Museum, Winterthur, Delaware.

14. Edwin Litchfield to Alexander J. Davis, February[?] 5, 1857, Davis Collection (27–14), Avery Architectural and Fine Arts Library, Columbia University, New York. This mantel can be attributed to Fisher and Bird on the basis of references to the firm that Davis made in his daybook. In the entry for July 24, 1857, he describes a visit to Fisher and Bird with members of the Litchfield family and other clients, most probably to check on the progress of this mantel and to show it off to the other members of the party. Davis Collection I, Daybook vol. 2, p. 102, Avery Architectural and Fine Arts Library.

15. A. J. Davis daybook, June 22, 1866. Davis Collection I, Daybook vol. 2, p. 254, Avery Architectural and Fine Arts Library. Lyndhurst, a property of the National Trust for Historic Preservation, is a house museum open to the public.

16. American Institute of the City of New York, Judges' reports, 7th Annual Fair, 1834, American Institute, case 2, Manuscript Department, The New-York Historical Society.

17. Philip R. Paulding to Alexander J. Davis, November 16, 1841, Archives, Lyndhurst, Tarrytown, New York.

18. *New-York Mercantile Register,* 1848–49, p. 261.

19. List of invoices paid, Davis's own copy of the specifications for Litchfield Villa, Brooklyn, vol. 15, 24.66.1414, Department of Drawings and Prints, Metropolitan Museum.

20. R. G. Dun Reports, December 10, 1860, and May 28, 1862 (New York vol. 375, p. 200), R. G. Dun & Co. Collection, Baker Library, Harvard University Graduate School of Business Administration, Cambridge, Massachusetts.

21. "Stewart's New Dry Goods Store," *New York Herald,* September 18, 1846, p. 2, col. 5.

22. *Official Catalogue of the New-York Exhibition of the Industry of All Nations, 1853* (New York: George P. Putnam and Co., 1853), class 27, no. 9; Association for the Exhibition of the Industry of All Nations, *Official Awards of Juries . . . 1853* (New York: Printed for the Association by William C. Bryant and Co., 1853), p. 60,

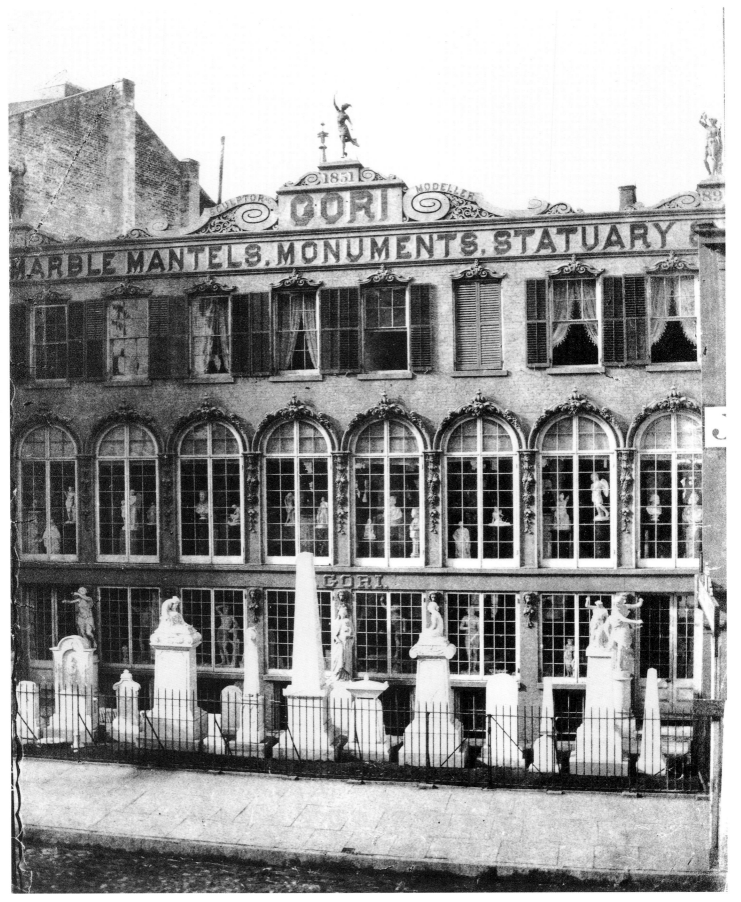

Fig. 217. Victor Prevost, *Ottaviano Gori's Marble Establishment, 895–897 Broadway*, ca. 1853. Modern gelatin silver print from waxed paper negative. Collection of The New-York Historical Society, Gift of Mr. Samuel V. Hoffman, 1906

Fig. 218. Manufacturer unknown, United States, Venetian carpet (detail), ca. 1825. Wool and cotton. The Metropolitan Museum of Art, New York, Gift of Mrs. Roger Donoho, 1931 31.24

Fig. 219. Manufacturer unknown, probably British, Brussels carpet (detail), ca. 1860. Wool, cotton, and linen. The Metropolitan Museum of Art, New York, Gift of Mrs. William Brown Meloney, 1941 41.196

India and China. Launched in a small way in the late 1820s, using only handlooms, American carpet manufacture began to gather strength after Erastus Bigelow invented the first power carpet loom, in 1843. Although most of the large producers were located in Pennsylvania, Connecticut, and Massachusetts, at least two carpet mills, Alexander Smith and A. and E. S. Higgins, existed in the New York City vicinity in 1850.

At the beginning of our period, wool two-ply flat-woven carpets, known as ingrain carpets, were by far the most popular and readily available textile floor covering in New York. The largest producers were located in Kidderminster, England, and Kilmarnock, Scotland. Ingrain was woven in strips about thirty-six inches wide, and these were sewn together and stretched to cover the entire floor of a room, wall to wall. Venetian carpet, a warp-faced flat-woven textile with multicolored stripes (see fig. 218), was also very popular in the early decades of the nineteenth century. The advertisement quoted below indicates that this brightly striped product was probably intended only for halls and stairways, but some people used it to cover the floors of entire rooms.[26] Along with these cheaper types some finer British floor coverings were imported, such as Brussels (looped pile; see fig. 219) and Wilton (cut pile) carpeting. When Albro and Hoyt (1828–57), a carpet retailer that eventually turned to marketing oilcloths, opened a shop in 1828, its management placed an advertisement that suggests the relative popularity of the wares offered: "The Subscribers having taken the house No. 105 Bowery, are making requisite alterations, which will be completed by the 12th day of March, when they will open 50 or 60 bales fine and superfine Ingrain Carpeting. Received by the latest arrivals from Europe 15 or 20 bales superfine and low priced Venetian Carpeting, for halls and stairs: will also offer for sale a general assortment of Brussels and Willow Hearth Rugs, Table & Piano Covers, Floor Baizes, Oil Cloths, India Matting, &c."[27]

During the 1830s and 1840s ingrain carpets remained in style; however, in the 1850s a multitude of floor-covering products suddenly became available to the consumer, and what might be described as a carpet mania ensued.

THE CARPET TRADE. *It is singular what a remarkable taste the American shows for a good carpet. It seems to be impossible for him to walk comfortably through life without a carpet under his feet. Every man who occupies a few square feet of house-room must have the brick or boards protected from his tread by so much carpeting . . . the well-to-do American . . . believes in enjoying life; and considering that carpets contribute to life's enjoyment, he does not hesitate to spread everywhere he is accustomed to tread with a due quantity of three-ply, or Tapestry, or Brussels, or Turkey.*[28]

In 1859 England exported $2,174,064 worth of carpets of all types to the United States, while France, which produced the highest-quality handmade Aubussons, exported only $10,317 worth.[29] Carpets of all prices were available to all types of consumers. George E. L. Hyatt, of 273 Canal Street, a dealer in carpets of middling quality who probably priced his stock at the

copies of both at the New York Public Library.

23. New York State Census, 1855, Eighteenth Ward, First Election District.

24. List of invoices paid, Davis's own copy of the specifications for Litchfield Villa, Brooklyn, vol. 15, 24.66.1414, Department of Drawings and Prints, Metropolitan Museum.

25. R. G. Dun Reports, August 7, 1857 (New York vol. 378, p. 331), R. G. Dun & Co. Collection, Baker Library, Harvard University Graduate School of Business Administration.

26. For an example of striped carpeting used wall to wall, see the watercolor of 1832 by Deborah Goldsmith titled *The Talcott Family* (Abby Aldrich Rockefeller Folk Art Collection, Williamsburg, Virginia).

27. "Carpet Store," *New-York Evening Post*, March 4, 1828, p. 3.

28. "The Carpet Trade," *Scientific American*, July 7, 1860, p. 18, reprinted from *United States Economist*.

29. *Manufactures of the United States in 1860*; reprinted in *American Industry and Manufactures in the 19th Century: A Basic Source Collection*, vol. 6 (Elmsford, New York: Maxwell Reprint Company, 1990), p. liii.

lower end of the scale, listed his inventory as follows in 1858:

> Velvet Carpets from $1.25 to 1.62½ per yard
> Tapestry Brussels from .90 to 1.12½ per yard
> Brussels from 1.00 to 1.25 per yard
> Three-ply Carpets from 1.00 to 1.12½ per yard
> Ingrain, All Wool from .50 to .80 per yard
> Ingrain Cotton and Wool from .25 to .37½ per yard.[30]

He also stocked oilcloths, Venetian carpeting, matting, and druggets (a kind of basic flat-woven rug used under dining tables to protect finer carpeting), but they are not priced in the advertisement. At the top end of the scale, in 1854 W. and J. Sloane sold Mr. J. G. Fisher, of 33 West Nineteenth Street, "Velvet Medallion Carpeting" for $2.50 per yard, Brussels carpeting for $1.60 per yard, and three-ply ingrain carpeting for $1.30 per yard.[31]

Carpeting a main room, such as a parlor, entailed a major family expenditure, often as much as $200 (Mr. Fisher's velvet medallion carpet and velvet border cost him $181.86). This purchase was much suffered over, since the variety of choices was so great and the dictates of fashion were so rigid. In the late 1850s and early 1860s Godey's Lady's Book and Magazine published a number of short stories, some humorous, some serious, that discussed the implications, both visual and moral, of choosing the appropriate carpet to correctly express a family's station in life.[32]

Oilcloth floor coverings were manufactured early in New York City, perhaps soon after the War of 1812. Made of wide-width (seamless) canvas that had been coated with layers of a mixture of oil and paint, they could be purchased either in plain colors or printed with patterns. They were used most frequently in hallways or other high-traffic areas, as they wore relatively well and were easy to clean. By the end of the period under consideration, most oilcloth sold in New York City was made there.[33]

Two major carpet manufacturers were active in the New York City area beginning in the late 1840s. A. and E. S. Higgins was started in the 1830s as a retail carpet company by Alvin and Elias S. Higgins, young men who had come to New York City from Maine. According to A Century of Carpet and Rug Making in America (1925):

> In 1840 they began the manufacture of carpeting on a small scale, making Ingrains only. In 1841 they established a factory at Jersey City and four years later they opened a new carpet mill in Brooklyn which was destroyed by fire shortly afterwards. They secured another factory at Haverstraw, New York, which they occupied for three years, at the same time establishing a mill at Paterson, New Jersey, and buying the carpet mill of Richard Clark at Astoria, Long Island. In 1847 they built a mill at 43rd Street and North River [the Hudson], to which they moved all the looms and machinery from their other plants, adding Body Brussels and Tapestries to Ingrains previously made.[34]

The retail business continued for a while under the aegis of Peterson and Humphrey. A. and E. S. Higgins was one of the first American carpet manufacturers to use power looms; it was known for manufacturing tapestry and velvet carpets on Bigelow's invention. The New York City factory seems to have operated until 1900; in 1882 the firm employed more than a thousand people and produced more than 3.4 million yards of carpeting each year. The Higgins firm merged with the Hartford Carpet Company in 1901.

Alexander Smith opened his first small carpet-making factory about 1847 in the town of West Farms, New York, today a neighborhood in the central Bronx. He began with twenty-five handlooms but soon changed the factory over to power weaving. Smith won a silver medal, the highest prize awarded for carpeting at the 1853 New York Crystal Palace exhibition. The citation read, "for Novelty of Invention, Elegance of Design and Color, Economy of Material, &c. in Two-Ply Ingrain Tapestry Carpets."[35] "Ingrain Tapestry" may refer to an ingrain carpet that had a multicolored printed warp. After fires at the West Farms factory in 1862 and 1864, Smith moved his concern to Yonkers, New York, where it prospered until 1954.[36] Smith, Higgins, and twenty-six other manufacturers from New York State (nine in New York City proper) produced 2,293,544 yards of carpeting in 1860 (the total for the entire country was 13,285,921 yards), making the need for imported carpeting almost a thing of the past.[37]

Retailers

WILLIAM W. CHESTER and THOMAS L. CHESTER were brothers who worked together in a carpet firm for fifteen years and then competed with each other for another ten; according to extant documents, however, they kept up cordial family relations. Both together, beginning in 1816, and separately they were successful carpet merchants. Surviving receipts indicate that the Chesters supplied carpets to many scions of the older New York families, including Samuel Tredwell Skidmore, a dry-goods wholesaler, and Evert A. Duyckinck, a writer and editor. Neither

30. *The Albion*, September 11, 1858, p. 443.

31. W. and J. Sloane to J. G. Fisher, Esq., invoice, March 28, 1854, Bella Landauer Collection, Floor Coverings Box, Department of Prints and Photographs, The New-York Historical Society.

32. Alice B. Neal, "The Tapestry Carpet; or, Mr. Pinkney's Shopping," *Godey's Lady's Book and Magazine* 52 (January 1856), pp. 15–19; Alice B. Haven, "The Story of a Carpet," *Godey's Lady's Book and Magazine* 58 (June 1859), pp. 531–37; Mary W. Janvrin, "A Great Bargain," *Godey's Lady's Book and Magazine* 62 (May 1861), pp. 418–24.

33. See *Manufactures of the United States in 1860*, reprinted in *American Industry: Basic Source Collection*, p. liv.

34. *A Century of Carpet and Rug Making in America* (New York: Bigelow-Hartford Carpet Company, 1925), p. 20.

35. *Industry of All Nations, Official Awards of Juries . . . 1853*, p. 58.

36. Rick Beard, *In the Mill* (exh. brochure, Yonkers, New York: Hudson River Museum, 1983).

37. *Manufactures of the United States in 1860*, reprinted in *American Industry: Basic Source Collection*, p. lix.

brother appears to have advertised; perhaps their business was so well established that only word-of-mouth recommendations were necessary. When the brothers split up in 1832, for unknown reasons, they kept shops within a block of each other on Broadway. They seem to have worked together again between 1843 and 1847. In 1836 Thomas L. Chester provided the carpets and floor cloths for the Astor House, the first great hotel built in New York City. At that date he owned a shop at 203 Broadway (see fig. 220) that was extremely modest by comparison with the grand carpet-selling emporiums of the 1850s (see figs. 221, 222). For this plum of a job he was paid $14,182.09.[38] No images survive of William's store, from which, in 1845, he furnished Mr. Skidmore with carpeting for every room in his new house at 369 Fourth Street, for the price of $631.28.[39]

Both Chesters served as judges at the American Institute fairs in the 1830s. William appears never to

Firm names: **W. W. and T. L. Chester** (1816–31), **W. W. Chester** (1832–47), **T. L. Chester** (1832–53)
Owners: William W. Chester (d. 1869), Thomas L. Chester, Stephen M. Chester (son of Thomas L. Chester, joined W. W. Chester in 1836), John N. Chester (son of Thomas L. Chester, joined T. L. Chester in 1840)
Locations
W. W. and T. L. Chester
1816	7 Park Place
1817–31	191 Broadway

W. W. Chester
1832–47	191 Broadway

T. L. Chester
1832–42	203 Broadway
1843–47	191 Broadway
1848–53	323 Broadway

38. "Inventory of the Furniture in the Astor House, August 1st, 1836," p. 13, Astor Papers, Astor House Box, Manuscript Department, The New-York Historical Society.

39. Skidmore Papers, Joseph Downs Collection of Manuscripts and Printed Ephemera, no. 70 x 53.52, courtesy The Winterthur Library.

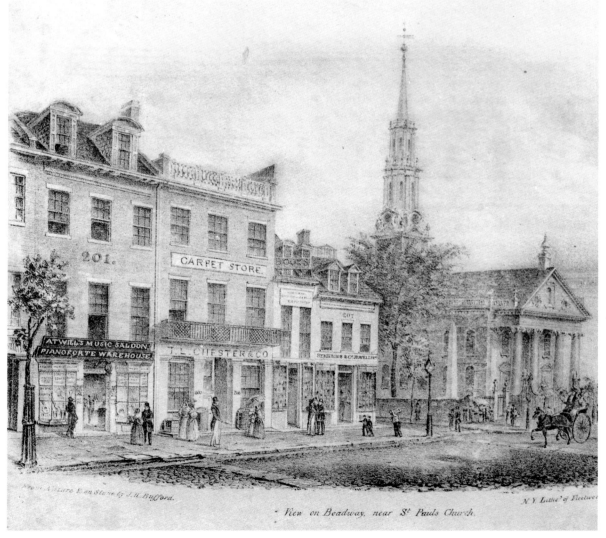

View on Broadway, near S.ᵗ Pauls Church.

Fig. 220. *Broadway Sights,* view of T. L. Chester and Company Carpet Store, 203 Broadway, ca. 1837. Lithograph by John H. Bufford. Collection of The New-York Historical Society, Bella Landauer Collection

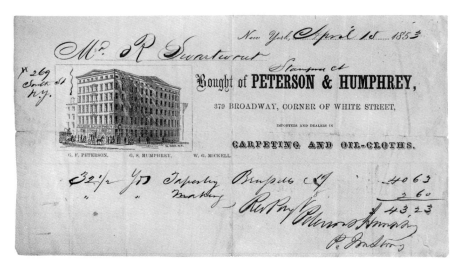

Fig. 221. Billhead with view of Peterson and Humphrey's Carpet Store, 379 Broadway, 1853. Wood engraving by Nathaniel Orr. Collection of The New-York Historical Society, Bella Landauer Collection

Fig. 222. *Interior of Peterson and Humphrey's Carpet Store, 379 Broadway*, 1853. Wood engraving, by Nathaniel Orr, from *The Illustrated American Biography* (New York: J. M. Emerson and Company, 1853), vol. 1, p. 31. The Metropolitan Museum of Art, New York, The Elisha Whittelsey Collection, The Elisha Whittelsey Fund, 1958 58.521.1

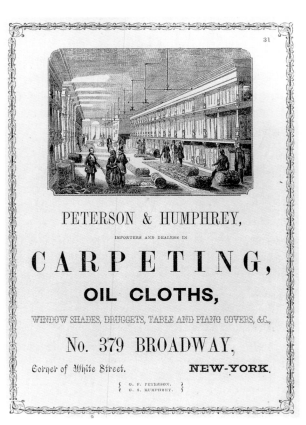

40. William W. Chester, Last Will and Testament, March 11, 1869, New York City Records Department, Liber 26, p. 384.
41. "The Palaces of Trade," *International Monthly Magazine of Literature, Science, and Art* 5 (April 1852), pp. 436–41.
42. Ibid., p. 438.
43. R. G. Dun Reports, July 15, 1848, for example. A report of June 15, 1852, states, "Are s[ai]d to be back[e]d by 'A. T. Higgins' who furnishes them with facilities," and one of August 16, 1854, relates, "They buy principally of 'Higgins & Co.'" For all the foregoing entries, see R. G. Dun Reports (New York vol. 365, p. 121, vol. 192, p. 569), R. G. Dun & Co. Collection, Baker Library, Harvard University Graduate School of Business Administration. For more about A. and E. S. Higgins, see *Century of Carpet and Rug Making in America*, pp. 19–22.

have married. In his will of March 11, 1869, he left most of what he owned to his brother Thomas and his brother's children. The will also reveals that he was involved in the very institutions and activities that engaged the elite of New York society. In addition to money, William left his various relatives the paintings and books he had collected, as well as his share in the New York Society Library, his pew at the Mercer Street church, his family seal, and an estate on Staten Island. William W. Chester may have been an early trustee of the University of the City of New York (now New York University); in his will he bequeathed the university "my portrait now hanging in the Chancellor's room of that Institution." In addition to property and investments, William left $30,500 to his heirs, a goodly sum for a carpet salesman.[40]

PETERSON AND HUMPHREY was in some ways more typical of midcentury retail carpet firms than the T. L. Chester company. The partnership rode the crest of the affluent 1840s and 1850s but failed in the years just before the Civil War. Both George F. Peterson and George S. Humphrey were experienced carpet salesmen, but neither seems to have had great financial means. They started out as a relatively small firm working out of a series of Pearl Street locations and in the 1850s raised enough money from a backer to build a big store on Broadway. Their huge "carpet house" at the corner of Broadway and White Street (see fig. 221)

was much illustrated during the period, both in advertisements and in newspaper articles dedicated to "palaces of trade."[41] A print of the interior of their selling floor is one of the very few illustrations of nineteenth-century carpet shopping known today (fig. 222).

In 1852 the store was described as follows: "[This] imposing edifice on the corner of Broadway and White-street . . . is one of the improvements of the city made during the last year. In the great carpet-house of Peterson & Humphrey are offered the productions of the best looms in the world, in a variety and profusion probably unequalled elsewhere in America. The principal saloon is like a street, and it is almost always thronged with people."[42] The image of the interior shows dapper salesmen unrolling bales of strip carpeting for well-dressed couples on a half-block-long sales floor. The racks holding rolls of carpet rise up through three levels, forming building-like structures to each side of the room, which is perhaps eighteen feet high.

In spite of its extravagant premises and nonstop advertising, Peterson and Humphrey was never on particularly sound financial footing. It was backed by A. and E. S. Higgins and took over that firm's retail business after 1847. According to the R. G. Dun credit reports, either Peterson or Humphrey was a nephew of one of the Higgins brothers.[43] An advertisement

Firm names: **George F. Peterson** (1844, 1859–64),
Peterson and Humphrey (1845–47, 1849–57),
Peterson, Humphrey and Ross (1848),
G. S. Humphrey and Company (1859–62),
E. A. Peterson and Company (1859–72)
Owners: George F. Peterson, George S. Humphrey
(d. 1898), David S. Ross, Edwin A. Peterson
(perhaps son of George F. Peterson)
Locations
George F. Peterson
1844 462 Pearl Street

Peterson and Humphrey, Peterson, Humphrey and Ross
1845 440 Pearl Street
1846–47 454 Pearl Street
1847–51 432 Pearl Street
1852–56 379 Broadway
1857 524 Broadway

G. S. Humphrey
1859–62 524 Broadway

George F. Peterson
1859–64 315 Canal Street

E. A. Peterson
1859–72 315 Canal Street

from 1847 proclaims: "Peterson, Humphrey & Ross, having purchas[ed] the entire stock of carpetings, druggets, oil-cloths &c., in the large and spacious Carpet Warerooms No. 432 Pearl-street, formerly owned by Messrs. A. & E. S. Higgins, are now prepared to offer their friends and the public the above stock, together with recent purchases, at prices far below the market."[44]

Peterson and Humphrey seems to have served as the Higginses' outlet in New York City, but the manufacturer's carpets were not the only wares sold by the retailer.[45] In its heyday, during the mid-1850s, Peterson and Humphrey cleared about $75,000 in profit each year; however, by March 1857 the firm had failed because of bad debts, perhaps a casualty of the financial panic of 1857. Although members of the original firm continued in the carpet business for a few years, they never flourished as they had in the splendid carpet house at 379 Broadway.

By contrast, the W. AND J. SLOANE company flourished into the twentieth century. After completing his training as a carpet weaver at an Edinburgh mill, William Sloane emigrated from Scotland to the United States in 1834. He worked for the Connecticut carpet-weaving firm of Thompson and Company for almost a decade before opening his own carpet warehouse in 1844, with some backing provided by Thompson and Company, whose wares he surely

stocked.[46] William's older brother John joined the business in 1853. The first Sloane shop was located at 245 Broadway in a three-story Federal-style town house with a converted first floor (see fig. 223). From the beginning, the firm catered to the high end of the market. The earliest receipt for Sloane's found during the course of research for this exhibition shows that in 1845 the wealthy dry-goods merchant Samuel Tredwell Skidmore purchased two Persian rugs, for $25 each, from William Sloane.[47] There is no evidence to suggest that any of the other carpet retailers discussed here sold Persian rugs; thus, Sloane's must have been one of a very few places that stocked such luxury goods. When the Clarendon Hotel was

44. "Carpetings," *Home Journal,* January 16, 1847, p. 3.
45. Their advertisements stated that they stocked carpets "selected from the most celebrated Factories in Europe and this country." *New York Mercantile Register,* 1848–49, p. 118.
46. In the *New York Business Directory for 1840 & 1841,* Thompson and Company is listed as one of only three carpet manufacturers selling its products in New York. The firm's listing stated that Thompson's showroom was at 8 Spruce Street and that it sold "Brussels, Ingrain, &c." For more on Sloane's relationship with Thompson and Company, see R. G. Dun

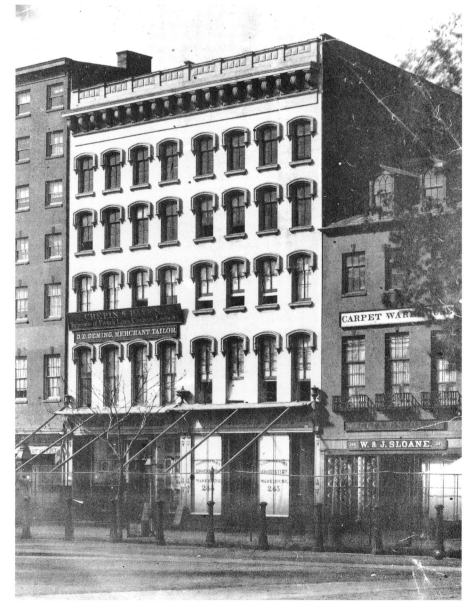

Fig. 223. Victor Prevost, *Solomon and Hart Upholstery Warehouse, 243 Broadway, and W. and J. Sloane Carpet Warehouse, 245 Broadway, New York City,* 1854. Modern gelatin silver print from waxed paper negative. Collection of The New-York Historical Society, Gift of Mr. Samuel V. Hoffman

Firm names: **William Sloane** (1844–52),
W. and J. Sloane (1853–1960s)
Owners: William Sloane (1810–1879; retired from
the firm in 1864), John Sloane (b. before 1810;
retired from the firm in 1860), John Sloane
(1834–1905; son of William Sloane), Douglas
Sloane (son of William Sloane)
Locations
1844–55 245 Broadway
1856–59 501 Broadway and 56 Mercer Street
1859–66 591 Broadway
Business conducted through the 1960s at various
locations

renovated in 1858, the management used Sloane's stellar reputation as a selling point, advertising that their new carpets were "carefully selected, of the most approved styles and quality, from the establishment of W. & J. Sloane."[48] In 1859 R. G. Dun and Company reported that the firm was prosperous and had "the custom of a lar[ge] number of first class families; sell mostly fine goods."[49] The store at 591 Broadway was considered by the editor of *Carroll's New York City Directory* (1859) to be "one of the greatest sights in N. Y."[50] An advertisement found in the same publication describes the wide range of Sloane's wares:

> *Strangers visiting New York are invited to examine our establishment, the largest building in the world devoted to the exclusive sale of Carpets. Our great advantage in buying and manufacturing, guarantees us to sell lower than any house in the trade, and our goods will be found superior in quality and style.*
> *$250,000 worth of English Medallion Bordered Carpets! English Royal Tapestry Velvet Carpeting! English Four-Frame Brussels Carpeting! English Tapestry Brussels Carpeting! English Imperial Three-Ply Carpeting! Floor Oil Cloths, from one to eight yards wide. India Mattings, White and Checkered; Mats, Rugs, Gold and Painted Window Shades, Druggets, French and English Table and Piano Covers. Cocoa Matting, $1\frac{1}{2}$, 2, 3, 4, 5 and 6 feet wide, for Churches, Offices, Hotels and Steamboats at the most unprecedented low prices.*[51]

As the notice suggests, William's familiarity with carpeting manufacture meant that the firm had a hand in the production of at least some of the goods sold at the shop. His longstanding ties to Thompson and Company were also surely an advantage; however, Thompson seems to have failed in 1851 (the firm was reorganized as the Hartford Carpet Company). William

managed to survive the crash, probably by aligning himself with other manufacturers both in the United States and abroad. At the time of his death, in 1879, William was a director and shareholder of the Bigelow Carpet Company of Massachusetts and of the Alexander Smith and Sons Carpet Company of Yonkers, New York, two of the leading carpet manufacturers in the country.[52] It is likely that he stocked carpets manufactured to his special order from those two firms, and he may have had the same relationship with mills in England and Scotland. In the mid-1860s, soon after William retired, the firm was worth between $200,000 and $300,000.

Wallpaper

Producers and retailers of wallpaper—more often called paper hangings during our period—found New Yorkers to be insatiable consumers of their wares. New wallpaper was the answer to many decorating problems: it was available in many different grades and at a wide range of prices; it was easily installed; and it was produced in myriad fashionable patterns. The novelty factor was important to the consumer. As *Godey's Lady's Book and Magazine* observed in 1857: "There is nothing, perhaps, that adds more to the beauty of a parlor, or in fact any other apartment, than a well-selected, handsome wall-paper. It is better than painting or frescoing, as one gets tired in time of a permanent fixture; while, at the same time, wallpaper is cheaper, and even more beautiful. . . . With wallpaper, you can make a change, which sometimes becomes necessary to suit a different style of furniture."[53]

The earliest advertisements from the period of this study reveal a ready market for both high-style French paper hangings and the cruder products of the fledgling American industry. In the 1820s wallpapers were advertised and sold by wholesale importers to upholsterers, who were the primary wallpaper retailers. In 1823 a merchant named F. Chazournes with offices "upstairs" at 162 Pearl Street took out an advertisement addressed "TO UPHOLSTERERS. Twenty-two bales French paper hanging, handsome patterns, for sale by the bale or in smaller quantity." In 1824 Calvin W. How and Company, located farther downtown at 135 Pearl Street, advertised "8000 rolls American made Room Papers, of various qualities, on hand and for sale at reduced prices," and two years later E. Malibran, of 31 South Street, offered "10 cases superb Velvet Papers, new patterns, worthy of the attention of upholsterers and others, as they are suitable for this or the South American market, for sale low to close a

Reports, for February 16, 1849, May 27, 1851, and September 23, 1851 (New York vol. 192, p. 564), R. G. Dun & Co. Collection, Baker Library, Harvard University Graduate School of Business Administration.

47. Skidmore Papers, Joseph Downs Collection of Manuscripts and Printed Ephemera, no. 70 x 53.66, courtesy The Winterthur Library.

48. *The Albion*, September 11, 1858, p. 443.

49. R. G. Dun Reports, October 25, 1859 (New York vol. 192, p. 564), R. G. Dun & Co. Collection, Baker Library, Harvard University Graduate School of Business Administration.

50. G. Danielson Carroll, *Carroll's New York City Directory . . .* (New York: Carroll and Company, 1859), p. 69.

51. Ibid.

52. See the biography of William Sloane in *America's Successful Men of Affairs*, p. 605.

53. "Paper Hangings," *Godey's Lady's Book and Magazine* 54 (April 1857), p. 376.

Fig. 224. Manufacturer unknown, probably New York City, Wallpaper, ca. 1850. Roller-printed paper. The Metropolitan Museum of Art, New York, Gift of Mrs. Adrienne A. Sheridan, 1956 56.599.12

Fig. 225. Manufacturer unknown, probably French, Wallpaper, ca. 1850. Paper with wool flocking. The Metropolitan Museum of Art, New York, Anonymous Gift, 1923 23.133.10

consignment."[54] Very little paper was imported from England or from countries on the Continent other than France. The French were the masters of wallpaper manufacturing at the time, and Americans avidly bought both their scenic papers, which illustrated exotic landscapes and peoples, and their more typical floral and trompe l'oeil designs. Until the latter part of the nineteenth century French papers were considered better designed than American papers, with more elegant patterns and subtler coloration.

In the mid-1820s a few retailers of paper hangings and bandboxes opened businesses in New York City offering both imported and American goods. At that time the American paper-hangings industry, which had been established in the late eighteenth century, was centered in New England and Philadelphia, but by 1840 twenty-five wallpaper concerns were listed in the New York business directories and ten of them appear as manufacturers as well as retailers. Also included in that number are a few firms, such as John Constantine, Phyfe and Brother, and Barnett L.

Solomon, that specialized in upholstery but sold wallpaper as well. Wallpapers could also be purchased at the shop of a "decorator," although few such professionals existed at the time. George Platt is one of the few about whom something is known. He advised and assisted clients in much the same way as interior designers do today, and he also retailed all types of decorative items for the home. Sidney George Fisher of Philadelphia visited Platt's shop at 60 Broadway with his brother and sister-in-law in 1847:

Went with Henry and Sarah Ann to Platt's, who is a 'decorateur' and furnishes everything connected with the interior ornamental work of houses. Saw quantities of elegant things, furniture, mirrors, picture frames, paper hangings, etc. Had no idea before of the beauty of French paper. The various patterns for drawing & dining rooms, halls & libraries were really works of art. The prices are immense, ranging from $5 to $10 per piece, whereas the best American is only $1. Henry chose some of the handsomest for his house.[55]

54. *New-York Evening Post,* April 25, 1823; *New-York Daily Advertiser,* May 19, 1824; *New-York Gazette and General Advertiser,* June 13, 1826.

55. Nicholas B. Wainwright, ed., *A Philadelphia Perspective: The Diary of Sidney George Fisher Covering the Years 1834–1871* (Philadelphia: Historical Society of Pennsylvania, 1967), p. 198.

Throughout the first half of the nineteenth century, French wallpaper remained expensive, owing in part to the high tariffs (in some years as much as 40 percent) placed on them in order to encourage the American industry. However, in 1850 Thomas Faye, a New York retailer who also manufactured wallpaper, placed an advertisement in the *Home Journal* that indicates Americans remained undaunted by the cost of buying French:

INTERIOR DECORATIONS. The Subscribers, sole Agents in America for many of the best French Factories, call the attention of those who intend refitting their houses, to their rich and splendid stock of Paper Decorations, for the walls of parlors, halls, boudoirs, saloons, drawing and dining-rooms, &c., &c. They are constantly receiving direct from Paris, Lyons, Constance and other cities of the continent all the latest styles and patterns in doré velouté, doré maroguin, double satin, Lambris, Bordures, Camés, &c., &c. A full assortment of samples can be seen, from which special importations can be made when desired, by steamer, in from two to three months.[56]

Comparison shoppers would have discovered, too, that some of the simpler French papers were not much more expensive than American examples (see figs. 224, 225). Thomas Faye sold a French Emboss Stripe paper to Evert A. Duyckinck for 75 cents a roll and two different types of Satin paper, probably of American manufacture, for 25 and 50 cents a roll, respectively. The cost of papering one of Duyckinck's rooms with the 25-cent paper was $9.18. This included $3.75 for the wallpaper, plus $1.20 for twenty-four yards of velvet (possibly flocked) border, and $4.23 for hanging the paper.[57]

After about 1840 American wallpaper manufacturers began to experience some success with a timesaving mechanized cylinder-printing process.[58] Although roller-printed paper made before 1860 is often poorly designed and printed and the best papers continued to be block printed by hand throughout the period of this study, the mechanization of the American wallpaper industry made it possible even for consumers with very little money to enliven their homes with bright, clean, and colorful wallpapers.

Retailers and Manufacturers

FRANCIS PARES and THOMAS FAYE were wallpaper merchants in New York City between 1824 and 1886. They each had a paper-hangings business before becoming partners in 1837; after their partnership broke up in 1846 they became competitors. Francis

Pares began as a maker of trunks and bandboxes in 1824. In an 1829 advertisement, the earliest found for his shop, he lists his wares as: "PAPER HANGINGS, TRUNKS, and BANDBOXES.—*Francis Pares.* . . . keeps constantly on hand, for sale, an extensive assortment of Paper Hangings, imported directly from Paris; also, of his own manufacture, Pedlars', Merchants', and Fancy Trunks, wholesale and retail; Bandboxes in nests for shipping."[59] He may have specialized in providing goods to retailers outside the New York area, since an advertisement placed in 1831 announces: "BANDBOXES.—Southern merchants and Milliners may be supplied with Bandboxes in nests for shipping, made of the best materials, and will be sold at the lowest prices at the old established manufactory of F. PARES, No. 379 Pearl st."[60] Bandboxes, such as the one illustrated here (fig. 226), were used for storing small items of clothing, for example collars (in pre-twentieth-century terminology "bands," hence the name "bandbox"), and as hatboxes. Some of the earliest known American block-printed decorative papers appear on bandboxes. Although these papers are similar to wallpapers, many of them were designed exclusively for bandboxes. Views of notable buildings, such as New York's Castle Garden (see fig. 226), were particularly popular for bandboxes.

Firm names: **Francis Pares** [and Company] (1824–36, 1846–66), **Thomas Faye** [and Company] (1835–36, 1851–77, 1883–86), **Pares and Faye** (1837–46), **Faye, Donnelly and Company** (1877–82)
Owners: Francis Pares, Thomas Faye (1810–1892)
Locations

Francis Pares

1824–36	379 Pearl Street
1847–53	379 Pearl Street
1854–56	59 Chambers Street
1857–59	336 Broadway
1860	836[?] Broadway
1861	828 Broadway
1862–66	828 Broadway and 45 Beaver Street

Pares and Faye

1837–46	379 Pearl Street

Thomas Faye

1835–36	367 Pearl Street
1851–54	436 Pearl Street
1855	257 Broadway
1856–60	257 Broadway and 152–156 West Twenty-ninth Street
1861–64	257 Broadway
1865–69	814 Broadway
1870–86	810 Broadway

56. *Home Journal*, June 8, 1850, p. 3.

57. Thomas Faye and Company to Mr. E. A. Duyckinck, invoices, August 24, 1859 (the French Emboss Stripe), and May 3, 1856 (the Satin paper), Duyckinck Family Papers, New York Public Library.

58. For good overviews of the effects of mechanization on the American wallpaper industry, see Elizabeth Redmond, "American Wallpaper, 1840–1860: The Limited Impact of Early Machine Printing" (Master's thesis, University of Delaware, Newark, May 1987); and Karen A. Guffey, "From Paper Stainer to Manufacturer: J. F. Bumstead & Co., Manufacturers and Importers of Paper Hangings," in *Wallpaper in New England*, by Richard Nylander et al. (Boston: Society for the Preservation of New England Antiquities, 1986), pp. 29–37.

59. *Workingman's Advocate*, October 31, 1829, p. 3.

60. Ibid., March 5, 1831, p. 6.

Fig. 226. Manufacturer unknown, Bandbox depicting Castle Garden, ca. 1835. Wood and block-printed paper. Collection of The New-York Historical Society 1937.1627

In 1835, although he was still manufacturing bandboxes, Pares was also selling very expensive imported wallpapers from his shop. To a Mr. Van Gorder of Warren, Ohio, he sold two sets of scenic paper, which he called The Suberbs [sic] of Rome, by an unidentified French maker for $60 per set.[61] It was to be hung in the parlor of an inn and coach stop in Warren.[62]

Thomas Faye, a native of Galway, came to America in 1818 as a child of eight. He went into the wallpaper business in 1835. The masthead on his receipts for that year lists his firm as the "Successors to Thomas Day, Jun., Importers and Dealers in Paper Hangings, and Manufacturers of Bandboxes."[63] In 1837 Pares and Faye formed a partnership and seem to have discontinued the manufacture of bandboxes. An 1840 advertisement makes it apparent that the firm continued Pares's wholesale business, selling mainly to the trade and especially to merchants outside New York:

> *Paper Hangings Borders etc. Pares and Faye No. 379 Pearl Street, offer to the trade and others, on terms of great reduction, the most extensive assortment of the newest patterns and styles of gold and silver, velvet and satin French Paper Hangings, Borders, Fireboard Prints, Views, Statues, Ceilings, etc. Also American Satin and Common Paper Hangings, from the most eminent manufactories, at the lowest manufacturers' prices. Merchants and others from all parts of the country are earnestly solicited to call and examine for themselves.*[64]

An 1845 advertisement was even more specific about the clients Pares and Faye preferred, announcing that

". . . Merchants, Dealers, Housekeepers, Landlords and others are respectfully invited . . . to call."[65] One of those "others" who bought papers from Pares and Faye happened to be the president of the United States. In a letter of about 1840, toward the end of his term, Martin Van Buren asked Mrs. Benjamin F. Butler, the wife of an Albany lawyer and politician, for her help and advice on choosing papers from the samples he had been sent from Pares and Faye's shop. Van Buren was in the midst of refurbishing a house in Kinderhook, New York, as his retirement home and, being a widower, he felt the need of a woman's advice in making his wallpaper choices. He numbered the papers he liked and suggested the rooms in which to install each paper. He had no opinion about some rooms, telling Mrs. Butler, "For the rest you must decide for yourself."[66]

After Pares and Faye parted company in 1846, both men continued to import fine French papers and both listed themselves as wallpaper manufacturers on their billheads. Pares sold printed window shades (perhaps like the Crystal Palace paper of cat. no. 218) as well as paper hangings. It is not known whether Pares actually made much paper; on the other hand, production appears to have been a significant part of Thomas Faye's business, because he proudly displayed pictures of both his store and his "manufactory" at 152–156 West Twenty-ninth Street at the top of his billheads (see fig. 227). Faye had some success with the papers he manufactured; in 1855 one of them won a gold medal at the American Institute fair. He seems to have retired briefly between 1859 and 1861; after that, he ran the business until 1886, perhaps with the help of his nine children. Faye also owned considerable real estate both on Broadway and in the Washington Heights area of Manhattan, which brought additional income to his family.[67] Pares left the paper-hangings business in 1866; he was listed simply as a merchant in New York City directories until 1881.

CHRISTY AND CONSTANT, another long-lived firm, was one of the major wallpaper manufacturers in America during the nineteenth century. It is first listed in the New York City directories as a manufacturer of paper hangings in 1844, the year that Thomas Christy's brother-in-law, Samuel S. Constant, became his partner. However, a late 1830s receipt from Thomas Christy and Company, 65 Maiden Lane, describes the business as "Importers and Manufacturers of French and American Paper Hangings," implying that Christy may have been manufacturing wallpaper from the time he started his business.[68] In addition to manufacturing, the firm seems to have maintained a retail

61. The archives of the Wallpaper Department, Cooper-Hewitt National Design Museum, Smithsonian Institution, New York, has a copy of Pares's invoice to Van Gorder. According to Catherine Lynn, who saw photos of the paper design Van Gorder called The Suberbs [sic] of Rome while researching her ground-breaking book *Wallpaper in America from the Seventeenth Century to World War I* (New York: W. W. Norton, 1980), it is identical to one that has been called *Les Bords de la Rivière* in the twentieth century. See ibid., p. 226, colorpl. 36.

62. Charles B. Proctor, Warren, Ohio, to Catherine Lynn, May 8, 1973, archives of the Wallpaper Department, Cooper-Hewitt National Design Museum.

63. Thomas Faye and Company to Mr. W. Porter, invoice for $20.94 in wallpapers, April 25, 1835, Joseph Downs Collection of Manuscripts and Printed Ephemera, no. 66 x 71.2, courtesy The Winterthur Library.

64. *New-York American*, October 2, 1840, p. 3.

65. *Evening Post* (New York), March 29, 1845, p. 3.

66. Martin Van Buren to Mrs. Benjamin F. Butler, n.d., Joseph Downs Collection of Manuscripts and Printed Ephemera, no. 77 x 58, courtesy The Winterthur Library.

67. Biographical information about Thomas Faye has been gleaned from the not completely accurate biography of him written in *America's Successful Men of Affairs*, p. 233.

68. Thomas Christy and Company to an unknown customer, invoice dated August 28, 183[], photocopy in the files of the Wallpaper Department, Cooper-Hewitt National Design Museum.

Fig. 227. Billhead with views of Thomas Faye and Company Store, 257 Broadway, and Manufactory, 152–156 West Twenty-ninth Street, 1859. Lithograph by Alexander Robertson, Henry Seibert, and James A. Shearman. The New York Public Library, Duyckinck Family Papers, Manuscripts and Archives Section

Fig. 228. *Christy, Constant and Company Paper-Hangings Manufactory, 510–544 West Twenty-third Street, New York*, ca. 1861–71. Lithograph by Endicott and Company. Collection of The New-York Historical Society, Print Room

Firm names: **Thomas Christy and Company** (1838–40), **Christy and Robinson** (1841–43), **Christy and Constant** [and Company] (1844–71), **Christy, Constant and Shepherd** (1872–73), **Christy, Shepherd and Garrett** (1874–84), **Christy, Shepherd and Walcott** (1885–87)
Owners: Thomas Christy (d. 1874), Samuel S. Constant (d. 1885; retired in 1874), John D. Robinson, Thomas Christy Shepherd (nephew of Thomas Christy, joined firm in 1872), Charles R. Christy (son of Thomas Christy took over the business in 1874), William Garrett, [] Walcott
Locations

1838–40	65 Maiden Lane
1841–48	61 Maiden Lane
1849–50	60 Maiden Lane and 21 Liberty Street
1850–55	60 Maiden Lane, 21 Liberty Street, and 328 West Twenty-third Street
1855–60	48 Murray Street and 328 West Twenty-third Street
1861–62	48 Murray Street and 512 West Twenty-third Street
1863–64	25 Murray Street and 512 West Twenty-third Street
1865–71	29 Warren Street, 25 Murray Street, and 512 West Twenty-third Street
1872–73	501 Broadway, 56 Mercer Street, and 512 West Twenty-third Street
1874–87	510 West Twenty-third Street

business through the end of the 1840s. An advertisement in the 1848–49 *New-York Mercantile Register* states that the shop stocked "PAPER HANGINGS, BORDERS, FIRE BOARD PATTERNS and CURTAIN PAPERS, in all varieties and styles, and of the best qualities. As C. & C. manufacture the article extensively, it enables them to offer their goods on the most advantageous terms, WHOLESALE and RETAIL."[69] Christy and Constant wallpapers won awards at the American Institute fairs of 1844 and 1846.[70] After 1850 it is likely that the partners concentrated primarily on manufacturing and their wholesale business, since they seem not to have advertised in the popular newspapers and journals and never opened a store on Broadway, remaining on Maiden Lane from 1838 to 1855, and on Murray Street from 1855 to 1864. The large Christy and Constant factory at West Twenty-third Street near Tenth Avenue began producing wallpapers in 1850 (see fig. 228). In 1868 the building was described as "one of the most imposing, in external appearance, of the manufacturing establishments of New York, and one of the largest of its kind in the United States."[71] In the special schedule of the 1860 federal census devoted to industry, Christy and Constant's annual product was valued at $250,000.

The report also noted that the firm employed 150 people (148 men and 2 women), had a capital investment of $150,000, and stocked $80,000 worth of raw materials (paper, paints, and fuel).[72]

The wallpapers that the firm manufactured had complex designs and were produced by two different printing techniques. In the 1860s the first floor of the factory held four large roller printers, each of which had the capacity to print twenty-four thousand yards of paper a day. The machines had a dozen rollers each, so that twelve separate colors could be printed in a single operation (see fig. 229). The second floor housed the hand-printing department, "where all the higher grades of Paper Hangings, including Gold and Velvet Papers . . . are produced."[73] On the three floors above were other large mechanical printing presses, machines for polishing papers with satin or glossy grounds, and large areas set aside for grinding pigments and mixing the paints used to print the papers. There does not seem to have been a design department at the factory; according to an account published in 1868, "The principal designer of this firm resides in France, which, it must be conceded, is the world's centre, in all that relates to Ornamental Art."[74] Doubtless, the firm produced all types of papers in all grades of quality, including some that may have rivaled the papers produced in France, but rarely before the 1880s did wallpaper manufacturers mark their products. Only one identifiable piece of Christy and Constant paper is known today.[75] Why the firm went out of business in 1887 remains unknown. Further research may show that it was bought out by another wallpaper company.

Tiny by comparison with Christy and Constant, the firm of PRATT—later PRATT AND HARDENBERGH—started out as wholesalers in the mid-1840s but by the mid-1850s had begun to pursue a retail business. In 1854 it placed an advertisement in *The Independent*, announcing: "PRATT & HARDENBERGH, Manufacturers and Importers, No. 360 Broadway, New-York, have added to their wholesale business A RETAIL DEPARTMENT, and are constantly receiving all the new varieties of WALL AND PAPER DECORATIONS, from the most eminent manufacturers of Europe which, with the best styles of American production, they will be pleased to exhibit to any and all who may call upon them, either with a view of purchasing, or to see the perfection this branch of manufacture has obtained."[76] That same year the company announced that it was planning to manufacture an American scenic paper equal in every way to the enormously popular French scenic papers. In a laudatory article

69. *New-York Mercantile Register*, 1848–49, p. 309.

70. See *List of Premiums Awarded by the Managers of the Seventeenth Annual Fair of the American Institute, October 1844* [New York, 1844], p. 11; and *List of Premiums Awarded by the Managers of the Nineteenth Annual Fair of the American Institute, October 1846* [New York, 1846], p. 20; copies of both in the library of the New-York Historical Society.

71. J. Leander Bishop, *A History of American Manufactures from 1608 to 1860, . . .* 3 vols. (Philadelphia: Edward Young and Co., 1868), vol. 3, p. 179.

72. *Manufactures of the United States in 1860.*

73. Bishop, *History of American Manufactures*, p. 180.

74. Ibid.

75. Nylander et al., *Wallpaper in New England*, p. 192.

76. *The Independent*, April 27, 1854, p. 135.

Fig. 229. *Printing the Paper,* interior views of Christy, Shepherd and Garrett, 1880. From *Scientific American,* July 24, 1880, front page. The New York Public Library, Astor, Lenox and Tilden Foundations, The Science and Technology Research Center

published in *Glances at the Metropolis* (1854), Pratt and Hardenbergh's store is described and its ambitions are discussed:

> But a sight of all the rooms of the most beautifully decorated dwellings in New York gives but a faint conception of the immense scope of variety, the genius and labor that strike the eye and kindle the fancy, in going through the vast Paper Hanging Establishment of PRATT, HARDENBERGH & Co., 390 [sic] Broadway. These young men, who are masters of this branch of luxurious commerce, opened their magnificent store last spring. It was built for them, and they have directed all its interior proportions with special reference to the convenience of visitors, and an artistic display of their goods. . . . They are the only House of the Trade in New York, that retails Paper Hangings of their own manufacture.
>
> There has hitherto been one thing to be desired in this department of Commerce—American Scenes. . . . We are rejoiced to learn that these accomplished young men are preparing to manufacture original styles of Paper, which will illustrate our own History and scenes. In this laudable design they will be greeted by praise, and be rewarded by the most generous appreciation.[77]

The passage above is followed by a poem entitled "Lines inscribed to Pratt, Hardenbergh & Co., on hearing that they had determined to manufacture Wall Paper illustrated with scenes from American History and Landscape." The poem is anti-European in tone, citing beautiful American landscapes that more than equal those found in Europe. The subtext is pro-American manufacturers and proposes that they can rival French firms such as Zuber, which had been producing papers showing American scenes since the 1830s.[78] Despite all the high hopes thus expressed, Pratt and Hardenbergh did not achieve a lasting success, possibly because the business was just too small. According to the 1855 New York State census records, it manufactured only $13,000 worth of paper that year and had a mere six employees.[79] Also the firm must have been hand printing its papers, which was enormously time consuming; this can be surmised because the census lists the value of the company's tools and machinery at only $100. According to the R. G. Dun credit reports, it was never financially strong, no matter how affluent the shop may have appeared. By October 21, 1856, the company had failed, although it limped along for a few more years, selling off stock to meet debts, finally closing in 1858.[80]

Firm names: **J. H. and J. M. Pratt** (1845–50), **John Pratt** (1851), **Pratt and Hardenbergh** (1851–58)
Owners: James H. Pratt, John M. Pratt, John P. Hardenbergh
Locations

1845	21 South William Street
1846–47	141 Pearl Street
1848–49	138 Pearl Street
1850–51	159 Pearl Street
1851–53	32 Broadway
1854–58	360 Broadway

Like Pratt and Hardenbergh, SUTPHEN AND BREED (later SUTPHEN AND WEEKS) must have received a large infusion of capital in the mid-1850s that it used to open a store on Broadway. Both companies kept their palatial shops for only a few years. Teneyck Sutphen had been a dry-goods merchant from 1840 to 1854, at which point he turned to wallpaper with his new partner, John B. Breed, and moved the business from Pine Street to 404 Broadway, where they opened a grand store (see figs. 230, 231). The existing illustrations of Sutphen and Breed's provide a wonderful record of the appearance of wallpaper emporiums in the 1850s, a time when there was a great deal of excitement over the transforming possibilities that wallpapers held for even the humblest room. As an 1855 editorial in the *Home Journal* euphorically expressed it:

> Within the last year, so much has been done for the interior decoration of our private, and many of our public buildings, that we may say with propriety, that the walls, heretofore so bare and unmeaning, are now beginning to assume a character that adds much to the pleasures and enjoyments of refined life. The production of paper of elegant designs, and of untold variety—placed in the hands of skilful decorators, who take their multiplied beauties, and, by new art, cut and arrange them, with reference to each room—is the very perfection of this especial business. Now, instead of that eternal sameness which once prevailed, we have the most pleasing variety and fitness.[81]

Firm names: **Sutphen and Breed** (1854–57), **Sutphen and Weeks** (1858–61)
Owners: Teneyck Sutphen, John B. Breed, Fielder S. Weeks
Locations

1854–59	404 Broadway
1860–61	100 Liberty Street and 105 Cedar Street

77. Charles Edwards Lester, ed., *Glances at the Metropolis* (New York: Isaac D. Guyer, 1854), p. 37.

78. See Zuber's papers called *Vues du l'Amérique du Nord* (1834–36), illustrated in Lynn, *Wallpaper in America*, p. 193.

79. New York State Census, 1855, Sixth Ward, Second Election District.

80. R. G. Dun Reports, October 21, 1856 (New York vol. 365, p. 134), R. G. Dun & Co. Collection, Baker Library, Harvard University Graduate School of Business Administration.

81. "Interior Decorations," *Home Journal*, March 23, 1855, p. 3.

Fig. 230. *Exterior of Sutphen and Breed's Paper-Hangings Store, 404 Broadway,* 1855. Wood engraving by William Roberts, after A. Waud(?), from *The Illustrated American Biography* (New York: J. M. Emerson and Company, 1855), vol. 3, p. 18. The Metropolitan Museum of Art, New York, The Elisha Whittelsey Collection, The Elisha Whittelsey Fund, 1958 58.521.3

Fig. 231. *Interior of Sutphen and Breed's Paper-Hangings Store, 404 Broadway,* 1855. Wood engraving by William Roberts, after A. Waud(?), from *The Illustrated American Biography* (New York: J. M. Emerson and Company, 1855), vol. 3, p. 21. The Metropolitan Museum of Art, New York, The Elisha Whittelsey Collection, The Elisha Whittelsey Fund, 1958 58.521.3

82. "Elegant Parlor Papers and Decorations," *The Independent,* March 30, 1854, p. 101.

83. Lynn, *Wallpaper in America,* p. 218.

84. All information in this paragraph was found in the R. G. Dun Reports (New York vol. 193, p. 625, vol. 195, p. 849, vol. 364, pp. 55, 58), R. G. Dun & Co. Collection, Baker Library, Harvard University Graduate School of Business Administration.

85. Statistics from the federal census of 1860, in Bishop, *History of American Manufactures,* vol. 3, pp. 119–22.

Sutphen and Breed apparently specialized in imported papers; in an 1854 advertisement announcing that the firm had "removed from their old stand in Pine street to the new and spacious building, 404 Broadway," it listed the French manufacturers whose wares it carried, including "Zuber, Delecourt, Lamperlier, Deguette, Mader, Gillon, and other Paris makers."[82] The illustration of the interior of the store shows clearly distinguishable French scenic papers, such as Eldorado over the paneled dado on the right, and Isola Bella on the left, both of which were made by Zuber.[83] The firm must have had a setback after the financial panic of 1857. Breed left the business in July 1857, perhaps taking capital with him. Fielder S. Weeks joined Teneyck Sutphen in 1858, and in 1860 Sutphen and Weeks moved back downtown to 100 Liberty Street to run a wholesale paper-hangings business. In 1862 the partnership was dissolved. In 1869 Sutphen changed his speciality, becoming a partner in a large Brooklyn carpet business.[84] Weeks continued to run a wholesale wallpaper concern until 1875.

Upholstery

Although the upholstery trade was never a major one in New York City, upholsterers performed essential services for many New Yorkers between 1825 and 1861. In comparison with the larger home-decoration industries discussed in this essay, upholstery workshops were numerous but small-scale. In 1860 there were twenty-four upholstery shops in the city, employing a total of ninety-five men and eighty women. Small though it was, this trade had a yearly product worth $653,460—only about $140,000 less than the paper-hanging business, which employed nearly five hundred people.[85] Upholsterers were skilled tradespeople who charged relatively high

prices for their services and were patronized, for the most part, by middle- and upper-class New Yorkers.

From the 1820s into the 1840s New York City upholsterers seem to have followed the traditional practices of the upholstery trade, which had their origins centuries earlier in Europe. These tradesmen concerned themselves with many aspects of a room's appearance, providing curtains as well as the requisite rods, rings, and ornaments; wallpapers; upholstery for furniture (sometimes also the wood frames); bed hangings; mattresses; and pillows. An advertisement placed in 1832 by the short-lived firm of Dickie and Murray gives a comprehensive description of the traditional upholsterer's realm:

DRAWING AND DINING ROOM CURTAINS, UPHOLSTERY &c. &c. DICKIE & MURRAY, Upholsterers in general, No. 152 Fulton street, respectfully inform their friends and the public, that they are now ready to execute any orders for drawing room, dining room, and bed room curtains, which will be made from the newest and best designs. . . .

D. & M. also furnishes and stuffs every kind of Cabinet Furniture in a superior manner. . . .

They have also for sale, which have either been imported or made to their order, a great variety of material for curtains or furniture, amongst which are viz. sattin damask furniture in patterns for sofas, chaise lounges, chairs, &c. with a new style satin for curtains to match, including galloons, cord, tassels, bell pulls, &c. for each sett of furniture.

India satin damask of the most fashionable colours; French furniture cottons of the newest styles; worst'd damasks; moreens; chintzes, &c. A great variety of fringes; gallons, cords, tassels, &c.

Orris Lace, of all colours, a new article for Curtains, and the first ever imported into this market, which they particularly recommend as a trimming for India Damask. They are likewise manufacturing an entire new style of cornices of most superior workmanship & got up entirely for their style of curtains. They have also constantly on hand a large assortment of feather beds, mattrasses, palliasters, paper hangings, &c. &c.[86]

The most expensive items purchased from upholsterers were undoubtedly bed hangings and window curtains. Precious silk was the fabric of choice for high-style draperies, and many homeowners paid hundred of dollars for the curtains in a main-floor room, including the fabric trimmings and fancy hardware. The well-known 1833 broadside for furniture makers Joseph Meeks and Sons (cat. no. 225) advertises both

bed hangings and curtains. Bedsteads shown on the broadside could be purchased for $50 to $100 apiece; if they were bought complete with hangings, the prices jumped to $200 to $600 per bed. The three sets of window curtains on the broadside were $200 to $300 per pair. Using silk often doubled the price of furniture: upholstered with haircloth, one advertised mahogany sofa sold for $100; with silk, it cost $150 to $200.

In the beginning of the period of this study, upholsterers purchased their fabrics from wholesale merchants and importers, but by the later years larger upholstery firms such as Solomon and Hart had begun to import textiles directly. Either way, they must have made money by retailing the fabrics and trimmings to their customers, as well as earning a modest sum for the upholstery fabrication. The firm of Isaac M. Phyfe reupholstered a leather chair for Evert A. Duyckinck in 1855. An existing invoice details what this relatively modest job entailed and reveals the interesting fact that upholsterers did not make a large amount of money for their day-to-day work:

4 Skins for chair	*$7.—*
6 Springs	*.38*
1½ Yds burlap & 1 Yd Muslin	*.35*
2½ lbs hair	*1.09*
5 Yds Gimp	*.78*
Restuffing Chair	*5.00*
Cartage	*.75*

The job fetched $15.35, including materials.[87]

Upholstery was one of the few trades in which men and women were employed in about equal numbers, judging from the 1860 federal census cited above. Women probably did much of the stitching and trimming, while men may have done more of the foundation work. In some cases, women owned upholstery workshops. We know that Eleanor D. Constantine inherited the workshop at 182 Fulton Street that she had run with her husband before his death, and *Wilson's Business Directory of New-York City* also lists several other women—Elizabeth Bedell at 13 Sixth Avenue, Jane Ferrin at 131 Canal Street, Mary B. McKinney at 228 Hudson Street, and Harriet Pomroy at 303 Division Street—as owners of upholstery workshops in 1850.

During the 1840s cabinetmakers began to advertise that they could provide many of the same services as upholsterers. Joseph Meeks and some others seem to have supplied clients with curtains and mattresses as early as the 1830s, but Meeks probably subcontracted that part of his business.[88] In 1844 Alexander Roux, a recent emigrant from Paris, advertised "Cabinet furniture, hair & spring mattresses, &c. made to order.

86. *New-York Evening Post*, October 1, 1832, p. 1. Dickie and Murray was in business between 1832 and 1834.
87. Isaac M. Phyfe to Evert A. Duyckinck, invoice, June 15, 1855, Duyckinck Family Papers, New York Public Library.
88. Conversation with Jodi Pollack, June 1999.

Always on hand a variety of curtain ornaments; and Curtains made to order in the most fashionable style."[89] In a business directory of 1840–41, six New York firms listed themselves both as manufacturers and dealers of cabinet furniture and as upholsterers. They were C. A. Baudouine at 332 Broadway; Deming, Bulkley and Company at 56 Beekman Street; A. Eggleso at 137 Broadway; M. W. King at 365 Pearl Street; Joseph N. Riley at 47 Beekman Street; and J. and W. C. Southack at 196 Broadway. By the end of the period of this study, the general upholsterer who provided interior-decorating services was being supplanted by high-end cabinetmakers, among them Léon Marcotte, Pottier and Stymus, and Gustave Herter, who supervised all aspects of a grand house's interior, not just the "soft" furnishings.[90] There were also professional decorators, such as the aforementioned George Platt. Paper-hangings retailing gradually became its own profession, until by the 1860s wallpaper was no longer necessarily included in the list of products an upholsterer provided. After centuries of overseeing the decoration of houses, upholsterers shortened their list of services until it became much more like what we know today: they upholstered furniture framed by a cabinetmaker, produced curtains, and often retailed fabric purchased from a wholesaler for a client's specific chair or curtain.

Retailers and Manufacturers

JOHN CONSTANTINE, the son of an English cabinetmaker who had immigrated to the United States in 1793, ran a business in New York from 1818 until 1845 that was probably very like a traditional European upholstery practice. An inventory taken of Constantine's shop soon after his death shows that he served as an interior decorator to his wealthy clients, supplying them with many decorative products.[91] At that time his shop on Fulton Street held thousands of pieces of wallpaper of all different varieties, as well as "4 Sets Landscape" paper, seemingly underpriced at $15 per set. His holdings in wallpaper were valued at $2,919.81. The "Contents of Glass Cases" in the shop included yards of fabrics, such as worsted damask, chintz, moreen, and green baize, and gimps and trims of all types. The stock of fine covering yardage was surprisingly limited; Constantine may have used fabric provided by his clients, or perhaps he went to wholesale textile merchants for expensive silk goods on a job-by-job basis. He stocked more trimmings than wide goods; the shop had silk cords, fringes, tassels, worsted tassels, and gimps and "18 pieces wide

galoon" at $6 each. The high price of this trim may indicate that it was the type of galloon made of silk or wool interwoven with gold threads. Next on the inventory came all that was needed for making up upholstered chairs and beds—from the moss, horsehair, and feather stuffing to the decorative hardware for the centers of bed canopies and fancy bed crowns. Constantine stocked furniture frames for upholstered pieces normally found in bedrooms, such as "Cott frames," "Bed chair frames," and screens with either six or eight leaves. He also had numerous ready-made mattresses, bolsters, and pillows. In addition, the inventory lists drapery supplies, such as figural pole ends and curtain pins, as well as the makings of window shades and finished shades painted with designs or landscapes. The final two pages of the inventory list all the hundreds of pieces of hardware he stocked, both utilitarian and decorative. The value of the goods in Constantine's shop came to $6,559.36.

The inventory of the items in his home, which was in the same building as his shop, suggests the relative affluence a well-placed upholsterer enjoyed.[92] Among other things, Constantine and his wife owned three haircloth-covered sofas, one dozen mahogany chairs, two sideboards, two breakfast tables and a dining table, mahogany and "curled maple" bedsteads, three looking glasses, and a piano.

Constantine's brother Thomas was a cabinetmaker in New York between 1817 and about 1827; after that, he sold mahogany to other cabinetmakers. In 1817–18 Thomas received the commission to produce all the chairs for the United States Senate in Washington. It is believed that Thomas and John worked together on this commission, since from 1818 to 1820 they shared a shop at 157 Fulton Street. In 1823 John was hired to provide new draperies, the Speaker's chair, and a canopy for that chair for the North Carolina State House. The carved mahogany chair frame appears to

Firm names: **John Constantine** (1818–45), **Eleanor D. Constantine** (1846–54), **John Constantine** [Jr.] (1854–64)
Owners: John Constantine (1796–1845), Eleanor D. Constantine (b. 1805; widow of John Constantine, not listed after 1854), John Constantine (son of John and Eleanor Constantine)
Locations

1818–20	157 Fulton Street
1820–21	218 Broadway (rear)
1821–28	162 Fulton Street
1828–53	182 Fulton Street
1854–64	201 Bleecker Street

89. *The Gem, or Fashionable Business Directory, for the City of New York* (New York: George Shidell, 1844), p. 23. Roux arrived in New York City in 1836 and was first listed as an upholsterer, adding cabinet furniture to his business a few years later.

90. For more on this later period, see Katherine S. Howe, Alice Cooney Frelinghuysen, and Catherine Hoover Voorsanger, *Herter Brothers; Furniture and Interiors for a Gilded Age* (exh. cat., New York: Harry N. Abrams, in association with the Museum of Fine Arts, Houston, 1994).

91. "Inventory of the Estate of John Constantine dec. / Filed June 12, 1846," Joseph Downs Collection of Manuscripts and Printed Ephemera, no. 54.106.12, courtesy The Winterthur Library.

92. The announcements of John Constantine's death invite "Friends of the family . . . to attend the funeral from his late residence, No. 182 Fulton st." See *Evening Post* (New York), October 23, 1845; and *New York Herald*, October 24, 1845.

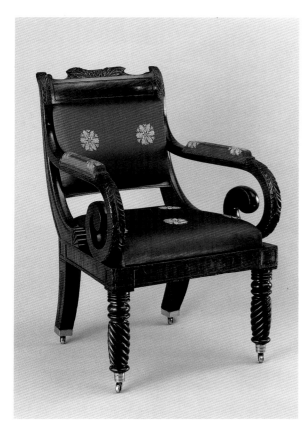

Fig. 232. Thomas Constantine, cabinetmaker; John Constantine, upholsterer, Chair for the Speaker of the North Carolina Senate, 1823. Mahogany; original underupholstery, replacement show-cover. North Carolina Division of Archives and History, Raleigh 91.171.1

be from Thomas's shop. John's original invoice for the job, dated July 19, 1823, still exists. In it he charged $1,650 "to furnishing draperie of Crimson Damask and ornaments complete for 6 windows, and a canopy & chair for the Speaker of Senate in the Capitol."[93] Contemporary viewers described the draperies as trimmed with gold fringe and tassels, which were looped up through the beak of a large gilt eagle that stood above each window.[94] Unfortunately, the State House burned to the ground in 1831, and the Speaker's chair was one of the few furnishings saved from the building. When it was brought to Colonial Williamsburg in 1992, conservators discovered that the under-upholstery of the chair (not the showcover) was original and could be attributed to John Constantine (fig. 232); this is the one example of his work that survives.[95]

John Constantine was a judge of the upholstery division of the American Institute fair in 1830, and he installed wallpaper with gilt borders at Mr. Evert Duyckinck's in 1840.[96] Constantine's wife, Eleanor, probably ran the shop from the time she inherited it in 1845 until 1854, when her son John took over and moved the business to 201 Bleecker Street. In 1860,

when the credit checkers of the R. G. Dun Company visited the shop, they found no one there but an old woman, perhaps Eleanor, "who states that J Constantine is not in bus[iness] there, alth[ou]g[h] his name appears abov[e] the door, she refused to state who is the proprietor of the store, or give her own name — There is a very small stock on hand & not the appearance of much bus[iness]."[97]

The PHYFE name is usually associated with Duncan Phyfe, the famous nineteenth-century maker of New York furniture, but in their day Duncan Phyfe's nephews were also well known as fine upholsterers. The sons of Duncan's brother John, a grocer, they were in business, working both in collaboration with their uncle's cabinetmaking firm and on their own, from the 1820s until just before the Civil War. The eldest of the sons, Isaac M. Phyfe, had his own upholstery business between 1830 and 1860; his brothers, James, William, Robert, and George, and James's son, John G. Phyfe, ran their firm from 1824 to 1861.

An early mention of the Phyfe brothers' work as upholsterers appeared in the New-York Mirror in 1829. Contained in a short description of an event called the Bachelors' Fancy Ball, it was highly complimentary: "The decorations of the ballroom in the city-hotel were, on the present occasion, unsurpassed in elegance and splendour. The arrangements, the ornaments, inscriptions, &c. were designed and executed by the Messrs. Phyfe, upholsterers in Maiden-lane, with the aid of Mr. Snooks, the carpenter."[98] The Phyfe brothers seem to have done a significant portion of their business in room decoration, namely, designing window draperies complete with cornices or other ornamental hanging systems to match upholstered furniture and coordinating wallpaper. The firm may have had practices similar to John Constantine's; by comparison, companies that opened their doors a bit later in the century, such as Solomon and Hart, made a good deal of their profit through the importation and sale of fine furnishing fabrics. The Phyfe brothers did import some items for sale: a receipt of 1830 made out to a Mr. D. W. Coxe lists the items J. and W. F. Phyfe (then of 44 Maiden Lane) could provide. In addition to hair mattresses and feather beds, the receipt states that the firm imported "paper hangings, fringes, &c." Indeed, Mr. Coxe purchased "30 Yds Silk Fringe" and "100 Yds Silk Galloon" from the brothers in yardages large enough to suggest that he may have been planning to retail the goods, rather than use them on his own furniture.[99]

Some of the best-documented work completed by the Phyfe brothers was done in collaboration with their

93. Invoice, Box 2, Treasurer's and Comptroller's Papers, North Carolina Archives, Capitol Buildings, Raleigh, North Carolina.

94. Wendy A. Cooper, Classical Taste in America, 1800–1840 (exh. cat., Baltimore: Baltimore Museum of Art; New York: Abbeville Press, 1993), p. 231.

95. Raymond L. Beck, "Thomas Constantine's 1823 Senate Speaker's Chair for the North Carolina State House: Its History and Preservation," Carolina Comments (Raleigh: North Carolina State Department of Archives and History) 41 (January 1993), pp. 25–30.

96. Duyckinck Family Papers, New York Public Library.

97. R. G. Dun Reports, November 7, 1860 (New York vol. 194, p. 728), R. G. Dun & Co. Collection, Baker Library, Harvard University Graduate School of Business Administration.

98. New-York Mirror, and Ladies' Literary Gazette, February 21, 1829, p. 263.

99. J. and W. F. Phyfe to Mr. D. W. Coxe, Esq., invoice, December 2, 1830, Misc. mss. Phyfe, J. & W. / F., Manuscript Department, The New-York Historical Society.

Firm names: **J. and W. F. Phyfe** (1824–33), **R. and W. F. Phyfe** (1833–35), **Phyfe and Brother** [James Phyfe and Robert Phyfe] (1835–43), **James Phyfe and George W. Phyfe** [separate listings, but at the same location] (1844–47), **James Phyfe** (1847–51), **Phyfe and Company** [James Phyfe, John G. Phyfe, and James Jackson] (1851–57), **Phyfe and Jackson** [John G. Phyfe and James Jackson] (1857–61)

Owners: James Phyfe (1800–87), William F. Phyfe (1803–42), Robert Phyfe (b. 1805), George W. Phyfe (b. 1812), John G. Phyfe (son of James Phyfe), James Jackson

Locations

1824–26	34 Maiden Lane
1826–32	44 Maiden Lane
1832–52	43 Maiden Lane
1852–57	323 Broadway
1857–61	706 Broadway

uncle Duncan Phyfe. In early 1842 the firm (then known as Phyfe and Brother) billed for the upholstery for many pieces of furniture made by Duncan Phyfe and his son James Duncan for Millford Plantation in central South Carolina (see fig. 233).[100] The house was built between 1839 and 1841 for John L. Manning and his wife, Susan Hampton Manning. In addition to upholstering the Duncan Phyfe–made furniture, Phyfe and Brother supplied the plantation house with drawing-room curtains topped with gilt cornices, as well as more pedestrian items, such as bed canopies, mattresses, bolsters, pillows, and silk fringe and tassels.[101]

Phyfe and Brother was especially esteemed for its ornamental curtain and drapery arrangements. In 1840 it sold a 13½-foot length of "Velvet Curtain bar" to Mrs. Duyckinck, enough for three windows. Included in the same order were three pairs of gilt curtain ornaments and thirty brass curtain rings.[102] In 1853 an advertisement for Phyfe and Company read "Upholstery, Paper Hangings and Interior Decorations, Wholesale and Retail."[103]

ISAAC M. PHYFE, the independent eldest brother, may have concentrated on less showy upholstery work. The few bills that have survived for work done by him are for jobs such as reupholstering a leather chair and making linen chandelier covers and crimson moreen valances for a bookcase.[104] (It was common practice to make overhanging fabric valances on the edges of bookshelves to protect fine bindings from light and dirt.) Isaac left the upholstery business between 1842 and 1845, and during those years he worked as a "U. S. Inspector," perhaps examining items that came into the port. He opened a shop on Broadway five

years before his brothers did and in 1859 served as a judge of the upholstery category at the American Institute fair.

During the 1830s and 1840s the firm of SOLOMON AND HART supplied New Yorkers with a wide variety of fine fabrics and upholstery services. An advertisement placed in the *New-York Commercial Advertiser* on September 2, 1844, gives a wonderful description of the European textiles that they stocked:

FALL UPHOLSTERY GOODS—Just received per Utica, Ville de Lyon and other packets from France; also, per steamers Hibernia and Caledonia, from England, the largest and handsomest assortment of the above goods that can be found in the city. . . . Among a variety of other articles will be found the following:

Rich French Silk Brocatels, various colors; Satin de Laines, a large assortment; Worsted; Satin striped and watered Tabouretts; India Satin Damasks; Chintz Furnitures, French and English; Printed Lustrings, French, large variety; Velvet Plush, figured, plain and striped, all colors; Satin and other Galloons, all widths and colors; broad and narrow Gimps; gilt and French Cornices, Bands, Pins, Clasps, &c.; Lace and embroidered Curtains, all sizes; Painted Window Shades, all sizes and prices; English Chintz and white and buff Hollands for shades.—Together with every other article in the Upholstery line.[105]

In 1844 the shop moved to 243 Broadway (see fig. 223) and the owners added French, English, and American wallpapers to their line, advertising them extensively. By the 1850s Solomon and Hart had become the leading upholstery firm in the city. It displayed both curtains and wallpapers at the 1853 New

Firm name: **Isaac M. Phyfe** (1830–60)

Owner: Isaac M. Phyfe (b. 1796)

Locations

1830–31	Tryon Row and Chatham Street (paperhanger)
1831–32	11 Ann Street (paperhanger)
1833–34	51 John Street (upholsterer)
1834–35	59 Church Street
1835–36	256 Greenwich Street
1836–42	128 William Street
1845–47	15 Rose Street
1847–49	669 Broadway
1849–54	687 Broadway
1854–60	893 Broadway

100. For the complete history of the decoration of Millford Plantation, see Thomas Gordon Smith, "Millford Plantation in South Carolina," *Antiques* 151 (May 1997), pp. 732–41.

101. Phyfe and Brother to John Laurence Manning, invoice, January 7, 1842, Williams-Chesnut-Manning Families Papers, South Caroliniana Library of the University of South Carolina, Columbia; cited in Smith, "Millford Plantation."

102. Phyfe and Brother to Mrs. Duyckinck, invoice, September 29, 1840, Duyckinck Family Papers, New York Public Library.

103. A. D. Jones, *The Illustrated American Biography,* . . . vol. 1 (New York: J. M. Emerson and Co., 1853), p. 89. Although, as the title promises, this volume contains some biographical sketches, it is actually a book of advertisements for merchants in New York and Boston.

104. Isaac M. Phyfe to Evert Duyckinck, receipts, June 18, 1852, and June 15, 1855, Duyckinck Family Papers, New York Public Library.

105. *New-York Commercial Advertiser,* September 2, 1844, p. 4, col. 7.

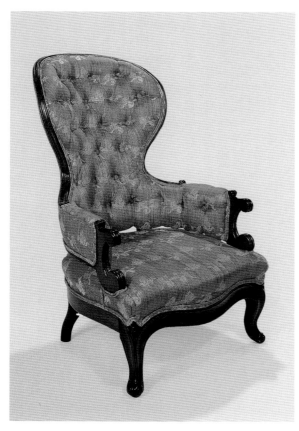

Fig. 233. Attributed to Phyfe and Son, cabinetmaker; Phyfe and Brother, upholsterer, Armchair for Millford Plantation, Clarendon County, South Carolina, 1842. Chestnut; replacement upholstery. Private collection

York Crystal Palace exhibition and was the only American firm to win an honorable mention in the upholstery category. An 1857 advertisement described not only the goods the company had for sale but also the services, such as curtain making, it could provide: "S. & H. being Practical upholsterers, purchasers can have their curtains, &c., made up in the best style, and after the Newest French Designs, received by every steamer from their House in Paris."[106] This description is somewhat unclear: were the curtains being sent by steamer from France, or were the "newest designs" sketches for curtains? It has not been ascertained if Solomon and Hart actually had a "house"—that is, a retail establishment—in Paris; however, by the 1860s the firm did have a store in San Francisco.[107]

The great success of Solomon and Hart is particularly interesting because the owners were both Jewish, a fact that is made much of in the R. G. Dun credit reports. An early entry on the firm, dated November 10, 1851, reveals that the owners "are Jews—was started some 10 [to] 12 years ago by his fath[er], a Pawnbroker in the Bowery reputed wealthy, who is said to have given the y[ou]ng man cap[ital] at starting." On March 1, 1853, the reporter from Dun noted "D[oin]g a large & profitable bus[iness]. Have rem[ove]d to B'way where they h[a]v[e] built a large store." His next remark, "Are decidedly the best Israelite ho[use] in this city" (the firm was estimated to have over $40,000 in capital at this time), must be evaluated in light of the fact that there were very few large Jewish-owned businesses catering to a high-end clientele in mid-nineteenth-century New York. None of the other Dun reports read in the course of preparing this essay mentions the religion of the merchant whose credit is being investigated.[108]

In 1863 Henry I. Hart died in Halifax, England (a noted textile manufacturing center), no doubt while he was on a buying trip. The firm continued under Barnett L. Solomon and his two sons; after 1866 it expanded its line, listing itself as "importers of upholstery goods, house linens & paper hangings: manufacturers of furniture & window shades" in the New York City directories.[109] The business survived until 1885.

This essay examines only a small number of the many businesses intent upon furnishing the thousands of new houses that sprang up along the streets of New York City between 1825 and 1861. The reader of this survey of a handful of the manufacturers and retailers in a mere four industries should bear in mind that there were many others who provided the comforts of home to New Yorkers—painters and stencilers, gilders, plaster molders, makers of mirrors, picture frames, and window cornices, and producers of chandeliers and other lighting fixtures. This essay was written in the hope of inspiring further research into the products and practices of these important yet mostly forgotten craftsmen of the nineteenth century.

106. *Frank Leslie's Illustrated Newspaper*, November 1, 1857, p. 561.
107. The R. G. Dun credit reports for January 1, 1864, state that after Henry I. Hart's death, in 1863, "the business will be continued in NY & San Francisco by Barnet [*sic*] L. Solomon & Sons" (New York vol. 191, p. 420), R. G. Dun & Co. Collection, Baker Library, Harvard University Graduate School of Business Administration.
108. Ibid., p. 406.
109. H. Wilson, comp., *Trow's New York City Directory* (New York: John F. Trow, 1870), p. 1040.

Firm names: **Solomon and Hart** (1834–38, 1843–64), **Barnett L. Solomon** (1838–43), **B. L. Solomon and Sons** (1864–85)
Owners: Barnett L. Solomon, Henry I. Hart (d. 1863), Isaac S. Solomon (son of Barnett L. Solomon), Solomon B. Solomon (son of Barnett L. Solomon)
Locations

1834–42	449 Broadway
1842–44	187 Broadway
1844–58	243 Broadway
1858–64	369 Broadway and 229 Chrystie Street
1864–68	369 Broadway
1868–79	657 Broadway
1879–85	29 Union Square

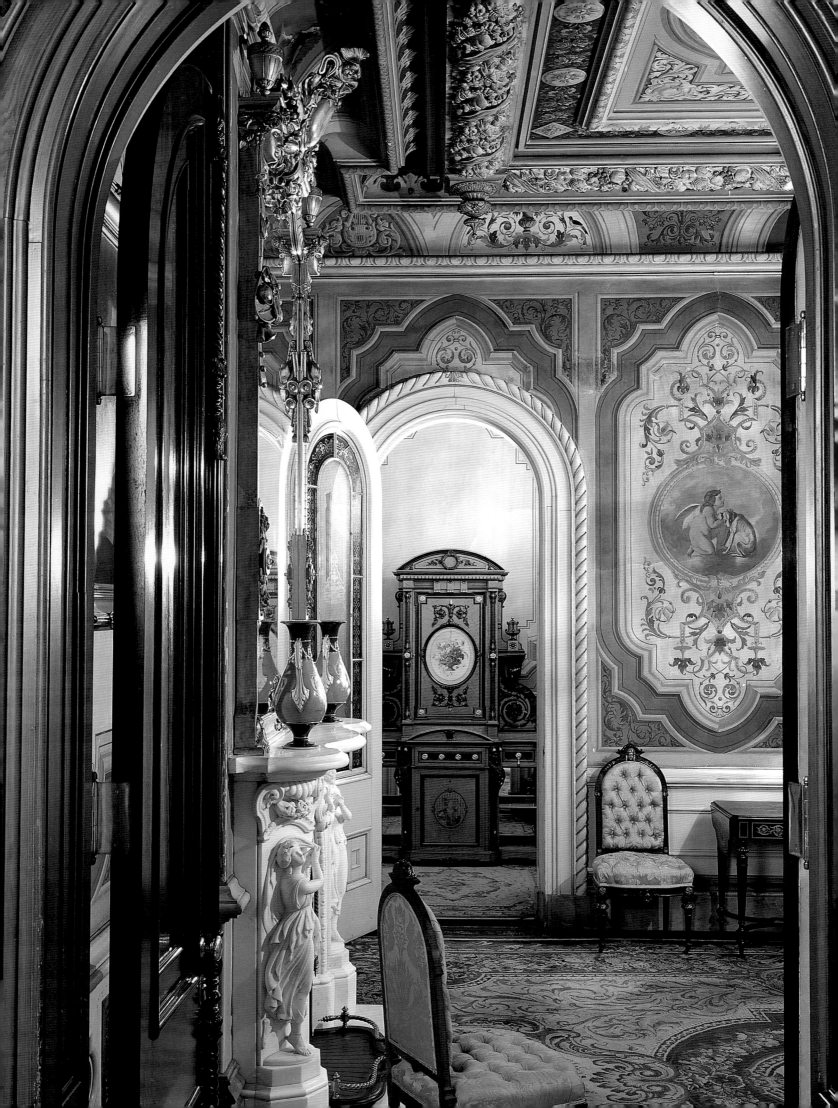

"Gorgeous Articles of Furniture": Cabinetmaking in the Empire City

CATHERINE HOOVER VOORSANGER

Among the thousands of tradesmen and artisans marching in the Grand Canal Celebration on November 4, 1825, were two hundred members of the Chair-Makers' Society—mechanics, journeymen, and apprentices. They proudly held aloft a two-sided banner that juxtaposed, on one side, a figure of Plenty with a side chair posing before a stand of native Indian corn, with a furniture manufactory at the edge of New York Harbor in the distance; the other side showed the chair makers' arms and tools as well as the products of their industry (fig. 234). The mottoes on the banner, "By Industry We Thrive" and "Rest for the Weary," conveyed the traditional republican values that the marchers professed—commitment to craft, a sense of responsibility to the community, and a belief in the importance of an individual's contribution to society.[1] To produce boxes that held commemorative medals coined for the occasion (cat. no. 282A, B), Duncan Phyfe, the most lionized cabinetmaker of the day, collaborated with the turner Daniel Karr, employing bird's-eye maple and cedar procured from the western forests and transported to New York on the *Seneca Chief,* the first canal boat to enter New York Harbor. Even as they celebrated the completion of the Erie Canal, and understood what it portended for their city, the chair makers and other members of the New York furniture making trades could not have predicted how much their world would be transformed in the decades before the Civil War. In fact, no word so aptly describes cabinetmaking in the second quarter of the nineteenth century as "change"—in the methods of producing and marketing furniture, in the relationship between mechanics and journeymen, and in the structure of an industry inundated by immigrant artisans and subjected to the vicissitudes of the economy.

This profound transformation is reflected in the constantly evolving appearance of the furniture itself. Indeed, the exciting multiplicity of styles represented in New York furniture from 1825 to 1861 is the most obvious evidence of how colorful and complex a story there is to be told. Furniture and, by extension, the

public reception rooms in private dwellings in which it was displayed, were obvious and calculated visual indicators of wealth, taste, and social standing, by which the social elite of New York (a relatively small segment of the population) judged themselves and each other.[2] In addition to using possessions and surroundings as a means of self-definition, New Yorkers were endeavoring to create a great world city on a par with London and Paris.[3] And, in satisfying both needs, they had regular recourse to Europe as a source of culture and tradition. American cabinetmakers and decorators, many of them European-born, naturally turned to European examples for the most fashionable designs. But, more often than not, they transformed these prototypes, making objects that are often extremely original. At their best, they are superb in quality, as the pieces selected for this exhibition demonstrate.

In the second quarter of the nineteenth century not only did New York become the largest furniture-manufacturing center in the country, eclipsing Philadelphia and Boston, but it also became known for producing the finest, most stylish handcrafted and custom-made furniture in America. "New York is the depot for everything made in a limited quantity," the author Virginia Penny advised her readers, "and for everything new in style."[4] Once the Erie Canal connected New York to the western states with inexpensive transportation, the city's primacy as the capital of American commerce and culture was assured. Cabinetmaking (and its allied trades) benefited from this newly established link with the West and from New York's hegemony in international and domestic trade, manufacturing, and finance. By the 1850s it had become one of the largest industries in the city.

The goal of achieving world-city status was understood to depend on the growth of New York's population, which, by extension, would result in an expanding clientele for the city's merchants, tradesmen, and artisans, including the cabinetmakers. In 1820, when the city's population exceeded Philadelphia's for the first time, there were nearly 124,000

Many people have contributed to the preparation of this essay over a long period, only some of whom can be mentioned here. My first thanks are to Cynthia V. A. Schaffner for invaluable research assistance and support. I am indebted as well to Medill Higgins Harvey, Austen Barron Bailly, Brandy S. Culp, and Jodi A. Pollack not only for research assistance but also for their superb management of myriad details involved in bringing this book to fruition. Without Jeni L. Sandberg's periodical research, the story could not have been told. Mary Ann Apicella, Nancy C. Britton, Barry R. Harwood, Peter M. Kenny, Thomas Gordon Smith, and Dell Upton generously shared insights and constructive criticisms, as did Bart Voorsanger. I sincerely thank Margaret Donovan for her deft and judicious editing, Carol Fuerstein for her refinements of the text, and Jean Wagner for her passionate attention to bibliographic accuracy.

The title of this essay is abridged from Thomas Mooney's comment, "The Americans begin to make gorgeous articles of furniture now," in Thomas Mooney, *Nine Years in America . . . in a Series of Letters to His Cousin, Patrick Mooney, a Farmer in Ireland,* 2d ed. (Dublin: James McGlashan, 1850), p. 150. For the sake of convenience, I have used the term "cabinetmaking" throughout to refer to all aspects of the furniture-making trade.

1. See Sean Wilentz, "Artisan Republican Festivals and the Rise of Class Conflict in New York City, 1788–1837," in *Working-Class America: Essays on Labor, Community, and American Society,* edited by Michael H. Frisch and Daniel J. Walkowitz (Urbana: University of Illinois Press, 1983), pp. 37–77. The description of the elements in the banner is drawn from Cadwallader D. Colden's *Memoir* (cat. no. 117), pp. 373–74.

2. In 1820 De Witt Clinton commented, "I find cabinetmakers in employ all over this country, and it is an

Opposite: Gustave Herter, cabinetmaker and decorator; James Templeton and Company, Glasgow, carpet manufacturer; painted wall and ceiling decorations attributed to Giuseppe Guidicini, Reception room, Victoria Mansion, Portland, Maine, the home of Ruggles Sylvester Morse and Olive Ring Merrill Morse. Victoria Mansion, The Morse-Libby House, Portland, Maine

occupation which deserves encouragement. I always judge the housewifery of the lady of the mansion by the appearance of the sideboard and the tables." Cited in Burl N. Osburn and Bernice B. Osburn, *Measured Drawings of Early American Furniture* (Milwaukee, Wisconsin: Bruce Publishing Company, 1926; unabridged and corrected republication, New York: Dover Publications, 1975), p. 70.

3. See Sven Beckert, "The Making of New York City's Bourgeoisie, 1850–1886" (Ph.D. dissertation, Columbia University, New York, 1995), pp. 29–132.

4. Virginia Penny, *How Women Can Make Money* (1863; reprint, New York: Arno Press, 1971), p. 446, as cited in Richard Stott, *Workers in the Metropolis: Class, Ethnicity, and Youth in Antebellum New York City* (Ithaca: Cornell University Press, 1990), p. 130.

5. Ira Rosenwaike, *Population History of New York City* (Syracuse: Syracuse University Press, 1972), pp. 33–36.

6. "Population of This City . . .," *New-York Mirror*, October 29, 1825, p. 11.

7. These figures are from Rosenwaike, *Population History of New York*, p. 33.

8. "Great Cities," *Putnam's Monthly* 5 (March 1855), pp. 254, 259.

9. The 1825 figure is drawn from the Berry Tracy Archives, Department of American Decorative Arts, Metropolitan Museum.

10. "The Industrial Classes of New York," *New York Herald*, June 18, 1853, p. 2: 3,000 cabinet makers, 300 carvers, 400 upholsterers, and 300 chair makers.

11. "Chronicle. Erie Canal Navigation," *Niles' Weekly Register*, September 4, 1824, p. 16.

12. *Hunt's Merchants' Magazine* 8 (1843), pp. 526–29, cited in Stott, *Workers in the Metropolis*, p. 56.

13. "Industrial Classes of New York," p. 1. In 1830, for example, Jesse Cady, at 30 South Street, advertised "Fancy Cabinetware. For Exportation. Portable writing desks, of mahogany, rosewood, &c. suitable for Buenos Ayres, the Mexican and South America markets, finished in every variety of style, for sale in quantities to suit." *Commercial Advertiser* (New York), March 27, 1830. See also "General Convention of the Friends

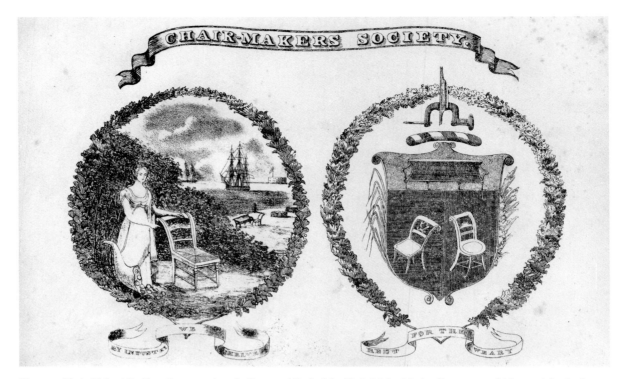

Fig. 234. *Chair-Makers' Emblems Represented on the Front and Back of the Chair-Makers' Society Banner*, 1825. Lithograph by Anthony Imbert from Cadwallader D. Colden, *Memoir, Prepared at the Request of a Committee of the Common Council of the City of New York, and Presented to the Mayor of the City, at the Celebration of the Completion of the New York Canals* (New York: Printed by W. A. Davis, 1825), opp. p. 373. The Metropolitan Museum of Art, New York, Harris Brisbane Dick Fund, 1941 41.51

inhabitants.[5] On the eve of the Canal celebration, the *New-York Mirror* proudly announced a new record—an estimated 170,000 inhabitants, an "astonishing" increase—and predicted that just "a few more years will place New-York among the proudest emporiums in the world."[6] During the 1830s New York surpassed Mexico City in size, becoming the largest metropolis in the Western Hemisphere. With a population of almost 630,000 in 1855 and close to 814,000 by 1860 (and the greater metropolitan area comprising more than one million),[7] New York saw itself fast closing in on its European counterparts. Equating size and population with importance, *Putnam's Monthly* proclaimed in 1855 "*the great phenomenon of the Age is the growth of great cities. . . .* New York . . . is greater than Paris or Constantinople, and will evidently be hereafter (in the twentieth century, if not sooner) greater than London."[8]

Keeping apace of the city's growth, cabinetmaking shops proliferated. In 1825 there were approximately 250 cabinetmakers in New York (not including carvers, gilders, turners, japanners, upholsterers, and makers of chairs, looking glasses, and frames, who were listed separately in the city directory that year).[9] In 1853 the *New York Herald* estimated 3,000 cabinetmakers, a twelvefold increase, among an industry that

employed about 4,000.[10] Accordingly, the volume of furniture production increased exponentially, not only to meet the needs of the local clientele and those who traveled to New York to furnish their houses but also to supply pieces for exterior markets. In this way, New York set the style for the rest of the country, as statistics make abundantly clear. The city of Utica, for example, received ten tons of furniture in one week during the summer of 1824.[11] In 1843 a total of 4,149 tons was shipped from New York along the Canal.[12] Ten years later, when the furniture produced in New York annually was valued at $15 million, nearly eighty-five percent of the city's output was destined for the South, Southwest, California, and South America and even as far away as China.[13]

Furniture making in New York was stratified by both quality and quantity, and even the best shops produced middle-range goods. Some of the better New York cabinetmakers, including Deming and Bulkley and Joseph Meeks and Sons, seized upon improved transportation systems and distributed their own furniture through warehouses they established in southern cities such as Charleston and New Orleans.[14] Many small New York shops that produced middle- and lower-grade goods sold their wares to wholesale merchants who dispersed them. Even though the vast

majority of the furniture made in New York was at the lower end of the quality scale, it was perceived as better than equivalent European manufactures, as Thomas Mooney, an Irish traveler in America, observed in 1850: "The inventive Americans are certainly before the English or Irish in the rapidity with which they get up work, and the high-finish they impart to cheap goods; it is likely they do not finish *fine* work better than we do, but it is certain that they do finish cheap work much better, quicker, and cheaper."[15]

As New York developed, various logistical problems made it increasingly uneconomical for dozens of industrial concerns, including some manufacturers of machinery, bricks, soap, textiles, and hats, to expand their operations within the city.[16] Crowding on the city's streets was legendary, and before the 1850s only Fulton Street connected the east and west shores of Manhattan. Real estate prices escalated wildly throughout the antebellum period (sometimes tripling within just a few years), and many manufacturers found it more profitable to sell their land than to stay in business.[17] Others chose to maintain a retail presence in lower Manhattan while moving their factories farther afield. Like most port cities, New York had little usable waterpower. New Jersey therefore beckoned, with falls and rivers, cheaper land, a lower cost of living, and, eventually, an extensive rail system, which was in place by 1860. Brooklyn, then a separate city, also became a haven for certain industries, such as glass, ceramics, and iron, that not only caused pollution but also posed serious fire hazards to Lower Manhattan, which was densely built.[18] An industrial belt was thus formed around New York, extending its economic boundaries and helping to supply its local, national, and international markets.

Cabinetmakers and other craftsmen such as goldsmiths, makers of shoes, boots, and cigars, and those involved in the needle trades, could afford to stay in Manhattan precisely because they had modest real estate requirements. Until after the Civil War the typical cabinetmaking shop was small and had its workshop and wareroom within the same narrow, multistoried building.[19] Proximity to the port and to related industries was essential; for cabinetmakers, these industries were lumber merchants, sawmills, dealers, auction houses, and craftsmen in allied businesses (upholsterers and turners, for example). Moreover, the inner-city trades depended almost entirely on hand labor, which was in plentiful supply from the early 1830s on, as hundreds of thousands of European immigrants disembarked in New York. Constantly changing styles helped keep cabinetmaking labor-intensive, and, as a

result, New York shops were slow to mechanize until after the Civil War.[20]

By 1855 more than 80 percent of New York workers were foreign born.[21] German craftsmen, both skilled and semiskilled, dominated cabinetmaking and piano making (a separate but related industry)[22] and constituted a major cultural, economic, and political force. Nearly 125,000 Germans immigrated to the United States in the 1830s, followed by nearly half a million between 1840 and 1850.[23] By 1861 their population in New York equaled that of the fourth largest city in the nation.[24] The vast majority of cabinetmakers—those who ran the middle- and lower-end shops—were clustered on the Lower East Side, and that area became known as Kleindeutschland because of the concentration of Germans who lived and worked there.

Nearly all the high-end cabinetmakers, whose work is the subject of this essay, lined Broadway, above City Hall, in the heart of the most elegant shopping district, their warerooms and manufactories dotted among posh hotels, purveyors of luxury goods, dress shops, and daguerreotypists. By the 1850s these included the elite of the New York cabinetmaking world: Charles A. Baudouine, J. H. Belter, Julius Dessoir, Gustave Herter, Edward Whitehead Hutchings, Léon Marcotte, Auguste-Émile Ringuet-Leprince, and Alexander Roux. Closer to City Hall, at 194 Fulton Street, Duncan Phyfe maintained his long and prolific practice until 1847. Still farther downtown, on Broad Street, and later on Vesey Street, Joseph Meeks and Sons, and subsequently J. and J. W. Meeks, continued a family-owned business that dated back to 1797. Belter, at 547 Broadway by 1853, was the only one of this group to so substantially enlarge his operations in the antebellum period that he had to seek larger quarters uptown. In 1856 he moved his factory to Third Avenue near Seventy-sixth Street, then an urban hinterland, occupying a five-story brick structure equivalent in size to half a city block, which he had built. For retailing purposes, however, Belter opened a new showroom at 552 Broadway, adjacent to Tiffany and Company, at the center of the carriage trade.[25]

As time went on, master cabinetmakers became more entrepreneurial businessmen and designers than craftsmen. By the 1850s many had enlarged their operations to supply the full spectrum of interior decoration, including carpets, draperies, upholstery, and wallpapers. Many of their luxury goods, among them fine silks and other fabrics, were of necessity imported from Europe because nothing of comparable quality was yet manufactured in the United States. Some of the high-end cabinetmakers (Roux and Marcotte,

of Domestic Industry, Assembled at New York October 26, 1831. Reports of Committees. Manufacture of Cabinet Ware," *Niles' Weekly Register*, addendum to vol. 42, p. 11: "The article [furniture], has become one of considerable export. It is carried in American ships to canton [*sic*], in China, South America and the West Indies."

14. On Deming and Bulkley, see Maurie D. McInnis and Robert A. Leath, "Beautiful Specimens and Elegant Patterns: New York Furniture for the Charleston Market, 1810–1840," in *American Furniture 1996*, edited by Luke Beckerdite (Hanover, New Hampshire: University Press of New England for the Chipstone Foundation, 1996), pp. 137–74. On the Meeks firm in New Orleans, see Jodi A. Pollack, "Three Generations of Meeks Craftsmen, 1797–1869: A History of Their Business and Furniture" (Master's thesis, Cooper-Hewitt, National Design Museum, and Parsons School of Design, New York, 1998), chap. 3.

15. Mooney, *Nine Years in America*, p. 150.

16. For this discussion, I have relied on Richard B. Stott, "Hinterland Development and Differences in Work Setting: The New York City Region," in *New York and the Rise of American Capitalism: Economic Development and the Social and Political History of an American State, 1780–1870*, edited by William Pencak and Conrad Edick Wright (New York: New-York Historical Society, 1989), pp. 45–71.

17. Ibid., pp. 46–48. Edwin G. Burrows and Mike Wallace, *Gotham: A History of New York City to 1898* (New York: Oxford University Press, 1999), p. 576.

18. See Joshua Brown and David Ment, *Factories, Foundries, and Refineries: A History of Five Brooklyn Industries* (Brooklyn: Brooklyn Educational and Cultural Alliance, 1980). I am grateful to Cynthia H. Sanford, Brooklyn Historical Society, for supplying me with a copy.

19. See Catherine Hoover Voorsanger, "From the Bowery to Broadway: The Herter Brothers and the New York Furniture Trade," in Katherine S. Howe, Alice Cooney Frelinghuysen, and Catherine Hoover Voorsanger, *Herter Brothers: Furniture and Interiors for a*

Gilded Age (exh. cat., New York: Harry N. Abrams, in association with the Museum of Fine Arts, Houston, 1994), pp. 56–77, 242–46.

20. See ibid. This observation is based on the Products of Industry schedules attached to the U.S. Censuses taken in New York in 1850 and 1860 as well as on the "Special Schedule for Industry other than Agriculture" attached to the 1855 New York State Census.

21. Robert Ernst, *Immigrant Life in New York City, 1825–1863* (1949; reprint, New York: Octagon Books, 1979), cited in Stott, *Workers in the Metropolis,* p. 3.

22. See Nancy Jane Groce, "Musical Instrument Making in New York City during the Eighteenth and Nineteenth Centuries," 2 vols. (Ph.D. dissertation, University of Michigan, Ann Arbor, 1982); and Aaron Singer, "Labor Management Relations at Steinway and Sons, 1853–1896" (Ph.D. dissertation, Columbia University, New York, 1977).

23. Mack Walker, *Germany and the Emigration, 1816–1885* (Cambridge, Massachusetts: Harvard University Press, 1964), cited in Charles L. Venable, "Germanic Craftsmen and Furniture Design in Philadelphia, 1820–1850," in *American Furniture 1998,* edited by Luke Beckerdite (Hanover, New Hampshire: University Press of New England for the Chipstone Foundation, 1998), p. 41.

24. Stanley Nadel, *Little Germany: Ethnicity, Religion, and Class in New York City, 1845–80* (Urbana: University of Illinois Press, 1990), pp. 1, 17–18, 22.

25. Generally these cabinetmakers had additional workshop space in contiguous buildings. See Voorsanger, "From Bowery to Broadway," pp. 63–64.
 Photographs of documents relating to the construction of Belter's building have been given to the Winterthur Library, Henry Francis du Pont Winterthur Museum, Winterthur, Delaware, by Richard and Eileen Dubrow, Courtesy of the Service Collection, Grant A. Oakes.

26. On Baudouine, see Ernest Hagen, "Personal Experiences of an Old New York Cabinet Maker," written in Brooklyn, October 1908, quoted in its entirety in Elizabeth A. Ingerman, "Personal Experiences

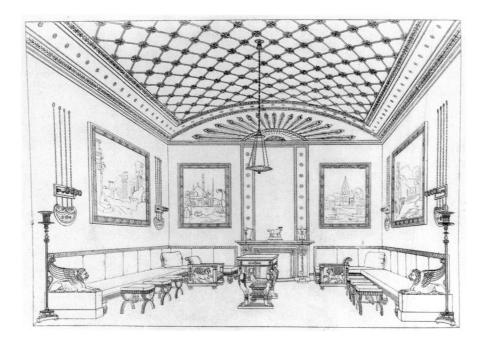

Fig. 235. *Drawing-Room.* Engraving, from Thomas Hope, *Household Furniture and Interior Decoration* (London: Longman, Hurst, Rees, and Orme, 1807), pl. 6. The Metropolitan Museum of Art, New York, Harris Brisbane Dick Fund, 1930 30.48.1

notably) had relatives in France who acted as business partners, shipping furniture and decorative accessories; others, such as Baudouine, made regular trips to Europe to assess what was in vogue.[26] Still others must have relied on American agents posted abroad, as a journalist reported in 1843: "We have a large colony of Americans in Paris engaged in the business of exporting French fabrics, elegancies, and conveniences, for this country, and almost none of the same class in England."[27] Ultimately, as the city expanded northward, many successful cabinetmakers seem to have made fortunes in real estate speculation. Baudouine, perhaps the best example, left an estate estimated at nearly $5 million upon his death in 1895.[28]

As early as 1830 the lives of the cabinetmakers and the journeymen who fabricated their products began to diverge. Relationships between employers and employees were strained throughout the antebellum period by workers' demands for higher wages, reduced hours, and a shorter work week, goals that were hard to achieve in the face of constant competition from newly arrived immigrants. And among the immigrants themselves, the Germans were actively involved in the movement for workers' rights.[29] The disparity in lifestyles between owners and workers was becoming increasingly visible. As one European visitor observed, the American "mechanic" "dresses like a member of Congress; and his wife and daughters are dressed like the wife and daughters of a rich New York merchant, and, like them, follow the Paris fashions. His house is warm, neat, comfortable; his table is almost

as plentifully provided as that of the wealthiest of his fellow citizens."[30]

Even the most affluent New Yorkers did not have homes with ostentatious exteriors; their town houses were meant to read as identical units (see cat. no. 87). Mrs. Trollope, a famous English visitor who was enthusiastic about her experiences in New York, recounted in 1832 that although she had "never [seen] a city more desirable as a residence," she found that "the great defect in the houses is their extreme uniformity—when you have seen one, you have seen all."[31] Behind the brick and marble facades of the 1820s and 1830s there were beautiful interiors and elegant furnishings in the classical style. In the summer of 1832 the wealthy businessman Matthew Morgan wrote to his friend James C. Colles, a merchant in New Orleans, about venturing from Staten Island into the city to witness the construction of new houses. One of these, that of Luman Reed, in Greenwich near the Battery, most impressed Morgan, both for its unusually large size (about one and half times the width of a normal New York town house of the period) and for the elegance of its appointments:

The principal story has a white marble base in the hall and parlours and for the pilaster and frieze between the parlours. The Chimney and pier glasses are set in the walls with frames of the same material. Italian marble mantels and mahogany doors polished as highly as any cabinet work ever is. . . .

Take it altogether perhaps it's not equalled by any house in the city, every part of it is completely finished. Silver plated knobs on every door in the house.[32]

The cost of a typical highly finished three-story house, on a twenty-five-by-fifty-two-foot lot, was about $10,000 or $11,000, Morgan reported, but Reed's house cost much more. From what he could gather, $16,000 to $17,000 would obtain a lot and house such as "our city [New Orleans] cannot produce."[33]

The social aristocracy of New York spared no expense in furnishing their houses. "The dwelling-houses of the higher classes are extremely handsome, and very richly furnished," Mrs. Trollope wrote admiringly in 1832. "Silk or satin furniture is as often, or oftener, seen than chintz; the mirrors are as handsome as in London; the cheffoniers [*sic*], slabs, and marble tables as elegant."[34] An exquisite watercolor rendering of about 1830 by the architect Alexander Jackson Davis (cat. no. 112) allows us to imagine the scale and stately ambience of such an interior. A pair of Corinthian pilasters and a mahogany door with a pedimented frame from a distinguished classical house in Brooklyn called Clarkson Lawn, dating to about 1835 (cat. no. 89A, B) are also illuminating in this context.

Davis's meticulous rendering illustrates the level of sophistication to which wealthy New Yorkers aspired. Its delicate white-and-gold sofa, which may have been imported from Europe, bears no specific reference to any extant piece of New York furniture;[35] yet the size and disposition of the mantel mirror and paintings, as well as the side table, klismos chairs, and torchère, compare closely with those of designs in *Household Furniture and Interior Decoration* (London, 1807) by Thomas Hope, a wealthy British connoisseur of the Regency period (fig. 235). Although Davis's two round center tables with tapering, three-sided concave supports have Renaissance prototypes, his use of the form is no doubt based on Hope's plate 39, a design for a "round monopodium or table in mahogany."[36] There is also a surviving counterpart, made in New York, that demonstrates the practical application of this particular Hope design in America: a richly decorated center table of this form, with rosewood and rosewood-grained mahogany veneers and an expensive black "Egyptian" marble top (cat. no. 222) made in 1829 for Governor Stephen D. Miller of South Carolina by Barzilla Deming and Erastus Bulkley, who had begun as early as 1818 to aggressively market New York furniture in Charleston.[37]

The splendid gilded decoration on the Deming and Bulkley table incorporates several different techniques

and draws on a number of French and English design sources for inspiration; the lyre-and-foliate motif on the base, for example, clearly derives from Hope's plate 39. While Hope's text recommended inlays of ebony and silver for such a piece, here the exquisite gilded decoration on the base, superimposed on the deep hue of the rosewood-grained veneer, conveys a different dual impression than that intended in the prototype: not only of metal inlay but also of marquetry executed in light-colored woods (a type of decoration seen on French furniture of about the same date).[38] The gilded swan-and-fountain motif on the apron derives from quite another source: a specific, nearly identical gilt-bronze mount made in Birmingham, England.[39] The overlapping ellipses carefully drawn and inscribed in gold on the plinth emulate die-cut inlaid brass, as does a small rim of repeated elements around the base of the apron. Finally, the snub-nosed dolphins (a Deming and Bulkley trademark) are freehand-gilded and highlighted with penwork to create the illusion of three-dimensional carving.[40]

Fig. 236. Asher B. Durand, after Samuel F. B. Morse, *The Wife*, 1830. Engraving, from *Atlantic Souvenir* (Philadelphia: H. C. Carey and I. Lea, 1830). The Metropolitan Museum of Art, New York, Gift of Randolph Gunter, 1959 59.627.3

of an Old New York Cabinet-Maker," *Antiques* 84 (November 1963), pp. 576–80.

27. "Sketches of New-York," *New Mirror*, May 13, 1843, p. 85.

28. *New York Herald*, January 14, 1895, p. 10. At the time of his death, Baudouine owned fifteen commercial properties, including the Baudouine building (1895), which still stands at 1181–1183 Broadway. My thanks to Kate Wood for sharing her unpublished paper on the Baudouine Building (December 1998).

29. See Sean Wilentz, *Chants Democratic: New York City and the Rise of the American Working Class, 1788–1850* (New York: Oxford University Press, 1984).

30. Michael Chevalier, *Society, Manners and Politics in the United States, Being a Series of Letters on North America*, translated from 3d French ed. (Boston: Weeks, Jordon and Company, 1839; reprint, New York: A. M. Kelley, 1966), p. 431.

31. Mrs. [Frances] Trollope, *Domestic Manners of the Americans* (London: Whittaker, Treacher and Co.; New York, reprinted for the booksellers, 1832), pp. 269–70.

32. Matthew Morgan to James Colles, July 29, 1832, in Emily Johnston de Forest, *James Colles, 1788–1883: Life and Letters* (New York: Privately printed, 1926), p. 83.

33. Ibid.

34. Trollope, *Domestic Manners of Americans,* p. 269.

35. John Morley compares this sofa to contemporary Italian furniture, specifically that of Filippo Pelagio Palagi (1775–1860). John Morley, *The History of Furniture: Twenty-five Centuries of Style and Design in the Western Tradition* (Boston: Little, Brown and Company, 1999), p. 217. A white-and-gold Italian drawing-room suite with turquoise blue and gold silk upholstery (Peabody-Essex Museum, Salem, Massachusetts) was acquired by Joseph Peabody in 1827 as a wedding gift for his daughter Catherine Peabody Gardiner. See Gerald W. R. Ward, *The Andrew-Safford House* (Salem, Massachusetts: Essex Institute, 1976), fig. 6.

36. Morley, *History of Furniture,* pp. 215–17, fig. 192. See also Thomas Hope, *Household Furniture and Interior Decoration* (London: Longman, Hurst, Rees and Orme, 1807); reprinted as *Regency Furniture and Interior Decoration,* with corrections and a new introduction by David Watkin (New York: Dover Publications, 1971), ill. opp. p. 30, pls. 20, 22, 39. Davis owned a copy of Hope's book, which he recorded in his notebook under "Furniture Practical Examples for Americans," A. J. Davis Collection, Todd System notebook, F-U, transcribed by Cynthia V. A. Schaffner, New York Public Library.

37. For a discussion of this table, see McInnis and Leath, "Beautiful Specimens," pp. 153–55. The firm of Deming and Bulkley is first listed in New York by *Longworth's American Almanac, New-York Register, and City-Directory* (New York: Thomas Longworth, 1820); it continued to be listed until 1850, with its last appearance being in *Doggett's New York City Directory for 1850–1851* (New York: John Doggett Jr., 1850). Erastus Bulkley was advertising furniture in

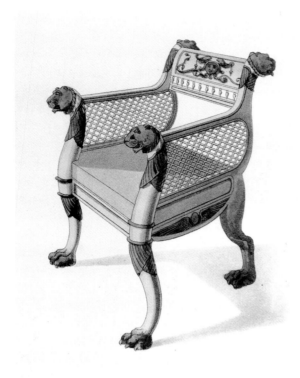

Fig. 237. *Drawing-Room Chair.* Aquatint with hand coloring, from George Smith, *A Collection of Designs for Household Furniture and Interior Decoration* (London: J. Taylor, 1808), pl. 56 (detail). The Metropolitan Museum of Art, New York, Harris Brisbane Dick Fund, 1930 30.48.2

Contemporary with Davis's rendering, an engraving by Asher B. Durand after *The Wife* by Samuel F. B. Morse depicts a handsome, although more modest parlor (fig. 236).[41] The scrolled sofa with paw feet, the little footstool, and the armchair in Morse's painting find general parallels in English design sources, such as George Smith's *Cabinet-Maker and Upholsterer's Guide* (London, 1828)[42] and Thomas King's *Modern Style of Cabinet Work Exemplified* (London, 1829). These probably document furniture Morse had at hand.

The style of New York furniture of the late 1820s has been called "Greek Revival" or "Empire" during the twentieth century; more recently, the period term "Grecian" has come into use. "Grecian," as applied to furniture of the 1820s and 1830s was synonymous with "modern" style, a synthetic version of Neoclassicism, rather than one based on purely archaeological prototypes.[43] Grecian furniture of the later 1820s differs from New York's delicate Federal-period furniture that was in favor up to about 1820 in that it is conspicuously assertive, featuring bold, architectonic forms and exaggerated elements (large bolection moldings, beefy scrolls) as well as classical details (anthemia, paw feet, Ionic capitals) that become inflated in scale.

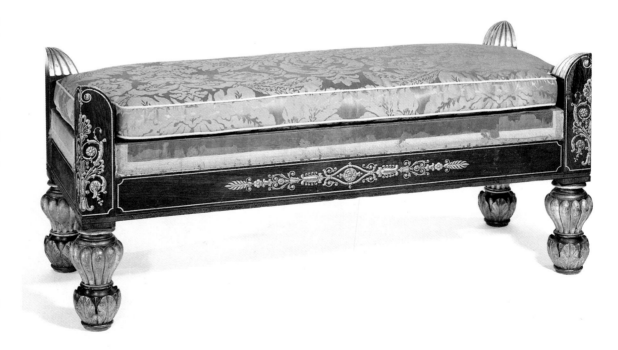

Fig. 238. Duncan Phyfe, Window bench (one of a pair), made for Robert Donaldson, Fayetteville, North Carolina, 1823. Rosewood veneer; probably pine; gilding; replacement underupholstery and showcover. Brooklyn Museum of Art, Gift of Mrs. J. Amory Haskell 42.118.13

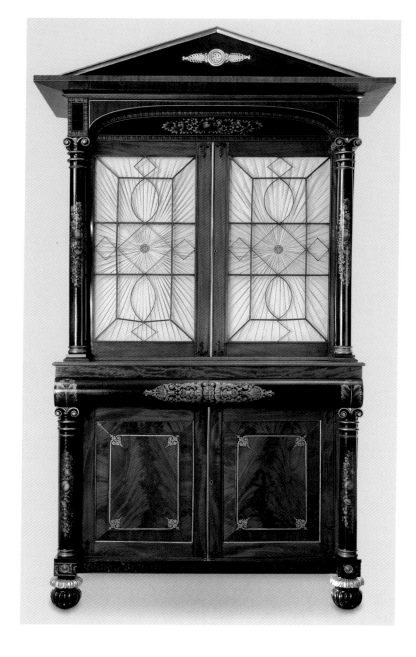

Fig. 239. Robert Fisher, Secretary-bookcase, 1829. Ebonized wood, mahogany veneer; painted and gilded decoration; replacement fabric; glass. Collection of Mr. and Mrs. Peter G. Terian

It shares some of these characteristics with Grecian architecture, which became fashionable in the mid-1820s and was much admired for "its Doric simplicity and grandeur."[44] (See "Building the Empire City" by Morrison H. Heckscher in this publication, pp. 171–80.) The ongoing publication (and republication) of James Stuart and Nicholas Revett's *Antiquities of Athens* (volumes 4 and 5 of which were published in 1816 and 1830, respectively) was also an important stimulus.[45] The Grecian style included elements inspired by Egyptian as well as ancient Greek architecture and furniture. Moreover, in its curvilinear outlines and in its lavish use of curling acanthus ornament and scrolling foliate embellishments (which often seem more Roman than Greek), the

Grecian style held the seeds of the Rococo Revival style predicated on naturalistic ornament that would become dominant by 1850, encompassing both the Louis XIV Revival and Louis XV Revival styles under its rubric.[46]

Although its maker remains anonymous, a highly animated ebonized armchair, with sweeping scroll arms, low-relief carving, gilded details, and resolutely forward-facing front and back legs terminating in animal feet, must surely have been manufactured in New York about 1825 (cat. no. 221). Both its stance and its form pay homage to ancient Greek and Egyptian furniture, as transformed in Hope's designs and in those of Smith's first publication, *A Collection of Designs for Household Furniture and Interior Decoration*

Charleston as early as 1818. Deming and Bulkley begin to advertise in Charleston about 1820 and remained active there until at least 1840. The table is documented to 1829 (not 1828 as stated in McInnis and Leath, "Beautiful Specimens," pp. 154–55, n. 38) by a letter from Deming and Bulkley to Stephen D. Miller, April 26, 1829, which describes shipping the marble top for the table.

38. See relevant French examples in Janine Leris-Laffargue, *Restauration, Louis Philippe* (Paris: Éditions Massin, 1994), pp. 58–59.

39. McInnis and Leath, "Beautiful Specimens," pp. 155, 173 n. 39.

40. On gilded ornamentation, see essays by Donald L. Fennimore and Cynthia Moyer in *Gilded Wood: Conservation and History* (Madison, Connecticut: Sound View Press, 1991). See also John A. Courtney Jr., "'All that Glitters': Freehand Gilding on Philadelphia Empire Furniture, 1820–1840" (Master's thesis, Antioch University, Baltimore, Maryland, 1998); and Cynthia Van Allen Schaffner, "Secrets and 'Receipts': American and British Furniture Finishers' Literature, 1790–1880" (Master's thesis, Cooper-Hewitt, National Design Museum, and Parsons School of Design, 1999).

41. See Paul J. Staiti, *Samuel F. B. Morse* (Cambridge: Cambridge University Press, 1989), pp. 129–30, 260, 278. I thank Valentijn Byvanck for bringing this image to my attention.

42. This volume is frequently dated 1826; however, as many of its plates are dated 1828, the compilation must be assigned the later date.

43. For this discussion, I have drawn on *Neo-Classical Furniture Designs: A Reprint of Thomas King's "Modern Style of Cabinet Work Exemplified," 1829*, with a new introduction by Thomas Gordon Smith (New York: Dover Publications, 1995). See also Thomas Gordon Smith, *John Hall and the Grecian Style in America* (New York: Acanthus Press, 1996).

44. "Public Buildings," *New-York Mirror, and Ladies' Literary Gazette,* August 23, 1828, p. 49, col. 1.

45. For example, an 1828 entry in Davis's daybook: "First study of Stuart's Athens from which I date professional practice." A. J.

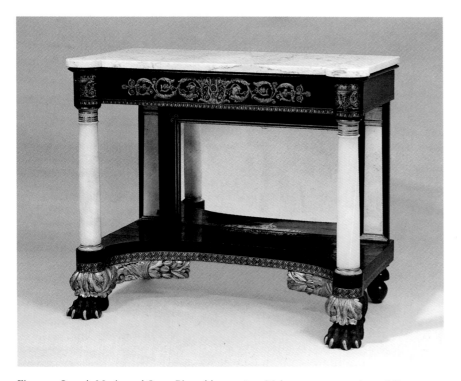

Fig. 240. Joseph Meeks and Sons, Pier table, ca. 1830. Mahogany veneer; pine; gilding; white marble; gilt-bronze mounts; mirror glass. The Cleveland Museum of Art, Gift of Mrs. R. Livingston Ireland 1981.65

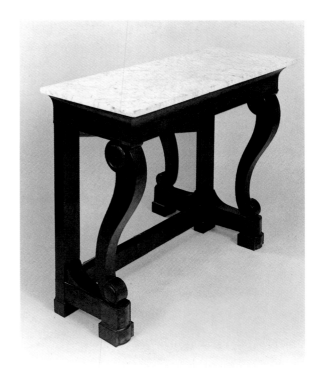

Fig. 241. Duncan Phyfe, Pier table, made for Benjamin Clark, Fanewood, New Windsor-on-Hudson, near Newburgh, New York, 1834. Mahogany veneer; white pine, tulip poplar; marble; mirror glass. The White House 961.45.1

Davis, Daybook, vol. 1, p. 13, transcribed by Cynthia V. A. Schaffner, New York Public Library.

46. For insight into the origins of the Rococo Revival, see Simon Jervis, *High Victorian Design* (exh. cat., Ottawa: National Gallery of Canada, 1974), pp. 61–88.

47. See *The New-York Book of Prices for Manufacturing Cabinet and Chair Work* (New York: Printed by J. Seymour, 1817), pl. 6; and *Second Supplement to the London Chair-Makers' and Carvers' Book of Prices for Workmanship,* 2d ed. (London: T. Brettell, 1829), pl. 1. From the late eighteenth through the mid-nineteenth century, shop owners and journeymen in Great Britain and America relied on published price books to establish the wages paid for certain tasks involved in making furniture. The books were updated as new styles created new demands in production procedures or as new techniques developed. It can be assumed that any detail documented by a price book had been in use for some time prior to its publication.

(London, 1808), from which plate 56 (fig. 237) makes an apt comparison. Other details—the "water-leaf" carving on the stiles and upper legs, the paw feet with carved hairy ankles—are part of a vocabulary that had become well established in New York earlier in the century. Large volute-shaped arms appear in the 1817 *New-York Book of Prices* and an even larger, more forceful version of the arm, closer to that of the present example, is illustrated in a London price book of 1829.[47] A related, although smaller and less exuberant, pair of ebonized and gilded armchairs with similar front legs and carving, now in the Museum of the City of New York, was acquired by Stephen and Harriet Suydam Whitney for their house at 7 Bowling Green, built in 1827.

Surely one of the earliest documented examples of the Grecian style is the suite of seating furniture made by Phyfe for Robert Donaldson of Fayetteville, North Carolina, in 1823. The suite, which returned to New York when Donaldson moved to the city in 1825, included a pair of window benches (fig. 238) that had extremely accomplished gilded ornamentation and posts adapted from chair-leg designs published by Hope.[48] The voluptuous feet, composed of ribbed, urn-shaped elements atop plump carved and gilded acanthus-encased spheres, are quite

a departure from the vocabulary employed by Phyfe before 1820.[49]

A previously unpublished ebonized and mahogany-veneered pedimented bookcase is distinguished by its monumental scale (nearly ten feet in height by five feet in width), its gilded decoration, and a penciled inscription by its maker (fig. 239). On the underside of the upper case Robert Fisher wrote his name and the date, 1829, making this handsome bookcase an extremely important document in the chronology of the late 1820s Grecian style.[50] Fisher, who was first listed in Longworth's city directory of 1824–25, occupied several addresses in lower Manhattan until 1837, when he disappeared, probably a casualty of the economic crisis of that year. In 1829 he was recorded at 148 Orchard Street, for only one year. Like the Deming and Bulkley table, the bookcase is embellished with a magnificent stencil of a mount, executed in gold, across the bolection-molded drawer front. Its chunky ribbed melon feet, separated from the case by carved and gilded "cushions," are related in spirit to those on the Donaldson window bench.[51]

Many details on the Fisher bookcase—notably, the distinctive pattern of the glazing bars on the cabinet doors, the flat, horizontal arch under the cornice, the double pair of Ionic columns with deeply carved and

gilded capitals, and the acanthus leaves and garlands stenciled in metallic powder—relate to an unsigned case piece in the Metropolitan Museum's collection (cat. no. 223). For sheer grandeur and monumentality, few pieces equal this ebonized and gilded secretary-bookcase, a masterpiece of New York's Grecian style. Its virtuosic gilded and metallic-powder ornamentation, applied freehand and with stencils, comprises six different border patterns of anthemia, Gothic arches, interlocking rings, and arabesques, as well as gilded striping and stenciled foliate clusters with fruit and acanthus—all in striking contrast to the black ground. The upper bookcase, surmounted by an architectural cornice, relates in form to New York wardrobes and French presses of the period. The lower half, which includes three short drawers over a bolection-molded desk drawer containing a baize-covered writing stand and storage compartments, is virtually identical in form to any number of contemporary New York pier tables. The powerful hairy-paw feet, with gilded cornucopia brackets that support the plinth on which the whole piece rests, are a common feature in New York's furniture vocabulary of the time.[52]

Many New York pier tables from the late 1820s share a vocabulary with the Metropolitan's secretary-bookcase—columnar supports, Ionic capitals, and oversized, carved paw feet attached to carved and gilded cornucopia that support the shelf—but few are labeled or firmly documented. A notable exception is a pier table by Joseph Meeks and Sons in the Cleveland Museum (fig. 240), which is distinguished by its white marble top and columns, ormolu caps and bases, and stenciled gilding; it can be firmly attributed and dated to 1829–35 on the basis of its paper label.[53] Comparison with an identically labeled Meeks pier table in the veneered style of the 1830s (cat. no. 227) as well as a Phyfe pier table firmly dated to 1834 (fig. 241) suggest a more narrowly focused date of about 1830. An elegant box sofa by an anonymous cabinetmaker (cat. no. 224) relates to the Cleveland table in its use of costly white marble columns and ormolu caps and bases. Its tapering feet, each surmounted by a sculpted, bell-like form, are ultimately derived from late-eighteenth-century Louis XVI precedents, here expanded to 1820s scale. Box sofas (in which the ends are the same height as the back) were particularly favored in New York City starting in the 1820s, and the form is documented in the *New-York Book of Prices* for 1834.[54]

About 1830 the appearance of New York furniture changed dramatically. Carving, gilding, painting, and other forms of surface decoration gave way to the use of highly figured and brightly polished mahogany and rosewood veneers that were selected for the intrinsic patterns and rubescent color of the wood. Ample forms with bold outlines that incorporate geometric components—large convex moldings, urn-shaped pillars, scrolled feet, and console standards, which replaced architectural columns—became the norm. Still called "Grecian" (and later referred to as the "present plain style"),[55] in order to denote its continuing affinity for the simple geometries associated with Greek architecture, the American furniture of the 1830s bears a pronounced resemblance to contemporary German Biedermeier furniture. This kinship can no doubt be related to the large number of well-trained German immigrant craftsmen who entered the New York cabinetmaking trades at this time.[56]

Several other factors contributed to the proliferation of veneered furniture in the 1830s and early 1840s. With its trade connections to the West Indies and South America, nineteenth-century New York had access to seemingly unlimited supplies of exotic woods (especially mahogany and rosewood), which were delivered to the city both for local use and for exportation. In one week in December 1838, 20,000 board feet of Santo Domingo mahogany arrived on the brig *America*; 220 logs, "part of [them] extra large size and fine quality," were deposited by the *Albert;* and the *Oriole* delivered another 210 logs, "a portion of which is crotch logs and large wood."[57] Concurrently, methods of cutting veneers improved.[58] Cabinetmakers procured the veneers from the lumberyards in which they were cut. As Ernest Hagen, a German who later worked for Baudouine, explained, "The work was all done by hand, but the scroll sawing, of course was done at the nearest sawmill. The employers . . . having no machinery at all, all the moldings were bought at the molding mill and the turning done at [the] turning mill."[59]

The invention of French (or friction) polishing about 1820 was another timely innovation that complemented the production of veneered furniture. The New York press announced in 1824 that "the Parisians have introduced an entirely new mode of polishing, which is called *plaque*, and is to wood precisely what plating is to metal. The wood . . . is made to resemble marble, and has all the beauty of that article, with much of its solidity."[60] A technique involving the application of numerous coats of transparent varnish to produce a glossy shine, French polishing replaced methods that employed waxing and oiling. It brought out the richly figured grain of the woods and was

48. See Hope, *Household Furniture,* pls. 24 no. 2, 26 no. 6.

49. This information is from correspondence in the object's file in the Department of Decorative Arts, Brooklyn Museum of Art. A couch with identical feet, gilded metal mounts, and brass inlay, has the same provenance as the benches.

50. The gilded mount on the pediment may be a later addition. The bookcase has been associated with the "Coffin" family of New York and Westchester. My thanks are extended to Peter G. Terian for permitting me to study the piece in 1996.

51. This kind of foot is documented in a design for a tea poy in Peter and Michael Angelo Nicholson, *The Practical Cabinet-Maker, Upholsterer, and Complete Decorator* (London: H. Fisher, Son, and Company, 1826).

52. This piece was attributed to the firm of Joseph Meeks and Sons for most of the twentieth century, but there is no firm basis for the attribution ("vv" [w] is incised in several places). The pattern of the glazing bars on the doors does not appear in the *New-York Book of Prices for Manufacturing Cabinet and Chair Work* (New York: Harper and Brothers, 1834), but it is illustrated in the *Book of Prices of the United Society of Journeymen Cabinet Makers of Cincinnati, for the Manufacture of Cabinet Ware* (Cincinnati: N. S. Johnson, 1836), no. 19 in table no. 44, and also is present on the Robert Fisher bookcase. To date, these two case pieces stand alone amidst New York furniture of about 1830; no others comparable in size have come to light.

Close inspection of this bookcase has raised questions about whether the doors originally had fabric behind the glass, as they do now (the present textile is a re-creation of the one the piece had by 1943). Construction details seem to confirm that there was always a textile presentation on the lower half of the piece, but the pattern and color of the original fabric remain a matter of speculation.

53. The pier table bears the paper label of Joseph Meeks and Sons, at 43 and 45 Broad Street, a firm that was in business between 1829 and 1835.

54. The Arabic meaning of the word "sopha" (a type of alcove) was interpreted by Pierre de la Mésangère as a type of seating

furniture in plate 20 of his *Collection des meubles et objets de goût* (Paris, 1802–31), which illustrated a banquet sofa, a rectilinear form with sofa ends equal in height to the back. George Smith illustrated a similar library sofa in 1808. Despite these early incarnations, the box sofa was not particularly popular in either France or England during the first quarter of the nineteenth century.

55. Smith, *Hall and Grecian Style in America*, p. v.

56. See Venable, "Germanic Craftsmen and Furniture Design," pp. 41–80.

57. *Evening Post* (New York), December 12, 1838.

58. See Clive D. Edwards, *Victorian Furniture: Technology and Design* (Manchester: Manchester University Press, 1993), p. 37.

59. Quoted in Ingerman, "Personal Experiences," p. 577.

60. See "New French Polish," *The Minerva*, March 6, 1824, p. 382. This description was published earlier in England, in *Mechanics' Magazine*, November 22, 1823. See Edwards, *Victorian Furniture*, pp. 76–77. According to Edwards, it was later asserted that French polishing had been developed as early as 1808, but the practice seemed to take hold in the later 1820s and the 1830s. See also Schaffner, "Secrets and 'Receipts,'" pp. 53–55.

61. See Pollack, "Three Generations of Meeks Craftsmen." The other complete copy of the broadside is at Yale University. The cut-and-pasted copy (including forty-two of the forty-four designs) is in Nicholson and Nicholson, *Practical Cabinet-Maker*, Thomas J. Watson Library, Metropolitan Museum.

62. Pollack, "Three Generations of Meeks Craftsmen," pp. 19–20.

63. John Hall, *The Cabinet Makers' Assistant: Embracing the Most Modern Style of Cabinet Furniture* (Baltimore: John Murphy, 1840). The *American Repertory of Arts, Sciences and Manufactures* (1 [July 1840], p. 467) announced the publication of Hall's book: "The drawings are all to a scale, and therefore available as working drawings."

64. This previously unpublished pier table came to light as a result of Jodi A. Pollack's research for her thesis, "Three Generations of Meeks Craftsmen."

65. Ernest Hagen recalled (with sketches augmenting his description), "A great many shops

admired for producing a bright, mirrorlike surface that was relatively impervious to liquid stains and scratches.

The Grecian style of the 1830s and early 1840s is best illustrated by the furniture of Joseph Meeks and Sons, one of the most prolific New York cabinetmaking firms during the second quarter of the nineteenth century. In 1833 the firm issued a large, hand-colored broadside (cat. no. 225) that has survived as one of the rarest documents in the history of American furniture. Perhaps intended to be hung as an advertising poster in the firm's warerooms, it may also have been distributed to other retail agents, as the instructions for placing orders at the bottom suggest. Yet, despite its having been printed as a lithograph (a medium that lends itself to multiple copies), only two intact examples of the broadside are known to exist; a third, cut up and pasted into a pattern book, attests to the fact that other cabinetmakers probably utilized it as a design source in its own right.[61]

The Meeks and Sons broadside presents a picture of an industry in transition. Of its forty-four images, seventeen are taken directly from Smith's 1828 *Cabinet-Maker and Upholsterer's Guide*.[62] The rest of the furniture pictured is in the new plain version of the Grecian style. The broadside is thus especially significant in that it predates by seven years John Hall's *Cabinet Makers' Assistant* (Baltimore, 1840), the first American pattern book to popularize Grecian furniture, which was by then being produced in many parts of the country.[63]

A labeled mahogany-veneered pier table (cat. no. 227), similar to but not exactly replicating one of the pier tables on the broadside, is an exceptional example of the furniture produced in the new Grecian style by Meeks and Sons. The curved serpentine plinth and the scrolled feet tucked under it are hallmarks of the 1830s style; the large calligraphic scrolls, which on similar tables often seem structurally incongruous, are here energetic whorls in perfect balance, effortlessly supporting both the molded rails and the "Egyptian" marble top. The simplicity of these shaped elements belies the considerable skill involved in selecting, matching, and applying thin, brittle veneers to such curvilinear forms.[64]

An index of retail prices at the bottom of the Meeks broadside indicates that furniture could be modified to fit the customer's taste and budget. Among the available options were selecting rosewood veneer over mahogany, black "Egyptian" marble over wood or white marble tops, and silk upholstery over horsehair or requesting gilding, all of which increased the price of an object by twenty to fifty percent. One

pier table (related to cat. no. 227), for example, sold for $90 with a white marble top and for $110 with one of black "Egyptian" marble. French chairs such as numbers 11 and 12 on the broadside, were advertised in rosewood with silk upholstery for $15 and in mahogany with horsehair for three dollars less.

The long-lived French chair was one of the most popular types of seating furniture during the second quarter of the nineteenth century, when many variations of this elegant form were made. Like the Greek klismos chair, the French chair has cyma-curved legs and a concave back rail that connects to the stiles, which curve continuously down to meet the front seat rail.[65] A particularly refined example (cat. no. 226), with mahogany veneers on the splat and crest rail, has the additional distinction of retaining its original underupholstery and horsehair (preserved beneath a replacement horsehair showcover). The chair is enriched by the use of such delicate details as the turned "buttons" at the edges of the crest rail and the stylized lotus leaves that conceal the joinery of the seat rails and embellish the tops of the legs. These carved details suggest a date about 1830, especially when the piece is compared with the absolutely undecorated chairs that Phyfe made in 1837 for a New York lawyer named Samuel Foot, now in the Metropolitan's collection.[66]

An unusual fall-front secretary attributed to New York represents the best of American 1830s veneered furniture (cat. no. 229). This type of secretary, which originated in France in the late eighteenth century, had been popular in New York since the early nineteenth century. However, none of the other extant examples from New York resemble this one, which recalls contemporary German or Austrian models. The book-matched veneers on the fall front are divided into panels that correspond to the paired cabinet doors below. The circular front feet are unusual, although they have applied rimmed disks, a detail that is associated with New York furniture of the 1830s.[67] Here, the tight, rectilinear outline found in French-inspired precedents has been transformed by the broad, overhanging cornice and applied bracket pilasters into a baroque statement of sculpted mass and glowing surface. In its flamboyant use of luminous mahogany veneers, the piece knows no equal.[68]

Although he worked within the rubric of the Grecian style, Phyfe was more attracted by French models (the Second Bourbon Restoration and early Louis-Philippe periods, from 1815 to about 1840) than by the German examples emulated by the Meekses and others. A pier table he made for Benjamin Clark in 1834 (fig. 241) has become a benchmark in the history

of American furniture: its being documented by a bill of sale allows for a precise determination of the early date by which Phyfe adapted to the 1830s version of Neoclassicism.[69] Elegantly attenuated and severe in its simplicity, Phyfe's table is all legs (standing on its maker's signature rounded block feet); unlike the Meeks pier tables (cat. no. 227; fig. 240), it has no shelf connecting them.

In 1836, as part of an order for furniture totaling an extravagant $1,900, Lewis Stirling of Wakefield Plantation, near Saint Francisville, Louisiana, commissioned from Phyfe a pair of larger pier tables similar to the cabinetmaker's 1834 piece. When Stirling visited New York with his family in the summer of 1836, he carried with him a rough sketch of Wakefield's floor plan, along with measurements of each room. These materials, supplemented by a note that read "width between windows for looking glasses, 5 feet 4," indicated two spaces, one each in the parlor and the dining room, for pier mirrors and tables.[70] Pier tables with gilded looking glasses were found in virtually every upper-class Grecian drawing room. The mirrors were often extremely tall, owing to the high ceilings in formal parlors, as is the example labeled by John H. Williams and Son of New York (cat. no. 228), which is nearly eight feet in height. In 1839 James Bleecker, a New York auctioneer, advertised "handsome pier glasses, 109 by 38 inches."[71] Placing such a looking glass above a pier table (which generally had a mirror between the legs) produced the effect of a continuous reflective surface often ten to twelve feet high, visually extending the size of the room and casting light back into the interior.[72]

Stirling was only one of many wealthy Southern plantation owners who decorated their magisterial Grecian houses with Phyfe's furniture. In June 1841 fifty-eight pieces of furniture in forty-seven boxes arrived in Charleston, South Carolina, from Duncan Phyfe and Son, destined for Millford Plantation in Clarendon County, home to John L. Manning and his new bride, Susan Hampton Manning; this partial delivery was in addition to two others comprising forty-two crates. Some seventy-five pieces, including thirty-one different types of furniture, survive from this well-documented commission.[73]

Couches were a popular form of seating furniture throughout the first half of the nineteenth century, and Phyfe made several pairs for the Millford commission. One, made of rosewood (cat. no. 232) probably for the drawing room, illustrates Phyfe's habit of producing particularly urbane versions of traditional forms. The piece is distinguished by its unusual scrolled feet outlined by arabesque bands of flat molding that also define all the contours, an innovative detail not previously seen on Phyfe's furniture. This detail reflects the revival of "Old French" styles, which were coming into vogue in Europe and America about 1840, and recalls, among other possible sources, furniture made during the reign of Louis XIV (1638–1715) and during the Restoration in France (1815–30).[74]

Phyfe's mahogany armchair for Millford, one of a suite of chairs (cat. no. 231), is also a sophisticated restatement of a French form that had tremendous longevity during the nineteenth century, both in France and in the United States. In fact, the *New-York Book of Prices* of 1834 includes specifications for "French Chairs," including the concave back shared by Phyfe's chair and the side chair previously discussed (cat. no. 226), as well as costs for supplying other details of Phyfe's chair, such as the scrolled arm uplifted by a carved lotus blossom and the peaked crest rail that hints at the growing influence of the Gothic Revival style.[75]

Finally, the smart little set of six nested tables from the Millford parlor (cat. no. 230) is unusual. Few American examples of the type have come to light, even though it had been known since the early nineteenth century (nested tables are depicted in Thomas Sheraton's *Cabinet Dictionary* [London, 1803]) and despite the fact that both the 1817 and the 1834 New York price books include sets of four tables, called "quartettos." Nested tables seem to come into favor with New York cabinetmakers about 1835–40.[76] Light and compact, the form was well suited to the economics of the China trade, which may explain why such tables, including the present example, are often conceived with ring-turned supports that are reminiscent of bamboo.

Frederick R. Spencer's *Family Group* of 1840 (cat. no. 13) presents a rare interior view of an upper-middle-class drawing room in the vicinity of New York City.[77] The mahogany-veneered Grecian center table is depicted in a colorful period context, created by the red curtains with gold trim, the red velvet (or plush) upholstery with fringe, and a carpet (probably British) with red, green, and black medallions—all typical of fashionable interior decoration in the 1830s and 1840s (see, for example, cat. no. 212). A comparison of this center table with the one owned about 1848 by a Mr. and Mrs. Charles Henry Augustus Carter (see fig. 242), in which the feet can just be discerned beneath the table skirt, shows how volumetric this particular brand of Neoclassicism became over

made what was then called a 'three-quarter French chair'; they were all the fashion then. The 'full French chair' had a round back and was more expensive and on that account was going out of style. . . . about 1855." Ingerman, "Personal Experiences," p. 577.

66. Nancy C. Britton, Associate Conservator in charge of upholstered works of art, Department of Objects Conservation, Metropolitan Museum, who has examined related chairs from the 1830s in close detail, posits an early 1830s date for this chair based on the structure and materials of the underupholstery. According to family tradition, this ten-piece suite of seating furniture (66.221.1–10) was purchased in 1837 from Duncan Phyfe for Samuel A. Foot's new residence at 678 Broadway.

67. See Hope, *Household Furniture*, pl. 27; and *Book of Prices of Journeymen Cabinet Makers of Cincinnati*, pl. 14. This detail does not appear in the New York price books. Such disks are considered a Phyfe trademark (see fig. 241), although they were also part of the general vocabulary of the period, and many variations exist.

68. The secretary can be dated to between 1833 and about 1841, when Lewis, McKee and Company of Terryville, Connecticut, made the lock, which bears an impressed mark. See Thomas F. Hennessy, *Locks and Lockmakers of America*, 3d ed. (Park Ridge, Illinois: Locksmith Publishing, 1997), pp. 6–7. Lewis, McKee was established in 1833. After the firm was dissolved in 1841, its successor agreed not to make any of the same locks until the inventory of Lewis, McKee was sold; hence, the circa 1841 bracket.

69. The pier table was originally one of a pair; Phyfe charged $130 for each table, making these the most expensive items among the thirty or so, for which Clark was charged $1,154.50. The White House retains a photograph of a photocopy of the original bill. I am grateful to Betty C. Monkman, curator, the White House, for supplying information and photographs of the table and the bill of sale. A related pier table made for Phyfe's daughter, Eliza Phyfe Vail, is on view at the Museum of the City of New York (L.5654.5). It is dated by the

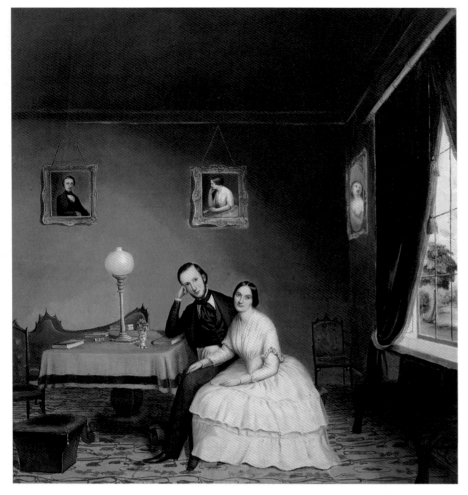

Fig. 242. Attributed to Nicholas Biddle Kittell, *Mr. and Mrs. Charles Henry Augustus Carter,* ca. 1848. Oil on canvas. Museum of the City of New York, Gift of Mrs. Edward C. Moen 62.234.12

well as high volume in a piecework system, was one of the factors that allowed New York cabinetmakers to export their furniture to the American South. Joseph Meeks established a presence in New Orleans as early as 1820.[79] A bold Meeks and Sons center table with a black "Egyptian" marble top, one of the firm's most aesthetically successful pieces, identical to number 27 on the Meeks broadside, is preserved at Melrose, a renowned Grecian house in Natchez, Mississippi. It was probably acquired by the McMurrans of that city at the time of their marriage in the early 1830s and moved with the family to Melrose when it was built in 1845.[80]

By the 1850s the meaning of the term "Grecian" had evolved again: it now connoted greatly simplified, rectilinear forms with painted decoration instead of veneers. "Modern Grecian furniture has the merit of being simple, easily made, and very moderate in cost," Andrew Jackson Downing stated in *The Architecture of Country Houses* (1850), in which he equated the style with painted "cottage" furniture. "Its universality is partly owing to the latter circumstance, and partly to the fact that by far the largest number of dwellings are built in the same style, and therefore are most appropriately furnished with it."[81]

As early as the 1830s the hegemony of Neoclassicism was beginning to be challenged by other sources of design, and by 1850 the consumer of furniture would be confronted by a multiplicity of choices that had been inconceivable just a quarter century before. The Gothic style, never fully eclipsed in England after the Middle Ages, gained momentum in the late 1820s and the 1830s as it became associated with the social reform effort led by the architect and designer A. W. N. Pugin, who became the most vociferous and influential polemicist for the style. In London, several important Gothic projects were under way by the mid-1830s, most notably the design of the new Houses of Parliament by Charles Barry, with interior details by Pugin, which began construction in 1836.

Although full-blown Gothic motifs did not proliferate in American furniture until the 1840s, harbingers of the style emerged in the 1830s. Under the influence of England, American cabinetmakers began to incorporate Gothic details into Grecian forms; number 28 on the 1833 Meeks broadside, for example, is a wardrobe that has recessed panels with Gothic arches on the doors.[82] By the early 1840s Gothic-style furniture was being manufactured with details borrowed from churches, such as window tracery (popular for the backs of chairs), crockets, and finials. Gothic furniture was used in domestic interiors alongside

Duncan Phyfe and Sons label tacked to the interior under the top. The firm included both of Phyfe's sons, James and William; it is listed in the city directories for 1837–38 through 1839–40; when William left the firm in 1840, it became Duncan Phyfe and Son, active from 1840 through 1847, when Phyfe terminated his business.

70. The tables are in a private collection. The Stirling papers are in the Rare Book Library, Louisiana State University, Baton Rouge. There is no Phyfe bill of sale, but the transfer of funds to Phyfe in February 1837 from Brown Brothers by Stirling's factor, Burke Watt and Company of New Orleans, is documented by a ledger entry. I am grateful to Deborah D. Waters for alerting me to the Stirling commission, and to Paul M. Haygood for sharing his research on Lewis Stirling and his furniture.

time. Such deceptively simple volumes and the monochromatic appearance of mahogany-veneered furniture are appreciated today for their intrinsic elegance and craftsmanship, but in 1833 they may have elicited Colonel Thomas Hamilton's remark that New York drawing rooms struck him as "comfortable," but "plain." Noting the absence of the "Buhl" tables, ormolu clocks, gigantic mirrors, and japanned cabinets that he was accustomed to seeing in England, he concluded, "In short, the appearance of an American mansion is decidedly republican."[78]

In fact, Grecian ultimately became the most characteristically republican style, for it was both distinctively American and national in scope. There were so many inventive interpretations of its exuberant curvilinear forms in the 1830s and 1840s that, in the absence of labels, regional differences are often difficult to distinguish. Many Grecian pieces were composed of identical, or nearly identical, elements that were combined in various furniture forms. This flexible method of design, which encouraged economy as

Grecian pieces, as the portrait of Mr. and Mrs. Carter (fig. 242) illustrates. A powerful, thronelike rosewood armchair (fig. 243) is an excellent example of a contemporaneous cabinetmaker's conception of the Gothic style. The chair can be attributed to Thomas Brooks on the basis of details that relate it to a documented twelve-piece suite of walnut parlor furniture that he made for Roseland Cottage, the Woodstock, Connecticut, retreat of Henry Chandler Bowen, a wealthy dry-goods merchant from Brooklyn.[83] Its fluidly carved handholds are draped with a stylized wilted-leaf motif, thought to be a Brooks hallmark, that melds into the carving on the arm supports, which end in an acanthus flourish where the support meets the rail.[84]

Alexander Jackson Davis was the major exponent of the Gothic style in America prior to the Civil War. With his older partner, Ithiel Town, the young Davis had established a reputation as an architect with his Grecian designs. Under the influence of Pugin he began to design Gothic Revival houses and furniture in the early 1830s (see "Building the Empire City" by Morrison H. Heckscher in this publication, p. 180).[85] Davis gained his understanding of the style by studying British architectural and design publications; from 1825 until 1827 he had access to plates from *Gothic Furniture* (London, 1828) by A. C. Pugin, the father of A. W. N., several of which appeared in Rudolph

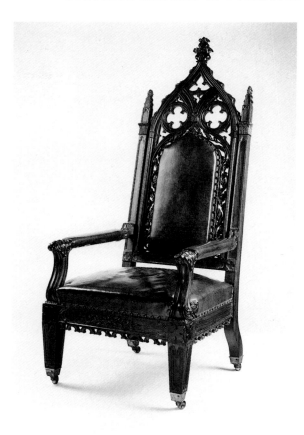

Fig. 243. Attributed to Thomas Brooks, Armchair, ca. 1847. Rosewood; replacement upholstery; casters. The Metropolitan Museum of Art, New York, Gift of Lee B. Anderson, 1999 1999.461

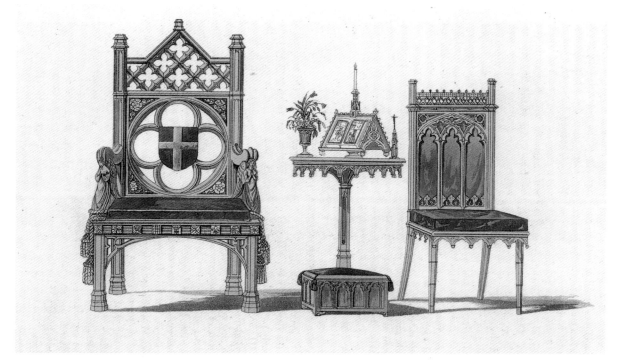

Fig. 244. *Gothic Furniture [Episcopal Chair, Table for a Boudoir, Drawing-Room Chair]*. Etching with aquatint and hand coloring, from Rudolph Ackermann's *Repository of Arts, Literature, Fashions, Manufactures, &c.*, ser. 3, November 1, 1825, pl. 29, opp. p. 307. The Metropolitan Museum of Art, New York, Harris Brisbane Dick Fund, 1942 42.74.2

71. *New-York Commercial Advertiser,* October 23, 1839.

72. Illustrations showing the use of pier mirrors in American interiors are rare. See a painting by Oliver Tarbell Eddy, *The Children of Israel Griffith,* ca. 1844 (Maryland Historical Society, Baltimore, 18.9.1), in Smith, *Hall and Grecian Style in America,* pl. 21; and Augustin Édouart, *Family in Silhouette* [New York City], 1842 (Winterthur Museum), in Elisabeth Donaghy Garrett, *At Home: The American Family, 1750–1870* (New York: Harry N. Abrams, 1990), p. 154.

73. A sofa related to the couch shown here (cat. no. 232) is in the Columbia Museum of Art, South Carolina. The Millford commission is extensively documented in the Williams-Chesnut-Manning Families Papers at the South Caroliniana Library, the University of South Carolina, Columbia. Additional papers are at the South Carolina Historical Society, Charleston, and the State Historical Society, Madison, Wisconsin. See Thomas Gordon Smith, "Millford Plantation in South Carolina," *Antiques* 151 (May 1997), pp. 732–41. My thanks are due to Brandy Culp, for her thorough reading of the family papers, and to Margize Howell and Mrs. Charles F. Johnson for photographs of Millford.

74. "Couch," derived from the medieval "*couche*" (bed), is the English term for a daybed, known as a *méridienne* or *lit de repos* in France. Thomas King, in *The Modern Style of Cabinet Work Exemplified* (1829), distinguished between sofas, which had two ends, and couches, which had one, as did the *New-York Book of Prices* for 1834. The couch had a long history in the nineteenth century. See a related French example with similar banded ornament in Leris-Laffargue, *Restauration, Louis-Philippe,* pp. 38–39. See also "Chaises Longues," pl. 10 (and also pl. 136) in George Smith, *Smith's Cabinet-Maker and Upholsterer's Guide . . .* (London: Jones and Company, 1828), used as the source for the upholstery presentation on this piece.

75. *New-York Book of Prices* for 1834, pl. 9. The showcover on this chair has been added for the exhibition. Its color was based on period sources from the early 1840s, such as *Le*

Garde-meuble, and on the color of some of the fabrics listed in Duncan Phyfe's auction sale of 1847, cited in note 76.

76. One Meeks and Sons table dated to 1829–35 is probably from a set. See Pollack, "Three Generations of Meeks Craftsmen," p. 127. The auctioneer James Bleecker listed "quartette and card tables" in 1839. *New-York Commercial Advertiser,* October 23, 1839. The 1847 catalogue of the sale of Duncan Phyfe and Son's inventory also includes mention of "quartett" tables. Edgar Jenkins, Auctioneer, *Peremptory and Extensive Auction Sale of Splendid and Valuable Furniture, on . . . April 16, and 17, . . . at the Furniture Ware Rooms of Messrs. Duncan Phyfe & Son, Nos. 192 and 194 Fulton Street . . .* (sale cat., New York: Halliday and Jenkins [1847]), copy in the Winterthur Library.

77. See Teresa A. Carbone, *American Paintings in the Brooklyn Museum of Art: Artists Born by 1876* (Brooklyn, forthcoming).

78. [Thomas Hamilton], *Men and Manners in America* (1833; reprint, with additions from the 1843 ed., New York: Augustus M. Kelley, 1968), p. 103. We do not know whom Colonel Hamilton was visiting when he made this remark. "Buhl" is the nineteenth-century version of the French "Boulle," connoting a decorative form of marquetry made with tortoiseshell and/or metals (usually silver or brass) in the manner of André-Charles Boulle (1642–1732).

79. See Pollack, "Three Generations of Meeks Craftsmen," pp. 24–27 and chap. 3. Joseph Meeks advertised the opening of a furniture warehouse in New Orleans as early as 1820. His two sons operated a furniture store there from 1830 to 1839.

80. The table is illustrated and discussed in Wendy A. Cooper, *Classical Taste in America, 1800–1840* (exh. cat., Baltimore Museum of Art; New York: Harry N. Abrams, 1993), pp. 215, 217. It no longer bears its original Meeks and Sons label. The price of the table, with an "Egyptian marble" top, was listed on the Meeks broadside as $100.

81. A. J. Downing, *The Architecture of Country Houses* (New York: D. Appleton and Company, 1850; reprint with a new introduction by J. Stewart Johnson, New York: Dover Publications, 1969), p. 413.

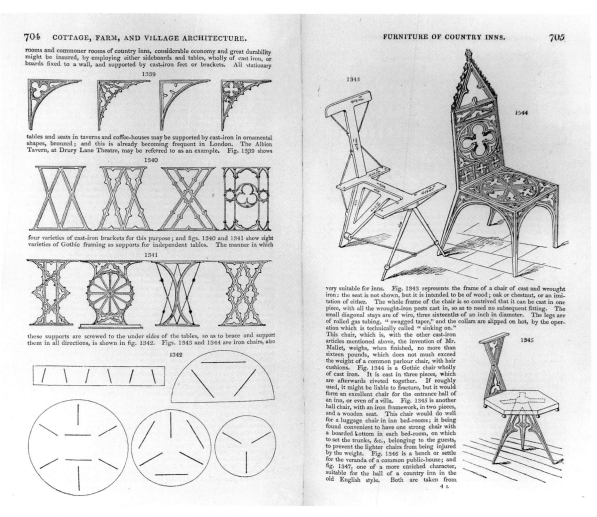

Fig. 245. *Cast-Iron Table Supports Designed by Robert Mallet.* Wood engraving, from J. C. Loudon, *An Encyclopaedia of Cottage, Farm, and Villa Architecture and Furniture* (1833; new ed., London: Longman, Brown, Green, and Longmans, 1842), pp. 704–5, fig. 1341. Courtesy of the American Antiquarian Society, Worcester, Massachusetts

Ackermann's influential serial publication *Repository of Arts, Literature, Fashions, Manufactures, &c.;* one of Ackermann's plates (fig. 244) was saved by Davis among his own furniture designs.[86] He accumulated an extensive library that included such British books as Henry Shaw's *Specimens of Ancient Furniture* (London, 1836), A. W. N. Pugin's *Gothic Furniture in the Style of the Fifteenth Century* (London, 1835), and J. C. Loudon's influential treatise *An Encyclopaedia of Cottage, Farm, and Villa Architecture and Furniture* (London, 1833), which Davis often consulted.[87]

It was accepted practice to leaf through such books for design ideas. Robert Donaldson, owner of the Phyfe window bench (fig. 238), called at Davis's office in January 1834 "to look for a gothic villa in books, and get a design for residence."[88] Philip R. Paulding, proprietor of Knoll, later renamed Lyndhurst, in Tarrytown, New York, inquired about the whereabouts of a design for a bookcase that Davis

had promised him, "I think you told me you found it going in [*sic*] one of your books."[89] Davis typically charged his clients $3, $4, or $5 to design a piece of furniture. His sketches were translated into walnut and oak (the woods most favored for Gothic furniture), in Westchester by cabinetmakers Richard Byrne and Ambrose Wright, and in New York by William Burns and his various partners; while in business with Peter Trainque, Burns was known for "the most correct Gothic furniture."[90]

Loudon recommended that Gothic houses be furnished in the Gothic style and that the entire commission be put under the direction of a competent architect. The latter was an innovative concept for American architects, and Davis enthusiastically embraced it. Thus, he designed not only the house but also the interiors and furniture for Knoll, which was built between 1838 and 1842 on the bluffs above the Hudson River for two-term New York mayor William

Paulding and his son Philip. The interiors, redolent of romantic medievalism, were appreciatively described in the press:

> This is a perfect specimen of the most beautiful of the pointed [Gothic] styles, and the whole interior is in keeping with the style. Mr. Davis has designed every article of furniture, so that every chair and every table would appear . . . to be at home in its place . . . as a necessary part of the whole. . . . Every window is of enameled glass, and the panes made of the small diamond shape. The coloured light thrown into the rooms when the sun shines . . . carries back the association to the olden times. There is, too, something aristocratic . . . (which we take to be gentlemanly) in these gorgeous windows . . . ; the lofty halls with ribbed ceilings of oak; the gothic sculptures; the regular irregularities of the rooms; the luxury of the bay windows and oriels . . . towers, and pinnacles, lawns and terraces . . . —all these are found in the estate of Mr. Paulding, and they remain a perpetual monument of a pure and cultivated taste.[91]

A wheel-back chair in oak (cat. no. 234)—one of a pair that Davis designed, probably about 1845, for the reception hall at Knoll—is among the earliest documented pieces of Gothic Revival furniture made in America. Davis's daybooks record that he began to conceive of furniture for the Pauldings in 1841, when he mentioned "fifty designs for furniture," and continued through 1847.[92] The chair is typical of antebellum Gothic Revival seating furniture in its appropriation of Gothic tracery for the dominant motif. It also displays a purposive stiffness, which Loudon said "belongs to the style."[93] Davis inventively adapted the wheel-shaped back from a cast-iron table support designed by an Irish engineer named Robert Mallet that was published in Loudon's *Encyclopaedia* (fig. 245). Cast-iron furniture was still a new idea, having been introduced in England during the early 1830s.[94] Loudon advocated its use in domestic settings because it was inexpensive and practical. Some of the designs he published emphasize structure over style to such an extent that they seem more protomodern than Gothic. Although there is no evidence that Davis designed any cast-iron pieces, he was sympathetic to the innovative use of the material and its possible applications to furniture, inscribing in his notebook Loudon's desire that "our furnishing ironmonger's [*sic*] would direct a portion of that power of invention . . . now almost exclusively occupied in

contriving bad fireplaces, to the improving of the designs, and lowering the price of cabinet furniture, by the judicious introduction of cast iron."[95]

A later Davis design (cat. no. 235), also documented by drawings, was probably first conceived about 1857 in conjunction with the architect's most ambitious castellated villa, Ericstan, 1855–59, the Tarrytown seat of the wealthy flour merchant John J. Herrick (see cat. no. 102).[96] By any standard, this walnut chair is one of the most aesthetically refreshing pieces of American Gothic furniture. Here again, there seems to be a relationship between Davis's design and the medium of cast iron: the way the sculpted vertical tracery elements of the chair back flow over the top of the crest is more characteristic of cast metalwork than of traditional cabinetmaker's joinery, and is even more remarkable here because hand craftsmanship is employed. The carved "ears" at the edges of the crest, an allusion to similar designs on medieval spires and canopies, are typical elements on Gothic Revival furniture. The delicate, animated legs, however, are unusual. Canted in front and ending in stylized hoofed feet poised as if *en pointe*, they recall little deer hooves, even including abstract dewclaws. These feet and the protruding "knees" at the juncture of the legs and the seat rail are both elements found in the cast-iron garden furniture then being made for the newly created urban parks and for the rustic landscapes of rural residences.[97]

While some took issue with Davis and his collaborator Downing for "corrupting the public taste, and infecting the parvenues with the mania of Gothic Castle-building,"[98] there were actually relatively few Gothic residences as monolithic or imposing as Knoll and Ericstan. In architecture the style was more typically disseminated in the form of designs for unpretentious rural cottages made of wood, not stone. And these were not necessarily furnished in the Gothic style, because, as Downing explained, "there has been little attempt made at adapting furniture in this style to the more simple Gothic of our villas and country houses in America."[99] In urban residences, Gothic decoration was generally confined to libraries, where—paradoxically, in an era in which technological advances made books accessible to everyone—it recalled medieval scholarship and the monastic preservation of knowledge.

Gothic furniture was also criticized. Downing, echoing Pugin, objected that it was often "too elaborately Gothic—with the same high-pointed arches, crockets, and carving usually seen in the front of some cathedral," which resulted in interiors that were "too ostentatious and stately."[100] As an alternative, Downing

82. See many examples in Katherine S. Howe and David B. Warren, *The Gothic Revival Style in America, 1830–1870* (exh. cat., Houston: Museum of Fine Arts, 1976).

83. See Amy M. Coes, "Thomas Brooks: Cabinetmaker and Interior Decorator" (Master's thesis, Bard Graduate Center for Studies in the Decorative Arts, New York, 1999), pp. 36–41, 58–61.

84. The motif may be a stylized oak leaf, in keeping with the acorns in the pierced carving on the chair back. Collectors' accounts are the basis for the suggestion that this detail is a Brooks hallmark. I am grateful to Lee B. Anderson and David Scott Parker for sharing their expertise in Gothic Revival furniture.

85. See also Amelia Peck, ed., *Alexander Jackson Davis, American Architect, 1803–1892* (exh. cat., New York: The Metropolitan Museum of Art and Rizzoli, 1992); Jane B. Davies, "Gothic Revival Furniture Designs of Alexander J. Davis" *Antiques* 111 (May 1977), pp. 1014–27; and Stanley Mallach, "Gothic Furniture Designs by Alexander Jackson Davis," (Master's thesis, University of Delaware, Newark, 1966).

86. Davis's copy of this plate is among his drawings housed in the Avery Architectural and Fine Arts Library, Columbia University.

87. Davis acquired a copy of Loudon's *Encyclopaedia* on September 8, 1835. Davis, Daybook, vol. 1, p. 1, New York Public Library. Published in 1833, Loudon's book was reissued (with revisions) in 1835, 1836, 1839, 1842, 1846, 1847, 1850, 1857, 1863, and 1867, attesting to its widespread popularity. See the preface to *Loudon Furniture Designs from the Encyclopaedia of Cottage, Farmhouse and Villa Architecture and Furniture, 1839* (East Ardsley: S. R. Publishers, 1970).

88. Davis, Daybook, January 15, 1834, vol. 1, p. 157, transcribed by Cynthia V. A. Schaffner, New York Public Library.

89. Davis, Correspondence, N-13-f (undated), A. J. Davis Collection, Avery Architectural and Fine Arts Library, transcribed by Cynthia V. A. Schaffner. Davies, "Gothic Revival Furniture Designs," p. 1027, n. 35, postulates an 1844 date.

90. Downing, *Architecture of Country Houses* (reprint), p. 440.

91. "The Architects and Architecture of New York," *Brother Jonathan*, July 15, 1843, pp. 301–3.

92. Davis Journal, vol. 1, p. 59, Department of Drawings and Prints, Metropolitan Museum (24.66.1400). One related drawing for this chair is in the A. J. Davis Collection, Avery Architectural and Fine Arts Library; the other is in the collection of the Museum of the City of New York. The identity of the cabinetmaker is suggested by an entry in Davis's Daybook, vol. 1, p. 457: "R. Byrne, Cabinet maker, White Plains, made Paulding's chairs," transcribed by Cynthia V. A. Schaffner, New York Public Library. The date of this entry is not clear; it appears in a section titled "Visiting Cards."

Richard Byrne came to America from Ireland in about 1833 and moved to White Plains in March or April 1845, according to the obituaries cited in Mallach, "Gothic Furniture Designs," pp. 132–33 (and notes, pp. 108–9). On the basis of these obituaries and the Davis diary entry cited above, a date of about 1845 is probable for the Knoll hall chairs.

93. J. C. Loudon, *An Encyclopaedia of Cottage, Farm, and Villa Architecture and Furniture, . . .* new ed. (London: Longman, Brown, Green, and Longmans, 1842), p. 1094.

94. J. Ian Cox, "Cast-Iron Furniture," in *Encyclopedia of Interior Design*, vol. 1, pp. 232–33.

95. Davis, Todd System Notebook, page F, transcribed by Cynthia V. A. Schaffner, New York Public Library.

96. The drawings are in the Avery Architectural and Fine Arts Library, Columbia University, A. J. Davis Collection (194000100432), and in the Department of Drawings and Prints, Metropolitan Museum (24.66.1892); the latter bears a later inscription. When oak versions of this form were discovered in the possession of Herrick descendants, the date for the design seemed confirmed. The walnut versions of the chair, such as this one, have details that differ slightly from those in oak and thus are thought to be variants of the Ericstan chairs. See Henry Hawley, "American Furniture of the Mid-Nineteenth Century," *Bulletin of the Cleveland Museum of Art* 74 (May 1987), pp. 186–93.

97. Cynthia V. A. Schaffner observed the subtle relationship of this

Fig. 246. *Antique Apartment—Elizabethan Style.* Wood engraving by John William Orr, from A. J. Downing, *The Architecture of Country Houses* (New York: D. Appleton and Company, 1850), fig. 184. Courtesy of the American Antiquarian Society, Worcester, Massachusetts

proposed Elizabethan or Flemish furniture for use in Gothic houses because these styles provided a successful combination of the picturesque and the domestic; moreover the admixture of styles could be justified on the basis of European precedents.[101] He also endorsed the Elizabethan style for interiors, because it had a "homely strength and sober richness" and was "addressed to the feelings, and capable of wonderfully varied expression."[102] It is telling that Downing gave as the best reason for the introduction of Elizabethan architecture to the United States "the natural preference which Europeans, becoming naturalized citizens among us, have for indulging the charm of old associations, by surrounding themselves by an antique style that has been familiar. . . ."[103] As his example of a fine Elizabethan interior, he chose an illustration from Sir Walter Scott's Waverly novels (fig. 246) that depicted a coffered ceiling, wainscoted oak wall paneling, tapestries, twisted columns, scrollwork, and "heavy and quaint carving in wood."[104] The effect was "often grand and sombre, always massive, rich, and highly picturesque—as well as essentially manorial

and country-like."[105] The Elizabethan dining room of James Penniman's "princely residence" (measuring about forty-six by eighty-five feet), built in 1846 on the south side of Union Square, was commended in the press, which noted in particular its "mantel . . . of fine statuary marble, each side being supported by two figures in armour, nearly the size of life," its busts in period costume, and its fresco-painted decorations.[106]

A portfolio cabinet attributed to the firm of J. and J. W. Meeks, successor to Joseph Meeks and Sons, which dates to about 1845, illustrates an American interpretation of the Elizabethan style (cat. no. 233).[107] It opens on one side to reveal a maple-veneered interior in which serpentine-shaped dividers create four vertical slots, probably designed to hold bound volumes or perhaps prints. Fretwork similar to that seen on the sides and gallery of the cabinet is a notable feature of Meeks furniture produced in the 1840s,[108] as is the machine-carved ripple moldings, which have precedents in seventeenth-century German and Dutch Baroque cabinets. The cabinet's most

prominent feature, the colorful "Berlin" needlework panel depicting a scene from *Romeo and Juliet*, emphasizes the link with the Elizabethan.[109]

The evocation of "old associations" and the equation of interior decoration with "something aristocratic" reflected values that New Yorkers, starting in the 1840s, increasingly came to prize. Objects with age became desirable indicators of established social position, for, among other things, they implied a long, distinguished family lineage. A new nostalgia for family heirlooms, especially those from the late eighteenth century, gave expression to an incipient Colonial Revival movement, which was to be even more strongly articulated after the Civil War. "The fact is, my friend," asserted an anonymous speaker in a brief tale called "The China Pitcher," "it is all the fashion to be unfashionable now. The older a thing is, the newer it is":

Garrets are ransacked, old cellars, lumber-rooms, and auction-shops, and everything turned topsy-turvy . . . pillaged over and over again by people who, six months ago, had their great-grandmother's [eighteenth-century] chairs lugged off into the wood-house, and stowed way for kindling-stuff. . . . something new in the shape of old furniture is always sure to turn up, at a prodigious bargain; some undoubted original, of great worth, in the finest possible preservation, which had been most unaccountably overlooked, as well as most unaccountably spared, for nobody knows how many generations. . . .

In short . . . the struggle now is between the families of yesterday and the families of the day before. The oldest furniture, and the ugliest, always did belong, and always must belong, of course, to the oldest families.[110]

The term given to all things old, odd, and "ugly" was "rococo." "Those . . . who have been lately in France will be familiar with the word," the *New Mirror* advised in 1844. "It came into use about four or five years ago, when it was the rage to look up costly and old-fashioned articles of jewelry and furniture. . . . A chair, or a table, of carved wood, costly once but unfashionable for many a day, was *rococo. . . . things intrinsically beautiful and valuable*, in short, but *unmeritedly obsolete*, were rococo."[111] The term would come to be synonymous with "Old French"—Louis XIV and Louis XV—styles revived during this period.

The mania for old things spurred the frenzied sport of shopping conducted in other people's houses, especially on May 1, when leases were up, and because of

frequent bankruptcies throughout the period. (See "Inventing the Metropolis" by Dell Upton in this publication, p. 18.) As the November 1848 *Home Journal* reported, "NEW-YORK is the greatest place in the world for sudden *sellings out*," but there was little embarrassment in doing so. "People build houses and furnish them as if for twenty generations, occupy them for a year or two, and sell out at auction; and so frequent is this summary laying down of splendor, that the discredit and mortification which would attach to it in older countries is here scarce thought of—the national love of change being its sufficient apology, if one were at all needed."[112] Grand tours of Europe usually preceded such sales, the *Home Journal* explained: "these suddenly enriched tourists pick up, and ship home, such articles of furniture as strike their fancy in foreign cities."[113] "The amount of importation of articles of luxury and taste" was "surprising," and "with the facility with which [such goods] soon come to the hammer, New-York [was] perhaps the best place in the world to purchase costly and curious furniture second hand."[114] Moreover, buying at auction combined "a good deal of the excitement of gambling"[115] with the opportunity to see "how every class 'furnishes,'" which is a considerable feature of living."[116] Sometimes a sorry sham was uncovered. "My suspicions, . . . that the fine furniture displayed by Mrs. B. at her party, was all borrowed for the occasion, were well founded," sniffed one nosy neighbor in a squib called "House-Hunting," "for her house is to let, and I examined it from garret to cellar; there was neither ottoman nor piano in the parlour—not a piece of French furniture in the house."[117] The "perfect mania"[118] for auctions also brought about the inevitable traumas associated with impulse buying, as numerous moralistic tales published in the popular press attested.[119]

Major fluctuations in the economy and imprudent expenditures by the socially ambitious were unfortunate stimuli to the secondhand furniture market. The Panic of 1837 plunged many New Yorkers into financial ruin. Philip Hone, who was a retired auctioneer in addition to his many other accomplishments, confided to his diary that "one of the signs of the times is to be seen in the sales of rich furniture, the property of men who a year ago thought themselves rich, and such expenditures justifiable, but are now bankrupt."[120] The effects of the depression dragged on for several years. In the spring of 1839 Hone attended an auction at the home of John L. Bailey of Lafayette Place, where the pictures, statuary, French hangings, mirrors, and such were "all of the most costly

chair to cast-iron garden furniture. Its upholstery has been re-created by Nancy C. Britton on the basis of Davis's own furniture designs and colored plates in Ackermann's *Repository* (for example, fig. 244); a related chair in the Museum of the City of New York is the source for the configuration of the box seat. The blue rep fabric replicates a fragment of period upholstery from a mid-nineteenth-century chair in the Museum of Fine Arts, Boston. Davis's drawings show the use of yellow-gold trim, and Loudon recommended both gold and silver trims on Gothic chairs made for domestic use.

98. "Our New Houses," *United States Magazine, and Democratic Review* 21 (November 1847), p. 392.

99. Downing, *Architecture of Country Houses*, p. 440.

100. Ibid.

101. Ibid.

102. Ibid., pp. 449, 391.

103. Ibid., p. 391.

104. Ibid., p. 392.

105. Ibid.

106. "A Princely Residence," *Morris's National Press*, April 11, 1846, p. 2.

107. The portfolio cabinet can be strongly attributed on the basis of a labeled J. and J. W. Meeks sofa table on loan to the Art Institute of Chicago that has similar bilaterally symmetrical supports.

108. Fretwork of this kind (*découpure*) first appears about 1844 in *Le Garde-meuble*.

109. Such needlework scenes, more common in midcentury fire screens than in case pieces, were stitched onto a canvas, stretched around a frame, and then inserted into the piece. Downing (*Architecture of Country Houses*, reprint, p. 436) illustrated a related piece by Alexander Roux, an "escritoire" (drop-front desk), next to a set of shelves with similar fretwork decoration, also by Roux.

110. "The China Pitcher," *New Mirror*, April 8, 1843, pp. 4–5. Such references contradict the opinion currently held by decorative arts scholars that the Antiques Movement—which advocated furnishing the home with old furniture (and equated old furniture with domestic virtue)—dates to the 1870s or slightly before. See George Whiteman, "The Beginnings of Furnishing with Antiques," *Antique Collector* 43 (February 1972), pp. 21–28;

Stefan Muthesius, "Why Do We Buy Old Furniture? Aspects of the Authentic Antique in Britain, 1870–1910," *Art History* 11 (June 1988), pp. 231–54; Julia Porter, "Antiques Movement," in *Encyclopedia of Interior Design*, vol. 1, pp. 28–30.

111. "Chit-Chat of New-York [The Rococo]," *New Mirror*, February 17, 1844, p. 318.

112. "Oddities in Furniture," *Home Journal*, November 18, 1848, p. 2.

113. Ibid.

114. Ibid.

115. "Attending Auctions," *Morris's National Press*, May 9, 1846, p. 2.

116. *New Mirror*, May 11, 1844, p. 90.

117. "House-Hunting," *New-York Mirror*, February 29, 1840, p. 287.

118. "Attending Auctions," p. 2.

119. For example, Fanny Smith, "My Experience in Auctions," *Peterson's Magazine* 25 (1854), pp. 113–16.

120. *The Diary of Philip Hone, 1828–1851*, edited by Allan Nevins (New York: Dodd, Mead and Company, 1927), vol. 1, p. 252, entry for April 10, 1837.

121. Philip Hone, Diary, entry for April 19, 1839. This passage does not appear in the published *Diary*, cited above. I am grateful to Jeffrey Trask for reviewing on microfilm the original manuscript in its entirety.

122. For example, in 1824 John T. Boyd and Company advertised a "large and general assortment of new and second-hand furniture," in the *New-York American*, May 13, 1824. In 1833 James C. Smith, a New York auctioneer, sent an important shipment of furniture, attributed to Phyfe, to Hyde Hall, the home of George Clarke, on Otsego Lake in central New York. See Douglas R. Kent, "History in Houses: Hyde Hall, Otsego County, New York," *Antiques* 92 (August 1967), pp. 187–93. Ira Cohen maintains that the auction system in New York, in use since the War of 1812, was done in by the economic crisis of 1837, after which the number of licensed auctioneers greatly declined. See Ira Cohen, "The Auction System in the Port of New York, 1817–1837," *Business History Review*, autumn 1971, pp. 488–510, esp. p. 510. But the auction sales of furniture seem to have been part of the distribution system for such goods in New York. Thomas Mooney included a long section

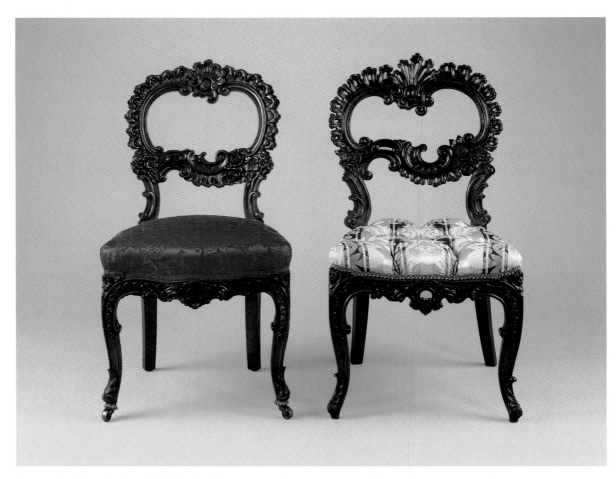

Fig. 247. (left) Possibly J. and J. W. Meeks, Side chair, ca. 1850. Rosewood; probably replacement underupholstery, replacement showcover; casters. The Metropolitan Museum of Art, New York, Gift of Bradford A. Warner, 1969 69.258.9
(right) Cabinetmaker unknown, New York City, Side chair, ca. 1850. Rosewood; probably replacement underupholstery, replacement showcover. The Metropolitan Museum of Art, New York, Friends of the American Wing Fund, 1992 1992.81

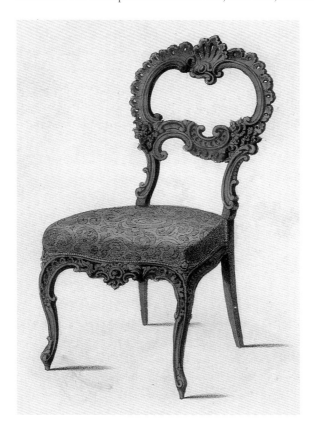

Fig. 248. Désiré Guilmard, designer, *Chaise de fantaisie*. Lithograph with hand coloring, from *Le Garde-meuble, ancien et moderne*, livraison 35, no. 194 (Paris, 1844). Smithsonian Institution Libraries, Cooper-Hewitt, National Design Museum Branch, New York

descriptions suitable for [a] european Nobleman with an income of £50,000 . . . and yet this man was probably never worth half that Sum, but swam upon the treacherous stream of commercial Speculation. . . . There are now, every day, three or four sales of such furniture. . . ."[121]

While the appreciation for old things may have been new, purchasing secondhand furniture was an established custom in New York.[122] There were "*mock auction shops*" in certain parts of town, Chatham Square notably, which were to be avoided (see cat. nos. 177, 178),[123] and no doubt a certain amount of fudging about the merchandise was to be expected no matter how reputable the auctioneer: "The furniture was made by Phyfe of course, . . . [It] was inventoried, and catalogued, and all the English names turned into French. French is so fashionable, and things in that winning language, command such excellent prices."[124] The resale market created its own class of dealers who purchased to sell again. Daniel Marley, a dealer in secondhand furniture and rococo curiosities, starting in 1840, was one of the city's first antique dealers, although that particular term did not come into common use until later in the century.[125]

The reason it had become "a famous time" to buy secondhand furniture was that French furniture had "come in lately with a rush" and everyone was "furnishing anew, *a la Francaise,* from skylight to basement."[126] Among the upper echelons of society, the predominance of Gallicism over Anglicism was striking. As one objective observer recounted, "The French language is heard all over a crowded drawing-room; and with costume entirely, and furniture mainly French, it is difficult . . . not to fancy ones self on the other side of the Atlantic."[127] French taste was embraced wholeheartedly, and there was even national pride taken in the fact that "with a separation of only twenty-miles from the French coast, the English assimilate not at all . . . while we [Americans], at a distance of three thousand miles, copy them with the readiness of a contiguous country."[128] Interest in the Louis XIV style was part and parcel of this pervasive Francophilia. "The style of interior decoration, so much in vogue in the days of Louis XIV, has lately been revived," *Brother Jonathan* reported in 1843. "It is elaborate and gorgeous in the highest degree—an immense quantity of gilding being used. . . . It is adapted about as well to one style [of] building as another, not being strictly appropriate to any. The Elizabethan character best accords with it, and the florid Roman seems to claim some consanguinity."[129]

From the late 1820s on, aristocratic New Yorkers had indulged in a taste for imported French furniture[130]—a taste that American cabinetmakers and journeymen viewed as a threat. In 1835 New Yorkers were shocked when a public sale of French furniture at the City Hotel was disrupted by journeymen and apprentices who had recently been on strike for wage increases and were determined that no foreign furniture should be sold in New York. Rich tapestry upholstery was slashed with knives, and French-polished pieces were scratched and mutilated. "The Devil is in the people," Philip Hone wrote in his diary that evening.[131] The press noted that the troublemakers were mostly German immigrant journeymen and that some master cabinetmakers had "openly justified the proceedings."[132]

In the ensuing decade, however, American cabinetmakers capitalized on New Yorkers' growing love of antiques and their adoption of French styles.[133] "The cabinet-maker who judiciously comes from the antique," Dr. George Washington Bethune, a clergyman, counseled in 1840, "will find the most ready demand for his furniture."[134] New York cabinetmakers, such as Duncan Phyfe, who had been working in the Grecian idiom had to accommodate this new trend. "So marked is this change of taste, and the new school of furnishing, that the oldest and most wealthy of the cabinet warehouse-men in this city has completely abandoned the making of English furniture," the *New Mirror* reported in 1844, perhaps referring to Phyfe. "He sold out an immense stock of high-priced articles last week at auction, and has sent to France for models and workmen to start new with the popular taste."[135] An upholstered armchair attributed to Phyfe that survives from Millford Plantation (fig. 233) may be of a type unfamiliar to modern eyes, but by the 1840s such a *fauteuil confortable* would have been deemed among the most fashionable Parisian designs. A portrait of the Fiedler family from about 1850 (fig. 211) shows similar chairs being used to update the drawing room, or front parlor, of a New York town house on Bond Street built in the 1830s.

The New York market enticed many accomplished cabinetmakers from Europe. The Frenchman Alexander Roux had come to America in 1835, going into business as an upholsterer on Broadway (1836–43), and thereafter as a cabinetmaker.[136] The German cabinetmakers who immigrated to America in the 1840s were also prepared to take advantage of the new market for French styles. Of these, Julius Dessoir, J. H. Belter, Anthony Kimbel, and Gustave Herter all managed to avoid the Kleindeutschland shops

on auctioneers in *Nine Years in America*, which begins (p. 132), "The root of auctioneering lies in New York, the great emporium of imported goods."

123. Mooney, *Nine Years in America*, p. 90.

124. K. K., "The Fashionable Auction, or the Mysterious Purchaser," *Arcturus* 3 (May 1842), pp. 417–18.

125. The term "antique dealer" first appeared in London trade directories in 1886. See Porter, "Antiques Movement," p. 28. During the 1840s Marley's shop was on Ann Street near P. T. Barnum's American Museum, which may have prompted one commentator to liken the "labyrinthine" shop to a rich museum. "Oddities in Furniture," p. 2; see also "To Seekers of Furniture," *Home Journal*, April 14, 1849, p. 2. Marley's old things were more valuable than new ones, it was said, and one-fifth the price. "On Furnishing a House," *Home Journal*, November 17, 1849, p. 1. Sypher and Company was the successor to Daniel Marley. See F. J. Sypher, "Sypher & Co., a Pioneer Antique Dealer in New York," *Furniture History* 28 (1992), pp. 168–79.

126. *New Mirror*, May 11, 1844, p. 90.

127. "Sketches of New-York," *New Mirror*, May 13, 1843, p. 85.

128. Ibid.

129. "The Architects and Architecture of New York," p. 301. The "florid Roman" style of architecture probably referred to the Corinthian order. See the gilded table made for Edwin Clark Litchfield (cat. no. 244) in its original setting, a drawing room with Corinthian columns and decorated pilasters (fig. 250).

130. For example, W. F. Pell and Company advertised a sale of "Splendid Parisian Furniture" in the *New-York Evening Post*, October 26, 1829. Horatio N. Davis, at 286 Broadway, opposite the Washington Hotel, boasted in 1835 that he had "received from Paris a rich Mahogany Bedstead, together with the most approved style of French Drapery" and, subsequently in 1836, "the latest French and English designs for fitting-up and decorating drawing-rooms." *Spirit of the Times*, December 12, 1835, p. 7, February 27, 1836, p. 16. James Bleecker advertised "HANDSOME NEW FRENCH PARLOR FURNITURE, just imported" in

the *Evening Post* (New York), March 15, 1841, p. 2.

131. *Diary of Philip Hone*, vol. 1, p. 157, entry for April 29, 1835.

132. "Fruits of the Trades' Union," *Niles' Weekly Register*, May 9, 1835, p. 171. In reporting the event, *Niles' Weekly Register* sympathized with the owner of the damaged goods. In view of the expense involved, if the French furniture were to have sold without a loss, it "must have sold for the *fashion* of it."

133. "Oddities in Furniture," p. 2. "The imitation of second-hand furniture was resorted to, at last, by the despairing furniture-dealers, and to avoid any look of *newness* in furniture, has every [*sic*] since been thought indispensable to style. . . ."

134. "Influence of Art," *The New-Yorker*, July 4, 1840, p. 248.

135. *New Mirror*, May 11, 1844, p. 90.

136. See note 203 below.

137. Dessoir, a Prussian (in spite of his French-sounding name) is discussed in note 209 below. Belter is discussed in note 217 below. Kimbel arrived in New York about 1847 (his death certificate, dated 1895, states that he had been in New York for forty-eight years). He was the principal designer for Baudouine for several years, perhaps starting in 1847, at 351 Broadway, and continuing at 335 Broadway from 1849 to either 1851 or to about 1854, when Baudouine closed his shop. See note 214 below. The information on Kimbel is drawn from a chronology prepared by Medill Higgins Harvey. Herter has been the subject of recent scholarly study. See Howe, Frelinghuysen, and Voorsanger, *Herter Brothers*; and Catherine Hoover Voorsanger, "Gustave Herter, Cabinetmaker and Decorator," *Antiques* 147 (May 1995), pp. 740–51.

138. The copies of *Le Garde-meuble* deposited with the Bibliothèque Nationale in Paris indicate that publication commenced in 1839. (Pencil inscriptions and, later, date stamps record when the copies were received by the library.) Approximately fifty-four lithographed plates were issued each year, and publication continued well into the twentieth century. See Jean Adhémar, Jacques Lethève, and François Gard, *Inventaire du fonds français après 1800* (Paris: Bibliothèque Nationale, 1958), vol. 10, pp. 48–50. See also Kenneth L. Ames, "Designed in France: Notes on the Trans-

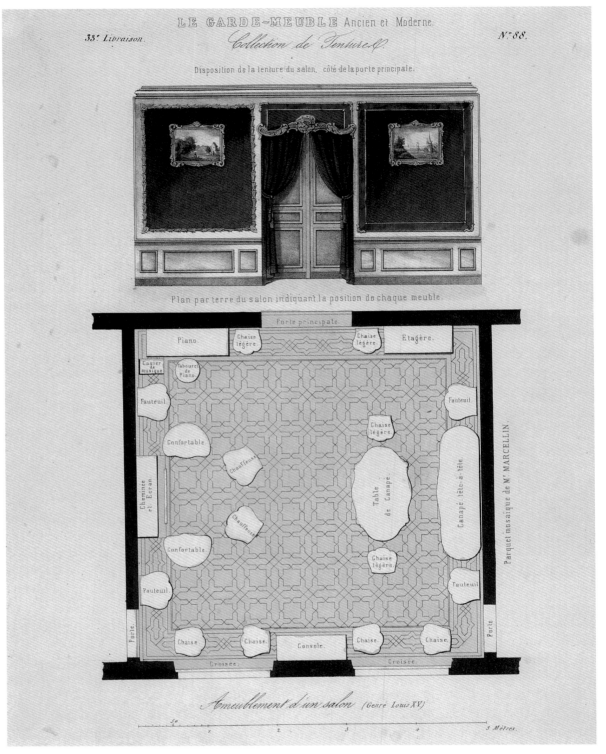

Fig. 249. *Ameublement d'un salon (genre Louis XV)*. Lithograph with hand coloring, from *Le Garde-meuble, ancien et moderne*, livraison 33, no. 88 (Paris, 1844). Smithsonian Institution Libraries, Cooper-Hewitt, National Design Museum Branch, New York

and were working on Broadway within a short time after arriving.[137]

Published French designs, along with news reports and illustrations of Parisian industrial expositions, were well known to New York cabinetmakers. A major source, issued serially as loose plates, was *Le Garde-meuble, ancien et moderne*, published in Paris by Désiré Guilmard starting in 1839.[138] Evidence of the relevance of this publication to American cabinetmakers is demonstrated by two charming, nearly identical rosewood side chairs (fig. 247). Each has a scalloped back, punctuated by a voided, asymmetrical

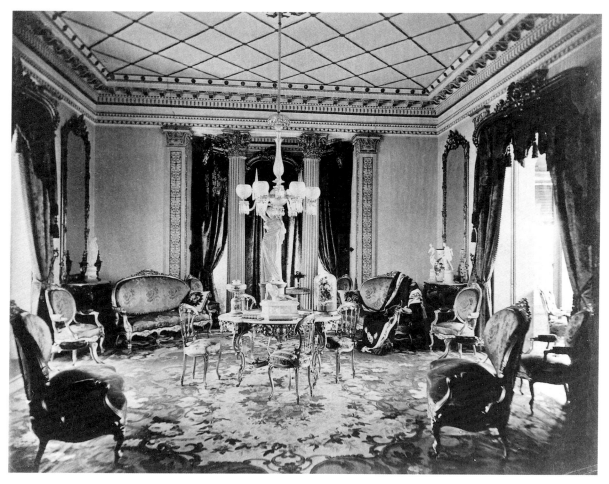

Fig. 250. *Drawing Room of Grace Hill,* the residence of Edwin Clark Litchfield and Grace Hill Hubbard Litchfield, Brooklyn, decorated ca. 1857; photograph by B. J. Smith, ca. 1876–86, showing center table (cat. no. 244). The New York Genealogical and Biographical Society, New York

mission of French Style to America," *Winterthur Portfolio* 12 (1977), pp. 103–14.

139. One of the chairs at the Metropolitan Museum (69.258.9) is attributed to J. and J. W. Meeks by family tradition. The mate to the other (1992.81) is in the Brooklyn Museum of Art. Two virtually identical designs, presumably copied from Guilmard's, were published, respectively, in Mainz, Germany, in 1846 and in 1853 by Wilhelm Kimbel, Anthony Kimbel's father. See Georg Himmelheber, *Deutsche Möbelvorlagen, 1800–1900* (Munich: Verlag C. H. Beck, 1988), p. 424 (no. 2708); and Heidrun Zinnkann, *Mainzer Möbelschreiner der ersten Hälfte des 19. Jahrhunderts* (Frankfurt am Main: Schriften des Historischen Museums, 1985), p. 345 (no. 221).

cartouche, a motif that has roots in eighteenth-century engravings but which is unusual in American Rococo Revival furniture. The slight differences between the two pieces suggest two makers working from a common source, a supposition that seems to be confirmed by the appearance of a related *"chaise de fantasie"* designed by Guilmard and published in *Le Garde-meuble* in 1844 (fig. 248).[139]

In addition to publishing designs for furniture, upholstery, and draperies, *Le Garde-meuble* occasionally printed floor plans and views of rooms that showed recommended arrangements of furniture and the number of pieces considered appropriate for a high-style drawing room. In one plate (fig. 249), twenty-four pieces in the Louis XV style are indicated. A series of large pieces appear along the four walls: clockwise from the top, a piano (with a stool and a canterbury to hold sheet music), an étagère, a *canapé tête-à-tête* (see cat. no. 236A) with a *table de canapé* (a sofa table, in lieu of a center table) in front of

it, a console (a table supported by two front legs and placed against a wall), and the chimneypiece, shielded by a fire screen. The seating furniture includes, in ascending order of size, four *chaises légères* (small, lightweight reception chairs), four *chaises* (side chairs), two *chauffeuses* (called slipper, or sewing, chairs in America), four *fauteuils* (armchairs), and two large *confortables* (large upholstered armchairs, often tufted). With the possible exception of the piano, the furniture was likely en suite, rendered in one style and in matching upholstery.

The extent to which the arrangement of American drawing rooms after 1840 conformed to such a plan is difficult to ascertain because there are few period images of interiors and because most photographs showing such furniture in situ are much later in date. Nevertheless, there is one photograph that is instructive in this regard—that of the drawing room of Grace Hill, the Brooklyn villa of Mr. and Mrs. Edwin Clark Litchfield designed by Alexander Jackson Davis

THE CHILDREN'S SOFA

Fig. 251. *The Children's Sofa*, frontispiece to Jacob Abbott, *John True; or The Christian Experience of an Honest Boy* in *Harper's Story Books: A Series of Narratives, Dialogues, Biographies, and Tales for the Instruction and Entertainment of the Young* (New York: Harper and Brothers, Publishers, 1856). Wood engraving by John William Orr, after Carl Emil Doepler. Courtesy of the American Antiquarian Society, Worcester, Massachusetts

140. Raymond S. Waldron Jr., "The Interior of Litchfield Mansion," *Park Slope Civic Council, Civic News* 29 (April 1966), pp. 20–21. Nine pieces survive in the collection of the Brooklyn Museum of Art: two sofas, two armchairs, four side chairs, and the center table, along with three pairs of red silk draperies, and two pieces of sculpture. Some of the seating furniture retains its original red silk damask; other pieces were reupholstered in 1956 by Ernest LoNano. Microanalysis by the Forest Products Laboratory, USDA, Madison, Wisconsin, reveals the wood used in the center table to be a poplar (*Populus sp.*) of European or American origin. The gilding is laid on a red bole under which there is white gesso. The interior sides of the skirt are painted with a matte ocher-yellow color not seen in contemporaneous New York furniture.

141. Davis, Daybook, p. 106, October 13, 1857, transcribed by Amelia Peck, A. J. Davis

(fig. 250). It shows a large suite of gilded French furniture, all embellished with intertwined Ls, comprising a center table with dove gray marble (cat. no. 244), four sofas, four armchairs, four side chairs, and four consoles with looking glasses above them. The same red silk damask fabric was used for the upholstery, striking against the burnished gold surfaces of the furniture, and for the draperies.[140] The furniture was disposed in a circular arrangement within the rectangular room, with the center table positioned where the axis of the colonnaded bay window and entrance met that of the windows on the side walls. As was the current fashion in France, the room was painted a neutral light color (probably ivory or white) with details and moldings picked out in gold. Davis specified a diaper pattern on the ceiling, marbleized painted decoration for the architraves, an imitation bronze finish for the sashes, and doors "painted and grained in imitation of old oak, varnished with copal root oak."[141] No doubt the "Aubusson" carpet was brightly colored to harmonize with the room.

Litchfield and his wife had ordered the suite between 1855 and 1857 in Europe, where they had traveled while their residence, designed in the Italianate style, was under construction. The Litchfields returned from Europe in the spring of 1857. In October Davis noted a visit to Brooklyn: "Went to Litchfields. The family had moved into the new house and were placing the furniture."[142] A frontispiece from a children's storybook of the mid-1850s (fig. 251), although obviously depicting an imagined interior, captures the imposing character of another upscale New York drawing room of the time; however, the diminutive Grecian sofa at the lower left, a family heirloom perhaps, and the piano seem anachronistic amid the ornate picture frames, swathes of draped fabric, and French furniture with cabriole legs.

Imported furniture such as the Litchfield suite was a status symbol among affluent New Yorkers, not only because of its style and the cachet of being French but also because of its exorbitant cost. Since the 1820s there had been a stiff 30 percent tariff on imported furniture. The General Convention of the Friends of Domestic Industry, held in New York in 1831, reported that protective tariffs had almost eliminated foreign imports.[143] Many well-to-do New Yorkers skirted the tariff, buying furniture and other decorative objects during their European sojourns. Others were effectively discouraged by it. In Paris in 1843 Howard Henderson, a colleague of James Colles, investigated the costs of French furniture and concluded, "American furniture must answer my purpose. The duty is 30 per cent, packing, transportation to Havre and freight home will render it very dear."[144]

As a result of the craze for all things French, several of the Broadway cabinetmakers, taking advantage of their own European backgrounds, began to import, as well as to make, furniture in the pedigreed styles of the European nobility. Starting in the mid-1840s, for example, Roux advertised furniture that he had commissioned in France:

> *Rich French Furniture. Alexandre Roux, Nos. 478 and 480 Broadway, having just returned from Paris, where he had made a very rich and choice selection of Furniture, manufactured in the finest and latest styles, . . . he has now ready for show a Bookcase, of black walnut, which for neatness and elegance of finish has never been equalled in this country, being after the styles of Henry 7th.*[145]

"We have no aristocracy of blood," scoffed Edgar Allan Poe in response to this phenomenon, "having,

therefore . . . fashioned for ourselves an aristocracy of dollars. . . . The people naturally imitate the nobles. . . . In short, the cost of an article of furniture has . . . come to be . . . nearly the sole test of its merit in a decorative point of view."[146] But neither Poe nor any other critic could stem the desire of New Yorkers to present themselves as cosmopolitan world citizens, which meant abandoning the old allegiances to British culture. "New-York is much more like Paris . . . than like an Anglo-American metropolis," *Morris's National Press* reported in its inaugural volume in 1846:

> It is true that the good old Knickerbocker blood still flows purely in many aristocratic veins, and . . . couples respect to the men, and worship to the women, who inherit it. True, also, that the full, steady-flowing, energetic stream of the pure Puritanic fluid which flowed at Bunker Hill, imbues us with its inimitable and unflagging business energies. But the literature, the amusements, the social peculiarities, the habits . . . the more etherial essence of society—are emphatically French in their inexhaustible brilliancy, gaiety, and sparkle. In fact, New-York is rapidly becoming a most delightful moyennais of all the good qualities and brilliant characteristics of all the nations of Europe—a sort of world-focus into which the rays from the whole horizon are concentrated.[147]

The correspondence between Colles (retired and soon to be a New Yorker), who was traveling in Europe between 1841 and 1844, and Matthew Morgan in New York provides a vivid firsthand account of New Yorkers' interest in the historical styles and furniture of France. Even during the extended banking crisis that had begun in 1837, Morgan was able to afford a magnificent new house near Washington Square, which was just being developed as the latest fashionable residential neighborhood. Amid descriptions of other people's bankruptcies, he noted in December 1842: "We have the Croton Water in every story, even the attic."[148] He was having the parlors ornamented in the "Louis Quatorze style," and thought that he might need to call upon Colles "to procure us a few things that come out with your own plunder."[149] Mrs. Samuel Jaudon of New York wrote to her friend Mrs. Colles in Paris to say that the Morgan drawing room "will be a stylish, elegant affair. . . . They have finished it in the most elaborate and gorgeous style of Louis XIV and when arranged will have a fine effect to us *Americans*. . . ."[150] In praising the Louis XIV style, a local periodical hastened to remark that "many of the

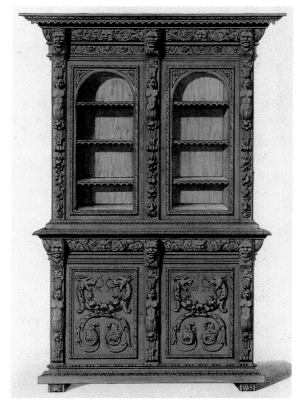

Fig. 252. Pierre Ribaillier, designer and cabinetmaker, *Dressoir-Renaissance (vieux bois)*. Lithograph with hand coloring, from *Le Garde-meuble, ancien et moderne*, livraison 72, no. 417 (Paris, 1850). Smithsonian Institution Libraries, Cooper-Hewitt, National Design Museum Branch, New York

excesses" of the original style had been avoided, lest it seem too rich for republican blood.[151] Blue was beginning to replace crimson as the modish color for upholstery,[152] and damask was de rigueur.[153]

In selecting furnishings and interior decoration schemes for their residences, the Morgans, Jaudons, and Colleses were assisted by a Parisian cabinetmaker, Auguste-Émile Ringuet-Leprince. Upon orders from his clients, Ringuet-Leprince shipped to New York entire rooms of furniture, carpets, looking glasses, wallpapers, decorative objects, and sculpture. Mrs. Jaudon was insistent nearly to the point of rudeness that Mrs. Colles do her the favor of ordering furnishings from Ringuet-Leprince (including two "Buhl" tables like Mr. Morgan's) while she was in Paris, because "we on this side feel as if everything [is] so much handsomer, and better, and desirable that comes from Paris."[154]

Colles corresponded regularly with Ringuet-Leprince while he was traveling in Europe and after his return to New York, ordering items to furnish the house he purchased late in 1844 at 35 University Place, between Tenth and Eleventh streets. The scale of the house

Collection, Avery Architectural and Fine Arts Library.

142. Ibid., document H1-2-0, May 1857.

143. "General Convention of the Friends of Domestic Industry," p. 11.

144. Howard Henderson, Paris, to James C. Colles, traveling in Naples, Italy, January 30, 1843, transcribed by Henry Metcalf (no. 630), James Colles Papers, Manuscripts and Archives Division, New York Public Library (hereafter Colles Papers). The Colles correspondence is voluminous, numbering some twelve hundred letters. Henry Metcalf, Colles's grandson, organized the letters chronologically and transcribed most of them, sometimes not completely. Some of the transcribed letters were subsequently edited and published with additional commentary by De Forest in *James Colles*. I am indebted to Brandy Culp for her detailed review of these original documents.

145. "Rich French Furniture," *Evening Post* (New York), October 14, 1846, p. 2. The style of "Henry 7th" was the French equivalent to the British Elizabethan, or Jacobean, Revival style.

146. Edgar Allan Poe, "The Philosophy of Furniture," *Burton's Gentleman's Magazine and American Monthly Review* 6 (May 1840), p. 243.

147. "Franco-Americanism," *Morris's National Press*, April 14, 1846, p. 2.

148. Matthew Morgan, New York, to James Colles, Paris, December 9, 1842, transcribed by Henry Metcalf (no. 622), Colles Papers. The house and grounds were worth $30,000, at a time when "Wall Street would not sell for 25 percent of the values of 1836." Ibid. See above, pp. 290–91.

149. Ibid.

150. Mrs. Jaudon, New York, to Mrs. Colles, Paris, May 12, 1843, in De Forest, *James Colles*, p. 170.

151. "The Architects and Architecture of New York," *Brother Jonathan*, July 15, 1843, p. 301.

152. Mary Davenport, "Mildred," *Godey's Lady's Book and Ladies' American Magazine* 26 (May 1843), p. 217.

153. "Neighbours," *New Mirror*, December 2, 1843, p. 137.

154. Mrs. Jaudon, Hell Gate, to Mrs. Colles, Paris, July 14, 1844, in De Forest, *James Colles*, p. 203.

155. James Colles to Ringuet-Leprince, Paris, December 28, 1844, transcribed by Henry Metcalf (no. 770), Colles Papers.

156. Two armchairs from the suite, no longer retaining the original showcover, remain in family hands. The French upholstery and European cabinetmaking woods used in this suite support its attribution to Paris rather than to New York, where Ringuet-Leprince was in business during the 1850s.

The suite has previously been dated as late as about 1854, and its provenance is confused in earlier publications. Its history is made clear by a letter in the Metropolitan Museum's Archives from Emily Johnston de Forest, the Colleses' grand-daughter, to Preston Remington, dated April 10, 1931, which reads, in part: "The furniture . . . belonged to my grand-father, Mr. James Colles, who then lived at 35 University Place. It was made in Paris in 1843 by Ringuet Le Prince, the famous Parisian Cabinetmaker and upholsterer. He was the father-in-law [brother-in-law] of Leon Marcotte, who held the same position in New York from about 1850. . . ." My thanks go to Priscilla de Forest Williams, a descendant, for her assistance with the history of the Colles suite.

157. See Ringuet-Leprince, Paris, to James C. Colles, c/o C. P. Leverich, New York City, January 2, 1845, accompanied by an invoice dated December 7, 1844 (no. 772½); and October 13, 1845, accompanied by an invoice dated December 7, 1844; April 23, 1845; and September 25 [1845], translated and transcribed by Henry Metcalf (no. 804), Colles Papers. A stylistically related piece, a superlative mid-nineteenth-century ebonized table with brass inlay, large figural and other gilt-bronze mounts, and possibly European woods (beech, hickory, white pine, and oak) is in the collection of the Brooklyn Museum of Art (86.4).

158. See James Colles to Ringuet-Leprince, December 28, 1844 (no. 770, transcribed); April 23, 1845 (no. 788, transcribed); May 14, 1845 (no. 790, transcribed); December 15, 1845 (no. 809, transcribed); Ringuet-Leprince to James Colles, January 30, 1845 (no. 773, neither translated nor

was impressive: its drawing room, second parlor, and dining room were each approximately eighteen by twenty-eight feet, and the ceilings were fourteen feet high.[155] In 1843, while in Paris, Colles had selected an ebonized Louis XV–style drawing-room suite embellished with chased ormolu mounts and richly upholstered in rose, red, and ivory silk brocatelle, which survives in remarkable condition (cat. no. 236A, B). Two sofas, four armchairs, and four side chairs from the suite descended in the family, along with a center table and a fire screen with an Aubusson-tapestry panel; except for two armchairs, all of these pieces were given to the Metropolitan Museum in 1969.[156] The Colles suite is an extraordinary document—perhaps unique in the United States—of high-style French drawing-room furniture and upholstery from the 1840s.

Invoices from Ringuet-Leprince indicate that other ebonized pieces with gilt-bronze decoration were shipped to the Colleses. These included three pieces of "Buhl" furniture (a large corner cabinet with two mirrored doors and Florentine-bronze "caryatides" and two matching corner cabinets), all with brass inlays, black marble, and gilt-bronze mounts.[157]

For his second parlor, Colles chose rosewood seating furniture in the Louis XVI style, upholstered in garnet-colored plush and trimmed with silk galloon, to which he later added a second sofa and an étagère. His dining-room furniture, in the Louis XV style, was also of rosewood: an extension table, a sideboard with carved decoration and a mirror, and ten side chairs and two matching armchairs with sprung horsehair seats upholstered in tufted green morocco leather, with draperies in green fabric to match. In addition, Colles anticipated needing enormous looking glasses, "4 plates each 6 feet wide, 7 feet 7 inches high, and 2 plates for piers each 3 feet 4 inches wide by 10 feet 6 inches high English measure," and later two richly gilded Louis XVI frames and chimney glasses. For her bedroom, Mrs. Colles was to have a rosewood bedstead and armoire in the Renaissance style, and a wool-and-silk damask with wide blue-and-white stripes for the draperies, bed curtains, and coverlet, a sofa, and six chairs.[158]

A first-quality Aubusson carpet in the spirit of Louis XIV, with "fine stripes with a centerpiece," was duly ordered for the drawing room and took four months to make.[159] Ringuet-Leprince had four suggestions for the wall treatments in the drawing room and the backdrop for the black-and-gold furniture. His letter of June 1845 offers a rare insight into interior decoration during the era of Louis-Philippe (1830

to 1848), although we do not know which scheme the Colleses decided on:

The best would be to cover the walls with stuff like your curtains, hung in panels surrounded by gilt moldings. The second best way would be to panel the walls with moldings and insert in the panels Louis XIV relief ornaments, all of which would be painted white. The third way, paper the wall with crimson velvet paper, plain or damasked, and paneled with gilt moldings. The fourth way, use white and gold paper or white velvet paper, with gilt moldings.[160]

On several occasions Colles expressed interest in "old oak" furniture, regretting that he had not chosen that up-to-the-minute look instead of rosewood for his dining-room suite and also that he had not acquired an oak bookcase he had seen at Ringuet-Leprince's Paris establishment. "Old oak," known in France as "*vieux bois*" or "*vieux chêne*," was just coming into vogue at the time, in response to the desire for furniture with the appearance of age. The bookcase Colles mentioned might have resembled a Renaissance-style

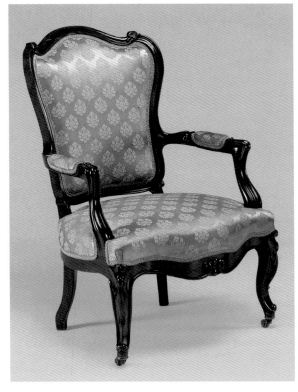

Fig. 253. Charles A. Baudouine, Armchair, purchased by James Watson Williams, Utica, New York, 1852. Rosewood, ash; replacement underupholstery and showcover. Munson-Williams-Proctor Arts Institute, Utica, New York; Proctor Collection PC.423.8

case piece illustrated in *Le Garde-meuble* in 1850 (fig. 252). Ringuet-Leprince may have had the carving done by hand, or he may have produced such pieces with the aid of new techniques that imitated the effect of carving. One, patented in England in 1840, was a pyrotechnic method of embossing wood by applying a red-hot mold under ten to thirty tons of pressure to a dampened surface. When the char was cleaned off, and any additional carving or undercutting done by hand, the end result was the appearance of "old oak."[161]

Colles's correspondence with Ringuet-Leprince continued through 1847 while the Frenchman supplied flocked wallpaper, ceiling papers, and a grand chandelier for the new Opera House at Astor Place that Colles, Morgan, and others were involved in building. With France in turmoil as a result of political uprisings in 1848, Ringuet-Leprince decided to expand his American clientele. He approached Colles about coming to New York with his brother-in-law, the architect Léon Marcotte, to set up a business that would design interiors for hotels and other buildings, supply elements such as papier-mâché and carved-wood ornaments for use as interior architectural decorations, and import furnishings made by his fabricators in Paris, Aubusson, and Lyon.[162] He

Fig. 254. Label of Charles A. Baudouine. Wood engraving, from back of imported lady's writing desk (cat. no. 237), 1849–54. Courtesy of the Museum of Fine Arts, Boston

Fig. 255. *Iron Warehouse of John B. Wickersham, No. 312 Broadway, New York.* Wood engraving by K. W. Roberts, from *Gleason's Pictorial Drawing-Room Companion,* February 4, 1854, p. 76. Courtesy of the American Antiquarian Society, Worcester, Massachusetts

transcribed); April 15, 1845 (no. 790A, translated); October 13, 1845 (no. 804, translated and transcribed), Colles Papers.

159. Ringuet-Leprince to Colles, June 16, 1845 (no. 793, translated); October 13, 1845 with detailed invoice (no. 804, invoice translated), Colles Papers.

160. Ibid., June 16, 1845 (no. 793, translated).

161. See Edwards, *Victorian Furniture*, pp. 57–61. For mentions of "old oak," see Colles to Ringuet-Leprince, letters nos. 762, 770, 773, 788, 790B, 795, 807, and 809, Colles Papers.

162. Ringuet-Leprince, Paris, to Colles, New York, March 30, 1848 (no. 846B, translated); and Colles to Ringuet-Leprince, May 9, 1848 (no. 847, transcribed), Colles Papers.

163. Colles to Ringuet-Leprince, May 9, 1848 (no. 847).

164. See Nina Gray, "Leon Marcotte: Cabinetmaker and Interior Decorator," in *American Furniture 1994*, edited by Luke Beckerdite (Hanover, New Hampshire: University Press of New England for the Chipstone Foundation, 1994), pp. 49–72.

165. See Phillip M. Johnston, "Dialogues between Designer and Client: Furnishings Proposed by Leon Marcotte to Samuel Colt in the 1850s," *Winterthur Portfolio* 19 (winter 1984), pp. 257–75.

166. See B. Silliman Jr. and C. R. Goodrich, eds., *The World of Science, Art, and Industry Illustrated from Examples in the New-York Exhibition, 1853–54* (New York: G. P. Putnam and Company, 1854), pp. 47, 52. The ebonized cabinet was also illustrated in "The American Crystal Palace," *Illustrated Magazine of Art* 2 (1853), p. 261.

167. The suite came in the form of two gifts: one (68.69.1–11) from Mrs. D. Chester Noyes, and the other (68.165.1–6) from her sister Mrs. Douglas Moffat.

168. I am grateful to Priscilla de Forest Williams for assisting me with the dating of this suite to ca. 1856, an assignment that differs slightly from that given in Gray, "Leon Marcotte."

169. Hagen, in Ingerman, "Personal Experiences," p. 578. The facts of Baudouine's life and career are drawn from a chronology prepared by Cynthia V. A. Schaffner.

170. This building is pictured on his billhead. See Anna T. D'Ambrosio, ed., *Masterpieces*

of American Furniture . . .
(Utica: Munson-Williams-
Proctor Institute, 1999), p. 84.

171. See ibid., pp. 82–84. Both the
worktable and the letter of
July 11, 1846, from which the
citation is taken, are in the
Munson-Williams-Proctor
Institute.

172. Ibid., pp. 85–87.

173. The Diary of George Templeton
Strong, edited by Allan Nevins
and Milton Halsey Thomas
(New York: Macmillan Com-
pany, 1952), vol. 1, p. 347, entry
for March 27, 1849.

174. Stephen Garmey, Gramercy
Park . . . (New York: Balsam
Press, 1984), p. 83. Garmey
states that this was said to be
the first time a professional
decorator was privately engaged
in New York, but he does not
supply a footnote.

175. The Andrews & Co. Stranger's
Guide in the City of New-York
(Boston: Andrews and Co.,
1852). Baudouine was the only
cabinetmaker or upholsterer
listed in this tourist pamphlet.

176. Ingerman, "Personal Experi-
ences," pp. 577–78. The follow-
ing descriptions and quotations
are taken from this source. The
original manuscript differs
slightly.

177. In the 7th Federal Census,
1850, Products of Industry
Schedule, Abel Swift at 53
Bowery in the Tenth Ward
reported 125 male "hands,"
and George Ebbinghausen in
the Thirteenth Ward reported
98, both firms operating in
Kleindeutschland. Baudouine's
Broadway competitors, Hutch-
ings, Roux, and Dessoir,
reported 75, 45, and 20 male
hands, respectively, in the
same census. Baudouine was
not listed in the 1850 census,
and Hagen is thus the only
source of information about
the very large size of his shop.

178. "Henry H. Leeds, Auctioneer.
MAGNIFICENT SALE of the rich-
est description of Furniture,
carved in the most elaborate
manner, covered with the rich-
est materials, and in the latest
Paris fashions, manufactured at
the well-known establishment
of Mr. C. A. Baudouin [sic] . . .
to be sold without reserve."
Home Journal, October 26,
1850, p. 3. The sale was to be
held November 5, 6, and 7.
Although no auction catalogue
has been located, the detailed
list of items published in the
Home Journal documents
the contents of Baudouine's
warerooms.

was also considering becoming involved in the silver-plating and gilding of bronze ornaments and decorative objects, because he had heard that no one in America was doing this kind of work. What Ringuet-Leprince envisioned, in short, was a comprehensive interior-design business of a kind that did not yet exist in New York. With Colles's cautious encouragement—"the great mass of purchasers, although desirous of having furniture themselves of late taste, look *very closely* at the cost"[163]—Ringuet-Leprince and Marcotte arrived in New York in the fall of 1848.

With entrée to the Colleses' elite social circles, and with Marcotte as the New York partner (Ringuet-Leprince traveled back and forth between Paris and America), the business became successful immediately.[164] Known first, while in Paris, as Maison Ringuet-Leprince (1840–48), then as Ringuet-Leprince and L. Marcotte (1848–60), and finally becoming L. Marcotte and Company in 1860 (at the time of Ringuet's retirement), the firm had a factory and showroom in New York and offered goods in a variety of styles. The French-born merchant and financier Hart M. Shiff was among its wealthy clients in the city, while those farther afield included William Shephard Wetmore of Newport, for whom a suite of ebonized ballroom furniture was made about 1853, and Samuel Colt of Hartford, who, starting in 1856, commissioned household furnishings and decorations.[165] In 1853 Ringuet-Leprince and L. Marcotte displayed several pieces at the New-York Exhibition of the Industry of All Nations, including an impressive carved sideboard (made in New York) and an ebonized cabinet with marquetry panels and gilt-bronze mounts (made in Paris).[166]

Colles's daughter Frances married the railroad executive and art patron John Taylor Johnston in 1850, and the couple moved into a new house at 8 Fifth Avenue in 1856. Their ballroom was decorated with an ebonized suite of Louis XVI–style furniture, highlighted with striking gilded mounts and yellow silk damask upholstery, ordered from Ringuet-Leprince and L. Marcotte. The Louis XVI style was just coming into vogue in Paris under the Second Empire, thanks to Empress Eugénie, the new bride of Napoleon III (see fig. 56). Seeking to emulate Marie-Antoinette, wife of Louis XVI, in whose royal palaces (the Louvre, the Tuileries, Fontainebleau, Compiègne, and Saint-Cloud) she was living, Eugénie avidly advocated the revival of late-eighteenth-century taste. In 1855 the style, dubbed "Louis Seize-Impératrice," was one of those featured at the Paris Exposition Universelle.

The Johnston suite comprised two sofas, two armchairs (see cat. no. 248), six side chairs, two lyre-back chairs, three cabinets, a table, and a fire screen, all of which descended in the family until the suite was given to the Metropolitan Museum in 1968.[167] The ebonized surface and deeply tufted sprung seats are typical of the period, but not of its eighteenth-century antecedents; the modern showcover of yellow silk damask recalls eighteenth-century fabrics. Some of the pieces incorporate fruitwood veneers (apple and pear) that are associated with French rather than American cabinetmaking. This suggests that Ringuet-Leprince forwarded at least some of them from Paris to New York. As extraordinary in its quality and provenance as the Colles furniture, the Johnston suite is a remarkable document of patrician taste in New York in the mid-1850s.[168]

Among the native-born cabinetmakers, Charles A. Baudouine played a central role, both as an enterprising cabinetmaker and as an importer of French furniture and fittings. The American-born son of a customs gauger of French Huguenot descent, Baudouine was

Fig. 256. Tiffany, Young and Ellis, retailer, Worktable, 1850–55. Papier-mâché; mother-of-pearl and gilded decoration; crimson watered silk, crimson velvet, paper; gold and mother-of-pearl sewing implements. Courtesy of Locust Grove, Poughkeepsie, New York NY0136300–00012

a self-made man, according to Ernest Hagen.[169] He started in the cabinetmaking business in 1829, married a milliner in 1833, and with her nest egg of $300 opened a small cabinetmaking workshop at 508 Pearl Street that specialized in mahogany chairs and sofas. In 1839 he moved to 332 Broadway, the first of three addresses along the thoroughfare, and five years later appeared (alongside Phyfe and Roux) in *The Gem, or Fashionable Business Directory, for the City of New York,* advertising his firm as "Chas. A. Baudouine's Fashionable Cabinet Furniture and Upholstery Manufactory and Warehouse." His business clearly expanding, Baudouine again moved northward in 1845 to a four-story building at 351 Broadway.[170] It was from there, in July 1846, that the lawyer James Watson Williams of Utica, New York, procured a rosewood-and-mahogany worktable for his fiancée. Williams was jubilant about his purchase, writing to his intended that "after looking [in] various places for a gift for you, I have selected at Baudouine's, a work table which I am sure must please you . . . the most approved French pattern."[171] In 1852, after his marriage, he returned to Baudouine, then at 335 Broadway, to purchase a suite of rosewood seating furniture upholstered in green "tapestry," which included two sofas, two armchairs (see fig. 253), and four side chairs along with a "multiform" table that was cleverly designed in halves that could serve as a center table when placed together or function separately as gaming tables, or, when the tops were closed, as individual consoles.[172]

Baudouine's reputation as one of the leading cabinetmakers of the day is supported by an 1849 entry in George Templeton Strong's diary concerning the anticipated cost of furnishing "Palazzo Strong" (on Twenty-first Street) in rosewood and red satin. "Confound the word *Dollar,*" Strong exclaimed in exasperation. "If I hadn't spent money like an extravagant fool in my bachelor days I should have enough now to be able to tell her [his much adored wife, Ellen] to march down to Baudoine's [*sic*] and order right and left whatever pleased her fancy. . . ."[173] Although Baudouine evidently did not decorate Strong's new house, he was engaged about 1851 to furnish the twin town houses built by the industrialist Cyrus West Field and his brother the lawyer David Dudley Field on Twenty-first Street, near Gramercy Park. Acting as both cabinetmaker and interior decorator, he created rooms in which "Louis XIV furniture abounded, as did Italian draperies, Greek statues, marble mantels, and frescoed ceilings."[174] By taking on the role of decorator, Baudouine was apparently ready to give Ringuet-Leprince and Marcotte a run for their money.

In 1849 Baudouine expanded again, into a much larger building (see fig. 254) at 335 Broadway, at the corner of Anthony Street. His salesroom was described in the 1852 *Stranger's Guide* as one of the greatest attractions in the city; it was said to be 275 feet long and to house an incalculable variety of costly and luxurious seating furniture as well as "various *et ceteras* of modern comfort and embellishment."[175] (A rare, perhaps unique, illustration of a contemporary New York wareroom [fig. 255] conveys some sense of such long interior spaces.) Hagen, who worked for Baudouine for about two years at this location, starting in 1853,[176] remembered his boss as a tall, gentlemanly person, "like an army officer," who spoke French fluently and "went to France every year and imported a great deal of French furniture and upholstery coverings, French hardware, trimmings, and other materials used in his shop." He states that Baudouine employed about 70 cabinetmakers and about 130 others (carvers, varnishers, and upholsterers); if these figures are correct, the firm probably was the largest cabinetmaking operation in the city.[177] Curiously, in 1850, shortly after moving into 335 Broadway, Baudouine auctioned off his entire inventory.[178] He did not display furniture at the Crystal Palace exhibition in 1853, and continued in business at this address only until May 1854, when he gave up his upholstery and furniture manufactory and temporarily opened an office at 475 Broadway. In the course of the next four decades, Baudouine turned his attention to his real estate investments and to his avocation as a four-in-hand driver. An R. G. Dun and Company report in 1856 was extremely succinct regarding the independently wealthy Baudouine: "Living on his income."[179]

Some furniture imported by Baudouine survives, including a small Rococo Revival lady's writing desk (cat. no. 237), or *bonheur du jour,* which bears Baudouine's label from the years 1849–54 (fig. 254) and is additionally stenciled "From C. A. Baudouine" with his address. The painted decoration is extremely fine, resembling contemporary enamel jewelry (see cat. no. 210) in its vibrantly colored floral bouquets and exotic birds. It also recalls the character of painted Paris-porcelain plaques set into eighteenth-century Louis XV furniture, but here the highly naturalistic articulation of roses, fuchsias, tulips, dahlias, morning glories, lilies of the valley, and forget-me-nots among lacy gold filigrees on a black ground is quintessentially of the mid-nineteenth century and clearly a product of the Second Empire.[180]

Baudouine and others imported a wide variety of papier-mâché goods, which became extremely popular

179. R. G. Dun and Company report, April 12, 1856 (New York Vol. 191, p. 1421). R. G. Dun & Co. Collection, Baker Library, Harvard University Graduate School of Business Administration.

180. See, for example, Odile Nouvel-Kammerer, *Napoléon III: Années 1880* (Paris: Éditions Massin, 1996), pp. 58–61. While cottonwood and aspen are poplars indigenous to both North America and continental Europe, they are not commonly recorded in American furniture. The attribution to France is further supported by words inscribed on the table: the right drawer is inscribed in pencil with the letter *D,* and the left with the letter *G,* suggesting a French cabinetmaker's designation of *droite* (right) and *gauche* (left). Such painted furniture also bears a resemblance to contemporary papier-mâché furniture (see fig. 256). For comparable French painted and papier-mâché examples, see Philippe Jullian, *Le style Second Empire* (Paris: Bachet et Cie, n.d.), pp. 92–93, 111.

181. Carry Stanley, "Ada Lester's Season in New York," *Peterson's Magazine* 25 (1854), p. 181.

182. Edwards, *Victorian Furniture,* pp. 124–34. In 1848 papier-mâché chairs said to be the first manufactured in the United States were exhibited at the American Institute Fair. "Scientific. Papier Mache Chairs," *Niles' National Register,* November 15, 1848, p. 316. By 1850 Henry L. Ibbotson, agent for Jennens, Bettridge and Sons (the largest British manufacturer of papier-mâché pieces), was established at 218 Pearl Street. *Home Journal,* June 8, 1850, p. 3. The next year, W. R. Fullerton, 275 Broadway, advertised his "Papier Mache Ware-Room" as the only store of its kind in America; see *Home Journal,* February 8, 1851.

183. "Diary of Town Trifles," *New Mirror,* May 18, 1844, p. 106. The worktable is inscribed in gold paint on the interior of the case.

184. "Jenny Lind at the Castle Amphitheater," *International Miscellany of Literature, Art and Science,* October 1, 1850, p. 448.

185. Burrows and Wallace, *Gotham,* p. 815.

186. Hagen, in Ingerman, "Personal Experiences," pp. 578–79.

187. Ibbotson advertisement, *Home Journal*, June 8, 1850, p. 3. See also *Home Journal*, September 14, 1850, p. 3 (pianofortes); Fullerton advertisement, *Home Journal*, February 8, 1851, p. 3; and "Chairs, Chairs," *The Independent*, May 13, 1852, p. 80.

188. The bookcase bears a large paper label with an illustration of Brooks's Cabinet Warehouse at 127 Fulton Street, corner of Sands Street, in Brooklyn. A line drawing and description of the bookcase and the engraved gold box (unlocated) were published with admiring comments by *Gleason's Pictorial Drawing-Room Companion* ("Memorial for Jenny Lind," June 21, 1851, p. 121). When the bookcase and books were given to the Museum of the City of New York, they were accompanied by a rosewood-veneered cabinet that served as a pedestal for the smaller piece. Because there are no period descriptions or illustrations of the larger cabinet, the bookcase is exhibited without it. My thanks are extended to Deborah D. Waters for allowing the Metropolitan to show the tabletop bookcase on its own, and to Amy M. Coes for her research on Brooks; see note 83 above.

189. London's fair comprised 18,109 exhibits from sixty-one foreign states, while New York's had 4,390 exhibits, one half of which were from twenty-four foreign countries. Nearly 30 percent of the American exhibits were displays of decorative arts. The New York exhibition was the first international world's fair to include painting and sculpture as well as decorative arts. This information is drawn from Janna Eggebeen, "Applied Arts at the New York Crystal Palace Exhibition, 1853–1854: Mirror to Victorian Culture," manuscript, 1999.

190. By the time of the 1853 exhibition, the sobriquet "Empire City," which expressed these cosmopolitan yearnings, was in common use. For example, Isabella Lucy Bird, an English visitor to New York in 1854, observed that the city "possesses the features of many different lands, but it has characteristics peculiarly its own; and as with its suburbs it may almost bear the name of the 'million-peopled city,' and as its growing influence and importance have earned it the name of the Empire City, I need not apologise for dwelling at some

Fig. 257. Gustave Herter, designer; Bulkley and Herter, cabinetmaker, Bookcase (detail of cat. no. 241), 1853. White oak; eastern white pine, eastern hemlock, yellow poplar; leaded glass not original. The Nelson-Atkins Museum of Art, Kansas City, Missouri (Purchase: Nelson Trust through the exchange of gifts and bequests of numerous donors and other Trust properties) 97–35

by the mid-1840s. As brightly colored as painted furniture, these were often inlaid with mother-of-pearl against a coal black ground. A mother-of-pearl-inlaid papier-mâché worktable, lined with crimson velvet and watered silk and furnished with gold and mother-of-pearl sewing implements (fig. 256), closely resembles one described as being in a New York drawing room in 1854.[181] It was probably made in England or France, although some papier-mâché goods were produced in America at least by 1848.[182] This piece was sold in New York by the "enterprising luxurifers" Tiffany, Young and Ellis, whose "brilliant curiosity shop" at the corner of Broadway and Warren Street was enlarged in 1844 by a second-story showroom where worktables and chairs were featured.[183]

Baudouine was one of many entrepreneurial manufacturers and merchants to seize upon the tremendous popularity of Jenny Lind, a Swedish soprano who was lured to America for a twenty-one-month concert tour by P. T. Barnum, who guaranteed her $150,000 plus expenses. The arrival of "the Swedish Nightingale"

was hailed as "the most memorable event thus far in our musical history," and, thanks to Barnum's advance publicity, her first American concert, on September 11, 1850, in the Castle Garden amphitheater, was attended by "the largest audience ever assembled for any such occasion in America."[184] Lind's reputation for moral virtue, which equaled the fame of her voice, helped to garner a following among homemakers, charity ladies, and writers of sentimental fiction.[185] Cabinetmakers soon recognized an audience that would respond if Lind's name were attached to their latest home furnishings. Hagen recollected:

Some of Boudouines [sic] *most conspicuous productions were those rosewood heavy over decorated parlour suits* [sic] *with round perforated backs generally known as "Belter furniture" from the original inventor* John H. Belter. *. . . At Baudouine's place this furniture was called the Jenny Lind setts* [sic], *on account of Jenny Linds singing in Castle Garden under Barnums protection at*

Fig. 258. Gustave
Herter, designer;
Bulkley and Herter,
cabinetmaker; Ernest
Plassman, carver, *Buffet*.
Wood engraving by
John William Orr,
from B. Silliman Jr.
and C. R. Goodrich,
eds., *The World of
Science, Art, and Indus-
try Illustrated from
Examples in the New-
York Exhibition, 1853–54,*
(New York: G. P. Put-
nam and Company,
1854), p. 168. The
Metropolitan Museum
of Art, New York,
The Thomas J.
Watson Library

*the time. This furniture was all the style at that
time amongst the wealthy New Yorkers. He used to
get 1200 a sett. They were generally covered in large
flowered silk brocades or brocatelle.*[186]

The Jenny Lind fad started before her arrival in
America and continued for several years after her
departure. Henry L. Ibbotson, the New York agent
for the English papier-mâché manufacturer Jennens,
Bettridge and Sons, advertised "folios bearing fac-
simile likenesses of Jenny Lind, taken from the orig-
inal," several months before the singer even arrived. In
reporting on the manufacture of fifty thousand
pianofortes in New York the previous year, the *Home
Journal* predicted, a few days after the Castle Garden
concert, that "the Jenny Lind furor will probably very
greatly increase the demand for pianos this year."
Ibbotson's competitor, W. R. Fullerton, announced
in 1851 that the Jenny Lind Cabinet and Bride-Work
Tables "would amply repay one for a visit" to his "Papier
Mache Ware-Room." The next year, the Ornamental

Iron Furniture company listed Jenny Lind sewing
chairs among its products.[187]

The magnanimous Lind donated $10,000 of the
proceeds of her Castle Garden concert to charities,
including $3,000 to the Fire Department Fund to
benefit widows and orphans. To express their grati-
tude, the firemen presented her with a copy of the
resolutions they had passed in her honor, housed in
an elaborately engraved box made of California gold,
along with a specially bound set of John James
Audubon's seven-volume *The Birds of America* (New
York, 1840–44; cat. no. 239; fig. 176). The firemen
commissioned Thomas Brooks of Brooklyn, rather
than any of the Broadway cabinetmakers, to make a
rosewood tabletop bookcase to hold the volumes
(cat. no. 238). Visible through glass-paneled doors,
the books are separated from one another by turned
ivory columns. There are two allegorical figures at the
top, on either side of a silver presentation plaque;
one, holding a lyre and a paper scroll, represents
Music and the Genius of Song; the other, resting on

length. . . ." Isabella Lucy Bird,
The Englishwoman in America
(1856; reprint, Madison: Uni-
versity of Wisconsin Press,
1966), p. 333.

191. The illustrations were engraved
under the supervision of Carl
Emil Doepler, from daguerreo-
types by H. Whittemore; the
names of the engravers, for the
most part, accompany each
image. A comparison of illus-
trations with exhibited pieces
that have survived attests to
their accuracy. I thank my col-
league Jeff L. Rosenheim for
bringing the daguerreotype
sources for the illustrations to
my attention.

192. Hagen recalled that "gorgeous
heavy carvings" were the style
about 1855–56. Ingerman, "Per-
sonal Experiences," p. 579.

193. Silliman and Goodrich, *World
of Science, Art, and Industry,*
p. 169.

194. R. G. Dun and Company re-
port, September 12, 1854 (New
York Vol. 191, p. 451). R. G.
Dun & Co. Collection, Baker
Library, Harvard University
Graduate School of Business
Administration.

195. Apparently, Herter and Bulkley
showed additional pieces. See
"The Crystal Palace," *Morning
Courier and New-York Enquirer,*
July 27, 1853, p. 3.

196. See Thomas Chippendale,
*The Gentleman and Cabinet-
Maker's Director,* 3d ed. (Lon-
don: Printed for the author,
1762; reprint, New York: Dover
Publications, 1966), pl. C. See
also Voorsanger, "From Bowery
to Broadway," pp. 61, 64–65,
244. Clive Wainright pointed
out that John Weale reprinted
Chippendale's designs in Eng-
land as early as 1834. By 1836
Weale had published *Chippen-
dale's One Hundred and Thirty-
rhree Designs . . .* (London:
J. Weale, 1834), as well as other
reprints of eighteenth-century
pattern books. See Clive Wain-
right, "The Dark Ages of Art
Revived, or Edwards and
Roberts and the Regency
Revival," *Connoisseur* 198 (1978),
pp. 95–105.

197. There are two women flanking
the salient center bay: one
(proper right) holding a paint-
er's palette and a brush (dam-
aged); the other (proper left),
a lyre and a sheet of music.
At each corner there is a male
figure, one (proper right;
fig. 257) holds a sculptor's mal-
let and a finishing chisel (dam-
aged); the other (proper left)
holds an architectural model of

a cathedral and a drawing implement.

198. The anonymous carver, no doubt an immigrant craftsman, could have been Herter himself, or may have been Ernst Plassman, who is associated with another of Herter's exhibition pieces. See note 201 below.

199. See Silliman and Goodrich, *World of Science, Art, and Industry,* p. 93, for an illustration and mention of Herter's responsibility for the design. In their text, Silliman and Goodrich describe this and the other example displayed by Brooks as rosewood étagères (pp. 12, 93), but they list this piece in their table of contents as a rosewood buffet. The *Official Awards of Juries* records Brooks as receiving a bronze medal and special notice for "Excellence of Design and Execution of Walnut Buffet" (presumably the rosewood piece under discussion here), but it omits mention of Herter in conjunction with it. Association for the Exhibition of the Industry of All Nations, *Official Awards of Juries* (New York: William C. Bryant and Co., 1853), p. 58. Curiously, Brooks is not listed at all in Class 26 (Decorative Furniture and Upholstery, including Papier-mâché, Paper-hangings and Japanned Goods) in the *Official Catalogue of the New-York Exhibition of the Industry of All Nations, 1853* (New York: George P. Putnam and Co., 1853), pp. 82–85. This illustrates the inconsistency of these sources, which must be used in tandem rather than as individual, authoritative records.

200. For an image of the Fourdinois piece, see Howe, Frelinghuysen, and Voorsanger, *Herter Brothers,* p. 39.

201. Silliman and Goodrich record Herter as the designer of this piece, but they also state that he collaborated on its construction with Ernst Plassman, a sculptor whom they credit with the carving. See Silliman and Goodrich, *World of Science, Art, and Industry,* pp. 168–69, which also states that the buffet was displayed by Bulkley and Herter. Plassman was not mentioned in either the *Official Catalogue,* where Herter alone is recorded as the author of the "richly carved oak buffet," or in the *Official Awards of Juries,* in which he received Honorable Mention for "fine Carving on Oak Buffet."

a cornucopia of flowers and holding coins in her extended hand, represents Charity.[188]

On July 14, 1853, with the opening of the New-York Exhibition of the Industry of All Nations, Brooks and other New York cabinetmakers had an opportunity to exhibit their furniture in an international forum. This world's fair, the first in the United States, was held in the Crystal Palace, a domed cast-iron-and-glass building, cruciform in plan, that was situated on Reservoir Square (behind the distributing reservoir of the Croton Aqueduct, between Fortieth and Forty-second Streets, now Bryant Park; see cat. nos. 141, 142, 179). In the scope of its international displays and in its stated mission to educate and edify the public, the fair emulated London's Great Exhibition of 1851, held under the aegis of Prince Albert. (It was approximately one third the size of the London exhibition, however, and, as a purely private enterprise, received no government support.)[189] Although not a financial success, as the London enterprise had been, the New York Crystal Palace exhibition—and, indeed, the Empire City itself—symbolized the aspirations of a nation seeking its place on the international stage of art and culture.[190] Many of the decorative arts exhibited at the Crystal Palace were illustrated in wood engravings compiled by two scientists, Benjamin Silliman Jr. and Charles Rush Goodrich, who published them in *The World of Science, Art, and Industry Illustrated from Examples in the New-York Exhibition, 1853–54* (New York, 1854). Since these engravings were based on daguerreotypes, they present a remarkably faithful record of the contents of the exhibition, clearly more accurate and detailed in the rendering of textile patterns, carving, and other decorative motifs than would have been the case before the invention of photography.[191]

Most of the American furniture shown at the Crystal Palace was characterized by the "gorgeous heavy carvings" that, in the 1850s, became the hallmark of fine furniture manufactured in the United States, regardless of whether it was Gothic Revival, Renaissance Revival, or a reinterpretation of the styles favored by eighteenth-century French kings.[192] Competitors such as Brooks, Dessoir, Herter, Roux, Ringuet-Leprince and Marcotte, and Rochefort and Skarren (see fig. 102) vied for attention with one extraordinary piece after another, many of them large buffets or bookcases profusely carved with naturalistic ornamentation. Such highly wrought furniture was seen as indicative of a mature and cultivated society and the mark of a world city. As Silliman and Goodrich noted, "The tendency of civilisation is always from plainness to

ornament. . . . The wealth, the manners, the refinement, all that relates to the social condition of a people, may be deduced from the history of their furniture. The condition of commerce, and of the industrial and fine arts, is contained in such a history, and [thus] the mutations of furniture are as important to be known as the changes of governments."[193]

It was at the New York Crystal Palace that Gustave Herter achieved public notice for the first time. The eldest son of a Stuttgart cabinetmaker, he had arrived in America five years earlier, at the age of eighteen, as one of the "Forty-eighters" who escaped political and economic turmoil in Europe by embarking for New York. He seems to have bypassed working in the Lower East Side shops as either a journeyman or an apprentice, for soon after his arrival he was employed as a silver designer for Tiffany, Young and Ellis. The Broadway cabinetmaker Hutchings took notice and introduced Herter to high-end cabinetmaking circles. By 1853, after a brief partnership with Auguste Pottier,

Fig. 259. Julius Dessoir, designer and cabinetmaker, *Armchair.* Wood engraving by John William Orr, from B. Silliman Jr. and C. R. Goodrich, eds., *The World of Science, Art, and Industry Illustrated from Examples in the New-York Exhibition, 1853–54* (New York: G. P. Putnam and Company, 1854), p. 191. The Metropolitan Museum of Art, New York, The Thomas J. Watson Library

who was to become his major competitor after the Civil War, Herter was in business with Erastus Bulkley. He was quickly recognized for his "good abilities as a designer of patterns for rich furniture."[194] From the outset, even though he initially described himself as a sculptor, Herter established himself as a designer rather than as a carver or cabinetmaker per se.

Only twenty-three when the Crystal Palace opened, young Herter was nothing if not ambitious: eager to make his mark, he designed three monumental pieces for the exhibition.[195] Displayed by the newly established firm of Bulkley and Herter, an immense three-bay Gothic-style bookcase in carved oak (cat. no. 241) was awarded a bronze medal for design and workmanship. No one remarked at the time that for the massing and outline of the piece Herter had relied heavily on the example of a Gothic bookcase by the eminent eighteenth-century British cabinetmaker Thomas Chippendale, whose designs had been reprinted by the mid-1830s.[196] Herter did, however,

make the conceit his own by altering many of the details, among them the shape of the glazing pattern on the doors, the number of spires, and the carved decorations on the base. The latter include, standing under Gothic canopies, four fully carved figures in medieval dress that represent the arts of sculpture (fig. 257), painting, music, and architecture.[197] Panels adroitly carved in deep relief are embellished with wreaths of oak leaves and acorns as well as with winding ribbons and leaves that curl around frames fashioned from rustic branches. The whole is a tour de force of the carver's art, although we do not know the identity of the talented artisan who executed the work.[198]

Herter also designed a rosewood étagère that was made and exhibited by Thomas Brooks. Whether Brooks commissioned Herter, or Herter hired Brooks to execute his design is not entirely clear.[199] But his pièce de résistance was a buffet—the form preferred by midcentury cabinetmakers for exhibition pieces

Fig. 260. Anthony Kimbel, artist; Bembé and Kimbel, cabinetmaker and decorator, *A Parlor View in a New York Dwelling House.* Wood engraving by Nathaniel Orr, from *Gleason's Pictorial Drawing-Room Companion,* November 11, 1854, p. 300. Courtesy of the American Antiquarian Society, Worcester, Massachusetts

Plassman was possibly responsible for the composition of some carved details. A sketchbook dated 1852–53, still in Plassman family hands, contains sketches of several elements on the sideboard. See Heather Jane McCormick, "Ernst Plassman, 1822–1877: A New York Carver, Sculptor, Designer and Teacher" (Master's thesis, Bard Graduate Center for Studies in the Decorative Arts, 1998), pp. 50–53, figs. 39–43.

202. Silliman and Goodrich, *World of Science, Art, and Industry,* p. 169.

203. Roux (1813–1886) arrived in New York in 1835, according to his death certificate. He started in business as an upholsterer in 1836 (according to the text on his printed labels, and the R. G. Dun and Company credit report of August 12, 1851 [New York Vol. 190, p. 397], R. G. Dun & Co. Collection, Baker Library, Harvard University Graduate School of Business Administration). He was first listed in the city directories in 1837, and listed as a cabinetmaker in 1843. (Doggett's city directory of 1842 listed Roux as an importer at 106 Bowery in the same year Longworth's listed him as an upholsterer at 478 Broadway.) He was recommended highly by Downing in the *Architecture of Country Houses* (1850), which also included several illustrations of furniture from Roux's shop. By 1855, Roux was one of the preeminent cabinetmakers in New York, as confirmed by the New York State Census, 1855, Special Schedule: Industry Other than Agriculture (New York County, Ward 8, District 1, lines 27–33, enumerated July 5, 1855), which reported that he had $20,000 in real estate, $3,000 in machinery and $30,000 in raw materials, and produced an annual product worth $144,000 while employing 120 men. In 1860, the federal census recorded a substantially larger figure ($200,000) in real and personal estate invested in the business, but a slightly smaller shop (80 men) and annual product ("furniture of all kinds, $100,000"). United States, Census Office, 8th Census, 1860, Products of Industry Schedule, New York City, Ward 8, p. 30. This information is drawn from a chronology prepared by David Sprouls.

204. Silliman and Goodrich, *World of Science, Art, and Industry*, pp. 162–63. As illustrated, Roux's black walnut sideboard had mirrored panels behind the shelves. Three related sideboards are known: the mate to this one, in the Newark Museum; a rosewood version with white marble, in the Art Institute of Chicago; and an identical oak model, with rose-colored marble, in a private collection.

205. Joseph Jeanselme, a noted Parisian cabinetmaker, showed a related example at the 1849 Paris Industrial Exposition. It is illustrated in J. M. W. van Voorst tot Voorst, *Tussen Biedermeier en Berlage: Meubel en Interieur in Nederland, 1835–1895*, 2d ed., 2 vols. (Amsterdam: De Bataafsche Leeuw, 1994), vol. 2, p. 662. In 1844, at the same exhibition, Ringuet-Leprince had shown a rectilinear version of the form, which was published by Désiré Guilmard in *Le Garde-meuble, album de l'exposition de l'industrie* (Paris, 1844), pl. 11. Roux followed Ringuet's 1844 model closely in a sideboard now in a private collection; see Eileen Dubrow and Richard Dubrow, *American Furniture of the 19th Century, 1840–1880* (Exton, Pennsylvania: Schiffer Publishing, 1983), p. 168. Seymour Guy's 1866 painting *The Contest for the Bouquet: The Family of Robert Gordon in Their New York Dining Room* (Metropolitan Museum, 1992.128) illustrates a similar sideboard in the home of a founding trustee of the Metropolitan; see *Metropolitan Museum of Art Bulletin* 50 (fall 1992), pp. 54–55.

206. See Kenneth L. Ames, *Death in the Dining Room and Other Tales of Victorian Culture* (Philadelphia: Temple University Press, 1992), pp. 44–96.

207. *Official Awards of Juries*, p. 58.

208. Pairs of sideboards are extremely unusual in post-Federal American dining rooms; this one may be unique to the 1850s. The Metropolitan's sideboard is not marked, but it can be identified by its close similarity to the wood engraving published by Silliman and Goodrich, *World of Science, Art, and Industry*, pp. 162–63. The Newark piece (92.72), the motifs of which were a departure from the canon, bears an impressed mark (A. Roux) on the top edge of one of the front drawers. The nineteenth-century provenance of the sideboards is not yet

(see cat. no. 243; fig. 102)—that was imposing both in its architectural scale and in its baroque verisimilitude. The iconography of this piece (fig. 258) was drawn from imagery of the hunt, the harvest, and the sea, motifs commonly used in dining rooms from the mid-nineteenth century on. What appears to have been a nearly lifesize stag, writhing beneath the attack of a hunting dog, is carved in the round and set inside an altarlike niche, the centerpiece of the composition. Birds and allegorical figures of plenty—Ceres holding a sheaf of wheat and two small putti perched, respectively, on piles of peaches and pineapples—are positioned on the crest, while three deeply sculpted reserves along the base are decorated with marine motifs.

This grandiose oak buffet was a calculated riposte to its show-stopping predecessor, a sideboard similar in scale and themes that was displayed at the London Crystal Palace exhibition by Alexandre-Georges Fourdinois, a prodigious Parisian cabinetmaker much patronized by Napoleon III and Eugénie, newly crowned as emperor and empress of France.[200] Herter did not hesitate to measure himself against Fourdinois, knowing that his own reputation would be enhanced by the comparison.[201] In describing this piece, Silliman and Goodrich remarked on the transformation of American furniture by European designers and craftsmen, "citizens by adoption," who, like Herter, brought with them the benefits of artistic education and training, supplemented by familiarity with "good models" of decorative art. In their minds, Herter's buffet "mark[ed] an era in our social existence—the transition period when the domestic appointments of our fathers are being replaced by the costly and elaborate furniture of Europe."[202]

Like Herter, Alexander Roux was a citizen by adoption who capitalized on his European heritage. But unlike Herter, by the time of the 1853 exhibition, Roux had been in America for close to twenty years and was already well established on Broadway, advertising himself as a French cabinetmaker.[203] He gauged his potential clientele differently than Herter did, displaying among several pieces of furniture a black walnut sideboard in the French Renaissance style (cat. no. 243 is a version of this piece), which while lavishly carved was also eminently practical. Modest in scale—a mere seven and a half feet high—the sideboard was "not too large for the use and style of moderately wealthy families."[204] This form, featuring a superstructure of shelves placed on a cabinet base, was called a *buffet étagère* in French (and dubbed an "étagère sideboard" by Downing). An invention of

the mid-nineteenth century, the type gained popularity in America about 1853 and remained a nearly ubiquitous feature in upper-class dining rooms for nearly a quarter century.[205] A stag's head framed by the heads of snarling dogs crowns the piece, while similar dogs' heads top the S-shaped scrolls supporting the lower shelf. At the sides, bold C and S scrolls are lined with wheat ears and cattails, and adorned with pendent clusters of plump, clearly defined fruits and vegetables. On the center doors, trophies of the hunt and the sea—three game birds and a hare on one, bass intertwined with a lobster, an eel, and a brace of oysters on the other—are sculpted in high relief. Although such motifs are typical of midcentury sideboards, these are distinguished by superb carving and bounteous details.[206] The jurors at the fair (William Gibson, a stained-glass maker; George Platt, an interior decorator; and John Sartain, an engraver) awarded Roux a bronze medal and "special notice" for "General Excellence in Carved and Upholstered Furniture."[207]

Among its contemporaries, the sideboard shown here is rare not only for its quality, early date, and firmly documented maker, but also because it was one of a pair, which suggests a special commission from a wealthy client, perhaps someone who had visited Roux's exhibit at the Crystal Palace. Its mate, now in the Newark Museum, is identical in form but differs in certain details. A steer's head framed by blossoms and sheaves of wheat and cattails replaces the stag and dogs at the top, for example, and the bouquets of fruits, vegetables, nuts, and berries vary slightly throughout. When paired, the sideboards contrast the untamed forest with the cultivated landscape and allude as well to the four seasons: the hunt sideboard representing fall and winter, the other the harvest months of spring and summer.[208]

Julius Dessoir, a neighbor of Roux and Herter on Broadway, has until now been best known by an engraved illustration in Silliman and Goodrich of an armchair in the Louis XIV style (fig. 259), which, as the official catalogue confirms, was one of a pair en suite with a sofa that the cabinetmaker displayed along with other pieces at the Crystal Palace.[209] Miraculously, the suite remained intact over the intervening years and was given to the Metropolitan Museum in 1995 (cat. no. 240A–C); it is presented publicly for the second time in this exhibition. Commended by Silliman and Goodrich for carving that was executed with taste and spirit,[210] this suite represents Dessoir's most ambitious work and constitutes a rare surviving example of Louis XIV Revival furniture manufactured in the United States. The tall backs, relatively

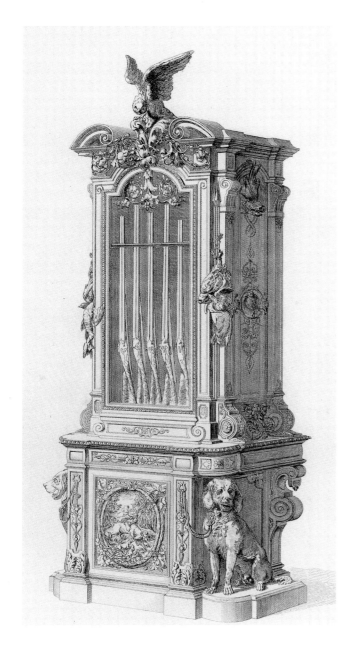

Fig. 261. Michel Liénard, designer; Jeanselme and Son, cabinetmaker, *Louis XIII Gun Case in Oak*, exhibited at the Exposition Universelle, Paris, 1855. Wood engraving, from J. Braund, *Illustrations of Furniture, Candelabra, Musical Instruments from the Great Exhibitions of London and Paris, with Examples of Similar Articles from Royal Palaces and Noble Mansions* (London: J. Braund, 1858), pl. 3. The Metropolitan Museum of Art, New York, The Thomas J. Watson Library

Fig. 262. Attributed to Alexander Roux, Sideboard, 1855–60. Black walnut. Brooklyn Museum of Art, Gift of Benno Bordiga, by Exchange 1995.15

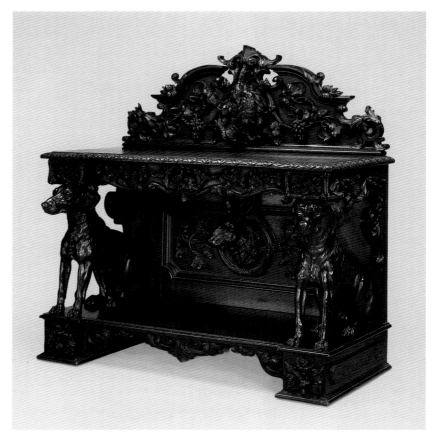

low seats, trapezoidal legs, and densely carved rosewood are aspects identified with the style. Each chair is embellished with expertly carved Rococo scrolls, cartouches, and flowers, as well as a crest on which a pair of sculpted birds flank a nest containing their fledglings. Fully carved youths and smaller putti entwined in leafy arabesques are among the elements that distinguish the sofa.

The suite is also remarkable in that each of its pieces retains its original underupholstery—an aspect of nineteenth-century American seating furniture that is so often carelessly destroyed—and thus presents a completely accurate profile. The showcover has been chosen to capture the spirit of the floral pattern on the original textile, as shown in the illustration published by Silliman and Goodrich. Although its green color

may be a surprise to some, because so much mid-nineteenth-century furniture has been reupholstered in red or purple, there is ample period documentation to support the choice. Small fragments on the Dessoir suite testify to an original showcover in sea-foam green and the contemporaneous seating furniture acquired in 1852 by James Williams from Baudouine (fig. 253) was covered in "green tapestry," according to the bill of sale. In 1854 Michel-Eugène Chevreul's seminal research into color theory, initially published in France in 1839, was issued in English for the first time, as *The Principles of Harmony and Contrast of Colours*. Chevreul's influential theories favored a palette that seems already to have been in use. The fashion editor of *Peterson's Magazine* reported in 1855 that vivid reds, cherry and orange-reds—such as scarlet, nacarat,

clear. In 1984 they were sold at auction from a house in Newport, Rhode Island, called Lansmere and were purchased by Paul Martini, a New York dealer, who sold them to Margot Johnson, who in turn placed them in their respective museums.

209. Born in Prussia in 1801, Dessoir came to America sometime between 1835 and 1841. He is listed in the city directories for the first time in 1842, as a cabinetmaker working at 88 Pitt Street. For a short while, between 1843 and 1845, he was at 372 Broadway. By 1845, and until 1851, he was located at 499 Broadway, and from 1851 until 1865, at 543 Broadway, adjacent to Belter and to

Herter, who moved to Belter's building, at 547 Broadway, in 1854. Dessoir ceases to be listed in 1866, apparently having moved to Greenburgh, New York, in Westchester County, where he died in 1884. This information is drawn from a chronology prepared by Julia H. Widdowson. See also Howe, Frelinghuysen, and Voorsanger, *Herter Brothers*, pp. 64–65.

In 1853 Dessoir also showed a bizarre octagon table with mermaidlike caryatid supports, paired rams on the apron, grotesques on the base, and lion's-head feet, along with a much-praised rosewood bookcase that is vacuous in comparison with Herter's; both were illustrated in Silliman and Goodrich, *World of Science, Art, and Industry*, pp. 175, 173, respectively. He also exhibited library and console tables that were not illustrated.

210. Silliman and Goodrich, *World of Science, Art, and Industry*, p. 191. (The authors state that the wood was black walnut.)

211. "Colors in Furniture," *Peterson's Magazine* 27 (1855), pp. 218–19. Fragments of the original showcover indicate an early form of tapestry weave, probably manufactured in northern France or in England. Nancy C. Britton deserves special thanks for her scholarly contribution to the choice of the replacement showcover, as well as for her masterly re-upholstering of these pieces. I am also grateful to Mary Schoeser for her research on 1850s furnishing fabrics in England.

212. Henry Ashworth, *A Tour in the United States, Cuba, and Canada . . .* (London: A. W. Bennett, 1861), p. 10.

213. Charles Richard Weld, *A Vacation Tour in the United States and Canada* (London: Longman, Brown, Green and Longmans, 1855), p. 367.

214. It is not clear what Kimbel was doing in New York between 1851 and 1854; it is possible, even likely, that he worked for Baudouine until establishing his own firm in February 1854. Were this the case, Baudouine's seemingly abrupt decision to close his shop in May 1854 might have been prompted by the loss of his chief designer. Bembé died in 1861, and the next year Kimbel formed a partnership with Joseph Cabus. Their firm, Kimbel and Cabus,

and aurora—for decades the most popular colors for furniture fabrics and carpets (see cat. no. 13) were now to be proscribed because they competed with the colors of mahogany and rosewood, whereas light green, by virtue of its being in contrast, was complementary not only to reddish woods but also to gilding and to complexions, whether pale or rosy. "We must assort rose or red-colored woods, such as mahogany, with green stuffs; yellow woods, such as citron, ash-root, maple, satin-wood, &c., with violet or blue stuffs; while red woods likewise do well with blue-greys, and yellow woods with green-greys. . . . Ebony and walnut can be allied with brown tones, also with certain shades of green and violet." "Just now," the editor told the reader, ". . . rose-wood sofas and chairs, covered with green cloth, are all the rage; and drawing-rooms are filled with this style, irrespective of the color of the carpet, the paper hangings, or the curtains."[211]

By the mid-1850s furniture such as the Dessoir suite would have been used in a drawing room on lower Fifth Avenue, by then the most desirable residential district. The Italianate style, with its attendant allusions to Renaissance nobility, had replaced Grecian as the favorite choice for a residence. Houses were considerably larger than they had been twenty years earlier, and travelers to New York in the 1850s and early 1860s often remarked on the magnificence of the city's mansions. One recalled visiting a drawing room (or perhaps a ballroom) that was 135 feet long; many commented on the "lavish outlay" typically expended by the inhabitants.[212] "The power of wealth here, is abundantly conspicuous," English barrister Charles Richard Weld recounted in 1855. "Every quarter of the globe has been subsidised to minister to the gratification of the merchant prince, who, despite his professions, is no longer the simple republican trader."[213] Rosewood furniture in the Rococo Revival (or "Old French") styles was considered the height of luxury for New York drawing rooms in the mid-1850s, as evidenced by a rare depiction of such a parlor from "the magnificent mansion up town of one of the most eminent . . . merchants," drawn and published in 1854 by Anthony Kimbel, an up-and-coming young cabinetmaker on Broadway (fig. 260). Kimbel, from a distinguished family of cabinetmakers, upholsterers, decorators, and furniture dealers in Mainz, Germany, apprenticed with Fourdinois and Guilmard in Paris before coming to New York about 1847. With this background, it is not surprising that he became the principal designer for Baudouine, for whom he worked from about 1848 until at least 1851. Helped by financial

backing from Anton Bembé, his uncle and partner in Germany, Kimbel established Bembé and Kimbel early in 1854, and later that year, through his drawing, showed the public what his new company could provide.[214] The interior was extolled for being a fitting abode for a man of refinement, and the furniture—executed in a kinetic, curvilinear Louis XV Revival style that, not surprisingly, relates to contemporary German designs—was praised as the production of a master hand. The author of the commentary accompanying the image observed that, in Bembé, the firm had "the advantage of an eminent European connection" but also astutely remarked that although the New York branch received all the newest European designs as soon as they appeared, "the furniture . . . manufactured . . . by Bembé and Kimbel, No. 56 Walker Street, is not altogether French in design. . . . Mr. Kimbel['s] . . . unique styles appear to be American modifications of those now in vogue abroad."[215]

This observation can be applied equally to nearly all the high-style New York furniture from this period. The Broadway cabinetmakers, most of them Europeans by birth and training, were well aware of current fashions, but, in the last analysis, furniture made in New York can rarely be mistaken for its French or English counterparts. While the Litchfield family's Parisian center table (cat. no. 244) is splendid in its gilded surface and dove gray marble top, it would not be confused with its American cousin, Roux's rosewood étagère (cat. no. 246), which is, notably, not gilded and is more richly and densely carved.[216] Similarly, although many contemporary European sofas share the general outline of Belter's elaborate rosewood sofa (cat. no. 245), few can match its Rococo Revival exuberance—carved flowers and arabesques erupt from a basket set within a dynamically undulating crest rail—or the magnificent refinement of its thin, laminated structure.[217] The extraordinary carving on a resplendent fire screen with an imported needlework panel by a yet unknown maker (cat. no. 247) almost assuredly was done in New York. The sculpted vines that wind sinuously around the standards at either side of the screen and across the crest are certainly as fine as anything of the type produced in Europe at the time. Similarly, the cabinetmaker responsible for the casework on a magnificent piano made by Nunns and Clark in 1853 (cat. no. 242) is unknown, but the masterly naturalistic carving is tangible evidence that the shop was one of the best in the business.[218]

Just at the time the Rococo Revival reached its apogee in New York, the Exposition Universelle, held in Paris in 1855, introduced new interpretations

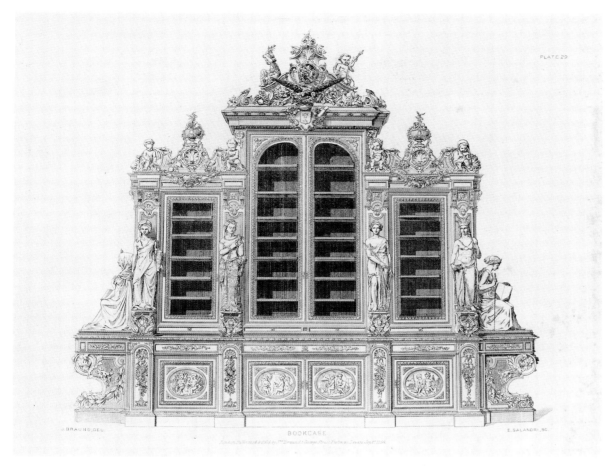

Fig. 263. Beaufils, cabinetmaker, *Renaissance Library Bookcase, Carved in Walnut*, exhibited at the Exposition Universelle, Paris, 1855. Wood engraving, from J. Braund, *Illustrations of Furniture, Candelabra, Musical Instruments from the Great Exhibitions of London and Paris, with Examples of Similar Articles from Royal Palaces and Noble Mansions* (London: J. Braund, 1858), pl. 29. The Metropolitan Museum of Art, New York, The Thomas J. Watson Library

of furniture forms, styles, and decoration that would resonate in the work of American cabinetmakers well into the next decade. Access to the visual record of the exhibition was no doubt abetted by the publication of numerous illustrations of pieces in the exhibition in John Braund's *Illustrations of Furniture, Candelabra, Musical Instruments from the Great Exhibitions of London and Paris* (London, 1858). Braund, an Englishman who in his preface identified himself as a furniture designer, envisioned his forty-nine plates as "subjects for the study of the artist in ornamental design, and as examples for the manufacturer to imitate, or improve."[219] His plate 7, for instance—a Louis XVI "Buhl" cabinet "in ebony and brass, mounted in or-molu," with gilt-bronze figural mounts and an oval plaque depicting Hercules with Cerberus, exhibited by "Charmois" (probably Christophe Charmois) in 1855—may have served as inspiration for a series of cabinets with metal plaques depicting Orpheus made by Herter between 1858 and 1864.[220] Much of the furniture at the exposition,

however, still incorporated the literal naturalism that was characteristic of the 1850s.

Braund chose not to illustrate Fourdinois's massive hunt sideboard from the 1851 London exhibition, regardless of its notoriety, perhaps because the conception did not have much practical domestic application. However, the mastiffs on Fourdinois's piece are the antecedents of the full-size hunting hounds on a piece that he did picture—a gun cabinet in the so-called Louis XIII style that was designed by Michel Liénard, manufactured and displayed at the Paris exposition of 1855 by Jeanselme and Son, and purchased by Empress Eugénie for Napoleon III (fig. 261).[221] The Jeanselme cabinet, in turn, may have inspired the canine sentinels on a black walnut server (fig. 262) that is attributed to Roux on the basis of its American woods (and perhaps because of the sense of humor shown by the cabinetmaker). Unaware of the proximity of their prey, the dogs stand at rapt attention, staring forward into space, while the rabbit, rendered totally out of scale—perhaps to indicate that it looms large in the

became known for furniture in the Modern Gothic style after the Civil War.

215. "A Parlor View," *Gleason's Pictorial Drawing-Room Companion,* November 11, 1854, p. 300.

216. Almost no gilded furniture is attributed to New York (or American) cabinetmakers of the 1850s. Two gilded, laminated rosewood sofas attributed to J. H. Belter are in the Virginia Museum of Fine Arts, Richmond, but the gilding is almost certainly a later nineteenth- or early twentieth-century addition. For an illustration of one sofa, see Cynthia Van Allen Schaffner and Susan Klein, *American Painted Furniture, 1790–1880* (New York: Clarkson Potter Publishers, 1997), p. 95.

217. John [Johann] H. Belter was born in 1804 in the village of Hilter (in the jurisdiction of Iburg) in the kingdom of Hannover, located in northwestern Germany near the Dutch border. He emigrated to the United States in 1833, became a naturalized citizen in 1839, and was first listed as a cabinetmaker in New York in 1844, at 40½ Chatham Street. The 1846 directories list him at 372 Broadway until 1853–54, when he moved to no. 547, where he stayed only through 1855. Belter's German passport and certificate of naturalization are among the papers cited in note 25 above. See also Ed Polk Douglas, "The Belter Nobody Knows," *New York–Pennsylvania Collector,* October 1981, pp. 11–12, 14–16; and Ed Polk Douglas, "The Furniture of John Henry Belter: Separating Fact from Fiction," *Antiques and Fine Art,* November–December 1990, pp. 112–19.

218. Nunns and Clark exhibited a piano, not illustrated in Silliman and Goodrich, at the Crystal Palace exhibition of 1853. Given the elaborate casework on this piece (as well as the materials used in the keyboard), it is thought that this piano might be that submission; it is clearly an exhibition piece. See Laurence Libin, "Keyboard Instruments," *Metropolitan Museum of Art Bulletin* 47 (summer 1989), p. 47.

219. J. Braund, *Illustrations of Furniture, Candelabra, Musical Instruments from the Great Exhibitions of London and*

Paris, with Examples of Similar Articles from Royal Palaces and Noble Mansions (London: J. Braund, 1858), preface (dated February 1856).

220. See Voorsanger, "Gustave Herter," p. 744, for an illustration of one of these.

221. Liénard is credited with the design of the Jeanselme and Son gun case by Denise Ledoux-Lebard, *Le mobilier français du XIXᵉ siècle, 1795–1889: Dictionnaire des ébénistes et des menuisiers* (Paris: Les Éditions de l'Amateur, 1989), p. 376. At least one other case piece in the 1855 Paris Exposition Universelle, a Renaissance-style "*buffet dressoir*" by Pierre Ribaillier and Paul Mazaroz, which was also purchased by Napoleon III, similarly utilized large sculpted hunting dogs as part of the composition. For an illustration, see Braund, *Illustrations of Furniture*, pl. 1.

222. *Ballou's Pictorial Drawing-Room Companion*, September 20, 1856, p. 188, discusses the "Gladiatorial Table" (a table supported by a carved figure of a nude gladiator holding a sword) that had been displayed at the London Crystal Palace in 1851 by J. Fletcher of Cork: "The introduction of sculpture in various forms into our drawing-rooms is a revival of the ancient classic taste, . . . Beautifully carved book-cases and buffets are now very common in our fashionable houses. Not many years since all such articles were imported from abroad, but now, in all our great cities there are manufacturers of these articles, and our American forests furnish an inexhaustible supply of material for them."

See also Howe, Frelinghuysen, and Voorsanger, *Herter Brothers*, p. 159 (the large carved dogs that served as fireplace guardians). This woodwork in Thurlow Lodge (1872–73), a Herter Brothers commission in Menlo Park, California, was once assumed to be by Herter Brothers. Rediscovered in San Francisco, where it remained throughout the twentieth century, the chimneypiece is clearly marked by Guéret Frères, a Parisian firm.

223. Burrows and Wallace, *Gotham*, p. 846.

224. "Removing upstairs" is mentioned in an advertisement placed by the auctioneer in the *New York Herald* on

Fig. 264. Édouard Baldus, *Detail of the Pavillon Rohan, Louvre, Paris*, ca. 1857. Salted paper print from glass negative. École Nationale Supérieure des Beaux-Arts, Paris PH3782

minds of its predators—looks on from the center of the backboard behind them; the rabbit's ultimate destiny, however, is reflected in the dead game suspended from the backsplash at the top of the piece. Furniture with sculpted figures such as these was acknowledged to be au courant by the American press, although American furniture with animals rendered in lifesize (or greater than lifesize) proportions is rare.[222]

The economic panic of 1857, which affected virtually everyone in New York, must have wreaked havoc with cabinetmakers' businesses, even if only temporarily. (Horace Greeley, editor of the *New-York Daily Tribune*, attributed part of the problem to a foreign trade imbalance caused by New Yorkers' lust for imported luxury goods, including "gaudy furniture.")[223] Although Roux, for example, had stellar credit ratings throughout the 1850s, in November 1857 he held a large auction sale to liquidate his entire stock "on account of removing upstairs"; the accompanying catalogue published by the auctioneer, Henry H. Leeds, lists over five hundred objects.[224] On the other hand, Bembé and Kimbel seemed to have survived in good form, thanks perhaps to the substantial wealth of the remote partner; moreover, in 1857 the firm was commissioned to make carved armchairs for the House of Representatives to the

design of Thomas Ustick Walter, architect of the United States Capitol.

The year 1858 marked a turning point, even though the economy had not yet fully recovered. Roux took on his foreman, Joseph Cabus, as a partner, although the association was short-lived.[225] Dessoir began to advertise that he was "also prepared to take orders for Interior Decorations, such as Stationary Bookcases, Wood Mantles [*sic*], Pier and Mantle Frames, Wood Chandeliers and Brackets, Figures for Newel Posts or Alcoves, &c., in every variety of Woods." George Platt, who had long since been in "decorations" (vending wallpapers and window shades, in particular, in addition to furniture, picture frames, and mirrors), ran a similar advertisement adjacent to Dessoir's in the same publication, in which he listed decorative painting, paneling, and cabinetwork as well as his other stock. He was feeling the heat of "strong competitors . . . [who] interfere materially with his bus[iness] . . ." the Dun report stated in 1858; moreover, he was "not popular." On the same page, Roux also announced the enlarged scope of his offerings, and that he was similarly ready to "execute all orders for the Furnishing of Houses," including architectural woodwork, ". . . in the best manner and at the lowest rates."[226] Meanwhile, Hutchings was "trying to get out of the bus. [and] . . . retire," although in the end he persevered and recovered financially.[227]

In 1858 Herter decided to establish his own firm, dissolving his partnership with Bulkley by mutual consent. Although not many specific details are known about Herter's activities between 1853 and 1858, he had clearly been successful in making contacts with the right architects and with wealthy clients. "Whoever selected the furniture deserves high praise for it, as well as the man who made it," *The Crayon* stated in August of that year in a squib about the Italianate house that Richard Upjohn had designed for Henry Evelyn Pierrepont in Brooklyn (see cat. no. 103). "It is said to have been furnished by Herter. We have heard of him in other places, and feel safe in predicting that he will make his mark in this country before long."[228] The trade card with which Herter promoted his eponymous firm proclaimed that he could do it all, manufacturing not only "decorative furniture" but also "fittings of banks and offices."[229]

The exact circumstances of Herter's commission to decorate the entire Italianate mansion belonging to Ruggles Sylvester Morse and his wife, Olive, in Portland, Maine (designed by Henry Austin of New Haven), are not precisely known, although it may well have been the assignment that inspired Herter to start

Fig. 265. Gustave Herter, designer and cabinetmaker; E. F. Walcker and Company, Ludwigsburg, Germany, manufacturer, Six-thousand-pipe organ for the Boston Music Hall, Methuen Memorial Music Hall, Methuen, Massachusetts, 1860–63. Black walnut. Courtesy of *The Magazine ANTIQUES*

his own business.[230] Known today as Victoria Mansion, the Morse-Libby House, the building is intact, with most of its original furnishings, carpets, French passementerie, gas lighting fixtures, French porcelains, silver, and stained glass, and many paintings and sculpture. With more than one hundred examples of

furniture and fixtures attributed to or supplied by Herter's workshop, the mansion is an extraordinary time capsule of high-style interior decor dating to about 1860.[231]

Herter was fully conversant with the most fashionable styles of interior decoration under the Second

November 5 and 7, 1857, probably meaning that Roux was contracting his space and giving up his street-level sales room. Henry H. Leeds, auctioneer, *Catalogue of Rich Cabinet Furniture Comprising a Large and Rich Assortment of Rosewood, Walnut, Oak, Buhl, and Marqueterie, at Alex. Roux & Co., 479 Broadway* (sale cat., New York: Henry H. Leeds and Co., November 11–12, 1857).

225. R. G. Dun and Company reported on December 14, 1858, that Cabus had "lately" become a partner with a small interest in the firm. Roux was said to be worth $75,000 and the business was deemed profitable, with excellent credit, and doing good business with the "best class of customers" (New York Vol. 190, p. 397), R. G. Dun & Co. Collection, Baker Library, Harvard University Graduate School of Business Administration. A subsequent report (recorded on the same page), in 1860, notes the dissolution of Roux and Cabus's partnership from the business. In 1862 Cabus joined Anthony Kimbel to form Kimbel and Cabus (1862–82).

226. Dessoir, Platt, and Roux, advertisements, *The Albion*, November 20, 1858, p. 564. R. G. Dun and Company report on Platt, October 18, 1858 (New York Vol. 367, p. 364), R. G. Dun & Co. Collection, Baker Library, Harvard University Graduate School of Business Administration.

227. R. G. Dun and Company report, February 27, 1858 (New York Vol. 190, p. 398), R. G. Dun & Co. Collection, Baker Library, Harvard University Graduate School of Business Administration. Earlier in 1857 the same company had reported that Hutchings had "removed his wareroom to the 2nd floor of the building, the 1st floor is being altered for other bs. . . ." R. G. Dun and Company report, June 24, 1857, ibid. The information on Platt and Hutchings cited here is drawn from chronologies prepared by Medill Higgins Harvey.

228. "Sketchings. The Residence of H. E. Pierrepont, Esq. Brooklyn," *The Crayon* 5 (August 1858), p. 236.

229. For an illustration, see Howe, Frelinghuysen, and Voorsanger, *Herter Brothers*, p. 80.

230. Arlene Palmer has surmised that during a trip to New York

in June 1858, Ruggles and Olive Morse commissioned Herter to decorate their new home. See Arlene Palmer, *A Guide to Victoria Mansion* (Portland, Maine: Victoria Mansion, 1997), p. 9.

231. Although nothing can equal a visit to the mansion itself, see Howe, Frelinghuysen, and Voorsanger, *Herter Brothers*, pp. 128–38; Susan Mary Alsop, "Victoria Mansion in Maine: Preserving a Rare Gustave Herter Interior," *Architectural Digest* 51 (September 1994), pp. 46, 50, 52, 54, 56; Voorsanger, "From Bowery to Broadway"; Arlene Palmer, "Gustave Herter's Interiors and Furniture for the Ruggles S. Morse Mansion," *Nineteenth Century* 16 (fall 1996), pp. 3–13 (and cover); Palmer, *Victoria Mansion*.

232. For more on this iconography, see Hugh Honour, *The European Vision of America* (exh. cat., Cleveland: Cleveland Museum of Art, 1975). For an alternate interpretation, see Palmer, "Herter's Interiors," p. 10. Prior to its publication in Braund, *Illustrations of Furniture*, pl. 29, the Bordeaux cabinet was singled out in an American periodical, "Taste in the Manufactures of Paris," *The Albion*, July 28, 1855, p. 353. The author commented, "The tendency of French designers to deal in the extravagant has been undoubtedly fostered and developed under the Empire. At the present time, to be costly is to be fashionable. . . . The present Exhibition is an evidence of this craving for gold and marble; . . . for furniture, at once uncomfortable and dazzling. The Bordeaux bookcase, carved in solid wood, is perhaps the only simple piece of French furniture in the Universal Exhibition."

233. See Malcolm Daniel, *The Photographs of Edouard Baldus* (exh. cat., New York: The Metropolitan Museum of Art, 1994).

234. Braund, *Illustrations of Furniture*, pls. 15, 18.

235. I thank Robert Wolterstorff, Director, Victoria Mansion, for this observation.

236. With regard to post-1860 British furniture, see Christopher Wilk, ed., *Western Furniture, 1350 to the Present Day, in the Victoria and Albert Museum* (New York: Cross River Press, 1996), pp. 164–65.

Empire in France, where the taste of Empress Eugénie held sway. Accordingly, and setting a standard that his firm followed for the next two decades, Herter employed the ivory-and-gold palette favored in France for the walls and woodwork of the drawing room; this was augmented by gilded mirrors and soft pastel tones in the imported carpet, silk-satin draperies, and decorative wall and ceiling paintings in the style of Louis XV. In striking contrast, opulent dark rosewood highlighted with gilding was used for the window cornices and furniture. The original champagne-colored silk upholstery punctuated by scarlet tufting buttons embroidered with gold thread on the seating furniture was trimmed with complex French passementerie (gimp and fringes) made of silk in gemstone colors.

The rosewood drawing-room furniture, conceived en suite, is unified by carved winged figures on the sofa and armchairs, center table, and console table. Herter modeled the seating furniture on a chair by Fourdinois that was published by Braund in his compendium of 1858 and which is particularly memorable for the little putti forming its arm supports, as well as for its cloven-hoof feet and hairy legs. Continuing this idea, Herter posted larger cherubs—veritable toddlers with protuberant bellies and tasseled headdresses—at the four corners of the center table. On the console table (actually a large pier table), two cabriole front legs terminate in mature female figures, one with thickly plaited braids, the other with unbound tresses, and each with a gilt-bronze turtle on her breast; these recall European allegorical depictions of America as a female Indian warrior, who often holds a tortoise. Given that Herter seems to have known Braund's publication, one of its illustrations (fig. 263), a large bookcase shown in 1855 by the French firm Beaufils from Bordeaux, is particularly relevant in this context. Of the four female figures, emblematic of the four continents, shown on the facade, America (on the far right) is depicted as an Indian with a feathered crown and long braids, and a turtle in her right hand.[232]

The masterpiece of the Morse mansion furniture is the cabinet of figured maple and rosewood that Herter designed for the reception room (shown outside the mansion for the first time in this exhibition; cat. no. 249; p. 286). Here Herter turned to the venerable Renaissance for inspiration; but it was the Renaissance as interpreted by Parisian cabinetmakers of the Second Empire, who witnessed and were clearly influenced by the architectural expansion of the "new" Louvre undertaken by Louis Visconti and Hector Lefuel starting in 1848, under the aegis of Napoleon III. This massive enterprise was well documented in photographs by Édouard Baldus (see fig. 264), and it is possible that American cabinetmakers knew the project firsthand through their travels to Paris.[233] The Herter cabinet's arched pediment (reiterated above the drawer that opens to reveal a small writing surface above the lower cabinet), salient verticality, open shelves, and solid scrolled supports at either side are all compositional devices shared with contemporary French exhibition pieces, such as Guilmard's "Renaissance" oak sideboard shown in 1855 and the walnut "Renaissance" cabinet exhibited by Jeanselme and Son in 1851.[234] Like these, Herter's cabinet is an exhibition piece. As the most elaborate object in the house, it stands alone in splendor in a small room that gives onto the reception room. Successive arched doorways and colorfully painted walls and ceiling create a theatrical framework for the cabinet (see p. 286), which, as it is on a perpendicular axis with the front hall, is one of the first things a visitor sees on entering the house.

Herter created a piece that is uniquely his, despite its similarities to contemporary French examples. His cabinet is striking for its use of the golden bird's-eye maple, which contrasts elegantly with rosewood components, among them beautifully carved caryatids with long hair and exotic, partially gilded headdresses that echo the iconography used in the drawing room; notable also are the gilded earrings on the figures above, which are echoed in the jewel-like drawer pulls on the cabinet.[235] Although maple furniture was not unknown in nineteenth-century America, ebonized wood, mahogany, rosewood, and black walnut had dominated the cabinetmaker's palette between 1825 and 1860. The predominant use of a light-colored wood (*bois clair*) accented by a darker one has antecedents in nineteenth-century French and German cabinetmaking practices and was to become more prevalent in American, and British, furniture after 1860.[236] Herter festooned this architectonic case piece with myriad decorative devices—relief-carved and partially gilded grapevines, ribbons, and a wreath, shapely urns, large rosewood rosettes, animated Renaissance-inspired scrollwork, and gilt-bronze mounts (the rectangular sunflower mount is a particular Herter hallmark) and hardware—all prioritized in a system of primary, secondary, and tertiary decoration that is one of the distinguishing features of his furniture. The oil-on-canvas panel depicting a pastel bouquet on the upper cabinet, used in lieu of a porcelain plaque, and the coquette shown in the marquetry panel below hark back to the era of Fragonard and Boucher. Such an

amalgamation of decorative vocabularies is characteristic of the Second Empire, particularly during the 1860s, but Herter succeeded in interpreting that French language in an entirely original manner.

Herter's work on the Morse mansion was nearly complete by the summer of 1860. The outbreak of the Civil War, in April 1861, interrupted his relationship with Morse, who was a hotelier in New Orleans; Morse remained in the South and did not return to Portland until 1866.[237] It is difficult to calculate the consequences of the war for cabinetmakers in New York, as business papers are virtually nonexistent, reliable accounts are hard to come by, and details gleaned from public records are scant and not always fully illuminating. By 1861 a chapter in American cabinetmaking was closing. Phyfe had died in 1854, Belter would die in 1863. Both Baudouine and Ringuet-Leprince retired once and for all in 1860. Dessoir continued to operate at 543 Broadway until 1865. Joseph W. Meeks retired in 1859, but his brother, John, continued in business until 1863. Upon the death of Bembé in 1861,

Kimbel dissolved his company, starting up again in 1862 with Cabus as his partner. The credit report issued for Roux in 1861, although otherwise excellent, described his business as "slack."[238] Herter's credit report intimated that he would survive the disruption caused by the war by applying himself "strictly to business," the business being making gunstocks for the Union Army.[239] What Dun and Company failed to mention, however, was the commission Herter had received in 1860 to design and manufacture the casework for a monumental six-thousand-pipe organ being made in Germany for the Boston Music Hall Association (fig. 265). The breathtaking product of his endeavor—equivalent in height to a five-story New York town house, gloriously carved in black walnut, and featuring a dozen sculpted herms, each more than ten feet tall—was at once a testament to the level of accomplishment achieved by cabinetmakers of the Empire City and a harbinger of the grandiloquent ambitions that would define the metropolis in the postwar Gilded Age.[240]

237. In November 1862 Morse gave Herter a deed to the house and its contents against an outstanding debt of $15,000. The discovery of this document was the first clue to Herter's authorship of the interior decorations. Palmer, "Herter's Interiors," pp. 6, 13 n. 16.

238. R. G. Dun and Company report for November 4, 1861 (New York Vol. 190, p. 397), R. G. Dun & Co. Collection, Baker Library, Harvard University Graduate School of Business Administration.

239. Ibid., October 7, 1861 (New York Vol. 191, p. 451).

240. The details of the Boston Music Hall commission are recounted in Voorsanger, "Gustave Herter."

Empire City Entrepreneurs: Ceramics and Glass in New York City

ALICE COONEY FRELINGHUYSEN

In their desire to acquire an urbanity equal to that of cosmopolitan society abroad, New Yorkers of the antebellum era surrounded themselves with the lavish physical trappings of stylish society, first and foremost with "fancy goods" imported from Europe. Local retailers proliferated in the burgeoning marketplace that served these New Yorkers, especially from the 1820s on, when a new type of commerce arose that allowed merchants to present a wide variety of wares to satisfy every need. New York overtook the ports of Boston, Philadelphia, Baltimore, and Charleston as the nation's leader in transatlantic trade after the opening of the Erie Canal in 1825. The expansion of trade between Europe and New York led to a broader representation of imported goods from a larger number of countries, making a wide range of luxury products newly available. It did not take long for entrepreneurs to recognize an opportunity in this strong marketplace, and they began to compete with the import trade by establishing domestic manufactures and producing goods similar to foreign products.

Imports

Fine porcelains from England and France were de rigueur for formal dining in the city, and a glittering assortment of richly cut European glass adorned many a sideboard. In the earliest years of the century Americans relied heavily on members of the diplomatic corps stationed in France to select fashionable ceramics and glassware and negotiate purchases for them.[1] By the mid-1820s and the 1830s, however, as numerous advertisements that appeared in newspapers demonstrate, French porcelain was readily available from shops in the commercial district of New York. For imported ceramics and glass it was increasingly retailers, rather than manufacturers and shippers, who dominated almost all aspects of the trade. Establishments such as Ebenezer Collamore (later Davis Collamore and Company), George Dummer and Company, Haughwout, Tingle and Marsh, Ovington Brothers,

Thomas A. Rees, and Baldwin Gardiner, to name only a few, could be found up and down Broadway and other commercial streets. The myriad house furnishings they offered included, in particular, English glass and French and English pottery and porcelain. Early in the century, when George Dummer opened his retail business at 112 Broadway, he advertised "a large and fashionable assortment of fine English and East India China, Rich Cut Glass, &c."[2] Decades later J. K. Kerr of 813 Broadway was selling "a large lot" of luxury dinnerware consisting of "white French China Dining Sets, for $20; elegant Tea Sets, Paris decoration, for $7; 500 dozen white French China Dining Plates, for 12s. per dozen; 800 dozen Cups and Saucers, best French, for 12s. per dozen . . . 200 dozen oval French Dishes, all sizes," as well as "Oyster Dishes, Soup Tureens, etc.," and "Gold Band Cake Plates."[3]

The social elite favored elegant white porcelain made in and around Paris. From the 1820s to midcentury most Parisian porcelain exported to America was unadorned except for a gold band, although sometimes it was further embellished with a monogram or cipher, also in gold. Lavishly decorated French porcelains were very costly. When George Hyde Clarke ordered a large number of furnishings for his estate in Cooperstown, New York, from Baldwin Gardiner's Furnishing Warehouse at 149 Broadway, his most expensive purchase was a set of dishes with hand-painted polychrome flowers on a yellow ground— "one porcelain Dining & dessr Service, rich bouquet and yellow border"—for $500.[4]

Some of the most impressive imported porcelains were specially ordered dinner services and elaborate ornamental vases that carry portraits of national heroes or topographical views of American cities. New Yorkers fully subscribed to this taste for elaboration: of all the Paris porcelain vases with American city views known to survive, those depicting New York are the most numerous. A very grand vase features a view of New York from Governors Island along with sumptuous gilding (cat. no. 250);[5] on one of a pair of smaller vases is a different view of Manhattan from

The following people were especially helpful to me in sharing their research, knowledge, ideas, and collections: Arthur Goldberg, David Goldberg, Jay Lewis, Arlene Palmer, and Diana and Gary Stradling. In addition, I benefited greatly from research conducted by Angela George, Medill Higgins Harvey, Jeni Sandburg, Cynthia Van Allen Schaffner, and Barbara Veith, particularly with regard to periodicals and New York City directories.

1. For a discussion of French porcelain imported into America, see Alice Cooney Frelinghuysen, "Paris Porcelain in America," *Antiques* 153 (April 1998), pp. 554–63.
2. *New-York Evening Post*, April 15, 1810. Dummer opened his retail business in New York in 1810. Two surviving pieces of imported porcelain bear the mark of his firm. One is an English pitcher with the arms of Cadwallader D. Colden and his wife (Colden had been one of the major promoters of the Erie Canal and an important figure in early-nineteenth-century New York). For an illustration of the pitcher and a French plate also marked by the Dummer firm, see Jane Shadel Spillman and Alice Cooney Frelinghuysen, "The Dummer Glass and Ceramic Factories in Jersey City, New Jersey," *Antiques* 137 (March 1990), pp. 706–17, ill. p. 709.
3. "French China," *Home Journal*, November 11, 1854, p. 3.
4. The bill of sale is in the George Hyde Clarke Family Papers, Division of Rare Books and Manuscripts Collections, Cornell University Library, Ithaca, New York. For an illustration of the large tureen from the service, see Frelinghuysen, "Paris Porcelain in America," p. 558, pl. 9.
5. The scene was taken from a series of twenty prints published in 1821–25 called *The Hudson River Portfolio*.

Opposite: fig. 266, left

Fig. 266. Maker unknown, French (Paris), Pair of vases depicting views of New York City from Governors Island (left) and the Elysian Fields, Hoboken (right), 1831–34. Porcelain, overglaze enamel decoration, and gilding. The Metropolitan Museum of Art, New York, Rogers Fund, 1917 17.144.1,2

Fig. 267. Maker unknown, French, decorated by E. V. Haughwout, New York City, Pitcher probably depicting view of Fifth Avenue Hotel, France, 1859–60. Porcelain, overglaze enamel decoration, and gilding. The Metropolitan Museum of Art, New York, Gift of Emma and Jay A. Lewis, 1995 1995.26

Governors Island (fig. 266, left); and another pair depicts lower Broadway and the interior of the Merchants' Exchange (cat. no. 251). The Parisian artists responsible for these pieces faithfully copied the views from a popular portfolio of contemporaneous engravings[6] but reduced the number of people visible and depicted them in fashionable attire, giving their New York scenes an air of elegant cosmopolitanism.

By the 1850s the few retailers who held the major share of the market in imported French porcelain also had acquired or had an interest in factories in Paris or in Limoges in central France, which had become a major porcelain-making center by midcentury. Now they could produce goods to their own specifications, dictating designs that would suit American tastes; the porcelain they ordered was either decorated abroad or brought to workrooms in New York for embellishment. Thomas Rees, an importer and dealer in French china at 78 Maiden Lane, advertised that he could supply his clients with "White, Band and Decorated Dinner, Tea and Dessert Ware" and "Fancy China Articles in great variety" directly from a factory in Limoges.[7] In 1850 D. G. and D. Haviland, which had a business relationship with Rees, announced that on hand at its 47 John Street showrooms were "decorated TABLE WARE and PARLOR ORNAMENTS . . . done by the house in France."[8]

Fig. 268. *Two plates with the Cipher of the President and the Arms of the United States.* Wood engraving by Robert Roberts, from B. Silliman Jr. and C. R. Goodrich, eds., *The World of Science, Art, and Industry Illustrated from Examples in the New-York Exhibition, 1853–54* (New York: G. P. Putnam and Company, 1854), p. 129. The Metropolitan Museum of Art, New York, The Thomas J. Watson Library

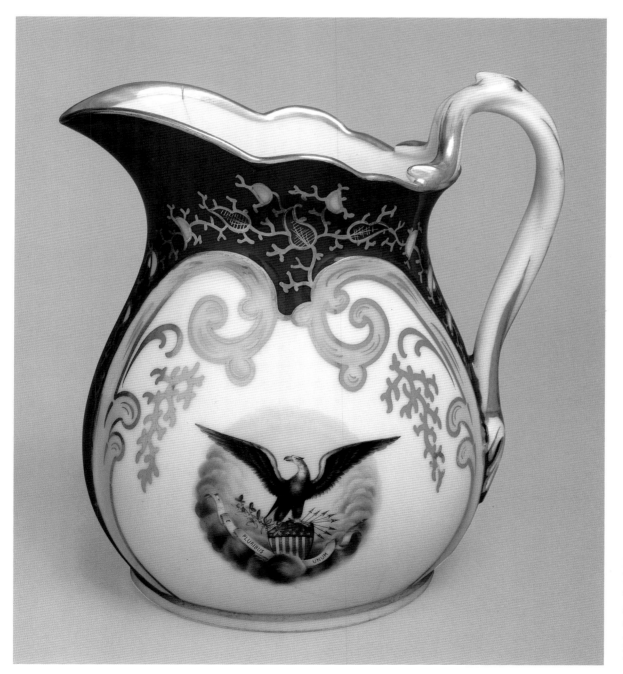

Fig. 269. Maker unknown, French, decorated by Haughwout and Dailey, New York City, Pitcher, ca. 1853–60. Porcelain, overglaze enamel decoration and gilding. The Metropolitan Museum of Art, New York, Friends of the American Wing Fund, 1996 1996.560

6. The scenes on these two vases were taken from two prints in a portfolio of thirty-nine engravings entitled *Views in New York and Its Environs*, published in New York and London by Peabody and Company, 1831–34. The two prints were engraved by Barnard and Dick; the view of lower Broadway was done from a drawing by James H. Dakin.

7. Thomas A. Rees and Company advertisement, in A. D. James, *The Illustrated American Biography . . .*, 3 vols. (New York: J. M. Emerson and Co., 1853–55), vol. 3, p. 221. Whether Rees owned the Limoges factory is not known.

8. D. G. and D. Haviland established their export firm in 1838 and became Haviland Brothers and Company in 1852. From 1846 to 1853 David Haviland was associated with Thomas Rees in the export business. See Jean d'Albis and Céleste Romanet, *La porcelaine de Limoges* (Paris: Sous le Vent, 1980), p. 133. "Porcelain," D. G. and D. Haviland, New York, and Haviland and Co., Limoges, advertisement, *The Independent*, November 7, 1850, p. 184.

9. Jean d'Albis, *Haviland* (Paris: Dessin et Tolra, 1988), p. 14.

10. "Art and Manufactures," *Home Journal*, March 22, 1851, p. 3.

11. From 1831 the Haughwout firm was controlled by a succession of different partnerships. It is cited in New York City directories as P. N. Haughwout and Son (1831–38), Woram and Haughwout (1838–52), Haughwout and Dailey (1852–54), Eder V. Haughwout (1855/56–56/57), and E. V. Haughwout and Company (1857–60/61).

12. Woram and Haughwout, 561 Broadway, "R. and G. Dun Reports," January 3, 1851 (New York Vol. 191, p. 481), R. G. Dun & Co. Collection, Baker Library, Harvard University Graduate School of Business Administration, Cambridge, Massachusetts.

13. A hotel-ware plate in a private collection carries a mark for E. V. Haughwout with both a Broadway address and a Parisian one, "24, R. de Paradis Poissre."

14. The coral-like motif in gold appears on two other Haughwout pitchers. One, for which bills survive, was ordered by Samuel Francis Du Pont from E. V. Haughwout in 1853; see Maureen O'Brien Quimby and Jean Woollens Fernald,

New York was not only a marketplace for European wares bought by its own residents but also the center for importing goods to be shipped on to many other cities, and the demand for such items grew at an unprecedented rate in our period. The quantity of wares exported by the Haviland firm alone increased from 753 barrels in 1842 to 8,594 barrels in 1853.[9] One commentator noted the range of that market: the products were for use in "hotels, steamboats, the private mansions of the rich, and the growing elegant boarding-houses, after the manner of the Clarendon [Hotel]."[10]

E. V. Haughwout's establishment on Broadway was one of the largest and oldest china and glass retailers in antebellum New York.[11] In 1850 it was purchasing as much as $60,000 worth of porcelain from one firm in Paris,[12] and it may have had its own interest in a French factory.[13] In 1849 Haughwout's established on the top floor of its three-story suite of showrooms a sizable decorating workshop, a response to the increased demand for decorated French porcelain. French-made goods could now be custom painted on the premises, greatly facilitating the process of filling orders from private consumers for personalized dinner services and from commercial establishments for wares with identifying images. Among such goods produced by Haughwout's were decorated water pitchers and cream pitchers—items much used in hotels—with an architect's rendering of what is probably the Fifth Avenue Hotel (fig. 267).

In an effort to secure presidential patronage, Haughwout's exhibited two sample dinner services at the New York Crystal Palace exhibition of 1853. An illustration showing plates from the two services was published at the time of the fair (fig. 268). One features the monogram of President Franklin Pierce; the other, in what is described in the text as the Alhambra pattern, had a blue border and in the center the great seal of the United States. A pitcher with a matching pattern displays both the seal and an elaborate gilded embellishment that includes a "coral" motif characteristic of Haughwout decoration (fig. 269).[14] Pierce ordered the first service but not the second. However, the pattern of the latter set was ultimately selected by Mrs. Lincoln for a service she purchased in 1861, with the request that the border be of "Solferino," a bright purplish red, rather than blue.[15] Haughwout encouraged his patrons to visit not just his extensive showrooms but the decorating studios as well, the province of "numbers of young women, . . . who are painting flowers, fruits, and groups of figures upon various articles, especially those large and beautiful (if rather

too brilliant) vases, now so very fashionable."[16] The last remark aptly describes three exuberant Rococo Revival style vases featured in the same illustration as the presidential plates. One of these was part of the Haughwout exhibit, and the other two were from Haviland and Company's Limoges factory. Their style, characterized by a profusion of leafy ornament that obscures the vessel form, also marks a pair of French vases from an unknown firm but probably made in Limoges specifically for export to America. These feature scenes illustrating Harriet Beecher Stowe's *Uncle Tom's Cabin*, which was first published in Paris in 1853 (cat. no. 252).[17]

A far less expensive alternative to French porcelain was white earthenware with transfer-printed decoration, a speciality of the potteries in Staffordshire, England. This attractive, durable ware became a staple in American homes throughout the antebellum period. An extensive trade between America and England commenced shortly after the War of 1812, and by the 1830s earthenware was Britain's fifth most important export to the United States.[18] In the highly competitive market of the moment the Staffordshire firms produced pottery with mainly blue underglaze transfer-printed decoration in a bewildering number of designs. Soon they began to offer commemorative wares of specifically American interest with subjects drawn from a myriad of readily available prints—of American cities, notable American buildings, and significant American events such as the opening of the Erie Canal or the celebrated arrival of General Lafayette at Castle Garden in the Battery (cat. nos. 253, 254).[19] Nearly forty different views of New York City alone appear on transfer-printed ceramics from Staffordshire.

Many of the Staffordshire firms established relationships with New York importing and retailing businesses. The Clews Pottery, for example, worked with Ogden, Ferguson and Company, commission merchants, but there are several plates with Clews marks, one transfer-printed with a scene of Lafayette's arrival at Castle Garden, that bear the inscription of John Greenfield, a New York City retailer and importer of ceramics at 77 Pearl Street.[20] New York was on Staffordshire potter John Ridgway's itinerary when in 1822 he made a special trip to the United States to establish ties with merchants and retailers. Several of the Staffordshire potteries with a large stake in the American market, such as those of Ridgway, William Adams, and E. Mayer and Son, opened their own agencies in New York to service their extensive importing and re-exporting businesses there.[21]

The Ridgway firm even developed special patterns for a line of "fine vitreous earthenware for the United States market" that it promoted at the 1851 Crystal Palace exhibition in London. Ridgway also prepared teacups in the "New American fluted shape," with simple designs printed in blue or pink and "filled in with colours."[22] A number of these New York importers considered starting their own potteries in New York. Other English products, such as relief-molded earthenware pitchers and "feather-edged" white earthenware with sponged decoration, found a ready market in America as well. Beginning in the mid-1840s figures of Parian ware and other ornamental ceramics made by the English firms Minton and Copeland were as much in favor in the Empire City as the highly decorative French vases and pitchers produced in Limoges.

Ceramics Made in New York City

The flourishing trade in French and English wares was accompanied by American expressions of concern about the extensive reliance on imported goods and its ultimate impact on the country's economic well-being. These sentiments eventually gave rise to a series of government-imposed tariffs on imports. The first protective tariff after the War of 1812 was levied in 1816, but it did little to encourage domestic production. Stronger tariff acts were passed in 1824, 1828, and 1832, and these undoubtedly acted as a stimulus for the growth of domestic manufactures, including glass and ceramics.[23] The protectionist climate of opinion was articulated in countless newspaper editorials, such as those in Hezekiah Niles's *Weekly Register*. Societies and institutes for the promotion of American manufactures sprang up, among them the American Institute of the City of New York, founded in 1827, which closely followed the new glass and ceramics industries.

The development of manufacturing in New York paralleled the tremendous growth of the Empire City, fed in part by the explosion of commercial activity in lower Manhattan after the opening of the Erie Canal. During this auspicious period, about 1814 to 1828, the manufacture of fine porcelain was attempted by three New York–area firms—Decasse and Chanou, Dr. Henry Mead, and the Jersey Porcelain and Earthenware Company of Jersey City—in an effort to break into the established market for luxury porcelains imported from France and England. Making porcelain was not an easy matter. It required specialized raw materials generally not locally available, complex

techniques, and a mastery of sophisticated kiln and clay technology. Moreover, the decorating process was more complicated for porcelain than for other wares: a great deal of labor went into the painstaking detail work of the ceramic artist and the subsequent firings of different enamel colors, and the costs of the materials, firing, and burnishing of the gilding were high. The entire undertaking necessitated large sums of capital and involved considerable risk. The three new firms that took it on had many things in common. They were founded by ambitious entrepreneurs; according to written accounts, they utilized only American materials, yet employed skilled French workers; and they all suffered continual difficulties that resulted in early failures.

Two of the firms were located on Lewis Street between Delancey and Rivington streets, in the buildings of a defunct copper factory. Henry Mead began production of porcelain on this site about 1816; a lone surviving vase is evidence of its quality.[24] Lack of capital and the inability to find suitable workers plagued the factory,[25] whose demise was reported by a New York newspaper in 1824.[26]

Louis Decasse and Nicolas Louis Édouard Chanou, both from France, took over Mead's defunct factory and established their own. A tea set with elaborate gilded decoration attests to the superb quality of the wares they produced during the three years of their partnership (cat. no. 255; fig. 270). The firm's mark is made up of the surnames of the two partners, the great seal of the United States, and the name of the city of manufacture (fig. 271)—an expression of the proprietors' pride in having made a premium porcelain from American materials in New York. Although Decasse and Chanou made porcelain comparable in quality to French products, they based the style of their tea sets on English shapes to cater to the specific tastes of the market. A similar approach was followed in France: Édouard Honoré, proprietor of the Parisian porcelain factory Dagoty et Honoré, which enjoyed a successful export trade with America, told the French minister of commerce in 1834, "For three to four years I have been producing goods to designs which the Americans have been sending me and which resemble English designs."[27]

In December 1825 the Jersey Porcelain and Earthenware Company was founded by New York City importer George Dummer in Jersey City, a block away from the glass factory he had founded the previous year.[28] This location was proximate to the New York markets; to the port of New York, which enabled the firm to attract skilled immigrant labor; and to

"A Matter of Taste and Elegance: Admiral Samuel Francis Du Pont and the Decorative Arts," *Winterthur Portfolio* 21 (summer/autumn 1986), p. 113, fig. 10. The other pitcher is in the collection of the Museum of the City of New York.

15. Margaret Brown Klapthor, *Official White House China, 1789 to the Present* (Washington, D.C.: Smithsonian Institution Press, 1975), pp. 80–82.

16. "Art Manufactures: Ornamental Porcelains," October 1853, publication unknown, photocopy, departmental files, Department of American Decorative Arts, Metropolitan Museum.

17. A number of pairs of such vases exist, in several different sizes and with varying polychrome decoration. One pair is the collection of the Museum of the City of New York; for another set, see *Nineteenth Century Decorative Arts* (sale cat., New York: Christie's East, October 27, 1998), lot 176; and for another, Jill Fenichell, Inc., New York.

18. F. Thistlethwaite, "The Atlantic Migration of the Pottery Industry," *Economic History Review* 11 (December 1958), pp. 264–78, esp. p. 267.

19. British firms were poised to act swiftly to take advantage of an eager market. In December 1824, for example, only four months after Lafayette was given a triumphal welcome in New York Harbor, transfer-printed views of the scene were being loaded onto ships in Liverpool heading to America.

20. The Clews plate with an underglaze blue-printed scene of the landing of General Lafayette is marked "J. GREENFIELD'S/ China Store/No 77/Pearl, Street./New York" (Metropolitan Museum, 14.102.288). A soup plate marked Clews bears a circular impressed mark: "John Greenfield, Importer of China & Earthenware, No 77, Pearl Street, New York." Greenfield's firm is listed in New York City directories from 1817 to 1843. See Frank Stefano Jr., "James and Ralph Clews, Nineteenth-Century Potters, Part I: The English Experience," *Antiques* 105 (February 1974), pp. 324–28.

21. John Ridgway and John Mayer each had such a presence in New York as an importer that they were listed in a New York City directory of 1846 among wealthy "non-residents" of the

city. See Thistlethwaite, "Atlantic Migration of Pottery Industry," p. 267.

22. The quotations are from a publicity handbook published by Ridgway for its Crystal Palace exhibit. The line of earthenware included services described as "Montpelier Shape, Light Blue Palestine," "Flowing Mulberry Berlin Vase," and "White China Glaze Ware" (nos. 340–42). A copy of the handbook is at the Bodleian Library, Oxford; the text is reproduced in Appendix III of Geoffrey A. Godden, *Ridgway Porcelains,* 2d ed. (Woodbridge, Suffolk: Antique Collectors' Club, 1985), pp. 221–54, with United States references on pp. 221–22.

23. F. W. Taussig, *The Tariff History of the United States,* 5th ed. (New York: G. P. Putnam's Sons, 1900), pp. 68–69.

24. The vase is in the Philadelphia Museum of Art. See Alice Cooney Frelinghuysen, *American Porcelain, 1770–1920* (exh. cat., New York: The Metropolitan Museum of Art, 1989), pp. 78–79, no. 4.

25. In 1820 Mead petitioned the New York Common Council to discuss the "practicability of employing the paupers in the Alms House and criminals in the Penitentiary in the manufacture of porcelain." Quoted in Arthur W. Clement, *Our Pioneer Potters* (New York: Privately printed, 1947), p. 66.

26. *Commercial Advertiser* (New York), December 1824.

27. Quoted in Régine de Plinval de Guillebon, *Paris Porcelain, 1770–1850,* translated by Robin R. Charleston (London: Barrie and Jenkins, 1972), p. 303.

28. The company was incorporated on December 10, 1825. Its establishment was announced eight months later by Hezekiah Niles, an avid promoter of American manufactures; see "Manufactures, &c.," *Niles' Weekly Register,* August 12, 1826, p. 422.

29. Ibid.

30. Thomas Tucker to General Bernard, January 31, 1831, Tucker Letter Books, Rare Book Collection, Philadelphia Museum of Art Library.

Fig. 270. Decasse and Chanou, Two plates, or stands, from tea service (cat. no. 255), 1824–27. Porcelain with gilding. The Metropolitan Museum of Art, New York, Lent by Kaufman Americana Foundation

important waterways—a strategic placement that served as a model when porcelain factories were established in Brooklyn two decades later. Employing a labor force said to number nearly one hundred, presumably made up of both immigrant and native-born workers, it was the largest pottery in operation in America at the time. Its wares, based like Mead's on current French styles, were reputedly "executed with great ingenuity and perfection, after the finest models of the antique."[29]

In spite of the quality of their products, all three of these early enterprises were too hampered by the difficulties of porcelain making to compete economically with French firms. Moreover, it was speculated that the French were taking advantage of a lax customs office in New York to avoid paying the tax on imports. Thomas Tucker, then director of a porcelain firm in Philadelphia, wrote in 1831 to United States Senator Simon Bernard: "I suffer materially from the duplicity of the French Manufacturers. They are continually in the habit of shipping porcelain to

New York under a false invoice below the real market value of the article, and by this means evade a part of the duty."[30]

Although competition with European porcelain making proved impossible, an initiative in another type of ware had a very different outcome. In 1828 David Henderson, a Scotsman, together with his brother James, purchased Dummer's defunct factory. The following August it was noted in *Niles' Weekly Register* that "The manufacture of a very superior ware, called 'flint stone ware' is extensively carried on

Fig. 271. Detail of mark from tea service made by Decasse and Chanou (cat. no. 255; fig. 270)

by Mr. Henderson, at Jersey City, opposite New York. It is equal to the best English and Scotch stone ware, and will be supplied in quantities at 33⅓ *per cent.* less, than like foreign articles will cost, if imported."[31] The Henderson pottery was to enjoy a twenty-seven-year success.[32] It supplied modestly priced ceramics for the growing market of consumers who could not afford expensive French porcelains, with their painted and gilded decoration. The Hendersons relied heavily on English designs, experimented with different clay bodies and modes of decoration, and based their methods and factory practices on those of Staffordshire firms. The Henderson brothers' systems were new in America and became the model for a significant reorganization of pottery making here. The process was divided into parts according to the skills and functions involved, and the resultant assembly-line method yielded newly standardized products while it saved time. The earliest wares were thrown on a potter's wheel and then decoration was applied (see cat. no. 256), but within a few years the manufacture had become increasingly mechanized: more economical molds were used to form the shape of the vessel and its decoration at the same time (see fig. 272). The wares that were produced featured elaborate relief decoration and were strong and light bodied.

Responding to market demands, utilizing the native skill of immigrant workers, and in some cases actually fabricating products from English molds,[33] the Hendersons manufactured pottery with a high degree of Englishness. Pitchers from the Ridgway pottery are closely imitated by the Hendersons' version in the Herculaneum pattern, which is ornamented on the body with such popular classical motifs as scrolls, anthemia, and satyrs' masks (or a vine-crowned Pan), and, on the handle, with a figure of Pan (cat. no. 258).[34] This ware, and in particular "a pair of very handsome and much admired pitchers," was described in 1829 as "equal to the best English and Scotch stone ware."[35] Another pitcher with naturalistic Rococo Revival decoration, this one depicting leaves, acorns, and berries, is a virtual duplicate of a Ridgway model (cat. no. 257).[36] However, a third pitcher, while borrowing an English form, displays what appears to be a uniquely American relief decoration of thistles (perhaps a reference to the Hendersons' native Scotland) on a stippled background that calls to mind patterns used in pressed glass (cat. no. 259). While pitchers were the dominant vessel form made by the firm, an 1830 price list shows that its inventory included butter tubs, coffeepots, teapots, spittoons, flowerpots, and

Fig. 272. D. and J. Henderson Flint Stoneware Manufactory, Jersey City, New Jersey, Pitcher, 1828–33. Stoneware, press-molded with applied decoration. The Metropolitan Museum of Art, New York, Gift of John C. Cattus, 1967 67.262.11

inkstands.[37] The most expensive item on the list, the Herculaneum pitcher (cat. no. 258), with its elaborate "embossed" design, sold for $13.50 per dozen. The price list reveals that the Hendersons did not sell directly to consumers but instead relied on retailers to buy and disperse their wares.[38]

In 1833, when the business was reorganized as the American Pottery Manufacturing Company (often abbreviated in the factory mark to American Pottery Company), refined white earthenwares were added to its line of English-style ceramics of medium price; an advertisement in a Washington newspaper specified "cream-color ware, dipped ware, painted and edged earthenware."[39] The firm also produced edged wares, white earthenware with a molded edge design of impressed lines; one surviving piece is a large dish bearing the mark "American Pottery Company" that has both a molded shell edge and sponged decoration in blue (cat. no. 260). English edged wares were being shipped to American markets by the boatload, but American-made examples are extremely rare,

31. "Glass and Earthen Wares," *Niles' Weekly Register*, August 1, 1829, p. 363. The word "flint" had been associated with stoneware since the eighteenth century, when flint was a component of English white salt-glaze stoneware.

32. The D. and J. Henderson Flint Stoneware Manufactory was reorganized in 1833 as the American Pottery Manufacturing Company. In 1845 David Henderson was killed in a shooting accident, but the pottery continued in business until about 1855. For more information on the Jersey City potteries, see Diana Stradling and Ellen Paul Denker, *Jersey City: Shaping America's Pottery Industry, 1825–1892* (exh. cat., Jersey City: Jersey City Museum, 1997).

33. The Hendersons acquired at least one master mold from a defunct British factory: the mold for their hound-handled hunt pitcher from the former

Phillips and Bagster Pottery in Staffordshire. See Stradling and Denker, *Jersey City*, p. [3].

34. The Ridgway example appears as design no. 1 in the factory pattern book. See Godden, *Ridgway Porcelains*, p. 141, fig. 155.

35. *Niles' Weekly Register*, August 1, 1829, p. 363.

36. The pitcher matches a design in a pattern book of William Ridgway and Company. For an illustration, see R. K. Henrywood, *Relief-Moulded Jugs, 1820–1900* (Woodbridge, Suffolk: Antique Collectors' Club, 1984), p. 63, fig. 43.

37. "List of Prices of Fine Flint Ware, Embossed and Plain, Manufactured by D. & J. Henderson, Jersey City, New Jersey," 1830, reproduced in *Antiques* 26 (September 1934), p. 109.

38. In about 1840 the Jersey City works employed an agent in New York, retailer George Tingle, to sell its products. According to the "R. and G. Dun Reports," January 23, 1854, Tingle, originally from England, "has been agent for the American Pottery Co. of New Jersey for the past 15 yrs, giving them entire satisfaction. He also commencd the crockery bus last Spring cor Pearl St & Peck Slip, under the style of Tingle & Marsh, & for that bus import most of their goods. . . ." April 9, 1855: "continues his Agency of the Amer Pottery Co." Marsh and Tingle, November 30, 1855, "lost his agency of The American Pottery Co." (New York Vol. 342, p. 288), Baker Library, Harvard University Graduate School of Business Administration. I thank Diana Stradling for bringing the Marsh and Tingle reference to my attention.

39. *The Intelligencer* (Washington, D.C.), July 16, 1833, quoted in Stradling and Denker, *Jersey City*, p. 8.

40. George L. Miller, Ann Smart Martin, and Nancy S. Dickinson, "Changing Consumption Patterns: English Ceramics and the American Market from 1780 to 1840," in *Everyday Life in the Early Republic: 1789–1828*, edited by Catherine E. Hutchins (Winterthur, Delaware: Henry Francis du Pont Winterthur Museum, 1994), pp. 219–48.

41. The House Furnishing Warehouse of Baldwin Gardiner, 149 Broadway, sold to George Hyde Clarke of Cooperstown, for his daughter, "One dining

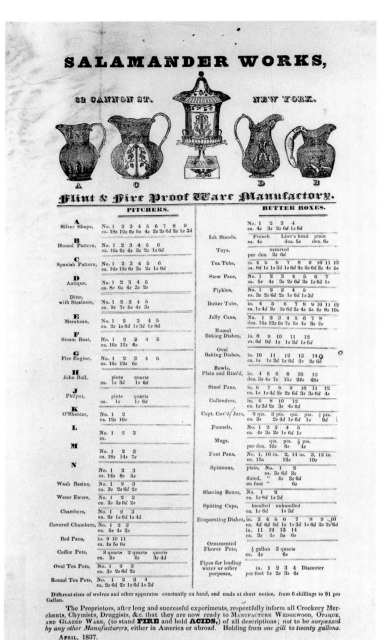

Fig. 273. Advertising broadside for Salamander Works, 62 Cannon Street, New York, 1837. Wood engraving. Collection of The New-York Historical Society, Bella Landauer Collection

suggesting that it was nearly impossible for American manufacturers to undercut the English competition in this type of ceramic.[40]

The Hendersons' ongoing need to attract consumers and stave off the competition of the Staffordshire potteries led them to initiate a line of transfer-printed white earthenware. Several plates with the mark of their pottery display a blue transfer-printed design in the popular Canova pattern (cat. no. 262) that is virtually identical to English examples.[41] The company's response to the 1840 presidential campaign of the business-friendly Whig politician William Henry Harrison was a hexagonal pitcher that featured three transfer-printed images on each panel, showing the candidate's portrait in the center, a log cabin at the top, and the great seal of the United States at bottom (cat. no. 263). Despite its efforts, however, the firm could never fully compete in the market for white earthenware. It did succeed in dominating the molded ware market by hiring talented modelers and designers, among them Daniel Greatbach and James Carr, both trained in Britain. The experience and earnings these two acquired in Jersey City enabled them to move on to other pottery enterprises in America.[42]

The Hendersons' most serious competition was Salamander Works, which was founded as a firebrick

Fig. 274. Salamander Works, New York City or Woodbridge, New Jersey, "Antique" ale pitcher, 1837–45. Stoneware, press-molded with applied decoration. Collection of Mr. and Mrs. Jay Lewis

Set, Blue Canova," consisting of dozens of dinner plates and a wide variety of serving dishes. The cost for the entire service was $25; Clarke paid $500 for an imported French dessert service with elaborate floral decoration on a yellow ground. The bill of sale is in the George Hyde Clarke Family Papers, Division of Rare Books and Manuscripts Collections, Cornell University Library, Ithaca, New York. Thomas Mayer of Staffordshire exported more ware in the Canova pattern to America than any other maker. See Ellen Denker and Diana Stradling, Exhibition Label Checklist for "Jersey City: Shaping America's Pottery Industry, 1825–1892," typescript, Jersey City Museum, 1997, p. 9.

42. Daniel Greatbach left the American Pottery Manufacturing Company about 1851 and probably went directly to Bennington, Vermont, where he worked for Christopher Webber Fenton's United States Pottery Company until it closed in 1858. He later started a pottery in Peoria, Illinois; after it failed in 1863, he returned to New Jersey. James Carr left the Jersey City works in 1852 first to found a pottery in South Amboy, New Jersey, and then start one in New York. His successful New York City Pottery operated from 1856 to 1888.

43. American Institute Fair Report, 1835, in M. Lelyn Branin, *The Early Makers of Handcrafted Earthenware and Stoneware in Central and Southern New Jersey* (Rutherford, New Jersey: Fairleigh Dickinson University Press, 1988), p. 186.

44. Salamander Works Advertising Broadside, 1837, Bella Landauer Collection, New-York Historical Society.

45. The Cartlidge factory brought in feldspar from Connecticut and china clay from Delaware.

46. Edwin Atlee Barber, *Historical Sketch of the Green Point (N.Y.) Porcelain Works of Charles Cartlidge & Co.* (Indianapolis: Clayworker, 1895), pp. 7–9.

47. Godden, *Ridgway Porcelains*, p. 169.

48. Walt Whitman, "Porcelain Manufactories," *Brooklyn Daily Times,* August 3, 1857, in *I Sit and Look Out: Editorials from the* Brooklyn Daily Times *by Walt Whitman,* edited by Emory Holloway and Vernolian Schwarz (New York: Columbia

pottery on Cannon Street between Rivington and Delancey streets, directly behind the original location of the Decasse and Chanou porcelain works. Operated by Michel Lefoulon and Henry Decasse, both from France, the Salamander Works produced several vessels remarkably close in design to those made by the American Pottery Manufacturing Company. The first mention of refined ware produced by Salamander dates to 1835, when the American Institute awarded its proprietors a diploma for "a fine specimen of flint stoneware."[43] In 1837 the company published an illustrated advertising broadside that boasted that it was ready to "manufacture Wedgewood [*sic*], Opaque and Glazed Ware (to stand Fire and hold Acids,) of all descriptions; not to be surpassed by any other Manufacturers, either in America or abroad."[44] A large ceramic water cooler that advertises the pottery and its location in applied clay letters (cat. no. 264) demonstrates the same spirit of vigorous marketing. The pottery remained at the Cannon Street location until 1840, when it was moved to Woodbridge, New Jersey. Salamander's wares, like those produced by the Hendersons' firm, were based on English relief-molded examples. Illustrations of four such pitchers appear as a decorative heading on the company's broadside of 1837 (fig. 273). The first, A, is the simplest, with stylized anthemia around the base. Example B shows a hound handle and a hunt scene. Vessel C is a bulbous-bodied pitcher called "Spanish Pattern" (cat. no. 266). And the last, D, titled "Antique" (fig. 274) is similar to the Hendersons' Herculaneum pitcher (cat. no. 258). The broadside enumerates fourteen different pitcher designs; however, by 1857 the Salamander Works had all but given up the production of such tableware and had reverted to its earlier industrial product line of firebricks, pipes for sewers and drains, tiles, and garden ornaments.

A new demand—for molded ware made of a hard, durable porcelain suitable for use in hotels and porterhouses—prompted the establishment of new manufactories around New York City. Several ambitious entrepreneurs constructed porcelain factories across the river from Manhattan, in the Greenpoint section of Brooklyn, on Newtown Creek. The location was ideal—close to the largest consumer market in the country and also readily accessible by navigable waterways, along which barges could deliver the raw clays required."[45] It is useful to examine one such factory in detail, to gain insights into the tremendous changes that had taken place since the demise of the Decasse and Chanou porcelain enterprise in 1827. The two decades that followed saw crucial developments in

New York, including a wave of energetic entrepreneurship, technological advances, an increase in the number of immigrant workers, and the growth of the middle-income market.

These changes are all reflected in the progress of the firm Charles Cartlidge founded in 1848. Cartlidge, a manufacturer whose origins were in retailing, possessed a firm understanding of the consumer markets for ceramics and glass. An Englishman from the Staffordshire potting district, he began his career in New York in 1832 as an agent for the Staffordshire firm of William Ridgway at 103 Water Street."[46] The demand for goods was growing, Ridgway products were among the most widely sought English earthenwares in America, and in 1841 Cartlidge expanded the business, taking on Herbert Q. Ferguson as a partner to handle operations in New Orleans. Ferguson may have convinced Ridgway of the opportunities for manufacturing in the United States, for in the early 1840s Cartlidge and Ridgway made plans to open a factory in Kentucky."[47] But that enterprise failed and the entire Ridgway firm went out of business in 1848. At that point Cartlidge purchased land in Greenpoint, determined to build his own factory. His first porcelain products were actually fired at the Hendersons' American Pottery Manufacturing Company in Jersey City, but soon Cartlidge's own works was in full-scale operation.

Unlike the earlier generation of New York porcelain factories, which catered exclusively to a taste for high-style, foreign-looking tableware, the Cartlidge firm and its competitors directed their efforts toward the burgeoning market of tradespeople and other members of the middle class, and they did so with a completely new range of products. Walt Whitman, that great chronicler of life in nineteenth-century Brooklyn, in his series of essays for the *Brooklyn Daily Times* wrote a rare eyewitness account of Cartlidge's porcelain factory that leaves an indelible image.[48] The factory scene becomes a metaphor for the times, its array of activities and goods paralleling the speed, bustle, and activity of New Yorkers on Broadway. Whitman located the Cartlidge porcelain factory squarely in the center of the swirl of revolutionary changes taking place in America at large. He cited in particular the company's large number of patented innovations, comparing the new manufacture of doorknobs and doorplates made of porcelain to such inventions as crinoline skirts, gutta-percha, lucifer (friction striking) matches, and street sweepers.

Cartlidge's three-story porcelain works was organized vertically by function. The ground floor was devoted to the storage of raw materials and their

Fig. 275. Charles Cartlidge and Company, Greenpoint (Brooklyn), New York, Doorplate depicting New York Harbor (enlarged), painted by Elijah Tatler, 1848–50. Porcelain with overglaze enamel decoration. Private collection

preparation in various stages. The second floor was the modelers' room, the core of the operation. Here, by means of costly molds that were difficult to produce, the processed raw material was transformed "with marvelous rapidity" into a wide array of unfired forms. These proceeded assembly-line fashion to the dipping kiln, a second firing, and finally to the decorating rooms on the third floor for enameling and gilding, after which they were fired again. Tableware produced included cups and saucers, fine dishes, and enormous ornamental pitchers. Porcelain "trimmings" formed a mainstay of the business, however, bringing the material into a realm hitherto undeveloped. Such trimmings included everything from doorplates of all types to piano keys (said to have been a Cartlidge invention), inkstands, clock faces, buttons, and speaking tubes. As Whitman declared, the quantities as well as the varieties of objects produced were extraordinary: "[of] barrels of 'castor-wheels' for beds and sofas, . . . door-knobs, plain and ornamented, there were enough to supply half the doors in the district, [and] of bell-handles there were enough to break all the bell-wires on the South Side. . . . there were more than sufficient numbers for church-pews, done in nice white and gold letters, than will be called for . . . for some time to come."[49] The decorating rooms contained a "profusion of petty wonders," including "some half dozen costly and richly ornamented 'presentation pitchers' intended for various societies, the least of which was capable of holding a pail of water."[50] Two of the gallon-sized pitchers

were made to be presented to the Assembly and the governor of the State of New York (see cat. no. 267) by the Manufacturing and Mercantile Union, an organization intent on protecting the interests of manufacturers in New York.[51]

The aesthetic merits of the wares elicited far less comment than their novelty and durability, qualities that preoccupied much of New York in this era of invention. Yet the general impression conveyed by these porcelains was of a profusion of decoration, "glittering with gold and variegated colors." Unlike the wares of an earlier generation, which were strict replications of foreign wares, works produced in this period began to display an element of native pride. A diminutive doorplate, for example, featured a delicately painted view of New York Harbor seen from Brooklyn (fig. 275). Pitchers, the staple of the firm's manufacture, featured relief decoration depicting native plants—cornstalks and oak trees—and sported eagles and versions of the United States shield. Of the known surviving pitchers, many were presentations to individuals who could be described as tradesmen—butchers, sailmakers, and coopers, for example—or were made for use in the growing numbers of establishments devoted to leisure and refreshment, such as hotels, boardinghouses, saloons, and porterhouses. One pitcher was presented to Edmund Jones, the proprietor of the Claremont, a popular resort hotel on the Bloomingdale road in New York (cat. no. 268). The vessel bears his name and the name of the hotel and is further inscribed "American Porcela[in]" on one of

University Press, 1932), pp. 132–38.

49. Ibid., p. 137.

50. Ibid., p. 136.

51. For further information on these pitchers, see Alice Cooney Frelinghuysen, *American Porcelain, 1770–1920* (exh. cat., New York: The Metropolitan Museum of Art, 1989), pp. 108–9.

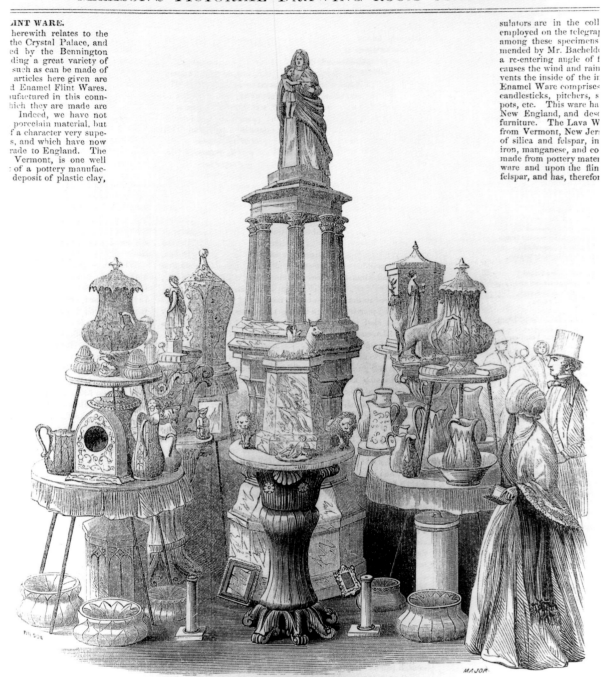

.INT WARE.
herewith relates to the
the Crystal Palace, and
ed by the Bennington
ding a great variety of
such as can be made of
articles here given are
d Enamel Flint Wares.
ufactured in this coun-
hich they are made are
Indeed, we have not
porcelain material, but
f a character very supe-
s, and which have now
rade to England. The
Vermont, is one well
: of a pottery manufac-
deposit of plastic clay,

sulators are in the coll
employed on the telegra
among these specimens
mended by Mr. Bacheld
a re-entering angle of t
causes the wind and rain
vents the inside of the in
Enamel Ware comprises
candlesticks, pitchers, s
pots, etc. This ware ha
New England, and des
furniture. The Lava W
from Vermont, New Jer:
of silica and felspar, in
iron, manganese, and co
made from pottery mater
ware and upon the flin
felspar, and has, therefor

PORCELAIN AND FLINT WARE, EXHIBITING AT THE CRYSTAL PALACE.

Fig. 276. *Porcelain and Flint Ware, Exhibiting at the Crystal Palace*. Wood engraving by Richard(?) Major, from *Gleason's Pictorial Drawing-Room Companion*, October 22, 1853, p. 266. Courtesy of the American Antiquarian Society, Worcester, Massachusetts

52. For further information on this pitcher and an illustration of the Claremont, see ibid., pp. 110–12.
53. Whitman, *I Sit and Look Out*, p. 133.
54. Ibid., p. 137.

the stripes of the American shield it displays, and thus it served a multiple purpose: dispensing a beverage, honoring a hotel, and promoting the porcelain works.[52]

Porcelain, that most exalted of the ceramic medi-ums, had entered, as Whitman suggests, "the modest dwelling houses of moderately well-off and poorer classes," a public that would particularly appreciate the product's durability.[53] He vividly recounts how a

factory guide gave a dramatic demonstration of the porcelain's soundness by making "a rash and frantic blow at a tray of these polished and semi-translucent articles, which sent them flying over the floor."[54] The guide then offered the items for inspection to demon-strate that all were intact.

Two Greenpoint porcelain manufactories exhibited their wares at the 1853 New-York Exhibition of the

Industry of All Nations held at the Crystal Palace. New York was deemed the most auspicious site for this fair, America's first great international exposition, "because of its great advantages as a commercial centre, and as the chief entrepôt of European goods."[55] As at the 1851 Crystal Palace exhibition in London, ceramics were among the most widely represented of the useful arts, coming from nations across the world. "The display of fine porcelain," it was written of the New York exposition at the time, "and of objects illustrating several other branches of the ceramic art, is one of the remarkable features of the place, and it is little to say, that it has proved a most novel and instructive spectacle to those who had not before seen the great National Museums of Europe."[56] Of the seven ceramics entries from the United States, those submitted by the two Greenpoint firms made a creditable showing. Charles Cartlidge and Company displayed a "Porcelain tea table and fancy ware" in addition to "door trimmings and sign letters." William Boch and Brothers showed "Stair rods and plates of decorated porcelain. Plain and gilded porcelain trimmings for doors, shutters, drawers, &c."[57] Several other firms, Haughwout and Dailey and Joseph Stouvenel and Brother among them, also exhibited decorated porcelains.

The most impressive of the American exhibits, however, was submitted by a New York retailer, O. A. Gager and Company, representing the United States Pottery Company in Bennington, Vermont. The official catalogue's modest entry describing the work simply as "Fenton's patent flint enameled ware" did not prepare visitors for the ten-foot-high monument made of ceramics that confronted them (cat. no. 270). Singled out by Horace Greeley as an exhibition "which is well worthy of observation by all those who take delight in the progress of American art and skill,"[58] the display was depicted in a woodcut published on the front page of the Boston newspaper *Gleason's Pictorial Drawing-Room Companion* (fig. 276). The monument and the utilitarian objects that surrounded it demonstrated the diversity of the United States Pottery Company's wares and presented examples of the varied clay bodies and glazes for which the firm became well known. The monument itself had four levels. At the bottom was a base of scroddled ware, that is, different colored clays mixed to resemble veined marble. Next came a columnar octagonal section made of the firm's yellow ware, with its famed color-flecked flint enamel glaze. The third section once contained a bust in Parian ware of Christopher Webber Fenton, the founder of the pottery and the inventor of new types of ceramic wares and glazes,

surrounded by a screen of Corinthian columns made of scroddled ware. Resting on the columns was a flint enamel glazed cap that also served as the base for a statue in Parian ware of a Madonna-like figure holding a child and a Bible. Stacked on the floor and on tiered display tables around the monument was a large assortment of practical and ornamental wares, from plates and pitchers to watercoolers and statuettes, all in the firm's signature types of ceramic. In its size and elaborate massing, the United States Pottery Company's display seemed to echo the aesthetic of the Crystal Palace itself. New York, then, was not the only locus of innovative pottery making.

In the New York area Greenpoint remained the center for the manufacture of Parian and heavy-grade porcelain throughout the nineteenth century. Cartlidge's firm remained in business until 1858; William Boch and Brothers (see cat. no. 269) was in operation during approximately the same period, from at least 1844 until 1861 or 1862. And in 1860 Thomas C. Smith founded the Union Porcelain Works, which later became the preeminent porcelain works in Brooklyn and, in spite of increasing competition from the whiteware firms in Trenton, New Jersey, remained a leading manufacturer in the field of hotel china until the early 1920s.

Glassware Made in New York City

The period from the opening of the Erie Canal to the onset of the Civil War was a time of transition in the American glass industry. Protective tariffs encouraged the development of domestic industry, including glassmaking, and masses of skilled immigrant laborers made it possible to staff large shops that could produce fine-quality tableware of blown, cut, or pressed glass. In the 1820s in New York City several glass factories were founded that produced middle-range and luxury table glass. During the three ensuing decades these firms established themselves securely and created the one serious chapter in the history of New York City glassmaking, but in the 1850s and 1860s many of them closed down one by one. Those that survived reestablished themselves in another part of the country or turned to the manufacture of optical glass or glass for streetlamps. It was not until the late nineteenth century that New York again became a glassmaking center, but this time for the limited production of fine art glass.

The earliest of the nineteenth-century glasshouses were located in Manhattan, outside the heavily populated commercial district. Like potteries, glassmaking

55. *Official Catalogue of the New-York Exhibition of the Industry of All Nations, 1853* (New York: George P. Putnam and Co., 1853), p. 16.
56. B. Silliman Jr. and C. R. Goodrich, eds., *The World of Science, Art, and Industry Illustrated from Examples in the New-York Exhibition, 1853–54* (New York: G. P. Putnam and Company, 1854), p. 186.
57. *Official Catalogue, Industry of All Nations, 1853*, p. 81.
58. Horace Greeley, *Art and Industry as Represented in the Exhibition at the Crystal Palace New York—1853–4, Showing the Progress and State of the Various Useful and Esthetic Pursuits* (New York: Redfield, 1853), p. 120.
59. In 1853 Pittsburgh had eight glasshouses employing five hundred people for the making of utilitarian glass only, and in addition, similar numbers employed in the manufacture of window glass and phials.
60. See [James Boardman], *America and the Americans by a Citizen of the World* (London: Longman, Rees, Orme, Brown, Green, and Longmans, 1833), pp. 21–23.
61. Thomson and Grant advertisement, *New Orleans Argus*, January 18, 1830, quoted in Arlene Palmer, *Glass in Early America: Selections from the Henry Francis du Pont Winterthur Museum* (Winterthur, Delaware: Henry Francis du Pont Winterthur Museum, 1993), p. 137.
62. Brooklyn Flint Glass Company, advertisement, *Carrington's Commissionaire*, January 1, 1856, transcribed in Maynard E. Steiner, "The Brooklyn Flint Glass Company, 1840–1868," *The Acorn, Journal of the Sandwich Glass Museum* 7 (1997), p. 61.
63. Baron Axel Klinkowström, *Baron Klinkowström's America, 1818–1820*, edited by Franklin D. Scott (Evanston, Illinois: Northwestern University Press, 1952), p. 128, quoted in Elisabeth Donaghy Garrett, *At Home: The American Family, 1750–1870* (New York: Harry N. Abrams, 1990), p. 89.

64. Margaret Hunter Hall, *The Aristocratic Journey: Being the Outspoken Letters of Mrs. Basil Hall Written During a Fourteen Months' Sojourn in America, 1827–1828*, edited by Una Pope-Hennessy (New York: G. P. Putnam's Sons, 1931), p. 65. I thank Arlene Palmer for giving me this reference.

65. [Boardman], *America and the Americans*, pp. 85–86.

66. Mitchell advertisement, *Baltimore American*, March 16, 1829, quoted in Palmer, *Glass in Early America*, p. 141.

67. *Niles' Weekly Register*, December 11, 1819, quoted in Kenneth M. Wilson, *New England Glass and Glassmaking* (New York: Thomas Y. Crowell Company, 1972), p. 245.

68. A primitive painting in the collection of the New-York Historical Society, signed B. Whittle and dated 1837, depicts the modest buildings of the factory. It shows a two-story brick warehouse and a conical brick chimney that makes clear the location of the glass furnace. Richard Fisher is seen at the door of the establishment supervising the loading of barrels onto a horse-drawn wagon—presumably finished goods on their way to the New York warehouse. The Hudson River is just beyond the factory.

69. See Clara M. Hobbes, "New York Produced Cut Glass," *New York Sun*, April 1, 1933.

70. American Institute of the City of New York, "List of Premiums Awarded, 1834–41," 1835, p. 24 (diploma); American Institute Judges' Reports, Eighth Annual Fair, 1835, "Report of the Judges on Glass and Earthenware," item 492 (quote), Manuscript Department, The New-York Historical Society.

71. New York City Records of Conveyances, cited in George S. McKearin and Helen McKearin, *American Glass* (New York: Crown Publishers, 1941), p. 595.

factories depended on furnaces fired to high temperatures, and disastrous fires plagued the industry. For that reason most glass factories were established not in the city center but across the Hudson and East rivers in areas such as Jersey City and Brooklyn, where fires could be more easily contained than in New York. As previously noted, these locations, near important navigable waterways, provided easy access for the shipping of raw materials and the dissemination of finished goods.

The glassmaking industry requires a skilled and experienced labor force. Without a longstanding tradition of glassmaking in America, would-be glassmakers initially were forced to look abroad for talented craftsmen. But increased immigration from the 1820s through the 1840s provided the much-needed workers, and by the second quarter of the nineteenth century this influx of skilled craftsmen and entrepreneurs, largely from England, helped transform the industry. Whereas once the primary objective had been the production of articles of common use, now manufactories in the glassmaking centers of Pittsburgh, New York, and Boston were turning out more high-quality glass tableware and decorative wares than utilitarian goods. This trend was stimulated in New York by competition with glassmakers in Europe and other parts of America. Although New York could never compete in the manufacture of utilitarian glass with great industrial centers such as Pittsburgh,[59] the high-end glass produced in the Empire City compared favorably with that of the established glassmaking centers of Pittsburgh and Boston.

New York factories apparently marketed their goods through the china and glass dealers that were beginning to proliferate along Pearl Street and Broadway. Here was the great burgeoning emporium where warehouses, retail shops, auction rooms, and wholesale depots commingled.[60] These dealers, who flourished because of a newly specialized consumerism, sold both high-end domestic products and imported ones. But not all territories were available for their trade. The New England market had been cornered by firms in Cambridge and Sandwich in Massachusetts, and Pittsburgh firms dominated the southern and western markets. The markets for New York glass generally ranged from the city along the eastern seaboard to Philadelphia and Baltimore and extended to the southern seaports of Richmond, Mobile, and New Orleans. As early as 1830 a New Orleans retailer announced the arrival of "80 packages from the Brooklyn Glass Company; all new and taste[ful] articles."[61] New York firms even explored

foreign markets, for in an 1856 advertisement the Brooklyn Flint Glass Works announced its "Pressed, Cut, Fancy and Engraved Glass-ware of varied patterns and styles . . . peculiarly adapted to the *Spanish* and *South American Markets*."[62]

The period from the 1820s through the 1840s saw a vogue for richly cut glass, which provided glittering ornament for dining tables and sideboards. One foreign traveler in the United States noted that in the American dining room "there is always a very elegant mahogany sideboard decorated with the silver and metal vessels of the household as well as with beautiful cut glass and crystal."[63] When Mrs. Basil Hall attended a family dinner with Governor De Witt Clinton in Albany in September 1827, she especially noticed the porcelain and the "cut glass an inch thick."[64] While very few pieces survive that can be firmly associated with New York families of this period, the few published descriptions and the handful of documented pieces indicate that glass made and cut in New York during the 1820s and 1830s was in the Regency style, then the vogue in England.

English Regency-style cut glass was showy and sparkling, a fitting symbol of wealth, status, and power. The steam-powered cutting lathe, a recent technological innovation, had made possible the creation of a wide range of new decorative patterns that transformed the look of cut glass. The new style featured such complex design elements as horizontal step cutting, bands of close diamond cutting, and the strawberry diamond, in which fine lines are cut in a crisscross pattern on the flat tops of diamonds. Another innovative feature was star cutting on the foot of the vessel, sometimes highly elaborate, with the points of the star extending nearly to the edge of the foot. Glass from New York firms embodied this style more thoroughly and expertly than did wares from any other American glassmaking center. For instance, few renditions of the popular motif of broad bands of close strawberry diamonds, or repeated crosshatched diamonds, from Pittsburgh or New England can compare in depth of cutting or robustness of design with the known examples of the pattern in New York pieces (see cat. no. 271).

In addition to producing cut glass, glasshouses in the New York area made molded and pressed glass. The glass press, one of the most important inventions in the history of glassmaking, is thought to be an American innovation. The press considerably reduced the amount of skilled handworking required in the manufacturing process, since a piece could be completely formed in its finished shape and surface decoration in

a single operation. Pressed glass caught the attention of Englishman James Boardman when he visited the fair of the American Institute of the City of New York in 1829. Boardman subsequently wrote, "The most novel article was the pressed glass, which was far superior, both in design and execution to anything of the kind I have ever seen in either London or elsewhere. The merit of its invention is due to the Americans, and it is likely to prove one of great national importance."[65]

While a distinctive New York style in cut glass can be identified, the molded and pressed glass objects made in New York demonstrate a remarkable consistency with those from New England and elsewhere in America. For example, Brooklyn-made "Labeled qt Decanters"—presumably the kind blown in a three-part full-size mold with a molded reserve enclosing the name of an alcoholic beverage—were advertised as part of the glass inventory of a Baltimore retailer in 1829,[66] but such decanters are also known to have been produced in New England. The same advertisement lists saltcellars made by the Brooklyn Flint Glass Works and pressed in the Grecian, Diamond, and Eagle patterns—again the very same patterns utilized by the New England firms. Thus, although pressed and molded glass played an important role in the history of American design, its contribution to New York arts was superseded by the vigorous development of cut glass.

Glassmaking began in New York in the 1820s in the hope of supplying to an ever increasing market a luxury product that could compare favorably with the foreign glassware so well entrenched in American tastes. Initially, three factories were established in the area: the Bloomingdale Flint Glass Works, the Brooklyn Flint Glass Works, and the Jersey Glass Company. ("Flint glass" was the term used during the period to denote high-quality glass with a substantial lead content that gave it brilliance and made it suitable for cutting.) In the mid-1850s another firm, the Dorflinger Works, entered the arena.

The Bloomingdale Flint Glass Works, the earliest of the glass factories to operate successfully in the city or its environs, was also the smallest and shortest lived. Two exceedingly talented glass workers, John Fisher and John L. Gilliland, left the successful New England Glass Company in East Cambridge, Massachusetts, perhaps in an attempt to stake out new markets, and came to New York to set up their own independent firm in 1820. Fisher and Gilliland had only the year before become famous for the quality of their product as a result of publicity about a much-exhibited

work they had made. The piece, a covered cut glass urn said to weigh forty-five pounds, displayed complex decoration. One observer's detailed description illustrates the design vocabulary of the day:

> *The cutting on the foot is in arched scollops, flutings, and deep splits with prismatic rings and splits beneath—the bowl round the bottom, in the language of the manufactory, has raised diamonds and deep sunk rings; and on the body there are still deeper strawberry diamonds, rings and arched scollops; the cover has a cheverel cut from the solid glass, edge arched scollops, prismatic rings with splits beneath; rows of strawberry diamonds, and head; [ringed] and raised diamonds.*[67]

The piece was first presented at a Brighton, Massachusetts, show of manufactures and was subsequently exhibited in New York, Philadelphia, and Baltimore, no doubt to draw attention to the wares of the New England Glass Company. In 1819, shortly after receiving this important exposure, Gilliland, Fisher, and Fisher's brother Richard purchased a large plot of land on the banks of the Hudson River, between Forty-eighth and Fiftieth streets, in what was called the Bloomingdale district of New York. Here they built a glass factory, the Bloomingdale Flint Glass Works (also called the New York Glass Works; see fig. 277).[68] The factory sold its goods wholesale through its office, which was located in the city's commercial district, before the firm was dissolved in 1840.

Attempts to trace the history of glassmaking in New York are frustrated by the near total absence of information about the Bloomingdale factory or its production. Nothing is known of any surviving products of the factory beyond the photographs published in the *New York Sun* in 1933 that show a group of richly cut tablewares owned by Richard Fisher's granddaughter (fig. 278).[69] In style and cutting the illustrated pieces are clearly related to the sumptuous design of the much-praised New England urn. Modeled closely on English glass of the same period, the vessels are of thick colorless glass deeply cut in a variety of patterns, among them many instances of the repeated strawberry diamond. Characteristic of the glassware is an abundance of cutting so that even areas traditionally left plain are embellished with faceting or cut rings, bases are star cut, handles are decorated, and a sawtooth pattern is cut into the rim. Products of the firm were exhibited at the annual fair of the American Institute in 1835 and earned a diploma for the "second best specimen of cut glass."[70]

72. For information on the Brooklyn Flint Glass Company, see Steiner, "Brooklyn Flint Glass Company," pp. 38–69. See also Lisa Bedell, "Brooklyn's Finest Glass: The Brooklyn Flint Glass Works," typescript, 1995, Master's Program, Cooper-Hewitt, National Design Museum, and Parsons School of Design.

73. Ira Rosenwaike, *Population History of New York City* (Syracuse: Syracuse University Press, 1972), p. 33.

74. Samuel Griscom, Diary, May 21–June 1824, "Journey from Salem, New Jersey, to Philadelphia, New Brunswick, New York City, Albany and return," copy available at the New-York Historical Society.

75. Gilliland's firm was awarded a First Premium for "glass that was of exceptional beauty and brilliancy" when it was exhibited at the New York Mechanical and Scientific Institute in 1824. One contemporary observer wrote that it "sparkles like a diamond"; quoted in Helen McKearin and George S. McKearin, *Two Hundred Years of American Blown Glass* (New York: Bonanza Books, 1950), p. 108.

76. Palmer, *Glass in Early America*, p. 136.

77. Deming Jarves, *Reminiscences of Glass-making*, 2d ed. (New York: Hurd and Houghton, 1865), p. 96.

78. In 1816 Dummer sold James Brinkerhoff "1 Set Rich cut Decanters, 4 Qt & 6 Pint" for $105 and dozens of "Rich cut Tumblers and Wines"; on October 2, 1819, he sold Brinkerhoff "One Rich cut Glass Dessert Set" for $225; Troup Papers, Box 3, Folder 4, New York Public Library. I thank Frances Bretter, Research Associate, Department of American Decorative Arts, Metropolitan Museum, for bringing these references to my attention.

79. George Dummer, invoice to Mr. Robert Kermit, New York, January 24, 1820, Joseph Downs Collection of Manuscripts and Printed Ephemera, courtesy The Winterthur Library, Henry Francis du Pont Winterthur Museum, Winterthur, Delaware.

80. Geo. Dummer and Co., New York, advertisement, *New-York Advertiser*, April 17, 1822, p. 4.

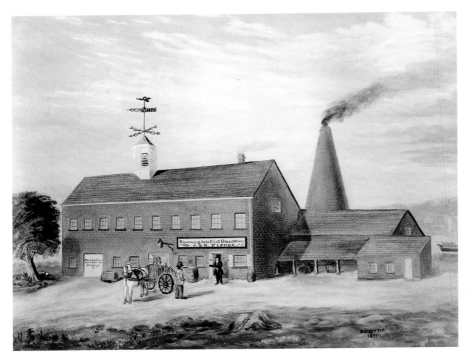

Fig. 277. B. Whittle, *J. and R. Fisher's Bloomingdale Flint Glass Works,* ca. 1837. Oil on canvas. Collection of The New-York Historical Society

81. *Franklin Journal and American Mechanics' Magazine* 2 (1826), p. 242.

82. Quoted in Kenneth M. Wilson, "Bohemian Influence on 19th Century American Glass," in *Annales du 5ᵉ Congrès International d'Étude Historique du Verre* (Liège: Association Internationale pour l'Histoire du Verre, 1972), p. 272.

83. The view of "City-Hall, New York" was published by J. and F. Tallis, London, ca. 1840–50. The same view appears on a goblet in the Corning Museum

On November 11, 1822, only two years after the Bloomingdale works commenced operation, Gilliland transferred his interest in the property to the Fishers[71] and moved on again. The following year he founded the Brooklyn Flint Glass Works at Columbia Street and Atlantic Avenue on the Brooklyn waterfront (see fig. 279).[72] (At the time Brooklyn was only beginning to be developed; in 1825 its population numbered 11,000, while Manhattan's was 166,000.)[73] The mysteries of glassmaking often attracted observers, and an early visitor to Gilliland's new factory recorded in his diary that he was "much gratified with observing the

manner in which they bring the fluid glass from the Furnaces, and the facility with which they form it into the various shapes required; . . . their machinery for grinding and annealing the glass was curious."[74] Brooklyn glass developed a reputation for clarity and brilliance, and the glassworks consistently won awards at fairs until it ceased to exist in 1868.[75] The absence of any reference to cut glass during the firm's early decades suggests that at the time cutting was not carried out on the premises. Brooklyn city directories list only one glasscutter at the glassworks before 1850. Apparently the company looked outside the factory for skilled individuals to cut its high-quality products and either subcontracted or sold its glass to retailers and independent cutting studios.[76] The founder of the Boston and Sandwich Glass Company, Deming Jarves, admitted, "John L. Gillerland [*sic*], late of the Brooklyn Glass-Works, is remarkably skilful in mixing metal. He has succeeded in producing the most brilliant glass of refractory power, which is so difficult to obtain."[77]

The third New York firm that produced luxury-glass tablewares was the Jersey Glass Company, founded by George Dummer, who had carried on an active retail business in both ceramics and cut glass before opening his factory. Surviving bills of sale show the wide range and quality of the glass he sold.[78] A bill to Mr. Robert Kermit dated 1820 lists an assortment of cut glass, including lemonades, wineglasses, goblets, jugs, and celery glasses, as well as "6 large Strawberry Cut Dishes."[79] Dummer added glasscutting to his retail business in 1822, announcing that at its warehouse and rooms at 31 Pine Street customers could find: "Castors, Liqueur Stands, Wine and Dessert Sets, Glass Lamps, and Chandeliers repaired, and orders executed to patterns, at the shortest notice."[80]

In its first few years of operation Dummer's Jersey Glass Company produced clear, colorless glass and for cutting utilized up-to-date technology in the form of thirty-two steam-driven wheels.[81] It produced glassware in a wide variety of shapes and patterns in the Regency style, as is evidenced by both an undated handbill (fig. 280) and surviving glass documented through Dummer family history (cat. nos. 273–275). The firm also made pressed glass and in 1827 secured two patents for improvements in pressing technology, which were applied to the manufacture of glass furniture knobs and decorative saltcellars. The similarity of its patterns to those used in New England may have prompted the company to impress its name and location on the underside of saltcellars: "Jersey Glass Co./ Nr. N. York" (see cat. no. 272).

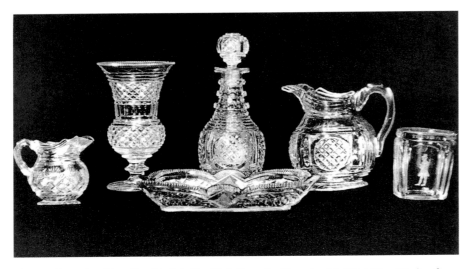

Fig. 278. *Examples of Cut Glass Made in New York,* from the Bloomingdale Flint Glass Works of Richard and John Fisher, New York City. From the *New York Sun,* April 1, 1933

The Dummer factory may have been the first New York firm to make colored glass, as exemplified by a pale green saltcellar bearing the company mark. The color, much employed for English Regency glass and especially well suited to cut decoration, can be seen in a panel-cut decanter and wineglasses, probably New York made, that were purportedly owned by New York merchant and art collector Luman Reed (cat. no. 276).

The Brooklyn Flint Glass Works expanded and reorganized during the 1840s and began to manufacture colored glass about 1849. Its production of new colors responded less to the demand for Regency-style glass than to a new taste for highly colored products: clear glass vessels plated or cased with a thin layer of colored glass and then cut so that both the vivid shade and the colorless areas are visible. Glass of this type was beginning to be imported in large numbers from Bohemian factories by businesses such as that of Charles Ahrenfeldt of New York City, who is identified on an 1852 billhead as an "importer of Bohemian Plain, Cut and Fancy Colored Glass Ware."[82] Bohemian glassware cased or stained red or blue and then embellished with ambitious cut and engraved designs found a ready market among Americans, who by the 1840s had succumbed to a weakness for overelaboration and excessive color in many areas of the decorative arts. Some of the Bohemian designs were market-specific to a particular city, with highly detailed renderings of city views or of individual buildings. In this category are several goblets and vases graced with images of New York's City Hall, all copied from the same print source (see fig. 281).[83] Highly colored, decorative Bohemian glassware received considerable attention at the New York Crystal Palace exhibition.

The Brooklyn Flint Glass Works capitalized on this interest by describing some of its own products as "Fancy Bohemian color glass ware."[84] According to an advertisement of 1850, it was making glass in a spectrum that included ruby, alabaster, chrysoprase (apple green), and turquoise;[85] and it claimed to be the first firm in America to produce "plated or Bohemia Glass Ware," thus briefly preempting its New England competition in this area. Wrote one critic for the *Brooklyn Evening Star* in May 1851, "The art of plating glass has not been understood at all in America till quite recently, and if we mistake not, this is the only establishment in the country that manufactures it to any extent."[86] In 1860 a group of Japanese diplomats were taken to Brooklyn "to view the process of making crystal, ruby, green, and blue glass . . . the most *interesting* art to be seen in *any* country."[87] Colored

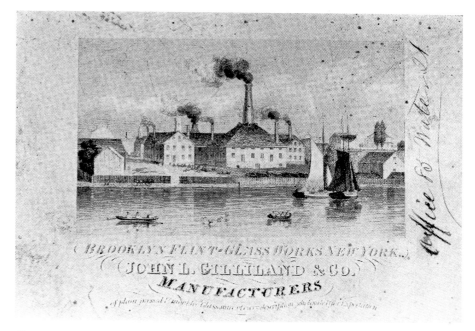

Fig. 279. Trade card of Brooklyn Flint Glass Works, Brooklyn, New York. Steel engraving, from *Antiques* 17 (March 1930), p. 262

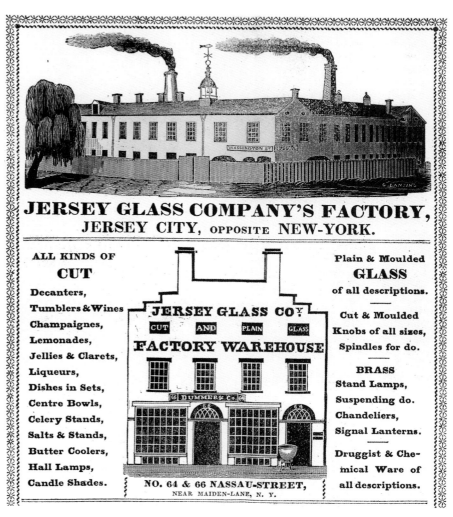

Fig. 280. Handbill for the Jersey Glass Company of George Dummer, Jersey City, New Jersey, undated. Wood engraving. Brooklyn Museum of Art, The Arthur W. Clement Collection 43.128.117

of Glass, Corning, New York (79.3.160), and on a vase and a goblet, whose current locations are unknown; see *Paul and Alma C. Bruner Americana Collection* (sale cat., Cleveland, Ohio: Wolf's Fine Arts Auctioneers, November 16–17, 1990), lots 352, 354D. See Jane Shadel Spillman, "Glasses with American Views—Addenda," *Journal of Glass Studies* 22 (1980), pp. 78–81. The view appears again as painted decoration on an opaque white glass vase, also of Bohemian origin. See N. Sakiel and Son, New York, advertisement, *Antiques* 116 (October 1979), p. 678.

84. American Institute of the City of New York, "Report of the Judges on Glass and China also Engraving on Glass and Painting on China Ware," 1850, item 933, Manuscript Department, The New-York Historical Society.

85. Brooklyn Flint Glass Works, advertisement, *Home Journal,* March 20, 1850.

86. *Brooklyn Evening Star,* May 28, 1851, quoted in Wilson, "Bohemian Influence on 19th Century American Glass," p. 272.

87. Francis Nicol to Samuel Francis Du Pont, June 17, 1860, Hagley Museum Library, quoted in Quimby and Fernald, "A Matter of Taste and Elegance," p. 131.

88. Palmer, *Glass in Early America,* p. 137.

89. See "Glass," *Niles' Weekly Register,* May 22, 1830, p. 232.

90. The notice was also published in Portland, Maine. It called attention to the Jackson and Baggott "manufactory of *Cut Flint Glass* . . . the articles of whose workmanship, comparing with any for neatness and elegance . . . do credit to the skill and enterprise of the artist." See *Eastern Argus* (Portland, Maine), May 29, 1816, in Arlene Palmer Schwind, "Joseph Baggott, New York Glasscutter," *Glass Club Bulletin of the National Early American Glass Club,* no. 142 (fall 1984–winter 1985), p. 9. According to Longworth's New York city directories for 1818–23, the partnership started out at the corner of Grand Street and the Bowery in 1818, moved to 163 Mulberry Street with a store at 196 Broadway, in 1820, and the following year moved to 7 Park Street near Grand Street.

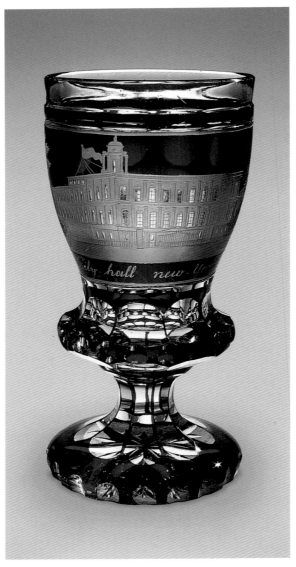

Fig. 281. Maker unknown, Bohemian, for the American market, Goblet depicting City Hall, New York, 1845–50. Colorless glass, ruby cased, cut to clear glass and engraved. Corning Museum of Glass, Corning, New York, Gift of The Ruth Bryan Strauss Memorial Foundation 79.3.160

glass played a visible role relatively short-lived but in the context of the entire history of New York glass manufacture.

However much this highly colored product captivated the public, it was in glasscutting—a piecework trade carried out in shops—that New York truly made its mark on the glass industry during the antebellum period. Although glasscutters had operated in all the major cities at least since the 1770s, they generally worked in small, independent workshops. However, responding to the surging market for luxury cut glass, from the 1820s on men skilled in the trade, largely immigrants, settled near New York's commercial district to cut the most fashionable patterns into glass in

workshops large and small. Since there was a symbiotic relationship between glassware factory and glass decorator, New York City became the center for the cutting of ornamental glass during the second quarter of the nineteenth century and was home to nearly seventy expert glasscutters between 1825 and 1835 alone.[88]

The glasscutting establishment of William Jackson and Joseph Baggott (Baggott alone after 1829) was one of the largest in operation in New York City if not the entire country. Baggott was probably "the gentleman at New York" referred to in Hezekiah Niles's 1830 newspaper article describing a firm that employed forty hands in the cutting of glass.[89] The partners had entered the business by 1816, when a notice announcing their workshop was published in a New York newspaper.[90] Since no glass factories are known to have been functioning in the city during the early years of the company's existence, presumably uncut glass vessels, or blanks, were imported from abroad, in particular from England, which was the primary supplier of fine glass at the time. In an 1822 advertisement (fig. 282) the firm mentions its correspondence with a number of fine English glasshouses, no doubt to obtain from them the glass blanks for its cutting wheels, while asserting that its own cutting is "equal to any done in London."[91] Later Baggott used blanks from the Brooklyn Flint Glass Works almost exclusively, because the Brooklyn firm's exceptionally clear glass was regarded as the best produced in the New York area.

Although no documented wares produced by Jackson and Baggott survive, an unusually comprehensive picture of the firm's activity is afforded by the detailed estate inventory that Baggott's widow and administratrix prepared in 1839, the year of his death.[92] Among the items of equipment named are "38 Glass Cutting Frames," suggesting that thirty-eight glasscutters were able to pursue their craft simultaneously. As for quantity, the inventory lists over seventeen thousand individual pieces of cut glass. They represent a wide range of luxury tablewares in an impressive variety of shapes and patterns. The most numerous were decanters, in several sizes. Other wares included claret decanters and carafes, drinking glasses of all sorts—from wineglasses and tumblers to clarets, cordials, champagnes, and lemonades—and jelly glasses, bowls and dishes in various sizes, sugar bowls, celeries, jugs, finger basins, wine coolers, butter dishes, salts, and flower stands. The inventory reveals as well that the firm also conducted a thriving business decorating glass items for lighting fixtures, such as lamp chimneys and shades of different types.

The patterns enumerated reflect the prevailing taste for English Regency styles, or, in the words of the 1822 advertisement, "the newest and most approved London patterns." Illustrated in the advertisement are two forms, a ring-neck decanter with diamond-cut and roundel decoration and a scallop-cornered dish with strawberry diamond cutting and vertical cuts surrounding a star-cut base. Strawberry diamonds and fluted designs predominated in the firm's stock, but other popular motifs, such as the strawberry diamond and fan, diamond flutes, and Gothic patterns, were part of its repertoire. Many of the patterns directly correspond to English ones.[93] Special-order patterns, or "glass cut to any figure," were offered, and a patron could have personalized initials or a monogram cut or engraved on each piece of a cut glass service.[94] Visitors to the workshop from the *New-York Mirror* were impressed by a skillful demonstration of "the curious art of cutting" and were given a large tumbler "on which numerous beautiful figures were cut in our presence."[95]

Jackson and Baggott was one of the few glasscutting workshops to receive recognition over an extended period of time. Its first recorded exhibition was at the Franklin Institute Fair in Philadelphia in 1825, when its work was compared favorably with an exceptional display by the New England Glass Company.[96] As early as 1828 the firm exhibited at the American Institute of the City of New York, at which time it was awarded a gold medal for the best piece of cut glassware. In subsequent showings at the American Institute, the firm continued to win some of the highest awards, capturing the silver medal in 1836 for the "best specimen of cut glass and cutting," while a competitor, Bonnell and Bradley, won a diploma for the "2d best specimen."[97]

Initially Jackson and Baggott sold its wares at the store of George Dummer and Company, which had been retailing china, glass, and earthenware since 1810. Even before Dummer commenced glasscutting at his establishment, Jackson and Baggott opened its own cut-glass store in New York, in April 1819 at 36 Maiden Lane.[98] By 1830 Baggott's agent was George Tingle of 78 Maiden Lane,[99] but, as is revealed in the list of outstanding amounts owed Baggott at his death, at this time the firm sold its products through nearly all of the major retailers in household goods, including Haviland, Richard Tyndale, Baldwin Gardiner, Haughwout, Ebenezer Cauldwell, and Cartlidge.[100] Indeed, Jackson and Baggott marketed its wares not only in New York City but also in Philadelphia and Washington. In the 1820s and 1830s

two Philadelphia firms, the Union Glass Works and the Kensington Glass Works, were making cut glass; nevertheless Baggott avidly pursued the Philadelphia market. A Philadelphia newspaper advertisement of 1830 notified the public that "Joseph Baggotts Cut Glass have been removed from No. 23 Dock St." Breakage was presumably a problem, because the agent subsequently advertised that he would replace the loss of any Baggott glass (or Gilliland glass, which he also sold) "with glass from the Union Glass Works and Kensington."[101]

Baggott's principal competitor in New York was the glasscutting firm of J. Stouvenel and Company.[102] Stouvenel received awards from the American Institute beginning in 1842.[103] The firm gained prominent exposure when, as Joseph Stouvenel and Brother, it showed "Cut crystal goblets, bowls, celery dishes, pitchers, wine-glasses, and other articles" at the New York Crystal Palace exhibition in 1853.[104] A publication from the fair illustrated some of these vessels, which demonstrate both the quality and the diversity of the firm's cutting (fig. 283). The celery dish shows an allover diamond motif with fans at the rim; honeycomb cutting, further embellished with what appears to be cross-hatching, is seen on the carafe and matching tumbler. The handled decanter displays diamond cutting on its bulbous base and flute cutting on the neck and stopper, typical features of the Regency style. The most unusual of all the pieces is a small rose bowl or vase with a deeply scalloped rim and cut

91. Jackson and Baggott, Glass Cutters, advertisement, December 1822 (source unknown), photostat, no. PH-62, Joseph Downs Collection of Manuscripts and Printed Ephemera, courtesy The Winterthur Library.

92. The Baggott Estate inventory is in the Joseph Downs Collection of Manuscripts and Printed Ephemera, courtesy The Winterthur Library.

93. For instance, the "Coburg" wineglass, which has a trumpet-shaped bowl and flutes cut around the base, is also listed in an illustrated price list for Apsley Pellatt's Falcon Glass Works in London. For an in-depth discussion of this and other patterns, see Schwind, "Joseph Baggott, New York Glasscutter," p. 10.

94. Jackson and Baggott, advertisement, in Joshua Shaw, *United States Directory for the Use of Travelers and Merchants* (Philadelphia: J. Maxwell, 1822), p. 50, quoted in Schwind, "Joseph Baggott, New York Glasscutter," p. 10.

95. "Improvement in the Arts," *New-York Mirror, and Ladies' Literary Gazette*, June 18, 1825, p. 375.

96. Lowell Innes, *Pittsburgh Glass, 1797–1891*, (Boston: Houghton Mifflin, 1976), p. 118.

97. "Fair of American Institute," *Mechanics' Magazine, and Journal of the Mechanics' Institute* 8 (December 1836), p. 304.

Fig. 282. Advertisement for Jackson and Baggott, Glass Cutters, December 1822. Wood engraving. Courtesy of The Winterthur Library, Winterthur, Delaware, Joseph Downs Collection of Manuscripts and Printed Ephemera PH-62

98. Jackson and Baggott, advertisement, *New-York Evening Post*, April 22, 1819, quoted in McKearin and McKearin, *American Blown Glass*, p. 108.

99. *Commercial Advertiser* (New York), August 23, 1830.

100. Baggott Estate inventory, Joseph Downs Collection of Manuscripts and Printed Ephemera, Winterthur Library.

101. John Southan (Philadelphia agent for Baggott's cut glass), advertisement, *Poulson's American Daily Advertiser* (Philadelphia), January 8, 1830, in N. Hudson Moore, *Old Glass, European and American* (New York: Tudor, 1941), p. 375.

102. Stouvenel worked at several different locations in New York: 35 John Street, 29 Gold Street, 567 Broadway, and, later, 56–60 Vesey Street (Perris Map, 1855).

103. In two consecutive years, 1842 and 1843, Stouvenel received a diploma "for the second best specimen of cut glass." The first place winner for the best specimen of cut glass in 1842 was a George Wightman of 561 Broadway, about whom little is known.

104. *Official Catalogue, Industry of All Nations*, p. 80.

105. A third independent cutter of note appears to have been Edward Yates. In 1828 an advertisement appeared in a Baltimore newspaper for the sale of "CUT GLASS from the celebrated establishment of Edward Yates, N. York; the character . . . of which, being so well known, nothing here is deemed necessary to be said in recommendation." See Alexander Mitchell, advertisement, *Baltimore American Mercury*, September 1, 1828; I thank Arlene Palmer for sharing this reference. Yates was one of the principals of the partnership styled as Sayre and Yates, independent glasscutters located at 23 Delancey Street. Its work was also celebrated and garnered the first premium of the American Institute of the City of New York in 1830 for a display of "numerous articles of beautiful Cut Glassware, among which were two Bowls uncommonly large, and the handsomest ever exhibited in this city." See *Report of the Third Annual Fair of the American Institute . . . 1830* (New York, 1830), p. 17, Manuscripts and Special Collections, New York State Library, Albany. The

fail to please the visitor, who, if critically educated, will at once refer this effect to its proper cause—the violation of the principle just stated. The Swiss table is such an instance of this pointed disregard of use and its consequent want of beauty. Nothing can be more obvious than that the top of a table should have a perfectly smooth and level surface; whatever ornaments are employed here must be inlaid. But the delicate floral de- | corations in this example are carved in high relief, always liable to be defaced, and only make the toy useless, which they were designed to make beautiful. Besides, there is no repose in the work. One part is as fully decorated as another. It bristles all over with carvings, which are spoilt by the want of contrast, and lose their beauty in its own excess. The rightly educated decorative artist understands the value of simplicity, | and that good taste is shown quite as frequently by the absence as the presence of ornament. Above all, he will avoid constructing decoration; but having first constructed, he will then decorate his work, with ornaments such

as a refined taste and judicious study of nature teach him to be appropriate in style and number and therefore to be beautiful. | Messrs. JOSEPH STOUVENEL & Co., of New-York, exhibit a great variety of glass ware, both pressed and cut, from their manufactory. These specimens are made of a | clear and beautiful glass, and display a high degree of skill in the manufacture.

Fig. 283. *Glassware from Joseph Stouvenel and Company, at the New York Crystal Palace Exhibition, 1853.* Wood engraving, from B. Silliman Jr. and C. R. Goodrich, eds., *The World of Science, Art, and Industry Illustrated from Examples in the New-York Exhibition, 1853–54* (New York: G. P. Putnam and Company, 1854), p. 159. The Metropolitan Museum of Art, New York, The Thomas J. Watson Library

decoration that resembles a crosshatched balloon alternating with delicate engraved urns and swags.

Although they did some decorating of porcelains, both Stouvenel's and Baggott's firms were principally glasscutting establishments.[105] Two other firms, Davis Collamore and Haughwout, added glasscutting, in 1850 and 1851, respectively, to the wide range of services they already provided; these included selling imported porcelains and glass, selling lighting fixtures in a variety of styles, and decorating porcelain. Davis Collamore and Haughwout as well as Stouvenel and Baggott could accommodate the growing market for personalized wares, of which one example is a table service richly cut in an allover diamond pattern and engraved with the arms of the Weld family (cat. no. 277).[106] Davis Collamore advertised in 1850 that it could provide just such a service, of "Heavy Cut Glass in great variety of shapes and patterns," and was "now prepared to execute orders for Engraved Glass to any pattern which may be designed by those wishing to purchase this style of Glass, now the most fashionable in use. The Crest, or Initials can be engraved on the glass at short notice, as a very superior German Engraver works in the store. . . . Seals engraven to order."[107] Haughwout and Dailey, located a door away from Stouvenel on Broadway in 1853, also advertised that it would perform cutting and engraving on glassware.

One of the few individuals skilled in glasscutting whose career can be followed is John Hoare. Like many New York glasscutters, Hoare learned his trade in Ireland and England before immigrating to the United States. Arriving in 1853, Hoare worked initially at Haughwout and Dailey, and it is possible that his wife, Catherine Dailey, was related to the William Dailey who was a partner in the firm and that William arranged for Hoare's employment. In any event, Hoare subsequently set up an independent shop with one or more partners. The little information available is somewhat confusing; it is known that his business operated under various partnership relationships and at various addresses, first on Second Avenue and later on Eighteenth Street. In August 1857, with new partners, the firm of Hoare, Burns and Dailey expanded its operations, purchasing the entire cutting department of the Brooklyn Flint Glass Works.[108]

By that time the Brooklyn Flint Glass Works was producing cut glass of superior quality. Although early on and for many years the company had relied almost exclusively on outside cutters to decorate the glass it manufactured, in the late 1840s it established its own cutting department and beginning in 1850 began to exhibit the results. These developments culminated in an extraordinary display at the world's fair, or Great Exhibition of the Works of Industry of All Nations, that took place in London in 1851. This and its successor fair held in New York in 1853 were enormously important showcases for industrially made decorative objects of the most elaborate sort.

Fig. 284. Advertising broadside for Brooklyn Flint Glass Works, Company Warehouse, 30 South William Street, New York. Lithograph, from Charles T. Rodgers, *American Superiority at the World's Fair* (Philadelphia: John J. Hawkins, 1852), opp. p. 57. The Metropolitan Museum of Art, New York, The Thomas J. Watson Library

products exhibited "superior workmanship and elegant patterns, comprising a great variety." See "Catalogue of Articles of American Manufacture, Produce, or Skill," a subtitled back section issued with *Report of the Third Annual Fair*, 1830.

106. The engraving on each piece depicts the crest of a wyvern with a cut shield and the motto NIL SINE NUMINE. The service may have been made for Harriet Corning Turner and Schaick Lansing Pruyn, who were married in 1840, or for Harriet's aunt, Harriet Weld, and her husband, Erastus Corning I. See Jane Shadel Spillman, "Service of Table Glass with the Weld Family Arms," in Tammis K. Groft and Mary Alice Mackay, eds., *Albany Institute of History and Art: 200 Years of Collecting* (New York: Hudson Hills Press, 1998), p. 264.

107. Davis Collamore, advertisement, "Engraved Glass!" *Home Journal*, March 9, 1850, p. 3.

108. See the printed announcement reproduced in Estelle Sinclair Farrar and Jane Shadel Spillman, *The Complete Cut and Engraved Glass of Corning* (New York: Crown Publishers, 1979), p. 27.

109. George Wallis, *New York Industrial Exhibition: Special Report of Mr. George Wallis, Presented to the House of Commons by Command of Her Majesty, 1854* (London: Harrison and Son, 1854), p. 43.

110. See Jane Shadel Spillman, *Glass from World's Fairs, 1851–1904* (Corning, New York: Corning Museum of Glass, 1986), p. 10.

111. "Recent American Patents: Manufacture of Glass," *Scientific American*, January 23, 1834, p. 55.

112. *The Art-Journal Illustrated Catalog: The Industry of All Nations 1851* (exh. cat., London: George Virtue, 1851), p. 246.

113. Miscellaneous Treasury Accounts for the President's House, Record Group 217, Account 141.158, no voucher, National Archives; quoted in Jane Shadel Spillman, *White House Glassware: Two Centuries of Presidential Entertaining* (Washington, D.C.: White House Historical Association, 1989), p. 68.

114. For a discussion of various possible attributions for the Lincoln service, see Spillman, *White House Glassware*, pp. 68–71.

The BROOKLYN FLINT GLASS-
WORKS, situated at New York,
U. S., contribute a well-filled

stand, which occupies a central
position in the American de-

partment of the Great Exhibi-
tion. There is enough novelty
of form in these works to

assure us that our transatlantic
brethren are fully aware of
the mercantile value of Art.

Fig. 285. Robert Roberts,
*Glassware from the Brooklyn
Flint Glass Works.* Wood
engraving, from the *Art-
Journal Illustrated Catalogue:
The Industry of All Nations
1851* (London: George
Virtue, 1851), p. 246. The
Metropolitan Museum of Art,
New York, The Thomas J.
Watson Library

Each exposition was held in a Crystal Palace, a grand glass building that was itself a technological marvel representing a highly innovative use of the material.

Of the glass exhibitions in the London Crystal Palace, the most impressive entry was an enormous fountain, twenty-seven feet tall, of molded and cut glass fabricated by F. and C. Osler of Birmingham. Displays of cut glass from many other English firms and of elaborately decorated colored glass from Bohemian glasshouses dominated the field. Exhibiting firms from the United States were noticeably absent with the important exceptions of Gilliland's Brooklyn Flint Glass Works and the New England Glass Company. The latter received bronze medals for its pressed glass and "fancy, cut, plated, and enameled Coloured Glass." However, the jurors awarded a silver medal to the Brooklyn Flint Glass Works "for their discovery in compounding Materials for making Glass, by which a superior brilliancy of colour is produced, and for their beautiful display of rich cut Flint Glass."[109] This citation surpassed not only those awarded the American competition but also those that went to well-established glass firms in France and Austria.

Praise for the Brooklyn Flint Glass Works centered on the intrinsic excellence and purity of its glass, qualities that had been admired by American critics from the firm's inception. So impressed were British glass companies that some even began to import American sand, which was most often cited as the basis for the superlative nature of the Brooklyn product.[110] (Opinions about the crucial role of sand notwithstanding, Gilliland secured a patent for an improvement in his glass furnace, which protected vessels from exposure to fumes, dust, and smoke, resulting in a "brighter and cleaner surface.")[111] Of the prizewinning glass, the *Art-Journal*'s catalogue for the fair opined, "There is enough novelty of form in these works to assure us that our transatlantic brethren are fully aware of the mercantile value of Art."[112] Three pieces, all from the Brooklyn Flint Glass Works (fig. 285), were illustrated to demonstrate the point. Stylistically the Brooklyn submissions were consistent with the wares fashionable in England at the time. For example, a decanter shown in the catalogue features a facet-cut neck and fine diamond cutting all over its bulbous body—a type of design that had been in vogue for at least two decades. However, the acorn stopper with its complementary patterns is quite unusual.

The fine diamond cutting used on this decanter was a new variation on a style that would retain its popularity for yet another decade. A similar pattern covers the bottom half of a compote that is part of a much larger service ordered for use in the White House by Mrs. Lincoln in 1861 (cat. no. 279). The service is described in the invoice from its Washington retailer simply as "one sett of Glass Ware rich cut & eng'd with U.S. Coat of Arms: $1500."[113] "Rich cut" refers not only to the diamond cutting on the bowls but also to the cutting on the stems and to star cutting on the feet. The component features, in addition to the diamond cutting, a delicate copper-wheel-engraved border design and, in the center, the insignia of the great seal of the United States. The elaborate service, intended for three to four dozen, was probably made at a Brooklyn glassworks established by the Alsatian glassmaker Christian Dorflinger.[114]

Dorflinger built a total of three glass factories in Brooklyn at different locations. The first, the Concord Street Flint Glass Works, opened in 1852, was a relatively small factory that primarily produced utilitarian wares, in particular druggists' bottles and chimneys for oil-burning lamps. Only two years after founding the factory, Dorflinger enlarged and rebuilt it, changing the firm's name to the Long Island Flint Glass Works. He subsequently built his second glassworks, which included a glasscutting shop with thirty-five cutting frames, on Plymouth Street.[115] His third factory, the Greenpoint Glass Works, constructed in 1860, was the only one devoted solely to the production of fine table glass. An elaborately decorated vase made as a presentation gift to Dorflinger's wife one year before the Greenpoint works opened is testament to the quality of cut glass the firm was able to manufacture (cat. no. 278). Within a cut shield it bears the engraved inscription, "Presented by the officers/& members of the/Dorflinger Guards/To Mrs/Dorflinger./January 14th/1859." (The Guards, a "colorfully uniformed body of trained men" who functioned in lieu of a police force,[116] were also called upon for ceremonial occasions and parades.) A tall, slender form supported by a faceted stem, the vessel is a virtual compendium of cut patterns and brings to bear all the skills of the glasscutter. A horizontal midrib divides the piece. Cut circles surround its lower part, while the top portion features lozenges with crosshatched cutting that alternate with cut fans, which form a scalloped rim. The same pattern is adapted in the elaborate design of the star-cut foot. Together, the tour-de-force craftsmanship and the message of the inscription demonstrate both the skill of the immigrant workers employed in Dorflinger's factories and the loyalty of his workforce. No one who admired that extraordinary object in 1859 could have imagined the chain of events that

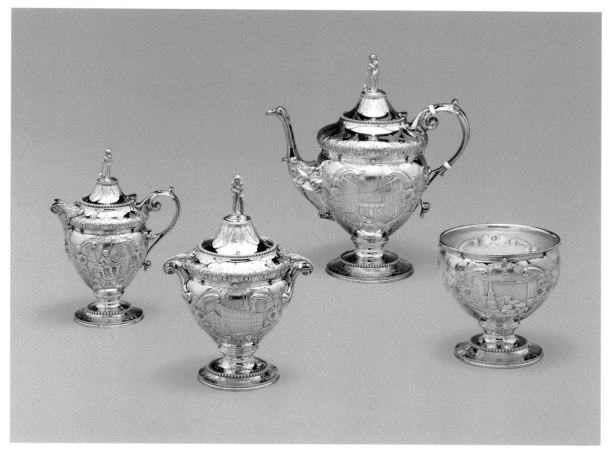

Fig. 286. Wood and Hughes, Tea service depicting views of Christian Dorflinger's Long Island Flint Glass Works, 1862–63. Silver. The Metropolitan Museum of Art, New York, Lent by Christian Dorflinger, in memory of his mother Margaret F. Dorflinger, and in honor of his father Lambert M. Dorflinger

within only a few years would radically transform the glass industry.

The Civil War years, which overturned the old order of life throughout the nation, were troublesome ones for Dorflinger. He was operating three separate glasshouses with a corps of workers that had been diminished by the departure of men called on to serve the war effort. The resultant physical and mental stress compelled Dorflinger to retire from the glassmaking business. His workers marked the retirement with an unusual presentation tea set made by a New York silversmith that provides an unexpected glimpse of the Dorflinger works (fig. 286). The teapot carries the presentation inscription on one side and on the other a view in repoussé of the inner yard of one of the Dorflinger factories, with loading barrels stacked about. Other components of the set advance the factory theme: on the sugar bowl the facade of the Long Island Flint Glass Works is depicted; the cream jug shows a glassblower working at his bench; and pictured on the waste bowl is the drying room for the

crucibles in which molten glass was heated.[117] On his departure, Dorflinger sold the Long Island Flint Glass Works, which continued to operate until the 1890s.[118]

Dorflinger's retirement exemplifies the changes then taking place throughout New York's glass industry. The Fisher brothers' Bloomingdale Flint Glass Works had been dissolved by 1840; the Jersey Glass Works, founded by Dummer, lasted until 1862; the Brooklyn Flint Glass Works, originated by Gilliland, closed its Brooklyn location in 1868. The manufacture of fine cut glass, along with its entrepreneurs and skilled craftsmen, migrated westward to more coalrich, less populous regions. Glass production was subject to technological advances and becoming a more fully mechanized industry, which required not only ever larger amounts of fuel but also space for new, larger factories. To remain in an urban location with a rapidly increasing population, such as Brooklyn, was no longer feasible. And urban markets were now accessible, even from distant locations, because

115. John Q. Feller, *Dorflinger: America's Finest Glass, 1852–1921* (Marietta, Ohio: Antique Publications, 1988), p. 13.

116. Frederick Dorflinger Suydam, *Christian Dorflinger: A Miracle in Glass* (White Mills, Pennsylvania: Privately printed, 1950), p. 20. Another Dorflinger Guards presentation piece is a compote with the inscription: "W. C. Fowler: Presented By The Dorflinger Guard Oct. 20th 1860."; see Helen Barger, Sheldon Butts, Ray La Tournous, "The Dorflinger Guard Presents," *Glass Club Bulletin of the National Early American Glass Club*, no. 136 (winter 1981–82), pp. 3–4.

117. For a complete discussion of this tea set, see Arlene Palmer and John Quentin Feller, "Christian Dorflinger's Presentation Silver Service," unpublished article, 1991.

118. Dorflinger started a new factory in 1865 in White Mills, Pennsylvania. In 1863 he sold the Long Island Flint Glass Works to Fowler, Crampton and Company, which ran it for four years. It was sold to a number of subsequent owners and continued in operation as the Plymouth Glass Works. Dorflinger leased the Greenpoint Glass Works to two former employees, Nathaniel Bailey and John Dobelman, who were succeeded by John W. Sibell. In 1882 (while retaining the name Greenpoint Glass Works), the firm was leased by the Elliot P. Gleason Manufacturing Company, which primarily made globes and chimneys for lighting. It later merged with Cornelius H. Tiebout, and in 1905 it was the Gleason-Tiebout Company that finally bought the property from Dorflinger.

119. John Bolton of Pelham exhibited a "Richly-stained Mosaic window, with Scripture studies and emblems. Specimens of illuminated lettering on glass." William J. Hannington of New York City submitted three separate entries that included a "Stained glass gothic window; stained glass plates, panels, borders, &c., for windows and doors. Stained glass portraits and fancy subjects." Sharp and Steele of 216 Sixth Avenue showed "Stained glass, in ancient and modern styles." See *Official Catalogue, Industry of All Nations*, pp. 80–81.

120. In 1638 Evert Duyckinck set up a business in New Amsterdam

STAINED GLASS WORKS,

AND

Gallery of Architectural Decorative Art,

NOS. 374 & 376 BROADWAY,

NEW YORK,

ON HAND, AND MANUFACTURING TO ORDER,

PLAIN, COLORED, ENAMELLED, ENGRAVED, GROUND,
EMBOSSED, LACE, AND ORNAMENTAL

STAINED GLASS.

RICH MOSAIC FIGURE & DOMESTIC WINDOWS

EXECUTED TO ORDER; AND

DESIGNS FURNISHED WITH ESPECIAL REFERENCE TO SITUATION.

ARCHITECTURAL ENRICHMENTS,

NUMBERING MANY THOUSAND SPECIMENS, EXECUTED FOR

INTERIOR AND EXTERIOR WORK,

IN THE IMPROVED

Papier Mache, Carton Pierre, Putty, Plaster, Cement, and other Plastic Compositions,

CONSISTING OF ALL THE VARIETIES OF

CAPS, FLOWERS, VENTILATORS, CORNICES,

CANTILEVERS, CONSOLES, BRACKETS, ETC.

ARCHITECTS' DRAWINGS FAITHFULLY CARRIED OUT.

NO EXTRA CHARGE FOR MODELLING.

Particular attention given to the revival of Ancient House Furniture, from the best examples of the Middle Ages.

PAINTING, GILDING, PAPER HANGING, ETC,

A Classified Tariff of Stained Glass forwarded on application.

Fig. 287. Advertisement from a four-page pamphlet for William Gibson's Stained Glass Works, 1850s. Wood engraving. Courtesy of The Winterthur Library, Winterthur, Delaware, Printed Book and Periodical Collection

as a glazier and "burner of glass." Some of the small panels of glass he painted with coats of arms survive at the Metropolitan Museum, the New-York Historical Society, and the Albany Institute of Art. These are the earliest known examples of American stained glass. See R. W. G. Vail, "Storied Windows Richly Delight," *New-York Historical Society Quarterly* 36 (April 1952), pp. 149–59, and R. W. G. Vail, "More Storied Windows," *New-York Historical Society Quarterly* 37 (January 1953), pp. 55–58.

121. *Evening Post* (New York), October 1840, quoted in *History of Architecture and the Building Trade of Greater New York*, 2 vols. (New York: Union History Company, 1899), vol. 2, p. 19.

of railroads and improved river transportation. The Houghton family purchased the Brooklyn Flint Glass Works in 1864, persuaded John Hoare's cutting firm to join the business, and moved the entire enterprise to Corning, New York. In 1870 Dorflinger established a new and thriving operation in White Mills in northeastern Pennsylvania. Thus the tradition that began in Brooklyn and New York City during the 1820s laid the foundation for a large and active industry of glass manufacturing and glasscutting that during the late nineteenth and early twentieth centuries would operate, elsewhere in the country, with extraordinary success.

Stained Glass

The eight submissions of stained glass at the New York Crystal Palace exhibition, which included several

from local makers,[119] emphasized the recent growth of a stained-glass industry in the metropolitan region. New York had seen little production of stained glass prior to the 1830s;[120] indeed, it was only during the late 1820s and the 1830s that the art and craft of stained glass were revived in England and on the Continent, consistent with a renewed interest in Gothic architecture and Gothic styles. Two of the earliest known stained-glass studios in New York were those founded in 1830 and 1833, respectively, by William J. Hannington and William Gibson, both of whom claimed to have opened the first such business in the city. It was not until the 1840s that the stained-glass industry gained momentum in New York, which in the last decade of the nineteenth century would become one of the largest and most successful centers in America for that art form.

In 1840, after viewing a display of stained glass at the American Institute, an unidentified reporter expressed his views on the relatively unfamiliar medium: "It is rather surprising to those who have observed how useful as well as ornamental windows set in stained glass are, . . . that they are not in more general use."[121] However unaccustomed to decorative window glass the observer may have been, records indicate that it was beginning to be utilized in a variety of ways not only in churches but also in residences and theaters and on steamboats. For example, in the early 1840s the new firm of Carse and West at 472 Pearl Street offered "specimens of staining upon glass . . . intended either for steamboat or packet ship lights, transparent signs, window blinds, sky lights and other purposes, for which painted glass is commonly used."[122] And Hannington's 1847 advertisement elaborates on the many types of stained glass available from his establishment:

> . . . *suitable for the embellishment of Churches, Public Buildings, Drawing Rooms, Sliding and Hall doors, Domed Sky-lights, Wall Lanterns, Damasked enamelled Glass, white or colored, for Basement windows; DOUBLE OBSCURED GLASS for BATHING-ROOMS. Conservatories, Cemeteries, Packet Ships, and Steamboat Cabins, and Office Windows. . . . Landscapes, figures, fruits, and flowers, painted and burnt into the glass in natural colors. . . .*
>
> *W. J. H. has constantly on hand a great stock of rich colored glass, of all sizes, in ruby red, purple, greens, blue, amber, gold, yellow, and violet, which can be forwarded in a few hours' notice to any part of the Union.*[123]

Like luxury table glass, stained glass made in New York has been largely overlooked, and few surviving documented examples are known. Beginning in the late 1870s, as congregations and the city prospered, early stained-glass installations were typically replaced with opalescent glass. Despite the paucity of existing examples, however, study yields a picture of a large and industrious group of studios. Many of these firms exhibited regularly at industrial fairs such as those of the American Institute, and the talents of their glass painters were duly recognized.[124]

The trade of stained-glass painting, although highly regulated in England, in America during this period encompassed a multitude of services beyond the provision of ornamental windows. An advertising broadside for William Gibson's Stained Glass Works dating to the 1850s (fig. 287) announces that in addition to stained glass the firm executed "architectural enrichments . . . for interior and exterior work in the improved Papier Mache, Carton Pierre, Putt, Plaster, Cement, and other Plastic Compositions," as well as furniture work and "painting, gilding, paper hanging, etc."[125] Although no examples of his work are known to survive, Hannington appears to have had a thriving career for at least four decades. In 1839 his firm advertised for skilled artists and an apprentice to supplement its staff.[126] His establishment consistently won awards at the American Institute fairs.

Little is known of Gibson's career, but his firm was long lived; it lasted until 1895, according to New York City directories, and presumably was run by his sons after he retired or died. After Gibson and Hannington opened the original New York studios, they were joined in the field by Thomas Thomas, who also operated as a glass stainer during the 1830s, and then by the partnership of Robert Carse and James West, both of whom are first listed in New York City directories as glass stainers in the early 1840s.[127] In the early 1850s Henry Sharp and William Steele established themselves in a partnership as glass stainers, working together at 216 Sixth Avenue from 1852–53 through 1854–55.[128] The stained-glass trade took root on or near Broadway, the primary commercial district of the city and also home to numerous churches that were built during the period and required its services. For these churches craftsmen in stained glass made figural religious windows and colored "panels, borders, &c, for windows and doors,"[129] presumably in the Gothic Revival style.

New York was the center from which stained glass was disseminated to other parts of the country. Trinity Church in New Orleans ordered ornamental stained-glass windows from Gibson, in New York, in 1854.[130] Architect Richard Upjohn favored the stained-glass studio of Sharp and Steele and utilized its services for Saint Paul's Church in Buffalo in 1851 and (in association with Carse and Reed, then practicing as glaziers in Brooklyn) for the Gothic-style chapel he designed for Bowdoin College in Brunswick, Maine, built 1846–51.[131]

Following English practice, stained-glass artists not only made their own designs for clients but also executed designs prepared by architects. For example, the Gothic Revival architect Alexander Jackson Davis commissioned two New York studios to paint glass from his designs for Litchfield Villa in Brooklyn. Gibson painted the "central window side light of south 2 story state bedroom at $2.00 per ft.," and Hannington "did the tower windows."[132] Davis's designs for stained-glass windows follow the stylistic preferences of the day; they generally call for panes filled with diamond-shaped sections of clear colorless or colored glass, surrounded by decorative borders in a bold contrasting color embellished with Gothic ornament (fig. 288). Stained glass such as this became a vehicle by which art and, consequently, refinement were brought into the Empire City home.

The most ambitious work in stained glass took place in the mid-1840s with the building of two important New York churches, Trinity Church on Wall Street, whose construction began in 1841, and Holy Trinity Church (now St. Ann and the Holy Trinity) at Clinton and Montague streets in Brooklyn Heights, dating to 1844–47. Each was designed in the Gothic Revival style by a noted architect, Trinity by Richard Upjohn and Holy Trinity by Minard Lafever, and each required a major installation of stained glass. An examination of these two parallel commissions offers a revealing insight into two widely differing stained-glass styles and processes.

Trinity Church was a parish of long standing on Wall Street, having been founded in 1698. It was old-line Episcopalian, conservative, and Anglican in its traditions. After its second building was torn down in the late 1830s, the congregation hired Richard Upjohn to design the majestic structure that still stands on its original site. His plan called for an extensive array of windows, including an enormous fourteen-light chancel window. Completed in 1846, Trinity was called the "glory of our City."[133] Holy Trinity in Brooklyn, on the other hand, was a completely new undertaking sponsored by Edgar John Bartow, a wealthy Brooklyn resident who wanted Brooklyn Heights to have a church that would rival Trinity in Manhattan.

122. Ibid.

123. W. J. Hannington, advertisement, *Spirit of the Times*, October 16, 1847, p. 401.

124. It is interesting to note that until the end of the 1840s, when a separate "stained-glass" category was established, stained-glass artists exhibited their work in the "artists" category.

125. William Gibson's Stained Glass Works, 374–376 Broadway, advertising broadside, ca. 1850–60, Joseph Downs Collection of Manuscripts and Printed Ephemera, courtesy The Winterthur Library.

126. Advertisement, *The Albion*, March 30, 1839, p. 104.

127. According to New York City directories, Thomas Thomas worked as a glass stainer from 1834–35 to 1848–49, beginning at 36 Wooster Street in 1834, moving to 136 Spring Street at Broadway in 1837–38, and in 1846–47 moving to 226 Avenue 6. Carse and West's partnership as glass stainers began at 472 Pearl Street in 1842–43. It was apparently dissolved by 1844–45, when they are listed separately in the directory, both as glass stainers, Carse at 61 White Street and West remaining at 472 Pearl. Carse began a new partnership with Joseph Read at 5 Spruce Street, and they remained together until 1848–49, after which time Carse continued the business at the same address through 1850–51. West remained an independent glass stainer, first at 6 Wall Street in 1846–47, then moving to 492 Broadway in 1847–48, in 1848–49 to 480 Broadway (across the street from furniture makers E. W. Hutchings and Alexander Roux), and further uptown to 1116 Broadway in 1852–53. Hannington (also spelled Hanington) started out in the city directories with his brother Henry as a decorative painter at 472½ and 568 Broadway in 1841–42, but in 1842–43 is listed on his own at 293 Broadway, at 46 Canal Street in 1844–45 to 1845–46, and at 418 Broadway the following year. In 1847–48 he moved to 364 Broadway, where he remained until 1854–55, when he is listed at 442 Broadway. He continued to be listed at various addresses on Broadway: 440 (corner of Pearl) in 1856–57; 418 (corner of Canal) in 1857–58, and finally, 820 in 1858–59.

128. Henry Sharp was listed for one additional year (1856–57), when he continued as a glass stainer independent of Steele at the same address.

129. In 1852 William Hannington was awarded a silver medal at the American Institute fair for "a stained glass church window figure of St. Peter." "List of Premiums Awarded by the Managers of the Twenty-fifth Annual Fair of the American Institute, October, 1852," p. 18, New-York Historical Society Library. Hannington received a bronze medal with special approbation at the 1853 New York Crystal Palace exhibition for his entry, a "Stained glass gothic window; stained glass plates, panels, borders, &c., for windows and doors. Stained glass portraits and fancy subjects." *Official Catalogue, Industry of All Nations*, pp. 80–81.

130. Regrettably, Gibson's windows for Trinity Church no longer survive, having been "upgraded" in the later nineteenth century.

131. The windows of Saint Paul's were undoubtedly typical for the day. The aisle windows were described as "of a rich salmon color, in small diamond panes, each pane bearing a *fleur-de-lis*." See Charles W. Evans, *History of St. Paul's Church, Buffalo, N.Y., 1817 to 1888* (Buffalo and New York: Matthews-Northrup Works, 1903), p. 69. I thank Arlene Palmer for bringing to my attention the Bowdoin College chapel windows and their documentation.

132. List of contractors and merchants mentioned by Alexander Jackson Davis in connection with Litchfield Villa. I thank Amelia Peck for bringing these references to my attention.

133. *The Diary of Philip Hone, 1828–1851*, 2 vols., edited by Allan Nevins (New York: Dodd, Mead and Company, 1927), vol. 2, p. 764.

134. The steeple was taken down in 1906 when the subway was built beneath the church, for fear the train's vibrations would dangerously weaken the structure.

135. Everard M. Upjohn, *Richard Upjohn: Architect and Churchman* (New York: Columbia University Press, 1939), pp. 54–55.

136. William Bolton had studied under Samuel F. B. Morse at the National Academy of Design in

Fig. 288. Alexander Jackson Davis, *Design Drawing for Stained-Glass Window*, ca. 1840. Watercolor and ink. The Metropolitan Museum of Art, New York, Harris Brisbane Dick Fund, 1924 24.66.1042

Bartow commissioned Lafever to design a monumental house of worship; the result was a soaring Gothic Revival structure with a tall, attenuated steeple encrusted with Gothic-style ornament.[134] Holy Trinity expresses a new spirit and sense of freedom and represents a departure from the ecclesiastical conservatism of Trinity.

In their process of manufacture as well as their design, the windows embody the differences between the churches themselves. At Trinity, following the traditional European practice, the architect was also the window designer. Upjohn retained complete artistic control; he prepared designs to be painted and glazed by Abner Stevenson, a glazier who erected a small workshop on the church grounds in order to accomplish this enormous task.[135] For the Brooklyn endeavor, which called for an ensemble of some sixty windows on three stories as well as an organ loft window and a majestic chancel window, Lafever hired William Jay Bolton, an artist from Pelham, New York, who served as designer, glazier, and painter at once.[136]

At Trinity, traditional Gothic Revival quarry, or diamond-paned, windows, the style favored by the High Church Anglican movement, were used throughout in the aisles, galleries, and clerestory. Both in their motifs and in their limited use of color, the windows are restrained. Figural designs appear only in the chancel window, where they stand one to a lancet, in

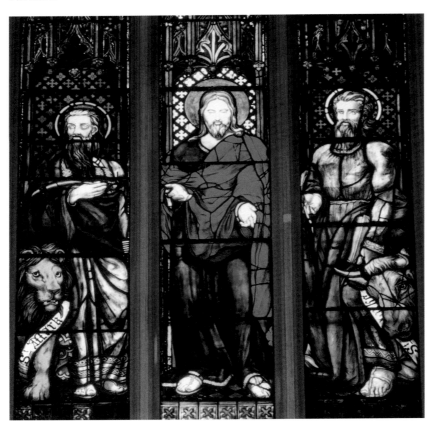

Fig. 289. Richard Upjohn, designer; Abner Stevenson, maker, *Saint Mark, Christ, and Saint Luke*, detail of chancel window, Trinity Church, Wall Street, 1842; photograph by David Finn. Paint and silver stain on pot-metal glass

traditional poses and with their appropriate attributes, surrounded by decorative diaper patterning and set under elaborate architectural canopies (fig. 289). In contrast, the windows at Holy Trinity in Brooklyn, reflecting its less conservative ecclesiastic spirit, carry an exuberant figural program of bold Renaissance-style narrative scenes. Bolton's designs are dense with people in complex compositions and often depart from traditional depictions of their subjects. The aisle windows represent scenes from the Old Testament, and the gallery or balcony windows present scenes from the life of Christ. In *Christ Stills the Tempest* Bolton has shown Christ and his disciples in an open boat in a raging storm on the Sea of Galilee, whose turbulent waves seem ready to engulf the vessel (cat. no. 280). Although illustrations of this miracle usually show Christ sitting peacefully or sleeping, here he is seen with his arms outstretched, about to still the waters, while his disciples regard him in awe. Jesus appears not as the familiar grown man with dark flowing hair and beard but as a clean-shaven youth with short blond hair. He and his disciples are depicted as individualized characters instead of iconic figures. Bolton utilized glass in a wide range of high colors, richly varied silver staining that ranges from pale lemon yellow to a deep amber, and colored enamel painted or, as seen in the stormy sea, sponged on: in short, any material or technique at his disposal that would heighten the artistic effect.

Liberal amounts of white glass also appear in his intricate designs. The traditional diaper patterns found in the windows of Trinity and in certain earlier windows by Bolton are absent here. Trained not as a technician but as an artist, Bolton approached his work from a painterly perspective rather than from the decorative viewpoint of a traditional glass stainer. The result, a series of intensely dramatic compositions, was also a most unusual example of the glass stainer's art.[137]

Bolton's complex, densely figured, individualistic art evokes the city that was its setting: an increasingly complex and populous New York with ever more richly colorful streetscapes and citizens. Yet Bolton's hand-executed craft, practiced in a small workshop next to his Pelham home, is the product of techniques that are the antithesis of the manufacturing developments that profoundly affected industry and its growth in the region. It was the glass and ceramics factories, especially the highly mechanized Brooklyn glassworks; the cutting shops using steam power; the new industrial potteries organized along English factory lines; and the tremendous influx of skilled immigrant labor that forever changed the city and, even more, the nation as a whole. For although after the Civil War neither glassmaking nor ceramic manufacture in and around the city was able to attain the production levels of the previous decades, it was in New York that the groundwork had been laid for an impressive further development of those industries in many other parts of the country.

New York, see Willene B. Clark, *The Stained Glass of William Jay Bolton* (Syracuse: Syracuse University Press, 1992), pp. 12–13. Bolton had earlier made a presentation to the vestry of Trinity Church in an attempt to secure the commission for its windows: appealing on the grounds of aesthetics, doctrine, and economy, he proposed a complex Ascension window for the chancel and a figural program for the aisles, a design that was not selected. Letter from William Jay Bolton to William H. Harison of the building committee of Trinity Church, October 19, 1844(?), Trinity Church Parish Archives, New York.

137. I am grateful to David J. Fraser, Stained Glass Conservator, St. Ann and the Holy Trinity Church, Brooklyn, who was responsible for the conservation of this and most of the other windows at the church, for sharing his observations.

"Silver Ware in Great Perfection": The Precious-Metals Trades in New York City

DEBORAH DEPENDAHL WATERS

Responding to an 1820 federal census questionnaire, New York silverware manufacturer Colin van Gelder Forbes (1776–1859) assessed current conditions in his industry. "From 1795 to 1816," he wrote, "the business was brisk and silver work was during those years in good demand. Since 1816 there has been but little doing."[1] The decline he described was relatively short lived, as the products of New York City's precious-metals trades, described by one observer as "Silver Ware in great perfection,"[2] came to dominate the American market in both artistic merit and quantity during the succeeding forty years, through stylistic, technological, and marketing transformations.

In 1824 a committee of Pearl Street merchants, charged with judging a competition for a pair of vases to be presented to Governor De Witt Clinton in recognition of his efforts in connection with the Erie and related canals, chose a submission by a firm outside New York, despite the presence within the city of some one hundred craftsmen working with precious metals. The well-known Philadelphia silversmith Thomas Fletcher modeled his winning designs (cat. no. 281 A, B; fig. 290) on a colossal Roman urn of the second century A.D. known as the Warwick Vase. They were manufactured in the workshop he owned with Sidney Gardiner. The vases impressed such New Yorkers as businessman and diarist Philip Hone when they were completed and exhibited in the assembly room of the City Hotel in March 1825. Some thirteen years later, Hone visited the shop of Thomas Fletcher in Philadelphia and observed, "Fletcher & Co. are the artists who made the Clinton vases. Nobody in this 'world' of ours hearabouts can compete with them in their kind of work."[3]

By comparison with these monumental Philadelphia vases, the New York–made presentation silver associated with Clinton and the canals is on a domestic scale and utilizes less handwrought ornament. Two years prior to the presentation of the Fletcher and Gardiner vases, the shop of William Gale, established in 1821, produced a covered pitcher (fig. 291) commissioned by a group of New York City flour manufacturers to commemorate the maiden voyage from Seneca Lake to New York City via the Seneca and Erie (Western) canals of the schooner *Mary and Hannah,* laden with a cargo of Western wheat, butter, and beans. Gale elongated the midsection of a typical pitcher form to accommodate a view of New York Harbor engraved after an unidentified source, and he incorporated such topical references in its decoration as die-rolled borders featuring sheaves of wheat alternating with scenes of rural life and a cast sheaf-of-wheat finial.[4]

Closer to the Clinton vases in scale and provenance is a mirrored plateau (fig. 292) struck with the mark of New York silversmith John W. Forbes (1781–1864).[5] More than five feet in length, the tripartite table ornament is in a form that originated in eighteenth-century France and was brought to American tables by stylish European ambassadors and American gentlemen, including George Washington, who ordered plateaus from France in 1789.[6] The frame of the Forbes plateau is closely related to London examples of the early nineteenth century, such as an 1810 model by Paul Storr.[7] The Forbes plateau has two widths of die-rolled floral scroll border centering a pierced central band. The latter is composed of alternating motifs of winged lions supporting an urn and grapevine with grape-cluster scrolls flanking a laurel wreath. Six pedestals with cast spread-eagle finials on cast acanthus-leaf legs terminating in lion's-paw feet support the mirrored frame. Mounted on the central pedestals are relief figures of Flora, the Roman goddess of flowers, and Pomona, the ancient Italian goddess of fruit trees. Ornamenting the two end-pedestals are relief trophies composed of symbolic devices, including a liberty cap on pole, a caduceus, an anchor, and an American flag. The only comparable American example, also marked by Forbes and now at the White House, is similarly ornamented.[8]

Forbes placed an announcement in the *New-York Daily Advertiser* for January 11, 1825, inviting customers and "admirers of good work in general" to examine what he characterized as "a superb Silver Plateau of

1. United States, Census Office, 4th Census, 1820, *Records of the 1820 Census of Manufactures,* National Archives Microfilm Publication, Microcopy no. 279, roll 10.

2. *New-York American,* October 20, 1835, p. 2, col. 3.

3. See Thomas H. Ormsbee, "Gratitude in Silver for Prosperity," *American Collector* 7 (April 1937), p. 3; and *The Diary of Philip Hone, 1828–1851,* 2 vols., edited by Allan Nevins (New York: Dodd, Mead and Company, 1927), vol. 1, pp. 301–2.

4. See Tammis K. Groft and Mary Alice Mackay, eds., *Albany Institute of History and Art: 200 Years of Collecting* (New York: Hudson Hills Press in association with Albany Institute of History and Art, 1998), pp. 198–99, no. 74. The pitcher is marked "w.g." and inscribed "Presented by the undernamed Manufacturers of flour in the City/of new York to John H. Osborne and Samuel S. Seely, of the Town of Hector, Tompkins County owners of the Boat Mary/& Hannah to Commemorate their enterprise in having first navigated/the Western Canal and Hudson River, from Seneca Lake to this/City with a Cargo of Wheat in Bulk, New York 1823" (followed by the names of ten individuals and firms). The reverse is engraved with a view of the *Mary and Hannah* in New York Harbor.

5. John W. Forbes was a second-generation New York silversmith, son of William Garret Forbes and younger brother of silversmith Colin van Gelder Forbes. The plateau is marked "I.W. FORBES" in a rectangle with pseudohallmarks of an anchor, star, monarch's head and the letter C, each in an oval. The center section is marked twice. The end-section with one foot is marked twice on each side. The other end-section is unmarked. For the mark, see Louise Conway Belden, *Marks of American*

Fig. 290. Hugh Bridport, Philadelphia, artist, after Thomas Fletcher, designer; Fletcher and Gardiner, Philadelphia, manufacturing silversmith. *Drawing of One of the Covered Vases Made for Presentation to Governor De Witt Clinton in March 1825,* ca. 1825. Watercolor. The Metropolitan Museum of Art, New York, The Elisha Whittelsey Collection, The Elisha Whittelsey Fund, 1953 53.652.2

Fig. 291. William Gale, Covered ewer presented to the owners of the boat *Mary and Hannah,* 1823. Silver. Collection of the Albany Institute of History and Art, gift of William Gorham Rice, grandson of Samuel Satterlee Seely X1940.435

Fig. 292. John W. Forbes, Plateau, ca. 1825. Silver, mirrored glass, and walnut. The Metropolitan Museum of Art, New York, Purchase, The AE Fund, Annette de la Renta, The Annenberg Foundation, Mr. and Mrs. Robert G. Goelet, John J. Weber, Dr. and Mrs. Burton P. Fabricand, The Hascoe Family Foundation, Peter G. Terian, and Erving and Joyce Wolf Gifts, and Friends of the American Wing Fund, 1993 1993.167a–c

Fig. 293. Pelletreau, Bennett and Cooke, Pitcher presented to the Honorable Richard Riker, 1826. Silver. The Metropolitan Museum of Art, Purchase, The Overbook Foundation Gift, 1996 1996.559

his own manufacture, which he believes to be, at least, equal to any imported or manufactured in the United States."[9] Although an official presentation of the piece to Clinton cannot be documented, the family history that accompanied the plateau confirms that it is indeed the one on which the Fletcher and Gardiner vases stood—a fact also noted in 1828 in the press coverage of the sale of Clinton's personal effects following his death.[10]

In 1824 and 1825 a series of grand civic celebrations honoring venerable Revolutionary War hero the marquis de Lafayette and the completion of the Erie Canal prompted the production of an array of presentation silver by city craftsmen. Following the Grand Canal Celebration of November 4, 1825, the Corporation of the City of New York ordered a medal coined in commemoration of the successful opening of a water route joining Lake Erie with the Atlantic Ocean (cat. nos. 282A, B, 283A, B). Preparation of the dies required to strike the medal was a collaborative project involving artist Archibald Robertson, engraver and diesinker Charles Cushing Wright, engraver, diesinker, and piercer Richard Trested, and iron- and steelworker William Williams. Silversmith Maltby Pelletreau, of the firm Pelletreau, Bennett and Cooke, struck the medals in gold, silver, and semimetal using a hand-powered screw press with a heavy end-weighted balance lever that drove the screw with sufficient momentum to coin them cleanly.[11] Pelletreau also struck the obverse die—depicting Neptune, Roman god of the sea, and goat-legged Pan, Greek god of forests, pastures, flocks, and shepherds—on the body of a globular silver pitcher (fig. 293) that his firm presented to the Honorable Richard Riker, recorder of New York City. As chairman of the Committee of Arrangements for the Grand Canal Celebration, Riker apparently selected the firm for the prestigious medal commission.

On January 1, 1826, the Corporation of the City of New York acknowledged the contributions of Charles Rhind to the success of the Lafayette visits and the canal celebration by presenting him with a silver service composed of a tea set by master craftsman Garret Eoff (1779–1845) and a tray (fig. 294) and cake basket from the shop of Stephen Richard (1769–1843).[12] Rhind, a Scottish-born merchant who acted as agent for the

Fig. 294. Stephen Richard, retailer; James D. Stout, engraver, Tray presented to Charles Rhind, 1826. Silver. The Metropolitan Museum of Art, New York, Lent by Mr. and Mrs. Samuel Schwartz

Fig. 295. Edgar Mortimer Eoff and George L. Shepard, silverware manufacturer; Ball, Black and Company, retailer, Pair of pitchers presented to Julie A. Vanderpoel, ca. 1855. Silver. Museum of the City of New York, Gift of Charles E. Loew and Miss Julie V. Loew 44.153.1–2

Silversmiths in the Ineson-Bissell Collection (Charlottesville: University Press of Virginia for the Henry Francis du Pont Winterthur Museum, 1980), p. 172, mark d.

6. For plateaus, see Martha Gandy Fales, *Early American Silver for the Cautious Collector* (New York: Funk and Wagnalls, 1970), pp. 148–49.

7. Alain Gruber, *Silver* (New York: Rizzoli International Publications, 1982), p. 186, fig. 265.

8. Graham Hood, *American Silver* (New York: Praeger Publishers, 1971), pp. 201–2, figs. 223, 224.

9. *New-York Daily Advertiser*, January 11, 1825.

10. "The Clinton Vases," *Niles' Weekly Register*, June 14, 1828.

11. For a description of a comparable coinage conducted at the Philadelphia Mint in the early nineteenth century, see the commentary prepared by George Escol Sellers, cited in Edgar P. Richardson, "The Cassin Medal," *Winterthur Portfolio* 4 (1968), pp. 80–81.

12. Marked "S. RICHARD" in a serrated rectangle with rounded corners, the tray is inscribed "Presented by the Corporation of the City of New York to Charles Rhind Esqr. Jany 1st 1826"; "Reception of Majr. Genl. LaFayette A.D. 1824"; "Grand Canal Celebrations A.D. 1825"; and "Engd. by I. D. Stout."

13. Stout advertised the execution of card and doorplate engraving as well as engraving on penknives, spoons, umbrellas, lockets and rings, and silver plate in the *Morning Courier* (New York), April 10, 1832, p. 2, col. 7.

14. The cake basket was illustrated in an advertisement published in *Antiques* 94 (December 1968), p. 795.

15. For example, William Thomson used the border on a tea service that descended in the Osgood-Field family of New York (Museum of the City of New York, 90.65.2).

16. *Minutes of the Common Council of the City of New York, 1784–1831* (New York: City of New York, 1917), vol. 8, August 6, 1816, p. 599.

North River Steam Boat Company, had served as chairman of the reception committee that welcomed Lafayette upon his arrival in New York in 1824 and as admiral of the fleet during the Grand Aquatic Display portion of the Grand Canal Celebration of November 1825. James D. Stout handsomely engraved the tray with a vignette depicting the arms of the city, flanked by its mariner and native American supporters, against a view of the city and its harbor.[13] Used on both the tray and the cake basket (unlocated)[14] is a die-stamped floral border of typical New York design. Like the die-rolled borders and sheaf-of-wheat finial of William Gale's pitcher (fig. 291), it appears on silver objects struck with marks identified with various shops, including that of silver manufacturer William Thomson.[15]

Available documentation suggests that Stephen Richard, active as a jeweler, enameler, and hair worker in New York at various locations in Manhattan between 1801 and 1829, operated a retail store selling both domestic and imported products. In 1816 his firm had provided a gold box presented to Commodore William Bainbridge by the Common Council of the City of New York, so a second city commission a decade later would not have been unexpected.[16] That these pieces for Rhind date from the end of Richard's career—as do other significant presentation commissions, including an undated ewer and salver given to Charles Bancroft by the Phenix Bank of New York (Bayou Bend Collection, Museum of Fine Arts, Houston) and a pair of pitchers presented

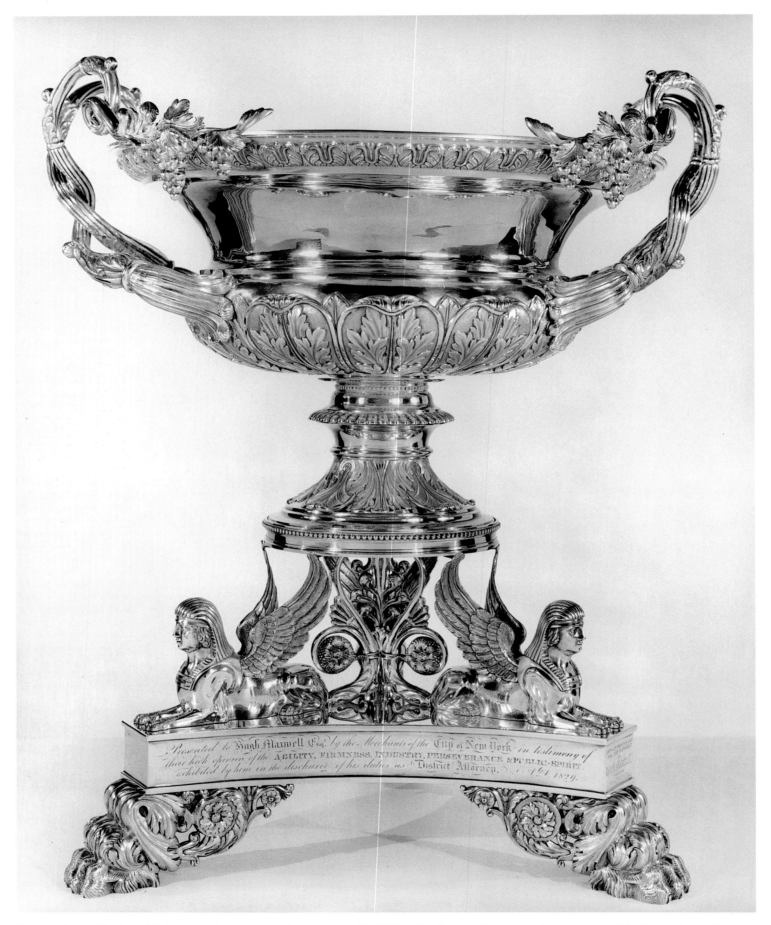

Fig. 296. Thomas Fletcher, Philadelphia, designer and manufacturer; marked by Baldwin Gardiner, retailer, Presentation vase presented by the merchants of New York to District Attorney Hugh Maxwell, Esq., 1828–29. Silver. On loan from The New York Law Institute to The New-York Historical Society

to Jameson Cox in 1829 (Museum of the City of New York)—indicates that Richard's shop either employed skilled journeymen or subcontracted its silver work to such manufacturing silversmiths as Garret Eoff. Eoff had announced his intention to "decline the retail business and confine himself to manufacturing exclusively" in April 1825.[17] Other manufacturing silversmiths, such as John W. Forbes, opposed wholesale selling to retailers. To differentiate himself from others, Forbes advertised that he attended personally to his manufactory, manufactured "solely to order and for cash," and that "all articles of silver of his manufacture [were] sold only by himself."[18]

Traditional kinship and apprenticeship networks continued to link many craftsmen in the luxury-metals trades from the 1820s through the outbreak of the Civil War, even as new models for the organization of the craft evolved. For example, the brothers John W. and Colin van Gelder Forbes continued a family tradition of silversmithing established in the eighteenth century by their father, William Garret Forbes (1751–1840), and their uncle Abraham G. Forbes. In 1826 Colin's son William joined his father's silver manufactory. Nine years later Colin V. G. Forbes and Son produced a distinguished hot-water urn ornamented with relief decoration after a design by Henry Inman (cat. no. 290).[19] The younger Forbes's entry in the 1838 American Institute fair won a silver medal for the best tea set, an award that came at the beginning of his independent career. The Forbes manufactory produced goods distributed by the New York retail silversmith and jewelry firm Ball, Tompkins and Black (see cat. no. 306) and its successor, Ball, Black and Company (active 1851–74), until William's retirement, about 1864. As a master craftsman, John W. Forbes proudly announced to potential customers that he had "served a regular apprenticeship at the business" and would execute all orders "in a masterly manner."[20] He continued to teach apprentices the "art and mystery" of the craft, preferring, as he stated in an advertisement of 1821, "an active lad about 14 years of age, of respectable connexions."[21] Although Forbes called his shop a "manufactory" and owned both a flatting mill (for preparing sheet silver) and an embossing mill (for die-rolling borders), he employed only three men and two boys in 1820, not the minimum workforce of twenty as proposed by historian Sean Wilentz in his definition of "manufactory."[22]

A shortened apprenticeship with Abraham G. Forbes, from April 1793 to April 1798, links Garret Eoff with the extended Forbes clan of silversmiths at the outset of his career. He in turn fostered the early career of John C. Moore when they worked in partnership as Eoff and Moore in 1835. At the beginning of the 1820s Eoff operated a retail silver and jewelry store at 163 Broadway, but in 1825 he decided to discontinue retail sales and to relocate away from the bustle of Broadway. Eoff sold off not only the stock he had on hand but also his shop fixtures, including "three glass side cases, one good awning, and two counter cases."[23]

One of Eoff's heirs, Edgar Mortimer Eoff, carried Garret's eighteenth-century craft legacy into the third quarter of the nineteenth century. As a manufacturing silversmith in partnership first with William M. Phyfe and then, beginning in 1852–53, with George L. Shepard, Eoff supplied goods not only to New York City retailers Ball, Black and Company (see fig. 295) but also to retail silversmiths as far afield as Richmond, Virginia.[24]

As the city grew and prospered following the opening of the Erie Canal, the silver-manufacturing industry offered financial opportunities to a second group of specialists whom Wilentz has identified as "craft entrepreneurs."[25] In the luxury-metals trades, not all entrepreneurs were skilled craftsmen. Often they were merchandisers whose expertise lay in their ability to persuade consumers to acquire goods from ever-changing assortments of domestic and imported merchandise. One of these was Baldwin Gardiner, brother of Sidney Gardiner. Trained as a shopkeeper in the firm of Fletcher and Gardiner, first in Boston and then in Philadelphia, Baldwin moved to New York late in 1826 or early in 1827. In New York he established a fashionable furnishings warehouse at 149 Broadway, at the corner of Liberty Street, where he sold lamps and other goods and filled special local orders for silver. After his brother's untimely death in 1827, Gardiner maintained contact with Thomas Fletcher, to whom he turned when seeking the commission for two pitchers and a vase to be presented to New York district attorney Hugh Maxwell, who had reached the midpoint of his twenty years in office.[26] As Gardiner explained when he requested design drawings from Fletcher in August 1828, "Of course, I should expect to have my name stamped upon the bottoms."

Gardiner received the commission, and the Fletcher shop manufactured the "splendid Vase" (fig. 296), which was stamped with Gardiner's name.[27] In designing the Maxwell vase, Fletcher once again took the Warwick Vase as his model, adapting its rustic grapevine handles, central foot, and repoussé acanthus-leaf decoration. Unlike the Warwick Vase or the earlier De Witt Clinton vases, however, the Maxwell

17. *New-York Evening Post*, April 13, 1825, p. 3, col. 2.

18. *New-York Daily Advertiser*, September 2, 1820; ibid., October 1, 1817, p. 3, col. 5.

19. Several previous publications, including *19th-Century America*, vol. 1, *Furniture and Other Decorative Arts*, by Marilynn Johnson, Marvin D. Schwartz, and Suzanne Boorsch (exh. cat., New York: The Metropolitan Museum of Art, 1970), no. 52; and David B. Warren, Katherine S. Howe, and Michael K. Brown, *Marks of Achievement: Four Centuries of American Presentation Silver* (exh. cat., Houston: Museum of Fine Arts, 1987), pp. 124–25, no. 156, have recorded the members of the firm as Colin van Gelder Forbes and John W. Forbes; John W. Forbes was the younger brother of Colin van Gelder Forbes, not his son.

20. *New-York Daily Advertiser*, December 16, 1819.

21. Ibid., July 30, 1821, p. 1, col. 7.

22. Sean Wilentz, *Chants Democratic: New York City and the Rise of the American Working Class, 1788–1850* (New York: Oxford University Press, 1984), p. 115.

23. *New-York Evening Post*, April 13, 1825, p. 3, col. 2; ibid., April 30, 1825, p. 3, col. 4.

24. See Decorative Arts Photographic Collection Files, Winterthur Library, Henry Francis du Pont Winterthur Museum, Winterthur, Delaware, for examples of Eoff and Phyfe products marked for non–New York retailers, including DAPC 69.1999 and DAPC 78.3897, a handled cup in the collection of the Valentine Museum, Richmond, Virginia.

25. Wilentz, *Chants Democratic*, pp. 35–37, 116–17.

26. David McAdam et al., eds., *History of the Bench and Bar of New York*, 2 vols. (New York: New York History Company, 1897–99), vol. 1, p. 413.

27. Baldwin Gardiner, New York, August 29, 1828, to Thomas Fletcher, Philadelphia, Fletcher Papers, Box 11, Athenaeum of Philadelphia.

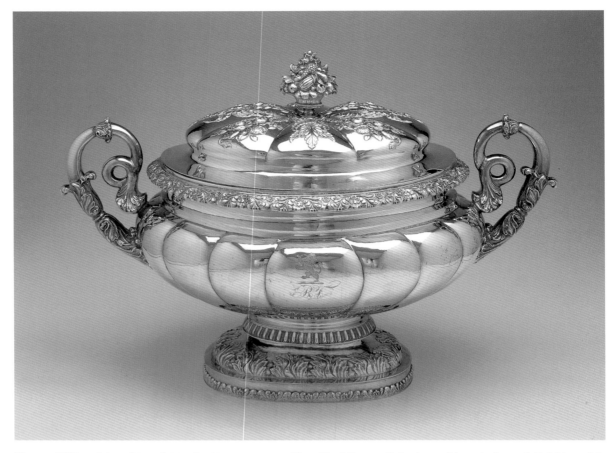

Fig. 297. William Gale and Joseph Moseley, Tureen, ca. 1830. Silver. The Minneapolis Institute of Arts, the James S. Bell Memorial Fund and the Christina N. and Swan J. Turnblad Memorial Fund 80.57

28. *Morning Courier and New-York Enquirer,* October 17, 1833.

29. On the history of J. and I. Cox and its successors, see: *New-York Daily Advertiser,* April 8, 1820, p. 2, col. 6; ibid., January 26, 1826, p. 1, col. 6; ibid., April 6, 1826, p. 1, col. 5; *New-York Evening Post,* October 24, 1826; *The American Advertising Directory for Manufacturers and Dealers for the Year 1832* (New York: Jocelyn, Darling and Co., 1832), p. 105; Thomas Cox, Birmingham, to Thomas Fletcher, Philadelphia, December 2, 1833, Fletcher Papers, Box III, Athenaeum of Philadelphia; *Third Annual Fair of the Mechanics' Institute of the City of New York* (New York, 1837), p. 16 (on the firm's diploma); *The New York Business Directory for 1840 & 1841* (New York: Publication Office, 1840), pp. 152–53; *The New-York City and Co-Partnership Directory for 1843 & 1844* (New York: John Doggett Jr., 1843), pp. 84, 85, 385; Gertrude A. Barber, comp., "Abstracts of Wills for New York County, New York," vol. 15,

presentation piece has an unadorned band around the body. Fletcher mounted the whole on a tripod base with crisply sculpted sphinxes, whose extended wings appear to support the vase above. Robust acanthus-and-paw feet in turn support the plinth. By 1831 Gardiner had his own silver manufactory in operation, with high-pressure steam power available. Two years later, Gardiner's entry in the fair of the American Institute brought praise from a newspaper reporter, who wrote, "We first viewed some superb silverware from the manufactory of B. Gardiner, 149 Broadway. The embossed silver waiters and pitchers were finished in admirable style" (see cat. nos. 284, 286).[28]

Preceding Baldwin Gardiner in New York as merchants of imported fancy hardware and lamps were the brothers Joseph (ca. 1790–1852) and John Cox from Birmingham, England, who traded as J. and I. Cox. In time for inclusion in the 1819–20 edition of *Longworth's Directory,* these merchants had settled at 5 Maiden Lane, near Broadway, at the Sign of the Lamp. The Cox firm, like others in the Maiden Lane neighborhood, moved from sales of imported fancy hardware and lamps to imported and domestic plated goods and furnishings and subsequently added silverware and gas fixtures to its product lines. At the third annual fair of the Mechanics' Institute, held at Niblo's Garden in September 1837, J. and I. Cox won a diploma for its entries of a silver tea set and pitchers, which "displayed great taste, both in design and workmanship." By 1843 two branches of "Cox's Furnishing Warehouse" served consumers, at 15 Maiden Lane and 349 Broadway, on the corner of Leonard Street. In 1848 the firm offered silverware only at the Maiden Lane warehouse. Following the death of Joseph Cox in December 1852, both the silver and gas-fixtures lines of merchandise were transferred to John Cox and Company, 349 Broadway. In 1856–57 John Cox and Company listed itself as an importer of gas fixtures, clocks, bronzes, plated ware, and related goods, and as a manufacturer of silverware, with Joseph's son a member of the firm.[29]

The relationship between manufacturing silversmith and silver retailer was often unclear to the public. J. and I. Cox offered silverware to its customers and entered silver into competitions under its name; its successor firm, John Cox and Company, advertised as

a manufacturer of silverware. In at least one instance, manufacturing silversmiths Cann and Dunn (John Cann and David Dunn; active ca. 1855–57) produced silver also struck with the Cox firm stamp.[30] Cann and Dunn succeeded the partnership Charters, Cann and Dunn (Thomas Charters, John Cann, and David Dunn; active 1848–54). In the 1855–56 edition of *Trow's New York City Directory,* the "old established silver ware manufactory of Cann and Dunn" took a display advertisement to announce its relocation to Brooklyn, where the firm remained the following year. With its new facilities, Cann and Dunn announced it was prepared "to fulfill as usual, all Orders from the Trade for Vases, Urns, Salvers, Pitchers, Tea and Coffee Services, TRUMPETS, / PLATES, GOBLETS, CUPS, &c. / From Designs Original and Selected, / Ancient and Modern."[31]

Silverware manufacturers and retail silversmiths both embraced the neutral showcase for shop products provided by the annual fairs sponsored by the American Institute of the City of New York (beginning in 1828) and those organized by the Mechanics' Institute of the City of New-York (from 1835 on). These juried fairs highlighting American improvements in the mechanical and fine arts quickly became significant venues for the display of new goods and product lines.[32] In each product category, men who had experience within the industry or in a related discipline were chosen as judges. Journalists sympathetic to the cause of protecting American manufactures wrote articles listing the winners of the competitive awards and often featuring specific exhibits or items within displays. Their accounts were printed both in New York and in such national publications as *Niles' Weekly Register.* Although the 1829 American Institute fair had no official class for precious metal objects, judges awarded discretionary premiums to the retail firm of Marquand and Brothers for "superior tea and dinner silver ware" and to silverware manufacturers William Gale and Joseph Moseley for "superior silver forks and spoons," decisions duly reported by *Niles' Weekly Register.*[33] Gale and Moseley produced a presentation coffee urn in 1829 (cat. no. 285) and an imposing handled tureen about 1830 (fig. 297).[34] The following year, in the class designated "Silver, Plated and Tin Ware, Clocks, etc," entrepreneur Baldwin Gardiner won a first premium, as did silver manufacturer Thomson. Retailers Stebbins and Howe won a premium for a case of jewelry, watches, and silverware described as "very tasty and elegant."[35] National pride colored the occasional commentary, as in an 1835 article published in the *Mechanics' Magazine*

and Register of Inventions and Improvements: "Silver Ware.—The specimens of Silver Ware exhibited by Mr. Marquand, 181 Broadway, and Mr. James Thompson [*sic*], 129 William-st., produced the most agreeable astonishment, especially to us, who well remember when to produce a common Silver Buckle in this country, was a thing viewed with utter astonishment."[36] Even *Holden's Dollar Magazine,* a publication that questioned the utility and expense of the expositions, noted that "the most showy exhibiters at the fairs are the confectioners, silversmiths, glass cutters, and milliners."[37]

Judges of the American Institute fairs often awarded premiums to one or more manufacturing silversmiths and one firm of retail silversmiths annually during the 1840s. In 1841 the retailer Ball, Tompkins and Black, located at 181 Broadway, was singled out for the best specimens of silver plate and chasing, while manufacturing silversmith William Adams, whose business was at 185 Church Street, received recognition for the second-best effort in those categories. Flatware specialist Albert Coles (1815–1885), then located at 6 Little Green Street, won a silver medal for the best silver knives and forks. The following year, the judges awarded premiums to the same entrants.[38]

Diesinker Moritz Fürst, who won a silver medal for "specimens of very superior die-sinking" at the sixth annual American Institute fair in 1833, subsequently executed prize medals for both the American Institute (cat. no. 291) and the Mechanics' Institute, employing similar designs.[39] American Institute judges awarded large numbers of medals struck in gold and silver as well as silver prize cups. At its eighteenth fair, in 1845, the institute distributed 34 gold medals, 80 silver medals, and 139 silver cups. Two years later, the ratio between the types of prizes had shifted, with 244 silver medals, 28 gold medals, and 44 silver cups awarded.[40]

Although articles on the entries in the fairs praise the products of New York silversmiths without commenting on style, surviving pieces marked by the city's craftsmen show that these artisans were called on to reconcile an increasingly severe Neoclassicism with a resurgence of the Rococo. Between 1830 and 1861 silversmiths needed to pay particular attention to the personal preferences of their patrons when weighing the merits of the Rococo against other historical styles, including not only Neoclassical but also Gothic and other modes. As a result, wares had become decidedly eclectic in style by the 1830s. A key example is a hot-water urn by Colin van Gelder Forbes and his son William Forbes (cat. no. 290). This grand piece

1852–1853, p. 74, typescript, 1950, New York Genealogical and Biographical Society; Gertrude A. Barber, comp., "Deaths Taken from the New York *Evening Post* from September 8, 1852, to September 24, 1853," vol. 29, p. 28, typescript, 1940, New York Genealogical and Biographical Society, New York; Will of Joseph Cox, proved January 17, 1853, New York County Will Liber 105, p. 224, microfilm, New York Genealogical and Biographical Society; "Wilson's Business Directory of New York City," in *Trow's New-York City Directory, 1854–1855,* compiled by H. Wilson (New York: John F. Trow, 1854), pp. 169, 65, 147; H. Wilson, comp., *Trow's New-York City Directory for 1856–1857* (New York: John F. Trow, 1856), p. 184; Albert Ulmann, *Maiden Lane: The Story of A Single Street* (New York: Maiden Lane Historical Society, 1931), p. 61.

30. The Art Institute of Chicago owns a pitcher in the "modern French" (Rococo Revival) taste manufactured by Cann and Dunn and retailed by J. and I. Cox. See Judith A. Barter, Kimberly Rhodes, and Seth A. Thayer, with contributions by Andrew Walker, *American Arts at the Art Institute of Chicago, from Colonial Times to World War I* (Chicago: Art Institute of Chicago, 1998), pp. 179–80, no. 80.

31. H. Wilson, comp., *Trow's New York City Directory for the Year Ending May 1, 1856* (New York: John F. Trow, 1855), advertisement section; William H. Smith, comp., *Smith's Brooklyn City Directory, 1855/56* (Brooklyn, 1855), p. 2; William H. Smith, comp., *Smith's Brooklyn City Directory, 1856/57* (Brooklyn, 1856).

32. Edwin Forrest Murdock, "The American Institute," in *A Century of Industrial Progress,* edited by Frederic W. Wile (Garden City, New York: Doubleday, Doran and Company, 1928), pp. v–xvi.

33. *Niles' Weekly Register,* October 24, 1829, p. 141.

34. The tureen is marked "G & M" in a serrated rectangle and has three pseudohallmarks: a crowned leopard's head, a sovereign's head, and a lion passant. It is inscribed with an unidentified crest of a lion rampant above the initials "RT."

35. *Report of the Third Annual Fair of the American Institute of the*

City of New York 1830 (New York: J. Seymour, 1830), p. 16.

36. "First Annual Fair of the Mechanics' Institute . . . Report," *Mechanics' Magazine and Register of Inventions and Improvements* 6 (November 1835), p. 270.

37. *Holden's Dollar Magazine* 2 (November 1848), p. 700.

38. *Premiums Awarded by the American Institute at the Fourteenth Annual Fair, October 1841* [New York, 1841], p. 10; and *List of Premiums Awarded by the Managers of the Fifteenth Annual Fair, of the American Institute, October 1842* [New York, 1842], p. 12, copies of both in the Manuscript Department, The New-York Historical Society. Medill Higgins Harvey, Research Assistant, Department of American Decorative Arts, Metropolitan Museum, compiled lists of premium winners from the American Institute files, New-York Historical Society, for which the author thanks her.

39. *Mechanics' Magazine and Journal of the Mechanics' Institute* 2 (October 1833), p. 180; Donald L. Fennimore, *Silver and Pewter* (New York: Alfred A. Knopf, 1984), p. 213.

40. *Niles' National Register*, November 8, 1845, pp. 150–52; ibid., October 30, 1847, p. 131.

41. *New Mirror*, May 18, 1844, p. 106.

42. J. Leander Bishop, *A History of American Manufactures from 1608 to 1860,* . . . 3 vols. (Philadelphia: Edward Young and Co., 1868), vol. 3, pp. 182–89; George F. Heydt, *Charles L. Tiffany and the House of Tiffany & Co.* (New York: Tiffany and Co., 1893), pp. 21–22.

43. Elizabeth L. Kerr Fish, "Edward C. Moore and Tiffany Islamic-Style Silver, c. 1867–1889," *Studies in the Decorative Arts* 6 (spring–summer 1999), pp. 42, 61 n. 3.

44. B. Silliman Jr. and C. R. Goodrich, eds., *The World Of Science, Art, and Industry Illustrated from Examples in the New-York Exhibition, 1853–54* (New York: G. P. Putnam and Company, 1854), p. 45. Since Tiffany, Young and Ellis imported bronzes as early as 1844, and Moore's mark is struck only on the silver dish at the top of the centerpiece, the possibility exists that Moore joined an existing figural base to his dish to create the centerpiece.

45. Ibid., pp. 80, 81, 126, 144, 157, 194.

46. Ibid., p. 194.

47. John Culme, *Nineteenth-Century Silver* (London:

Fig. 298. *Four Elements Centerpiece by Tiffany, Young and Ellis.* Wood engraving by Robert Roberts, from B. Silliman Jr. and C. R. Goodrich, eds., *The World of Science, Art, and Industry Illustrated from Examples in the New-York Exhibition, 1853–54* (New York: G. P. Putnam and Company, 1854), p. 45 (lower right). The Metropolitan Museum of Art, New York, The Thomas J. Watson Library

was presented in 1835 to grocer and longtime New York City resident John Degrauw on his resignation from the post of presiding officer of the board of trustees of the New York Fire Department. Neoclassical relief ornament after a design by New York artist Henry Inman for a discharge certificate cannot hide the inverted pyriform (pear-shaped) body of the urn, a form that was initially popular in the decades preceding the American Revolution.

In the five years between 1837 and 1842 a number of seemingly unrelated events occurred that would contribute to the transformation of silver manufacturing and retailing in New York by the outbreak of the Civil War. These were the establishment of the retailers Tiffany and Young (1837) and Ball, Tompkins and Black (1839) and the passage of the protective tariff of 1842. During the autumn of 1837, two brothers-in-law from Windham County, Connecticut, Charles L. Tiffany and John B. Young, launched a stationery and fancy-goods

business at 259 Broadway, an address north of the district where Marquand and Company and other jewelers and dealers in high-class fancy articles clustered. When J. L. Ellis joined as a partner in the spring of 1841, the firm became Tiffany, Young and Ellis. It specialized in English and Parisian personal luxuries, such as gloves, canes, dress fans, portfolios, and toilette boxes. Three years later, a correspondent for the *New Mirror* wrote admiringly of "the brilliant CURIOSITY SHOP of TIFFANY and YOUNG. No need to go to Paris now for any indulgence of taste, any vagary of fancy. It is as well worth an artist's while as a purchaser's, however, to make the round of this museum of luxuries. . . . I think that shop at the corner of Broadway and Warren is the most curious and visitworthy spot in New-York—money in your pocket or no money."[41]

In 1847 Tiffany, Young and Ellis moved to more commodious quarters at 271 Broadway, at the corner of Chambers Street. Among its clientele was Swedish singer Jenny Lind, who made the shop one of her first retail stops during her inaugural 1850 American concert tour organized by P. T. Barnum. Although the firm began to manufacture gold and diamond jewelry in 1848, Tiffany, Young and Ellis continued to retail the products of many manufacturing silversmiths until 1851, when it secured the exclusive services of the firm headed by John C. Moore,[42] which had been supplying Tiffany, Young and Ellis with products since 1846.[43]

At the New York Crystal Palace exhibition in 1853, Tiffany, Young and Ellis displayed Moore's Four Elements centerpiece depicting Earth, Air, Water, and Fire as allegorical figures clothed in classical draperies (fig. 298).[44] There it competed successfully for attention with an array of other eye-catching figural centerpieces, many with literary themes, from the shops of such eminent London silversmiths as Joseph Angell, Hunt and Roskell, and R. and S. Garrard. Such centerpieces frequently incorporated candle branches or a dish, as Moore's piece does.[45] Having noted that centerpieces were by far the most costly works in precious metals displayed at the Crystal Palace, the American exhibition reviewers Benjamin Silliman Jr. and Charles R. Goodrich expressed doubt that such pieces should have been included at all: "Sculpture on a large scale in the precious metals is a mistake; and the attempts at exact imitations of fruits, flowers, and foliage, which so largely abound in the exhibited specimens, are absurdities beneath criticism."[46] Neither British nor American silversmiths heeded Silliman and Goodrich, however, and large figural groups

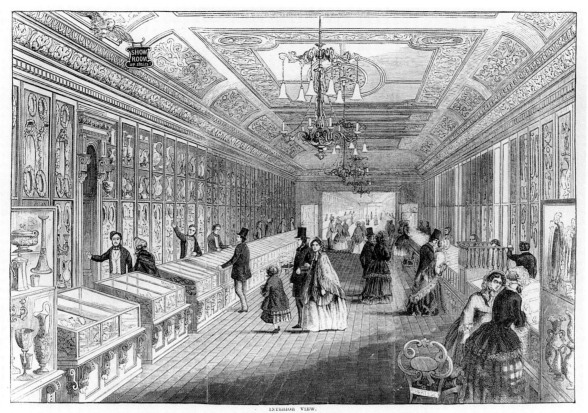

INTERIOR VIEW.

BALL, BLACK & CO.

Sign of the Golden Eagle, 247 Broadway, South Corner of Murray Street, opposite City Hall, New York.

HENRY BALL. WILLIAM BLACK. EBENEZER MONROE.

Fig. 299. *Interior View of Ball, Black and Company Premises,* 247 Broadway, ca. 1855. Wood engraving, from David Bigelow, *History of Prominent Mercantile and Manufacturing Firms in the United States . . .* (Boston: D. Bigelow and Company, 1857), vol. 6, p. 139. Courtesy of the American Antiquarian Society, Worcester, Massachusetts

Fig. 300. Advertisement for Ball, Black and Company, 1854. Wood engraving, from A. D. Jones, *The Illustrated American Biography* (New York: J. M. Emerson and Company, 1854), vol. 2, p. 206. Courtesy of the American Antiquarian Society, Worcester, Massachusetts

continued to dominate exhibition lists throughout the nineteenth century.[47]

Following the death of Isaac Marquand in 1838, the Marquand family withdrew from the old retail firm of Marquand and Company (see cat. no. 288). It became Ball, Tompkins and Black in 1839, with three former employees, Henry Ball, Erastus O. Tompkins, and William Black, at its helm. The firm remained at 181 Broadway until 1848, when it moved into its own newly built premises at 247 Broadway, on the corner of Murray Street, opposite City Hall (see figs. 299, 300). As an emblem of continuity, Ball, Tompkins and Black retained as its logo the golden eagle adopted by the Marquands.[48] Skillful merchandising—local, national, and international—attracted American merchant and professional families in ever-increasing numbers to the firm's elegant gaslit showrooms lined with cases displaying imported silver-plated ware, watches, clocks, diamonds, jewelry, fancy goods, cutlery, Bohemian glassware, and silverware "in every variety of Style and Patterns."[49] In 1851 the New York *Evening Post* noted: "Their collection of solid silver and silver-plated ware is the most splendid and extensive in the city, and embraces many of the richest looking sets that we have known. In adding a large manufacturing department,

206

BALL, BLACK & Co.,

SUCCESSORS TO

MARQUAND & CO.,

Manufacturers and Importers of

SILVER AND PLATED WARE,

DIAMONDS,

WATCHES, JEWELRY, &c. &c.

Sign of the Golden Eagle,

247 BROADWAY,

NEW YORK.

Henry Ball, } South corner of Murray St.
Wm. Black, } Opposite the City Hall.
Ebenezer Monroe.

Country Life Books, 1977), pp. 203–20; Charles L. Venable, *Silver in America, 1840–1940: A Century of Splendor* (exh. cat., Dallas: Dallas Museum of Art, 1995), pp. 107–21; Charlotte Gere, "European Decorative Arts at the World's Fairs: 1850–1900," *Metropolitan Museum of Art Bulletin* 56 (winter 1998–99), pp. 3–56.

48. "Frederick Marquand," in *The National Cyclopaedia of American Biography*, vol. 19 (New York: James T. White and Company, 1926), p. 399.

49. *Home Journal*, January 1, 1850, p. 3.

50. *Evening Post* (New York), September 16, 1851, p. 3, col. 4.

51. "Ball, Black & Co.'s New Marble Store," *Frank Leslie's Illustrated Newspaper*, October 6, 1860, pp. 313–14.

52. D. Albert Soeffing, "Ball, Black & Co. Silverware Merchants," *Silver* 30 (November–December 1998), pp. 46–47.

53. Deborah Dependahl Waters, "From Pure Coin: The Manufacture of American Silver Flatware, 1800–1860," *Winterthur Portfolio* 12 (1977), p. 27.

54. *Jewelers' Circular Keystone*, June 22, 1892, p. 6.

55. Dorothy T. Rainwater and Judy Redfield, *Encyclopedia of American Silver Manufacturers*, 4th ed. (Atglen, Pennsylvania: Schiffer Publishing, 1998), pp. 121–22.

they have consulted the wishes of their customers as well as their own interests."[50]

In 1860 Ball, Black and Company—the successor to Ball, Tompkins and Black—opened a "superb" store and manufactory constructed of white East Chester marble on the southwest corner of Broadway and Prince Street. Designed by the architectural firm of Kellum and Son, and with interior decorations designed and executed by Charles Greiff, the six-story building had showrooms on the first three floors and manufacturing workrooms on the upper levels. Richly stained wood and gold fittings provided an elegant backdrop for the display of jewelry and silverware on the first floor. The wares offered for sale ranged from "an unadorned eggcup to the most gorgeously chased and exquisitely patterned epergnes, all designed and manufactured on the premises."[51] In 1860 Bostonian Augustus Rogers, John R. Wendt (a talented German-born designer and chaser), and George Wilkinson, the English-born and English-trained chief designer for the Gorham Manufacturing Company in Providence, Rhode Island, formed a short-lived partnership to manufacture silverware for Ball, Black and Company. After his erstwhile partners abandoned the new firm, Wendt moved his operation to the fourth and fifth floors of the new building at Broadway and Prince and supplied unmarked goods to Ball, Black and Company for retail sale.[52]

William Gale patented his roller-die method of producing bas-relief ornament on both surfaces of silver flatware at the same time and throughout the length of the handle.[53] While Gale held the patent on this improvement on the flatting (rolling) mill, his firm had "a great advantage over coexisting competitors, and they controlled the trade in sterling flatware to a great extent in several sections of the United States."[54] However, in December 1840, fourteen years after he had taken it out, his patent expired. Subsequently, spoon mills with roller dies were more widely adapted within the American industry, and more innovative designs appeared. Beginning in the mid-1840s New York designers of flatware, including William Gale, Michael Gibney, and Philo B. Gilbert, took advantage of the extension of patent protection to designs, including those for flatware. Gibney obtained the first flatware design patent in December 1844, for a pattern sold through Ball, Tompkins and Black and its successor, Ball, Black and Company. His Tuscan pattern, patented in 1846, was developed at the request of shipping magnate Edward K. Collins for the dining room of a new transatlantic steamer.[55] The firm of Gale and Hayden obtained

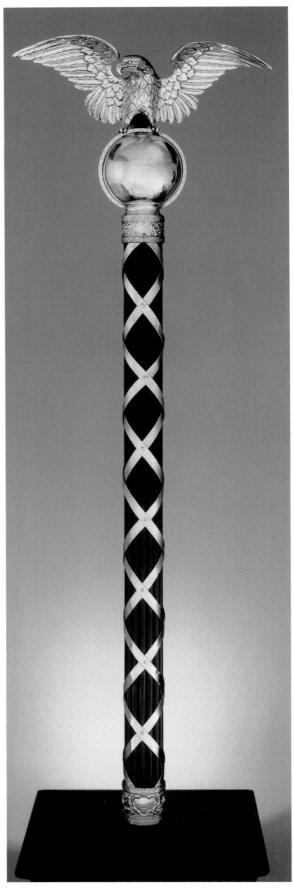

Fig. 301. William Adams, Mace of the United States House of Representatives, 1841. Silver and ebony. United States House of Representatives, Washington, D.C.

design patent 150 in 1847 for its Gothic-pattern flat-ware (cat. nos. 299, 300).

In October 1841 Speaker John White commissioned New York silversmith William Adams to manufacture a mace for the House of Representatives of the United States.[56] White authorized Adams "to have made a *Mace*, similar to the one destroyed by fire in the year 1814" (no sketch or list of specifications survives). On December 30, 1841, Adams signed a receipt for $400 for "Making a Silver Mace surmounted with a Globe and Spread Eagle" (fig. 301). It consists of thirteen cylindrical ebony rods bound around a central shaft by four silver thongs wound spirally from top to bottom. Silver repoussé-chased bands edged with die-rolled floral guilloche borders and with asymmetrical scrolls, flowers, and raffles (ragged-edged acanthus leaves) hold the rods at top and bottom. Surmounting the mace is a hollow silver globe engraved with images of the continents and the meridians of longitude. Grasping an attached band engraved with the degrees of latitude is a cast-silver American eagle with outspread wings. On the lower band, engraved within a cartouche, are the words "Wm. Adams/Manufacturer/New York/1841."[57]

Adams was a native of Troy, New York, where he served his apprenticeship with one Pierre Chicotree (possibly Peter Chitry), whose widow he subsequently married. A nineteenth-century biographer of Adams noted that "by close application and hard industry, combined with stringent economy, he was enabled to save a large amount of money, with which he bought real estate, and upon its certain rise," he became "immensely rich."[58] A competent silversmith, Adams won awards on several occasions for the best or the second-best specimen of silverware displayed at the annual fairs of the American Institute. In 1852 he and two others judged the silverware class. However, Speaker White probably awarded him the mace commission not so much for his skill as for his political activism and his friendship with Kentucky statesman Henry Clay. Like Clay a Whig in his politics, Adams was an assistant alderman and alderman for the Fifth Ward of New York City during the 1840s, and he subsequently served as commissioner of repairs and supplies in 1850 and 1852.[59]

As the shop of William Adams was completing the mace for the House of Representatives in 1841, more than five hundred silversmiths and precious-metals workers from New York signed a petition calling for increased tariff duties on imported plate. Fairs promoting American manufactures had not halted the sale of foreign plated wares, silver goods, and fancy

articles in New York, all of which competed in the marketplace with American-made goods. In 1820 New York retailers such as Henry Cheavens, whose shop was at 143 Broadway, near Liberty Street, advertised connections with British suppliers that would be to the advantage of the American consumer. Auction consignment sales of London, Sheffield, and Birmingham plated ware and silver tablewares and flatware were another source of such goods, at prices often below retail. Agents for the Sheffield plated-ware manufacturer Thomas Bradbury and Son solicited orders directly from such New York firms as J. and I. Cox, Marquand and Company, Baldwin Gardiner, and Ball, Tompkins and Black beginning in the mid-1830s until the late 1840s.[60] When in 1840 manufacturing silversmiths and jewelers Storr and Mortimer of New Bond Street, London, set up shop at 20 Warren Street, near Broadway, with a fashionable assortment of jewelry, plate, and plated ware of "the very best quality & workmanship," the New York crafts community became alarmed, as it was still suffering from the economic dislocations of the Bank War, begun in 1833–34. By the spring of 1841, when Storr and Mortimer, which had moved to 356 Broadway, two doors north of the Carlton House, announced that it was "now enabled to manufacture here every description of Plate & Jewellery,"[61] the threat of foreign competition had become all too real.

Henry Clay, the champion of the American system and protectionism, took up the cause of the silversmiths. In 1842 he drafted and advocated an amendment to tariff legislation pending before Congress that would increase duties on incoming goods. Clay's proposal was adopted, and duties rose on imported silverware and foreign jewelry. The increased tariffs had the desired effect, making imported silver goods no longer competitive in price with domestic products of like quality. Storr and Mortimer's New York branch closed within a year of the implementation of the new tariff.[62]

On October 14, 1842, as part of the Croton Celebration honoring the completion of the Croton Aqueduct, the city's gold and silver artisans marched together as a craft, along with members of the Mercantile Library Association, the Marine Society, the General Society of Mechanics and Tradesmen, the Mechanics' Society school, a delegation of the Home League, the American and Mechanics' institutes, officers of the federal government, and pupils of the Deaf and Dumb Institution. They escorted "a table covered with rich gold and silver ware, which was borne on the shoulders of four colored men."[63] This show of

56. After the original mace was destroyed when the British army burned the Capitol on August 24, 1814, during the War of 1812, a substitute of painted pine was used for twenty-eight years.

57. The pertinent Congressional records are cited and the mace is illustrated in Silvio A. Bedini, "The Mace and the Gavel Symbols of Government in America," *Transactions of the American Philosophical Society* 87, part 4 (1997), pp. 28–33, figs. 13–18.

58. An Old Resident [William Armstrong], *The Aristocracy of New York: Who They Are, and What They Were, Being a Social and Business History of the City for Many Years* (New York: New York Publishing Company, 1848), pp. 10, 12; "Silversmith William Adams," *Jewelers' Circular and Horological Review*, August 5, 1896, p. 34; *Transactions of the American Institute of the City of New-York*, 1852, p. 500.

59. Joan Sayers Brown, "William Adams and the Mace of the United States House of Representatives," *Antiques* 108 (July 1975), pp. 76–77, frontis.

60. *New-York Daily Advertiser*, April 8, 1820; ibid., June 14, 1820; ibid., March 17, 1826, p. 1, col. 4; *New-York Evening Post*, June 21, 1826, p. 3; D. Albert Soeffing, "A Selection of Letters from the Black, Starr & Frost Scrapbooks," *Silver* 29 (November–December 1997), pp. 48–51.

61. *The Albion*, January 25, 1840, p. 32; *Spirit of the Times*, May 1, 1841, p. 105. A four-piece service with a history of ownership in the de Peyster family of New York, now in the collection of the Museum of the City of New York (40.108.4–.8), may have been purchased from Storr and Mortimer in New York. The components of the service are struck variously with London hallmarks used between 1838 and 1840 and the maker's marks of Paul Storr and his successor John Samuel Hunt, as well as an incised "Storr & Mortimer" on the teapot (40.108.4) and coffeepot (40.108.5).

62. Venable, *Silver in America*, p. 19.

63. *Niles' National Register*, October 22, 1842, pp. 124–27; *New World*, October 22, 1842, pp. 268–69.

64. Joan Sayers Brown, "Henry Clay's Silver Urn," *Antiques* 112 (July 1977), pp. 108, 112, frontis.; *Niles' National Register*, October 25, 1845, p. 113; *The New-York City and Co-Partnership Directory for 1843 & 1844* (New York: John Doggett Jr., 1843), pp. 15, 25, 63, 109.

65. N. W. A., "Nationality of Taste," *Home Journal*, April 14, 1849, p. 1.

66. The vase is marked "GALE AND HAYDEN," "G&H," and "1846"; the mark "GOWDEY & PEABODY" appears on the base. The vase is inscribed "Presented to Henry Clay, the gallant champion of the Whig cause by the Whig Ladies of Tennessee. . . ."

67. *New-York Daily Tribune*, November 23, 1846, p. 1; Warren, Howe, and Brown, *Marks of Achievement*, p. 114, no. 139, ill.

68. Paul von Khrum, *Silversmiths of New York City, 1684–1850* (New York: Von Khrum, 1978), pp. 18–19; [Armstrong], *Aristocracy of New York*, pp. 15–16.

69. "Housekeeper's Department," *Home Journal*, May 10, 1851, p. 3.

70. *The Independent*, May 26, 1859, p. 5.

71. "The Decorative Arts in America," *International Monthly Magazine of Literature, Science, and Art* 4 (September 1851), p. 171.

72. *Home Journal*, October 18, 1851, p. 3.

73. United States, Census Office, 7th Census, 1850, New York City, First Election District, Eighth Ward, p. 102, microfilm, New York Public Library; United States, Census Office, 7th Census, 1850, New York State, Products of Industry Schedule, First Election District, Eighth Ward, City and County of New York, p. 443, manuscript, New York State Library, Albany (microfilm, Eleutherian Mills-Hagley Library, Greenville, Delaware); New York State Census, 1855, First Election District, Eighth Ward, manuscript, New York County Clerk's Office, Surrogates' Court Building, 31 Chambers Street, New York. The 1850 federal census records Boyce's age as fifty-four, and five years later the New York State census records his age as fifty-nine, suggesting he was born in 1795 or 1796.

74. *Evening Post* (New York), October 13, 1846, p. 2.

75. Gerardus Boyce used a twelve-sided form for a child's mug (Museum of the City of New York, 36.17). E. Stebbins and Company (active 1835–ca. 1846) provided an octagonal teapot presented by merchant Abraham

corporate craft solidarity reflected the optimism of the industry under tariff protection.

In 1845 the working gold and silver artisans in New York City, both employers and journeymen, once again joined together as a trade group—this time to provide funds for the raw materials and manufacture of an elaborate vase to be presented to Henry Clay in recognition of his role in securing the favorable tariff of 1842. The shop of presentation-committee member Adams fabricated the vase using the classical Greek krater form with an eagle finial similar to the bird perched atop his 1841 mace of the House of Representatives (fig. 301), updated with a Rococo scroll base and handles (cat. no. 296).[64] Four years after its presentation to Clay, a correspondent of the *Home Journal* recalled the "beautiful silver vase" and asked rhetorically "Could London, Paris, or Geneva, have produced anything more tasteful or artistic, of the same value?"[65]

Clay received a second New York City–made silver presentation vase in 1846 (fig. 302). From the New York City manufactory of William Gale and Nathaniel Hayden, the gift presented by the Whig Ladies of Tennessee features a bas-relief portrait medallion of Clay and a crowning three-dimensional figure of Liberty above an architectural base composed of Gothic arches.[66] A writer for the *New-York Daily Tribune* noted that the Gale and Hayden urn was "admirably adapted as a companion to the beautiful vase which had been previously presented to Mr. Clay by the Gold and Silver Smiths of New-York."[67]

With the successful implementation of the tariff of 1842 and continued economic recovery, the precious-metals trades in New York City embarked on a period of expansion, during which a silversmith was elected mayor of the city. A contemporary biographer noted that William V. Brady (1801–1870), listed in city directories from 1834 through 1846–47, had made a large amount of money at his trade, which he had successfully invested in real estate. A Whig, Brady served as alderman of the Fifteenth Ward from 1842 to 1846 before becoming mayor in May 1847.[68]

The widespread application of new technologies—such as an improved method of spinning up round bodies from sheet metal, which was patented in 1834 by Massachusetts metalworker William W. Crossman (see fig. 303), and electroplating, a technique patented by Elkington and Company of Birmingham, England, in 1840—also encouraged the growth of the precious-metals trades. Electroplated tablewares became widely available in the early 1850s from establishments such as Berrains' House-Furnishing Warerooms, at

601 Broadway,[69] and later from Bray and Manvel, manufacturers of silver-plated ware located at 15 Maiden Lane (the former premises of J. and I. Cox).[70] One commentator noted, "though silver is unquestionably silver, the imitation table furniture of the most classical shapes, that is sold now for a fifth of the cost of the coinable metal, looks quite as well upon a salver."[71] Even the French manufacturer C. S. Christofle and Company, which had licensed the Elkington and Company patent for use in France, entered the New York market. The agency distributing Christofle products advertised its line of plated table-service articles warranted for four or five years in household use.[72]

Among the master craftsmen still manufacturing silver in a small shop in the 1840s was Gerardus Boyce (ca. 1795–1880), who had been in business since 1820. In 1835 Boyce had moved to 110 Greene Street, in the Eighth Ward, where he remained until 1857, when he apparently retired. According to the entry under his name in the Products of Industry Schedule of the federal census for 1850, Boyce employed eight men and one woman to produce silverware valued at $11,200. Five years later, his workforce had declined in size to four men and one boy and the shop's output was valued at $6,000. Two apprentice silversmiths, one American and one Irish, lived with Boyce and his family.[73] His entry in the 1846 American Institute fair prompted a complimentary notice in the New York *Evening Post*. The *Post* reporter described Boyce's exhibit as a "case of very beautiful silver ware. These articles are [both] highly chased and plain, and give evidence of superior workmanship. All articles in his line [are] equally well finished," and all were available at his establishment.[74]

Boyce and his contemporaries utilized straight-sided, seamed geometric forms for wares ranging from mugs and footed cups (see fig. 304) to complete tea sets, and they frequently embellished the vertical panels with floral and swag "bright-cut" engraving, in which shallow incisions created the design and refracted available light.[75] The trophy supplied by watchmaker and retail jeweler William F. Ladd for the fledgling New York Yacht Club's first Corinthian regatta, held in the fall of 1846 (cat. no. 297), employed similar construction.

The 1850 federal census also indicates that silver manufacturer Zalmon Bostwick was born Zalmon Stone Bostwick, son of Heman and Belinda Palmer Bostwick, in Hinesburg, Vermont, on September 9, 1811.[76] Unlike Boyce, who had worked for more than twenty-five years in the trade by 1845, Bostwick was a

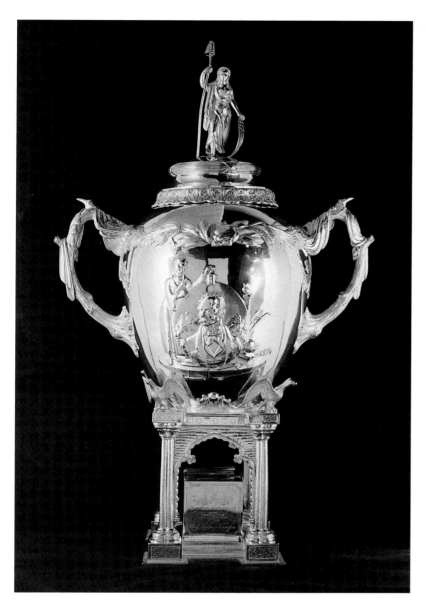

Fig. 302. William Gale and Nathaniel Hayden, silver manufacturer; Thomas Gowdey and John Peabody, Nashville, Tennessee, retailer, Urn presented to Henry Clay by the Whig Ladies of Tennessee, 1846. Silver. Tennessee State Museum Collection, Nashville 83.15

Fig. 303. *Spinning.* Wood engraving by Cornelius T. Hinckley, from *Godey's Lady's Book* 46 (March 1853), p. 201. The Metropolitan Museum of Art, New York, The Thomas J. Watson Library

newcomer to the business, first recorded as a "silversmith," with premises at 128 William Street, Manhattan, in 1846–47. Bostwick placed an advertisement in the New York *Evening Post* for March 11, 1847, describing himself as "successor to Thompson [*sic*], 128 William street," and announcing his willingness to manufacture "to order a full and complete assortment of SILVER WARE in all its branches, embracing plain, chased and wrought SILVER CUPS, URNS, VASES, &c. Also complete sets of plate of different patterns." The announcement suggests that Bostwick was continuing the business of William Thomson, a firm long established at 129 William Street. Bostwick placed a similarly worded advertisement with illustrations in the *New-York Mercantile Register* for 1848–49. By the 1851–52 edition of the city directory, Bostwick's manufactory of silverware was listed at "r[ear] 19 Beekman"

and his residence at "111 Orchard." The manufactory remained listed at 19 Beekman Street in the 1853–54 edition, but by that date Bostwick had moved his home to Bedford Avenue in East Brooklyn, and then apparently he withdrew from the trade.[77] In addition to English Gothic pitchers and goblets (see cat. no. 298), his shop produced goods in the chased "modern French" (Rococo Revival) style, including an unusual pair of ritual Torah finials, or *rimmonim* (fig. 305).[78]

By 1850 the neighborhood that encompassed Liberty Place and Maiden Lane in the Second Ward housed many of the city's manufacturing silversmiths. Platt and Brother, which operated a gold and silver refinery and bullion office at 4 Liberty Place supplying raw materials to the trade, also wholesaled imported watches, jewelry, cutlery, and fancy goods to its clients

Van Nest to his daughter and her husband about 1838–45 (Museum of the City of New York, 34.73.1). Manufacturing silversmiths Charters, Cann and Dunn produced a five-piece octagonal beverage service for Ball, Tompkins and Black with tapered straight-sided pots, which became part of the silver of a woman who married in 1850 (Museum of the City of New York, 70.68.1a–d–.5).

76. United States, Census Office, 7th Census, 1850, New York City, Tenth Ward, National Archives Microform publication M-432, roll 545, p. 216.

77. Von Khrum, *Silversmiths of New York City,* p. 17; *The New York City Directory for 1851–52* (New York: Doggett and Rode, 1851), p. 66; H. Wilson, comp., *Trow's*

New-York City Directory for 1853–1854 (New York: John F. Trow, 1853), p. 76.

78. A service at the Museum of the City of New York (33.58.24.a–c) is engraved "AMB/Jany 1st 1849," probably for Adeline Matilda Creamer Brooks, who married Edward Sands Brooks, of the clothier Brooks Brothers, in 1844. The *rimmonim* are marked "ZB" in a diamond with an anchor in an oval and a profile head in an oval. They were sold at Christie's, Amsterdam, June 1, 1999, lot 539; see *Christie's Magazine* 16 (June 1999), p. 26, fig. 2.

79. United States, Census Office, 7th Census, 1850, New York State, Products of Industry Schedule, Second Ward, City and County of New York, pp. 330, 334, 361.

80. See Jennifer M. Swope, "Francis W. Cooper, Silversmith," *Antiques* 155 (February 1999), pp. 290–97. The location of the alms basin is unknown; one paten and one chalice are part of the collection of the Museum of Fine Arts, Boston; see ibid., pl. 1, figs. 1, 2.

81. The set is marked "STEBBINS & Co./264 B.way NY." Another octagonal teapot, which recalled medieval Italian baptistries in its architectural ornament, was sold by J. and I. Cox, about 1835–53. See Katherine S. Howe and David B. Warren, *The Gothic Revival Style in America, 1830–1870* (exh. cat., Houston: Museum of Fine Arts, 1976), p. 71, no. 145.

82. *Gleason's Pictorial Drawing-Room Companion*, September 20, 1851, p. 336, described and illustrated the service; *The Independent*, August 21, 1851, p. 139, carried the commentary.

83. United States, Census Office, 7th Census, 1850, New York State, Products of Industry Schedule, Fifth Ward, City and County of New York, p. 380.

84. Charles H. Carpenter Jr. and Janet Zapata, *The Silver of Tiffany & Co., 1850–1987* (exh. cat., Boston: Museum of Fine Arts, 1987), pp. 25, 61–62, no. 68a–c, e–i.

85. Gertrude A. Barber, comp., "Marriages Taken from the *New York Evening Post* from July 8, 1852, to September 26, 1854," vol. 14, typescript, 1937, New York Genealogical and Biographical Society; *The Diary of George Templeton Strong*, edited by Allan Nevins and Milton Halsey Thomas, 4 vols. (New York: Macmillan Company, 1952), vol. 2, p. 126.

Fig. 304. Gerardus Boyce, Footed cup presented by Mrs. L. Brooks to Mary Lavinia Brooks, ca. 1845. Silver. Museum of the City of New York, Gift of the Reverend William H. Owen 33.58.25

from a wareroom at 20 Maiden Lane. At 6 Liberty Place were the shops of silver-flatware manufacturers Philo B. Gilbert, Albert Coles, and George C. [O.] Smith. Smith specialized in thimbles, combs, and fruit knives, while Gilbert and Coles produced forks and spoons by the dozens. At 8 Liberty Place, Henry David also made silver knives and forks. Of these four firms, both the Gilbert and Coles enterprises used steam power. With five men producing $9,000 worth of flatware annually, Henry David's was the smallest and least productive shop. At the other end of the scale was Gilbert's, where forty-four men and six women produced flatware valued at $65,000 in the year preceding the 1850 census.[79]

Founded in 1848, the New-York Ecclesiological Society promoted the use of correct (Gothic) style in the architecture and decoration of Protestant Episcopal churches. As its official silversmith, Francis W. Cooper had access to designs and communion silver produced by the society's English counterpart, the Anglican Cambridge Camden Society (later the Ecclesiological Society). In 1855 Cooper and his partner, Richard Fisher, began production of an unusually elaborate silver service for Trinity Chapel, Parish of Trinity Church in the City of New York (cat. no. 304). Composed originally of an alms basin, two chalices for communion wine, a footed paten for consecration of the bread, and two patens for distribution of the bread to communicants, the service was closely modeled on designs drawn by English architect William Butterfield (1814–1900).[80] Although patronage generated by the New-York Ecclesiological Society ended with the demise of the society in 1855, Cooper continued to make Gothic Revival communion silver as well as a wide range of secular silver forms during the course of his career. Other New York silver manufacturers created octagonal domestic silver forms ornamented with a touch of romantic Gothic fantasy. A tea set of this type was marketed about 1850 (fig. 306) by Stebbins and Company, the partnership of William Stebbins and Alexander Rumrill Jr. that succeeded Edwin Stebbins and Company, at 264 Broadway.[81]

Precious-metal wares made in New York first attracted international attention in 1851, when Ball, Tompkins and Black sent to the London Crystal Palace exhibition a $23\frac{1}{2}$-karat California gold beverage service. This impressive set had been commissioned by a group of Manhattan merchants for presentation to shipping magnate Edward K. Collins, who had recently established an American flag line of transatlantic steamers (fig. 307). The four-piece tea service, "finished with the same care that fine jewelry is," stood on a massive silver salver "of exquisitely chaste and simple design." As one commentator reported, "the impression produced is rather that of elegance of form than richness of material, as should be the case with every work of art. Grapes and vine-leaves in high relief are all the ornamental work even to the feet upon which the pieces stand, except that the lids are surmounted by eagles."[82] Its naturalistic "modern French" style won international praise both for Ball, Tompkins and Black and for manufacturing silversmith John C. Moore, who had already employed the rusticated grapevine handles and bodies chased with repoussé grape clusters in the decoration of the Marshall Lefferts beverage service of 1850 (cat. no. 301).

According to the federal census of 1850, Moore's firm, John C. Moore and Son, located at 85 Leonard Street, operated with steam power and employed a workforce numbering twenty men and two women. It produced goods valued at $30,000 in the year covered by the census.[83] The firm continued to produce beverage services in the naturalistic style for Tiffany, Young and Ellis and later for Tiffany and Company, after it entered into an exclusive production agreement with that retail house the following year. A notable

Fig. 305. Zalmon Bostwick, silver manufacturer, *Rimmonim* (Torah finials), ca. 1850. Silver. Location unknown

Fig. 306. Stebbins and Company (William Stebbins and Alexander Rumrill Jr.), retailer, Three-piece tea service in Gothic Revival style, ca. 1850. Silver. Private collection, Houston

Fig. 307. *Service of Plate Presented by the Citizens of New York to Edward K. Collins.* Wood engraving by Nathaniel Orr, from B. Silliman Jr. and C. R. Goodrich, eds., *The World of Science, Art, and Industry Illustrated from Examples in the New-York Exhibition, 1853–54* (New York: G. P. Putnam and Company, 1854), p. 107. The Metropolitan Museum of Art, New York, The Thomas J. Watson Library

openwork grapevines with a pendant cluster of grapes. Since the Astor service was intended for domestic use, the Moore shop incorporated no references to contemporary technology in its ornament, as it had in the Lefferts hot-water kettle on stand, with its forest of telegraph poles and lines and Zeus-with-thunderbolts finial (cat. no. 301).

During the first half of the nineteenth century, the pieces in a service for dispensing hot beverages with style increased in number and in size, so in those respects the eight-piece Astor service should be considered representative of its era. Additional silver items, including spoons, sugar tongs, and a tray to accommodate the entire ensemble, probably accompanied the surviving pieces when Mrs. Astor served tea at home in her mansion on fashionable Fifth Avenue between Thirty-third and Thirty-fourth streets. The second set of initials engraved on the bases of the pieces may be those of the third Astor daughter, Charlotte Augusta, who married her second husband, George Ogilvy Haig, in London in 1896.[86] The service is exceptional in including both a covered sugar bowl and a sugar basket. Perhaps it was assembled from gifts to the couple from various well-wishers.[87]

J. L. Ellis withdrew from Tiffany, Young and Ellis in February 1850. When John B. Young retired in 1853, the firm was renamed Tiffany and Company, and its retail premises moved farther uptown, to 550 Broadway, between Spring and Prince streets, on or before May 1, 1854 (fig. 308).[88] The change of name coincided with the opening of the New-York Exhibition of the Industry of All Nations at the Crystal Palace. Scheduled to begin in May 1853, the exhibition did not officially open until July 14, when President Franklin Pierce attended the inaugural ceremonies. Among the Crystal Palace's many attractions was

> *a showy service of solid California gold. It is a tea service, and consists of twenty-nine pieces, arranged upon a chaste and beautiful plateau of silver. This work is the contribution of Ball, Black & Co. It is valued at $15,000—a very large sum to be invested in gold cups and saucers; which, although exhibiting a neat design—an embossed vine wreath—are all exact duplicates of each other. The great defect of many of the costly works of the gold and silversmiths represented in the Exhibition, is an almost total lack of artistic beauty.*[89]

Ball, Black and Company also displayed the Edward K. Collins service of fine gold made by John C. Moore for Ball, Tompkins and Black (fig. 307). Tiffany and Company exhibited a rich silver toiletry service, a

86. On the William Astors, see John D. Gates, *The Astor Family* (Garden City, New York: Doubleday and Co., 1981), pp. 78–79, 83–84; Derek Wilson, *The Astors, 1763–1992: Landscape with Millionaires* (New York: St. Martin's Press, 1993), pp. 104–5, 193–200; and Edwin G. Burrows and Mike Wallace, *Gotham: A History of New York City to 1898* (New York: Oxford University Press, 1999), pp. 716, 962–63. Their daughter Charlotte Augusta's first husband was James Coleman Drayton; following a scandalous affair and divorce that roiled New York and Newport society, she married Haig and settled in London.

example is the beverage service given to Caroline Webster Schermerhorn, daughter of the noted New York attorney Abraham Schermerhorn, and William Backhouse Astor Jr., a grandson of fur trader and real-estate investor John Jacob Astor, on the occasion of their marriage, in September 1853.[84] (After learning of the Astor-Schermerhorn engagement, diarist George Templeton Strong noted, tongue-in-cheek, "Trust the young couple will be able to live on their little incomes together.")[85] The scroll spout and handles of the Astor kettle on stand are cast as rusticated grapevines. The bodies of all the items in the service are chased with repoussé grape clusters, and the finials are cast

variety of silver articles, including the Four Elements centerpiece (fig. 298), and a dazzling display of gemset jewelry. Other American firms, including Bailey and Company of Philadelphia, also exhibited. Jones, Ball and Company of Boston once again brought out the vase presented by the citizens of Boston to statesman Daniel Webster in 1835 that had been fashioned by silversmiths Obadiah Rich and Samuel Ward after the Warwick Vase for the firm's predecessor, Jones, Low and Ball.[90]

To acknowledge the services of Admiral Samuel Francis Du Pont as one of two superintendents of the Crystal Palace, the directors of the exhibition voted to allot $2,000 for a testimonial in plate. Offered a choice of something exhibited at the Crystal Palace, Du Pont chose instead an eleven-piece table service (fig. 309) consisting of a tureen, two sauceboats, two vegetable dishes, two vegetable dishes with warmers and stands, and four salts fabricated by Tiffany and Company, for Du Pont thought a presentation service should be "ordered and made by Americans . . . simplicity of good taste in design and usefulness of purpose is the main thing. The idea of selecting anything ready made . . . is quite repugnant to me . . . and takes away all sentiment and much of the value of the tribute."[91]

The statistics recorded in the New York State census of 1855 indicate continued expansion within portions of the precious-metals trades. William Gale and Son, located at 447 Broome Street, one door west of Broadway, employed sixty-five men and ten boys to produce goods valued at $175,000 in that year. In 1855 the firm initiated newspaper advertising aimed at both the retail and the wholesale markets, which stressed that "every article [is] made on our own premises, under our personal inspection, and [we] are constantly manufacturing to order everything in the line, of any design, either antique or modern, and however rich or elaborate."[92]

In 1855 William Gale and Son's competitors Charles Wood and Jasper W. Hughes—partners in the firm of Wood and Hughes—produced $225,000 worth of silver; their employees numbered sixty men, twenty women, ten boys, and fifteen girls (see cat. no. 305). The firm of silverware manufacturers traced its history back to silversmith William Gale, with whom the original partners, Jacob Wood and Jasper W. Hughes, had apprenticed. The three men then formed the firm of Gale, Wood and Hughes, which was active from 1833 to 1844 or 1845. In 1845 Wood and Hughes established a partnership of their own. They were joined by Stephen T. Fraprie and Charles Hughes in 1850.

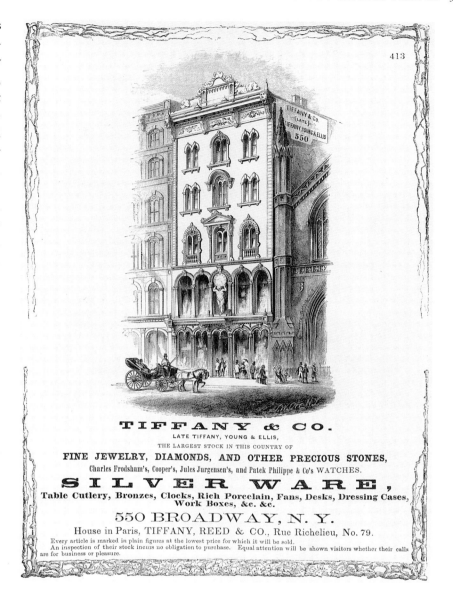

Fig. 308. *Exterior of Tiffany and Company Premises,* 550 Broadway. Wood engraving, from John R. Chapin, *The Historical Picture Gallery; or, Scenes and Incidents in American History* (Boston: D. Bigelow and Company, 1856), vol. 5, p. 413. The New York Public Library, Astor, Lenox and Tilden Foundations, The Irma and Paul Milstein Division of United States History, Local History and Genealogy

Charles Wood, brother of Jacob, had joined the firm by 1855. By 1860 Wood and Hughes had greatly expanded its male workforce—to ninety men—and reduced the number of women and children employed; however, women and girls worked as silver burnishers here, as at most of the major firms, since it was widely thought that female hands were especially suited to burnishing and polishing chores. The firm had also increased its capital investment, using silver valued at $187,000 to make silverware worth $300,000. Steam power, eighteen lathes for spinning up hollowware, and six rolling mills to produce sheet silver and borders all facilitated production.[93]

87. Multiple donors might account for the variation in model numbers on the various pieces. The two retailers identified by the marks struck on the underside of the various components of the ensemble document a shift one block uptown in the location of the shop of Tiffany, Young and Ellis, from 259 and 260 Broadway to 271 Broadway. See *Spirit of the Times,* December 19, 1846, p. 514. The firm opened its new store in 1847 with some two hundred cases of new stock comprised of "elegantly USEFUL AND FANCY ARTICLES of a higher order of taste, beauty, and richness

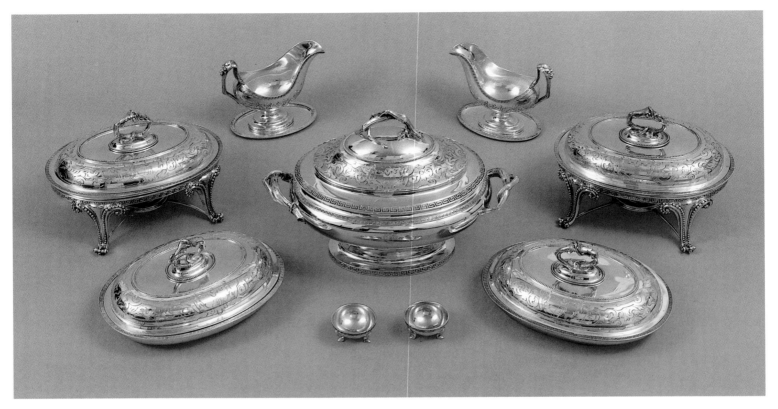

Fig. 309. Tiffany and Company, manufacturing and retail silversmith and jeweler, Partial presentation table service made for Samuel Francis du Pont, 1853–54. Silver. Hagley Museum and Library, Wilmington, Delaware G91.30

than has ever been exhibited in New York." *New-York Mercantile Register*, 1848–49, p. 356.

88. Therefore, the items in the Astor service marked "TIFFANY & CO./ 271 Broadway/J.C.M./85" can be dated to the months between Young's retirement and May 1, 1854. On the changes between 1850 and 1854 at Tiffany, see *Home Journal*, November 17, 1849, p. 3; Heydt, *Charles L. Tiffany*, pp. 11–23; and Venable, *Silver in America*, pp. 28–30.

89. William C. Richards, *A Day in the New York Crystal Palace, and How to Make the Most of It; Being a Popular Companion to the Official Catalogue and a Guide to All the Objects of Special Interest in the New York Exhibition of the Industry of All Nations* (New York: G. P. Putnam and Co., 1853), pp. 152–53.

90. Ibid., p. 127; Wendy A. Cooper, *Classical Taste in America,*

By 1855 Eoff and Shepard (see fig. 295) ranked among the midsized silverware manufacturing operations in Manhattan, with $6,000 invested in tools and machinery. The enterprise used steam power and employed twenty men and five boys. In the year covered by the census, this workforce converted 20,800 ounces of silver, worth more than $26,000, into silverware valued at nearly $37,000. Sometime before 1861, the partners moved from their original quarters at 83 Duane Street to 135 Mercer, where Shepard continued alone in 1861–62. Eoff may have retired or withdrawn from the trade before 1860, a federal census year. The operation continued, with staffing levels and raw-materials consumption constant but with an increase in the value of the flatware and hollowware to $50,000.[94]

Smaller still was the partnership of William Adams and Edmund Kidney, at 38 White Street, near Church Street. Adams lived on Church Street, between White and Franklin streets. He had $30,000 invested in real estate and $1,000 worth of capital in tools and machinery. His shop used silver valued at $10,000 to produce goods of an unspecified value. The shop had steam power and employed five men and three boys.[95]

It was New York's carriage-trade retailer firms, Ball, Black and Company and Tiffany and Company, that captured public attention through production of both civic presentation pieces and popularly priced keepsakes. One opportunity for such unified marketing came with the completion of the first submarine telegraph cable linking Europe and the United States on August 5, 1858. When the Common Council of the City of New York and the New York Chamber of Commerce chose to honor Cyrus W. Field, the promoter of the venture, and several of his colleagues by commissioning gold boxes and medals, Tiffany

1800–1840 (exh. cat., Baltimore: Baltimore Museum of Art; New York: Abbeville Press, 1993), pp. 248–50, no. 201.

91. Quoted in Maureen O'Brien Quimby and Jean Woollens Fernald, "A Matter of Taste and Elegance: Admiral Samuel Francis Du Pont and the Decorative Arts," *Winterthur Portfolio* 21 (summer/autumn 1986), p. 108.

92. *Home Journal,* September 22, 1855, p. 3.

93. United States, Census Office, 7th Census, 1850, New York State, Products of Industry Schedule, Second Ward, New York County, p. 354; New York State Census, 1855, Products of Industry Schedule, First Election District, Second Ward, New York County, manuscript, New York County Clerk's Office, 31 Chambers Street, New York, n.p., original, New York State Library; United States, Census Office, 8th Census, 1860, New York State, Products of Industry Schedule, Second Ward, New York County, p. 24, original, New York State Library.

94. New York State Census, 1855, New York City, First Election District, Sixth Ward, manuscript, New York County Clerk's Office; United States, Census Office, 8th Census, 1860, New York State, Products of Industry Schedule, Third District, Eighth Ward, manuscript, New York State Library.

95. New York State Census, 1855, New York City, Products of Industry Schedule, Third Election District, Fifth Ward, New York County Clerk's Office.

96. *Frank Leslie's Illustrated Newspaper* 8 (July 1859), p. 84. The lithographic firm of Sarony, Major and Knapp, at 449 Broadway, published a lithograph showing the steamships *Niagara, Valorous, Gorgon,* and *Agamemnon* laying the cable, and it is similar to the scene engraved on the lid of the box. For a copy, see Print Archives, Communications-Telegraphy, Folder 3/5, Museum of the City of New York.

97. *The Albion,* August 28, 1858, p. 419.

98. Heydt, *Charles L. Tiffany,* p. 37.

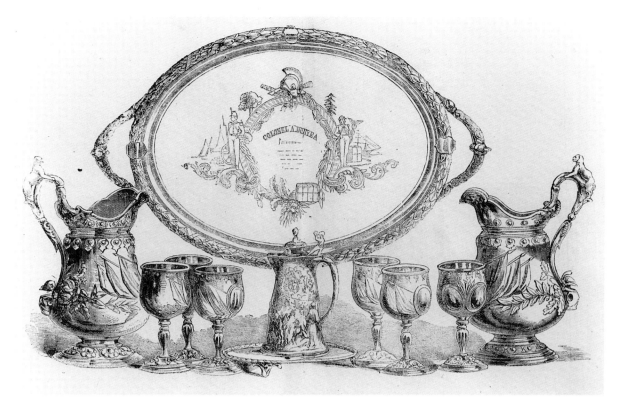

Fig. 310. Tiffany and Company, manufacturing and retail silversmith and jeweler, *Plate Presented by the Merchants of New York to Colonel Duryee, 7th Regiment National Guard,* 1859. Wood engraving, from *Frank Leslie's Illustrated Newspaper,* January 7, 1860, pp. 88–89. Courtesy of The New-York Historical Society

obtained the orders. The boxes and the medals (cat. nos. 307, 308), each enclosed in a rich purple velvet jewel case lined with white satin, bearing the stamp "Tiffany & Co." on the inside of the case, were exhibited at the firm's premises at 550 Broadway.[96] At the same time, capitalizing on the public interest in Field and the transatlantic telegraph cable, several New York City silver and jewelry firms, including Tiffany, Ball, Black and Company, and Dempsey and Fargis, acquired pieces of the cable and offered them to the public as souvenirs. For 50 cents retail, Tiffany sold four-inch lengths mounted "neatly with brass ferrules" and accompanied by copyrighted facsimile certificates signed by Field authenticating the genuineness of the cable (cat. no. 309).[97]

Like 1842, the year 1859 proved to be a watershed for the precious-metals trades in New York. Although the consequences of the great discoveries of silver in

Nevada and other Western territories were initially obscured by the economic turmoil of the Civil War, a flood of silver from the rich Western lodes eventually led to a decline in the price of the raw metal. As the 1850s came to an end, the Moore shop produced for Tiffany a service valued at $5,000 for presentation to citizen-soldier Colonel Abram Duryee upon his retirement from the Seventh Regiment of the New York National Guard (cat. no. 310; fig. 310). The martial theme of the set (which Tiffany later publicized as one of its "notable productions")[98] presaged the ensuing national conflict. In the same year, the Gorham Manufacturing Company of Providence, Rhode Island, opened a wholesale showroom in Manhattan, initiating competition with New York silver manufacturers for access to what had become a national market for "Silver Ware in great perfection."

Works in the Exhibition

JOHN TRUMBULL
1. *Alexander Hamilton*, 1792
 Oil on canvas
 Donaldson, Lufkin &
 Jenrette Collection of
 Americana, New York 81.11

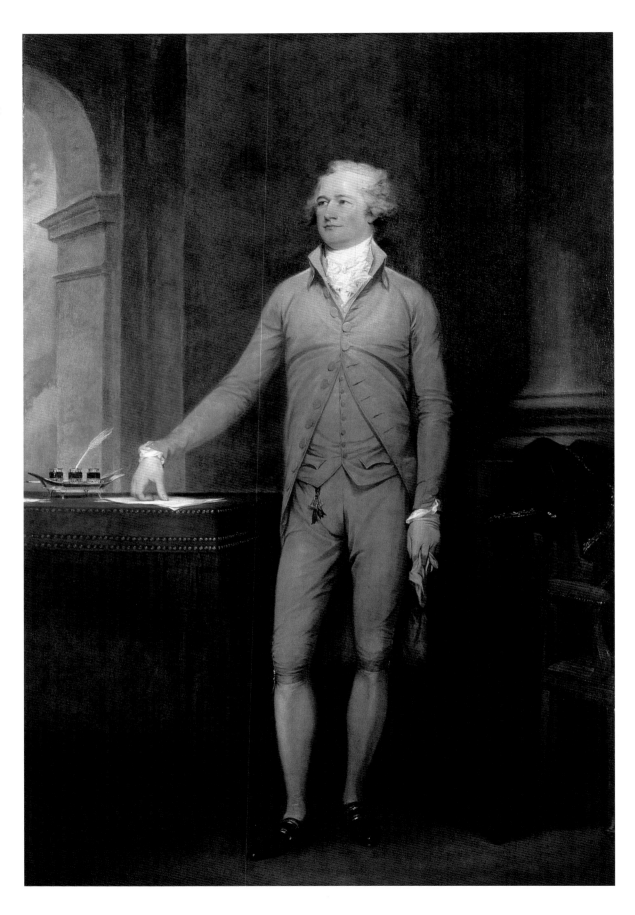

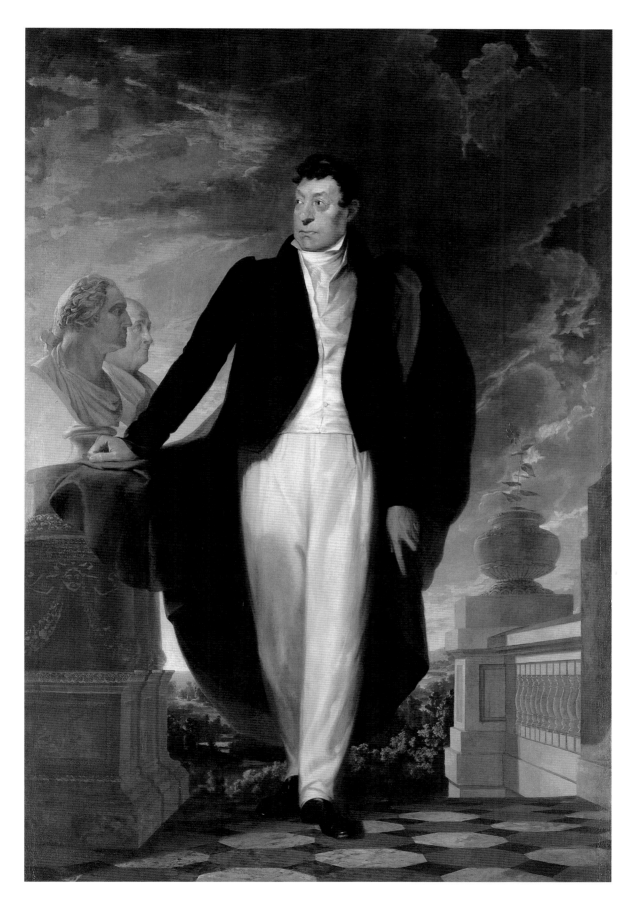

SAMUEL F. B. MORSE
2. *Marquis de Lafayette,* 1825–26
Oil on canvas
Collection of the City of New
York, courtesy of the Art
Commission of the City of
New York

JOHN WESLEY JARVIS
3. *Washington Irving*, 1809
Oil on panel
Historic Hudson Valley,
Tarrytown, New York
SS.62.2

SAMUEL F. B. MORSE
4. *De Witt Clinton*, 1826
Oil on canvas
The Metropolitan Museum
of Art, New York, Rogers
Fund, 1909 09.18

SAMUEL F. B. MORSE
5. *Fitz-Greene Halleck*, 1828
Oil on canvas
The New York Public
Library, Astor, Lenox and
Tilden Foundations

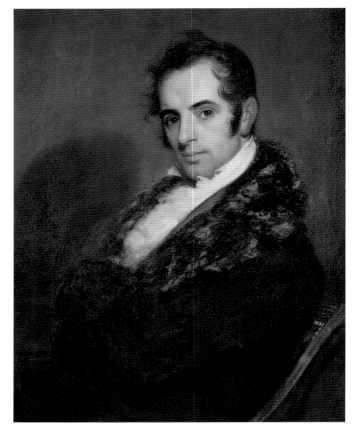

3

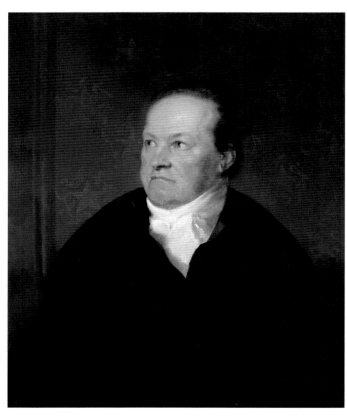

4

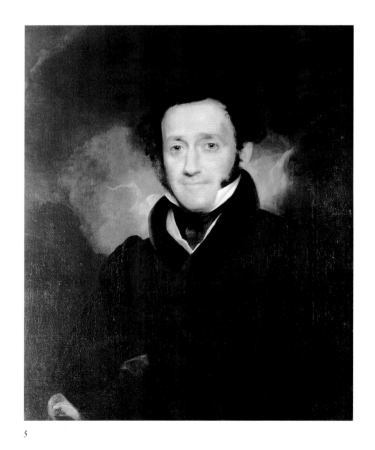

5

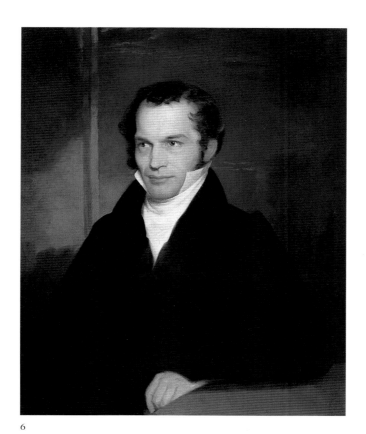

6

SAMUEL F. B. MORSE
6. *William Cullen Bryant*,
1828–29
Oil on canvas
National Academy of
Design, New York 892–P

CHARLES CROMWELL
INGHAM
7. *Gulian Crommelin Verplanck*,
ca. 1830
Oil on canvas
The New-York Historical
Society, Gift of Members of
the Society 1878.2

ASHER B. DURAND
8. *Self-Portrait*, ca. 1835
Oil on canvas
National Academy of
Design, New York 384–P

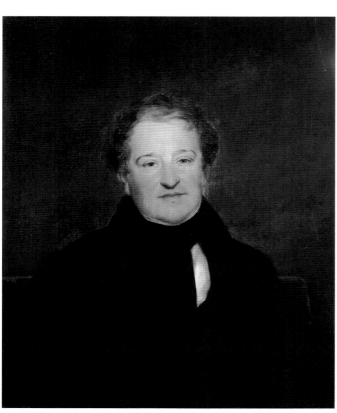

7

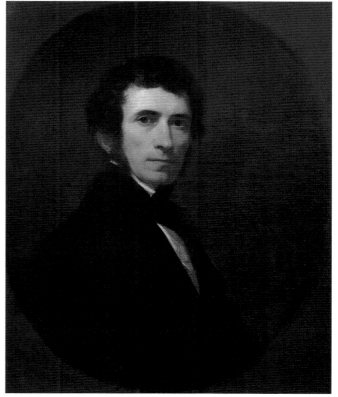

8

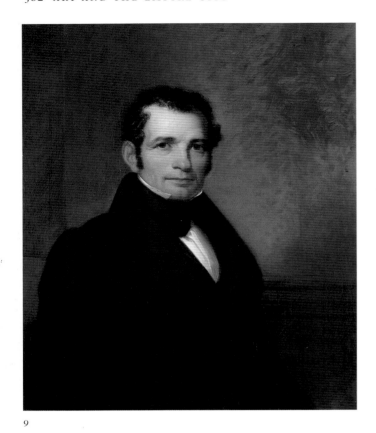

9

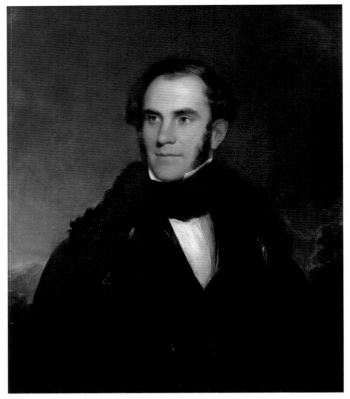

10

ASHER B. DURAND
9. *Luman Reed,* 1835–36
Oil on canvas
The Metropolitan
Museum of Art, New
York, Bequest of Mary
Fuller Wilson, 1962 63.36

ASHER B. DURAND
10. *Thomas Cole,* 1837
Oil on canvas
The Berkshire Museum,
Pittsfield, Massachusetts
1917.13

HENRY INMAN
11. *Georgianna Buckham and
Her Mother,* 1839
Oil on canvas
Museum of Fine Arts,
Boston, Bequest of
Georgianna Buckham
Wright 19.1370

HENRY INMAN
12. *Dr. George Buckham,* 1839
Oil on canvas
Worcester Art Museum,
Worcester, Massachusetts,
Bequest of Georgianna
Buckham Wright 1921.84

FREDERICK R.
SPENCER
13. *Family Group,* 1840
Oil on canvas
Brooklyn Museum of Art,
Dick S. Ramsay Fund
57.68

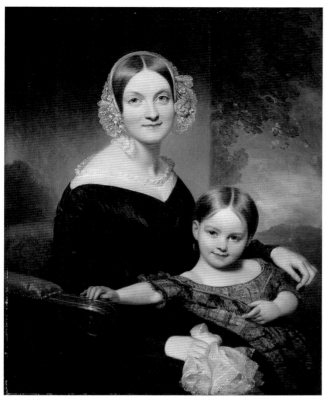

11

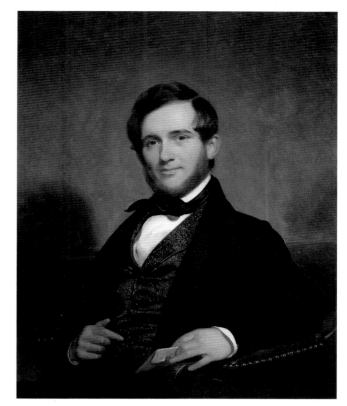

12

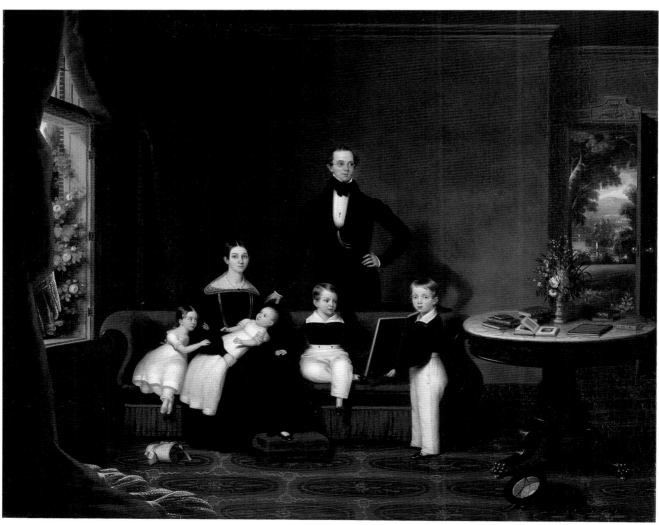

13

NATHANIEL ROGERS
14. *Mrs. Stephen Van Rensselaer III (Cornelia Paterson)*, 1820s
Watercolor on ivory
The Metropolitan Museum of Art, New York, Morris K. Jesup Fund, 1932 32.68

HENRY INMAN *and* THOMAS SEIR CUMMINGS
15. *Portrait of a Lady*, ca. 1825
Watercolor on ivory
The Metropolitan Museum of Art, New York, Dale T. Johnson Fund, 1996 1996.562

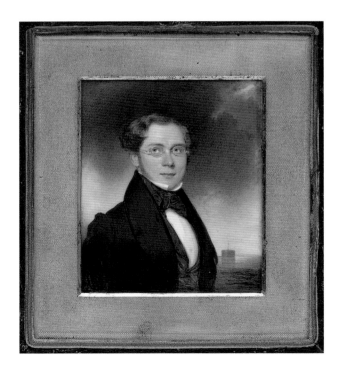

NATHANIEL ROGERS
16. *John Ludlow Morton*, ca. 1829
Watercolor on ivory
Lent by Gloria Manney

THOMAS SEIR CUMMINGS
17. *Gustavus Adolphus Rollins*, ca. 1835
Watercolor on ivory
The Metropolitan Museum of Art, New York, Gift of E. A. Rollins, through his son, A. C. Rollins, 1933 27.216

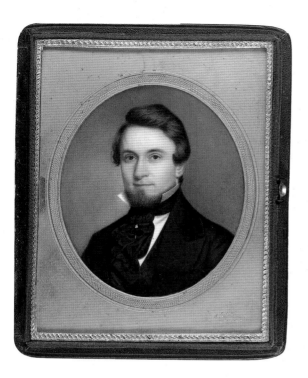

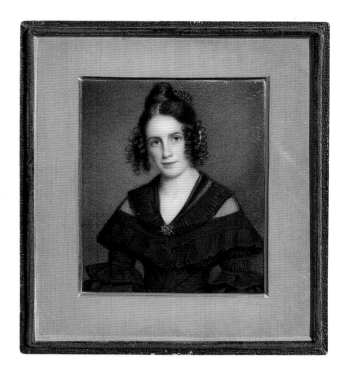

EDWARD S. DODGE
18. *John Wood Dodge,* ca. 1836–37
 Watercolor on ivory
 Lent by Gloria Manney

JAMES WHITEHORNE
19. *Nancy Kellogg,* 1838
 Watercolor on ivory
 Lent by Gloria Manney

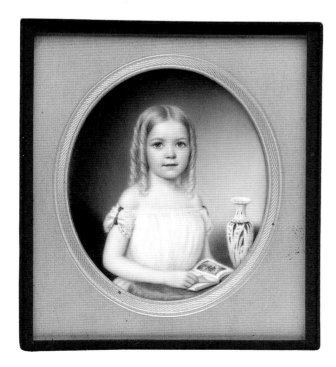

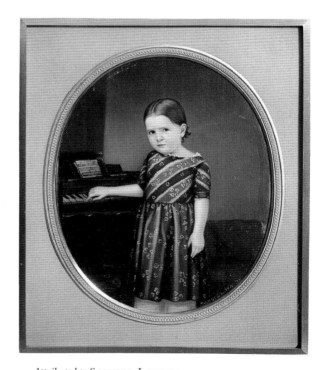

JOHN WOOD DODGE
20. *Kate Roselie Dodge,* 1854
 Watercolor on ivory
 The Metropolitan Museum of
 Art, New York, Morris K.
 Jesup Fund, 1988 1988.280

Attributed to SAMUEL LOVETT
WALDO
21. *Portrait of a Girl,* after 1854
 Oil on panel
 The Metropolitan Museum of Art,
 New York, Fletcher Fund, 1938
 38.146.5

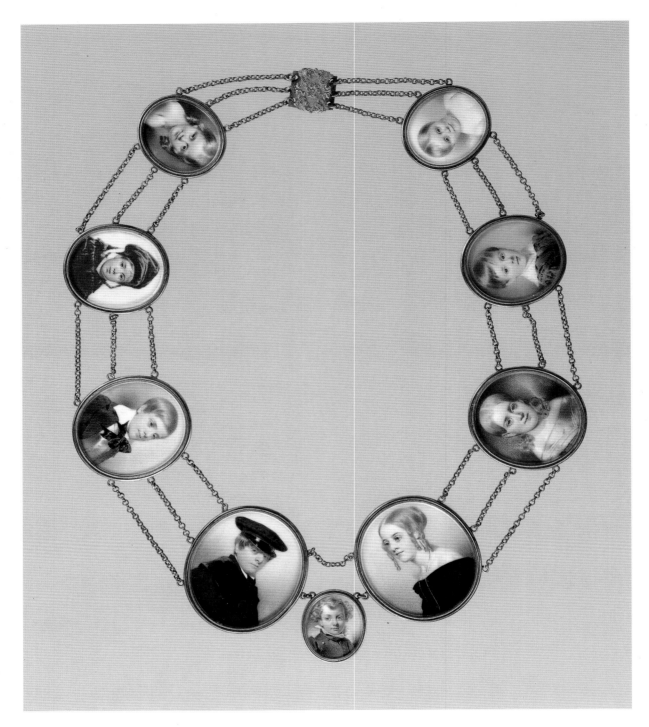

THOMAS SEIR CUMMINGS
22. *A Mother's Pearls (Portraits of the Artist's Children)*, 1841
Watercolor on ivory
The Metropolitan Museum of Art, New York, Gift of Mrs. Richard B. Hartshorne and Miss Fanny S. Cummings (through Miss Estelle Hartshorne), 1928 28.148.1

THOMAS COLE
23. *View of the Round-Top in the Catskill Mountains,* ca. 1827
Oil on panel
Museum of Fine Arts, Boston, Gift of Martha C. Karolik for the M. and M. Karolik Collection of American Paintings, 1815–1865 47.1200

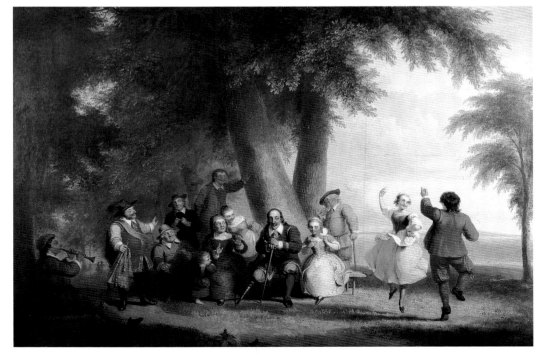

THOMAS COLE

24. *Scene from "The Last of the Mohicans": Cora Kneeling at the Feet of Tamenund*, 1827
Based on James Fenimore Cooper's novel (1826)
Oil on canvas
Wadsworth Atheneum, Hartford, Connecticut, Bequest of Alfred Smith 1868.3

ASHER B. DURAND

25. *Dance on the Battery in the Presence of Peter Stuyvesant*, 1838
Scene from *A History of New-York* by Washington Irving (under the pseudonym Diedrich Knickerbocker; 1809)
Oil on canvas
Museum of the City of New York, Gift of Jane Rutherford Faile through Kenneth C. Faile, 1955 55.248

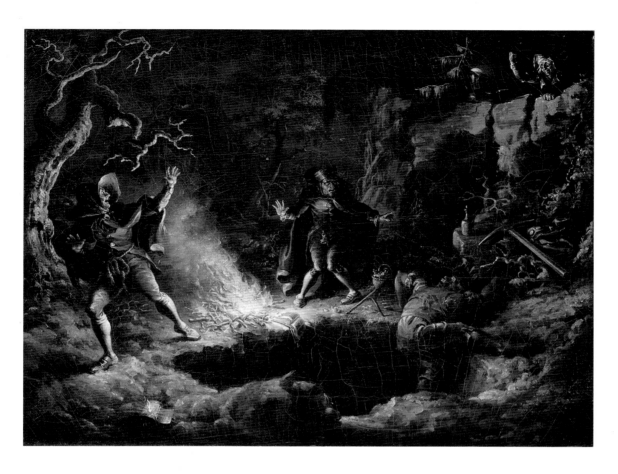

JOHN QUIDOR
26. *The Money Diggers*, 1832
Scene from Washington
Irving's *Tales of a Traveller*
(1824)
Oil on canvas
Brooklyn Museum of Art,
Gift of Mr. and Mrs.
Alastair B. Martin 48.171

ROBERT WALTER
WEIR
27. *A Visit from Saint
Nicholas*, ca. 1837
Scene from Clement
Clarke Moore's poem
(1823)
Oil on panel
The New-York Historical
Society, Gift of George A.
Zabriskie, 1951 1951.76

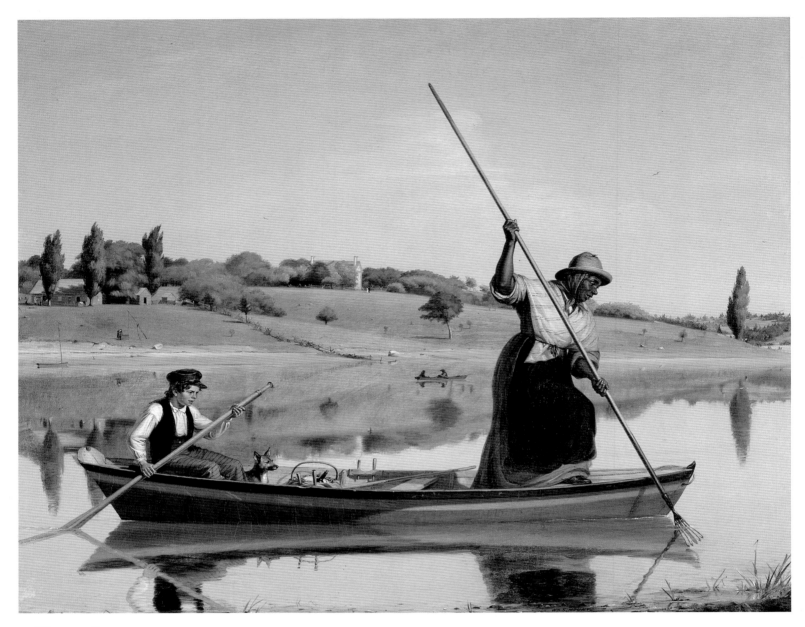

WILLIAM SIDNEY
MOUNT
28. *Eel Spearing at Setauket*
(Recollections of Early Days—
"Fishing along Shore"), 1845
Oil on canvas
New York State Historical
Association, Cooperstown,
Gift of Stephen C. Clark

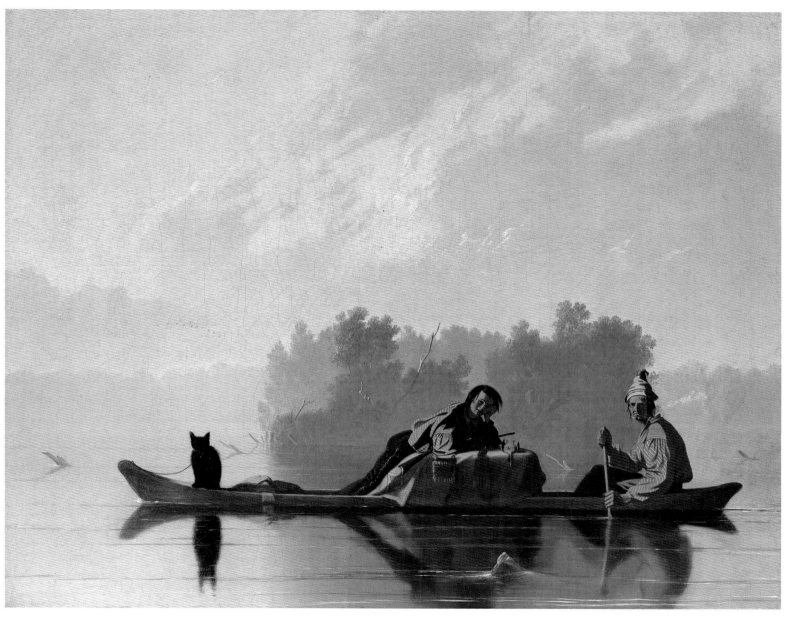

GEORGE CALEB
BINGHAM
29. *Fur Traders Descending the
Missouri*, 1845
Oil on canvas
The Metropolitan
Museum of Art, New
York, Morris K. Jesup
Fund, 1933 33.61

ASHER B. DURAND
31. *In the Woods,* 1855
Oil on canvas
The Metropolitan Museum of Art,
New York, Gift in memory of
Jonathan Sturges by his children,
1895 95.13.1

ASHER B. DURAND
30. *Kindred Spirits,* 1849
Oil on canvas
The New York Public Library,
Gift of Julia Bryant

CHARLES CROMWELL
INGHAM
32. *The Flower Girl*, 1846
Oil on canvas
The Metropolitan
Museum of Art, New
York, Gift of William
Church Osborn, 1902
02.7.1

LILLY MARTIN
SPENCER
33. *Kiss Me and You'll Kiss the
'Lasses*, 1856
Oil on canvas
Brooklyn Museum of Art,
A. Augustus Healy Fund
70.26

EMANUEL LEUTZE
34. *Mrs. Schuyler Burning Her
Wheat Fields on the Approach
of the British*, 1852
Oil on canvas
The Los Angeles County
Museum of Art, Bicentennial
Gift of Mr. and Mrs. J. M.
Schaaf, Mr. and Mrs. William
D. Witherspoon, Mr. and
Mrs. Charles M. Shoemaker,
and Mr. and Mrs. Julian
Ganz, Jr. M.76.91

FITZ HUGH LANE
35. *New York Harbor,* 1850
Oil on canvas
Museum of Fine Arts,
Boston, Gift of Maxim
Karolik for the M. and
M. Karolik Collection of
American Paintings,
1815–1865 48.446

SANFORD ROBINSON
GIFFORD
36. *Lake Nemi,* 1856–57
Oil on canvas
The Toledo Museum of Art,
Toledo, Ohio; Purchased
with funds from the Florence
Scott Libbey Bequest in
Memory of her Father,
Maurice A. Scott 1957.46

JOHN F. KENSETT
37. *Beacon Rock, Newport
Harbor,* 1857
Oil on canvas
National Gallery of Art,
Washington, D.C., Gift
of Frederick Sturges, Jr.
1953.1.1

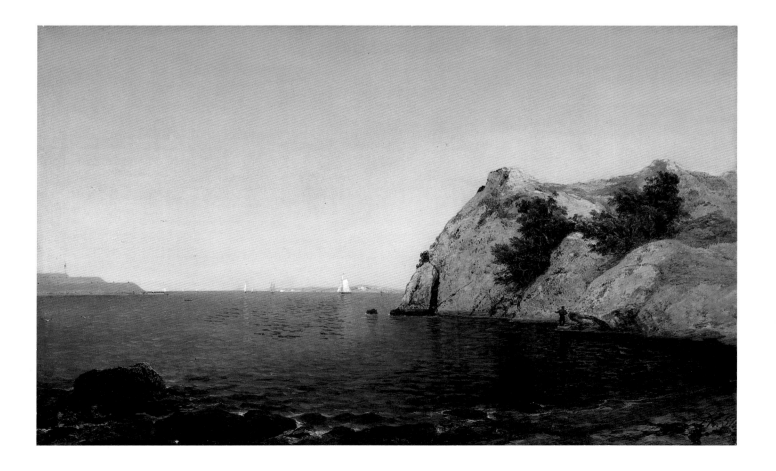

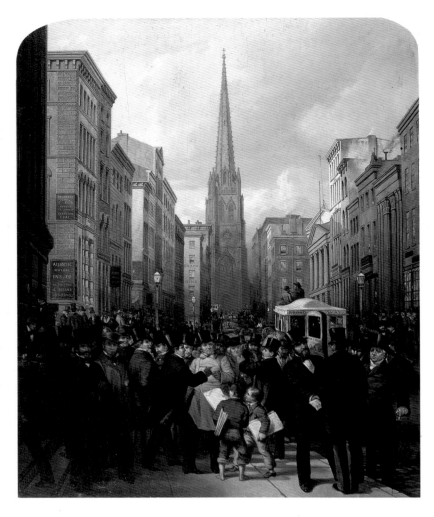

James H. Cafferty *and*
Charles G. Rosenberg
38. *Wall Street, Half Past 2 O'Clock,*
 October 13, 1857, 1858
 Oil on canvas
 Museum of the City of New
 York, Gift of the Honorable
 Irwin Untermyer 40.54

Francis William
Edmonds
39. *The New Bonnet,* 1858
 Oil on canvas
 The Metropolitan Museum
 of Art, New York, Purchase,
 Erving Wolf Foundation Gift
 and Gift of Hanson K. Corning,
 by exchange, 1975 1975.27.1

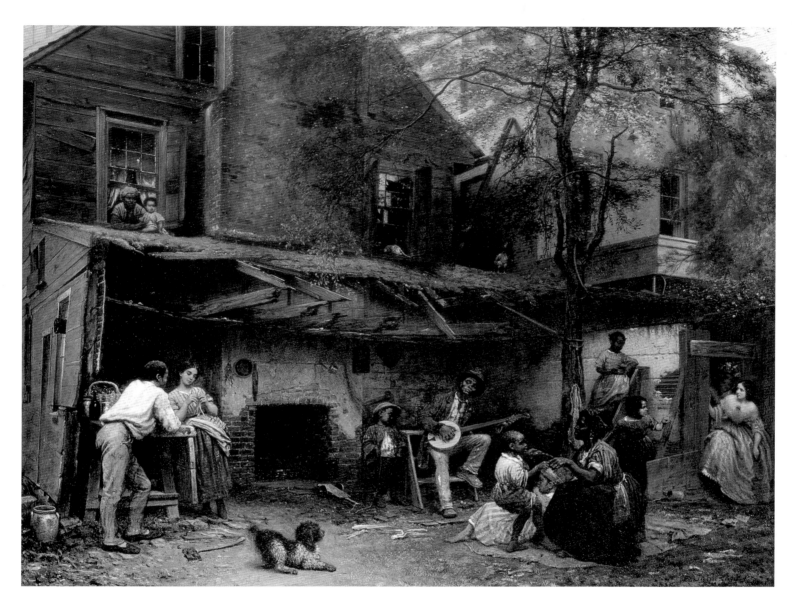

EASTMAN JOHNSON
40. *Negro Life at the South,*
1859
Oil on canvas
The New-York Historical
Society, The Robert L.
Stuart Collection, on
permanent loan from
The New York Public
Library s–225

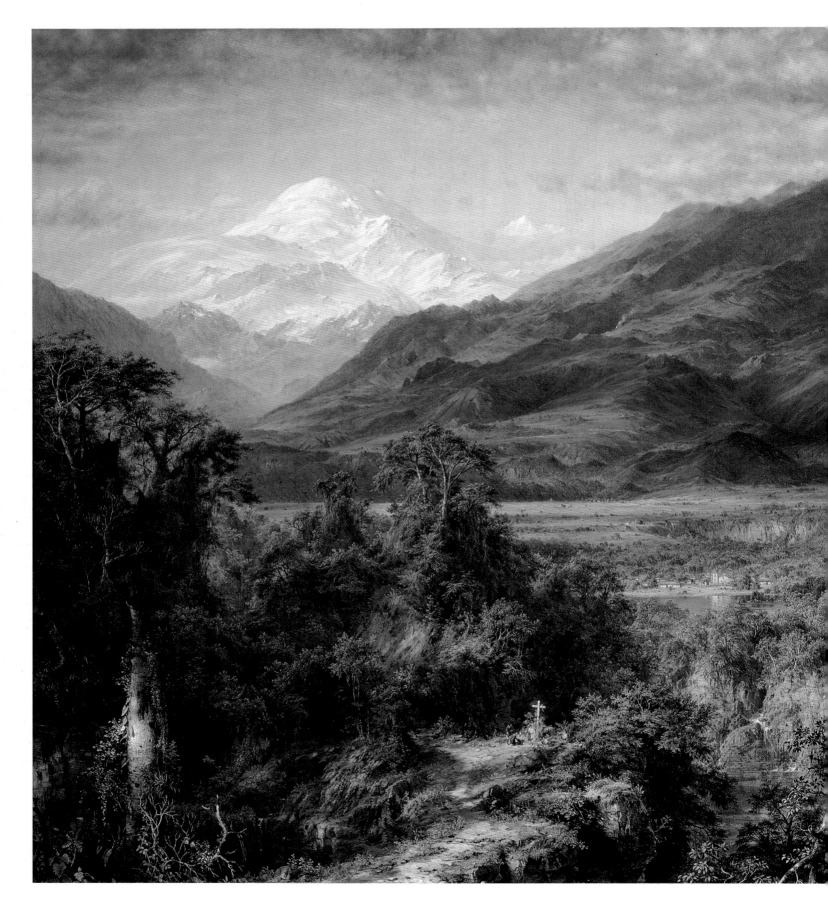

FREDERIC E. CHURCH
41. *The Heart of the Andes*, 1859
Oil on canvas
The Metropolitan Museum of Art, New York,
Bequest of Margaret E. Dows, 1909 09.95

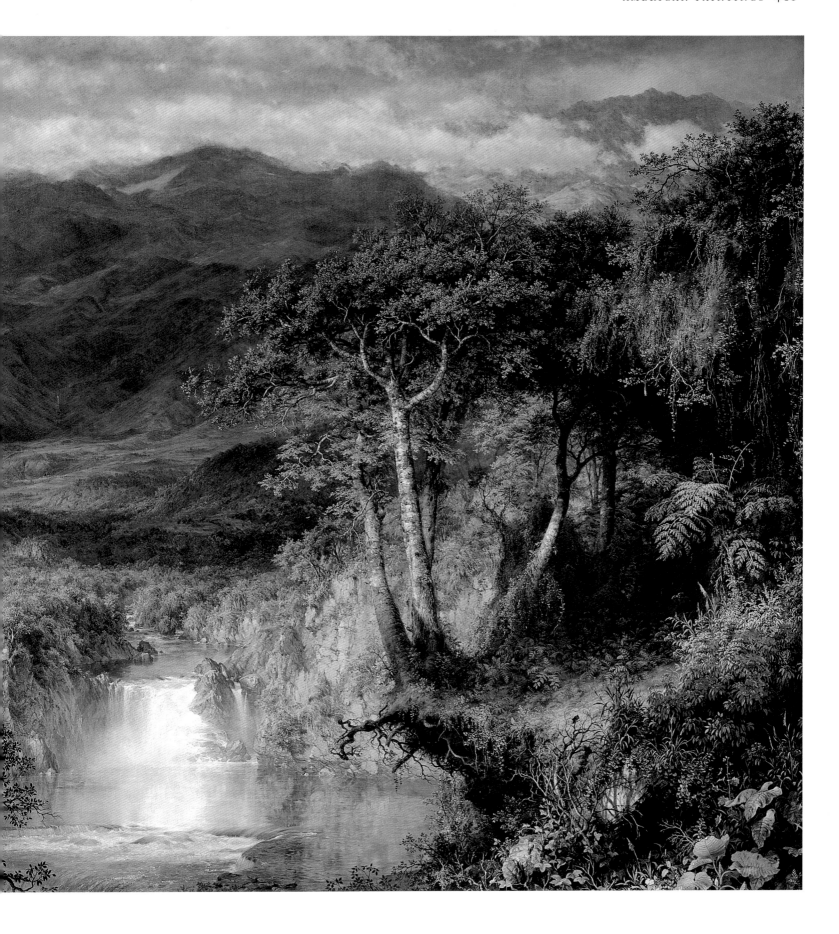

GIOVANNI DI SER
GIOVANNI DI SIMONE
(*called* SCHEGGIA)

42. *The Triumph of Fame,* birth
tray of Lorenzo de'Medici
(recto); *Arms of the Medici
and Tornabuoni Families*
(verso), 1449
Tempera, silver, and gold on
wood
The Metropolitan Museum of
Art, New York, Purchase in
memory of Sir John Pope-
Hennessy: Rogers Fund, The
Annenberg Foundation, Drue
Heinz Foundation, Annette
de la Renta, Mr. and Mrs.
Frank E. Richardson, and The
Vincent Astor Foundation
Gifts, Wrightsman and Gwynne
Andrews Funds, special funds,
and Gift of the children of
Mrs. Harry Payne Whitney,
Gift of Mr. and Mrs. Joshua
Logan, and other gifts and
bequests, by exchange, 1995
1995.7

JAN ABRAHAMSZ.
BEERSTRATEN

45. *Winter Scene*, ca. 1660
Oil on canvas
The New-York Historical
Society, Gift of Thomas J.
Bryan, 1867 1867.84

ARTIST UNKNOWN,
after WILLEM KALF

46. *Still Life with Chinese
Sugarbowl, Nautilus
Cup, Glasses, and Fruit*,
ca. 1675–1700
Oil on canvas
The New-York Historical
Society, Luman Reed
Collection—New-York
Gallery of Fine Arts
1858.15

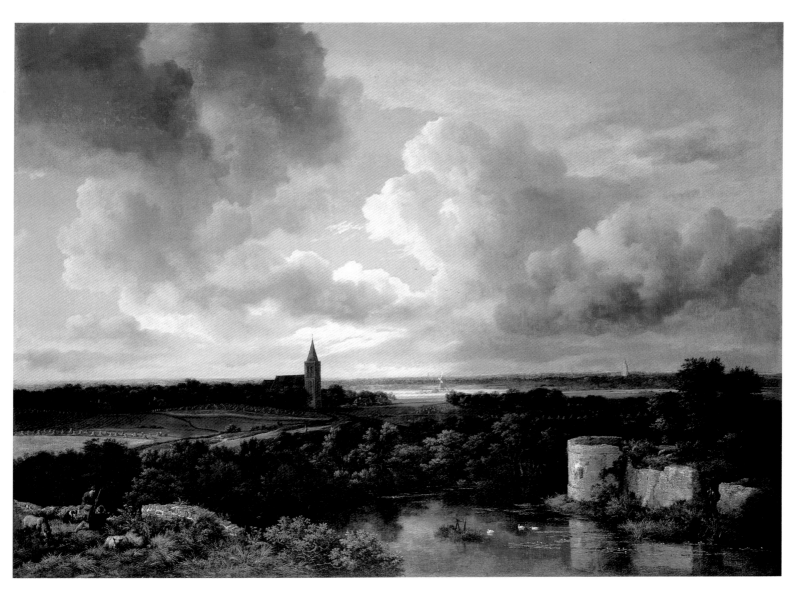

JACOB VAN RUISDAEL
47. *A Landscape with a Ruined
 Castle and a Church (A Grand
 Landscape)*, 1665–70
 Oil on canvas
 The National Gallery, London
 NG990

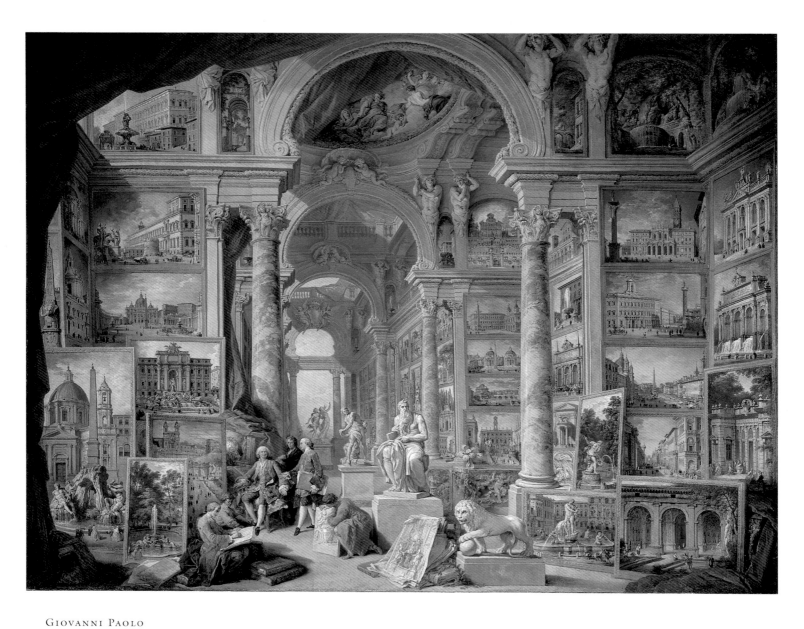

GIOVANNI PAOLO
PANINI (*or* PANNINI)
48. *Modern Rome*, 1757
Oil on canvas
The Metropolitan
Museum of Art, New
York, Gwynne Andrews
Fund, 1952 52.63.2

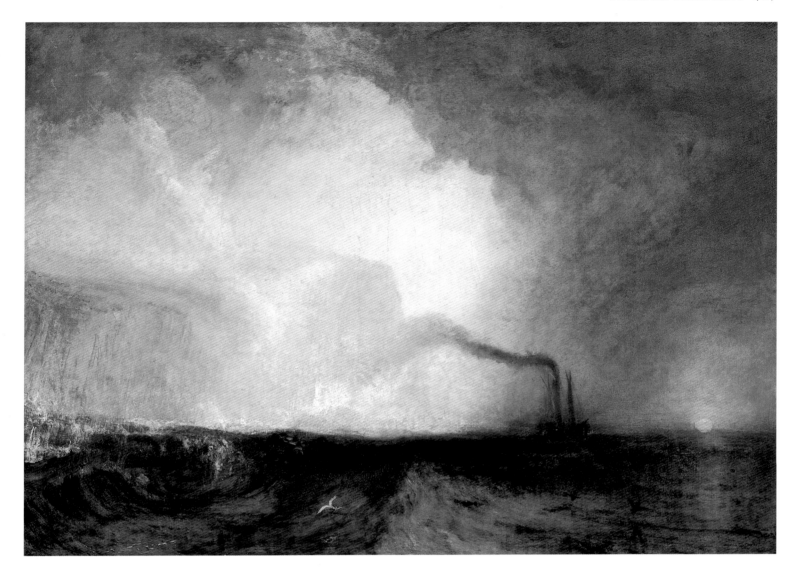

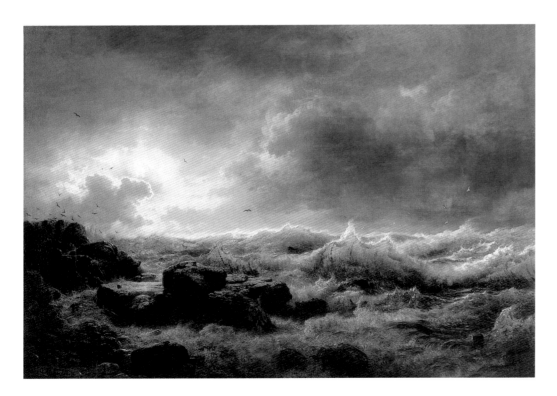

J. M. W. TURNER
49. *Staffa, Fingal's Cave,*
exhibited 1832
Oil on canvas
Yale Center for British Art,
New Haven, Connecticut,
Paul Mellon Collection
B1978.43.14

ANDREAS
ACHENBACH
50. *Clearing Up—Coast of
Sicily,* 1847
Oil on canvas
The Walters Art Gallery,
Baltimore WAG37.116

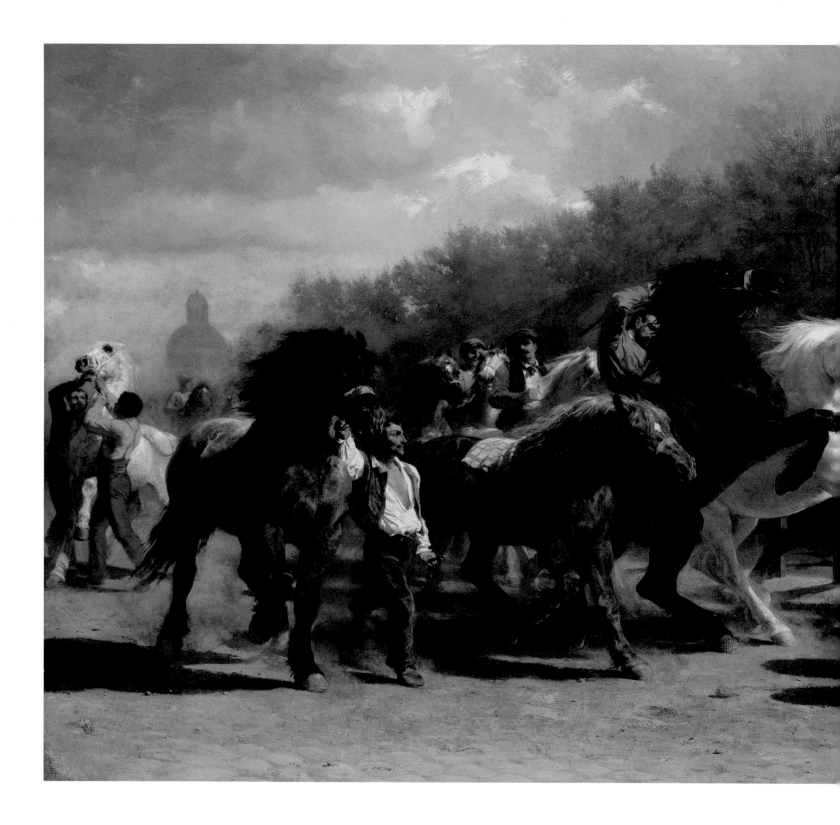

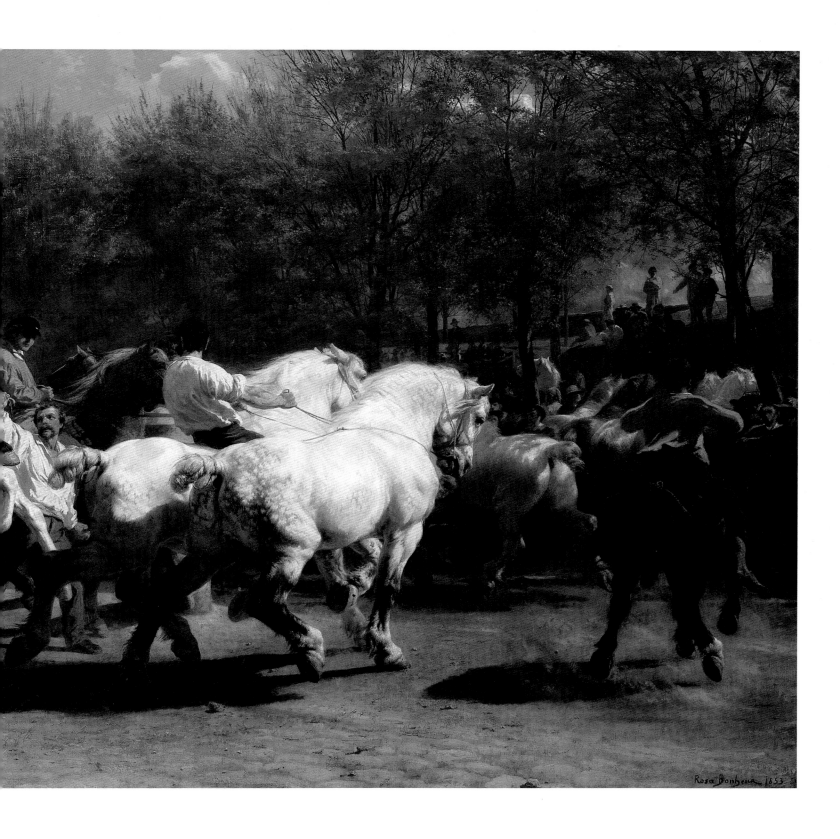

GIUSEPPE CERACCHI
52. *George Washington,* 1795
Marble
The Metropolitan Museum
of Art, New York, Bequest of
John L. Cadwalader, 1914
14.58.235

JEAN-ANTOINE HOUDON
53. *Robert Fulton,* 1803–4
Painted plaster
The Metropolitan Museum of
Art, New York, Wrightsman
Fund, 1989 1989.329

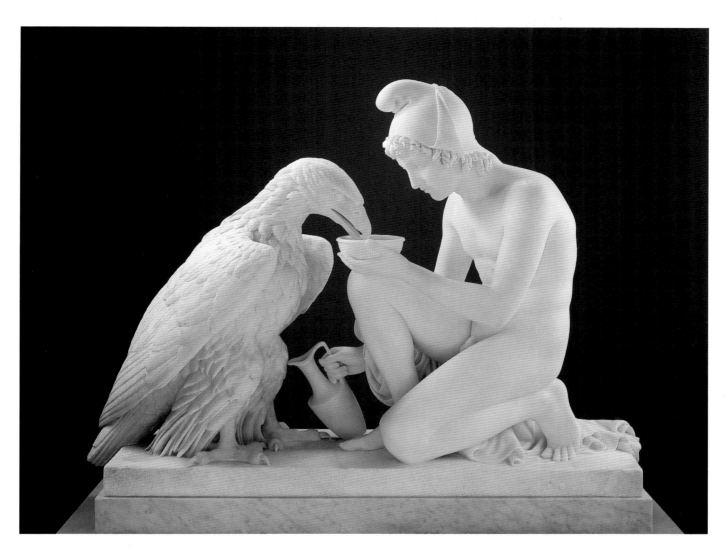

BERTEL THORVALDSEN
54. *Ganymede and the Eagle,*
1817–29
Marble
The Minneapolis Institute of
Arts, Gift of the Morse
Foundation 66.9

HIRAM POWERS
55. *Andrew Jackson,* modeled
1834–35; carved 1839
Marble
The Metropolitan
Museum of Art, New
York, Gift of Mrs.
Frances V. Nash, 1894
94.14

JOHN FRAZEE
56. *Nathaniel Prime,* 1832–34
Marble
National Portrait Gallery,
Smithsonian Institution,
Washington, D.C., Gift
of Sylvester G. Prime
NPG.84.72

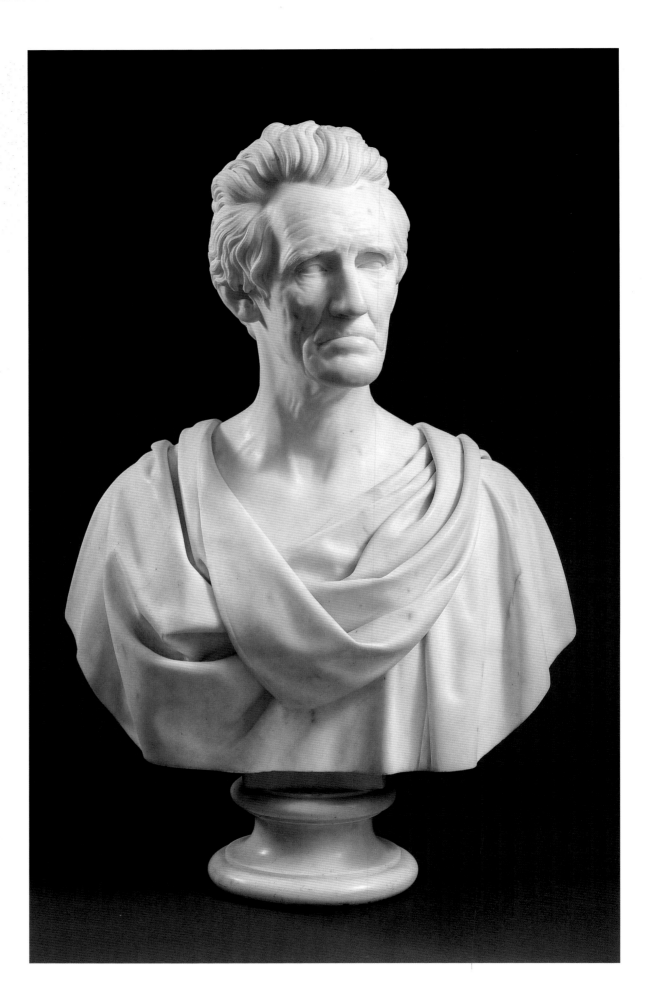

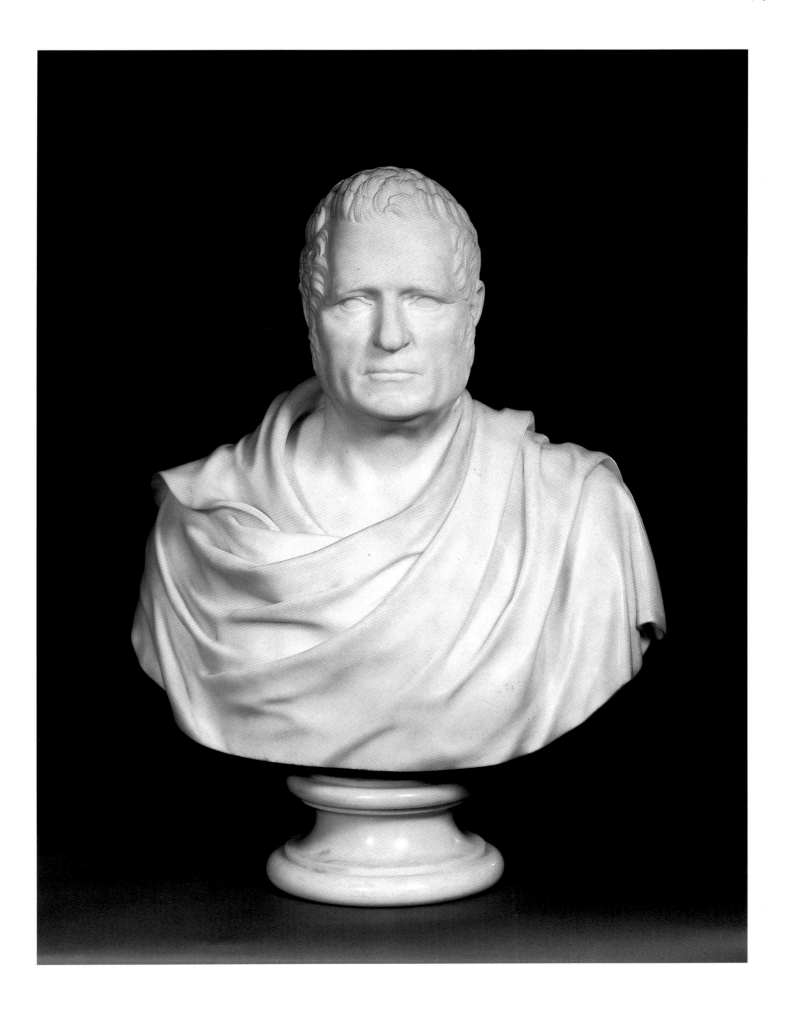

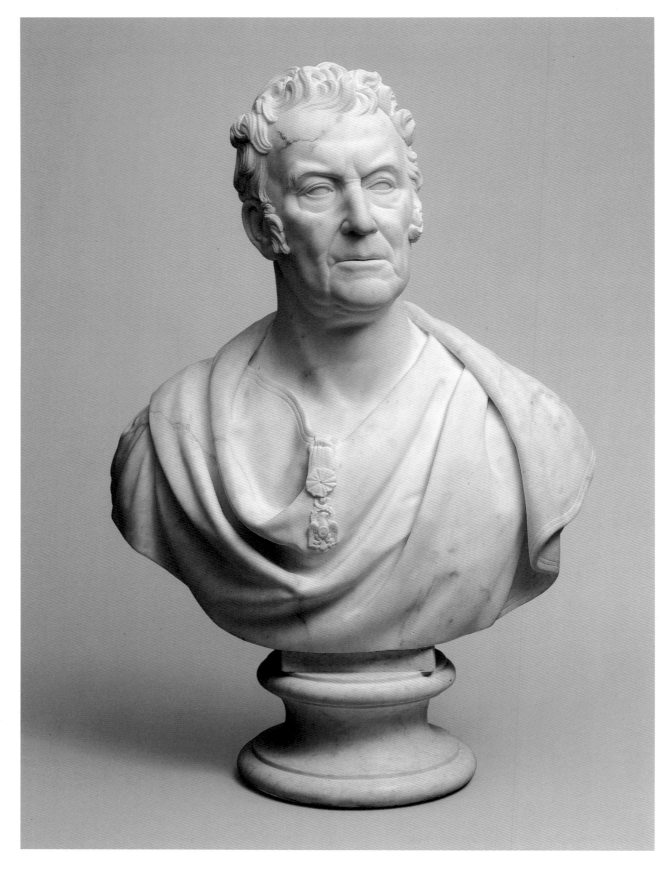

ROBERT BALL HUGHES
57. *John Trumbull,* modeled ca. 1833;
carved 1834–after 1840
Marble
Yale University Art Gallery, New
Haven, Connecticut, University
Purchase 1851.2

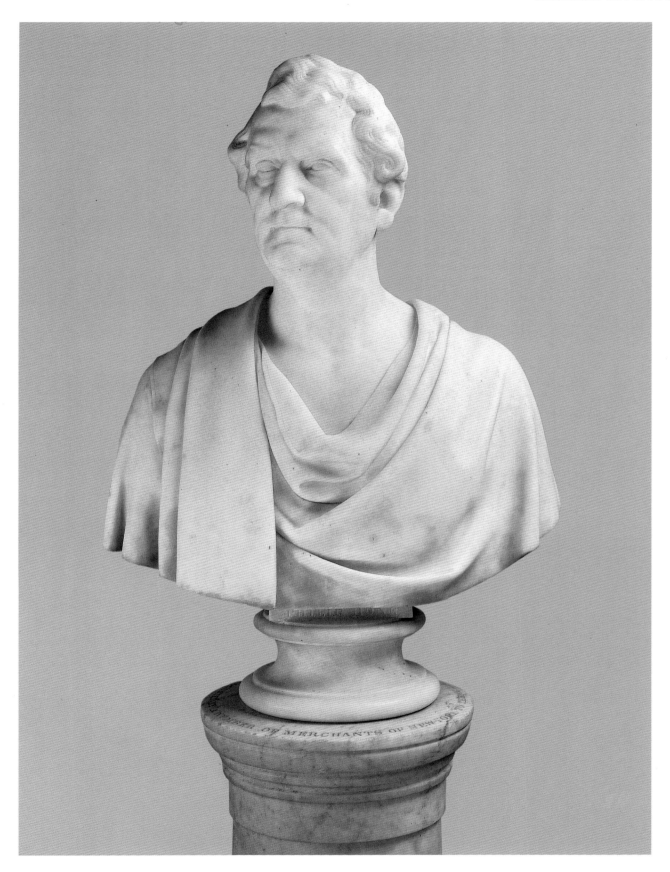

SHOBAL VAIL
CLEVENGER
58. *Philip Hone*, modeled
1839; carved 1844–46
Marble
Mercantile Library
Association, New York

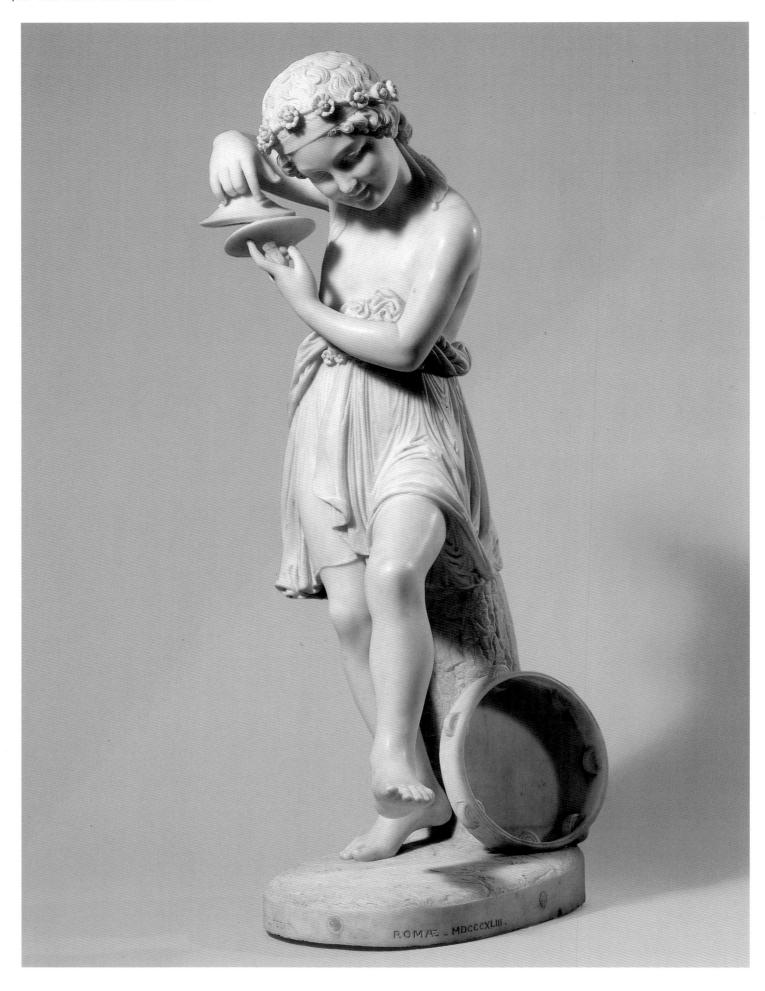

THOMAS CRAWFORD
59. *Genius of Mirth,* modeled
1842; carved 1843
Marble
The Metropolitan
Museum of Art, New
York, Bequest of Annette
W. W. Hicks-Lord, 1896
97.13.1

HIRAM POWERS
60. *Greek Slave,* modeled
1841–43; carved 1847
Marble
The Newark Museum, Gift
of Franklin Murphy, Jr.,
1926 26.2755

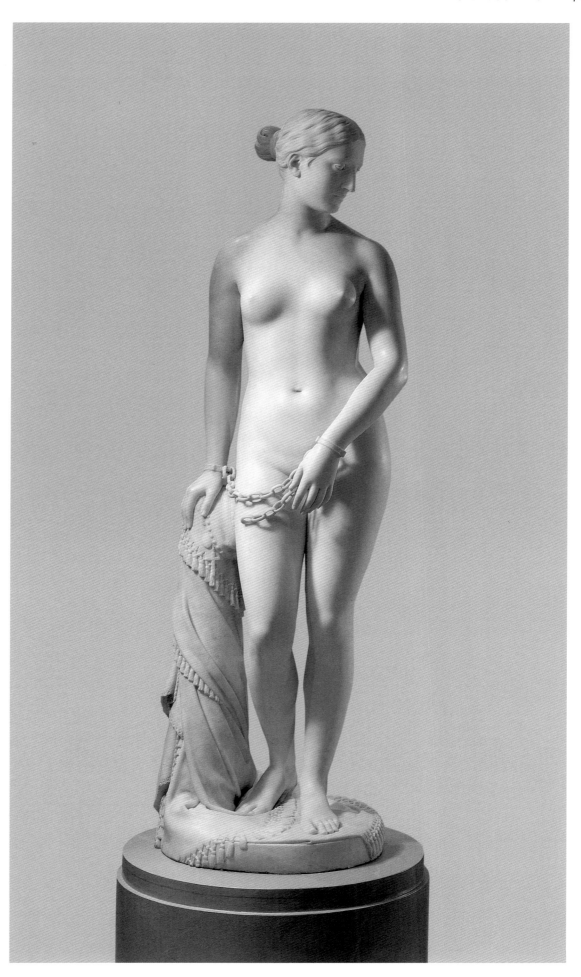

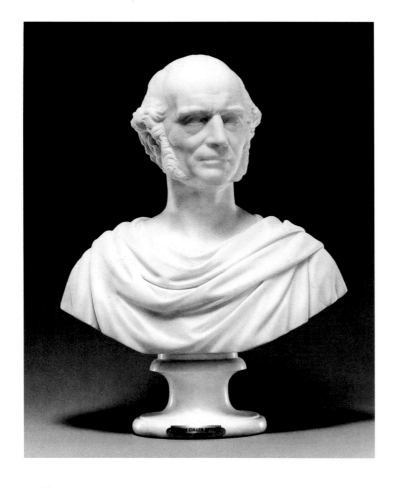

HENRY KIRKE BROWN
61. *William Cullen Bryant,*
 1846–47
 Marble
 The New-York Historical
 Society, Bequest of Mr.
 Charles M. Leupp 1860.6

HENRY KIRKE BROWN
62. *Thomas Cole,* 1850 or earlier
 Marble
 The Metropolitan Museum
 of Art, New York, Gift in
 memory of Jonathan Sturges,
 by his children, 1895 95.8.1

THOMAS CRAWFORD
63. *Louisa Ward Crawford*, modeled
 1845; carved 1846
 Marble
 Museum of the City of New York,
 Gift of James L. Terry, Peter T.
 Terry, Lawrence Terry, and Arthur
 Terry III 86.173

64

CHAUNCEY BRADLEY IVES
64. *Ruth,* modeled ca. 1849; carved 1851
or later
Marble
Chrysler Museum of Art, Norfolk,
Virginia, Gift of James H. Ricau
and Museum Purchase 86.479

JOSEPH MOZIER
65. *Diana,* ca. 1850
Marble
Huguenot Historical Society,
New Paltz, New York

HENRY KIRKE BROWN
66. *Filatrice,* 1850
Bronze
The Metropolitan Museum of Art,
New York, Purchase, Gifts in memory
of James R. Graham, and Morris K.
Jesup Fund, 1993 1993.13

65

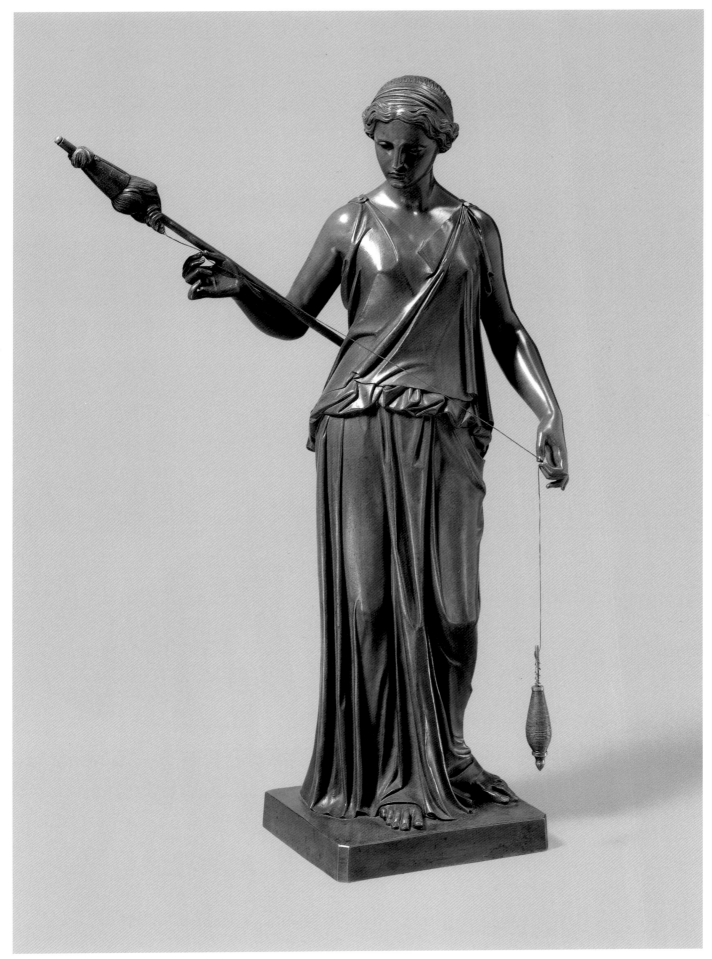

JOHN ROGERS
67. *The Slave Auction*, 1859
 Painted plaster
 The New-York Historical
 Society, Gift of Samuel V.
 Hoffman 1928.28

JOHN QUINCY ADAMS
WARD
68. *The Indian Hunter*, modeled
 1857–60; cast before 1910
 Bronze
 The Metropolitan Museum
 of Art, New York, Morris K.
 Jesup Fund, 1973 1973.257

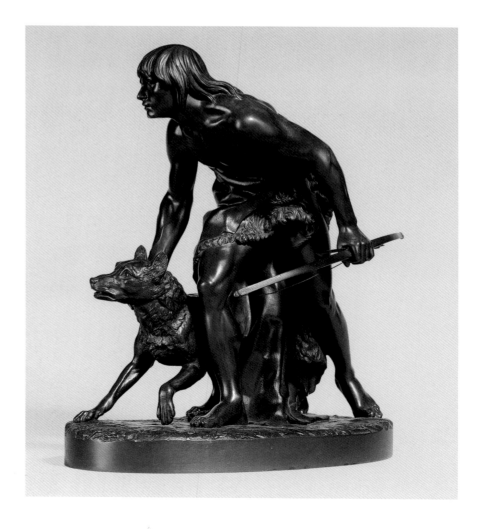

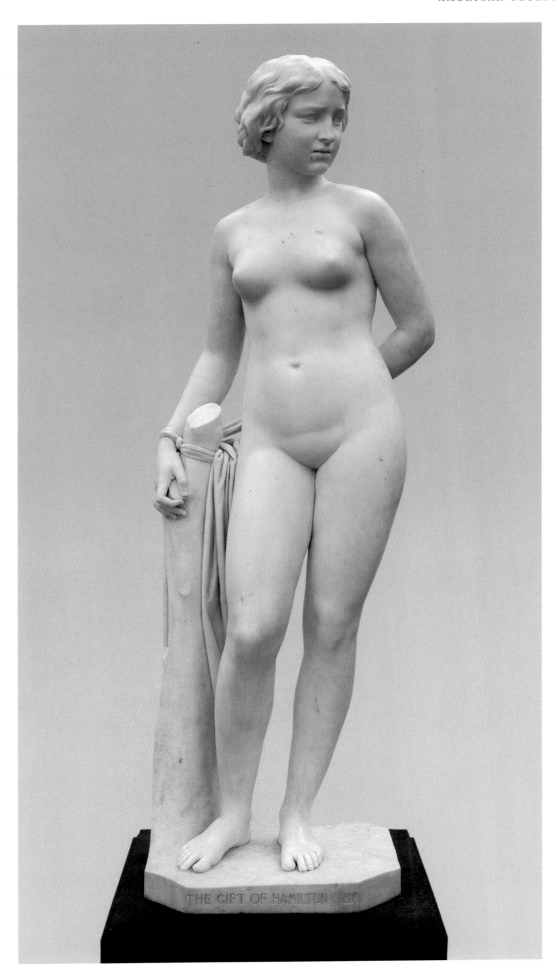

ERASTUS DOW
PALMER
69. *The White Captive*,
modeled 1857–58;
carved 1858–59
Marble
The Metropolitan
Museum of Art, New
York, Bequest of
Hamilton Fish, 1894
94.9.3

ALEXANDER JACKSON
DAVIS, *artist*
ANTHONY IMBERT,
lithographer
Design attributed to JOHN
VANDERLYN

70. *The Rotunda, Corner of*
Chambers and Cross Streets, fron-
tispiece to *Views of the Public*
Buildings in the City
of New-York, 1827
Lithograph
The New-York Historical
Society, A. J. Davis Collection 25

ALEXANDER JACKSON
DAVIS, *artist*
ANTHONY IMBERT,
lithographer
MARTIN EUCLID
THOMPSON, *architect*

71. *Branch Bank of the United States,*
15–17 Wall Street, from *Views*
of the Public Buildings in the City
of New-York, 1827
Lithograph
The Metropolitan Museum of
Art, New York, The Edward
W. C. Arnold Collection of New
York Prints, Maps, and Pictures,
Bequest of Edward W. C. Arnold,
1954 54.90.672

ALEXANDER JACKSON
DAVIS, *artist*
ANTHONY IMBERT,
lithographer
JOSIAH R. BRADY, *architect*

72. *Second Congregational (Unitarian)*
Church, Corner of Prince and
Mercer Streets, from *Views of the*
Public Buildings in the City of
New-York, 1827
Lithograph
The New-York Historical Society

ALEXANDER JACKSON
DAVIS, *artist and architect*
ANTHONY IMBERT,
lithographer

73. *Design for Improving the Old*
Almshouse, North Side of City
Hall Park, Facing Chambers
Street, 1828
Lithograph
The Metropolitan Museum of
Art, New York, The Elisha
Whittelsey Collection, The
Elisha Whittelsey Fund, 1954
54.546.9

70

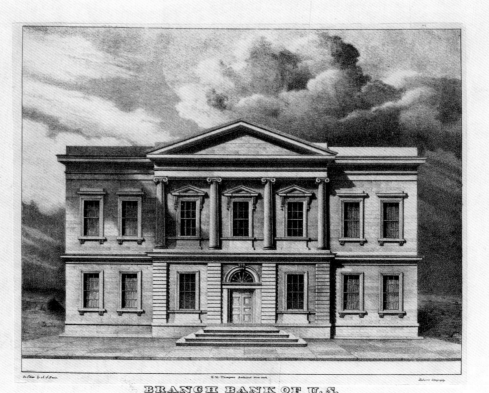

BRANCH BANK OF U. S.
Erected 1825.—Front 75 feet.

71

A. J. Davis del. J. R. Brady Architect Imbert's lithography

SECOND CONGREGATIONAL CHURCH N.Y.
Erected 1826 corner of Prince and Mercer Streets—Front Sixty three feet.

72

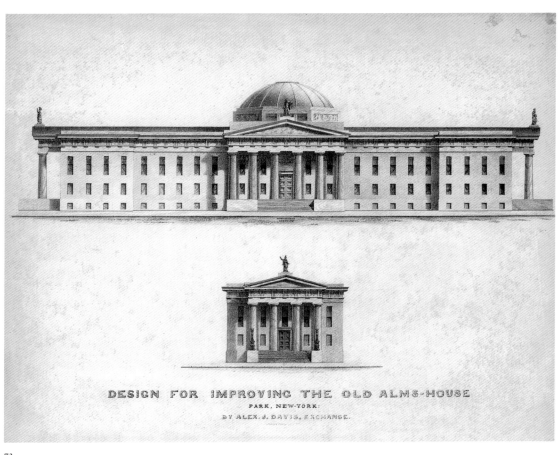

DESIGN FOR IMPROVING THE OLD ALMS-HOUSE
PARK, NEW-YORK:
BY ALEX. J. DAVIS, EXCHANGE.

73

ALEXANDER JACKSON
DAVIS, *artist*
MARTIN EUCLID
THOMPSON *and* JOSIAH
R. BRADY, *architects*
74. *First Merchants' Exchange,*
35–37 Wall Street, Elevation,
probably 1826
Ink and wash
The Metropolitan Museum of
Art, New York, The Edward
W. C. Arnold Collection of
New York Prints, Maps, and
Pictures, Bequest of Edward
W. C. Arnold, 1954 54.90.137

ALEXANDER JACKSON
DAVIS, *artist*
MARTIN EUCLID
THOMPSON *and* JOSIAH
R. BRADY, *architects*
75. *First Merchants' Exchange,*
35–37 Wall Street, First Floor
Plan, probably 1829
Ink and wash
The Metropolitan Museum
of Art, New York, Harris
Brisbane Dick Fund, 1924
24.66.622 (recto)

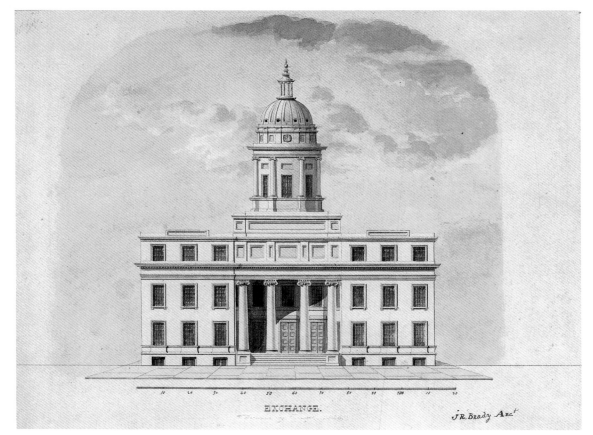

74

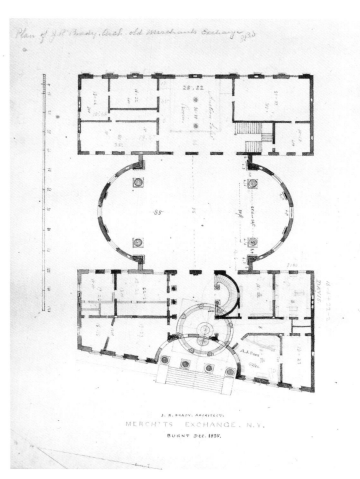

75

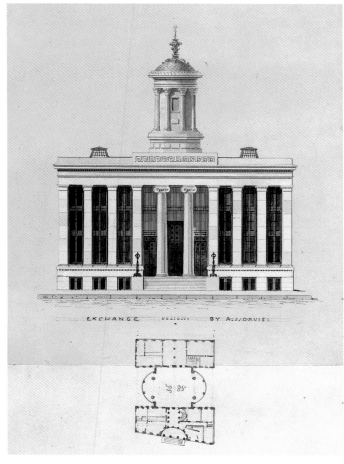

76

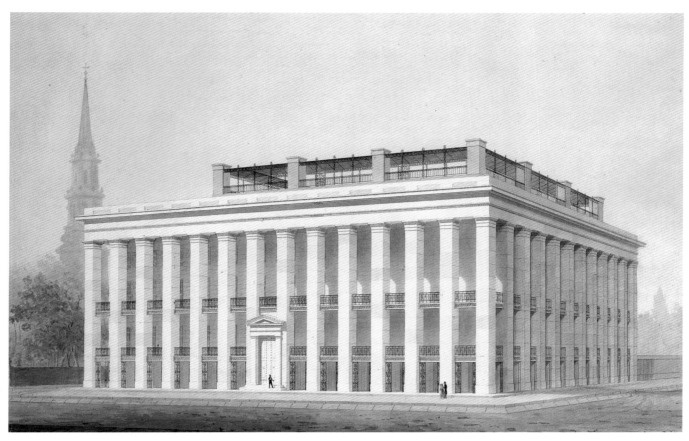

77

ALEXANDER JACKSON
DAVIS
76. *First Merchants' Exchange,
35–37 Wall Street, Alternate,
Unexecuted Elevation and
Plan,* 1829
Ink and wash
The Metropolitan Museum
of Art, New York, Harris
Brisbane Dick Fund, 1924
24.66.621

ALEXANDER JACKSON
DAVIS, *artist*
ITHIEL TOWN *and*
ALEXANDER JACKSON
DAVIS, *architects*
77. *Park Hotel (Later Called
Astor House), Broadway
between Vesey and Barclay
Streets, Proposed, Unexecuted
Design,* 1830
Watercolor
The Metropolitan Museum
of Art, New York, Harris
Brisbane Dick Fund, 1924
24.66.30

ALEXANDER JACKSON
DAVIS, *artist*
ITHIEL TOWN *and*
ALEXANDER JACKSON
DAVIS, *architects*
78. *Park Hotel (Later Called
Astor House), Broadway
between Vesey and Barclay
Streets, Proposed, Unexecuted
Perspective and Plan,* ca. 1830
Watercolor
The New-York Historical
Society, A. J. Davis
Collection 18

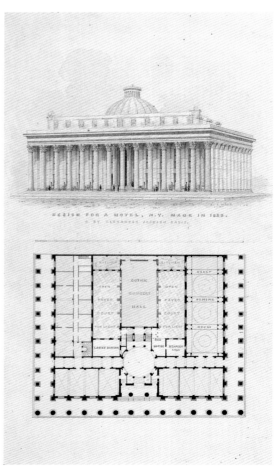

78

ALEXANDER JACKSON
DAVIS, *artist*
ITHIEL TOWN *and*
ALEXANDER JACKSON
DAVIS, *architects*
79. *United States Custom House,*
Wall and Nassau Streets,
Longitudinal Section, 1833
Watercolor and ink
Avery Architectural and Fine
Arts Library, Columbia
University, New York
1940.001.00132

ALEXANDER JACKSON
DAVIS, *artist*
ITHIEL TOWN *and*
ALEXANDER JACKSON
DAVIS, *architects*
80. *United States Custom House,*
Wall and Nassau Streets, Plan,
1833
Watercolor
The Metropolitan Museum
of Art, New York, Harris
Brisbane Dick Fund, 1924
24.66.1403 (45)

ALEXANDER JACKSON
DAVIS, *artist*
ITHIEL TOWN *and*
ALEXANDER JACKSON
DAVIS, *architects*
81. *United States Custom House,*
Wall and Nassau Streets,
Perspective, 1834
Watercolor
The Metropolitan Museum of
Art, New York, The Edward
W. C. Arnold Collection of
New York Prints, Maps, and
Pictures, Bequest of Edward
W. C. Arnold, 1954 54.90.176

JOHN HAVILAND
82. *Halls of Justice and House of*
Detention, Centre Street, between
Leonard and Franklin Streets,
First Floor Plan, 1835
Ink
Royal Institute of British
Architects Library, London,
Drawings Collection W14/6(2)

JOHN HAVILAND
83. *Halls of Justice and House of*
Detention, Centre Street, between
Leonard and Franklin Streets,
Bird's-Eye View, 1835
Ink and wash
Royal Institute of British
Architects Library, London,
Drawings Collection
W14/6(9)

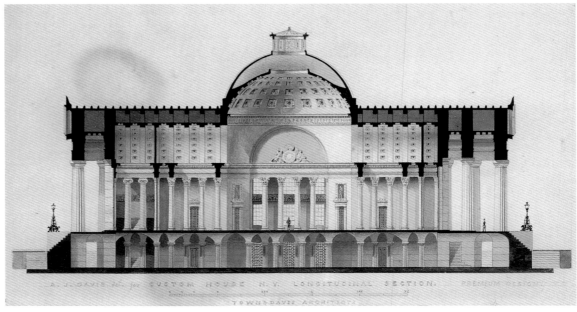

79

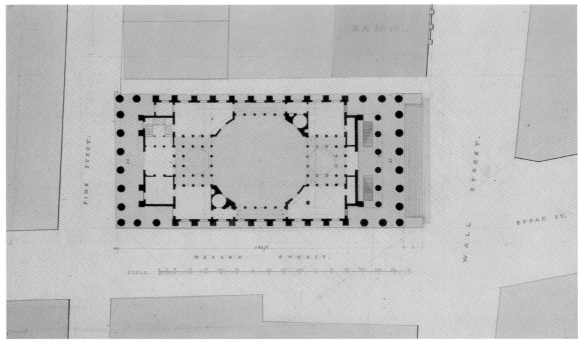

80

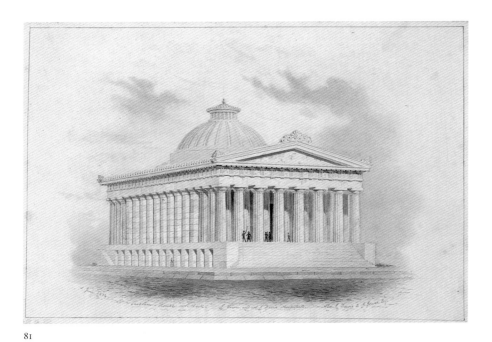

81

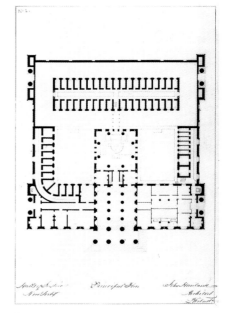

82

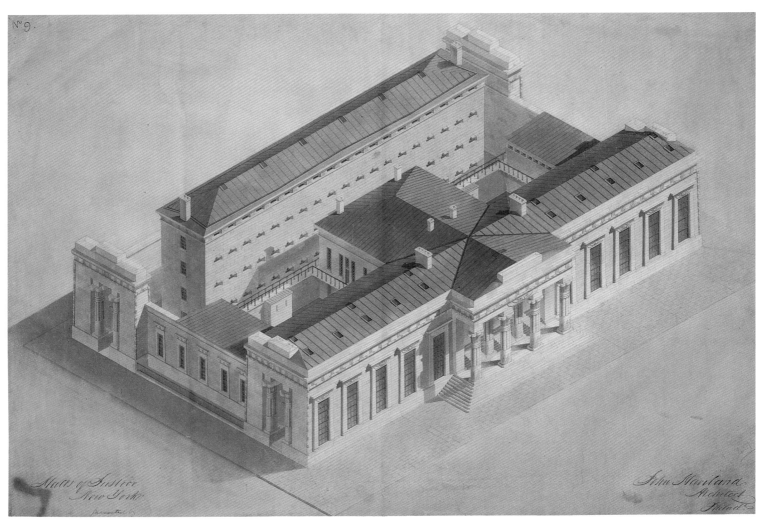

83

ALEXANDER
JACKSON DAVIS
84. *"Syllabus Row,"
Proposed, Unexecuted
Design for Terrace
Houses*, ca. 1830
Watercolor
The Metropolitan
Museum of Art,
New York, The
Edward W. C.
Arnold Collection
of New York Prints,
Maps, and Pictures,
Bequest of Edward
W. C. Arnold, 1954
54.90.140

ALEXANDER JACKSON
DAVIS
85. *"Terrace Houses," Proposed,
Unexecuted Design for Cross-
Block Terrace Development,*
ca. 1831
Watercolor
The Metropolitan Museum
of Art, New York, Harris
Brisbane Dick Fund, 1924
24.66.1291

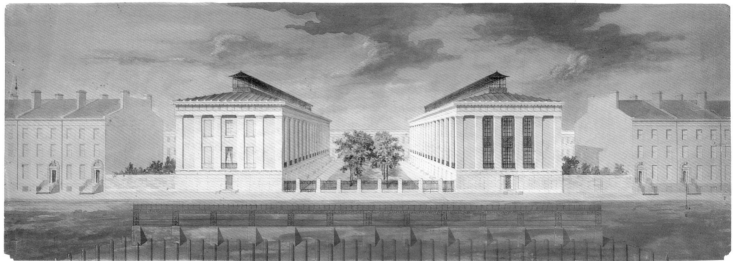

JOHN STIREWALT, *artist*
ALEXANDER JACKSON
DAVIS *and* SETH GEER,
architects
86. *Colonnade Row, 428–434
Lafayette Street, near Astor
Place, Elevation and Plans,*
1833–34
Watercolor
Avery Architectural and Fine
Arts Library, Columbia
University, New York
1940.001.00739

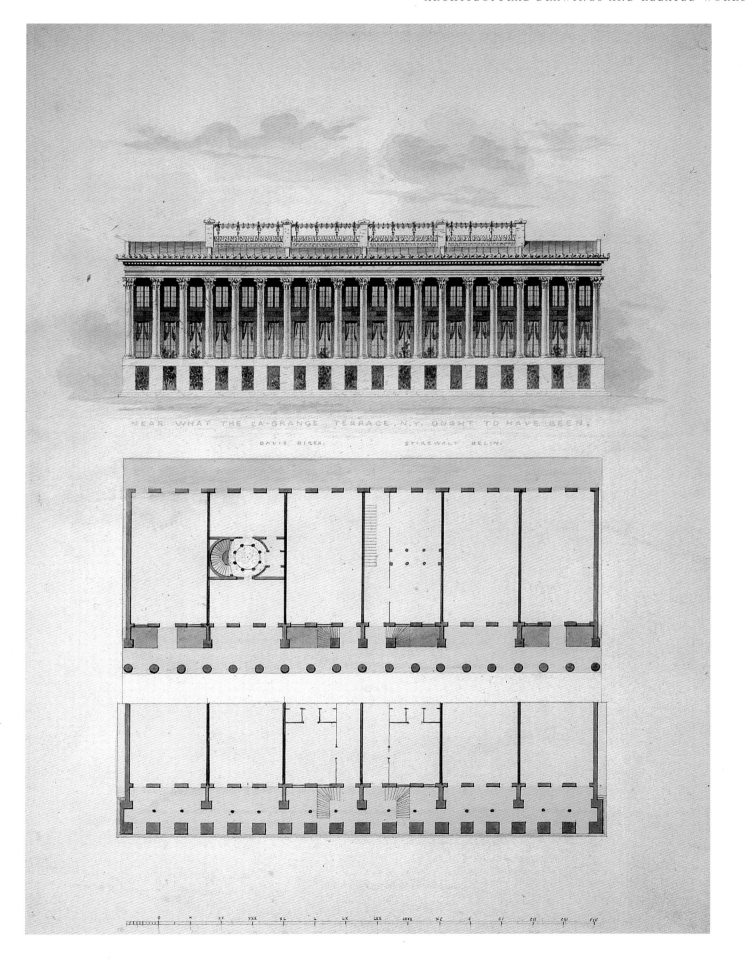

NEAR WHAT THE LA-GRANGE TERRACE, N.Y. OUGHT TO HAVE BEEN.

DAVIS DIREX. STIREWALT DELIN.

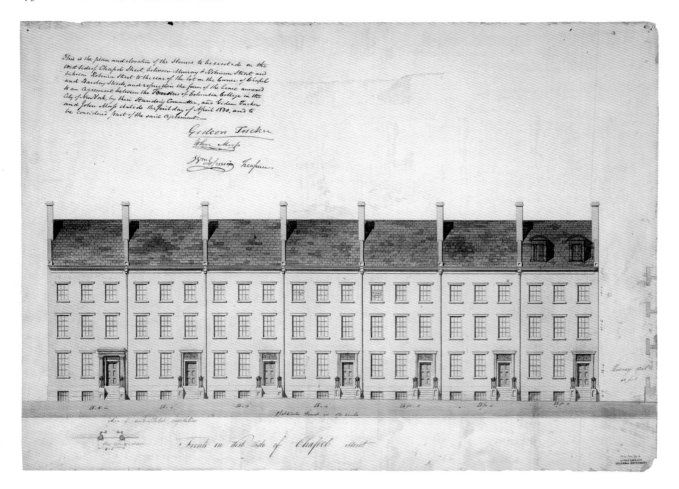

Attributed to MARTIN EUCLID THOMPSON

87. *Row of Houses on Chapel Street, between Murray and Robinson Streets,* 1830
Watercolor and ink on paper, mounted on board
Avery Architectural and Fine Arts Library, Columbia University, New York Gideon Tucker DR165

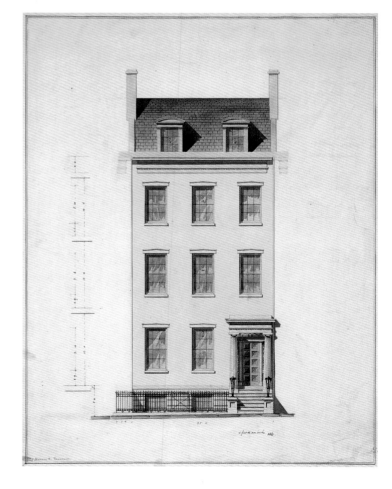

Attributed to MARTIN EUCLID THOMPSON

88. *House on Chapel Street, between Murray and Robinson Streets,* 1830
Watercolor
Avery Architectural and Fine Arts Library, Columbia University, New York 1000.010.00013

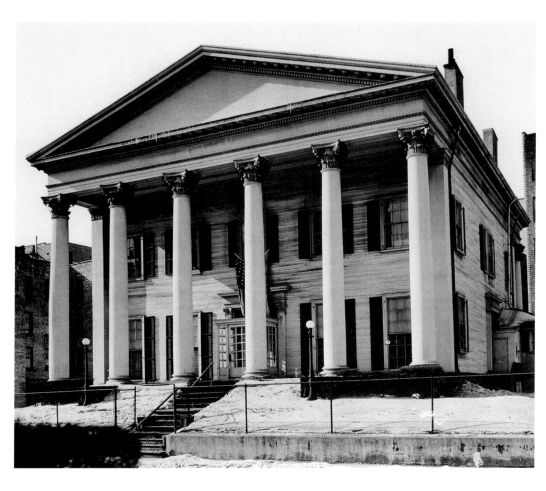

ARCHITECT UNKNOWN
Clarkson Lawn (Matthew Clarkson Jr. House), Flatbush and Church Avenues, Brooklyn, New York, built ca. 1835 (demolished 1940); photograph, 1940
Courtesy of the Brooklyn Museum of Art

89A. Door and doorframe from the entry hall of Clarkson Lawn, ca. 1835
Mahogany; painted pine; metal
Brooklyn Museum of Art, Gift of the Young Men's Christian Association, 1940
40.931.2A–B

89B. Pair of pilasters from the double parlor of Clarkson Lawn (capital illustrated), ca. 1835
Painted pine
Brooklyn Museum of Art, Gift of the Young Men's Christian Association, 1940
40.931.3, 4

89B

89A

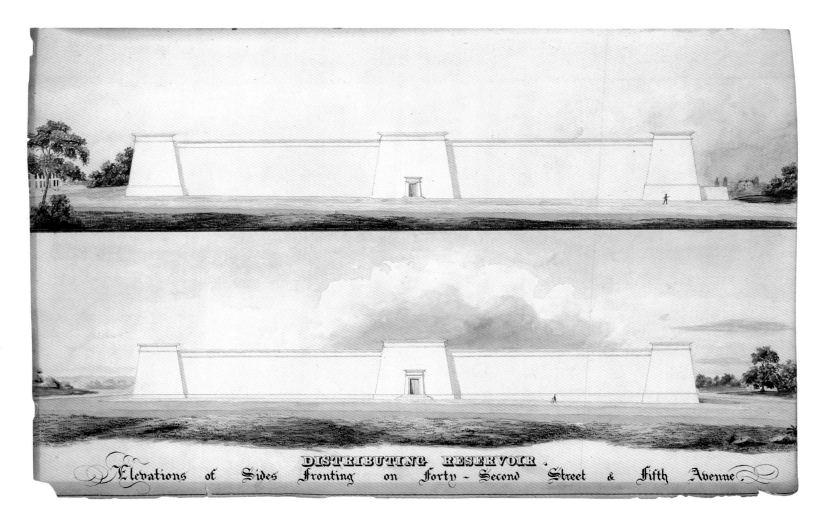

DISTRIBUTING RESERVOIR.

Elevations of Sides Fronting on Forty-Second Street & Fifth Avenue

JOHN B. JERVIS, *chief
engineer*

90. *Distributing Reservoir of
the Croton Aqueduct,
Fifth Avenue between
Fortieth and Forty-second
Streets,* 1837–39
Ink and watercolor
Jervis Public Library,
Rome, New York

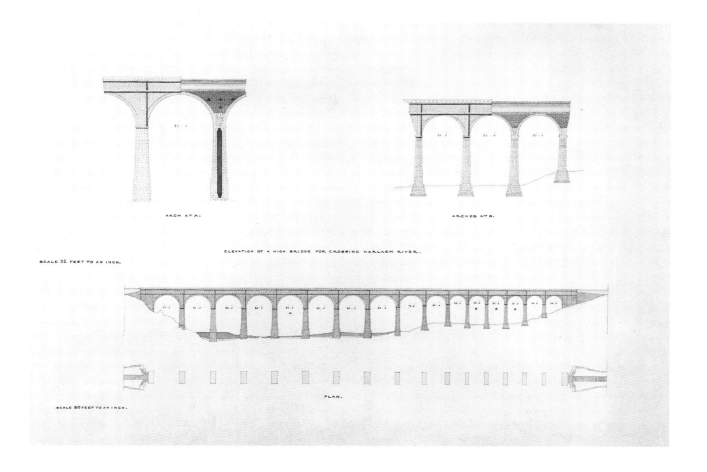

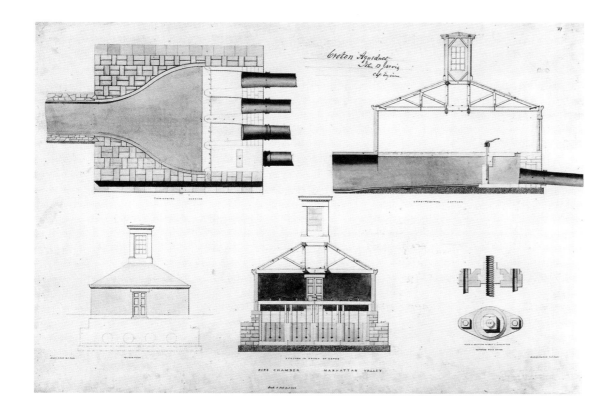

JOHN B. JERVIS, *chief engineer*

91. *High Bridge of the Croton Aqueduct, over the Harlem River, Elevation and Plan*, ca. 1839–40
Ink and watercolor
Jervis Public Library, Rome, New York Drawing 249

JOHN B. JERVIS, *chief engineer*

92. *Manhattan Valley Pipe Chamber of the Croton Aqueduct*, ca. 1839–40
Ink and watercolor
Library of Congress, Washington, D.C., Prints and Photographs Division 1997.86.1

ARTIST UNKNOWN
RICHARD UPJOHN,
architect

93. *Trinity Church, Broadway, opposite Wall Street, Presentation Drawing Depicting View from the Southwest,* probably 1841
Watercolor
Avery Architectural and Fine Arts Library, Columbia University, New York
1000.011.01098

93

JAMES RENWICK JR.

94. *Church of the Puritans, Union Square, Fifteenth Street and Broadway,* 1846
Watercolor
The New-York Historical Society

FERDINAND JOACHIM
RICHARDT, *artist*
JAMES RENWICK JR., *architect*

95. *Grace Church, Broadway and Tenth Street,* 1858
Oil on canvas
Grace Church in New York

94

JOSEPH TRENCH *and*
JOHN BUTLER SNOOK
96. *A. T. Stewart Store, Broadway between Reade and Chambers Streets, Chambers Street Elevation,* 1849
Watercolor
The New-York Historical Society

JAMES BOGARDUS, *inventor*
WILLIAM L. MILLER, *architectural-iron manufacturer*
97. Spandrel panel from Edgar H. Laing Stores, Washington and Murray Streets, 1849
Cast iron
The Metropolitan Museum of Art, New York, Gift of Margaret H. Tuft, 1979
1979.134

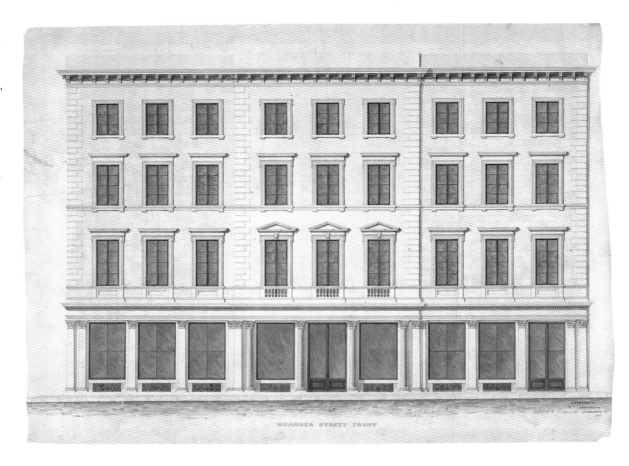

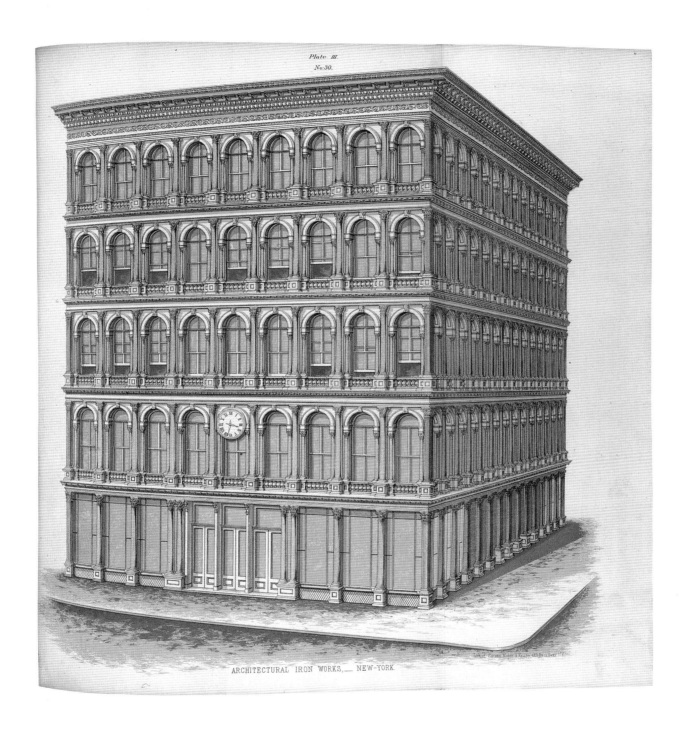

Plate III.
No. 30.

ARCHITECTURAL IRON WORKS,— NEW-YORK.

JOHN P. GAYNOR, *architect*
DANIEL D. BADGER,
architectural-iron manufacturer
SARONY, MAJOR AND KNAPP,
printer

98. *Haughwout Building, Broadway and Broome Street*, 1865
Lithograph printed in colors
Smithsonian Institution Libraries,
Washington, D.C. FNA 3503.7832
1865 XCHRMB

DETLEF LIENAU

99. *Hart M. Shiff House, Fifth Avenue
 and Tenth Street, Front Elevation*, 1850
 Pen and ink
 Avery Architectural and Fine Arts
 Library, Columbia University, New
 York 1936.002.00013

DETLEF LIENAU

100. *Hart M. Shiff House, Fifth Avenue
 and Tenth Street, Side Elevation*, 1850
 Pen and ink
 Avery Architectural and Fine Arts
 Library, Columbia University, New
 York 1936.002.00014

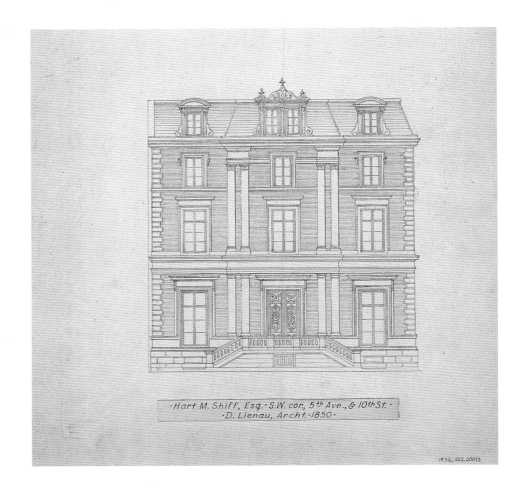

·Hart M. Shiff, Esq.· S.W. cor, 5ᵗʰ Ave., & 10ᵗʰ St.·
·D. Lienau, Archt.·1850·

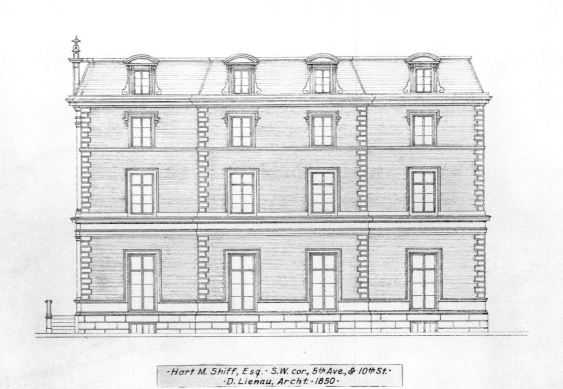

·Hart M. Shiff, Esq.· S.W. cor., 5ᵗʰ Ave, & 10ᵗʰ St.·
·D. Lienau, Archt.·1850·

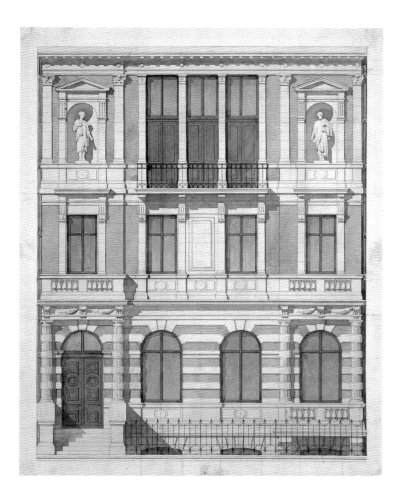

RICHARD MORRIS HUNT
101. *Thomas P. Rossiter House,*
11 West Thirty-eighth Street,
Facade Study, 1855
Ink and wash
Octagon Museum, Washington,
D.C., American Architectural
Foundation, Prints and
Drawings Collection 81.6617

ALEXANDER JACKSON
DAVIS
102. *Ericstan (John J. Herrick House),*
Tarrytown, New York, Rear
Elevation, ca. 1855
Watercolor, ink, and graphite
The Metropolitan Museum
of Art, New York, Harris
Brisbane Dick Fund, 1924
24.66.10

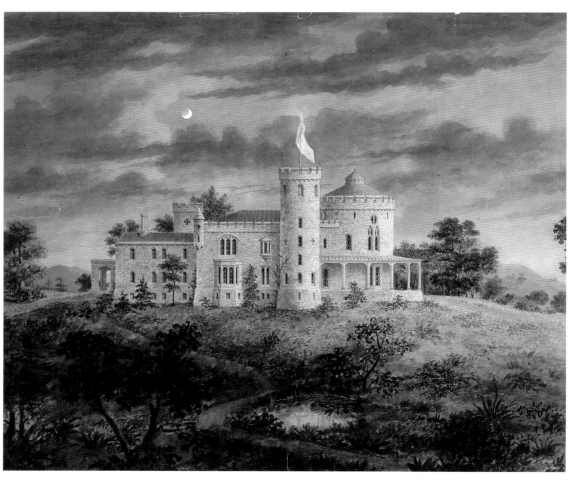

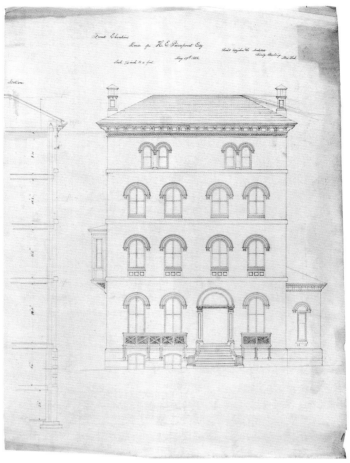

103

RICHARD UPJOHN
103. *Henry Evelyn Pierrepont House, 1 Pierrepont Place, Brooklyn, New York, Front Elevation and Section,* 1856
Ink on cloth
Avery Architectural and Fine Arts Library, Columbia University, New York
1985.003.00001

CHARLES METTAM *and* EDMUND A. BURKE
104. *The New-York Historical Society, Second Avenue and Eleventh Street,* 1855
Watercolor on paper, mounted on cloth
The New-York Historical Society x.370

PETER BONNETT WIGHT
105. *National Academy of Design, Fourth Avenue and Twenty-third Street,* 1861
Watercolor
The Art Institute of Chicago, Gift of Peter Bonnett Wight 1992.81.4

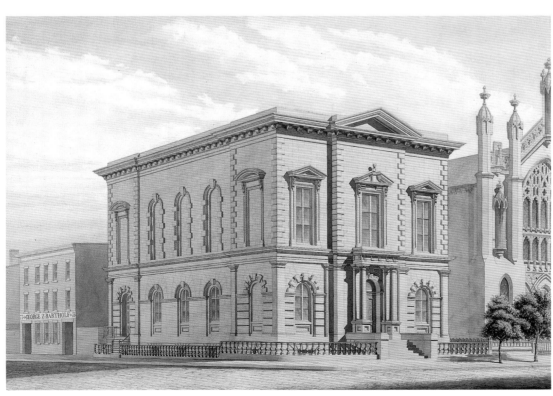

104

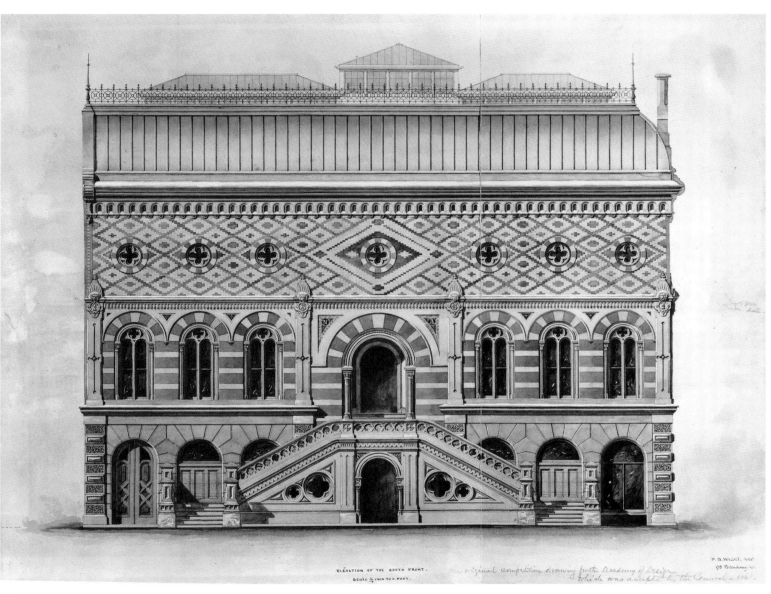

ELEVATION OF THE SOUTH FRONT.
Scale ⅛ inch to a foot.

P. B. WIGHT, Arch'
58 Broadway, N.Y.

105

JOHN WILLIAM
HILL
106. *View on the Erie Canal,*
1829
Watercolor
The New York Public
Library, Astor, Lenox
and Tilden Foundations,
Miriam and Ira D. Wallach
Division of Art, Prints
and Photographs, The
Phelps Stokes Collection,
Print Collection
1830–32E–29

JOHN WILLIAM
HILL
107. *View on the Erie Canal,*
1831
Watercolor
The New York Public
Library, Astor, Lenox
and Tilden Foundations,
Miriam and Ira D. Wallach
Division of Art, Prints
and Photographs, The
Phelps Stokes Collection,
Print Collection
1830–32E–24

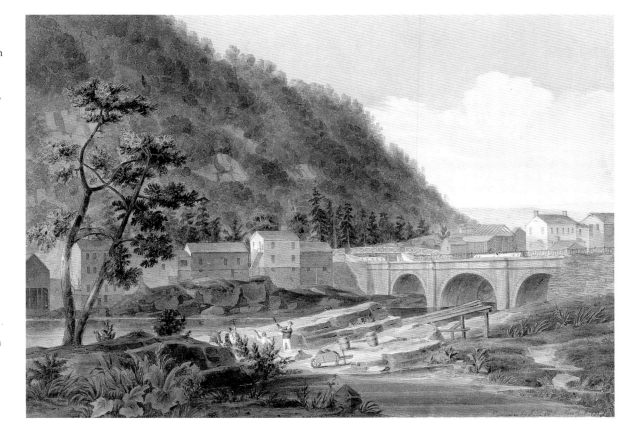

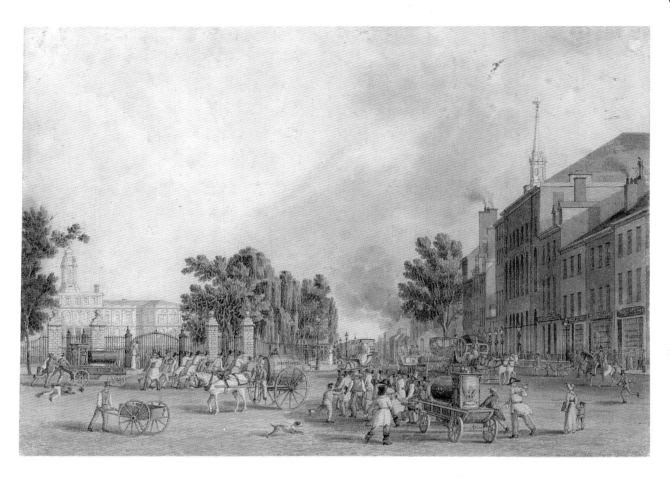

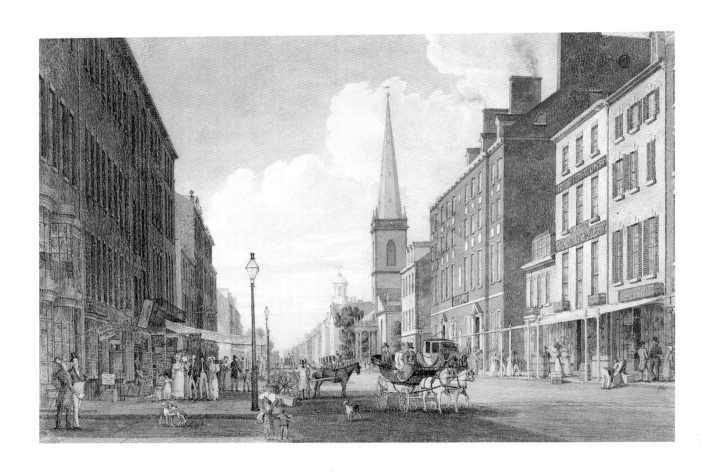

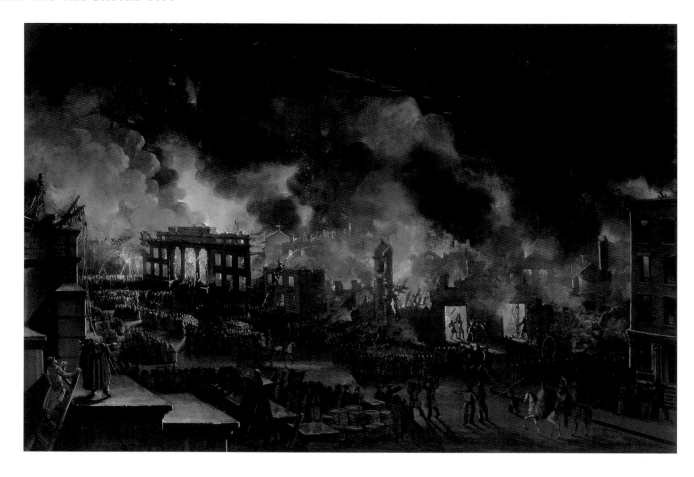

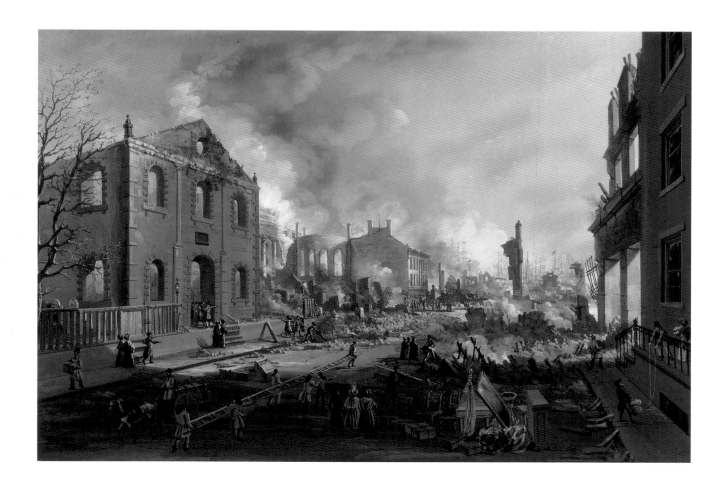

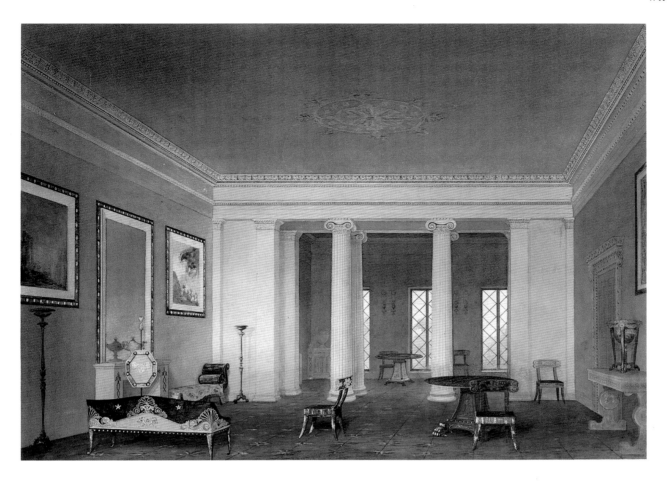

ALEXANDER JACKSON
DAVIS
112. *Greek Revival Double Parlor,*
ca. 1830
Watercolor
The New-York Historical Society,
Gift of Daniel Parish, Jr.
1908.28

JOHN WILLIAM HILL
113. *Chancel of Trinity Chapel,*
ca. 1856
Watercolor, gouache, black ink,
graphite, and gum arabic
The Metropolitan Museum of
Art, New York, The Edward
W. C. Arnold Collection of
New York Prints, Maps, and
Pictures, Bequest of Edward
W. C. Arnold, 1954 54.90.157

NICOLINO CALYO
110. *View of the Great Fire of New
York, December 16 and 17, 1835,
as Seen from the Top of the New
Building of the Bank of America,
Corner Wall and William Streets,*
1836
Gouache on paper, mounted
on canvas
The New-York Historical
Society, Bryan Fund 1980.53

NICOLINO CALYO
111. *View of the Ruins after the Great
Fire in New York, December 16
and 17, 1835, as Seen from Exchange
Place,* 1836
Gouache on paper, mounted
on canvas
The New-York Historical
Society, Bryan Fund 1980.54

JOHN HILL, *engraver*
After WILLIAM GUY WALL,
artist
HENRY J. MEGAREY,
publisher

114. *New York from Governors Island,*
1823–24, from *The Hudson River*
Portfolio (1821–25)
Aquatint with hand coloring
The Metropolitan Museum of
Art, New York, The Edward W.
C. Arnold Collection of New
York Prints, Maps, and Pictures,
Bequest of Edward W. C.
Arnold, 1954 54.90.1274.18

ASHER B. DURAND,
engraver
DURAND, PERKINS AND
COMPANY, *printer and publisher*

115. $1,000 bill for the Greenwich
Bank, City of New York, ca. 1828
Engraving, cancelled proof
The Metropolitan Museum of
Art, New York, Harris Brisbane
Dick Fund, 1917 17.3.3585 (14)

ASHER B. DURAND, *engraver*
DURAND, PERKINS AND
COMPANY, *printer and publisher*

116. Specimen sheet of bank note engraving,
ca. 1828
Engraving
The Metropolitan Museum of Art, New
York, Harris Brisbane Dick Fund, 1917
17.3.3585 (47)

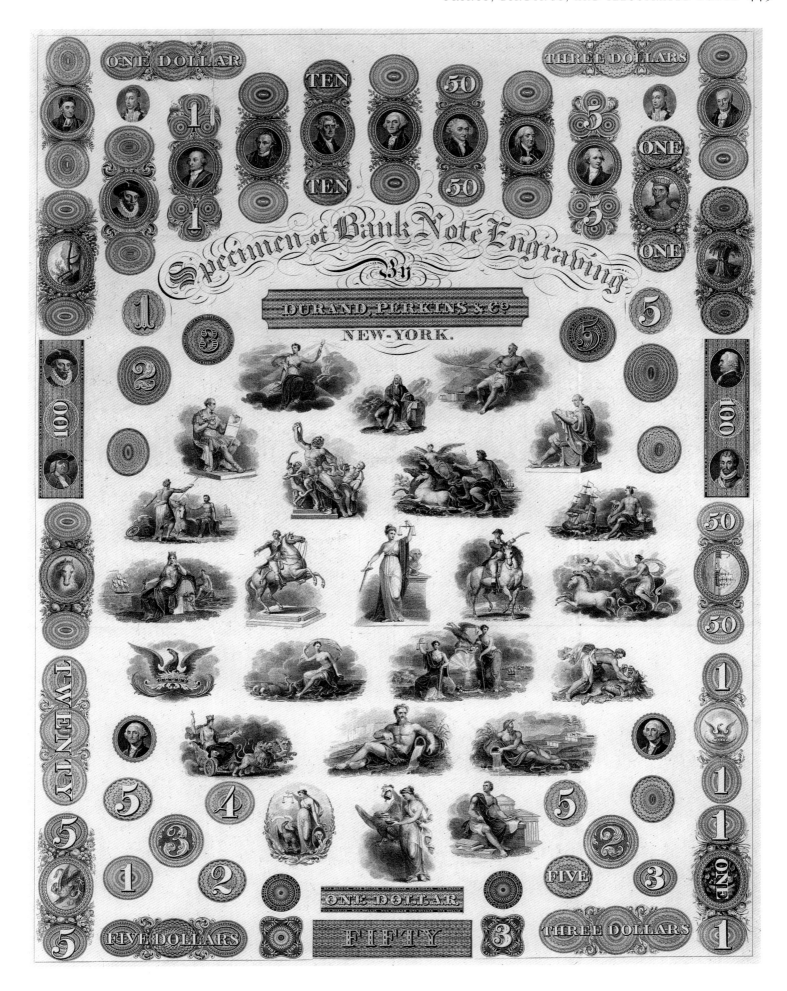

CADWALLADER COLDEN,
author
ARCHIBALD ROBERTSON,
artist
ANTHONY IMBERT, *printer*
WILSON AND NICHOLLS,
bookbinder

117. *Memoir, Prepared at the
Request of a Committee of the
Common Council of the City
of New York, and Presented to
the Mayor of the City, at the
Celebration of the Completion
of the New York Canals*, 1825
Bound in red leather with
gold stamping
American Antiquarian
Society, Worcester,
Massachusetts

ARCHIBALD ROBERTSON,
artist
ANTHONY IMBERT,
printer

118. *Grand Canal Celebration: View
of the Fleet Preparing to Form
in Line*, 1825, from Cadwallader
Colden, *Memoir* (1825)
Lithograph
The Metropolitan Museum
of Art, New York, Harris
Brisbane Dick Fund, 1923
23.69.23

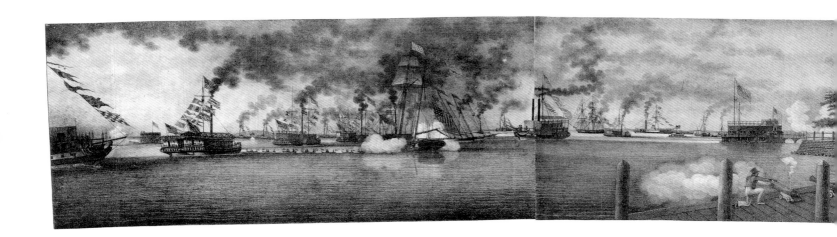

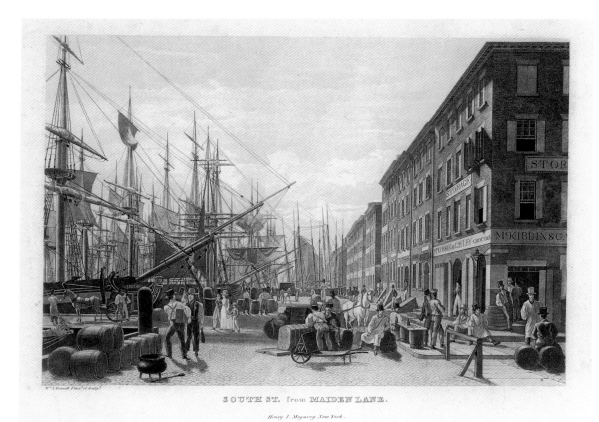

SOUTH ST. from MAIDEN LANE.

Henry I. Megarey New York.

WILLIAM JAMES BENNETT,
artist and engraver
HENRY J. MEGAREY,
publisher

119. *South Street from Maiden Lane,*
ca. 1828, from *Megarey's Street
Views in the City of New-York*
(1834)
Aquatint
The Metropolitan Museum of
Art, New York, The Edward
W. C. Arnold Collection of
New York Prints, Maps, and
Pictures, Bequest of Edward
W. C. Arnold, 1954 54.90.1177

WILLIAM JAMES BENNETT,
artist and engraver
HENRY J. MEGAREY,
publisher

120. *Fulton Street and Market,*
1828–30, from *Megarey's Street
Views in the City of New-York*
(1834)
Aquatint
The Metropolitan Museum of
Art, New York, Bequest of
Charles Allen Munn, 1924
24.90.1276

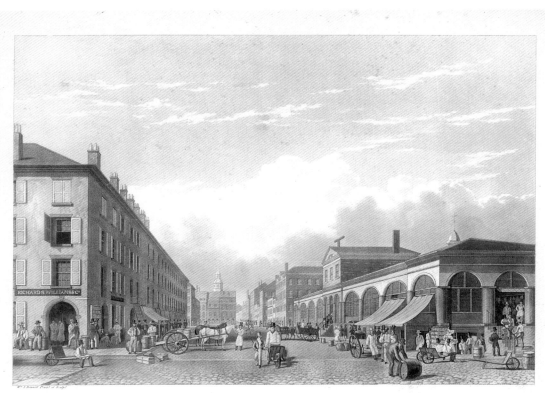

FULTON ST. & MARKET.

Henry I. Megarey New York

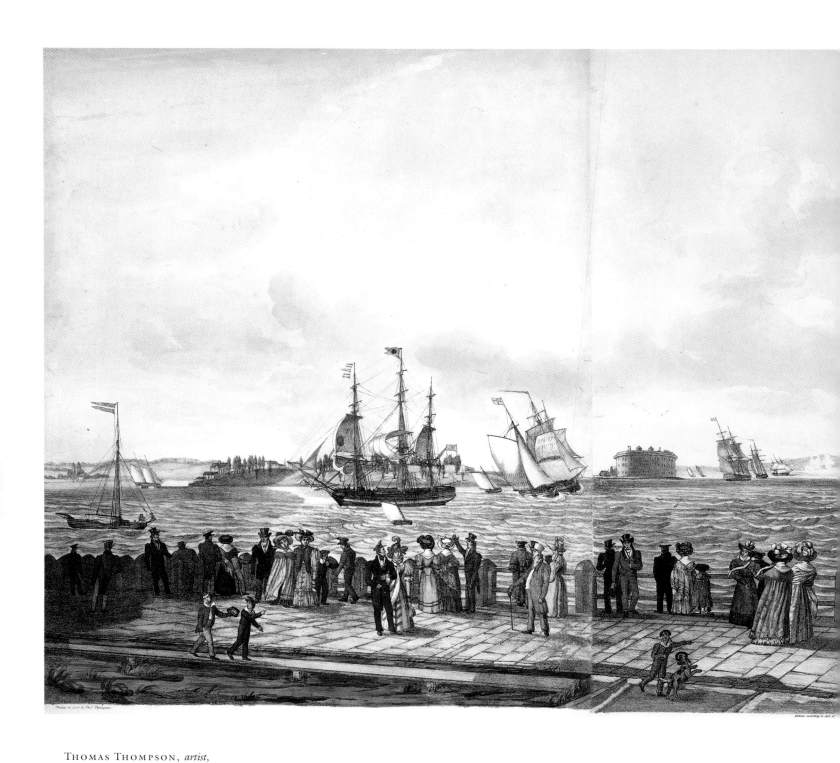

THOMAS THOMPSON, *artist,
lithographer, and publisher*
121. *New York Harbor from the Battery,*
1829
Lithograph with hand coloring
The Metropolitan Museum of
Art, New York, The Edward W. C.
Arnold Collection of New York
Prints, Maps, and Pictures, Bequest
of Edward W. C. Arnold, 1954
54.90.1182 (1–3)

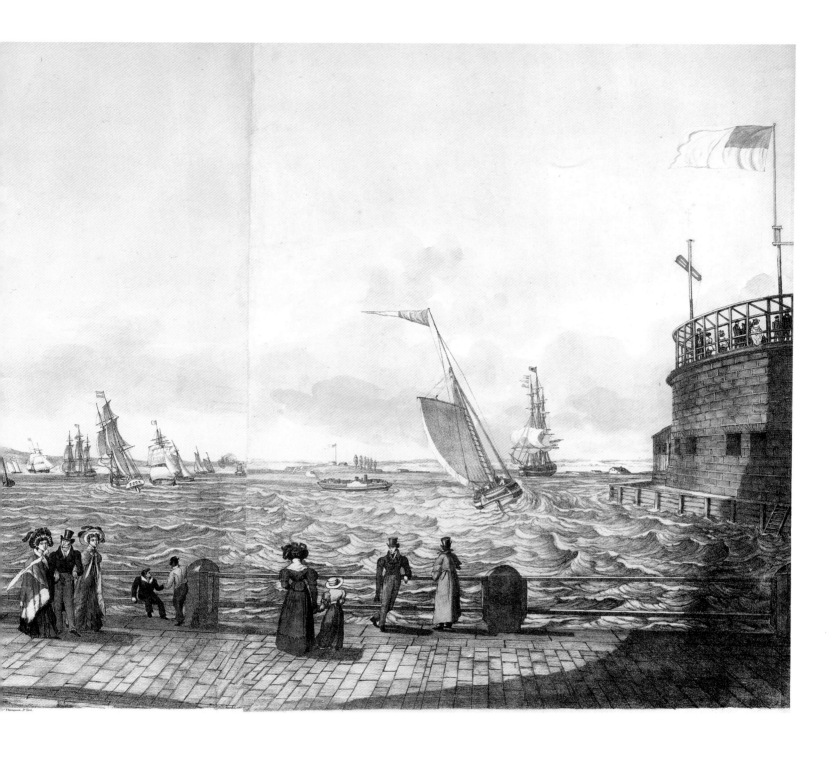

JAMES BARTON LONGACRE
and JAMES HERRING,
publishers

122A. *National Portrait Gallery of*
Distinguished Americans
(1833–39), vol. 3 (1836)
Bound in red leather with gold
stamping
The Metropolitan Museum of
Art, New York, Bequest of
Charles Allen Munn, 1924
24.90.1911

ASHER B. DURAND,
engraver
After CHARLES CROMWELL
INGHAM, *artist*

122B. *De Witt Clinton*, 1834, from
National Portrait Gallery of
Distinguished Americans, vol. 2
(1835)
Engraving
The Metropolitan Museum of
Art, New York, Gift of John K.
Howat, 1998 1998.520.2

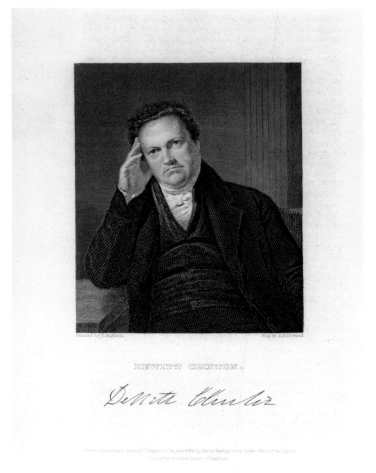

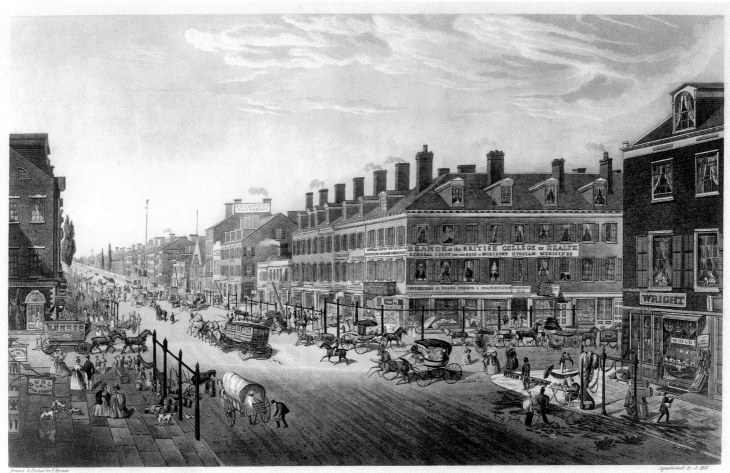

BROADWAY, NEW-YORK.
Shewing each Building from the Hygeian Depot, corner of Canal Street to beyond Niblo's Garden.
Published by JOSEPH STANLEY & Cᵒ.
Entered according to act of Congress by Jos.ʰ Stanley & Cᵒ. in the Clerks office of the Southern District of New York.
January 16ᵗʰ 1836.

JOHN HILL, *engraver*
After THOMAS HORNOR, *artist*
W. NEALE, *printer*
JOSEPH STANLEY AND
COMPANY, *publisher*

123. *Broadway, New York, Showing Each
Building from the Hygeian Depot
Corner of Canal Street to beyond Niblo's
Garden,* 1836
Aquatint and etching with hand
coloring
The Metropolitan Museum of Art,
New York, The Edward W. C. Arnold
Collection of New York Prints, Maps,
and Pictures, Bequest of Edward
W. C. Arnold, 1954 54.90.703

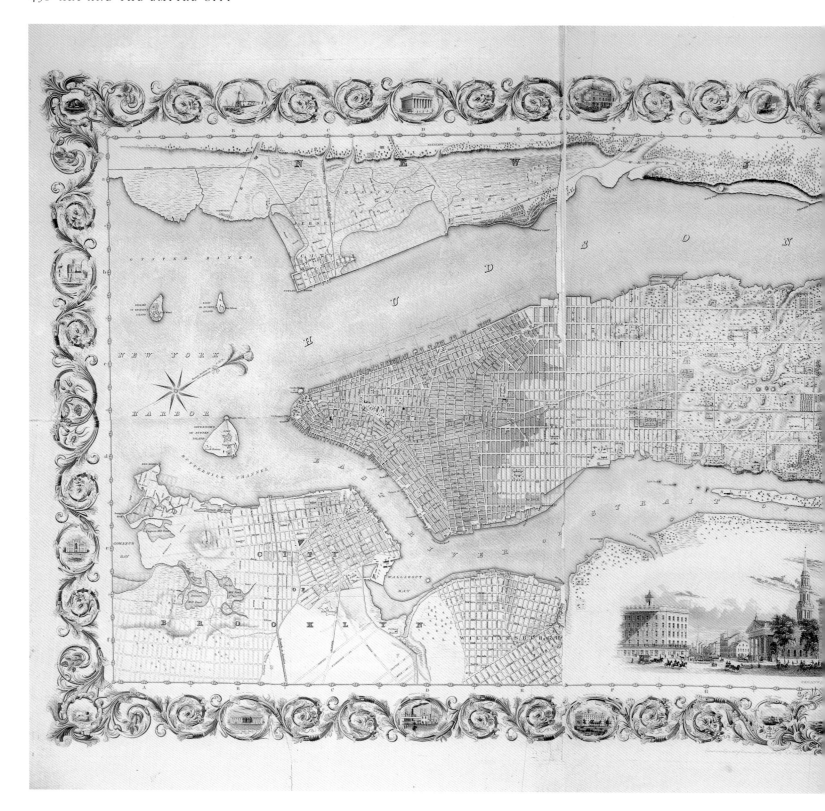

DAVID H. BURR, *cartographer*
J. H. COLTON, *publisher*
S. STILES AND COMPANY, *printer*

124. *Topographical Map of the City and County of New York
and the Adjacent Country: with Views in the Border of the
Principal Buildings, and Interesting Scenery of the Island,*
1836
Engraving, first state
Library of Congress, Washington, D.C., Geography
and Map Division

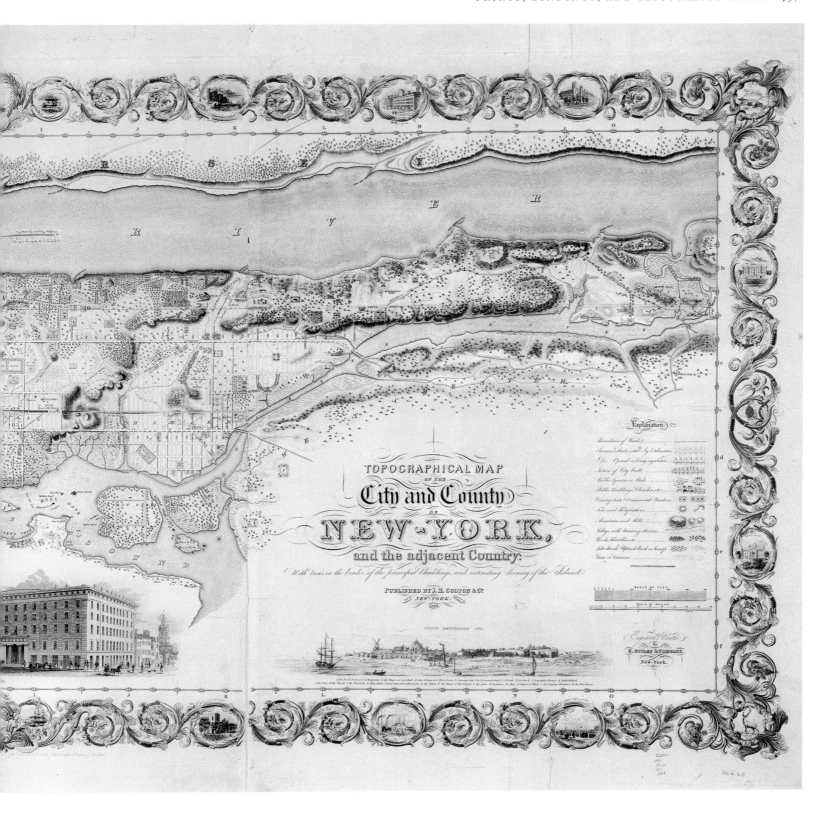

ASHER B. DURAND,
engraver and publisher
After JOHN VANDERLYN,
artist
A. KING, *printer*
125. *Ariadne,* 1835
Engraving, third state, proof
before letters; printed on
chine collé
Museum of Fine Arts,
Boston, Harvey D. Parker
Collection, 1897 P12793

HENRY HEIDEMANS,
lithographer
After HENRY INMAN,
artist
ENDICOTT AND COMPANY,
printer and publisher
126. *Fanny Elssler,* 1841
Lithograph
Library of Congress,
Washington, D.C., Prints
and Photographs Division

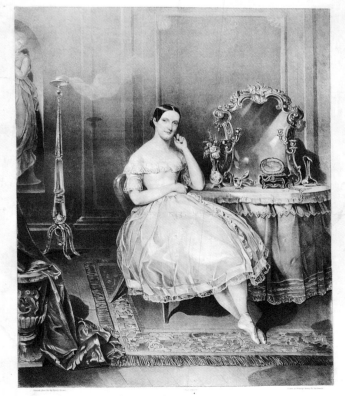

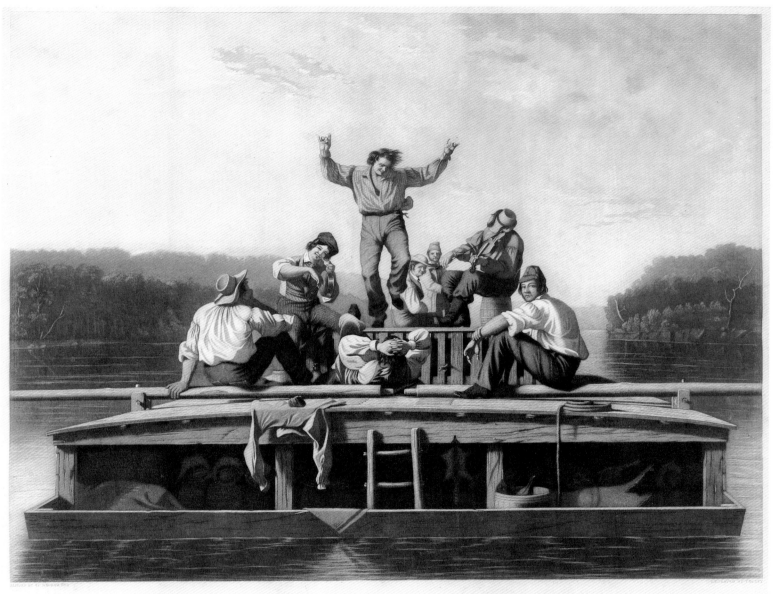

THOMAS DONEY, *engraver*
After GEORGE CALEB
BINGHAM, *artist*
AMERICAN ART-UNION,
publisher
POWELL AND COMPANY,
printer
127. *The Jolly Flat Boat Men,* 1847
Mezzotint
The Metropolitan Museum of
Art, New York, Gertrude and
Thomas Jefferson Mumford
Collection, Gift of Dorothy
Quick Mayer, 1942 42.119.68

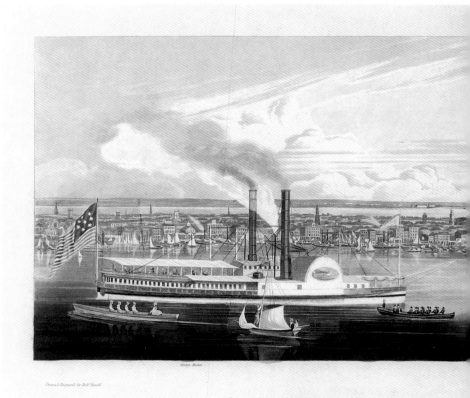

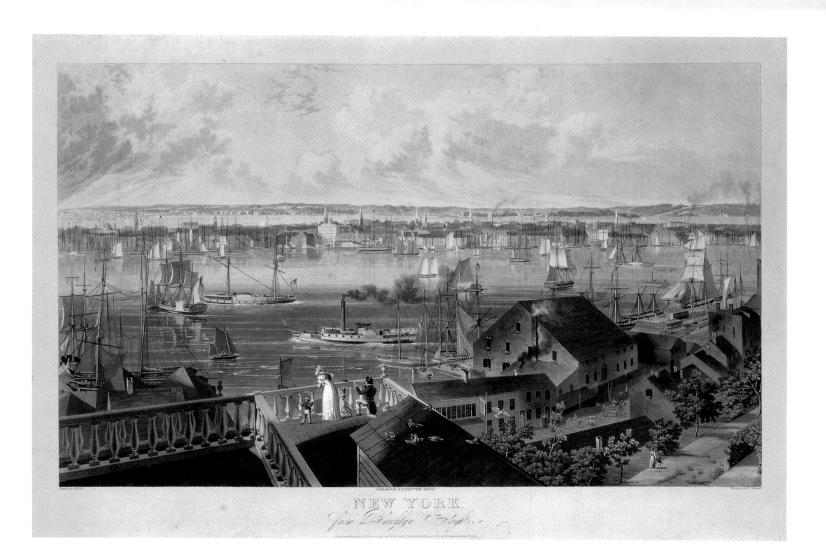

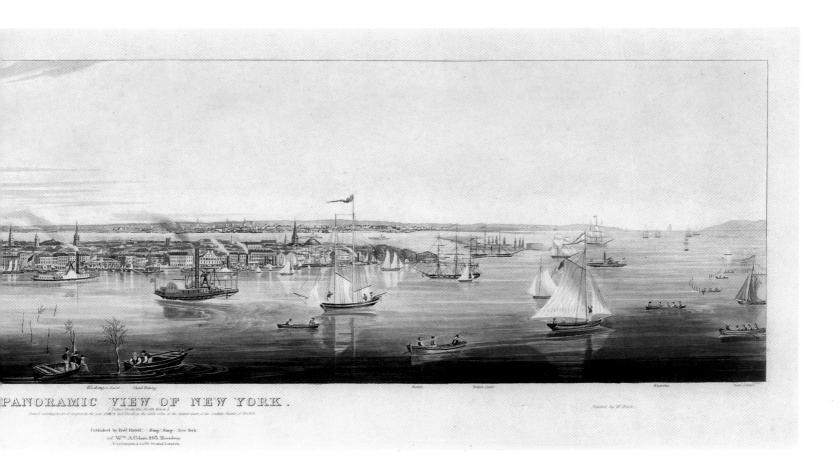

PANORAMIC VIEW OF NEW YORK.

ROBERT HAVELL JR.,
artist and engraver
W. NEALE, *printer*
ROBERT HAVELL JR.,
WILLIAM A. COLMAN,
and ACKERMANN AND
COMPANY, *publishers*

129. *Panoramic View of New York
(Taken from the North River),*
1844
Aquatint with hand coloring,
fifth state
The Metropolitan Museum of
Art, New York, The Edward
W. C. Arnold Collection of
New York Prints, Maps, and
Pictures, Bequest of Edward
W. C. Arnold, 1954 54.90.623

WILLIAM JAMES
BENNETT, *engraver*
After JOHN WILLIAM
HILL, *artist*
LEWIS P. CLOVER,
publisher

128. *New York, from Brooklyn
Heights,* ca. 1836
Aquatint printed in colors
with hand coloring, first state
Collection of Leonard L.
Milberg

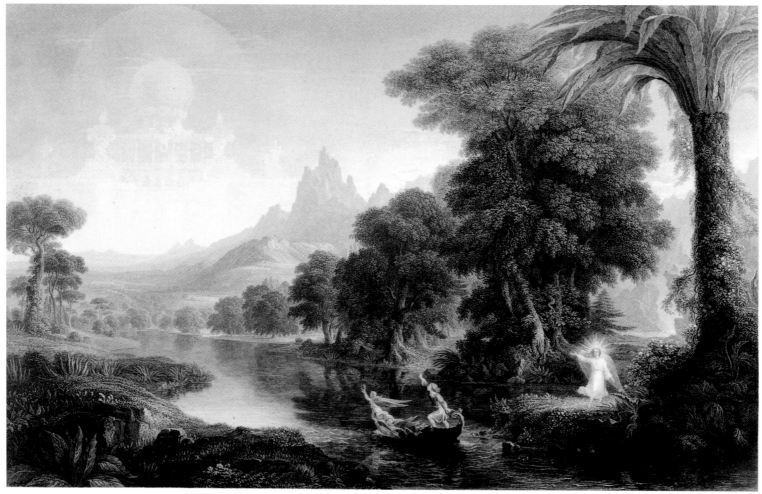

130

131

CHAPTER VII.

'God has diffused beauty—and art
has combined it.'—HOUSSAYE

A STUDY
AND
A SKETCH
are too commonly considered
identical in meaning. A *Sketch*
is but a graphic memorandum—an expedient; a *Study*, the more faithful record of well-digested
investigation. However well a sketch may serve to retain a transitory impression, and, to some

22

132

JAMES SMILLIE, *engraver*
After THOMAS COLE, *artist*

130. *The Voyage of Life: Youth,* 1849
Engraving, proof before letters
Museum of Fine Arts, Boston,
Harvey D. Parker Collection
P12796

GEORGE LORING BROWN

131. *Cascades at Tivoli,* 1854
Etching
Museum of Fine Arts, Boston,
Harvey D. Parker Collection
P12262

ASHER B. DURAND, *artist*
JOHN GADSBY CHAPMAN,
author
W. J. WIDDLETON, *publisher*

132. *A Study and a Sketch,* from
The American Drawing-Book
(1st ed., 1847)
Reproduction of wood engrav-
ing from 3d edition, 1864
The Metropolitan Museum of
Art, New York, Harris Brisbane
Dick Fund, 1954 54.524.2

WASHINGTON IRVING,
author
FELIX OCTAVIUS CARR
DARLEY, *artist and lithographer*
SARONY AND MAJOR,
printer

133. Plate 5, *Illustrations of "Rip van
Winkle,"* 1848
Lithograph
The Metropolitan Museum of
Art, New York, Gift of Mrs.
Frederic F. Durand, 1933
33.39.123

WASHINGTON IRVING,
author
FELIX OCTAVIUS CARR
DARLEY, *artist and lithographer*
SARONY AND MAJOR,
printer

134. Plate 6, *Illustrations of "The
Legend of Sleepy Hollow,"* 1849
Lithograph
The Metropolitan Museum of
Art, New York, Rogers Fund,
transferred from the Library,
1944 44.40.2

133

134

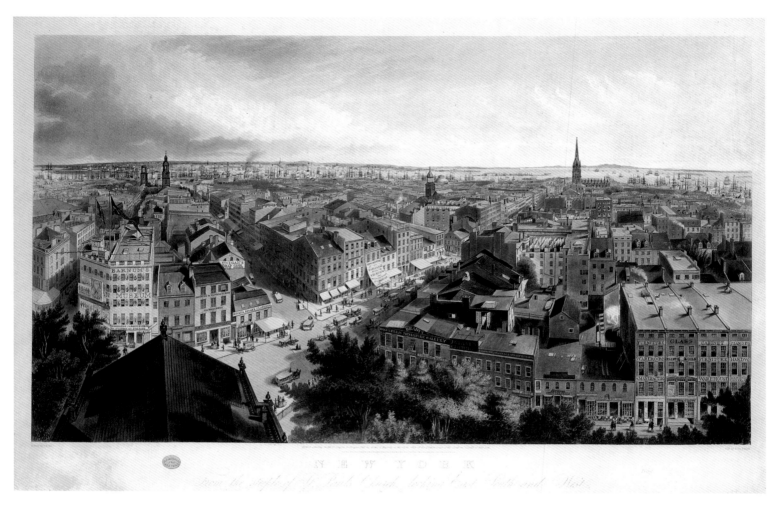

HENRY PAPPRILL,
engraver
After JOHN WILLIAM
HILL, *artist*
HENRY J. MEGAREY,
publisher

135. *New York from the Steeple of
Saint Paul's Church, Looking
East, South, and West,* ca. 1848
Aquatint printed in colors
with hand coloring, second
state
The Metropolitan Museum
of Art, New York, The
Edward W. C. Arnold
Collection of New York
Prints, Maps, and Pictures,
Bequest of Edward W. C.
Arnold, 1954 54.90.587

JOHN F. HARRISON, *cartographer*
KOLLNER, CAMP AND
COMPANY, *Philadelphia, printer*
MATTHEW DRIPPS, *publisher*

136. *Map of the City of New York,
Extending Northward to Fiftieth
Street,* 1851
Lithograph with hand coloring
Collection of Mark D. Tomasko

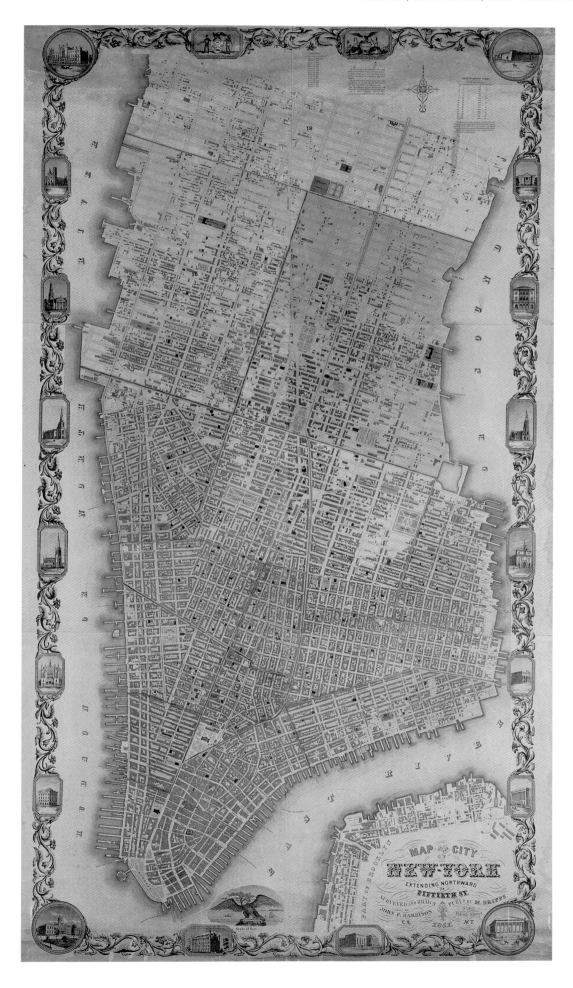

137

138

139

140

WASHINGTON IRVING, *under the pseudonym* DIEDRICH KNICKERBOCKER, *author*
GEORGE P. PUTNAM, *publisher*

137. *A History of New-York from the Beginning of the World to the End of the Dutch Dynasty* (1st ed., 1809), 1850 edition
Bound in blue morocco leather with gold stamping and rose-and-gold inset
American Antiquarian Society, Worcester, Massachusetts, Papantonio Collection

ALFRED ASHLEY, *artist and designer*
W. H. SWEPSTONE, *author*
STRINGER AND TOWNSEND, *publisher*

138. *Christmas Shadows, a Tale of the Poor Needle Woman with Numerous Illustrations on Steel,* New York and London, 1850
Bound in blue cloth with gold stamping
Collection of Jock Elliott

EDWARD WALKER AND SONS, *bookbinder*

139. *The Odd-Fellows Offering,* 1851
Bound in red cloth with gold stamping
American Antiquarian Society, Worcester, Massachusetts, Kenneth G. Leach Collection

SAMUEL HUESTON, *publisher*

140. *The Knickerbocker Gallery,* 1855
Bound in red leather with gold stamped inset
American Antiquarian Society, Worcester, Massachusetts, Papantonio Collection B, Copy 3

JOHN BACHMANN, *artist, printer, and publisher*

141. *Bird's-Eye View of the New York Crystal Palace and Environs,* 1853
Lithograph printed in colors with hand coloring
Museum of the City of New York, The J. Clarence Davies Collection
29.100.2387

CHARLES PARSONS, *artist and lithographer*
ENDICOTT AND COMPANY, *printer*
GEORGE S. APPLETON, *publisher*

142. *An Interior View of the Crystal Palace,* 1853
Lithograph printed in colors
The Metropolitan Museum of Art, New York, The Edward W. C. Arnold Collection of New York Prints, Maps, and Pictures, Bequest of Edward W. C. Arnold, 1954 54.90.1047

BIRDS EYE VIEW OF THE
NEW YORK CRYSTAL PALACE.
and Environs.

141

AN INTERIOR VIEW OF THE CRYSTAL PALACE.
New York, Published by Geo. S. Appleton, 346 Broadway N.Y.

142

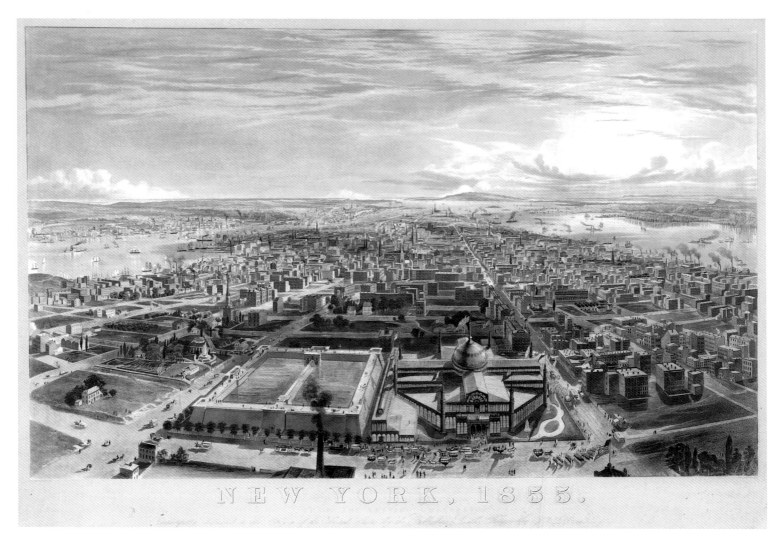

WILLIAM WELLSTOOD, *engraver*
After BENJAMIN F. SMITH JR., *artist*
SMITH, FERN AND COMPANY,
publisher

143. *New York, 1855, from the Latting Observatory,*
1855
Engraving with hand coloring
The New York Public Library, Astor, Lenox
and Tilden Foundations, Miriam and Ira
D. Wallach Division of Art, Prints and
Photographs, The Phelps Stokes Collection,
Print Collection 1855–E–138

THOMAS BENECKE, *artist*
NAGEL AND LEWIS, *printer*
EMIL SEITZ, *publisher*

144. *Sleighing in New York,* 1855
Lithograph printed in colors with hand
coloring
The Metropolitan Museum of Art,
New York, The Edward W. C. Arnold
Collection of New York Prints, Maps,
and Pictures, Bequest of Edward
W. C. Arnold, 1954 54.90.1061

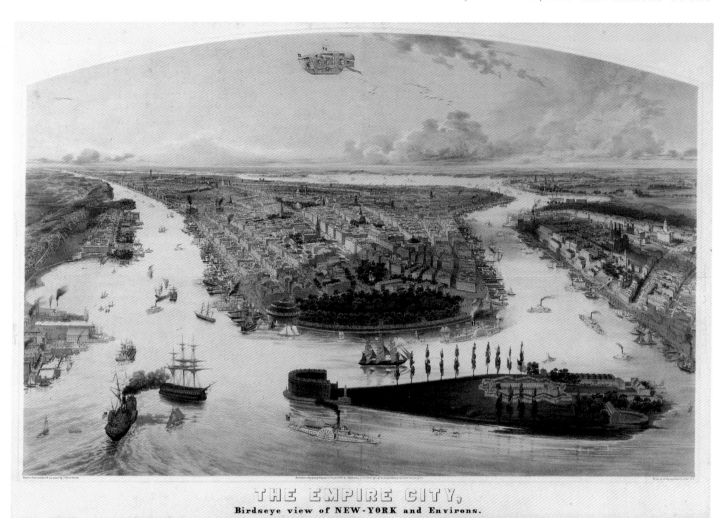

THE EMPIRE CITY,
Birdseye view of NEW-YORK and Environs.

JOHN BACHMANN, *artist*
ADAM WEINGARTNER, *printer*
L. W. SCHMIDT, *publisher*

145. *The Empire City,* 1855
Lithograph printed in colors with
hand coloring
The Metropolitan Museum of Art,
New York, The Edward W. C. Arnold
Collection of New York Prints, Maps,
and Pictures, Bequest of Edward
W. C. Arnold, 1954 54.90.1198

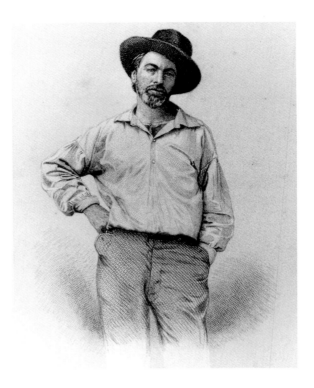

WALT WHITMAN, *author*
146. *Leaves of Grass*, Brooklyn, New York, 1855
Bound in dark green cloth with title stamped in gold

SAMUEL HOLLYER, *engraver*
After a daguerreotype by GABRIEL HARRISON
Walt Whitman, 1855, from *Leaves of Grass* (1855)
Engraving

Columbia University New York, Rare Book and Manuscript Library, Solton and Julia Engel Collection

JOHN GADSBY CHAPMAN
147. *Italian Goatherd*, 1857
Etching
Museum of Fine Arts, Boston, Gift of Sylvester Rosa Koehler
K858

JEAN-BAPTISTE-ADOLPHE LAFOSSE, *lithographer*
After WILLIAM SIDNEY MOUNT, *artist*
FRANÇOIS DELARUE, *printer*
WILLIAM SCHAUS, *publisher*
148. *The Bone Player*, 1857
Lithograph with hand coloring
The Metropolitan Museum of Art, New York, Purchase, Leonard L. Milberg Gift, 1998
1998.416

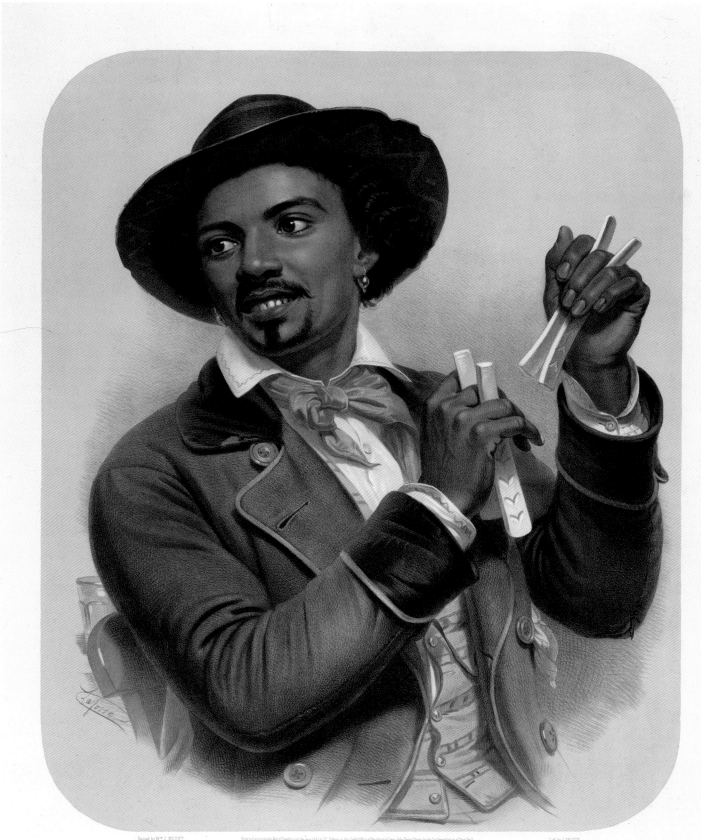

Painted by W^m S. MOUNT Entered according to Act of Congress in the year 1856 by W. Schaus, in the Clerk's Office of the District Court of the United States for the Southern district of New York Lith by LAFOSSE

The Bone Player.

New York, pub^d by W. SCHAUS, 629 Broadway Imp. Lemercier, Paris

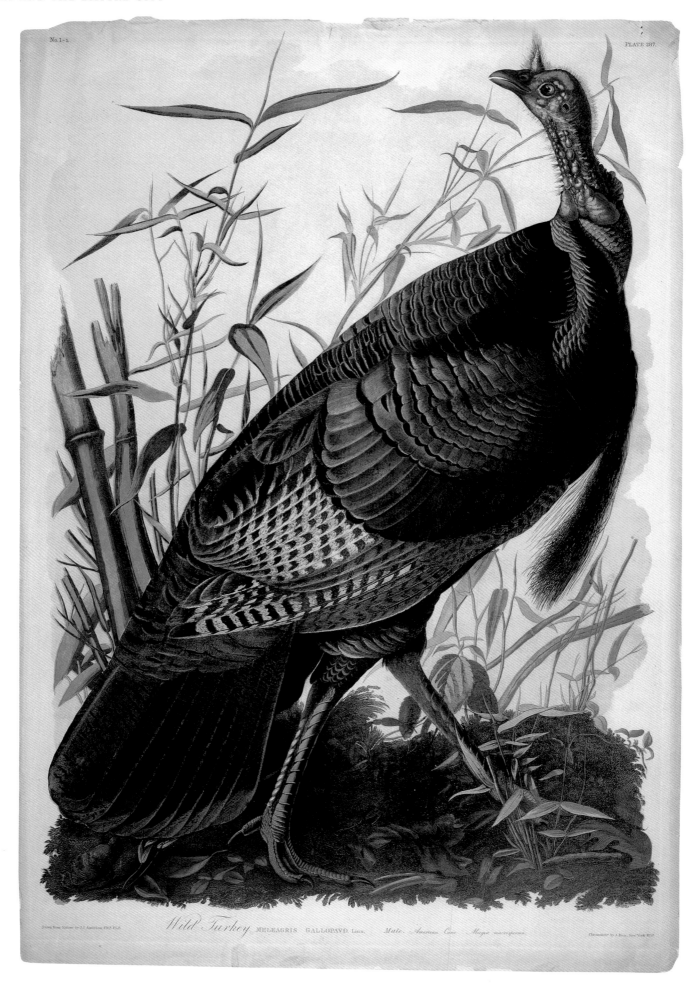

No. 1-1. PLATE 287.

Wild Turkey. MELEAGRIS GALLOPAVO, Linn. Male. American Cane. Miegia macrosperma.

JOHN BACHMANN, *artist,
lithographer, and publisher*
C. FATZER, *printer*
150. *New York City and Environs,* 1859
Lithograph printed in colors
Museum of the City of New
York, Gift of James Duane
Taylor, 1931 31.24

JULIUS BIEN, *lithographer*
After JOHN JAMES AUDUBON,
artist, and ROBERT HAVELL
JR., *engraver*
149. *Wild Turkey,* 1858
Lithograph printed in colors
Brooklyn Museum of Art x633.3

DeWitt Clinton
Hitchcock, *artist*
Hy. J. Crate, *printer*

151. *Central Park, Looking South
from the Observatory,* 1859
Lithograph printed in
colors with hand coloring
Museum of the City of
New York, The J. Clarence
Davies Collection
29.100.2299

Arthur Lumley,
artist
W. R. C. Clark and
Meeker, *publisher*

152. *The Empire City, New York,
Presented to the Subscribers
to "The History of the City
of New York,"* 1859
Wood engraving and
lithograph printed in
colors
The New-York Historical
Society

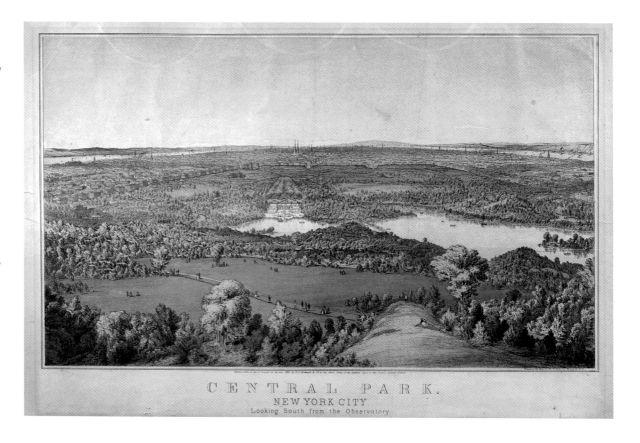

CENTRAL PARK.
NEW YORK CITY.
Looking South from the Observatory.

PRESENTED TO THE SUBSCRIBERS TO THE HISTORY OF THE CITY OF NEW-YORK.
BY THE PUBLISHERS, W. R. C. CLARK & MEEKER, 49 WALKER STREET, NEW-YORK.

CHARLES PARSONS,
artist
CURRIER AND IVES,
printer and publisher

153. *Central Park, Winter: The Skating Pond,* ca. 1861
Lithograph with hand coloring
The Metropolitan Museum of Art, New York, Bequest of Adele S. Colgate, 1962
63.550.266

REMBRANDT VAN
RIJN, *artist*

154. *Saint Jerome Reading in a Landscape,* ca. 1654
Etching, drypoint, and engraving, second state
Museum of Fine Arts, Boston, Harvey D. Parker Collection P496

CARLO LOSSI, *engraver*
After TIZIANO VECELLI (TITIAN), *artist*

155. *Bacchus and Ariadne,* 1774
Etching and engraving
The New-York Historical Society 1858.92.043

WILLIAM SHARP, *engraver*
After BENJAMIN WEST, *artist*
JOHN AND JOSIAH BOYDELL, *London, publisher*

156. *Act 3, Scene 4, from William Shakespeare's "King Lear,"* 1793
Engraving
The Metropolitan Museum of Art, New York, Gift of Georgiana W. Sargent, in memory of John Osborne Sargent, 1924 24.63.1869

JOHN BURNET, *engraver*
After DAVID WILKIE, *artist*
JOSIAH BOYDELL, *London, publisher*

157. *The Blind Fiddler,* 1811
Engraving
The New York Public Library, Astor, Lenox and Tilden Foundations, Miriam and Ira D. Wallach Division of Art, Prints and Photographs, Print Collection

154

155

SHAKSPEARE.
King Lear.
ACT III. SCENE IV.

156

157

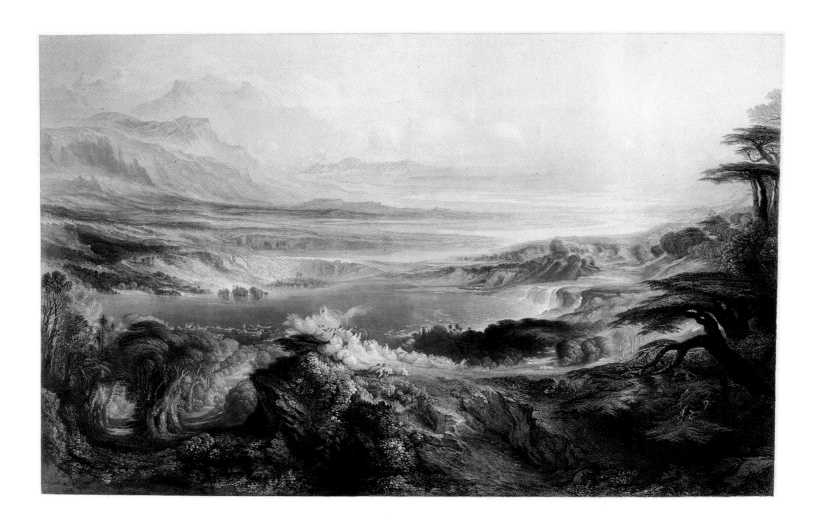

CHARLES MOTTRAM,
engraver
After JOHN MARTIN, *artist*
WILLIAMS, STEVENS
AND WILLIAMS, *publisher*

159. *The Plains of Heaven*, 1855
Mezzotint, proof before letters
The New York Public Library,
Astor, Lenox and Tilden
Foundations, Miriam and
Ira D. Wallach Division of
Art, Prints and Photographs,
Print Collection

ALPHONSE FRANÇOIS,
engraver
After PAUL DELAROCHE,
artist

158. *Napoleon Crossing the Alps*,
1852
Engraving, proof
The Metropolitan Museum
of Art, New York, The
Elisha Whittelsey Collection,
The Elisha Whittelsey
Fund, 1949 49.40.177

Samuel F. B. Morse
160. *Young Man*, 1840
 Daguerreotype
 Gilman Paper Company Collection,
 New York

MATHEW B. BRADY
161. *Thomas Cole,* 1844–48
Daguerreotype
National Portrait Gallery, Smithsonian
Institution, Washington, D.C., Gift of
Edith Cole Silberstein NPG.76.11

ARTIST UNKNOWN
162. *Asher B. Durand,* ca. 1854
Daguerreotype
The New-York Historical Society
PR–012–2–80

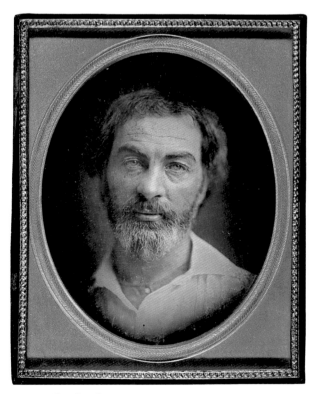

Attributed to GABRIEL
HARRISON
163. *Walt Whitman,* ca. 1854
Daguerreotype
The New York Public Library,
Astor, Lenox and Tilden
Foundations, Rare Books Division

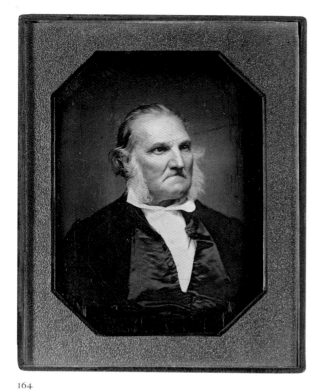

164

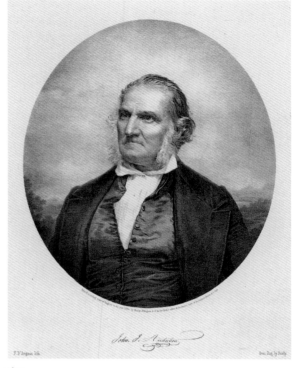

165A

165B

MATHEW B. BRADY
164. *John James Audubon,* 1847–48
Daguerreotype
Cincinnati Art Museum, Centennial Gift of
Mr. and Mrs. Frank Shaffer, Jr. 1981.144,
1982.268

FRANCIS D'AVIGNON, *lithographer*
After a daguerreotype by MATHEW B.
BRADY
165A. *John James Audubon,* 1850, from *The Gallery of
Illustrious Americans* (1850)
Lithograph
The Metropolitan Museum of Art, New York,
Bequest of Charles Allen Munn, 1924 24.90.576

C. EDWARDS LESTER, *editor*
FRANCIS D'AVIGNON, *lithographer*
MATHEW B. BRADY, *daguerreotypist*
BRADY, D'AVIGNON AND COMPANY,
publisher
165B. *The Gallery of Illustrious Americans,* 1850
Bound in blue cloth with gold stamping
The Metropolitan Museum of Art, New York,
Bequest of Charles Allen Munn, 1924
24.90.1966

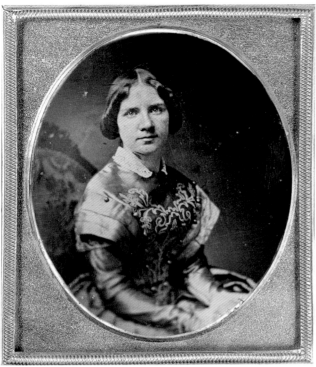

166

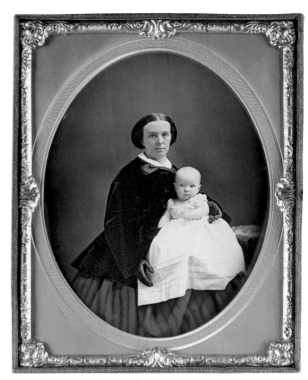

167

MATHEW B. BRADY
166. *Jenny Lind,* 1852
Daguerreotype
Chrysler Museum of Art, Norfolk,
Virginia, Museum Purchase and gift of
Kathryn K. Porter and Charles and
Judy Hudson 89.75

JEREMIAH GURNEY
167. *Mrs. Edward Cooper and Son Peter
(Pierre) Who Died,* 1858–60
Daguerreotype
The New-York Historical Society
PR–012–2–811

Attributed to SAMUEL ROOT *or*
MARCUS AURELIUS ROOT
168. *P. T. Barnum and Charles Stratton
("Tom Thumb"),* 1843–50
Daguerreotype
National Portrait Gallery, Smithsonian
Institution, Washington, D.C.
NPG.93.254

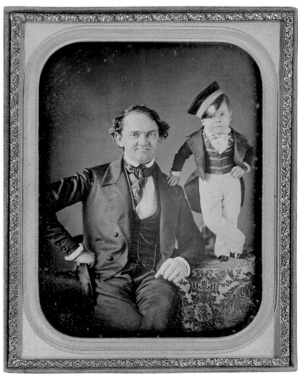

168

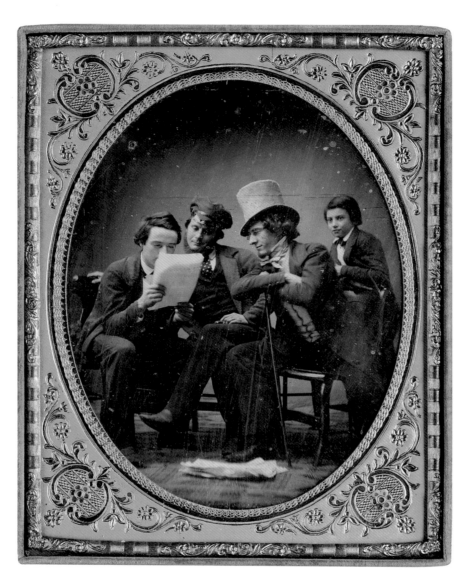

GABRIEL HARRISON
169. *California News*, 1850–51
Daguerreotype
Gilman Paper Company
Collection, New York

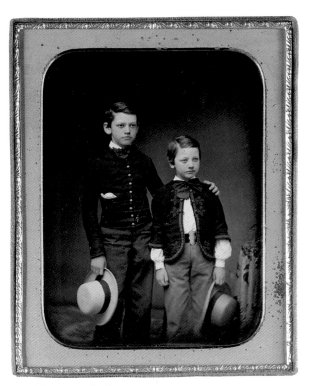

MATHEW B. BRADY
170. *The Hurlbutt Boys,* ca. 1850
Daguerreotype
The New-York Historical Society

MATHEW B. BRADY
171. *Young Boy,* 1850–54
Daguerreotype
Hallmark Photographic Collection,
Hallmark Cards, Inc., Kansas City,
Missouri P5.428.013.98

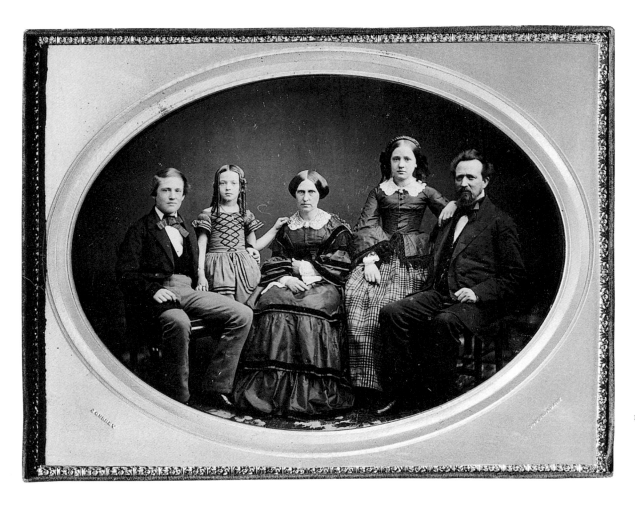

JEREMIAH GURNEY
172. *The Kellogg-Comstock*
Family, 1852–58
Daguerreotype
The New-York
Historical Society

ARTIST UNKNOWN

173. *Brooklyn Grocery Boy with Parcel,* 1850s
Daguerreotype
Hallmark Photographic
Collection, Hallmark Cards,
Inc., Kansas City, Missouri
P5.400.053.96

JEREMIAH GURNEY

174. *Young Girl,* 1858–60
Daguerreotype
Hallmark Photographic
Collection, Hallmark Cards,
Inc., Kansas City, Missouri
P5.424.005.97

ARTIST UNKNOWN

175. *Blind Man and His Reader Holding the
"New York Herald,"* 1840s
Daguerreotype
Gilman Paper Company Collection, New York

JEREMIAH GURNEY

176. *A Fireman with His Horn,* ca. 1857
Daguerreotype
Collection of Matthew R. Isenburg

Attributed to CHARLES
DEFOREST FREDRICKS
177. *Amos Leeds, Confidence
Operator,* ca. 1860
Salted paper print from glass
negative
Hallmark Photographic
Collection, Hallmark Cards,
Inc., Kansas City, Missouri
P5.390.003.97

ARTIST UNKNOWN
178. *Chatham Square, New York,*
1853–55
Daguerreotype
Gilman Paper Company
Collection, New York

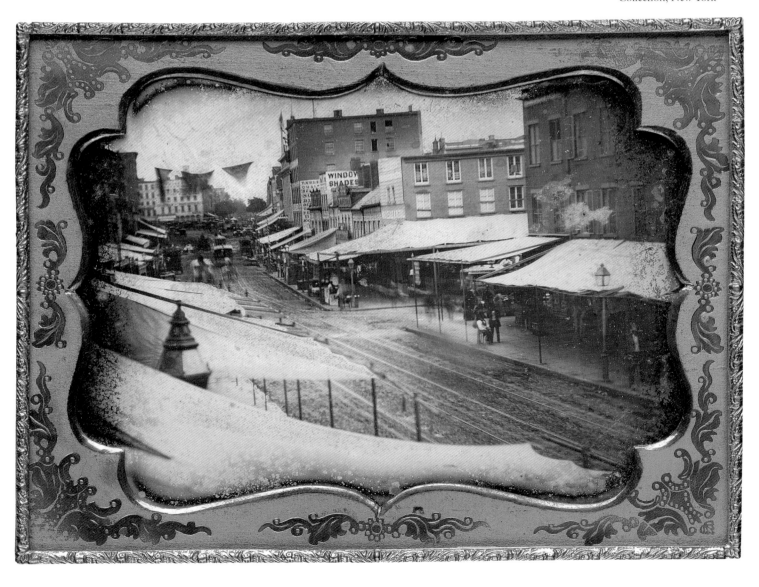

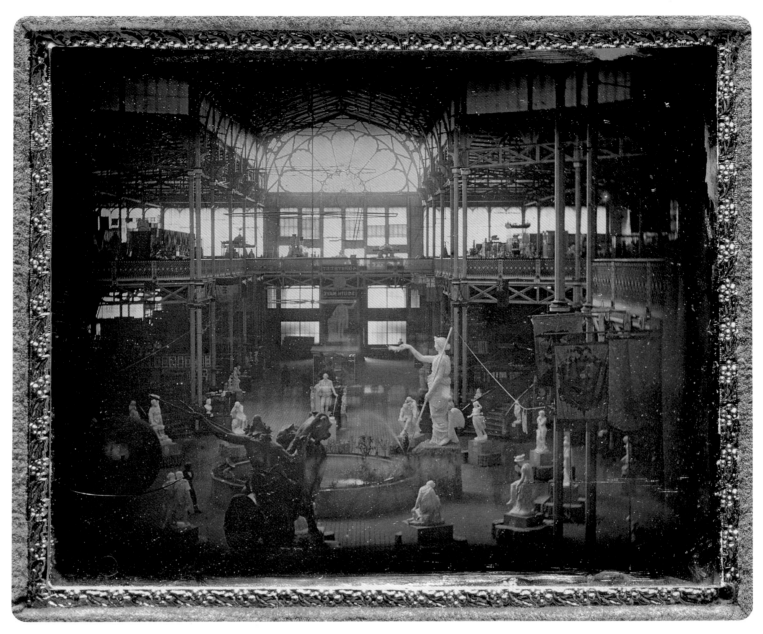

ARTIST UNKNOWN

179. *Interior View of the Crystal Palace Exhibition*, 1853–54
Daguerreotype
The New-York Historical Society

ARTIST UNKNOWN

180. *The New Paving on Broadway, between Franklin and Leonard Streets*, 1850–52
Stereo daguerreotype (left panel illustrated)
Collection of Matthew R. Isenburg

WILLIAM *and* FREDERICK LANGENHEIM

181. *New York City and Vicinity, View from Peter Cooper's Institute toward Astor Place*, ca. 1856
Stereograph glass positive
The New York Public Library, Astor, Lenox and Tilden Foundations, Miriam and Ira D. Wallach Division of Art, Prints and Photographs, Robert N. Dennis Collection of Stereoscopic Views

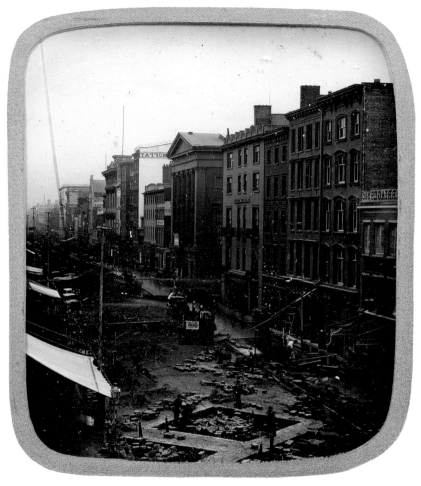

180

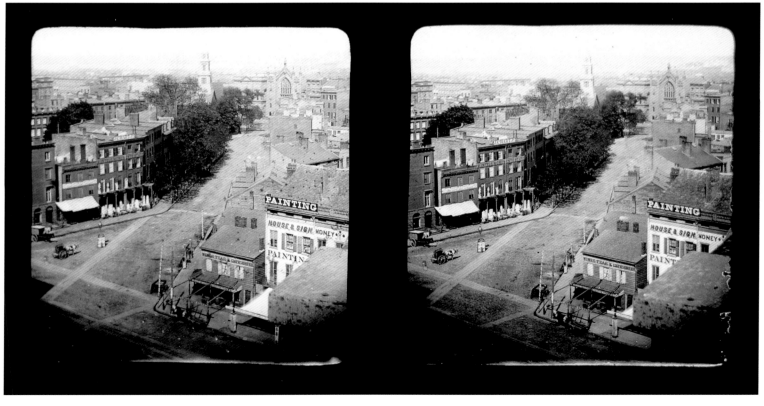

181

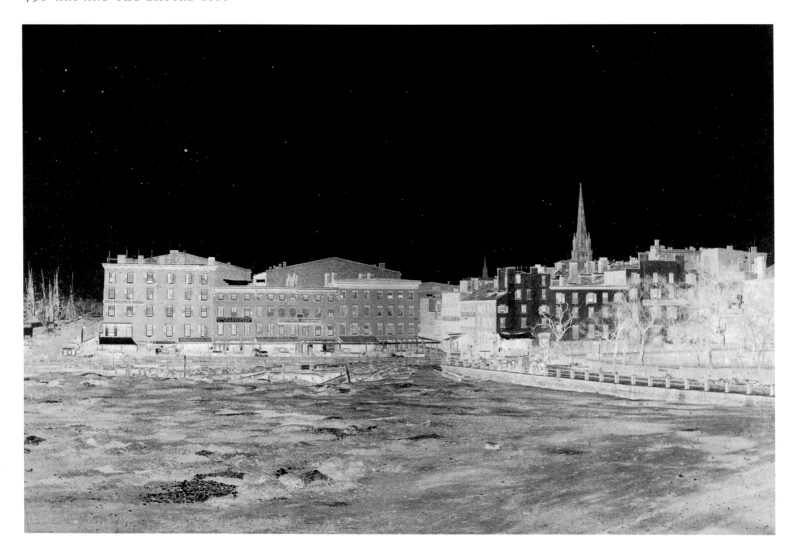

VICTOR PREVOST
182. *Battery Place, Looking North,*
1854
Waxed paper negative
The New-York Historical
Society

VICTOR PREVOST
183. *Looking North toward Madison
Square from Rear Window of
Prevost's Apartment at 28 East
Twenty-eighth Street, Summer,* 1854
Waxed paper negative
The New-York Historical Society

VICTOR PREVOST
184. *Looking North toward Madison
Square from Rear Window of
Prevost's Apartment at 28 East
Twenty-eighth Street, Winter,* 1854
Waxed paper negative
The New-York Historical Society

Attributed to SILAS A. HOLMES
or CHARLES DEFOREST
FREDRICKS
185. *View down Fifth Avenue,* ca. 1855
Salted paper print from glass
negative
The J. Paul Getty Museum,
Los Angeles 84.XM.351.10

183

184

185

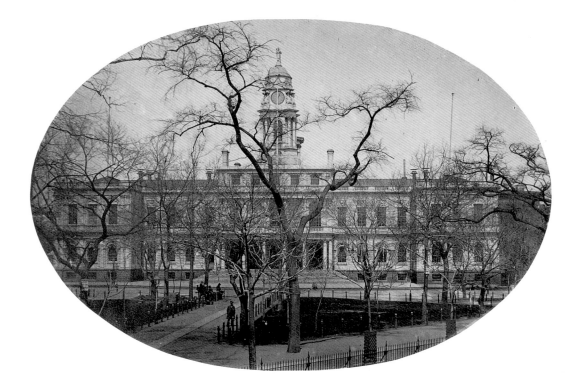

Attributed to SILAS A.
HOLMES *or* CHARLES
DEFOREST FREDRICKS
186. *City Hall, New York*, ca. 1855
Salted paper print from glass
negative
The J. Paul Getty Museum,
Los Angeles 84.XM.351.9

Attributed to SILAS A.
HOLMES *or* CHARLES
DEFOREST FREDRICKS
187. *Washington Square Park Fountain
with Pedestrians*, ca. 1855
Salted paper print from glass
negative
The J. Paul Getty Museum,
Los Angeles 84.XM.351.16

Attributed to SILAS A.
HOLMES *or* CHARLES
DEFOREST FREDRICKS
188. *Washington Monument, at
Fourteenth Street and Union
Square,* ca. 1855
Salted paper print from
glass negative
The J. Paul Getty Museum,
Los Angeles 84.XM.351.12

Attributed to SILAS A. HOLMES *or*
CHARLES DEFOREST FREDRICKS
189. *Palisades, Hudson River, Yonkers Docks,*
ca. 1855
Salted paper print from glass negative
The J. Paul Getty Museum, Los Angeles
84.XM.351.1

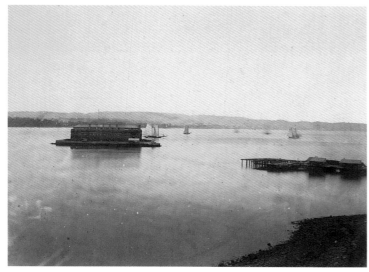

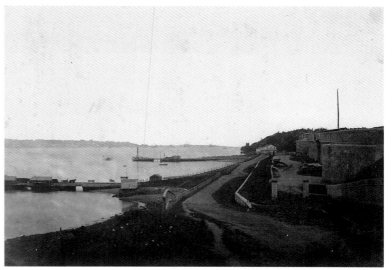

Attributed to SILAS A. HOLMES *or*
CHARLES DEFOREST FREDRICKS
190. *Fort Hamilton and Long Island*, ca. 1855
Salted paper print from glass negative
The J. Paul Getty Museum, Los Angeles
84.XM.351.7

Attributed to SILAS A. HOLMES *or*
CHARLES DEFOREST FREDRICKS
191. *Fort Hamilton and Long Island*, ca. 1855
Salted paper print from glass negative
The J. Paul Getty Museum, Los Angeles
84.XM.351.14

FREDERICK LAW OLMSTED *and*
CALVERT VAUX, *designers*
MATHEW B. BRADY, *photographer*
CALVERT VAUX, *artist*

192. *"Greensward" Plan for Central Park, No. 4: From Point D, Looking Northeast across a Landscape Depicting Belvedere Castle, Lake, Gondola, and Gazebo,* 1857
Lithograph, albumen silver print from glass negative, and oil on paper, mounted on board
Municipal Archives, Department of Records and Information Services, City of New York
DPR3084

FREDERICK LAW OLMSTED *and*
CALVERT VAUX, *designers*
MATHEW B. BRADY, *photographer*
CALVERT VAUX, *artist*

193. *"Greensward" Plan for Central Park, No. 5: From Point E, Looking Southwest,* 1857
Lithograph, albumen silver print from glass negative, and oil on paper, mounted on board
Municipal Archives, Department of Records and Information Services, City of New York
DPR3085

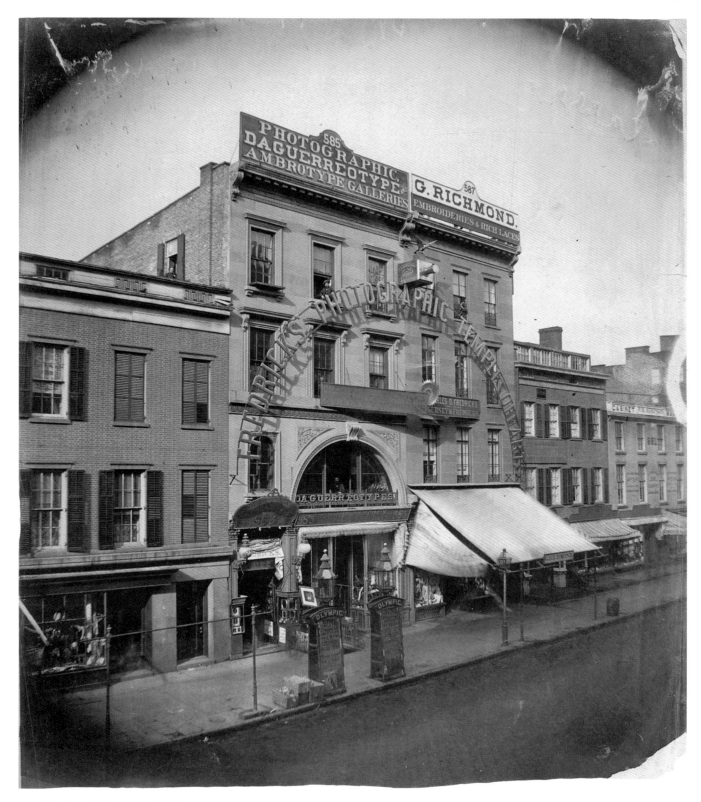

Attributed to CHARLES DEFOREST
FREDRICKS

194. *Fredricks's Photographic Temple of Art,*
New York, 1857–60
Salted paper print from glass negative
Hallmark Photographic Collection,
Hallmark Cards, Inc., Kansas City,
Missouri P5.390.001.95

MATHEW B. BRADY
195. *Martin Van Buren,* ca. 1860
Salted paper print from glass
negative
The Metropolitan Museum
of Art, New York, David
Hunter McAlpin Fund, 1956
56.517.4

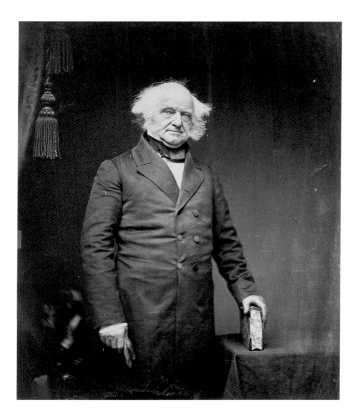

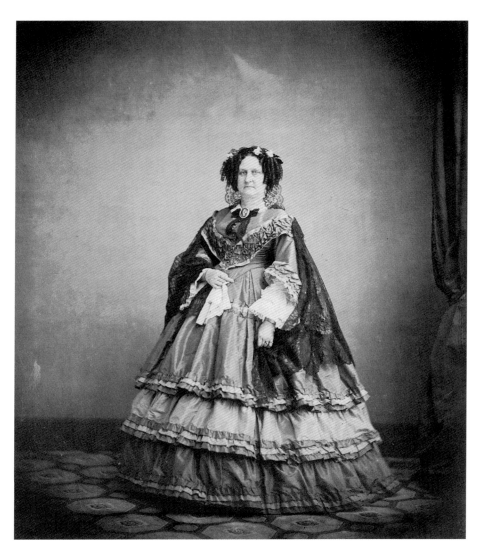

MATHEW B. BRADY
196. *Cornelia Van Ness Roosevelt,* ca. 1860
Salted paper print from glass negative
Gilman Paper Company Collection,
New York

197. Man's tailored ensemble, English, ca. 1833. The Metropolitan Museum of Art, New York

Tail coat, blue silk
Purchase, Catherine Brayer Van Bomel Foundation Fund, 1981
1981.210.4

Vest, yellow silk
Purchase, Irene Lewisohn Bequest, 1976 1976.235.3d

Trousers, natural linen
Purchase, Irene Lewisohn and Alice L. Crowley Bequests, 1982 1982.316.11

Stock, black silk and wool
Purchase, Gifts from various donors, 1983
1983.27.2

Hat, beige beaver
Purchase, Irene Lewisohn Bequest, 1972 1972.139.1

198. Woman's walking ensemble, American, 1832–33. The Metropolitan Museum of Art, New York

Dress and pelerine, brown silk
Gift of Randolph Gunter, 1950 50.15a,b

Hat, brown straw
Gift of Mr. Lee Simpson, 1939 39.13.118

Belt, brown woven ribbon with gilt metal buckle
Purchase, Gifts from various donors, 1984
1984.144

Boots, brown leather and linen
Gift of Mr. Lee Simpson, 1938 38.23.150a,b

Collar, embroidered muslin
Gift of The New-York Historical Society, 1979
1979.346.223

Mitts, cotton mesh
Gift of Mrs. Margaret Putnam, 1946 46.104a,b

Cuffs, embroidered muslin
Gift of Mrs. Albert S. Morrow, 1937 37.45.101a,b

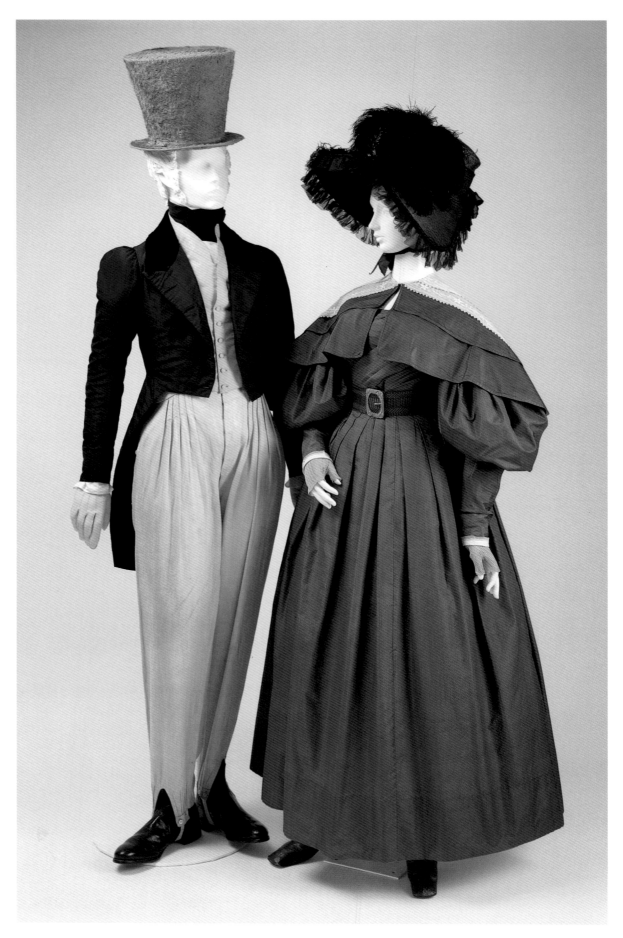

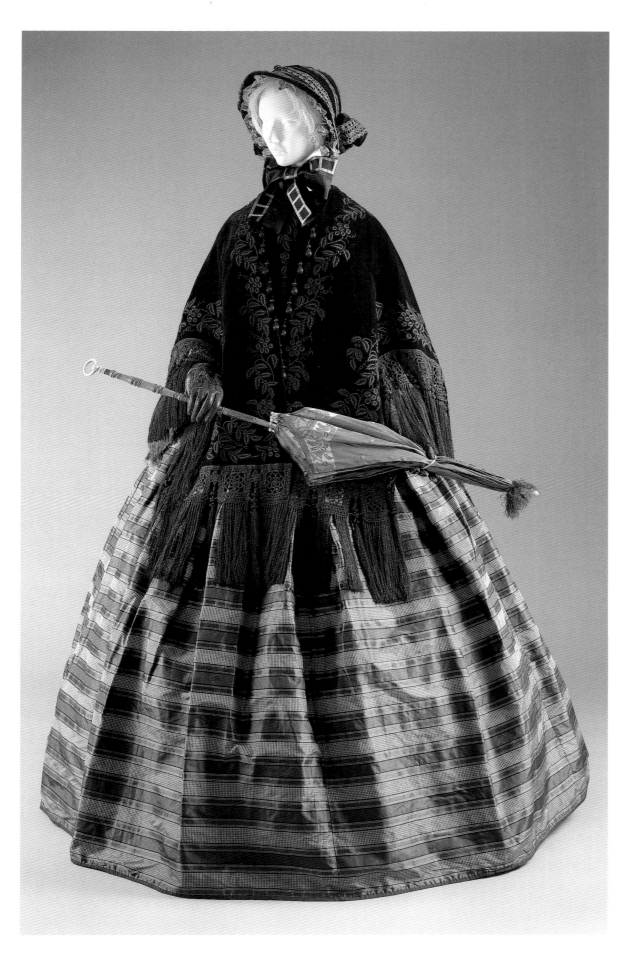

199. Woman's afternoon walking ensemble, American

ARNOLD CONSTABLE AND COMPANY, *retailer*
Two-piece day dress, worn as a wedding gown in 1855 by Mrs. Peter Herrman, 1855
Green-striped taffeta
Museum of the City of New York, Gift of Mrs. Florien P. Gass 44.247.1ab–2ab

Attributed to GEORGE BRODIE
Mantilla wrap, worn to the Prince of Wales Ball, ca. 1853
Embroidered red-brown velvet
The Metropolitan Museum of Art, New York, Gift of Mrs. Henry A. Lozier, 1948 48.65

Bonnet, ca. 1856
Straw, lace, and brown velvet
Museum of the City of New York, Gift of Mrs. Cuyler T. Rawlins 59.124.1

S. REDMOND, *manufacturer*
Parasol, ca. 1824–31
Brown silk woven with leaf-and-flower border; turned and carved wood stick
Museum of the City of New York, from the Estate of Miss Jessie Smith, Gift of Clifton H. Smith 70.127

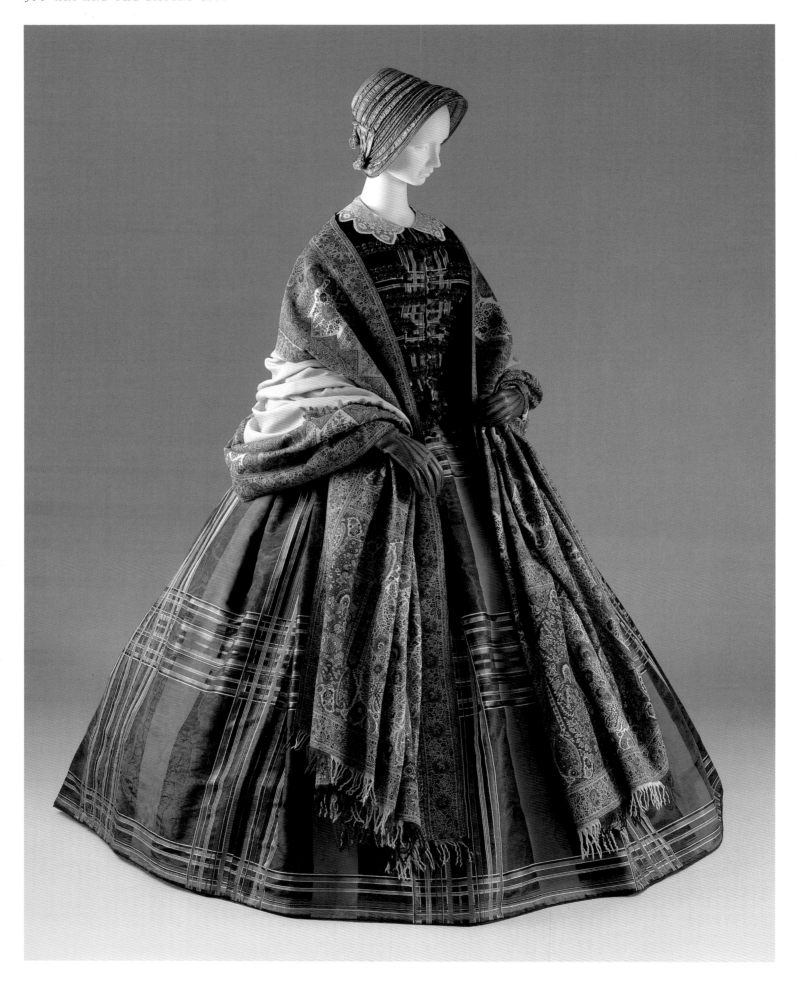

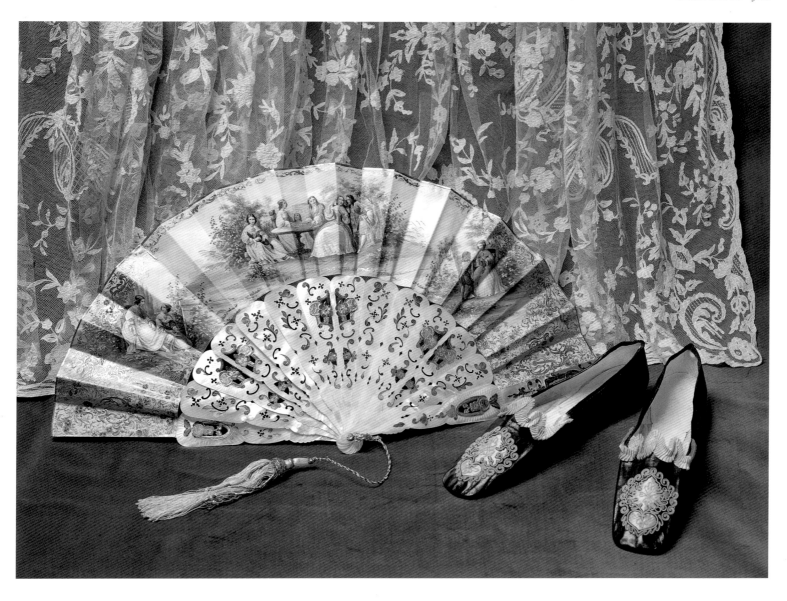

200. Woman's afternoon walking
ensemble

Two-piece day dress,
American, ca. 1855
Plaid taffeta and silk braid
The Metropolitan Museum
of Art, New York, Gift of
Mrs. Edwin R. Metcalf, 1969
69.32.2a,b

Paisley shawl, European,
mid-19th century
Silk and wool
The Metropolitan Museum
of Art, New York, Gift of
Mr. E. L. Waid, 1955 CI.55.41

Bonnet, American, ca. 1850
Silk
Museum of the City of
New York, Gift of Grant
Keehn 62.235.2

A. T. STEWART, *retailer*

201. Wedding veil (detail), Irish,
1850
Net with Carrickmacross
appliqué
Valentine Museum, Richmond,
Virginia, Gift of Elizabeth
Valentine Gray 05.21.10

TIFFANY AND COMPANY,
retailer

202. Fan, European, 1850s
Printed vellum, carved and gilded
mother-of-pearl
The Metropolitan Museum of
Art, New York, Gift of Caroline
Ferriday, 1981 1981.40

MIDDLETON AND
RYCKMAN, *manufacturer*

203. Pair of slippers, 1848–50
Bronze kid with robin's-egg blue
embroidery
Museum of the City of New
York, Gift of Miss Florence A.
Williams 58.212.1a,b

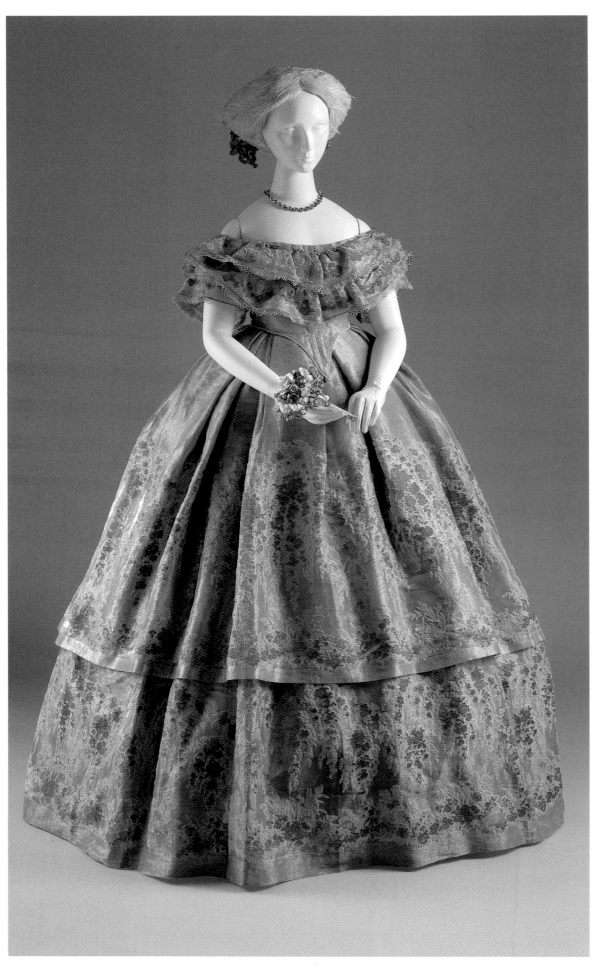

204. Woman's evening toilette, worn
to the Prince of Wales Ball, 1860

Attributed to WORTH ET
BOBERGH, *Paris*
Ball gown, worn by Mrs. David
Lyon Gardiner, 1860
Cut velvet, woven in Lyon
Museum of the City of New
York, Gift of Miss Sarah Diodati
Gardiner 39.26a,b

Bouquet holder, carried by
Mrs. Antonio Yznaga, 1860
Gold filigree
Museum of the City of New
York, Gift of Lady Lister-Kaye
33.27.1

George IV–style rivière, mid-
19th century
Paste, silver, and gold
James II Galleries, Ltd.

Headdress, ca. 1860
Teal chenille with satin glass beads
Museum of the City of New
York, Gift of Mrs. John Penn
Brock 42.445.9

205. Woman's evening toilette, worn
to the Prince of Wales Ball, 1860

Ball gown, worn by the great-aunt
of the Misses Braman, 1860
Cut velvet *en disposition* woven
in Lyon, point-de-gaze lace
Museum of the City of New
York, Gift of the Misses Braman
53.40.16a–d

Fan, carried by Mrs. William H.
Sackett, 1860
Black Chantilly lace and mother-
of-pearl
Museum of the City of New
York, Gift of the Misses Emma
C. and Isabel T. Sackett, 1937
37.326.4

Mantilla wrap, worn by Mrs.
Jonas C. Dudley, 1860
Black embroidered net
Museum of the City of New
York, Gift of Mrs. Russell deC.
Greene 49.101

Necklace, American, mid-19th
century
Strung pearlwork
The Metropolitan Museum
of Art, New York, Gift of Mrs.
Alfred Schermerhorn, in memory
of Mrs. Ellen Schermerhorn
Auchmuty, 1946 46.101.8

Headdress, ca. 1860
Black Chantilly lace, silk-and-
wool flowers
Museum of the City of
New York, Gift of Miss Martia
Leonard 33.143.4

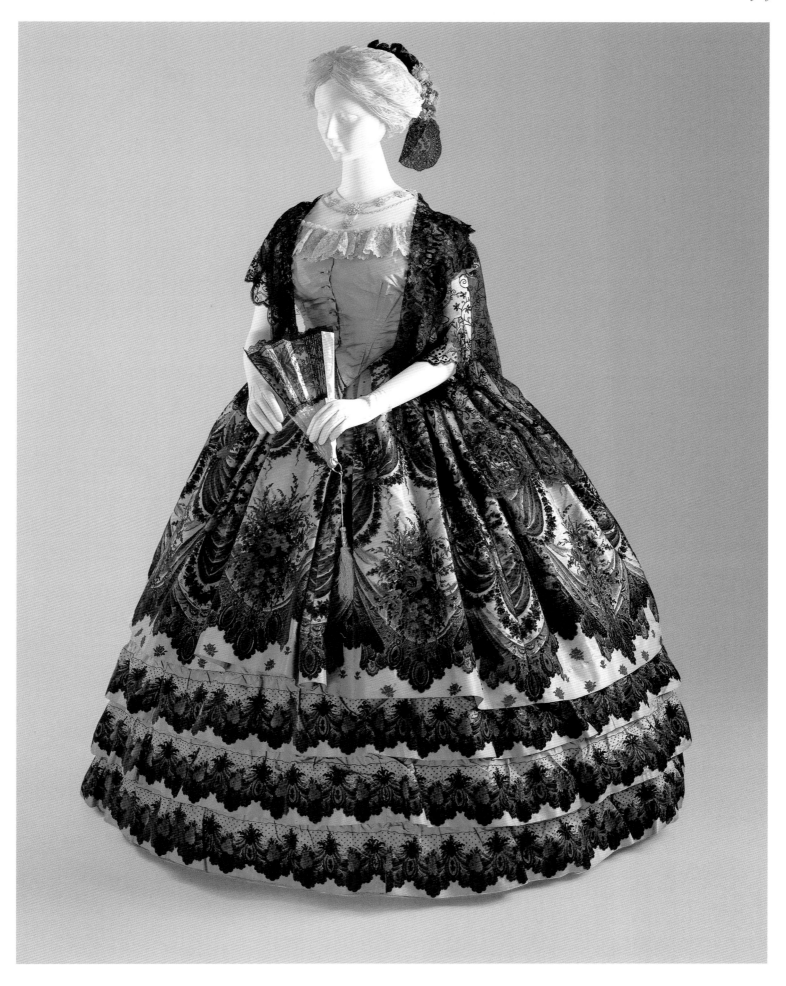

GEORGE W. JAMISON, *cameo cutter*
WILLIAM ROSE, *jeweler*

206. Cameo with portrait bust of Andrew
Jackson, ca. 1835
Helmet conch shell, enamel, and gold
Private collection

GELSTON AND TREADWELL
207. Bouquet holder, 1847
Silver
Historic Hudson Valley, Tarrytown, New
York SS.75.21a,b

TIFFANY AND COMPANY
208. Five-piece parure in fitted box, 1854–61
Agate, coral, pearls, yellow gold, and black
enamel
Collection of Janet Zapata

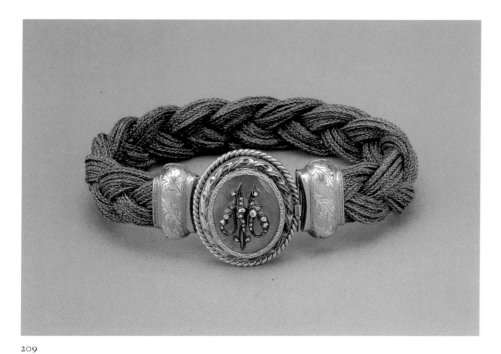

209

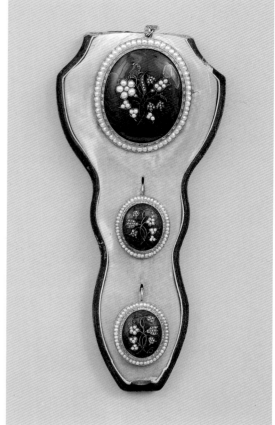

210

TIFFANY AND COMPANY,
retailer

209. Hair bracelet, ca. 1850
Hair, yellow gold, glass,
diamonds, silver, and textile
The New-York Historical
Society INV.774

EDWARD BURR

210. Parure (brooch and earrings),
1858–60
Yellow gold, pearls, diamonds,
enamel, and blue enamel
Private collection

TIFFANY AND COMPANY

211. Seed-pearl necklace and pair
of bracelets, purchased by
President Abraham Lincoln
for Mary Todd Lincoln,
ca. 1860
Seed pearls and yellow gold
Library of Congress,
Washington, D.C., Rare Book
and Special Collections
Division 2.87.276.1–3

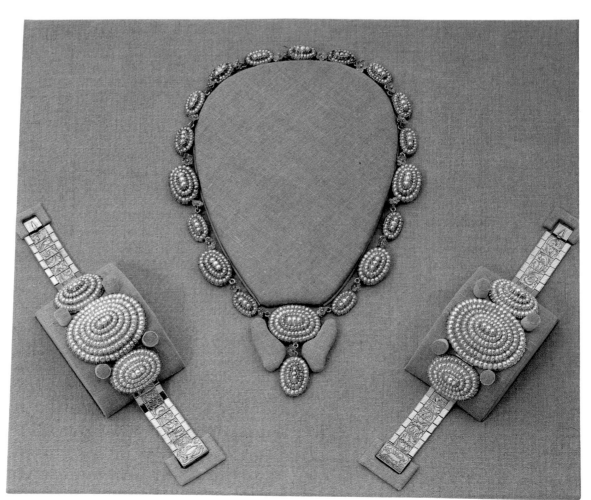

211

MANUFACTURER
UNKNOWN, *British*

212. Ingrain carpet, ca. 1835–40
Wool
The Metropolitan
Museum of Art, New
York, Gift of Mr. and
Mrs. Stuart Feld, 1980
1980.511.8

MANUFACTURER
UNKNOWN, *probably
American*
213. Ingrain carpet, ca. 1850–60
Wool
The Metropolitan
Museum of Art, New
York, Gift of Frances W.
Geyer, 1972 1972.203

ELIZABETH VAN HORNE
CLARKSON
214. Honeycomb quilt, ca. 1830
Cotton
The Metropolitan Museum of
Art, New York, Gift of Mr. and
Mrs. William A. Moore, 1923
23.80.75

Our cherished Washington! the praise be thine.
And yet, alas! by thee regarded not,
One curse remains—a monstrous, hideous blot.
State linked to State—Oh! Unity divine!

But should thy spirit in new form burst forth,
The stain to raze that tarnishes the South,
This proffered Quilt would proudly claim to be
Spread o'er the cradle of his infamy.

MARIA THERESA BALDWIN
HOLLANDER

215. Abolition quilt, ca. 1853
Silk embroidered with silk and
silk-chenille thread
Society for the Preservation of
New England Antiquities, Boston,
Loaned by the Estate of Mrs.
Benjamin F. Pitman 2.1923

216. Wallpaper depicting the west side
of Wall Street; the Battery and
Castle Garden; Wall Street with
Trinity Church; Grace Church;
and City Hall, ca. 1850
Roller-printed paper
The Metropolitan Museum of Art,
New York, The Edward W. C.
Arnold Collection of New York
Prints, Maps, and Pictures, Bequest
of Edward W. C. Arnold, 1954
54.90.734

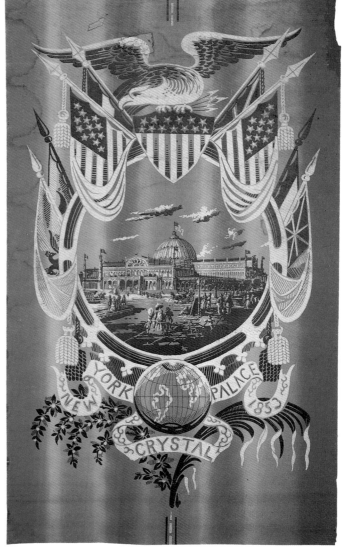

MANUFACTURER UNKNOWN,
probably New York City
217. Entrance-hall wallpaper from
the George Collins house,
Unionvale, New York, ca. 1850
Roller-printed paper
The Metropolitan Museum of
Art, New York, Gift of Mrs.
Adrienne A. Sheridan, 1956
56.599.10

MANUFACTURER UNKNOWN,
probably New York City
218. Window shade depicting the
Crystal Palace, 1853
Hand-painted and roller-printed
paper
Cooper-Hewitt, National Design
Museum, Smithsonian Institution,
New York, Museum purchase in
memory of Eleanor and Sarah
Hewitt 1944.66.1

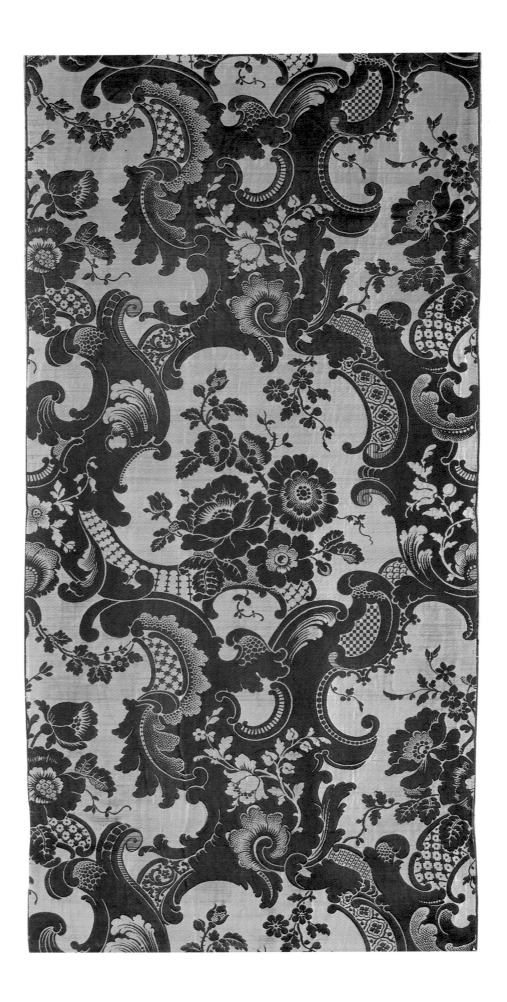

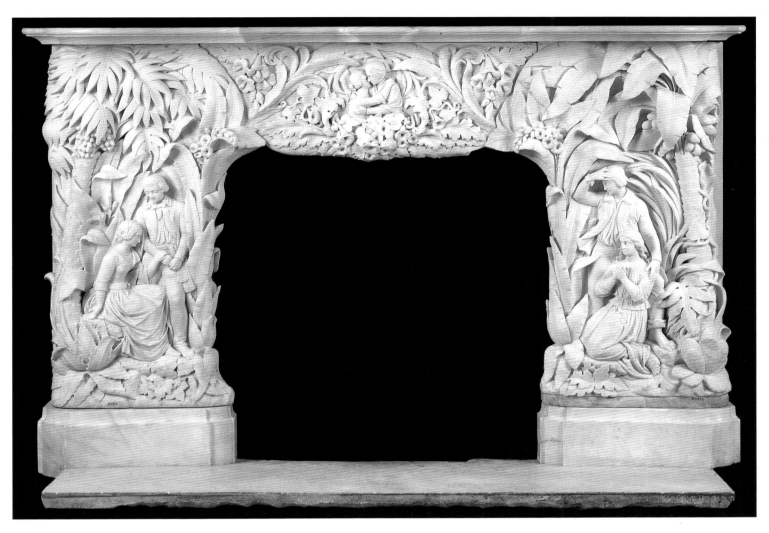

FISHER AND BIRD
220. Mantel depicting scenes
from Jacques-Henri
Bernardin de Saint-Pierre's
Paul et Virginie (1788), 1851
Marble
Museum of the City of
New York, Gift of Mrs.
Edward W. Freeman, 1932
32.269a–h,j

MANUFACTURER
UNKNOWN, *French*
219. Brocatelle, ca. 1850–55
Silk and linen
The Metropolitan Museum
of Art, New York, Rogers
Fund, 1948 48.55.4

CABINETMAKER
UNKNOWN, *New York
City*

221. Armchair, ca. 1825
Ebonized maple and
cherry; walnut; gilding;
replacement underuphol-
stery and showcover
Winterthur Museum,
Winterthur, Delaware,
Bequest of Henry F. du
Pont 57.0739

DEMING AND
BULKLEY

222. Center table, 1829
Rosewood and mahogany
veneers; pine, chestnut,
mahogany; gilding, rose-
wood graining, bronzing;
"Egyptian" marble; casters
Mulberry Plantation,
Camden, South Carolina

CABINETMAKER
UNKNOWN, *New York
City*

223. Secretary-bookcase,
ca. 1830
Ebonized mahogany,
mahogany, mahogany
veneer; pine, poplar,
cherry; gilding, bronzing;
stamped brass orna-
ments; glass drawer pulls;
replacement fabric; glass
The Metropolitan
Museum of Art, New
York, Gift of Francis
Hartman Markoe, 1960
60.29.1a,b

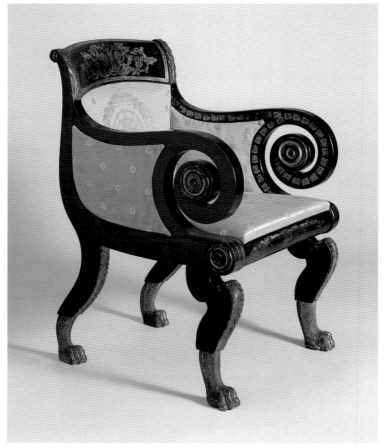

221

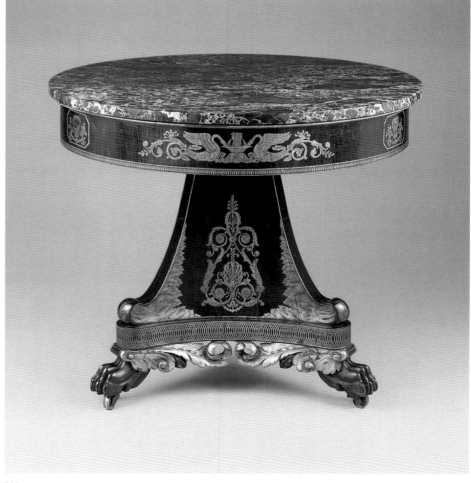

222

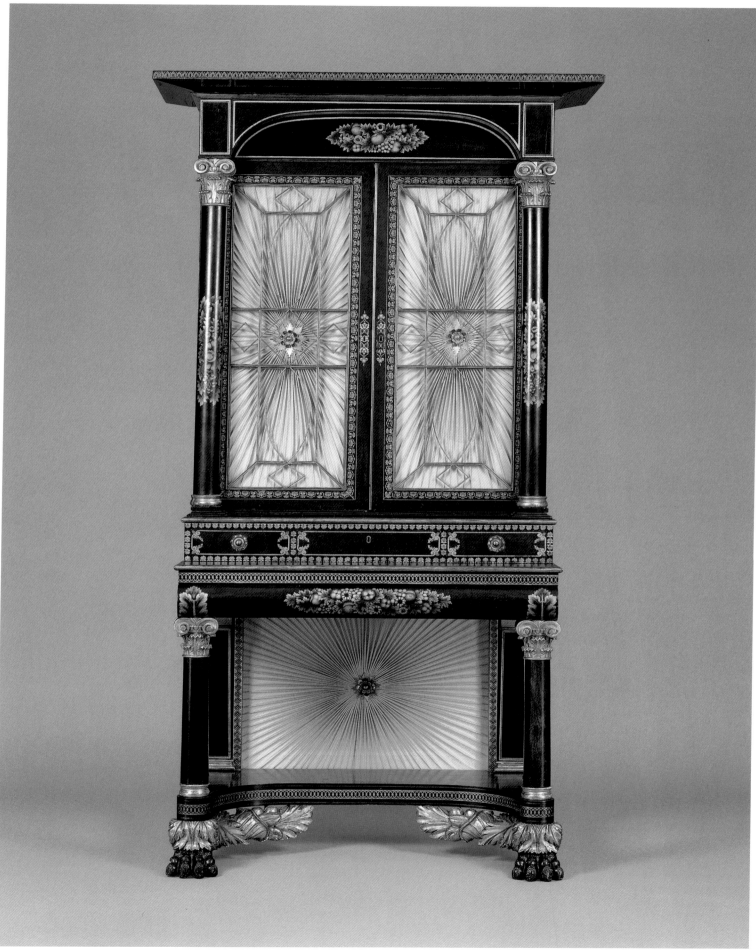

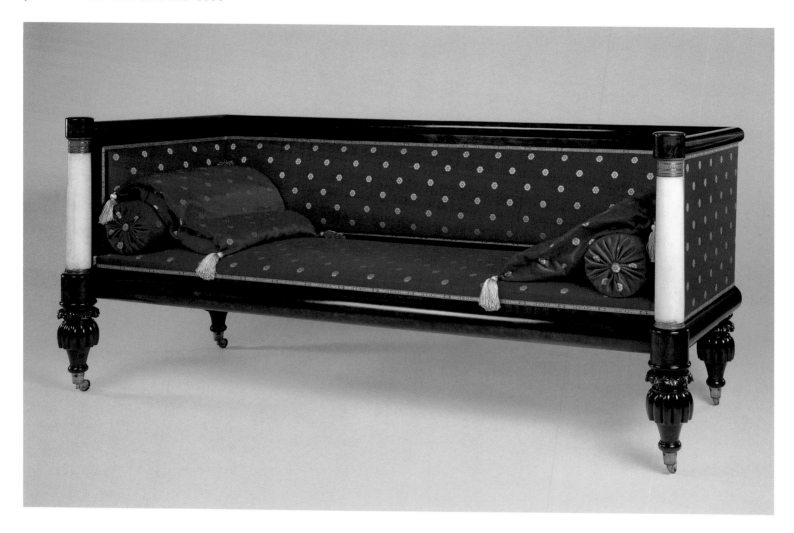

CABINETMAKER
UNKNOWN, *New York City*
224. Sofa, ca. 1830
Mahogany, mahogany
veneer; marble; gilt-bronze
mounts; original under-
upholstery on back and sides,
replacement showcover;
casters
Brooklyn Museum of Art,
Maria L. Emmons Fund
41.1181

ENDICOTT AND SWETT,
printer and publisher
225. Broadside for Joseph Meeks and
Sons, 1833
Lithograph with hand coloring
The Metropolitan Museum of
Art, New York, Gift of Mrs.
Reed W. Hyde, 1943 43.15.8

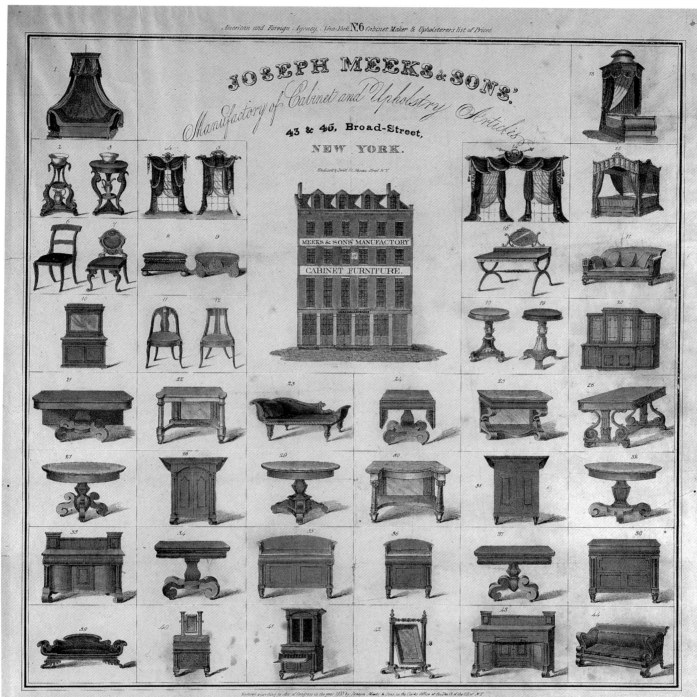

American and Foreign Agency, New-York. Nº 6 Cabinet Maker & Upholsterers list of Prices.

JOSEPH MEEKS & SONS.
Manufactory of Cabinet and Upholstry Articles

43 & 45, Broad-Street,

NEW YORK.

MEEKS & SONS' MANUFACTORY
of
CABINET FURNITURE.

Entered according to Act of Congress in the year 1833 by Joseph Meeks & Sons, in the Clerks Office at the Dis. Ct. of the US of N.Y.

CIRCULAR.

THE above constitute but a small part of the variety of Furniture made by the subscribers; it would be impossible to exhibit all the patterns on this sheet, as we are obliged to keep so great a variety, to suit the taste of our numerous purchasers—the patterns in this and foreign countries are so constantly varying, as to render it necessary for us to make alterations and improvements, and we are constantly getting up new and costly patterns, much to the satisfaction of the public, all of which are warranted to be made of the best materials and workmanship, and will bear the makers' card and names inside, as a guarantee to that effect. Our establishment being one of the oldest, and now the largest in the United States, we are able to execute orders, at wholesale prices, to any amount, and at the shortest notice.

No. 1—A Canopy Bedstead, $90	No. 7—A Mahogany Chair, silk seat and back, 25	No. 30—A Library, Secretary, and Book Case, 200
Do. Do. with Curtains and Top, $250 to 500	Nos. 11 and 12—Rosewood Chairs and Silk Seats, each, 23	No. 31—A Mahogany End Dining Table $50—three in a set, 150
No. 1B—A Canopy Bedstead, 100	Mahogany do. hair cloth Seats, each, 19	No. 34—A Breakfast Table, 40
No. 15—A High Post Bedstead, 300 to 600	Nos. 8 and 9—Foot Stools, Mahogany, and covered with hair cloth, each 10	No. 35—An occasional Table, 100
Do. do. with Curtains, 50	Do. do. Rosewood and Gilt, and covered with Silk, each 15	Nos. 22 and 30—A Rosewood or Mahogany Pier Table, white marble top and columns, 90
No. 2—A Rosewood and Gilt Washstand, 75	No. 17—A Mahogany Sofa, covered with hair cloth, 100	Do. do. do. Egyptian marble, 150
No. 5—A Mahogany Washstand, 35	Do. do. covered with silk, 150 to 300	No. 23—A Mahogany Pier Table, white marble top, 90
Nos. 4, 5 and 14—Window Curtains, each 200 to 300	No. 23—A Mahogany Couch, covered with hair cloth, 90	Do. do. Egyptian marble top, 110
No. 10—A French Dressing Bureau, 100	Do. do. covered with silk, 140	Nos. 27, 28 and 29—Mahogany Centre Tables, white marble tops, each 90
No. 18—A Dressing Table, 35	No. 39—A Mahogany Sofa, covered with hair cloth, 80	Do. do. Egyptian marble tops, 100
No. 6—A Mahogany Chair, each 7	No. 44—A Mahogany Sofa, 100	No. 36—A Mahogany Wardrobe, 110
	No. 18 and 19—Piano Stools, Rosewood and Gilt, each 22	No. 21—A Mahogany Wardrobe, 90



No. 33—A Mahogany Sideboard, 90
No. 43—A Mahogany Sideboard, 130
Nos. 34 and 37—Mahogany Card Tables, each, 50
No. 25—A Double Washstand, with a white marble top, 50
Do. do. Egyptian top, 60
No. 26—A Single Washstand, with white marble top, 20
Do. do. Egyptian top, 30
No. 38—A Mahogany Bureau, 40
No. 40—A Mahogany Dressing Bureau, 40
No. 41—A Secretary and Book Case, 100
No. 42—A Mahogany Dressing Glass, with brass candle sticks complete, 90

☞ We would observe, that when any Furniture is wanted of the above patterns, by referring to the above table or card, and giving the number of the same, or by giving a description of any other peice of Furniture in our line, to the Proprietors of the above establishment, the orders will be punctually attended to.

JOSEPH MEEKS & SONS.

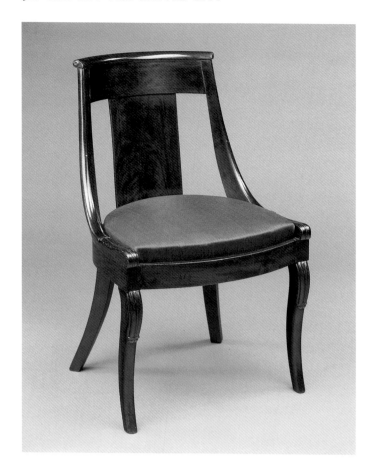

CABINETMAKER
UNKNOWN, *New York City*
226. French chair, ca. 1830
Mahogany, mahogany veneer;
chestnut; original underupholstery
and showcover fragments, replace-
ment showcover
Private collection

JOSEPH MEEKS AND SONS
227. Pier table, ca. 1835
Mahogany veneer, mahogany;
"Egyptian" marble; mirror glass
Collection of Dr. and Mrs. Emil
F. Pascarelli

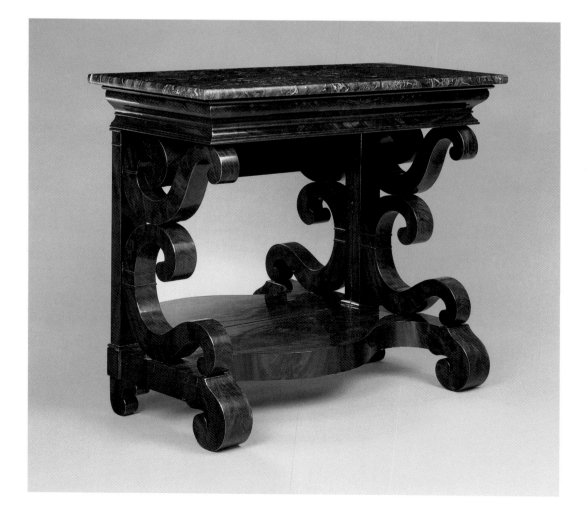

JOHN H. WILLIAMS AND
SON

228. Pier mirror, ca. 1845
Gilded pine; pine; plate-glass
mirror
Collection of Mr. and Mrs. Peter
G. Terian

CABINETMAKER
UNKNOWN, *New York City*

229. Fall-front secretary, 1833–ca. 1841
Mahogany veneer, mahogany,
ebonized wood; pine, poplar,
cherry, white oak; brass; leather;
mirror glass
Collection of Frederick W.
Hughes

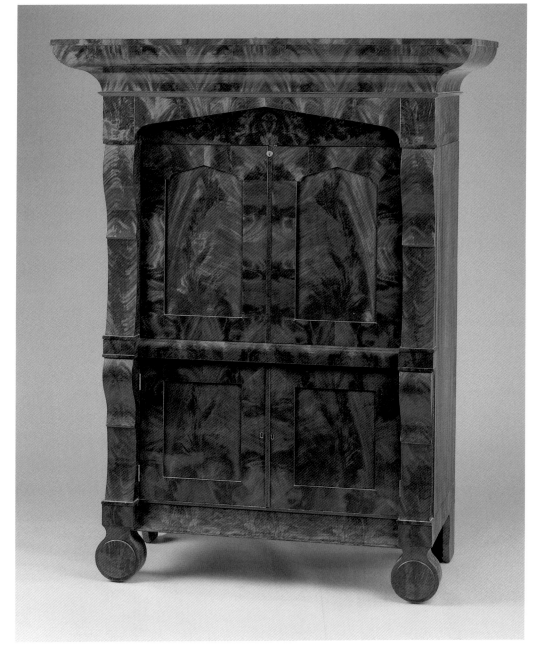

DUNCAN PHYFE AND SON
230. Six nested tables, 1841
Rosewood, rosewood veneer; mahogany;
gilding not original
Collection of Mr. and Mrs. Peter G. Terian

DUNCAN PHYFE AND SON
231. Armchair, 1841
Mahogany, mahogany veneer; chestnut;
replacement underupholstery and showcover
Collection of Richard Hampton Jenrette

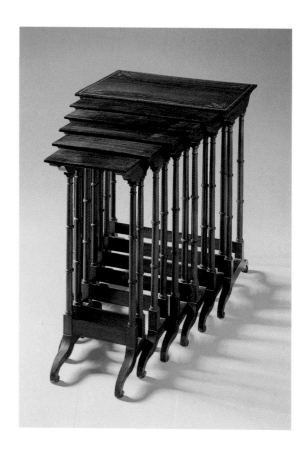

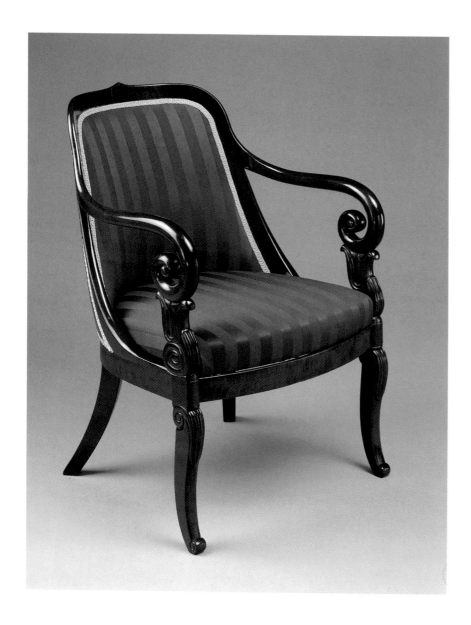

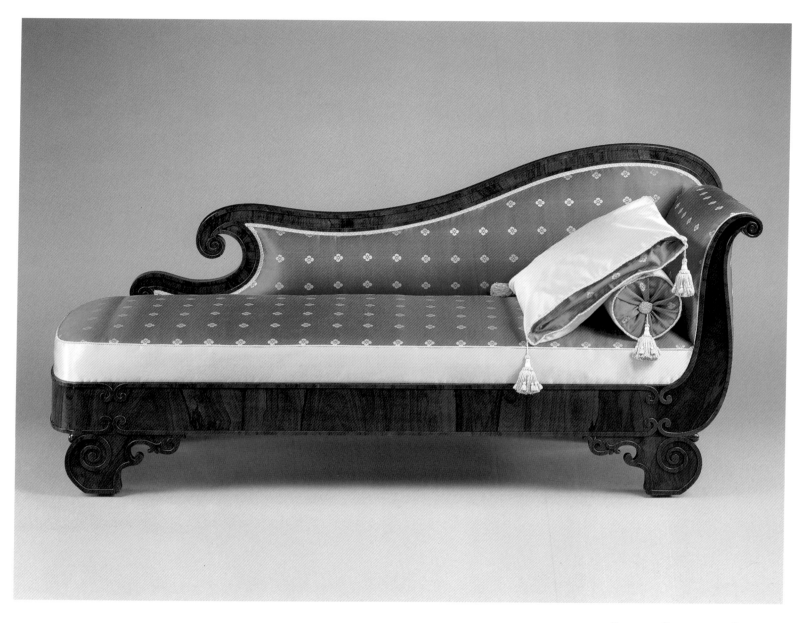

DUNCAN PHYFE AND SON
232. Couch, 1841
Rosewood veneer, rosewood,
mahogany; sugar pine, ash, poplar;
rosewood graining; replacement
underupholstery and showcover
Collection of Richard Hampton
Jenrette

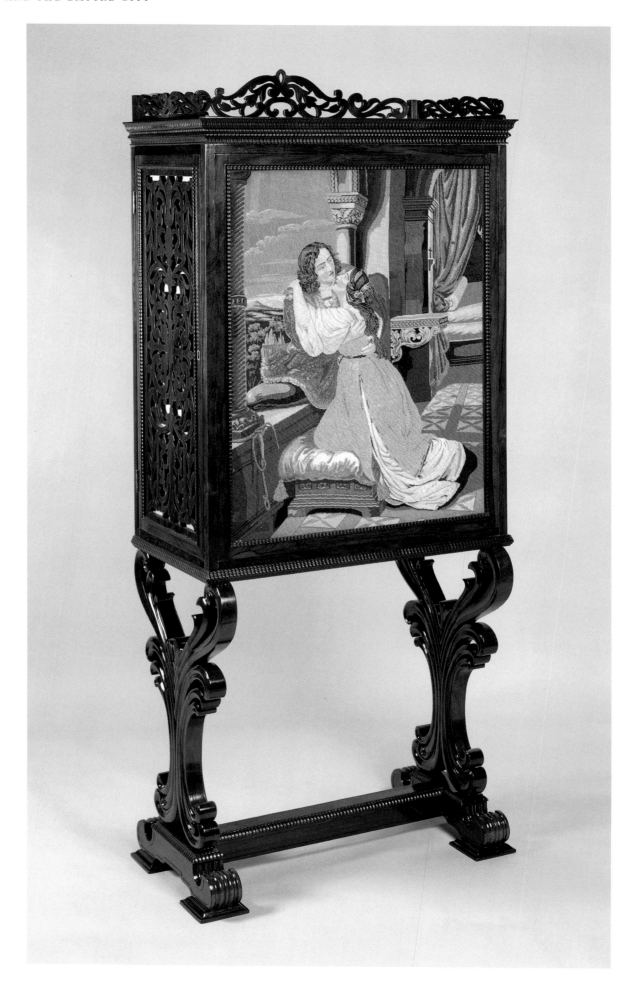

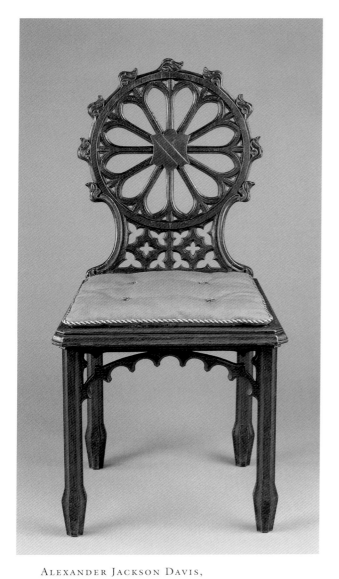

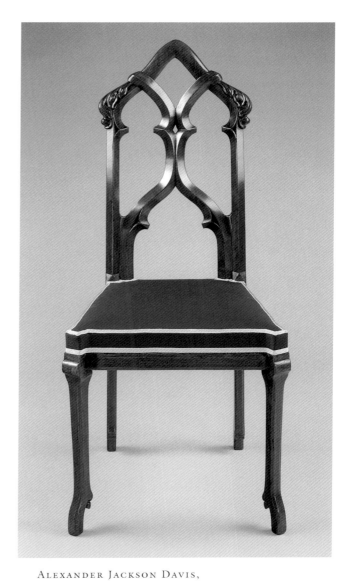

ALEXANDER JACKSON DAVIS,
designer
RICHARD BYRNE, *White Plains,*
New York, cabinetmaker
234. Hall chair, ca. 1845
Oak; original cane seat, replacement
cushion
Lyndhurst, A National Trust
Historic Site, Tarrytown, New York

ALEXANDER JACKSON DAVIS,
designer
Possibly BURNS AND BROTHER,
cabinetmaker
235. Side chair, ca. 1857
Black walnut; replacement underuphol-
stery and showcover
The Metropolitan Museum of Art,
New York, Gift of Jane B. Davies, in
memory of Lyn Davies, 1995 1995.111

J. AND J. W. MEEKS
233. Portfolio cabinet-on-stand, with a
scene from Shakespeare's *Romeo and
Juliet,* ca. 1845
Rosewood; rosewood and maple
veneers; cross-stitched needlepoint
panel; replacement fabric; glass
Collection of Mrs. Sammie Chandler

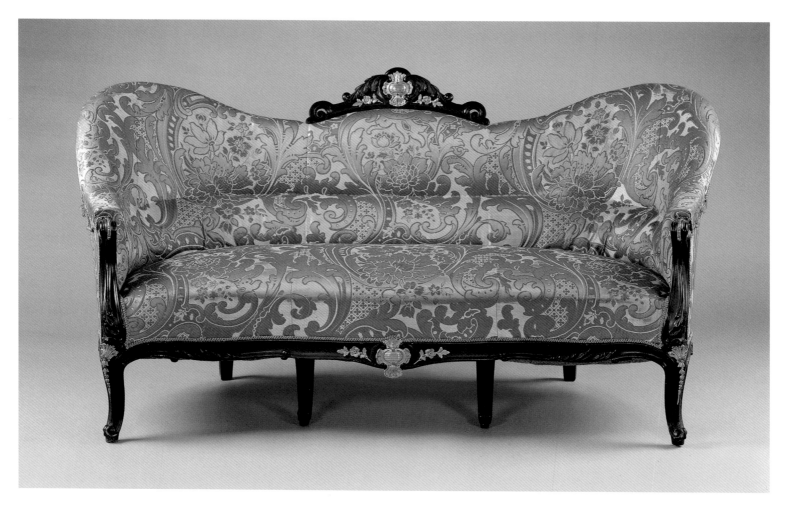

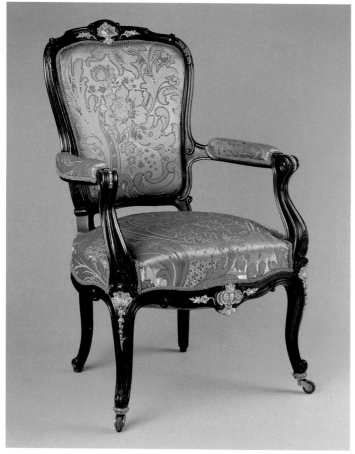

AUGUSTE-ÉMILE
RINGUET-LEPRINCE,
French (Paris)
236A, B. Sofa and armchair, 1843
Ebonized fruitwood (apple
or pear); beech; gilt-bronze
mounts; original under-
upholstery and silk brocatelle
showcover; casters (on
armchair)
The Metropolitan Museum
of Art, New York, Gift of
Mrs. Douglas Williams, 1969
69.262.1, 69.262.3

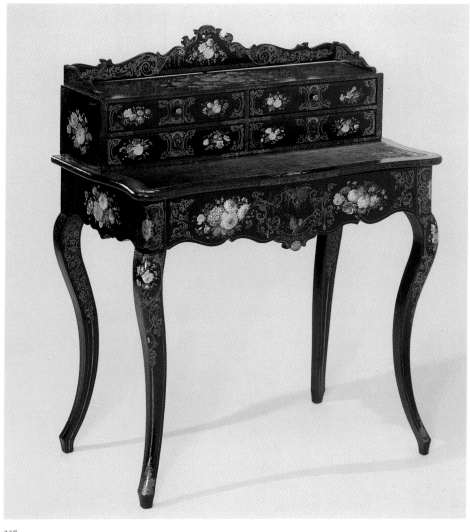

237

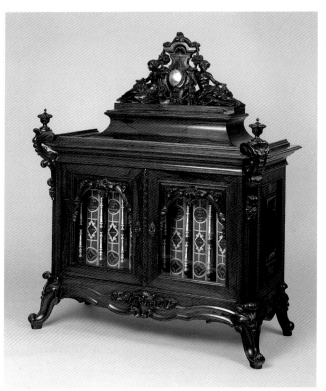

238

CABINETMAKER UNKNOWN, *probably French (probably Paris)* Retailed *by* CHARLES A. BAUDOUINE, *cabinetmaker*

237. Lady's writing desk, 1849–54
Ebonized poplar (aspen or cottonwood); painted and gilded decoration; velvet
Museum of Fine Arts, Boston, Gift of the William N. Banks Foundation in memory of Laurie Crichton 1979.612

THOMAS BROOKS, *Brooklyn, New York*

238. Table-top bookcase made for Jenny Lind, 1851
Rosewood; ivory; silver
Museum of the City of New York, Gift of Arthur S. Vernay 52.24.1a

JOHN T. BOWEN, *Philadelphia, lithographer*
After JOHN JAMES AUDUBON, *artist, and* ROBERT HAVELL JR., *engraver*
J. J. AUDUBON AND J. B. CHEVALIER, *New York and Philadelphia, publisher*
MATTHEWS AND RIDER, *bookbinders*

239. *The Birds of America, from Drawings Made in the United States and Their Territories,* 1840–44
Bound in ivory, red, green, and blue leather with gold stamping
Museum of the City of New York, Gift of Arthur S. Vernay 52.24.2a–g

239

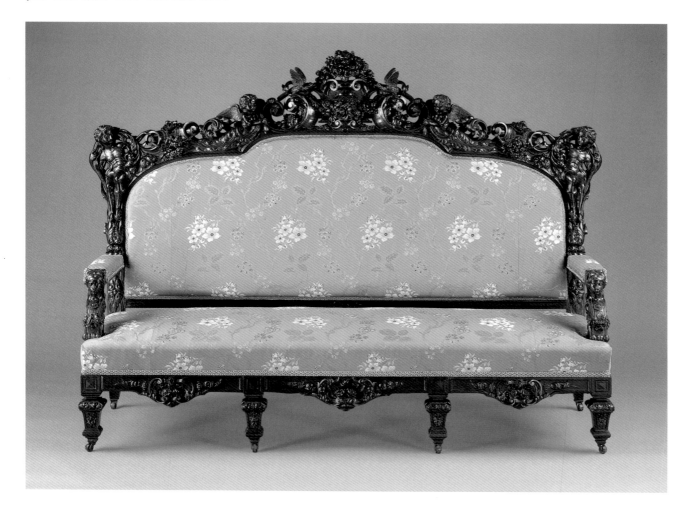

JULIUS DESSOIR
240A–C. Sofa and two armchairs, 1853
Rosewood; chestnut; original
underupholstery and replacement
showcover; casters
The Metropolitan Museum of
Art, New York, Gift of Lily and
Victor Chang, in honor of the
Museum's 125th Anniversary,
1995 1995.150.1–3

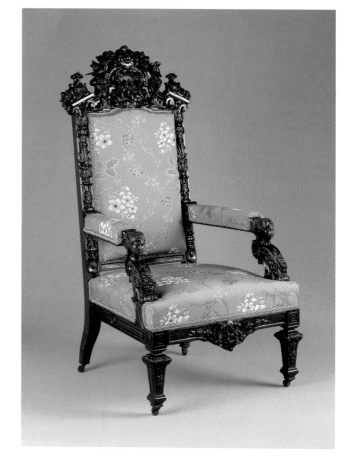

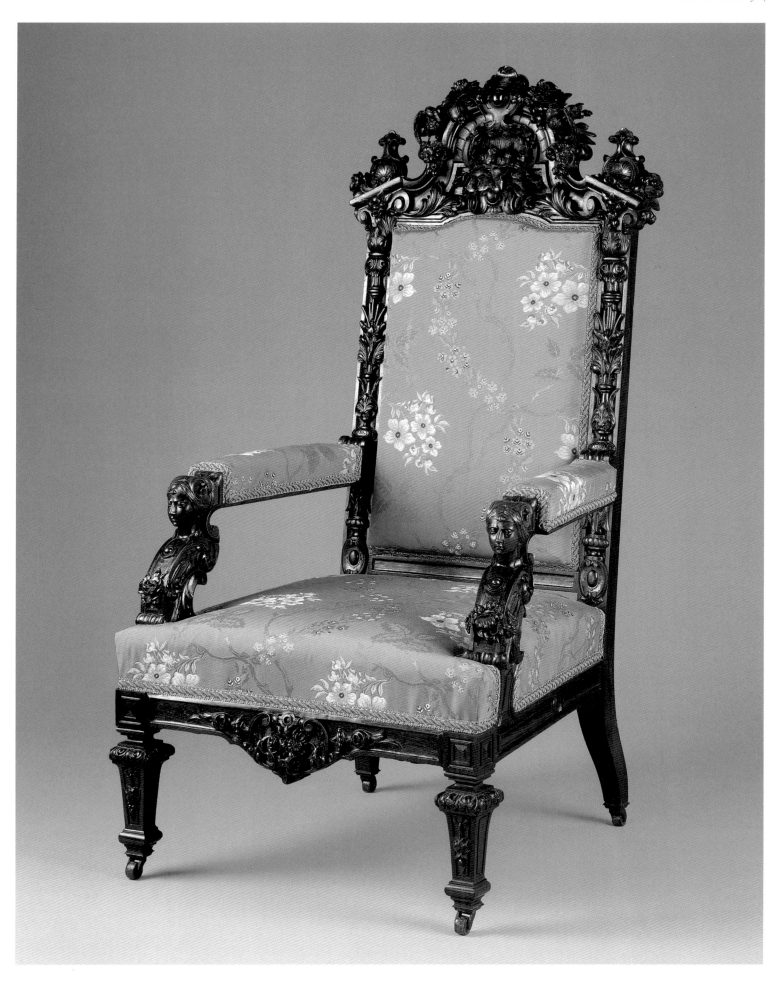

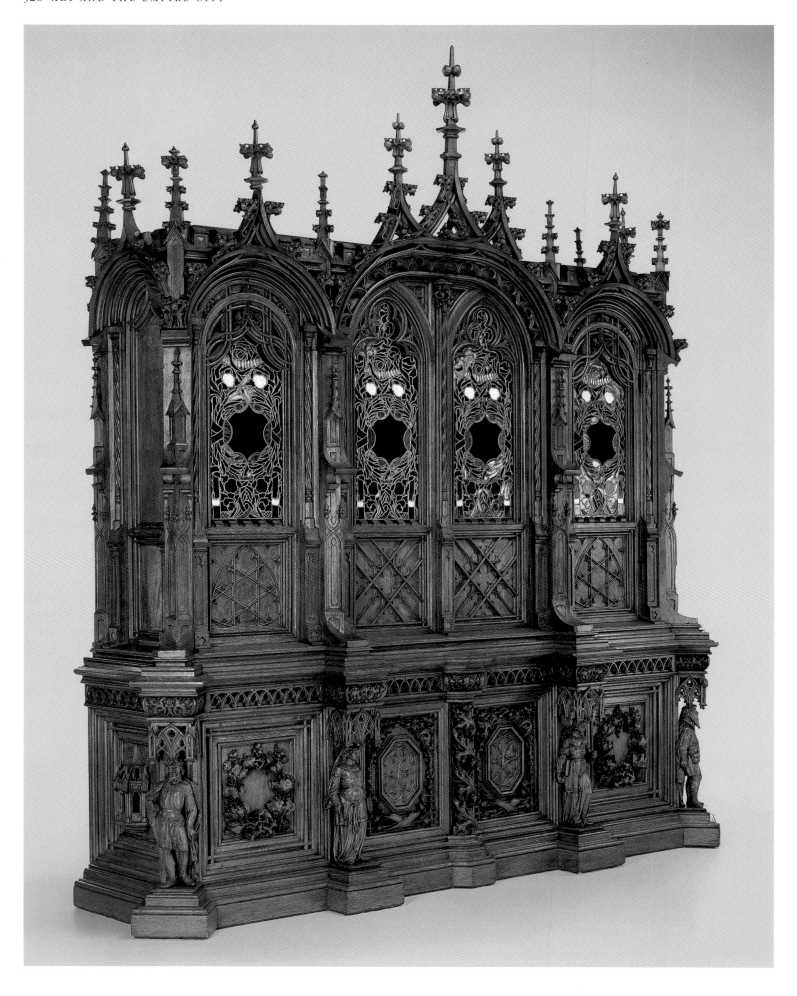

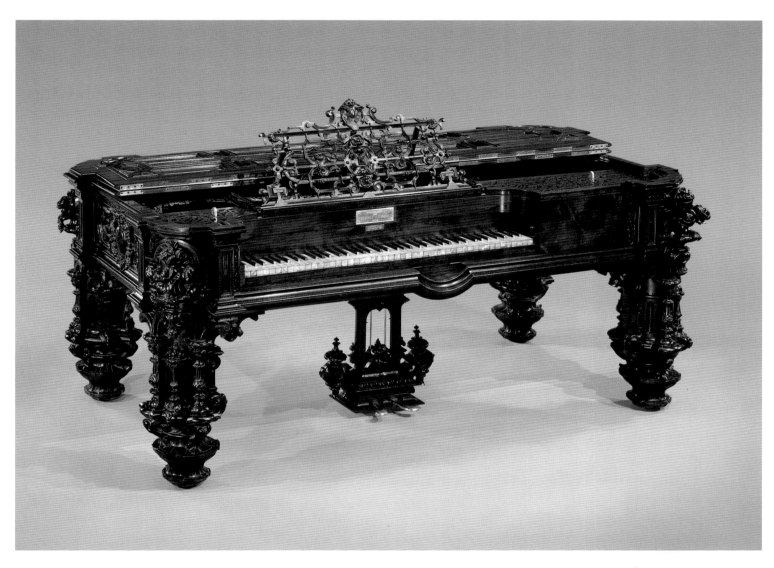

GUSTAVE HERTER,
designer
BULKLEY AND HERTER,
cabinetmaker
241. Bookcase, 1853
White oak; eastern white
pine, eastern hemlock, yellow
poplar; leaded glass not
original
The Nelson-Atkins Museum
of Art, Kansas City, Missouri
(Purchase: Nelson Trust
through the exchange of gifts
and bequests of numerous
donors and other Trust prop-
erties) 97–35

CABINETMAKER
UNKNOWN, *New York City*
NUNNS AND CLARK,
piano manufacturer
242. Square piano, 1853
Rosewood, rosewood veneer;
mother-of-pearl, tortoiseshell,
abalone shell
The Metropolitan Museum
of Art, New York, Gift of
George Lowther, 1906
06.1312

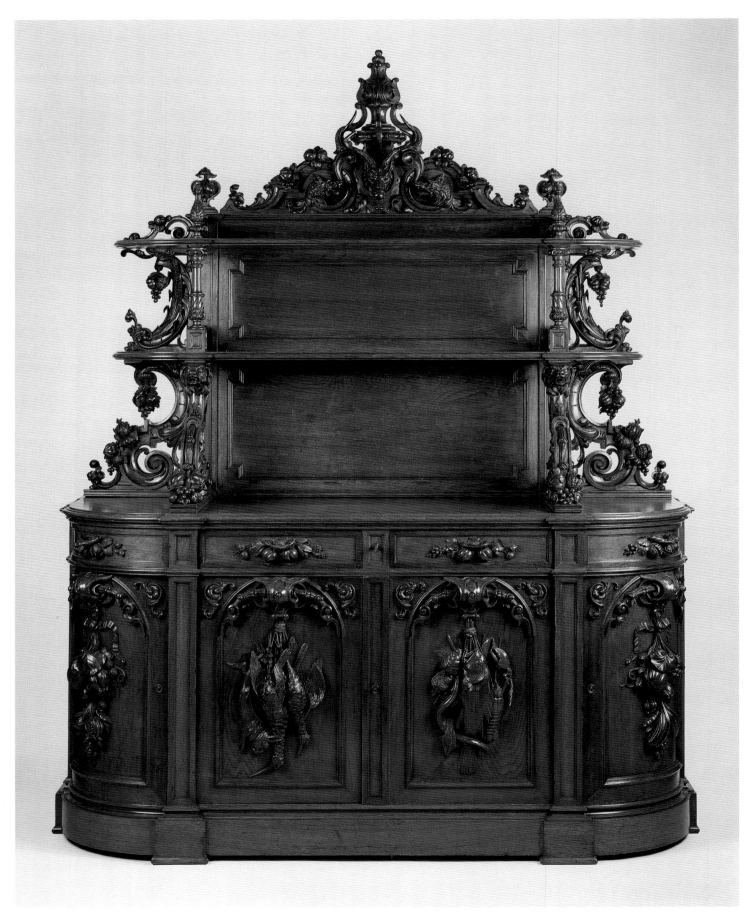

ALEXANDER ROUX
243. Étagère-sideboard, ca. 1853–54
Black walnut; pine, poplar
The Metropolitan Museum of Art,
New York, Purchase, Friends of the
American Wing Fund and David
Schwartz Foundation Inc. Gift, 1993
1993.168

CABINETMAKER UNKNOWN,
French (probably Paris)
244. Center table, 1855–57
Gilded poplar (possibly aspen or cot-
tonwood); beech; marble top; casters
Brooklyn Museum of Art, Gift of
Marion Litchfield 51.112.9

Attributed to J. H. BELTER AND
COMPANY
245. Sofa, ca. 1855
Rosewood; probably replacement
underupholstery, replacement
showcover; casters
Milwaukee Art Museum, Purchase,
Bequest of Mary Jane Rayniak in
Memory of Mr. and Mrs. Joseph G.
Rayniak M1987.16

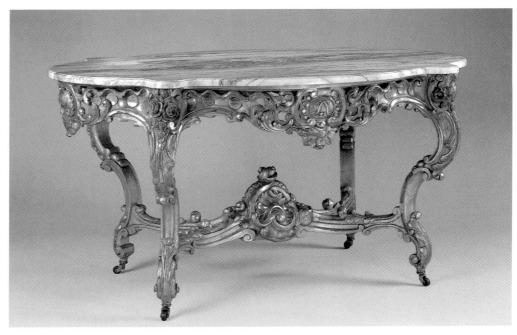

244

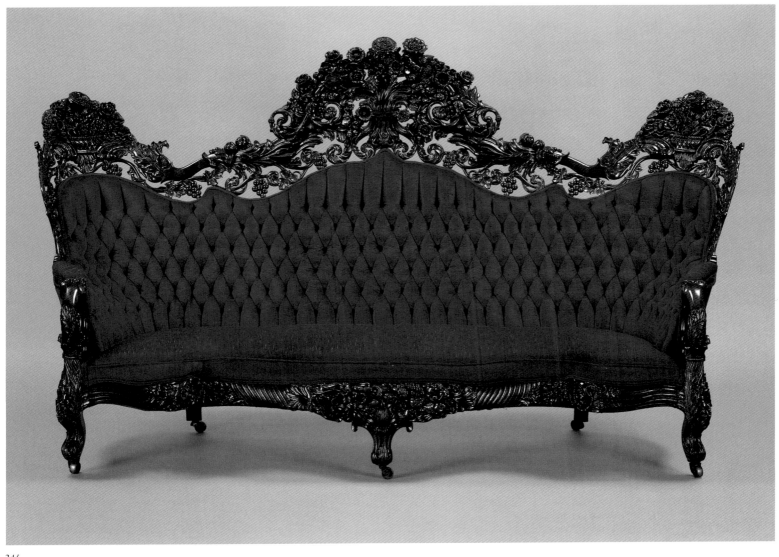

245

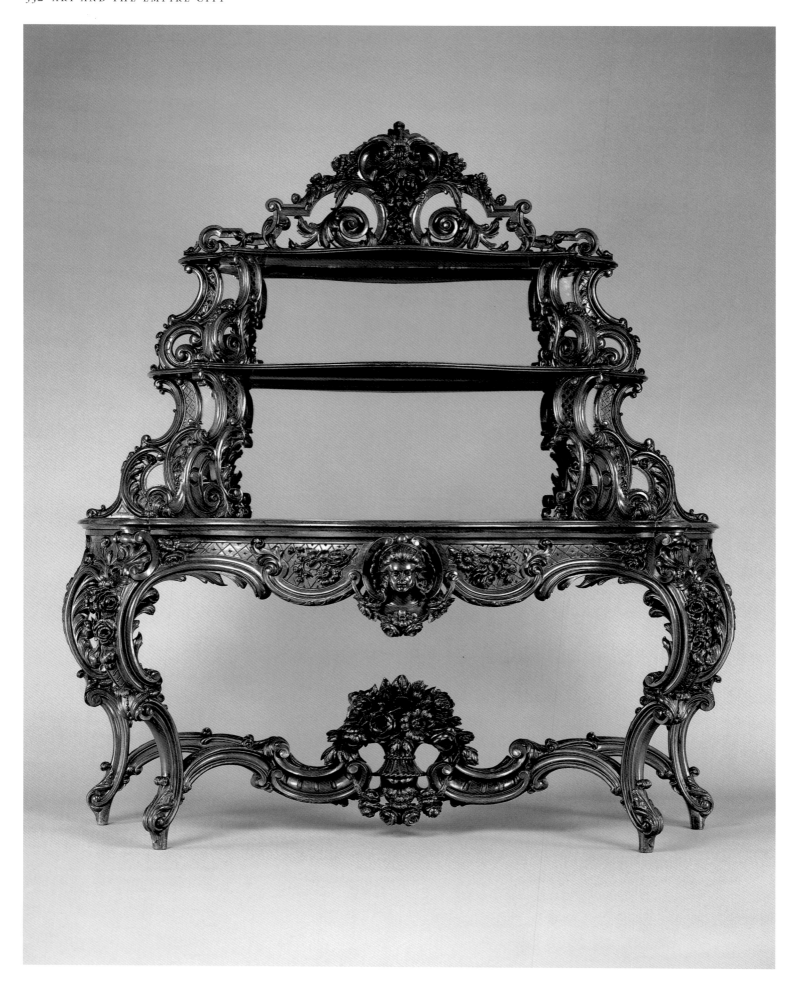

ALEXANDER ROUX
246. Étagère, ca. 1855
Rosewood, rosewood
veneer; chestnut, poplar,
bird's-eye maple veneer;
replacement mirror glass
The Metropolitan Museum
of Art, New York, Sansbury-
Mills Fund, 1971 1971.219

CABINETMAKER
UNKNOWN, *probably New
York City*
247. Fire screen, ca. 1855
Rosewood; white pine;
tent-stitched needlepoint
panel; glass; replacement
silk backing; casters
The Art Institute of
Chicago, Mary Waller
Langhorne Endowment
1989.155

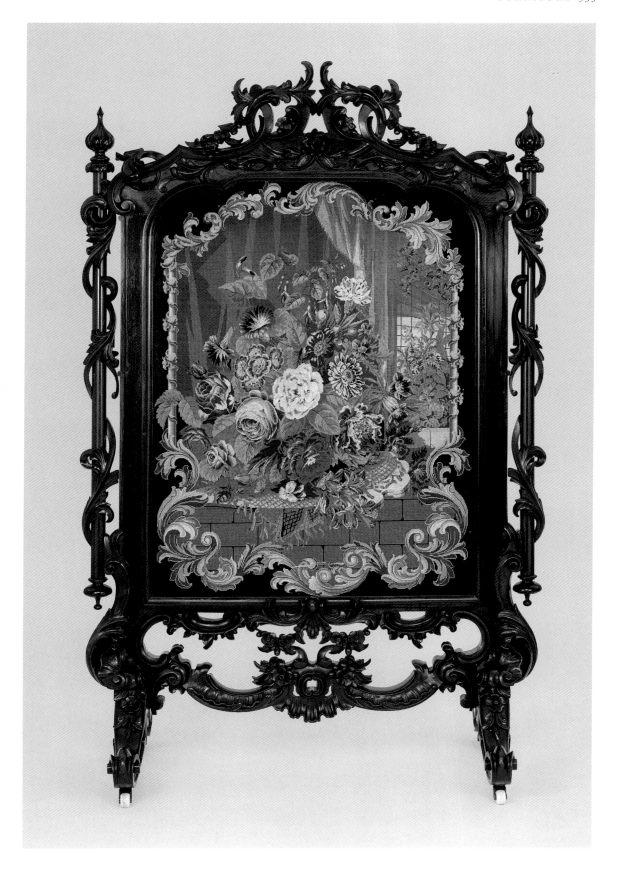

RINGUET-LEPRINCE
AND L. MARCOTTE
248. Armchair, ca. 1856
Ebonized maple; pine; gilt-
bronze mounts; replacement
underupholstery and
showcover; casters
The Metropolitan Museum
of Art, New York, Gift of
Mrs. D. Chester Noyes, 1968
68.69.2

GUSTAVE HERTER
249. Reception-room cabinet,
ca. 1860
Bird's-eye maple, rosewood,
ebony, marquetry of various
woods; white pine, cherry,
poplar, oak; oil on canvas;
gilt-bronze mounts; brass
inlay; gilding; mirror glass
Victoria Mansion, The
Morse-Libby House,
Portland, Maine 1984.65

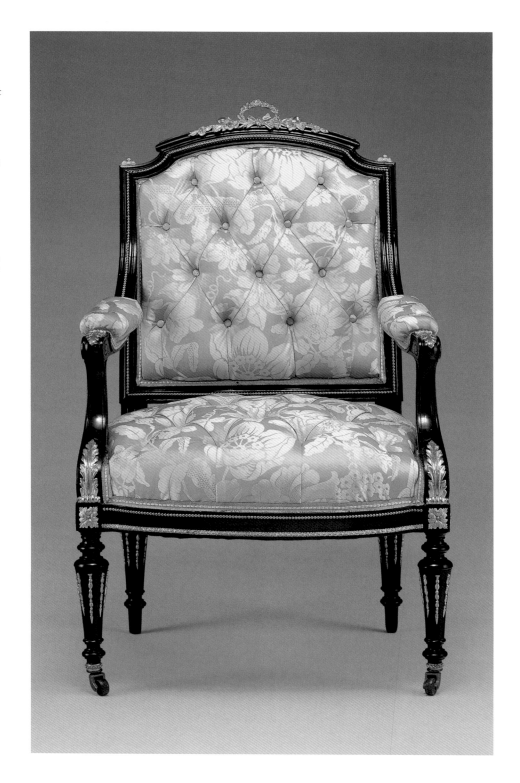

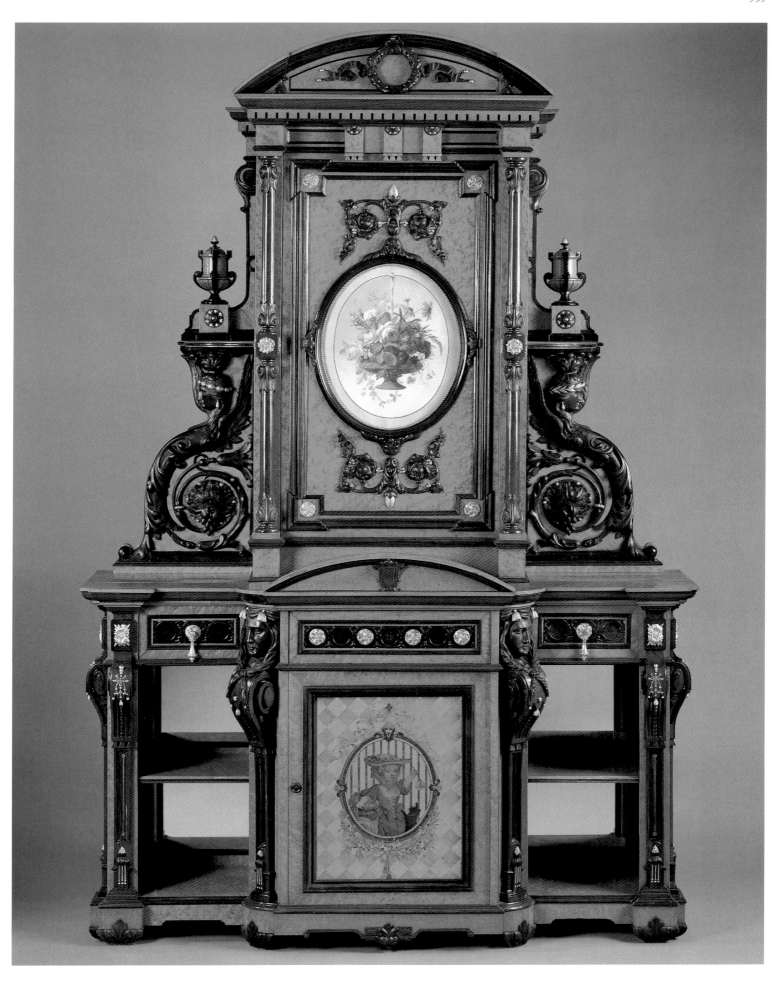

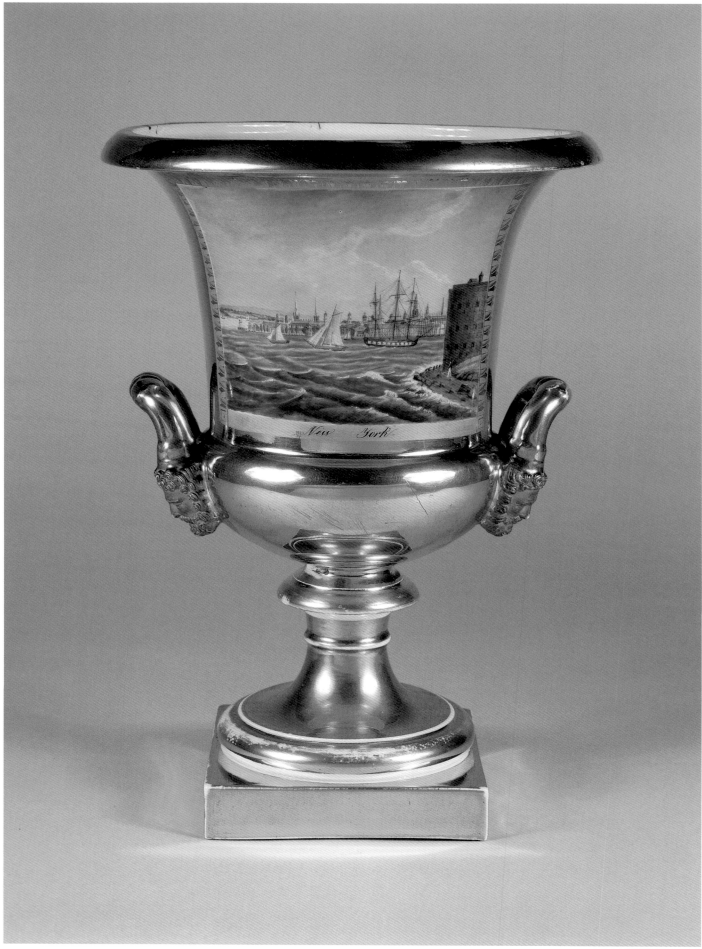

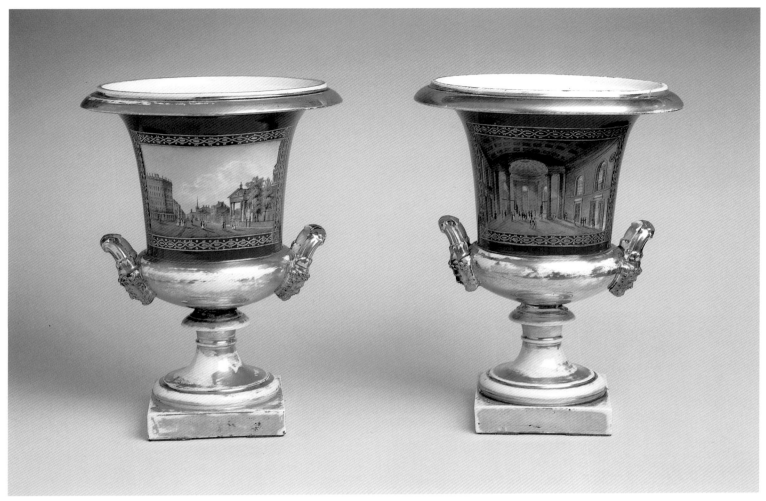

251

MAKER UNKNOWN, *French*
(Paris)

250. Vase depicting New York City from
Governors Island, ca. 1828–30
Porcelain, overglaze enamel
decoration, and gilding
Collection of Mr. and Mrs. Stuart
P. Feld

MAKER UNKNOWN, *French*
(Paris)

251. Pair of vases depicting a scene on
Lower Broadway with Saint Paul's
Chapel and an interior view of
the First Merchants' Exchange,
ca. 1831–35
Porcelain, overglaze enamel
decoration, and gilding
The Metropolitan Museum of Art,
New York, Harris Brisbane Dick
Fund, 1938 38.165.35, 38.165.36

MAKER UNKNOWN, *French*
(probably Limoges)

252. Pair of vases with scenes from
Harriet Beecher Stowe's *Uncle Tom's
Cabin* (1852), ca. 1852–65
Porcelain with gilding
The Newark Museum, Purchase,
1968, Mrs. Parker O. Griffith Fund
68.106a,b

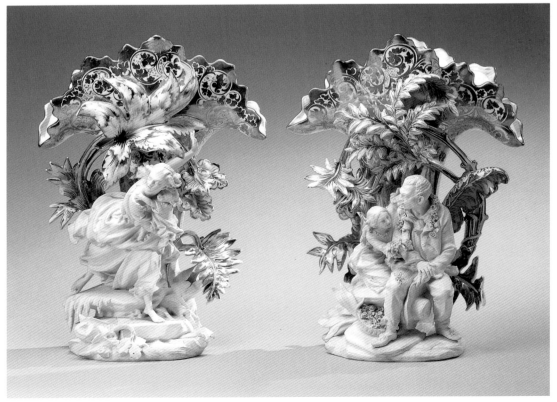

252

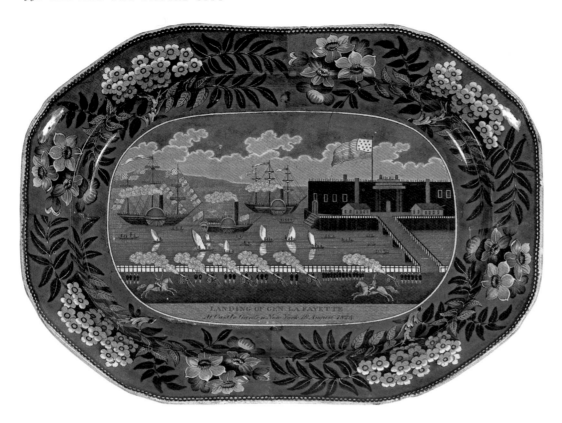

JAMES *and* RALPH CLEWS,
English (Staffordshire)

253. Platter depicting the Marquis de
Lafayette's arrival at Castle Garden,
August 16, 1824, ca. 1825–34
White earthenware with blue
transfer-printed decoration
Museum of the City of New York,
Gift of Mrs. Harry Horton
Benkard 34.508.2

JOSEPH STUBBS, *English
(Longport, Burslem, Staffordshire)*

254. Pitcher depicting City Hall, New
York, ca. 1826–36
White earthenware with blue
transfer-printed decoration
Winterthur Museum, Winterthur,
Delaware, Bequest of Henry F.
du Pont 58.1819

DECASSE AND CHANOU
255. Tea service, 1824–27
Porcelain with gilding
Kaufman Americana Foundation

D. AND J. HENDERSON
FLINT STONEWARE
MANUFACTORY, *Jersey City,
New Jersey*

256. End of the Rabbit Hunt pitcher,
ca. 1828–30
Stoneware, wheel-thrown with
applied decoration
Collection of Mr. and Mrs. Jay
Lewis

D. AND J. HENDERSON
FLINT STONEWARE
MANUFACTORY, *Jersey City,
New Jersey*

257. Acorn and Berry pitcher,
ca. 1830–35
Stoneware, press-molded with
applied decoration
The Metropolitan Museum of Art,
New York, Purchase, Dr. and Mrs.
Burton P. Fabricand Gift, 2000
2000.87

D. AND J. HENDERSON
FLINT STONEWARE
MANUFACTORY, *Jersey City,
New Jersey*

258. Herculaneum pitcher, ca. 1830–33
Stoneware, press-molded with
applied decoration
Collection of Mr. and Mrs. Jay
Lewis

AMERICAN POTTERY
MANUFACTURING
COMPANY, *Jersey City,*
New Jersey
DANIEL GREATBACH,
probable modeler
259. Thistle pitcher, 1838–52
Stoneware, press-molded with
brown Rockingham glaze
The Metropolitan Museum of
Art, New York, Gift of Maude B.
Feld and Samuel B. Feld, 1992
1992.230

AMERICAN POTTERY
MANUFACTURING
COMPANY, *Jersey City,*
New Jersey
260. Vegetable dish, ca. 1833–45
White earthenware, press-molded
with feather-edged and blue
sponged decoration
The Metropolitan Museum of Art,
New York, Purchase, Herbert
and Jeanine Coyne Foundation
and Cranshaw Corporation Gifts,
1997 1997.105

AMERICAN POTTERY
MANUFACTURING
COMPANY, *Jersey City,*
New Jersey
261. Covered hot-milk pot or teapot
and underplate, ca. 1835–45
White earthenware, press-molded
with blue sponged decoration
Collection of Mr. and Mrs. Jay
Lewis

259

260, 261

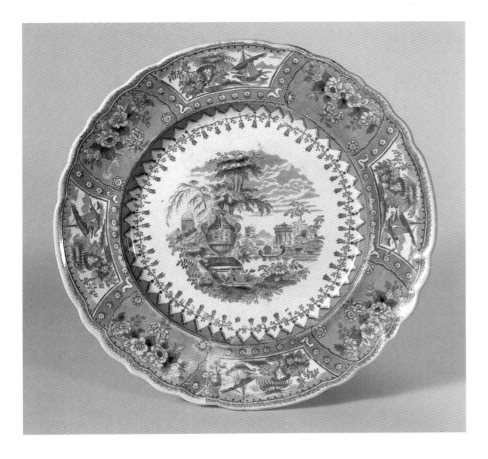

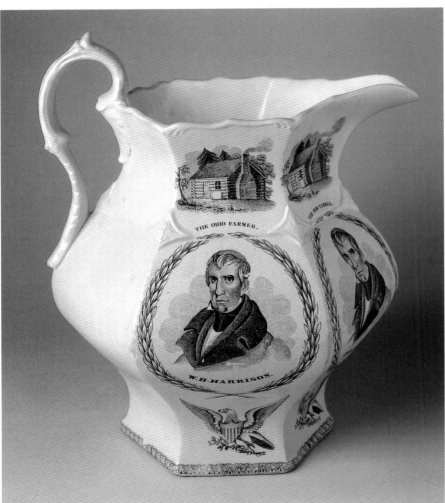

AMERICAN POTTERY
MANUFACTURING
COMPANY, *Jersey City,
New Jersey*

262. Canova plate, 1835–45
White earthenware, press-
molded with blue underglaze
transfer-printed decoration
Brooklyn Museum of Art
50.144

AMERICAN POTTERY
MANUFACTURING
COMPANY, *Jersey City,
New Jersey*
DANIEL GREATBACH,
modeler

263. Pitcher made for William Henry
Harrison's presidential campaign,
1840
Cream-colored earthenware,
press-molded with black
underglaze transfer-printed
decoration
New Jersey State Museum,
Trenton CH1986.11

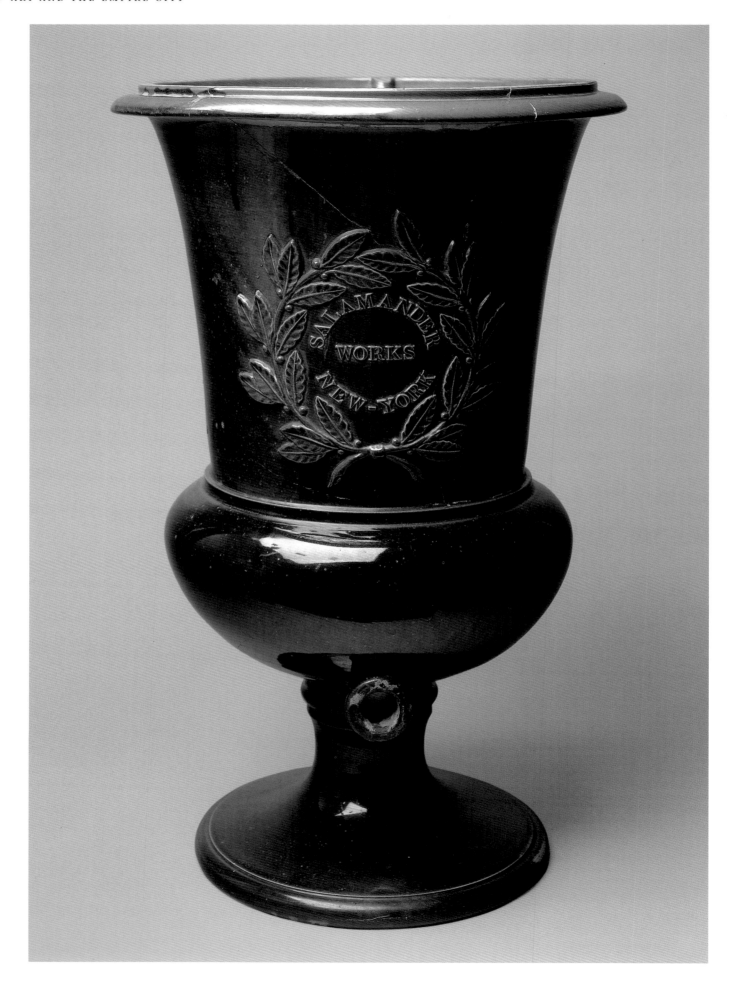

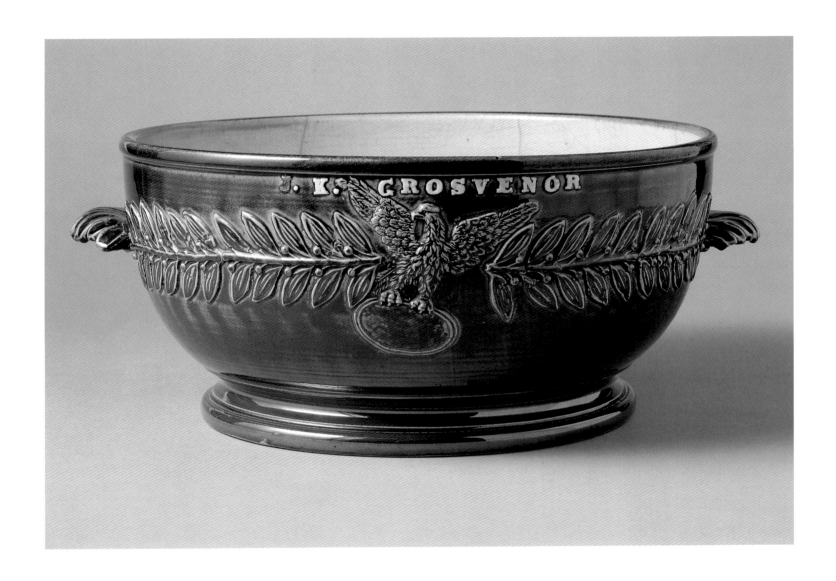

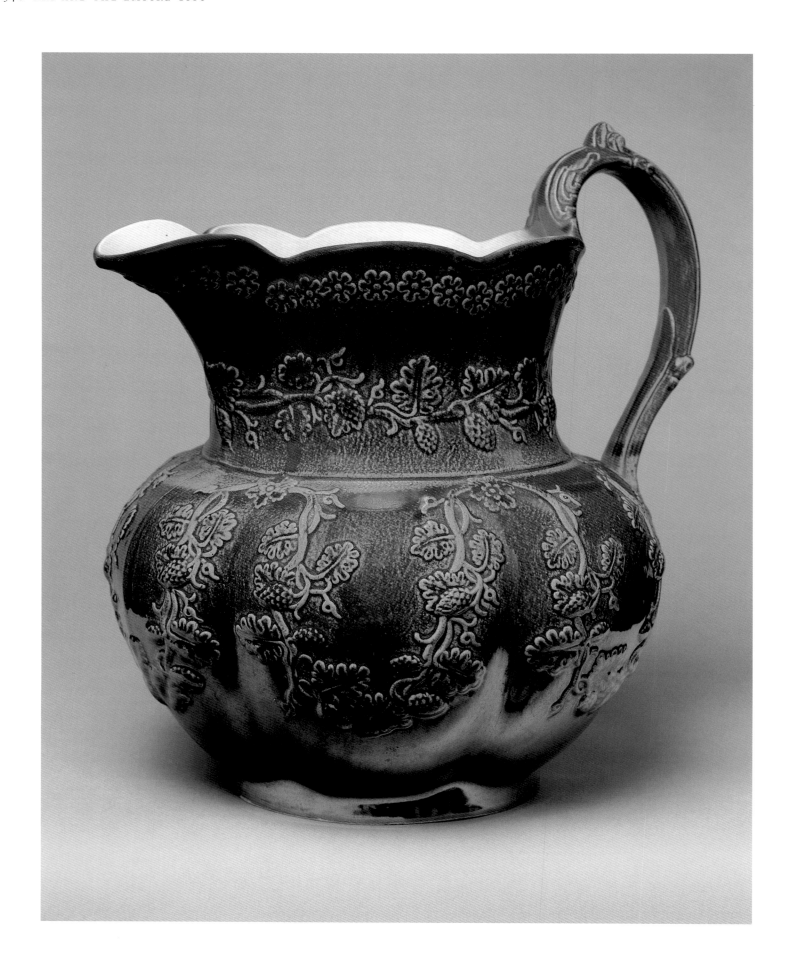

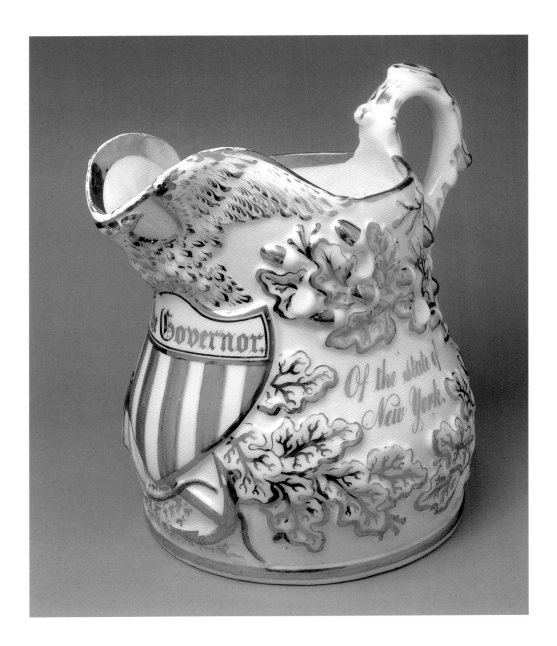

SALAMANDER WORKS, *New York City or Woodbridge, New Jersey*
266. "Spanish" pitcher, ca. 1837–42
Stoneware, press-molded with brown Rockingham glaze
Collection of Arthur F. and Esther Goldberg

CHARLES CARTLIDGE AND COMPANY, *Greenpoint (Brooklyn), New York*
267. Presentation pitcher for the governor of the state of New York from the Manufacturing and Mercantile Union, 1854–56
Porcelain, with overglaze decoration in polychrome enamels and gilding
Collection of Mr. and Mrs. Jay Lewis

268

UNITED STATES POTTERY
COMPANY, *Bennington,
Vermont*

270. Central monument from the
United States Pottery Company
display at the New-York Exhibition
of the Industry of All Nations
(1853–54), 1851–53
Earthenware, including
Rockingham and Flint enamel-
glazed earthenware, scroddled
ware; parian porcelain
Bennington Museum, Bennington,
Vermont 1989.63

CHARLES CARTLIDGE AND
COMPANY, *Greenpoint
(Brooklyn), New York*

268. Pitcher made for the Claremont,
1853–56
Porcelain, with overglaze
decoration in polychrome
enamels and gilding
Museum of the City of New
York, Gift of Miss Dorothy
Rogers and Mrs. Edward H.
Anson 49.44.4

WILLIAM BOCH AND
BROTHERS, *Greenpoint
(Brooklyn), New York*

269. Pitcher, 1844–57
Porcelain
The Metropolitan Museum of
Art, New York, Purchase,
Anonymous Gift, 1968 68.112

269

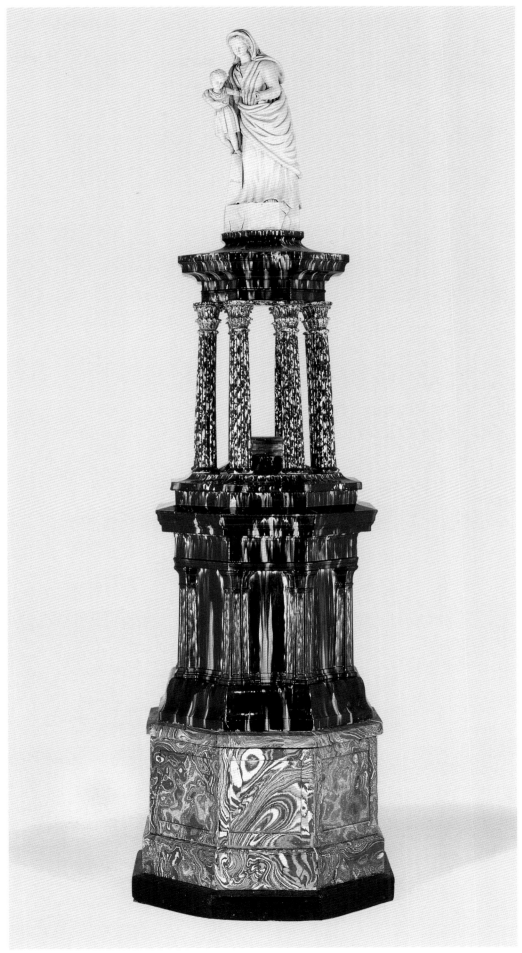

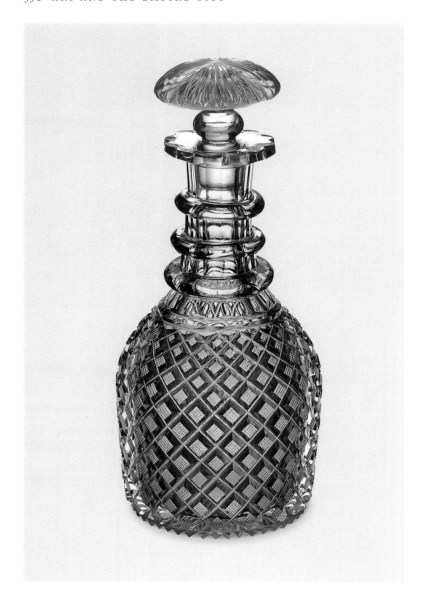

Probably BLOOMINGDALE FLINT
GLASS WORKS *of Richard and John
Fisher, New York City, or* BROOKLYN
FLINT GLASS WORKS *of John
Gilliland, Brooklyn, New York*

271. Decanter (one of a pair), 1825–45
Blown colorless glass, with cut
decoration
Winterthur Museum, Winterthur,
Delaware, Gift of Mr. and Mrs. Robert
Trump 77.0181.001a,b

JERSEY GLASS COMPANY *of
George Dummer, Jersey City, New Jersey*

272. Salt, 1830–40
Pressed green glass
The Metropolitan Museum of Art,
New York, Purchase, Butzi Moffitt
Gift, 1985 1985.129

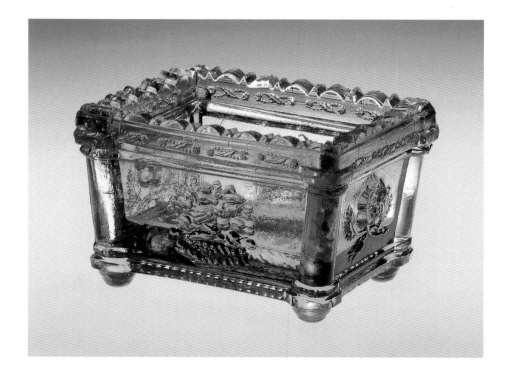

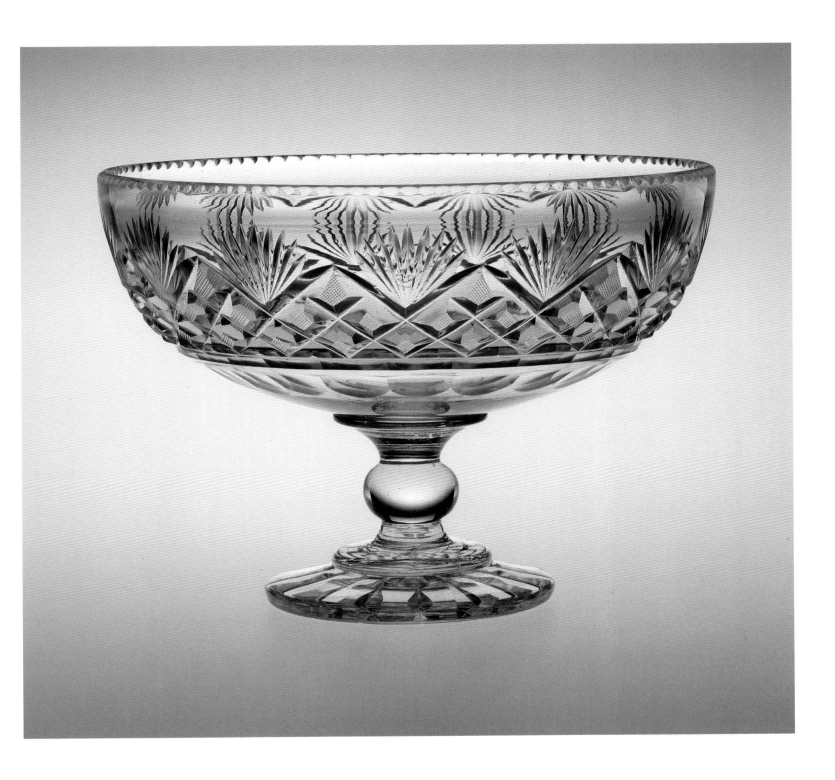

JERSEY GLASS COMPANY *of*
George Dummer, Jersey City, New Jersey
273. Compote, ca. 1830–40
 Blown colorless glass, with cut decoration
 The Corning Museum of Glass,
 Corning, New York 71.4.108

BLOOMINGDALE FLINT GLASS
WORKS *of Richard and John Fisher,
New York City, or* BROOKLYN GLASS
WORKS *of John L. Gilliland, Brooklyn,
New York, or* JERSEY GLASS
COMPANY *of George Dummer, Jersey
City, New Jersey
Possibly cut by* JACKSON AND
BAGGOTT

276. Decanter and wine glasses, ca. 1825–35
Blown green glass, with cut decoration
The Metropolitan Museum of Art,
New York, Gift of Berry B. Tracy, 1972
1972.266.1–7

JERSEY GLASS COMPANY *of
George Dummer, Jersey City, New Jersey*
274. Covered box, ca. 1830–40
Blown colorless glass, with cut
decoration; silver cover
The Corning Museum of Glass,
Corning, New York 71.4.110

JERSEY GLASS COMPANY *of
George Dummer, Jersey City, New Jersey*
275. Oval dish, ca. 1830–40
Blown colorless glass, with cut decoration
The Corning Museum of Glass,
Corning, New York 71.4.113

MAKER UNKNOWN, *New York City area*

277. A selection from a service of table glass made for a member of the Weld family, Albany, 1840–59
Blown colorless glass, with cut and engraved decoration
Albany Institute of History and Art
1984.24.3.1–14

LONG ISLAND FLINT GLASS WORKS *of Christian Dorflinger, Brooklyn, New York*

278. Presentation vase for Mrs. Christian Dorflinger from the Dorflinger Guards, 1859
Blown colorless glass, with cut and engraved decoration
The Metropolitan Museum of Art, New York, Gift of Isabel Lambert Dorflinger, 1988 1988.391.1

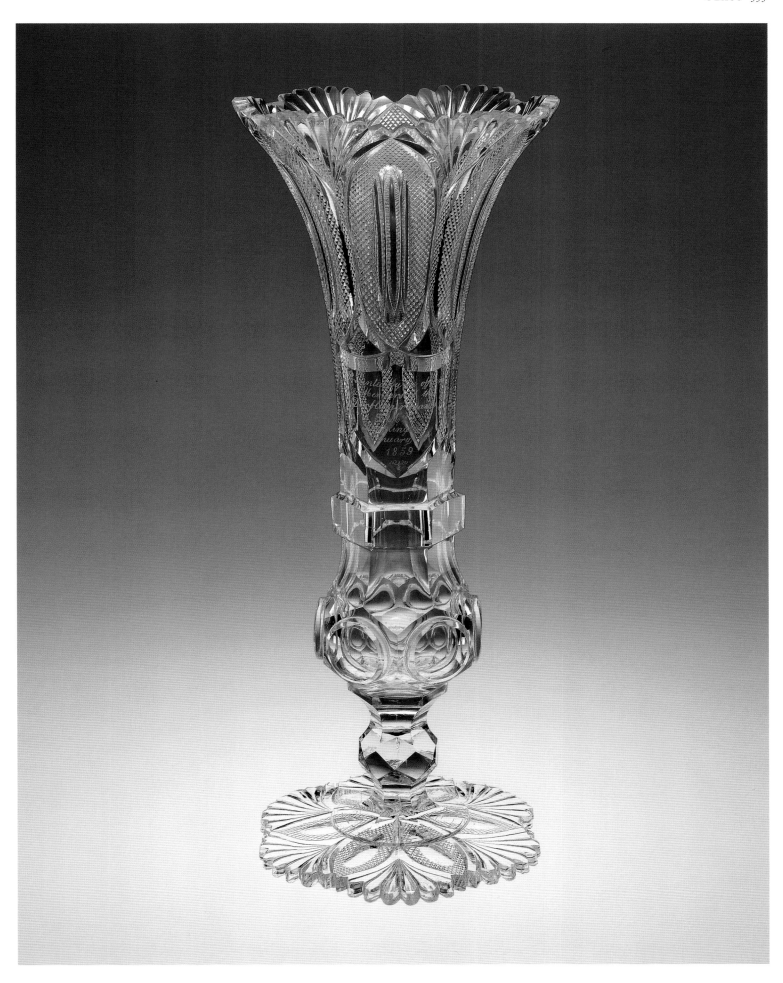

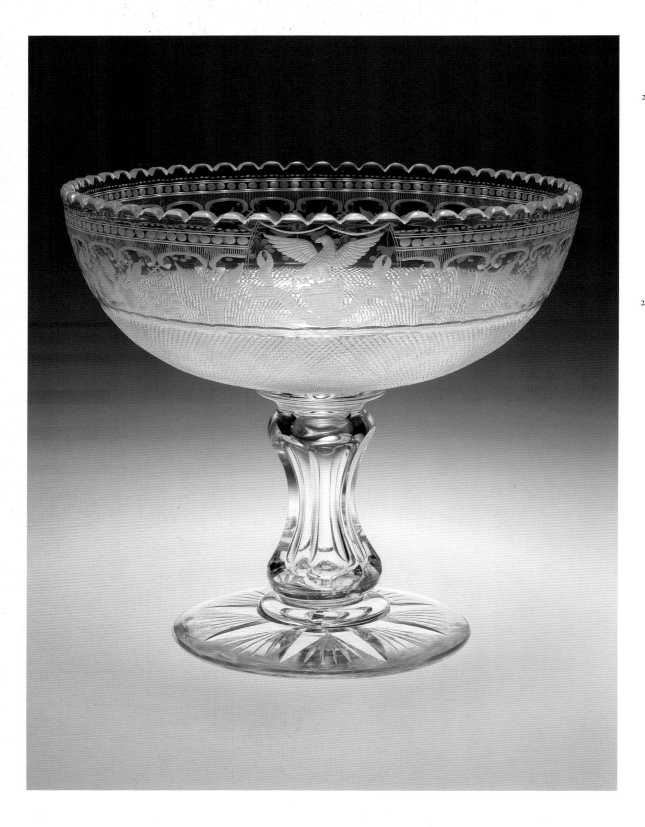

LONG ISLAND FLINT
GLASS WORKS *of*
Christian Dorflinger,
Brooklyn, New York

279. Compote made for the
White House, 1861
Blown colorless glass,
with cut and engraved
decoration
The Metropolitan
Museum of Art, New
York, Gift of Katheryn
Hait Dorflinger Manchee,
1972 1972.232.1

WILLIAM JAY
BOLTON, *assisted by*
JOHN BOLTON

280. *Christ Stills the Tempest,*
one of sixty figural win-
dows made for Holy
Trinity Church (now St.
Ann and the Holy Trinity
Church), Brooklyn,
1844–47
Opaque glass paint,
enamels, and silver stain
on pot-metal glass
St. Ann and the Holy
Trinity Church, Brooklyn,
New York. The window
has been restored with
the support of Catherine
S. Boericke and Francis
T. Chambers, III,
descendants of William
Jay Bolton, and public
funds from The New
York City Department of
Cultural Affairs Cultural
Challenge Program.

281A

ARCHIBALD ROBERTSON, *designer*
CHARLES CUSHING WRIGHT,
engraver and die sinker
Lettering by RICHARD TRESTED, *upon*
die made by WILLIAM WILLIAMS
Struck by MALTBY PELLETREAU,
silversmith

282A, B. Grand Canal Celebration medal and
original box, 1826
Medal: silver; box: bird's-eye maple and
paper
New York State Historical Association,
Cooperstown, gift of James Fenimore
Cooper (1858–1938, grandson of author)
N0361.63(1)

ARCHIBALD ROBERTSON, *designer*
CHARLES CUSHING WRIGHT,
engraver

283A, B. Grand Canal Celebration medal and
presentation case, 1826
Medal: gold; case: wood and red leather
The New-York Historical Society, Gift of
Miss G. Wilbour 1932.68a,b

BALDWIN GARDINER, *silverware*
manufacturer and fancy-hardware
retailer

284. Four-piece tea service, ca. 1830
Silver
Museum of the City of New York, Gift of
Mrs. Arthur Percy Clapp 34.292.1–4

FLETCHER AND GARDINER,
Philadelphia, manufacturing silversmith
THOMAS FLETCHER, *designer*

281A. Presentation vase, 1824
Silver
The Metropolitan Museum of Art,
New York, Purchase, Louis V. Bell
and Rogers Funds; Anonymous and
Robert G. Goelet Gifts; and Gifts
of Fenton L. B. Brown and of the
grandchildren of Mrs. Ranson
Spaford Hooker, in her memory, by
exchange, 1982 1982.4

FLETCHER AND GARDINER,
Philadelphia, manufacturing silversmith
THOMAS FLETCHER, *designer*

281B. Presentation vase, 1825
Silver
The Metropolitan Museum of Art,
New York, Gift of the Erving and
Joyce Wolf Foundation, 1988
1988.199

281B

282A,B

283A,B

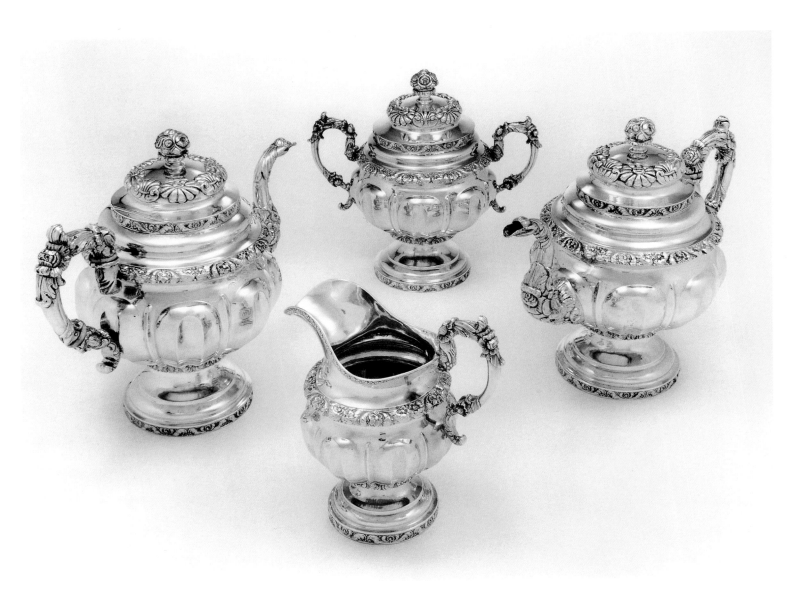

284

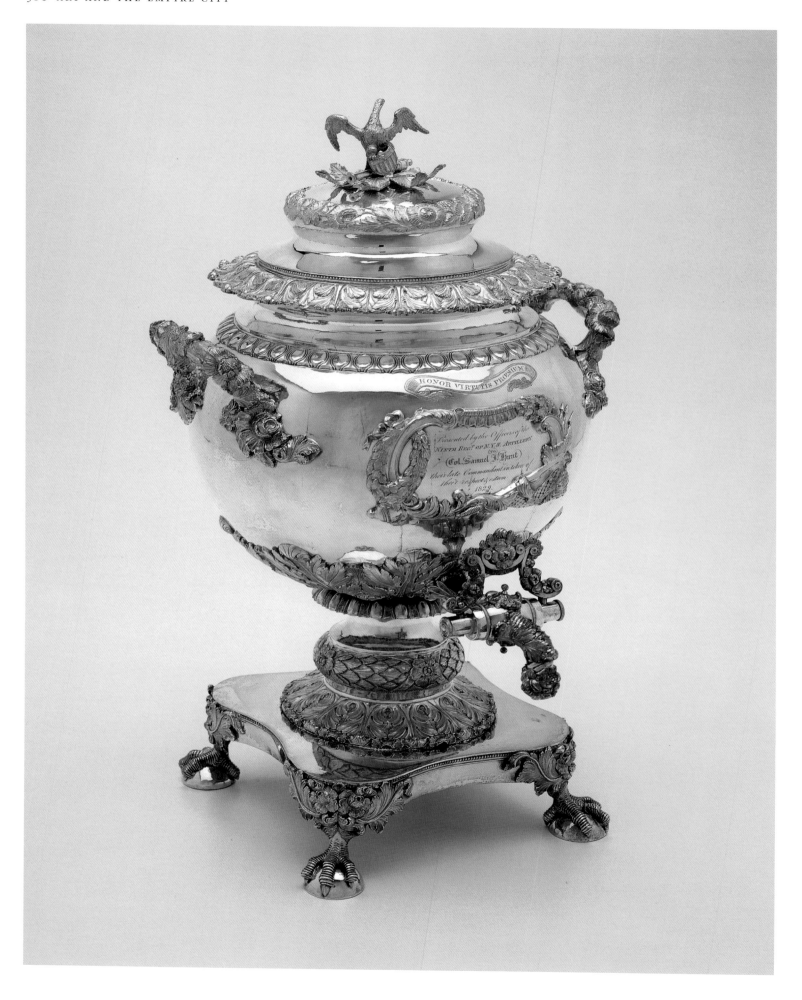

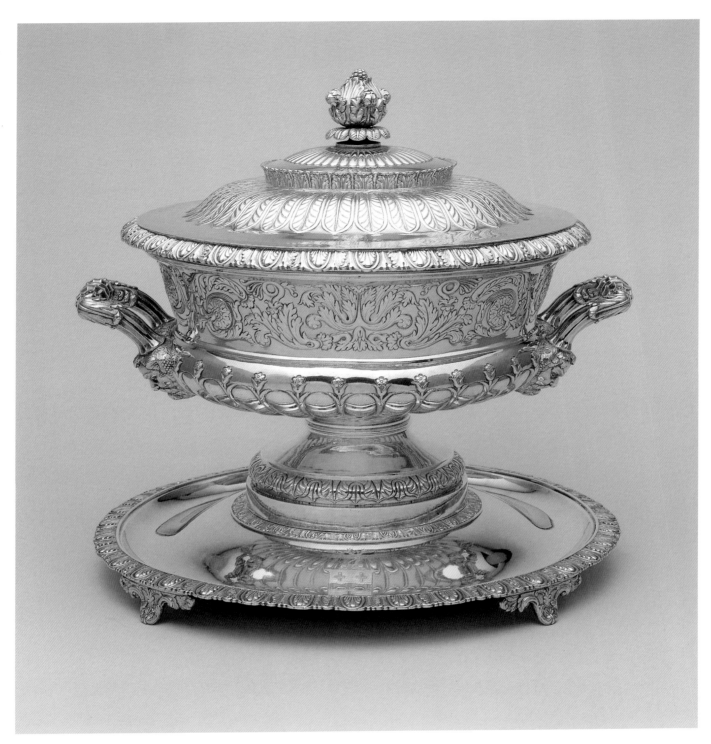

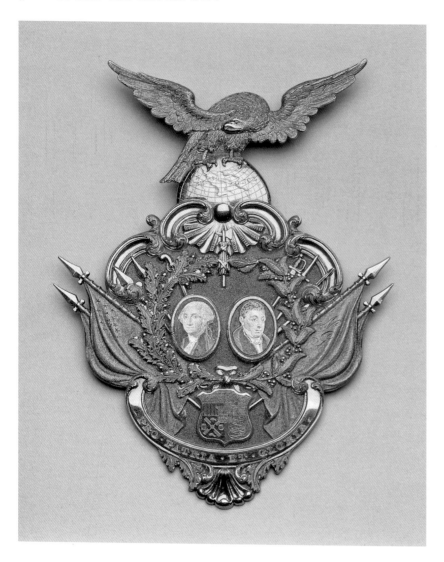

T. BROWN, *designer*
MARQUAND AND BROTHERS, *jeweler*
287. Presentation medal, 1832
Gold
Winterthur Museum, Winterthur, Delaware,
Museum Purchase 78.0113a,b

MARQUAND AND COMPANY, *retail
silversmith and jeweler*
288. Basket, 1833–38
Silver
The Baltimore Museum of Art, Decorative
Arts Fund BMA1988.6

MAKER UNKNOWN, *probably English*
J. AND I. COX (*or* J. AND J. COX),
retailer
289. Pair of argand lamps, ca. 1835
Brass and glass
Dallas Museum of Art 1992.B.152.1,2

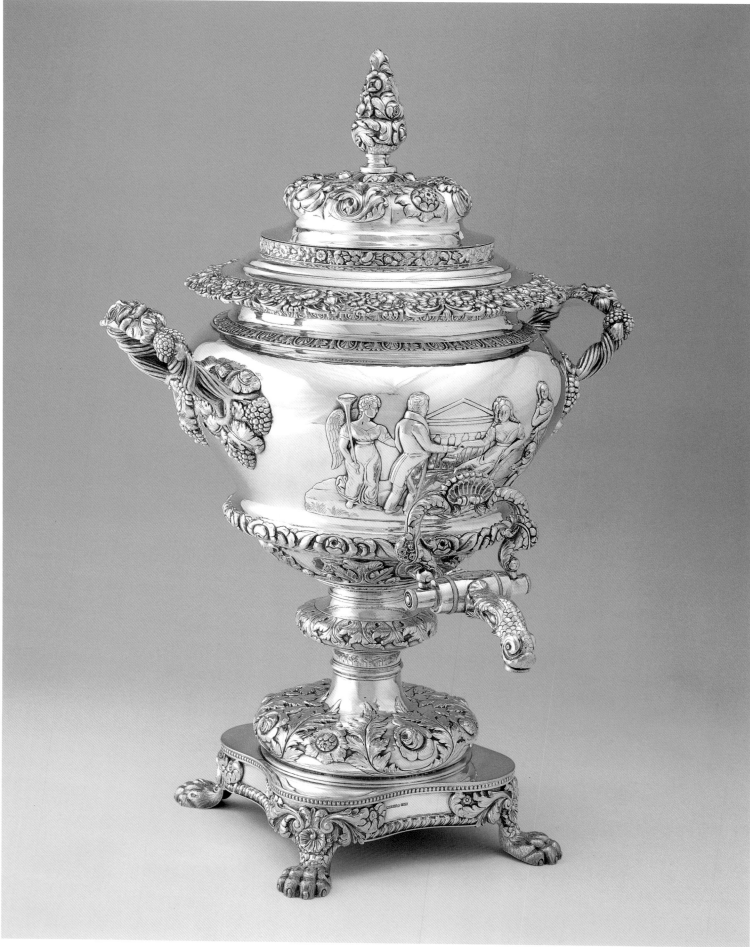

COLIN V. G. FORBES AND
SON, *manufacturing silversmith*

290. Presentation hot-water urn, 1835
Silver; iron heating core
Collection of Mr. and Mrs.
Gerard L. Eastman, Jr.

MORITZ FÜRST, *engraver and
die sinker*

291. Medal (obverse and reverse),
ca. 1838
Silver
The Metropolitan Museum of
Art, New York, Gift of William
Forbes II, 1952 52.113.2

CHARLES CUSHING
WRIGHT, *engraver*
PETER PAUL DUGGAN,
designer

292. American Art-Union medal
depicting Washington Allston,
1847
Bronze
The Metropolitan Museum of
Art, New York, Gift of Janis
Conner and Joel Rosenkranz,
1997 1997.484.1

CHARLES CUSHING
WRIGHT, *engraver*
SALATHIEL ELLIS, *modeler*

293. American Art-Union medal
depicting Gilbert Stuart, 1848
Bronze
The Metropolitan Museum of
Art, New York, Gift of Janis
Conner and Joel Rosenkranz,
1997 1997.484.2

CHARLES CUSHING
WRIGHT, *engraver*
PETER PAUL DUGGAN,
designer

294. Seal of the American Art-Union
(reverse of medal depicting
Gilbert Stuart), 1848
Bronze
The Metropolitan Museum of
Art, New York, Gift of Mr. and
Mrs. F. S. Wait, 1907 1907.07.34

CHARLES CUSHING
WRIGHT, *engraver*
ROBERT BALL HUGHES,
modeler
PETER PAUL DUGGAN,
designer of reverse

295. American Art-Union medal
depicting John Trumbull, 1849
Bronze
The Metropolitan Museum of
Art, New York, Gift of Janis
Conner and Joel Rosenkranz,
1997 1997.484.3

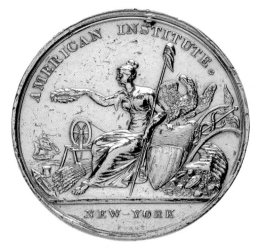

291 (obverse)

291 (reverse)

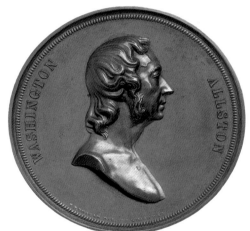

292

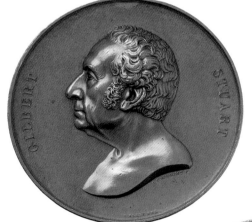

293

294

295

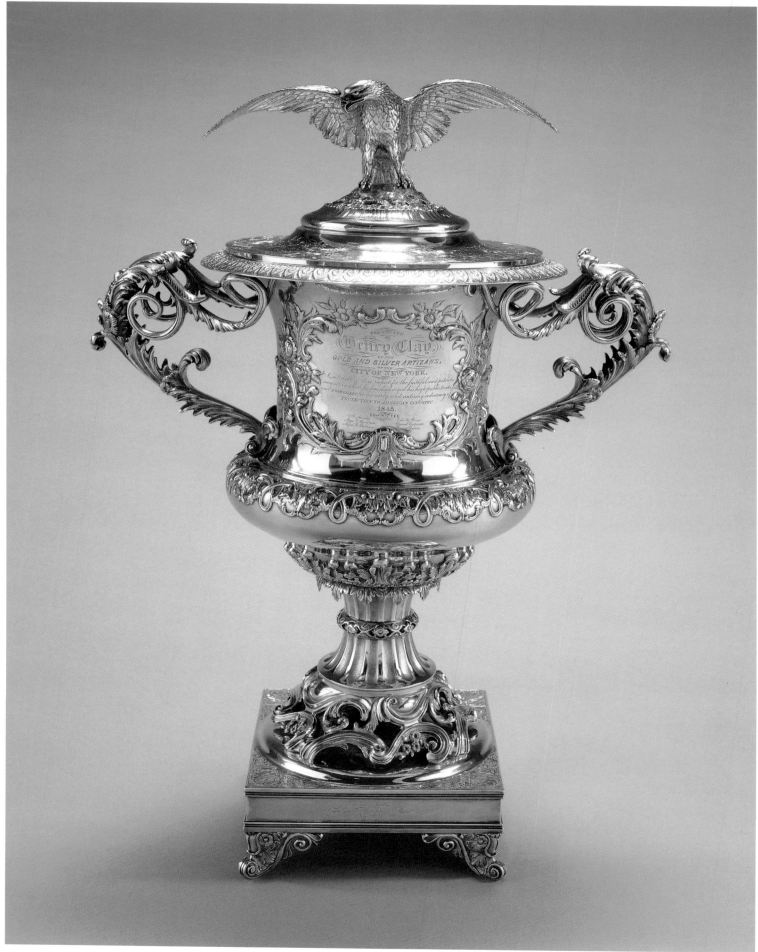

297

WILLIAM ADAMS,
manufacturing silversmith

296. Presentation vase with cover,
1845
Silver
The Henry Clay Memorial
Foundation, located at Ashland,
The Henry Clay Estate in
Lexington, Kentucky. Gift of
Colonel Robert Pepper Clay
88.039a,b

WILLIAM F. LADD,
watchmaker and retail jeweler

297. Trophy pitcher, 1846
Silver
The New-York Historical
Society, Purchase, Lyndhurst
Corporation Abbott-Lenox Fund
1981.19

ZALMON BOSTWICK,
silverware manufacturer

298. Pitcher and goblet, 1845
Silver
Brooklyn Museum of Art, gift of
the Estate of May S. Kelley, by
exchange 81.179.1,2

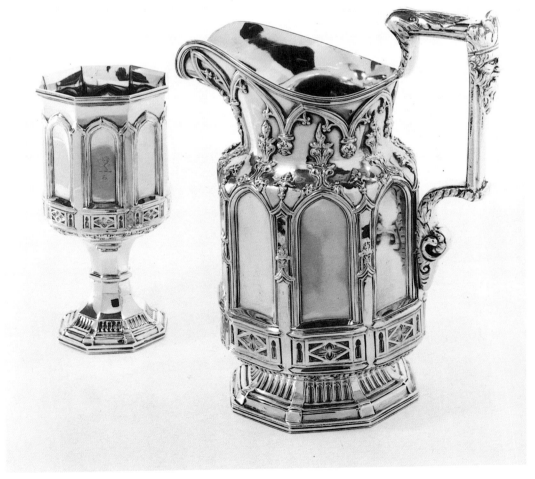

298

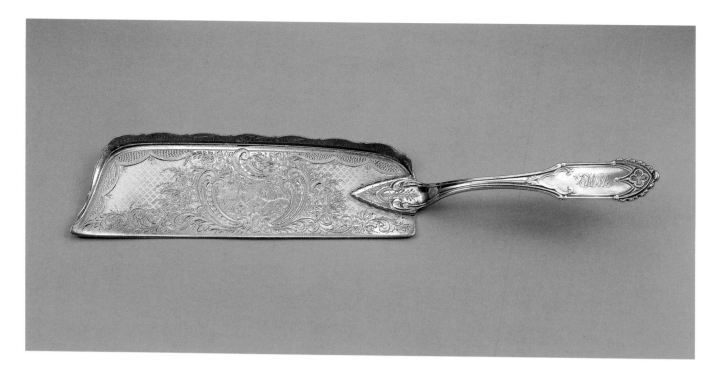

GALE AND HAYDEN,
patentee of design
WILLIAM GALE AND
SON, *manufacturing
silversmith*

299. Gothic-pattern crumber,
design patented 1847
Silver
Collection of Robert
Mehlman

GALE AND HAYDEN,
patentee of design
WILLIAM GALE AND
SON, *manufacturing
silversmith*

300. Gothic-pattern dessert knife,
sugar sifter, fork, and spoon,
design patented 1847, knife
dated 1852, fork 1853, and
spoon 1848
Silver
Dallas Museum of Art
1991.12 (knife), 1991.101.14.1–3
(sifter, fork, and spoon)

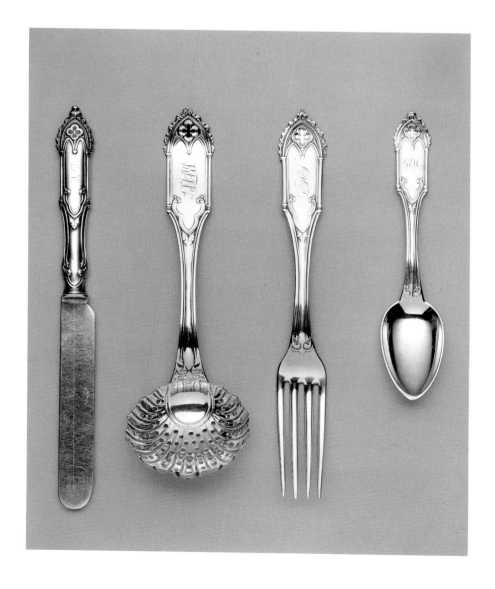

JOHN C. MOORE,
manufacturing silversmith
JAMES DIXON AND
SONS, *English (Sheffield),*
manufacturer of tray
BALL, TOMPKINS AND
BLACK, *retail silversmith*
and jeweler

301. Presentation tea and coffee
service with tray
Silver

Pitcher, 1850
Museum of the City of
New York, gift of Charles
Stedman, Jr. 62.161

Hot-milk pot, 1850
The Metropolitan
Museum of Art, New
York, Gift of Mrs. F. R.
Lefferts, 1969 69.141.3

Hot-water kettle on stand,
1850
The Metropolitan
Museum of Art, New
York, Gift of Mrs. F. R.
Lefferts, 1969 69.141.1a–d

Sugar bowl with cover,
1850
The Metropolitan
Museum of Art, New
York, Gift of Mrs. F. R.
Lefferts, 1969 69.141.2a,b

Tray, ca. 1850
Silver-plated base metal
The Metropolitan
Museum of Art, New
York, Gift of Mrs. F. R.
Lefferts, 1969 69.141.4

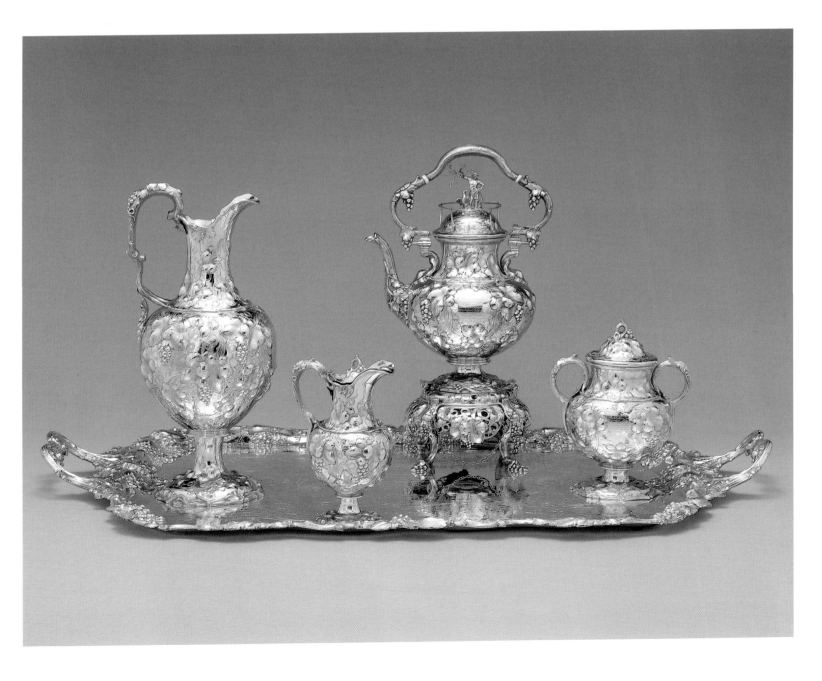

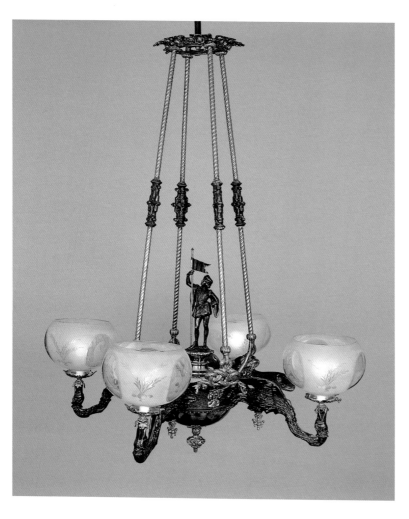

STARR, FELLOWS AND
COMPANY *or* FELLOWS,
HOFFMAN AND
COMPANY

302. Four-branch gasolier with
central figure of Christopher
Columbus, ca. 1857
Patinated spelter, gilt brass,
lacquered brass, iron, and glass
Louisiana State University
Museum of Art, Baton
Rouge, Louisiana, Gift of the
Baton Rouge Coca-Cola
Bottling Company 82.13

DIETZ, BROTHER AND
COMPANY

303. Three-piece girandole set
depicting Louis Kossuth,
leader of the Hungarian
Revolution (1848), 1851
Bronze, lacquer, and brass
The Newark Museum,
Anonymous Gift of Two
Friends of the Decorative
Arts, 1992 92.6a–c

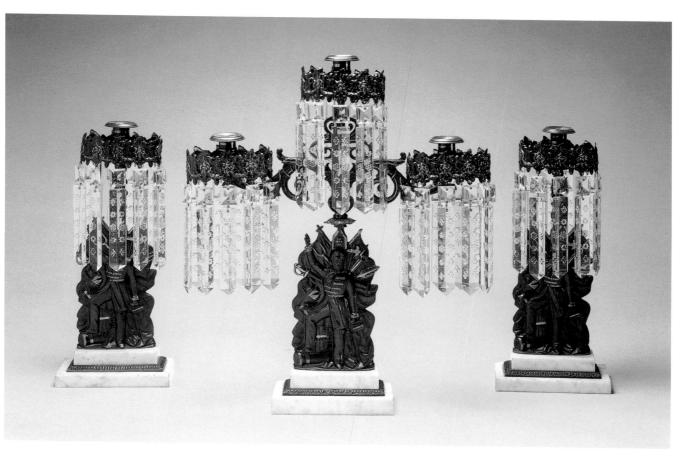

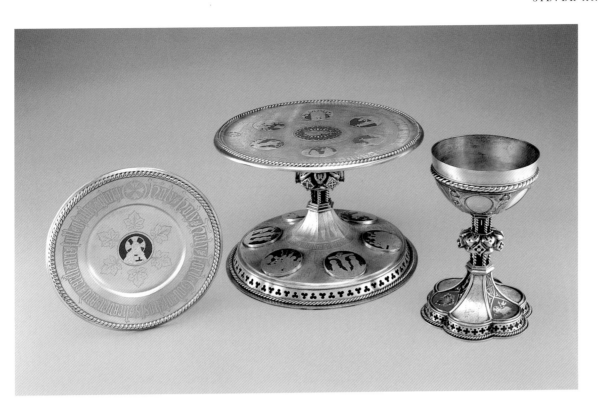

COOPER AND FISHER,
silverware manufacturer

304. Chalice, paten, and footed
paten, 1855–56
Coin and fine silver, gilding,
and enamel
Parish of Trinity Church in the
City of New York 80.14.1–3

WOOD AND HUGHES,
silverware manufacturer

305. Commemorative pitcher,
Kiddush goblets, and tray, 1856
Silver; goblets with gilt interiors
Courtesy of Congregation
Emanu-El of the City of New
York CEE–29–43a,b (pitcher
and tray), CEE–56–1,2 (goblets)

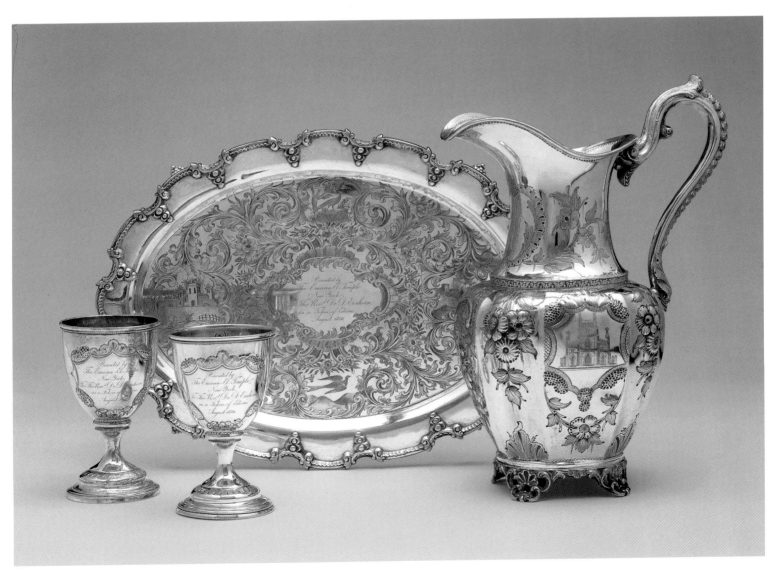

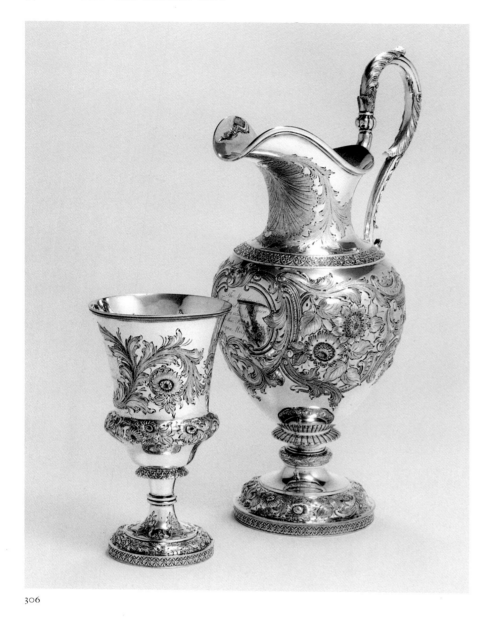

306

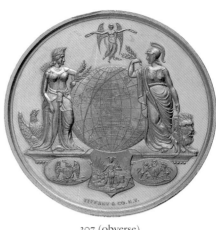

307 (obverse)

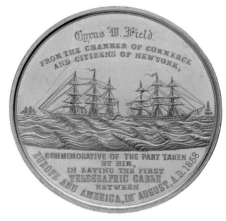

307 (reverse)

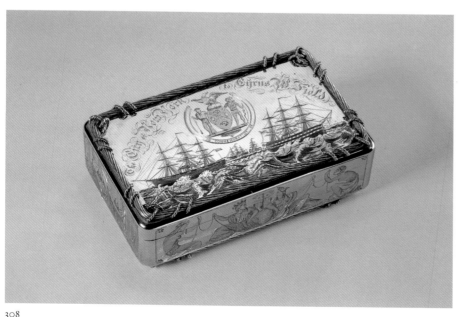

308

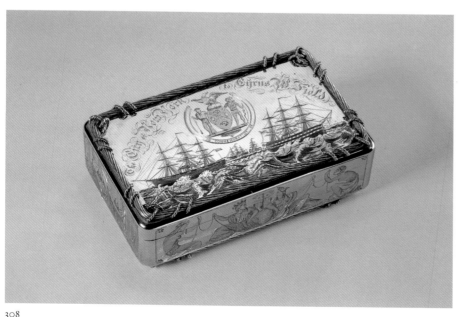

309

WILLIAM FORBES,
manufacturing silversmith
BALL, TOMPKINS AND
BLACK, *retail silversmith and
jeweler*

306. Pitcher and goblet (one of two),
1851
Silver
Museum of the City of
New York, Gift of Frank D.
Morgans 54.97.1a,b

TIFFANY AND COMPANY,
*manufacturing and retail
silversmith and jeweler*

307. Medal (obverse and reverse),
1859
Gold
The Metropolitan Museum of
Art, New York, Gift of Cyrus
W. Field, 1892 92.10.3

TIFFANY AND COMPANY,
*manufacturing and retail
silversmith and jeweler*

308. Presentation box, 1859
Gold
The Metropolitan Museum of
Art, New York, Gift of Cyrus
W. Field, 1892 92.10.7

TIFFANY AND COMPANY,
*manufacturing and retail
silversmith and jeweler*

309. Mounted section of
transatlantic telegraph
cable, 1858
Steel and brass
Collection of D. Albert
Soeffing

TIFFANY AND COMPANY,
*manufacturing and retail
silversmith and jeweler*

310. Pitcher from a service presented
to Colonel Abram Duryee of
the Seventh Regiment, New
York National Guard, by his
fellow citizens, 1859
Sterling silver
Museum of the City of New
York, Bequest of Emily
Frances Whitney Briggs
55.257.5

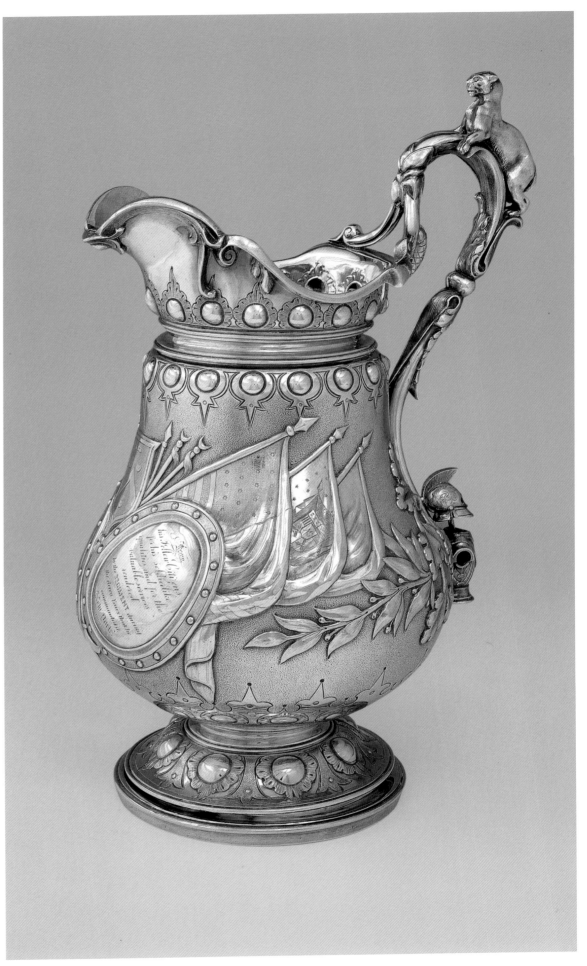

310

Checklist of the Exhibition

John Trumbull, 1756–1843
1. *Alexander Hamilton,* 1792
Oil on canvas
86¼ x 57½ in. (219.1 x 146.1 cm)
Donaldson, Lufkin & Jenrette Collection of
Americana, New York 81.11
Commissioned by the New York Chamber
of Commerce

Samuel F. B. Morse, 1791–1872
2. *Marquis de Lafayette (Marie-Joseph-Paul-Yves-
Roch-Gilbert du Motier de Lafayette),* 1825–26
Oil on canvas
96 x 64 in. (243.8 x 162.6 cm)
Signed at bottom right: Morse
Collection of the City of New York, courtesy of
the Art Commission of the City of New York
Commissioned by the City of New York

John Wesley Jarvis, 1780–1840
3. *Washington Irving,* 1809
Oil on panel
33 x 26 in. (83.8 x 66 cm)
Historic Hudson Valley, Tarrytown, New
York ss.62.2

Samuel F. B. Morse, 1791–1872
4. *De Witt Clinton,* 1826
Oil on canvas
30 x 25⅛ in. (76.2 x 63.8 cm)
The Metropolitan Museum of Art, New York,
Rogers Fund, 1909 09.18
Exhibited at the National Academy of Design
in 1826, the year Morse became its president

Samuel F. B. Morse, 1791–1872
5. *Fitz-Greene Halleck,* 1828
Oil on canvas
29⅞ x 24⅞ in. (75.9 x 63.2 cm)
The New York Public Library, Astor, Lenox
and Tilden Foundations

Samuel F. B. Morse, 1791–1872
6. *William Cullen Bryant,* 1828–29
Oil on canvas
30 x 24⅞ in. (76.2 x 63.2 cm)
National Academy of Design, New York 892–P

Charles Cromwell Ingham, born Ireland,
1796–1863
7. *Gulian Crommelin Verplanck,* ca. 1830
Oil on canvas
30 x 25¼ in. (76.2 x 64.1 cm)
Signed at lower right: C.C. Ingham pinxᵗ;
on verso: C.C. Ingham pinxᵗ New York
The New-York Historical Society, Gift of
Members of the Society 1878.2

Asher B. Durand, 1796–1886
8. *Self-Portrait,* ca. 1835
Oil on canvas
30⅛ x 25¼ in. (76.5 x 64.1 cm)
National Academy of Design, New York 384–P

Asher B. Durand, 1796–1886
9. *Luman Reed,* 1835–36
Oil on canvas
30⅛ x 25⅜ in. (76.5 x 64.5 cm)
The Metropolitan Museum of Art, New York,
Bequest of Mary Fuller Wilson, 1962 63.36

Asher B. Durand, 1796–1886
10. *Thomas Cole,* 1837
Oil on canvas
30⅛ x 25 in. (76.5 x 63.5 cm)
The Berkshire Museum, Pittsfield,
Massachusetts 1917.13

Henry Inman, 1801–1846
11. *Georgianna Buckham and Her Mother,* 1839
Oil on canvas
34⅛ x 27⅛ in. (86.7 x 68.9 cm)
Museum of Fine Arts, Boston, Bequest of
Georgianna Buckham Wright 19.1370

Henry Inman, 1801–1846
12. *Dr. George Buckham,* 1839
Oil on canvas
34 x 27 in. (86.4 x 68.6 cm)
Worcester Art Museum, Worcester,
Massachusetts, Bequest of Georgianna
Buckham Wright 1921.84

Frederick R. Spencer, 1806–1875
13. *Family Group,* 1840
Oil on canvas
29¼ x 36 in. (74.3 x 91.4 cm)
Signed and dated at lower right: Painted by
F.R. Spencer/1840
Brooklyn Museum of Art, Dick S. Ramsay
Fund 57.68
Exhibited at the Cosmopolitan Art Association
in 1856

Nathaniel Rogers, 1787–1844
14. *Mrs. Stephen Van Rensselaer III (Cornelia
Paterson),* 1820s
Watercolor on ivory
3¼ x 2½ in. (8.3 x 6.2 cm)
Signed along center right edge: N Rogers. N.Y.
Inscribed on backing paper: Mrs Stephen
Van Rensselaer/(Cornelia Paterson)/Manor
House/Albany/by N. Rogers
The Metropolitan Museum of Art, New York,
Morris K. Jesup Fund, 1932 32.68

Henry Inman, 1801–1846, and Thomas Seir
Cummings, 1804–1894
15. *Portrait of a Lady,* ca. 1825
Watercolor on ivory
3⅜ x 2⅜ in. (8.6 x 6 cm)
Signed along right edge: Inman &
Cummings
The Metropolitan Museum of Art, New York,
Dale T. Johnson Fund, 1996 1996.562

Nathaniel Rogers, 1787–1844
16. *John Ludlow Morton,* ca. 1829
Watercolor on ivory
3 x 2¼ in. (7.6 x 5.7 cm)
Inscribed on label on verso: John Ludlow
Morton/(1792–1871)/by Nathaniel Rogers
Lent by Gloria Manney

Thomas Seir Cummings, 1804–1894
17. *Gustavus Adolphus Rollins,* ca. 1835
Watercolor on ivory
2⅞ x 2⅜ in. (7.3 x 6 cm) sight
Signed along left edge: Cummings
The Metropolitan Museum of Art, New York,
Gift of E. A. Rollins, through his son, A. C.
Rollins, 1933 27.216

Edward S. Dodge, 1816–1857
18. *John Wood Dodge,* ca. 1836–37
Watercolor on ivory
3 x 2½ in. (7.6 x 6.4 cm)
Stamped on mat at lower right: E. S. Dodge/
Artist
Lent by Gloria Manney

James Whitehorne, 1803–1888
19. *Nancy Kellogg,* 1838
Watercolor on ivory
3⅛ x 2⅝ in. (7.9 x 6.7 cm)
Signed and dated on backing paper: J.
Whitehorne Pxt/1838
Lent by Gloria Manney

John Wood Dodge, 1807–1893
20. *Kate Roselie Dodge,* 1854
Watercolor on ivory; original mat in new frame
3 x 2½ in. (7.6 x 6.4 cm) sight
Signed, dated, and inscribed on verso:
Likeness of (aged 8 years)/ Kate Roselie
Dodge,/Painted from Life, by/her Father/
John W. Dodge./St. Louis, Mo/Finished
July 18th/1854
Printed on trade card (cut in pieces as spacers) in
frame: J. W. Dodge/Artist/No. 362 BROADWAY
The Metropolitan Museum of Art, New York,
Morris K. Jesup Fund, 1988 1988.280

Attributed to Samuel Lovett Waldo, 1783–1861
21. *Portrait of a Girl,* after 1854
Oil on panel
4⅝ x 3¾ in. (11.7 x 9.5 cm)

Signed at lower right: SAMUEL L. WALDO.
The Metropolitan Museum of Art, New York,
Fletcher Fund, 1938 38.146.5

Thomas Seir Cummings, 1804–1894
22. *A Mother's Pearls (Portraits of the Artist's Children)*, 1841
Watercolor on ivory
L. 17½ in. (44.5 cm)
The Metropolitan Museum of Art, New York,
Gift of Mrs. Richard B. Hartshorne and Miss
Fanny S. Cummings (through Miss Estelle
Hartshorne), 1928 28.148.1
Exhibited at the National Academy of Design
in 1841

AMERICAN PAINTINGS

Thomas Cole, born England, 1801–1848
23. *View of the Round-Top in the Catskill Mountains*, ca. 1827
Oil on panel
18⅝ x 25⅜ in. (47.3 x 64.5 cm)
Signed at lower center: Cole
Museum of Fine Arts, Boston, Gift of
Martha C. Karolik for the M. and M. Karolik
Collection of American Paintings, 1815–1865
47.1200
Originally owned by Henry Ward; exhibited
at the National Academy of Design in 1828

Thomas Cole, born England, 1801–1848
24. *Scene from "The Last of the Mohicans": Cora Kneeling at the Feet of Tamenund*, 1827
Oil on canvas
25 x 35 in. (63.5 x 88.9 cm)
Signed on rock at lower center: T. Cole. 1827
Wadsworth Atheneum, Hartford, Connecticut,
Bequest of Alfred Smith 1868.3
Based on James Fenimore Cooper's novel
(1826); exhibited at the National Academy of
Design in 1828

Asher B. Durand, 1796–1886
25. *Dance on the Battery in the Presence of Peter Stuyvesant*, 1838
Oil on canvas
32 x 46½ in. (81.3 x 118.1 cm)
Museum of the City of New York, Gift of
Jane Rutherford Faile through Kenneth C.
Faile, 1955 55.248
Scene from *A History of New-York* by
Washington Irving (under the pseudonym
Diedrich Knickerbocker; 1809); exhibited
at the National Academy of Design in 1838
and at the New York Gallery of the Fine
Arts in 1844

John Quidor, 1801–1881
26. *The Money Diggers*, 1832
Oil on canvas
16¾ x 21½ in. (42.5 x 54.6 cm)
Signed, dated, and inscribed at center right:
J. Quidor Pinxt/N. York June, 1832
Brooklyn Museum of Art, Gift of Mr. and
Mrs. Alastair B. Martin 48.171

Scene from Washington Irving's *Tales of a Traveller* (1824); exhibited at the National
Academy of Design in 1833

Robert Walter Weir, 1803–1889
27. *A Visit from Saint Nicholas*, ca. 1837
Oil on panel
30 x 24⅜ in. (76.2 x 61.9 cm)
The New-York Historical Society, Gift of
George A. Zabriskie, 1951 1951.76
Related to a scene from Clement Clarke
Moore's poem (1823) and to the description
of Saint Nicholas in *A History of New-York* by
Washington Irving (under the pseudonym
Diedrich Knickerbocker; 1809)

William Sidney Mount, 1807–1868
28. *Eel Spearing at Setauket (Recollections of Early Days—"Fishing along Shore")*, 1845
Oil on canvas
28½ x 36 in. (72.4 x 91.4 cm)
Signed and dated at lower right: Wm. S.
Mount/1845
New York State Historical Association,
Cooperstown, Gift of Stephen C. Clark
Commissioned by George Washington
Strong; exhibited at the National Academy
of Design in 1846

George Caleb Bingham, 1811–1879
29. *Fur Traders Descending the Missouri*, 1845
Oil on canvas
29 x 36½ in. (73.7 x 92.7 cm)
The Metropolitan Museum of Art, New York,
Morris K. Jesup Fund, 1933 33.61
Exhibited at the American Art-Union in
1845; awarded to Robert S. Bunker of Mobile,
Alabama, at the Art-Union's annual distribution
of prizes in 1845

Asher B. Durand, 1796–1886
30. *Kindred Spirits*, 1849
Oil on canvas
46 x 36 in. (116.8 x 91.4 cm)
Signed and dated at lower left: A. B. Durand /
1849
Inscribed on a tree at left: Bryant /Cole
The New York Public Library, Gift of Julia Bryant
Commissioned by Jonathan Sturges as a gift
to William Cullen Bryant; exhibited at the
National Academy of Design in 1849

Asher B. Durand, 1796–1886
31. *In the Woods*, 1855
Oil on canvas
60¾ x 48 in. (154.3 x 121.9 cm)
Signed and dated at lower right: A.B. Durand /
1855
The Metropolitan Museum of Art, New York,
Gift in memory of Jonathan Sturges by his
children, 1895 95.13.1
Commissioned by Jonathan Sturges

Charles Cromwell Ingham, born Ireland,
1796–1863
32. *The Flower Girl*, 1846
Oil on canvas
36 x 28⅞ in. (91.4 x 73.3 cm)

Signed and dated on basket handle: C.C.
Ingham/1846
The Metropolitan Museum of Art, New York,
Gift of William Church Osborn, 1902 02.7.1
Exhibited at the National Academy of Design
in 1847; owned thereafter by Jonathan Sturges

Lilly Martin Spencer, 1822–1902
33. *Kiss Me and You'll Kiss the 'Lasses*, 1856
Oil on canvas
30⅛ x 25⅛ in. (76.5 x 63.8 cm)
Signed and dated at lower right: Lilly M.
Spencer/1856
Brooklyn Museum of Art, A. Augustus Healy
Fund 70.26
Exhibited at the Cosmopolitan Art Association
in 1856; awarded to E. A. Carmen of Newark,
New Jersey, at the Association's annual
distribution of prizes in the same year

Emanuel Leutze, born Germany, 1816–1868
34. *Mrs. Schuyler Burning Her Wheat Fields on the Approach of the British*, 1852
Oil on canvas
32 x 40 in. (81.3 x 101.6 cm)
Signed and dated at lower left: E. Leutze. 1852
The Los Angeles County Museum of Art,
Bicentennial Gift of Mr. and Mrs. J. M. Schaaf,
Mr. and Mrs. William D. Witherspoon, Mr.
and Mrs. Charles M. Shoemaker, and Mr. and
Mrs. Julian Ganz, Jr. M.76.91
Scene from Elizabeth F. Ellet's *Eminent and Heroic Women of America* (New York, 1846);
owned by Charles M. Leupp and sold at the
noted public auction of his estate in 1860

Fitz Hugh Lane, 1804–1865
35. *New York Harbor*, 1850
Oil on canvas
36 x 60¼ in. (91.4 x 153 cm)
Signed and dated at lower right: Fitz H.
Lane./1850.
Museum of Fine Arts, Boston, Gift of Maxim
Karolik for the M. and M. Karolik Collection
of American Paintings, 1815–1865 48.446
A smaller version of this painting was exhibited at the American Art-Union in 1850.

Sanford Robinson Gifford, 1823–1880
36. *Lake Nemi*, 1856–57
Oil on canvas
39⅝ x 60⅜ in. (100.6 x 153.4 cm)
Signed and dated on reverse (covered by
lining canvas): Nemi/S. R. Gifford/Rome
1856–57
The Toledo Museum of Art, Toledo, Ohio;
Purchased with funds from the Florence Scott
Libbey Bequest in Memory of her Father,
Maurice A. Scott 1957.46
Exhibited at the National Academy of Design
in 1858

John F. Kensett, 1816–1872
37. *Beacon Rock, Newport Harbor*, 1857
Oil on canvas
22½ x 36 in. (57.2 x 91.4 cm)

National Gallery of Art, Washington, D.C.,
Gift of Frederick Sturges, Jr. 1953.1.1
Owned by Jonathan Sturges

James H. Cafferty, 1819–1869, and Charles G.
Rosenberg, 1818–1879
38. *Wall Street, Half Past 2 O'Clock, October 13,
1857,* 1858
Oil on canvas
50 x 39½ in. (127 x 100.3 cm)
Signed and dated on risers of steps at lower
left: Cafferty 58/Rosenberg
Museum of the City of New York, Gift of the
Honorable Irwin Untermyer 40.54
Exhibited at the National Academy of Design
in 1858

Francis William Edmonds, 1806–1863
39. *The New Bonnet,* 1858
Oil on canvas
25 x 30⅛ in. (63.5 x 76.5 cm)
Signed and dated at lower left: FW Edmonds/
1858
Inscribed: on label on frame, SCHAUS/FINE
ART/REPOSITORY,/749 Broadway,/NEW
YORK; on paper fragment on frame, The
[New] Bonnet/F. W. Edm[ond]s.
The Metropolitan Museum of Art, New York,
Purchase, Erving Wolf Foundation Gift and
Gift of Hanson K. Corning, by exchange,
1975 1975.27.1
Exhibited at the National Academy of Design
in 1859

Eastman Johnson, 1824–1906
40. *Negro Life at the South,* 1859
Oil on canvas
36 x 45¼ in. (91.4 x 114.9 cm)
Signed and dated at lower right: E. Johnson/1859
The New-York Historical Society, The Robert L.
Stuart Collection, on permanent loan from
The New York Public Library s–225
Exhibited at the National Academy of Design
in 1859; owned by William P. Wright of
Weehawken, New Jersey, and subsequently
by Robert L. Stuart of New York City

Frederic E. Church, 1826–1900
41. *The Heart of the Andes,* 1859
Oil on canvas
66⅛ x 119¼ in. (168 x 302.9 cm)
Signed and dated on tree at lower left: 1859/
F.E. CHURCH
The Metropolitan Museum of Art, New York,
Bequest of Margaret E. Dows, 1909 09.95
Exhibited in New York at the Tenth Street
Studio Building in 1859; subsequently toured
Europe for two years, including a much-
heralded show in London; purchased by
William T. Blodgett for $10,000

FOREIGN PAINTINGS

Giovanni di Ser Giovanni di Simone (called
Scheggia), Italian (Florence), 1407–1487
42. *The Triumph of Fame,* birth tray of Lorenzo
de'Medici (recto); *Arms of the Medici and*

Tornabuoni Families (verso), 1449
Tempera, silver, and gold on wood
Diam. 36½ in. (92.7 cm) overall with engaged
frame
The Metropolitan Museum of Art, New
York, Purchase in memory of Sir John Pope-
Hennessy: Rogers Fund, The Annenberg
Foundation, Drue Heinz Foundation,
Annette de la Renta, Mr. and Mrs. Frank E.
Richardson, and The Vincent Astor Founda-
tion Gifts, Wrightsman and Gwynne Andrews
Funds, special funds, and Gift of the children
of Mrs. Harry Payne Whitney, Gift of Mr.
and Mrs. Joshua Logan, and other gifts and
bequests, by exchange, 1995 1995.7
Owned by Thomas Jefferson Bryan, who
established the Bryan Gallery of Christian
Art in 1852

David Teniers the Younger, Flemish, 1610–1690
43. *Judith with the Head of Holofernes,* 1650s
Oil on copper
14½ x 10⅜ in. (36.8 x 26.4 cm)
Signed at upper right: O·Teniers·F
The Metropolitan Museum of Art, New York,
Gift of Gouverneur Kemble, 1872 72.2
Owned and exhibited in New York City by
John Trumbull, president of the American
Academy of the Fine Arts

Bartolomé Esteban Murillo, Spanish, 1617–1682
44. *Four Figures on a Step (A Spanish Peasant
Family),* ca. 1655–60
Oil on canvas
43¼ x 56½ in. (109.9 x 143.5 cm)
Kimbell Art Museum, Fort Worth, Texas
AP1984.18
Exhibited by the London dealer Richard
Abraham at the American Academy of the
Fine Arts in 1830

Jan Abrahamsz. Beerstraten, Dutch, 1622–1666
45. *Winter Scene,* ca. 1660
Oil on canvas
35½ x 52 in. (90.2 x 132.1 cm)
Signed at lower left: J. BEERSTRATEN
The New-York Historical Society, Gift of
Thomas J. Bryan, 1867 1867.84
Owned by Thomas Jefferson Bryan, who
established the Bryan Gallery of Christian
Art in 1852

Artist unknown, after Willem Kalf, Dutch,
1619–1693
46. *Still Life with Chinese Sugarbowl, Nautilus Cup,
Glasses, and Fruit,* ca. 1675–1700
Oil on canvas
32 x 27 in. (81.3 x 68.6 cm)
The New-York Historical Society, Luman
Reed Collection—New-York Gallery of Fine
Arts 1858.15
Owned by Luman Reed

Jacob van Ruisdael, Dutch, 1628/29–1682
47. *A Landscape with a Ruined Castle and a
Church (A Grand Landscape),* 1665–70
Oil on canvas

43 x 57½ in. (109.2 x 146.1 cm)
Signed in water at bottom right:
JvRuisdael
The National Gallery, London NG990
Exhibited by the London dealer Richard
Abraham at the American Academy of the
Fine Arts in 1830

Giovanni Paolo Panini (or Pannini), Italian
(Rome), 1691–1765
48. *Modern Rome,* 1757
Oil on canvas
67¾ x 91¾ in. (172.1 x 233 cm)
Signed and dated on base of statue of Moses
at lower center: I.P. PANINI.1757
The Metropolitan Museum of Art, New York,
Gwynne Andrews Fund, 1952 52.63.2
Replica of a painting of the same title
exhibited at the American Academy of the
Fine Arts in 1834

J. M. W. Turner, British, 1775–1851
49. *Staffa, Fingal's Cave,* exhibited 1832
Oil on canvas
35¾ x 47¾ in. (90.8 x 121.3 cm)
Signed lower right: JMW Turner RA
Yale Center for British Art, New Haven,
Connecticut, Paul Mellon Collection
B1978.43.14
Purchased by James Lenox in 1845

Andreas Achenbach, German, 1815–1910
50. *Clearing Up—Coast of Sicily,* 1847
Oil on canvas
32½ x 45¾ in. (82.6 x 116.2 cm)
Signed and dated at lower left: A. Achenbach./
1847
The Walters Art Gallery, Baltimore WAG37.116
Exhibited at the Düsseldorf Gallery between
1849 and 1857

Rosa Bonheur, French, 1822–1899
51. *The Horse Fair,* 1853; retouched 1855
Oil on canvas
96¼ x 199½ in. (244.5 x 506.7 cm)
Signed and dated at lower right: Rosa
Bonheur 1853.5.
The Metropolitan Museum of Art, New York,
Gift of Cornelius Vanderbilt, 1887 87.25
Exhibited by the London dealer Ernest
Gambart at Williams, Stevens and Williams
in 1857–58; purchased at the exhibition by
William P. Wright of Weehawken, New Jersey

FOREIGN SCULPTURE

Giuseppe Ceracchi, Italian, 1751–1802
52. *George Washington,* Philadelphia, 1795
Marble
28⅞ x 23½ x 13½ in. (73.3 x 59.7 x 34.3 cm)
Signed and dated on back: Ceracchi faciebat/
Philadelphia/1795
The Metropolitan Museum of Art, New
York, Bequest of John L. Cadwalader, 1914
14.58.235

Exhibited along with Richard Worsam Meade's collection of European paintings at the National Academy of Design in 1831

Jean-Antoine Houdon, French, 1741–1828
53. *Robert Fulton*, Paris, 1803–4
Painted plaster
26⅞ x 15⅜ x 12 in. (68.3 x 39.1 x 30.5 cm)
Signed on right shoulder: houdon f
The Metropolitan Museum of Art, New York, Wrightsman Fund, 1989 1989.329
A version of this bust was in the cast collection of the American Academy of the Fine Arts.

Bertel Thorvaldsen, Danish, 1770–1844
54. *Ganymede and the Eagle*, Rome, 1817–29
Marble
37¼ x 46⅝ x 19½ in. (94.6 x 118.4 x 49.5 cm)
Signed on back of base, at right: THOR-WALDSEN/FECIT
The Minneapolis Institute of Arts, Gift of the Morse Foundation 66.9
Exhibited at the New-York Exhibition of the Industry of All Nations, 1853–54

AMERICAN SCULPTURE

Hiram Powers, 1805–1873
55. *Andrew Jackson*, modeled in Washington, D.C., 1834–35; carved in Florence 1839
Marble
34¾ x 23½ x 15½ in. (88.3 x 59.7 x 39.4 cm)
Signed on back: HIRAM POWERS/Sculp.
The Metropolitan Museum of Art, New York, Gift of Mrs. Frances V. Nash, 1894 94.14
Exhibited with Powers's *Greek Slave* at the Lyceum Gallery in 1849

John Frazee, 1790–1852
56. *Nathaniel Prime*, 1832–34
Marble
28½ x 19 x 9 in. (72.4 x 48.3 x 22.9 cm)
National Portrait Gallery, Smithsonian Institution, Washington, D.C., Gift of Sylvester G. Prime NPG.84.72
Probably commissioned by Samuel Ward and James Gore King as a retirement gift to Prime

Robert Ball Hughes, 1806–1868
57. *John Trumbull*, modeled ca. 1833; carved 1834–after 1840
Marble
30 x 20¼ x 9¼ in. (76.2 x 51.4 x 23.5 cm)
Yale University Art Gallery, New Haven, Connecticut, University Purchase 1851.2

Shobal Vail Clevenger, 1812–1843
58. *Philip Hone*, modeled 1839; carved in Florence 1844–46
Marble
31⅞ x 22¾ x 14⅝ in. (81 x 57.8 x 37.1 cm)
Signed on back: S. V. CLEVENGER./Sculptor
Inscribed: on front of socle, PHILIP HONE; on top of original pedestal, PRESENTED BY

"A NUMBER OF MERCHANTS OF NEW-YORK" TO THE M. L. A. 1846.
Mercantile Library Association, New York

Thomas Crawford, ca. 1813–1857
59. *Genius of Mirth*, Rome, modeled 1842; carved 1843
Marble
47 x 20 x 24 in. (119.4 x 50.8 x 61 cm)
Signed and dated on front of base: CRAWFORD_FECIT [;] ROMÆ_MDCCCXLIII_
The Metropolitan Museum of Art, New York, Bequest of Annette W. W. Hicks-Lord, 1896 97.13.1
Commissioned by Henry W. Hicks and exhibited at the National Academy of Design in 1844

Hiram Powers, 1805–1873
60. *Greek Slave*, Florence, modeled 1841–43; carved 1847
Marble
H. 65½ in. (166.4 cm); diam. (base) 19 in. (48.3 cm)
Signed and dated on base: Hiram Powers/Sculp./L'anno 1847
The Newark Museum, Gift of Franklin Murphy, Jr., 1926 26.2755
First exhibited in New York City in 1847 at the National Academy of Design, and then at the New-York Exhibition of the Industry of All Nations in 1853–54

Henry Kirke Brown, 1814–1886
61. *William Cullen Bryant*, 1846–47
Marble
26⅞ x 18½ x 11 in. (67 x 47 x 27.9 cm)
Inscribed on brass plaque on socle: WILLIAM CULLEN BRYANT/HENRY K. BROWN
The New-York Historical Society, Bequest of Mr. Charles M. Leupp 1860.6
Commissioned by Charles M. Leupp and exhibited at the National Academy of Design in 1849

Henry Kirke Brown, 1814–1886
62. *Thomas Cole*, 1850 or earlier
Marble
28 x 18 x 12 in. (71.1 x 45.7 x 30.5 cm)
The Metropolitan Museum of Art, New York, Gift in memory of Jonathan Sturges, by his children, 1895 95.8.1
Probably commissioned by Jonathan Sturges; exhibited at the National Academy of Design in 1850

Thomas Crawford, ca. 1813–1857
63. *Louisa Ward Crawford*, Rome, modeled 1845; carved 1846
Marble
31 x 21 x 12 in. (78.7 x 53.3 x 30.5 cm)
Signed, dated, and inscribed on back of base: SI NOMEN QVAERIS/SVM ALOYSIA/MARITVS ME SCVLPSIT/THOMA/DE NOMINE CRAWFORD/CVM NATA ET CONIVGE/IVNGIT

CARVS AMOR/DVLCES ROMA DAT/LARES/MDCCXLVII
Museum of the City of New York, Gift of James L. Terry, Peter T. Terry, Lawrence Terry, and Arthur Terry III 86.173
Exhibited at the American Art-Union in 1849 and at the New-York Exhibition of the Industry of All Nations in 1853–54

Chauncey Bradley Ives, 1810–1894
64. *Ruth*, Rome, modeled ca. 1849; carved 1851 or later
Marble
23¼ x 12½ x 9½ in. (59.1 x 31.8 x 24.1 cm)
Signed on back: C. B. IVES/FECIT.ROMÆ
Chrysler Museum of Art, Norfolk, Virginia, Gift of James H. Ricau and Museum Purchase 86.479
A version of this sculpture was exhibited at the artist's studio in Stoppani's building, 398 Broadway, in 1849; four replicas were commissioned by New Yorkers.

Joseph Mozier, 1812–1870
65. *Diana*, Florence, ca. 1850
Marble
26 x 16⅛ x 10¼ in. (66 x 41 x 26 cm)
Huguenot Historical Society, New Paltz, New York
Commissioned by the American Art-Union in 1850; awarded to Levi Hasbrouck, New Paltz, New York, at the Art-Union's annual distribution of prizes in 1850

Henry Kirke Brown, 1814–1886
66. *Filatrice*, 1850
Bronze
20 x 12 x 8 in. (50.8 x 30.5 x 20.3 cm)
The Metropolitan Museum of Art, New York, Purchase, Gifts in memory of James R. Graham, and Morris K. Jesup Fund, 1993 1993.13
Multiple casts of this figure were awarded by the American Art-Union to various recipients at its annual distribution of prizes in 1850.

John Rogers, 1829–1904
67. *The Slave Auction*, 1859
Painted plaster
13⅜ x 8 x 8¾ in. (34 x 20.3 x 22.2 cm)
Signed on top of base at center: JOHN ROGERS/NEW YORK
Inscribed: on front of base, THE SLAVE AUCTION; on rostrum, GREAT SALE/OF/HORSES CATTLE/NEGROES & OTHER/FARM STOCK/THIS DAY AT/PUBLIC AUCTION
The New-York Historical Society, Gift of Samuel V. Hoffman 1928.28
Exhibited at the National Academy of Design in 1860; examples owned by New York abolitionists Lewis Tappan and Henry Ward Beecher

John Quincy Adams Ward, 1830–1910
68. *The Indian Hunter*, modeled 1857–60; cast before 1910
Bronze
16⅛ x 10½ x 15¼ in. (41 x 26.7 x 38.7 cm)

Signed and dated on top of base, beneath
dog: J.Q.A. WARD/1860
The Metropolitan Museum of Art, New York,
Morris K. Jesup Fund, 1973 1973.257
Exhibited at the Artists' Fund Society in 1859
and at the National Academy of Design in 1862

Erastus Dow Palmer, 1817–1904

69. *The White Captive*, Albany, modeled 1857–58;
carved 1858–59
Marble
65 x 20¼ x 17 in. (165.1 x 51.4 x 43.2 cm)
Signed and dated on left side of base: E.D.
PALMER SC. 1859.
Inscribed on front of base: THE GIFT OF
HAMILTON FISH
The Metropolitan Museum of Art, New York,
Bequest of Hamilton Fish, 1894 94.9.3
Commissioned by Hamilton Fish and displayed
at the gallery of William Schaus in 1859–60

ARCHITECTURAL DRAWINGS AND RELATED WORKS

Alexander Jackson Davis, 1803–1892, artist
Anthony Imbert, French, active in New York
City 1825–38, lithographer
Design attributed to John Vanderlyn, 1775–1852

70. *The Rotunda, Corner of Chambers and Cross
Streets,* frontispiece to *Views of the Public
Buildings in the City of New-York,* 1827
Building constructed 1818; demolished 1870
Lithograph
19½ x 15⅞ in. (49.5 x 40.3 cm)
Inscribed: Views/Prosper Desobry Scripsit./
OF/THE PUBLIC BUILDINGS/in the/City of
New-York/Correctly drawn on Stone by/A. J.
DAVIS./Printed & Published/by/A. IMBERT/
Lithographer Nº. 79 Murray St./NEW-YORK
The New-York Historical Society, A. J. Davis
Collection 25

Alexander Jackson Davis, 1803–1892, artist
Anthony Imbert, French, active in New York
City 1825–38, lithographer
Martin Euclid Thompson, ca. 1786–1877,
architect

71. *Branch Bank of the United States, 15–17 Wall
Street,* from *Views of the Public Buildings in the
City of New-York,* 1827
Building constructed 1822–24; demolished
1915; facade reerected at The Metropolitan
Museum of Art, New York, 1924
Lithograph
12⅝ x 14⅞ in. (32.1 x 37.8 cm)
Inscribed: On Stone by A. J. Davis.[;] E.M.
[*sic*] Thompson Architect New York[;]
Imbert's Lithography./BRANCH BANK OF
U.S./Erected 1825,–Front 75 feet.
The Metropolitan Museum of Art, New York,
The Edward W. C. Arnold Collection of New
York Prints, Maps, and Pictures, Bequest of
Edward W. C. Arnold, 1954 54.90.672

Alexander Jackson Davis, 1803–1892, artist
Anthony Imbert, French, active in New York
City 1825–38, lithographer
Josiah R. Brady, ca. 1760–1832, architect

72. *Second Congregational (Unitarian) Church, Cor-
ner of Prince and Mercer Streets,* from *Views of
the Public Buildings in the City of New-York,* 1827
Building constructed 1826; destroyed by fire
1837
Lithograph
10¼ x 11⅞ in. (26 x 30.2 cm)
Inscribed: A. J. Davis del.[;] J. R. Brady
Architect[;] Imbert's Lithography/SECOND
CONGREGATIONAL CHURCH N. Y./Erected
1826 corner of Prince and Mercer Streets—
Front Sixty three feet.
The New-York Historical Society

Alexander Jackson Davis, 1803–1892, artist
and architect
Anthony Imbert, French, active in New York
City 1825–38, lithographer

73. *Design for Improving the Old Almshouse, North
Side of City Hall Park, Facing Chambers Street,*
1828
Building constructed 1778; destroyed by fire
1853
Lithograph
18 x 22¼ in. (45.7 x 56.5 cm)
Inscribed: DESIGN FOR IMPROVING THE OLD
ALMS-HOUSE/PARK, NEW-YORK:/BY ALEX J.
DAVIS, EXCHANGE./Imbert's Lithograph[y]
[illegible]
The Metropolitan Museum of Art, New York,
The Elisha Whittelsey Collection, The Elisha
Whittelsey Fund, 1954 54.546.9

Alexander Jackson Davis, 1803–1892, artist
Martin Euclid Thompson, ca. 1786–1877, and
Josiah R. Brady, ca. 1760–1832, architects

74. *First Merchants' Exchange, 35–37 Wall Street,
Elevation,* probably 1826
Building constructed 1825–27; destroyed in
the Great Fire of 1835
Ink and wash
8⅛ x 10½ in. (20.6 x 26.7 cm)
Signed at lower right: JR. Brady Arcᵗ
Inscribed: EXCHANGE./Drawn by Davis, 1826
[partially erased]
The Metropolitan Museum of Art, New York,
The Edward W. C. Arnold Collection of New
York Prints, Maps, and Pictures, Bequest of
Edward W. C. Arnold, 1954 54.90.137

Alexander Jackson Davis, 1803–1892, artist
Martin Euclid Thompson, ca. 1786–1877, and
Josiah R. Brady, ca. 1760–1832, architects

75. *First Merchants' Exchange, 35–37 Wall Street,
First Floor Plan,* probably 1829
Building constructed 1825–27; destroyed in
the Great Fire of 1835
Ink and wash
11¼ x 9 in. (28.6 x 22.9 cm)
Inscribed (probably later): J. R. BRADY,
ARCHITECT./MERCH'TS EXCHANGE, N.Y./
BURNT DEC. 1835

The Metropolitan Museum of Art, New York,
Harris Brisbane Dick Fund, 1924 24.66.622
(recto)

Alexander Jackson Davis, 1803–1892

76. *First Merchants' Exchange, 35–37 Wall Street,
Alternate, Unexecuted Elevation and Plan,* 1829
Building constructed 1825–27; destroyed in
the Great Fire of 1835
Ink and wash
10 x 6⅝ in. (25.4 x 16.8 cm)
Inscribed: EXCHANGE DESIGN. BY A.J. DAVIS
The Metropolitan Museum of Art, New York,
Harris Brisbane Dick Fund, 1924 24.66.621

Alexander Jackson Davis, 1803–1892, artist
Ithiel Town, 1784–1844, and Alexander
Jackson Davis, architects

77. *Park Hotel (Later Called Astor House),
Broadway between Vesey and Barclay Streets,
Proposed, Unexecuted Design,* 1830
Building constructed 1834–36; demolished
in stages in 1913 and 1926
Watercolor
20⅜ x 31½ in. (51.8 x 80 cm)
The Metropolitan Museum of Art, New York,
Harris Brisbane Dick Fund, 1924 24.66.30
Commissioned by John Jacob Astor for this
site and ultimately designed by Isaiah Rogers

Alexander Jackson Davis, 1803–1892, artist
Ithiel Town, 1784–1844, and Alexander
Jackson Davis, architects

78. *Park Hotel (Later Called Astor House), Broadway
between Vesey and Barclay Streets, Proposed,
Unexecuted Perspective and Plan,* ca. 1830
Building constructed 1834–36; demolished in
stages in 1913 and 1926
Watercolor
18¾ x 12⅝ in. (47.6 x 32.1 cm)
Inscribed (probably later): DESIGN FOR A
HOTEL, N.Y. MADE IN 1828 / BY ALEXANDER
JACKSON DAVIS
The New-York Historical Society, A. J. Davis
Collection 18

Alexander Jackson Davis, 1803–1892, artist
Ithiel Town, 1784–1844, and Alexander
Jackson Davis, architects

79. *United States Custom House, Wall and Nassau
Streets, Longitudinal Section,* 1833
Building constructed 1833–42; extant
Watercolor and ink
8½ x 14⅜ in. (21.6 x 36.5 cm)
Inscribed: A. J. Davis. del. for CUSTOM HOUSE
N.Y. LONGITUDINAL SECTION. Premium
Design./TOWN & DAVIS ARCHITECTS
Avery Architectural and Fine Arts Library,
Columbia University, New York
1940.001.00132

Alexander Jackson Davis, 1803–1892, artist
Ithiel Town, 1784–1844, and Alexander
Jackson Davis, architects

80. *United States Custom House, Wall and Nassau
Streets, Plan,* 1833

Building constructed 1833–42; extant
Watercolor
9 x 14⅜ in. (22.9 x 36.5 cm)
The Metropolitan Museum of Art, New
York, Harris Brisbane Dick Fund, 1924
24.66.1403 (45)

Alexander Jackson Davis, 1803–1892, artist
Ithiel Town, 1784–1844, and Alexander
Jackson Davis, architects

81. *United States Custom House, Wall and Nassau
Streets, Perspective,* 1834
Building constructed 1833–42; extant
Watercolor
6⅝ x 9½ in. (16.8 x 24.1 cm)
Inscribed: June 1834[;] Custom House N.
York[;] I. Town. and A. J. Davis Architects.[;]
Alex J. Davis to J. Jones, Esq.
The Metropolitan Museum of Art, New York,
The Edward W. C. Arnold Collection of New
York Prints, Maps, and Pictures, Bequest of
Edward W. C. Arnold, 1954 54.90.176

John Haviland, British, 1792–1852, active in
the United States from 1816

82. *Halls of Justice and House of Detention, Centre
Street, between Leonard and Franklin Streets,
First Floor Plan,* 1835
Building constructed 1835–38; demolished
1897
Ink
29⅜ x 17 in. (74.6 x 43.2 cm)
Inscribed: Halls of Justice / New York[;]
Principal Floor[;] John Haviland Archt. /
Philad[a].
Royal Institute of British Architects Library,
London, Drawings Collection W14/6(2)

John Haviland, British, 1792–1852, active in
the United States from 1816

83. *Halls of Justice and House of Detention, Centre
Street, between Leonard and Franklin Streets,
Bird's-Eye View,* 1835
Building constructed 1835–38; demolished
1897
Ink and wash
23¾ x 33¾ in. (60.3 x 85.7 cm)
Inscribed: Halls of Justice / New York[;] John
Haviland Archt. / Philada
Royal Institute of British Architects Library,
London, Drawings Collection W14/6(9)

Alexander Jackson Davis, 1803–1892

84. *"Syllabus Row," Proposed, Unexecuted Design
for Terrace Houses,* ca. 1830
Watercolor
18¾ x 26½ in. (47.6 x 67.3 cm)
Inscribed: SYLLABUS RŌW.
The Metropolitan Museum of Art, New York,
The Edward W. C. Arnold Collection of New
York Prints, Maps, and Pictures, Bequest of
Edward W. C. Arnold, 1954 54.90.140

Alexander Jackson Davis, 1803–1892

85. *"Terrace Houses," Proposed, Unexecuted Design
for Cross-Block Terrace Development,* ca. 1831

Watercolor
9¾ x 26½ in. (24.8 x 67.3 cm)
The Metropolitan Museum of Art, New York,
Harris Brisbane Dick Fund, 1924 24.66.1291

John Stirewalt, artist
Alexander Jackson Davis, 1803–1892, and
Seth Geer, architects

86. *Colonnade Row, 428–434 Lafayette Street, near
Astor Place, Elevation and Plans,* 1833–34
Buildings constructed 1832–34; partly extant
(16 of 28 bays demolished 1901)
Watercolor
13⅝ x 9⅝ in. (34.6 x 24.4 cm)
Inscribed: NEAR WHAT THE LA-GRANGE
TERRACE, N.Y. OUGHT TO HAVE BEEN /
DAVIS DIREX.[;] STIREWALT DELIN.
Avery Architectural and Fine Arts Library,
Columbia University, New York
1940.001.00739

Attributed to Martin Euclid Thompson,
ca. 1786–1877

87. *Row of Houses on Chapel Street, between Murray
and Robinson Streets,* 1830
Buildings probably constructed 1830;
demolished
Watercolor and ink on paper, mounted
on board
18½ x 25¼ in. (47 x 64.1 cm) sheet
Inscribed: This is the plan and elevation of
the Houses to be erected on the / West side of
Chapel Street, between Murray & Robinson
Street, and / between Robinson Street to the
rear of the lot on the Corner of Chapel / and
Barclay Streets, and referred to in the form of
the lease annexed / to an Agreement between
the Trustees of Columbia College in the / City
of New York, by their Standing Committee,
and Gideon Tucker / and John Morss the first
day of April 1830, and to / be considered part of
the said agreement. / [signed] Gideon Tucker /
John Morss / Wm Johnston Treasurer. / Fronts
on west side of Chapel street.
Avery Architectural and Fine Arts Library,
Columbia University, New York Gideon
Tucker DR165

Attributed to Martin Euclid Thompson,
ca. 1786–1877

88. *House on Chapel Street, between Murray and
Robinson Streets,* 1830
Building probably constructed 1830
Watercolor
22⅞ x 18 in. (58.1 x 45.7 cm)
Inscribed: 4 feet to an inch
Avery Architectural and Fine Arts Library,
Columbia University, New York
1000.010.00013

Architect unknown
*Clarkson Lawn (Matthew Clarkson Jr. House),
Flatbush and Church Avenues, Brooklyn, New
York,* photograph, 1940
Building constructed ca. 1835; demolished
1940

Courtesy of the Brooklyn Museum of Art

89A. Door and doorframe from the entry hall of
Clarkson Lawn, ca. 1835
Mahogany; painted pine; metal
120⅛ x 72¾ x 5¼ in. (305.1 x 184.9 x 13.3 cm)
Brooklyn Museum of Art, Gift of the
Young Men's Christian Association, 1940
40.931.2A–B

89B. Pair of pilasters from the double parlor of
Clarkson Lawn (capital illustrated), ca. 1835
Painted pine
Each 129¼ x 17⅛ x 4½ in. (328.3 x 43.5 x 11.4 cm)
Brooklyn Museum of Art, Gift of the Young
Men's Christian Association, 1940 40.931.3, 4

John B. Jervis, 1795–1885, chief engineer

90. *Distributing Reservoir of the Croton Aqueduct,
Fifth Avenue between Fortieth and Forty-second
Streets,* 1837–39
Croton Aqueduct constructed 1837–42;
distributing reservoir demolished 1899–1901
Ink and watercolor
Bound in *Reports of J. B. J., Vol. II, N. Y. W. W.*
Book: 15 x 10 in. (38.1 x 25.4 cm)
Inscribed: DISTRIBUTING RESERVOIR. /
Elevations of Sides Fronting on Forty-Second
Street & Fifth Avenue.
Jervis Public Library, Rome, New York

John B. Jervis, 1795–1885, chief engineer

91. *High Bridge of the Croton Aqueduct over the
Harlem River, Elevation and Plan,* ca. 1839–40
Croton Aqueduct constructed 1837–42;
bridge extant (central arches removed during
World War II)
Ink and watercolor
16¾ x 24¼ in. (42.5 x 61.6 cm)
Inscribed: Arch at A.[;] Arches at B. /
Elevation of a High Bridge for Crossing
Harlaem [sic] River. / Scale 32 feet to an Inch. /
Plan. / Scale 80 feet to an Inch.
Jervis Public Library, Rome, New York
Drawing 249
The Croton Aqueduct system became
operational in 1842, although the bridge was
not completed until 1848.

John B. Jervis, 1795–1885, chief engineer

92. *Manhattan Valley Pipe Chamber of the Croton
Aqueduct,* ca. 1839–40
Croton Aqueduct constructed 1837–42
Ink and watercolor
22⅝ x 33 in. (57.5 x 83.8 cm)
Signed and inscribed: Croton Aqueduct /
John B. Jervis / Chief Engineer / HORIZONTAL
SECTION[;] LONGITUDINAL SECTION / SCALE
5 FEET TO AN INCH[;] ELEVATION[;] SECTION
IN FRONT OF GATES[;] PLAN AND SECTION OF
NUT AND SCREW FOR / WORKING THE GATES /
SCALE IS ⅜ OF AN INCH TO AN INCH / PIPE
CHAMBER[;] MANHATTAN VALLEY / SCALE
4 FEET TO AN INCH
Library of Congress, Washington, D.C.,
Prints and Photographs Division 1997.86.1
Manhattan Valley was the area bounded today

by 100th and 110th streets, Central Park West, and Broadway.

Artist unknown
Richard Upjohn, British, 1802–1878, active in New York City from 1839, architect

93. *Trinity Church, Broadway, opposite Wall Street, Presentation Drawing Depicting View from the Southwest,* probably 1841
Building constructed 1841–46; extant
Watercolor
20¾ x 26⅜ in. (52.7 x 67 cm)
Avery Architectural and Fine Arts Library, Columbia University, New York
1000.011.01098

James Renwick Jr., 1818–1895

94. *Church of the Puritans, Union Square, Fifteenth Street and Broadway,* 1846
Building constructed 1846–47; later moved to West Fifty-seventh Street; demolished
Watercolor
30½ x 20½ in. (77.5 x 52.1 cm)
Signed at bottom right: J. Renwick Jun. Architect
The New-York Historical Society

Ferdinand Joachim Richardt, Danish, 1819–1895, active in New York City 1856–59, artist
James Renwick Jr., 1818–1895, architect

95. *Grace Church, Broadway and Tenth Street,* 1858
Building constructed 1843–46; extant
Oil on canvas
59¼ x 47¼ in. (150.5 x 120 cm)
Signed, dated, and inscribed at lower right: New York [illegible] 1858/Ferdinand Richardt
Grace Church in New York

Joseph Trench, 1810–1879, and John Butler Snook, 1815–1901

96. *A. T. Stewart Store, Broadway between Reade and Chambers Streets, Chambers Street Elevation,* 1849
Building constructed 1846; expanded 1850 and 1852; extant
Watercolor
20½ x 29¼ in. (52.1 x 74.3 cm)
Inscribed: CHAMBER STREET FRONT/
J. TRENCH & CO./ARCHITECTS/12 CHAMBER ST/N.Y.
The New-York Historical Society

James Bogardus, 1800–1874, inventor
William L. Miller, architectural-iron manufacturer

97. Spandrel panel from Edgar H. Laing Stores, Washington and Murray Streets, 1849
Building constructed 1849; demolished 1971
Cast iron
15¾ x 51 x 3¾ in. (40 x 129.5 x 9.5 cm)
The Metropolitan Museum of Art, New York, Gift of Margaret H. Tuft, 1979 1979.134

John P. Gaynor, ca. 1826–1889, architect
Daniel D. Badger, 1806–1884, architectural-iron manufacturer
Sarony, Major and Knapp, printer

98. *Haughwout Building, Broadway and Broome Street,* 1865
Plate 3 in Daniel D. Badger's *Illustrations of Iron Architecture* (New York: Baker and Godwin, 1865)
Building constructed 1856; extant
Lithograph printed in colors; book bound in original green pressed cloth
14 x 24 in. (35.6 x 61 cm) open
Inscribed: ARCHITECTURAL IRON WORKS,_ NEW-YORK.
Smithsonian Institution Libraries, Washington, D.C. FNA 3503.7832 1865XCHRMB

Detlef Lienau, German (Ütersen, Schleswig-Holstein), 1818–1887, active in New York City from 1848

99. *Hart M. Shiff House, Fifth Avenue and Tenth Street, Front Elevation,* 1850
Building constructed 1850–52; demolished 1923
Pen and ink
16¼ x 11⅜ in. (41.3 x 28.9 cm)
Inscribed on applied label: · Hart M. Shiff, Esq. · S.W. cor., 5ᵗʰ Ave., & 10ᵗʰ St.– · /
· D. Lienau, Archt. · 1850 ·
Avery Architectural and Fine Arts Library, Columbia University, New York
1936.002.00013

Detlef Lienau, German (Ütersen, Schleswig-Holstein), 1818–1887, active in New York City from 1848

100. *Hart M. Shiff House, Fifth Avenue and Tenth Street, Side Elevation,* 1850
Building constructed 1850–52; demolished 1923
Pen and ink
11⅜ x 16¼ in. (28.9 x 41.3 cm)
Inscribed on applied label: · Hart M. Shiff, Esq. · S.W. cor., 5ᵗʰ Ave., & 10ᵗʰ St. · /
· D. Lienau, Archt. · 1850 ·
Avery Architectural and Fine Arts Library, Columbia University, New York
1936.002.00014

Richard Morris Hunt, 1827–1895

101. *Thomas P. Rossiter House, 11 West Thirty-eighth Street, Facade Study,* 1855
Building constructed 1855–57; demolished before 1900
Ink and wash
12⅛ x 10½ in. (30.8 x 26.7 cm)
Octagon Museum, Washington, D.C., American Architectural Foundation, Prints and Drawings Collection 81.6617
Hunt's first commission upon his return to New York in 1855 from the École des Beaux-Arts in Paris

Alexander Jackson Davis, 1803–1892

102. *Ericstan (John J. Herrick House), Tarrytown, New York, Rear Elevation,* ca. 1855
Building constructed 1855–59; demolished 1944
Watercolor, ink, and graphite

25⅜ x 30 in. (64.5 x 76.2 cm)
The Metropolitan Museum of Art, New York, Harris Brisbane Dick Fund, 1924 24.66.10

Richard Upjohn, British, 1802–1878, active in New York City from 1839

103. *Henry Evelyn Pierrepont House, 1 Pierrepont Place, Brooklyn, New York, Front Elevation and Section,* 1856
Building constructed 1856–57; demolished 1946
Ink on cloth
26¾ x 19¾ in. (67.9 x 50.2 cm)
Inscribed: Front Elevation/House for H.E. Pierrepont Esq/Richd Upjohn & Co Architects/Trinity Building/New York/May 19th 1856
Avery Architectural and Fine Arts Library, Columbia University, New York
1985.003.00001

Charles Mettam, Irish, 1819–1897, active in New York City from 1848, and Edmund A. Burke

104. *The New-York Historical Society, Second Avenue and Eleventh Street,* 1855
Building constructed 1855–57; demolished 1920
Watercolor on paper, mounted on cloth
22½ x 31⅝ in. (57.2 x 80.3 cm)
Inscribed: Mettam & Burke/architects/18 City Hall Place, N. Y.
The New-York Historical Society x.370

Peter Bonnett Wight, 1838–1925

105. *National Academy of Design, Fourth Avenue and Twenty-third Street,* 1861
Building constructed 1863–65; demolished 1899 (elements incorporated into Our Lady of Lourdes, 142nd Street between Convent and Amsterdam Avenues, 1904)
Watercolor
20⅞ x 27 in. (53 x 68.6 cm)
Signed and dated at bottom right: P.B. WIGHT, Archᵗ/98 Broadway, N.Y.
Inscribed: ELEVATION OF THE SOUTH FRONT./Scale ¼ INCH TO A FOOT./The original competition drawing for the Academy of Design/which was accepted by the Council—1861.
The Art Institute of Chicago, Gift of Peter Bonnett Wight 1992.81.4

WATERCOLORS

John William Hill, 1812–1879

106. *View on the Erie Canal,* 1829
Watercolor
9¾ x 13¾ in. (24.8 x 34.9 cm)
Inscribed at lower left: Drawn by J. W. Hill 1829
The New York Public Library, Astor, Lenox and Tilden Foundations, Miriam and Ira D. Wallach Division of Art, Prints and Photographs, The Phelps Stokes Collection, Print Collection 1830–32E–29

John William Hill, 1812–1879

107. *View on the Erie Canal,* 1831
Watercolor
9⅝ x 13⅝ in. (24.4 x 34.6 cm)

Inscribed at lower right: [Drawn?] by
J. W. Hill 1831
The New York Public Library, Astor, Lenox
and Tilden Foundations, Miriam and Ira D.
Wallach Division of Art, Prints and Photo-
graphs, The Phelps Stokes Collection, Print
Collection 1830–32E–24

John William Hill, 1812–1879
108. *City Hall and Park Row*, 1830
Watercolor
9¾ x 13⅝ in. (24.8 x 34.6 cm)
Signed and dated at lower right: J. W. Hill 1830
The New York Public Library, Astor, Lenox
and Tilden Foundations, Miriam and Ira D.
Wallach Division of Art, Prints and Photo-
graphs, The Phelps Stokes Collection, Print
Collection 1830 E–81

John William Hill, 1812–1879
109. *Broadway and Trinity Church from Liberty
Street*, 1830
Watercolor
9⅝ x 13⅝ in. (24.4 x 34.6 cm)
Signed and dated at lower right: J. W. Hill 1830
The New York Public Library, Astor, Lenox
and Tilden Foundations, Miriam and Ira D.
Wallach Division of Art, Prints and Photo-
graphs, The Phelps Stokes Collection, Print
Collection 1830 E–73
Exhibited at the National Academy of Design
in 1832

Nicolino Calyo, Italian, 1799–1884, active in
the United States from the early 1830s
110. *View of the Great Fire of New York, December 16
and 17, 1835, as Seen from the Top of the New
Building of the Bank of America, Corner Wall
and William Streets*, 1836
Gouache on paper
16⅜ x 24 in. (41.6 x 61 cm)
Inscribed along bottom: Veiw [*sic*] of the
Great Fire of New-York, December 16th &
17th, 1835, was seen from the Top of the New
Building of the Bank of America corner Wall
and William Street.— —New York, Jan, 1836.—
The New-York Historical Society, Bryan
Fund 1980.53
Reproduced as an engraving by William
James Bennett in New York City in 1836

Nicolino Calyo, Italian, 1799–1884, active in
the United States from the early 1830s
111. *View of the Ruins after the Great Fire in New
York, December 16 and 17, 1835, as Seen from
Exchange Place*, 1836
Gouache on paper
16½ x 24 in. (41.9 x 61 cm)
Inscribed along bottom: View of the Ruins
after the Great Fire in New-York, Decem-
ber 16th & 17th 1835, as seen from Exchange
Place.— —New-York, Jan 1836—
The New-York Historical Society, Bryan Fund
1980.54
Reproduced as an engraving by William
James Bennett in New York City in 1836

Alexander Jackson Davis, 1803–1892
112. *Greek Revival Double Parlor*, ca. 1830
Watercolor
13¼ x 18⅛ in. (33.7 x 46 cm)
The New-York Historical Society, Gift of
Daniel Parish, Jr. 1908.28

John William Hill, 1812–1879
113. *Chancel of Trinity Chapel*, ca. 1856
Watercolor, gouache, black ink, graphite, and
gum arabic
18⅜ x 14¼ in. (46.7 x 36.2 cm)
Signed at lower right: J. W. Hill
The Metropolitan Museum of Art, New York,
The Edward W. C. Arnold Collection of New
York Prints, Maps, and Pictures, Bequest of
Edward W. C. Arnold, 1954 54.90.157
Exhibited at the National Academy of
Design in 1857

PRINTS, BINDINGS, AND
ILLUSTRATED BOOKS

John Hill, British, 1770–1850, active in New
York City 1822–50, engraver
After William Guy Wall, Irish, 1792–after
1864, artist
Henry J. Megarey, publisher
114. *New York from Governors Island*, 1823–24
From *The Hudson River Portfolio* (1821–25)
Aquatint with hand coloring
14⅛ x 21½ in. (35.9 x 53.7 cm) image;
19⅛ x 25¾ in. (48.6 x 65.4) sheet
Inscribed: Painted by W. G. Wall[;] Engraved
by I. [J.] Hill/NEW YORK, FROM GOVERNORS
ISLAND./Nº· 20 of the Hudson River Port
Folio./Published by Henry I. [J.] Megarey
New York.
The Metropolitan Museum of Art, New York,
The Edward W. C. Arnold Collection of New
York Prints, Maps, and Pictures, Bequest of
Edward W. C. Arnold, 1954 54.90.1274.19

Asher B. Durand, 1796–1886, engraver
Durand, Perkins and Company, printer and
publisher
115. $1,000 bill for the Greenwich Bank, City of
New York, ca. 1828
Engraving, cancelled proof
2⅞ x 7 in. (7.3 x 17.8 cm) image; 3 x 7⅛ in.
(7.6 x 18.1 cm) sheet
The Metropolitan Museum of Art, New York,
Harris Brisbane Dick Fund, 1917 17.3.3585(14)

Asher B. Durand, 1796–1886, engraver
Durand, Perkins and Company, printer and
publisher
116. Specimen sheet of bank note engraving,
ca. 1828
Engraving
16⅞ x 12⅝ in. (42.9 x 32.1 cm) image;
17⅜ x 13⅛ in. (44.1 x 33.3 cm) sheet
The Metropolitan Museum of Art, New York,
Harris Brisbane Dick Fund, 1917 17.3.3585(47)

Cadwallader Colden, 1769–1834, author
Archibald Robertson, Scottish, 1765–1835,
active in New York City 1791–1821, artist
Anthony Imbert, French, active in New York
City 1825–38, printer
Wilson and Nicholls, bookbinder
117. *Memoir, Prepared at the Request of a Committee
of the Common Council of the City of New York,
and Presented to the Mayor of the City, at the
Celebration of the Completion of the New York
Canals*, 1825
Bound in red leather with gold stamping
10⅛ x 8⅜ x 1⅞ in. (25.7 x 21.3 x 4.8 cm)
Stamped on cover: PRESENTED BY THE CITY/
OF NEW YORK/TO/THE HONORABLE GIDEON
LEE/ALDERMAN OF THE 12TH WARD IN THE
YEARS/1829 & 1830/AND MAYOR OF THE/
CITY OF NEW YORK IN THE YEARS 1833 & 1834
American Antiquarian Society, Worcester,
Massachusetts
A copy of this work was presented on board the
steamboat *Washington* on November 4, 1825.

Archibald Robertson, Scottish, 1765–1835,
active in New York City 1791–1821, artist
Anthony Imbert, French, active in New York
City, 1825–38, printer
118. *Grand Canal Celebration: View of the Fleet
Preparing to Form in Line*, 1825
From Cadwallader Colden, *Memoir* (1825)
Lithograph
8½ x 40⅛ in. (21.6 x 101.9 cm)
The Metropolitan Museum of Art, New York,
Harris Brisbane Dick Fund, 1923 23.69.23

William James Bennett, British, 1784–1844,
active in New York City by 1824, artist and
engraver
Henry J. Megarey, active 1818–45, publisher
119. *South Street from Maiden Lane*, ca. 1828
From *Megarey's Street Views in the City of New-
York* (1834)
Aquatint
9½ x 13⅝ in. (24.1 x 34.6 cm) image;
13¾ x 17¾ in. (34.9 x 45.1 cm) sheet
Inscribed: Wᴹ. I. Bennett Pinxᵗ et Sculp.ʳ/
SOUTH ST. from MAIDEN LANE./Henry I. [J.]
Megarey New York.
The Metropolitan Museum of Art, New York,
The Edward W. C. Arnold Collection of New
York Prints, Maps, and Pictures, Bequest of
Edward W. C. Arnold, 1954 54.90.1177

William James Bennett, British, 1784–1844,
active in New York City by 1824, artist and
engraver
Henry J. Megarey, active 1818–45, publisher
120. *Fulton Street and Market*, 1828–30
From *Megarey's Street Views in the City of New-
York* (1834)
Aquatint
9¼ x 13⅝ in. (23.5 x 34 cm) image; 12¾ x 18⅛ in.
(32.4 x 46 cm) sheet
Inscribed: Wᴹ I. Bennett Pinxᵗ et Sculp.ʳ/

FULTON ST. & MARKET./Henry I. [J.]
Megarey New York.
The Metropolitan Museum of Art, New York,
Bequest of Charles Allen Munn, 1924
24.90.1276

Thomas Thompson, 1775–1852, artist, lithographer, and publisher

121. *New York Harbor from the Battery,* 1829
Lithograph with hand coloring
24¾ x 59¾ in. (151.8 x 62.9 cm) overall
Inscribed: Drawn on stone by Thoˢ Thompson.[;] Entered according to Act of Congress
May 11th. 1829. by Thoˢ Thompson, N. York.
The Metropolitan Museum of Art, New York,
The Edward W. C. Arnold Collection of New
York Prints, Maps, and Pictures, Bequest of
Edward W. C. Arnold, 1954 54.90.1182(1–3)

James Barton Longacre, 1794–1869, and
James Herring, 1794–1867, publishers

122A. *National Portrait Gallery of Distinguished
Americans,* 1833–39, vol. 3 (1836)
One volume of a four-volume set, bound in
red leather with gold stamping
10¾ x 7¼ x 1⅝ in. (27.3 x 18.4 x 4.1 cm)
The Metropolitan Museum of Art, New York,
Bequest of Charles Allen Munn, 1924
24.90.1911 (vol. 3)
Project directed by James B. Longacre,
Philadelphia, and James Herring, New York
City, under the superintendence of the American Academy of the Fine Arts

Asher B. Durand, 1796–1886, engraver
After Charles Cromwell Ingham, born Ireland, 1796–1863, artist

122B. *De Witt Clinton,* 1834
From *National Portrait Gallery of Distinguished
Americans,* vol. 2 (1835)
Engraving; volume bound in green leather with
gold stamping; ex libris Stephen van Rensselaer
4⅜ x 3½ in. (11.1 x 8.9 cm) platemark;
10¾ x 6⅞ in. (27.3 x 17.5 cm) sheet
The Metropolitan Museum of Art, New York,
Gift of John K. Howat, 1998 1998.520.2

John Hill, British, 1770–1850, active in New
York City 1822–50, engraver
After Thomas Hornor, British, active in New
York City ca. 1828–44, artist
W. Neale, printer
Joseph Stanley and Company, publisher

123. *Broadway, New York, Showing Each Building
from the Hygeian Depot Corner of Canal Street
to beyond Niblo's Garden,* 1836
Aquatint and etching with hand coloring
17⅝ x 26⅞ in. (44.8 x 68.3 cm) image;
22⅝ x 32¼ in. (57.5 x 81.9 cm) sheet
Inscribed: Drawn & Etched by T. Hornor[;]
Aquatinted by J. Hill/BROADWAY, NEW-
YORK./Shewing [sic] each Building from the
Hygeian Depot corner of Canal Street, to
beyond Niblo's Garden/Published by JOSEPH
STANLEY & Cº./Printed by W. Neale/Entered
according to act of Congress by Jos.h Stanley

& Co., in the Clerks Office of the Southern
District of New York/January 26, 1836
The Metropolitan Museum of Art, New York,
The Edward W. C. Arnold Collection of New
York Prints, Maps, and Pictures, Bequest of
Edward W. C. Arnold, 1954 54.90.703

David H. Burr, cartographer
J. H. Colton, publisher
S. Stiles and Company, printer

124. *Topographical Map of the City and County of
New York and the Adjacent Country: with Views
in the Border of the Principal Buildings, and
Interesting Scenery of the Island,* 1836
Engraving, first state
29⅜ x 67⅛ in. (74.6 x 170.5 cm)
Inscribed: TOPOGRAPHICAL MAP/OF THE/
City and County/of/NEW-YORK,/and the
adjacent Country:/With views in the border
of the principal Buildings, and interesting
Scenery of the Island/PUBLISHED BY J.H.
COLTON & Cº./No. 4[;] New-York[;] Spruce
St.[;] 1836./Engraved and printed/by/
S. STILES & COMPANY, New-York/Entered
according to act of Congress in the year 1836.
By J.H. Colton & Co. in the Clerks Office of
the District Court of the Southern District
of New York.
Library of Congress, Washington, D.C.,
Geography and Map Division

Asher B. Durand, 1796–1886, engraver and
publisher
After John Vanderlyn, 1775–1852, artist
A. King, printer

125. *Ariadne,* 1835
Engraving, third state, proof before letters;
printed on *chine collé*
14⅛ x 17⅞ in. (35.9 x 45.4 cm) image;
21¼ x 26⅞ in. (54 x 68.3 cm) sheet
Inscribed: Painted by J. Vanderlyn[;] Eng.
By A. B. Durand/Published by A. B. Durand
New York, Hodgson, Boys & Graves, London,
Rittner & Goussil à Paris 1835./Entered
according to act of Congress In the year 1835
by A. B. Durand in the Clerk's Office of the
District Court of the Southern District of
New York./Printed by A. King
Museum of Fine Arts, Boston, Harvey D.
Parker Collection, 1897 P12793
Owned by Henry Foster Sewall; after
Vanderlyn's *Ariadne Asleep on the Isle of Naxos*
of 1812, which was owned by Durand

Henry Heidemans, German, active in New
York City ca. 1840, lithographer
After Henry Inman, 1801–1846, artist
Endicott and Company, printer and publisher

126. *Fanny Elssler,* 1841
Lithograph
27⅝ x 22⅛ in. (70.2 x 56.2 cm) image;
34⅝ x 25⅝ in. (87.9 x 65.1 cm) sheet
Inscribed: [in ink] Deposited in the W. I.
Dist. Court Clk's Office for the/Southern
Dist. Of N.Y. this 25th Nov: 1841 / [printed]
Painted from life by Henry Inman[;] Lith of

Endicott[;] Drawn on Stone by Henry Pʰ·
Heidemans/Fanny Elssler/Enterd [sic]
according to Act of Congress in the year 1841
by H. Inman in the Clerk's Office of the
District Court of the Southern Diᵗ of N. York
Library of Congress, Washington, D.C.,
Prints and Photographs Division

Thomas Doney, French, active in New York
City 1844–49, engraver
After George Caleb Bingham, 1811–1879, artist
American Art-Union, publisher
Powell and Company, printer

127. *The Jolly Flat Boat Men,* 1847
Mezzotint
18¾ x 24 in. (47.6 x 61 cm) image; 21½ x 26⅜ in.
(54.6 x 67 cm) sheet
Inscribed: PAINTED BY G.C. BINGHAM ESQ[;]
ENGRAVED BY T. DONEY/THE JOLLY FLAT
BOAT MEN./From the Original painting
distributed/by the American Art Union in
1847/Published exclusively for/The Members
of that Year/PRINTED BY POWELL & CO./
Entered according to Act of Congress in the
year 1847 by the American Art Union/in the
Clerk's Office of the U.S. District Court for
the Southern District of New York
The Metropolitan Museum of Art, New York,
Gertrude and Thomas Jefferson Mumford
Collection, Gift of Dorothy Quick Mayer,
1942 42.119.68
After Bingham's painting of 1846

William James Bennett, British, 1784–1844,
active in New York City by 1824, engraver
After John William Hill, 1812–1879
Lewis P. Clover, publisher

128. *New York, from Brooklyn Heights,* ca. 1836
Aquatint printed in colors with hand coloring,
first state
19⅝ x 31¼ in. (49.8 x 80.6 cm) image
Inscribed: Painted by J. W. Hill[;] Published
by L.P. CLOVER New York[;] Engraved by
W. J. Bennett/NEW YORK,/from Brooklyn
Heights / Entered according to Act of Congress
in the Year 1837 by Lewis P. Clover in the
Office of the Southern district of New York
Collection of Leonard L. Milberg

Robert Havell Jr., British, 1793–1878, active in
the United States 1839–78, artist and engraver
W. Neale, printer
Robert Havell Jr., William A. Colman, and
Ackermann and Company, publishers

129. *Panoramic View of New York (Taken from the
North River),* 1844
Aquatint with hand coloring, fifth state
8¾ x 32⅝ in. (22.2 x 82.9 cm) image;
13⅜ x 37½ in. (34 x 95.3 cm) sheet
Inscribed: Clinton Market[;] Washington
Market[;] Shad Fishing[;] Battery[;] British
Queen[;] Narrows[;] Staten Island/Drawn
& Engraved by Robᵗ Havell/PANORAMIC
VIEW OF NEW YORK./(Taken from the North
River)./Entered according to Act of Congress,
in the year 1844, by Robᵗ. Havell, in the

Clerk's office of the District Court, of the Southern District, of New York./Printed by W. Neale/Published by Rob.t Havell Sing Sing New York/and W^m. A. Colman, 203 Broadway/Ackermann & Co 96 Strand London
The Metropolitan Museum of Art, New York, The Edward W. C. Arnold Collection of New York Prints, Maps, and Pictures, Bequest of Edward W. C. Arnold, 1954 54.90.623
The Hudson River is known as the North River at its southern end.

James Smillie, 1807–1884, engraver
After Thomas Cole, born England, 1801–1848, artist

130. *The Voyage of Life: Youth*, 1849
Engraving, proof before letters
15¼ x 22¾ in. (38.7 x 57.8 cm) image;
23¼ x 29⅜ in. (59.1 x 74.6 cm) sheet
Inscribed in pencil: Artist's proof of Smillie's Voyage of Life (Youth) after Cole
Museum of Fine Arts, Boston, Harvey D. Parker Collection P12796
Owned by Henry Foster Sewall; after Cole's painting of 1840; published by the American Art-Union

George Loring Brown, 1814–1889

131. *Cascades at Tivoli*, 1854
Etching
8¾ x 5⅞ in. (22.2 x 14.9 cm) platemark;
9⅛ x 6½ in. (23.2 x 16.5 cm) sheet
Signed: in plate, G L Brown Rome 1854; in pencil outside plate, at lower left, G L Brown
Museum of Fine Arts, Boston, Harvey D. Parker Collection P12262
Owned by Henry Foster Sewall

Asher B. Durand, 1796–1886, artist
John Gadsby Chapman, 1808–1889, author
W. J. Widdleton, publisher

132. *A Study and a Sketch*
Frontispiece to chapter 7 of *The American Drawing-Book* (1st ed., 1847)
Reproduction (by stereotype) of wood engraving from 3d edition, 1864
12 x 9½ in. (30.5 x 24.1 cm) sheet
The Metropolitan Museum of Art, New York, Harris Brisbane Dick Fund, 1954 54.524.2

Washington Irving, 1783–1859, author
Felix Octavius Carr Darley, 1822–1888, artist and lithographer
Sarony and Major, printer

133. Plate 5, *Illustrations of "Rip Van Winkle" Designed and Etched by F. O. C. Darley for the Members of the American Art-Union*, 1848
Lithograph
8¾ x 11⅛ in. (22.2 x 28.3 cm) image;
12⅜ x 15⅛ in. (31.4 x 38.4 cm) sheet
Inscribed: Darley invent et sculp.t/Printed by Sarony & Major New York
The Metropolitan Museum of Art, New York, Gift of Mrs. Frederic F. Durand, 1933
33.39.123

Washington Irving, 1783–1859, author
Felix Octavius Carr Darley, 1822–1888, artist and lithographer
Sarony and Major, printer

134. Plate 6, *Illustrations of "The Legend of Sleepy Hollow" Designed and Etched by F. O. C. Darley for the Members of the American Art-Union*, 1849
Lithograph
8½ x 11⅛ in. (21.6 x 28.3 cm) image;
12¼ x 14⅜ in. (31.1 x 36.5 cm) sheet
Inscribed: Darley invent et sculp.t/Printed by Sarony & Major New York
The Metropolitan Museum of Art, New York, Rogers Fund, transferred from the Library, 1944 44.40.2

Henry Papprill, British, died 1896, active in New York City 1846–50, engraver
After John William Hill, 1812–1879, artist
Henry J. Megarey, publisher

135. *New York from the Steeple of Saint Paul's Church, Looking East, South, and West*, ca. 1848
Aquatint printed in colors with hand coloring, second state
21¼ x 36⅝ in. (54 x 93 cm) image; 25¼ x 38⅜ in. (64.1 x 97.5 cm) sheet
Inscribed: Drawing by J. W. Hill[;] Entered according to Act of Congress in the year 1849 by Henry I. [J.] Megarey, in the Clerks office of the District Court of the Southern District of New York.[;] Eng.d by Henry Papprill/[on seal] H. I. [J.] MEGAREY/PUB./NEW YORK/ NEW YORK/from the steeple of St. Paul's Church Looking East, South and West./Proof
The Metropolitan Museum of Art, New York, The Edward W. C. Arnold Collection of New York Prints, Maps, and Pictures, Bequest of Edward W. C. Arnold, 1954 54.90.587
The correct name for Saint Paul's Church was, and remains, Saint Paul's Chapel (built 1764–66); the Chapel is located on Broadway between Fulton and Vesey streets.

John F. Harrison, cartographer
Kollner, Camp and Company, Philadelphia, printer
Matthew Dripps, publisher

136. *Map of the City of New York, Extending Northward to Fiftieth Street*, 1851
Lithograph with hand coloring
78½ x 37¼ in. (199.4 x 94.6 cm) sheet (mounted on original rollers)
Inscribed: MAP OF THE CITY/OF/NEW-YORK/ EXTENDING NORTHWARD/TO FIFTIETH ST./ SURVEYED AND DRAWN BY JOHN F. HARRISON C. E./PUBL^D BY M. DRIPPS, N° 403 FULTON STREET/N.Y./1851./Engraved and printed at Kollner, Camp, and Co.'s Lith c Establishment, Phil a
Collection of Mark D. Tomasko

Washington Irving, 1783–1859, author, under the pseudonym Diedrich Knickerbocker
George P. Putnam, publisher

137. *A History of New-York from the Beginning of the World to the End of the Dutch Dynasty* (1st ed., 1809), 1850 edition

Bound in black leather with gold stamping and rose-and-gold inset depicting silhouette of "William the Testy"
8¾ x 6½ x 1⅝ in. (22.2 x 16.5 x 4.1 cm)
American Antiquarian Society, Worcester, Massachusetts, Papantonio Collection

Alfred Ashley, artist and designer
W. H. Swepstone, author
Stringer and Townsend, publisher

138. *Christmas Shadows, a Tale of the Poor Needle Woman with Numerous Illustrations on Steel*, New York and London, 1850
Bound in blue cloth with gold stamping
7⅜ x 5¼ x ⅞ in. (18.7 x 13.3 x 2.2 cm)
Inscribed in ink on the flyleaf: Mademoiselle/ E. Barker/100. Exemptions/C. Reichard/ 24 Juillet 1850
Collection of Jock Elliott

Edward Walker and Sons, active 1835–72, bookbinder

139. *The Odd-Fellows Offering*, 1851
Bound in red leather with gold stamping
8¾ x 5⅞ x 1¼ in. (22.2 x 14.9 x 3.2 cm)
American Antiquarian Society, Worcester, Massachusetts, Kenneth G. Leach Collection

Samuel Hueston, publisher

140. *The Knickerbocker Gallery*, 1855
Bound in red leather with gold stamped inset of Sunnyside, Washington Irving's home
9¼ x 7 x 2¼ in. (23.5 x 17.8 x 5.7 cm)
American Antiquarian Society, Worcester, Massachusetts, Papantonio Collection B, Copy 3

John Bachmann, German, active in New York City 1849–85, artist, printer, and publisher

141. *Bird's-Eye View of the New York Crystal Palace and Environs*, 1853
Lithograph printed in colors with hand coloring
21 x 31 in. (53.3 x 78.7 cm) image; 25½ x 33¾ in. (64.8 x 85.7 cm) sheet
Inscribed: DRAWN FROM NATURE[;] Entered According to Act of Congress in the Year 1853. by J. Bachman, in the Clerk's Office of the District Court of the Southⁿ Dis^{tt} of N.Y.[;] & ON STONE BY J. BACHMAN./BIRDS EYE VIEW OF THE/NEW YORK CRYSTAL PALACE./ and Environs.
Museum of the City of New York, The J. Clarence Davies Collection 29.100.2387

Charles Parsons, 1821–1910, artist and lithographer
Endicott and Company, printer
George S. Appleton, publisher

142. *An Interior View of the Crystal Palace*, 1853
Lithograph printed in colors
13½ x 20⅜ in. (34.3 x 51.8 cm) image;
16⅜ x 23 in. (41.6 x 58.4 cm) sheet
Inscribed: C. Parsons, Del and lith.[;] Printed by Endicott & Co. N.Y/AN INTERIOR VIEW OF THE CRYSTAL PALACE. / New York, Published by Geo. S. Appleton, 356 Broadway

N. Y./Entered according to Act of Congress in the year 1853 by Geo. S. Appleton, in the Clerks Office of the district Court of the Southern district of N.Y.
The Metropolitan Museum of Art, New York, The Edward W. C. Arnold Collection of New York Prints, Maps, and Pictures, Bequest of Edward W. C. Arnold, 1954 54.90.1047

William Wellstood, 1819–1900, engraver
After Benjamin F. Smith Jr., 1830–1927, artist
Smith, Fern and Company, publisher

143. *New York, 1855, from the Latting Observatory,* 1855
Engraving with hand coloring
29⅜ x 46⅛ in. (74.6 x 117 cm) image
Inscribed: NEW YORK, 1855./B. F. SMITH, JUN. DEL. W. WELLSTOOD, SC. RESPECTFULLY DEDICATED TO THE CITIZENS OF THE UNITED STATES BY THE PUBLISHERS, SMITH, FERN, & CO. 340 BROADWAY NEW YORK. ENTERED ACCORDING TO ACT OF CONGRESS IN THE YEAR 1855 BY SMITH, FERN & CO. IN THE CLERK'S OFFICE OF THE DISTRICT COURT OF THE UNITED STATES FOR THE SOUTHERN DISTRICT OF NEW YORK.
The New York Public Library, Astor, Lenox and Tilden Foundations, Miriam and Ira D. Wallach Division of Art, Prints and Photographs, The Phelps Stokes Collection, Print Collection 1855–E–138

Thomas Benecke, active in New York City 1855–56, artist
Nagel and Lewis, printer
Emil Seitz, publisher

144. *Sleighing in New York,* 1855
Lithograph printed in colors with hand coloring
21½ x 30⅜ in. (54.4 x 77 cm) image;
27⅞ x 36¼ in. (69.6 x 92 cm) sheet
Signed in stone at lower left: T. Benecke, N.Y.
Inscribed: Composed & lith. by TH. BENECKE[;] Entered according to Act of Congress, in the Year 1855, by L. NAGEL in the Clerks Office of the Dist. Court of the Southern Dist. of New York.[;] Printed by NAGEL & LEWIS, 122 Fulton St. N.Y./SLEIGHING IN NEW YORK./Published by EMIL SEITZ/413 Broadway N.Y.
The Metropolitan Museum of Art, New York, The Edward W. C. Arnold Collection of New York Prints, Maps, and Pictures, Bequest of Edward W. C. Arnold, 1954 54.90.1061

John Bachmann, German, active in New York City 1849–85, artist
Adam Weingartner, active in New York City 1849–56, printer
L. W. Schmidt, publisher

145. *The Empire City,* 1855
Lithograph printed in colors with hand coloring
22⅝ x 33½ in. (57.5 x 85.2 cm) image;
28⅜ x 38¼ in. (72 x 97.1 cm) sheet
Inscribed: Drawn from nature & on stone by

J. Bachmann.[;] Entered according to act of Congress in the year 1855 by J. Bachmann, in the Clerk's Office of the District Court of the South-n District of NY.[;] Print of A. Weingartner's Lith-y N.Y./THE EMPIRE CITY,/Birdseye view of NEW-YORK and Environs./Published by J. Bachmann, 134 Spring St. & 143 Fulton St. New-York
The Metropolitan Museum of Art, New York, The Edward W. C. Arnold Collection of New York Prints, Maps, and Pictures, Bequest of Edward W. C. Arnold, 1954 54.90.1198

Walt Whitman, 1819–1892, author

146A. *Leaves of Grass* (1st ed.), Brooklyn, New York, 1855
Bound in dark green cloth with title stamped in gold
11⅜ x 8¼ x ½ in. (28.9 x 20.6 x 1.3 cm)
Contains Whitman's own transcription of the letter Ralph Waldo Emerson wrote to him after receiving a copy from Whitman

Samuel Hollyer, 1826–1919, engraver
After a daguerreotype by Gabriel Harrison

146B. *Walt Whitman,* 1855
Frontispiece from *Leaves of Grass* (1855)
Engraving
2⅛ x 2 in. (5.4 x 5.1 cm)
Columbia University, New York, Rare Book and Manuscript Library, Solton and Julia Engel Collection

John Gadsby Chapman, 1808–1889

147. *Italian Goatherd,* 1857
Etching
7¼ x 4⅝ in. (18.4 x 11.7 cm) image;
17⅝ x 12½ in. (44.8 x 31.8 cm) sheet
Signed and dated in graphite at lower left: J. Chapman fect Rome 1857
Museum of Fine Arts, Boston, Gift of Sylvester Rosa Koehler K858

Jean-Baptiste-Adolphe Lafosse, French, 1810–1879, lithographer
After William Sidney Mount, 1807–1868, artist
François Delarue, French, printer
William Schaus, publisher

148. *The Bone Player,* 1857
Lithograph with hand coloring
25 x 19¾ in. (63.5 x 50.2 cm) image;
32 x 24¼ in. (81.3 x 61.6 cm) sheet
Signed in stone: Lafosse
Inscribed: Painted by WM. S. MOUNT[;] Entered according to Act of Congress in the year 1857, by W. Schaus, in the clerk's Office of the district Court of the United States for the Southern district of New-York[;] Lith. by LAFOSSE./The Bone Player./New-York, pubd. by W. SCHAUS, 629 Broadway[;] Imp. Fois Delarue, Paris
The Metropolitan Museum of Art, New York, Purchase, Leonard L. Milberg Gift, 1998 1998.416
After Mount's painting of 1856

Julius Bien, German (Kassel, Hesse-Kassel), 1826–1909, active in the United States from 1849, lithographer
After John James Audubon, French, born Haiti, 1785–1851, active in the United States 1806–51, artist, and Robert Havell Jr., British, 1793–1878, active in the United States 1839–78, engraver

149. *Wild Turkey,* 1858
Lithograph printed in colors
40 x 27 in. (101.6 x 68.6 cm)
Inscribed: No. 1-1[;] PLATE 287./Drawn from Nature by J. J. Audubon, F.R.S. F.L.S.[;] Wild Turkey MELEAGRIS GALLOPAVO Linn, Male. American Cane Miegea macrosperma[;] chromolith-y. by J. Bien, New York, 1858.
Brooklyn Museum of Art X633.3

John Bachmann, German, active in New York City 1849–85, artist, lithographer, and publisher
C. Fatzer, printer

150. *New York City and Environs,* 1859
Lithograph printed in colors
Diam. 21¾ in. (55.2 cm)
Inscribed: NEW-YORK & ENVIRONS.[;] ASTORIA.[;] GREENPOINT.[;] WILLIAMS-BURG.[;] NAVY YARD.[;] BROOKLYN.[;] CONEY ISLAND.[;] GREENWOOD CEMETERY.[;] FORT LAFAYETTE.[;] FORT RICHMOND.[;] SANDY HOOK.[;] STATEN ISLAND.[;] GOVERNOR'S [sic] ISLAND.[;] AMBOY.[;] ELIZABETH PORT.[;] ELIZABETH TOWN.[;] MILLVILLE.[;] ORANGE.[;] BERGEN.[;] NEWARK.[;] BELLVILLE [sic].[;] JERSEY CITY.[;] PATERSON.[;] HOBOCKEN[sic].[;] HARLEM./Drawn from Nature on Stone by BACHMAN./Publihed [sic] by Bachman No. 73 Nassau St NY/Entered according to act of Congress in the year 1859, by H Bachman in the clerk's office of the district Court of the United States of the Southern district of N.Y./Printed by C. FATZER 216 William St. N.Y.
Museum of the City of New York, Gift of James Duane Taylor, 1931 31.24

DeWitt Clinton Hitchcock, active 1845–79, artist
Hy. J. Crate, printer

151. *Central Park, Looking South from the Observatory,* 1859
Lithograph printed in colors with hand coloring
16 x 26 in. (40.6 x 65.9 cm) image;
20⅜ x 28½ in. (51.8 x 72.4 cm) sheet
Inscribed: Printed in Oil Colors by Hy. J. Crate 181 William St. N.Y./Entered according to Act of Congress in the year 1859 by D. C. Hitchcock & Co. in the Clerk's Office of the District Court of the Southern District of N.Y./CENTRAL PARK./NEW YORK CITY/Looking South from the Observatory.
Museum of the City of New York, The J. Clarence Davies Collection 29.100.2299

Arthur Lumley, Irish, active in the United
States ca. 1837–1912, artist
W. R. C. Clark and Meeker, publisher

152. *The Empire City, New York, Presented to the
Subscribers to "The History of the City of New
York,"* 1859
Wood engraving and lithograph printed
in colors
24⅝ x 35⅝ in. (62.5 x 90.5 cm) image;
27 x 38⅜ in. (68.6 x 97.5 cm) sheet
Inscribed: PRESENTED TO THE SUBSCRIBERS
TO THE HISTORY OF THE CITY OF NEW-
YORK,/ BY THE PUBLISHERS, W.R.C. CLARK &
MEEKER, 19 WALKER STREET, NEW-YORK./
Entered according to act of Congress, in the
year 1859, by W.R.C. CLARK & MEEKER, in
the Clerk's Office of District Court for the
Southern District of New-York./ Printed by
S. Booth, 109 Nassau Street, New York.
The New-York Historical Society

Charles Parsons, 1821–1910, artist
Currier and Ives, active 1857–1907, printer
and publisher

153. *Central Park, Winter: The Skating Pond,* ca. 1861
Lithograph with hand coloring
18⅛ x 26⅝ in. (46 x 67.6 cm) image;
21⅞ x 29⅞ in. (55.6 x 75.9 cm) sheet
Signed in stone at lower right: LWA
Inscribed: CURRIER & IVES, LITH. N.Y./
ENTERED ACCORDING TO ACT OF CONGRESS
IN THE YEAR 1862, IN THE CLERK'S OFFICE
OF THE DISTRICT COURT OF THE UNITED
STATES, FOR THE SOUTHERN DISTRICT OF
NEW YORK./ C. PARSONS, DEL./ CENTRAL-
PARK, WINTER./ THE SKATING POND./ NEW
YORK, PUBLISHED BY CURRIER & IVES,
152 NASSAU ST.
The Metropolitan Museum of Art, New York,
Bequest of Adele S. Colgate, 1962 63.550.266

FOREIGN PRINTS

Rembrandt van Rijn, Dutch, 1606–1669
154. *Saint Jerome Reading in a Landscape,* ca. 1654
Etching, drypoint, and engraving, second state
10⅛ x 8¼ in. (25.7 x 21 cm) sheet trimmed
to platemark
Museum of Fine Arts, Boston, Harvey D.
Parker Collection P496
Owned by Henry Foster Sewall

Carlo Lossi, Italian, engraver
After Tiziano Vecelli (Titian), Italian,
1485–1576
155. *Bacchus and Ariadne,* 1774
Etching and engraving
12⅜ x 15¾ in. (31.4 x 40 cm) platemark;
15⅜ x 20 in. (39.1 x 50.8 cm) sheet
Inscribed: AL ILL ᵐᵒ SIGʳᵉ DON FABIO DELLA
CORGNA/ Titianus inven: Gio Andrea Podesta
Genovese D.D. la presente sua opera/ Supe-
riorum licentia[;] In Roma presso Carlo
Lossi 1774
The New-York Historical Society 1858.92.043
Owned by Luman Reed

William Sharp, British, 1749–1824, engraver
After Benjamin West, 1738–1820, artist
John Boydell, 1719–1804, and Josiah Boydell,
1752–1818, London, publisher
156. *Act 3, Scene 4, from William Shakespeare's
"King Lear,"* 1793
Engraving
17⅜ x 23¼ in. (44.2 x 59.2 cm) image;
19¼ x 24½ in. (48.9 x 62.1 cm) sheet
Inscribed: Painted by B. West Esqʳ. R. A./ &
Presidᵗ of the Royal Academy/ Engrav'd by
W. Sharp/ SHAKSPEARE./ King Lear./ Act III.
Scene IV/ Publish'd March 25, 1793, by JOHN
& JOSIAH BOYDELL, at the Shakspeare Gallery,
Pall Mall, & Nᵒ· 90, Cheapside London./
— Off, off you lendings:/ Come; unbutton
here. — /[Tearing off his clothes.
The Metropolitan Museum of Art, New York,
Gift of Georgiana W. Sargent, in memory of
John Osborne Sargent, 1924 24.63.1869
After West's painting of 1788, which was
commissioned by John and Josiah Boydell
and subsequently owned by Robert Fulton

John Burnet, British, 1784–1868, engraver
After David Wilkie, British, 1785–1841, artist
Josiah Boydell, 1752–1818, London, publisher
157. *The Blind Fiddler,* 1811
Engraving
16 x 21⅝ in. (40.6 x 54.9 cm) image;
22⅝ x 30⅛ in. (57.5 x 76.5 cm) sheet
Inscribed: The Blind Fiddler/ To Sir George
Beaumont Barᵗ/ Whose superior Judgement
& Liberality have led/ him to appreciate &
encourage early &/ extraordinary merit[;]
This Plate, from a Picture painted for him by
Mr. D. Wilkie, is respectfully dedicated by
his obliged & obedᵗ Serᵛᵗ/ Josiah Boydell/
Published 1st Oct 1811 by Messʳˢ Boydell &
Co./ 90 Cheapside London.
The New York Public Library, Astor, Lenox
and Tilden Foundations, Miriam and Ira D.
Wallach Division of Art, Prints and Photo-
graphs, Print Collection
After Wilkie's painting of 1806

Alphonse François, French, 1814–1882,
engraver
After Paul Delaroche, French, 1797–1856, artist
158. *Napoleon Crossing the Alps,* 1852
Engraving, proof
24⅞ x 19 in. (63.2 x 48.3 cm) image;
31¼ x 24⅜ in. (79.4 x 61.9 cm) sheet
Inscribed: PEINT PAR PAUL DELAROCHE./
London_ Published October 1ˢᵗ 1852, by P. &
D. Colnaghi & Cᵒ, 13 & 14, Pall Mall East/
GRAVÉ PAR ALPHˢᵉ FRANÇOIS/ Berlin-Verlag
von Goupil & Cⁱᵉ/ Publié par Goupil & Cⁱᵉ
Paris—London—New York/ Imprimerie de
Goupil & Cⁱᵉ
The Metropolitan Museum of Art, New York,
The Elisha Whittelsey Collection, The Elisha
Whittelsey Fund, 1949 49.40.177
After Delaroche's acclaimed painting of 1848;
exhibited by Goupil that year at the National
Academy of Design and purchased by Wood-
bury Langdon in 1850

Charles Mottram, engraver
After John Martin, British, 1789–1854, artist
William, Stevens and Williams, publisher
159. *The Plains of Heaven,* 1855
Mezzotint, proof before letters
24¼ x 37½ in. (61.6 x 95.3 cm) image;
28⅝ x 43½ in. (72.7 x 110.5 cm) sheet
Embossed stamp at lower left: Printsellers
Association YOR
The New York Public Library, Astor, Lenox
and Tilden Foundations, Miriam and Ira D.
Wallach Division of Art, Prints and Photo-
graphs, Print Collection
After Martin's painting of 1851–53, which
inspired Frederic E. Church's *Niagara Falls*
and *The Heart of the Andes*

PHOTOGRAPHY

Samuel F. B. Morse, 1791–1872
160. *Young Man,* 1840
Daguerreotype
Ninth plate, 2½ x 2 in. (6.4 x 5.1 cm)
Stamped on brass mat: SFB MORSE
Gilman Paper Company Collection, New
York
The earliest, and only, surviving daguerreo-
type by Morse

Mathew B. Brady, 1823/24–1896
161. *Thomas Cole,* 1844–48
Daguerreotype
Half plate, 5½ x 4¼ in. (14 x 10.8 cm)
National Portrait Gallery, Smithsonian
Institution, Washington, D.C., Gift of Edith
Cole Silberstein NPG.76.11
Owned by Thomas Cole

Artist unknown
162. *Asher B. Durand,* ca. 1854
Daguerreotype
Half plate, 5½ x 4¼ in. (14 x 10.8 cm)
The New-York Historical Society
PR–012–2–80
Owned by Nora Durand Woodman

Attributed to Gabriel Harrison, 1818–1902
163. *Walt Whitman,* ca. 1854
Daguerreotype
Quarter plate, 4¼ x 3¼ in. (10.8 x 8.3 cm)
The New York Public Library, Astor, Lenox
and Tilden Foundations, Rare Books
Division

Mathew B. Brady, 1823/24–1896
164. *John James Audubon,* 1847–48
Daguerreotype
Half plate, 5½ x 4¼ in. (14 x 10.8 cm)
Cincinnati Art Museum, Centennial Gift of
Mr. and Mrs. Frank Shaffer, Jr. 1981.144,
1982.268

Francis D'Avignon, French, 1813–1861, active in the United States 1840–60, lithographer
After a daguerreotype by Mathew B. Brady, 1823/24–1896

165A. *John James Audubon*, 1850
From *The Gallery of Illustrious Americans* (1850)
Lithograph
11¼ x 9⅝ in. (28.3 x 24.4 cm) image; 18⅞ x 13⅜ in. (47.9 x 34 cm) sheet
The Metropolitan Museum of Art, New York, Bequest of Charles Allen Munn, 1924
24.90.576

C. Edwards Lester, editor
Francis D'Avignon, French, 1813–1861, active in the United States 1840–60, lithographer
After Mathew Brady, 1823/24–1896, daguerreotypist
Brady, D'Avignon and Company, publisher

165B. *The Gallery of Illustrious Americans, Containing the Portraits and Biographical Sketches of Twenty-four of the Most Eminent Citizens of the American Republic, since the Death of Washington. From Daguerreotypes by Brady, Engraved by D'Avignon*, 1850
Bound in blue cloth with gold stamping
21¾ x 15½ x ¾ in. (55.2 x 39.4 x 1.9 cm)
The Metropolitan Museum of Art, New York, Bequest of Charles Allen Munn, 1924
24.90.1966

Mathew B. Brady, 1823/24–1896
166. *Jenny Lind*, 1852
Daguerreotype
Sixth plate, 3¼ x 2¾ in. (8.3 x 7 cm)
Chrysler Museum of Art, Norfolk, Virginia, Museum Purchase and gift of Kathryn K. Porter and Charles and Judy Hudson 89.75

Jeremiah Gurney, 1812–after 1886
167. *Mrs. Edward Cooper and Son Peter (Pierre) Who Died*, 1858–60
Daguerreotype
Half plate, 5½ x 4¼ in. (14 x 10.8 cm)
Stamped on brass mat: J. GURNEY[;] 707 BROADWAY N.Y.
The New-York Historical Society
PR–012–2–811

Attributed to Samuel Root, 1819–1889, or Marcus Aurelius Root, 1808–1888
168. *P. T. Barnum and Charles Stratton ("Tom Thumb")*, 1843–50
Daguerreotype
Half plate, 5½ x 4¼ in. (14 x 10.8 cm)
National Portrait Gallery, Smithsonian Institution, Washington, D.C. NPG.93.254

Gabriel Harrison, 1818–1902
169. *California News*, 1850–51
Daguerreotype
Half plate, 5½ x 4¼ in. (14 x 10.8 cm)
Gilman Paper Company Collection, New York

Mathew B. Brady, 1823/24–1896
170. *The Hurlbutt Boys*, ca. 1850
Daguerreotype
Half plate, 5½ x 4¼ in. (14 x 10.8 cm)

Stamped on velvet case lining: BRADY'S GALLERY/205 & 207/BROADWAY, NEW-YORK
The New-York Historical Society

Mathew B. Brady, 1823/24–1896
171. *Young Boy*, 1850–54
Daguerreotype
Half plate, 5½ x 4¼ in. (14 x 10.8 cm)
Stamped on velvet case lining: BRADY'S GALLERY/205 & 207/BROADWAY, NEW-YORK
Hallmark Photographic Collection, Hallmark Cards, Inc., Kansas City, Missouri
P5.428.013.98

Jeremiah Gurney, 1812–after 1886
172. *The Kellogg-Comstock Family*, 1852–58
Daguerreotype
Whole plate, 6½ x 8½ in. (16.5 x 21.6 cm)
Stamped on brass mat: J. GURNEY[;] 349 BROADWAY
The New-York Historical Society

Artist unknown
173. *Brooklyn Grocery Boy with Parcel*, 1850s
Daguerreotype
Sixth plate, 3¼ x 2¾ in. (8.3 x 7 cm)
Hallmark Photographic Collection, Hallmark Cards, Inc., Kansas City, Missouri
P5.400.053.96

Jeremiah Gurney, 1812–after 1886
174. *Young Girl*, 1858–60
Daguerreotype
Sixth plate, 3¼ x 2¾ in. (8.3 x 7 cm)
Stamped on brass mat: J. GURNEY[;] 707 BROADWAY N.Y.
Hallmark Photographic Collection, Hallmark Cards, Inc., Kansas City, Missouri
P5.424.005.97

Artist unknown
175. *Blind Man and His Reader Holding the "New York Herald*,*"* 1840s
Daguerreotype
Quarter plate, 4¼ x 3¼ in. (10.8 x 8.3 cm)
Gilman Paper Company Collection, New York

Jeremiah Gurney, 1812–after 1886
176. *A Fireman with His Horn*, ca. 1857
Daguerreotype
Quarter plate, 4¼ x 3¼ in. (10.8 x 8.3 cm)
Stamped on brass mat: J. GURNEY[;] 349 BROADWAY
Collection of Matthew R. Isenburg

Attributed to Charles DeForest Fredricks, 1823–1894
177. *Amos Leeds, Confidence Operator*, ca. 1860
Salted paper print from glass negative
8 x 6 in. (20.3 x 15.2 cm)
Inscribed in ink on mount at lower right:
Amos Leeds Confidence operator/Alias "Morrison"—/"Comstock"
Hallmark Photographic Collection, Hallmark Cards, Inc., Kansas City, Missouri
P5.390.003.97

Artist unknown
178. *Chatham Square, New York*, 1853–55
Daguerreotype
Half plate, 4¼ x 5½ in. (10.8 x 14 cm)
Inscribed on paper label attached to verso:
Chat., Sq./NEW YORK
Gilman Paper Company Collection, New York

Artist unknown
179. *Interior View of the Crystal Palace Exhibition*, 1853–54
Daguerreotype
Sixth plate, 2¾ x 3¼ in. (7 x 8.3 cm)
The New-York Historical Society

Artist unknown
180. *The New Paving on Broadway, between Franklin and Leonard Streets*, 1850–52
Stereo daguerreotype (left panel illustrated)
3⅛ x 7 in. (7.9 x 17.8 cm) overall
Collection of Matthew R. Isenburg

William Langenheim, born Germany, 1807–1874, and Frederick Langenheim, born Germany, 1809–1879
181. *New York City and Vicinity, View from Peter Cooper's Institute toward Astor Place*, ca. 1856
Stereograph glass positive
3¼ x 6⅞ in. (8.3 x 17.5 cm)
Inscribed on glass mount (not illustrated):
NEW YORK CITY & VICINITY/View from Peter Cooper's Institute/towards Astor Place/LANGENHEIM'S PATENT, NOV. 19, 1850/Entered according to Act of Congress in the year 1856, by F. Langenheim, in the Clerk's Office of the District Court for the Eastern District of Pennsylvania
The New York Public Library, Astor, Lenox and Tilden Foundations, Miriam and Ira D. Wallach Division of Art, Prints and Photographs, Robert N. Dennis Collection of Stereoscopic Views

Victor Prevost, French, 1820–1881, active in the United States late 1840s–1850s
182. *Battery Place, Looking North*, 1854
Waxed paper negative
9 x 12⅝ in. (22.9 x 32.1 cm)
The New-York Historical Society

Victor Prevost, French, 1820–1881, active in the United States late 1840s–1850s
183. *Looking North toward Madison Square from Rear Window of Prevost's Apartment at 28 East Twenty-eighth Street, Summer*, 1854
Waxed paper negative
13¼ x 10¼ in. (33.7 x 26 cm)
The New-York Historical Society

Victor Prevost, French, 1820–1881, active in the United States late 1840s–1850s
184. *Looking North toward Madison Square from Rear Window of Prevost's Apartment at 28 East Twenty-eighth Street, Winter*, 1854
Waxed paper negative
13⅜ x 10¼ in. (34 x 26 cm)
The New-York Historical Society

Attributed to Silas A. Holmes, 1820–1886, or
Charles DeForest Fredricks, 1823–1894

185. *View down Fifth Avenue,* ca. 1855
Salted paper print from glass negative
12¾ x 15¾ in. (32.4 x 40 cm)
Inscribed in pencil on mount: 5ᵗʰ avenue
New York & St. Germain Hotel–New York[;]
Holmes ou Fredricks; on printed paper label,
collection/Marguerite Milhau/Paris
The J. Paul Getty Museum, Los Angeles
84.XM.351.10

Attributed to Silas A. Holmes, 1820–1886, or
Charles DeForest Fredricks, 1823–1894

186. *City Hall, New York,* ca. 1855
Salted paper print from glass negative
11½ x 16⅜ in. (29.2 x 41.6 cm)
Inscribed in pencil on mount: City Hall
NY[;] Holmes?
The J. Paul Getty Museum, Los Angeles
84.XM.351.9

Attributed to Silas A. Holmes, 1820–1886, or
Charles DeForest Fredricks, 1823–1894

187. *Washington Square Park Fountain with
Pedestrians,* ca. 1855
Salted paper print from glass negative
11⅝ x 16⅛ in. (29.5 x 41 cm)
Inscribed in pencil on mount: on recto,
Wasingtton [*sic*] Park[;] Fredricks? Holmes?[;]
[erased] phot. Americain, calotype vers 1850;
on verso, col. M[arguerite] M[ilhau]
The J. Paul Getty Museum, Los Angeles
84.XM.351.16

Attributed to Silas A. Holmes, 1820–1886, or
Charles DeForest Fredricks, 1823–1894

188. *Washington Monument, at Fourteenth Street
and Union Square,* ca. 1855
Salted paper print from glass negative
12¼ x 15⅞ in. (31.1 x 40.3 cm)
Inscribed in pencil on mount: on recto,
14ᵗʰ street a Union Square N.Y. vers 1853
Holmes? Fredricks?; on verso, 6730/30150
dans 9 x 14 del.[;] col. M[arguerite] M[ilhau]
The J. Paul Getty Museum, Los Angeles
84.XM.351.12

Attributed to Silas A. Holmes, 1820–1886, or
Charles DeForest Fredricks, 1823–1894

189. *Palisades, Hudson River, Yonkers Docks,* ca. 1855
Salted paper print from glass negative
11½ x 15¼ in. (29.2 x 38.6 cm)
Inscribed in pencil on mount: on recto,
Palisades, Hudson River, Yonkers Docks,
[illegible][;] [erased] vers 1855[;] Fredricks
ou Holmes[;] calotype/collection André
Jammes; on verso, col. M[arguerite] M[ilhau]
The J. Paul Getty Museum, Los Angeles
84.XM.351.1

Attributed to Silas A. Holmes, 1820–1886, or
Charles DeForest Fredricks, 1823–1894

190. *Fort Hamilton and Long Island,* ca. 1855
Salted paper print from glass negative
11¼ x 15½ in. (28.6 x 39.4 cm)

Inscribed in pencil on mount: Fort Hamilton
& Long Island[;] Fredricks ou Holmes?
The J. Paul Getty Museum, Los Angeles
84.XM.351.7

Attributed to Silas A. Holmes, 1820–1886, or
Charles DeForest Fredricks, 1823–1894

191. *Fort Hamilton and Long Island,* ca. 1855
Salted paper print from glass negative
11 x 15⅜ in. (27.8 x 39.2 cm)
Inscribed in pencil on mount: on recto,
Narrows entrée de la Baie de New York[;]
Holmes? Fredricks?[;] [erased] calotype; on
verso, col. M[arguerite] M[ilhau]
The J. Paul Getty Museum, Los Angeles
84.XM.351.14

Frederick Law Olmsted, 1822/23–1903, and
Calvert Vaux, 1824–1895, designers
Mathew B. Brady, 1823/24–1896, photographer
Calvert Vaux, artist

192. *"Greensward" Plan for Central Park, No. 4:
From Point D, Looking Northeast across a
Landscape Depicting Belvedere Castle, Lake,
Gondola, and Gazebo,* 1857
Lithograph, albumen silver print from glass
negative, and oil on paper, mounted on board
28⅝ x 21⅛ in. (72.7 x 53.6 cm)
Municipal Archives, Department of Records
and Information Services, City of New York
DPR 3084

Frederick Law Olmsted, 1822/23–1903, and
Calvert Vaux, 1824–1895, designers
Mathew B. Brady, 1823/24–1896, photographer
Calvert Vaux, artist

193. *"Greensward" Plan for Central Park, No. 5:
From Point E, Looking Southwest,* 1857
Lithograph, albumen silver print from glass
negative, and oil on paper, mounted on board
28⅝ x 21½ in. (72.7 x 54.5 cm)
Municipal Archives, Department of Records
and Information Services, City of New York
DPR 3085

Attributed to Charles DeForest Fredricks,
1823–1894

194. *Fredricks's Photographic Temple of Art, New York,*
1857–60
Salted paper print from glass negative
16¼ x 13⅞ in. (41 x 35.2 cm)
Stamped on verso, in circle at bottom center,
in dark purple ink: COLLECTION albert GILLES
Inscribed on verso in pencil: (Calotype)
Temple de l'art Photographique/New-York
en 1853
Hallmark Photographic Collection, Hallmark
Cards, Inc., Kansas City, Missouri
P5.390.001.95

Mathew B. Brady, 1823/24–1896

195. *Martin Van Buren,* ca. 1860
Salted paper print from glass negative
19 x 15⅝ in. (48.3 x 39.7 cm)
The Metropolitan Museum of Art, New York,
David Hunter McAlpin Fund, 1956 56.517.4

Mathew B. Brady, 1823/24–1896

196. *Cornelia Van Ness Roosevelt,* ca. 1860
Salted paper print from glass negative
17¾ x 15 in. (45.1 x 38.1 cm)
Gilman Paper Company Collection, New
York

COSTUMES

197. Man's tailored ensemble, English, ca. 1833
The Metropolitan Museum of Art, New York

Tailcoat, blue silk
Purchase, Catherine Brayer Van Bomel
Foundation Fund, 1981 1981.210.4

Vest, yellow silk
Purchase, Irene Lewisohn Bequest, 1976
1976.235.3d

Trousers, natural linen
Purchase, Irene Lewisohn and Alice L.
Crowley Bequests, 1982 1982.316.11

Stock, black silk and wool
Purchase, Gifts from various donors, 1983
1983.27.2

Hat, beige beaver
Purchase, Irene Lewisohn Bequest, 1972
1972.139.1

198. Woman's walking ensemble, American,
1832–33
The Metropolitan Museum of Art, New York

Dress and pelerine, brown silk
Gift of Randolph Gunter, 1950 50.15a,b

Hat, brown straw
Gift of Mr. Lee Simpson, 1939 39.13.118

Belt, brown woven ribbon with gilt metal
buckle
Purchase, Gifts from various donors, 1984
1984.144

Boots, brown leather and linen
Gift of Mr. Lee Simpson, 1938 38.23.150a,b

Collar, embroidered muslin
Gift of The New-York Historical Society, 1979
1979.346.223

Mitts, cotton mesh
Gift of Mrs. Margaret Putnam, 1946
46.104a,b

Cuffs, embroidered muslin
Gift of Mrs. Albert S. Morrow, 1937
37.45.101a,b

199. Woman's afternoon walking ensemble,
American

Arnold Constable and Company, retailer
Two-piece day dress, worn as a wedding
gown in 1855 by Mrs. Peter Herrman, 1855
Green-striped taffeta
Museum of the City of New York, Gift of
Mrs. Florien P. Gass, 44.247.1ab–2ab

Attributed to George Brodie
Mantilla wrap, worn to the Prince of Wales
Ball in 1860, ca. 1853
Embroidered red-brown velvet
The Metropolitan Museum of Art, New York,
Gift of Miss Henry A. Lozier, 1948 48.65

Bonnet, ca. 1856
Straw, lace, and brown velvet
Museum of the City of New York, Gift of
Mrs. Cuyler T. Rawlins 59.124.1

S. Redmond, manufacturer
Parasol, ca. 1824–31
Brown silk woven with leaf-and-flower
border; turned and carved wood stick
Museum of the City of New York, from the
Estate of Miss Jessie Smith, Gift of Clifton H.
Smith 70.127

200. Woman's afternoon walking ensemble

Two-piece day dress, American, ca. 1855
Plaid taffeta and silk braid
The Metropolitan Museum of Art, New York,
Gift of Mrs. Edwin R. Metcalf, 1969
69.32.2a,b

Paisley shawl, European, mid-nineteenth century
Silk and wool
The Metropolitan Museum of Art, New York,
Gift of Mr. E. L. Waid, 1955 CI.55.41

Bonnet, American, ca. 1850
Silk
Museum of the City of New York, Gift of
Grant Keehn 62.235.2

Alexander T. Stewart, active 1823–76, retailer
201. Wedding veil (detail), Irish, 1850
Net with Carrickmacross appliqué
40 x 100 in. (101.5 x 254 cm)
Valentine Museum, Richmond, Virginia, Gift
of Elizabeth Valentine Gray 05.21.10

Tiffany and Company, active 1837–present,
retailer
202. Fan, European, 1850s
Printed vellum, carved and gilded mother-of-
pearl
10⅝ x 20⅛ in. (27 x 51 cm) open
The Metropolitan Museum of Art, New York,
Gift of Caroline Ferriday, 1981 1981.40

Middleton and Ryckman, manufacturer
203. Pair of slippers, 1848–50
Bronze kid with robin's-egg blue embroidery
L. 9 in. (22.8 cm) heel to toe; h. 1⅝ in. (4 cm)
Museum of the City of New York, Gift of
Miss Florence A. Williams 58.212.1a,b

204. Woman's evening toilette, worn to the Prince
of Wales Ball, 1860

Attributed to Worth and Bobergh, active
1857/58–70/71, Paris
Ball gown, worn by Mrs. David Lyon
Gardiner, 1860
Cut velvet, woven in Lyon

Museum of the City of New York, Gift of
Miss Sarah Diodati Gardiner 39.26a,b

Bouquet holder, carried by Mrs. Antonio
Yznaga, 1860
Gold filigree
Museum of the City of New York, Gift of
Lady Lister-Kaye 33.27.1

George IV–style rivière, mid-nineteenth century
Paste, silver, and gold
James II Galleries, Ltd

Headdress, ca. 1860
Teal chenille with satin glass beads
Museum of the City of New York, Gift of
Mrs. John Penn Brock 42.445.9

205. Woman's evening toilette, worn to the Prince
of Wales Ball, 1860

Ball gown, worn by the great-aunt of the
Misses Braman, 1860
Cut velvet *en disposition* woven in Lyon, point-
de-gaze lace
Museum of the City of New York, Gift of the
Misses Braman 53.40.16a–d

Fan, carried by Mrs. William H. Sackett, 1860
Black Chantilly lace and mother-of-pearl
Museum of the City of New York, Gift of the
Misses Emma C. and Isabel T. Sackett, 1937
37.326.4

Mantilla wrap, worn by Mrs. Jonas C.
Dudley, 1860
Black embroidered net
Museum of the City of New York, Gift of
Mrs. Russell deC. Greene 49.101

Necklace, American, mid-nineteenth century
Strung pearlwork
The Metropolitan Museum of Art, New York,
Gift of Mrs. Alfred Schermerhorn, in memory
of Mrs. Ellen Schermerhorn Auchmuty, 1946
46.101.8

Headdress, ca. 1860
Black Chantilly lace, silk-and-wool flowers
Museum of the City of New York, Gift of
Miss Martia Leonard 33.143.4

JEWELRY

George W. Jamison, d. 1868, active in New
York City as a cameo cutter 1835–38
William Rose, active in New York City
1839–50, jeweler
206. Cameo with portrait bust of Andrew Jackson,
ca. 1835
Helmet conch shell, enamel, and gold
2½ x 2¼ in. (6.4 x 5.7 cm)
Signed below cavetto: GJ [in relief]
Inscribed on frame: THE UNION IT MUST AND
SHALL BE PRESERVED
Private collection

Gelston and Treadwell, active 1843/44–1850/51
207. Bouquet holder, 1847

Silver
H. 5⅛ in. (13 cm); diam. 1⅝ in. (4.1 cm)
Impressed on original box: Gelston &
Treadwell/No. 1 Astor House, N. York/
Manufacturers and Importers of/Fine
Jewelry, Watches/& Fancy Goods
Historic Hudson Valley, Tarrytown, New
York ss.75.21a,b
Presented by Washington Irving to his niece
Charlotte, youngest child of his brother
Ebenezer, on the occasion of her marriage to
William R. Grinnell in 1847

Tiffany and Company, active 1837–present
208. Five-piece parure in fitted box (brooch,
earrings, cuff buttons), 1854–61
Agate, coral, pearls, yellow gold, and black
enamel
Diam. (brooch) 1¼ in. (3.2 cm)
Impressed on interior lid: TIFFANY & CO./
550 B. WAY/NEW-YORK
Collection of Janet Zapata

Tiffany and Company, active 1837–present,
retailer
209. Hair bracelet, ca. 1850
Hair, yellow gold, glass, diamonds, silver,
and textile
L. 7½ in. (19.1 cm); w. 1⅛ in. (2.9 cm)
Glass medallion set with a silver monogram
"M" in diamonds
Engraved on fastener: MEM/10th July 1851
The New-York Historical Society INV.774

Edward Burr, active in New York City 1838–68
210. Parure (brooch and earrings), ca. 1858–60
Yellow gold, pearls, diamonds, enamel, and
blue enamel
H. (brooch) 2¼ in. (5.7 cm)
Imprinted inside lid of original box: E.W.
BURR/573 B.WAY/NEW-YORK
Private collection

Tiffany and Company, active 1837–present
211. Seed-pearl necklace and pair of bracelets,
ca. 1860
Seed pearls and yellow gold
L. (necklace) 15¼ in. (38.7 cm)
Library of Congress, Washington, D.C., Rare
Book and Special Collections Division
2.87.276.1–3
Purchased (along with matching earrings and
brooch) for $530 by President Abraham
Lincoln for Mary Todd Lincoln, who wore
them to her husband's inaugural ball in 1861

DECORATIONS FOR THE HOME

Manufacturer unknown, British
212. Ingrain carpet, ca. 1835–40
Wool
152⅜ x 35½ in. (387 x 90.2 cm)
The Metropolitan Museum of Art, New York,
Gift of Mr. and Mrs. Stuart Feld, 1980
1980.511.8

Manufacturer unknown, probably American
213. Ingrain carpet, ca. 1850–60
Wool
84 x 34½ in. (213.4 x 87.6 cm)
The Metropolitan Museum of Art, New York,
Gift of Frances W. Geyer, 1972 1972.203

Elizabeth Van Horne Clarkson, 1771–1852
214. Honeycomb quilt, ca. 1830
Cotton
107⅝ x 98¼ in. (273.4 x 249.6 cm)
The Metropolitan Museum of Art, New York,
Gift of Mr. and Mrs. William A. Moore, 1923
23.80.75

Maria Theresa Baldwin Hollander
215. Abolition quilt, ca. 1853
Silk embroidered with silk and silk-chenille
thread
43½ x 43¾ in. (110.5 x 111.1 cm)
Society for the Preservation of New England
Antiquities, Boston, Loaned by the Estate of
Mrs. Benjamin F. Pitman 2.1923
Exhibited at the New-York Exhibition of the
Industry of All Nations, 1853–54

Manufacturer unknown, New York City
216. Wallpaper depicting west side of Wall Street;
the Battery and Castle Garden; Wall Street
with Trinity Church; Grace Church; and
City Hall, ca. 1850
Roller-printed paper
20⅞ x 18½ in. (52.9 x 47 cm) repeat; 20⅞ x
19¾ in. (52.9 x 50.1 cm) paper
The Metropolitan Museum of Art, New York,
The Edward W. C. Arnold Collection of New
York Prints, Maps, and Pictures, Bequest of
Edward W. C. Arnold, 1954 54.90.734

Manufacturer unknown, probably New
York City
217. Entrance-hall wallpaper from the George
Collins house, Unionvale, New York, ca. 1850
Roller-printed paper
26 x 20 in. (66 x 50.8 cm)
The Metropolitan Museum of Art, New York,
Gift of Mrs. Adrienne A. Sheridan, 1956
56.599.10

Manufacturer unknown, probably New
York City
218. Window shade depicting the Crystal Palace,
New York City, 1853
Hand-painted and roller-printed paper
60¼ x 35⅜ in. (153 x 90 cm)
Cooper-Hewitt, National Design Museum,
Smithsonian Institution, New York, Museum
purchase in memory of Eleanor and Sarah
Hewitt 1944.66.1

Manufacturer unknown, French
219. Brocatelle, ca. 1850–55
Silk and linen
98 x 21 in. (248.9 x 53.3 cm)
The Metropolitan Museum of Art, New York,
Rogers Fund, 1948 48.55.4

Fisher and Bird, active 1832–85
(John T. Fisher, d. 1860; Clinton G. Bird,
d. 1861; Michael Bird, d. after 1853)
220. Mantel depicting scenes from Jacques-Henri
Bernardin de Saint-Pierre's *Paul et Virginie*
(1788), 1851
Marble
51¾ x 80 x 26½ in. (131.4 x 203.2 x 67.3 cm)
Museum of the City of New York, Gift of
Mrs. Edward W. Freeman, 1932 32.269 a–h,j
Ordered by Hamilton Fish in 1851 for his
New York parlor

FURNITURE

Cabinetmaker unknown, New York City
221. Armchair, ca. 1825
Ebonized maple and cherry; walnut; gilding;
replacement underupholstery and showcover
38 x 26½ x 27¾ in. (96.5 x 67.3 x 70.5 cm)
Winterthur Museum, Winterthur, Delaware,
Bequest of Henry F. du Pont 57.0739

Deming and Bulkley, active in New York City
ca. 1820–50 and in New York City and
Charleston, South Carolina, ca. 1820–ca. 1840
(Barzilla Deming, 1781–1854, active 1805–50;
Erastus Bulkley, 1798–1872, active ca. 1818–60)
222. Center table, 1829
Rosewood and mahogany veneers; pine, chest-
nut, mahogany; gilding, rosewood graining,
bronzing; "Egyptian" marble; casters
H. 30¼ in. (76.8 cm); diam. 36 in. (91.4 cm)
Mulberry Plantation, Camden, South Carolina
Made for Governor Stephen Decatur Miller,
Camden, South Carolina

Cabinetmaker unknown (possibly Robert
Fisher, active 1824–37), New York City
223. Secretary-bookcase, ca. 1830
Ebonized mahogany, mahogany, mahogany
veneer; pine, poplar, cherry; gilding, bronzing;
stamped brass ornaments; glass drawer pulls;
replacement fabric; glass
101⅛ x 55¾ x 29½ in. (256.9 x 141.6 x 74.9 cm)
The Metropolitan Museum of Art, New York,
Gift of Francis Hartman Markoe, 1960
60.29.1a,b

Cabinetmaker unknown, New York City
224. Sofa, ca. 1830
Mahogany, mahogany veneer; marble; gilt-
bronze mounts; original underupholstery on
back and sides, replacement showcover; casters
36 x 80 x 31 in. (91.4 x 203.2 x 78.7 cm)
Brooklyn Museum of Art, Maria L. Emmons
Fund 41.1181

Endicott and Swett, active 1830–34, printer
and publisher
225. Broadside for Joseph Meeks and Sons (active
1829–35), 1833
Lithograph with hand coloring
21½ x 17 in. (54.6 x 43.2 cm)
Inscribed: American and Foreign. Agency.

New-York Nº 6 Cabinet Maker & Upholster-
ers list of Prices./Joseph Meeks & Sons'./
Manufactory of Cabinet and Upholstery
Articles/43 & 45, Broad-Street,/New York./
Endicott & Swett 111 Nassau Street N.Y./
Entered according to Act of Congress in the
year 1833 by Joseph Meeks & Sons, in the
Clerks Office of the Des. [*sic*] Ct. of the
S.D. of N.Y.
The Metropolitan Museum of Art, New York,
Gift of Mrs. Reed W. Hyde, 1943 43.15.8

Cabinetmaker unknown, New York City
226. French chair (one of six), ca. 1830
Mahogany, mahogany veneer; chestnut;
original underupholstery and showcover
fragments, replacement showcover
31¾ x 19¼ x 20⅜ in. (80.6 x 48.9 x 51.8 cm)
Private collection

Joseph Meeks and Sons, active 1829–35
(Joseph Meeks, 1771–1868, active 1797–1836;
John Meeks, 1801–1875, active 1829–63; Joseph
W. Meeks, 1805–1878, active 1829–59)
227. Pier table, ca. 1835
Mahogany veneer, mahogany; "Egyptian"
marble; mirror glass
37 x 43 x 20⅛ in. (94 x 109.2 x 51.1 cm)
Printed on fragmentary paper label on inside
face of rear rail: MEEKS & SONS [MANUFAC-
TORY]/[OF]/CABI[NET-FURNITURE]/43 & 45
Br[oad Street]/N[ew-York.]
Collection of Dr. and Mrs. Emil F. Pascarelli

John H. Williams and Son, active ca. 1844–57
(John H. Williams, active ca. 1820–ca. 1862;
George H. Williams, active 1844–ca. 1857)
228. Pier mirror, ca. 1845
Gilded pine; pine; plate-glass mirror
94 x 38½ x 3¼ in. (238.8 x 97.8 x 8.3 cm)
Inscribed in black paint on back: TOP
Stenciled in black ink, twice, on back: From/
J. H. Williams & Son/Nº 315/Pearl Street/
New-York
Collection of Mr. and Mrs. Peter G. Terian

Cabinetmaker unknown, New York City
229. Fall-front secretary, 1833–ca. 1841
Mahogany veneer, mahogany, ebonized
wood; pine, poplar, cherry, white oak; brass;
leather; mirror glass
67⅝ x 50⅛ x 26 in. (171.8 x 127.3 x 66 cm)
Impressed on fall front lock plate, above an eagle:
at left, McKEE CO; at right, TERRYSVILLE CONN.
Impressed on proper left cabinet-door lock
plate: at top, LEWIS · McKEE/& CO.; at
bottom, TERRYSVILLE/CONN.
Collection of Frederick W. Hughes

Duncan Phyfe and Son, active 1840–47
(Duncan Phyfe, Scottish, 1768–1854, active in
New York City 1792–1847; James D. Phyfe,
b. 1797, active 1837–47)
230. Six nested tables, 1841
Rosewood, rosewood veneer; mahogany;
gilding not original

Largest table 29⅜ x 22⅛ x 16 in. (74.6 x 56.2 x 40.6 cm)
Collection of Mr. and Mrs. Peter G. Terian
Made for John Laurence Manning and Susan Hampton Manning, Millford Plantation, Clarendon County, South Carolina

Duncan Phyfe and Son, active 1840–47 (Duncan Phyfe, Scottish, 1768–1854, active in New York City 1792–1847; James D. Phyfe, b. 1797, active 1837–47)

231. Armchair, 1841
Mahogany, mahogany veneer; chestnut; replacement underupholstery and showcover
32½ x 22⅛ x 24 in. (82.4 x 56.2 x 61 cm)
Collection of Richard Hampton Jenrette
Made for John Laurence Manning and Susan Hampton Manning, Millford Plantation, Clarendon County, South Carolina

Duncan Phyfe and Son, active 1840–47 (Duncan Phyfe, Scottish, 1768–1854, active in New York City 1792–1847; James D. Phyfe, b. 1797, active 1837–47)

232. Couch (one of a pair), 1841
Rosewood veneer, rosewood, mahogany; sugar pine, ash, poplar; rosewood graining; replacement underupholstery and showcover
35⅝ x 74⅞ x 22⅞ in. (90.5 x 190.2 x 58.1 cm)
Collection of Richard Hampton Jenrette
Made for John Laurence Manning and Susan Hampton Manning, Millford Plantation, Clarendon County, South Carolina

J. and J. W. Meeks, active 1836–59 (John Meeks, 1801–1875, active 1829–63; Joseph W. Meeks, 1805–1878, active 1829–59)

233. Portfolio cabinet-on-stand, with a scene from Shakespeare's *Romeo and Juliet,* ca. 1845
Rosewood, rosewood and maple veneers; cross-stitched needlepoint panel; replacement fabric; glass
66 x 27⅞ x 16⅞ in. (167.6 x 70.8 x 42.9 cm)
Collection of Mrs. Sammie Chandler

Alexander Jackson Davis, 1803–1892, designer
Richard Byrne, Irish, 1805–1883, active in White Plains, New York, 1845–ca. 1883, cabinetmaker

234. Hall chair (one of a pair), ca. 1845
Oak; original cane seat, replacement cushion
37⅞ x 18½ x 20¼ in. (94.9 x 47 x 51.4 cm)
Lyndhurst, A National Trust Historic Site, Tarrytown, New York (NT 64.25.9[a])
Made for William Paulding and his son Philip for Knoll (later renamed Lyndhurst), Tarrytown, New York

Alexander Jackson Davis, 1803–1892, designer
Possibly Burns and Brother, active 1857–60, cabinetmaker
(William Burns, Scottish, ca. 1807–1867, active in New York City 1835–66; Thomas Burns, Scottish, d. 1860, active in New York City 1854–60)

235. Side chair, ca. 1857
Black walnut; replacement underupholstery and showcover

39⅝ x 18½ x 18½ in. (100.6 x 47 x 47 cm)
The Metropolitan Museum of Art, New York, Gift of Jane B. Davies, in memory of Lyn Davies, 1995 1995.111
Similar to chairs made for Ericstan (John J. Herrick House), Tarrytown, New York

Auguste-Émile Ringuet-Leprince, French, 1801–1886, active in Paris 1840–48 and in New York City 1848–60

236A, B. Sofa and armchair, Paris, 1843
Ebonized fruitwood (apple or pear); beech; gilt-bronze mounts; original underupholstery and silk brocatelle showcover; casters (on chair)
Sofa: 38¼ x 72 x 29¾ in. (97.2 x 182.9 x 75.6 cm)
Armchair: 37⅞ x 23½ x 25⅞ in. (96.2 x 59.7 x 65.7 cm)
The Metropolitan Museum of Art, New York, Gift of Mrs. Douglas Williams, 1969 69.262.1, 69.262.3
From a drawing-room suite made for James C. Colles and Harriet Wetmore Colles, 35 University Place

Cabinetmaker unknown, probably French (probably Paris)
Retailed by Charles A. Baudouine, 1808–1895, active 1829–54, cabinetmaker

237. Lady's writing desk, 1849–54
Ebonized poplar (aspen or cottonwood); painted and gilded decoration; velvet
40¾ x 32½ x 17½ in. (103.5 x 82.6 x 44.5 cm)
Printed on paper label on back: Baudouine's / Fashionable Furniture & Upholstery / Establishment / 335 Broadway / New-York / Keeps constantly on hand the / Largest Assortment of Elegant Furniture / to be found in the United States.
Stenciled in ink on proper left side of apron drawer: From / C.A. Baudouine / 335 / Broadway / New York
Inscribed in ink inside the desk: on left side, G [*Gauche*]; on right side, D [*Droite*]
Museum of Fine Arts, Boston, Gift of the William N. Banks Foundation in memory of Laurie Crichton 1979.612

Thomas Brooks, 1810/11–1887, active 1844–75, Brooklyn, New York

238. Table-top bookcase made for Jenny Lind, 1851
Rosewood; ivory; silver
39 x 32 x 13 in. (99.1 x 81.3 x 33 cm)
Engraved on paper label on underside of drawer: BROOKS' / CABINET WAREHOUSE. / 127 Fulton St. Cor. Sands Brooklyn, N. Y.
Engraved on silver presentation plaque: Presented to / Jenny Lind / by the / Members of / the / Fire Department / of the / City of New York.
Museum of the City of New York, Gift of Arthur S. Vernay 52.24.1a

John T. Bowen, British, ca. 1801–1856, active in New York City 1834–38, active in Philadelphia 1839–56, lithographer
After John James Audubon, French, born Haiti, 1785–1851, active in the United States

1806–51, artist, and Robert Havell Jr., British, 1793–1878, active in the United States 1839–78, engraver
J. J. Audubon and J. B. Chevalier, New York and Philadelphia, publisher
Matthews and Rider, bookbinders

239. *The Birds of America, from Drawings Made in the United States and Their Territories,* 1840–44
Seven volumes; bound in ivory, red, green, and blue leather with gold stamping
10⅝ x 7⅞ x 2⅛ in. (27 x 18.7 x 5.4 cm)
Museum of the City of New York, Gift of Arthur S. Vernay 52.24.2a–g
Specially bound for and presented to Jenny Lind

Julius Dessoir, German (Prussia), 1801–1884, active in New York City ca. 1842–65

240A–C. Sofa and two armchairs, 1853
Rosewood; chestnut; original underupholstery and replacement showcover; casters
Sofa: 59⅛ x 82⅝ x 34½ in. (150.2 x 209.9 x 87.6 cm)
Armchairs: 55 x 28 x 31⅜ in. (139.7 x 71.1 x 79.7 cm)
The Metropolitan Museum of Art, New York, Gift of Lily and Victor Chang, in honor of the Museum's 125th Anniversary, 1995 1995.150.1–3
Exhibited at the New-York Exhibition of the Industry of All Nations, 1853–54

Gustave Herter, German (Stuttgart, Württemberg), 1830–1898, active in New York City 1848–70, designer
Bulkley and Herter, active ca. 1853–58, cabinetmaker
(Erastus Bulkley, 1798–1872, active ca. 1818–60; Gustave Herter)

241. Bookcase, 1853
White oak; eastern white pine, eastern hemlock, yellow poplar; leaded glass not original
134½ x 118¾ x 30¼ in. (341.6 x 301.6 x 76.8 cm)
Inscribed in pencil: on interior face of proper left side of lower case, No. 2[?]; on interior face of proper right side of lower case, No. 3
The Nelson-Atkins Museum of Art, Kansas City, Missouri (Purchase: Nelson Trust through the exchange of gifts and bequests of numerous donors and other Trust properties) 97-35
Exhibited at the New-York Exhibition of the Industry of All Nations, 1853–54

Cabinetmaker unknown, New York City
Nunns and Clark, active 1840–60, piano manufacturer
(Robert Nunns, active 1823–ca. 1860; John Clark, active 1833–57)

242. Square piano, 1853
Rosewood, rosewood veneer; mother-of-pearl, tortoiseshell, abalone shell
37¾ x 87⅞ x 43½ in. (95.9 x 223.3 x 118 cm)

Engraved on silver plate on nameboard:
R. Nunns & Clark./New York.
Inscribed in pencil: on inside left side of case,
Thompson; on underside of soundboard,
Joseph Gassin/Aug.ᵗ 20/1853
Stamped: on pin block, back of nameboard,
right side of key frame, 8054; on lowest key,
D. Perrin[?]
The Metropolitan Museum of Art, New York,
Gift of George Lowther, 1906 06.1312

Alexander Roux, French, 1813–1886, active in
New York City 1836–80

243. Étagère-sideboard, ca. 1853–54
Black walnut; pine, poplar
93 x 72¾ x 26 in. (236.2 x 184.8 x 66 cm)
The Metropolitan Museum of Art, New York,
Purchase, Friends of the American Wing
Fund and David Schwartz Foundation, Inc.
Gift, 1993 1993.168
Similar to the model exhibited at the New-
York Exhibition of the Industry of All
Nations, 1853–54

Cabinetmaker unknown, French (probably
Paris)

244. Center table, 1855–57
Gilded wood (possibly aspen or cottonwood);
beech; marble top; casters
29⅝ x 56⅝ x 37⅜ in. (75.2 x 143.8 x 94.9 cm)
Brooklyn Museum of Art, Gift of Marion
Litchfield 51.112.9
Made for Edwin Clark Litchfield and Grace
Hill Hubbard Litchfield for Grace Hill,
Brooklyn, New York

Attributed to J. H. Belter and Company,
active 1844–66
(John H. Belter, German [Hilter, Hannover],
1804–1863, active in New York City 1833–63)

245. Sofa, ca. 1855
Rosewood; probably replacement under-
upholstery, replacement showcover; casters
54 x 93½ x 40 in. (137.2 x 237.5 x 101.6 cm)
Milwaukee Art Museum, Purchase, Bequest
of Mary Jane Rayniak in Memory of Mr. and
Mrs. Joseph G. Rayniak M1987.16

Alexander Roux, French, 1813–1886, active in
New York City 1836–80

246. Étagère, ca. 1855
Rosewood, rosewood veneer; chestnut,
poplar, bird's-eye maple veneer; replacement
mirror glass
86 x 79½ x 29⅞ in. (218.4 x 201.9 x 75.9 cm)
Engraved on label on back of shelves:
A. Roux 479/481/A. Roux/Gaime.
Guillemot & Co. Roux/Cabinet Maker/
481 Broadway/New-York
The Metropolitan Museum of Art, New York,
Sansbury-Mills Fund, 1971 1971.219

Cabinetmaker unknown, probably New
York City

247. Fire screen, ca. 1855
Rosewood; white pine; tent-stitched

needlepoint panel; glass; replacement silk
backing; casters
67 x 42¾ in. (170.2 x 108.6 cm)
The Art Institute of Chicago, Mary Waller
Langhorne Endowment 1989.155

Ringuet-Leprince and L. Marcotte, active
1848–60
(Auguste-Émile Ringuet-Leprince, French,
1801–1886, active in Paris 1840–48 and in
New York City 1848–60; Léon Marcotte,
French, 1824–1887, active in New York City
1848–87)

248. Armchair, ca. 1856
Ebonized maple; pine; gilt-bronze mounts;
replacement underupholstery and showcover;
casters
40½ x 25¼ x 26½ in. (102.9 x 64.1 x 67.3 cm)
The Metropolitan Museum of Art, New York,
Gift of Mrs. D. Chester Noyes, 1968 68.69.2
From a ballroom suite made for John Taylor
Johnston and Frances Colles Johnston,
8 Fifth Avenue

Gustave Herter, active 1858–64
(Gustave Herter, German [Stuttgart,
Württemberg], 1830–1898, active in New
York City 1848–70)

249. Reception room cabinet, ca. 1860
Bird's-eye maple, rosewood, ebony,
marquetry of various woods; white pine,
cherry, poplar, oak; oil on canvas; gilt-bronze
mounts; brass inlay; gilding; mirror glass
90¼ x 59¾ x 19½ in. (229.2 x 151.8 x 49.5 cm)
Victoria Mansion, The Morse-Libby House,
Portland, Maine 1984.65
Made for the Ruggles Sylvester Morse
and Olive Ring Merrill Morse mansion,
Portland, Maine

CERAMICS

Maker unknown, French (Paris)

250. Vase depicting view of New York City from
Governors Island, ca. 1828–30
Porcelain, overglaze enamel decoration,
and gilding
H. 12⅞ in. (32.7 cm); diam. 9⅛ in. (23.2 cm)
Collection of Mr. and Mrs. Stuart P. Feld
The scene depicted is based on a print in *The
Hudson River Portfolio* (1821–25; see cat. no. 114).

Maker unknown, French (Paris)

251. Pair of vases depicting a scene on Lower
Broadway with Saint Paul's Chapel and
an interior view of the First Merchants'
Exchange, ca. 1831–35
Porcelain, overglaze enamel decoration,
and gilding
H. 13 in. (33 cm); diam. 9⅞ in. (25.1 cm)
The Metropolitan Museum of Art, New York,
Harris Brisbane Dick Fund, 1938 38.165.35,
38.165.36
The scenes depicted are copied from
Theodore Fay's *Views in New York and Its
Environs* (1831–34).

Maker unknown, French (probably Limoges)

252. Pair of vases depicting scenes from Harriet
Beecher Stowe's *Uncle Tom's Cabin* (1852),
ca. 1852–65
Porcelain with gilding
19 x 14 in. (48.3 x 35.6 cm)
The Newark Museum, Purchase, 1968,
Mrs. Parker O. Griffith Fund 68.106a,b

James and Ralph Clews, English
(Staffordshire), active ca. 1815–34

253. Platter depicting the Marquis de Lafayette's
arrival at Castle Garden, August 16, 1824,
ca. 1825–34
White earthenware with blue transfer-printed
decoration
L. 19 in. (48.3 cm); w. 14½ in. (36.8 cm)
Impressed on underside within a circle,
surrounding a crown: CLEWS WARRANTED
STAFFORDSHIRE
Museum of the City of New York, Gift of
Mrs. Harry Horton Benkard 34.508.2

Joseph Stubbs, English (Longport, Burslem,
Staffordshire), active ca. 1822–36

254. Pitcher depicting City Hall, New York,
ca. 1826–36
White earthenware with blue transfer-printed
decoration
7⅝ x 9 x 7½ in. (19.4 x 22.9 x 19.1 cm)
Winterthur Museum, Winterthur, Delaware,
Bequest of Henry F. du Pont 58.1819
The view is after a drawing by William Guy
Wall, which was engraved by John William
Hill in 1826.

Decasse and Chanou, active 1824–27
(Louis-François Decasse, French, b. 1790,
active until 1850; Nicolas-Louis-Édouard
Chanou, French, 1803?–1828)

255. Tea service, 1824–27
Porcelain with gilding
Teapot: 6½ x 11 x 5½ in. (16.5 x 27.9 x 14 cm)
Sugar bowl: 5½ x 7 x 4⅝ in. (14 x 17.8 x 11.7 cm)
Cream pitcher: 4¼ x 6 x 3⅛ in. (10.8 x 15.2 x
7.9 cm)
Cup: 2¼ x 4¼ in. (5.7 x 10.8 cm)
Saucer: diam. 5 in. (12.7 cm)
Plates: diam. 7⅜ in., 8⅜ in. (18.7 cm, 21.3 cm)
Stamped in red on underside within circle
(all pieces except for teapot and large plate):
DECASSE & CHANOU./[eagle]/New York.
Incised on large plate: EC No 3/x
Kaufman Americana Foundation

D. and J. Henderson Flint Stoneware Manu-
factory, Jersey City, New Jersey, active 1828–33
(David Henderson, d. 1845; James Henderson)

256. End of the Rabbit Hunt pitcher, ca. 1828–30
Stoneware, wheel-thrown with applied
decoration
8⅞ x 9 x 7½ in. (22.5 x 22.9 x 19.1 cm)
Inscribed on front: JAMES N. WELLS/38/
Hudson Street
Collection of Mr. and Mrs. Jay Lewis

D. and J. Henderson Flint Stoneware Manufactory, Jersey City, New Jersey, active 1828–33 (David Henderson, d. 1845; James Henderson)

257. Acorn and Berry pitcher, ca. 1830–35
Stoneware, press-molded with applied decoration
$8\frac{3}{4}$ x $6\frac{3}{4}$ x $8\frac{1}{2}$ in. (22.2 x 17 x 21.7 cm)
Impressed on underside within circle: D & J/ Henderson/Jersey/City
The Metropolitan Museum of Art, New York, Purchase, Dr. and Mrs. Burton P. Fabricand Gift, 2000 2000.87

D. and J. Henderson Flint Stoneware Manufactory, Jersey City, New Jersey, active 1828–33 (David Henderson, d. 1845; James Henderson)

258. Herculaneum pitcher, ca. 1830–33
Stoneware, press-molded with applied decoration
$10\frac{3}{8}$ x $7\frac{3}{4}$ x $6\frac{1}{2}$ in. (26.4 x 19.7 x 16.5 cm)
Impressed on underside: 8
Collection of Mr. and Mrs. Jay Lewis

American Pottery Manufacturing Company, Jersey City, New Jersey, active 1833–55
Daniel Greatbach, active 1838–58, probable modeler

259. Thistle pitcher, 1838–52
Stoneware, press-molded with brown Rockingham glaze
$9\frac{5}{8}$ x $9\frac{1}{8}$ x 7 in. (24.5 x 23.2 x 17.8 cm)
Impressed on underside within circle: AMERICAN/POTTERY, CO/-O-/JERSEY, CITY, N.J.
The Metropolitan Museum of Art, New York, Gift of Maude B. Feld and Samuel B. Feld, 1992 1992.230

American Pottery Manufacturing Company, Jersey City, New Jersey, active 1833–55

260. Vegetable dish, ca. 1833–45
White earthenware, press-molded with feather-edged and blue sponged decoration
H. $2\frac{1}{2}$ in. (6.4 cm); diam. 11 in. (27.9 cm)
Impressed on underside within circle: AMERICAN/POTTERY CO/5/JERSEY CITY, N.J.
The Metropolitan Museum of Art, New York, Purchase, Herbert and Jeanine Coyne Foundation and Cranshaw Corporation Gifts, 1997 1997.105

American Pottery Manufacturing Company, Jersey City, New Jersey, active 1833–55

261. Covered hot-milk pot or teapot and underplate, ca. 1835–45
White earthenware, press-molded with blue sponged decoration
Pot (including cover): $6\frac{3}{8}$ x 7 x $4\frac{3}{4}$ in. (16.2 x 17.8 x 12.1 cm)
Plate: diam. $7\frac{1}{2}$ in. (19.1 cm)
Impressed on underside of pot within circle: AMERICAN/POTTERY CO/-O-/JERSEY CITY, N.J.
Impressed on underside of plate within circle: AMER[ICAN]/POTTERY [CO]/JERSEY [CITY, N.J.]
Collection of Mr. and Mrs. Jay Lewis

American Pottery Manufacturing Company, Jersey City, New Jersey, active 1833–55

262. Canova plate, 1835–45
White earthenware, press-molded with blue underglaze transfer-printed decoration
Diam. $9\frac{1}{8}$ in. (23.2 cm)
Printed on underside in ellipse: AMERICAN POTTERY/MANUFACTURING CO./CANOVA/JERSEY CITY
Brooklyn Museum of Art 50.144

American Pottery Manufacturing Company, Jersey City, New Jersey, active 1833–55
Daniel Greatbach, active 1849–58, modeler

263. Pitcher made for William Henry Harrison's presidential campaign, 1840
Cream-colored earthenware, press-molded with black underglaze transfer-printed decoration
$11\frac{5}{8}$ x $8\frac{1}{4}$ x 10 in. (29.5 x 21 x 25.4 cm)
Printed in black on underside within flag: AM. POTTERY/MANUFG CO/JERSEY CITY
New Jersey State Museum, Trenton CH1986.11

Salamander Works, New York City or Woodbridge, New Jersey, active 1836–55

264. Water cooler, 1836–45
Stoneware, press-molded with brown Rockingham glaze
H. $18\frac{1}{2}$ in. (47 cm); diam. $11\frac{3}{4}$ in. (29.8 cm)
Inscribed on front: SALAMANDER/WORKS NEW-YORK
New Jersey State Museum, Trenton CH1971.70

Salamander Works, New York City or Woodbridge, New Jersey, active 1836–55

265. Punch bowl, ca. 1836–42
Stoneware, press-molded with brown Rockingham glaze, porcelain letters
H. 7 in. (17.8 cm); w. 17 in. (43.2 cm); diam. $14\frac{1}{4}$ in. (36.2 cm)
Marked with raised white letters applied on the front: J. K. GROSVENOR
Winterthur Museum, Winterthur, Delaware, Bequest of Henry F. du Pont 59.1937

Salamander Works, New York City or Woodbridge, New Jersey, active 1836–55

266. "Spanish" pitcher, ca. 1837–42
Stoneware, press-molded with brown Rockingham glaze
$13\frac{3}{8}$ x $10\frac{3}{4}$ x $13\frac{3}{8}$ in. (34 x 27.3 x 34 cm)
Raised, molded mark on underside: C1
Collection of Arthur F. and Esther Goldberg

Charles Cartlidge and Company, Greenpoint (Brooklyn), New York, active 1848–56
(Charles Cartlidge, 1800–1860)

267. Presentation pitcher for the governor of the state of New York from the Manufacturing and Mercantile Union, 1854–56
Porcelain, with overglaze decoration in polychrome enamels and gilding
$13\frac{1}{4}$ x $14\frac{1}{4}$ x 10 in. (33.7 x 36.2 x 25.4 cm)

Inscribed on sides and front in gold: Presented by the/M. & M. Union/To the Governor./Of the state of/New York.
Collection of Mr. and Mrs. Jay Lewis

Charles Cartlidge and Company, Greenpoint (Brooklyn), New York, active 1848–56
(Charles Cartlidge, 1800–1860)

268. Pitcher made for the Claremont, 1853–56
Porcelain, with overglaze decoration in polychrome enamels and gilding
$10\frac{1}{2}$ x $11\frac{1}{2}$ x $6\frac{1}{2}$ in. (26.7 x 29.2 x 16.5 cm)
Inscribed on front: E. Jones./CLAREMONT./American Porcela[in]
Museum of the City of New York, Gift of Miss Dorothy Rogers and Mrs. Edward H. Anson 49.44.4
The Claremont was a hotel located at what is now Riverside Drive and 124th Street; Edmund Jones was its proprietor.

William Boch and Brothers, Greenpoint (Brooklyn), New York, active before 1844–1861/62
(William Boch, 1797–1872; Anthony Boch, active 1855–62; Francis Victor Boch, 1855–60)

269. Pitcher, 1844–57
Porcelain
$9\frac{5}{8}$ x $8\frac{1}{2}$ x 6 in. (24.4 x 21.6 x 15.2 cm)
Impressed on underside, following the oval shape of the base: W B & BR'S/Greenpoint. L. I.
The Metropolitan Museum of Art, New York, Purchase, Anonymous Gift, 1968 68.112

United States Pottery Company, Bennington, Vermont, active 1847–58

270. Central monument from the United States Pottery Company display at the New-York Exhibition of the Industry of All Nations (1853–54), 1851–53
Earthenware, including Rockingham and Flint enamel-glazed earthenware, scroddled ware; parian porcelain
H. 120 in. (304.8 cm)
Bennington Museum, Bennington, Vermont 1989.63
Displayed at the exhibition by O. A. Gager and Company, New York City retailer

GLASS

Probably Bloomingdale Flint Glass Works of Richard and John Fisher, New York City, active 1820–40, or Brooklyn Flint Glass Works of John Gilliland, Brooklyn, New York, active 1823–68
(Richard Fisher, 1783–1850; John Fisher, d. 1848; John L. Gilliland, 1787–1868)

271. Decanter (one of a pair), 1825–45
Blown colorless glass, with cut decoration
H. $9\frac{1}{8}$ in. (23.2 cm); diam. 4 in. (10.2 cm)
Winterthur Museum, Winterthur, Delaware, Gift of Mr. and Mrs. Robert Trump 77.0181.001a,b

Jersey Glass Company of George Dummer, Jersey City, New Jersey, active 1824–62 (George Dummer, 1782–1853)

272. Salt, 1830–40
Pressed green glass
1⅞ x 3 x 2⅜ in. (4.8 x 7.6 x 6 cm)
Impressed on underside: JERSEY/GLASS CO.,/ Nr. N. YORK
The Metropolitan Museum of Art, New York, Purchase, Butzi Moffitt Gift, 1985 1985.129

Jersey Glass Company of George Dummer, Jersey City, New Jersey, active 1824–62 (George Dummer, 1782–1853)

273. Compote, ca. 1830–40
Blown colorless glass, with cut decoration
H. 7½ in. (19 cm); diam. (rim) 10⅛ in. (25.8 cm)
The Corning Museum of Glass, Corning, New York 71.4.108

Jersey Glass Company of George Dummer, Jersey City, New Jersey, active 1824–62 (George Dummer, 1782–1853)

274. Covered box, ca. 1830–40
Blown colorless glass, with cut decoration; silver cover
1¾ x 4⅞ x 1⅞ in. (4.5 x 12.3 x 4.8 cm)
Engraved on cover: Mary Sarah Dummer
The Corning Museum of Glass, Corning, New York 71.4.110

Jersey Glass Company of George Dummer, Jersey City, New Jersey, active 1824–62 (George Dummer, 1782–1853)

275. Oval dish, ca. 1830–40
Blown colorless glass, with cut decoration
L. 7¾ in. (19.7 cm); h. 1¾ in. (4.5 cm)
The Corning Museum of Glass, Corning, New York 71.4.113

Bloomingdale Flint Glass Works of Richard and John Fisher, New York City, active 1820–40, or Brooklyn Glass Works of John Gilliland, Brooklyn, New York, active 1823–68, or Jersey Glass Company of George Dummer, Jersey City, New Jersey, active 1824–62
Possibly cut by Jackson and Baggott
(Richard Fisher, 1783–1850; John Fisher, d. 1848; John L. Gilliland, 1787–1868; George Dummer, 1782–1853; William Jackson, active 1816–30; Joseph Baggott, d. 1839)

276. Decanter and wineglasses, ca. 1825–35
Blown green glass, with cut decoration
Decanter: h. 10⅝ in. (27 cm); diam. 4 in. (10.2 cm)
Wineglasses: 4⅞ in. (12.5 cm); diam. 2⅞ in. (7.3 cm)
The Metropolitan Museum of Art, New York, Gift of Berry B. Tracy, 1972 1972.266.1–7
Owned by Luman Reed, according to tradition

Maker unknown, New York City area

277. A selection from a service of table glass made for a member of the Weld family, Albany, 1840–59
Blown colorless glass, with cut and engraved decoration

Claret decanters with handles: (1984.24.3.1.1a,b) h. 16 in. (40.6 cm); circumference 15½ in. (39.4 cm). (1984.24.3.1.2a,b) h. 15¼ in. (38.7 cm); circumference 15½ in. (39.4 cm)
Compote (1984.24.3.2.1): h. 6⅛ in. (15.6 cm); diam. 6⅛ in. (15.6 cm)
Oval serving bowl (1984.24.3.3.1): 2¼ x 9½ x 6 in. (5.7 x 24.1 x 15.2 cm)
Finger bowl (1984.24.3.4.1): h. 3¼ in. (8.3 cm); diam. (rim) 4⅞ in. (12.4 cm)
Carafe (1984.24.3.5.1): h. 7 in. (17.8 cm); circumference 15½ in. (39.4 cm)
Punch cup (1984.24.3.6.1): h. 2⅞ in. (7.3 cm); diam. (rim) 2⅝ in. (6.7 cm)
Wineglasses: (1984.24.3.7.1) h. 4⅞ in. (12.4 cm); diam. (rim) 2¼ in. (5.7 cm). (1984.24.3.8.1) h. 3⅝ in. (9.2 cm); diam. (rim) 1⅝ in. (4.1 cm)
Tumblers: (1984.24.3.9.1) h. 2¾ in. (7 cm); diam. 2⅝ in. (6.7 cm). (1984.24.3.10.1) h. 3¾ in. (9.5 cm); diam. (rim) 3⅜ in. (8.6 cm). (1984.24.3.11.1) h. 3⅝ in. (9.2 cm); diam. (rim) 3⅛ in. (7.9 cm)
Decanters: (1984.24.3.12.1a,b) h. 11¾ in. (29.8 cm); circumference 12 in. (30.5 cm). (1984.24.3.14.1a,b) h. 13½ in. (34.3 cm); circumference 14½ in. (36.8 cm)
Engraved on front of each: [Weld family crest with motto:] NIL SINE NUMINE
Albany Institute of History and Art 1984.24.3.1–.14
Made for Harriet Weld Corning (1793–1883) or her niece Harriet Corning Turner Pruyn (1822–1859)

Long Island Flint Glass Works of Christian Dorflinger, Brooklyn, New York, active 1852–63
(Christian Dorflinger, born France [Alsace], 1828–1915)

278. Presentation vase for Mrs. Christian Dorflinger from the Dorflinger Guards, 1859
Blown colorless glass, with cut and engraved decoration
H. 16⅞ in. (42.9 cm); diam. 6⅛ in. (15.4 cm)
Engraved on shield: Presented by the officers/ & Members of the/ Dorflinger Guards/ To Mrs./ Dorflinger/ January 14th/ 1859
The Metropolitan Museum of Art, New York, Gift of Isabel Lambert Dorflinger, 1988 1988.391.1

Long Island Flint Glass Works of Christian Dorflinger, Brooklyn, New York, active 1852–63
(Christian Dorflinger, born France [Alsace], 1828–1915)

279. Compote made for the White House, 1861
Blown colorless glass, with cut and engraved decoration
H. 8⅞ in. (22.5 cm); diam. (rim) 9⅜ in. (23.8 cm)
The Metropolitan Museum of Art, New York, Gift of Katheryn Hait Dorflinger Manchee, 1972 1972.232.1
Part of state service commissioned by Mrs. Abraham Lincoln through a Washington, D.C., retailer

William Jay Bolton, 1816–1884, assisted by John Bolton, 1818–1898

280. *Christ Stills the Tempest,* one of sixty figural windows made for Holy Trinity Church (now St. Ann and the Holy Trinity Church), Brooklyn, 1844–47
Opaque glass paint, enamels, and silver stain on pot-metal glass
Three lancets; each lancet 63¾ x 18¾ (161.9 x 47.6 cm)
St. Ann and the Holy Trinity Church, Brooklyn, New York. The window has been restored with the support of Catherine S. Boericke and Francis T. Chambers, III, descendants of William Jay Bolton, and public funds from The New York City Department of Cultural Affairs Cultural Challenge Program.
The first ensemble of figural stained-glass windows made in America

SILVER AND OTHER METALWORK

Fletcher and Gardiner, Philadelphia, active 1808–27, manufacturing silversmith
Thomas Fletcher, 1787–1866, designer
(Thomas Fletcher; Sidney Gardiner, 1787–1827)

281A. Presentation vase, 1824
Silver
23⅜ x 20 x 14½ in. (59.4 x 50.8 x 36.8 cm)
Marked on underside: FLETCHER & GARDINER [within two concentric circles] PHILA [in rectangle in center][;] FLETCHER &/ GARDINER [in ribbon] / PHILA [in rectangle]
Engraved below presentation inscription: Fletcher & Gardiner, Makers Philadᵃ December 1824
Inscribed on plaque on front of base: The Merchants of Pearl Street, New York,/ TO THE HON. DEWITT CLINTON,/ Whose claim to the proud Title of "Public Benefactor,"/ is founded on those magnificent works,/ The Northern and Western CANALS.
The Metropolitan Museum of Art, New York, Purchase, Louis V. Bell and Rogers Funds; Anonymous and Robert G. Goelet Gifts; and Gifts of Fenton L. B. Brown and of the grandchildren of Mrs. Ranson Spaford Hooker, in her memory, by exchange, 1982 1982.4
The scenic views on this pair of vases (cat. nos. 281A, B) are based on drawings made about 1823 by James Eights (1798–1882) for the Erie Canal geological survey.

Fletcher and Gardiner, Philadelphia, active 1808–27, manufacturing silversmith
Thomas Fletcher, 1787–1866, designer
(Thomas Fletcher; Sidney Gardiner, 1787–1827)

281B. Presentation vase, 1825
Silver
23¾ x 20¾ x 14¾ in. (60.3 x 52.7 x 37.5 cm)
Marked on underside: FLETCHER & GARDINER [within two concentric circles]

PHILA [in rectangle in center]; FLETCHER &/ GARDINER [in ribbon]/PHILA [in rectangle]
Engraved below presentation inscription: Fletcher & Gardiner, Makers Philadᵃ February 1825
Inscribed on plaque on front of base: TO THE HON. DEWITT CLINTON,/Who has developed the resources of the State of New York./AND ENNOBLED HER CHARACTER/The Merchants of Pearl Street offer this testimony of their/ GRATITUDE AND RESPECT.
The Metropolitan Museum of Art, New York, Gift of the Erving and Joyce Wolf Foundation, 1988 1988.199

Archibald Robertson, Scottish, 1765–1835, active in New York City 1791–ca. 1825, designer
Charles Cushing Wright, 1796–1854, engraver and diesinker
Lettering by Richard Trested, d. 1829, upon die made by William Williams
Struck by Maltby Pelletreau, 1791–1846, silversmith
282A, B. Grand Canal Celebration medal and original box, 1826
Medal: silver; box: bird's-eye maple and paper
Medal: diam. 1¾ in. (4.4 cm)
Box: diam. 2 in. (5.1 cm)
Stamped into obverse: UNION OF THE ERIE WITH THE ATLANTIC[;] R.DEL[;] W. SC
Stamped into reverse: ERIE CANAL COMM. 4 JULY 1817 COMP. 26 OCT 1825[;] EXCELSIOR [on banner beneath the eagle, globe, and shield][;] C.C. WRIGHT SC./1826/PRESENTED BY THE CITY OF N. YORK; scratched into reverse: 441
Printed on paper inside box, along top edges: PRESENTED BY THE CITY OF NEW YORK
Hand-written on paper inside bottom of box and on inside of box base: 441
New York State Historical Association, Cooperstown, gift of James Fenimore Cooper (1858–1938, grandson of author) NO361.63(1)
Box made by Duncan Phyfe, cabinetmaker, and Daniel Karr, turner, from timber transported via the Erie Canal to New York City on the *Seneca Chief*

Archibald Robertson, Scottish, 1765–1835, active in New York City 1791–ca. 1825, designer
Charles Cushing Wright, 1796–1854, engraver
283A, B. Grand Canal Celebration medal and presentation case, 1826
Medal: gold; case: wood and red leather
Medal: diam. 1¾ in. (4.4 cm)
Case: diam. 2¼ in. (5.7 cm)
Stamped into obverse: UNION OF THE ERIE WITH THE ATLANTIC[;] R.DEL[;] W. SC
Stamped into reverse: ERIE CANAL COMM. 4 JULY 1817 COMP. 26 OCT 1825[;] EXCELSIOR

[on banner beneath the eagle, globe, and shield][;] C.C. WRIGHT SC./1826/PRESENTED BY THE CITY OF N. YORK
Box inscribed: Maj. Gen. Andrew Jackson 1827
The New-York Historical Society, Gift of Miss G. Wilbour 1932.68a,b

Baldwin Gardiner, 1791–1869, active in Philadelphia 1814–26 and in New York City 1826–47, silverware manufacturer and fancy-hardware retailer
284. Four-piece tea service, ca. 1830
Silver
Pots: (34.292.1) h. 9⅞ in. (25.1 cm); (34292.2) h. 10½ in. (26.7 cm)
Sugar bowl (34.292.3): h. 9⅝ in. (24.5 cm)
Cream pot (34.292.4): h. 8½ in. (21.6 cm)
Marked on underside of base of each piece: B [pellet] GARDINER [in serrated rectangle]
Inscribed (later) with initials on each piece: on body, S.S.S.; on foot, S.S.C.
Museum of the City of New York, Gift of Mrs. Arthur Percy Clapp 34.292.1–4

Gale and Moseley, active 1828–33, silverware manufacturer
(William Gale Sr., 1799–1867; Joseph Moseley, d. 1838)
285. Coffee urn, 1829
Silver
17⅞ x 4⅜ x 11¾ in. (44.8 x 11.1 x 28.9 cm)
Marked on bottom: in serrated rectangle, G & M; pseudo-hallmarks of sovereign's head, lion passant, and crowned leopard's head
Inscribed in banner: above cartouche, HONOR VIRTUTIS PROEMIUM; within cartouche, Presented by the Officers of the/NINTH REGᵀ. OF N.Y.S ARTILLERY/To/Col. Samuel I. [J.] Hunt/their late Commandant in token of/ their respect & esteem / 1829.
The Detroit Institute of Arts, Founders Society Purchase, Edward E. Rothman Fund, Mrs. Charles Theron Van Dusen Fund, and the Gibbs-Williams Fund 1999.3.a,b
Samuel J. Hunt, a New York City hardware merchant and bank director, served as colonel from 1826 to 1829.

Baldwin Gardiner, 1791–1869, active in Philadelphia 1814–26 and in New York City 1826–47, silverware manufacturer and fancy-hardware retailer
286. Tureen with cover on stand, ca. 1830
Silver
14⅛ x 15 x 12¾ in. (35.9 x 38.1 x 32.4 cm)
Marked on underside of base of stand and tureen: in serrated rectangles, B. [effaced on stand] [pellet] GARDINER/NEW YORK; in rectangles, pseudo-hallmarks of lion passant, hammer in hand, and letter "G"
Engraved with the coat-of-arms and crest of John Gerard Coster of New York City
Private collection 92.24.USa–c

T. Brown, designer (possibly Thomas Brown, stone seal engraver, active in New York City 1800–1811 and 1814–50)
Marquand and Brothers, active as jewelers 1831/32–1833/34, jeweler
(Frederick Marquand, 1799–1882; Josiah P. Marquand, probably died in 1837)
287. Presentation medal, 1832
Gold
6¼ x 4¾ x ⅜ in. (16 x 11.9 x 1.1 cm)
Engraved: on obverse on base scroll in Roman caps, PRO [pellet] PATRIA [pellet] ET [pellet] GLORIA; on obverse on partial globe at top, N/AMERICA[;] FRANCE; on reverse in script, Gothic, and Roman lettering, The/ National Guard/27th New York State Artillery/To/La Fayette,/Centennial Anniversary/ of the Birth Day of/Washington/New York/ 22d. February/1832
Winterthur Museum, Winterthur, Delaware, Museum Purchase 78.0113a,b

Marquand and Company, active 1833–38, retail silversmith and jeweler
(Frederick Marquand, 1799–1882; Josiah P. Marquand, probably died in 1837; Henry G. Marquand, 1819–1902; Henry Ball; William Black)
288. Basket, 1833–38
Silver
4½ x 16½ in. (11.4 x 41.9 cm)
Marked on underside: in curved rectangles, MARQUAND[;] & Co.; in curved, serrated rectangle, NEW-YORK
Engraved with initial "W"
The Baltimore Museum of Art, Decorative Arts Fund BMA1988.6
This New York–made object has a history of ownership in Natchez, Mississippi.

Maker unknown, probably English
J. & I. Cox (or J. and J. Cox), active 1817–52, retailer
(John Cox; Joseph Cox, ca. 1790–1852)
289. Pair of argand lamps, ca. 1835
Brass and glass
Each 23½ x 18½ x 9 in. (59.7 x 47 x 22.9 cm)
Metal stamp on each arm: J & I Cox/ New York
Dallas Museum of Art 1992.B.152.1, 2

Colin V. G. Forbes and Son, active 1826–38, manufacturing silversmith
(Colin van Gelder Forbes, 1776–1859; William Forbes, baptized 1799)
290. Presentation hot-water urn, 1835
Silver; iron heating core
20 x 13 x 10 in. (50.8 x 33 x 25.4 cm)
Marked twice on outer edge of base in three rectangles: FORBES/&/SON
Inscribed on body: PRESENTED BY/The Firemen of the City of New York/to John W. Degrauw Esqr./upon his retiring from the active/duties of the department, as a token of/ their approbation for his faithful &/valuable

services as the presiding/officer of the Board of Trustees./NEW-YORK FEBRUARY/1835.
Collection of Mr. and Mrs. Gerard L. Eastman, Jr.

Moritz Fürst, born Hungary 1782, active in the United States 1807–ca. 1840, engraver and diesinker

291. Medal (obverse and reverse), ca. 1838
Silver
Diam. 2 in. (5.1 cm)
Inscribed: on obverse, AMERICAN INSTITUTE/ NEW-YORK/FURST; on reverse, Awarded to/ Wm. Forbes/For the best/Silver Tea Sett [sic]/ 1838
The Metropolitan Museum of Art, New York, Gift of William Forbes II, 1952 52.113.2

Charles Cushing Wright, 1796–1854, engraver
Peter Paul Duggan, d. 1861, active in New York City 1845–56, designer

292. American Art-Union medal depicting Washington Allston, 1847
Bronze
Diam. 2½ in. (6.4 cm)
Inscribed: on obverse, P. P. DUGGAN DEL. C.C. WRIGHT SC.[;] WASHINGTON/ ALLSTON; on reverse, P. P. DUGGAN DEL./ C.C. WRIGHT SC.[;] 1847[;] AMERICAN/ART UNION
The Metropolitan Museum of Art, New York, Gift of Janis Conner and Joel Rosenkranz, 1997 1997.484.1

Charles Cushing Wright, 1796–1854, engraver
Salathiel Ellis, 1803–1879, active in New York City, 1842–64, modeler

293. American Art-Union medal depicting Gilbert Stuart, 1848
Bronze
Diam. 2½ in. (6.4 cm)
Inscribed: C.C. WRIGHT F.[;] S. ELLIS DEL[;] AMERICAN/ART-UNION
The Metropolitan Museum of Art, New York, Gift of Janis Conner and Joel Rosenkranz, 1997 1997.484.2

Charles Cushing Wright, 1796–1854, engraver
Peter Paul Duggan, d. 1861, active in New York City 1845–56, designer

294. Seal of the American Art-Union (reverse of medal depicting Gilbert Stuart), 1848
Bronze
Diam. 2½ in. (6.4 cm)
Inscribed: C.C. WRIGHT[;] DUGGAN DEL.
The Metropolitan Museum of Art, New York, Gift of Mr. and Mrs. F. S. Wait 1907.07.34

Charles Cushing Wright, 1796–1854, engraver
Robert Ball Hughes, 1806–1868, modeler
Peter Paul Duggan, d. 1861, active in New York City 1845–56, designer of reverse

295. American Art-Union medal depicting John Trumbull, 1849
Bronze
Diam. 2½ in. (6.4 cm)

Inscribed: on obverse, AMERICAN/ART-UNION[;] C. C. WRIGHT F.[;] B. HUGHES DEL.; on reverse, P.P.D. D. / C.C.W. F.[;] 1849
The Metropolitan Museum of Art, New York, Gift of Janis Conner and Joel Rosenkranz, 1997 1997.484.3

William Adams, active 1829–61, manufacturing silversmith

296. Presentation vase with cover, 1845
Silver
23½ x 19 x 11½ in. (59.7 x 48.3 x 29.2 cm)
Engraved: on front of base, William Adams/ Manufacturer of Silver Ware/New York; on right side of base, Manufactured by William Adams
Inscribed: on front of body, Presented/to/ Henry Clay/by the/Gold and Silver Artizans [sic],/of the/City of New York./As a tribute of their respect for the faithful and patriotic/ manner in which he has discharged his high public trust/and ESPECIALLY for his early and untiring advocacy of/PROTECTION TO AMERICAN INDUSTRY/1845./COMMITTEE/ Wm. Adams/Moses G. Baldwin/Alfred G. Peckham/Edward Y. Prime/Daniel Carpen-ter/David Dunn; on reverse, PROTECTION
The Henry Clay Memorial Foundation, located at Ashland, The Henry Clay Estate in Lexington, Kentucky. Gift of Colonel Robert Pepper Clay 88.039a,b
Clay aided New York silver and gold artisans by sponsoring a provision in the Tariff of 1842 that increased duties on imported silverware and foreign jewelry.

William F. Ladd, active 1829–90, watchmaker and retail jeweler

297. Trophy pitcher, 1846
Silver
10 x 9 x 5 in. (25.4 x 22.9 x 12.7 cm)
Marked on bottom: in rectangle, Wm. F. LADD; in serrated rectangle, NEW-YORK
Inscribed on body: NEW YORK YACHT CLUB/ Subscription Stakes/October 7th 1846
The New-York Historical Society, Purchase, Lyndhurst Corporation Abbott-Lenox Fund 1981.19
The sloop Maria, owned by New York Yacht Club Commodore John C. Stevens, won this trophy in the club's first Corinthian regatta, held in New York Harbor on October 7, 1846.

Zalmon Bostwick, 1811–before 1876, active ca. 1845–53 , silverware manufacturer

298. Pitcher and goblet, 1845
Silver
Pitcher: 11 x 8½ x 5½ in. (27.9 x 21.6 x 14 cm)
Goblet: 7¼ x 3⅞ x 3⅝ in. (18.4 x 9.8 x 9.2 cm)
Marked on underside of pitcher (each stamped twice): Z Bostwick [in script][;] NEW YORK
Inscribed: on base of pitcher, John W. Livingston to/Joseph Sampson/1845; on goblet, JWL to JS 1845
Brooklyn Museum of Art, Gift of the Estate of May S. Kelley, by exchange 81.179.1–.2

Gale and Hayden, active 1845/46–1849/50, patentee of design
(William Gale Sr., 1799–1867; Nathaniel Hayden, 1805–1875)
William Gale and Son, active ca. 1850–59 and 1862–67, manufacturing silversmith
(William Gale Sr.; William Gale Jr., 1825–1885)

299. Gothic-pattern crumber, design patented 1847
Silver
L. 13⅛ in. (33.3 cm)
Marked on back of handle: W. GALE & SON/ 925 STERLING [incuse]
Engraved on obverse of handle: EWM [in script]
Collection of Robert Mehlman

Gale and Hayden, active 1845/46–1849/50, patentee of design
(William Gale Sr., 1799–1867; Nathaniel Hayden, 1805–1875)
William Gale and Son, active ca. 1850–59 and 1862–67, manufacturing silversmith
(William Gale Sr.; William Gale Jr., 1825–1885)

300. Gothic-pattern dessert knife, sugar sifter, fork, and spoon, design patented 1847, knife dated 1852, fork 1853, and spoon 1848
Silver
Knife: L. 8⅛ in. (20.6 cm); w. ¾ in. (1.9 cm)
Sugar sifter: 7½ x 2⅜ x 1⅝ in. (19.1 x 6 x 4.1 cm)
Fork: 8 x 1 x ¾ in. (20.3 x 2.5 x 1.9 cm)
Spoon: 6 x 1¼ x ¾ in. (15.2 x 3.2 x 1.9 cm)
Knife marked on blade: Church & Batterson/ 1852/[pellet]/G & S
Engraved: J.M. [knife]; SHJ [sifter]; LTCS [fork]; GEM [spoon]
Dallas Museum of Art, 1991.12 (knife), 1991.101.14.1–3 (sifter, fork, and spoon)

John C. Moore, ca. 1802–1874, manufacturing silversmith
James Dixon and Sons, English (Sheffield), active 1806–after 1887, manufacturer of tray
Ball, Tompkins and Black, active 1839–51, retail silversmith and jeweler
(Henry Ball; Erastus O. Tompkins, d. 1851; William Black)

301. Presentation tea and coffee service with tray
Service: silver; tray: silver-plated base metal

Hot-water kettle on stand, 1850
17⅜ x 10¼ x 7 in. (44 cm x 26 cm x 17.8 cm)
Marked on underside: BALL, TOMPKINS & BLACK/NEW YORK/[incuse in semicircle]/ J.C.M./22
Inscribed: in one reserve, To/MARSHALL LEFFERTS, ESQ./President/of the/New York/ and/New England/and/New York State/ Telegraph Companies; in second reserve, From/the Stockholders/and Associatied Press/of New York City;/Viz., Courier & Enquirer,/Journal of Commerce, Express,/ Herald, Sun and Tribune;/As a token of the satisfaction and/confidence inspired by his efficient/services in advancing the cause and credit/of the Telegraph System, the noblest/ enterprise of this eventful age./New York, June 1850.

The Metropolitan Museum of Art, New York, Gift of Mrs. F. R. Lefferts, 1969 69.141.1a–d

Sugar bowl with cover, 1850
H. 9 in. (22.9 cm); w. 7 in. (17.9 cm); diam. 5⅜ in. (13.5 cm)
Marked on underside of base: BALL, TOMPKINS & BLACK / NEW YORK / [pellet] / J.C.M. / 22
Inscription virtually identical to that on urn
The Metropolitan Museum of Art, New York, Gift of Mrs. F. R. Lefferts, 1969 69.141.2a,b

Hot-milk pot, 1850
H. 8⅜ in. (21.3 cm); w. 5 in. (12.8 cm); diam. 4⅛ in. (10.6 cm)
Marked on underside of base: BALL, TOMPKINS & BLACK / NEW YORK / [pellet] / J.C.M. / 22
Inscription virtually identical to that on urn
The Metropolitan Museum of Art, New York, Gift of Mrs. F. R. Lefferts, 1969 69.141.3

Pitcher, 1850
16⅛ x 7⅞ x 7 in. (41 x 19.4 x 17.8 cm)
Marked on underside of base: BALL, TOMPKINS & BLACK NEW YORK [incuse in semicircle] J.C.M. / 9
Inscription virtually identical to that on urn
Museum of the City of New York, gift of Charles Stedman, Jr. 62.161

Tray, ca. 1850
23¼ x 36⅞ in. (59.1 x 93.7 cm)
Marked on underside of rim in partial octagon: JAMES DIXON & SONS / SHEFFIELD [below variation on royal coat of arms with lion and unicorn issuing from behind oval shield with motto "[DIEU] ET MON[DRO]IT"
Incised on handle: 358
Stamped on underside of rim on a long side: [small crown device]
Inscription virtually identical to that on urn
The Metropolitan Museum of Art, New York, Gift of Mrs. F. R. Lefferts, 1969 69.141.4
Related in form and decoration to an acclaimed gold service made for E. K. Collins by John C. Moore, shown by Ball, Tompkins and Black at the Great Exhibition, London, in 1851 and at the New-York Exhibition of the Industry of All Nations in 1853–54

Starr, Fellows and Company, active 1850–57, or Fellows, Hoffman, and Company, active 1857–81
(William H. Starr; Charles H. Fellows; Charles O. Hoffman; Jer. A. G. Comstock; James G. Dolbeare; George Nichols)
302. Four-branch gasolier with central figure of Christopher Columbus, ca. 1857
Patinated spelter, gilt brass, lacquered brass, iron, and glass
43 x 29¼ x 29¼ in. (109.2 x 74.3 x 74.3 cm)
Louisiana State University Museum of Art, Baton Rouge, Louisiana. Gift of the Baton Rouge Coca-Cola Bottling Company 82.13

Dietz, Brother and Company, active ca. 1840–55
(Robert Edwin Dietz, 1818–1897; William Henry Dietz, d. 1860)
303. Three-piece girandole set depicting Louis Kossuth, leader of the Hungarian Revolution (1848), 1851
Bronze, lacquer, and brass
92.6a: 20⅛ x 6½ x 3⅝ in. (51 x 16.5 x 9.2 cm)
92.6b: 15⅝ x 6½ x 3⅞ in. (39.7 x 16.5 x 9.7 cm)
92.6c: 15½ x 6½ x 3⅞ in. (39.4 x 16.5 x 9.7 cm)
Marked: on back of 92.6a, DIETZ / PATENT / NEW YORK / DEC. 1851; on back of 92.6b, c, DIETZ / NEW YORK / PATENT / DEC. 1851
The Newark Museum, Anonymous Gift of Two Friends of the Decorative Arts, 1992 92.6a–c

Cooper and Fisher, active 1854–62, silverware manufacturer
(Francis W. Cooper, ca. 1811–1898, silversmith; Richard Fisher, jeweler)
304A–C. Chalice, paten, and footed paten, 1855–56
Coin and fine silver, gilding, and enamel
Chalice: 10 x 6½ in. (25.4 x 16.5 cm)
Paten: diam. 9½ in. (24.1 cm)
Footed paten: h. 9 in. (22.9 cm); diam. 12 in. (30.5 cm)
Marked twice on rims of bases of chalice and footed paten and once on base of paten: COOPER & FISHER / 131 AMITY ST NY
Inscribed around rim of paten and on foot of footed paten: Holy:Holy:Holy—Lord God of Hosts—Heaven and Earth Are Full of Thy Glory
Inscribed around rim of footed paten: Holy Holy Holy Lord God of Hosts, Heaven and Earth are Full of Thy Glory. Glory be to Thee O Lord Most High. Amen.[;] Hosanna For The Lord God Omnipotent Reigneth Alleluia.
Parish of Trinity Church in the City of New York 80.14.1–3

Wood and Hughes, active 1845–99, silverware manufacturer
305. Commemorative pitcher, Kiddush goblets, and tray, 1856
Silver; goblets with gilt interiors
Pitcher: 13¾ x 10 in. (34.9 x 25.4 cm)
Goblets: h. 5¾ in. (14.6 cm); diam. 3¾ in. (9.5 cm)
Tray: 15¾ x 12 in. (40 x 30.5 cm)
Marked: W & H / New YORK
Inscribed within a cartouche on each object: Presented by / The EMANU-EL TEMPLE / NEW YORK, / To the Revd. Dr. D. Einhorn / as a Token of Esteem / August 1856
Inscribed on the bowl of one goblet: Presented to / Rev. Dr. Samuel Schulman / By the Einhorn Family / as a Token of Appreciation / May 1909 / Bequeathed to / Congregation Emanu-El / by / Rev. Dr. Samuel / Schulman / 1956
Courtesy of Congregation Emanu-El of the City of New York CEE–29–43a,b (pitcher/ tray), CEE–56–1,2 (goblets)
Dr. David Einhorn (1809–1879) was a leading

international advocate of Reform Judaism; the pitcher depicts the congregation's home on East Twelfth Street, occupied from 1854 to 1868.

William Forbes, worked independently in New York 1837–63, manufacturing silversmith
Ball, Tompkins and Black, active 1839–51, retail silversmith and jeweler
(Henry Ball; Erastus O. Tompkins, d. 1851; William Black)
306. Pitcher and goblet (one of two), 1851
Silver
Goblet: 4.9 in. (22.9 cm); diam. (rim) 4⅞ in. (12.4 cm)
Pitcher: 18 x 9½ x 7 in. (45.7 x 24.1 x 17.8 cm)
Marked: BALL, TOMPKINS & BLACK [in Roman caps in semicircle] / SUCCESSORS TO [in rectangle] / MARQUAND & CO. [in semicircle] / [an eagle in an oval, struck twice, flanking MARQUAND & CO.] / NEW YORK [in rectangle] / W.F. [in rectangle, struck twice, flanking NEW YORK]
Inscribed within reserve on body: The Members of / the / Board of Aldermen / of 1850 & 51 / To / Their President / Morgan Morgans Esqr.
Museum of the City of New York, Gift of Frank D. Morgans 54.97.1a,b

Tiffany and Company, active 1837–present, manufacturing and retail silversmith and jeweler
307. Medal (obverse and reverse), 1859
Gold
Diam. 2¾ in. (7 cm)
Marked on reverse in exergue: TIFFANY & CO. N.Y.
Inscribed in field on obverse: CYRUS W. FIELD / FROM THE CHAMBER OF COMMERCE / AND CITIZENS OF NEW YORK,
Inscribed in field on obverse in exergue: COMMEMORATIVE OF THE PART TAKEN / BY HIM, / IN LAYING THE FIRST / TELEGRAPHIC CABLE / BETWEEN / EUROPE AND AMERICA, IN AUGUST, A.D. 1858
The Metropolitan Museum of Art, New York, Gift of Cyrus W. Field, 1892 92.10.3

Tiffany and Company, active 1837–present, manufacturing and retail silversmith and jeweler
308. Presentation box, 1859
Gold
1½ x 4½ x 2¾ in. (3.8 cm x 11.4 cm x 7 cm)
Inscribed on lid: on exterior, The City of New York to Cyrus W. Field; on interior, The City of New York to Cyrus W. Field / Commemorating his Skill Fortitude and Perseverance / in Originating and Completing / the First Enterprise for an Ocean Telegraph / successfully accomplished on the 5th August 1858. / Uniting Europe and America.
The Metropolitan Museum of Art, New York, Gift of Cyrus W. Field, 1892 92.10.7

Tiffany and Company, active 1837–present, manufacturing and retail silversmith and jeweler

309. Mounted section of transatlantic telegraph cable, 1858
Steel and brass
L. 4 in. (10.2 cm); diam. ¾ in. (1.9 cm)
Marked on mount: ATLANTIC TELEGRAPH CABLE/GUARANTEED BY/TIFFANY & CO./BROADWAY. NEW YORK.
Collection of D. Albert Soeffing
Tiffany and Company offered the public these four-inch lengths of cable, mounted as souvenirs, at a retail cost of fifty cents each.

Tiffany and Company, active 1837–present, manufacturing and retail silversmith and jeweler

310. Pitcher from a service presented to Colonel Abram Duryee of the Seventh Regiment, New York National Guard, by his fellow citizens, 1859
Sterling silver
14½ x 9¾ x 7½ in. (36.8 x 24.8 x 19.1 cm)
Marked on underside of base: TIFFANY & CO./1004/ENGLISH STERLING/925–1000/6248/M [Gothic style in oval]/550 Broadway/M [Gothic style in oval]
Inscribed on body within reserves: To/Colo.

A. Duryee/this testimonial is presented/on his retireing [sic] from the Colonelcy/of the/Seventh Regiment/National Guard/as a mark of high/appreciation From/his fellow citizens/for his soldierlike/qualities and for the/valuable services/rendered by the Regiment during/the eleven years that he/commanded it/New York/1859
Museum of the City of New York, Bequest of Emily Frances Whitney Briggs 55.257.5
The records of Tiffany and Company indicate that this service consisted of two pitchers, six goblets, a twenty-three-inch waiter, and a small waiter.

Bibliography

Authors' note: This bibliography is a partial listing of the books and articles consulted during the preparation of the exhibition and publication *Art in the Empire City: New York, 1825–1861*. The titles of the nineteenth-century periodicals that were surveyed page-by-page are included, but individual articles from these sources are not itemized here. Nineteenth-century newspapers were consulted as is reflected in the notes to the catalogue essays. Extensive use was made of city directories; for a detailed listing consult Dorothea Spear, *Bibliography of American Directories through 1860* (Worcester, Massachusetts: American Antiquarian Society, 1961).

PERIODICALS REVIEWED

The Albion. New York, weekly, 1822–76.

American Athenaeum. New York, weekly, April 21, 1825–March 2, 1826. Merged into *New York Literary Gazette, and American Athenaeum*.

American Eagle Magazine. New York, monthly, June–July 1847.

American Journal of Fine Arts Devoted to Painting, Sculpture, Architecture, Music. New York, 1844.

American Journal of Photography and the Allied Arts and Sciences. New York, weekly, 1852–67.

American Ladies' Magazine. Boston, monthly, 1828–36. Merged into *Godey's Lady's Book*.

American Mechanic. New York and Boston, weekly, January 8–December 31, 1842.

American Mechanics' Magazine. New York, weekly, February 5, 1825–February 11, 1826.

American Metropolitan Magazine. New York, monthly, January and February 1849.

American Monthly Magazine. New York, monthly, March 1833–October 1838.

American People's Journal of Science, Literature, and Art. New York, monthly, January and February 1850.

American Repertory of Arts, Sciences, and Manufactures. New York, monthly, February 1840–January 1842.

American Repertory of Arts, Sciences, and Useful Literature. Philadelphia, monthly, 1830–July 1832.

American Turf Register and Sporting Magazine. Baltimore, monthly, September 1829–38; New York, 1838–December 1844.

Anglo American. New York, weekly, April 29, 1843–November 13, 1847. Merged into *The Albion*.

Appletons' Mechanics' Magazine and Engineers' Journal. New York, 1851–53.

Arcturus. New York, monthly, December 1840–May 1842.

Arthur's Home Magazine. Philadelphia, monthly, October 1852–December 1898. Title varies: *Home Magazine*, October 1852–December 1855; *Lady's Home Magazine*, January 1857–

December 1859; *Arthur's Home Magazine*, January 1861–June 1863.

Arthur's Magazine. Philadelphia, monthly, January 1844–April 1846. Title varies: *Ladies' Magazine of Literature, Fashion and Fine Arts*, January–June 1844; *Arthur's Ladies' Magazine of Elegant Literature and the Fine Arts*, July 1844–December 1845; *Arthur's Magazine*, January–April 1846; merged with *Godey's Lady's Book*.

The Artist. New York, monthly, September 1842–May 1843.

Atlantic Magazine. New York, monthly, May 1824–April 1825.

Atlantic Monthly. Boston, monthly, 1857–62.

Broadway Journal. New York, weekly, January 4, 1845–January 3, 1846.

Brother Jonathan. New York, weekly, January 1, 1842–December 23, 1843.

Bulletin of the American Art-Union. New York, monthly, April 25, 1848–53.

Burton's Gentleman's Magazine and American Monthly Review. Philadelphia, monthly, July 1837–December 1840. Title varies: *Gentleman's Magazine*, July 1837–February 1839; *Burton's Gentleman's Magazine and American Monthly Review*, March 1839–November 1840; *Graham's Magazine*, December 1840.

Christian Parlor Magazine. New York, monthly, May 1844–55.

Columbian Lady's and Gentleman's Magazine. New York, monthly, January 1844–February 1849.

The Corsair. New York, weekly, March 16, 1839–March 7, 1840.

Cosmopolitan Art Journal. New York, quarterly, 1856–61.

The Crayon. New York, monthly, January 1855–July 1861.

The Critic. New York, weekly, November 1, 1828–June 20, 1829.

Dollar Magazine. New York, monthly, January 1848–December 1851. Title varies: *Holden's Dollar Magazine*, . . . January 1848–December 1850.

Dramatic Mirror, and Literary Companion. New York and Philadelphia, weekly, August 14, 1841–May 7, 1842.

Eclectic Magazine of Foreign Literature. New York and Philadelphia, monthly, 1844–1907.

Eclectic Museum of Foreign Literature, Science and Art. New York and Philadelphia, monthly, January 1843–January 1844.

Emerson's Magazine and Putnam's Monthly. New York, monthly, May 1854–November 1858. Title varies: *United States Magazine of Science, Art, Manufactures, Agriculture, Commerce and Trade*, May 15, 1854–April 1856; *United States Magazine*, July 1856–June 1857; *Emerson's United States Magazine*, July–September 1857; *Emerson's Magazine and Putnam's Monthly*, October 1857–November 1858.

The Expositor. New York, weekly, December 8, 1838–July 20, 1839.

Frank Leslie's Illustrated Newspaper. New York, weekly, December 15, 1855–June 17, 1922. Title varies after 1891.

Gleason's Pictorial Drawing-Room Companion. Boston, weekly, May 3, 1851–December 24, 1859. Title varies: *Ballou's Pictorial Drawing-Room Companion*, January 6, 1855–December 24, 1859.

Godey's Lady's Book. Philadelphia, monthly, 1830–98. Title varies: variations on *Lady's Book*, 1830–39; *Godey's Lady's Book and Ladies' American Magazine*, 1840–43; *Godey's Magazine and Lady's Book*, January 1844–June 1848; *Godey's Lady's Book*, July 1848–June 1854; *Godey's Lady's Book and Magazine*, July 1854–December 1882.

Graham's American Monthly Magazine of Literature, Art, and Fashion. Philadelphia, monthly, January 1826–December 1858. Title varies: *The Casket*, February 1826–December 1830; *Atkinson's Casket*, January 1831–April 1839; *The Casket*, May 1839–November 1840; *Graham's Lady's and Gentleman's Magazine*, January 1841–December 1842; *Graham's Magazine of Literature and Art*, January–June 1843; *Graham's Lady's and Gentleman's Magazine*, July 1843–June 1844; *Graham's American Monthly Magazine of Literature, Art, and Fashion*, July 1844–December 1858.

Hardware Man's Newspaper and American Manufacturer's Circular. Middletown, New York, and New York, 1855–59.

Harper's New Monthly Magazine. New York, monthly, June 1850–November 1900.

Harper's Weekly. New York, weekly, from January 3, 1857.

Home Journal. New York, weekly, from February 14, 1846. Title varies: *Morris's National Press, a Journal for Home*, February 14–November 14, 1846.

Horticulturist and Journal of Rural Art and Rural Taste. Albany, monthly, from October 1846.

Humphrey's Journal. New York, monthly, 1850–early 1870s.

Hunt's Merchants' Magazine. New York, monthly, July 1839–December 1870. Title varies: *Hunt's Merchants' Magazine and Commercial Review*; *Merchant's Magazine and Commercial Review*.

Illustrated Magazine of Art. New York, monthly, 1853–54.

Illustrated News. New York, weekly, January 1–November 26, 1853. Merged into *Gleason's Pictorial Drawing-Room Companion*.

The Independent. New York, weekly, December 7, 1848–October 13, 1928.

International Art-Union Journal. New York, monthly, February–November 1849.

International Monthly Magazine of Literature, Science, and Art. New York, monthly, July 1850–April 1852.

The Iris; or, Literary Messenger. New York, monthly, November 1840–October 1841.

The Knickerbocker. New York, monthly, January 1833–December 1865. Title varies: *The Knickerbocker; or, New York Monthly Magazine*, January 1833–December 1862.

Ladies' Companion. New York, monthly, May 1834–October 1844. Title varies: *Ladies' Companion, a Monthly Magazine*, May 1834–April 1843; *Ladies' Companion, and Literary Expositor*, May 1843–October 1844.

Ladies' Repository. Cincinnati and New York, monthly, January 1841–December 1867. Title varies: *Ladies Repository, and Gatherings of the West*, January 1841–December 1848; *Ladies' Repository; a Monthly Periodical, . . .* January 1849–December 1862.

Ladies' Wreath. New York, monthly, May, 1846–January 1862.

Literary Gazette and American Athenaeum. New York, weekly, September 10, 1825–March 3, 1827. Title varies: *New York Literary Gazette and Phi Beta Kappa Repository*, September 10, 1825–March 4, 1826; *New York Literary Gazette and American Athenaeum*, March 11–September 2, 1826; *Literary Gazette and American Athenaeum*, September 9, 1826–March 3, 1827.

Literary World. New York, weekly, February 6, 1847–December 31, 1853.

Magazine of Useful and Entertaining Knowledge. New York, monthly, June 15, 1830–May 1831. Title varies: *Mechanics' and Farmers' Magazine of Useful Knowledge*, June 15–July 15, 1830.

Mechanic's Advocate. Albany, weekly, December 3, 1846–1848. Succeeded the *New York State Mechanic*.

Mechanics' Magazine, and Journal of Public Internal Improvement; Devoted to the Useful Arts, and the Recording of Projects, Inventions, and Discoveries of the Age. Boston, monthly, February 1830–January 1836.

Mechanics' Magazine, and Journal of the Mechanics' Institute. New York, monthly, January 1833–August 1837.

The Minerva. New York, weekly, April 6, 1822–September 3, 1825. Superseded by the *New York Literary Gazette and Phi Beta Kappa Repository*.

Monthly Chronicle of Events, Discoveries, Improvements, and Opinions. Boston, monthly, April 1840–December 1842.

National Magazine. New York, monthly, July 1852–December 1858.

National Police Gazette. New York, weekly, September 1845–August 31, 1867. (Includes attacks on the Art Union.)

New Mirror. New York, weekly, April 8, 1843–September 28, 1844. Supersedes the *New York Mirror* (1823–42). After about a year, it was discontinued in favor of a daily newspaper, the *Evening Mirror*, and its adjunct, the *Weekly Mirror*.

New World. New York, weekly, June 6, 1840–May 10, 1845.

New York Illustrated Magazine of Literature and Art. New York, weekly, September 20–December 1845; monthly, January 1846–June 1847.

New York Literary Gazette. New York, weekly, February 2–July 13, 1839.

New York Literary Gazette and Journal of Belles Lettres, Arts, Science &c. New York, semi-monthly, September 1, 1834–March 14, 1835.

New York Mirror. New York, weekly, August 2, 1823–December 31, 1842. Title varies: *New-York Mirror, and Ladies' Literary Gazette*, August 2, 1823–July 3, 1830; superseded by *New Mirror*.

New York Quarterly Devoted to Science, Philosophy and Literature. New York, quarterly, 1825–55.

New York Review. New York, quarterly, March 1837–April 1842.

New York Review, and Atheneum Magazine. New York, monthly, June 1825–May 1826.

New York State Mechanic. Albany, weekly, November 20, 1841–June 17, 1843.

The New-Yorker. New York, weekly, March 26, 1836–September 11, 1841.

Niles' National Register. Washington, D.C., Baltimore, and Philadelphia, weekly, September 2, 1837–September 28, 1849.

Niles' Weekly Register. Baltimore, weekly, September 7, 1811–August 26, 1837. Title varies: *Weekly Register*, September 7, 1811–August 27, 1814.

Opera Glass, Devoted to the Fine Arts, Literature and Drama. New York, September 8–November 3, 1828.

Peterson's Magazine. Philadelphia, monthly, January 1842–December 1861. Title varies: *Lady's World of Fashion*, January–December 1842; *Lady's World*, January–May 1843; *Artist and Lady's World*, June 1843; *Ladies' National Magazine*, July 1843–December 1848; *Peterson's Magazine*, January 1849–November 1892.

Philadelphia Album and Ladies' Literary Port Folio. Philadelphia, weekly, April 26, 1826–December 27, 1834. Title varies: *Album and Ladies' Weekly Gazette*, June 7, 1826–May 30, 1827; *Philadelphia Album and Ladies' Literary Gazette*, June 6, 1827–July 3, 1830.

Photographic and Fine Art Journal. New York, monthly, January 1851–1860. Title varies: *Photographic Art-Journal*, January 1851–December 1853.

Political Economist. Philadelphia, weekly, January 24–May 1, 1824.

Port Folio. Philadephia, 1801–5, 1806–8, 1809–12, 1813–15, 1816–25, monthly, July 1826–December 1827.

Putnam's Monthly. New York, monthly, January 1853–December 1857. New series, titled *Putnam's Magazine*, January 1868–November 1870.

The Republic: A Monthly Magazine of American Literature, Politics, and Art. New York, monthly, 1851–52.

Sargent's New Monthly Magazine, of Literature, Fashion, and the Fine Arts. New York, monthly, January–June 1843.

Sartain's Union Magazine of Literature and Art. New York and Philadelphia, monthly, July 1847–August 1852. Title varies: *Union Magazine of Literature and Art*, July 1847–December 1848; *Sartain's Union Magazine of Literature and Art*, January 1849–August 1852.

Spirit of the Times. New York, weekly, December 10, 1831–June 22, 1861. Title varies: *Traveller and Spirit of the Times*, December 1, 1832–October 6, 1833.

The Talisman. New York, annually, 1828–30.

Transactions of the Literary and Philosophical Society of New-York. New York, irregularly, 1815–25.

United States Democratic Review. Washington, D.C., and New York, monthly, October 1837–December 1851. Title varies: *United States Magazine, and Democratic Review*, October 1837–December 1851; *Democrat's Review*, January–December 1852; *United States Review*, January 1853–January 1856.

United States Review and Literary Gazette. Boston and New York, monthly, October 1826–September 1827.

Washington Quarterly Magazine of Arts, Science and Literature. Washington, D.C., quarterly, July 1823–April 1824.

Working Man's Advocate. New York, weekly, October 31, 1829–1836; new series, 1844–49. Title varies: *Workingman's Advocate*, October 31, 1829–June 5, 1830; *New York Sentinel and Working Man's Advocate*, June 9–August 14, 1830; *Workingman's Advocate*, August 21, 1830–August 10, 1833; *Radical, in Continuation of Working Man's Advocate*, January 1841–April 1843; *Workingman's Advocate*, March 16–July 20, 1844; *People's Rights*, July 24–27, 1844; *Workingman's Advocate*, August 3–October 5, 1844; *Subterranean, United with the Workingman's Advocate*, October 12–December 21, 1844; *Workingman's Advocate*, December 28, 1844–March 22, 1845; *Young America*, March 29, 1845–September 23, 1848.

BOOKS AND JOURNAL ARTICLES

Abbott, Jacob. *The Harper Establishment; or, How the Story Books Are Made*. New York: Harper and Brothers Publishers, 1855.

Abdy, Edward S. *Journal of a Residence and Tour in the United States of North America, from April, 1833, to October, 1834*. 3 vols. London: J. Murray, 1835.

Adkins, Nelson F. *Fitz-Greene Halleck, an Early Knickerbocker Wit and Poet*. New Haven: Yale University Press, 1930.

Albion, Robert Greenhalgh. *The Rise of New York Port (1815–1860)*. New York: C. Scribner's Sons, 1939. Reprint, Boston: Northeastern University Press, 1984.

Albis, Jean d'. *Haviland*. Paris: Dessin et Tolra, 1988.

Albis, Jean d', and Céleste Romanet. *La porcelaine de Limoges*. Paris: Sous le Vent, 1980.

Allen, Sue. "Machine-Stamped Bookbindings, 1834–1860." *Antiques* 115 (March 1979), pp. 564–72.

Alsop, Susan Mary. "Victoria Mansion in Maine: Preserving a Rare Gustave Herter Interior." *Architectural Digest* 51 (September 1994), pp. 46–56.

American Academy of the Fine Arts. *The Charter and By-laws of the American Academy of Fine*

Arts, Instituted February 12, 1802, under the Title of the American Academy of the Arts. With an Account of the Statues, Busts, Paintings, Prints, Books, and Other Property Belonging to the Academy. New York: David Longworth, 1817.

———. *A Descriptive Catalogue of the Paintings, by the Ancient Masters, Including Specimens of the First Class, by the Italian, Venetian, Spanish, Flemish, Dutch, French, and English Schools.* New York: W. Mitchell, 1832.

———. *Exhibition of Rare Paintings at the Academy of Fine Arts, New York.* Exh. cat. New York: American Academy of the Fine Arts, 1828.

The American Advertising Directory for Manufacturers and Dealers for the Year 1832. New York: Jocelyn, Darling and Company, 1832.

American Art-Union. *Transactions of the American Art-Union, for the Promotion of the Fine Arts in the United States, for the Year 1844.* New York, 1844.

America's Successful Men of Affairs: An Encyclopedia of Contemporaneous Biography. Edited by Henry Hall. New York: New York Tribune, 1895.

Ames, Kenneth L. *Death in the Dining Room and Other Tales of Victorian Culture.* Philadelphia: Temple University Press, 1992.

———. "Designed in France: Notes on the Transmission of French Style to America." *Winterthur Portfolio* 12 (1977), pp. 103–14.

Ampère, J. J. *Promenade en Amérique: États-Unis–Cuba–Mexique.* Paris: Michel Lévy Frères, 1855.

Anderson, Patricia. *The Course of Empire: The Erie Canal and the New York Landscape, 1825–1875.* Exh. cat. Rochester: Memorial Art Gallery of the University of Rochester, 1984.

The Andrews & Co. Stranger's Guide in the City of New-York. Boston: Andrews and Company, 1852.

Appleby, Joyce O. *Capitalism and a New Social Order: The Republican Vision of the 1790s.* New York: New York University Press, 1984.

———. *Economic Thought and Ideology in Seventeenth Century England.* Princeton: Princeton University Press, 1978.

Archives of the National Academy of Design. *Constitution and Bylaws of the National Academy of Design with a Catalogue of the Library and Property of the Academy.* New York: I. Sackett, 1843.

Aresty, Esther B. *The Best Behavior: The Course of Good Manners—from Antiquity to the Present—as Seen through Courtesy and Etiquette Books.* New York: Simon and Schuster, 1970.

Arfwedson, Carl David. *The United States and Canada, in 1832, 1833, and 1834.* London: Richard Bentley, 1834.

[Armstrong, William] An Old Resident. *The Aristocracy of New York: Who They Are, and What They Were, Being a Social and Business History of the City for Many Years.* New York: New York Publishing Company, 1848.

Arrington, Joseph Earl. "John Banvard's Moving Panorama of the Mississippi, Missouri, and Ohio Rivers." *Filson Club History Quarterly* 32 (July 1958), pp. 224–27.

Art and Commerce: American Prints of the Nineteenth Century. Proceedings of a Conference Held in Boston May 8–10, 1975, Museum of Fine Arts, Boston, Massachusetts. Charlottesville: University Press of Virginia, 1978.

The Art-Journal Illustrated Catalog: The Industry of All Nations 1851. Exh. cat. London: George Virtue, 1851.

Ashworth, Henry. *A Tour in the United States, Cuba, and Canada. . . . A Course of Lectures Delivered before Members of the Bolton Mechanics' Institution.* London: A. W. Bennett, 1861.

Aspinwall, W. H. *Descriptive Catalogue of the Pictures of the Gallery of W. H. Aspinwall, No. 99 Tenth Street, New-York.* N.p., 1860.

Association for the Exhibition of the Industry of All Nations. *Official Awards of Juries. . . 1853.* New York: Printed for the Association by William C. Bryant and Company, 1853.

Audubon, John James. *The Birds of America.* 87 parts. London: J. J. Audubon, 1827–38.

———. *The Birds of America from Drawings Made in the United States and Their Territories.* 7 vols. New York and Philadelphia: J. J. Audubon and J. B. Chevalier, 1840–44.

Avery, Kevin J. *Church's Great Picture: The Heart of the Andes.* Exh. cat. New York: The Metropolitan Museum of Art, 1993.

———. "*The Heart of the Andes* Exhibited: Frederic E. Church's Window on the Equatorial World." *American Art Journal* 18 (winter 1986), pp. 52–60.

———. "Movies for Manifest Destiny: The Moving Panorama Phenomenon in America." In *The Grand Moving Panorama of Pilgrim's Progress,* pp. 1–12. Exh. cat. Montclair, New Jersey: Montclair Art Museum, 1999.

———. "The Panorama and Its Manifestation in American Landscape Painting, 1795–1870." Ph.D. dissertation, Columbia University, New York, 1995.

Avery, Kevin J., and Peter L. Fodera. *John Vanderlyn's Panoramic View of the Palace and Gardens of Versailles.* New York: The Metropolitan Museum of Art, 1988.

Bacot, H. Parrott. *Nineteenth Century Lighting: Candle-powered Devices, 1788–1883.* Exton, Pennsylvania: Shiffer Publishing, 1987.

Badger, Daniel D. *Illustrations of Iron Architecture Made by the Architectural Iron Works of the City of New York.* New York: Baker and Godwin, 1865. Reprinted as *Badger's Illustrated Catalogue of Cast-Iron Architecture,* New York: Dover Publications, 1981. See also *Origins of Cast Iron Architecture in America* below.

Bagnall, W. R. *The Textile Industries of the United States* Cambridge, Massachusetts: Riverside Press, 1893.

Bailey, Rosalie Fellows. *Guide to Genealogical and Biographical Sources for New York City (Manhattan), 1793–1898.* Newton, Massachusetts: Garden City Print, 1954.

Baker, Paul R. *Richard Morris Hunt.* Cambridge, Massachusetts: MIT Press, 1980.

Banham, Joanna. *Encyclopedia of Interior Design.* 2 vols. London and Chicago: Fitzroy Dearborn Publishers, 1997.

Barber, Edwin Atlee. *Historical Sketch of the Green Point (N.Y.) Porcelain Works of Charles Cartlidge & Co.* Indianapolis: Clayworker, 1895.

Barber, John W., and Henry Howe. *Historical Collections of the State of New York.* New York: S. Tuttle, 1842.

Barck, Dorothy C. "Proposed Memorials to Washington in New York City." *New-York Historical Society Quarterly Bulletin* 15 (October 1931), pp. 79–90.

Barger, Helen, Sheldon Butts, and Ray La Tournous. "The Dorflinger Guard Presents." *Glass Club Bulletin of the National Early American Glass Club,* no. 36 (winter 1981–82), pp. 3–4.

Barnum, Phineas T. *Life of P. T. Barnum.* New York: Redfield, 1855.

———. *Struggles and Triumphs; or, Forty Years' Recollections of P. T. Barnum. Written by Himself.* Hartford, Connecticut: J. B. Burr and Company, 1870.

Barry, Charles. *The Travellers' Club House.* London: J. Weale, 1839.

Barter, Judith A., Kimberly Rhodes, and Seth A. Thayer, with contributions by Andrew Walker. *American Arts at the Art Institute of Chicago, from Colonial Times to World War I.* Chicago: Art Institute of Chicago, 1998.

Barth, Gunther. *City People: The Rise of Modern City Culture in Nineteenth-Century America.* New York: Oxford University Press, 1980.

Beach, Moses Y. *The Wealth and Biography of Wealthy Citizens of the City of New York.* New York: The Sun, 1855.

Beall, Karen F. *American Prints in the Library of Congress.* Baltimore: Johns Hopkins Press, 1970. Reprint, Baltimore: Johns Hopkins Press for the Library of Congress, 1981.

Beard, Rick. *In the Mill.* Exh. brochure. Yonkers, New York: Hudson River Museum, 1983.

Beck, Raymond L. "Thomas Constantine's 1823 Senate Speaker's Chair for the North Carolina State House: Its History and Preservation." *Carolina Comments* (Raleigh: North Carolina State Department of Archives and History) 41 (January 1993), pp. 25–30.

Beckert, Sven U. P. "The Making of New York City's Bourgeoisie, 1850–1886." Ph.D. dissertation, Columbia University, New York, 1995.

Bedini, Silvio A. "The Mace and the Gavel Symbols of Government in America." *Transactions of the American Philosophical Society* 87, part 4 (1997), pp. 28–33.

Belden, E[zekiel] Porter. *New-York: Past, Present, and Future: Comprising a History of the City of New-York, a Description of Its Present Condition and an Estimate of Its Future Increase.* 2d ed. New York: G. P. Putnam, 1849.

———. *New-York—As It Is, Being the Counterpart of the Metropolis of America.* New York: John P. Prall, 1849.

Belden, Louise Conway. *Marks of American Silversmiths in the Ineson-Bissell Collection.* Charlottesville: University Press of Virginia for the Henry Francis du Pont Winterthur Museum, 1980.

Bender, Thomas. *New York Intellect: A History of Intellectual Life in New York City from 1750 to the Beginnings of Our Own Time.* New York: Alfred A. Knopf, 1987.

———. *Toward an Urban Vision: Ideas and Institutions in Nineteenth-Century America.* Lexington: University of Kentucky, 1975.

Benisovich, Michel. "Sales of French Collections of Paintings in the United States during the First Half of the Nineteenth Century." *Art Quarterly* 19 (autumn 1956), pp. 288–301.

Bennett, Whitman. *A Practical Guide to American Nineteenth-Century Color Plate Books.* New York: Bennett Book Studios, 1949.

Berger, Max. *The British Traveller in America, 1836–1860.* New York: Columbia University Press, 1943.

Berthoff, Rowland. "Independence and Attachment, Virtue and Interest: From Republican Citizen to Free Enterprise, 1787–1837." In *Uprooted Americans: Essays to Honor Oscar Handlin,* edited by Richard Bushman et al., pp. 97–124. Boston: Little, Brown and Company, 1979.

Bigelow, David. *History of Prominent Mercantile and Manufacturing Firms in the United States, with a Collection of Truthful Illustrations, Representing Mercantile Buildings, Manufacturing Establishments, and Articles Manufactured.* Boston: David Bigelow, 1857.

Bigelow, Erastus B. *The Tariff Question Considered in Regard to the Policy of England and the Interests of the United States; with Statistical and Comparative Tables.* Boston: Little, Brown and Company, 1862.

Binder, Frederick M., and David M. Reimers. *All the Nations under Heaven: An Ethnic and Racial History of New York City.* New York: Columbia University Press, 1995.

A Biographical and Critical Dictionary of Painters, Engravers, Sculptors, and Architects from Ancient to Modern Times; with Monograms, Ciphers, and Marks Used by Distinguished Artists to Certify Their Works. New York: George P. Putnam, 1852.

Bird, Isabella Lucy. *The Englishwoman in America.* London: John Murray, 1856. Reprint, Madison: University of Wisconsin Press, 1966.

Bishop, J. Leander. *A History of American Manufactures from 1608 to 1860, Exhibiting the Origin and Growth of the Principal Mechanic Arts and Manufactures from the Earliest Colonial Period to the Adoption of the Constitution; and Comprising Annals of the Industry of the United States in Machinery, Manufactures and Useful Arts, with a Notice of the Important Inventions, Tariffs, and the Results of Each Decennial Census.* 3 vols. Philadelphia: Edward Young and Company, 1868.

Blackmar, Elizabeth. *Manhattan for Rent, 1785–1850.* Ithaca, New York: Cornell University Press, 1989.

———. "Uptown Real Estate and the Creation of Times Square." In *Inventing Times Square: Commerce and Culture at the Crossroads of the World,* edited by William R. Taylor. New York: Russell Sage Foundation, 1991.

Blaugrund, Annette. "John James Audubon: Producer, Promoter, and Publisher." *Imprint* 21 (March 1996), pp. 11–19.

[Blodget, Samuel]. *Thoughts on the Increasing Wealth and National Economy of the United States of America.* Washington, D.C.: Printed by Way and Groff, 1801.

Blumin, Stuart M. *The Emergence of the Middle Class: Social Experience in the American City, 1760–1900.* Cambridge: Cambridge University Press, 1989.

———. "Explaining the New Metropolis: Perception, Depiction, and Analogies in Mid-Nineteenth Century New York City." *Journal of Urban History* 11 (1984), pp. 9–38.

[Boardman, James]. *America and the Americans by a Citizen of the World.* London: Longman, Rees, Orme, Brown, Green, and Longmans, 1833.

[Bobo, William M.]. *Glimpses of New-York City by a South Carolinian (Who Had Nothing Else to Do).* Charleston: J. J. McCarter, 1852.

Bodder, Geoffrey A. *Ridgway Porcelains.* 2d ed. Woodbridge, Suffolk: Antique Collectors' Club, 1985.

Bode, Carl. *Antebellum Culture.* Carbondale: Southern Illinois University Press, 1970. Originally published in 1959 as *The Anatomy of Popular Culture, 1840–1861.*

Bogardus, James [with John W. Thompson]. *Cast Iron Buildings; Their Construction and Advantages.* New York: J. W. Harrison, 1856. See also *Origins of Cast Iron Architecture in America.*

Bolles, A. S. *The Industrial History of the United States.* Norwich, Connecticut: Henry Bill Publishing Company, 1878.

Book of Prices of the United Society of Journeymen Cabinet Makers of Cincinnati, for the Manufacture of Cabinet Ware. Cincinnati: N. S. Johnson, 1836.

Boyer, M. Christine. *Manhattan Manners: Architecture and Style, 1850–1900.* New York: Rizzoli, 1985.

Branin, M. Lelyn. *The Early Makers of Handcrafted Earthenware and Stoneware in Central and Southern New Jersey.* Rutherford, New Jersey: Fairleigh Dickinson University Press, 1988.

Braund, J[ohn]. *Illustrations of Furniture, Candelabra, Musical Instruments from the Great Exhibitions of London and Paris, with Examples of Similar Articles from Royal Palaces and Noble Mansions.* London: J. Braund, 1858.

Bremer, Fredrika. *The Homes of the New World; Impressions of America.* Translated by Mary Howitt. 2 vols. New York: Harper and Brothers, 1853.

Bremner, Robert H. "The Big Flat: History of a New York Tenement House." *American Historical Review* 64 (October 1958), pp. 54–62.

Bridges, Amy. *A City in the Republic: Antebellum New York and the Origins of Machine Politics.* Cambridge: Cambridge University Press, 1984.

Brimo, René. *L'évolution du goût aux États Unis, d'après l'histoire des collections.* Paris: Chez James Fortune, 1938.

Broderick, Mosette. "Fifth Avenue, New York, New York." In *The Grand American Avenue, 1850–1920,* edited by Jan Cigliano and Sarah Bradford Landau, pp. 3–34. Exh. cat. New Orleans: Historic New Orleans Collection; Washington, D.C.: Octagon Museum, 1994.

Bromwell, William J. *History of Immigration to the United States, Exhibiting the Number, Sex, Age, Occupation, and Country of Birth, of Passengers Arriving by Sea from Foreign Countries, from September 30, 1819, to December 31, 1855.* New York: Redfield, 1856.

Brooks, Van Wyck. *The World of Washington Irving.* New York: E. P. Dutton, 1944.

Brown, Charles H. *William Cullen Bryant.* New York: Charles Scribner's Sons, 1971.

Brown, Joan Sayers. "Henry Clay's Silver Urn." *Antiques* 112 (July 1977), pp. 108, 112.

———. "William Adams and the Mace of the United States House of Representatives." *Antiques* 108 (July 1975), pp. 76–77.

Brown, Joshua, and David Ment. *Factories, Foundries, and Refineries: A History of Five Brooklyn Industries.* Brooklyn: Brooklyn Educational and Cultural Alliance, 1980.

Brown, Solyman, ed. *The Citizen and Strangers' Pictorial and Business Directory for the City of New-York and Its Vicinity.* New York: Charles Spalding and Company, 1853.

Bruhn, Thomas P. *The American Print: Originality and Experimentation, 1790–1890.* Additional essay by Kate Steinway. Exh. cat. Storrs: William Benton Museum of Art, University of Connecticut, 1993.

Brumbaugh, Thomas B. "A Ball Hughes Correspondence." *Art Quarterly* 21 (winter 1958), pp. 422–27.

———. "Shobal Clevenger: An Ohio Stonecutter in Search of Fame." *Art Quarterly* 29 (1966), pp. 29–45.

Brust, James, and Wendy Shadwell. "The Many Versions and States of *The Awful Conflagration of the Steam Boat Lexington.*" *Imprint* 15 (autumn 1990), pp. 2–13.

Bryant, William Cullen. *A Funeral Oration Occasioned by the Death of Thomas Cole, Delivered before the National Academy of Design, New York, May 4, 1848.* New York: D. Appleton and Company, 1848.

———. *The Letters of William Cullen Bryant.* Edited by Thomas G. Voss. 3 vols. New York: Fordham University Press, 1975.

Buckingham, James S. *America: Historical, Statistic, and Descriptive.* 2 vols. New York: Harper and Brothers, 1841.

Bumgardner, Georgia Brady. "George and William Endicott: Commercial Lithography in New York, 1831–51." In *Prints and Printmakers of New York State, 1825–1940,* edited by David Tatham, pp. 43–66. Syracuse: Syracuse University Press, 1986.

Burkett, Nancy H., and John B. Hench, eds. *Under Its Generous Dome: The Collections and Programs of the American Antiquarian Society.* Worcester, Massachusetts: American Antiquarian Society, 1992.

Burnet, John. *A Practical Treatise on Painting, in Three Parts*. London, 1828.

Burnham, Alan. *New York City: The Development of the Metropolis: An Annotated Bibliography*. New York: Garland, 1988.

Burrows, Edwin G., and Mike Wallace. *Gotham: A History of New York City to 1898*. New York: Oxford University Press, 1999.

Bushman, Richard L. *The Refinement of America: Persons, Houses, Cities*. New York: Alfred A. Knopf, 1992.

Byvanck, Valentijn. "Public Portraits and Portrait Publics." *Explorations in Early American Culture / Pennsylvania History: A Journal of Mid-Atlantic Studies* 65 (1998), pp. 199–242.

———. "Representative Heads: Politics and Portraiture in Antebellum America." Ph.D. dissertation, New York University, 1998.

Callow, James T. "American Art in the Collection of Charles M. Leupp." *Antiques* 118 (November 1980), pp. 998–1009.

———. *Kindred Spirits: Knickerbocker Writers and American Artists, 1807–1855*. Chapel Hill: University of North Carolina Press, 1967.

Campbell, Catherine H., and Marcia Schmidt Blaine. *New Hampshire Scenery: A Dictionary of Nineteenth-Century Artists of New Hampshire Mountain Landscapes*. Canaan, New Hampshire: Published for the New Hampshire Historical Society by Phoenix Pub., 1985.

Campbell, Colin. *The Romantic Ethic and the Spirit of Modern Consumerism*. Oxford: Basil Blackwell, 1987.

Carbone, Teresa A. *American Paintings in the Brooklyn Museum of Art: Artists Born by 1876*. Brooklyn: Brooklyn Museum of Art, forthcoming.

Carbone, Teresa A., and Patricia Hills. *Eastman Johnson: Painting America*. Exh. cat. New York: Brooklyn Museum of Art and Rizzoli International Publications, 1999.

Carman, Harry James, and Arthur W. Thompson. *A Guide to the Principal Sources for American Civilization, 1800–1900, in the City of New York: Manuscripts*. New York: Columbia University Press, 1960.

———. *A Guide to the Principal Sources for American Civilization, 1800–1900, in the City of New York: Printed Materials*. New York: Columbia University Press, 1962.

Caroll, Betty Boyd. *America's First Ladies*. Pleasantville, New York: Reader's Digest, 1996.

Carpenter, Charles H., Jr., with Mary Grace Carpenter. *Tiffany Silver*. New York: Dodd, Mead and Company, 1978.

Carpenter, Charles H., Jr., and Janet Zapata. *The Silver of Tiffany & Co., 1850–1987*. Exh. cat. Boston: Museum of Fine Arts, 1987.

Carr, Gerald L. *Frederic Edwin Church—The Icebergs*. Dallas: Dallas Museum of Fine Arts, 1980.

Carrott, Richard G. *The Egyptian Revival: Its Sources, Monuments, and Meaning, 1808–1858*. Berkeley: University of California Press, 1978.

Carson, Cary, Ronald Hoffman, and Peter J. Albert, eds. *Of Consuming Interests: The Style of Life in the Eighteenth Century*. Charlottesville: University Press of Virginia for the United States Capitol Historical Society, 1994.

Carstensen, George, and Charles Gildemeister. *New York Crystal Palace: Illustrated Description of the Building*. New York: Riker, Thorne, and Company, 1854.

Catalogue of the Palmer Marbles, at the Hall Belonging to the Church of the Divine Unity, 548 Broadway, New York. Albany: J. Munsell, 1856.

A Century of Carpet and Rug Making in America. New York: Bigelow-Hartford Carpet Company, 1925.

Chamberlain, Georgia Stamm. *Studies on American Painters and Sculptors of the Nineteenth Century*. Annandale, Virginia: Turnpike Press, 1965.

Chapman, John Gadsby. *The American Drawing-Book. A Manual for the Amateur and Basis of Study for the Professional Artist, Especially Adapted to the Use of Public and Private Schools, as Well as Home Instruction*. New York: J. S. Redfield, 1847. Enlarged ed., New York: W. J. Widdleton, 1864.

Chevalier, Michael. *Society, Manners, and Politics in the United States, Being a Series of Letters on North America*. Translated from 3d French ed. Boston: Meeks, Jordon and Company, 1839. Reprint, New York: Augustus M. Kelley, 1966.

Christman, Henry M., ed. *Walt Whitman's New York: A Collection of Walt Whitman's Journalism Celebrating New York from Manhattan to Montauk*. New York: Macmillan Company, 1963.

Cikovsky, Nicolai, Jr., and Franklin Kelley. *Winslow Homer*. Exh. cat. Washington, D.C.: National Gallery of Art, 1995.

Clark, Eliot C. *History of the National Academy of Design, 1825–1953*. New York: Columbia University Press, 1954.

Clark, Henry Nichols Blake. *Francis W. Edmonds: American Master in the Dutch Tradition*. Washington, D.C.: Published for Amon Carter Museum by Smithsonian Institution Press, 1988.

———. *A Marble Quarry: The James H. Ricau Collection of Sculpture at the Chrysler Museum of Art*. New York: Hudson Hills Press, in association with the Chrysler Museum of Art, 1997.

Clark, Victor S. *History of Manufactures in the United States*. 3 vols. New York: McGraw-Hill Book Company, 1929.

Clark, Willene B. *The Stained Glass of William Jay Bolton*. Syracuse, New York: Syracuse University Press, 1992.

Clement, Arthur W. *Our Pioneer Potters*. New York: Privately printed, 1947.

Coes, Amy M. "Thomas Brooks: Cabinetmaker and Interior Decorator." Master's thesis, Bard Graduate Center for Studies in the Decorative Arts, New York, 1999.

Cohen, Ira. "The Auction System in the Port of New York, 1817–1837." *Business History Review*, autumn 1971, pp. 488–510.

Cohen, Paul E., and Robert T. Augustyn. *Manhattan in Maps, 1527–1995*. New York: Rizzoli International Publications, 1997.

Colden, Cadwallader D. *Memoir, Prepared at the Request of a Committee of the Common Council of the City of New York, and Presented to the Mayor of the City, at the Celebration of the Completion of the New York Canals*. New York: Printed by Order of the Corporation of New York by W. A. Davis, 1825. Copy available in the Department of Drawings and Prints, The Metropolitan Museum of Art.

Cole, Arthur H., and Harold F. Williamson. *The American Carpet Manufacture: A History and Analysis*. Cambridge, Massachusetts: Harvard University Press, 1941.

Collins, John. *The City and Scenery of Newport, Rhode Island*. Burlington, New Jersey: Privately published, 1857.

Conningham, Frederic A., and Mary B. Conningham. *An Alphabetical List of 5735 Titles of N. Currier and Currier & Ives Prints, with Dates of Publications, Sizes, and Recent Auction Prices*. New York: Privately printed, 1930.

Constable, William G. *Art Collecting in the United States of America*. London: Thomas Nelson and Sons; Paris: Société Française d'Éditions Nelson, 1963.

Cooney, John D. "Acquisition of the Abbott Collection." *Brooklyn Museum Bulletin* 10 (spring 1949), pp. 16–23.

Cooper, Helen A. *John Trumbull: The Hand and Spirit of a Painter*. With essays by Patricia Mullan Burnham et al. Exh. cat. New Haven: Yale University Art Gallery, 1982.

Cooper, James Fenimore. *America and the Americans: Notions Picked up by a Travelling Bachelor*. 2 vols. 2d ed. London: Published for Henry Colburn by R. Bentley; Edinburgh: Bell and Bradfute; Dublin: John Cuming, 1836. Revised ed., *Notions of the Americans*, Albany: State University of New York Press, 1991.

———. *Excursions in Italy*. 2 vols. London: Richard Bentley, 1838.

———. *The Last of the Mohicans: A Narrative of 1757*. 2 vols. Philadelphia: H. C. Carey and I. Lea, 1826.

———. *The Letters and Journals of James Fenimore Cooper*. Edited by James Franklin Beard. 6 vols. Cambridge, Massachusetts: Belknap Press of Harvard University Press, 1960–68.

———. *New York: Being an Introduction to an Unpublished Manuscript, by the Author, Entitled the Towns of Manhattan*. New York: William Farquhar Payson, 1930.

———. *The Pioneers; or, The Sources of the Susquehanna: A Descriptive Tale*. London: T. Allman, 1823.

Cooper, James Fenimore, ed. *Correspondence of James Fenimore-Cooper*. 2 vols. New Haven: Yale University Press, 1922.

Cooper, Wendy A. *Classical Taste in America, 1800–1840*. Exh. cat. Baltimore: Baltimore Museum of Art; New York: Abbeville Press, 1993.

Cornog, Evan. *The Birth of Empire: De Witt Clinton and the American Experience, 1769–1828*. New York: Oxford University Press, 1998.

Courtney, John A., Jr. "'All that Glitters': Freehand Gilding on Philadelphia Empire Furniture, 1820–1840." Master's thesis, Antioch University, Baltimore, Maryland, 1998.

Cowdrey, Mary Bartlett. *National Academy of Design Exhibition Record, 1826–1860*. 2 vols. New York: New-York Historical Society, 1943.

Cowdrey, Mary Bartlett, and Theodore Sizer. *American Academy of Fine Arts and American Art-Union, 1816–1852. With a History of the American Academy*. 2 vols. Vol. 1: *Introduction*. Vol. 2: *Exhibition Record*. New York: New-York Historical Society, 1953.

Crane, Sylvia E. *White Silence: Greenough, Powers, and Crawford: American Sculptors in Nineteenth-Century Italy*. Coral Gables, Florida: University of Miami Press, 1972.

Craven, Wayne. "Henry Kirke Brown: His Search for an American Art in the 1840's." *American Art Journal* 4 (November 1972), pp. 44–58.

———. *Sculpture in America*. Rev. ed. Newark: University of Delaware Press, 1984.

Crawford, Rachael B. "The Forbes Family of Silversmiths." *Antiques* 107 (April 1975), pp. 730–35.

Culme, John. *Nineteenth-Century Silver*. London: Country Life Books, 1977.

Cummings, Thomas S[eir]. *Historic Annals of the National Academy of Design, New-York Drawing Association, etc., with Occasional Dottings by the Way-side, from 1825 to the Present Time*. Philadelphia: George W. Childs, 1865.

Currier & Ives: A Catalogue Raisonné. A Comprehensive Catalogue of the Lithographs of Nathaniel Currier, James Merritt Ives, and Charles Currier, Including Ephemera Associated with the Firm, 1834–1907. Detroit: Gale Research, 1984.

Currier & Ives: The New Best Fifty. Fairfield, Connecticut: American Historical Print Collectors Society, 1991.

Curtis, George William. *Lotus-Eating: A Summer Book*. New York: Harper and Brothers, 1852.

D'Ambrosio, Anna Tobin, ed. *Masterpieces of American Furniture from the Munson-Williams-Proctor Institute*. Utica: Munson-Williams-Proctor Institute, 1999.

Darley, Felix Octavius Carr. *The Cooper Vignettes*. New York: James G. Gregory, 1862.

Darrah, William C. *Cartes de visite in Nineteenth Century Photography*. Gettysburg, Pennsylvania: W. C. Darrah, 1981.

Davis, Alexander Jackson. *Rural Residences*. New York: The Author, 1837.

Davis, Elliot Bostwick. "Training the Eye and the Hand: Drawing Books in Nineteenth-Century America." Ph.D. dissertation, Columbia University, New York, 1992.

———. *Training the Eye and the Hand: Fitz Hugh Lane and Nineteenth-Century American Drawing Books*. Exh. cat. Gloucester, Massachusetts: Cape Ann Historical Society, 1993.

Davison, Gideon M. *The Fashionable Tour in 1825: An Excursion to the Springs, Niagara, Quebec, and Boston*. Saragota Springs: G. M. Davison, 1825.

Davison, Nancy Reynolds. "E. W. Clay: American Political Caricaturist of the Jacksonian Era." Ph.D. dissertation, University of Michigan, Ann Arbor, 1980.

Deák, Gloria Gilda. *American Views: Prospects and Vistas*. New York: Viking Press and New York Public Library, 1976.

———. *Picturing America, 1497–1899: Prints, Maps, and Drawings Bearing on the New World Discoveries and on the Development of the Territory That Is Now the United States*. 2 vols. Princeton: Princeton University Press, 1988.

———. *William James Bennett: Master of the Aquatint View*. Exh. cat. New York: New York Public Library, 1988.

Dearinger, David Bernard. "American Neoclassic Sculptors and Their Private Patrons in Boston." 2 vols. Ph.D. dissertation, City University of New York, 1993.

———. "Asher B. Durand and Henry Kirke Brown: An Artistic Friendship." *American Art Journal* 20 (1988), pp. 74–83.

DeBow, J. D. B. *Statistical View of the United States . . . Being a Compendium of the Seventh Census, to Which Are Added the Results of Every Previous Census, Beginning with 1790. . . .* Washington, D.C.: Beverly Tucker, Senate Printer, 1854.

de Forest, Emily Johnston. *James Colles, 1788–1883: Life and Letters*. New York: Privately printed, 1926.

DeLuce, Olive S. "Percival DeLuce and His Heritage." *Northwest Missouri State Teachers College Studies*, June 1, 1948, pp. 71–132.

Depew, Chauncey M., ed. *One Hundred Years in American Commerce (1795–1895)*. 2 vols. New York: D. O. Haynes and Company, 1895.

Description of J. Frazee's Design for the Washington Monument (in Four Large Drawings) Now Exhibiting at the Art-Union. New York: Printed by Jared W. Bell, 1848.

Dickens, Charles. *American Notes for General Circulation*. 2 vols. London: Chapman and Hall, 1842; "cheap edition," 1850.

Dietz and Company. *Victorian Lighting: The Dietz Catalogue of 1860, with a New History of Dietz and Victorian Lighting by Ulysses G. Dietz*. Watkins Glen, New York: American Life Foundation, 1982.

Dillistin, William H. "National Bank Notes in the Early Years." *The Numismatist* 61 (December 1948), pp. 791–814.

Dimmick, Lauretta. "A Catalogue of the Portrait Busts and Ideal Works of Thomas Crawford (1813?–1857), American Sculptor in Rome." 3 vols. Ph.D. dissertation, University of Pittsburgh, 1986.

———. "Robert Weir's Saint Nicholas: A Knickerbocker Icon." *Art Bulletin* 66 (September 1984), pp. 465–83.

———. "Thomas Crawford's *Orpheus*: The American *Apollo Belvedere*." *American Art Journal* 19, no. 4 (1987), pp. 47–84.

Disturnell, John. *A Gazetteer of the State of New-York Comprising Its Topography, Geology, Mineralogical Resources, Civil Divisions, Canals, Railroads and Public Institutions, Together with General Statistics, the Whole Alphabetically Arranged: Also, Statistical Tables, Including the Census of 1840, and Tables of Distances, with a New Township Map of the State, Engraved on Steel*. Albany: J. Disturnell, 1842.

[Dix, John Ross]. *A Hand-book of Newport, and Rhode Island*. Newport: C. E. Hammett Jr., 1852.

Dorrill, Lisa K. "Illustrating the Ideal City: Nineteenth-Century American Bird's Eye Views." *Imprint* 18 (autumn 1993), pp. 21–31.

Douglas, Ed Polk. "The Belter Nobody Knows." *New York-Pennsylvania Collector*, October 1981, pp. 11–12, 14–16.

———. "The Furniture of John Henry Belter: Separating Fact from Fiction." *Antiques and Fine Art*, November–December 1990, pp. 112–19.

———. *Rococo Roses: A Series of Articles Describing the Nineteenth Century American Furniture in the Rococo Revival Style Produced by John Henry Belter, J. and J. W. Meeks, and Others*. Pittsford, New York: New York-Pennsylvania Collector [1980]. Reprints of Douglas's articles from *New York-Pennsylvania Collector*, January/February 1979–January/February 1980.

Downing, A[ndrew] J[ackson]. *The Architecture of Country Houses, Including Designs for Cottages, Farmhouses, and Villas, with Remarks on Interiors, Furniture, and the Best Modes of Warming and Ventilating*. New York: D. Appleton and Company, 1850. Reprint, with a new introduction by J. Stewart Johnson, New York: Dover Publications, 1969.

———. *Cottage Residences; or, A Series of Designs for Rural Cottages and Cottage Villas, and Their Gardens and Grounds Adapted to North America*. New York: Wiley and Putnam, 1842.

———. *Rural Essays*. Edited by George W. Curtis. New York: G. P. Putnam, 1853.

———. *A Treatise on the Theory and Practice of Landscape Gardening, Adapted to North America with a View to the Improvement of Country Residences. Comprising Historical Notices and General Principles of the Art, Directions for Laying Out Grounds and Arranging Plantations, the Description and Cultivation of Hardy Trees, Decorative Accompaniments to the House and Grounds, the Formation of Pieces of Artificial Water Flower Gardens, etc. with Remarks on Rural Architecture. . . .* New York and London: Wiley and Putnam; Boston: C. C. Little, 1841.

Dubrow, Eileen, and Richard Dubrow. *American Furniture of the 19th Century, 1840–1880*. Exton, Pennsylvania: Schiffer Publishing, 1983.

Duncan, Carol. *Civilizing Rituals: Inside Public Art Museums*. London: Routledge, 1995.

Dunlap, David W. *On Broadway: A Journey Uptown over Time*. New York: Rizzoli, 1990.

Dunlap, William. *Diary of William Dunlap, 1766–1839. . . .* Edited by Dorothy C. Barck. 3 vols. New York: New-York Historical Society, 1931.

———. *History of the Rise and Progress of the Arts of Design in the United States*. 2 vols. New York: George P. Scott, 1834.

———. *A History of the Rise and Progress of the Arts of Design in the United States*. New ed., edited by Frank W. Bayley and Charles E. Goodspeed. 3 vols. Boston: C. E. Goodspeed and Company, 1918.

Dupee, Frederick W., ed. *Henry James: Autobiography—A Small Boy and Others, Notes of a Son and Brother, The Middle Years*. Princeton: Princeton University Press, 1983.

Durand, Asher B. *Studies in Oil by Asher B. Durand, N. A., Deceased. Engravings by Durand, Raphael Morghen, Turner, W. Sharp, Bartolozzi, Wille, Strange, and Others, . . .* Executor's sale. New York: Ortgies' Art Gallery, 845 and 847 Broadway, April 13–14, 1887.

Durand, John. *The Life and Times of A. B. Durand*. New York: C. Scribner's Sons, 1894. Facsimile ed., New York: Kennedy Graphics, 1970.

[Dwight, Theodore] An American. *A Journal of a Tour in Italy, in the Year 1821*. New York: Printed by Abraham Paul, 1824.

[———]. *The Northern Traveller, Containing the Routes to Niagara, Quebec and the Springs; with Descriptions of the Principal Scenes, and Useful Hints to Strangers*. New York: Wilder and Campbell, 1825.

[———]. *The Northern Traveller, Containing the Routes to Niagara, Quebec and the Springs; with the Tour of New England and the Route to the Coal Mines of Pennsylvania*. 2d ed. New York: A. T. Goodrich, 1826.

[———]. *Sketches of Scenery and Manners in the United States*. New York: A. T. Goodrich, 1829.

———. *Things as They Are; or, Notes of a Traveller through Some of the Middle and Northern States*. New York: Harper and Brothers, 1834.

Dwight, Timothy. *Travels; in New-England and New-York*. 4 vols. New Haven: Timothy Dwight, 1821–22. Facsimile ed., edited by Barbara Miller Solomon, Cambridge, Massachusetts: Belknap Press of Harvard University Press, 1969.

Dyson, Robert H., Jr. "A Gift of Nimrud Sculptures." *Brooklyn Museum Bulletin* 18 (spring 1957), pp. 1–13.

Eastman, Samuel Coffin. *The White Mountain Guide Book*. Concord, New Hampshire: Edson C. Eastman, 1858.

[Eddy, Thomas]. *An Account of the State Prison or Penitentiary House, in the City of New-York; by One of the Inspectors of the Prison*. New York: Isaac Collins and Son, 1801.

Edward, James G. *The Newport Story*. Newport: Remington Ward, 1952.

Edwards, Clive D. *Victorian Furniture: Technology and Design*. Manchester: Manchester University Press, 1993.

Eliot, William H. *A Description of the Tremont House, with Architectural Illustrations*. Boston: Gray and Bowen, 1830.

Ellington, George, pseud. *The Women of New York; or, The Under-world of the Great City. . . .* New York: New York Book Company, 1869.

Elliott, Jock. *"A Ha! Christmas": An Exhibition of Jock Elliott's Christmas Books*. Exh. cat. New York: Grolier Club, 1999.

Ernst, Robert. *Immigrant Life in New York City, 1825–1863*. Ph.D. dissertation, Columbia University, New York, 1949. Reprint, New York: Octagon Books, 1979; Syracuse: Syracuse University Press, 1994.

Falconer, John M. *Catalogue of the Interesting and Valuable Collection of Oil Paintings, Water-Colors and Engravings Formed by the Late John M. Falconer*. Sale cat. New York: Anderson Auction Company, 1904.

Fales, Martha Gandy. *Early American Silver for the Cautious Collector*. New York: Funk and Wagnalls, 1970.

———. *Jewelry in America, 1600–1900*. Woodbridge, Suffolk: Antique Collectors' Club, 1995.

Farrar, Estelle Sinclair, and Jane Shadel Spillman. *The Complete Cut and Engraved Glass of Corning*. New York: Crown Publishers, 1979.

Faxon, Frederick W. *Literary Annuals and Gift Books: A Bibliography, 1823–1903*. Boston, 1912. Reprint, Middlesex, England: Private Libraries Association, 1973.

Fay, Theodore S. *Views of New York and Its Environs*. New York: Peabody and Company, 1831.

Fehl, Philipp. "John Trumbull and Robert Ball Hughes's Restoration of the Statue of Pitt the Elder." *New-York Historical Society Quarterly* 56 (January 1972), pp. 7–28.

Feifer, Maxine. *Going Places: The Ways of the Tourist from Imperial Rome to the Present Day*. London: Macmillan Company, 1985.

Fein, Albert, ed. *Landscape into Cityscape: Frederick Law Olmsted's Plans for a Greater New York City*. Ithaca, New York: Cornell University Press, 1968. Reprint, New York: Van Nostrand Reinhold Co., 1981.

Feller, John Quentin. *Dorflinger: America's Finest Glass, 1852–1921*. Marietta, Ohio: Antique Publications, 1988.

Felton, Mrs. *Life in America: A Narrative of Two Years' City and Country Residence in the United States*. Hull, Massachusetts: Printed by J. Hutchinson, 1838.

Fennimore, Donald L. "Elegant Patterns of Uncommon Good Taste: Domestic Silver by Thomas Fletcher and Sidney Gardiner." Master's thesis, University of Delaware Winterthur Program in Early American Culture, 1972.

———. "Gilding Practices and Processes in Nineteenth-Century American Furniture." In *Gilded Wood: Conservation and History*, pp. 139–51. Madison, Connecticut: Sound View Press, 1991.

———. *Silver and Pewter*. New York: Alfred A. Knopf, 1984.

———. "A Solid Gold Testimonial: An American Medal for Lafayette." *Antiques* 117 (February 1980), pp. 426–30.

Ferber, Linda S., and William H. Gerdts. *The New Path: Ruskin and the American Pre-Raphaelites*. Exh. cat. Brooklyn: Brooklyn Museum, 1985.

Fielding, Mantle. *American Engravers on Copper and Steel: Biographical Sketches and Check-Lists of Engravings. A Supplement to David McNeely Stauffer's American Engravings*. Philadelphia: Privately printed, 1917.

———. *Dictionary of American Painters, Sculptors and Engravers*. Philadelphia: Printed for the Subscribers, 1926.

Fink, Lois M. "French Art in the United States, 1850–1870: Three Dealers and Collectors." *Gazette des Beaux-Arts*, ser. 6, 92 (September 1978), pp. 87–100.

———. "The Role of France in American Art." Ph.D. dissertation, University of Chicago, 1970.

Finlay, Nancy. *Inventing the American Past: The Art of F. O. C. Darley*. Foreword by Roberta Waddell. Exh. cat. New York: New York Public Library, 1999.

Fisher, Sidney George. *A Philadelphia Perspective: The Diary of Sidney George Fisher Covering the Years, 1834–1871*. Edited by Nicholas B. Wainwright. Philadelphia: Historical Society of Pennsylvania, 1967.

Flick, Alexander C., ed. *The History of the State of New York*. 10 vols. New York: Columbia University Press, 1933–37.

Fontaine, Claude G. *Catalogue of Original Paintings. From Italian, Dutch, Flemish and French Masters of the Ancient and Modern Times, Selected by the Best Judges from Eminent Galleries in Europe and Intended for a Private Gallery in America*. Sale cat. New York, April 24, 1821.

Foresta, Merry A., and John Wood. *Secrets of the Dark Chamber: The Art of the American Daguerreotype*. Exh. cat. Washington, D.C.: National Museum of American Art, Smithsonian Institution, 1995.

Foshay, Ella M. *Mr. Luman Reed's Picture Gallery: A Pioneer Collection of American Art*. Introduction by Wayne Craven; catalogue by Timothy Anglin Burgard. New York: New-York Historical Society, 1990.

———. "Luman Reed, a New York Patron of American Art." *Antiques* 138 (November 1990), pp. 1074–85.

Foshay, Ella M., and Sally Mills. *All Seasons and Every Light: Nineteenth Century American Landscapes from the Collection of Elias Lyman Magoon*. Exh. cat. Poughkeepsie, New York: Vassar College Art Gallery, 1983.

Foster, George G. *New York by Gas-Light, and Other Urban Sketches*. Edited by Stuart M. Blumin. Berkeley: University of California Press, 1990.

———. *New York by Gas-Light, with Here and There a Streak of Sunshine*. New York: Dewitt and Davenport, 1850.

———. *New York in Slices: By an Experienced Carver; Being the Original Slices Published in the N.Y. Tribune*. New York: W. F. Burgess, 1849.

Fowble, E. McSherry. "Currier & Ives and the American Parlor." *Imprint* 15 (autumn 1990), pp. 14–19.

———. *Two Centuries of Prints in America, 1680–1880: A Selective Catalogue of the Winterthur Museum Collection*. Charlottesville: University Press of Virginia, 1987.

Fox, Charles Patrick. *Fashion: The Power That Influences the World.* 3d ed. New York: Sheldon and Company, 1872.

Fox, Louis H. *New York City Newspapers, 1820–1850: A Bibliography.* Papers of the Bibliographical Society of America, vol. 21, parts 1–2. Chicago, 1927.

Francis, John Wakefield. *Old New York; or, Reminiscences of the Past Sixty Years.* New York: W. J. Widdleton, 1866.

Francis's New Guide to the Cities of New-York and Brooklyn, and the Vicinity. New York: C. S. Francis and Company, 1853.

Frankenstein, Alfred. *William Sidney Mount.* New York: Harry N. Abrams, 1975.

Frederick Dorflinger Suydam, Christian Dorflinger: A Miracle in Glass. White Mills, Pennsylvania: Privately printed, 1950.

Freedberg, David. *The Power of Images: Studies in the History and Theory of Response.* Chicago: University of Chicago Press, 1989.

Frelinghuysen, Alice Cooney. *American Porcelain, 1770–1920.* Exh. cat. New York: The Metropolitan Museum of Art, 1989.

———. "Paris Porcelain in America." *Antiques* 153 (April 1998), pp. 554–63.

French, H. W. *Art and Artists in Connecticut.* Boston: Lee and Shepard, 1879. Reprint, New York: Kennedy Graphics, Da Capo Press, 1970.

Fries, Waldemar H. *The Double Elephant Folio: The Story of Audubon's Birds of America.* Chicago: American Library Association, 1973.

Frisch, Michael H., and David J. Walkowitz, eds. *Working Class America: Essays on Labor, Community, and American Society.* Urbana: University of Illinois Press, 1983.

Gale, Robert L. *Thomas Crawford: American Sculptor.* Pittsburgh: University of Pittsburgh Press, 1964.

Gallati, Barbara. *Asher B. Durand, an Engraver's and a Farmer's Art.* Exh. cat. Yonkers: Hudson River Museum, 1983.

Gallier, James. *Autobiography of James Gallier, Architect.* Paris: E. Briere, 1864. Reprint, New York: Da Capo Press, 1973.

Gardner, Albert TenEyck. *Yankee Stonecutters: The First American School of Sculpture, 1800–1850.* New York, Columbia University Press for The Metropolitan Museum of Art, 1945.

Garmey, Stephen. *Gramercy Park: An Illustrated History of a New York Neighborhood.* New York: Balsam Press, 1984.

Garrett, Elisabeth Donaghy. *At Home: The American Family, 1750–1870.* New York: Harry N. Abrams, 1990.

Gates, John D. *The Astor Family.* Garden City, New York: Doubleday and Company, 1981.

Gayle, Margot, and Carol Gayle. *Cast-Iron Architecture in America: The Significance of James Bogardus.* New York: W. W. Norton, 1998.

Gerdts, Abigail Booth, ed. *Catalogue of the Permanent Collection of Paintings and Sculpture of the National Academy of Design.* New York: Hudson Hills Press, forthcoming.

———. "Newly Discovered Records of the New-York Gallery of the Fine Arts." *Archives of American Art Journal* 21, no. 4 (1981), pp. 2–9.

Gerdts, William H. *American Neo-Classic Sculpture: The Marble Resurrection.* New York: Viking Press, 1973.

———. "Die Düsseldorf Gallery." In *Vice Versa: Deutsche Maler in Amerika, amerikanische Maler in Deutschland, 1813–1913,* edited by Katharina Bott and Gerhard Bott, pp. 44–61. Exh. cat. Berlin: Deutsches Historisches Museum; Munich: Hirmer, 1996.

Gere, Charlotte. "European Decorative Arts at the World's Fairs: 1850–1900." *Metropolitan Museum of Art Bulletin* 56 (winter 1998–99).

Gibson, Jane Mork. "The Fairmount Waterworks." *Philadelphia Museum of Art, Bulletin* 84 (summer 1988), pp. 2–11.

Gifford, Don, ed. *The Literature of American Architecture: The Evolution of Architectural Theory and Practice in Nineteenth-Century America.* New York: E. P. Dutton and Company, 1966.

Gifford Memorial Meeting of The Century . . . November 19th, 1880. New York: Century Rooms, 1880.

Gilfoyle, Timothy J. *City of Eros: New York City, Prostitution, and the Commercialization of Sex, 1790–1920.* New York: W. W. Norton, 1992.

Gillespie, William Mitchell. *Rome: As Seen by a New Yorker in 1843–4.* New York: Wiley and Putnam, 1845.

Gobright, J[ohn] C[hristopher]. *The Union Sketch-Book: A Reliable Guide, Exhibiting the History and Business Resources of the Leading Mercantile and Manufacturing Firms of New York. . . .* New York: Rudd and Carleton, 1861.

Godden, Geoffrey A. *Ridgway Porcelains.* 2d ed. Woodbridge, Suffolk: Antique Collectors' Club, 1985.

Godwin, Parke. *A Biography of William Cullen Bryant.* 2 vols. New York: Russell and Russell, 1883.

Goldstein, Malcolm. "Paff, Michael." In *American National Biography,* edited by John A. Garraty and Mark C. Carnes, vol. 16, pp. 895–96. New York: Oxford University Press, 1999.

[Goodrich, A. T.]. *The Picture of New-York, and Stranger's Guide to the Commercial Metropolis of the United States.* New York: A. T. Goodrich, 1828.

Goodrich, Charles Rush, ed. *Science and Mechanism: Illustrated by Examples in the New York Exhibition, 1853–54. Including Extended Descriptions of the Most Important Contribution in the Various Departments, with Annotations and Notes Relative to the Progress and Present Date of Applied Science, and the Useful Arts.* New York: G. P. Putnam, 1854.

Gordon, Carol Emily. "The Skidmore House: An Aspect of the Greek Revival in New York." Master's thesis, University of Delaware, Newark, 1978.

Gottesman, Rita S. "Early Commercial Art: Bella C. Landauer Collection in the New-York Historical Society." *Art in America* 43 (December 1955), pp. 34–42.

Grandfort, Marie Fontenay de. *The New World.* Translated by Edward C. Wharton. New Orleans: Sherman, Wharton and Company, 1855.

Gray, Nina. "Leon Marcotte: Cabinetmaker and Interior Decorator." In *American Furniture 1994,* edited by Luke Beckerdite, pp. 49–71. Hanover, New Hampshire: University Press of New England for the Chipstone Foundation, 1994.

The Great Metropolis; or, New York in 1845. . . . or, Guide to New-York for 1846. . . . or, Guide to New-York for 1847. . . . 3 annuals. New York: John Doggett Jr., 1844–46.

The Great Metropolis; or, New-York Almanac for 1850. . . . for 1851. . . . for 1852. 3 annuals. New York: H. Wilson, 1849; New York: H. Wilson and John F. Trow, 1850–51.

Greeley, Horace. *Art and Industry as Represented in the Exhibition at the Crystal Palace New York—1853–4, Showing the Progress and State of the Various Useful and Esthetic Pursuits.* New York: Redfield, 1853.

Greene, Asa. *A Glance at New York: Embracing the City Government, Theatres, Hotels, Churches, Mobs, Monopolies, Learned Professions, Newspapers, Rogues, Dandies, Fires and Firemen, Water and Other Liquids, &c., &c.* New York: A. Greene, Craighead and Allen, printers, 1837.

Greene, John C. *American Science in the Age of Jefferson.* Ames: Iowa State University Press, 1984.

Greenthal, Kathryn, Paula M. Kozol, and Jan Seidler Ramirez. *American Figurative Sculpture in the Museum of Fine Arts.* Boston: Museum of Fine Arts, 1986.

Grier, Katherine C. *Culture and Comfort: People, Parlors, and Upholstery, 1850–1930.* Exh. cat. Rochester, New York: Strong Museum; Amherst, Massachusetts: University of Massachusetts Press, 1988.

Groce, George C., and David H. Wallace. *The New-York Historical Society's Dictionary of Artists in America, 1564–1860.* New Haven: Yale University Press, 1975.

Groce, Nancy. *Musical Instrument Makers of New York: A Directory of Eighteenth- and Nineteenth-Century Urban Craftsmen.* Stuyvesant, New York: Pendragon Press, 1991.

Groft, Tammis K., and Mary Alice Mackay, eds. *Albany Institute of History and Art: 200 Years of Collecting.* New York: Hudson Hills Press, in association with Albany Institute of History and Art, 1998.

Gross, Sally Lorensen. *Toward an Urban View: The Nineteenth-Century American City in Prints.* Exh. cat. New Haven: Yale University Art Gallery, 1989.

Grossman, Cissy. *A Temple Treasury: The Judaica Collection of Congregation Emanu-El of the City of New York.* New York: Hudson Hills Press, 1989.

Gruber, Alain. *Silver.* New York: Rizzoli International Publications, 1982.

Grund, Francis J. *Aristocracy in America from the Sketch-Book of a German Nobleman.* 2 vols. London: Richard Bentley, 1839.

Guffey, Karen A. "From Paper Stainer to Manufacturer: J. F. Bumstead & Co., Manufacturers and Importers of Paper Hangings." In *Wallpaper*

in New England, by Richard Nylander et al., pp. 29–37. Boston: Society for the Preservation of New England Antiquities, 1986.

A Guide to the Central Park. With a Map of the Proposed Improvements. By an Officer of the Park. New York: A. O. Moore and Company, 1859.

Guillebon, Régine de Plinval de. *Paris Porcelain, 1770–1850*. Translated by Robin R. Charleston. London: Barrie and Jenkins, 1972.

Guzik, Estelle M., ed. *Genealogical Resources in the New York Metropolitan Area.* New York: Jewish Genealogical Society, 1989.

Hales, Peter B. *Silver Cities: The Photography of American Urbanization, 1839–1915.* Philadelphia: Temple University Press, 1984.

Hall, John. *The Cabinet Makers' Assistant: Embracing the Most Modern Style of Cabinet Furniture.* Baltimore: John Murphy, 1840.

Hall, Margaret Hunter. *The Aristocratic Journey: Being the Outspoken Letters of Mrs. Basil Hall Written During a Fourteen Months' Sojourn in America, 1827–1828.* Edited by Una Pope-Hennessey. New York: G. P. Putnam and Co., 1931.

Halsey, R. T. Haines. *Pictures of Early New York on Dark Blue Staffordshire Pottery, Together with Pictures of Boston and New England, Philadelphia, the South and West.* New York: Dodd, Mead and Company, 1899.

Halttunen, Karen. *Confidence Men and Painted Women: A Study of Middle-Class Culture in America, 1830–1870.* New Haven: Yale University Press, 1982.

Hamilton, Sinclair. *Early American Book Illustrators and Wood Engravers, 1670–1870.* 2 vols. Princeton: Princeton University Press, 1968.

[Hamilton, Thomas]. *Men and Manners in America.* 2 vols. Edinburgh: William Blackwood; Philadelphia: Carey, Lea, and Blanchard, 1833. Reprint, New York: Augustus M. Kelley, 1968.

Hamlin, Talbot. *Greek Revival Architecture in America: Being an Account of Important Trends in American Architecture and American Life Prior to the War between the States.* London: Oxford, 1944. Reprint, New York: Dover Publications, 1964.

Harris, Neil. *The Artist in American Society: The Formative Years, 1790–1860.* New York: Braziller, 1966. Reprint, New York: Clarion Books, 1970.

———. *Humbug: The Art of P. T. Barnum.* Boston: Little, Brown and Company, 1973.

Hart, Charles. "Lithography, Its Theory and Practice. Including a Series of Short Sketches of the Earliest Lithographic Artists, Engravers, and Printers of New York." New York: Charles Hart, 1902. Manuscript Division, New York Public Library.

Hartog, Hendrik. *Public Property and Private Power: The Corporation of the City of New York in American Law, 1730–1870.* Chapel Hill: University of North Carolina Press, 1983.

Haskell, Daniel C., ed. *Manhattan Maps: A Co-operative List.* New York: New York Public Library, 1931.

Haswell, Charles H. *Reminiscences of an Octogenarian of the City of New York (1816 to 1860).* New York: Harper and Brothers, 1896.

Hawley, Henry. "American Furniture of the Mid-Nineteenth Century." *Bulletin of the Cleveland Museum of Art* 74 (May 1987), pp. 186–215.

Hazen, Edward. *The Panorama of Professions and Trades; or, Every Man's Book Embellished with Eighty-Two Engravings.* Philadelphia: Uriah Hunt, 1836.

Hennessy, Thomas F. *Locks and Lockmakers of America.* 3d ed. Park Ridge, Illinois: Locksmith Publishing Company, 1997.

Henrywood, R. K. *Relief-Moulded Jugs, 1820–1900.* Woodbridge, Suffolk: Antique Collectors' Club, 1984.

Heydt, George F. *Charles L. Tiffany and the House of Tiffany & Co.* New York: Tiffany and Company, 1893.

Hills, Patricia. "The American Art-Union as Patron for Expansionist Ideology in the 1840s." In *Art in Bourgeois Society, 1790–1850*, edited by Andrew Hemingway and William Vaughan, pp. 314–39. Cambridge: Cambridge University Press, 1998.

Himmelheber, Georg. *Deutsche Möbelvorlagen, 1800–1900: Ein Bilderlexikon der gedruckten Entwürfe und Vorlagen im deutschen Sprachgebiet.* Munich: Verlag C. H. Beck, 1988.

Hindle, Brooke. *The Pursuit of Science in Revolutionary America, 1735–1789.* Chapel Hill: University of North Carolina Press, 1956.

———. *Technology in Early America: Needs and Opportunities for Study.* Chapel Hill: University of North Carolina Press, 1966.

Hindle, Brooke, and Steven Lubar. *Engines of Change: The American Industrial Revolution, 1790–1860.* Washington, D.C.: Smithsonian Institution Press, 1986.

History of Architecture and the Building Trade of Greater New York. 2 vols. New York: Union History Company, 1899.

The History of Lord & Taylor. New York: Lord and Taylor, 1926.

Hitchcock, J. R. W. *Etching in America.* New York: White, Stokes, and Allen, 1886.

Hobbes, Clara M. "New York Produced Cut Glass." *New York Sun*, April 1, 1933.

Homberger, Eric. *The Historical Atlas of New York City: A Visual Celebration of Nearly 400 Years of New York City's History.* New York: Henry Holt and Company, 1994.

Hone, Philip. *The Diary of Philip Hone, 1828–1851.* Edited by Allan Nevins. 2 vols. New York: Dodd, Mead and Company, 1927.

———. *The Diary of Philip Hone, 1828–1851.* Edited by Bayard Tuckerman. New York: Dodd, Mead and Company, 1889.

Honour, Hugh. *The European Vision of America.* Exh. cat. Cleveland: Cleveland Museum of Art, 1975.

Hood, Graham. *American Silver.* New York: Praeger Publishers, 1971.

Hope, Thomas. *Household Furniture and Interior Decoration.* London: Longman, Hurst, Rees, and Orme, 1807. Reprinted as *Regency Furniture and Interior Decoration*, with a new introduction by David Watkin, New York: Dover Publications, 1971.

Hosack, David. *Memoir of De Witt Clinton.* New York: J. Seymour, 1829.

Hough, Franklin B., ed. *Census of the State of New York for 1855 Taken in Pursuance of Article Third of the Constitution of the State, and of Chapter Sixty-Four of the Laws of 1855.* Albany: Printed by C. Van Benthuysen, 1857.

Hounshell, David. *From the American System to Mass Production, 1800–1932: The Development of Manufacturing Technology in the United States.* Baltimore: Johns Hopkins University Press, 1984.

Hovey, Charles Mason. *The Fruits of America, Containing Richly Colored Figures and Full Descriptions of All the Choicest Varieties Cultivated in the United States.* 3 vols. Boston: C. C. Little and J. Brown, and Hovey and Company; New York: D. Appleton and Company, 1852–56.

Howat, John K., ed. *American Paradise: The World of the Hudson River School.* Exh. cat. New York: The Metropolitan Museum of Art, 1987.

———. "Washington Crossing the Delaware." *Metropolitan Museum of Art Bulletin* 26 (March 1968), pp. 289–99.

Howe, Julia Ward. *Reminiscences, 1819–1899.* Boston and New York: Houghton Mifflin and Company, 1899.

Howe, Katherine S., Alice Cooney Frelinghuysen, and Catherine Hoover Voorsanger, et al. *Herter Brothers: Furniture and Interiors for a Gilded Age.* Exh. cat. New York: Harry N. Abrams, in association with the Museum of Fine Arts, Houston, 1994.

Howe, Katherine S., and David B. Warren. *The Gothic Revival Style in America, 1830–1870.* Exh. cat. Houston: Museum of Fine Arts, 1976.

Howe, Winifred E. *A History of The Metropolitan Museum of Art.* New York: The Metropolitan Museum of Art, 1913.

How to See the New York Crystal Palace: Being a Concise Guide to the Principal Objects in the Exhibition as Remodelled, 1854. Part First. General View,—Sculpture,—Paintings. New York: G. P. Putnam and Company, 1854.

Hugins, Walter. *Jacksonian Democracy and the Working Class: A Study of the New York Workingmen's Movement, 1829–1837.* Stanford: Stanford University Press, 1960.

Hull, Judith Salisbury. "Richard Upjohn: Professional Practice and Domestic Architecture." Ph.D. dissertation, Columbia University, New York, 1987.

Humboldt, Alexander von. *Cosmos: A Sketch of a Physical Description of the Universe.* 5 vols. Translated by E. C. Otté. London: H. G. Bohn, 1849–58.

Humboldt, Alexander von, and Aimé Bonpland. *Personal Narrative of Travels to the Equinoctial Regions of America, during the Years 1799–1804.* 3 vols. Translated and edited by Thomasina Ross. London: H. G. Bohn, 1852–53.

Huxtable, Ada Louise. *Classic New York: Georgian Gentility to Greek Elegance.* Garden City, New York: Doubleday, 1964.

Hyde, Ralph. *Panoramania! The Art and Entertainment of the 'All-Embracing' View.* London: Barbican Art Gallery and Trefoil Publications, 1988.

Hyman, Linda. "From Artisan to Artist: John Frazee and the Politics of Culture in Antebellum America." Ph.D. dissertation, City University of New York, 1978.

———. "*The Greek Slave* by Hiram Powers: High Art as Popular Culture." *Art Journal* 35 (spring 1976), pp. 216–23.

Idzerda, Stanley J., Anne C. Loveland, and Marc H. Miller. *Lafayette, Hero of Two Worlds: The Art and Pageantry of His Farewell Tour of America, 1824–1825: Essays.* Flushing, New York: Queens Museum, 1989.

An Index to the Illustrations in the Manuals of the Corporation of the City of New York, 1841–1870. Introduction by William Loring Andrews. New York: Society of Iconophiles, 1906.

Ingerman, Elizabeth A. "Personal Experiences of an Old New York Cabinet-Maker." *Antiques* 84 (November 1963), pp. 576–80.

International Art Union. *Prospectus.* New York: Printed by Oliver and Brother, 1849.

Irving, Pierre M. *The Life and Letters of Washington Irving.* 2 vols. New York: G. P. Putnam, 1862.

Irving, Washington. *History, Tales and Sketches: Letters of Jonathan Oldstyle, Gent.; Salmagundi; . . . A History of New-York; . . . The Sketch Book of Geoffrey Crayon, Gent.* Edited by James W. Tuttleton. New York: Library of America, 1983.

———. *Journals and Notebooks, 1819–1827.* Edited by Walter A. Reichart. Vol. 3 of *Complete Works of Washington Irving,* edited by Henry A. Pochmann. 5 vols. Madison: University of Wisconsin Press, 1970.

———. *Journals of Washington Irving. From July 1815 to July 1842.* Edited by William P. Trent and George S. Hellman. 3 vols. Boston: Bibliophile Society, 1919.

———. *Life of George Washington.* 5 vols. New York: G. P. Putnam, 1857–59.

———. *The Works of Washington Irving.* New ed., revised. 15 vols. New York: G. P. Putnam, 1854–55.

Jackson, Joseph. "Bass Otis, America's First Lithographer." *Pennsylvania Magazine of History and Biography* 37 (1913), pp. 385–94.

Jackson, Kenneth T., ed. *The Encyclopedia of New York City.* New Haven: Yale University Press; New York: New-York Historical Society, 1995.

Jackson, Kenneth T., and Stanley K. Schultz, eds. *Cities in American History.* New York: Alfred A. Knopf, 1972.

Jaffe, Irma B. *John Trumbull: Patriot-Artist of the American Revolution.* Boston: New York Graphic Society, 1975.

James, Henry. *A Small Boy and Others.* London: Macmillan Company, 1913.

Jarves, Deming. *Reminiscences of Glass-making.* 2d ed. New York: Hurd and Houghton, 1865.

Jarves, James Jackson. *The Art-Idea: Sculpture, Painting, and Architecture in America.* New York: Hurd and Houghton, 1864. Reprint, edited by Benjamin Rowland Jr., Cambridge, Massachusetts: Belknap Press of Harvard University Press, 1960.

———. *Italian Sights and Papal Principles, Seen through American Spectacles.* New York: Harper and Brothers, 1856.

Jefferys, C. P. B. *Newport: A Short History.* Newport: Newport Historical Society, 1992.

Jervis, Simon. *High Victorian Design.* Exh. cat. Ottawa: National Gallery of Canada, 1974.

Johns, Elizabeth. *American Genre Painting: The Politics of Everyday Life.* New Haven: Yale University Press, 1991.

Johnson, Deborah J. *William Sidney Mount: Painter of American Life.* Essays by Elizabeth Johns, Deborah J. Johnson, Franklin Kelly, and Bernard F. Reilly Jr. Exh. cat. New York: American Federation of Arts, 1998.

Johnson, Paul. *The Birth of the Modern: World Society 1815–1830.* New York: Harper Collins, 1991.

Johnston, Phillip M. "Dialogues between Designer and Client: Furnishings Proposed by Leon Marcotte to Samuel Colt in the 1850s." *Winterthur Portfolio* 19 (winter 1984), pp. 257–75.

Jones, A[bner] D[umont]. *The Illustrated American Biography, Containing Correct Portraits and Brief Notices of the Principal Actors in American History; Embracing Distinguished Women, Naval and Military Heroes, Statesmen, Civilians, Jurists, Divines, Authors and Artists; Together with Celebrated Indian Chiefs. . . .* 3 vols. New York: J. M. Emerson and Company, 1853–55.

Judd, Sylvester. *Margaret: A Tale of the Real and Ideal, Blight and Bloom, Including Sketches of a Place Not before Described, Called Mons Christi.* Boston: Jordan and Wiley, 1845.

Jullian, Philippe. *Le style Second Empire.* Paris: Bachet et Cie, n.d.

Kane, Elisha Kent. *Arctic Explorations: The Second Grinnell Expedition in Search of Sir John Franklin, 1853, '54, '55.* 2 vols. Philadelphia: Childs and Peterson, 1856. New ed., London: T. Nelson and Sons, 1861.

Kaplan, Justin. *Walt Whitman: A Life.* New York: Simon and Schuster, 1980.

Kasson, John F. *Rudeness and Civility: Manners in Nineteenth-Century Urban America.* New York: Hill and Wang, 1990.

Kasson, Joy S. *Marble Queens and Captives: Women in Nineteenth-Century American Sculpture.* New Haven: Yale University Press, 1990.

Keckley, Elizabeth. *Behind the Scenes: Formerly a Slave, but More Recently Modiste, and Friend to Mrs. Lincoln; or, Thirty Years a Slave and Four Years in the White House.* New York: G. W. Carleton and Company, 1868.

Kelly, Franklin, et al. *Frederic Edwin Church.* Exh. cat. Washington, D.C.: National Gallery of Art, 1989.

Kendall, Isaac C. *The Growth of New York.* New York: G. W. Wood, 1865.

Kent, Douglas R. "History in Houses: Hyde Hall, Otsego County, New York." *Antiques* 92 (August 1967), pp. 187–93.

von Khrum, Paul. *Silversmiths of New York City, 1684–1850.* New York: Von Khrum, 1978.

Kidwell, Claudia, and Margaret C. Christman. *Suiting Everyone: The Democratization of Clothing in America.* Washington, D.C.: National Museum of History and Technology, Smithsonian Institution, 1974.

King, Charles. *A Memoir of the Construction, Cost, and Capacity of the Croton Aqueduct, Compiled from Official Documents; Together with an Account of the Civic Celebration of the Fourteenth October, 1842, on Occasion of the Completion of the Great Work. . . .* New York, 1843.

King, Thomas. *The Modern Style of Cabinet Work Exemplified.* 1829; 2d ed., 1835; expanded 2d ed., London: H. G. Bohn, 1862. Reprinted as *Neo-Classical Furniture Designs,* with a new introduction by Thomas Gordon Smith, New York: Dover Publications, 1995.

King, Thomas Starr. *The White Hills; Their Legends, Landscape and Poetry.* Boston: Isaac N. Andrews, 1859.

Klapthor, Margaret Brown. *Official White House China, 1789 to the Present.* Washington, D.C.: Smithsonian Institution Press, 1975.

Klein, Rachel. "Art and Authority in Antebellum New York City: The Rise and Fall of the American Art-Union." *Journal of American History* 81 (March 1995), pp. 1534–61.

Klinkowström, Baron Axel. *Baron Klinkowström's America, 1818–1820.* Edited by Franklin D. Scott. Evanston, Illinois: Northwestern University Press, 1952.

Klumpke, Anna. *Rosa Bonheur.* Ann Arbor: University of Michigan Press, 1997.

Knapp, Samuel L. *The Life of Thomas Eddy; Comprising an Extensive Correspondence with Many of the Most Distinguished Philosophers and Philanthropists of This and Other Countries.* New York: Conner and Cooke, 1834.

Koke, Richard J. *American Landscape and Genre Paintings in the New-York Historical Society: A Catalogue of the Collection, Including Historical, Narrative, and Marine Art.* 3 vols. New York: New-York Historical Society, 1982.

———. *A Checklist of the American Engravings of John Hill (1770–1850).* New York: New-York Historical Society, 1961.

———. "John Hill, Master of Aquatint, 1770–1850." *New-York Historical Society Quarterly* 43 (January 1959), pp. 51–117.

Kouwenhoven, John A. *The Columbia Historical Portrait of New York: An Essay in Graphic History in Honor of the Tricentennial of New York City and the Bicentennial of Columbia University.* Garden City, New York: Doubleday, 1953.

Kramer, Ellen W. "The Architecture of Detlef Lienau, A Conservative Victorian." Ph.D. dissertation, New York University, 1958.

———. "Contemporary Descriptions of New York City and Its Public Architecture ca. 1850." *Journal of the Society of Architectural Historians* 27 (December 1968), pp. 264–80.

Lafever, Minard. *The Beauties of Modern Architecture Illustrated by Forty-eight Original Plates Designed Expressly for This Work.* New York: D. Appleton, 1835.

———. *Modern Builders' Guide.* New York: Henry C. Sleight, Collins and Hannay, 1833.

———. *The Young Builder's General Instructor Containing the Five Orders of Architecture, Selected from the Best Specimens of the Greek and Roman . . . and a Variety of Mouldings, and Fancy Pilasters, Square and Circle Head Front Doors . . . etc., the Whole Exemplified on Sixty-Six Elegant Copper-Plate Engravings.* Newark, New Jersey: W. Tuttle, 1829.

Lafont-Couturier, Hélène. "'Le bon livre'"; ou, La portée éducative des images éditées et publiées par la maison Goupil." In *État des lieux.* Bordeaux: Musée Goupil, 1994.

Lakier, Alexandr Borisovich. *A Russian Looks at America.* Translated from the 1857 Russian edition. Edited by Arnold Schrier and Joyce Story. Chicago: University of Chicago Press, 1979.

Landau, Sarah Bradford. *P. B. Wight—Architect, Contractor, and Critic, 1838–1925.* Exh. cat. Chicago: Art Institute of Chicago, 1981.

Landau, Sarah Bradford, and Carl W. Condit. *Rise of the New York Skyscraper, 1865–1913.* New Haven: Yale University Press, 1996.

Landy, Jacob. *The Architecture of Minard Lafever.* New York: Columbia University Press, 1970.

———. "The Washington Monument Project in New York." *Journal of the Society of Architectural Historians* 28 (December 1969), pp. 291–97.

Lankton, Larry D. *The "Practicable" Engineer: John B. Jervis and the Old Croton Aqueduct.* Chicago: Public Works Historical Society, 1977.

Lanman, Charles. *Haphazard Personalities; Chiefly of Noted Americans.* New York: Charles T. Dillingham, 1886.

Larkin, Jack. *The Reshaping of Everyday Life, 1790–1840.* New York: Harper and Row, 1988.

Launitz, R. E. *Collection of Monuments and Head Stones, Designed by R. E. Launitz.* New York: L. Prang and Company, 1866.

Laurie, Bruce. *Artisans into Workers: Labor in Nineteenth-Century America.* New York: Hill and Wang, 1989.

Lawrence, Vera Brodsky. *Repercussions, 1857–1862.* Strong on Music, vol. 3. Chicago: University of Chicago Press, 1999.

———. *Strong on Music: The New York Music Scene in the Days of George Templeton Strong, 1836–1875.* New York: Oxford University Press, 1988.

Ledoux-Lebard, Denise. *Le mobilier français du XIXᵉ siècle, 1795–1889: Dictionnaire des ébénistes et des menuisiers.* Paris: Les Éditions de l'Amateur, 1989.

[Lee, Hannah Farnham]. *Familiar Sketches of Sculpture and Sculptors.* 2 vols. Boston: Crosby, Nichols, and Company, 1854.

Lee, James. *The Equestrian Statue of Washington.* New York: John F. Trow, Printer, 1864.

Lehmann-Haupt, Hellmut, ed. *Bookbinding in America: Three Essays. . . .* Portland, Maine: Southworth-Athoensen Press, 1941. Reprint, New York: R. R. Bowker, 1967.

Leris-Laffargue, Janine. *Restauration / Louis Philippe.* Le mobilier français. Paris: Éditions Massin, 1994.

Lester, Charles Edwards. *The Gallery of Illustrious Americans, Containing the Portraits and Bio-graphical Sketches of Twenty-four of the Most Eminent Citizens of the American Republic, since the Death of Washington.* New York: Mathew B. Brady, Francis D'Avignon, C. E. Lester, 1850.

———, ed. *Glances at the Metropolis.* New York: Isaac D. Guyer, 1854.

Levasseur, Auguste. *Lafayette in America in 1824 and 1825; or, Journal of a Voyage to the United States.* Translated by John Godman. 2 vols. Philadelphia: Carey and Lea, 1829.

Levine, Lawrence W. *Highbrow/Lowbrow: The Emergence of Cultural Hierarchy in America.* Cambridge, Massachusetts: Harvard University Press, 1988.

Libin, Laurence. *American Musical Instruments.* New York: The Metropolitan Museum of Art and W. W. Norton Company, 1985.

———. "Keyboard Instruments." *Metropolitan Museum of Art Bulletin* 47 (summer 1989), pp. 1–56.

Licht, Walter. *Industrializing America: The Nineteenth Century.* Baltimore: Johns Hopkins University Press, 1995.

Liedtke, Walter. *Flemish Paintings in America.* Antwerp: Fonds Mercator, 1992.

Lockwood, Charles. *Bricks and Brownstone: The New York Row House, 1783–1929, an Architectural and Social History.* New York: McGraw-Hill, 1972.

———. *Manhattan Moves Uptown: An Illustrated History.* Boston: Houghton Mifflin Company, 1976.

Long, Eleanor Julian Stanley. *Twenty Years at Court, from the Correspondence of the Hon. "Eleanor Stanley, Maid of Honour to Her Late Majesty Queen Victoria, 1842–1862.* London: Nisbeet and Company, 1916.

Longacre, James Barton, and James Herring. *National Portrait Gallery of Distinguished Americans.* 4 vols. Philadelphia: Rice, Rutter, 1834–39.

Lossing, Benson J. *History of New York City.* 2 vols. New York: A. S. Barnes, 1884.

Loudon, J[ohn] C[laudius]. *An Encyclopaedia of Cottage, Farm, and Villa Architecture and Furniture: Containing Numerous Designs for Dwellings . . . Each Design Accompanied by Analytical and Critical Remarks. . . .* London: Longman, Rees, Orme, Brown, Green, and Longmans, 1833. New edition, London: Longman, Brown, Green, and Longmans, 1842.

———. *Loudon Furniture Designs: From the Encyclopaedia of Cottage, Farmhouse and Villa Architecture and Furniture, 1839.* Introduction by Christopher Gilbert. [Yorkshire, England]: S. R. Publishers and *The Connoisseur,* 1970.

Lowenstrom, C. *New-York Pictorial Business Directory of Wall Street.* New York: C. Lowenstrom, 1850.

Ludlow, E. H. *Inventory of Paintings, Statuary, Medals, &c. &c., the Property of the Late Philip Hone . . . Wednesday, April 28, 1852.* Sale cat. New York: P. Miller and Son, 1852.

Lunt, Peter. "Psychological Approaches to Consumption: Varieties of Research—Past, Present and Future." In *Acknowledging Consumption: A Review of New Studies,* edited by Daniel Miller. London: Routledge, 1994.

Lynn, Catherine. *Wallpaper in America: From the Seventeenth Century to World War I.* New York: W. W. Norton and Company, 1980.

Maas, Jeremy. *Gambart: Prince of the Victorian Art World.* London: Barrie and Jenkins, 1975.

Mackay, Alexander. *The Western World; or, Travels in the United States in 1846–47: Exhibiting Them in Their Latest Development, Social, Political, and Industrial; Including a Chapter on California.* 2d ed. 3 vols. London: R. Bentley, 1849.

Making the American Home: Middle-Class Women and Domestic Material Culture, 1840–1940. Edited by Marilyn Ferris Motz and Pat Browne. Bowling Green, Ohio: Bowling Green State University Popular Press, 1988.

Mallach, Stanley. "Gothic Furniture Designs by Alexander Jackson Davis." Master's thesis, University of Delaware, Newark, 1966.

Mann, Maybelle. *The American Art-Union.* Exh. cat. Otisville, New York: ALM Associates, 1977; rev. ed., [Jupiter, Florida]: ALM Associates, 1987.

———. "The Arts in Banknote Engraving, 1836–1864." *Imprint* 4 (April 1979), pp. 29–36.

Manufactures of the United States in 1860; Compiled from the Original Returns of the Eighth Census. Washington, D.C.: Government Printing Office, 1865.

Mapleson, Thomas W. Gwilt, illuminator. *Lays of the Western World.* New York: Putnam, [1848].

———. *The Songs and Ballads of Shakespeare.* New York: Lockwood, 1849.

The Marble-Workers' Manual, Designed for the Use of Marble-Workers, Builders, and Owners of Houses. New York: Sheldon, Blakeman, 1856; Philadelphia: Henry Carey Baird, 1871.

Marcuse, Peter. "The Grid as City Plan: New York City and Laissez-Faire Planning in the Nineteenth Century." *Planning Perspectives* 2 (September 1987), pp. 287–310.

Marshall, Gordon M. "The Golden Age of Illustrated Biographies." In *American Portrait Prints: Proceedings of the Tenth Annual American Print Conference,* edited by Wendy Wick Reaves, pp. 29–82. Charlottesville: University Press of Virginia, for the National Portrait Gallery, Smithsonian Institution, 1984.

Martin, Edgar W. *The Standard of Living in 1860: American Consumption Levels on the Eve of the Civil War.* Chicago: University of Chicago Press, 1942.

Martineau, Harriet. *Retrospect of Western Travel.* 3 vols. London: Saunders and Otley; New York: Harper and Brothers, 1838. Reprint, with a new introduction by Daniel Feller, Armonk, New York: M. E. Sharpe, 2000.

Marzio, Peter C. "Chromolithography as a Popular Art and an Advertising Medium: A Look at Strobridge and Company of Cincinnati." In *Prints of the American West: Papers Presented at the Ninth Annual North American Print*

Conference, edited by Ron Tyler. Fort Worth: Amon Carter Museum, 1983.

———. *The Democratic Art, Chromolithography, 1840–1900: Pictures for a 19th-Century America*. Boston: David Godine, 1979.

———. "Mr. Audubon and Mr. Bien: An Early Phase in the History of American Chromolithography." *Prospects*, 1975, pp. 138–54.

Mason, George C. *Newport Illustrated in a Series of Pen and Pencil Sketches*. Newport: C. E. Hammett Jr., 1854.

Maury, Sarah Mytton. *An Englishwoman in America*. London: Thomas Richardson and Son, 1848.

Mayhew, Edgar, and Minor Myers Jr. *A Documentary History of American Interiors: From the Colonial Era to 1915*. New York: Charles Scribner's Sons, 1980.

McAdam, David, Hon., et al., eds. *History of the Bench and Bar of New York*. 2 vols. New York: New York History Company, 1897–99.

McClelland, Nancy. *Duncan Phyfe and the English Regency, 1795–1830*. New York: William R. Scott, 1939. Reprint, New York, Dover Publications, 1980.

McCormick, Heather Jane. "Ernst Plassman, 1822–1877: A New York Carver, Sculptor, Designer and Teacher." Master's thesis, Bard Graduate Center for Studies in the Decorative Arts, 1998.

McGrath, Daniel Francis. "American Colorplate Books, 1800–1900." Ph.D. dissertation, University of Michigan, Ann Arbor, 1966.

McInnis, Maurie D., and Robert A. Leath. "Beautiful Specimens and Elegant Patterns: New York Furniture for the Charleston Market, 1810–1840." In *American Furniture 1996*, edited by Luke Beckerdite, pp. 137–74. Hanover, New Hampshire: University Press of New England for the Chipstone Foundation, 1996.

McKay, Ernest. *The Civil War and New York City*. Syracuse: Syracuse University Press, 1990.

McKearin, George S., and Helen McKearin. *American Glass*. New York: Crown Publishers, 1941.

McKearin, Helen, and George S. McKearin. *Two Hundred Years of American Blown Glass*. New York: Bonanza Books, 1950.

McKendrick, Neil. "Josiah Wedgwood and the Commercialization of the Potteries." In *The Birth of a Consumer Society: The Commercialization of Eighteenth-Century England*, by Neil McKendrick, John Brewer, and J. H. Plumb, pp. 108–12. Bloomington: Indiana University Press, 1982.

McNulty, J. Bard, ed. *The Correspondence of Thomas Cole and Daniel Wadsworth: Letters in the Watkinson Library, Trinity College, Hartford, and in the New York State Library, Albany, New York*. Hartford: Connecticut Historical Society, 1983.

Meier, Henry. "The Origin of the Printing and Roller Press." *Print Collector's Quarterly* 28 (1941), pp. 9–55.

Mercantile Library Association. *The Twenty-third Annual Report of the Board of Directors of the Mercantile Library Association, Clinton Hall, New York, January, 1844*. New York: Printed by George W. Wood, 1844.

Merritt, Jennifer M. "'Communion Plate of the Most Approved and Varied Patterns, in True Ecclesiastical Style': Francis W. Cooper, Silversmith for the New York Ecclesiological Society, 1851 to 1855." Master's thesis, University of Delaware, Newark, 1997.

Meschutt, David. *A Bold Experiment: John Henri Isaac Browere's Life Masks of Prominent Americans*. Cooperstown: New York State Historical Association, 1988.

———. "'A Perfect Likeness': John H. I. Browere's Life Mask of Thomas Jefferson." *American Art Journal* 21, no. 4 (1989), pp. 4–25.

Mesick, Jane Louise. *The English Traveller in America, 1785–1835*. New York: Columbia University Press, 1922. Reprint, Westport, Connecticut: Greenwood Press, 1970.

Metropolitan Museum of Art. *19th-Century America*. Vol. 1, *Furniture and Other Decorative Arts*, by Marilynn Johnson, Marvin D. Schwartz, and Suzanne Boorsch. Vol. 2, *Paintings and Sculpture*, by John K. Howat and Natalie Spassky, et al. Exh. cat. New York: The Metropolitan Museum of Art, 1970.

Milbert, Jacques-Gérard. *Itinéraire pittoresque du fleuve Hudson et des parties latérales de l'Amérique du Nord, d'après les dessins originaux pris sur les lieux*. 3 vols. Paris: H. Gaugain et Cie, 1828–29.

Miller, Agnes. "Centenary of a New York Statue." *New York History* 38 (April 1957), pp. 167–76.

Miller, Angela. *The Empire of the Eye: Landscape Representation and American Cultural Politics, 1825–1875*. Ithaca, New York: Cornell University Press, 1993.

Miller, George L., Ann Smart Martin, and Nancy S. Dickinson. "Changing Consumption Patterns: English Ceramics and the American Market from 1780 to 1840." In *Everyday Life in the Early Republic: 1789–1828*, edited by Catherine E. Hutchins, pp. 219–48. Winterthur, Delaware: Henry Francis du Pont Winterthur Museum, 1994.

Miller, Lillian B. *Patrons and Patriotism: The Encouragement of the Fine Arts in the United States, 1790–1860*. Chicago: University of Chicago Press, 1982.

Minutes of the Common Council of the City of New York, 1784–1831. 19 vols. New York: City of New York [M. B. Brown Printing and Binding Company], 1917.

Moebs, Thomas Truxtun. *U.S. Reference-iana: 1481–1899. . . .* Williamsburg: Moebs Publishing Company, 1989.

Moehring, Eugene P. "Public Works and Patterns of Real Estate Growth in Manhattan, 1835–1894." Ph.D. dissertation, City University of New York, 1976.

———. "Space, Economic Growth, and the Public Works Revolution in New York." In *Infrastructure and Urban Growth in the Nineteenth Century*. Chicago: Public Works Historical Society, 1985.

Mollenkopf, John Hull, ed. *Power, Culture, and Place: Essays on New York City*. New York: Russell Sage Foundation, 1988.

Monaghan, Frank. *French Travellers in the United States, 1765–1932: A Bibliography*. New York: New York Public Library, 1933; supplement by Samuel J. Marino, N.p., 1961.

Mooney, Thomas. *Nine Years in America . . . in a Series of Letters to His Cousin, Patrick Mooney, a Farmer in Ireland*. 2d ed. Dublin: James McGlashan, 1850.

Moore, N. Hudson. *Old Glass, European and American*. New York: Tudor, 1941.

Morgan, Ann Lee. "The American Audubons: Julius Bien's Lithographed Edition." *Print Quarterly* 4 (December 1987), pp. 362–78.

Morley, John. *The History of Furniture: Twenty-five Centuries of Style and Design in the Western Tradition*. Boston: Little, Brown and Company, 1999.

Morris, Lloyd. *Incredible New York: High Life and Low Life from 1850 to 1950*. New York: Random House, 1951. Reprint, Syracuse: Syracuse University Press, 1996.

Morse, Edward Lind, ed. *Samuel F. B. Morse, His Letters and Journals*. 2 vols. Boston: Houghton Mifflin, 1914.

Morse, John D., ed. *Prints in and of America to 1850*. Sixteenth Winterthur Conference on Museum Operation and Connoisseurship. Charlottesville: University Press of Virginia, 1970.

Morse, Samuel F. B. *Academies of Arts. A Discourse Delivered on Thursday, May 3, 1827, in the Chapel of Columbia College, before the National Academy of Design, on Its First Anniversary*. New York: G. and C. Carvill, 1827.

———. *Examination of Col. Trumbull's Address, in Opposition to the Projected Union of the American Academy of Fine Arts, and the National Academy of Design*. New York: Clayton and Van Norden, 1833.

Mott, Frank Luther. *American Journalism: A History of Newspapers in the United States through 260 Years: 1690 to 1950*. 4 vols. Rev. ed. New York: Macmillan Company, 1950.

———. *A History of American Magazines*. 5 vols. Cambridge, Massachusetts: Harvard University Press, 1938–68.

Moyer, Cynthia. "Conservation Treatments for Border and Freehand Gilding and Bronze-Powder Stenciling and Freehand Bronze." In *Gilded Wood: Conservation and History*, pp. 331–41. Madison, Connecticut: Sound View Press, 1991.

Murdock, Edwin Forrest. "The American Institute." In *A Century of Industrial Progress*, edited by Frederic W. Wile, pp. v–xvi. Garden City: Doubleday, Doran and Company, 1928.

Murray, Amelia M. *Letters from the United States, Cuba, and Canada*. New York: G. P. Putnam and Company, 1856.

Muthesius, Stefan. "Why Do We Buy Old Furniture? Aspects of the Authentic Antique in Britain, 1870–1910." *Art History* 11 (June 1988), pp. 231–54.

Myers, Andrew B., ed., *The Knickerbocker Tradition: Washington Irving's New York*. Tarrytown: Sleepy Hollow Restorations, 1974.

Myers, Kenneth. *The Catskills: Painters, Writers, and Tourists in the Mountains, 1820–1895.* Exh. cat. Yonkers: Hudson River Museum of Westchester, 1987.

Nadel, Stanley. *Little Germany: Ethnicity, Religion, and Class in New York City, 1845–80.* Urbana: University of Illinois Press, 1990.

National Academy of Design. *Catalogue of Statues, Busts, Studies, etc., Forming the Collection of the Antique School of the National Academy of Design.* New York: Israel Sackett, 1846.

The National Cyclopaedia of American Biography. New York: James T. White and Company, 1892–1984.

Nevins, Allan, ed. *American Social History as Recorded by British Travellers.* New York: Henry Holt and Company, 1931.

———. *America through British Eyes.* Gloucester, Massachusetts: Peter Smith, 1968.

Newlin, Alice. "Asher B. Durand, American Engraver." *Metropolitan Museum of Art Bulletin,* n.s., 1 (January 1943), pp. 165–70.

Newman, Harry S. *Best Fifty Currier & Ives Lithographs, Large Folio Size.* New York: Old Print Shop, 1938.

Newton, Roger Hale. *Town & Davis, Architects: Pioneers in American Revivalist Architecture, 1812–1870, Including a Glimpse of Their Times and Their Contemporaries.* New York: Columbia University Press, 1942.

The New-York Book of Prices for Manufacturing Cabinet and Chair Work. New York: Printed by J. Seymour, 1817; New York: Printed by Harper and Brothers, 1834.

New-York Historical Society. *Catalogue of American Portraits in the New-York Historical Society.* 2 vols. New Haven: Yale University Press for The New-York Historical Society, 1974.

New York Public Library. "The Eno Collection of New York City Views." *New York Public Library Bulletin* 29 (May 1925), pp. 327–54, 385–414.

Nicholson, Peter. *The New Practical Builder and Workman's Companion.* 2 vols. London: Thomas Kelly, 1823–25.

Nicholson, Peter, and Michael Angelo Nicholson. *The Practical Cabinet-Maker, Upholsterer, and Complete Decorator.* London: H. Fisher, Son, and Company, 1826.

Nissenbaum, Stephen. *The Battle for Christmas.* New York: Alfred A. Knopf, 1996.

Noble, Louis Legrand. *Church's Painting: The Heart of the Andes.* New York: D. Appleton and Company, 1859.

———. *The Course of Empire, Voyage of Life, and Other Pictures of Thomas Cole, N.A., with Selections from His Letters and Miscellaneous Writings: Illustrative of His Life, Character, and Genius.* New York: Cornish, Lamport and Company, 1853. Reprint, edited by Elliot S. Vesell, Hensonville, New York: Black Dome Press, 1997.

North, Douglass C., and Robert P. Thomas, eds. *The Growth of the American Economy to 1860.* New York: Harper and Row, 1968.

Nouvel-Kammerer, Odile. *Napoléon III / années 1880.* Le mobilier français. Paris: Éditions Massin, 1996.

Nygren, Edward C. *Views and Visions: American Landscape before 1830.* Exh. cat. Hartford, Connecticut: Wadsworth Atheneum; Washington, D.C.: Corcoran Gallery of Art, 1986.

Nylander, Richard C., Elizabeth Redmond, and Penny J. Sander. *Wallpaper in New England.* Boston: Society for the Preservation of New England Antiquities, 1986.

O'Brien, Maureen C., and Patricia C. F. Mandel. *The American Painter-Etcher Movement.* Exh. cat. Southampton, New York: Parrish Art Museum, 1984.

O'Connell, Shaun. *Remarkable, Unspeakable New York: A Literary History.* Boston: Beacon Press, 1995.

Oettermann, Stephan. *The Panorama: History of a Mass Medium.* Translated by Deborah L. Schneider. New York: Zone Books, 1997.

Official Catalogue of the New-York Exhibition of the Industry of All Nations, 1853. New York: George P. Putnam and Company, 1853.

Official Catalogue of the Pictures Contributed to the Exhibition of the Industry of All Nations, in the Picture Gallery of the Crystal Palace. New York: G. P. Putnam and Company, 1853.

The Old Croton Aqueduct: Rural Resources Meet Urban Needs. Yonkers: Hudson River Museum of Westchester, 1992.

Olyphant, Robert M. *Mr. Robert M. Olyphant's Collection of Paintings by American Artists. . . .* Sale cat. New York: R. Somerville, December 18, 19, 1877.

The Origins of Cast Iron Architecture in America; Including Illustrations of Iron Architecture Made by the Architectural Iron Works of the City of New York, and Cast Iron Buildings, Their Construction and Advantages. New York: Da Capo Press, 1970. Reprint of Badger, *Illustrations of Iron Architecture,* and Bogardus, *Cast Iron Buildings.*

Ormsbee, Thomas H. "Gratitude in Silver for Prosperity." *American Collector* 7 (April 1937), pp. 3, 10–11.

Orosz, Joe. *Curators and Culture: The Museum Movement in America, 1740–1870.* Tuscaloosa: University of Alabama Press, 1990.

Paff, Michael. *Catalogue of the Extensive and Valuable Collection of Pictures, Engravings, and Works of Art . . . Collected by Michael Paff. . . .* Sale cat. New York: A. Levy, Auctioneer, 1838.

Palmer, Arlene. *Glass in Early America: Selections from the Henry Francis du Pont Winterthur Museum.* Winterthur, Delaware: Henry Francis du Pont Winterthur Museum, 1993.

———. *A Guide to Victoria Mansion.* Portland, Maine: Victoria Mansion, 1997.

———. "Gustave Herter's Interiors and Furniture for the Ruggles S. Morse Mansion." *Nineteenth Century* 16 (fall 1996), pp. 3–13.

Palmer, Arlene, and John Quentin Feller. "Christian Dorflinger's Presentation Silver Service." Typescript, 1991.

Panzer, Mary. *Mathew Brady and the Image of History.* Exh. cat. Washington, D.C.: Smithsonian Institution Press for the National Portrait Gallery, 1997.

Papantonio, Michael. *Early American Bookbindings from the Collection of Michael Papantonio.* 2d ed. Worcester, Massachusetts: American Antiquarian Society, 1985.

Parker, Barbara N. "George Harvey and His Atmospheric Landscapes." *Bulletin of the Museum of Fine Arts* (Boston) 41 (February 1943), pp. 7–9.

Parry, Ellwood C., III. *The Art of Thomas Cole: Ambition and Imagination.* Newark: University of Delaware Press, 1988.

———. "Landscape Theater in America." *Art in America* 59 (December 1971), pp. 52–56.

[Paulding, James Kirke] An Amateur. *The New Mirror for Travellers; and Guide to the Springs.* New York: G. and C. Carvill, 1828.

Peck, Amelia, ed. *Alexander Jackson Davis: American Architect, 1803–1892.* Exh. cat. New York: The Metropolitan Museum of Art, in association with Rizzoli, 1992.

Peirce, Donald C. *Art and Enterprise: American Decorative Art, 1825–1917: The Virginia Carroll Crawford Collection.* Exh. cat. Atlanta: High Museum of Art, in association with Antique Collectors' Club, 1999.

Pelletreau, William S. *Early New York Houses (1750–1900) with Historical and Genealogical Notes, in Ten Parts.* New York: Francis P. Harper, 1900.

Penny, Virginia. *How Women Can Make Money, Married or Single, in All Branches of the Arts and Sciences, Professions, Trades, Agricultural and Mechanical Pursuits.* Philadelphia: John E. Potter and Company, 1863. Published also under title *The Employments of Women.* Reprint, New York: Arno Press, 1971.

Pessen, Edward. *Riches, Class, and Power before the Civil War.* Lexington, Massachusetts: D. C. Heath and Company, 1973.

Peters, Harry T. *America on Stone: The Other Printmakers to the American People. A Chronicle of American Lithography Other Than That of Currier & Ives, from Its Beginning, Shortly before 1820, to the Years When the Commercial Single-Stone Hand-Colored Lithograph Disappeared from the American Scene.* Garden City, New York: Doubleday, Doran, and Company, 1931. Reprint, New York: Arno Press, 1976.

———. *Currier & Ives: Printmakers to the American People. A Chronicle of the Firm, and of the Artists and Their Work, with Notes on Collecting; Reproductions of 142 of the Prints and Originals, Forming a Pictorial Record of American Life and Manners in the Last Century; and a Checklist of All Known Prints Published by N. Currier and Currier & Ives.* 2 vols. Garden City, New York: Doubleday, Doran, and Company, 1929–31.

Phelps, H. *Phelps' New-York City Guide and Conductor to Environs for 30 Miles Around: Being a Pocket Directory for Strangers and Citizens to the Prominent Objects of Interest in the Great Commercial Metropolis, and Conductor to Its Environs.*

With the Engravings of Public Buildings. New York: T. C. Fanning, 1852.

———. *Phelps' New York City Guide; Being a Pocket Directory for Strangers and Citizens to the Prominent Objects of Interest in the Great Commercial Metropolis, and Conductor to Its Environs. With Engravings of Public Buildings.* New York: Ensign, Bridgman and Fanning, 1854. Includes a large fold-out pocket map.

———. *What to See and How to See It. Phelps' Stranger's and Citizen's Guide to New-York City, with Maps and Engravings.* New York: Gaylord Watson, 1857.

Phyfe, Duncan. *Peremptory and Extensive Auction Sale of Splendid and Valuable Furniture, on . . . April 16, & 17, . . . at the Furniture Ware Rooms of Messrs. Duncan Phyfe & Son, Nos. 192 & 194 Fulton Street.* Sale cat. New York: Halliday and Jenkins [Edgar Jenkins, Auctioneer], 1847.

Pierce, Sally, with Catharina Slautterback and Georgia Brady Barnhill. *Early American Lithography: Images to 1830.* Exh. cat. Boston: Boston Athenaeum, 1997.

Pierson, William H., Jr. *American Buildings and Their Architects.* Vol. 1: *The Colonial and Neoclassical Styles.* Vol. 2: *Technology and the Picturesque: The Corporate and the Early Gothic Styles.* Garden City, New York: Doubleday, 1970, 1978.

Plunz, Richard. *A History of Housing in New York City: Dwelling Type and Social Change in the American Metropolis.* New York: Columbia University Press, 1990.

Pocock, William. *Designs for Churches and Chapels, of Various Dimensions and Styles; Consisting of Plans, Elevations, and Sections, with Estimates: Also Some Designs for Altars, Pulpits, and Steeples.* London: J. Taylor, 1819; [2d ed.], 1824.

Poe, Edgar Allan. *Doings of Gotham, as Described in a Series of Letters to the Editors of "The Columbia Spy" Together with Various Editorial Comments and Criticisms by Poe, also a Poem Entitled "New Year's Address of the Carriers of the Columbia Spy."* Edited by Jacob E. Spannuth and Thomas Ollive Mabbott. Pottsville, Pennsylvania: Jacob E. Spannuth, 1929.

———. *The Literati, Some Honest Opinions about Autorial Merits and Demerits, with Occasional Words of Personality; Together with Marginalia, Suggestions, and Essays.* New York: J. S. Redfield; Boston: B. B. Mussey and Company, 1850.

Pollack, Jodi A. "Three Generations of Meeks Craftsmen, 1797–1869: A History of Their Business and Furniture." Master's thesis, Cooper-Hewitt, National Design Museum, and Parsons School of Design, 1998.

Porter, Glenn, and Harold C. Livesay. *Merchants and Manufacturers: Studies in the Changing Structure of Nineteenth-Century Marketing.* Baltimore: Johns Hopkins University Press, 1971.

Power, Tyrone. *Impressions of America; during the Years 1833, 1834, and 1835.* 2d ed. 2 vols. Philadelphia: Carey, Lea, and Blanchard, 1836.

Prime, Samuel Irenaeus. *The Life of Samuel F. B. Morse, LL.D., Inventor of the Electro-magnetic Recording Telegraph.* New York: D. Appleton and Company, 1875.

Prime, William Cowper. *Boat Life in Egypt and Nubia.* New York: Harper and Brothers, 1857.

———. *Coins, Medals, and Seals, Ancient and Modern Illustrated and Described: With a Sketch of the History of Coins and Coinage, Instructions for Young Collectors, Tables of Comparative Rarity, Price Lists of English and American Coins, Medals and Tokens, &c., &c.* New York: Harper and Brothers, 1861.

———. *The Little Passion of Albert Dürer.* New York: J. W. Bouton, 1868.

———. *Pottery and Porcelain of All Times and Nations with Tables of Factory and Artists' Marks for the Use of Collectors.* New York: Harper and Brothers, 1878.

———. *Tent Life in the Holy Land.* New York: Harper and Brothers, 1857.

Pugin, A. W. N. *The True Principles of Pointed or Christian Architecture Set Forth in Two Lectures Delivered at St. Marie's, Oscott.* London: J. Weale, 1841.

Pugin, Augustus Charles. *Gothic Furniture: Consisting of Twenty-Seven Coloured Engravings from Designs by A. Pugin, with Descriptive Letter-Press.* London: R. Ackermann, [1828].

Pursell, Carroll W. *The Machine in America: A Social History of Technology.* Baltimore: Johns Hopkins University Press, 1995.

Purtell, Joseph. *The Tiffany Touch.* New York: Random House, 1971.

[Putnam, George P.] *The Tourist in Europe: or, A Concise Summary of the Various Routes, Objects of Interest, &c. in Great Britain, France, Switzerland, Italy, Germany, Belgium, and Holland; with Hints on Time, Expenses, Hotels, Conveyances, Passports, Coins, &c.; Memoranda during a Tour of Eight Months in Great Britain and on the Continent.* New York: Wiley and Putnam, 1838.

Quimby, Ian M. G., with Dianne Johnson. *American Silver at Winterthur.* Winterthur, Delaware: The Henry Francis du Pont Winterthur Museum, 1995.

Quimby, Maureen O'Brien, and Jean Woollens Fernald. "A Matter of Taste and Elegance: Admiral Samuel Francis Du Pont and the Decorative Arts." *Winterthur Portfolio* 21 (summer/autumn 1986), pp. 103–32.

Rainey, Sue, and Mildred Abraham. *Embellished with Numerous Engravings: The Works of American Illustrators and Wood Engravers, 1670–1880. . . .* Exh. cat. Charlottesville: University of Virginia Library, 1986.

Rainwater, Dorothy T., and Judy Redfield. *Encyclopedia of American Silver Manufacturers.* 4th ed. Atglen, Pennsylvania: Schiffer Publishing, 1998.

Reaves, Wendy Wick, ed. *American Portrait Prints: Proceedings of the Tenth Annual Print Conference.* Charlottesville: University Press of Virginia, for the National Portrait Gallery, Smithsonian Institution, 1984.

Rebora, Carrie. "The American Academy of the Fine Arts, New York, 1802–1842." 2 vols. Ph.D. dissertation, City University of New York, 1990.

———. "Robert Fulton's Art Collection." *American Art Journal* 22, no. 3 (1990), pp. 41–63.

Redmond, Elizabeth. "American Wallpaper, 1840–1860: The Limited Impact of Early Machine Printing." Master's thesis, University of Delaware, Newark, 1987.

Reese, William S. *Stamped with a National Character: Nineteenth Century American Color Plate Books.* Exh. cat. New York: Grolier Club, 1999.

Reilly, Bernard F., Jr. *American Political Prints, 1766–1876: A Catalog of the Collections in the Library of Congress.* Boston: G. K. Hall and Co., 1991.

Reps, John W. *Bird's Eye Views. Historic Lithographs of North American Cities.* New York: Princeton Architectural Press, 1998.

———. *Views and Viewmakers of Urban America: Lithographs of Towns and Cities in the United States and Canada, Notes on the Artists and Publishers, and a Union Catalog of Their Work, 1825–1925.* Columbia: University of Missouri Press, 1984.

Resseguie, Harry E. "Alexander Turney Stewart and the Department Store." *Business History Review* 39 (1965), pp. 301–22.

———. "Stewart's Marble Palace—the Cradle of the Department Store." *New-York Historical Society Quarterly* 48 (April 1964), pp. 130–62.

Reynolds, David S. *Beneath the American Renaissance: The Subversive Imagination in the Age of Emerson and Melville.* New York: Alfred A. Knopf, 1988.

———. *Walt Whitman's America: A Cultural Biography.* New York: Alfred A. Knopf, 1995.

Reynolds, Donald M. *Monuments and Masterpieces: Histories and Views of Public Sculpture in New York City.* New York: Macmillan Publishing Company; London: Collier Macmillan, 1988.

Richards, William C. *A Day in the New York Crystal Palace and How to Make the Most of It; Being a Popular Companion to the Official Catalogue and a Guide to All the Objects of Special Interest in the New York Exhibition of the Industry of All Nations.* New York: G. P. Putnam and Company, 1853.

Richardson, Edgar P. "The Cassin Medal." *Winterthur Portfolio* 4 (1968), pp. 80–81.

Richmond, John Frances. *New York and Its Institutions, 1609–1872.* New York: E. B. Treat, 1872.

Roberson, Samuel A., and William H. Gerdts. "The Greek Slave." *The Museum* (Newark), n.s., 17 (winter–spring 1965), pp. 1–30.

Rock, Howard B. *Artisans of the New Republic: The Tradesmen of New York in the Age of Jefferson.* New York: New York University Press, 1979.

———. *The New York City Artisan, 1789–1825: A Documentary History.* Albany: State University of New York Press, 1989.

Rock, Howard B., Paul A. Gilje, and Robert Asher, eds. *American Artisans: Crafting Social Identity, 1750–1850.* Baltimore: Johns Hopkins University Press, 1995.

Romaine, Lawrence B. *A Guide to American Trade Catalogs, 1744–1900.* New York: Bowker, 1960.

Roorback, Oliver A., comp. *Biblioteca Americana: A Catalogue of American Publications, Including Reprints and Original Works, from 1820–1852 and 1852–1861.* 4 vols. New York: Peter Smith, 1939.

Root, Marcus A. *The Camera and the Pencil; or, The Heliographic Art. . . .* Philadelphia: M. A. Root, 1864. Reprint, Pawlet, Vermont: Helios, 1971.

Rose, Anne C. *Voices of the Marketplace: American Thought and Culture, 1830–1860.* New York: Twayne Publishing, 1995.

Rosen, Christine Meisner. "Noisome, Noxious, and Offensive Vapors: Fumes and Stenches in American Towns and Cities, 1840–1865." *Historical Geography* 25 (1997), pp. 67–82.

Rosenwaike, Ira. *Population History of New York City.* Syracuse: Syracuse University Press, 1972.

Rosenzweig, Roy, and Elizabeth Blackmar. *The Park and the People: A History of Central Park.* Ithaca, New York: Cornell University Press, 1992.

Ross, Ishbel. *Crusades and Crinolines: The Life and Times of Ellen Curtis Demorest and William Jennings Demorest.* New York: Harper and Row, 1963.

Ross, Joel H. *What I Saw in New York; or, A Bird's Eye View of City Life.* Auburn, New York: Derby and Miller, 1851.

Roux, Alexander. *Catalogue of Rich Cabinet Furniture Comprising a Large and Rich Assortment of Rosewood, Walnut, Oak, Buhl, and Marqueterie, at Alex. Roux & Co., 479 Broadway. . . .* Sale cat. New York: Henry H. Leeds and Co., November 11–12, 1857.

Royall, Anne. *Sketches of History, Life, and Manners in the United States, by a Traveller.* New Haven: Printed for the author, 1826.

Roylance, Dale. *American Graphic Arts. A Chronology to 1900 in Books, Prints, and Drawings.* Princeton: Princeton University Library, 1990.

Roylance, Dale, and Nancy Finlay. *Pride of Place. Early American Views from the Collection of Leonard L. Milberg '53.* Princeton: Princeton University Library, 1983.

Ruskin, John. *Modern Painters.* 5 vols. London: Smith, Elder, and Company, 1843–60.

Rutledge, Anna Wells. "William John Coffee as a Portrait Sculptor." *Gazette des Beaux-Arts,* ser. 6, 28 (November 1945), pp. 297–312.

Ryan, Mary P. *Civic Wars: Democracy and Public Life in the American City during the Nineteenth Century.* Berkeley: University of California Press, 1997.

Sabin, Joseph. *A Catalogue of the Books, Autographs, Engravings, and Miscellaneous Articles Belonging to the Estate of the Late John Allan.* Sale cat. New York, 1864.

———. *Catalogue of the . . . Collection of . . . the Late Mr. E. B. Corwin.* Sale cat. New York: Bangs, Brother and Company, November 10, 1856.

Sabin, Joseph, and Wilberforce Eames. *A Dictionary of Books Relating to America, from Its Discovery to the Present Time.* 29 vols. New York: J. Sabin; New York: Bibliographical Society of America; Portland, Maine, 1868–92, 1927–36.

Santé, Luc. *Low Life: Lures and Snares of Old New York.* New York: Farrar Straus Giroux, 1991.

Sarmiento, Domingo Faustino. *Sarmiento's Travels in the United States in 1847.* Translated by Michael Aaron Rockland. Princeton: Princeton University Press, 1970.

Schaffner, Cynthia Van Allen. "Secrets and 'Receipts': American and British Furniture Finishers' Literature, 1790–1880." Master's thesis, Cooper-Hewitt, National Design Museum, and Parsons School of Design, New York, 1999.

Schaffner, Cynthia Van Allen, and Susan Klein. *American Painted Furniture, 1790–1880.* New York: Clarkson Potter Publishers, 1997.

Schofield, Robert E. "The Science Education of an Enlightened Entrepreneur: Charles Willson Peale and His Philadelphia Museum, 1784–1827." *American Studies* 30 (fall 1989), pp. 21–40.

Schultz, Ronald. *The Republic of Labor: Philadelphia Artisans and the Politics of Class, 1720–1830.* New York: Oxford University Press, 1993.

Schuyler, David. *Apostle of Taste: Andrew Jackson Downing, 1815–1852.* Baltimore: Johns Hopkins University Press, 1996.

———. *The New Urban Landscape: The Redefinition of City Form in Nineteenth-Century America.* Baltimore: Johns Hopkins University Press, 1986.

Schwind, Arlene Palmer. "Joseph Baggott, New York Glasscutter." *Glass Club Bulletin of the National Early American Glass Club,* no. 142 (fall 1984–winter 1985), pp. 9–13.

Scoville, J[oseph] A. *The Old Merchants of New York, by Walter Barrett, Clerk.* 5 vols. in 3 parts. New York: Carleton; M. Doolady, 1864–70.

Scully, Arthur, Jr. *James Dakin, Architect: His Career in New York and the South.* Baton Rouge: Louisiana State University Press, 1973.

Seager, Robert, II. *And Tyler Too, A Biography of John and Julia Gardiner Tyler.* New York: McGraw-Hill Book Company, 1963.

Second Supplement to the London Chair-Makers' and Carvers' Book of Prices for Workmanship. 2d ed. London: T. Brettell, 1829.

Sellers, Charles Coleman. *Mr. Peale's Museum: Charles Willson Peale and the First Popular Museum of Natural Science and Art.* New York: W. W. Norton, 1980.

Sellers, Charles Grier. *The Market Revolution: Jacksonian America, 1815–1846.* New York: Oxford University Press, 1991.

Severini, Lois. *The Architecture of Finance: Early Wall Street.* Ann Arbor, Michigan: UMI Research Press, 1983.

Shadwell, Wendy. "Genin, the Celebrated Hatter." *Seaport, New York's History Magazine,* spring 1999, pp. 22–27.

Shapiro, Michael Edward. *Bronze Casting and American Sculpture, 1850–1900.* Newark: University of Delaware Press, 1985.

Sharp, Lewis I. *John Quincy Adams Ward: Dean of American Sculpture.* Newark: University of Delaware Press, 1985.

Shaw, Joshua. *Picturesque Views of American Scenery, 1820.* Philadelphia: M. Carey and Son, 1820.

Shelley, Donald A. "George Harvey and His Atmospheric Landscapes of North America." *New-York Historical Society Quarterly* 32 (April 1948), pp. 104–13.

———. "William Guy Wall and His Watercolors for the Historic *Hudson River Portfolio.*" *New-York Historical Society Quarterly* 31 (January 1947), pp. 25–45.

Sheriff, Carol. *The Artificial River: The Erie Canal and the Paradox of Progress, 1817–1862.* New York: Hill and Wang, 1996.

Sill, Geoffrey M., and Roberta K. Tarbell, eds. *Walt Whitman and the Visual Arts.* New Brunswick, New Jersey: Rutgers University Press, 1992.

Silliman, Benjamin. *A Tour to Quebec in the Autumn of 1819.* London: Sir Richard Phillips and Company, 1822.

Silliman, B[enjamin], Jr., and C[harles] R[ush] Goodrich, eds. *The World of Science, Art, and Industry Illustrated from Examples in the New-York Exhibition, 1853–54.* New York: G. P. Putnam and Company, 1854.

Simon, Janice. "*The Crayon,* 1855–1861: The Voice of Nature in Criticism, Poetry, and the Fine Arts." 2 vols. Ph.D. dissertation, University of Michigan, Ann Arbor, 1990.

Singer, Aaron. "Labor Management Relations at Steinway and Sons, 1853–1896." Ph.D. dissertation, Columbia University, New York, 1977.

Sitt, Martina. *Andreas und Oswald Achenbach, "Das A und O der Landschaft."* Exh. cat. Düsseldorf: Kunstmuseums Düsseldorf; Cologne: Wienand Verlag, 1997.

Sizer, Theodore, ed. *The Autobiography of Colonel John Trumbull, Patriot-Artist, 1756–1843.* New Haven: Yale University Press, 1953.

Smith, Dinitia. "Spirit of Christmas Past and Present, All Stuffed into One Man's Collection." Part 2. *New York Times,* December 15, 1999, p. B17.

Smith, George. *A Collection of Designs for Household Furniture and Interior Decoration in the Most Approved and Elegant Taste . . . with Various Designs for Rooms. . . .* London: J. Taylor, 1808.

———. *Smith's Cabinet-Maker and Upholsterer's Guide: Drawing Book, and Repository of New, and Original Designs for Household Furniture and Interior Decoration in the Most Approved and Modern Taste; Including Specimens of the Egyptian, Grecian, Gothic, Arabesque, French, English, and Other Schools of the Art.* London: Jones and Company, 1828.

Smith, Mary Ann. "The Commercial Architecture of John Butler Snook." Ph.D. dissertation, Pennsylvania State University, University Park, 1974.

———. "John Snook and the Design for A. T. Stewart's Store." *New-York Historical Society Quarterly* 58 (January 1974), pp. 18–33.

Smith, Thomas Gordon. *John Hall and the Grecian Style in America: A Reprint of Three Pattern Books Published in Baltimore in 1840.* New York: Acanthus Press, 1996.

———. "Millford Plantation in South Carolina." *Antiques* 151 (May 1997), pp. 732–41.

———. *Neo-Classical Furniture Designs: A Reprint of Thomas King's "Modern Style of Cabinet Work Exemplified," 1829.* New introduction by Thomas Gordon Smith. New York: Dover Publications, 1995.

Snowman, A. Kenneth, ed. *The Master Jewelers.* New York: Harry N. Abrams, 1990.

Soeffing, D. Albert. "Ball, Black & Co. Silverware Merchants." *Silver* 30 (November–December 1998), pp. 44–49.

———. "A Selection of Letters from the Black, Starr & Frost Scrapbooks." *Silver* 29 (November–December 1997), pp. 48–51.

Spafford, Horatio Gates. *A Gazetteer of the State of New-York. . . .* Albany: H. C. Southwick, 1813.

———. *A Gazetteer of the State of New-York.* Albany: B. D. Packard, 1824. Reprint, Interlaken, New York: Heart of the Lakes Publishing, 1981.

Spann, Edward K. "The Greatest Grid: The New York Plan of 1811." In *Two Centuries of American Planning*, edited by Daniel Schaffer. Baltimore: Johns Hopkins University Press, 1988.

———. *Ideals and Politics: New York Intellectuals and Liberal Democracy, 1820–1880.* Albany: State University of New York Press, 1972.

———. *The New Metropolis: New York City, 1840–1857.* New York: Columbia University Press, 1981.

Spaulding, John H. *Historical Relics of the White Mountains. Also, a Concise White Mountain Guide.* Mt. Washington: J. R. Hitchcock, 1855.

Spear, Dorothea N. *Bibliography of American Directories through 1860.* Worcester, Massachusetts: American Antiquarian Society, 1961. Reprint, Westport, Connecticut: Greenwood Press, 1978.

Spillman, Jane Shadel. "Glasses with American Views—Addenda." *Journal of Glass Studies* 22 (1980), pp. 78–81.

———. *Glass from World's Fairs, 1851–1904.* Corning, New York: Corning Museum of Glass, 1986.

———. *White House Glassware: Two Centuries of Presidential Entertaining.* Washington, D.C.: White House Historical Association, 1989.

Spillman, Jane Shadel, and Alice Cooney Frelinghuysen. "The Dummer Glass and Ceramic Factories in Jersey City, New Jersey." *Antiques* 137 (March 1990), pp. 706–17.

Spooner, Shearjashub. *The American Edition of Boydell's Illustrations of the Dramatic Works of Shakespeare, by the Most Eminent Artists of Great Britain. Restored and Published with Original Descriptions of the Plates.* 2 vols. New York: Shearjashub Spooner, 1852.

———. *An Appeal to the People of the United States in Behalf of Art, Artists, and the Public Weal.* New York: J. J. Reed, Printer, 1854.

———. *A Biographical and Critical Dictionary of Painters, Engravers, Sculptors, and Architects, from Ancient to Modern Times; with the Monograms, Ciphers, and Marks Used by Distinguished Artists to Certify Their Works.* New York: G. P. Putnam and Company, 1852.

Staiti, Paul J. *Samuel F. B. Morse.* Cambridge: Cambridge University Press, 1989.

Stanford, Thomas N. *A Concise Description of the City of New York Giving an Account of Its Early History, Public Buildings, Amusements, Exhibitions, Benevolent and Literary Institutions; Together with Other Interesting Information.* New York: The Author, 1814.

Staniland, Kay. *In Royal Fashion: The Clothes of Princess Charlotte of Wales and Queen Victoria, 1796–1901.* London: Museum of London, 1997.

Stansell, Christine. *City of Women: Sex and Class in New York, 1789–1860.* New York: Alfred A.

Knopf, 1986; Urbana: University of Illinois Press, 1987.

Stanton, Phoebe B. *The Gothic Revival and American Church Architecture: An Episode in Taste, 1840–1856.* Baltimore: Johns Hopkins University Press, 1968. Reprint, 1997.

Stapp, William F. "Daguerreotypes onto Stone: The Life and Work of Francis D'Avignon." In *American Portrait Prints: Proceedings of the Tenth Annual American Print Conference*, edited by Wendy Wick Reaves. Charlottesville: University Press of Virginia, for the National Portrait Gallery, Smithsonian Institution, 1984.

Starr, Fellows and Company. *Illustrated Catalogue of Lamps, Gas Fixtures, &c.* New York: Starr, Fellows and Company, 1856.

Stauffer, David McNeely. *American Engravers upon Copper and Steel.* New York: Grolier Club, 1907.

Stebbins, Theodore E., Jr., et al. *Lure of Italy: American Artists and the Italian Experience, 1760–1914.* Exh. cat. Boston: Museum of Fine Arts, in association with Harry N. Abrams, 1992.

Steege, Gwen W. "The *Book of Plans* and the Early Romanesque Revival in the United States: A Study in Architectural Patronage." *Journal of the Society of Architectural Historians* 46 (September 1987), pp. 215–27.

Stefano, Frank, Jr. "James and Ralph Clews, Nineteenth-Century Potters, Part I: The English Experience." *Antiques* 105 (February 1974), pp. 324–28.

Stehle, R. H. "The Düsseldorf Gallery of New York." *New-York Historical Society Quarterly* 63 (October 1974), pp. 305–14.

Stein, Roger. *John Ruskin and Aesthetic Thought in America, 1840–1900.* Cambridge, Massachusetts: Harvard University Press, 1967.

Steiner, Maynard E. "The Brooklyn Flint Glass Company, 1840–1868." *The Acorn, Journal of the Sandwich Glass Museum* 7 (1997), pp. 38–69.

Stephens, Stephen DeWitt. *The Mavericks, American Engravers.* New Brunswick, New Jersey: Rutgers University Press, 1950.

Stevens, Henry. *Recollections of James Lenox and the Formation of His Library.* Edited by Victor H. Paltsits. New York: New York Public Library, 1951.

Stewart, Robert G. *A Nineteenth-Century Gallery of Distinguished Americans.* Exh. cat. Washington, D.C., National Portrait Gallery, Smithsonian Institution, 1969.

Stiles, Henry R. *The Civil, Political, Professional and Ecclesiastical History and Commercial and Industrial Record of the County of Kings and the City of Brooklyn, New York from 1683 to 1884.* New York: W. W. Munsell and Company, 1884.

Still, Bayrd. *Mirror for Gotham: New York as Seen by Contemporaries from Dutch Days to the Present.* New York: New York University Press, 1956. Reprint, New York: Fordham University Press, 1994.

Stillwell, John E. "Thomas J. Bryan—The First Art Collector and Connoisseur in New York City." *New-York Historical Society Quarterly Bulletin* 1 (January 1918), pp. 103–5.

Stokes, I. N. Phelps. *The Iconography of Manhattan Island, 1498–1909, Compiled from Original Sources and Illustrated by Photo-intaglio Reproductions of Important Maps, Plans, Views, and Documents in Public and Private Collections.* 6 vols. New York: Robert H. Dodd, 1915–28. Reprint, Union, New Jersey: Lawbook Exchange; Mansfield Centre, Connecticut: Martino Fine Books, 1998.

Stokes, I. N. Phelps, and Daniel C. Haskell. *American Historical Prints: Early Views of American Cities, etc. From the Phelps Stokes and Other Collections.* New York: New York Public Library, 1933.

Stott, Richard B. "Hinterland Development and Differences in Work Setting: The New York City Region." In *New York and the Rise of American Capitalism: Economic Development and the Social and Political History of an American State, 1780–1870*, edited by William Pencak and Conrad Edick Wright, pp. 45–71. New York: New-York Historical Society, 1989.

———. *Workers in the Metropolis: Class, Ethnicity, and Youth in Antebellum New York City.* Ithaca, New York: Cornell University Press, 1990.

Stradling, Diana, and Ellen Paul Denker. *Jersey City: Shaping America's Pottery Industry, 1825–1892.* Exh. cat. Jersey City, New Jersey: Jersey City Museum, 1997.

The Stranger's Guide around New York and Its Vicinity. What to See and What Is to Be Seen, with Hints and Advice to Those Who Visit the Great Metropolis. New York: W. H. Graham, 1853.

Stranger's Guide to the City and Crystal Palace, with a Full Description of the City of New York, and a Complete History of the American Industrial Exhibition; Its Origin, Inauguration, and Present Appearance. A Work of Universal Interest. New York: Union Book Association, 1853.

Strong, George Templeton. *The Diary of George Templeton Strong.* 4 vols. Edited by Allan Nevins and Milton Halsey Thomas. New York: Macmillan Company, 1952.

Stuart, Mrs. R. L. *Catalogue of Mrs. R. L. Stuart's Collection of Paintings.* New York: Privately printed, 1885.

Stuart-Wortley, Lady Emmeline. *Travels in the United States, etc., during 1849 and 1850.* 3 vols. London: R. Bentley, 1851.

Sturges, Henry C., and Richard Henry Stoddard. *The Poetical Works of William Cullen Bryant.* New York: D. Appleton and Company, 1910.

Sturges, Mrs. Jonathan [Mary Pemberton Cady]. *Reminiscences of a Long Life.* New York: F. E. Parrish and Company, 1894.

Suydam, Frederick Dorflinger. *Christian Dorflinger: A Miracle in Glass.* White Mills, Pennsylvania: Privately printed, 1950.

Suydam, James A. *Catalogue of a Choice Private Library. Being the Collection of the Late Mr. James A. Suydam.* Sale cat. New York: Bangs, Merwin and Company, 1865.

Swope, Jennifer M. "Francis W. Cooper, Silversmith." *Antiques* 155 (February 1999), pp. 290–97.

Sypher, F. J. "Sypher & Co., a Pioneer Antique Dealer in New York." *Furniture History: The*

Journal of the Furniture History Society 28 (1992), pp. 168–79.

Taft, Kendall B. "*Adam and Eve* in America." *Art Quarterly* 22 (summer 1960), pp. 171–79.

Talbot, William S. *Jasper F. Cropsey, 1823–1900*. Ph.D. dissertation, New York University, 1972. Reprint, New York: Garland Publishing, 1977.

Tatham, David, ed. "The Lithographic Workshop, 1825–1850." In *The Cultivation of Artists in Nineteenth-Century America*, edited by Georgia Brady Barnhill, Diana Korzenik, and Caroline F. Sloat, pp. 45–54. Worcester, Massachusetts: American Antiquarian Society, 1997.

———. *Prints and Printmakers of New York State, 1825–1840*. Syracuse: Syracuse University Press, 1986.

Taussig, F. W. *The Tariff History of the United States*. 5th ed., rev., with additional material. New York: G. P. Putnam's Sons, 1900.

Taylor, George Rogers. *The Transportation Revolution*. New York: Rinehart, 1951. Reprint, Armonk, New York: M. E. Sharpe, 1989.

Taylor, J. Bayard. *Views A-Foot; or, Europe Seen with Knapsack and Staff*. New York: Wiley and Putnam, 1846.

Thistlethwaite, F. "The Atlantic Migration of the Pottery Industry." *Economic History Review* 11 (December 1958), pp. 264–78.

Thom, J. *Exhibition. Tam O'Shanter, Souter Johnny, and the Landlord and Landlady, Executed in Hard Ayrshire Stone, by the Self-taught Artist, Mr. J. Thom*. New York, [1833?].

Thompson, Ralph. *American Literary Annuals and Gift Books*. New York: H. W. Wilson Company, 1936.

Thomson, William. *A Tradesman's Travels in the United States and Canada in the Years 1840, 41, and 42*. Edinburgh: Oliver and Boyd, 1842.

Thornwell, Emily. *The Lady's Guide to Perfect Gentility, in Manners, Dress, and Conversation, in the Family, in Company, at the Piano Forte, the Table, in the Street, and in Gentlemen's Society. Also a Useful Instructor in Letter Writing, Toilet Preparations, Fancy Needlework, Millinery, Dressmaking, Care of Wardrobe, the Hair, Teeth, Hands, Lips, Complexion, etc.* New York: Derby and Jackson, 1858.

Thorp, Margaret Farrand. *The Literary Sculptors*. Durham, North Carolina: Duke University Press, 1965.

Tiffany, Young and Ellis. *Catalogue of Useful and Fancy Articles, Imported by Tiffany, Young & Ellis*. New York, 1845.

de Tocqueville, Alexis. *Democracy in America*. Edited by P. Bradley. 2 vols. New York: Alfred A. Knopf, 1945.

———. *Journey to America*. Edited by J. P. Mayer. New Haven: Yale University Press, 1960.

Tolles, Thayer, ed. *American Sculpture in The Metropolitan Museum of Art. Volume I: A Catalogue of Works by Artists Born before 1865*. New York: The Metropolitan Museum of Art, 1999.

Tomasko, Mark D. *Security for the World: Two Hundred Years of American Bank Note Company*. Exh. cat. New York: Museum of American Financial History, 1995.

Tooker, Elva. *Nathan Trotter, Philadelphia Merchant, 1787–1853*. Cambridge, Massachusetts: Harvard University Press, 1955.

Torres, Louis. "John Frazee and the New York Custom House." *Journal of the Society of Architectural Historians* 23 (October 1964), pp. 143–50.

Torrielli, Andrew J. *Italian Opinion on America as Revealed by Italian Travellers, 1850–1900*. Cambridge, Massachusetts: Harvard University Press, 1941.

Town, Ithiel. *The Outlines of a Plan for Establishing in New-York, an Academy and Institution of the Fine Arts on Such a Scale as Is Required by the Importance of the Subject, and the Wants of a Great and Growing City, the Constant Resort of an Immense Number of Strangers from All Parts of the World. The Result of Some Thoughts on a Favorite Subject*. New York: George F. Hopkins and Son, 1835.

Tracy, Berry, and William Gerdts. *Classical America, 1815–1845*. Exh. cat. Newark: Newark Museum, 1963.

Trollope, Mrs. [Frances]. *Domestic Manners of the Americans*. London: Whittaker, Treacher and Company; New York, reprinted for the booksellers, 1832.

Trumbull, John. *Address Read before the Directors of the American Academy of the Fine Arts, January 28th, 1833*. New York: N. B. Holmes, 1833.

———. *Autobiography, Reminiscences and Letters of John Trumbull, from 1756 to 1841*. New York: Wiley and Putnam, 1841.

———. *Letters Proposing a Plan for the Permanent Encouragement of the Fine Arts, by the National Government, Addressed to the President of the United States*. New York: Printed by William Davis Jr., 1827. Reprint, New York: Olana Gallery, 1973.

Tryon, Warren S., ed. *A Mirror For Americans: Life and Manners in the United States, 1790–1870 As Recorded by American Travelers*. Vol. 1, *Life in the East*. Chicago: University of Chicago Press, 1952.

Tuckerman, Henry T. *America and Her Commentators with a Critical Sketch of Travel in the United States*. New York: Charles Scribner, 1864. Reprint, New York: Augustus M. Kelley, 1970.

———. *Book of the Artists, American Artist Life, Comprising Biographical and Critical Sketches of American Artists: Preceded by an Historical Account of the Rise and Progress of Art in America*. New York: G. P. Putnam and Son; London: Sampson Low and Company, 1867. Reprint, New York: James F. Carr, 1967.

———. *The Italian Sketch Book*. 3d ed., revised and enlarged. New York: J. C. Riker, 1848. First edition published anonymously, Philadelphia, 1835.

Turner, Justin G., and Linda Levitt Turner. *Mary Todd Lincoln: Her Life and Letters*. New York: Alfred A. Knopf, 1972. Reprint, New York: Fromm International, 1987.

The Twenty-third Annual Report of the Board of Directors of the Mercantile Library Association, Clinton Hall, New York, January, 1844. New York: Printed by George W. Wood, 1844.

Ulmann, Albert. *Maiden Lane: The Story of a Single Street*. New York: Maiden Lane Historical Society, 1931.

United States Commercial Register Containing Sketches of the Lives of Distinguished Merchants, Manufacturers, and Artisans with an Advertising Directory at Its Close. New York: George Prior, 1851.

Upjohn, Everard M. *Richard Upjohn: Architect and Churchman*. New York: Columbia University Press, 1939.

———. *Richard Upjohn and American Architecture*. New York: Columbia University Press, 1939.

Upton, Dell. "Another City: The Urban Cultural Landscape in the Early Republic." In *Everyday Life in the Early Republic*, edited by Catherine E. Hutchins. Winterthur, Delaware: Henry Francis du Pont Winterthur Museum, 1994.

———. "The City as Material Culture." In *The Art and Mystery of Historical Archaeology: Essays in Honor of James Deetz*, edited by Anne E. Yentsch and Mary C. Beaudry. Boca Raton, Florida: CRC Press, 1992.

———. "Lancasterian Schools, Republican Citizenship, and the Spatial Imagination in Early Nineteenth-Century America." *Journal of the Society of Architectural Historians* 55 (September 1996), pp. 238–53.

———. "Pattern Books and Professionalism: Aspects of the Transformation of American Domestic Architecture, 1800–1860." *Winterthur Portfolio* 19 (summer/autumn 1984), pp. 107–50.

Vail, R. W. G. *Knickerbocker Birthday: A Sesqui-Centennial History of the New-York Historical Society, 1804–1954*. New York: New-York Historical Society, 1954.

———. "More Storied Windows." *New-York Historical Society Quarterly* 37 (January 1953), pp. 55–58.

———. "Storied Windows Richly Delight." *New-York Historical Society Quarterly* 36 (April 1952), pp. 149–59.

Valentine, David T. *Valentine's Manuals: A General Index to the Manuals of the Corporation of the City of New York, 1841–1870*. Reprinted from 1906 and 1900 editions. Compiled by Otto Hufeland and Richard Hoe Lawrence Harrison. New York: Harbor Hill Books, 1981.

Vance, William J. *America's Rome*. Vol. 1: *Classical Rome*. New Haven: Yale University Press, 1989.

Van Zandt, Roland. *Chronicle of the Hudson: Three Centuries of Travel and Adventure*. 2d ed. Hensonville, New York: Black Dome Press, 1992.

Venable, Charles L. "Germanic Craftsmen and Furniture Design in Philadelphia, 1820–1850." In *American Furniture 1998*, edited by Luke Beckerdite, pp. 41–80. Hanover, New Hampshire: University Press of New England for the Chipstone Foundation, 1998.

———. *Silver in America, 1840–1940: A Century of Splendor*. Exh. cat. Dallas: Dallas Museum of Art, 1995.

Voorsanger, Catherine Hoover. "Gustave Herter: Cabinetmaker and Decorator." *Antiques* 147 (May 1995), pp. 740–51.

Voorst tot Voorst, J. M. W. van. *Tussen Biedermeier en Berlage: Meubel en Interieur in Nederland, 1835–1895*. 2d ed. 2 vols. Amsterdam: De Bataafsche Leeuw, 1994.

Vose, Arthur W. *The White Mountains*. Barre, Massachusetts: Barre Publishers, 1968.

Voss, Frederick S., with Dennis Montagna and Jean Henry. *John Frazee, 1790–1852, Sculptor*. Exh. cat. Washington, D.C.: National Portrait Gallery, Smithsonian Institution; Boston: Boston Athenaeum, 1986.

Wainwright, Clive. "The Dark Ages of Art Revived, or Edwards and Roberts and the Regency Revival." *Connoisseur* 198 (1978), pp. 95–105.

Wainwright, Nicholas B., ed. *A Philadelphia Perspective: The Diary of Sidney George Fisher Covering the Years 1834–1871*. Philadelphia: Historical Society of Pennsylvania, 1967.

Waldron, Raymond S., Jr. "The Interior of Litchfield Mansion." *Park Slope Civic Council, Civic News* 29, no. 4 (April 1966), pp. 20–21.

Walker, Alexander. *Woman Physiologically Considered, as to Mind, Morals, Marriage, Matrimonial Slavery, Infidelity and Divorce*. New York: N.p., 1843.

Walker, Mack. *Germany and the Emigration, 1816–1885*. Cambridge, Massachusetts: Harvard University Press, 1964.

Wall, Diana diZerega. "The Separation of the Home and Workplace in Early Nineteenth-Century New York City." *American Archeology* (Albuquerque) 5, no. 3 (1985), pp. 185–89.

Wall, William Guy, and John Hill. *The Hudson River Portfolio: Views from the Drawings by W. G. Wall*. New York: Henry J. Megarey, 1821–25.

Wallace, David H. *John Rogers: The People's Sculptor*. Middletown, Connecticut: Wesleyan University Press, 1967.

Wallace, Marcia B. "The Great Bear and the Prince of Evil Spirits: The American Response to J. M. W. Turner before the Advent of John Ruskin." 2 vols. Ph.D. dissertation, City University of New York, 1993.

Wallach, Alan. "Long-Term Visions, Short-Term Failures: Art Institutions in the United States, 1800–1860." In *Art in Bourgeois Society, 1790–1850*, edited by Andrew Hemingway and William Vaughan, pp. 297–313. Cambridge: Cambridge University Press, 1998.

———. "Thomas Cole and the Aristocracy." *Arts Magazine* 56 (November 1981), pp. 94–106.

Wallach, Alan, and William H. Truettner, eds. *Thomas Cole: Landscape into History*. Exh. cat. Washington, D.C.: National Museum of American Art, Smithsonian Institution; New Haven: Yale University Press, 1994.

Wallis, George. *New York Industrial Exhibition: Special Report of Mr. George Wallis, Presented to the House of Commons by Command of Her Majesty, 1854*. London: Harrison and Son, 1854.

Ward, Gerald W. R., ed. *The American Illustrated Book in the Nineteenth Century*. Winterthur, Delaware: Henry Francis du Pont Winterthur Museum, 1987.

Warren, David B., Katherine S. Howe, and Michael K. Brown. *Marks of Achievement: Four Centuries of American Presentation Silver*. Exh. cat. Houston: Museum of Fine Arts, 1987.

Waters, Deborah Dependahl, ed. *Elegant Plate: Three Centuries of Precious Metals in New York City, Museum of the City of New York*. Essays by Kristan H. McKinsey, Gerald W. R. Ward, and Deborah Dependahl Waters. New York: Museum of the City of New York, 2000.

———. "From Pure Coin: The Manufacture of American Silver Flatware, 1800–1860." *Winterthur Portfolio* 12 (1977), pp. 19–33.

———. *A Treasury of New York Silver*. Exhibition Checklist. New York: Museum of the City of New York and the New York Silver Society, 1994.

Watson, John F. *Annals and Occurrences of New York City and State, in the Olden Time Being a Collection of Memoirs, Anecdotes, and Incidents Concerning the City, County, and Inhabitants from the Days of the Founders: Intended to Preserve the Recollections of Olden Time, and to Exhibit Society in Its Changes of Manners and Customs, and the City and Country in Their Local Changes and Improvements. Embellished with Pictorial Illustrations*. Philadelphia: H. F. Anners, 1846.

———. *Annals of Philadelphia, Being a Collection of Memoirs, Anecdotes, and Incidents of the City and Its Inhabitants from the Days of the Pilgrim Founders. Intended to Preserve the Recollections of Olden Time, and to Exhibit Society in Its Changes of Manners and Customs, and the City in Its Local Changes and Improvements. To Which Is Added an Appendix, Containing Olden Time Researches and Reminiscences of New York City. By John F. Watson, Member of the Historical Society of Pennsylvania*. Philadelphia: E. L. Carey and A. Hart; New York: G. & C. & H. Carvill, 1830.

———. *Annals of Philadelphia and Pennsylvania in the Olden Time*. 2d ed. Philadelphia: J. B. Lippincott, 1868.

Weale, John. *Chippendale's One Hundred and Thirty-three Designs of Interior Decorations in the Old French and Antique Styles: For Carvers, Cabinet Makers, Ornamental Painters, Brass Workers, Modellers, Chasers, Silversmiths, General Designers, and Architects*. London: J. Weale, 1834.

Webster, J. Carson. *Erastus D. Palmer*. Newark: University of Delaware Press, 1983.

Weeks, Lyman H., ed. *Prominent Families of New York: Being an Account in Biographical Form of Individuals and Families Distinguished as Representatives of the Social, Professional, and Civic Life of New York City*. New York: Historical Company, 1897.

Wegmann, Edward. *The Water-Supply of the City of New York, 1658–1895*. New York: J. Wiley and Sons, 1896.

Weisberg, Gabriel. *Rosa Bonheur: All Nature's Children*. Exh. cat. New York: Dahesh Museum, 1998.

Weisman, Winston. "Commercial Palaces of New York: 1845–1875." *Art Bulletin* 36 (December 1954), pp. 285–302.

Weiss, Ila. *Poetic Landscape: The Art and Experience of Sanford R. Gifford*. Newark: University of Delaware Press, 1987.

Weitenkampf, Frank. *American Graphic Art*. Rev. ed. New York: Macmillan Company, 1924. Reprint, with a new introduction by E. Maurice Bloch, New York: Johnson Reprint Corporation, 1970.

———. "F. O. C. Darley, American Illustrator." *Art Quarterly* 10 (March 1947), pp. 100–113.

Weld, Charles Richard. *A Vacation Tour in the United States and Canada*. London: Longman, Brown, Green, and Longmans, 1855.

[White, Richard Grant]. *Catalogue of the Bryan Gallery of Christian Art, from the Earliest Masters to the Present Time*. New York: George F. Nesbitt and Company, 1852.

———. *Companion to the Bryan Gallery of Christian Art: Containing Critical Descriptions of the Pictures, and Biographical Sketches of the Painters; with an Introductory Essay, and an Index*. New York: Baker, Godwin and Company, 1853.

White, Shane. *Somewhat More Independent: The End of Slavery in New York City, 1770–1810*. Athens: University of Georgia Press, 1991.

Whiteman, George. "The Beginnings of Furnishing with Antiques." *Antique Collector* 43 (February 1972), pp. 21–28.

The White Mountains: Place and Perceptions. Exh. cat. Durham: University Art Galleries, University of New Hampshire, 1980.

Whitman, Walt. *I Sit and Look Out: Editorials from the Brooklyn Daily Times by Walt Whitman*, edited by Emory Holloway and Vernolian Schwarz. New York: Columbia University Press, 1932.

———. *Leaves of Grass*. Garden City, New York: Doubleday and Company, 1855.

———. *New York Dissected: A Sheaf of Recently Discovered Newspaper Articles by the Author of Leaves of Grass*. Edited by Emory Holloway and Ralph Adimari. New York: R. R. Wilson, 1936.

Whitworth, Joseph, and George Wallace. *The Industry of the United States in Machinery, Manufactures, and Useful and Ornamental Arts*. London: George Routledge and Company, 1854.

Wilentz, Sean. "Artisan Republican Festivals and the Rise of Class Conflict in New York City, 1788–1837." In *Working-Class America: Essays on Labor, Community, and American Society*, edited by Michael H. Frisch and Daniel J. Walkowitz, pp. 37–77. Urbana: University of Illinois Press, 1983.

———. *Chants Democratic: New York City and the Rise of the American Working Class, 1788–1850*. New York: Oxford University Press, 1984.

Wilk, Christopher, ed. *Western Furniture, 1350 to the Present Day, in the Victoria and Albert Museum*. New York: Cross River Press, 1996.

Willey, Benjamin G. *Incidents in White Mountain History: Containing Facts Relating to the Discovery and Settlement of the Mountains, Indian History and Traditions, a Minute and Authentic Account of the Destruction of the Willey Family, Geology and Temperature of the Mountains; Together with Numerous Anecdotes Illustrating Life in the Back Woods*. [3d] ed. Boston: Nathaniel Noyes; New York: M. W. Dodd;

Cincinnati, Ohio: H. W. Derby; Portland, Maine: Francis Blake, 1856.

Williams, Caroline. "The Place of the New-York Historical Society in the Growth of American Interest in Egyptology." *New-York Historical Society Quarterly Bulletin* 4 (April 1920), pp. 3–20.

Willis, N. P. *Pencillings by the Way* (1836). "First Complete Edition." New York: Morris and Willis, 1844.

Wilmerding, John. *The Artist's Mount Desert: American Painters on the Maine Coast*. Princeton: Princeton University Press, 1994.

———. *Paintings by Fitz Hugh Lane*. Exh. cat. Washington, D.C.: National Gallery of Art, 1988.

Wilson, Derek. *The Astors, 1763–1992: Landscape with Millionaires*. New York: St. Martin's Press, 1993.

Wilson, James Grant, ed. *Memorial History of the City of New-York and the Hudson River Valley: From Its Settlement to the Year 1892*. 4 vols. [New York]: New York History Company, 1892–96.

Wilson, Kenneth M. "Bohemian Influence on 19th Century American Glass." In *Annales du 5ᵉ Congrès International d'Étude Historique du Verre*. Liège: Association Internationale pour l'Histoire du Verre, 1972.

———. *New England Glass and Glassmaking*. New York: Thomas Y. Crowell Company, 1972.

Winthrop, Theodore. *A Companion to The Heart of the Andes*. New York: D. Appleton, 1859.

Witthoft, Brucia. *The Fine-Arts Etchings of James David Smillie, 1833–1909: A Catalogue Raisonné*. Lewiston, New York: Edwin Mellen Press, 1992.

Wolf, Edwin. *From Gothic Windows to Peacocks: American Embossed Leather Bindings, 1825–1855*. Philadelphia: Library Company of Philadelphia, 1990.

Wood, John, ed. *America and the Daguerreotype*. Iowa City: University of Iowa Press, 1991.

Woods, Mary N. *From Craft to Profession: The Practice of Architecture in Nineteenth-Century America*. Berkeley: University of California Press, 1999.

Woods, Nicholas Augustus. *The Prince of Wales in Canada and the United States*. London: Bradbury and Evans, 1861.

Wright, Frances. *Views of Society and Manners in America in a Series of Letters from That Country to a Friend in England during the Years 1818, 1819, 1820*. London: Longman, Hurst, Rees, Orme and Brown, 1822.

Wright, Gwendolyn. *Building the Dream: A Social History of Housing in America*. New York: Pantheon Books, 1981.

Wright, Nathalia. "The Chanting Cherubs: Horatio Greenough's Marble Group for James Fenimore Cooper." *New York History* 38 (April 1957), pp. 177–97.

———. *Horatio Greenough: The First American Sculptor*. Philadelphia: University of Pennsylvania Press, 1963.

———. *Letters of Horatio Greenough, American Sculptor*. Madison: University of Wisconsin Press, 1972.

Wunder, Richard P. *Hiram Powers: Vermont Sculptor, 1805–1873*. Newark: University of Delaware Press, 1991.

Wynne, James. *Private Libraries of New York*. New York: E. French, 1860.

Yarnall, James L., and William H. Gerdts, with Katherine Fox Stewart and Catherine Hoover Voorsanger, comps. *The National Museum of American Art's Index to American Art Exhibition Catalogues: From the Beginning through the 1876 Centennial Year*. Boston: G. K. Hall, 1986.

Zeisloft, E. Idell, ed. *The New Metropolis: Memorable Events of Three Centuries, 1600–1900, from the Island Mana-hat-ta to Greater New York at the Close of the Nineteenth Century*. New York: D. Appleton and Company, 1899.

Zinnkann, Heidrun. *Mainzer Möbelschreiner der ersten Hälfte des 19. Jahrhunderts*. Frankfurt am Main: Schriften des Historischen Museums, 1985.

MANUSCRIPT COLLECTIONS

American Academy of the Fine Arts. Papers. The New-York Historical Society.

American Institute of the City of New York for the Encouragement of Science and Invention.

Records, 1828–1941, including reports of judges and awards of the annual fairs. The New-York Historical Society.

Belter, John Henry. Papers, ca. 1856–ca. 1904. The Winterthur Library, Henry Francis du Pont Winterthur Museum, Winterthur, Delaware.

Chesnut Family. Papers, 1741–1900. South Carolina Historical Society, Charleston, South Carolina.

Colles, James. Papers. Manuscripts and Archives Division, New York Public Library. Henry Metcalf, Colles's grandson organized the papers chronologically and transcribed and translated most, though not all of the correspondence. A selection of the transcribed letters was subsequently edited and published with additional commentary by Emily Johnston de Forest in *James Colles, 1788–1883, Life and Letters* (New York: Privately printed, 1926).

Davis, Alexander Jackson. Collections are in the Department of Drawings and Prints, The Metropolitan Museum of Art, New York; the Avery Architectural and Fine Arts Library, Columbia University, New York; and the Manuscripts and Archives Division, New York Public Library. The Museum of the City of New York and The New-York Historical Society have selected manuscripts and drawings.

Dun, R. G., & Co. Credit ledgers, R. G. Dun & Co. Collection, Baker Library, Harvard University Graduate School of Business Administration, Cambridge, Massachusetts.

Hone, Philip. Diary, 1825–51. Complete manuscript, The New-York Historical Society. Microfilm copy, The Thomas J. Watson Library, The Metropolitan Museum of Art.

Strong, George Templeton. Diary, 1837–75. Complete manuscript, The New-York Historical Society.

Williams-Chesnut-Manning Families. Papers. Manuscripts Division, South Caroliniana Library, University of South Carolina, Columbia, South Carolina. Selected letters are on microfilm and microfiche. See also, Chesnut Family Papers, microfilm edition, 1979, Manuscripts Division, State Historical Society of Wisconsin.

Index

Photograph Credits

© Allen Memorial Art Museum: fig. 37

David Allison: cat. no. 280

Jörg P. Anders: fig. 40

Jörg P. Anders, 1975: fig. 47

© 1999 The Art Institute of Chicago: cat. no. 105

Gavin Ashworth, Courtesy of *The Magazine* ANTIQUES: cat. no. 304

Michael Bodycomb: cat. no. 44

Davis Bohl, Courtesy of *The Magazine* ANTIQUES: fig. 266

Erik Borg 1987: fig. 81

© The British Museum: figs. 42, 43

Nicholas L. Bruen: fig. 211

Richard Caspole, Yale Center for British Art: cat. no. 49

Courtesy of Christie's, Amsterdam: fig. 306

© Chrysler Museum of Art, Norfolk, Va.: cat. nos. 64, 166; fig. 124

© 1999 The Cleveland Museum of Art: fig. 241

© 2000 The Cleveland Museum of Art: figs. 69, 86

A. C. Cooper, © Royal Institute of British Architects: cat. no. 82

© 1989 Dallas Museum of Art: cat. no. 289

© 1993 Dallas Museum of Art: cat. nos. 300, 309

© 1995 Dallas Museum of Art: fig. 100

© 1989 The Detroit Institute of Arts: fig. 76

© 1999 The Detroit Institute of Arts: cat. no. 285

G. R. Farley: fig. 60

G. R. Farley Photography: cat. nos. 90, 91

David Finn: fig. 290

Courtesy of Flomaton Antique Auction, 1999: fig. 213

Matt Flynn: cat. nos. 98, 218

Matt Flynn/Art Resource, N.Y.: fig. 18

Richard Goodbody, 1999/© The Newark Museum: cat. no. 60

Helga Photo Studio: cat. nos. 25, 63, 141, 151, 238, 239, 253, 290, 310; figs. 110, 176

Alt Lee, Courtesy of *The Magazine* ANTIQUES: fig. 233

Schecter Lee: figs. 271, 276

Schecter Lee/Courtesy of The Metropolitan Museum of Art: cat. no. 255

Schecter Lee for The Metropolitan Museum of Art/Courtesy of the Museum of the City of New York: cat. no. 268

Hanz Lorenz of Colonial Williamsburg Foundation, 1992: fig. 232

Melville McLean, Fine Art Photography: cat. no. 249; fig. 234

Maertens: fig. 54

© Manchester City Art Galleries: fig. 46

The Metropolitan Museum of Art, New York, The Photograph Studio: cat. nos. 2, 18, 46, 58, 61, 65, 67, 70, 78, 94, 95, 104, 110–12, 128, 136, 138, 155, 160, 162, 167, 169, 170, 172, 175, 178, 179, 182–84, 196, 201, 208, 222, 226–29, 231, 232, 256, 258, 261, 263, 264, 266, 267, 283, 286, 297; figs. 126, 127, 130, 167, 182, 186, 215, 220, 221, 226, 228, 240, 275

The Metropolitan Museum of Art, New York, The Photograph Studio/ Courtesy of the Museum of the City of New York: cat. nos. 150, 199 (dress and bonnet), 200 (bonnet), 203, 204 (evening gown and headdress), 205 (evening gown, fan, wrap, and headdress), 220, 301

© 1998 Museum Associates, Los Angeles County Museum of Art: cat. no. 34

© 1999 Museum of Fine Arts, Boston: cat. nos. 11, 35, 125, 130, 131, 147, 154, 237; fig. 39

© 2000 Museum of Fine Arts, Boston: cat. no. 23; figs. 64, 65

© 1999 The Museum of Modern Art, New York: fig. 181

© Museum of the City of New York: cat. no. 38; figs. 25, 57, 145, 179, 185, 196, 197, 199, 212

© 2000 Board of Trustees, National Gallery of Art, Washington, D.C.: fig. 84

The Newark Museum/Art Resource, N.Y.: fig. 74

Robert Newcombe/© 1998 The Nelson Gallery Foundation: cat. no. 241; fig. 258

© Collection of the New-York Historical Society: figs. 15 (neg. no. 2684), 44 (neg. no. 36263), 48 (neg. no. 52607), 58 (neg. no. 2090), 59 (neg. no. 6352), 67, 72 (neg. no. 27194), 75 (neg. no. 41267), 91–95, 115 (neg. no. 1025), 117 (neg. no. 26115), 120 (neg. no. 26153), 129 (neg. no. 73286), 141 (neg. no. 47399T), 151 (neg. no. 73287), 183 (neg. no. 26134), 187 (neg. no. 26131), 188 (neg. no. 26143), 189 (neg. no. 26142), 195 (neg. no. 60778), 209 (neg. no. 73292), 217 (neg. no. 26140), 223 (neg. no. 26120), 274 (neg. no. 6252), 278 (neg. no. 23279), 297 (neg. no. 43251)

©The New-York Historical Society: cat. nos. 7, 27, 40, 45, 72 (neg. no. 43759), 96 (neg. no. 52485T), 152, 209

John Parnell: cat. nos. 284, 306; figs. 296, 305

Photo Archives, Bob Lorenzon, Courtesy of T. Augustyn and Paul E. Cohen: fig. 36

© Photo Réunion des Musées Nationaux: fig. 56

Mark Rabinowitz: fig. 118

M. S. Rezny Photography: cat. no. 296

© Royal Institute of British Architects: cat. no. 83

Larry Sanders: cat. no. 245

Courtesy of Sotheby's, New York: cat. no. 230

Lee Stalsworth: cat. no. 101

John Bigelow Taylor: fig. 254

Don Templeton: figs. 11, 21, 128, 134, 135, 236, 238, 245, 279, 280, 284–86, 304

Jerry L. Thompson: cat. nos. 16, 19, 21, 55, 57, 59, 62, 68, 69, 206, 207, 210, 299; figs. 73, 111, 112, 114, 125, 143

Courtesy of Phyllis Tucker Antiques: fig. 307

Richard Walker/© New York State Historical Association, Cooperstown, N.Y.: cat. nos. 28, 282

Scott Wolff, 2000: fig. 119

© Worcester Art Museum: fig. 123

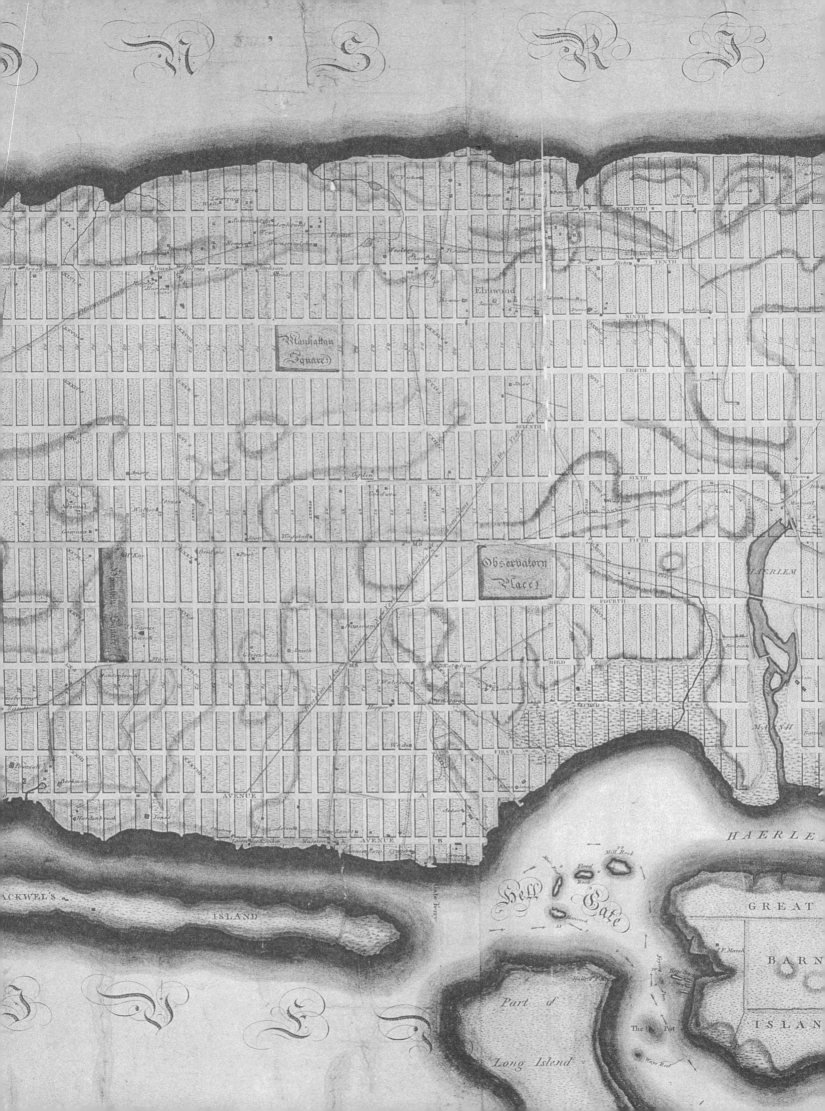